Culture and Values

	file.		
1			
5.3			
- 3.6	1/11/1/1/1/1/1/1/1/1/1/1/1/1/1/1/1/1/1/1	1000	## 1 TO 1 L
			-
16.5			PRINTED IN U.S.A.
	Lit	e, Californi	

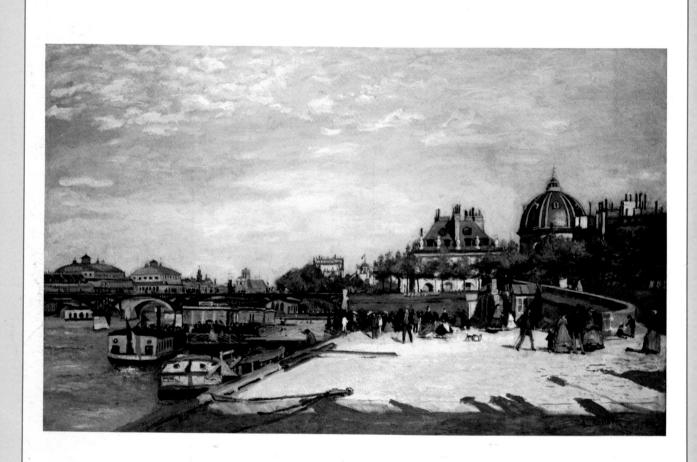

Culture and Values

A SURVEY OF THE WESTERN HUMANITIES

VOLUME II

Lawrence S. Cunningham University of Notre Dame

John J. Reich

CB245 .C86 1990 Cunningham, Lawrence. Culture and values : a survey of the Western humanities

rices. leen Ferguson

York Graphic Services Printing and Binding R. R. Donnelley & Sons

Library of Congress Cataloging-in-Publication Data

Cunningham, Lawrence.

Culture and values: a survey of the Western humanities/Lawrence Cunningham, John Reich.—2nd ed.

p. cm.

Includes bibliographical references.

ISBN 0-03-026589-4 (v. 1).—ISBN 0-03-026592-4 (v. 2) 1. Civilization, Occidental. 2. Europe—Intellectual life.

I. Reich, John. II. Title.

CB245, C86 1990 909'.09821-dc20

89-19989

CIP

ISBN: 0-03-026592-4

Copyright © 1990, 1982 by Holt, Rinehart and Winston, Inc.

All rights reserved. No part of this publication may be reproduced or transmitted in any form or by any means, electronic or mechanical, including photocopy, recording or any information storage and retrieval system, without permission in writing from the publisher.

Requests for permission to make copies of any part of the work should be mailed to: Copyrights and Permissions Department, Harcourt Brace Jovanovich, Inc., Orlando, Florida 32887.

Address Editorial Correspondence to: 301 Commerce Street, Suite 3700, Fort Worth, TX 76102

Address Orders to: 6277 Sea Harbor Drive, Orlando, FL 32887 1-800-782-4479, or 1-800-433-0001 (in Florida)

Printed in the United States of America

1 2 0 3 9 9876543

Harcourt Brace Jovanovich, Inc. The Dryden Press Saunders College Publishing

Literary acknowledgments appear on page 482. Photographic credits appear on pages 483-484.

Preface

In the first edition of this book we set out our aim: to create a readable and reliable textbook for college and university students in the integrated humanities that would satisfy the needs of the students and the standards of their instructors. We hoped to describe the most important landmarks of Western civilization's cultural heritage as enthusiastically as we could so that students would learn to love and appreciate them as we did when we first studied them ourselves.

We trust that our basic philosophy in preparing this book still shows forth in this new edition. We are still convinced of the need to use a historical approach to the humanities. We still believe that the text should focus fundamentally on the Western tradition, even if we try and remind ourselves that culture is not so neatly packaged. We are unapologetic about our focus on high culture—since that is the heritage which has shaped our civilization, for better or worse. Finally, we have held to our principle of selectivity both because we did not want this book to look like a catalogue and because we feel that fewer things understood well can stand as a springboard for broader understanding. Behind all of these convictions is our strong conviction that any textbook should be the first word and not the final one. We trust in the teacher to explain what we have left unexplained and to speak where we have been silent.

In the nearly ten-year period since the first edition appeared we have enjoyed the contact with students and teachers who have used the books and given us their reactions, generous in their praise and pointed in their criticisms, as they have tried to make our book their own. In that period, as we have predicted in the first preface, we also became aware that deficiencies, omissions, errors of fact, and unsubtle judgments would be found. And so they were. We are grateful for those criticisms just as we were chagrined by our mistakes. We trust that this new edition will respond to those criticisms and suggestions. We have taken them seriously and have tried to be responsive to them.

The decision to do a second edition of the book was made in late 1987 after the entire work was reviewed both by users and those who had no previous acquaintance with it. Their criticisms, our own discussions, and consultations with the Holt editors form the critical background for this second edition. *Culture and Values* is still here, but some significant changes and additions have been made.

In the first place, we have completely rewritten the chapter on the biblical tradition and placed it in a different part of the book to provide a better sense of chronological continuity. Secondly, we have added some boxed features to highlight different areas of cultural importance that we could not adequately treat in the text itself. The Arts and Invention talks about technological advances which help the student understand the arts better. Each chapter also has a box relating the contact of the West with other parts of the world; this addition is headed East Meets West. In order to personalize the chapters we also have a box entitled Contemporary Voices that provides some contact with a "living voice" of the period.

There have also been some editorial shifts in the chapters. In the first edition the primary readings were integrated into the running text. In this edition they are all at the ends of the chapters. We have also redone the end matter of each chapter with updated bibliographies, a pronunciation guide, and some exercises for further student reflection and discussion. We have also greatly expanded the glossary of terms in this edition. These changes were all done in response to the pedagogical needs expressed by our reviewers. It is for that same reason that we rearranged some of the sections in the individual chapters to make matters easier for those who use a team teaching approach in the classroom.

Some sections of the chapters were rewritten for greater clarity. We have also added more material on music, in response to a number of requests. Some readings were changed to provide longer selections or more representative ones. We felt that some of the earlier readings were too short and there were too many of them.

With the addition of so much new material it was necessary to cut the manuscript lest it should end up unmanageably bulky. With a heavy heart we reduced the interludes because instructors told us that they loved to read them but had not the time to present them in class. We have retained some of them because we think they provide a model for students to consider when they work in an interdisciplinary fashion. Likewise, we have cut the final epilogue to the book. Those cuts have been modest ones and we hope that they have not been in places which reflect favorites among our users; we hope, similarly, that the additions will be adequate compensation for those omissions.

We are now left with the happy task of expressing our gratitude to those who have helped us in preparing this second edition.

Jan Widmayer
Boise State University, Boise, ID
Dr. Charline Burton
Central State University, Edmond, OK
Jim Axley
Rose State College, Norman, OK
Donald Andrews
Valencia Community College, Orlando, FL
Janice Allen
Seminole Community College, Sanfore, FL
Timothy Ulman
Palomar College, San Marcos, CA
Kenneth Simonsen

College of Lake County, Wildwood, IL

Rosemary De Paolo Augusta College, Augusta, GA

In addition, the helpful comments given by reviewers of the first edition were most appreciated. Our thanks go to:

Margaret Flansburg Central State University, Edmond, OK Anna C. Blackman Brevard Community College, Melbourne, FL Karl Schleunes University of North Carolina at Greensboro, NC Paul Turpen Eastern New Mexico University, Portales, NM Dorothy Corsberg Northeastern Ir. College, Sterling, CO David McKillop Grove City College, Grove City, PA Sylvia White Florida Jr. College Kent, Jacksonville, FL Alma Williams Savannah State College, Savannah, GA

Julia Walther Grambling University, Rustin, LA Arthur Chiasson Suffolk University, Boston, MA Barbara Kramer Santa Fe Community College, Gainesville, FL Charles Davis Boise State University, Boise, ID

This book began—as did the first stages of the revisions—while we served on the faculty of the Florida State University. We wish to thank the faculty and staff of the Department of Classics and the Department of Religion as well as the Program in Humanities and The Florida State University Study Center in Florence, Italy, for their assistance and their many kindnesses. Lawrence S. Cunningham is now with the Department of Theology at the University of Notre Dame. He is grateful to that department and its chair, Richard McBrien, for unfailing support and collegial atmosphere within which it is possible to write and think.

The staff at Holt, Rinehart and Winston exemplified professionalism and meticulous care in the production of this edition. We would like to single out Karen Dubno, who dealt with two not infrequently recalcitrant authors with a wholesome blend of determination and kindness. If this book deserves any praise at all, a large measure of it must be directed to Karen. Special thanks go to Mary Jo Gregory of York Production Services and Kathy Ferguson of Holt who effectively managed the intricate design and production; Elsa Peterson, for her dedication to the massive task of picture research; Buddy Barkalow, for his expertise in informational processing; Mary Pat Sitlington, for her many creative ideas, so important to the marketing of this book; and to our current editor, Janet Wilhite, who managed to move the office from New York to Fort Worth, and keep the book on schedule and on target.

Finally, we are grateful to all of the teachers and students who have used *Culture and Values* over the years. In a very basic sense, this book is theirs.

LSC ||R

Contents

Preface v The Arts: An Introduction xii How to Look at Art 1 How to Listen to Music 3 How to Read Literature 7
THE EARLY RENAISSANCE 10 Toward the Renaissance 12 The First Phase: Masaccio, Ghiberti, and Brunelleschi 12
The Arts and Invention: Fresco Technique 18 The Medici Era 18 Cosimo de' Medici 19 Piero de' Medici 23 Lorenzo the Magnificent 24 Contemporary Voices: Fra Savonarola 30 East Meets West: The Renaissance in Exploration 30 The Character of Renaissance Humanism 31 Pico della Mirandola 31 Printing Technology and the Spread of Humanism 32 Two Styles of Humanism 32 Machiavelli 33 Erasmus 34 Music in the Fifteenth Century 35 Guillaume Dufay 35 Music in Medici Florence 35
Summary 36 Pronunciation Guide 36 Exercises 36 Further Reading 37
Reading Selections 37 Pico della Mirandola, from Oration on the Dignity of Man, paragraphs 1–4 37 Niccolò Machiavelli, from The Prince, Chapters 15–18 38 Desiderius Erasmus, from The Praise of Folly, excerpt 42

THE HIGH RENAISSANCE IN ITALY 48

Popes and Patronage 50
Raphael 50
Michelangelo 52
The New Saint Peter's 57
Contemporary Voices: Donna Vittoria and
Michelangelo 58
The High Renaissance in Venice 59
Giorgione 59
Titian 59
Mannerism 61
Music in the 16th Century 63
Music at the Papal Court 63
East Meets West: The Discovery of the New
World 64
Venetian Music 65
Contrasting Renaissance Voices 65
Castiglione 65
Cellini 67
The Arts and Invention: Bronze Casting 67
Summary 68
Pronunciation Guide 68
Evercises 68
Exercises 68
Exercises 68 Further Reading 68
Further Reading 68 Reading Selections 69 Boldassare Castiglione, from The Courtier,
Further Reading 68 Reading Selections 69 Boldassare Castiglione, from The Courtier, On Women 69
Further Reading 68 Reading Selections 69 Boldassare Castiglione, from The Courtier, On Women 69 Benvenuto Cellini, from The Autobiography,
Further Reading 68 Reading Selections 69 Boldassare Castiglione, from The Courtier, On Women 69
Further Reading 68 Reading Selections 69 Boldassare Castiglione, from The Courtier, On Women 69 Benvenuto Cellini, from The Autobiography,

THE RENAISSANCE IN THE NORTH

East Meets West: Spice Trading in Asia 81 The Reformation Causes of the Reformation Renaissance Humanism and the Reformation 83 Contemporary Voices: Katherine Zell Cultural Significance of the Reformation 86 The Arts and Invention: Paper and Printing 87 Intellectual Developments Montaigne's Essays The Growth of Science 90 The Visual Arts in Northern Europe Painting in Germany: Dürer, Grünewald, Altdorfer Painting in the Netherlands: Bosch and Breugel Art and Architecture in France Art in Elizabethan England Music of the Northern Renaissance 102 Music in France and Germany Elizabethan Music 102 English Literature: Shakespeare 104 Summary 107 Pronunciation Guide 108 Exercises 108 **Further Reading** 108

109 Reading Selections Michel Eyquem de Montaigne, "Of Repentance" 109 William Shakespeare, Twelfth Night 115

149

THE BAROOUE WORLD 144

The Counter-Reformation Spirit 146 East Meets West: The Spanish Empire in America 148 The Visual Arts in the Baroque Period Painting in Rome: Caravaggio and the Carracci 149 Roman Baroque Sculpture and Architecture: Bernini and Borromini 153 Baroque Art in France and Spain 155 Contemporary Voices: Giambattista Passeri 155 Baroque Art in Northern Europe 161 **Baroque Music** 167 The Birth of Opera Baroque Instrumental and Vocal Music: Johann Sebastian Bach 169 The Arts and Invention: The Equally-Tempered Scale 170 Philosophy and Science in the Baroque

Period 172

Galileo 172 Descartes 173 Hobbes 174 Literature in the 17th Century

175 French Baroque Comedy and Tragedy 175 175 The Novel in Spain: Cervantes 176 The English Metaphysical Poets Milton's Heroic Vision

178 Summary Pronunciation Guide 179 179 Exercises 179 Further Reading

Reading Selections 180 Thomas Hobbes, from Leviathan, Part I, Chapter XIII 180 Richard Crashaw, "On the Wounds of Our Crucified Lord" 181 John Donne, "The Canonization" 182 John Donne, "Holy Sonnet X" 182 Molière, from Tartuffe, Act III Miguel de Cervantes Saavedra, from The Adventures of Don Quixote, Part II, Chapters 10 and 11 194 John Milton, Paradise Lost, Book I

228

Age of Diversity 206
The Visual Arts in the 18th Century 208
The Rococo Style 208
Neoclassical Art 213
Classical Music 217
The Classical Symphony 218
Haydn 219

Mozart 220
The Arts and Invention

The Arts and Invention: The Keyboard: from Harpsichord to Pianoforte 221

Literature in the 18th Century
Intellectual Developments 222
Pope's Rococo Satires 223
Swift's Savage Indignation 224
Rational Humanism: The Encyclopedists

Rational Humanism: The Encyclopedists
Voltaire's Philosophical Cynicism: Candide
East Meets West: The Slave Trade

225

226

The Late 18th Century: Time of Revolution 228

Contemporary Voices: Horace Walpole

Summary 231
Pronunciation Guide 232
Exercises 232
Further Reading 232

Reading Selections 233

Alexander Pope, "Epigram" and "On Receiving
... a Standish and Two Pens" 233

Jonathan Swift, A Modest Proposal 233

Voltaire, from Candide, Chapters I–XIII, XXVI–XXX 237

THE ROMANTIC ERA 254

The Concerns of Romanticism 256 The Intellectual Background 257 Music in the Romantic Era 260 Beethoven 260 Instrumental Music after Beethoven 262 The Age of the Virtuosos Musical Nationalism 264 Opera in Italy: Verdi 264 Opera in Germany: Wagner 266 Romantic Art 268 Painting at the Turn of the Century: Gova 268 Painting and Architecture in France: Romantics and Realists 270 East Meets West: European Perceptions of the American Indian 276 Painting in Germany and England Literature in the 19th Century 278 Goethe 278 Romantic Poetry 279 The Novel

The Romantic Era in America
American Literature 283
Contemporary Voices: Isabella Bird Meets
a Mountain Man 283
American Painting 284
The Arts and Invention: Photography 286

Summary 287
Pronunciation Guide 288
Exercises 288
Further Reading 289

Reading Selections 289 Johann Wolfgang von Goethe, from Faust 289 William Wordsworth, "Tintern Abbey" 292 Percy Bysshe Shelley, "To ——" and "Ozymandias" John Keats, "Ode to a Nightingale" 294 Honoré de Balzac, from Lost Illusions 295 Charles Dickens, Horatio Sparkins 302 Walt Whitman, from Leaves of Grass 308

Interlude: Frédéric Chopin and George Sand 312

TOWARD THE MODERN ERA: 1870–1914 318

The Growing Unrest 320 East Meets West: The Emergence of Japan 322 New Movements in the Visual Arts 323 The Arts and Invention: The Movies Impressionism 325 Post-Impressionism 331 Fauvism and Expressionism 335 New Styles in Music Orchestral Music at the Turn of the Century 338 Contemporary Voices: Gustav Mahler 340 Impressionism in Music The Search for a New Musical Language 342 New Subjects for Literature Psychological Insights in the Novel 344 Responses to a Changing Society: The Role of Women 345

Summary 346
Pronunciation Guide 347
Exercises 347
Further Reading 347

Reading Selections 348

Fyodor Dostoyevsky,
from Crime and Punishment 348

Henrik Ibsen, A Doll's House, Act III,
final scene 350

Kate Chopin, The Story of an Hour 353

402

358

BETWEEN THE WORLD WARS 356

The "Great War" and Its Significance

Literary Modernism 358 T. S. Eliot and James Joyce 358 Franz Kafka 360 Virginia Woolf 360 The Revolution in Art: Cubism 360 East Meets West: "Primitive" Arts Freud, the Unconscious, and Surrealism 366 The Age of Jazz 368 George Gershwin 370 Duke Ellington 370 370 Ballet: Collaboration in Art Art as Escape: Dada 371 Art as Protest: Guernica Art as Propaganda: Film 373 The Arts and Invention: Mass Media: Radio and Television 374 Photography Art as Prophecy: From Futurism to Brave New World 376 Contemporary Voices: Virginia Woolf 376 Summary 378 Pronunciation Guide 378 Exercises 378 378 Further Reading **Reading Selections** 379 T. S. Eliot, "The Hollow Men" 379 James Joyce, Ulysses, Chapter 1, opening 380 Franz Kafka, The Trial, Before the Law 389 Aldous Huxley, from Brave New World 394

Interlude: Virginia and Leonard Woolf

THE CONTEMPORARY CONTOUR 406

Toward a Global Culture 408 East Meets West: A Global Culture 409 409 Existentialism Painting Since 1945 410 Contemporary Voices: Georgia O'Keeffe 412 Abstract Expressionism The Return to Representation 415 Contemporary Sculpture Architecture 424 Some Trends in Contemporary 429 Literature A Note on the Post-Modern 430 **Music Since 1945** 431 Avant-Garde Developments The New Minimalists 432 433 Traditional Approaches to Modern Music Popular Music 433 The Arts and Invention: The Computer 434

Summary 435 Pronunciation Guide 436 **Exercises** 436 436 Further Reading Reading Selections 437 Jean Paul Sartre, from Existentialism as a Humanism 437 Elie Wiesel, from Night, Chapter V 440 Flannery O'Connor, Revelation Jorge Luis Borges, The Book of Sand 452

Glossary 454 Index 461 Literary Acknowledgments 482 Photographic Credits 483

Maps

Renaissance Italy 33
Religious Divisions in Europe c. 1600 84
Overseas Possessions at the End of
the 17th Century 147
Eighteenth Century Europe 206
Europe in 1848 259
Europe after World War I 359

THE ARTS: AN INTRODUCTION

One way to see the arts as a whole is to consider a widespread mutual experience: a church or synagogue service. Such a gathering is a celebration of written literature done, at least in part, in music in an architectural setting decorated to reflect the religious sensibilities of the community. A church service makes use of visual arts, literature, and music. While the service acts as an integrator of the arts, considered separately, each art has its own peculiar characteristics that give it shape.

Music is primarily a temporal art, which is to say that there is music when there is someone to play the instruments and sing the songs. When the performance is over,

the music stops.

The visual arts and architecture are spatial arts that have permanence. When a religious service is over people may still come into the building to admire its architecture or marvel at its paintings or sculptures or look at the decorative details of the

Literature has a permanent quality in that it is recorded in books, although some literature is meant not to be read but to be heard. Shakespeare did not write plays for people to read but for audiences to see and hear performed. Books nonetheless have permanence in the sense that they can be read not only in a specific context but also at one's pleasure. Thus, to continue the religious-service example, one can read the psalms for their poetry or for devotion apart from their communal use in worship.

What we have said about the religious service applies equally to anything from a rock concert to grand opera: artworks can be seen as an integrated whole. Likewise, we can consider these arts separately. After all, people paint paintings, compose music, or write poetry to be enjoyed as discrete experiences. At other times, of course, two arts may be joined when there was no original intention to do so, as when a composer sets a poem to music or an artist finds inspiration in a literary text or, to use a more complex example, when a ballet is inspired by a literary text and is danced against the background of sets created by an artist to enhance both the dance and the text that inspired it.

However we view the arts, either separately or as integrated, one thing is clear: they are the product of human invention and human genius. When we speak of culture we are not talking about something strange or "highbrow"; we are talking about something that derives from human invention. A jungle is a product of nature, but a garden is a product of culture: human ingenuity has modified the vegetative world.

In this book we discuss some of the works of human culture that have endured over the centuries. We often refer to these works as masterpieces, but what does the term mean? The issue is complicated because taste and attitudes change over the centuries. Two hundred years ago the medieval cathedral was not appreciated; it was called Gothic because it was considered barbarian. Today we call such a building a masterpiece. Very roughly we can say that a masterpiece of art is any work that carries with it a surplus of meaning.

Having "surplus of meaning" means that a certain work not only reflects technical and imaginative skill but that its very existence also sums up the best of a certain age, which spills over as a source of inspiration for further ages. As one reads through the history of the Western humanistic achievement it is clear that certain

products of human genius are looked to by subsequent generations as a source of inspiration; they have a "surplus of meaning." Thus the Roman achievement in architecture with the dome of the Pantheon both symbolized their skill in architecture and became a reference point for every major dome built in the West since. The dome of the Pantheon finds echoes in 6th-century Constantinople (Hagia Sophia); in 15th-century Florence (the Duomo); in 16th-century Rome (St. Peter's); and in 18th-century Washington, D.C. (the Capitol building).

The notion of "surplus of meaning" provides us with a clue as to how to study the humanistic tradition and its achievements. Admittedly simplifying, we can say that such a study has two steps that we have tried to synthesize into a whole in this

book:

1. The work in itself. At this level we are asking the question of fact and raising the issue of observation: What is the work and how is it achieved? This question includes not only the basic information about, say, what kind of visual art this is (sculpture, painting, mosaic) or what its formal elements are (Is it geometric in style? bright in color? very linear? and so on) but also questions of its function: Is this work homage to politics? for a private patron? for a church? We look at artworks, then, to ask questions about both their form and their function.

This is an important point. We may look at a painting or sculpture in a museum with great pleasure, but that pleasure would be all the more enhanced were we to see that work in its proper setting rather than as an object on display. To ask about form and function, in short, is to ask equally about context. When reading certain literary works (such as the Iliad or the Song of Roland) we should read them aloud since, in their original form, they were written to be recited, not read silently on a page.

2. The work in relation to history. The human achievements of our common past tell us much about earlier cultures both in their differences and in their similarities. A study of the tragic plays that have survived from ancient Athens gives us a glimpse into Athenians' problems, preoccupations, and aspirations as filtered through the words of Sophocles or Euripides. From such a study we learn both about the culture of Athens and something about how the human spirit has faced the perennial issues of justice, loyalty, and duty. In that sense we are in dialogue with our ancestors across the ages. In the study of ancient culture we see the roots of our own.

To carry out such a project requires willingness really to look at art and closely read literature with an eye equally to the aspect of form/function and to the past and the present. Music, however, requires a special treatment because it is the most abstract of arts (How do we speak about that which is meant not to be seen but to be heard?) and the most temporal. For that reason a somewhat more extended guide to music appears below.

How to Look at Art

Anyone who thumbs through a standard history of art can be overwhelmed by the complexity of what is discussed. We find everything from paintings on the walls of caves and huge sculptures carved into the faces of mountains to tiny pieces of jewelry or miniature paintings. All of these are art because they were made by the human hand in an attempt to express human ideas and/or emotions. Our response to such objects depends a good deal on our own education and cultural biases. We may find some modern art ugly or stupid or bewildering. We may think of all art as highbrow or elitist despite the fact that we like certain movies (film is an art) enough to see them over and over.

Our lives are so bound up with art that we often fail to recognize how much we are shaped by it. We are bombarded with examples of graphic art (television commercials, magazine ads, record-album jackets, displays in stores) every day; we use art to make statements about who we are and what we value in the way we decorate our rooms and in the style of our dress. In all of these ways we manipulate artistic symbols to make statements about what we believe in, what we stand for, and how we want others to see us.

The history of art is nothing more than the record of how people have used their minds and imaginations to symbolize who they are and what they value. If a certain age spends enormous amounts of money to build and decorate churches (as in 12thcentury France) and another spends the same kind of money on palaces (like 18th-

century France) we learn about what each age values the most.

The very complexity of human art makes it difficult to interpret. That difficulty increases when we are looking at art from a much different culture and/or a far different age. We may admire the massiveness of Egyptian architecture but find it hard to appreciate why such energies were used for the cult of the dead. When confronted with the art of another age (or even our own art, for that matter) a number of questions we can ask of ourselves and of the art may lead us to greater understanding.

For what was this piece of art made? This is essentially a question of context. Most of the religious paintings in our museums were originally meant to be seen in churches in very specific settings. To imagine them in their original setting helps us to understand that they had a devotional purpose that is lost when they are seen on a museum wall. To ask about the original setting, then, helps us to ask further whether the painting is in fact devotional or meant as a teaching tool or to serve

some other purpose.

Setting is crucial. A frescoed wall on a public building is meant to be seen by many people while a fresco on the wall of an aristocratic home is meant for a much smaller, more elite, class of viewer. A sculpture designed for a wall niche is going to have a shape different than one designed to be seen by walking around it. Similarly, art made under official sponsorship of an authoritarian government must be read in a far different manner than art produced by underground artists who have no standing with the government. Finally, art may be purely decorative or it may have a didactic purpose, but (and here is a paradox) purely decorative art may teach us while didactic art may end up being purely decorative.

What, if anything, does this piece of art hope to communicate? This question is one of intellectual or emotional context. Funeral sculpture may reflect the grief of the survivors or a desire to commemorate the achievements of the deceased or to affirm what the survivors believe about life after death or a combination of these purposes. If we think of art as a variety of speech we can then inquire of any

artwork: What is it saying?

An artist may strive for an ideal ("I want to paint the most beautiful woman in the world" or "I wish my painting to be taken for reality itself" or "I wish to move people to love or hate or sorrow by my sculpture") or to illustrate the power of an idea or (as is the case with most primitive art) to "capture" the power of the spirit

world for religious and/or magical purposes.

An artist may well produce a work simply to demonstrate inventiveness or to expand the boundaries of what art means. The story is told of Pablo Picasso's reply to a woman who said that her ten-year-old child could paint better than he. Picasso replied, "Congratulations, Madame. Your child is a genius." We know that before he was a teenager Picasso could draw and paint with photographic accuracy. He said that during his long life he tried to learn how to paint with the fresh eye and spontaneous simplicity of a child.

How was this piece of art made? This question inquires into both the materials and the skills the artist employs to turn materials into art. Throughout this book we will speak of different artistic techniques, like bronze casting or etching or panel painting; here we make a more general point. To learn to appreciate the craft of the artist is a first step toward enjoying art for its worth as art—to developing an "eye" for art. This requires looking at the object as a crafted object. Thus, for example, a close examination of Michelangelo's Pietà shows the pure smooth beauty of marble while his Slaves demonstrate the roughness of stone and the sculptor's effort to carve meaning from hard material. We might stand back to admire a painting as a whole, but then to look closely at one portion of it teaches us the subtle manipulation of color and line that creates the overall effect.

What is the composition of this artwork? This question addresses how the artist "composes" the work. Much Renaissance painting uses a pyramidal construction so that the most important figure is at the apex of the pyramid and lesser figures form the base. Some paintings presume something happening outside the picture itself (such as an unseen source of light); a cubist painting tries to render simultaneous views of an object. At other times an artist may enhance the composition by the manipulation of color with a movement from light to dark or a stark contrast between dark and light, as in the chiaroscuro of Baroque painting. In all these cases the artists intend to do something more than merely "depict" a scene; they appeal to our imaginative and intellectual powers as we enter into the picture or engage the sculpture or look at their film.

Composition, obviously, is not restricted to painting. Filmmakers compose with close-ups or tracking shots just as sculptors carve for frontal or side views of an object. Since all these techniques are designed to make us see in a particular manner, only by thinking about composition do we begin to reflect on what the artist has done. If we do not think about composition, we tend to take an artwork at "face value" and, as a consequence, are not training our "eye."

What elements should we notice about a work of art? The answer to this question is a summary of what we have stated above. Without pretending to exclu-

sivity, we should judge art on the basis of the following three aspects:

Formal elements. What kind of artwork is it? What materials are employed? What is its composition in terms of structure? In terms of pure form, how does this particular work look when compared to a similar work of the same or another artist?

Symbolic elements. What is this artwork attempting to "say"? Is its purpose didactic, propagandistic, to give pleasure, or what? How well do the formal elements contribute to the symbolic statement being attempted in the work of art?

Social elements. What is the context of this work of art? Who is paying for it and why? Whose purposes does it serve? At this level many different philosophies come into play. A Marxist critic might judge a work in terms of its sense of class or economic aspects, while a feminist might inquire whether it affirms women or acts as an agent of subjugation and/or exploitation.

It is possible to restrict oneself to formal criticism of an artwork (Is this well done in terms of craft and composition?), but such an approach does not do full justice to what the artist is trying to do. Conversely, to judge every work purely in terms of social theory excludes the notion of an artistic work and, as a consequence, reduces art to politics or philosophy. For a fuller appreciation of art, then, all the elements mentioned above need to come into play.

How to Listen to Music

The sections of this book devoted to music are designed for readers who have no special training in musical theory and practice. Response to significant works of music, after all, should require no more specialized knowledge than the ability to respond to Oedipus Rex, say, or a Byzantine mosaic. Indeed, many millions of people buy recorded music in one form or another, or enjoy listening to it on the radio, without the slightest knowledge of how the music is constructed or performed.

The gap between the simple pleasure of the listener and the complex skills of composer and performer often prevents the development of a more serious grasp of

music history and its relation to the other arts. The aim of this section is to help bridge that gap without trying to provide too much technical information. After a brief survey of music's role in Western culture we shall look at the "language" used to discuss musical works, both specific terminology, such as sharp and flat, and more general concepts, such as line and color.

Music in Western Culture

The origins of music are unknown, and neither the excavations of ancient instruments or depictions of performers nor the evidence from modern primitive societies gives any impression of its early stages. Presumably, like the early cave paintings, it served some kind of magical or ritual purpose. This is borne out by the fact that music still forms a vital part of most religious ceremonies today, from the hymns sung in Christian churches or the solo singing of the cantor in an Orthodox Jewish synagogue to the elaborate musical rituals performed in Buddhist or Shinto temples in Japan. The Old Testament makes many references to the power of music, most notably in the famous story of the battle of Jericho, and it is clear that by historical times music played an important role in Jewish life, both sacred and secular.

By the time of the Greeks, the first major Western culture to develop, music had become as much a science as an art. It retained its importance for religious rituals; in fact, according to Greek mythology the gods themselves invented it. At the same time the theoretical relationships between the various musical pitches attracted the attention of philosophers such as Pythagoras (c. 550 B.C.), who described the underlying unity of the universe as the "harmony of the spheres." Later 4th-century-B.C. thinkers like Plato and Aristotle emphasized music's power to affect human feeling and behavior. Thus for the Greeks music represented a religious, intellectual, and moral force. Once again, music is still used in our own world to affect people's feelings, whether it be the stirring sound of a march, a solemn funeral dirge, or the eroticism of much modern "pop" music (of which Plato would thoroughly have disapproved).

Virtually all the music—and art, for that matter—to have survived from the Middle Ages is religious. Popular secular music certainly existed, but since no real system of notation was invented before the 11th century, it has disappeared without trace. The ceremonies of both the Western and the Eastern (Byzantine) church centered around the chanting of a single musical line, a kind of music that is called monophonic (from the Greek "single voice"). Around the time musical notation was devised, composers began to become interested in the possibilities of notes sounding simultaneously-what we would think of as harmony. Music involving several separate lines sounding together (as in a modern string quartet or a jazz group) became popular only in the 14th century. This gradual introduction of polyphony ("many voices") is perhaps the single most important development in the history of music, since composers began to think not only horizontally (that is, melodically) but also vertically, or harmonically. In the process the possibilities of musical expression were immeasurably enriched.

The Experience of Listening

"What music expresses is eternal, infinite, and ideal. It does not express the passion, love, or longing of this or that individual in this or that situation, but passion, love, or longing in itself; and this it presents in that unlimited variety of motivations which is the exclusive and particular characteristic of music, foreign and inexpressible in any other language" (Richard Wagner). With these words one of the greatest of all composers described the power of music to express universal emotions. Yet for those unaccustomed to serious listening, it is precisely this breadth of experience that is difficult to identify with. We can understand a joyful or tragic situation. Joy and tragedy themselves, though, are more difficult to comprehend.

There are a number of ways by which the experience of listening can become more rewarding and more enjoyable. Not all of them will work for everyone, but over the course of time they have proved helpful for many newcomers to the satisfactions of music.

1. Before listening to the piece you have selected, ask yourself some questions: What is the historical context of the music? For whom was it composed—for a

general or for an elite audience?

Did the composer have a specific assignment? If the work was intended for performance in church, for example, it should sound very different from a set of dances. Sometimes the location of the performance affected the sound of the music: composers of masses to be sung in Gothic cathedrals used the buildings' acoustical

properties to emphasize the resonant qualities of their works.

With what forces is the music to be performed? Do they correspond to those intended by the composer? Performers of medieval music, in particular, often have to reconstruct much that is missing or uncertain. Even in the case of later traditions, the original sounds can sometimes be only approximated. The superstars of the 18th-century world of opera were the castrati, male singers who had been castrated in their youth and whose voices had therefore never broken; contemporaries described the sounds they produced as incomparably brilliant and flexible. The custom, which seems to us so barbaric, was abandoned in the 19th century, and even the most fanatic musicologist must settle for a substitute today. The case is an extreme one, but it points the moral that even with the best of intentions, modern performers cannot always reproduce the original sounds.

Does the work have a text? If so, read it through before you listen to the music; it is easiest to concentrate on one thing at a time. In the case of a translation, does the version you are using capture the spirit of the original? Translators sometimes take a simple, popular lyric and make it sound archaic and obscure in order to convey the sense of "old" music. If the words do not make much sense to you, probably they would seem equally incomprehensible to the composer. Music, of all the arts, is

concerned with direct communication.

Is the piece divided into sections? If so, why? Is their relationship determined by purely musical considerations—the structure of the piece—or by external factors,

the words of a song, for example, or the parts of a Mass?

Finally, given all the above, what do you expect the music to sound like? Your preliminary thinking should have prepared you for the kind of musical experience in store for you. If it has not, go back and reconsider some of the points above.

2. While you are listening to the music:

Concentrate as completely as you can. It is virtually impossible to gain much from music written in an unfamiliar idiom unless you give it your full attention. Read record-sleeve notes or other written information before you begin to listen, as you ask yourself the questions above, not while the music is playing. If there is a

text, keep an eye on it but do not let it distract you from the music.

Concentrating is not always easy, particularly if you are mainly used to listening to music as a background, but there are some ways in which you can help your own concentration. To avoid visual distraction, fix your eyes on some detail near you—a mark on the wall, a design in someone's dress, the cover of a book. At first this will seem artificial, but after a while your attention should be taken by the music. If you feel your concentration fading, do not pick up a magazine or gaze around; consciously force your attention back to the music and try to analyze what you are hearing. Does it correspond to your expectations? How is the composer trying to achieve an effect? By variety of instrumental color? Are any of the ideas, or tunes, repeated?

Unlike literature or the visual arts, music occurs in the dimension of time. When you are reading, you can turn backward to check a reference or remind yourself of a character's identity. In looking at a painting, you can move from a detail to an overall view as often as you want. In music, the speed of your attention is controlled by the composer. Once you lose the thread of the discourse, you cannot regain it by going back; you must try to pick up again and follow the music as it continues—and

that requires your renewed attention.

On the other hand, in these times of easy access to recordings, the same pieces can be listened to repeatedly. Even the most experienced musicians cannot grasp some works fully without several hearings. Indeed, one of the features that distinguishes "art" music from more "popular" works is its capacity to yield increasing rewards. On a first hearing, therefore, try to grasp the general mood and structure and note features to listen for the next time you hear the piece. Do not be discouraged if the idiom seems strange or remote, and be prepared to become familiar with a few works from each period you are studying.

As you become accustomed to serious listening, you will notice certain patterns used by composers to give form to their works. They vary according to the styles of the day, and throughout this book there are descriptions of each period's musical characteristics. In responding to the general feeling the music expresses, therefore, you should try to note the specific features that identify the time of its composition.

3. After you have heard the piece, ask yourself these questions:

Which characteristics of the music indicated the period of its composition? Were they due to the forces employed (voices and/or instruments)?

How was the piece constructed? Did the composer make use of repetition? Was there a change of mood and, if so, did the original mood return at the end?

What kind of melody was used? Was it continuous or did it divide into a series of shorter phrases?

If a text was involved, how did the music relate to the words? Were they audible? Did the composer intend them to be? If not, why not?

Were there aspects of the music that reminded you of the literature and visual arts of the same period? In what kind of buildings can you imagine it being performed?

What does it tell you about the society for which it was written?

Finally, ask yourself the most difficult question of all: What did the music express? Richard Wagner described the meaning of music as "foreign and inexpressible in any other language." There is no dictionary of musical meaning, and listeners must interpret for themselves what they hear. We all understand the general significance of words like contentment or despair, but music can distinguish between a million shades of each.

Concepts in Music

There is a natural tendency in talking about the arts to use terms from one art form in describing another. Thus most people would know what to expect from a "colorful" story or a painting in "quiet" shades of blue. This metaphorical use of language helps describe characteristics that are otherwise often very difficult to isolate, but some care is required to remain within the general bounds of comprehension.

Line. In music, line generally means the progression in time of a series of notes: the melody. A melody in music is a succession of tones related to one another to form a complete musical thought. Melodies vary in length and in shape and may be made up of several smaller parts. They may move quickly or slowly, smoothly or with strongly accented (stressed) notes. Some melodies are carefully balanced and proportional, others are irregular and asymmetrical. A melodic line dictates the basic character of a piece of music, just as lines do in a painting or the plot line does for a story or play.

Texture. The degree to which a piece of music has a thick or thin *texture* depends on the number of voices and/or instruments involved. Thus the monophonic music of the Middle Ages, with its single voice, has the thinnest texture possible. At the opposite extreme is a 19th-century opera, where half a dozen soloists, chorus, and a large orchestra were sometimes combined. Needless to say, thickness and thinness

of texture are neither good nor bad in themselves, merely simple terms of description.

Composers control the shifting texture of their works in several ways. The number of lines heard simultaneously can be increased or reduced—a full orchestral climax followed by a single flute, for example. The most important factor in the texture of the sound, however, is the number of combined independent melodic lines; this playing (or singing) together of two or more separate melodies is called counterpoint. Another factor influencing musical texture is the vertical arrangement of the notes: six notes played close together low in the scale will sound thicker than six notes more widely distributed.

Color. The color, or timbre, of a piece of music is determined by the means employed. Gregorian chant is monochrome, having only one line. The modern symphony orchestra has a vast range to draw upon, from the bright sound of the oboe or the trumpet to the dark, mellow sound of the cello or French horn. Some composers have been more interested than others in exploiting the range of color instrumental combinations can produce; not surprisingly, Romantic music provides

some of the most colorful examples.

Medium. The medium is the method of performance. Pieces can be written for solo piano, string quartet, symphony orchestra, or any other combination the composer chooses. A prime factor will be the importance of color in the work. Another is the length and seriousness of the musical material. It is difficult, although not impossible, for a piece written for solo violin to sustain the listener's interest for half an hour. Still another is the practicality of performance. Pieces using large or unusual combinations of instruments stand less chance of being frequently programmed. In the 19th century composers often chose a medium that allowed perfor-

mance in the home, thus creating a vast piano literature.

Form. Form is the outward, visible (or hearable) shape of a work as opposed to its substance (medium) or color. This structure can be created in a number of ways. Baroque composers worked according to the principle of unity in variety. In most Baroque movements the principal melodic idea continually recurs in the music, and the general texture remains consistent. The formal basis of much classical music is contrast, where two or more melodies of differing character (hard and soft, or brilliant and sentimental) are first laid out separately, then developed and combined, then separated again. The Romantics often pushed the notion of contrasts to extremes, although retaining the basic notions of classical form. Certain types of work dictate their own form. A composer writing a requiem mass is clearly less free to experiment with formal variation than one writing a piece for symphony orchestra. The words of a song strongly suggest the structure of the music, even if they do not impose it. Indeed, so pronounced was the Baroque sense of unity that the sung arias in Baroque operas inevitably conclude with a repetition of the words and music of the beginning, even if the character's mood or emotion has changed.

Thus music, like the other arts, involves the general concepts described above. A firm grasp of them is essential to an understanding of how the various arts have changed and developed over the centuries and how the changes are reflected in similarities—or differences—between art forms. The concept of the humanities implies that the arts did not grow and change in isolation from one another or from the world around. As this book shows, they are integrated both among themselves

and with the general developments of Western thought and history.

How to Read Literature

"Reading literature" conjures up visions of someone sitting in an armchair with glasses on and nose buried in a thick volume—say, Tolstoy's War and Peace. The plain truth is that a fair amount of the literature found in this book was never meant

to be read that way at all. Once that fact is recognized, reading becomes an exercise in which different methods can serve as a great aid for both pleasure and understanding. That becomes clear when we consider various literary forms and ask ourselves how their authors originally meant them to be encountered. Let us consider some of the forms that will be studied in this volume to make the point more specifically:

Dramatic literature. This is the most obvious genre of literature that calls for something more than reading the text quietly. Plays-ancient, medieval, Elizabethean, or modern—are meant to be acted, with living voices interpreting what the playwright wrote in the script. What seems to be strange and stilted language as we first encounter Shakespeare becomes powerful and beautiful when we

hear his words spoken by someone who knows and loves language.

A further point: Until relatively recent times most dramas were played on stages nearly bare of scenery and, obviously, extremely limited in terms of lighting, theatrical devices, and the like. As a consequence, earlier texts contain a great deal of description that in the modern theater (and, even more, in a film) can be supplied by current technology. Where Shakespeare has a character say "But look, the morn in russet mantle clad / Walks o'er the dew of yon high eastward hill," a modern writer might simply instruct the lighting manager to make the sun come up.

Dramatic literature must be approached with a sense of its oral aspect as well as an awareness that the language reflects the intention of the author to have the words

acted out. Dramatic language is meant to be heard and seen.

Epic. Like drama, epics have a strong oral background. It is a commonplace to note that before Homer's Iliad took its present form it was memorized and recited by a professional class of bards. Similarly, the Song of Roland was probably heard by many people and read by relatively few in the formative decades of its composition. Even epics that are more consciously literary echo the oral background of the epic; Vergil begins his elegant Aeneid with the words "Arms and the man I sing" not "Of Arms and the man I write."

The practical conclusion to be drawn from this is that these long poetic tales take on a greater power when they are read aloud with sensitivity to their cadence.

Poetry. Under this general heading we have a very complicated subject. To approach poetry with intelligence we need to inquire about the kind of poetry with which we are dealing. The lyrics of songs are poems, but they are better heard sung than read in a book. On the other hand, certain kinds of poems are so arranged on a page that not to see them in print is to miss a good deal of their power or charm. Furthermore, some poems are meant for the individual reader while others are public pieces meant for the group. There is, for example, a vast difference between a love sonnet and a biblical psalm. Both are examples of poetry, but the former expresses a private emotion while the latter most likely gets its full energy from use in worship: we can imagine a congregation singing a psalm but not the same congregation reciting one of Petrarch's sonnets to Laura.

In poetry, then, context is all. Our appreciation of a poem is enhanced once we have discovered where the poem belongs: with music? on a page? for an aristocratic circle of intellectuals? as part of a national or ethnic or religious heritage? as propa-

ganda or protest or to express deep emotions?

At base, however, poetry is the refined use of language. The poet is the maker of words. Our greatest appreciation of a poem comes when we say to ourselves that this could not be said better. An authentic poem cannot be edited or paraphrased or glossed. Poetic language, even in long poems, is economical. One can understand that by simple experiment: take one of Dante's portraits in the Divine Comedy and try to do a better job of description in fewer words. The genius of Dante (or Chaucer in the Prologue to The Canterbury Tales) is his ability to sketch out a fully formed person in a few stanzas.

Prose. God created humans, the writer Elie Wiesel once remarked, because he loves a good story. Narrative is as old as human history. The stories that stand behind the Decameron and The Canterbury Tales have been shown to have existed not

only for centuries but in widely different cultural milieus. Stories are told to draw out moral examples or to instruct or warn, but, by and large, stories are told because we enjoy hearing them. We read novels in order to enter into a new world and suspend the workaday world we live in, just as we watch films for the same purpose. The difference between a story and a film is that one can linger over a story, but in a film there is no "second look."

Some prose obviously is not fictional. It can be autobiographical like Augustine's Confessions or it may be a philosophical essay like Jean-Paul Sartre's attempt to explain what he means by existentialism. How do we approach that kind of writing? First, with a willingness to listen to what is being said. Second, with a readiness to judge: Does this passage ring true? What objections might I make to it? and so on. Third, with an openness that says, in effect, there is something to be learned here.

A final point has to do with attitude. We live in an age in which much of what we know comes to us in very brief "sound bites" via television and much of what we read comes to us in the disposable form of newspapers and magazines and inexpensive paperbacks. To read—really to read—requires that we discipline ourselves to cultivate a more leisurely approach to that art. There is merit in speed-reading the morning sports page; there is no merit in doing the same with a poem or a short story. It may take time to learn to slow down and read at a leisurely pace (leisure is the basis of culture, says Aristotle), but if we learn to do so we have taught ourselves a skill that will enrich us all our lives.

1400

15th cent. Florence center of European banking system; renaissance in exploration outside Europe begins

1417 Council of Constance ends "Great Schism"

1432 Florentines defeat Sienese at San Romano

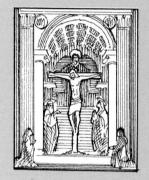

1401 Competition for North Doors of Florence Baptistery won by Ghiberti's Sacrifice of Isaac

1403 Ghiberti begins Baptistery doors: Brunelleschi, Donatello study Roman ruins

c. 1416-1417 Donatello, Saint George

1423 Fabriano, The Adoration of the Magi, International Style altarpiece

1425 Masaccio begins frescoes for Brancacci Chapel, Santa Maria del Carmine, Florence; The Tribute Money (1425), Expulsion from the Garden (c. 1425)

c. 1425-c. 1452 Ghiberti sculpts panels for East Doors of Florence Baptistery; The Story of Jacob and Esau (1435)

Use of linear perspective to create three-dimensional space; naturalistic rendering of figures; return to classical ideals of beauty and proportion: Masaccio, The Trinity, Santa Maria Novella, Florence (c. 1428)

c. 1430-1432 Donatello, David, first free-standing nude since antiquity

FLORENTINE RENAISSANCE 1434

1434 Cosimo de' Medici becomes de facto ruler of Florence

1439-1442 Ecumenical Council of Florence deals with proposed union of Greek and Roman churches

1453 Fall of Constantinople to Turks; scholarly refugees bring Greek manuscripts to Italy

1464 Piero de' Medici takes power in Florence after death of Cosimo

1469 Lorenzo de' Medici rules city after death of Piero

1478 Pazzi conspiracy against the Medici fails

1489 Savonarola begins sermons against Florentine immorality

1492 Death of Lorenzo de' Medici

1446-1450 Gutenberg invents movable printing type

1456 Gutenberg Bible printed at Mainz

1462 Cosimo de' Medici founds Platonic Academy in Florence, headed by Marsilio Ficino

1465 First Italian printing press, at Subiaco

1470-1527 Height of humanist learning

1475 Recuyell of the Historyes of Troye, printed by William Caxton, first book published in English

c. 1476-1477 Lorenzo de' Medici begins Comento ad Alcuni Sonetti

1482 Ficino, Theologia Platonica

1486 Pico della Mirandola. Oration on the Dignity of Man

1490 Lorenzo de' Medici, The Song of Bacchus

1491 Lorenzo de' Medici, Laudi

1434 Jan Van Eyck, Giovanni Arnolfini and His Bride

1445-1450 Fra Angelico, Annunciation, fresco for Convent of San Marco, Florence

c. 1455 Donatello, Mary Magdalene; Uccello, Battle of San Romano 1459-1463 Gozzoli,

The Journey of the Magi c. 1467-1483 Leonardo works in Florence

1475 The Medici commission Botticelli's Adoration of the Magi for Santa Maria Novella

1478-c. 1482 Botticelli. La Primavera, The Birth of Venus, Pallas and the Centaur

c. 1489 Michelangelo begins studies in Lorenzo's sculpture garden; Madonna of the Stairs (1489-1492)

1494

Medici Era

1494 Medici faction in exile; Savonarola becomes de facto ruler of Florence; Charles VIII of France invades Italy. beginning foreign invasions

1498 Savonarola burned at stake by order of Pope c. 1494 Aldus Manutius establishes Aldine Press in Venice

1496 Burning of books inspired by Savonarola

1502 Erasmus, Enchiridion Militis Christiani

1498-1499 Michelangelo, Pietà late 15th-early 16th cent. Leonardo,

c. 1495-1498 Leonardo, Last Supper c. 1496 Botticelli burns some of his work

in response to Savonarola's sermons 1501-1504 Michelangelo, David

RENAISSANCE ROMAN 1503

1512 Medici power restored in Florence; Machiavelli exiled

1506 Erasmus travels to Italy 1509 Erasmus, The Praise of Folly 1513 Machiavelli, The Prince 1516 Erasmus, Greek New Testament c. 1503-1505 Leonardo, Mona Lisa 1506 Ancient Laocoon sculpture discovered

1520

ARCHITECTURE

MUSIC

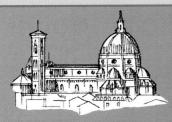

1417-1420 Brunelleschi designs and begins construction of Florence Cathedral dome (completed 1436)

1419-1426 Brunelleschi, Foundling Hospital

Use of classical order and proportion to achieve rational harmony of elements; Brunelleschi, Pazzi Chapel, Santa Croce, Florence (1430-1433)

The Early Renaissance

1437-1452 Michelozzo, Convent of San Marco, Florence 1444-1459 Michelozzo, Palazzo Medici-Riccardi, Florence c. 1450-1500 Johannes Ockeghem, motets, chansons, masses; Missa pro Defunctis, earliest known polyphonic requiem mass 1479-1492 Heinrich Isaac, court composer to Medici family and organist and choirmaster at Florence Cathedral, sets Lorenzo's poems to music

Toward the Renaissance

The 14th century was a period of great social strife and turmoil as well as a time in which new stirrings were abroad in Europe. It was the century of Dante, Petrarch, Boccaccio, and Chaucer. The entrenched scholastic approach to learning was being tempered by renewed interest in classical literature. The longcherished Byzantine art style was being challenged by the new realism of such Italian artists as Cimabue and Giotto in Florence, Simone Martini, and the Lorenzetti brothers, among others. Renewed interest in the world of nature was fueled by the enormous impact of Saint Francis of Assisi (1181-1226), who taught Europeans to see God in the beauty of the world and its creatures.

Europe was slowly recovering from the fearful plague-stricken years around 1348, a rebirth aided by a new growth in economics and trade. Wealth was being created by an emerging class whose claim to eminence was based less on noble blood than on ability to make money.

In the 15th century the center of this new vitality was Florence in Italy. No city its size has in its day exerted more influence on culture at large than this focus of banking and commerce. From roughly the 1420s until the end of the century a collaborative effort of thinkers, artists, and wealthy patrons enriched the city, in the process making it a magnet for all Europe. To that city and its cultural development we now turn.

The First Phase: Masaccio, Ghiberti, and Brunelleschi

At the beginning of the 15th century Florence had every reason to be a proud city. It stood on the main road connecting Rome with the north. Its language known at the time as the Tuscan dialect or the Tuscan idiom—was the strongest and most developed of the Italian dialects; its linguistic power had been demonstrated more than a century earlier by Dante Alighieri and his literary successors, Petrarch and Boccaccio. The twelve great Arti or trade guilds of Florence were commercially important for the city; in addition, representatives of the seven senior guilds formed the body of magistrates that ruled the city from the fortresslike town hall, the Palazzo Vecchio. This "representative" government, limited though it was to the prosperous guilds, preserved Florence from the rise of the terrible city tyrants who plagued so many other Italian cities.

Florence had been one of the centers of the wool

TABLE 10.1 Major Social Events of the 15th Century

- 1439—Council of Florence attempts to reconcile Catholic and Orthodox churches
- 1453—End of the Hundred Years War
- 1453—Constantinople (Byzantium) falls to the Turks
- 1469—Spain united under Ferdinand and Isabella
- 1485—Henry VIII begins reign as first Tudor king of England
- 1486—First European voyage around Cape of Good Hope
- 1492—Columbus discovers America
- 1492—Last Islamic city in Spain (Granada) falls to Ferdinand and Isabella
- 1494—Spain and Portugal divide spheres of influence in the New World
- 1497—Vasco da Gama begins first voyage to India
- 1498—Savonarola executed in Florence

trade since the late Middle Ages. In the 15th century it was also the center of the European banking system. In fact, our modern banks (the work bank is from the Italian banco, which means a counter or table—the place where money is exchanged) and their systems of handling money are based largely on practices developed by the Florentines. They devised advanced accounting methods, letters of credit, and a system of checks; they were the first to emphasize the importance of a stable monetary system. The gold florin minted in Florence was the standard coin in European commerce for centuries.

Great Florentine banking families made and lost fortunes in trading and banking. These families—the Strozzi, Bardi, Tornabuoni, Pazzi, and Mediciwere justly famous in their own time. They, in turn, were justly proud of their wealth and their city. The visitor to Florence today walks on streets named for these families and past palaces built for them. They combined a steady sense of business conservatism with an adventuresome pursuit of wealth and fame. No great Florentine banker would have thought it odd that one of this group began his will with the words "In the name of God and profit. Amen."

For all their renown and wealth, it was not the bankers who really gave Florence its lasting fame. By some mysterious stroke of good fortune Florence and its immediate surroundings produced, in the 15th century, a group of artists who revolutionized Western art to such an extent that later historians refer to the period as a time of rebirth in the arts.

The character of this revolutionary change in art is not easy to define, but we can evolve a partial definition by comparing two early 15th-century Florentine paintings. Sometime before 1423 a wealthy Floren-

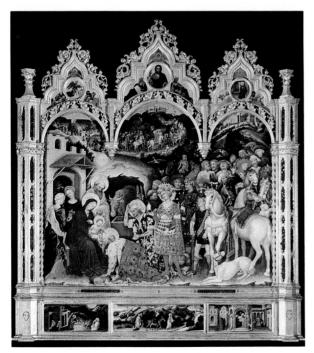

10.1 Gentile da Fabriano. Adoration of the Magi. 1423. Gold leaf and tempera on wood, $9'10'' \times 9'3''$ (3.02 × 2.81 m). Uffizi, Florence. The painting reflects the flat two-dimensional quality of most Byzantine and medieval painting. Notice the very crowded composition.

tine banker, Palla Strozzi, commissioned Gentile da Fabriano (c. 1385–1427) to paint an altarpiece for the Florentine church of Santa Trinità. The Adoration of the Magi [10.1], completed in 1423, is ornately framed in the style of Gothic art, with evidence of influences from the miniature painting of Northern Europe and from the older painting tradition of Italy itself. The altarpiece is in the style called "International" because it spread far beyond the area of its origins in France. This style reflects the old-fashioned tendency to fill up the spaces of the canvas, to employ the brightest colors on the palette, to use gold lavishly for halos and in the framing, and to ignore any proportion between the characters and the space they occupy. Gentile's altarpiece is, in fact, a strikingly beautiful painting that testifies to the lush possibilities of the conservative International Gothic style.

Only about five years later Tommaso Guidi (1401–1428), known as Masaccio, the precocious genius of Florentine painting, painted for the Dominican Church of Santa Maria Novella in Florence a fresco, The Holy Trinity [10.2], that is strikingly different from the kind of painting by Gentile. The most apparent difference is in the utilization of space. In The Holy Trinity the central figures of God the Father, the Holy Spirit, and the crucified Christ seem to stand in the foreground of deep three-dimensional

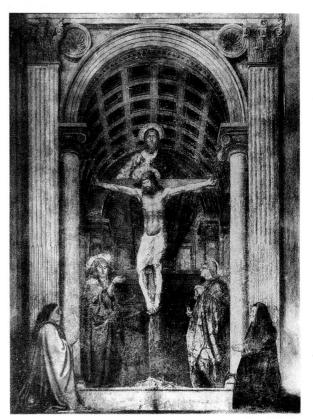

10.2 Masaccio. The Holy Trinity. 1428. Fresco, 21'101/2" × 10'5" (6.66 × 3.19 m). Santa Maria Novella, Florence. The donors of the panel kneel at bottom left and right. The Trinity, the Holy Spirit symbolized as a dove, is set in a classical Roman architectural frame.

space created by the illusionistically painted architectural framing of the Trinity. The character of the architecture is Roman, its barrel vaulting and coffering sustained by Corinthian columns and pilasters. At the sides, and slightly lower, Mary looks out at the viewer, while Saint John looks at Mary. At the edge of the scene, members of the donor family kneel in profile. The entire scene has an intense geometrical clarity based on the pyramid, with God as the apex of the triangle formed with the line of donors and saints at the ends of the base line.

In this single fresco appear many of the characteristics of Florentine Renaissance painting that mark it off from earlier painting styles: clarity of line, a concern for mathematically precise perspective, close observation of "real people," concern for psychological states, and an uncluttered arrangement that rejects the earlier tendency in painting to produce crowded scenes to fill up all the available space.

Masaccio's earlier frescoes in the Brancacci Chapel of the Church of the Carmine in Florence also show his revolutionizing style. His 1425 fresco called The

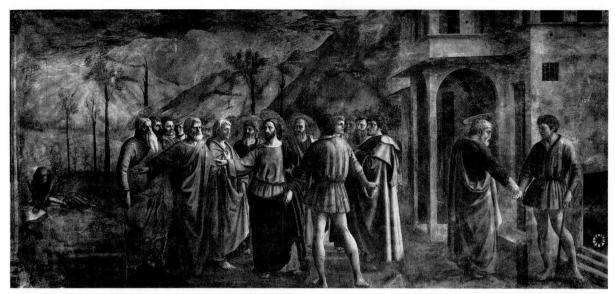

10.3 Masaccio. The Tribute Money. c. 1425. Fresco, 8'4" × 19' (2.54 × 5.9 m). Brancacci Chapel, Santa Maria del Carmine, Florence. Three moments of the story are seen simultaneously: Jesus instructs Peter to find the coin of tribute, at center; at the left, Peter finds it in the mouth of a fish; at the right, Peter pays the tribute money. The story is in Matthew 17:24-27.

Tribute Money [10.3] reflects his concern with realistic depiction of human beings. The central scene portrays Christ telling Peter that he can find the tax money for the temple in the mouth of a fish; at the left Peter recovers the coin of tribute; at the right he makes the tribute payment (Matthew 17:24–27). The clusters of figures surrounding Christ reflect a faithfulness to observed humanity that must have been startling to Masaccio's contemporaries, who had never seen anything quite like that in painting. The figures are in a space made believable by the receding lines of the buildings to the right. The fresco of the expulsion of Adam and Eve from Eden [10.4] in the same chapel shows not only realism in the figures but also a profound sense of human emotions: the shame and dismay of the first human beings as they are driven from the Garden of Paradise.

The revolutionary character of Masaccio's work was recognized in his own time. His influence on any number of Florentine painters who worked later in the century is clear. Two generations after Masaccio's death the young Michelangelo often crossed the Arno to sketch the frescoes in the Brancacci chapel. In the next century Giorgio Vasari (1511–1574) in his Lives of the Artists would judge Masaccio's influence as basic and crucial: "The superb Masaccio . . . adopted a new manner for his heads, his draperies, buildings, and nudes, his colours, and foreshortening. He thus brought into existence the modern style which, beginning during his period, has been employed by all of our artists down to the present day. . . .

The innovative character of 15th-century art was not limited to painting. Significant changes were occurring in sculpture and architecture as well. A famous competition was announced in 1401 for the right to decorate the doors of the Florence Baptistery, dedicated to Saint John the Baptist and a focal point of Florentine life. The baptistery is an ancient octagonal Romanesque building, which in the 15th century had such a reputation for antiquity that some thought it had originally been a Roman temple. Vasari tells us that an eminent group of artists including Lorenzo Ghiberti (1378-1455) and Filippo Brunelleschi (1377–1466) were among the competitors. Ghiberti won.

A comparison of Brunelleschi's and Ghiberti's panels shows the differences between the two and allows us to infer the criteria used to judge the winner. The assigned subject for the competition was Abraham's sacrifice of Isaac (Genesis 22:1–14). Brunelleschi's version [10.5] has a certain vigor, but it is a busy and crowded composition. The figures of the servants spill out of the four-leaf or quatrefoil frame while the major figures (the ram, the angel, and the two principals) are in flattened two-dimensional profile with little background space.

By contrast, Ghiberti's panel on the same subject [10.6] is divided dramatically by a slashing diagonal line separating the two sets of actors into clearly designated planes of action. The drastically foreshortened angel appears to be flying into the scene from deep space. Furthermore, as a close examination of the cast shows, Ghiberti's panel is a technical tour de

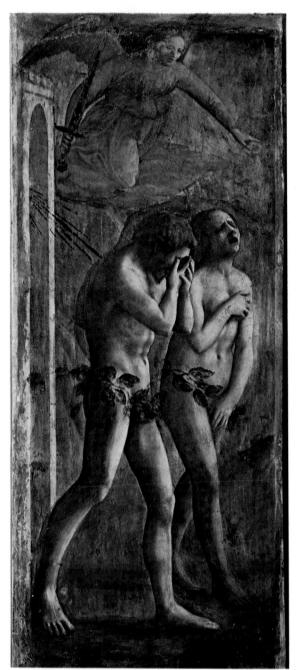

10.4 Masaccio. The Expulsion from the Garden. c. 1427. Fresco, 6'6" × 2'9" (1.98 × .84 m). Brancacci Chapel, Santa Maria del Carmine, Florence. The artist manages to convey both a sense of movement and a sense of the deep psychological distress and shame of the expelled couple.

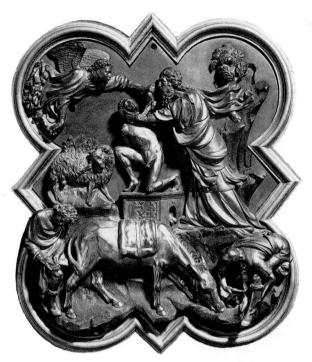

10.5 Filippo Brunelleschi. *The Sacrifice of Isaac.* 1401. Gilt bronze, $21 \times 17\frac{1}{2}$ " (53 × 44 cm). Museo Nazionale del Bargello, Florence. Note the figures spilling over the bottom part of the frame.

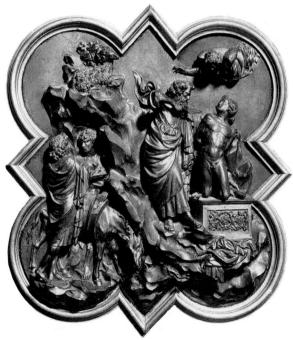

10.6 Lorenzo Ghiberti. The Sacrifice of Isaac. 1401. Gilt bronze, $21\times171/2''$ (53 \times 44 cm). Museo Nazionale del Bargello, Florence. This was the winning panel in the competition.

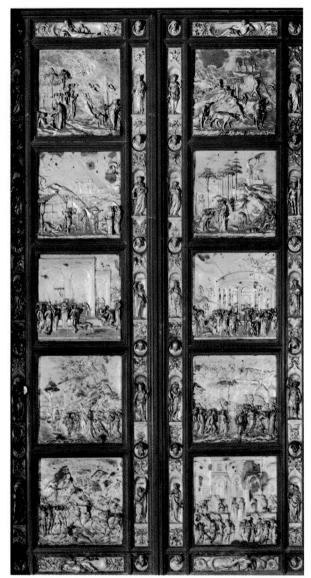

10.7 Lorenzo Ghiberti. East Doors of the Baptistery of the Cathedral of Florence. 1425-1432. Gilt bronze, height 17' (5.18 m). "The Gates of Paradise."

force. Except for the figure of Isaac and Abraham's left foot (and part of the rock it rests on), the entire scene was cast as a single unit. Demonstrating his strong background as a goldsmith, Ghiberti finely modeled and skillfully finished his panel. It is a piece of fierce sentiment, mathematical perspective, and exquisite work.

Ghiberti worked for almost a quarter of a century on the North Doors, completing twenty panels. Just as he was finishing, the Cathedral authorities commissioned him in 1425 to execute another set of panels for the East Doors, those facing the Cathedral itself. This commission occupied the next quarter of a

century (from roughly 1425 to 1452 or 1453), and the results of these labors were so striking that Michelangelo later in the century said Ghiberti's East Doors were not unworthy to be called the "Gates of Paradise," and so they are often called today.

The panels of the East Doors [10.7] were radically different in style and composition from the North Door panels. The Gothic style quatrefoils were replaced by more classically severe rectangular frames. The complete set of panels was framed, in turn, by a series of portrait busts of prophets and sybils.

Although Filippo Brunelleschi lost to Ghiberti in the sculpture competition of 1401, he made a major contribution to this early developmental phase of Renaissance art in another area, architecture. During his stay in Rome, where he had gone with the sculptor Donatello after the competition, he made a study of Roman architectural monuments. In fact, Vasari records that Brunelleschi and Donatello were reputed to be treasure hunters because of their incessant prowlings amid the ruins of the Roman Forum. It was these intensive studies, together with his own intuitive genius, that gave Brunelleschi an idea for solving a problem then thought insoluble: how to construct the dome for the still unfinished Cathedral of Saint Mary of the Flower in Florence.

The Cathedral of Florence had been built by Arnolfo di Cambio in the previous century over the remains of the older church of Santa Reparata. In the early 15th century, however, the church was still

10.8 Florence Cathedral in 1390. An artist's reconstruction of the cathedral as Brunelleschi would have found it when he began his work. (1) Facade and side wall. (2) Gallery. (3) Circular windows. (4) Armature under construction.

(5) Vaulting under construction. (6) Sacristy piers.

10.9 Florence Cathedral in 1418. (1) Buttressing. (2) Completed drum (tambour). (3) Side tribunes under construction. (4) Armature under construction. (5) Vaulting under construction. (6) Sacristy piers.

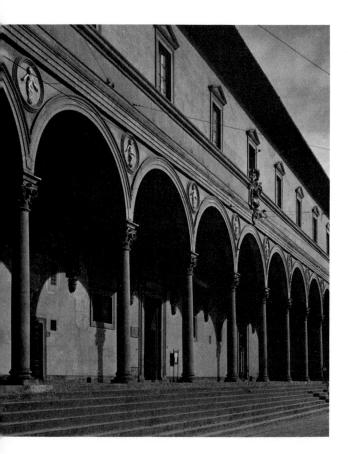

unfinished, although the nave was already complete [10.8]. No one had quite figured out how to span the great area without immense buttresses on the outside and supporting armatures on the inside. Brunelleschi worked on this problem between 1417 and 1420, trying, simultaneously, to solve the technical aspects of doming the building and convincing the skeptical cathedral overseers that it could be done. He eventually won the day, but work on the dome was not completed until 1436.

His solution, briefly, was to combine the buttressing methods of the Gothic cathedral and classical vaulting techniques that he had mastered by his careful study of the Roman Pantheon and other buildings from antiquity. By putting a smaller dome within the larger dome to support the greater weight of the outside dome, he could not only cover the great tambour or drum [10.9] but also free the inside of the dome from any need for elaborate armatures or supporting structures. This dome was strong enough to support the lantern that eventually crowned the whole construction. It was a breathtaking technical achievement, as well as an aesthetic success, as any person viewing Florence from the surrounding hills can testify. Years later, writing about his own work on the dome of Saint Peter's in the Vatican, Michelangelo had Brunelleschi's dome in mind when he said "I will create your sister; bigger but no more beautiful."

The technical brilliance of Brunelleschi's dome cannot be overpraised, but his real architectural achievement lies in his designs for buildings that make a break with older forms of architecture. His Foundling Hospital [10.10], with its open columned loggias and their graceful Corinthian pillars, arches, and entablature, is, despite its seeming simplicity, a highly intricate work, its proportions calculated with mathematical rigor. The building is an open departure from the heaviness of the Romanesque so common in the area of Tuscany as well as a rejection of the overly elaborate Gothic exteriors.

This same concern with classical order, proportion, and serenity can be seen in Brunelleschi's finest work, the chapel he designed for the Pazzi family next to the Franciscan Church of Santa Croce in Florence [10.11]. Its exterior evokes Roman austerity with its delicate columns, severe facade, and small dome reminiscent of the lines of Rome's Pantheon.

In this very brief look at three different art forms and artists in the early 15th century certain recurring words and themes give a rough descriptive outline of what the Florentine Renaissance style reflects: a concern with, and the technical ability to handle, space

10.10 Filippo Brunelleschi. Foundling Hospital, Florence. 1419-1426. The glazed terra cotta medallions of the swaddled children are from the Della Robbia workshop in Florence.

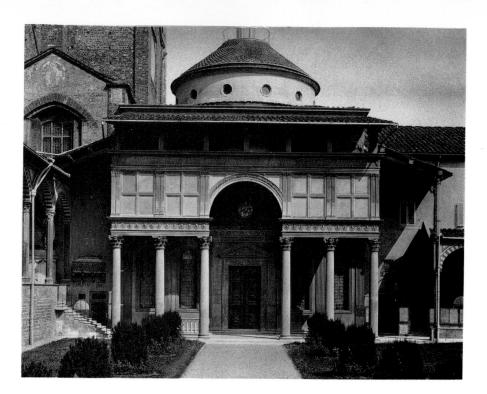

10.11 Filippo Brunelleschi. Pazzi Chapel, Florence. 1430-1433. Part of the Franciscan church of Santa Croce can be seen in the left background.

and volume in a believable way; a studious approach to models of art from ancient Rome; a departure from the more ethereal mode of medieval otherworldliness to a greater concern for human realism. The Florentine artistic temperament leaped over its medieval heritage (although not completely) in order to reaffirm what it considered the classical ideal of ancient Rome and Greece.

The Medici Era

The Florentine Republic was governed by representatives of the major trade guilds. This control by a very select group of people who represented commercial power and wealth inevitably led to domination by the most wealthy of the group. From 1434

THE ARTS AND INVENTION: Fresco Technique

The technique of painting on a plastered wall is very ancient. The Renaissance brought to perfection the art of fresco (in Italian, "fresh" or "wet"), one of two kinds of painting: fresco secco (dry fresco, painting on hardened plaster) and, more usual during the Renaissance, buon fresco ("good fresco"), painting on wet plaster. In fresco secco paint is mixed with a binding agent to make it adhere to the plaster. In buon fresco the paint blends with the damp plaster and the two, in blend, harden together.

Renaissance fresco painting had several steps. First, the artist's assistants would lay a coarse level of plaster on the wall. Dried and smooth, this layer would then be the base for two further layers of plaster, each smoother and more refined than the others. When the surface was adequately prepared, the artist could proceed in either of two ways. He might roughly sketch out in red chalk the subject to be painted (a drawing called a sinopia), cover with a very thin layer of plaster that would allow the red to show through, then paint on the wet plaster, using

the sinopia as a guide for the painting. Or he might use a large perforated drawing called a cartoon, placed over the final coat of wet plaster. This fine layer, called the intonaco, would be dusted with charcoal, leaving a stencil on the wall to serve as the painter's guide.

Since it was important to paint on the wet plaster only a portion was done each day, but the skilled artist finished an entire fresco without leaving any visible seams from this daily work. The speed of execution required in fresco also meant that the artist could not afford the time for the delicate shadings and nuances of color possible for those who paint on canvas or a panel.

It is a mark of the great skill of modern art restorers that they have learned how to peel a fresco off a wall while leaving the sinopia in place. An examination of the finished fresco and its earlier sinopia often reveals how an artist changed the style of painting between the sketch and the finished product. Such changes are known in art as pentimenti, "changes of heart."

until 1492 Florence was under the control of one familv: the Medici.

The Medici family had old, though up to then undistinguished, roots in the countryside around Florence. Their prosperity in the 15th century rested mainly on their immense banking fortune. By the middle of that century Medici branch banks existed in London, Naples, Cologne, Geneva, Lyons, Basel, Avignon, Bruges, Antwerp, Lübeck, Bologna, Rome, Pisa, and Venice. The great Flemish painting by Jan van Eyck, Giovanni Arnolfini and His Bride [10.12], in fact, commemorates van Eyck's witnessing of the marriage of this Florentine representative of the Medici bank in 1434 in Bruges. While it is more usual to look at the painting because of its exquisite technique, its rich symbolism, and its almost microscopic concern for detail, it is also profitable to view it sociologically as a testimony to how far the influence of the Medici extended.

Cosimo de' Medici

Cosimo de' Medici (de facto ruler of Florence from 1434 to 1464) was an astute banker and a highly culti-

vated man of letters. His closest friends were professional humanists, collectors of books, and patrons of the arts. Cosimo himself spent vast sums on the collecting and copying of ancient manuscripts. He had his copyists work in a neat cursive hand that would be the later model for the form of letters we call *italic*. His collection of books (together with those added by later members of his family) formed the core of the great humanist collection housed in the Laurentian library in Florence.

Although Cosimo never mastered Greek to any degree, he was intensely interested in Greek philosophy and literature. He financed the chair of Greek at the Studium of Florence. When Greek prelates visited Florence during the ecumenical council held in 1439 (the council sought a union between the Greek and Latin churches), Cosimo took the opportunity to seek out scholars in the retinue of the prelates from Constantinople. He was particularly struck with the brilliance of Genisthos Plethon (c. 1355–1452), who lectured on Plato. Cosimo persuaded Plethon to remain in the city to continue his lectures.

Cosimo's most significant contribution to the advancement of Greek studies was the foundation

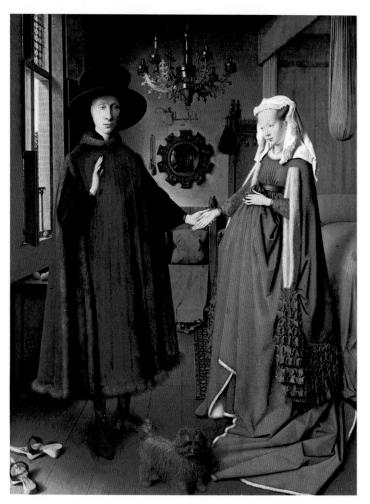

10.12 Jan Van Eyck. Giovanni Arnolfini and His Bride. 1434. Oil on panel, 33 × 221/2" (83.8 × 57.2 cm). National Gallery, London (by courtesy of the Trustees). The artist, reflected in the mirror, stands in the doorway. The Latin words on the wall read "Jan Van Eyck was here." The pair of sandals at lower left symbolizes a sacred event; the dog is a symbol of fidelity and domestic peace.

and endowment of an academy for the study of Plato. For years Cosimo and his heirs supported a priest, Marsilio Ficino, in order to allow him to translate and comment on the works of Plato. In the course of his long life (he died in 1499), Ficino translated into Latin all of Plato, Plotinus, and other platonic thinkers. He wrote his own compendium of platonism called the *Theologia Platonica*. These translations and commentaries had an immense influence on art and intellectual life in Italy and beyond the Alps.

Cosimo often joined his friends at a suburban villa to discuss Plato under the tutelage of Ficino. This elite group embraced Plato's ideas of striving for the ideal good and persistently searching for truth and beauty. This idealism became an important strain in Florentine culture. Ficino managed to combine his study of Plato with his own understanding of Christianity. It was Ficino who coined the term "Platonic love"—the spiritual bond between two persons who were joined together in the contemplative search for the true, the good, and the beautiful. Cosimo, a pious man in his own right, found great consolation in this Christian platonism of Ficino. "Come and join me as soon as you possibly can and be sure to bring with you Plato's treatise On the Sovereign Good,' Cosimo once wrote his protégé; "there is no pursuit to which I would devote myself more zealously than the pursuit of truth. Come then and bring with you the lyre of Orpheus."

Cosimo, a fiercely patriotic Florentine, known to his contemporaries as Pater Patriae (Father of the Homeland), lavished his funds on art projects to enhance the beauty of the city, at the same time glorifying his family name and atoning for his sins, especially usury, by acts of generous charity. He befriended and supported many artists. He was a very close friend and financial supporter of the greatest Florentine sculptor of the first half of the 15th century, Donato di Niccoló di Betto Bardi (1386-1466), known as Donatello. Donatello was an eccentric genius who cared for little besides his work; it was said that he left his fees in a basket in his studio for the free use of his apprentices or whoever else might be in need.

Even today a leisurely stroll around the historic center of Florence can in a short time give an idea of the tremendous range of Donatello's imaginative and artistic versatility. One need only compare his early Saint George [10.13], fiercely tense and classically severe, with the later bronze David [10.14]. The Saint George is a niche sculpture originally executed for the church of Orsanmichele, while the David is meant to be seen from all sides. The David, a near-life-size figure, is the first freestanding statue of a nude figure sculpted since Roman antiquity. It also marks a defi-

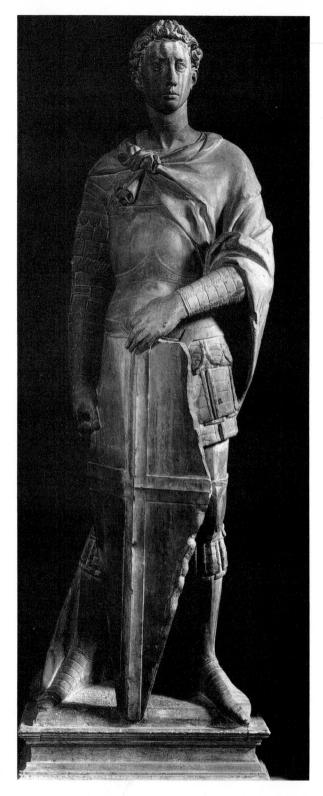

10.13 Donatello. Saint George. 1416-1417. Marble, height 6'5" (1.96 m). Museo Nazionale del Bargello, Florence. Originally, the saint grasped a spear in his right hand.

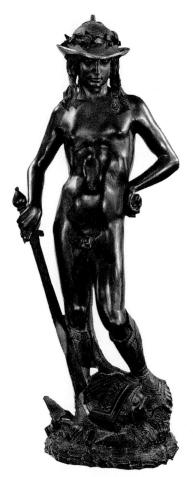

10.14 Donatello. David. c. 1430-1432. Bronze, height 5'21/2" (1.58 cm). Museo Nazionale del Bargello, Florence. The killing of Goliath is shown at three stages in this book. Michelangelo's David is shown as he sees his foe (figure 10.27). Bernini's David is shown in the exertion of his attack (figure 13.9). Donatello's David reposes after the attack as he leans on the sword of the giant and rests his other foot on Goliath's severed head.

nite step in Renaissance taste: In spite of its subject, it is more clearly "pagan" than biblical in spirit. The sculptor obviously wanted to show the beauty of form of this adolescent male clothed only in carefully fashioned military leg armor and a Tuscan shepherds's hat. The figure was most likely made for a garden. Some scholars have speculated that the commission was from Cosimo himself, although clear documentary proof is lacking.

Donatello's over-life-size wooden figure of Mary Magdalene [10.15] seems light years away from the spirit of David. Carved around 1455, it shows the Magdalene as an ancient penitent, ravaged by time and her own life of penance. The viewer is asked, mentally, to compare this older woman with the younger sinner described in the Bible. The statue, then, is a profound meditation on the vanity of life, a

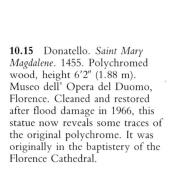

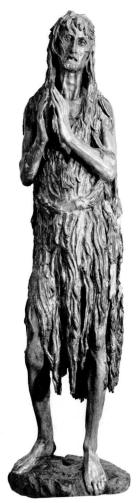

theme lingering in Florentine culture from its medieval past, and, at the same time, a hymn to the penitential spirit that made the Magdalene a saint.

Cosimo de' Medici had a particular fondness for the Dominican Convent of San Marco in Florence. In 1437 he asked Michelozzo, the architect who designed the Medici palace in Florence, to rebuild the convent for the friars. One of the Dominicans who lived there was a painter of established reputation, Fra Angelico (1387–1455). When Michelozzo's renovations were done, Fra Angelico decorated many of the convent walls and most of the cells of the friars with paintings, executing many of these works under the watchful eye of Cosimo, who stayed regularly at the convent. Fra Angelico's famous Annunciation fresco [10.16] shows his indebtedness to the artistic tradition of Masaccio: the use of architecture to frame space, a sense of realism and drama, and a close observation of the actual world.

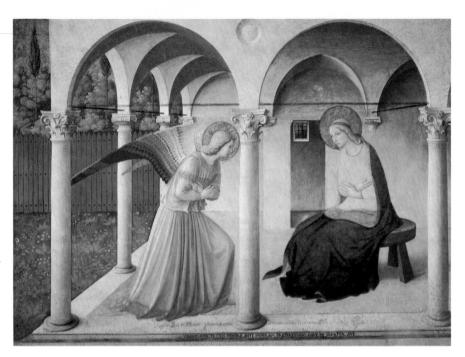

10.16 Fra Angelico. Annunciation. 1445-1450, Fresco, 7'6" × 10'5" $(2.29 \times 3.18 \text{ m})$. Monastery of San Marco, Florence. Note how the architecture frames the two principal figures in the scene. Botanists can identify the flowers in the garden to the left.

Another painter who enjoyed the Medici largesse was Paolo Uccello (1397-1475), who did a series of three paintings for the Medici palace commemorating the earlier battle of San Romano (1432) in which the Florentines defeated the Sienese. The paintings (now dispersed to museums in London, Florence, and Paris) show Uccello's intense fascination with perspective [10.17]. The scenes are marked by slashing lines, foreshortened animals, receding backgrounds, and seemingly cluttered landscapes filled with figures of different proportions. When the three paintings were together as a unit they gave a pano-

10.17 Paolo Uccello. The Battle of San Romano. 1455. Tempera on wood, 6'10" × 10'7" (1.83 × 3.22 m). Uffizi, Florence. The upraised spears and javelins give the picture a sense of frantic complexity.

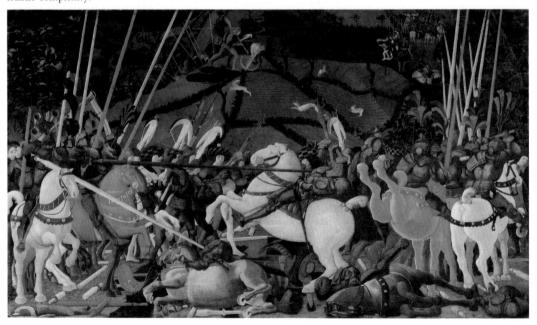

ramic sweep of the battle running across 34 feet (10.3) meters) of the wall space.

Cosimo's last years were racked with chronic illness and depression brought on by the premature deaths of his son Giovanni and a favorite grandson, as well as the physical weakness of his other son. Piero. Toward the end of his life Cosimo's wife once found him in his study with his eyes closed. She asked him why he sat in that fashion. "To get them accustomed to it," he replied. Cosimo de' Medici died on August 1, 1464. His position as head of the family and as first citizen of the city was taken by his son Piero, called "the Gouty" in reference to the affliction of gout from which he suffered all his life.

Piero de' Medici

Piero's control over the city lasted only five years. It was a time beset by much political turmoil as well as continued artistic activity. Piero continued to support his father's old friend Donatello and maintained his patronage of Ficino's platonic labors and his generous support of both religious and civic art and architecture.

One new painter who came under the care of Piero was Alessandro di Mariano dei Filipepi (1444– 1510), known more familiarly as Sandro Botticelli. Botticelli earlier had been an apprentice of the painter

Fra Filippo Lippi (c. 1406–1469), but it was Piero and his aristocratic-wife Lucrezia Tornabuoni (a highly cultivated woman who was a religious poet) who took Botticelli into their home and treated him as a member of the family. Botticelli stayed closely allied with the Medici for decades.

One tribute to the Medici was Botticelli's painting Adoration of the Magi [10.18], a work commissioned for the Florentine church of Santa Maria Novella. The Magi are shown as three generations of the Medici family; there are also portraits of Lorenzo and Giuliano, the sons of Piero. The painting was paid for by a friend of the Medici family. Many scholars think it was a votive offering to the church in thanksgiving for the safety of the family during the political turmoil of 1466.

The theme of the Magi was a favorite of the Medici. They regularly took part in the pageants in the streets of Florence celebrating the Three Kings on the feast of the Epiphany (January 6). It is for that reason, one assumes, that Piero commissioned a fresco of that scene for the chapel of his own palace. The painter was Benozzo Gozzoli (1420-1495), once an apprentice of Fra Angelico. Benozzo produced an opulent scene filled with personages of Oriental splendor modeled on the Greek scholars who had come to Florence during the ecumenical council and who staved on to teach Greek. The fresco also in-

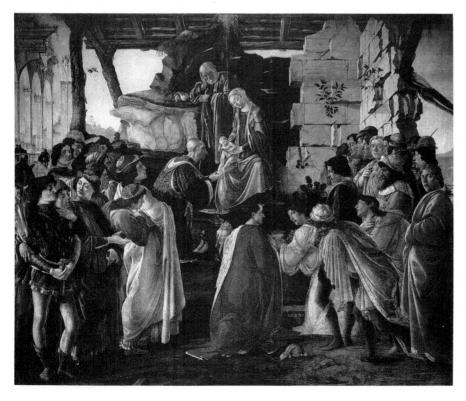

10.18 Sandro Botticelli. Adoration of the Magi. 1475. Tempera on wood, $3'7\frac{1}{2}'' \times 4'4\frac{3}{4}''$ $(1.1 \times 1.34 \text{ m})$. Uffizi, Florence. Cosimo de' Medici kneels in front of the Virgin; Lorenzo is in the left foreground; Giuliano is at right against the wall. The figure in the right foreground looking out is thought to be the artist.

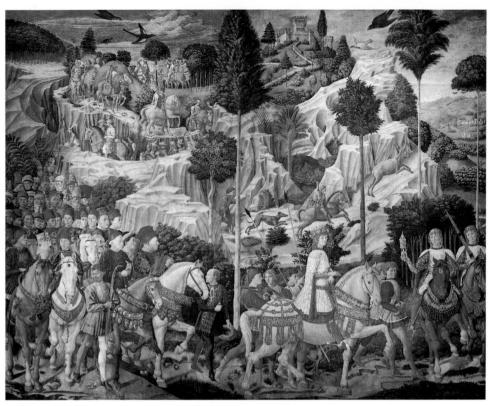

10.19 Benozzo Gozzoli. The Journey of the Magi, detail. 1459. Fresco, length (entire work), 12'41/2" (3.77 m). Medici Palace Chapel, Florence. The horseman, representing one of the Magi, is thought to be an idealized portrait of the Byzantine emperor John VII Paleologus, who visited Florence at the invitation of Cosimo de' Medici for a church council in 1439.

cluded some contemporary portraits, including one of the artist himself [10.19].

Lorenzo the Magnificent

Piero de' Medici died in 1469. The mantle of power settled on the shoulders of his son Lorenzo, who accepted the responsibility with pragmatic resignation, since, as he said, "It bodes ill for any wealthy man in Florence who doesn't control political power." Lorenzo, a rather ugly man with a high raspy voice, became the most illustrious of the family; in his own day he was known as "the magnificent"—Lorenzo il Magnifico. His accomplishments were so many and varied that the last half of the 15th century in Florence is often called the Laurentian Era.

Lorenzo continued the family tradition of art patronage by supporting various projects and by adding to the Medici collection of ancient gems, other antiquities, and books. He was also more directly involved in the arts. Lorenzo was an accomplished poet, but his reputation as a political and social leader has made us forget that he was an important contributor to the development of vernacular Italian poetry.

He continued the sonnet tradition begun by Petrarch. One of his most ambitious projects—done in conscious imitation of Dante's Vita Nuova—was a long work that alternated his own sonnets with extended prose commentaries; this was the Comento ad alcuni sonetti (A Commentary on Some Sonnets, begun around 1476–1477). In addition to this very ambitious work, Lorenzo wrote hunting songs, poems for the carnival season, religious poetry, and occasional burlesque poems with a cheerfully bawdy tone to them.

The poem for which Lorenzo is best known is "The Song of Bacchus." Written in 1490, its opening stanzas echo the old Roman dictum of living for the present because of the shortness of life and the uncertainty of the future.

Lorenzo de' Medici

THE SONG OF BACCHUS

How beautiful is youth, That flees so fleetingly by. Let him be who chases joy For tomorrow there is no certainty.

Look at Bacchus and Ariadne So beautiful and much in love.

Since deceitful time flees They are always happy.

Joyful little satyrs of the nymphs enamored, In every cave and glade Have set traps by the hundred; Now, by Bacchus intoxicated, Dance and leap without end.

Let him be who chases joy For tomorrow there is no certainty.

Lorenzo's interests in learning were deep. He had been tutored as a youth by Ficino and as an adult he continued the habit of spending evenings with an elite group of friends and Ficino. He often took with him his friend Botticelli and a young sculptor who worked in a Medici-sponsored sculpture garden, Michelangelo Buonarroti.

The Laurentian patronage of learning was extensive. Lorenzo contributed the funds necessary to rebuild the university of Pisa and designated it the principal university of Tuscany (Galileo taught there in the next century). He continued to underwrite the study of Greek at the Studium of Florence.

The Greek faculty at Florence attracted students from all over Europe. Indeed, this center was a principal means by which Greek learning was exported to the rest of Europe, especially to countries beyond the Alps. English scholars like Thomas Linacre, John Colet, and William Grocyn came to Florence to study Greek and other classic disciplines. Linacre was later to gain fame as a physician and founder of England's Royal College of Physicians. Grocyn returned to England to found the chair of Greek at Oxford. Colet used his training to become a biblical scholar and a founder of Saint Paul's School in London. The two greatest French humanists of the 16th century had, as young men, come under the influence of Greek learning from Italy. Guillaume Budé (died 1540) founded, under the patronage of the French kings, a library at Fontainebleau that was the beginning of the Bibliothèque Nationale of Paris. He also founded the Collège de France, still the most prestigious center of higher learning in France. Jacques Lefèvre d' Étaples had also studied in Florence and became the greatest intellectual church reformer of 16th-century France.

Lorenzo was less interested in painting than either his father Piero or his grandfather Cosimo. Nevertheless, some of the paintings done in his lifetime have come to epitomize the spirit of the age because of their close familial and philosophical links to Lorenzo's family. This is especially true of the work of Botticelli and, more specifically, his paintings Primavera and The Birth of Venus.

Botticelli painted La Primavera (Springtime) [10.20] for a cousin of Lorenzo named Lorenzo di' Pierfrancesco. One of the most popular paintings in the history of Western art, La Primavera is an elaborate mythological allegory of the burgeoning fertility of the world. The allegory itself has never been fully explicated, but the main characters are clearly discernible: at the extreme right the wind god Zephyr pursues a nymph who is transmuted into the goddess Flora (next figure), who scatters her flowers; at the left are the god Mercury and three dancing Graces.

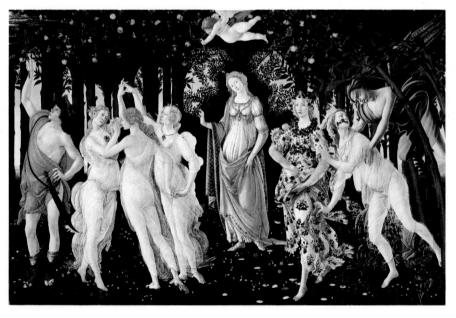

10.20 Sandro Botticelli. La Primavera (Springtime). c. 1478. Tempera on canvas, $6'8'' \times 10'4''$ $(2.03 \times 3.14 \text{ m})$. Uffizi, Florence. This work and The Birth of Venus (figure 10.21) are the best examples of Botticelli's fusion of pagan symbolism, Neoplatonic idealism, and the quest for the ideal feminine.

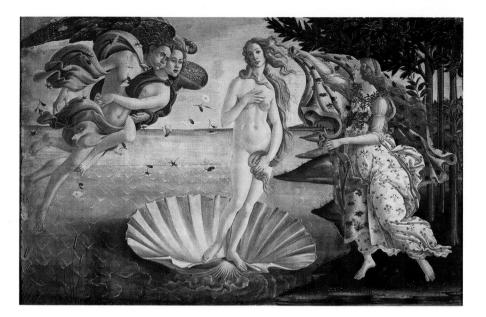

10.21 Sandro Botticelli. The Birth of Venus. 1480. Tempera on canvas, $6'7'' \times 9'2''$ (2.01 × 2.79 m). Uffizi, Florence. Scholars have made great exertions to unlock the full meaning of this work and La Primavera. A comparison of the two shows some close similarity in the figures.

Over the Graces and the central female figure (who represents Spring) is blind Cupid ready to launch an arrow that will bring love to the one he hits. The rich carpeting of springtime flowers and the background of the orange grove provide luxuriant surroundings.

In the 16th century Vasari saw La Primavera in Lorenzo di' Pierfrancesco's villa together with another painting by Botticelli, The Birth of Venus (1480). A gentle, almost fragile work of idealized beauty, The Birth of Venus [10.21] shows the wind gods gently stirring the sea breezes as Venus emerges from the sea and an attendant waits for her with a billowing cape. The Venus figure is inspired by the Venus pudica (the Modest Venus) figures of antiquity. The most significant aspect of the painting (and of La Primavera) is the impulse, motivated by platonism, to idealize the figures. Botticelli is trying to depict not a particular woman but the essential ideal of female beauty. The Venus of this painting reflects a complex synthesis of platonic idealism, Christian mysticism relating to the Virgin, and the classical ideal of the female figure of Venus.

Two other artists who lived in Laurentian Florence are of worldwide significance: Leonardo da Vinci (1452–1519) and Michelangelo Buonarroti. Leonardo came from a small Tuscan town near Florence called Vinci. He lived in Florence until the 1480s, when he left for Milan; from there he moved restlessly from place to place until his death in France. Leonardo has been called the genius of the Renaissance not so much for what he left in the way of art (although his Last Supper and Mona Lisa are surely among the more famous set pieces of all time) as for the things that he dreamed of doing and the

10.22 Leonardo da Vinci. Helicopter or Aerial Screw. c. 1485-1490. Bibliothèque de l'Institut de France, Paris. Leonardo's "code writing" is decipherable only when held against a mirror.

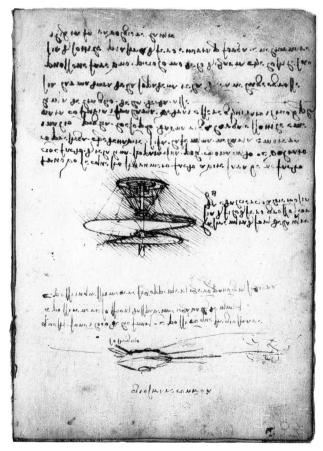

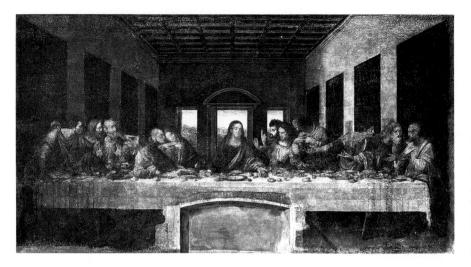

10.23 Leonardo da Vinci. The Last Supper. 1495-1498. Fresco, $14'5'' \times 281/4'' (4.39 \times 8.61 \text{ m}).$ Refectory, Santa Maria delle Grazie, Milan. Below the figure of Christ one can still see the doorway cut into the wall during the Napoleonic period by soldiers who used the monastery as a military headquarters.

10.24 Leonardo da Vinci. Madonna of the Rocks. Begun 1483. Panel painting transferred to canvas, 78 × 48". Louvre, Paris. There is another version of this painting in London's National Gallery, but this one is thought to be completely from the hand of Leonardo. It was to be part of a large altarpiece, never completed, in honor of the Virgin.

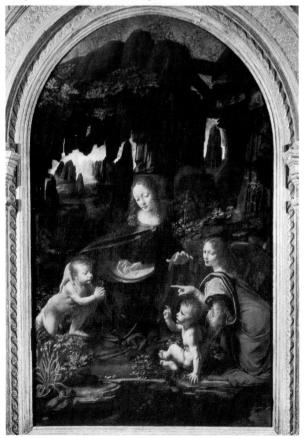

problems he set himself to solve and the phenomena he observed and set down in his Notebooks.

If we had nothing but the Notebooks, we would still say that Leonardo had one of humanity's most fertile minds. He left sketches for flying machines, submarines, turbines, elevators, ideal cities, and machines of almost every description [10.22]. His knowledge of anatomy was unsurpassed (he came very close to discovering the circulation path of blood), while his interest in the natural worlds of geology and botany was keen. The Notebooks, in short, reflect a restlessly searching mind that sought to understand the world and its constituent parts. Its chosen fields of inquiry are dominated by many of the characteristics common to the period: a concern with mathematics, a deep respect for seeing the natural world, and a love for beauty.

Leonardo's The Last Supper [10.23] is a good example of these characteristics. Leonardo chooses the moment when Jesus announces that someone at the table will betray him. The apostles are arranged in four distinct groups. The central figure of Christ is highlighted by the apostles who either look at him or gesture toward him. Christ is haloed by the central window space behind him, with the lines of the room all converging toward that point. The painting has great emotional power even though it is one of the most carefully mathematical paintings ever executed.

Leonardo's expressive power as a painter is ably illustrated in his striking Madonna of the Rocks [10.24], begun shortly after his arrival in Milan in 1483, a decade before he painted The Last Supper. The Virgin drapes her right arm over the figure of the infant Saint John the Baptist while her hand hovers in protective benediction over the Christ child. An exquisitely rendered angel points to the scene. The cavernlike space in the background would remind the perceptive viewer both of the cave at Bethlehem

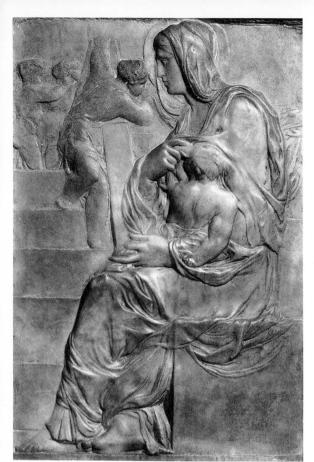

10.25 Michelangelo. Madonna of the Stairs. 1489–1492. Marble, $21\frac{1}{4} \times 15\frac{1}{4}$ " (55 \times 40 cm). Casa Buonarroti, Florence. A very fine example of low-relief (bas-relief) carving, with its figures nearly flush to the marble surface.

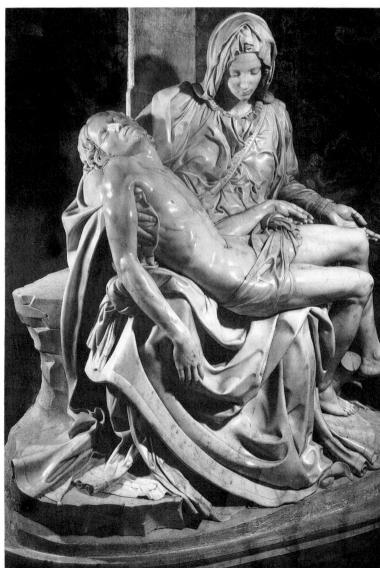

10.26 Michelangelo. *Pietà*. 1498–1499. Marble, height 5'9" (1.75 m). Saint Peter's, Vatican, Rome. One of the most "finished" of Michelangelo's sculptures, its high sheen is the result of intense polishing of the marble.

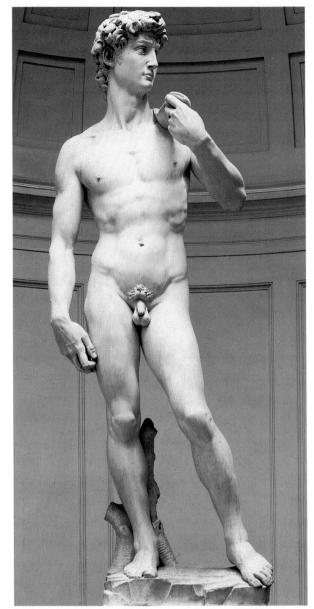

10.27 Michelangelo. David. 1501-1504. Marble, height 18' (5.49 m). Accademia, Florence. Much of the weight of this figure is borne by David's right leg (with the stylized treetrunk in the rear) in a position called contraposto in Italian.

where Christ was born and the cave in which he would be buried. Leonardo's rendering of the jagged rocks stands in sharper relief because of the misty light in the extreme background. The particular beauty of the painting derives at least partially from the juxtaposition of the beautifully rendered persons in all their humanity with the wildly mysterious natural frame in which they are set.

The other great genius of the late 15th century is Michelangelo Buonarroti (1476–1564). After his early days in the sculpture garden of Lorenzo, he produced many of his greatest works in Rome; they are considered in the next chapter. However, even a few examples of his early works show both the great promise of Michelangelo's talent and some of the influences he absorbed in Florence under the Medici. The Madonna of the Stairs [10.25], an early marble relief, reflects his study of ancient reliefs or cameo carving (which he may well have seen in Lorenzo's collection.) By 1498 his style had matured enough for him to carve, for a French cardinal in Rome, the universally admired Pietà [10.26], which combines his deep sensitivity with an idealism in the beauty of the Madonna's face that is reminiscent of Botticelli.

Finally, this early period of Michelangelo's work includes a sculpture that has become almost synonymous with Florence: the David [10.27], carved in 1501–1504 from a massive piece of Carrara marble that had lain behind the cathedral in Florence since the middle of the preceding century. The sculpture's great size and its almost photographically realistic musculature combine to make it one of Michelangelo's clearest statements of idealized beauty. The statue was intended to be seen from below with the left arm (the one touching the shoulder) facing the viewer and the right side turned back toward the Cathedral. In fact, it was placed outside the Palazzo Vecchio as a symbol of the civic power of the city, where it remained until weathering and damage required its removal to a museum in the 19th century.

It has been said that Botticelli's paintings, the Davids of both Donatello and Michelangelo, and the general skepticism of a mind like Leonardo's are all symptoms of the general pagan tone of Laurentian Florence—that Athens and Rome, in short, seemed far more important to 15th-century Florence than Ierusalem did. There is no doubt that the classical revival was central to Florentine culture. Nor is there any doubt that the times had little patience with, or admiration for, medieval culture. However, the notion that the Renaissance spirit marked a clean break with medieval ideals must take into account the life and career of the Dominican preacher and reformer Fra Savonarola (1452-1498).

Savonarola lived at the Convent of San Marco in Florence from 1490 until his execution in 1498. His urgent preachings against the vanities of Florence in general and the degeneracy of its art and culture in particular had an electric effect on the populace. His influence was not limited to the credulous masses of the workers of the city. Lorenzo called him to his own deathbed in 1492 to receive the last sacraments even though Savonarola had been a bitter and open enemy of Medici control over the city. Savonarola, in fact, wanted a restored Republic with a strong ethical and theocratic base. Botticelli was so impressed by Savonarola that he burned some of his more

CONTEMPORARY VOICES

Fra Savonarola

Creatures are beautiful insofar as they share in and approach the beauty of the soul. Take two women of like bodily beauty, and if one is holy and the other is evil, you will notice that the holy one is more loved by everyone than the evil one, so all eyes will rest on her. The same is true of men. A holy man, however deformed bodily, pleases everyone because, no matter how ugly he may be, his holiness shows itself and makes everything he does gracious.

Think how beautiful the Virgin was, who was so holy. She shines forth in all she does. St. Thomas [Aquinas says that no one who saw her ever looked on her with evil desire, so evident was her sanctity.

But now think of the saints as they are painted in the churches of the city. Young men go about saying "This is the Magdalen and that is Saint John," and only because the paintings in the church are modeled on them. This is a terrible thing because the things of God are undervalued.

You fill the churches with your own vanity.

Do you think that the Virgin Mary went about dressed as she is shown in paintings? I tell you she went about dressed like a poor person with simplicity and her face so covered that it was hardly seen. The same is true of Saint Elizabeth.

You would do well to destroy pictures so unsuitably conceived. You make the Virgin Mary look like a whore. How the worship of God is mocked!

From a sermon of Fra Savonarola to a congregation in the Cathedral of Florence.

worldly paintings, and scholars see in his last works a more profound religiosity derived from the contact with the reforming friar. Michelangelo, when an old man in Rome, told a friend that he could still hear the words of Savonarola ringing in his ears. Pico della Mirandola (1463–1494), one of the most brilliant humanists of the period, turned from his polyglot studies of Greek, Hebrew, Aramaic, and Latin to a devout life under the direction of the friar; only his early death prevented him from joining Savonarola as a friar at San Marco.

Savonarola's hold over the Florentine political order (for a brief time he was the de facto ruler of the city) came to an end in 1498 when he defied papal excommunication and was then strangled in the public square before the Palazzo Vecchio. By that time. Lorenzo had been dead for six years and the Medici family had lost power in Florence. They were to return in the next century, but the Golden Age of Lorenzo had ended with a spasm of medieval piety. The influence of the city and its ideals, however, had already spread far beyond its boundaries.

EAST MEETS WEST

The Renaissance in Exploration

Travel outside Europe had persisted throughout the Middle Ages, but the 15th century saw a renaissance in exploration because of some technological advances. Although both the compass and the astrolabe (for measuring latitudes) had been known for centuries, under Islamic influence they were greatly refined in this period. Furthermore, it was in the 15th century that the first three-masted ships, with their great advance in power, came into common use. In 1410 there appeared a Latin translation of the astronomical and geographical works of Ptolemy, the late-Latin writer whose writings had been lost to the West but known in the Muslim world. This translation provided further impetus for better maps and other navigational aids.

The Portuguese can claim star billing for 15thcentury exploration. Under Prince Henry the Navigator (1390-1460), explorations down the west coast of Africa were undertaken in an effort to find a sea route to the fabled land of India. By midcentury the Portuguese had trading centers on the coast of Africa, where they

engaged in a lucrative commerce in pepper, ivory, and gold. By 1446 these explorers and traders had pushed fifteen hundred miles down the African coast and passed the Cape Verde Islands. The motives for such risky travel were complex: partly a matter of expanded economics, partly an attempt to outflank the Muslims who controlled all of North Africa, and partly, a desire to extend Christian influence in the world.

By the last decade of the century Vasco da Gama had rounded the tip of Africa, proving that there was a sea route to India. In 1499 da Gama returned to Lisbon and a tumultuous welcome with a cargo of spices and precious stones. India had been reached by sea. The stranglehold of the Venetians and the Muslims (with their ports on the Mediterranean) had been broken. Europe now looked to the Atlantic-which would have enormous consequences, as Christopher Columbus proved in the same decade.

As early as 1441, however, Portuguese traders had sent back captured Africans to the European homeland. These merchants soon realized that Africa could supply cheap labor by the simple expedient of enslaving people. The explorers of Portugal, then, have the dubious honor of having begun the African slave trade.

The Character of Renaissance Humanism

Jules Michelet, a 19th-century French historian, first coined the word Renaissance specifically to describe the cultural period of 15th-century Florence. The broad outline of this rebirth is described by the Swiss historian Jakob Burckhardt in his massive The Civilization of the Renaissance in Italy, first published in 1860, a book that is the beginning point for any discussion of the topic. Burckhardt's thesis is simple and persuasive. European culture, he argued, was reborn in the 15th century after a long dormant period that extended from the fall of the Roman Empire until the beginning of the 14th century.

The characteristics of this new birth, Burckhardt said, were first noticeable in Italy and were the foundation blocks of the modern world. It was in late 14th- and 15th-century Italy that new ideas about the nature of the political order developed of which the Republican government of Florence is an example, as well as the consciousness of the artist as an individual seeking personal fame. This pursuit of glory and fame was in sharp contrast to the self-effacing and world-denying attitude of the Middle Ages. Burckhardt also saw the thirst for classical learning, the desire to construct a humanism from that learning, and an emphasis on the good life as an intellectual repudiation of medieval religion and ethics.

Burckhardt's ideas have provoked strong reactions from historians and scholars, many of whom reject his theory as simplistic. Charles Homer Haskins, an American scholar, attacked Burckhardt's ideas in 1927 in a book whose title gives away his line of argument: The Renaissance of the Twelfth Century. Haskins pointed out that everything Burckhardt said about Florentine life in the 15th century could be said with equal justification about Paris in the 12th century. Furthermore (as noted in Chapter 7 of his textbook), scholars have also spoken of a Carolingian Renaissance identified with the court of the emperor Charlemagne.

What is the truth? Was there a genuine Renaissance in 15th-century Italy? Many scholars today try to mediate a position between Burckhardt and his detractors. They admit that something new was happening in the intellectual and cultural life of 15thcentury Italy and that contemporaries were conscious of it. "May every thoughtful spirit thank God that it has been given to him to be born in this new age, so filled with hope and promise, which already enjoys a greater array of gifted persons than the world has seen in the past thousand years," wrote Matteo Palmieri, a Florentine businessman, in 1436. Yet this "new age" of which Palmieri spoke did not spring up

overnight. The roots must be traced to Italy's long tradition of lay learning, the Franciscan movement of the 13th century, the relative absence of feudalism in Italy, and the long maintenance of Italian city life. In short, something new was happening precisely because Italy's long historical antecedents permitted it.

The question remains, however: What was new in the Renaissance? The Renaissance was surely more than a change in artistic taste or an advance in technological artistic skill. We need to go deeper. What motivated the shift in artistic taste? What fueled the personal energy that produced artistic innovation? What caused flocks of foreign scholars to cross the Alps to study in Florence and in other centers where they could absorb the "new learning"?

The answer to these questions, briefly, is this: There arose in Italy, as early as the time of Petrarch (1304–1372), but clearly in the 15th century, a strong conviction that humanist learning would not only ennoble and perfect the individual but could also serve as a powerful instrument for social and religious reform. Very few Renaissance humanists denied the need for God's grace, but all felt that human intellectual effort should be the first concern of anyone who wished truly to advance the good of self or society. The career of Pico della Mirandola, one of the most brilliant and gifted Florentine humanist scholars, illustrates this humanist belief.

Pico della Mirandola

Pico della Mirandola (1462-1494) was an intimate friend of Lorenzo de' Medici and a companion of the platonic scholar Marsilio Ficino. Precociously brilliant, Pico once bragged, not implausibly, that he had read every book in Italy. He was deeply involved with the intellectual life of his day.

Pico was convinced that all human learning could be synthesized in such a way as to yield basic and elementary truths. To demonstrate this, he set out to master all the systems of knowledge that then existed. He thoroughly mastered the Latin and Greek classics. He studied medieval Aristotleanism at the University of Paris and learned Arabic and the Islamic tradition. He was the first Christian in his day to take an active interest in Hebrew culture; he learned Hebrew and Aramaic and studied the Talmud with Jewish scholars.

At the age of twenty Pico proposed to defend at Rome his nine hundred theses (intellectual propositions), which he claimed summed up all current learning and speculation. Church leaders attacked some of his propositions as unorthodox; Pico left Rome and the debate was never held.

The preface to these theses, called the Oration on the Dignity of Man, has often been cited as the first and most important document of Renaissance humanism. Its central thesis is that humanity stands at the apex of creation in such a way as to create the link between the world of God and that of the creation. Pico brings his wide learning to bear on this fundamental proposition: humanity is a great miracle. He not only calls on the traditional biblical and classical sources but also cites, from his immense reading, the opinions of the great writers of the Jewish, Arabic, and Neoplatonic traditions. The enthusiasm of the youthful Pico for his subject is as apparent as his desire to display his learning.

Scholars disagree on Pico's originality as a thinker. Many argue that his writings are a hodgepodge of knowledge without any genuine synthesis. There is no disagreement, however, about Pico's immense ability as a student of languages and culture to open new fields of study and, in that way, contribute much to the enthusiasm for learning in his own day. His reputation attracted students to him. The most influential of these was a German named Johann Reuchlin (1455–1522), who came to Florence to study Hebrew with him. After mastering that language and Greek as well. Reuchlin went back to Germany to pursue his studies and to apply them to biblical scholarship. In the early 16th century he came under the influence of Martin Luther (see Chapter 12) but never joined the Reformation. Reuchlin passionately defended the legitimacy of biblical studies oriented to the original languages. When his approach was attacked in one of those periodic outbursts of anti-Semitism so characteristic of European culture of the time, Reuchlin, true to his humanist impulses, not only defended his studies as a true instrument of religious reform but also made an impassioned plea for toleration that was not characteristic of his time.

Printing Technology and the Spread of Humanism

The export of humanist learning was not restricted to the exchange of scholars between Italy and the countries to the north. Printing had been invented in the early 15th century, so books were becoming more accessible to the educated classes. The most famous humanist printer and publisher of the 15th century was Aldus Manutius (1449–1515), whose Aldine Press was in Venice, his native city (see map opposite). Aldus was a scholar in his own right; he learned Greek from refugee scholars who settled in Venice after the fall of Constantinople in 1453. Recognizing the need for competent and reliable editions of the classical authors, he employed professional humanists to collate and correct manuscripts. Erasmus, the greatest of the northern humanists, was, for a time, in his employ.

Aldus was also a technical innovator. He designed Greek typefaces, created italic type fonts (modeled after the scribal hand used for copying Florentine manuscripts), developed new inks, and obtained new paper from the nearby town of Fabriano, still a source of fine papers for artists and printmakers. His books were near pocket-size, easily portable, and inexpensive. The scope of the press's activities was huge: after 1494 Aldus (and, later, his son) published. in about twenty years, the complete works of Aristotle and the works of Plato, Pindar, Herodotus, Sophocles, Aristophanes, Xenophon, and Demosthenes. Aldus reissued the Latin classics in better editions and published vernacular writers like Dante and Petrarch as well as contemporary poets like Poliziano, the Florentine friend of Lorenzo.

The Aldine Press was not an isolated phenome-Germany, where Western printing really started, already had an active printing and publishing tradition. Johannes Gutenberg (c. 1395-1468) originated the method of printing from movable type that was then used with virtually no change until the late 19th century. Gutenberg finished printing a Bible at Mainz in 1455. The first book printed in English, The Recuyell (collection) of the Historyes of Troye, was published by William Caxton in 1475. Historians have estimated that before 1500 European presses produced between six and nine million books in thirteen thousand different editions. Nearly fifty thousand of these books survive in libraries throughout the world.

This conjunction of pride in humanist learning and technology of printing had profound consequences for European culture. It permitted the wide diffusion of ideas to a large number of people in a relatively short time. There is no doubt that vigorous intellectual movements—one thinks immediately of the Protestant Reformation—benefited immensely from printing. This communications revolution was as important for the Renaissance period as radio, film, and television have been for our own.

Two Styles of Humanism

In the generation after the death of Lorenzo de' Medici the new learning made its way north, where it was most often put to use in attempts to reform the religious life of the area; in Italy, however, the learning remained tied to more worldly matters. The double usage of humanist learning for secular and spiritual reform can be better appreciated by a brief consideration of the work of the two most important writers of the period after the golden period of the Medicean Renaissance: Niccolò Machiavelli and Desiderius Erasmus.

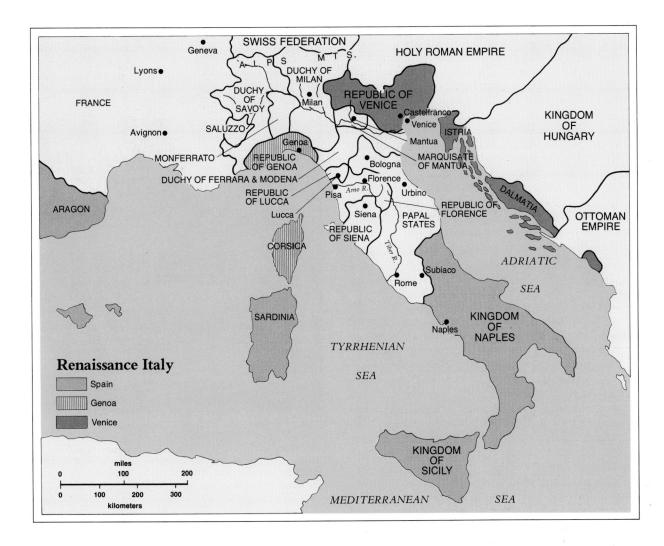

Machiavelli

Niccolò Machiavelli (1469-1527), trained as a humanist and active as a diplomat in Florence, was exiled from the city when the Medici reassumed power in 1512. In his exile, a few miles from the city which he had served for many years, Machiavelli wrote a political treatise on politics called The Prince that was published only after his death.

The Prince is often considered the first purely secular study of political theory in the West. Machiavelli's inspiration is the government of Republican Rome (509–31 B.C.). He sees Christianity's role in politics as a disaster that destroys the power of the state to govern. For that reason, Machiavelli asserts, the state needs to restrict the power of the church, allowing it to exercise its office only in the spiritual realm. The prince, as ruler of the state, must understand that the key to success in governing is in the exercise of power. Power is to be used with wisdom and ruthlessness. The prince, in a favorite illustration of Machiavelli, must be as sly as the fox and as brutal as the lion. Above all, the prince must not be deterred from his tasks by any consideration of morality beyond that of power and its ends. In this sense, cruelty or hypocrisy is permissible; judicious cruelty consolidates power and discourages revolution. Senseless cruelty is, however, counterproductive.

The basic theme of *The Prince* is the pragmatic use of power for state management. Previously the tradition of political theory had always invoked the transcendent authority of God to insure the stability and legitimacy of the state. For Machiavelli it was power, not the moral law of God, that provided the state with its ultimate sanction. The final test of the successful ruler was the willingness to exercise power judiciously and freedom from the constraints of moral suasion. "A prince must not keep faith when by doing so it would be against his self-interest," Machiavelli says in one of the most famous passages

from his book. His justification is ". . . If all men were good this precept would not be a good one but as they are bad and would not observe their faith with you, so you are not bound to keep faith with them." This bold pragmatism explains why the Catholic Church put The Prince on its Index of Prohibited Books and why the adjective "machiavellian" means, in English, devious or unscrupulous in political dealings. Machiavelli had such a bad reputation that many 16th-century English plays had a stock evil character—an Italian called "Old Nick." The English phrase "to be filled with the Old Nick," meaning to be devilish, derives from Machiavelli's reputation as an immoral man. But Machiavelli's realistic pragmatism also explains why Catherine the Great of Russia and Napoleon read him with great care.

Erasmus

Desiderius Erasmus (1466-1536) has been called the most important Christian humanist in Europe [10.28]. Educated in Holland and at the University of Paris, Erasmus was a monk and priest who soon tired of his official church life. He became aware of humanist learning through his visits to England, where he met men like John Colet and Thomas More. Fired by their enthusiasm for the new learning. Erasmus traveled to Italy in 1506, with lengthy stays in both Rome and Venice. Thereafter he led the life of a wandering scholar, gaining immense fame as both scholar and author.

Erasmus' many books were attempts to combine classical learning and a simple interiorized approach to Christian living. In the Enchiridion Militis Christiani (1502) he attempted to spell out this Christian humanism in practical terms. The title has a typical Erasmian pun; the word enchiridion can mean either "handbook" or "short sword"; thus the title can mean the handbook or the short sword of the Christian knight. His Greek New Testament (1516) was the first attempt to edit the Greek text of the New Testament by a comparison of extant manuscripts. Because Erasmus used only three manuscripts his version is not technically good, but it was a noteworthy attempt and a clear indication of how a humanist felt he could contribute to ecclesiastical work.

The most famous book Erasmus wrote, The Praise of Folly (1509), was dashed off almost as a joke while he was a houseguest of Sir Thomas More in England. Again the title is a pun; Encomium Moriae can mean either "praise of folly" or "praise of More"— Thomas More, his host. The Praise of Folly is a humorous work, but beneath its seemingly lighthearted spoof of the foibles of the day there are strong denunciations of corruption, evil, ignorance, and prejudice in society. Erasmus flailed away at the makers of war

10.28 Albrecht Dürer. Erasmus of Rotterdam. 1526. Engraving, $9\frac{3}{4} \times 7\frac{1}{2}$ " (25 × 19 cm). Metropolitan Museum of Art, New York (Fletcher Fund, 1919). The Latin inscription says that Erasmus was drawn from life by the artist; the Greek epigram praises the written word. The stylized letters AD are the signature letters of the artist and appear in all his engravings and prints.

(he had a strong pacifist streak), venal lawyers, and fraudulent doctors, but, above all, he bitterly attacked religious corruption: the sterility of religious scholarship and the superstitions in religious practice. Reading The Praise of Folly makes one wonder why Luther never won Erasmus over to the Reformation (Erasmus debated Luther, in fact). Erasmus remained in the old Church, but as a bitter critic of its follies and an indefatigable proponent of its reform.

This sweeping social criticism struck an obvious nerve. The book delighted not only the great Sir Thomas More (who was concerned enough about religious convictions to die for them later in the century) but also many sensitive people of the time. The Praise of Folly went through 27 editions in the lifetime of Erasmus and outsold every other book except the Bible in the 16th century.

Comparing Machiavelli and Erasmus is a bit like comparing apples and potatoes, but a few points of contact can be noted that help us to generalize about the meaning of the Renaissance. Both men were heavily indebted to the new learning coming out of 15th-century Italy. Both looked back to the great classical heritage of the past for their models of inspiration. Both were elegant Latinists who avoided the style and thought patterns of the medieval world. Machiavelli's devotion to the Roman past was total. He saw the historic development of Christianity as a threat and stumbling block to the fine working of the state. Erasmus, by contrast, felt that learning from the past could be wedded to the Christian tradition to create an instrument for social reform. His ideal was a Christian humanism based on this formula. It was a formula potent enough to influence thinking throughout the 16th century.

The tug and pull of classicism and Christianity may be one key to understanding the Renaissance. It may even help us understand something about the character of almost everything we have discussed in this chapter. The culture of the 15th century often was, in fact, a dialectical struggle: at times classical ideals clashed with biblical ideals; at other times, the two managed to live either in harmony or in a temporary marriage of convenience. The strains of classicism and Christianity interacted in complex and subtle ways. This important fact helps us to understand a culture that produced, in a generation, an elegant scholar like Ficino and a firebrand like Savonarola, a pious artist like Fra Angelico and a titanic genius like Michelangelo—and a Machiavelli and an Erasmus.

Music in the Fifteenth Century

By the early 15th century the force of the Italian Ars Nova movement in music had spent itself. The principal composers of the early Renaissance were from the North. Strong commercial links between Florence and the North ensured the exchange of ideas, and a new musical idiom that had been developed to please the ear of the prosperous merchant families of the North soon found its way to Italy.

Guillaume Dufay

Guillaume Dufay (c. 1400-1474), the most famous composer of the century, perfectly exemplifies the tendency of music to cross national boundaries. As a young man Dufay spent several years in Italy studying music and singing in the papal choir at Rome. He later served as music teacher in the French (Burgundian) court of Charles the Good. The works he composed there included masses and motets; he was one the first composers since Machaut to write complete settings of the mass. His secular works include a number of charming chansons (songs) that are free in form and expressive in nature.

Among the changes introduced into music by Dufay and his Burgundian followers (many of whom went to Italy for employment) was the secularization of the motet, a choral work that had previously used a religious text. Motets were now written for special occasions like coronations or noble marriages and the conclusion of peace treaties. Composers who could supply such motets on short notice found welcome in the courts of Renaissance Italian city-states.

Dufay was also one of the first composers to introduce a familiar folk tune into the music of the mass, the best-known example being his use of the French folk tune "L'homme arme" ("The Man in Armor") in a mass that is now named for it. Other composers followed suit and the so-called chanson masses were composed throughout the 15th and 16th centuries. The "L'homme arme" alone was used for more than thirty different masses, including ones by such composers as Josquin and Palestrina. The intermingling of secular with religious elements is thoroughly in accord with Renaissance ideals.

Among Dufay's most prominent pupils was the Flemish composer Johannes Okeghem (c. 1430-1495), whose music was characterized by a smoothflowing but complex web of contrapuntal lines generally written in a free style (the lines do not imitate one another). The resulting mood of the music is more serious than Dufay's, partly because of the intellectual complexity of the counterpoint and partly because Okeghem sought a greater emotional expression. The combination of intellect and feeling is characteristic of the Renaissance striving for classical balance. Okeghem's requiem mass is the oldest of the genre to survive (Dufay wrote one that has not been preserved).

Music in Medici Florence

The fact that Italian composers were overshadowed by their northern contemporaries did not in any way stifle Italian interest in music. Lorenzo de' Medici founded a school of harmony that attracted musicians from many parts of Europe; he himself had some skill as a lute player. Musical accompaniment enlivened the festivals and public processions of Florence. Popular dance tunes for the salterello and the pavana have survived in lute transcriptions.

We know that the platonist writer Marsilio Ficino played the lyre before admiring audiences, although he had intentions more serious than mere entertainment. Unlike the visual artists who had models from classical antiquity for inspiration, students of music had no classical models to follow: no Greek or Roman music had survived in any significant form. Still, the ideas about music expressed by Plato and other writers fascinated Ficino and others. Greek music had been patterned after the meter of verse and its character carefully controlled by the mode in which it was composed. The Greek doctrine of "characteristic" or ethos is still not fully understood today, but Ficino and his friends realized that Plato and Aristotle regarded music as of the highest moral (and hence political) significance. The closest they could come to imitating ancient music was to write settings of Greek and Roman texts in which they tried to follow the meter as closely as possible. Among the most popular works was Vergil's Aeneid: The lament of Dido was set to music by no fewer than fourteen composers in the 15th and 16th centuries.

A more popular musical form was the frottola, probably first developed in Florence although the earliest surviving examples come from the Renaissance court of Mantua. The frottola was a setting of a humorous or amorous poem for three or four parts consisting of a singer and two or three instrumentalists. Written to be performed in aristocratic circles. the frottola often had a simple folk quality. The gradual diffusion of frottole throughout Europe gave Italy a reputation for good simple melody and clear vigorous expression.

The carnival song (canto carnascialesco) was a specifically Florentine form of the frottola. Written to be sung during the carnival season preceding Lent, such songs were very popular. Even the great Flemish composer Heinrich Issac wrote some during his stay with Lorenzo de' Medici around 1480. With the coming of the Dominican reformer Savonarola, however, the carnivals were abolished because of their alleged licentiousness. The songs also disappeared. After the death of Savonarola the songs were reintroduced but died out again in the 16th century.

Summary

The main focus of this chapter is on the city of Florence in the 15th century. There are two basic reasons for this attention, one rooted in economics and the other in something far more difficult to define.

Florence was not a feudal city governed by a hereditary prince; it had a species of limited participatory government that was in the hands of its landed and moneyed peoples. It was the center of European banking in the 15th century and the hub of the international wool and cloth trade. The vast moneys in Florentine hands combined with a great sense of civic pride to give the city unparalleled opportunities for expansion and public works. The results can be seen in the explosion of building, art, sculpture, and learning that stretched throughout the century. The great banking families of Florence built and supported art to enhance their own reputations, that of their cities, and, partly, as a form of expiation for the sin of taking interest on money, a practice forbidden by the Church. We tend to see Florence today from the perspective of their generosity.

Other forces were, of course, at work. The urban workers were exploited; they had rioted during the end of the 14th century and were ready for further protest. An undercurrent of medieval religiosity in the city manifested itself most conspicuously in the rise of a Savonarola, who not only appealed to the common people but who had a reputation for sanctity that could touch the lives of an educated man like Pico della Mirandola and a powerful one like Lorenzo the Magnificent. Every Florentine could visit the Duomo or see the art in the city's churches, but not everyone was equally touched by the great renaissance in ideas and art that bubbled up in Florence.

Most puzzling about Florence in this period is the sheer enormity of artistic talent it produced. Florence was not a huge city; it often portrayed itself as a David in comparison to a Roman or Milanese Goliath. Yet this relatively small city produced a tradition of art that spanned the century: In sculpture Donatello and Michelangelo bridged the generations, as did Masaccio and Botticelli in painting. Part of the explanation, of course, was native talent, but part of it also lies in the character of a city that supported the arts, nurtured artists, and enhanced civic life with beauty and learning.

Pronunciation Guide

Botticelli: Boh-TEE-chel-ee Brunelleschi: Brew-nee-LESS-ki

Cosimo: cah-ZE-mow

de' Medici: deh-MED-e-chee Donatello: don-ah-TELL-oh

Dufay: dew-FAY Duomo: DWO-mow Ficino: feh-CHEE-no Ghiberti: ghe-BER-tee Lorenzo: lo-WREN-zo

Machiavelli: MA-key-ah-VEL-ee Manutius: Mah-KNEW-see-us Masaccio: Mah-ZA-che-o

Pico della Mirandola: PEE-ko dell-ah meh-

RAN-dough-la Piero: pea-A-row

Savonarola: sa-van-ah-ROLL-ah

Exercises

1. Choose one of the major paintings of this period and analyze it closely in terms of composition, gradations of color, and use of perspective.

2. List the chief problems of construction involved in raising the dome of the Florence Cathedral in an age that

did not have today's building technologies.

3. To what artistic and cultural enterprises would wealthy people most likely contribute today if they had the resources and the power of a Medici family in a contemporary city?

4. What does the word humanism mean today and how does that meaning differ from its use in the 15th cen-

5. If Erasmus were writing today, what would be his most likely targets of satire? What are the great follies of our

6. What advice would a contemporary Machiavelli give a contemporary "prince" (powerful political leader)? Why do political philosophers still study Machiavelli?

Further Reading

Brucker, Gene. Renaissance Florence. New York: Wiley, 1969. A readable introduction to the city and its institu-

Burckhardt, Jakob. The Civilization of the Renaissance in Italy. 2 vols. New York: Harper, 1958. The point of departure for all Renaissance study. A classic.

Hale, J. R. (ed). A Concise Encyclopedia of the Italian Renaissance. New York: Oxford University Press, 1982. A useful reference tool for Renaissance studies.

Hartt, Frederick. A History of Italian Renaissance Art. London: Thames and Hudson, 1970. The standard work; many fine illustrations.

Hays, Denys (ed). The Renaissance Debate. New York: Holt, Rinehart and Winston, 1965. An anthology of texts on the historiography of the Renaissance period.

Kristeller, Paul O. Renaissance Essays I and II. New York: Harper, 1968. Classic studies of Italian humanism.

Rice, Eugene. Saint Jerome in the Renaissance. Baltimore: Johns Hopkins, 1985. A brilliant book that shows how Jerome became a symbol of humanism. Interdisciplinary scholarship at its finest.

Simon, Kate. A Renaissance Tapestry: The Gonzaga of Mantua. New York: Harper, 1988. A readable history with fine profiles of Renaissance figures and a good bibliog-

raphy.

Trinkaus, Charles. In Our Image and Likeness. 2 vols. Chicago: University of Chicago Press, 1970. A brilliant study of humanism in the Renaissance.

Reading Selections

Pico della Mirandola from Oration on the Dignity of Man

These four paragraphs introduce the nine hundred theses Pico wrote to summarize his philosophy; in many ways they can stand as the position paper on Renaissance ideals. Pico argues that it is humans who stand at the apex of the world. In Pico's formulation humans, as a composite of body and soul, are the meeting point of the physical world (the body) and the spiritual (the soul) and, as a consequence, sum up the glory and potentiality of the created world.

- 1. I have read in the records of the Arabians, reverend Fathers, that Abdala the Saracen, when questioned as to what on this stage of the world, as it were, could be seen most worthy of wonder, replied: "There is nothing to be seen more wonderful than man." In agreement with this opinion is the saying of Hermes Trismegistus: "A great miracle, Asclepius, is man." But when I weighed the reason for these maxims, the many grounds for the excellence of human nature reported by many men failed to satisfy methat man is the intermediary between creatures, the intimate of the gods, the king of the lower beings, by the acuteness of his senses, by the discernment of his reason, and by the light of his intelligence the interpreter of nature, the interval between fixed eternity and fleeting time, and (as the Persians say) the bond, nay, rather, the marriage song of the world, on David's testimony but little lower than the angels. Admittedly great though these reasons be, they are not the principal grounds, that is, those which may rightfully claim for themselves the privilege of the highest admiration. For why should we not admire more the angels themselves and the blessed choirs of heaven? At last it seems to me I have come to understand why man is the most fortunate of creatures and consequently worthy of all admiration and what precisely is that rank which is his lot in the universal chain of Being-a rank to be envied not only by brutes but even by the stars and by minds beyond this world. It is a matter past faith and a wondrous one. Why should it not be? For it is on this very account that man is rightly called and judged a great miracle and a wonderful creature indeed.
- 2. But hear, Fathers, exactly what this rank is and, as friendly auditors, conformably to your kindness, do me this favor. God the Father, the supreme Architect, had already built this cosmic home we behold, the most sacred temple of His godhead, by the laws of His mysterious wisdom. The region above the heavens He had adorned with Intelligences, the heavenly spheres He had quickened with eternal souls, and the excrementary and filthy parts of the lower world He had filled with a multitude of animals of every kind. But, when the work was finished, the Craftsman kept wishing that there were someone to ponder the plan of so great a work, to love its beauty, and to wonder at its vastness. Therefore, when everything was done (as Moses and Timaeus bear witness), He finally took thought concerning the creation of man. But there was not among His archetypes that from which He could fashion a new offspring, nor was there in His treasurehouses anything which He might bestow on His new son as an inheritance, nor was there in the seats of all the world a place where the latter might sit to contemplate the universe. All was now complete;

all things had been assigned to the highest, the middle, and the lowest orders. But in its final creation it was not the part of the Father's power to fail as though exhausted. It was not the part of His wisdom to waver in a needful matter through poverty of counsel. It was not the part of His kindly love that he who was to praise God's divine generosity in regard to others should be compelled to condemn it in regard to himself.

3. At last the best of artisans ordained that that creature to whom He had been able to give nothing proper to himself should have joint possession of whatever had been peculiar to each of the different kinds of being. He therefore took man as a creature of indeterminate nature and, assigning him a place in the middle of the world, addressed him thus: "Neither a fixed abode nor a form that is thine alone nor any function peculiar to thyself have we given thee, Adam, to the end that according to thy longing and according to thy judgment thou mayest have and possess what abode, what form, and what functions thou thyself shalt desire. The nature of all other beings is limited and constrained within the bounds of laws prescribed by Us. Thou, constrained by no limits, in accordance with thine own free will, in whose hand We have placed thee, shalt ordain for thyself the limits of thy nature. We have set thee at the world's center that thou mayest from thence more easily observe whatever is in the world. We have made thee neither of heaven nor of earth, neither mortal nor immortal, so that with freedom of choice and with honor, as though the maker and molder of thyself, thou mayest fashion thyself in whatever shape thou shalt prefer. Thou shalt have the power to degenerate into the lower forms of life, which are brutish. Thou shalt have the power, out of thy soul's judgment, to be reborn into the higher forms, which are divine."

4. O supreme generosity of God the Father, O highest and most marvelous felicity of man! To him it is granted to have whatever he chooses, to be whatever he wills. Beasts as soon as they are born (so says Lucilius) bring with them from their mother's womb all they will ever possess. Spiritual beings, either from the beginning or soon thereafter, become what they are to be for ever and ever. On man when he came into life the Father conferred the seeds of all kinds and the germs of every way of life. Whatever seeds each man cultivates will grow to maturity and bear in him their own fruit. If they be vegetative, he will be like a plant. If sensitive, he will become brutish. If rational, he will grow into a heavenly being. If intellectual, he will be an angel and the son of God. And if, happy in the lot of no created thing, he withdraws into the center of his own unity, his spirit, made one with God, in the solitary darkness of God, who is set above all things, shall surpass them all.

Who would not admire this our chameleon? Or who could more greatly admire aught else whatever? It is man who Asclepius of Athens, arguing from his mutability of character and from his self-transforming nature, on just grounds says was symbolized by Proteus in the mysteries. Hence those metamorphoses renowned among the Hebrews and the Pvthagoreans.

Niccolò Machiavelli from THE PRINCE

This selection from Machiavelli's great work on political philosophy is typical of his approach to the subject, the most notable aspect of which is an unswerving pragmatism. Machiavelli never wavers from his basic conviction that the politician (the Prince) should act on one basic principle: Is what I am doing going to work to attain my goals? Questions of morality or popularity are always secondary to the issue of how best to use power to attain one's goals and to maintain one's authority. If the Prince is to be a success, Machiavelli argues, he cannot afford to be moral if morality undermines his capacity to rule.

Chapter 15

Those Things for Which Men and Especially Princes are Praised or Censured

Now it remains to examine the wise prince's methods and conduct in dealing with subjects or with allies. And because I know that many have written about this, I fear that, when I too write about it. I shall be thought conceited, since in discussing this material I depart very far from the methods of the others. But since my purpose is to write something useful to him who comprehends it, I have decided that I must concern myself with the truth of the matter as facts show it rather than with any fanciful notion. Yet many have fancied for themselves republics and principalities that have never been seen or known to exist in reality. For there is such a difference between how men live and how they ought to live that he who abandons what is done for what ought to be done learns his destruction rather than his preservation, because any man who under all conditions insists on making it his business to be good will surely be destroyed among so many who are not good. Hence a prince, in order to hold his position, must acquire the power to be not good, and understand when to use it and when not to use it, in accord with necessity.

Omitting, then, those things about a prince that are fancied, and discussing those that are true, I say that all men, when people speak of them, and especially princes, who are placed so high, are labeled

with some of the following qualities that bring them either blame or praise. To wit, one is considered liberal, one stingy (I use a Tuscan word, for the avaricious man in our dialect is still one who tries to get property through violence; stingy we call him who holds back too much from using his own goods); one is considered a giver, one grasping; one cruel, one merciful; one a promise-breaker, the other truthful; one effeminate and cowardly, the other bold and spirited; one kindly, the other proud; one lascivious, the other chaste; one reliable, the other tricky; one hard, the other tolerant; one serious, the other lightminded; one religious, the other unbelieving; and the

I am aware that everyone will admit that it would be most praiseworthy for a prince to exhibit such of the above-mentioned qualities as are considered good. But because no ruler can possess or fully practice them, on account of human conditions that do not permit it, he needs to be so prudent that he escapes ill repute for such vices as might take his position away from him, and that he protects himself from such as will not take it away if he can; if he cannot, with little concern he passes over the latter vices. He does not even worry about incurring reproach for those vices without which he can hardly maintain his position, because when we carefully examine the whole matter, we find some qualities that look like virtues, yet—if the prince practices them—they will be his destruction, and other qualities that look like vices, yet—if he practices them they will bring him safety and well-being.

Chapter 16

Liberality and Stinginess

Beginning then with the first qualities mentioned above, I say that to be considered liberal is good. Nevertheless, liberality, when so practiced that you get a reputation for it, damages you, because if you exercise that quality wisely and rightfully, it is not recognized, and you do not avoid the reproach of practicing its opposite. Therefore, in order to keep up among men the name of a liberal man, you cannot neglect any kind of lavishness. Hence, invariably a prince of that sort uses up in lavish actions all his resources, and is forced in the end, if he wishes to keep up the name of a liberal man, to burden his people excessively and to be a tax-shark and to do everything he can to get money. This makes him hateful to his subjects and not much esteemed by anybody, as one who is growing poor. Hence, with such liberality having injured the many and rewarded the few, he is early affected by all troubles and is ruined early in any danger. Seeing this and trying to pull back from it, he rapidly incurs reproach as stingy.

Since, then, a prince cannot, without harming himself, make use of this virtue of liberality in such a way that it will be recognized, he does not worry, if he is prudent, about being called stingy; because in the course of time he will be thought more and more liberal, since his economy makes his income adequate; he can defend himself against anyone who makes war on him; he can carry through enterprises without burdening his people. Hence, in the end, he practices liberality toward all from whom he takes nothing, who are countless, and stinginess toward all whom he gives nothing, who are few. In our times we have not seen great things done except by those reputed stingy; the others are wiped out. Pope Julius II, although he made use of the name of a liberal man in order to gain the papacy, afterward paid no attention to keeping it up, in order to be able to make war. The present King of France carries on so many wars, without laying an excessive tax on his people, solely because his long stinginess helps pay his enormous expenses. The present King of Spain, if he were reputed liberal, would not engage in or complete so

many undertakings.

Therefore, in order not to rob his subjects, in order to defend himself, in order not to grow poor and contemptible, in order not to be forced to become extortionate, a wise prince judges it of little importance to incur the name of a stingy man, for this is one of those vices that make him reign. And if somebody says: "Caesar through his liberality attained supreme power, and many others through being and being reputed liberal have come to the highest positions," I answer: "Either you are already prince or you are on the road to gaining that position. In the first case, the kind of liberality I mean is damaging; in the second, it is very necessary to be thought liberal. Now Caesar was one of those who were trying to attain sovereignty over Rome. But if, when he had got there, he had lived on and on and had not restrained himself from such expenses, he would have destroyed his supremacy." If somebody replies: "Many have been princes and with their armies have done great things, who have been reputed exceedingly liberal," I answer you: "The prince spends either his own money and that of his subjects, or that of others. In the first case the wise prince is economical; in the second he does not omit any sort of liberality. For that prince who goes out with his armies, who lives on plunder, on booty, and on ransom, has his hands on the property of others; for him this liberality is necessary; otherwise he would not be followed by his soldiers. Of wealth that is not yours or your subjects,' you can be a very lavish giver, as were Cyrus, Caesar, and Alexander, because to spend what belongs to others does not lessen your reputation but adds to it. Nothing hurts you except to spend your own money."

Moreover, nothing uses itself up as fast as does liberality; as you practice it, you lose the power to practice it, and grow either poor and despised or, to escape poverty, grasping and hated. Yet the most important danger a wise prince guards himself against is being despised and hated; and liberality brings you to both of them. So it is wiser to accept the name of a niggard, which produces reproach without hatred, than by trying for the name of freespender to incur the name of extortioner, which produces reproach with hatred.

Chapter 17

Cruelty and Mercy: Is it Better to be Loved Than Feared, or the Reverse?

Passing on to the second of the above-mentioned qualities, I say that every sensible prince wishes to be considered merciful and not cruel. Nevertheless, he takes care not to make a bad use of such mercy. Cesare Borgia was thought cruel; nevertheless that wellknown cruelty of his re-organized the Romagna, united it, brought it to peace and loyalty. If we look at this closely, we see that he was much more merciful than the Florentine people, who, to escape being called cruel, allowed the ruin of Pistoia. A wise prince, then, is not troubled about a reproach for cruelty by which he keeps his subjects united and loyal because, giving a very few examples of cruelty. he is more merciful than those who, through too much mercy, let evils continue, from which result murders or plunder, because the latter commonly harm a whole group, but those executions that come from the prince harm individuals only. The new prince—above all other princes—cannot escape being called cruel, since new governments abound in dangers. As Virgil says by the mouth of Dido, "My hard condition and the newness of my sovereignty force me to do such things, and to set guards over my boundaries far and wide.

Nevertheless, he is judicious in believing and in acting, and does not concoct fear for himself, and proceeds in such a way, moderated by prudence and kindness, that too much trust does not make him reckless and too much distrust does not make him unbearable.

This leads to a debate: Is it better to be loved than feared, or the reverse? The answer is that it is desirable to be both, but because it is difficult to join them together, it is much safer for a prince to be feared than loved, if he is to fail in one of the two. Because we can say this about men in general: they are un-

grateful, changeable, simulators and dissimulators, runaways in danger, eager for gain; while you do well by them they are all yours; they offer you their blood, their property, their lives, their children, as was said above, when need is far off; but when it comes near you, they turn about. A prince who bases himself entirely on their words, if he is lacking in other preparations, falls; because friendships gained with money, not with greatness and nobility of spirit, are purchased but not possessed, and at the right times cannot be turned to account. Men have less hesitation in injuring one who makes himself loved than one who makes himself feared, for love is held by a chain of duty which, since men are bad, they break at every chance of their own profit; but fear is held by a dread of punishment that never fails

Nevertheless, the wise prince makes himself feared in such a way that, if he does not gain love, he escapes hatred; because to be feared and not to be hated can well be combined; this he will always achieve if he refrains from the property of his citizens and his subjects and from their women. And if he does need to take anyone's life, he does so when there is proper justification and a clear case. But above all. he refrains from the property of others, because men forget more quickly the death of a father than the loss of a father's estate. Besides, reasons for seizing property never fail, for he who is living on plunder continually finds chances for appropriating other men's goods; but on the contrary, reasons for taking life are rarer and cease sooner.

But when the prince is with his armies and has in his charge a multitude of soldiers, then it is altogether essential not to worry about being called cruel, for without such a reputation he never keeps an army united or fit for any action. Among the most striking of Hannibal's achievements is reckoned this: though he had a very large army, a mixture of countless sorts of men, led to service in foreign lands, no discord ever appeared in it, either among themselves or with their chief, whether in bad or in good fortune. This could not have resulted from anything else than his well-known inhuman cruelty, which, together with his numberless abilities, made him always respected and terrible in the soldiers' eyes; without it, his other abilities would not have been enough to get him that result. Yet historians, in this matter not very discerning, on one side admire this achievement of his and on the other condemn its main cause.

And that it is true that Hannibal's other abilities would not have been enough, can be inferred from Scipio (a man unusual indeed not merely in his own days but in all the record of known events) against whom his armies in Spain rebelled—an action that resulted from nothing else than his too great mercy,

which gave his soldiers more freedom than befits military discipline. For this, he was rebuked in the Senate by Fabius Maximus, who called him the destrover of the Roman soldiery. The Locrians, who had been ruined by a legate of his, Scipio did not avenge nor did he punish the legate's arrogance-all a result of his tolerant nature. Hence, someone who tried to apologize for him in the Senate said there were many men who knew better how not to err than how to punish errors. This tolerant nature would in time have damaged Scipio's fame and glory, if, having it, he had kept on in supreme command: but since he lived under the Senate's control, this harmful trait of his not merely was concealed but brought him fame.

I conclude, then, reverting to being feared and loved, that since men love at their own choice and fear at the prince's choice, a wise prince takes care to base himself on what is his own, not on what is another's; he strives only to avoid hatred; as I have said.

Chapter 18

How Princes Should Keep Their Promises

How praiseworthy a prince is who keeps his promises and lives with sincerity and not with trickery, everybody realizes. Nevertheless, experience in our time shows that those princes have done great things who have valued their promises little, and who have understood how to addle the brains of men with trickery; and in the end they have vanquished those who have stood upon their honesty.

You need to know, then, that there are two ways of fighting: one according to the laws, the other with force. The first is suited to man, the second to the animals: but because the first is often not sufficient, a prince must resort to the second. Therefore he needs to know well how to put to use the traits of animal and of man. This conduct is taught to princes in allegory by ancient authors, who write that Achilles and many other well-known ancient princes were given for upbringing to Chiron the Centaur, who was to guard and educate them. This does not mean anything else (this having as teacher one who is half animal and half man) than that a prince needs to know how to adopt the nature of either animal or man, for one without the other does not secure him permanence.

Since, then, a prince is necessitated to play the animal well, he chooses among the beasts the fox and the lion, because the lion does not protect himself from traps; the fox does not protect himself from the wolves. The prince must be a fox, therefore, to recognize the traps and a lion to frighten the wolves. Those who rely on the lion alone are not perceptive.

By no means can a prudent ruler keep his word—and he does not-when to keep it works against himself and when the reasons that made him promise are annulled. If all men were good, this maxim would not be good, but because they are bad and do not keep their promises to you, you likewise do not have to keep yours to them. Never has a shrewd prince lacked justifying reasons to make his promise-breaking appear honorable. Of this I can give countless modern examples, showing how many treaties of peace and how many promises have been made null and empty through the dishonesty of princes. The one who knows best how to play the fox comes out best, but he must understand well how to disguise the animal's nature and must be a great simulator and dissimulator. So simple-minded are men and so controlled by immediate necessities that a prince who deceives always finds men who let themselves be deceived.

I am not willing, among fresh instances, to keep silent about one of them. Alexander VI never did anything else and never dreamed of anything else than deceiving men, yet he always found a subject to work on. Never was there a man more effective in swearing and who with stronger oaths confirmed a promise, but yet honored it less. Nonetheless, his deceptions always prospered as he hoped, because he understood well this aspect of the world.

For a prince, then, it is not necessary actually to have all the above-mentioned qualities, but it is very necessary to appear to have them. Further, I shall be so bold as to say this: that if he has them and always practices them, they are harmful; and if he appears to have them, they are useful; for example, to appear merciful, trustworthy, humane, blameless, religiousand to be so-yet to be in such measure prepared in mind that if you need to be not so, you can and do change to the contrary. And it is essential to realize this: that a prince, and above all a prince who is new, cannot practice all those things for which men are considered good, being often forced, in order to keep his position, to act contrary to truth, contrary to charity, contrary to humanity, contrary to religion. Therefore he must have a mind ready to turn in any direction as Fortune's winds and the variability of affairs require, yet, as I said above, he holds to what is right when he can but knows how to do wrong when

A wise prince, then, is very careful never to let out of his mouth a single word not weighty with the above-mentioned five qualities; he appears to those who see him and hear him talk, all mercy, all faith, all integrity, all humanity, all religion. No quality does a prince more need to possess—in appearance—than this last one, because in general men judge more with their eyes than with their hands, since everybody can see but few can perceive. Everybody sees what you appear to be; few perceive what you are, and those few dare not contradict the belief of the many, who have the majesty of the government to support them. As to the actions of all men and especially those of princes, against whom charges cannot be brought in court, everybody looks at their result. So if a prince succeeds in conquering and holding his state, his means are always judged honorable and everywhere praised, because the mob is always fascinated by appearances and by the outcome of an affair; and in the world the mob is everything; the few find no room there when the many crowd together. A certain prince of the present time, whom I refrain from naming, never preaches anything except peace and truth, and to both of them he is utterly opposed. Either one, if he had practiced it, would many times have taken from him either his reputation or his power.

Desiderius Erasmus from THE PRAISE OF FOLLY

It may be tempting to read Erasmus' satire on all manner of human follies as plain and bitter criticism. But, as in the work of all great satirists, there is a deep vein of moral outrage in these pages. Erasmus was a teacher and a reformer. He uses his biting wit not only to score against stupidity but also to improve the way people live in society.

In the same realm are those who are authors of books. All of them are highly indebted to me ["me" = the goddess Folly], especially those who blacken their pages with sheer triviality. For those who write learnedly to be criticized by a few scholars, not even ruling out a Persius or a Laelius as a judge, seem to be more pitiable than happy to me. simply because they are continuously torturing themselves. They add, they alter, they cross something out, they reinsert it, they recopy their work, they rearrange it, they show it to friends, and they keep it for nine years; yet they still are not satisfied with it. At such a price, they buy an empty reward, namely praise—and the praise of only a handful, at that. They buy this at the great expense of long hours, no sleep, so much sweat, and so many vexations. Add also the loss of health, the deterioration of their physical appearance, the possibility of blindness or partial loss of their sight, poverty, malice, premature old age, an early death, and if you can think of more, add them to this list. The scholar feels that he has been compensated for such ills when he wins the sanction of one or two other weak-eyed scholars. But my author is crazy in a far happier way for he, without any hesitation, rapidly writes down anything that comes to his mind, his pen, or even his dreams.

There is little or no waste of paper, since he knows that if the trifles are trivial enough the majority of the readers, that is, the fools and ignoramuses, will approve of them. What is the difference if one should ignore two or three scholars, even though he may have read them? Or what weight will the censure of a few scholars carry, so long as the multitudes give it

Actually, the wiser writers are those who put out the work of someone else as their own. By a few alterations they transfer someone else's glory to themselves, disregarding the other person's long labor and comforting themselves with the thought that even though they might be publicly convicted of plagiarism, meanwhile they shall have enjoyed the fruits and glory of authorship. It is worth one's while to observe how pleased authors are with their own works when they are popular and pointed out in a crowd—as celebrities! Their work is on display in bookstores, with three cryptic words in large type on the title page, something like a magician's spell. Ye gods! After all, what are they but words? Few people will ever hear of them, compared to the total world population, and far fewer will admire them, since people's tastes vary so, even among the common people. And why is it that the very names of the authors are often false, or stolen from the books of the ancients? One calls himself Telemachus, another Stelenus or Laertes, still another Polycrates, and another Thrasymachus. As a result, nowadays it does not matter whether you dedicate your book to a chameleon or a gourd, or simply to alpha or beta, as the philosophers do.

The most touching event is when they compliment each other and turn around in an exchange of letters, verses, and superfluities. They are fools praising fools and dunces praising dunces. The first, in the opinion of the second, is an Alcaeus, and the second, in the opinion of the first, is a Callimachus. One holds another in higher esteem than Cicero, the other finds the one more learned than Plato. Or sometimes they will choose a competitor and increase their reputation by rivaling themselves with him. As a result the public is split with opposing viewpoints, until finally, when the dispute is over, each reigns as victor and has a triumphal parade. Wise men deride this as being absolute nonsense, which is just what it is. Who will deny it? Meanwhile, our authors are leading a luxurious life because of my excellence, and they would not exchange their accomplishments for even those of Scipius. And while the scholars most certainly derive a great deal of pleasure from laughing at them, relishing to the utmost the madnesses of others, they themselves owe me a great deal, which they cannot deny without being most ungrateful

Among men of the learned professions, a most

self-satisfied group of men, the lawyers may hold themselves in the highest esteem. For while they laboriously roll up the stone of Sisyphus by the force of weaving six hundred laws together at the same time, by the stacking of commentary upon commentary and opinion upon opinion regardless of how far removed from the purpose, they contrive to make their profession seem to be most difficult of all. What is actually tedious they consider brilliant. Let us include with them the logicians and sophists, a breed of men more loquacious than the famed brass kettles of Dodona. Any one of them can outtalk any twenty women. They would be happier, though, if they were just talkative and not quarrelsome as well. In fact, they are so quarrelsome that they will argue and fight over a lock of a goat's wool, absurdly losing sight of the truth in the furor of their dispute. Their egotistical love keeps them happy, and manned with but three syllogisms, they will unflinchingly argue on any subject with any man. Their mere obstinacy affords them victory, even though you place Stentor against them.

Next in line are the scientists, revered for their beards and the fur on their gowns. They feel that they are the only men with any wisdom, and all other men float about as shadows. How senilely they daydream, while they construct their countless worlds and shoot the distance to the sun, the moon, the stars, and spheres, as with a thumb and line. They postulate causes for lightening, winds, eclipses, and other inexplicable things, never hesitating for a moment, as if they had exclusive knowledge about the secrets of nature, designer of elements, or as if they visited us directly from the council of the gods. Yet all this time nature is heartily laughing at them and their conjectures. It is a sufficient argument just proving that they have good intelligence for nothing. They can never explain why they always disagree with each other on every subject. In summation, knowing nothing in general they profess to know everything in particular. They are ignorant even to themselves, and at times they do not see the ditch or stone lying across their path, because many of them are day-dreamers and are absent-minded. Yet they proclaim that they perceive ideas, universals, forms without matter, primary substances, quiddities, entities, and things so tenuous that I'm afraid that Lynceus could not see them himself. The common people are especially disdained when they bring out their triangles, quadrangles, circles, and mathematical figures of the like. They place one on top of the other and arrange them into a maze. Then they deploy some letters precisely, as if in a battle formation, and finally they reverse them. And all of this is done only to confuse those who are ignorant of their field. These scientists do not like those who predict the future from the stars, and promise even more fantastic miracles. And these fortunate men find people who believe them.

Perhaps it would be better to pass silently over the theologians. Dealing with them, since they are hottempered, is like crossing Lake Camarina or eating poisonous beans. They may attack me with six hundred arguments and force me to retract what I hold; for if I refuse, they will immediately declare me a heretic. By this blitz action they show a desire to terrify anyone to whom they are ill-disposed. No other people are so adverse to acknowledge my favors to them, yet the divines are bound to me by extraordinary obligations. These theologians are happy in their self-love, and as if they were presently inhabiting a third heaven, they look down on all men as though they were animals that crawled along the ground, coming near to pity them. They are protected by a wall of scholastic definitions, arguments, corollaries, and implicit and explicit propositions. They have so many hideouts that not even the net of Vulcan would be able to catch them; for they back down from their distinctions, by which they also cut through the knots of an argument, as if with a double-blade ax from Tenedos; and they come forth with newly invented terms and monstrous-sounding words. Furthermore, they explain the most mysterious matters to suit themselves, for instance, the method by which the world was set in order and began, through what channels original sin has come down to us through generations, by what means, in what measure, and how long the Omnipotent Christ was in the Virgin's womb, and how accidents subsist in the Eucharist without their substance.

But those have been beaten to death down through the ages. Here are some questions that are worthy of great (and some call them) illuminated theologians, questions that will really make them think, if they should ever encounter them. Did divine generation take place at a particular time? Are there several sonships in Christ? Whether this is a possible proposition: Does God the Father hate the Son? Could God the Father have taken upon Himself the likeness of a woman, a devil, an ass, a gourd, or a piece of flint? Then how would that gourd have preached, performed miracles, or been crucified? Also, what would Peter have consecrated, if he had administered the Eucharist, while Christ's body hung on the cross? Another thought: could Christ have been said to be a man at that very moment? Will we be forbidden to eat and drink after the resurrection? (Now, while there is time, they are providing against hunger and thirst!) These intricate subtleties are infinite, and there are others that are even more subtle, concerning instances of time, notions, relations, accidents, quiddities, and entities, which no one can perceive unless, like Lynceus, he can see in the blackest darkness things that aren't there.

We must insert those maxims, rather contradictions, that, compared to the Stoic paradoxes, appear to be the most common simplicity. For instance: it is a lesser crime to cut the throats of a thousand men than to sew a stitch on a poor man's shoe on the sabbath; it is better to want the earth to perish, body, boots, and breeches (as the saying goes), than to tell a single lie, however inconsequential. The methods that our scholastics follow only render more subtle the subtlest of subtleties; for you will more easily escape from a labyrinth than from the snares of the Realists, Nominalists, Thomists, Albertists, Occamists, and Scotists. I have not named them all, only a few of the major ones. But there is so much learning and difficulty in all of these sects that I should think the apostles themselves must have the need of some help from some other's spirit if they were to try to argue these topics with our new generation of theologians.

Paul could present faith. But when he said, "Faith is the substance of things hoped for, the evidence of things not seen," he did not define it doctorally. The same apostle, though he exemplified charity to its utmost, divided and defined it with very little logical skill in the first epistle to the Corinthians, Chapter 13. And there is no doubt that the apostles consecrated the Eucharist devoutly enough, but suppose you had questioned them about the "terminus a quo" and the "terminus ad quem," or about transubstantiation—how the body is in many places at once, and the difference between the body of Christ in heaven. on the cross, in the Eucharist at the point when transubstantiation occurs (taking note that the prayer effecting it is a discrete quantity having extension in time)—I say that they would not have answered with the same accuracy with which the pupils of Scotus distinguish and define these matters. The apostles knew the mother of Jesus, but who among them has demonstrated philosophically just how she was preserved from the stain of original sin, as our theologians have done? Peter received the keys from One who did not commit them to an unworthy person, and yet I doubt that he ever understood—for Peter never did have a profound knowledge for the subtle that a person who did not have knowledge could have the key to knowledge. They went everywhere baptizing people, and yet they never taught what the formal, material, efficient, and final causes of baptism were, nor did they mention that it has both a delible and indelible character. They worshipped, this is certain, but in spirit, following no other teaching than that of the gospel, "God is a spirit, and those that worship Him must do so in spirit and in truth." They seem never to have known that a picture drawn in charcoal on a wall ought to be worshipped as though it was Christ Himself, at least if it is drawn

with two outstretched fingers and the hair uncombed, and has three sets of rays in the nimbus fastened to the back of the head. For who would comprehend these things had they not spent all the thirty-six years on the Physics and Metaphysics of Aristotle and the Scotists?

In the same way the apostles teach grace, and yet they never determined the difference between a grace freely given and one that makes one deserving. They urge us to do good works, but they don't separate work in general, work being done, and work that is already finished. At all times they inculcate charity, but they don't distinguish infused charity from that which is acquired, or state whether charity is an accident or a substance, created or uncreated. They abhor sin, but may I be shot if they could define sin scientifically as we know it, unless they were fortunate enough to have been instructed by the Scotists.

You could never persuade me to believe that Paul, upon whose learning others can be judged, would have condemned so many questions, disputes, genealogies, and what he called "strifes for words," if he had really been a master of those subtle topics, especially since all of the controversies at that time were merely little informal discussions. Actually, when compared with the Chrysippean subtleties of our masters, they appeared quite amateurish. And yet these masters are extremely modest; for if by chance the apostles were to have a written document carelessly or without proper knowledge of the subject. the masters would have properly interpreted what they wrote, they would not have condemned it. Therefore, they greatly respect what the apostles wrote, both because of the antiquity of the passage and their apostolic authority. And good heavens, it would almost be unjust to expect scholarly work from the apostles, for they had been told nothing about which they were writing by their Master. But if a mistake of the same kind appears in Chrysostom, Basil, or Jerome, our scholars would unhesitatingly say: "It is not accepted."

The apostles also defeated the pagan philosophers and the Jews in debates, and they are, by nature, the stubbornnest of all. But they did this by using their lives as examples and by performing miracles. And, of course, they dealt with people who were not even smart enough to comprehend the most basic ideas of Scotus. Nowadays, what heathen or heretic does not immediately submit when faced with one of these cob-webbed subtleties? Unless, of course, he is either so stupid that he cannot follow them, or so impudent that he hisses them in defiance, or, possibly, so well instructed in the same ambiguities that the contest is a draw. Then it would appear that you had matched one magician against another, or two men fighting each other with magic swords. It would amount to

nothing more than reweaving Penelope's tapestry. In my humble opinion it would be much wiser for the Christians to fight off the Turks and Saracens with these brawling Scotists, stubborn Occamists, invincible Albertists, and a whole band of Sophists, rather than with the undisciplined and unwieldy battalions of soldiers with whom they have been fighting for quite some time, and without any particular favor from Mars. Then I daresay they would witness the most onesided battle that they had ever seen, and one of the greatest victories ever achieved. Who is so impassive that the shrewdness of these fighters would not excite him? And who could be so stupid that these sophistries would not quicken him? And finally, who could be so alert that they would not cloud his vision?

But you think that I say all these things as a joke. Certainly, it is no wonder, since there are some even among the divines, instructed in aural learning, who are nauseated by what they consider the petty subtleties of the theologians. There are those who abhor speaking about holy things with a smutty mouth as a kind of sacrilege and the greatest impiety. These things are to be worshipped and not expounded upon. I am speaking of the heathen's profane methods of arguing, this arrogant way that they define things, and this defiance of the majesty of sacred theology by silly and sordid terms and sentiments. And vet, for all that, the others revel and even applaud themselves in their happiness, and they are so attentive about their precious trifles, both night and day, that they don't even have enough time to read a gospel or epistle from St. Paul. And while they waste their time away in school, they think that they are upholding the universal church, which is otherwise about to crumble to ruins, by the influence of their syllogisms, in the same way that Atlas supports the heavens on his shoulders, according to the poets. You can imagine how much pleasure they derive from shaping and reshaping the Holy Scriptures, as if they were made of wax. And they insist that their own conclusions, subscribed to by a few students, are more valid than Solon's laws and preferred before a pope's decrees; and as world censors they will force a retraction of any statement that does not completely adhere both to their explicit and implicit conclusions. And they announce these conclusions as if they were oracles. "This proposition is scandalous." "This one lacks reverence." "This one tends toward heresy." "This one does not have the right ring." The inference is that neither baptism nor the gospel, Peter and Paul, St. Jerome and Augustine, no, not even the great Aristotelian Thomas, himself, can convert a Christian, unless these scholarly men give their approval. And how kind it is of them to pass judgment! Who would ever have thought, unless

these wise men had instructed us, that a man who approves of both "matula putes" and "matula putet," or "ollae fervere" and "ollam fervere," as good Latin, is not a Christian? Who else would have purged the Church from treacherous errors of this sort, which no one would have ever had the occasion to read if these wise men had not published them under the great seals of their universities? Henceforth, aren't they happy while they do these things?

And furthermore, they draw exact pictures of every part of hell, as though they had spent many years in that region. They also fabricate new heavenly regions as imagination dictates, adding the biggest of all and the finest, for there must be a suitable place for the blessed souls to take their walks, to entertain at dinner, or even to play a game of ball. Their heads are so stuffed and stretched with these and two thousand other trivialities of the same sort that I am certain Jupiter's brain was no more pregnant when he velled for Vulcan's help to bring forth Pallas. Therefore, do not be astonished when you see one of their heads all wrapped up in swathes at a public debate, for if it wasn't it would certainly fly to pieces. I often derive much pleasure myself when these theologians, who, holding themselves in such great esteem, begin speaking in their slovenly and barbarous tongues and jabber so that no one except a jabberer can understand them, reaching a high pitch—"highest acumen," they call it. This the common man cannot attain. It is their claim that it is beyond the station of sacred discourse to be obliged to adhere to the rules of grammarians. What an amazing attribute for theologians that incorrect speech be allowed them alone! As a matter of fact they share this honor with most intellectuals. When they are addressed as "Our Masters," they feel that they are in the proximity of the gods. They feel that the term has the same religious vigor as the unspeakable four letters of the Hebrews. They say it is sacrilegious to even write MAGISTER NOSTER in small letters, and should one mistakenly utter the term, he destroys in one stroke the sublimity of the theological order.

Those who are the closest to these in happiness are generally called "the religious" or "monks," both of which are deceiving names, since for the most part they stay as far away from religion as possible and frequent every sort of place. I cannot, however, see how any life could be more gloomy than the life of these monks if I did not assist them in many ways. Though most people detest these men so much that accidentally meeting one is considered to be bad luck, the monks themselves believe that they are magnificent creatures. One of the chief beliefs is that to be illiterate is to be of a high state of sanctity, and so they make sure that they are not able to read. Another is that when braying out their gospels in church they are making themselves very pleasing and satisfying to God, when in fact they are uttering these psalms as a matter of repetition rather than from their hearts. Indeed, some of these men make a good living through their uncleanliness and beggary by bellowing their petitions for food from door to door; there is not an inn, an announcement board, or a ship into which they are not accessible, here having a great advantage over other common beggars. According to them, though, they are setting an apostolic example for us by their filthiness, their ignorance, their bawdiness, and their insolence.

Moreover, it is amusing to find that they insist that everything be done in fastidious detail, as if employing the orderliness of mathematics, a small mistake in which would be a great crime. Just so many knots must be on each shoe and the shoelace may be of only one specified color; just so much lace is allowed on each habit; the girdle must be of just the right material and width; the hood of a certain shape and capacity; their hair of just so many fingers' length; and finally they can sleep only the specified number of hours per day. Can they not understand that, because of a variety of bodies and temperaments, all this equality of restrictions is in fact very unequal? Nevertheless, because of all this detail that they employ they think that they are superior to all other people. And what is more, amid all their pretense of Apostolic charity, the members of one order will denounce the members of another order clamorously because of the way in which the habit has been belted or the slightly darker color of it. You will find some among the monks who are so strictly religious and pious that they will wear no outer clothes other than those made of Cilician goat's hair or inner garments other than the ones made of Milesian wool; some others, however, will permit linen outer garments, but they again insist on wool underneath. Members of other orders shrink from the mere touch of money as if it were poison. They do not, however, retreat from the touch of wine or of women. All derive a great deal of joy in choosing the name of their order; some prefer to call themselves Cordeliers, who are subdivided into the Coletes, the Minors, the Minims, and the Crutched; others prefer to be called Benedictines or Bernardines; while still others prefer the names Bridgetines, Augustinians, Williamists, or Jacobines—as if it were not enough to be called Christians. In short, all the different orders make sure that nothing in their lives will be uniform; nor is it so much their concern to be like Christ as it is to be unlike one another.

Many of them work so hard at protocol and at traditional fastidiousness that they think one heaven hardly a suitable reward for their labors; never recalling, however, that the time will come when Christ

will demand a reckoning of that which he has prescribed, namely charity, and that he will hold their deeds of little account. One monk will then exhibit his belly filled with every kind of fish; another will profess a knowledge of over a hundred hymns. Still another will reveal a countless number of fasts that he has made, and will account for his large belly by explaining that his fasts have always been broken by a single large meal. Another will show a list of church ceremonies over which he has officiated so large that it would fill seven ships, while still another will brag that he hasn't touched any money in over sixty years unless he wore two pairs of gloves to protect his fingers. Another will take pride in the fact that he has lived a beggarly life as exampled by the filthiness and dirtiness of his hood, which even a sailor would not see fit to wear. Another will take glory in the fact that he has parasitically lived in the same spot for over fifty-five years. Another will exhibit his hoarse voice, which is a result of his diligent chanting; another, a lethargy contracted from his reclusive living; and still another, muteness as a result of his vow of silence. But Christ, interrupting their otherwise unending pleas will ask to himself, "Where does this new race of Jews come from? I recognize only one commandment that is truly mine and yet I hear nothing of it. Many years ago in the sight of all men I promised, in clear language, not through the use of parables, the inheritance of My Father to those who perform works of mercy and charity-not to those who merely wear hoods, chant prayers, or perform fasts. Nor do I reward those who acknowledge their own good works too much. Let those who think themselves holier than I, dwell in those six hundred heavens of Basilides, if they wish, or let them command those whose fastidious customs they have followed in the place of my commandments to build them a new heaven." Having heard these words and seeing that even sailors and teamsters are considered better company than they are, it should be interesting to see what looks they give each other! Yet they are, in the meantime, with my assistance, contented with their present hopes of happiness.

No one, however, even though isolated from public life, will dare to rebuke one of these monks. because through the confessional these men acquire the secrets of everyone. To be sure, they believe it a crime to publish these secrets, but they may accidentally divulge them when drinking heavily or when wishing to promote amusement by relating funny stories. The names, of course, are not revealed, because the stories are told by means of implications in most cases. In other words, if anyone offends the monks, the monks in turn will take revenge against the offender. They will reveal their enemies in public sermons by direct implications, so that everyone will know of whom they speak. And they will continue this malicious chatter until bribed to stop.

Show me any actor or charlatan you would rather watch than these monks as they drone through their sermons, trying to exemplify all the art of rhetoric that has been handed down through the ages. Good Lord! How wonderfully they gesture with their hands; how skillfully they pitch their voice; how cleverly they intone their sermons, throwing themselves about, changing facial expressions, and in the end leaving their audience in a complete state of confusion by their contradictory arguments. Yet this "art of rhetoric" is handed down with much ceremony from monk to monk, as if it required the greatest skill, craft, and ingenuity. It is forbidden for me to know this art, but I shall relate what I think are a few of its foundations. First, each oration is begun with an invocation, a device they have borrowed from the poets. Next, if charity is to be their topic, they commence their sermon with a dissertation on the Nile River in Egypt. Or they are contented to begin with Baal, the Babylonian snake god, if they intend to speak on the mystery of the cross. If fasting is their subject, they open with the twelve signs of the Zodiac; if they wish to expound faith, they initiate their sermon with the problem of squaring the

I know of one notable fool—there I go again! I meant to say scholar—who was ready to expound the mystery of the Holy Trinity to a very distinguished assembly. Wishing to exhibit exceptional scholarship and to please the Divine in a special way, he embarked upon his lecture in an unheard-of manner—that is, he began by showing the relation of letters, syllables, and words; from there, he explained the agreement between nouns and verbs and nouns and adjectives. At once everyone became lost in amazement at this new approach and began to ask among themselves the question that Horace had once asked, "What is all this stink about?" As his oration progressed, however, he drew out this observation, that through the foregoing elements of grammar he could demonstrate the Holy Trinity so clearly that no mathematician could demonstrate it more understandably through his use of symbols in the sand. This fastidious monk had worked so hard on this one sermon for the previous eight months that he became blind as a mole afterward, all the keenness of his sight having given way to the sharpness of his mind. This man, to this day, however, does not regret the loss of his sight to any degree, because he believes it to have been a small price, indeed, to pay for so much glory.

I know of another monk of eighty years of age who was so scholarly that it was often said that Scotus, himself, was reborn in him. He expounded the mystery of the name of Jesus, showing with admirable subtlety that the letters of the name served to explain all that could be understood about Him. The fact that the name can be declined in three different cases—Jesus, Jesum, and Jesu—clearly illustrates the threefold nature of God. In one case the name ends with "s," this showing that He is the sum; in the second case it ends with "m," illustrating that He is the middle; and finally, in the third case we find the ending "u," this symbolizing that He is the ultimate. He amazed his audience even more when he treated the letters of the name mathematically. The name Jesus was equally divided into two parts with an s left in the middle. He then proceeded to point out that this lone letter was "in the Hebrew language and was pronounced Schin, or Sin, and that furthermore this Hebrew letter was a word in the Scottish dialect that means peccatum (Latin for sin). From the above premises he declared to his audience that this connection showed that Jesus takes away the sins of the world. His listeners, especially the theologians, were so amazed at this new approach that some of them came near to being overtaken by the same mysterious force that transformed Niobe to stone; as for my reaction. I was more inclined to imitate shoddy Priapus, who upon witnessing the nocturnal rites of Canidia and Sagona fled from the spot. And I had reason to flee, too, for when did the Greek Demosthenes or Roman Cicero ever cook up such a rhetorical insinuation as that?

These great rhetoricians insisted that any introduction that had no explicit connection with the matter of the oration was faulty, and was used only by swineherds, who had mere nature as their guide. Nevertheless, these eminent preachers hold that their preamble, as they have named it, contains its rhetorical values only insofar as it has nothing to do with the matter of the discourse, so that the listener will be asking himself, "Now what is he getting at?"

As a third step, instead of a narration they substitute the hasty explanation of some verse from a gospel, when in fact this above all other things is the part that needs to be dwelt upon. As a fourth rule, they interpret some questions of divinity through references to things that are neither in earth or in heaven. Here is where they reach the height of their theological and rhetorical ability in that they astound their audience by flowering their speech, when referring to other preachers, with such illustrious titles as Renowned Doctor, Subtle Doctor, Very Subtle Doctor, Seraphic Doctor, Holy Doctor, and Invincible Doctor. Next, they mystify their uneducated audience by their use of syllogisms, majors, minors, conclusions, corollaries, conversions, and other scholarly devices, playing on the ignorance of the crowd. And they consider all these things necessary and unique to their

FLORENTINE	RENAISSANCE	1501
		130.
	HIGH RENAISSANCE IN ITALY	
	RENAISSANCE	1520

GENERAL EVENTS

LITERATURE & PHILOSOPHY

ART

1471-1484 Reign of Pope Sixtus IV (della Rovere)

1492 Columbus discovers

1494 Foreign invasions of Italy begin

c. 1494 Aldine Press established in Venice 1471-1484 Perugino, Botticelli, and others

decorate Sistine Chapel side walls 1493-1506 Ancient frescoes and statues uncovered in Rome; Laocoon found 1506

c. 1494 Decline of Medici power in Florence causes artists to migrate to Rome

1494-1495 Dürer's first trip to Venice

1503-1513 Reign of Pope Julius II (della Rovere)

c. 1500-1505 Giorgione, Enthroned Madonna with Saint Liberalis and Saint Francis, altarpiece

1505 Michelangelo called to Rome by Julius II to begin Pope's tomb; Moses (1513-1515), Captives (1527-1528)

1505-1508 Raphael works in Florence; Madonna of the Meadows (1505)

1508 Raphael begins frescoes for rooms in Vatican Palace; The School of Athens, Stanza della Segnatura (1510-1511)

1508-1511 Michelangelo, Sistine Chapel

c. 1510 Giorgione, Fête Champêtre

1511 Raphael, Portrait of Julius II

1515-1547 Francis I lures Leonardo and other Italian artists to France

Painting in Venice emphasizes brilliant color and light; less linear than in Rome and Florence; Titian, The Assumption of the Virgin (1518)

1519 Death of Leonardo

1519-1534 Michelangelo works on Medici Chapel sculptures

trade as result of new geographic discoveries 1513-1521 Reign of Pope Leo X (de' Medici) 1517 Reformation begins in

c. 1510 Decline of Venetian

Germany with Luther's 95 Theses, challenging the practice of indulgences

1523-1534 Reign of Pope Clement VII (de' Medici)

1527 Sack of Rome by Emperor Charles V

1534 Churches of Rome and England separate

1545 Council to reform Catholic Church begins at Trent

c. 1524-1534 Strozzi, poem on Michelangelo's Night

1527 Luther translates Bible into German

1528 Castiglione, The Courtier, dialogue on ideal courtly life

1550 Vasari, Lives of the Painters

1558-1566 Cellini, Autobiography of Benvenuto Cellini

1561 The Courtier translated into English by Sir Thomas Hoby 1520 Death of Raphael

c. 1520 Mannerism emerges as artistic style

c. 1528 Pontormo, Deposition, Capponi Chapel, Santa Felicitá, Florence

c. 1534 Parmigianino, Madonna of the Long Neck

1534-1541 Michelangelo, Last Judgment fresco, Sistine Chapel

1538 Titian, Venus of Urbino

1554 Cellini casts bronze Perseus in Florence 1564 Death of Michelangelo

1576 Titian dies of plague

MANNERISM AND LATE

ARCHITECTURE

MUSIC

1473-1480 Sistine Chapel built for Pope Sixtus IV 1473 Sistine Choir established by Sixtus IV

1486-1494 Josquin des Préz intermittently in service of Sistine Choir as composer of masses and motets; *Tu Pauperum Refugium*

1504 Bramante, Tempietto, San Pietro in Montorio, Rome

1506 Pope Julius II commissions Bramante to rebuild Saint Peter's Basilica

1514 Death of Bramante; Raphael, Sangallo, and others continue work on Saint Peter's

1512 Julian Choir established by Julius II for Saint Peter's Basilica

1519-1534 Michelangelo, Medici Chapel, Church of San Lorenzo, Florence

1524 Michelangelo, Laurentian Library, Florence, begun; entrance staircase finished 1559

1547 Michelangelo appointed architect of Saint Peter's; apse and dome begun 1547

1592 Michelangelo's dome for Saint Peter's finished by Giacomo della Porta 1527 Adrian Willaert becomes choirmaster of Saint Mark's, Venice; multiple choirs and addition of instrumental music are Venetian innovations to liturgical music

1567 Palestrina, Missa Papae Marcelli

1571-1594 Palestrina, choirmaster of Sistine Choir, in charge of musical reform for Vatican

1603 Victoria, Requiem Mass for the Empress Maria

11

The High Renaissance in Italy

Popes and Patronage

Artists must work where their art is appreciated and their labors rewarded. Florence in the 15th century, shaped by the generous and refined patronage of the Medici and others, was an extremely congenial place for the talented artist. But when the political power of the Medici declined in the last decade of the century, many major artists inevitably migrated or were summoned to other centers of wealth and stability. The papal court at the Vatican in Rome was preeminently such a center.

In the 15th century (and even earlier) artists found rewarding work at the Vatican. Pope Sixtus IV (reigned 1471-1484) commissioned many artists famous in Florence—among them Ghirlandaio, Botticelli and Perugino—to fresco the side walls of the Sistine Chapel, named for himself, as well as work on other projects that caught his artistic fancy. Not the least of these projects was the enlargement and systematization of the Vatican library.

The period known as the High Renaissance really began, however, in 1503, when a nephew of Sixtus IV became Pope Julius II (died 1513); both were members of the della Rovere family. Pope Julius was

TABLE 11.1 Some Renaissance Popes of the 16th Century

Julius II (1503–1513). Of the della Rovere family: patron of Raphael and Michelangelo.

Leo X (1513-1521). Son of Lorenzo the Magnificent; patronized Michelangelo. Excommunicated Martin

Hadrian VI (1522-1523). Born in the Netherlands; a ferocious reformer and the last non-Italian pope until the 1970s.

Clement VII (1523-1534). Bastard grandson of Lorenzo de' Medici; commissioned the Medici tombs in Florence. Excommunicated Henry VIII. Commissioned the Last Judgment for the Sistine chapel just before his death.

Paul III (1534-1549). Commissioned Michelangelo to build the Farnese Palace in Rome. Called the reform Council of Trent, which first met in 1545.

Julius III (1550–1555). Patron of the composer Palestrina. Confirmed the Constitutions of the Jesuits in 1550. Appointed Michelangelo as chief architect of St. Peter's.

Marcellus II (1555). Reigned as pope 22 days. Palestrina composed the Missa Papae Marcelli in his honor.

Paul IV (1555-1559). Began the papal reaction against the Renaissance spirit. A fanatical reformer; encouraged the Inquisition and instituted the Index of Forbidden Books in 1557.

a fiery man who did not hesitate to don full military armor over his vestments and lead his papal troops into battle. Thanks to the influence of his papal uncle, he appreciated the fine arts, indulging his artistic tastes with the same single-mindedness that characterized his military campaigns. It was Pope Julius called by his contemporaries il papa terribile (the awesome pope)—who summoned both Raphael Sanzio and Michelangelo Buonarroti to Rome.

Raphael

Raphael Sanzio (1483-1520) was born in Urbino, a center of humanist learning east of Florence dominated by the court of the Duke of Urbino. His precocious talent was first nurtured by his father, a painter, whose death in 1494 cut short the youth's education. The young Raphael then went to Perugia as an apprentice to the painter Perugino. Here his talents were quickly recognized. In 1505, at the age of 22, he moved on to Florence, where he worked for three years.

11.1 Raphael. Madonna of the Meadow. 1506. Oil on panel, $44\frac{1}{2} \times 34\frac{1}{4}$ " (113 × 87 cm). Kunsthistorisches Museum, Vienna. The infant John the Baptist kneels at the left of the picture in homage to the Christ child, who stands before his mother.

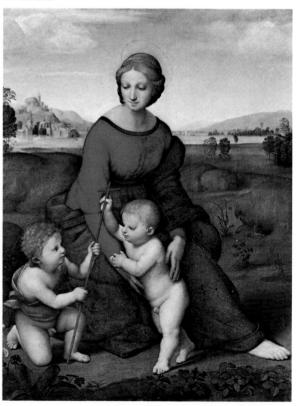

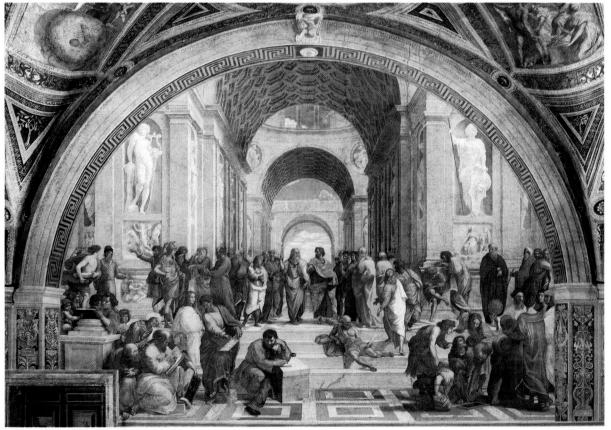

11.2 Raphael. School of Athens. 1510–1511. Fresco, 26 × 18' (7.92 × 5.48 cm). Stanza della Segnatura, Vatican Palace, Rome.

During his stay in Florence, Raphael painted a large number of madonnas in a style that has become almost synonymous with his name. The Madonna of the Meadow [11.1] is typical. In this painting Raphael arranged his figures in a pyramidal configuration to create a believable and balanced space. This geometrical device, which had already been popularized by Leonardo da Vinci, was congenial to the Renaissance preoccupation with rationally ordered composition. More important than the arrangement of shapes, however, is the beautiful modeling of the human forms, especially the figures of the two children, and the genuine sweetness and warmth conveyed by the faces. The head of the Madonna is peaceful and luminous, while the infant Christ and Saint John convey a somewhat more playful mood. The very human quality of the divine figure is Raphael's trademark.

Raphael left Florence for Rome in 1508. By the following year, Pope Julius, whom Raphael later caught in an unforgettably fine portrait, had him working in the Vatican on a variety of projects. The pope, who genuinely loved Raphael, commissioned him to decorate various rooms of his palace. Raphael spent the rest of his brief life working on these projects and filling assorted administrative posts for the papacy, including, at one time, the office of architect of Saint Peter's Basilica and at another time superintendent of the Vatican's collection of antiquities.

One of Raphael's most outstanding works and certainly one of the most important for defining the meaning of the 16th-century Renaissance in Rome is a large fresco executed in 1510-1511 on the wall of the Stanza della Segnatura, an office in the Vatican palace where documents requiring the pope's signature were prepared. Called now the School of Athens [11.2], the fresco is a highly symbolic homage to philosophy that complements Raphael's similar frescoes in the same room that symbolize poetry, law, and theology.

The School of Athens sets the great philosophers of antiquity in an immense illusionistic architectural framework that must have been at least partially inspired by the impressive ruins of Roman baths and basilicas, and perhaps by the new Saint Peter's, then under construction. Raphael's fresco depicts Roman barrel vaulting, coffered ceilings, and broad expanses not unlike the still-existing baths of ancient Rome. Occupying the center of the fresco, in places of honor

framed by the receding lines of the architecture as a device to focus the viewer's eye, are the two greatest ancient Greek philosophers, Plato and Aristotle. Plato holds a copy of the Timaeus in one hand and with the other points to the heavens, the realm of ideal forms. Aristotle holds a copy of his Ethics and points to the earth, where his science of empirical observation must begin. Clustered about the two philosphers in varying poses and at various distances are other great figures of antiquity. Diogenes sprawls in front of the philosophers, while Pythagoras calculates on a slate and Ptolemy holds a globe. At the right, the idealized figure of Euclid with his compass is actually a portrait of Raphael's Roman protector, the architect Bramante. Raphael himself, in a selfportrait, looks out at the viewer at the extreme lower right corner of the fresco.

Raphael's School of Athens reflects a high degree of sensitivity to ordered space, a complete ease with classical thought, an obvious inspiration from the Roman architectural past, a brilliant sense of color and form, and a love for intellectual claritycharacteristics that could sum up the Renaissance ideal. That such a fresco should adorn a room in the Vatican, the center of Christian authority, is not difficult to explain. The papal court of Julius II shared the humanist conviction that philosophy is the servant of theology and that beauty, even if derived from a pagan civilization, is a gift of God and not to be despised. To underscore this point, Raphael's homage to theology across the room, his fresco called the Disputà, shows in a panoramic form similar to the School of Athens the efforts of theologians to penetrate divine mystery.

Michelangelo

In the lower center of Raphael's School of Athens is a lone figure leaning one elbow on a block of marble and scribbling, taking no notice of the exalted scene about him. Strangely isolated in his stonecutter's smock, the figure has recently been identified, at least tentatively, as Michelangelo. If the identification is correct, this is the younger artist's act of homage to the solitary genius who was working just a few yards away from him in the Sistine Chapel.

Michelangelo Buonarroti (1475-1564) was called to Rome in 1505 by Pope Julius II to create for him a monumental tomb. We have no clear sense of what the tomb was to look like, since over the years it went through at least five conceptual revisions. Certain features, however, at least in the initial stages, are definite. It was to have three levels; the bottom level was to have sculpted figures representing Victory and bound slaves. The second level was to have statues of Moses and Saint Paul as well as symbolic

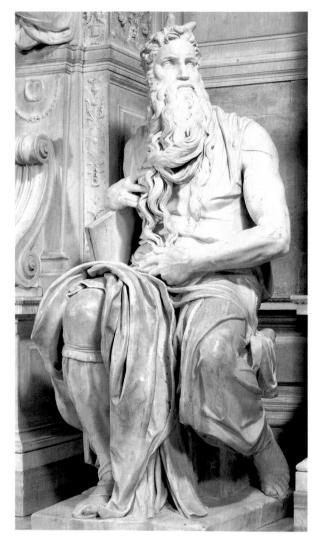

11.3 Michelangelo. Moses. 1513-1515. Marble, height 8'4" (2.54 m). San Pietro in Vincoli, Rome. The horns on the head of Moses represent rays of light; the use of horns instead of rays is based on a mistranslation in the Latin Vulgate Bible.

figures of the active and contemplative life representative of the human striving for, and reception of, knowledge. The third level, it is assumed, was to have an effigy of the deceased pope.

The tomb of Pope Julius II was never finished. Michelangelo was interrupted in his long labors by both Pope Julius himself and, after the pope's death, the popes of the Medici family, who were more concerned with projects glorifying their own family. What was finished of the tomb represents a twentyyear span of frustrating delays and revised schemes. Even those finished pieces provide no sense of the whole, but they do represent some of the highest achievements of world art.

One of the finished pieces is the Moses [11.3] begun after the death of Julius in 1513. We easily

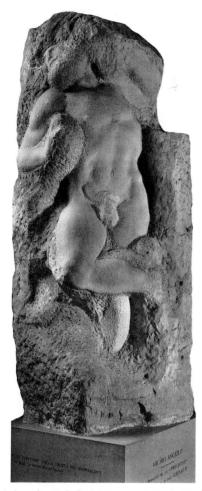

11.4 Michelangelo. Boboli Captive. 1527-1528. Marble, height 7'61/2" (2.3 m). Accademia, Florence. These captives once stood in the Boboli Gardens of Florence, hence their name.

sense both the bulky physicality of Moses and the carefully modeled particulars of musculature, drapery, and hair. The fiercely inspired look on the face of Moses is appropriate for one who has just come down from Mount Sinai after seeing God. The face radiates both divine fury and divine light. It is often said of Michelangelo that his works can overwhelm the viewer with a sense of awesomeness; Italians speak of his terribilità. If any single statue has this awesomeness, it is the Moses.

The highly finished quality of the *Moses* should be compared with the roughness of the Captives [11.4], one of the four figures Michelangelo worked on for the tomb of Julius in Florence in 1527–1528. There is no evidence that Michelangelo intended to leave these figures in so crude a state. Nevertheless, these magnificent works give a visual demonstration of the sculptor's methods. Michelangelo sometimes said that a living figure was concealed in a block of marble

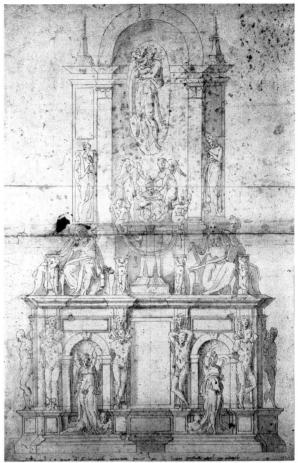

11.5 Drawing of Tomb of Julis II. After Michelangelo, by his pupil Giacomo Rocchetti. Brown ink, 22½ × 15¼" (57 × 39 cm). Kupferstichkabinett, State Museums, Berlin. This is only one of many projected plans for the tomb of Julius. Note the slaves/captives at the bottom level and Moses on the right at the second level. The semirecumbent figure of the deceased pope is supported by angelic figures with an allegorical figure of Victory overhead in the center.

and that only the excess needed to be carved away to reveal it. The truth of the Neoplatonic notion that ideal form struggles to be freed from the confines of gross matter can almost be seen in these figures. A close examination reveals the bite marks of the sculptor's chisel as he worked to reveal each living figure by removing hard marble. Seldom do we have a chance, as we do here, to see the work of a great artist still unfolding.

It is not clear where the Captives fit into the overall plan of the tomb of Julius. It is most likely that they were meant to serve as corner supports for the bottom level of the tomb, writhing under the weight of the whole [11.5]. Whatever was the ultimate plan for these figures, they are a stunning testament to the monumentally creative impulse of Michelangelo the sculptor.

11.6 Michelangelo. Ceiling, Sistine Chapel. 1508-1512. Fresco, $44 \times 128'$ (13.41 × 39.01 m). Vatican Palace, Rome.

Michelangelo had hardly begun work on the pope's tomb when Julius commanded him to fresco the ceiling of the Sistine Chapel to complete the work done in the previous century under Sixtus IV. But Michelangelo resisted the project (he actually fled Rome and had to be ordered back by papal edict). He considered himself a sculptor, and there were technical problems presented by the shape of the ceiling. Nevertheless, he gave in and in three years (1508-1511) finished the ceiling. He signed it "Michelan-

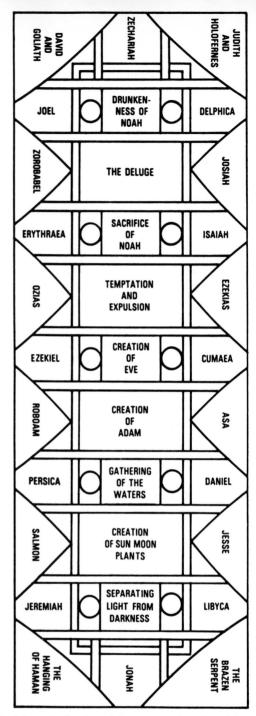

11.7 Schematic drawing of the iconographic plan of the Sistine ceiling. The corner triangles are called the vele (Italian "sails").

gelo, Sculptor" to remind Julius of his reluctance and his own true vocation.

The ceiling [11.6] is as difficult to describe as it is to observe when standing in the Sistine Chapel. The overall organization consists of four large triangles at the corners; a series of eight triangular spaces on the outer border; an intermediate series of figures; and nine central panels (four larger than the other five), all bound together with architectural motifs and nude male figures. The corner tirangles depict heroic action in the Old Testament (Judith beheading Holofernes; David slaying Goliath; Haman punished for his crimes; the rod of Moses changing into a serpent), while the other eight triangles depict the biblical ancestors of Jesus Christ. The ten major intermediate figures are alternating portraits of pagan sibyls (prophetesses) and Old Testmanet prophets. The central panels are scenes from the book of Genesis. The one closest to the altar shows God dividing darkness from light and the one at the other end shows the drunkenness of Noah (Genesis 9:20-27). This bare outline oversimplifies what is actually a complex, intricate design [11.7].

Michelangelo conceived and executed this huge work (128 by 44 feet, or 39 by 13.4 meters) as a single unit. Its overall meaning is a problem. The issue has engaged historians of art for generations without satisfactory resolution. Any attempt to formulate an authoritative statement must include a number of ele-

1. Michelangelo's interest in the Neoplatonism he had studied as a youth in Florence. Many writers have noted the Neoplatonic roots of his interest in the manipulation of darkness and light (the progression of darkness to light from the outer borders to the center panels; the panel of God creating light itself), the liberation of spirit from matter (the souls represented by nudes; the drunkenness of Noah, symbolic of humanity trapped by gross

matter and thereby degraded), and the numerous geometrical allusions done in triads, a triple division being much loved in Neoplatonic number symbolism.

2. The Christian understanding of the Old Testament as a work pointing to the coming of Christ, combined with the notion that even pagan prophets were dimly prophetic figures of Christ.

- 3. The complex tree symbolism in seven of the nine central panels, which refer to the symbolism of the tree in the Bible (the tree of good and evil in the Genesis story, the tree of the Cross, and so forth), as well as being allusions to the pope's family name, which happened to be della Rovere (the oak tree).
- 4. The traditional theories of the relationship of the world of human wisdom (represented by the sibyls) and God's revelation (represented by the prophets).

In the panel depicting the Creation of Adam [11.8], to cite one specific example, many of these elements come together. A majestically muscular Adam rises, as if from sleep, from the bare earth as God stretches forth his creative finger to call him into being. God's left arm circles a woman and child who represent simultaneously Eve and her children and by extension the New Eve, who is the Blessed Virgin. Adam is a prefigurement of Christ. Below Adam a youth holding a cornucopia spilling forth leaves and acorns (symbols of the della Rovere family) stands just above the Persian sibyl. Stylistically, the fresco dem-

11.8 Michelangelo. Creation of Adam, detail of the Sistine ceiling. 1508-1512. Compare the figure of Adam with the figure of David to get a sense of Michelangelo's concept of musculature.

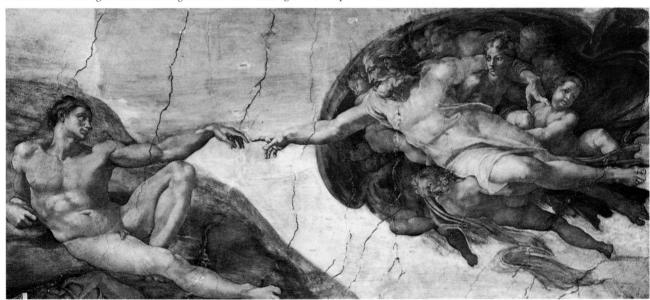

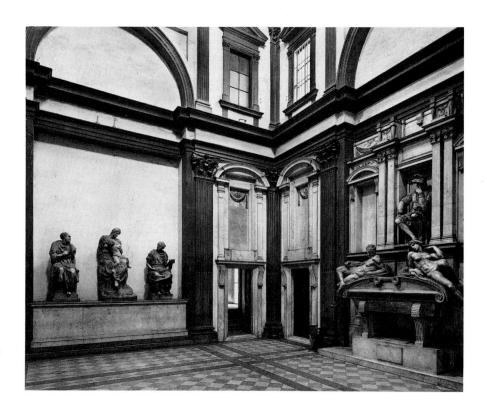

11.9 Michelangelo. Medici Chapel. 1519-1534. Church of San Lorenzo, Florence, It is not clear that the statues of the Madonna and saints were finished by Michelangelo himself.

onstrates Michelangelo's intense involvement with masculine anatomy seen as muscular monumentality. His ability to combine great physical bulk with linear grace and a powerful display of emotion fairly well defines the adjective michelangeloesque, applied to many later artists who were influenced by his style.

Under the patronage of Popes Leo X and Clement VII—both from the Medici family—Michelangelo worked on another project, the Medici Chapel in the Florentine church of San Lorenzo. This chapel is particulary interesting because Michelangelo designed and executed both the sculptures and the chapel in which they were to be placed. Although Michelangelo first conceived the project in 1519, he worked on it only in fits and starts from 1521 to 1534. He never completely finished the chapel. In 1545 some of his students put the statues into place.

The interior of the Medici Chapel [11.9] echoes Brunelleschi's Pazzi Chapel with its dome, its use of a light stone called pietra serena, its classical decoration, and its very chaste and severe style. The plan envisioned an altar at one end of the chapel and opposite it, at the other end, statues of the Madonna and Child with Saints Cosmas and Damian. The saints were the patrons of physicians, an allusion to the name Medici, which means "the doctor's family." At the base of these statues are buried in utter simplicity the bodies of Lorenzo the Magnificent and his brother Giuliano. On opposite walls are niches with idealized seated

11.10 Michelangelo. Night, detail of the tomb of Giuliano de' Medici. 1519-1534. Marble, length 6'41/2" (1.94 m.) The owl and the mask under the recumbent figure are emblems of night and dreams.

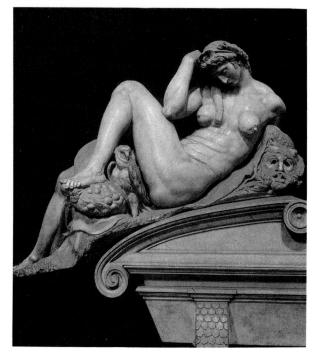

figures of relatives of Lorenzo the Magnificent, the Dukes Lorenzo and Giuliano de' Medici, in Roman armor. Beneath each are two symbolic figures resting on a sarcophagus, Night and Day and Dawn and Dusk.

This great complex, unfinished like many of Michelangelo's projects, is a brooding meditation on the shortness of life, the inevitability of death, and the Christian hope for resurrection. Both the stark decoration of the chapel and the positioning of the statues (Duke Lorenzo seems always turned to the dark with his head in shadow while Duke Giuliano seems more readily to accept the light) form a mute testament to the rather pessimistic and brooding nature of their creator. When Michelangelo had finished the figure of Night [11.10], a Florentine poet named Strozzi wrote a poem in honor of the statue, with a pun on the name Michelangelo:

The Night you see sleeping in sweet repose Was carved in stone by an angel.

Because she sleeps, she has life. If you do not believe this, touch her and She will speak.

Michelangelo, an accomplished poet in his own right, answered Strozzi's lines with a pessimistic rejoiner:

Sleep is precious; more precious to be stone When evil and shame are abroad; It is a blessing not to see, not to hear. Pray, do not disturb me. Speak softly!

The New Saint Peter's

In 1506 Pope Julius II, in a gesture typical of his imperious nature, commissioned the architect Donato Bramante (1444–1514) to rebuild Saint Peter's Basilica in the Vatican. Old Saint Peter's had stood on the Vatican hill since it was first constructed more than a thousand years earlier, during the time of the Roman

11.11 Floor plans for the new Saint Peter's Basilica, Rome. Maderna's final additions, especially the elongated nave, narthex, and large facade, obscured Michelangelo's original design. (1) Area of papal altar under dome. (2) Transept. (3) Portal. (4) Chapel (not all are identified). (5) Apsc. (6) Choir. (7) Nave; (8) Narthex. (a) Bernini's piazza, done in 1656.

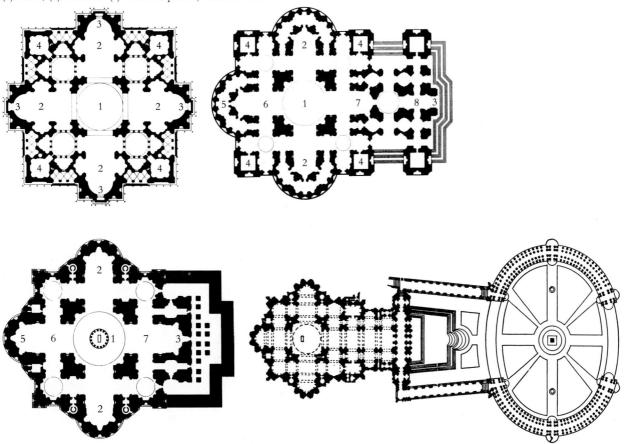

emperor Constantine. By the early 16th century it had suffered repeatedly from roof fires, structural stresses, and the simple ravages of time. In the minds of the Renaissance "moderns" it was a shaky anachronism.

Bramante's design envisioned a central domed church with a floor plan in the shape of a Greek cross with four equal arms [11.11]. The dome would have been set on a columned arcade with an exterior columniated arcade, called a peristyle, on the outer perimeter of the building. Any of the four main doors was to be directly across from a portal or door on the opposite side. This central plan was not executed in Bramante's lifetime, but a small chapel he built in 1502 next to the Church of San Pietro in Montorio, Rome, may give us a clue as to what Bramante had in mind. This tempietto (little temple) is believed to have been done in a style similar to what Bramante wanted later for Saint Peter's.

After Bramante's death a series of architects, including Raphael and Sangallo, worked on the massive project. Both these architects added a nave and aisles. In 1546 Michelangelo was appointed architect, since the plans previously drawn up seemed unworkable. Michelangelo returned to Bramante's plan for a central domed Greek cross church but envisioned a ribbed arched dome somewhat after the manner of the cathedral in Florence but on a far larger scale.

The present Saint Peter's seen from the front gives us no clear sense of what Michelangelo had in mind when he drew up his plans. Michelangelo's church had a long nave and a facade added by Carlo Maderna in the early 17th century. The colonnaded piazza was completed under the direction of Gian Lorenzo Bernini in 1663, almost a century after Michelangelo's death. Michelangelo lived to see the completion of the drum which was to support his dome. The dome itself was raised some thirty years after his death by Giacomo della Porta. The best way to understand what Michelangelo intended is to view Saint Peter's

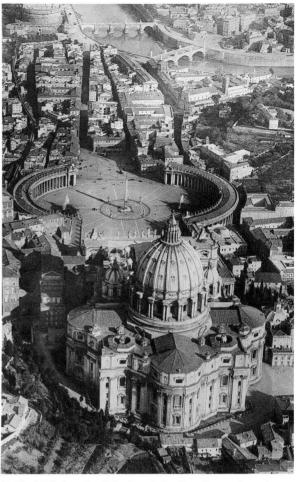

11.12 Michelangelo. Saint Peter's Basilica, Rome, from the southwest. 1546-1564; completed 1590 by Giacomo della Porta. The Vatican Gardens are behind the basilica visible at the lower center of this photograph.

from behind, from the Vatican Gardens, where one can see the great dome looming up over the arms of the Greek cross design [11.12].

CONTEMPORARY VOICES

Donna Vittoria and Michelangelo

Donna Vittoria Colonna to Michelangelo:

Most honored Master Michelangelo, your art has brought you such fame that you would perhaps never have believed that this fame could fade with time or through any other cause. But the heavenly light has shone into your heart and shown you that, however long earthly glory may last, it is doomed to suffer the second death.

Michelangelo's poem on this theme:

I know full well that it was a fantasy That made me think that art could be made into An idol or a king. Though all men do This, they do it half-unwillingly. The loving thoughts, so happy and so vain, Are finished now. A double death comes near-The one is sure, the other is a threat.

An exchange between Michelangelo's friend and spiritual adviser (for whom he made some small sculptures and drawings, according to Vasari) and the artist. She was the recipient of a number of his poems.

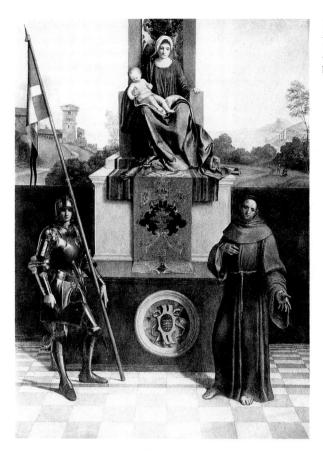

The High Renaissance in Venice

The brilliant and dramatic outbreak of artistic activity in 16th-century Rome and Florence does not diminish the equally creative art being done in the Republic of Venice to the north. While Rome excelled in fresco, sculpture, and architecture, Venice was famous for its tradition of easel painting. Venice's impressive cosmopolitanism derived from its position as a maritime port and its trading tradition.

Because of the damp atmosphere of their watery city, Venetian painter's quickly adopted oil painting, which had first been popularized in the north. Oil painting gave the artist unparalleled opportunities to enrich and deepen color by the application of many layers of paint. Oil painting in general, and Venetian painting in particular, put great emphasis on the brilliance of its color and the subtlety of its light. The sunny environment of Venice, with light reflecting off the ever-present waterways, further inspired the Venetian feel for color and light. Although the generalization is subject to refinement, there is truth in the observation that Venetian painters emphasized color while painters in the south were preoccupied with

11.13 Giorgione. Madonna Enthroned with Saints Liberalis and Francis of Assisi. c. 1500–1505. Oil on panel, $6'6\frac{3}{4}'' \times 5'$ (1.99 × 1.52 m). Cathedral, Castelfranco. Saint Francis shows the wounds (the so-called stigmata) of Christ that he bore on his

line. Venetian painters, like their counterparts in northern Europe, had an eye for close detail and a love for landscape (an ironic interest, since Venice had so little of it).

Giorgione

The most celebrated and enigmatic painter in early 16th-century Venice was Giorgio di Castelfranco (c. 1477-1510), more commonly known as Giorgione. His large altarpiece, Enthroned Madonna with Saints Liberalis and Francis of Assisi [11.13], painted for the cathedral of his home town of Castelfranco, illustrates many of the characteristics of the Venetian Renaissance style. It is a highly geometric work (using the now-conventional form of the triangle with the Madonna at the apex) typical of Renaissance aesthetics of form. At the same time it shows some idiosvncratic characteristics—the luminous quality of the armor of Saint Liberalis and the minutely rendered landscape. This landscape, with its two soldiers in the bend of the road and the receding horizon, echoes painters from the north like Jan van Eyck.

Far more typical of Giorgione's work are his paintings without religious content or recognizable story line or narrative quality. Typical of these is Le Concert Champêtre [11.14], done in the last year of the painter's life. The two voluptuous nudes frame two young men who are shadowed but also glowing in their richly rendered costumes. The sky behind threatens a storm, but Giorgione counterposes the storm to a serene pastoral scene that includes a distant farmhouse and shepherds with their flock. What does the painting hope to convey? Why does one woman pour water into the well? Is the lute in the hand of one man or the recorder in the hand of the other woman a clue? We do not know. It may be an elaborate allegory on music or poetry. What is clear is that the painting is a frankly secular homage to the profane joy of life rendered with the richness and lushness of concept and color.

Titian

If Giorgione's life was short, that of his onetime apprentice Tiziano Vecelli (c. 1488-1576), known as Titian, was long. Titian brought the Venetian love

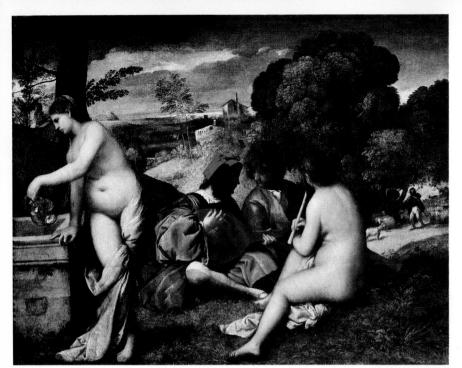

11.14 Giorgione. Le Concert Champêtre. c. 1510. Oil on canvas, 3'7½" × 4'6½" (1.1 × 1.38 m). Louvre, Paris. Giorgione's robust nude figures would be much imitated by later baroque painters like Peter Paul Rubens.

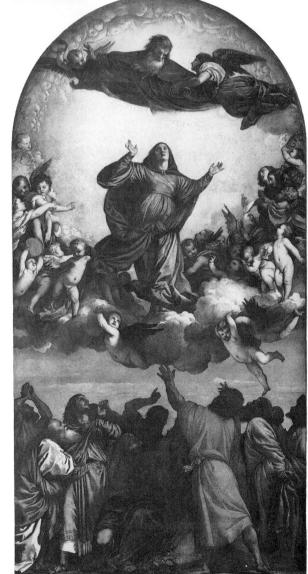

11.15 Titian. Assumption of the Virgin. 1516-1518. Oil on canvas, $22'6'' \times 11'8''$ (6.86 × 3.56 m). Church of the Frari, Venice. Note the three distinct levels in the composition of the painting.

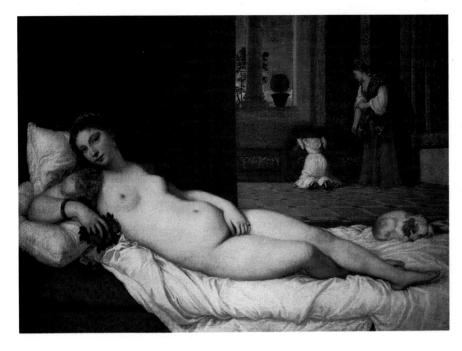

11.16 Titian. Venus of Urbino. 1538. Oil on canvas, 3'11" × 5'5" $(1.19 \times 1.62 \text{ m})$. Uffizi, Florence.

for striking color to its most beautiful fulfillment. His work had an impact not only on his contemporaries but also on later Baroque painters in other countries, such as Peter Paul Rubens in Antwerp and Diego Velázquez in Spain.

Titian's artistic output during seventy years of activity was huge. His reputation was such that he was lionized by popes and princes. He was a particular favorite of the Holy Roman Emperor Charles V, who granted him noble rank after having summoned him on a number of occasions to work at the royal court. From this tremendous body of work two representative paintings, emblematic of the wide range of his abilities, provide a focus.

The huge panel painting in the Venetian Church of the Frari called Assumption of the Virgin [11.15] shows Titian at his monumental best. The swirling color in subtly different shadings and the dramatic gestures of the principals, all of which converge on the person of the Madonna, give a feeling of vibrant upward movement; color and composition define the subject of the assumption of Mary into heaven. The energy in the panel, however, should not distract the viewer from its meticulous spatial relationships. The use of a triangular composition, the subtle shift from dark to light, the lines converging on the Madonna from both above and below are all part of carefully wrought ideas that give the work its final coherence.

Contrast this Assumption with Titian's work of twenty years later, the Venus of Urbino [11.16]. The religious intensity of the Assumption gives way to the sensual delight of the Venus done in homage to feminine beauty from a purely human perspective. The

architectural background, evenly divided between light and dark coloration, replaces Giorgione's natural landscapes. The lushness of the nude figure is enhanced by the richness of the brocade, the small bouquet of flowers, the little pet dog, and the circumspect maids at their tasks around a rich clothes chest in the background. The Venus of Urbino reflects a frank love of the human body, which is presented in a lavish artistic vocabulary. It is obvious that Titian painted this work for an aristocratic and wealthy patron.

Mannerism

There is general agreement that at the end of the second decade of the 16th-century High Renaissance art in Italy, under severe intellectual, psychological, and cultural pressure, gave way to an art style that seemed to be an exaggeration of Renaissance form and a loosening of Renaissance intellectuality. It is not so much that a new school of artists arose but that a mood touched some artists at some point in their careers and captivated others totally. An earlier generation of art historians saw this tendency, called Mannerism, as a sign of decadence and decay. Scholarly opinion is less harsh today, viewing Mannerism as a distinct aesthetic to be judged on its own terms.

Mannerism is hard to define and the term is often used without any precise sense. The schema proposed by the art historian Frederick Hartt might serve in place of a strict definition:

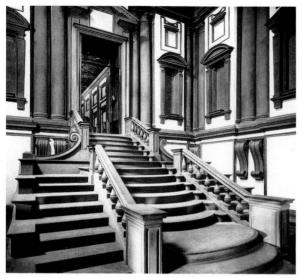

11.17 Michelangelo. Vestibule of the Laurentian Library, Florence. Begun 1524; stairway completed 1559. This library today contains many of the books and manuscripts collected by the Medici family.

High Renaissance

Content: Normal, supernormal, or ideal; appeals

to universal

Narrative:

Space:

Direct, compact, comprehensible Controlled, measured, harmonious,

ideal

Composition: Harmonious, integrated, often central-

ized

Proportions:

Figure:

Normative, idealized

Easily posed, with possibility of mo-

tion to new position

Color: Balanced, controlled, harmonious Substance: Natural

Mannerism

Content: Abnormal or anormal; exploits

strangeness of subject, uncontrolled

emotion, or withdrawal

Narrative: Elaborate, involved, abstruse

Space: Disjointed, spasmodic, often limited to

foreground plane

Composition: Conflicting, acentral, seeks frame Proportions: Uncanonical, usually attenuated

Figure: Tensely posed; confined or overex-

tended

Color: Contrasting, surprising

Substance: Artificial

Using Hartt's schema we can detect Mannerist tendencies in some of Michelangelo's later work. The figures of Night, Day, Dawn, and Dusk seem to reflect

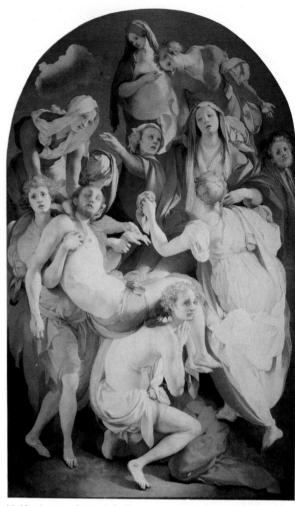

11.18 Jacopo Carucci da Pontormo. Deposition. c. 1528. Oil on panel, $11' \times 6'6''$ (3.5 × 1.98 m). Capponi Chapel, Church of Santa Felicità, Florence. The twisted figures seem suspended in an airy space of no definite location. Note the odd palette the painter used to emphasize the horror and strangeness of the facial expressions.

the exaggerations of the Mannerist style Hartt describes. The entrance to the Laurentian Library [11.17] in Florence, begun by Michelangelo in 1524 to rehouse the Medici book collection, shows some of these characteristics. Its windows are not windows, its columns support nothing, its staircases with their rounded steps seem agitated and in motion, its dominant lines break up space in odd and seemingly unresolved ways.

Mannerist characteristics show up in only some of Michelangelo's works (the Last Judgment fresco in the Sistine Chapel might also be analyzed in this fashion), but some of his contemporaries quite clearly broke with the intellectual unity of the High Renaissance. Two in particular deserve some attention be-

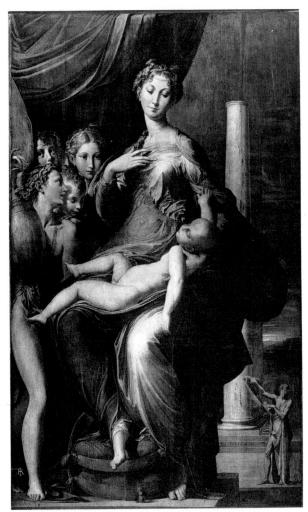

11.19 Parmigianino. Madonna of the Long Neck. c. 1534. Oil on panel, $7'1'' \times 4'4''$ (2.15 × 1.32 m). Uffizi, Florence. Note the odd prophetic figure and the elongated column in the background.

cause they so clearly illustrate the Mannerist imagina-

Jacopo Carucci da Pontormo (1494-1557) was an eccentric and reclusive painter who had studied with Leonardo da Vinci in his youth. Pontormo's greatest painting is the Deposition [11.18] painted around 1528 for the church of Santa Felicita in Florence. The most striking feature of this work is its shocking colors: pinks, apple greens, washed-out blues. It is very hard to think of any other painting in the Renaissance to which this stunningly original and exotic work can be compared.

An even more dramatic example of the Mannerist aesthetic is by Francesco Mazzola (1503-1540), called Parmigianino. He painted the Madonna of the Long Neck [11.19] for a church in Bologna. The gigantic proportions in the picture space are made all the more exaggerated by forcing the eye to move from the tiny prophetic figure in the background to the single column and then to the overwhelmingly large Madonna. The infant almost looks dead; in fact, his hanging left arm is reminiscent of the dead Christ in Michelangelo's Pietà. The Virgin's figure is rendered in a strangely elongated, almost serpentine, fashion. There is something oddly erotic and exotic about her due to the shape of her body, the long fingers, and the great curving "S" of her neck. The implied eroticism is reinforced by the partially clad figures clustered at her side.

How and under what circumstances Mannerism grew and matured is the subject of much debate. Some elements of that debate must include the intellectual and social upheavals of the time (everything from wars to the Protestant Reformation) and the human desire and need to innovate once the problems and potential of a given art style have been fully worked out. In a sense, Mannerism is a testament to the inventiveness and restlessness of the human spirit.

Music in the 16th Century

Music at the Papal Court

The emphasis in this chapter on painting, sculpture, and architecture makes it easy to forget that many of these artistic creations were intended for the service of Roman Catholic worship. It should be no surprise that fine music was subsidized and nurtured in Rome at the papal court. In fact, the active patronage of the popes for both the creation and the performance of music dates back to the earliest centuries of the papacy. Gregorian chant, after all, is considered a product of the interest of Pope Gregory and the school of Roman chant. In 1473 Pope Sixtus IV established a permanent choir for his private chapel, which came to be the most important center of Roman music. Sixtus' nephew Julius II endowed the choir for Saint Peter's, the Julian Choir.

The Sistine Choir used only male voices. Preadolescent boys sang the soprano parts, while older men, chosen by competition, sang the alto, tenor, and bass parts. The number of voices varied then from 16 to 24 (the choir eventually became, and still is, much larger). The Sistine Choir sang a cappella (without accompaniment), although we know that the popes enjoyed instrumental music outside the confines of the church. Cellini, for example, mentions that he played instrumental motets for Pope Clement VII.

While Botticelli and Perugino were decorating the walls of the Sistine Chapel, the greatest composer of the age, Josquin des Prez (c. 1440-1521), was in the service of the Sistine Choir, composing and directing music for its members from 1486 to 1494. From his music we can get some sense of the quality and style of the music of the time.

Josquin, who was Flemish, spent only those eight years in Rome, but his influence was widely felt in musical circles. He has been called the bridge figure between the music of the Middle Ages and the Renaissance. Although he wrote madrigals and many masses in his career, it was in the motet for four voices, a form not held to traditional usages in the way the masses were, that he showed his true genius for creative musical composition. Josquin has been most praised for homogeneous musical structure, a sense of balance and order, a feel for the quality of the word. These are all characteristics common to the aspirations of the 16th-century Italian humanists. In that sense, Josquin combined the considerable musical tradition of northern Europe with the new intellectual currents of the Italian south.

The Renaissance motet uses a sacred text sung by four voices in polyphony. Josquin divided his texts into clear divisions but disguised them by using overlapping voices so that one does not sense any break in his music. He also took considerable pains to marry his music to the obvious grammatical sense of the words while still expressing their emotional import by the use of the musical phrase. A portion of the motet Tu Pauperum Refugium ("Thou Refuge of the

Poor") illustrates both points clearly. The text shows the principle of overlapping (look at the intervals at which the voices enter with, for example, the end of the phrase obdormiat in morte). Likewise, the descending voices underscore the sense of the words ne unquam obdormiat in morte anima mea ("lest my soul sleep in death") in a way that to one musicologist suggests death itself is entering.

EAST MEETS WEST

The Discovery of the New World

When Genoese sailor and explorer Christopher Columbus (1451-1506) died after four voyages to the New World, he was still convinced that he had discovered a sea route to Asia—the goal and dream of many explorers from the Middle Ages on. For all his navigational genius, Columbus was still gripped by the power of the medieval dream of the mythical lands of the East, ruled by the imaginary emperor Prester John.

Columbus' desire to sail westward was fueled in part by the maps and writings of a Florentine humanist named Paolo Toscanelli (1397-1482), who had argued that such a voyage would provide a route to Asia. When Columbus sailed in 1492, in three ships financed by the King and Queen of Spain, he finally reached land in the West (precisely where is still controversial) on October 12 of that year. In the course of his own further voyages he explored much of what we know today as the Caribbean and parts of Central America. Another Florentine, Amerigo Vespucci (1451-1512), in 1504 described these new lands as a continent. A German mapmaker inscribed those lands with his name, from which we get the word America.

North America was discovered in this same period from two different directions. John Cabot (1461–1498) sailed from Bristol, England, in 1497 and made landfall the same year at what is present-day Newfoundland in Canada. Juan Ponce de Leon (1460-1521), a member of Columbus' later voyages, sailed out of Puerto Rico in search of gold and a fabled Fountain of Youth. During the Easter season (Pascua Florida) of 1513 he sighted and then explored a land he called La Florida. Despite subsequent explorations, the Spanish did not colonize Florida until 1556, when a permanent settlement was made at what is now Saint Augustine.

The explorations of these new lands, fueled by imagination, greed, commercial interest, and religious zeal, would occupy the European powers for subsequent centuries. Their very existence and their vast expanse would change irrevocably the culture of Europe and, in the process, destroy or significantly modify the original peoples the Europeans, not quite understanding where they were, called Indians.

The 16th-century composer most identified with Rome and the Vatican is Giovanni Pierluigi da Palestrina (1525-1594). He came from the Roman hill town of Palestrina as a youth and spent the rest of his life in the capital city. At various times in his career he was the choirmaster of the choir of Saint Peter's (the cappella Giulia), a singer in the Sistine Choir, choirmaster of two other Roman basilicas (Saint John Lateran and Saint Mary Major). Finally, from 1571 until his death he directed all music for the Vatican.

Palestrina flourished during the rather reactionary period in which the Catholic Church tried to reform itself in response to the Protestant Reformation by returning to the simpler ways of the past. It should not surprise us, then, that the more than one hundred masses he wrote were very conservative. His polyphony, while a model of order, proportion, and clarity, is nonetheless tied very closely to the musical tradition of the ecclesiastical past. Rarely does Palestrina move from the Gregorian roots of church music. For example, amid the polyphony of his Mass in Honor of Pope Marcellus one can detect the traditional melodies of the Gregorian Kyrie, Agnus Dei, and so on. Despite that conservatism, he was an extremely influential composer whose work is still regularly heard in the Roman basilicas. His music was consciously imitated by the Spanish composer Victoria (or Vittoria c. 1548-1611), whose motet O Vos Omnes is almost traditional at Holy Week Services in Rome, and by William Byrd (c. 1543-1623), who brought Palestrina's style to England.

Venetian Music

The essentially conservative character of Palestrina's music can be contrasted with the much more adventuresome situation in Venice, a city less touched by the ecclesiastical powers of Rome. In 1527 a Dutchman, Adrian Willaert, became choirmaster of the Church of Saint Mark's. He in turn trained Andrea Gabrieli and his more famous nephew, Giovanni Gabrieli, who became the most renowned Venetian composer of the 16th century.

The Venetians pioneered the use of multiple choirs for their church services. Saint Mark's regularly used two choirs, called split choirs, which permitted greater variation of musical composition in that the choirs could sing to and against each other in increasingly complex patterns. The Venetians also were more inclined to add instrumental music to their liturgical repertoire. They pioneered in the use of the organ for liturgical music. The independent possibilities of the organ gave rise to innovative compositions that highlighted the organ itself. These innovations became, in time, standard organ pieces: the prelude, the music played before the services began (called in

Italy the intonazione), and the virtuoso prelude called the toccata (from the Italian toccare, "to touch"). The toccata was designed to feature the range of the instrument and the dexterity of the performer.

Both Roman and Venetian music were deeply influenced by the musical tradition of the north. Josquin des Prez and Adrian Willaert were, after all, both from the Low Countries. In Italy their music came in contact with the intellectual tradition of Italian humanism. Without pushing the analogy too far it could be said that Rome gave the musician the same Renaissance sensibility that it gave the painter: a sense of proportion, classicism, and balance. The Venetian composers, much like Venetian painters of the time, were interested in color and emotion.

Contrasting Renaissance Voices

Early 16th-century Renaissance culture was a study in contrasts. The period marked a time when some of the most refined artistic accomplishments were achieved, but it was also a period of great social upheaval. The lives of both Raphael and Leonardo ended at precisely the time Luther was struggling with the papacy. In 1527 Rome was sacked by the soldiers of the Emperor Charles V in an orgy of rape and violence the city had not seen since the days of the Vandals in the 5th century. It would be simplistic to reduce the period of the High Renaissance to a contrast between cool intellectual sophistication and intensely violent passion; nevertheless, it is true that two of the most interesting writers of the period in Italy do reflect rather precisely those opposing tendencies.

Castiglione

Baldassare Castiglione (1478-1529) served in the diplomatic corps of Milan, Mantua, and Urbino. He was a versatile man—a person of profound learning, equipped with physical and martial skills, and possessed of a noble and refined demeanor. Raphael's famous portrait of Castiglione [11.20] faithfully reflects both Castiglione's aristocratic and intellectual

While serving at the court of Urbino from 1504 to 1516 Castiglione decided to write The Courtier, a task that occupied him for the next dozen years. It was finally published by the Aldine Press in Venice in 1528, a year before the author's death. In The Courtier, cast in the form of an extended dialogue and borrowing heavily from the style and thought of ancient writers from Plato to Cicero, Castiglione has his

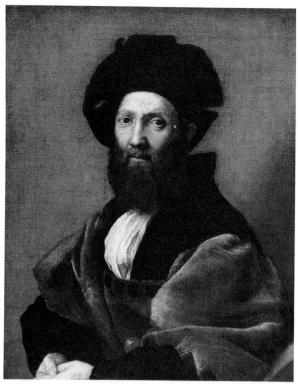

11.20 Raphael. Baldassare Castiglione. 1515-1516. Oil on panel, transferred to canvas. $29\frac{1}{2} \times 25\frac{1}{2}$ " (75 × 65 cm). Louvre, Paris. Raphael would have known the famous humanist through family connections in his native Urbino.

learned friends discuss a range of topics—the ideals of chivalry, classical virtues, the character of the true courtier, the ideals of platonic love. Posterity remembers Castiglione's insistent plea that the true courtier should be a person of humanist learning, impeccable ethics, refined courtesy, physical and martial skills, and fascinating conversation. He should not possess any of these qualities to the detriment of any other.

The uomo universale—the well-rounded person should do all things with what Castiglione calls sprezzatura. Sprezzatura, which is almost impossible

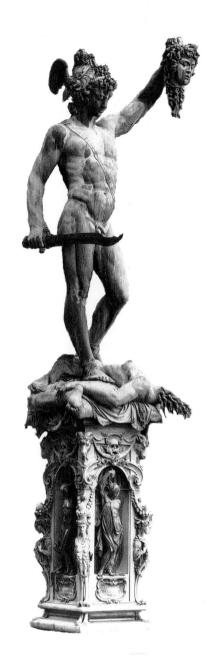

to translate into a single English word, means something like effortless mastery. The courtier, unlike the pedant, wears learning lightly, while his mastery of sword and horse has none of the fierce clumsiness of the common soldier in the ranks. The courtier does everything equally well but with an air of unhurried and graceful effortlessness.

Castiglione's work was translated into English by Sir Thomas Hoby in 1561. It exercised an immense influence on what the English upper classes thought the educated gentleman should be. We can detect echoes of Castiglione in some of the plays of Ben Jonson as well as in the drama of William Shakespeare. When in Hamlet (III,i), for example, Ophelia cries out in horror at the lunatic behavior of Hamlet (at his loss of sprezzatura?) the influence of Castiglione is clear:

Oh, what a noble mind is here o'erthrown! The courtier's, soldier's, scholar's eye, tongue,

The expectancy and rose of the fair state, The glass of fashion and the mould of form, The observed of all observers . . .

The most common criticism of Castiglione's courtier is that he reflects a world that is overly refined, too aesthetically sensitive, and excessively preoccupied with the niceties of decorum and decoration. The courtier's world, in short, is the world of the very wealthy, the very aristocratic, and the most select of the elite. If the reader shares that criticism when reading Castiglione, the Autobiography of Benvenuto Cellini should prove a bracing antidote to the niceties of Castiglione.

Cellini

Benvenuto Cellini (1500-1571) was a talented Florentine goldsmith and sculptor whose life, frankly chronicled, was a seemingly never-ending panorama of violence, intrigue, quarrel, sexual excess, egotism, and political machination. His Autobiography, much of it dictated to a young apprentice who wrote while Cellini worked, is a vast and rambling narrative of Cellini's life from his birth to the year 1562. We read vignettes about popes and commoners, artists and soldiers, cardinals and prostitutes, assassins and artists, as well as a gallery of other characters from the Renaissance demimonde of Medicean Florence and papal Rome.

Above all, we meet Benvenuto Cellini, who makes no bones about his talent, his life of love, or his taste for violence. Cellini is not one of Castiglione's courtiers. Cellini fathered eight legitimate and illegitimate children; he was banished from florence for sodomy; imprisoned for assault; fled Rome after murdering a man; and fought on the walls of the Castel Sant' Angelo in Rome during the seige of 1527 in defense of the Medici pope Clement VII. Anyone who thinks of the Renaissance artist solely in terms of proportion, love of the classics, Neoplatonic philosophy, and genteel humanism is in for a shock when encountering Cellini's Autobiography.

One particular part of Cellini's book is interesting not for its characteristic bravado or swagger but for its insight into the working methods of an artist. In a somewhat melodramatic account Cellini describes the process of casting the bronze statue of Perseus that actually turned out to be his most famous work [11.21]. It now stands in the Loggia dei Lanzi just to the right of the Palazzo Vecchio in Florence.

Cellini does not belong to the first rank of sculptors, although nobody has denied his skill as a craftsman. The Perseus, finished in 1554 for Duke Cosimo I de' Medici, is a highly refined work made more interesting because of Cellini's record of its genesis.

THE ARTS AND INVENTION: Bronze Casting

Benvenuto Cellini's Autobiography provides a dramatic account of his casting of the bronze statue of Perseus. It does not, however, give us a clear picture of a procedure that is one of the oldest forms of metallurgy known to humanity: bronze casting by the so-called lost wax method. In general, the steps of this method are as follows:

- · The artist makes a full-sized sculpture by molding soft clay on a skeletal form made of wood or metal called an armature.
- · A mold is made of the completed sculpture from a material such as plaster.
- · The plaster mold, cut open, is coated inside with a buildup of roughly an eighth of an inch of melted wax. The rest of the mold is filled with a heat-resistant material.
 - · With the plaster mold removed, a wax replica of

the original sculpture remains. Wax rods called gates are attached to the wax figure to create channels and escape vents for air and gases.

- The wax replica is placed upside down into a container and is covered with a fireproof mixture. The hardened whole is called an investment.
- · When the investment is heated in a kiln, the wax melts and runs out of the gates, hence the name "lost wax." The molten bronze (an alloy of copper and tin roughly nine parts copper to one of tin) is then poured
- · When the mold is broken, the resultant figure, bristling with the gates and vents, is cleaned and polished (the gates are cut away) until the artist gets the desired surface or patina.

Depending on the size and complexity of the figure, the sculpture is cast as one piece or as a number of pieces that are later joined.

Summary

Art follows patronage, as we have noted. The "high" Renaissance is summed up in the lives and works of three artists: Michelangelo, Raphael, and Leonardo da Vinci. The first two did their most famous work in the Vatican in the 16th century while Leonardo, true to his restless spirit, sojourned there only for a time before he began his wanderings through the courts of Europe. It is their work that gives full meaning to the summation of Renaissance ideals.

When we look at the work of Raphael and Michelangelo under the patronage of the popes, we should not forget that this explosion of art and culture was taking place while a new and formidable revolution was in the making: the Protestant Reformation. While it would be overly simplistic to think that the Renaissance caused the Reformation, it certainly must be seen as a factor—as we will see in the next chapter. Even so, there is a marked shift in the atmosphere in which Michelangelo worked in Rome before 1521 and afterward, when the full force of the Protestant revolt in the North was making itself felt in Rome.

The artistic work in Rome can be profitably contrasted with that which took place in Venice during roughly the same period. The Roman renaissance was under the patronage of the church. Venetian art and music enjoyed the same patronage source as did Florence in the preceding century: commerce and trade. Venice made its fortune from the sea: the shipping of its busy port looked to both Europe and the Middle East. It was fiercely protective of its independence (including its independence from papal Rome) and proud of its ancient traditions. Even the religious art of Venice had a certain freedom from the kind of art being produced in Rome in the same century because Venice had less contact with the seething ideas current in the century.

Renaissance ideas had also penetrated other areas of Italy. Florence still had its artistic life (although somewhat diminished from its great days in the 15th century) but provincial cities like Parma and Mantua were not without their notables. Much of this artistic activity rested in the courts of the nobility, who supplied the kind of life and leisure that made possible the courtier and the court lifestyle immortalized in the book by Castiglione. The insufficiencies of this court culture would become clear when the religious wars of the 16th century broke out and humanism had to confront the new realities coming from the increasingly Protestant North.

Pronunciation Guide

Bramante: bra-MAHN-tay Buonarroti: bwon-ah-RAH-tay Castiglione: KAS-tig-lee-oh-nav

Cellini: che-LEE-nee

Le Concert Champêtre: leh kon-CER sham-PET-

reh

Giorgione: jor-JOAN-eh

Josquin des Pres: Joss-KIN-day-PRAY

Laurentian: law-WREN-shen

Palestrina: pal-es-TRIN-ah

Parmigianino: PAR-me-jan-eh-no Pontormo: pon-TOR-mo

sprezzatura:: spray-ze-TOUR-ah

Strozzi: STROH-zee tempietto: tem-pea-ET-toe

Titian: TEA-shan

Exercises

1. If you were to transpose Raphael's School of Athens into a contemporary setting, what kind of architecture would you use to frame the scene and who would you include among the personages in the picture?

2. Critics use the adjective michelangeloesque. Now that you have studied his work what does that adjective mean to vou? Give an all-inclusive definition of the term.

3. Michelangelo's Medici Chapel represents the artist's best attempt to express a permanent tribute to the dead. How does it differ in spirit from such monuments today? (You might begin by comparing it with the Vietnam Memorial in Washington, D.C., or some other such public monument.

4. Castiglione's concept of sprezzatura was an attempt to summarize the ideal of the educated courtier. Is there a word or phrase that would best sum up the character of the well-rounded person today? Do we have a similar

ideal? How would you characterize it?

5. Mannerism as an art style contains an element of exaggeration. Can you think of any art form with which we are familiar that uses exaggeration to make its point?

6. Art patronage in the 16th century came mainly from the church and from the wealthy. Are they equally sources of patronage today? What has replaced the church as a source of art patronage today? What does that say about our culture?

Further Reading

D'Amico, John F. Renaissance Humanism in Papal Rome. Baltimore: Johns Hopkins, 1983. Good background reading for the art of the period.

Kelly, J. N. D. (ed.). The Oxford Dictionary of Popes. New York: Oxford, 1986. A handy compendium of the papacy that includes material about papal patronage of the arts

Levey, Michael. High Renaissance. New York: Penguin, 1975. A handy survey of the period.

Logan, Oliver. Culture and Society in Venice: 1470-1790. New York: Scribner, 1972. A readable and well-illustrated survey.

Morris, James. The World of Venice. New York: Harcourt Brace Jovanovich, 1974. One of the best travel books on Venice. Readable, entertaining, and informative.

Partner, Peter. Renaissance Rome: 1500-1559. Berkeley: University of California Press, 1976. An excellent paperback social history of the city.

Rosand, David. Painting in Cinquecento Venice. New Haven: Yale University Press, 1982. Studies of Titian, Veronese, and Tintoretto.

Stinger, Charles. The Renaissance in Rome. Bloomington: Indiana University Press, 1985. A good cultural history.

Summers, David. Michelangelo and the Language of Art. Princeton, N.J.: Princeton University Press, 1982. A scholarly study of the relationship between artistic language and Michelangelo's works.

Wohl, Alice, and Helmut Wohl (eds. and trans.). Ascanio Condivi's Life of Michelangelo. Baton Rouge: Louisiana State University Press, 1976. Translation of an early life of Michelangelo with clear illustrations and excellent notes.

Reading Selections

Baldassare Castiglione from THE COURTIER

This chapter deals with the position of women in the courtly life of Renaissance Italy. Remember that this was an aristocratic setting in which the discussion of women reflects none of the popular prejudice or social conservatism of ordinary 16th-century life. One strikingly modern note sounds in this selection when the Magnifico argues that women imitate men not because of masculine superiority but because they desire to "gain their freedom and shake off the tyranny that men have imposed on them by their one-sided authority."

On Women

"Leaving aside, therefore, those virtures of the mind which she must have in common with the courtier, such as prudence, magnanimity, continence and many others besides, and also the qualities that are common to all kinds of women, such as goodness and discretion, the ability to take good care, if she is married, of her husband's belongings and house and children, and the virtues belonging to a good mother, I say that the lady who is at Court should properly have, before all else, a certain pleasing affability whereby she will know how to entertain graciously every kind of man with charming and honest conversation, suited to the time and the place and the rank of the person with whom she is talking. And her serene and modest behaviour, and the candour that ought to inform all her actions, should be accompanied by a quick and vivacious spirit by which she shows her freedom from boorishness; but with such a virtuous manner that she makes herself thought no less chaste, prudent and benign than she is pleasing, witty and discreet. Thus she must observe a certain difficult mean, composed as it were of contrasting qualities, and take care not to stray beyond certain fixed limits. Nor in her desire to be thought chaste and virtuous, should she appear withdrawn or run off if she dislikes the company she finds herself in or thinks the conversation improper. For it might easily be thought that she was pretending to be straitlaced simply to hide something she feared others could find out about her; and in any case, unsociable manners are always deplorable. Nor again, in order to prove herself free and easy, should she talk immodestly or practise a certain unrestrained and excessive familiarity or the kind of behaviour that leads people to suppose of her what is perhaps untrue. If she happens to find herself present at such talk, she should listen to it with a slight blush of shame. Moreover, she should avoid an error into which I have seen many women fall, namely, eagerly talking and listening to someone speaking evil of others. For those women who when they hear of the immodest behaviour of other women grow hot and bothered and pretend it is unbelievable and that to them an unchaste woman is simply a monster, in showing that they think this is such an enormous crime, suggest that they might be committing it themselves. And those who go about continually prying into the love affairs of other women, relating them in such detail and with such pleasure, appear to be envious and anxious that everyone should know how the matter stands lest by mistake the same thing should be imputed to them; and so they laugh in a certain way, with various mannerisms which betray the pleasure they feel. As a result, although men seem ready enough to listen, they nearly always form a bad opinion of them and hold them in very little respect, and they imagine that the mannerisms they affect are meant to lead them on; and then often they do go so far that the women concerned deservedly fall into ill repute, and finally they come to esteem them so little that they do not care to be with them and in fact regard them with distaste. On the other hand, there is no man so profligate and brash that he does not respect those women who are considered to be chaste and virtuous; for in a woman a serious disposition enhanced by virtue and discernment acts as a shield against insolence and beastliness of arrogant men; and thus we see that a word, a laugh or an act of kindness, however small, coming from an honest woman is more universally appreciated than all the blandishments and caresses of those who without reserve display their lack of shame, and who, if they are not unchaste, with their wanton laughter, loquacity, brashness and scurrilous behavior of this sort, certainly appear to be.

"And then, since words are idle and childish unless they are concerned with some subject of importance, the lady at Court as well as being able to recognize the rank of the person with whom she is talking should possess a knowledge of many subjects; and when she is speaking she should know how to

choose topics suitable for the kind of person she is addressing, and she should be careful about sometimes saying something unwittingly that may give offence. She ought to be on her guard lest she arouse distaste by praising herself indiscreetly or being too tedious. She should not introduce serious subjects into light-hearted conversation, or jests and jokes into a discussion about serious things. She should not be inept in pretending to know what she does not know, but should seek modestly to win credit for knowing what she does, and, as was said, she should always avoid affectation. In this way she will be adorned with good manners; she will take part in the recreations suitable for a woman with supreme grace; and her conversation will be fluent, and extremely reserved, decent and charming. Thus she will be not only loved but also revered by all and perhaps worthy to stand comparison with our courtier as regards qualities both of mind and body."

Having said this, the Magnifico fell silent and seemed to be sunk in reflection, as if he had finished what he had to say. And then signor Gaspare said:

"You have indeed, signor Magnifico, beautifully adorned this lady and made her of excellent character. Nevertheless, it seems to me that you have been speaking largely in generalities and have mentioned qualities so impressive that I think you were ashamed to spell them out; and, in the way people sometimes hanker after things that are impossible and miraculous, rather than explain them you have simply wished them into existence. So I should like you to explain what kind of recreations are suitable for a lady at Court, and in what way she ought to converse, and what are the many subjects you say it is fitting for her to know about; and also whether you mean that the prudence, magnanimity, purity and so many other qualities you mentioned are to help her merely in managing her home, and her family and children (though this was not to be her chief occupation) or rather in her conversation and in the graceful practice of those various activities. And now for heaven's sake be careful not to set those poor virtues such degraded tasks that they come to feel ashamed!"

The Magnifico laughed and said:

"You still cannot help displaying your ill-will towards women, signor Gaspare. But I was truly convinced that I had said enough, and especially to an audience such as this; for I hardly think there is anyone here who does not know, as far as recreation is concerned, that it is not becoming for women to handle weapons, ride, play the game of tennis, wrestle or take part in other sports that are suitable for men."

Then the Unico Aretino remarked: "Among the ancients women used to wrestle naked with men; but we have lost that excellent practice, along with many others."

Cesare Gonzaga added: "And in my time I have seen women play tennis, handle weapons, ride, hunt and take part in nearly all the sports that a knight can enjov.

The Magnifico replied: "Since I may fashion this lady my own way, I do not want her to indulge in these robust and manly exertions, and, moreover, even those that are suited to a woman I should like her to practise very circumspectly and with the gentle delicacy we have said is appropriate to her. For example, when she is dancing I should not wish to see her use movements that are too forceful and energetic, nor, when she is singing or playing a musical instrument, to use those abrupt and frequent diminuendos that are ingenious but not beautiful. And I suggest that she should choose instruments suited to her purpose. Imagine what an ungainly sight it would be to have a woman playing drums, fifes, trumpets or other instruments of that sort; and this is simply because their stridency buries and destroys the sweet gentleness which embellishes everything a woman does. So when she is about to dance or make music of any kind, she should first have to be coaxed a little, and should begin with a certain shyness, suggesting the dignified modesty that brazen women cannot understand. She should always dress herself correctly, and wear clothes that do not make her seem vain and frivolous. But since women are permitted to pay more attention to beauty than men, as indeed they should, and since there are various kinds of beauty, this lady of ours ought to be able to judge what kind of garments enhance her grace and are most appropriate for whatever she intends to undertake, and then make her choice. When she knows that her looks are bright and gay, she should enhance them by letting her movements, words and dress incline towards gaiety; and another woman who feels that her nature is gentle and serious should match it in appearance. Likewise she should modify the way she dresses depending on whether she is a little stouter or thinner than normal, or fair or dark, though in as subtle a way as possible; and keeping herself all the while dainty and pretty, she should avoid giving the impression that she is going to great pains.

"Now since signor Gaspare also asks what are the many things a lady at Court should know about, how she ought to converse, and whether her virtues should be such as to contribute to her conversation, I declare that I want her to understand what these gentlemen have said the courtier himself ought to know; and as for the activities we have said are unbecoming to her, I want her at least to have the understanding that people can have of things they do not practise themselves; and this so that she may know how to value and praise the gentlemen concerned in all fairness, according to their merits. And, to repeat in just a few words something of what has already been said, I want this lady to be knowledgeable about literature and painting, to know how to dance and play games, adding a discreet modesty and the ability to give a good impression of herself to the other principles that have been taught the courtier. And so when she is talking or laughing, playing or jesting, no matter what, she will always be most graceful, and she will converse in a suitable manner with whomever she happens to meet, making use of agreeable witticisms and jokes. And although continence, magnanimity, temperance, fortitude of spirit, prudence and the other virtues may not appear to be relevant in her social encounters with others, I want her to be adorned with these as well, not so much for the sake of good company, though they play a part in this too, as to make her truly virtuous, and so that her virtues, shining through everything she does, may make her worthy of honour.'

"I am quite surprised," said signor Gaspare with a laugh, "that since you endow women with letters, continence, magnanimity and temperance, you do not want them to govern cities as well, and to make laws and lead armies, while the men stay at home to

cook and spin."

The Magnifico replied, also laughing: "Perhaps that would not be so bad, either."

Then he added: "Do you not know that Plato, who was certainly no great friend of women, put them in charge of the city and gave all the military duties to the men? Don't you think that we might find many women just as capable of governing cities and armies as men? But I have not imposed these duties on them, since I am fashioning a Court lady and not a queen. I'm fully aware that you would like by implication to repeat the slander that signor Ottaviano made against women yesterday, namely, that they are most imperfect creatures, incapable of any virtuous act, worth very little and quite without dignity compared with men. But truly both you and he would be very much in error if you really thought this."

Then signor Gaspare said: "I don't want to repeat things that have been said already; but you are trying hard to make me say something that would hurt the feelings of these ladies, in order to make them my enemies, just as you are seeking to win their favour by deceitful flattery. However, they are so much more sensible than other women that they love the truth, even if it is not all that much to their credit, more than false praises; nor are they aggrieved if anyone maintains that men are of greater dignity, and they will admit that you have made some fantastic claims and attributed to the Court lady ridiculous and impossible qualities and so many virtues that Socrates and Cato and all the philosophers in the world are as nothing in comparison. And to tell the truth I wonder that you haven't been ashamed to go to such exaggerated lengths. For it should have been quite enough for you to make this lady beautiful, discreet, pure and affable, and able to entertain in an innocent manner with dancing, music, games, laughter, witticisms and the other things that are in daily evidence at Court. But to wish to give her an understanding of everything in the world and to attribute to her qualities that have rarely been seen in men, even throughout the centuries, is something one can neither tolerate nor bear listening to. That women are imperfect creatures and therefore of less dignity than men and incapable of practising the virtues practised by men, I would certainly not claim now, for the worthiness of these ladies here would be enough to give me the lie; however, I do say that very learned men have written that since Nature always plans and aims at absolute perfection she would, if possible, constantly bring forth men; and when a woman is born this is a mistake or defect, and contrary to Nature's wishes. This is also the case when someone is born blind, or lame, or with some other defect, as again with trees, when so many fruits fail to ripen. Nevertheless, since the blame for the defects of women must be attributed to Nature, who has made them what they are, we ought not to despise them or to fail to give them the respect which is their due. But to esteem them to be more than they are seems to me to be manifestly wrong."

The Magnifico Giuliano waited for signor Gaspare to continue, but seeing that he remained silent he remarked:

"It appears to me that you have advanced a very feeble argument for the imperfection of women. And, although this is not perhaps the right time to go into subtleties, my answer, based both on a reliable authority and on the simple truth, is that the substance of anything whatsoever cannot receive of itself either more or less; thus just as one stone cannot, as far as its essence is concerned, be more perfectly stone than another stone, nor one piece of wood more perfectly wood than another piece, so one man cannot be more perfectly man than another; and so, as far as their formal substance is concerned, the male cannot be more perfect than the female, since both the one and the other are included under the species man, and they differ in their accidents and not their essence. You may then say that man is more perfect than woman if not as regards essence then at least as regards accidents; and to this I reply that these accidents must be the properties either of the body or of the mind. Now if you mean the body, because man is more robust, more quick and agile, and more able to endure toil, I say that this is an argument of very little validity since among men themselves those who pos-

sess these qualities more than others are not more highly regarded on that account; and even in warfare, when for the most part the work to be done demands exertion and strength, the strongest are not the most highly esteemed. If you mean the mind, I say that everything men can understand, women can too; and where a man's intellect can penetrate, so along with it can a woman's."

After pausing for a moment, the Magnifico then added with a laugh:

"Do you not know that this proposition is held in philosophy: namely, that those who are weak in body are able in mind? So there can be no doubt that being weaker in body women are abler in mind and more capable of speculative thought than men."

Then he continued: "But apart from this, since you have said that I should argue from their acts as to the perfection of the one and the other, I say that if you will consider the operations of Nature, you will find that she produces women the way they are not by chance but adapted to the necessary end; for although she makes them gentle in body and placid in spirit, and with many other qualities opposite to those of men, yet the attributes of the one and the other tend towards the same beneficial end. For just as their gentle frailty makes women less courageous, so it makes them more cautious; and thus the mother nourishes her children, whereas the father instructs them and with his strength wins outside the home what his wife, no less commendably, conserves with diligence and care. Therefore if you study ancient and modern history (although men have always been very sparing in their praises of women) you will find that women as well as men have constantly given proof of their worth; and also that there have been some women who have waged wars and won glorious victories, governed kingdoms with the greatest prudence and justice, and done all that men have done. As for learning, cannot you recall reading of many women who knew philosophy, of others who have been consummate poets, others who prosecuted, accused and defended before judges with great eloquence? It would take too long to talk of the work they have done with their hands, nor is there any need for me to provide examples of it. So if in essential substance men are no more perfect than women, neither are they as regards accidents; and apart from theory this is quite clear in practice. And so I cannot see how you define this perfection of theirs.

"Now you said that Nature's intention is always to produce the most perfect things, and therefore she would if possible always produce men, and that women are the result of some mistake or defect rather than of intention. But I can only say that I deny this completely. You cannot possibly aruge that Nature does not intend to produce the women without whom the human race cannot be preserved,

which is something that Nature desires above everything else. For by means of the union of male and female, she produces children, who then return the benefits received in childhood by supporting their parents when they are old; then they renew them when they themselves have children, from whom they expect to receive in their old age what they bestowed on their own parents when they were young. In this way Nature, as if moving in a circle, fills out eternity and confers immortality on mortals. And since woman is as necessary to this process as man, I do not see how it can be that one is more the fruit of mere chance than the other. It is certainly true that Nature always intends to produce the most perfect things, and therefore always intends to produce the species man, though not male rather than female; and indeed, if Nature always produced males this would be imperfection: for just as there results from body and soul a composite nobler than its parts, namely, man himself, so from the union of male and female there results a composite that preserves the human species, and without which its parts would perish. Thus male and female always go naturally together, and one cannot exist without the other. So by very definition we cannot call anything male unless it has its female counterpart, or anything female if it has no male counterpart. And since one sex alone shows imperfection, the ancient theologians attribute both sexes to God. For this reason, Orpheus said that Jove was both male and female in His own likeness; and very often when the poets speak of the gods they confuse the sex."

The signor Gaspare said: "I do not wish us to go into such subtleties because these ladies would not understand them; and though I were to refute you with excellent arguments, they would still think that I was wrong, or pretend to at least; and they would at once give a verdict in their own favour. However, since we have made a beginning, I shall say only that, as you know, it is the opinion of very learned men that man is as the form and woman as the matter, and therefore just as the form is more perfect than matter, and indeed it gives it its being, so man is far more perfect than woman. And I recall having once heard that a great philosopher in certain of his Problems asks: Why is it that a woman always naturally loves the man to whom she first gave herself in love? And on the contrary, why is it that a man detests the woman who first coupled with him in that way? And in giving his explanation he affirms that this is because in the sexual act the woman is perfected by the man, whereas the man is made imperfect, and that everyone naturally loves what makes him perfect and detests what makes him imperfect. Moreover, another convincing argument for the perfection of man and the imperfection of woman is that without exception every woman wants to be a man, by reason

of a certain instinct that teaches her to desire her own perfection."

The Magnifico Giuliano at once replied:

"The poor creatures do not wish to become men in order to make themselves more perfect but to gain their freedom and shake off the tyranny that men have imposed on them by their one-sided authority. Besides the analogy you give of matter and form is not always applicable; for woman is not perfected by man in the way that matter is perfected by form. To be sure, matter receives its being from form, and cannot exist without it; and indeed the more material a form is, the more imperfect it is, and it is most perfect when separated from matter. On the other hand, woman does not receive her being from man but rather perfects him just as she is perfected by him, and thus both join together for the purpose of procreation which neither can ensure alone. Moreover, I shall attribute woman's enduring love for the man with whom she has first been, and man's detestation for the first woman he possesses, not to what is alleged by your philosopher in his Problems but to the resolution and constancy of women and the inconstancy of men. And for this, there are natural reasons: for because of its hot nature, the male sex possesses the qualities of lightness, movement and inconstancy, whereas from its coldness, the female sex derives its steadfast gravity and calm and is therefore more susceptible."

At this point, signora Emilia turned to the Mag-

nifico to say:

"In heaven's name, leave all this business of matter and form and male and female for once, and speak in a way that you can be understood. We heard and understood quite well all the evil said about us by signor Ottaviano and signor Gaspare, but now we can't at all understand your way of defending us. So it seems to me that what you are saying is beside the point and merely leaves in everyone's mind the bad impression of us given by these enemies of ours."

"Do not call us that," said signor Gaspare, "for your real enemy is the Magnifico who, by praising women falsely, suggests they cannot be praised hon-

estly."

Then the Magnifico Giuliano continued: "Do not doubt, madam, that an answer will be found for everything. But I don't want to abuse men as gratuitously as they have abused women; and if there were anyone here who happened to write these discussions down, I should not wish it to be thought later on, in some place where the concepts of matter and form might be understood, that the arguments and criticisms of signor Gaspare had not been refuted."

"I don't see," said signor Gaspare, "how on this point you can deny that man's natural qualities make him more perfect than woman, since women are cold in temperament and men are hot. For warmth is far

nobler and more perfect than cold, since it is active and productive; and, as you know, the heavens shed warmth on the earth rather than coldness, which plays no part in the work of Nature. And so I believe that the coldness of women is the reason why they are cowardly and timid."

"So you still want to pursue these sophistries," replied the Magnifico Giuliano, "though I warn you that you get the worst of it every time. Just listen to this, and you'll understand why. I concede that in itself warmth is more perfect than cold; but this is not therefore the case with things that are mixed and composite, since if it were so the warmer any particular substance was the more perfect it would be, whereas in fact temperate bodies are the most perfect. Let me inform you also that women are cold in temperament only in comparison with men. In themselves, because of their excessive warmth, men are far from temperate; but in themselves women are temperate, or at least more nearly temperate than men, since they possess, in proportion to their natural warmth, a degree of moisture which in men, because of their excessive aridity, soon evaporates without trace. The coldness which women possess also counters and moderates their natural warmth, and brings it far nearer to a temperate condition; whereas in men excessive warmth soon brings their natural heat to the highest point where for lack of sustenance it dies away. And thus since men dry out more than women in the act of procreation they invariably do not live so long; and therefore we can attribute another perfection to women, namely, that enjoying longer life than men they fulfill far better than men the intention of Nature. As for the warmth that is shed on us from the heavens, I have nothing to say, since it has only its name in common with what we are talking about and preserving as it does all things beneath the orb of the moon, both warm and cold, it cannot be opposed to coldness. But the timidity of women, though it betrays a degree of imperfection, has a noble origin in the subtlety and readiness of their senses which convey images very speedily to the mind, because of which they are easily moved by external things. Very often you will find men who have no fear of death or of anything else and yet cannot be called courageous, since they fail to recognize danger and rush headlong without another thought along the path they have chosen. This is the result of a certain obtuse insensitivity; and a fool cannot be called brave. Indeed, true greatness of soul springs from a deliberate choice and free resolve to act in a certain way and to set honour and duty above every possible risk, and from being so stout-hearted even in the face of death, that one's faculties do not fail or falter but perform their functions in speech and thought as if they were completely untroubled. We have seen and heard of great men of this sort, and also of many women, both in recent centuries and in the ancient world, who no less than men have shown greatness in spirit and have performed deeds worthy of infinite praise."

Benvenuto Cellini from THE AUTOBIOGRAPHY

This selection recalls Cellini's casting of the bronze statue of the Perseus that now stands in the Piazza della Signoria in Florence. The box on p. 67 provides technical details of the process. The reader quickly hears common note Cellini strikes throughout this work: his own powerful ego. If there ever was a story of the self—an autobiography—this work is it. Cellini has no doubts about either his talent or his genius and, in this case—as the finished work clearly demonstrates—he has reason for his self-assurance.

Casting the Perseus

Then one morning when I was preparing some little chisels for my work a very fine steel splinter flew into my right eye and buried itself so deeply in the pupil that I found it impossible to get out. I thought for certain that I would lose the sight of that eye. After a few days I sent for the surgeon, Raffaello de'Pilli, who took two live pigeons, made me lie on my back on a table, and then holding the pigeons opened with a small knife one of the large veins they have in the wings. As a result the blood poured out into my eye: I felt immediate relief, and in under two days the steel splinter came out and my sight was unimpeded and improved.

As the feast of St. Lucy fell three days later, I made a golden eye out of a French crown piece and had it offered to the saint by one of my six nieces, the daughter of my sister Liperata, who was about ten years old. I gave thanks with her to God and to St. Lucy. For a while I was reluctant to work on the Narcissus. But, in the difficult circumstances I mentioned, I continued with the Perseus, with the idea of finishing it and then clearing off out of Florence.

I had cast the Medusa—and it came out very well—and then very hopefully I brought the Perseus towards completion. I had already covered it in wax, and I promised myself that it would succeed in bronze as well as the Medusa had. The wax Perseus made a very impressive sight, and the Duke thought it extremely beautiful. It may be that someone had given him to believe that it could not come out so well in bronze, or perhaps that was his own opinion, but anyhow he came along to my house more frequently than he used to, and on one of his visits he said:

"Benvenuto, this figure can't succeed in bronze, because the rules of art don't permit it."

I strongly resented what his Excellency said. "My lord," I replied, "I'm aware that your Most

Illustrious Excellency has little faith in me, and I imagine this comes of your putting too much trust in those who say so much evil of me, or perhaps it's because you don't understand the matter."

He hardly let me finish before exclaiming: "I claim to understand and I do understand, only too well."

"Yes," I answered, "like a patron, but not like an artist. If your Excellency understood the matter as you believe you do, you'd trust in me on the evidence of the fine bronze bust I made of you: that large bust of your Excellency that has been sent to Elba. And you'd trust me because of my having restored the beautiful Ganymede in marble; a thing I did with extreme difficulty and which called for much more exertion than if I had made it myself from scratch: and because of my having cast the Medusa, which is here now in your Excellency's presence; and casting that was extraordinarily difficult, seeing that I have done what no other master of this devilish art has ever done before. Look, my lord, I have rebuilt the furnace and made it very different from any other. Besides the many variations and clever refinements that it has, I've constructed two outlets for the bronze: that was the only possible way of ensuring the success of this difficult, twisted figure. It only succeeded so well because of my inventiveness and shrewdness, and no other artist ever thought it possible.

"Be certain of this, my lord, that the only reason for my succeeding so well with all the important and difficult work I did in France for that marvellous King Francis was because of the great encouragement I drew from his generous allowances and from the way that he met my request for workmen—there were times when I made use of more than forty, all of my own choice. That was why I made so much in so short a time. Now, my lord, believe what I say, and let me have the assistance I need, since I have every hope of finishing a work that will please you. But if your Excellency discourages me and refuses the assistance I need, I can't produce good results, and neither could anyone else no matter who."

The Duke had to force himself to stay and listen to my arguments; he was turning now one way and now another, and, as for me, I was sunk in despair, and I was suffering agonies as I began to recall the fine circumstances I had been in in France.

All at once the Duke said: "Now tell me, Benvenuto, how can you possibly succeed with this beautiful head of Medusa, way up there in the hand of the Perseus?"

Straight away I replied: "Now see, my lord: if your Excellency understood this art as you claim to then you wouldn't be worried about that head not succeeding; but you'd be right to be anxious about the right foot, which is so far down."

At this, half in anger, the Duke suddenly turned to some noblemen who were with him and said:

"I believe the man does it from self-conceit, con-

tradicting everything."

Then all at once he turned towards me with an almost mocking expression that was imitated by the others, and he said:

"I'm ready to wait patiently and listen to the argu-

ments you can think up to convince me."

"I shall give such convincing ones." I said.

"I shall give such convincing ones," I said, "that your Excellency will understand only too well."

Then I began: "You know, my lord, the nature of fire is such that it tends upwards, and because this is so I promise you that the head of Medusa will come out very well. But seeing that fire does not descend I shall have to force it down six cubits by artificial means: and for that very cogent reason I tell your Excellency that the foot can't possibly succeed, though it will be easy for me to do it again."

"Well then," said the Duke, "why didn't you take precautions to make sure the foot comes out in the

way you say the head will?"

"I would have had to make the furnace much bigger," I replied, "and build in it a conduit as wide as my leg, and then the weight of the hot metal would have enabled me to bring it down. As it is, the conduit now descends those six cubits I mentioned before down to the feet, but it's no thicker than two fingers. It was not worth the expense of changing it, because I can easily repair the fault. But when my mould has filled up more than half-way, as I hope it will, then the fire will mount upwards, according to its nature, and the head of the Perseus, as well as that of Medusa, will come out perfectly. You may be sure of that."

After I had expounded these cogent arguments and endless others which it would take me too long to write down here, the Duke moved off shaking his head.

Left to myself in this way, I regained my selfconfidence and rid myself of all those troublesome thoughts that used to torment me from time to time, often driving me to bitterly tearful regret that I had ever quit France, even though it had been to go on a charitable mission to Florence, my beloved birthplace, to help out my six nieces. I now fully realized that it was this that had been at the root of all my misfortunes, but all the same I told myself that when my Perseus that I had already begun was finished, all my hardships would give way to tremendous happiness and prosperity.

So with renewed strength and all the resources I had both in my limbs and my pocket (though I had very little money left) I made a start by ordering several loads of wood from the pine forest at Serristori, near Monte Lupo. While waiting for them to arrive I clothed my Perseus with the clays I had prepared some months previously in order to ensure that they would be properly seasoned. When I had made its clay tunic, as it is called, I carefully armed it, enclosed

it with iron supports, and began to draw off the wax by means of a slow fire. It came out through the air vents I had made—the more of which there are, the better a mould fills. After I had finished drawing off the wax, I built round my Perseus a funnel-shaped furnace. It was built, that is, round the mould itself, and was made of bricks piled on top of the other, with a great many gaps for the fire to escape more easily. Then I began to lay on wood, in fairly small amounts, keeping the fire going for two days and

nights.

When all the wax was gone and the mould well baked, I at once began to dig the pit in which to bury it, observing all the rules that my art demands. That done, I took the mould and carefully raised it up by pulleys and strong ropes, finally suspending it an arm's length above the furnace, so that it hung down just as I wanted it above the middle of the pit. Very, very slowly I lowered it to the bottom of the furnace and set it in exact position with the utmost care: and then, having finished that delicate operation, I began to bank it up with the earth I had dug out. As I built this up, layer by layer, I left a number of air holes by means of little tubes of terracotta of the kind used for drawing off water and similar purposes. When I saw that it was perfectly set up, that all was well as far as covering it and putting those tubes in position was concerned, and that the workmen had grasped what my method was-very different from those used by all the others in my profession—I felt confident that I could rely on them, and I turned my attention to the

I had had it filled with a great many blocks of copper and other bronze scraps, which were placed according to the rules of our art, that is, so piled up that the flames would be able to play through them, heat the metal more quickly, and melt it down. Then, very excitedly, I ordered the furnace to be set alight.

The pine logs were heaped on, and what with the greasy resin from the wood and the excellence of my furnace, everything went so merrily that I was soon rushing from one side to another, exerting myself so much that I became worn out. But I forced myself to

carry on.

To add to the difficulties, the workshop caught fire and we were terrified that the roof might fall in on us, and at the same time the furnace began to cool off because of the rain and wind that swept in at me from the garden.

I struggled against these infuriating accidents for several hours, but the strain was more than even my strong constitution could bear, and I was suddenly attacked by a bout of fever—the fiercest you can possibly imagaine—and was forced to throw myself on to my bed.

Very upset, forcing myself away from the work, I gave instructions to my assistants, of whom there

were ten or more, including bronze-founders, craftsmen, ordinary labourers, and the men from my own workshop. Among the last was Bernardino Mannellini of Mugello, whom I had trained for a number of

years; and I gave him special orders.

"Now look, my dear Bernardino," I said, "do exactly as I've shown you, and be very quick about it as the metal will soon be ready. You can't make any mistakes—these fine fellows will hurry up with the channels and you yourself will easily be able to drive in the two plugs with these iron hooks. Then the mould will certainly fill beautifully. As for myself, I've never felt so ill in my life. I'm sure it will make an end of me in a few hours."

And then, very miserably, I left them and went to bed.

As soon as I was settled, I told my housemaids to bring into the workshop enough food and drink for everyone, and I added that I myself would certainly be dead by the next day. They tried to cheer me up, insisting that my grave illness would soon pass and was only the result of excessive tiredness. Then I spent two hours fighting off the fever, which all the time increased in violence, and I kept shouting out: "I'm dying!"

Although my housekeeper, the best in the world, an extraordinarily worthy and lovable woman called Fiore of Castel del Reio, continually scolded me for being so miserable, she tended to all my wants with tremendous devotion. But when she realized how very ill I was, and how low my spirits had fallen, for all her unflagging courage she could not keep back her tears, though even then she did her best to prevent my noticing them.

In the middle of this dreadful suffering I caught sight of someone making his way into my room. His body was all twisted, just like a capital S, and he began to moan in a voice full of gloom, like a preist consoling a prisoner about to be executed.

"Poor Benvenuto! Your work is all ruined—

there's no hope left!"

On hearing the wretch talk like that I let out a howl that could have been heard echoing from the farthest planet, sprang out of bed, seized my clothes, and began to dress. My servants, my boy, and everyone else who rushed up to help me found themselves treated to kicks and blows, and I grumbled furiously at them:

"The jealous traitors! This is deliberate treachery but I swear by God I'll get to the root of it. Before I die I'll leave such an account of myself that the whole world will be dumbfounded!"

As soon as I was dressed, I set out for the workshop in a very nasty frame of mind, and there I found the men I had left in such high spirits all standing round with an air of astonished dejection.

"Come along now," I said, "listen to me. As you either couldn't or wouldn't follow the instructions I left you, obey me now that I'm here with you to direct my work in person. I don't want any objections—we need work now, not advice."

At this, a certain Alessandro Lastricati cried out: "Look here, Benvenuto, what you want done is beyond the powers of art. It's simply impossible."

When I heard him say that I turned on him so furiously and with such a murderous glint in my eye that he and all the others shouted out together:

"All right then, let's have your orders. We'll obey you in everything while there's still life in us."

And I think they showed this devotion because they expected me to fall down dead at any minute.

I went at once to inspect the furnace, and I found that the metal had all curdled, had caked as they say. I ordered two of the hands to go over to Capretta, who kept a butcher's shop, for a load of young oak that had been dried out a year or more before and had been offered me by his wife, Ginevra. When they carried in the first armfuls I began to stuff them under the grate. The oak that I used, by the way, burns much more fiercely than any other kind of wood, and so alder or pinewood, which are slower burning, is generally preferred for work such as casting artillery. Then, when it was licked by those terrible flames, you should have seen how that curdled metal began to glow and sparkle!

Meanwhile I hurried on with the channels and also sent some men up to the roof to fight the fire that had begun to rage more fiercely because of the greater heat from the furnace down below. Finally I had some boards and carpets and other hangings set up to keep out the rain that was blowing in from the gar-

As soon as all that terrible confusion was straightened out, I began roaring: "Bring it here! Take it there! And when they saw the metal beginning to melt my whole band of assistants were so keen to help that each one of them was as good as three men put together.

Then I had someone bring me a lump of pewter, weighing about sixty pounds, which I threw inside the furnace on to the caked metal. By this means, and by piling on the fuel and stirring with pokers and iron bars, the metal soon became molten. And when I saw that despite the despair of all my ignorant assitants that I had brought a corpse back to life, I was so reinvigorated that I quite forgot the fever that had put the fear of death into me.

At this point there was a sudden explosion and a tremendous flash of fire, as if a thunderbolt had been hurled in our midst. Everyone, not least myself, was struck with unexpected terror. When the glare and noise had died away, we stared at each other, and then realized that the cover of the furnace had cracked open and that the bronze was pouring out. I hastily opened the mouths of the mould and at the same time drove in the two plugs.

Then, seeing that the metal was not running as easily as it should, I realized that the alloy must have been consumed in that terrific heat. So I sent for all my pewter plates, bowls, and salvers, which numbered about two hundred, and put them one by one in front of the channels, throwing some straight into the furnace. When they saw how beautifully the bronze was melting and the mould filling up, everyone grew excited. They all ran up smiling to help me, and fell over themselves to answer my calls, while I-now in one place, now another-issued instructions, gave a hand with the work, and cried out loud: "O God, who by infinite power raised Yourself from the dead and ascended into heaven!" And then in an instant my mould was filled. So I knelt down and thanked God with all my heart.

Then I turned to a plate of salad that was there on some bench or other, and with a good appetite ate and drank with all my band of helpers. Afterwards I went to bed, healthy and happy, since it was two hours off dawn, and so sweetly did I sleep that it was as if I hadn't a thing wrong with me. Without a word from me that good servant of mine had prepared a fat capon, and so when I got up—near dinner time—she

came to me smiling and said:

"Now then, is this the man who thought he was going to die? I believe the blows and kicks you gave us last night, with you so enraged and in such a devilish temper, made your nasty fever frightened that it would come in for a beating as well, and so it ran

away."

Then all my poor servants, no longer burdend by anxiety and toil, immediately went out to replace those pewter vessels and plates with the same number of earthenware pots, and we all dined happily. I never remember in my life having dined in better

spirits or with a keener appetite.

After dinner all those who had assisted came to visit me; they rejoiced with me, thanking God for what had happened and saying that they had learnt and seen how to do things that other masters held to be impossible. I was a little boastful and inclined to show off about it, and so I preened myself a little. Then I put my hand in my purse and paid them all to their satisfaction.

My mortal enemy, that bad man Pier Francesco Riccio, the Duke's majordomo, was very diligent in trying to find out how everything had gone: those two whom I strongly suspected of being responsible for the metal's curdling told him that I obviously wasn't human but rather some powerful fiend, since I had done the impossible, and some things which even a devil would have found baffling.

They greatly exaggerated what had happened perhaps to excuse themselves—and without delay, the majordomo wrote repeating it all to the Duke who was at Pisa, making the story even more dramatic and marvellous than he had heard it.

I left the cast to cool off for two days and then very, very slowly, I began to uncover it. The first thing that I found was the head of Medusa, which had come out beautifully because of the air vents, just as I had said to the Duke that the nature of fire was to ascend. Then I began uncovering the rest, and came to the other head—that is the head of the Perseus which had also succeeded beautifully. This came as much more of a surprise because, as can be seen, it's a good deal lower than the Medusa.

The mouths of the mould were placed above the head of the Perseus, and by the shoulders, and I found that all the bronze there was in my furnace had been used up in completing the head of the Perseus. It was astonishing to find that there was not the slightest trace of metal left in the channels, nor on the other hand was the statue incomplete. This was so amazing that it seemed a certain miracle, with everything con-

trolled and arranged by God.

I carried on happily with the uncovering, and without exception I found everything perfect until I reached the foot of the right leg on which it rests. There I discovered that the heel was perfectly formed, and continuing farther I found it all complete: on the one hand, I rejoiced very much, but on the other I was half disgruntled if only because I had told the Duke that it could not come out. But then on finishing the uncovering I found that the toes of the foot had not come out: and not only the toes, because there was missing a small part above the toes as well, so that just under a half was missing. Although this meant a little more work I was very glad of it, merely because I could show the Duke that I knew my business. Although much more of the foot had come out than I had expected, the reason for this was thatwith all that had taken place—the metal had been hotter than it would have been, and at the same time I had had to help it out with the alloy in the way described, and with those pewter vesselssomething no one else had ever done before.

Seeing that the work was so successful I immediately went to Pisa to find my Duke. He welcomed me as graciously as you can imagine, and the Duchess did the same. Although their majordomo had sent them news about everything, it seemed to their Excellencies far more of a stupendous and marvellous experience to hear me tell of it in person. When I came to the foot of the Perseus which had not come out—just as I had predicted to his Excellency—he was filled with astonishment and he described to the Duchess how I had told him this beforehand. Seeing how pleasantly my patrons were treating me I begged the Duke's permission to go to Rome. He gave me leave, with great kindness, and told me to return quickly and finish his Perseus; and he also gave me letters recommending me to his ambassador, who was Averardo Serristori: these were the first years of Pope Julius de' Monti.

	GENERAL EVENTS	LITERATURE & PHILOSOPHY	ART
1494	1498 da Gama lands in India		1494-1495 Dürer visits Italy,
GENESIS OF THE REFORMATION 1522	1515-1547 Reign of Francis I in France 1517 Reformation begins in Germany with Luther's 95 Theses, challenging the practice of indulgences 1519-1556 Reign of Charles V as Holy Roman Emperor 1521 Excommunication of Luther by Pope Leo X 1524-1525 Peasants' War in Germany	1506-1532 Ariosto active in Italy 1509 Erasmus, <i>The Praise of Folly</i> 1516 More, <i>Utopia</i> 1521 Luther begins translation of Bible into German, published 1534 1524 Erasmus, <i>De Libero Arbitrio</i> (On Free Will)	1500 Dürer, Self-Portrait early 16th cent. Italian Renaissance art and thought spread northward c. 1505-1510 Bosch, Garden of Earthly Delights, triptych 1508-1511 Dürer, Adoration of the Trinity 1513 Dürer, Knight, Death and the Devil, engraving 1515 Grünewald, Isenheim Altarpiece
SPREAD OF PROTESTANTISM	1525 Francis I defeated by Charles V at Pavia 1527 Sack of Rome by Charles V 1534 Henry VIII founds Anglican Church in England when Parliament passes Act of Supremacy 1539 Society of Jesus (Jesuits) founded by Saint Ignatius of Loyola 1545-1564 Council of Trent initiates Counter-Reformation under Jesuit guidance	1525 Luther, De Servo Arbitrio (On the Bondage of the Will) 1530 Budé persuades Francis I to found Collège de France as center for humanism 16th cent. Humanism spreads, along with interest in scientific inquiry; availability of books increases literacy 1543 Copernicus, On the Revolution of Celestial Bodies; Vesalius, Seven Books on the Structure of the Human Body	1525 Altdorfer, Landscape, early example of pure landscape painting 1528 Dürer, Four Books on Human Proportions 1529 Altdorfer, Battle of Alexander and Darius c. 1530 Clouet, Portrait of Francis I c. 1530-1550 Sacred art denounced as idolatry by reforming iconoclasts c. 1533-1540 Decorations by Rosso Fiorentino for Palace at Fontainebleau 1539-1540 Holbein the Younger, Portrait of Henry VIII 1540-1543 Cellini, Salt-Cellar, commissioned by Francis I 1548-1549 Goujon, Fountain of the Innocents, Louvre, Paris
GROWTH OF COUNTER- REFORMATION	1550-1555 Wars between Lutheran and Catholic princes in Germany; ended by Peace of Ausburg in 1555 1556 Retirement of Charles V 1556-1598 Reign of Philip II in Spain and Netherlands 1558-1603 Reign of Elizabeth in England 1572 Saint Bartholomew's Day Massacre in France	1559 Pope Paul IV publishes first Index of Prohibited Books	c. 1562-1567 Bruegel the Elder, The Triumph of Death, Hunters in the Snow, Peasant Wedding
IONALISTIC UNREST	1581 United Provinces of Netherlands declare independence from Spain 1585 England sends troops to support Netherlands against Spain 1588 Philip's Spanish Armada defeated by English 1598 Edict of Nantes establishes religious toleration in France 1600 British found East India Tea Company 1607 English found colony of Virginia in New World	1580 Montaigne's first Essays c. 1587 Marlowe, Tamburlaine, tragedy 1590 Sidney, Arcadia 1590-1596 Spenser, The Faerie Queene, allegorical epic 1590-1610 Drama at height in Elizabethan England 1593 Marlowe, Dr. Faustus, tragedy late 16th-early 17th cent. Cervantes active in Spain, Jonson in England, Tasso in Italy c. 1600 Shakespeare, Hamlet	c. 1590 Hilliard, Portrait of a Youth, miniature c. 1600 Patronage for sacred art wanes in Reformation countries, flourishes in Counter-Reformation countries

c. 1600 Shakespeare, Hamlet

c. 1604-1605 Shakespeare, Othello, King Lear, Macbeth 1611 Authorized Version of Bible 1620 Francis Bacon, Novum Organum

1609 Independence of Netherlands recognized by Spain

ARCHITECTURE

MUSIC

1506 Rebuilding of Saint Peter's Basilica, Rome, begins 1519 Château of Chambord built by Francis I Vernacular hymns stressed by Reformers; musical elements in Protestant services simplified by Luther to increase comprehension

Ein' Feste Burg ist Unser' Gott (A Mighty Fortress Is Our God), c. 1525-1530

19

The Renaissance in the North

1546 Lescot and Goujon, Square Court of Louvre, begun

c. 1550 Reformation ends building of elaborate churches in Protestant countries 1544 Gregorian chant is basis for first English-language litany in England

1549 Merbecke, The Book of Common Praier Noted

c. 1570 Tallis, English court organist, composes Lamentations of Jeremiah

1588 Musica Transalpina translated into English

1591 Byrd, My Ladye Nevells Booke

late 16th-early 17th cent. English madrigals by Byrd, Morley, and Weelkes follow Italian models; ayres by Dowland

The ideas and artistic styles that developed in Italy during the 15th and 16th centuries produced immense changes in the cultural life of England, France, Germany, and the Netherlands. As the Renaissance spread beyond the Alps, the new humanism it carried roused northern Europe from its conservative intellectual patterns and offered an alternative to traditional religious doctrines. The infusion of Italian ideas produced a new breadth of vision that was responsible for some of the greatest northern painting and for important developments in music. By the end of the 16th century, under the influence of humanism a brilliant cultural life had developed in Elizabethan England, where Renaissance English drama achieved its greatest glory in the work of William Shakespeare.

This was not the first time northern Europe and Italy had come into contact. During the 14th century a style of late-Gothic painting reflecting the grace and elegance of courtly life on both sides of the Alps had developed. Known as the International Style, it was popular in both Italy and northern Europe. Furthermore, as early as the beginning of that century German scholars who had gone to study in Italy returned home with a new enthusiasm for classical antiquity. Nor was the northern Renaissance a purely imported phenomenon, the filling of a cultural void by the wholesale adoption of foreign ways and styles. Northern artists drew upon a rich native past and were able to incorporate exciting new ideas from Italy into their own vision of the world. One of the chief characteristics of northern Renaissance art, in fact, was its emphasis on individualism; painters like Albrecht Dürer and Albrecht Altdorfer are as different from each other as they are from the Italian artists who initially influenced them.

The spread of Italian Renaissance ideas to the north was in many respects political rather than cultural. Throughout most of the 16th century the great monarchs of northern Europe vied with one another for political and military control over the states of Italy, and in the process were brought into contact with the latest developments in Italian artistic and intellectual life—and often based their own courts on Italian models. Francis I, who ruled France from 1515 to 1547, made a deliberate attempt to expose French culture to Italian influences by doing everything he could to attract Italian artists to the French court; among those who came were Leonardo da Vinci, Andrea del Sarto (1486-1530), and Benvenuto Cellini [12.1]. Francis and his successors also esteemed literature and scholarship highly. Francis' sister, Marguerite of Navarre, herself a writer of considerable gifts, became the center of an intellectual circle that included many of the finest minds of the age.

The history of Germany is intimately bound up

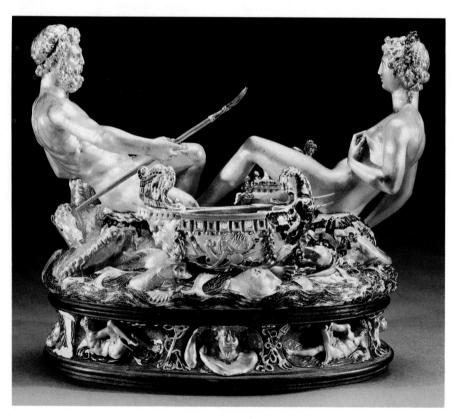

12.1 Benvenuto Cellini. The Saltcellar of Francis I. 1539-1543. Gold, $10\frac{1}{4} \times 13\frac{1}{8}$ " (26 × 33 cm). Kunsthistorisches Museum. Vienna. The male figure is Sea; the female is Land. "Both figures were seated with their legs interlaced, just as the arms of the sea run into the land," Cellini said.

EAST MEETS WEST

Spice Trading in Asia

The Hapsburgs and other rulers and bankers in northern Europe during the 15th and 16th centuries became increasingly powerful through a new source of wealth: trade with Asia. Fine silks, rugs, and spices such as ginger and nutmeg had been imported into Europe throughout the Middle Ages, but always through Muslim middlemen who sold the goods in the principal port cities of the eastern Mediterranean like Alexandria and Constantinople. The first European nation to conquer and occupy territory in Asia was Portugal: in 1498 the Portuguese navigator Vasco da Gama landed on the southwest coast of India. By 1509 fortified trading stations had been built along the Indian coast. From these Portuguese traders traveled to China and the Spice Islands of the Western Pacific.

For all their imperialist determination, however, the Portuguese lacked both the natural resources and the wealth to exchange for the cinnamon and cloves that were becoming increasingly sought after in northern Europe. Many of the Portuguese missions were thus financed by German and Flemish bankers, like the Fuggers of Augsburg. These northern investors provided either loans of cash or supplied in advance, on credit, cargoes of goods to be traded for spices. The gold, silver, copper, lead, and mercury carried to the East was produced mainly in Germany.

The bankers expected a return on their investment in the form of interest. Throughout the Middle Ages, however, the taking of interest was condemned as usury. The Catholic church continued to hold to this prohibition, and Martin Luther in his turn warned against Fuggerism. Nonetheless, the practice was impossible to stop. Theologians began to distinguish between "usury" and "legitimate return." With this development of commerce, patterns of industrial life that lasted until the Industrial Revolution of the 19th century were established throughout northern Europe. The imperialist example of Portugal was soon imitated by other countries; the British East India Tea Company, for example, was founded in 1600.

12.2 Leone Leoni. Bust of Emperor Charles V. 1533–1555. Bronze, height 44" (112 cm). Kunsthistorisches Museum, Vienna. The sculptor deliberately portrayed the German ruler as a Roman emperor, thus associating Charles with both Italy and classical antiquity.

with that of the Hapsburg family. In the first half of the 16th century the same Hapsburg who ruled Germany (under the old name of the Holy Roman Empire) as Charles V ruled Spain at the same time as Charles I. Charles was the principal competitor of Francis I for political domination of Italy, and although his interest in the arts was less cultivated than that of his rival his conquests brought Italian culture to both Spain and the north [12.2]. On his abdication in 1556 he divided his vast territories between his brother Ferdinand and his son Philip. The Austrian and Spanish branches of the Hapsburg family remained the principal powers in Europe until the 1650s.

For most of the Renaissance, England remained under the dominion of a single family, the Tudors, whose last representative was Elizabeth I. Like her fellow rulers, in the course of her long reign (1558-1603) Elizabeth established her court as a center of art and learning. Although the influence of Italian models on the visual arts was less marked in England than elsewhere, revived interest in classical antiquity and the new humanism it inspired is reflected in the works of Shakespeare and other Elizabethan writers.

Although the art of the great northern centers drew heavily on Italy for inspiration, another factor was equally important. The 15th century was a pe-

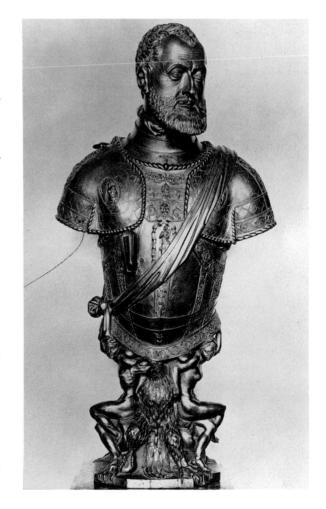

riod of almost unparalleled intellectual ferment, in which traditional ideas on religion and the nature of the universe were shaken and often permanently changed. Many of the revolutionary movements of the age were, in fact, northern in origin, and not surprisingly they had a profound effect on the art, music, and literature being produced in the same place and time. While northern artists were being influenced by the styles of their fellow artists south of the Alps, their cultural world was being equally shaped by theologians and scientists nearer home. The intellectual developments of this world form a necessary background to its artistic achievements.

The Reformation

On the eve of All Saint's Day in 1517, a German Augustinian friar, Martin Luther (1483–1546), tacked a parchment containing 95 academic propositions (theses) written in Latin on the door of the collegiate church of Wittenberg—the usual procedure for advertising an academic debate [12.3]. Luther's theses constituted an attack on the Roman Catholic doctrine of indulgences (forgiveness of punishment for sins, usually obtained either through good works or prayers along with the payment of an appropriate sum of money); a timely topic since an indulgence was currently being preached near Wittenberg to help raise funds for the rebuilding of Saint Peter's in Rome.

Luther's act touched off a controversy that went far beyond academic debate. For the next few years there were arguments among theologians, while Luther received emissaries and directives from the Vatican as well as official warnings from the pope. Luther did not waver in his criticisms. On June 15, 1520, Pope Leo X (Giovanni de' Medici, son of Lorenzo the Magnificent) condemned Luther's teaching as heretical and on January 3, 1521, excommunicated him from the Catholic Church. The Protestant Reformation had been born.

Luther's reformation principles began to be applied in churches throughout Germany and a rapid and widespread outbreak of other reforming movements was touched off by Luther's example. By 1523 radical reformers far more iconoclastic than Luther began to agitate for a purer Christianity free from any trace of "popery." These radical reformers are often called anabaptists because of their insistence on adult baptism even if there had been baptism in infancy (the word means "baptized again"). Many of these anabaptist groups had radical social and political ideas, including pacifism and the refusal to take oaths or participate in civil government, which appealed to the discontent of the lower classes. One

outcome was the Peasants' War in Germany, put down with ferocious bloodshed in 1525.

The Reformation was not confined to Germany. In 1523 Zurich, Switzerland, accepted the reformation ideal for its churches. Under the leadership of Ulrich Zwingli (1484–1531) Zurich, and later Berne and Basel, adopted Luther's reforms, including the abolition of statues and images and the right of the clergy to marry. In addition, the system of sacraments was greatly modified and reduced to include only baptism and the Lord's Supper. In Geneva, John Calvin (1509-1564) preached a brand of Protestantism even more extreme than that of either Luther or Zwingli. Calvin's doctrines soon spread north to the British Isles, especially Scotland, under the Calvinist John Knox, and west to the Low Countries, espe-

12.3 Lucas Cranach. Portrait of Martin Luther. c. 1526. Oil on panel, 15 × 9" (38 × 24 cm). Uffizi Gallery, Florence.

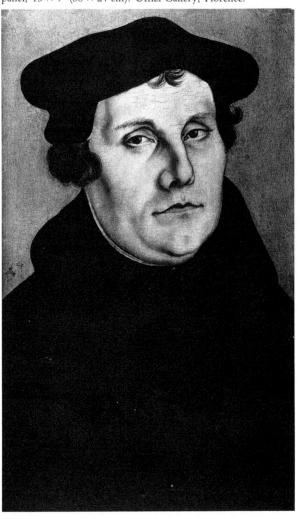

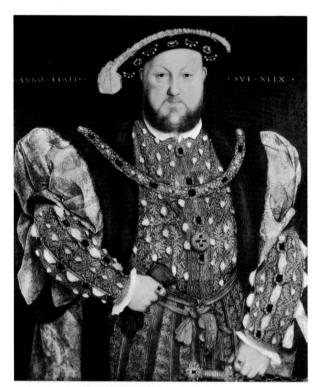

12.4 Hans Holbein the Younger. Henry VIII in Wedding Dress. 1540. Oil on panel, $32\frac{1}{2} \times 29''$ (83 × 74 cm). Galleria Barberini, Rome. Weddings were not uncommon events in Henry's life. This wedding, when he was in his 49th year, as the inscription says, was probably the ill-fated one to his fourth wife, Anne of Cleves (see figure 12.26).

cially Holland. In England, King Henry VIII (born 1491, reigned 1509–1547), formerly a stout opponent of Lutheranism, broke with Rome in 1534 after he failed to obtain a marital annulment from the pope [12.4]. In 1534 Henry issued the Act of Supremacy, declaring the English sovereign head of the church in

By the middle of the 16th century, therefore, Europe—for centuries solidly under the authority of the Church of Rome—was divided in a way that has remained essentially unaltered ever since. Spain and Portugal, Italy, most of France, southern Germany, Austria, parts of eastern Europe (Poland, Hungary, and parts of the Balkans), and Ireland remained Catholic, while most of Switzerland, the British Isles, all of Scandinavia, northern and eastern Germany, and other parts of eastern Europe gradually switched to Protestantism (see map).

Causes of the Reformation

What conditions permitted this rapid and revolutionary upheaval in Europe? The standard answer is that the medieval church was so riddled with corruption and incompetence that it was like a house of cards waiting to be toppled. This answer, while containing some truth, is not totally satisfactory since it does not explain why the Reformation did not happen a century earlier, when similar or worse conditions prevailed. Why had the Reformation not taken place during the 14th century, when there were such additional factors as plague, schisms, and wars as well as incipient reformers clamoring for change?

The exact conditions that permitted the Reformation to happen are hard to pinpoint, but any explanation must take into account a number of elements that were clearly emerging in the 16th century. First, there was a rising sense of nationalism in Europe combined with increasing resentment at the economic and political demands made by the papacy, many of which ignored the rights of individual countries. Thus Luther's insistence that the German rulers reform the Church because the Church itself was impotent to do so appealed to both economic and nationalistic self-interests.

Second, the idea of reform in the Church had actually been maturing for centuries, with outcries against abuses and pleas for change. Some of the great humanists who were contemporaries of Luther, including Erasmus of Rotterdam, Thomas More in England, and Jacques Lefevre d'Étaples in France, had also pilloried the excesses of the church. These men, and many of their followers and devoted readers, yearned for a deeper, more interior piety, free from the excessive pomp and ceremony that characterized so much of popular medieval religion. Luther's emphasis on personal conversion and his rejection of much of the ecclesiastical superstructure of Catholicism appealed to the sensibilities of many people. That the reformers to the left of Luther demanded even more rejection of Catholic practices shows how widespread was the desire for change.

Third, there were a number of other factors clustered around the two already mentioned: the low moral and intellectual condition of much of the clergy was a scandal; the wealth and lands of the monastic and episcopal lords were envied. In short, a large number of related economic and political factors fed the impulses of the Reformation.

Renaissance Humanism and the Reformation

The relationship between Renaissance humanism and the Protestant Reformation is significant if complex. With the single exception of John Calvin, none of the major church reformers was a professional humanist, although all of them came into contact with the

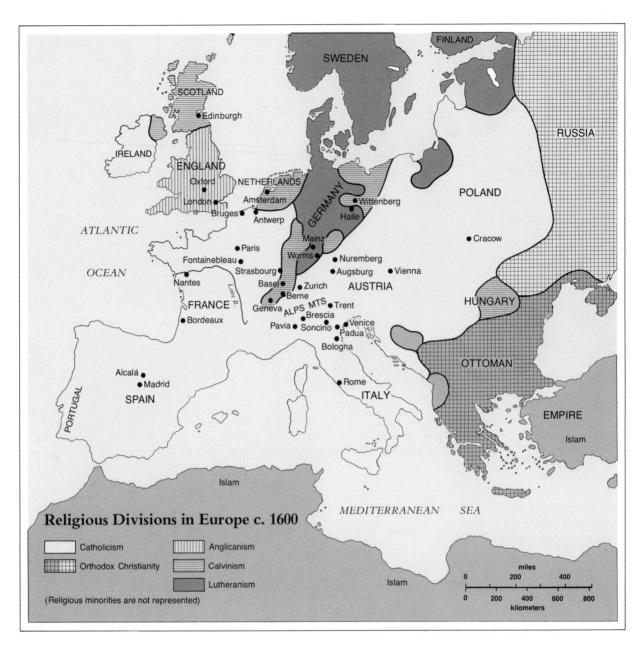

movement. Luther himself had no early contact with the "new learning," though he utilized its fruits. Nevertheless, humanism as far back as the time of Petrarch shared many intellectual and cultural sentiments with the Reformation. We should note these similarities before treating the wide differences between the two movements.

The reformers and the humanists shared a number of religious aversions. They were both fiercely critical of monasticism, the decadent character of most popular devotion to the saints, the low intellectual preparation of the clergy, and the general venality and corruption of the higher clergy, especially the

papal curia (the body of tribunals and assemblies through which the pope governed the Church).

Both the humanists and the reformers felt that the scholastic theology of the universities had degenerated into quibbling arguments, meaningless discussions, and dry academic exercises bereft of any intellectual or spiritual significance. In a common reaction both rejected the scholastics of the medieval universities in favor of Christian writers of an earlier age. John Calvin's reverence in the 16th century for the writings of the early Christian church father and philosopher Augustine (354–430) echoed the equal devotion of Petrarch in the 14th.

CONTEMPORARY VOICES

Katherine Zell

Many of the Reformation's most active figures were women. Katherine Zell (1497-1562) was the wife of Matthew Zell, one of the first priests to demonstrate his break from the Church by marrying. When he died, she continued his teaching and pastoral work. She wrote this letter in 1558 to an old friend who was suffering from leprosy:

My dear Lord Felix, since we have known each other for a full 30 years I am moved to visit you in your long and frightful illness. I have not been able to come as often as I would like, because of the load here for the poor and the sick, but you have been ever in my thoughts. We have often talked of how you have been stricken, cut off from rank, office, from your wife and friends, from all dealings with the world which recoils from your loathsome disease and leaves you in utter loneliness. At first you were bitter and utterly cast down till God gave you strength and patience, and now you are able to thank him that out of love he has taught you to bear the cross. Because I know that your illness weighs upon you daily and may easily cause you again to fall into despair and rebelliousness, I have gathered some passages which may make your voke light in the spirit. though not in the flesh. I have written meditations on the 51st Psalm: 'Have mercy upon me, O God, according to thy loving-kindness,' and the 130th, 'Out of the depths have I cried unto thee, O Lord.' And then on the Lord's Prayer and the Creed.

From R. H. Bainton, Women of the Reformation in Germany and Italy (Boston: Beacon, 1974), p. 69.

Humanists and reformers alike spearheaded a move toward a better understanding of the Bible based not on the authority of theological interpretation but on close, critical scrutiny of the text, preferably in the original Hebrew and Greek. Indeed, the mastery of the three biblical languages (Latin, Greek, and Hebrew) was considered so important in the 16th century that schools were founded especially for the specific purpose of instruction in them. Some famous academic institutions, including Corpus Christi College, Oxford, the University of Alcalá, Spain, and the Collège de France in Paris, were founded for that purpose. Luther's own University of Wittenberg had three chairs for the study of biblical languages.

We can see the connection between humanist learning and the Reformation more clearly by noting some aspects of Luther's great translation of the Bible into German. Although there had been many earlier vernacular translations into German, Luther's, which he began in 1521, was the first produced entirely from the original languages, and the texts he used illuminate the contribution of humanist learning. For the New Testament he used the critical Greek edition prepared by Erasmus. For the book of Psalms he used a text published in Hebrew by the humanist printer Froben at Basel in 1516. The other Hebrew texts were rendered from a Hebrew version published by Italian Jewish scholars who worked in the Italian cities of Soncino and Brescia. His translations of the Apocrypha (books not found in the Hebrew canon) utilized the Greek edition of the Apocrypha printed in 1518 by Aldus Manutius at his press in Venice. As an aid for his labors Luther made abundant use of grammars and glossaries published by the humanist scholar Johannes Reuchlin.

In short, Luther's great achievement was possible only because much of the spadework had already been done by a generation of humanist philologists. This scholarly tradition endured: In 1611, when the translators of the famous English King James Version (see page 176) wrote their preface to the Bible, they noted that they had consulted commentaries and translations as well as translations or versions in Chaldee, Hebrew, Syriac, Greek, Latin, Spanish, French, Italian, and Dutch.

Although there were similarities and mutual influences between humanists and reformers, there were also vast differences. Two are of particular importance. The first relates to concepts of the nature of humanity. The humanist program was rooted in the notion of human perfectibility. This was as true of the Florentine humanists with their strong platonic bias as it was of northern humanists like Erasmus. The humanists put great emphasis on the profoundly Greek (or, more accurately, Socratic) notion that education can produce a moral person. Both humanist learning and humanist education had a strong ethical bias: learning improves and ennobles. The reformers, by contrast, felt that humanity was hopelessly mired in sin and could only be raised from that condition by the free grace of God. For the reformers, the humanists' position that education could perfect a person undercut the notion of a sinful humanity in need of redemption.

The contrast between these two points of view is most clearly evident in a polemical debate between Luther and Erasmus on the nature of the human will. In a 1524 treatise called De Libero Arbitrio (On Free Will), Erasmus defended the notion that human effort cooperates in the process of sanctification and salvation. Luther answered in 1525 with a famous tract entitled De Servo Arbitrio (On the Bondage of the Will). The titles of the two pamphlets provide a shorthand description of the severe tensions between the two points of view.

A second difference between the humanists and the reformers begins with the humanist notion that behind all religious systems lies a universal truth that can be detected by a careful study of religious texts. Pico della Mirandola, for example, thought that the essential truth of Christianity could be detected in talmudic, platonic, Greek, and Latin authors. He felt that a sort of universal religion could be constructed from a close application of humanist scholarship to all areas of religion. The reformers, on the other hand, held to a simple yet unshakable dictum: Scriptura sola (the Bible alone). While the reformers were quite ready to use humanist methods to investigate the sacred text they were adamant in their conviction that only the Bible held God's revelation to humanity.

As a result of the translation of the Bible into the vernacular language of millions of northern Europeans, Reformation theologians were able to lay stress on the Scriptures as the foundation of their teachings. Luther and Calvin furthermore encouraged lay education, urging their followers to read the Bible for themselves and find there—and only there— Christian truth. In interpreting what they read, individuals were to be guided by no official religious authority but were to make their own judgment following their own consciences. This doctrine is known as universal priesthood, since it denies a special authority to the clergy. All these teachings, although primarily theological, were to have profound and long-range cultural impacts.

We can see that there was an intense positive and negative interaction between humanism and the Reformation—a movement energized by books in general and the Bible in particular. The intensely literary preoccupations of 14th- and 15th-century humanism provided a background and impetus for the 16thcentury Reformation. As a philosophical and cultural system, however, humanism was in general too optimistic and ecumenical for the more orthodox reformers. In the later 16th century humanism as a world view found a congenial outlook in the Christian humanism of Cervantes and the gentle skepticism of Montaigne, but in Reformation circles it was used only as an intellectual instrument for other ends.

Cultural Significance of the Reformation

Cultural historians have attributed a great deal of significance to the Reformation. Some have argued, for example, that with its strong emphasis on individuals and their religious rights, the Reformation was a harbinger of the modern political world. However, with equal plausibility one could make the case that with its strong emphasis on social discipline and its biblical authoritarianism, the Reformation was the last great spasm of the medieval world. Likewise, in a famous thesis developed in the early 20th century by the German sociologist Max Weber, Calvinism was seen as the seedbed and moving force of modern capitalism. Weber's proposition has lingered in our vocabulary in phrases like work ethic or Puritan ethic, although most scholars now see it as more provocative than provable. Regardless of the scholarly debates about these large questions, there are other, more clearly defined ways in which the Protestant Reformation changed the course of Western culture.

First, the Reformation gave a definite impetus to the already growing use of books in European life. The strong emphasis on the reading and study of the Bible produced inevitable concern for increased literacy. Luther, for example, wanted free education to be provided for all children of all classes in Germany.

The central place of the Bible in religious life made an immense impact on the literary culture of the time. Luther's Bible in Germany and the King James Version in England (to say nothing of the Anglican Book of Common Prayer) exercised an inestimable influence on the very shape of the language spoken by their readers. In other countries touched by the Reformation the literary influence of the Bible in translation was absolutely fundamental. In the Scandinavian countries, vernacular literature really begins with translations of the Bible. In Finland, a more extreme example, Finnish was used as a written language for the first time in translating the Bible.

The Bible was not the only book to see widespread diffusion in this period. Books, pamphlets, and treatises crisscrossed Europe as the often intricate theological battles were waged for one or another theological position. It is not accidental that the Council of Trent (1545–1564), a prime instrument of the Catholic counter-reform, stringently legislated the manner in which Bibles were to be translated and distributed. The fact that a list of forbidden books (the infamous *Index*) was instituted by the Catholic Church at this time is evidence that the clerical leadership recognized the immense power of books. The number of books circulating in this period is staggering: between 1517 and 1520 (even before his break with Rome) Luther's various writings sold about three hundred thousand copies in Europe.

None of this, of course, would have been possible before the Reformation for the simple reason that printing did not exist in Europe. The invention of the printing press and movable type revolutionized Ren-

THE ARTS AND INVENTION: Paper and Printing

By the late 15th century printing presses were in use in both Italy and Germany, and throughout the 16th century books and printed pictures became widespread in Europe. Before the invention of printing, the production of books had been limited by two factors: every copy of a work had to be individually handwritten, and the material of manuscripts was either parchment (split sheepskin) or vellum (calfskin), both of which were expensive and time-consuming to prepare.

The Chinese had invented paper as early as the 1st century A.D., and in the 8th century devised a system of block printing whereby a block of wood carved with the reverse or mirror form of a text or picture was inked and stamped on a piece of paper. Individual pages could be bound together, and the first printed book, published in 868, was composed of six pages.

Toward the end of the 12th century paper was manufactured for the first time in Europe, by the Arabs of southern Spain, but the technique did not reach Germany and Switzerland until the early 15th century. With Gutenberg's invention of movable type, the production of paper became a major industry, and thousands of books and pamphlets began to circulate. The implications of this general spread of information, along with the increase in literacy, were not lost on Pope Alexander VI (ruled 1492-1508), who introduced a counterweapon in the form of official Church censorship.

The effects of the new technology were by no means limited to religious debate. By the time of the Reformation, universities throughout Europe were expanding as prosperous businessmen and craftsmen sought to educate their children. There soon developed a thriving textbook market for grammars, encyclopedias, history books, and law books as students began to read for themselves rather than being dependent on the instruction handed down ex cathedra—from the professor's chair.

aissance culture north and south of the Alps in the same way that films, radio, and television changed the 20th century [12.5]. There were two important side effects. The early availability of "book learning" undermined the dominance of universities, which had acted as the traditional guardians and spreaders of knowledge. Also, Latin began to lose its position as the only language for scholarship, since many of the new readers did not understand it. Luther fully grasped the implications of the spread of literacy, and his use of it to advance his cause was imitated countless times in the following centuries.

A second cultural fact about the Reformation, closely allied to the first, is also noteworthy. The reformers put a great emphasis on the Word. Besides reading and listening there was also singing, and the reformers—especially Luther—stressed the vernacular hymn. The hymn was seen as both a means of praise and an instrument of instruction. Luther himself was a hymn writer of note. The famous "Ein' Feste Burg ist Unser' Gott" ("A Mighty Fortress Is Our God"), one of the best-loved hymns in Christianity, is generally attributed to him [12.6]. Indeed, the German musical tradition, which ultimately led to Johann Sebastian Bach in the 17th century, was very much the product of the Lutheran tradition of

On the other hand, the 16th-century reformers had little need or sympathy for the plastic arts. They were in fact, militantly iconoclastic. One of the hallmarks of the first reformers was their denunciation of paintings, statues, and other visual representations as forms of papist idolatry. The net result of this iconoclastic spirit was that by the beginning of the 17th century patronage for the sacred visual arts had virtually died in countries where the Reformation was

Molice ergo allimilari cis. Brit enim pater velter quid opus lit vobis: an requā perans eum. Bir ergo vos ora bins. Dacer notter qui es in celis fan dificetur nome tuū. Adveniat regnū tuū. Ifat volūtas tua: litut in telo et în terra. Panë nostrū suplubstārialē da nobis hodie. Et dimitte nobis a hira nottra: ficut et nos dimicimus debitoribus noltris. Et ne nos indu ras în remutacione: led libera nos a malo. Si emm dimiferitis pominiba peccara eou: dimittet et vobis pater velter relestis delicta veltra. Bi autem non dimiletitis hominibus : nec pa

12.5 Portion of a page from the Gutenberg Bible. 1455. Rare Books and Manuscripts Division, New York Public Library. The Latin text of the Lord's Prayer (Matthew 6:9-13) begins on the fourth line with Pater noster. The first edition of this Bible, printed at Mainz, was probably 150 copies.

12.6 Luther's German Psalter. Staatliche Lutherhalle, Wittenberg. The book is open at Luther's hymn "Ein' Feste Burg," which is taken from one of the Psalms. The Latin words above Luther's name mean "God our refuge and strength.' The hymn itself is printed in German.

strong. With the single exception of Rembrandt (and the exception is a gigantic one) it is difficult to name any first-rate painter or sculptor who worked from a Reformation religious perspective after the 16th century, although much secular art was produced.

The attitude of the 16th-century reformers toward the older tradition of the visual arts may be best summed up by the church of Saint Peter's in Geneva, Switzerland. Formerly a Romanesque Catholic cathedral of the 12th century, Saint Peter's became Calvin's own church. The stained glass was removed, the walls whitewashed, the statues and crucifixes taken away, and a pulpit placed where the high altar once stood. The church of Saint Peter's is a thoroughly reformed church, a building whose entire function is for the hearing of the preached and read word. Gone is the older notion (represented, for example, by the Cathedral of Chartres) of the church reflecting the other-worldly vision of heaven in the richness of its art. Reformation culture was in short an aural, not a visual, culture.

Intellectual Developments

Montaigne's Essays

Michel Eyquem de Montaigne (1533-1593) came from a wealthy Bordeaux family. His father, who had been in Italy and was heavily influenced by Renaissance ideas, provided his son with a fine early education. Montaigne spoke nothing but Latin with his tutor when he was a child, so that when he went to

school at the age of six he spoke Latin not only fluently but with a certain elegance. His later education (he studied law for a time) was a keen disappointment to him because of its pedantic narrowness. After a few years of public service Montaigne retired with his family to a rural estate in 1571 to write and study. There, with the exception of a few years traveling and some further time of public service, he remained until his death.

The times were not happy. France was split over the religious issue, as was Montaigne's own family. He remained a Catholic, but his mother and sisters became Protestants. Only a year after his retirement came the terrible Saint Bartholomew's Day Massacre (August 24, 1572), in which thousands of French Protestants were slaughtered in a bloodbath unequaled in France since the days of the Hundred Years' War. In the face of this violence and religious bigotry. Montaigne turned to a study of the classics and wrote out his ideas for consolation.

Montaigne's method was to write on a widely variegated list of topics gleaned either from his readings or from his own experiences. He called these short meditations Essays. Our modern form of the essay is rooted in Montaigne's first use of the genre in Europe. The large numbers of short essays Montaigne wrote share certain qualities characteristic of a mind wearied by the violence and religious bigotry of the time: a sense of Stoic calmness (derived from his study of Cicero and Seneca), a tendency to moralize (in the best sense of that abused word) from his experiences, a generous nondogmatism, a vague sense of world-weariness.

12.7 Giulio Campagnola. The Astrologer. 1509. Engraving, $3\frac{3}{4} \times 6''$ (9.5 × 15 cm). British Museum, London (reproduced by courtesy of the Trustees). The old-fashioned astrologer is shown with all the paraphernalia of his craft, immersed in mystical speculation and apparently accompanied by his pet monster.

The Growth of Science

The 16th century was not merely a turning point in the history of religions; it was a decisive age in the history of science. In earlier times a scientist was likely enough to be an ingenious tinkerer with elaborate inventions who dabbled in alchemy, astrology, and magic [12.7]. The new Renaissance scientist, a person of wide learning with a special interest in mathematics and philosophy, would develop bold and revolutionary ideas but always subject them to the test of practical experience [12.8].

The age produced many advances in science. In England alone William Gilbert (1540-1603) discovered that the earth was a large magnet whose pole points approximately northward; Sir William Harvey (1578-1657) solved the problem of how the blood could "circulate"—get from the arteries to the veins and return to the heart—by postulating the existence of the then-undiscovered channels we now call capillaries; John Napier (1550-1615) discovered the very practical mathematical tool called the logarithm, which greatly reduced the time and effort needed to solve difficult equations. Elsewhere in Europe, the German Paracelsus (1493–1541) laid the foundations of modern medicine by his decisive rejection of traditional practices. Although his own theories were soon rejected, his insistence on observation and inquiry had important consequences, one of which can be seen in the work of Andreas Vesalius (1514-1564), who was born in Brussles and studied in Padua. Vesalius' Seven Books on the Structure of the Human Body, published in 1543, comprise a complete 12.8 Hans Holbein the Younger. Nikolaus Kratzer. 1528. Tempera on panel, $32 \times 26''$ (83 × 67 cm.). Louvre, Paris. The new scientists are represented here by Kratzer, official astronomer to the court of Henry VIII and a friend of Dürer. The tools used in the calculation he is making are devised for maximum precision, and the room in which Kratzer is working is equipped as a laboratory.

anatomical treatise, illustrating in minute detail and with impressive accuracy the human form [12.9].

The philosophical representative of the "new science" was Francis Bacon (1561-1626), who combined an active and somewhat disreputable political career with the writing of works intended to demolish traditional scientific views. The chief of these books was the Novum Organum (1620), which aimed to free science from the two-thousand-year-old grasp of Aristotle while at the same time warning against the unrestrained use of untested hypotheses.

Science and religion came into direct conflict in the work of the Polish astronomer Nicholas Copernicus (1473-1543), who studied at the universities of Cracow and Bologna. In 1543, the same year Vesalius' work appeared, he published On the Revolutions of Celestial Bodies, a treatise in which he denied that the sun and the planets revolve around the earth, and reverted instead to a long-dead Greek theory that the earth and planets orbit the sun. Catholic and Protestant theologians found themselves for once united in their refusal to accept an explanation of the universe that seemed to contradict the teaching of the Bible, but Copernicus' work, though not a complete break with the past, provided stimulus for Galileo's astronomical discoveries in the following century.

Furthermore, the general principle behind Copernicus' method had important repercussions for the entire history of science. Up to his time scientists had taken the position that, with certain exceptions, reality is as it appears to be. If the sun appears to revolve about the earth, that appearance is a "given" in nature, not to be questioned. Copernicus questioned the assumption, claiming that it was equally plausible to take the earth's mobility as a given, since everything that had been explainable in the old way was fully explainable in the new. He thus made a breach between "common sense" and scientific truth that every major scientist since has widened (Table 12.1).

The Visual Arts in Northern Europe

Painting in Germany: Dürer, Grünewald, Altdorfer

The conflict between Italian humanism, with its belief in human perfectibility, and the Reformation, which emphasized sin and the need for prayer, is reflected in the art of the greatest German painters of the early 16th century. It might even be said that the intellectual and religious battles of the times stimulated German art to its highest achievements, for both Albrecht Dürer (1471-1528) and Matthias

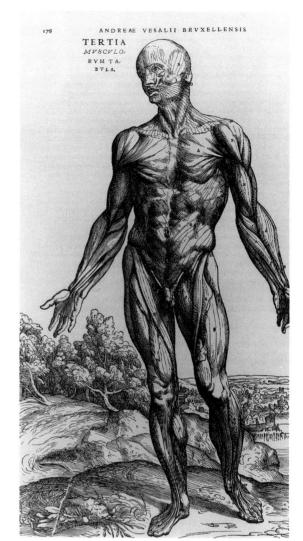

12.9 Andreas Vesalius. Third Musculature Table from De humani corporis fabrica. Brussels, 1543. National Library of Medicine, Bethesda, Maryland.

Grünewald (about 1500-1528) are, in very different ways, towering figures in the development of European painting. In spite of his sympathy with Luther's beliefs. Dürer was strongly influenced by Italian artistic styles and, through Italian models, by classical ideas. Grünewald, on the other hand, rejected almost all Renaissance innovations and turned instead to traditional northern religious themes, treating them with new passion and emotion. Other artists, meanwhile, chose not to wrestle with the problems of the times. Some, including Albrecht Altdorfer (1480-1538), preferred to stand back and create a world view of their own.

Dürer was born in Nuremburg, the son of a goldsmith. Even as a child he showed remarkable skill in

TABLE 12.1 Principal Discoveries and Inventions in the 16th Century

Marin all Mills and Color Republic Color of the Mills	
1486	Diaz rounds Cape of Good Hope
1492	Columbus discovers America
1493–1541	Paracelsus pioneers the use of chemicals to treat disease
1513	Balboa sights the Pacific Ocean
1516	Portuguese reach China
1520–22	First circumnavigation of globe, by Magellan
1530–43	Copernicus refutes geocentric view of universe
1533	Gemma Frisius invents principle of triangulation in surveying
1542	Leonhart Fuchs publishes herbal guide to medicine
1543	Vesalius publishes anatomical treatise
1546	Agriola publishes guide to metallurgy
1569	Mercator devises system of mapmaking
1572	Tycho Brahe observes first supernova and produces first modern star catalogue
1582	Pope Gregory XIII reforms the calendar
c. 1600	First refracting telescope constructed in Holland
1600	William Gilbert publishes treatise on magnetism

drawing. His father apprenticed him to a wood engraver, and in 1494-1495—after finishing his traning—Dürer made the first of two visits to Italy. In Italy he saw for the first time the new technique of linear perspective, whereby all parallel lines converge at a single vanishing point, and came into contact with the growing interest in human anatomy. Quite as important as these technical discoveries, however, was his perception of a new function for the artist. The traditional German—indeed, medieval—view of the artist was as an artisan whose task was humbly, if expertly, to reproduce God's creations. Dürer adopted Renaissance humanism's conception of the artist as an inspired genius, creating a unique personal world. It is not by chance that a first glance at his Self-Portrait of 1500 [12.10] suggests a Christlike figure rather than a prosperous German painter of the turn of the century. The effect is intentional. The lofty gaze of the eyes underlines the solemn, almost religious nature of the artist's vision, while the prominent hand draws attention to his use of the pen and the brush to communicate it to us.

In his paintings Dürer shows a fondness for precise and complex line drawing rather than the softer use of mass and color typical of Italian art. In fact, much of his greatest work was created in the medium of graphic art. In 1498 he published a series of fifteen woodcuts illustrating the Revelation of Saint John, known as the *Apocalypse* series. Woodcut engravings are produced by drawing a design on a block of soft wood, then cutting away the surrounding wood to leave the lines of the drawing standing in relief. The blocks of wood can then be coated with ink and used to print an impression on paper. In the hands of Dürer this relatively simple technique was raised to new heights of expressiveness, as in his depiction of Saint Michael's fight against the dragon from the Apocalypse series [12.11]. In the upper part of the scene Michael and other angels, all of them with long hair curiously like Dürer's own, do battle with a gruesome horde of fiends, while the peaceful German landscape below seems untouched by the cosmic fight in progress. Dürer's vision of an apocalyptic struggle between good and evil reflected the spirit of the time and copies of the Apocalypse series sold in large quantities. Growing discontent with the Church was, as we have seen, one of the causes of Luther's Reformation; the general sense of forthcoming trouble and upheaval gave Dürer's woodcuts a particular aptness.

12.10 Albrecht Dürer. Self-Portrait. 1500. Panel, 25\% × 187\%" (64 × 48 cm). Alte Pinakothek, Munich. The frontal pose and solemn gaze convey Dürer's belief in the seriousness of his calling.

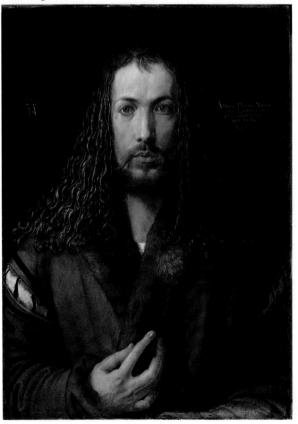

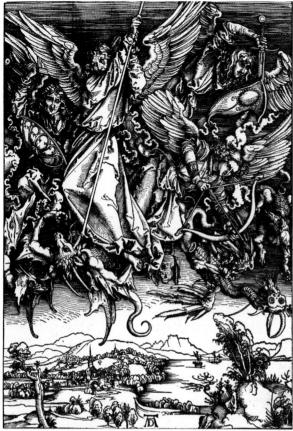

12.11 Albrecht Dürer. Saint Michael Fighting the Dragon, from the Apocalypse series. 1498. Woodcut, 15½ × 11½ (39 × 28 cm). British Museum, London (reproduced by courtesy of the Trustees). Note Dürer's characteristic signature in the center bottom.

The medium of line engraving was also one to which Dürer brought an unsurpassed subtlety and expressiveness. Unlike a woodblock, where the artist can complete the drawing before cutting away any material, the copper plate from which a line engraving is printed has to be directly incised with the lines of the design by means of a sharp-pointed steel instrument called a burin. The richness of effect Dürer achieved in this extremely difficult medium, as in his engraving of Adam and Eve [12.12], is almost incredible. The engraving furthermore demonstrates not only his technical brilliance but also the source of much of his artistic inspiration. The carefully shaded bodies of Adam and Eve reflect the influence of contemporary Italian ideals of beauty, while the proportions of the figures are derived from classical literary sources. Dürer made up for the lack of actual Greek and Roman sculpture in Germany by a careful reading of ancient authors, from which he derived a system of proportion for the human figure.

In 1505-1507 Dürer returned to Italy, where he spent most of his time in Venice, discussing theoretical and practical aspects of Renaissance art with Bellini and other Venetian artists. It was inevitable that the rich color characteristic of Venetian painting would make an impression on him, and many of his works of this period try to outdo even the Venetians in splendor.

His renewed interest in painting was, however, brief. For almost the rest of his life he devoted himself to engraving and to writing theoretical works on art. Between 1513 and 1515 he produced his three greatest engravings. The earliest of these, Knight, Death, and the Devil [12.13], again reflects contemporary religious preoccupations with its symbolic use of the Christian knight, accompanied by a dog who represents untiring devotion and beset by the temptations of the devil (in a particularly untempting guise, it must be admitted). Neither this fearsome creature nor the appearance of Death, armed with an hourglass, can shake the knight's steadfast gaze.

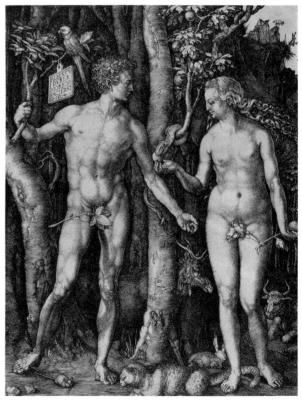

12.12 Albrech Dürer. Adam and Eve. 1504. Engraving, 91/8 × 75/8" (25 × 19 cm). Metropolitan Museum of Art, New York (Fletcher Fund, 1919). The animals represent the sins and diseases that resulted from Adam and Eve's eating of the tree of knowledge: the cat pride and cruelty, the ox gluttony and sloth, and so on.

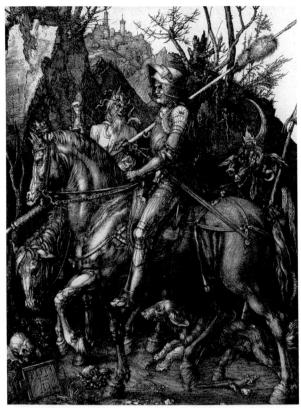

12.13 Albrecht Dürer. Knight, Death, and the Devil. 1513. Engraving, $9\frac{1}{4} \times 7\frac{1}{2}$ " (25 × 19 cm). British Museum, London (reproduced by courtesy of the Trustees). The knight's calm determination reflects Dürer's confidence in the ability of the devout Christian to resist temptation. This engraving may have been inspired by Erasmus' book Handbook of the Christian Knight.

By the end of his life Dürer was acknowledged as one of the great figures of his time. Like Luther, he made use of the new possibilities of the printing press to spread his ideas. At the time of his death he was working on Four Books on Human Proportions. This work, in Latin, aimed to accomplish for art what Vesalius' did for medicine. It was inspired by two of the great intellectual concerns of the Renaissance: a return to classical ideals of beauty and proportion and a new quest for knowledge and scientific precision.

Although the work of Grünewald represents the other high point in German Renaissance art, very little is known about his life. Only in the 20th century did we discover his real name, Mathis Gothart Neithart; the date of his birth and early years of his career are still a mystery. Grünewald seems to have worked for a while at the court of the Cardinal Archbishop of Mainz, but in the 1525 Peasants' War he sided with the German peasants in their revolt against the injustices of their rulers, after which his enthusiasm for Luther's new ideas kept him from returning

to the Cardinal's service. He retired to Halle, where he died in 1528.

What we know about his political and religious sympathies—his support for the oppressed and for the ideals of the Reformation—is borne out by the characteristics of his paintings. Unlike Dürer, Grünewald never went to Italy, and he showed no interest in the new styles developed there. The Renaissance conception of ideal beauty and the humanist interest in classical antiquity left him unmoved. Instead, he turned again and again to the traditional religious themes of German medieval art, bringing to them a passionate, almost violent intensity that must at least in part reflect the religious heart-searchings of the times. Yet it would be a mistake to see Grünewald's unforgettable images as merely another product of the spirit of the age, for an artist capable of so unique and personal a vision is in the last analysis inspired by factors that cannot be explained in historical terms. All that can safely be said is that no artist, before or since, has depicted the Crucifixion as a more searing tragedy or Christ's Resurrection as more radiantly triumphant.

Both these scenes occur in Grünewald's greatest work, the Isenheim Altarpiece, finished in 1515, which was commissioned for the church of a hospital run by members of the Order of St. Anthony. The folding panels are painted with scenes and figures appropriate to its location, including saints associated with the curing of disease and events in the life of St. Anthony himself. In particular, the patients who contemplated the altarpiece were expected to meditate on Christ's Crucifixion and Resurrection and derive from them

comfort for their own sufferings.

In his painting of Christ in the Crucifixion panel [12.14], Grünewald uses numerous details to depict the intensity of Christ's anguish—from his straining hands, frozen in the agony of death, to the thorns stuck in his festering body, to the huge iron spike that pins his feet to the cross. It is difficult to imagine anything further from the Italian Renaissance and its concepts of ideal beauty than this tortured image. Grünewald reveals an equal lack of interest in Renaissance or classical theories of proportion or perspective. The figure of Christ, for example, is not related in size to the other figures but dominates the panel, as a glance at the comparative size of the hands will show. Yet the sheer horror of this scene only throws into greater relief the triumph of the Resurrection [12.15]. Christ seems almost to have exploded out of the tomb, in a great burst of light that dazzles the viewers as well as the soldiers stumbling below. No greater contrast can be imagined than between the drooping body on the cross and this soaring weightless image that suggests a hope of similar resurrection to the sufferers in the hospital.

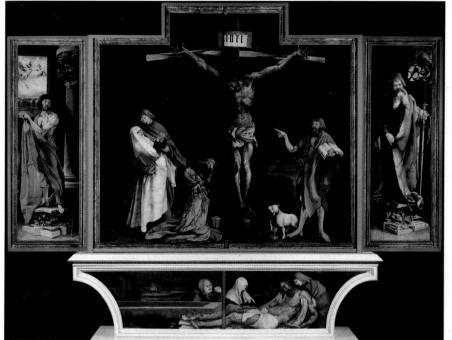

12.14 Matthias Grünewald. Crucifixion from the Isenheim Altarpiece, exterior. Completed 1515. Panel (with framing) c. $9'9\frac{1}{2}'' \times 10'9''$ (2.98 × 3.28 m). Musée d'Unterlinden, Colmar. Behind Mary Magdalene, who kneels in grief, stand Mary and John, while on the other side John the Baptist points to Christ's sacrifice. Beside him, in Latin, are inscribed the words "He must increase, but I must decrease." Above Christ are the initial letters of the Latin words meaning "Jesus of Nazareth, King of the Jews."

The drama of Grünewald's spiritual images is in strong contrast to the quiet, poetic calm of the work of Albrecht Altdorfer. Although closer in style to Grünewald than to Dürer. Altdorfer found his favorite subject not in religious themes but in landscapes. Danube Landscape near Regensburg [12.16], probably dating from around 1525, is one of the first examples in the Western tradition of a painting without a single human figure. From the time of the Greeks, art had served to tell a story, sacred or secular, or to illustrate some aspect of human behavior. Now for the first time the contemplation of the beauties of nature was in itself deemed a worthy subject for an artist. In this painting Altdorfer depicts a kind of ideal beauty very different from Dürer's Fall of Man but no less moving. Part of his inspiration may have come from the landscapes that can be seen in the background of paintings by Venetian artists like Giorgione, although there is no evidence that Altdorfer ever visited Italy. Even if he did, his sympathy with the forces of nature, its light and scale and sense of life, seems more directly inspired by actual contact.

In Altdorfer's most famous work, the Battle of Alexander and Darius [12.17], the thousands of soldiers

12.15 Matthias Grünewald. Resurrection from the Isenheim Altarpiece, first opening. Completed 1515. Panel, 8'21/2" × 3'1/2" (2.45 × .93 m). Musée d'Unterlinden, Colmar. Note the absence of any natural setting and the confused perspective, which give the scene an otherworldly quality.

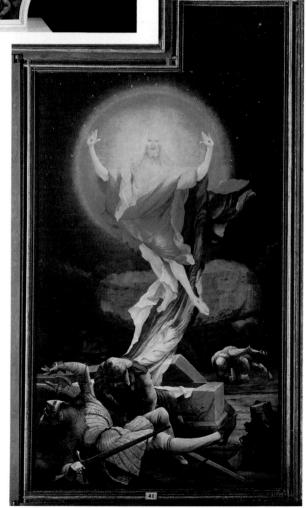

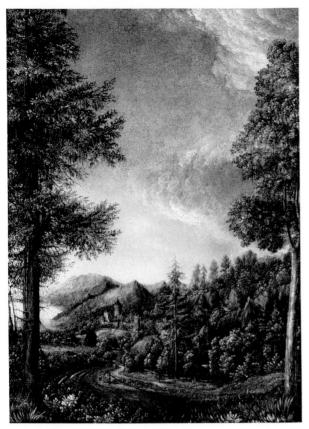

12.16 Albrecht Altdorfer. Danube Landscape near Regensburg. c. 1522-1525. Panel, 11 × 85/8" (28 × 22 cm). Alte Pinakothek, Munich. The only traces of human existence here are the road and the distant castle to which it leads.

under their mighty leaders wheel and turn in scenes of hectic activity. Their violence seems to express the futility of human existence when set against the grandeur of the rivers and mountain peaks that provide their setting. The almost-mystical power of the natural world Altdorfer conveys was to be rediscovered later in the 19th century in the work of German romantic painters like Caspar David Friedrich (1774-1840).

Painting in the Netherlands: Bosch and Bruegel

The two greatest Netherlandish painters of the Renaissance, Hieronymus Bosch (c. 1450-1516) and Pieter Bruegel (1525–1569), are linked both by their pessimistic view of human nature and by their use of satire to express it. Bosch furthermore drew upon an apparently inexhaustible imagination to create a fantasy world that alternately fascinates and repels as the

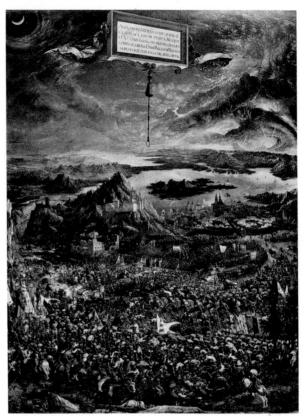

12.17 Albrecht Altdorfer. Battle of Alexander and Darius. 1529. Panel, $5'2'' \times 3'11''$ (1.58 × 1.2 m). Alte Pinakothek, Munich. The tassel hanging from the descriptive plaque floating above the scene leads the eye down to the center of the conflict, where Alexander pursues the Persian king Darius trying to escape in his chariot.

eve wanders from one bizarre scene to another. Although modern observers have interpreted Bosch's work in a variety of ways, it is generally agreed that, contrary to appearances, he was in fact a deeply religious painter. His chief subject is human folly in its innumerable forms, his theme that the inevitable punishment of sin is Hell. Salvation is possible through Christ, but few, according to Bosch, have the sense to look for it. His paintings show us the consequences.

Almost nothing is known of Bosch's life, and his works must speak for themselves. The most elaborate in its fantasy is a triptych (a painting made up of three panels) known as the Garden of Earthly Delights [12.18], which was probably finished around 1510. Into it are crowded hundreds of nude figures engaged in activities that range from the unimaginable to the indescribable, all in pursuit of erotic pleasure. The movement from the apparently innocent scene of the creation of Eve on the left to the fires of Hell on the right illustrates Bosch's belief that the pleasures of the

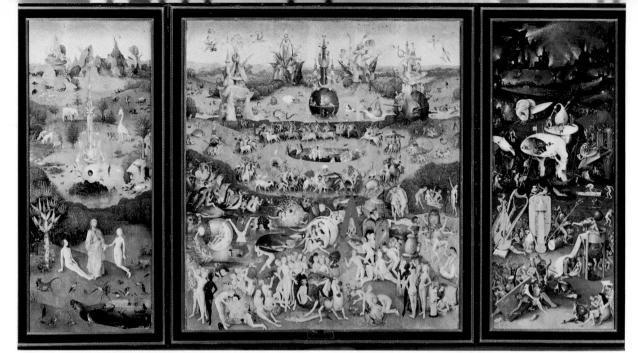

12.18 Hieronymus Bosch. Garden of Earthly Delights. c. 1505-1510. Panel; center 7'25%" × 6'4¾" (2.2 × 1.95 m), each wing 7'25/8" × 3'21/4" (2.2 × .97 m). Prado, Madrid. Perhaps surprisingly, this catalogue of the sins of the flesh was among the favorite works of the gloomy King Philip II of Spain.

body lead to damnation along a road of increasing depravity. Even in the Garden of Eden we sense what is to come, as Adam sits up with excited enthusiasm on being presented with the naked Eve, while God seems to eye him nervously.

The bright world of the middle panel, in which the pallid, rubbery figures seem to arrange themselves (and one another) in every conceivable position and permutation, gives way on the right to a hallucinating vision of eternal damnation.

Bosch's symbolism is too complex and too private to permit a detailed understanding of the scene, yet his general message is clear enough: Hell is not terrifying so much as it is sordid and pathetic. The frantic

12.19 Pieter Bruegel the Elder. The Triumph of Death. c. 1562-1564. Oil on panel, 3'10" × $5'3\frac{3}{4}''$ (1.17 × 1.62 m). Prado, Madrid. Note the huge coffin on the right, guarded by rows of skeleton-soldiers, into which the dead are being piled.

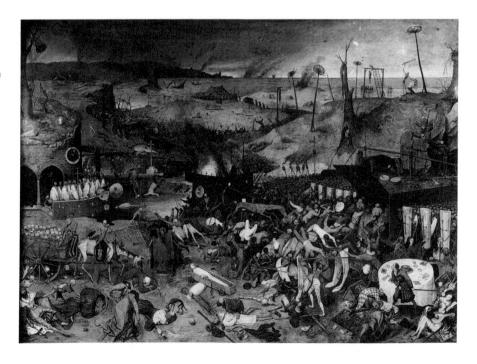

scenes of activity are as senseless and futile as those of worldly existence, but in Hell their monstrous nature

becomes fully apparent.

The sources of Bosch's inspiration in this and other works are unknown. Many of his demons and fantastic animals seem related to similar manifestations of evil in medieval art, but no medieval artist ever devised a vision such as this or had the technique to execute it. To modern eyes some of his creations, like the human-headed monster on the right-hand panel turning both face and rear toward us, seem to prefigure the surrealist art of the 20th century. There is a danger, however, in applying labels from the art of later times to that of an earlier period. Bosch must simply be allowed to stand on his own as one of the great originals in the history of painting.

Pieter Bruegel, often called the Elder to distinguish him from his son of the same name, represents the culmination of Renaissance art in the Netherlands. Like that of Bosch, his work is often fantastic, and his crowded canvases are frequently filled with scenes of grotesque activity. Some of his paintings suggest that he shared Bosch's view of the apparent futility of human existence and the prevalence of sin. In many of his pictures, however, the scenic backgrounds reveal a love and understanding of nature very different from Bosch's weird view of the world and represent one of the keys to understanding his work. For Bruegel, the full range of human activity formed part of a world in which there existed an underlying order. The beauty of nature forms the background not only to his pictures but actually to the lives of us all, he seems to say; by seeing ourselves as part of the natural cycle of existence we can avoid the folly of sin. If this interpretation of his work is correct, it places Bruegel with the humanists, who believed in the possibilities for human good, and there is some evidence to suggest that his friends did include members of a group of humanist philosophers active at Antwerp.

Although Bruegel's best-known paintings are scenes of peasant life, it is a mistake to think of him as unsophisticated. On the contrary, during the last years of his life, which he spent in Brussels, he was familiar with many of the leading scholars of the day and seems to have been a man of considerable culture. He certainly traveled to Italy, where he was apparently unaffected by the art but deeply impressed by the beauty of the landscape. Back home, he may well have supported the move to free the Netherlands from Spanish rule; some of his paintings seem to contain allusions to Spanish cruelties.

Bruegel's vision is so rich and so understanding of the range of human experience that it almost rivals that of Shakespeare, who was born in 1564, five years before Bruegel's death. In his great painting The Tri-

umph of Death [12.19], Bruegel looks with uncompromising honesty at the universal phenomenon of death—which comes eventually to all, rich and powerful or poor and hopeless. Unlike Bosch, who reminds us that the righteous (if there are any) will be saved, Bruegel seems to offer no hope. Yet the same

artist painted the Peasant Wedding Feast [12.20], a scene of cheerful celebration. True, Bruegel's peas-

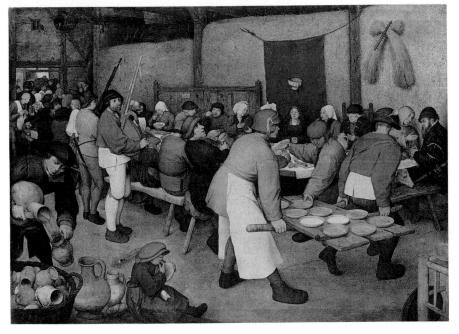

12.20 Pieter Bruegel the Elder. Peasant Wedding Feast. 1566-1567. Oil on panel, $3'8\%'' \times 5'4\%''$ $(1.14 \times 1.63 \text{ m})$. Kunsthistorisches Museum, Vienna. The composition of the painting is based on the diagonal line of the receding table that leads the eye past the bride and the bagpiper to the back of the room.

12.21 Pieter Bruegel the Elder. Hunters in the Snow. 1565. Oil on panel, $3'10'' \times 5'3^{3/4}''$ $(1.17 \times 1.62 \text{ m})$. Kunsthistorisches Museum, Vienna. Note Bruegel's careful use of color to suggest a cold, clear, sunless day. From his first crossing of the Alps in the 1530s Bruegel was inspired by mountain scenery, and it reappeared throughout his work. In this painting, the panoramic sweep from the foreground to the lofty peaks behind makes the scene appear a microcosm of human existence. Thus Bruegel's "world landscapes" or Weltlandschaften are both literal depictions of scenes from nature and symbolic representations of the relationship between human beings and the world around them.

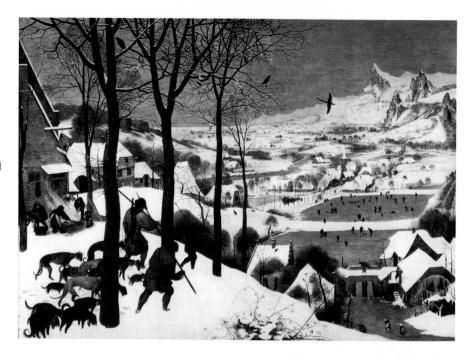

ants find pleasure in simple rather than sophisticated delights, in this case chiefly food and drink, but he reminds us that some are luckier than others. The little boy in the foreground so completely engrossed in licking up every last delicious morsel of food is counterbalanced by the bagpiper who looks wistfully and wanly over his shoulder at the tray of pies going by. Nor should we be too hasty to think of Bruegel's peasants as unthinking creatures, content with a brutish existence. The bride certainly does not seem either bright or beautiful, but she radiates happiness. and the general air of merriment is very attractive.

Bruegel's most profound statements are perhaps to be found in a cycle of paintings intended to illustrate the months of the year, rather like the Très Riches Heures of the Limbourg Brothers a century earlier. Bruegel finished only five of them, including the magnificent Hunters in the Snow of 1565 [12.21]. In the background tower lofty peaks, which represent Bruegel's memory of the Alps, seen on his trip to Italy. From the weary hunters in the foreground a line of barren trees leads the eye to fields of snow where peasants are hard at work. The scene can hardly be called a happy one, but neither is it unhappy. There is an inevitability in the way humans, animals, birds, and nature are all bound into a unity, expressive of a sense of order and purpose. The lesson of Italian humanism has been translated into a very different language, spoken with a highly individual accent, but Bruegel's northern scene seems in its own way inspired by a similar regard for human dignity.

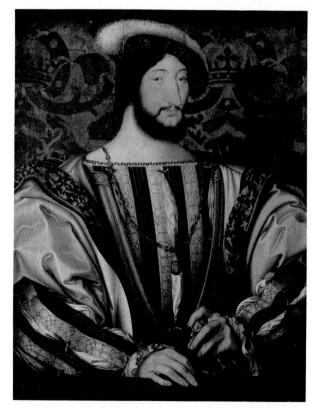

12.22 Jean Clouet (?). Francis I. c. 1525-1530. Tempera and oil on panel, $37\frac{3}{4} \times 29\frac{1}{8}$ " (96 × 74 cm). Louvre, Paris. This famous work is now thought to be by an unknown artist rather than Clouet himself, but its style is very similar to that of his many official portraits of the king.

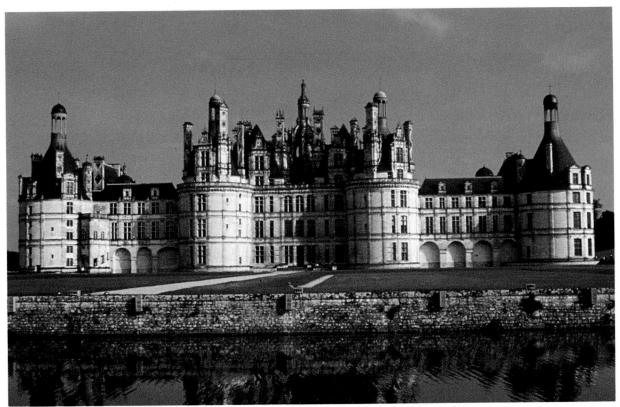

12.23 Château of Chambord. Begun 1529. Although the turrets and pinnacles are reminiscent of French medieval architecture, the central block and much of the decorative detail suggest Italian Renaissance models.

Art and Architecture in France

France of the 16th century has little to compare with the artistic achievements of Germany and the Netherlands. The influence of Italian art on France was so strong, due in great part to the actual presence at the French court of Italian artists, that French painting was almost completely overwhelmed. The only native artist of note was Jean Clouet (c. 1485-1541), who was retained by Francis I chiefly to serve as his official portrait painter. Among the many portraits of the king attributed to Clouet is one of around 1530 [12.22] that does full justice to the sensual but calculating character of his master.

More interesting than French painting during the 16th century is French architecture. The series of luxurious châteaux that Francis I had built along the valley of the river Loire combined the airiness of the earlier French Gothic style with decorative motifs imported from Italian Renaissance architecture. The result was buildings like the beautiful Château of Chambord [12.23].

The love of decoration shown by the builders of Chambord emerges even more strongly as a feature of French architectural style in the design of the

Square Court of the Louvre [12.24]. This structure was begun in 1546 by the architect Pierre Lescot (1510-1578) and the sculptor Jean Goujon (c. 1510-1568), working for once without Italian guidance. The facade of the court is a compendium of classical

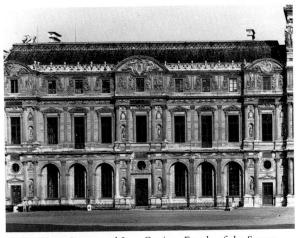

12.24 Pierre Lescot and Jean Goujon. Facade of the Square Court of the Louvre, Paris. Begun 1546. The architectural and sculptural decoration is Italian in origin but used here as typically French elaborate ornamentation.

forms, from the window moldings to the Corinthian columns to the decorative motifs. The total effect, however, is very different from Italian buildings using the same features. Instead of being grand or awe-inspiring the building seems graceful and harmonious, perhaps even a little fussy, and the emphasis on decoration became a prominent characteristic of French art in the following two centuries.

Art in Elizabethan England

Throughout the 16th century English political and cultural life followed a path notably different from that of continental Europe, as it did so often in its previous history. The social unrest that had marked the later Middle Ages in England was finally brought to an end in 1485 by the accession of Henry VII. the first of the Tudor dynasty. For the entire 16th century, England enjoyed a new stability and commercial prosperity on the basis of which it began to play an increasingly active part in international politics. Henry VIII's final break with the Catholic Church in 1534 led to the later development of ties between England and the other countries of the Reformation, particularly the Netherlands. When years of tension between the Netherlanders and their Spanish rulers finally broke into open rebellion, England—by now ruled by Queen Elizabeth I (born 1533, reigned 1558-1603)—supplied help secretly. Relations between Elizabeth and the Spanish king, Philip II, were already strained, and English interference in the Spanish Netherlands was unlikely to help. In 1585, a new Spanish campaign of repression in the Netherlands, coupled with the threat of a Spanish invasion of England, drove the queen to take more open action, and she sent six thousand troops to fight alongside the Netherlanders. Their presence proved decisive.

Philip's anger at his defeat and at the progress of the campaign for an independent Netherlands was turned in fury against England. The massive Spanish Armada, the largest fleet the world had ever seen. was ready early in 1588 and sailed majestically north, only to be met by a fleet of much lighter, faster English ships commanded by Sir Francis Drake. The rest is part history, part legend. Even before the expedition sailed, Drake had "singed the beard of the King of Spain" by sailing into Cadiz harbor and setting fire to some of the Spanish galleons waiting there. The rest of the Armada reached the English Channel, where it was totally destroyed, partly by superior English tactics, partly by a huge storm promptly dubbed (by the victors, at least) the Protestant Wind. The subsequent tales told of English valor and daring brought a new luster to the closing years of the Elizabethan Age [12.25].

In view of England's self-appointed position as

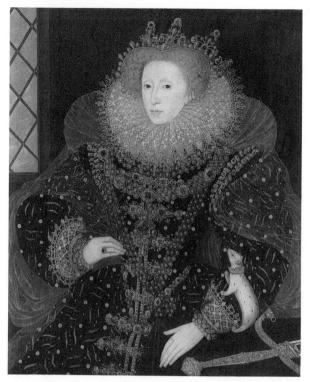

12.25 Nicholas Hilliard(?). Ermine Portrait of Queen Elizabeth I. 1585. Oil on canvas, $41\frac{3}{4} \times 35$ " (106 × 89 cm). Hatfield House, England (collection of the Marquess of Salisbury). The ermine on the queen's sleeve is a symbol of virginity. The portrait as a whole is a symbol of her majesty, not intended to show her actual appearance.

bulwark of Protestantism against the Catholic Church in general and Spain in particular, it is hardly surprising that Renaissance ideas developed south of the Alps took some time to affect English culture. Few Italian artists were tempted to work at the English court or, for that matter, were likely to be invited there. Furthermore, England's geographic position inevitably cut it off from intellectual developments in continental Europe and produced a kind of psychological insularity that was bolstered in the late 16th century by a wave of national pride. The finest expression of this is probably to be found in the lines William Shakespeare put into the mouth of John of Gaunt in Act II, scene i of Richard II, a play written some six years after the defeat of the Spanish Armada:

This royal throne of kings, this sceptered isle, This earth of majesty, this seat of Mars, This other Eden, demi-Paradise, This fortress built by Nature for herself Against infection and the hand of war, This happy breed of men, this little world, This precious stone set in the silver sea. Which serves it in the office of a wall

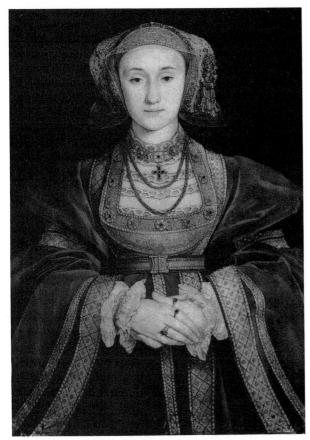

12.26 Hans Holbein the Younger. Anne of Cleves. c. 1539-1540. Vellum applied to canvas, $25\% \times 18\%$ " (65 × 48 cm). Louvre, Paris. Viewing this portrait, Henry VIII sent for Anne of Cleves and made her his fourth queen. Note the formal pose and the suitably modest downturned gaze.

12.27 Nicholas Hilliard. Portrait of a Youth. c. 1590. Parchment, $5\% \times 2\%$ " (14 × 7 cm). Victoria and Albert Museum, London. Crown copyright. (By courtesy of the Board of Trustees.) The thorns of the wild rose growing in the foreground may represent friendship in adversity. (The miniature is shown here at almost exactly its actual size.)

Or as a moat defensive to a house Against the envy of less happier lands— This blessed plot, this earth, this realm, this England. . . .

On the other hand, the same spirit of nationalism was bound to produce a somewhat narrowminded rejection of new ideas from outside. English sculpture and painting suffered as a result.

The only foreign painter to work in England was himself a northerner, Hans Holbein the Younger (1497/8-1543), whose portrait of Henry VIII is reproduced on page 83. A magnificent portraitist, Holbein found himself sent by Henry to paint prospective brides so that the king could make his choice with at least some idea of their appearance—an effective if

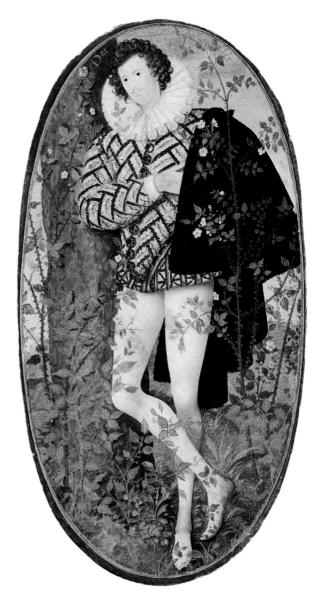

rather tedious method before photography. It must be added that the artist seems to have done his work rather too well, since his picture of Anne of Cleves [12.26] inspired Henry to marry the princess only to divorce her within six months, contemptuously dismissing her as his "Flanders Mare."

Apart from Holbein, English artists were virtually cut off from the new ideas current elsewhere. The only English painter of note during the 16th century was Nicholas Hiliard (1547-1619), best known for his miniatures, small portraits often painted in watercolor. The finest is of an unidentified young man who has something of the poetic melancholy of a Shakespearean lover [12.27]. When Hilliard turned to larger works, specifically to portraits of Queen Elizabeth, he was inevitably inhibited by his monarch's demand for a painting that would look regal and imposing rather than realistic. The result [see figure 12.25] is a symbolic representation of majesty rather than a mere portrait.

Music of the Northern Renaissance

As in the visual arts, the Renaissance produced major stylistic changes in the development of music; nonetheless, in general, musical development in the Renaissance was marked by a less severe break with medieval custom than was the case with the visual arts. Although 16th-century European composers began to increase the complexity of their style, making frequent use of polyphony (several musical parts combined and sounding together), they continued to use forms developed in the High Middle Ages and the early Renaissance. In religious music the motet remained popular; this was a short choral piece for three or more voices, generally unaccompanied, set to a religious text. Composers also continued to compose madrigals, songs for three or more solo voices based generally on secular poems. For the most part these were intended for performance at home, and the skill of the singers was often tested by elaborate, interweaving polyphonic lines. The difficulty of the parts often made it necessary for the singers to use an instrumental accompaniment. This increasing complexity produced a significant change in the character of madrigals, which were especially popular in Elizabethan England. Nonetheless, 16thcentury musicians were recognizably the heirs of their 13th- and 14th-century predecessors.

Music In France and Germany

The madrigal form was originally devised in Italy for the entertainment of courtly circles. By the early 16th century French composers, inspired by such lyric poets as Clement Marot (1496–1544), were writing more popular songs known as chansons. The bestknown composer of chansons was Clement Janequin (c. 1485-c. 1560), who was famous for building his works around a narrative program. In "La Guerre" ("The War") the music imitates the sound of shouting soldiers, fanfares, and rattling guns; other songs feature street cries and birdsongs. Frequently repeated notes and the use of nonsense syllables help to give Janequin's music great rhythmic vitality although it lacks the harmonic richness of Italian madrigals.

The same tendency to appeal to a general public characterized German and Flemish songs of the period with texts that were romantic, military, or sometimes even political in character. Among the great masters of the period was the Flemish composer Heinrich Isaac (c. 1450-1517), who composed songs in Italian and French as well as German. His style ranges from simple chordlike settings to elaborately interweaving lines that imitate one another. Isaac's pupil the German Ludwig Senfl (c. 1490c. 1542) was, if anything, more prolific than his teacher; his music is generally less complex and graceful-almost wistful-in mood.

Elizabethan Music

English music suffered far less than the visual arts from the cultural isolationism of Elizabethan England; the Elizabethan Age, in fact, marks one of the high points in its history. Almost two hundred years earlier the English musician John Dunstable (c. 1385– 1453) had been one of the leading composers in Europe. By bringing English music into the mainstream of continental developments he helped prepare the way for his Elizabethan successors.

A number of other factors were also responsible for the flourishing state of English music. To begin with, in England there had always been a greater interest in music than in the visual arts.

Also, the self-imposed ban on the importation of foreign art works and styles did not extend to printed music, with the result that by the early years of the reign of Elizabeth, Italian secular music began to circulate in English musical circles. A volume of Italian songs in translation was published in 1588 under the title Musica Transalpina (Music from Across the Alps).

As for sacred music, when Henry VIII staged his break with the pope in 1534, he was not at all ready to convert wholeheartedly to Lutheranism or Calvinism and discard the sung parts of the liturgy. The services, psalms, and hymns the new Anglican Church had to devise generally (although by no means invariably) used English rather than Latin texts, echoing Luther's use of the vernacular, but continued for the most part to follow Catholic models.

Thus, when the first official version of the English litany was issued in 1544 by the Archbishop of Canterbury, Thomas Cranmer, it made use of the traditional Gregorian chant, simplified in such a way that only one note was allowed to each syllable of the text. This preserved the flavor of the original music, while making it easier for a listener to follow the meaning of the words and thereby participate more

12.28 John Merbecke. Book of Common Praier Noted. British Library, London (reproduced by courtesy of the Trustees). The Lord's Prayer is on the left page and part of the right page. The words are in English, but note the Latin title Agnus Dei (Lamb of God) retained on the right page.

directly in the worship. The tendency to simplify is also visible, literally [12.28], in the first published musical setting of the words of the Book of Common Prayer, which had appeared in 1549. This first musical edition, The Book of Common Praier Noted [set to music] by John Merbecke (c. 1510-c. 1585), again used only one note to each syllable, and his settings followed the normal accentuation of the English words. This work is still used by the Episcopal Church.

In more elaborate music the effects of the Reformation were even less evident. Most of the professional composers of the day, after all, had been brought up in a Catholic musical tradition, and while the split with Rome affected religious dogma (and of course permitted Henry to marry and divorce at will), it did not alter their freedom to compose as they wished. They continued to write pieces that alternated and combined the two chief styles of the day: blocks of chords in which every voice moved at the same time and the elaborate interweaving of voices known as counterpoint.

The musical forms also remained unchanged except in name. Among the most popular compositions throughout Europe were motets, short choral works, the words of which were often in Latin. English composers continued to write works of this kind but used English texts and called them anthems. A piece that used the full choir throughout was called a full anthem and one containing passages for solo voice or voices a verse anthem. English musicians nevertheless did not entirely abandon the use of Latin. A number of the greatest figures of the period continued to write settings of Latin texts as well as ones in the vernacular.

The dual nature of Elizabethan music is well illustrated by the career of Thomas Tallis (c. 1505-1585), who spent more than forty years of his life as organist of the Chapel Royal at the English Court. Although his official duties required him to compose works for formal Protestant occasions, he also wrote Latin motets and Catholic masses. Tallis was above all a master of counterpoint, bringing the technique of combining and interweaving a number of vocal lines to a new height of complexity in one of his motets, Spem in Alium (Hope in Another), written for no less than forty voices, each moving independently. In his anthems, however, he adopted a simpler style with a greater use of chord passages, so that the listener could follow at least part of the English text. His last works combine both techniques to achieve a highly expressive, even emotional effect, as in his setting of the Lamentations of Jeremiah.

Among Tallis' many pupils was William Byrd (c. 1543-1623), the most versatile of Elizabethan composers and one of the greatest in the history of English music. Like Tallis, he produced both Protestant and Catholic church music, writing three Latin masses and four English services, including the socalled Great Service for five voices. Byrd also composed secular vocal and instrumental music, including a particularly beautiful elegy for voice and strings, Ye Sacred Muses, inspired by the death of Tallis himself. The concluding bars, setting the words "Tallis is dead and music dies," demonstrate his ability to achieve considerable emotional pathos with simple means, in this case the rise of an octave in the next-to-last bar:

Much of Byrd's instrumental music was written for the virginal, an early keyboard instrument in the form of an oblong box small enough to be placed on a table or even held in the player's lap. It was once believed that the instrument was so called because of its popularity at the court of Elizabeth, the self-styled Virgin Queen, but references have been found to the name before her time, and its true origin is unknown. Forty-two pieces written for the virginal by Byrd were copied down in 1591 in an album known as My Ladye Nevells Booke. They include dances, variations,

and fantasias and form a rich compendium of Byrd's

range of style.

Byrd also wrote madrigals, songs performed by a small group of singers, often for their own entertainment at home. The madrigal had begun its life in Italy, where the words themselves were as important as the music, and Italian composers often chose poems that reflected the Renaissance interest in classical antiquity. The English madrigal was less concerned with Renaissance ideas of refinement than with the expression of emotional extremes. Many of the madrigals of Thomas Morley (1557-1602) are lighthearted in tone and fast moving, making use of refrains like "Fa-la-la." Among the best-known are Sing we and chaunt it and Now is the month of Maying, settings of popular verses rather than literary texts, intended not for an élite but for domestic performance by an increasingly prosperous middle class.

Other madrigals were more serious, even mournful. Both Morley and his younger contemporary Thomas Weelkes (c. 1575-1623) composed madrigals in memory of Henry Noel, an amateur musician who was a favorite at the court of Queen Elizabeth. Weelkes' piece Noel, adieu is striking for its use of extreme dissonances to express grief. In the following bars, the clash of C against C# seems strikingly

modern in its harshness:

The most melancholy works of all Elizabethan music are the ayres of John Dowland (1562-1626), simple songs for one voice accompanied either by other voices or instruments. Dowland is the rare example of an Elizabethan musician who traveled widely. Irish by birth, he visited France, Germany, and Italy and even worked for a while at the court of King Christian IV of Denmark; ultimately he settled in England.

Dowland was the greatest virtuoso of his day on the lute, a plucked string instrument that is a relative of the guitar, and used it to accompany his ayres. Dowland's gloomy temperament was given full expression both in the ayres and in his solo pieces for lute, most of which are as obsessively depressed and woeful as Morley's madrigals are determinedly cheerful. Popular in his own day, in more recent times Dowland's music has undergone something of a revival with the growth of interest in the guitar and other similar instruments.

English Literature: Shakespeare

English literature in the 16th century, unlike the visual arts and to a greater extent even than music, was strongly affected by new currents of Renaissance thought. One reason for this is purely practical. Soon after the invention of printing in Germany (see page 87), William Caxton (c. 1421-1491) introduced the printing press into England, and during the first half of the 16th century books became increasingly plentiful and cheap. With the spread of literature an increased literacy developed, and the new readers were anxious to keep in touch with all the latest ideas of

The development of humanism in England undoubtedly influenced Erasmus of Rotterdam, who was brought into contact with humanist ideas during his visits there. In addition to teaching at Cambridge, Erasmus formed a warm personal friendship with the English statesman Sir Thomas More (1478–1535). who became Lord Chancellor in 1529.

More's Utopia, a philosophical romance in Latin describing an ideal world resembling that of Plato's Republic, was written under Erasmus' influence and was firmly based on humanistic ideals. Once introduced, these ideas caught on, and so did the use of classical or Italian models to express them. Sir Philip Sidney (1554–1586), the dashing youth who has been described as Castiglione's courtier come to life, wrote a series of sonnets in imitation of Petrarch and a romance, Arcadia, of the kind made popular in Italy by Lodovico Ariosto (1474-1533). Edmund Spenser (1552-1599), the greatest nondramatic poet of Elizabethan England, was also influenced by Ariosto and by Torquato Tasso (1544-1595), Ariosto's Italian successor in the production of massive epic poems. In The Faerie Queene Spenser combined the romance of Ariosto and the Christian allegory of Tasso to create an immensely complex epic. Its chivalrous hero, the Knight of the Red Cross, represents both Christianity and, through his resemblance to Saint George, England. At the same time the tests he undergoes make him a Renaissance version of the medieval figure of Everyman. The epic takes place in the imaginary land of Faerie, where the knight's path is frequently blocked by dragons, witches, wizards, and other magical creatures. All this mythological paraphernalia not only advances the plot but also provides a series of allegorical observations on moral and political questions of the day. The result has, in general, been more admired than read.

The greatest of all English achievements in the Renaissance were in drama. The classical models of English drama were the Latin tragedies of Seneca and

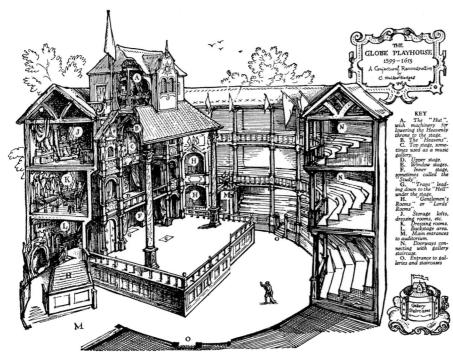

12.29 The Globe Playhouse, London. 1599–1613. This conjectural reconstruction by C. Walter Hodges shows the playhouse during the years when Hamlet, King Lear, and other Shakespearean plays were first performed there.

the comedies of Plautus and Terence, which, with the introduction of printing, became more frequently read and performed. These ancient Roman plays created a taste for the theater that English dramatists began to satisfy in increasing quantities.

At the same time the same prosperity and leisure that created a demand for new madrigals produced a growing audience for drama. To satisfy this audience, traveling groups of actors began to form, often attaching themselves to the household of a noble who acted as their patron. These companies gave performances in public places, especially the courtyards of inns. When the first permanent theater buildings were constructed, their architects imitated the form of the inn courtyards, with roofs open to the sky and galleries around the sides. The stage generally consisted of a large platform jutting out into the center of the open area known as the pit or ground [12.29].

The design of these theaters allowed—indeed, encouraged-people of all classes to attend performances regularly since the price of admission varied for different parts of the theater. The more prosperous spectators sat in the galleries, where they had a clear view of the stage, while the poorer spectators stood around the stage in the ground. Dramatists and actors soon learned to please these so-called groundlings by appealing to their taste for noise and specta-

Not all performances were given in public before so democratic an audience. The most successful companies were invited to entertain Queen Elizabeth and her court. The plays written for these state occasions were generally more sophisticated in both content and style than those for more general performance. The works written for the court of James I, Elizabeth's successor, are among the more elaborate of all.

In general, English drama developed from a relatively popular entertainment in the mid-16th century to a more formal artificial one in the early 17th century. It is probably no coincidence that the greatest of all Elizabethan dramatists, Shakespeare and Marlowe, wrote their best works at about the midpoint in this development, from about 1590 to 1610. Their plays reflect the increasing appreciation and demand for real poetry and high intellectual content without losing the "common touch" that has given their work its continual appeal.

Christopher Marlowe (1564-1593) was born two months before Shakespeare. Had he not been killed in a fight over a tavern bill at the age of 29, he might well have equaled Shakespeare's mighty achievements. It is certainly true that by the same age Shake-

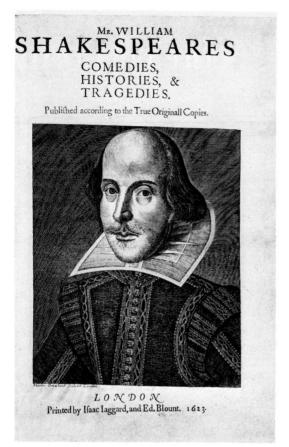

12.30 Title page of the First Folio, the first collected edition of Shakespeare's works, which was prepared by two of the playwright's fellow actors. London, 1623. Rare Books and Manuscripts Division, New York Public Library.

speare had written relatively little of importance, while Marlowe's works include the monumental two-part Tamburlaine, a vast tragic drama that explores the limits of human power; exuberant erotic verse like his Hero and Leander; and his greatest masterpiece, Dr. Faustus. Marlowe's use of blank verse for dramatic expression was imitated by virtually every other Elizabethan playwright, including Shakespeare. It consists of nonrhyming lines of iambic pentameter-lines of five metrical feet in which each foot has two syllables, the second one generally bearing the rhythmic stress. In style Marlowe's works reflect the passion and violence of his own life, their heroes striving to achieve the unachievable by overcoming all limits, only to be defeated by destiny.

Regret at the loss of what Marlowe might have written had he lived longer is balanced by gratitude for the many works William Shakespeare (1564-1616) left us. Shakespeare [12.30] is universally acknowledged the greatest writer in the English language, and one of the very greatest ever in any tongue. His position is best summarized in the words of his leading contemporary and rival playwright Ben Jonson (1572–1637): "He was not of an age, but for all time!"

Surprisingly little is known about Shakespeare's life. He was born at Stratford-upon-Avon; his early years and education seem to have been typical of provincial England, although no details are known. In 1582 he married Anne Hathaway; over the next three years they had three children. By 1592, he was established in London as an actor and playwright. Exactly how he became involved in the theater and what he did from 1585 to 1592 remain a mystery.

From the beginning of his time in London Shakespeare was associated with the leading theatrical company of the day, the Lord Chamberlain's Men, which changed its name to the King's Men at the accession of James I in 1603.

Shakespeare's earliest plays followed the example of classical models in being carefully constructed, although their plots seem sometimes unnecessarily overcomplicated. In the Comedy of Errors (1594-1594), for example, Shakespeare combined two plays by the Roman comic writer Plautus (c. 254–184 B.C.) to create a series of situations racked by mistaken identities and general confusion. The careful manipulation of plot in the early plays is achieved at the expense of characterization, and the poetry tends to use artificial literary devices. Even Shakespeare's first great tragedy, Romeo and Juliet (1595), is not altogether free from an excessive use of puns and plays on words, although the psychological depiction of the young lovers is convincing and the play contains some magnificent passages.

The comedies of the next few years, including both The Merchant of Venice (c. 1596) and Twelfth Night (c. 1600), are more lyrical. The brilliant wit of the earlier plays often is replaced by a kind of wistful melancholy.

Twelfth Night, in fact, is often regarded as Shakespeare's supreme achievement in the field of comedy. Although the plot hinges on a series of well-worn comic devices—mistaken identities, separated twins, and so on—the characters are as vivid and individual as in any of his plays. Furthermore, the work's principal subject, romantic love, is shown from an almost infinite number of points of view. Yet at the same time Shakespeare was attracted to historical subjects, generally drawn from English history, as in Henry IV, Parts I and II (1597-1598), but also from Roman history, as in Julius Caesar.

Julius Caesar (1599) is notable for a number of reasons. It shows that Shakespeare shared the renewed interest of his contemporaries in classical antiquity. It is, in fact, based directly on the *Lives* of Caesar, Brutus, and Mark Antony by the Greek historian Plutarch (c. 46–c. 127), which had appeared in a new translation by Sir Thomas North in 1579. *Julius Caesar* also illustrates Shakespeare's growing interest in psychological motivation rather than simply the sequence of events. The playwright tells us not so much what his characters do as why they do it, making use of the *soliloquy*, a kind of speech in which characters utter their thoughts out loud, without addressing them to anyone else, and thereby reveal to the audience the inner workings of their minds.

The use of this device becomes increasingly common in Shakespeare's supreme achievements, the series of tragedies he wrote between 1600 and 1605: Hamlet (c. 1600), Othello (c. 1604), King Lear (c. 1605), and Macbeth (c. 1605). In dramatic truth, poetic beauty, and profundity of meaning these four plays achieve an artistic perfection equaled only by the tragic dramas of Classical Greece. Through his protagonists, Shakespeare explores the great problems of human existence—the many forms of love, the possibilities and consequences of human error, the mystery of death—with a subtlety and yet a directness that remain miraculous through countless readings or performances and continue to provide inspiration to artists and writers.

Shakespeare's later plays explore new directions. Antony and Cleopatra (c. 1607–1608) returns to Plutarch and to ancient Rome, but with a new richness and magnificence of language. The conciseness of his great tragedies is replaced by a delight in the sound of words, and the play contains some of the most musical of all Shakespearean verse. His very last works examine the borderline between tragedy and comedy with a sophistication that was perhaps intended to satisfy the new aristocratic audience of the court of King James I. The Tempest (1611), set on an enchanted island, blends high romance and low comedy to create a world of fantasy unlike that of any of the other plays.

In the year he wrote *The Tempest*, Shakespeare left London and retired to Stratford to live out the remaining years of his life in comparative prosperity. Although he continued to write, it is tempting to see in the lines he gave to Prospero toward the end of *The Tempest* (IV, i, 148–158) his own farewell to the theater, and to the world he created for it:

Our revels now are ended. These our actors, As I foretold you, were all spirits, and Are melted into air, into thin air. And, like the baseless fabric of this vision, The cloud-capped towers, the gorgeous palaces, The solemn temples, the great globe itself—Yea, all which it inherit—shall dissolve And, like this insubstantial pageant faded, Leave not a rack behind. We are such stuff As dreams are made on, and our little life Is rounded with a sleep.

Summary

The political and cultural life of northern Europe was profoundly changed by the Reformation. After centuries of domination by the Church of Rome, many northern countries gradually switched to one of the various forms of Protestantism, whose ideas and teachings were rapidly spread by the use of the newly invented printing press. The consequences of this division did much to shape modern Europe, while the success of the Reformation movement directly stimulated the Counter-Reformation of the 17th century.

The growth of literacy both north and south of the Alps made possible by the easy availability of books produced a vast new reading public. Among the new literary forms to be introduced was that of the essay, first used by Montaigne. Epic poems were also popular; the works of Lodovico Ariosto and Torquato Tasso circulated widely and were imitated by a number of writers, including Edmund Spenser. The revival of interest in classical drama produced a new and enthusiastic audience for plays; those written by Elizabethan dramatists like Christopher Marlowe combined high poetic and intellectual quality with popular appeal. The supreme achievement in English literature of the time—and perhaps of all time—can be found in the works of William Shakespeare. Furthermore, in an age when the importance of education was emphasized, many advances in science were made and important scientific publications appeared. They included Vesalius' work on anatomy and Copernicus' revolutionary astronomical theories.

In the visual arts the 16th century saw the spread of Italian Renaissance ideas northward. In some cases they were carried by Italian artists like Benvenuto Cellini, who went to work in France. Some major northern artists, like Albrecht Dürer, actually traveled to Italy. Dürer's art was strongly influenced by Italian theories of perspective, proportion, and color, although he retained the strong interest in line typical of northern art. But not all his contemporaries showed the same interest in Italian styles. Matthias Grünewald's paintings do not show Renaissance concerns for humanism and ideal beauty; instead, they draw on traditional medieval German art to project the artist's own passionate religious beliefs, formed against the background of the bitter conflict of the Peasants' War.

The two leading Netherlandish artists of the century, Hieronymus Bosch and Pieter Bruegel the Elder, were also influenced by contemporary religious ideas. Their work has other characteristics in common: a pessimistic attitude toward human nature and the use of satire—yet the final effect is very different. Bosch's paintings are complex and

bizarre; Bruegel shows a broader range of interest in human activities, together with a love of nature.

Elsewhere in northern Europe artistic inspiration was more fitful. The only English painter of note was the miniaturist Nicholas Hilliard, while in France the principal achievements were in the field of architecture. Even in Germany and the Netherlands, by the end of the century the Reformation movement's unsympathetic attitude to the visual arts had produced a virtual end to official patronage for religious art.

Music, on the other hand, was central to Reformation practice: Luther himself was a hymn writer of note. In England, after Henry VIII broke with Rome to form the Anglican Church, the hymns devised by the new church generally followed Reformation practice by using texts in the vernacular rather than in Latin. The music, however, retained the complexity of the Italian style; as a result the religious works of musicians like Tallis and Byrd are among the finest of northern Renaissance compositions.

Secular music also had a wide following throughout northern Europe, particularly as the printing of music became increasingly common. The form of the madrigal, originally devised in Italy, spread to France, Germany, the Netherlands, and England. Many of the works of the leading composers of the day, including the French Clement Janequin and the Flemish Heinrich Isaac, were intended for a popular audience and dealt with romantic or military themes.

Thus the combination of new Renaissance artistic ideas and new Reformation religious teachings roused northern Europe from its conservative traditions and stimulated a series of vital cultural developments.

Pronounciation Guide

Altdorfer: ALT-door-fer Apocalypse: ah-POC-a-lips

Bosch: BOSH Bruegel: BROY-gull

Bvrd: BIRD

Chambord: Sham-BORE Chanson: Shans-ON

Copernicus: Cop-EARN-ik-us

Dürer: DUE-rer

Grunewald: GROON-ee-vald Guttenberg: GOOT-en-burg

Holbein: HOLE-bine Isenheim: IZ-en-hime Janequin: ZHAN-u-can

Loire: LWAR Luther: LOO-ther Montaigne: Mont-ANE Polyphonic: Pol-i-FON-ic

Exercises

- 1. Discuss the career of Albrecht Dürer and compare his work with that of his contemporaries in Germany and
- 2. What were the principal causes of the Reformation? What was its impact on the development of the arts?
- 3. Describe the effect of the spread of humanism in northern Europe. What part was played by the invention of printing?
- 4. What are the main features of musical development during the 16th century? Discuss the relationship between sacred and secular music.
- 5. Describe Shakespeare's development as a dramatist and analyse the plot of one of his plays.

Further Reading

- Campbell, O. J., and E. G. Quinn (eds.). A Shakespeare Encyclopedia. New York: Crowell, 1966. A valuable source of information on a wide variety of Shakespearean topics.
- Davis, N. Society and Culture in Early Modern France. Stanford, Calif: Stanford University Press, 1975. A study of popular culture in the 16th and 17th centuries that makes use of much fascinating material.
- Dickens, A. G. Reformation and Society in Sixteenth Century Europe. New York: Harcourt Brace Jovanovich, 1966. A traditional account of social trends in Reformation Europe.
- Eisenstein, E. The Printing Press as an Instrument of Change. Cambridge: Cambridge University Press, 1979. An important book on an important subject; discusses conventional books and also woodcuts, broadsheets, and printed illustrations.
- Hitchcock, H. R. German Renaissance Architecture. Princeton, N.J.: Princeton University Press, 1981. A wellillustrated study of a surprisingly neglected field; provides a background to contemporary achievements in other artistic fields.
- Leech, C. Twelfth Night and Shakespearian Comedy. Toronto: University of Toronto Press, 1968. An analysis of the play that sets it in context among Shakespeare's other comedies.
- Newman, J. Renaissance Music. Englewood Cliffs, N.J.: Prentice-Hall, 1965. A handy and compact account of the main developments in Renaissance music throughout Europe.
- Ozment, S. Reformation Europe: A Guide to Research. St. Louis, Mo.: St. Louis University Press, 1982. This very useful collection of essays deals with a variety of aspects of Reformation life: art, society and the sexes, and others.

Panofsky, E. The Life and Art of Albrecht Dürer. Princeton, N.J.: Princeton University Press, 1971. A magisterial account by one of the greatest of all art historians. Difficult at times but immensely rewarding.

Rose, M. B. Women in the Middle Ages and the Renaissance. Syracuse, N.Y.: Syracuse University Press, 1986. An anthology of readings that brings together a great deal of remarkable material and casts light on a subject that has only recently begun to be studied in its own right.

Snyder, J. Northern Renaissance Art. Englewood Cliffs, N.J.: Prentice-Hall, 1985. The most up-to-date general survey of painting, sculpture, and the graphic arts in northern Europe from 1350 to 1575.

Reading Selections

Michel Eyquem de Montaigne OF REPENTANCE

The essay "Of Repentance" is Montaigne at his best and most typical. Although the title of the work suggests a religious tract, there is almost no Christian or biblical reference. It is his own personal experience that most excites Montaigne, who has the rare habit of looking at all sides of a question without forming a dogmatic opinion. His style is speculative and meditative. Even in translation we can sense the easy, lucid style of writing. It is little wonder that once his Essays were available to the English in translation his essay style should have been so eagerly imitated.

Others form man; I tell of him, and portray a particular one, very ill-formed, whom I should really make very different from what he is if I had to fashion him over again. But now it is done.

Now the lines of my painting do not go astray, though they change and vary. The world is but a perennial movement. All things in it are in constant motion—the earth, the rocks of the Caucasus, the pyramids of Egypt—both with the common motion and with their own. Stability itself is nothing but a more languid motion.

I cannot keep my subject still. It goes along befuddled and staggering, with a natural drunkenness. I take it in this condition, just as it is at the moment I give my attention to it. I do not portray being: I portray passing. Not the passing from one age to another, or, as the people say, from seven years to seven years, but from day to day, from minute to minute. My history needs to be adapted to the moment. I may presently change, not only by chance, but also by intention. This is a record of various and changeable occurrences, and of irresolute and, when it so befalls, contradictory ideas: whether I am different myself, or whether I take hold of my subjects in

different circumstances and aspects. So, all in all, I may indeed contradict myself now and then; but truth, as Demades said, I do not contradict. If my mind could gain a firm footing, I would not make essays, I would make decisions; but it is always in apprenticeship and on trial.

I set forth a humble and inglorious life; that does not matter. You can tie up all moral philosophy with a common and private life just as well as with a life of richer stuff. Each man bears the entire form of man's estate.

Authors communicate with the people by some special extrinsic mark; I am the first to do so by my entire being, as Michel de Montaigne, not as a grammarian or a poet or a jurist. If the world complains that I speak too much of myself, I complain that it does not even think of itself.

But is it reasonable that I, so fond of privacy in actual life, should aspire to publicity in the knowledge of me? Is it reasonable too that I should set forth to the world, where fashioning and art have so much credit and authority, some crude and simple products of nature, and of a very feeble nature at that? Is it not making a wall without stone, or something like that, to construct books without knowledge and without art? Musical fancies are guided by art, mine by chance.

At least I have one thing according to the rules: that no man ever treated a subject he knew and understood better than I do the subject I have undertaken; and that in this I am the most learned man alive. Secondly, that no man ever penetrated more deeply into his material, or plucked its limbs and consequences cleaner, or reached more accurately and fully the goal he had set for his work. To accomplish it, I need only bring it to fidelity; and that is in it, as sincere and pure as can be found. I speak the truth, not my fill of it, but as much as I dare speak; and I dare to do so a little more as I grow old, for it seems that custom allows old age more freedom to prate and more indiscretion in talking about oneself. It cannot happen here as I see it happening often, that the craftsman and his work contradict each other: "Has a man whose conversation is so good written such a stupid book?" or "Have such learned writings come from a man whose conversation is so feeble?"

If a man is commonplace in conversation and rare in writing, that means that his capacity is in the place from which he borrows it, and not in himself. A learned man is not learned in all matters; but the capable man is capable in all matters, even in ignorance.

In this case we go hand in hand and at the same pace, my book and I. In other cases one may commend or blame the work apart from the workman; not so here; he who touches the one, touches the

other. He who judges it without knowing it will injure himself more than me; he who has known it will completely satisfy me. Happy beyond my deserts if I have just this share of public approval, that I make men of understanding feel that I was capable of profiting by knowledge, if I had had any, and that I deserved better assistance from my memory.

Let me here excuse what I often say, that I rarely repent and that my conscience is content with itself not as the conscience of an angel or a horse, but as the conscience of a man; always adding this refrain, not perfunctorily but in sincere and complete submission: that I speak as an ignorant inquirer, referring the decision purely and simply to the common and authorized beliefs. I do not teach, I tell.

There is no vice truly a vice which is not offensive, and which a sound judgment does not condemn; for its ugliness and painfulness is so apparent that perhaps the people are right who say it is chiefly produced by stupidity and ignorance. So hard it is to imagine anyone knowing it without hating it.

Malice sucks up the greater part of its own venom, and poisons itself with it. Vice leaves repentance in the soul, like an ulcer in the flesh, which is always scratching itself and drawing blood. For reason effaces other griefs and sorrows; but it engenders that of repentance, which is all the more grievous because it springs from within, as the cold and heat of fevers is sharper than that which comes from outside. I consider as vices (but each one according to its measure) not only those that reason and nature condemn, but also those that man's opinion has created, even false and erroneous opinion, if it is authorized by laws and customs.

There is likewise no good deed that does not rejoice a wellborn nature. Indeed there is a sort of gratification in doing good which makes us rejoice in ourselves, and a generous pride that accompanies a good conscience. A boldly vicious soul may perhaps arm itself with security, but with this complacency and satisfaction it cannot provide itself. It is no slight pleasure to feel oneself preserved from the contagion of so depraved an age, and to say to oneself: "If anyone should see right into my soul, still he would not find me guilty either of anyone's affliction or ruin, or of vengeance or envy, or of public offense against the laws, or of innovation and disturbance, or of failing in my word; and in spite of what the license of the times allows and teaches each man, still I have not put my hand either upon the property or into the purse of any Frenchman, and have lived only on my own, both in war and in peace; nor have I used any man's work without paying his wages." These testimonies of conscience give us pleasure; and this natural rejoicing is a great boon to us, and the only payment that never fails us.

To found the reward for virtuous actions on the approval of others is to choose too uncertain and shaky a foundation. Especially in an age as corrupt and ignorant as this, the good opinion of the people is a dishonor. Whom can you trust to see what is praise-worthy? God keep me from being a worthy man according to the descriptions I see people every day giving of themselves in their own honor. What were vices now are moral acts [Seneca].

Certain of my friends have sometimes undertaken to call me on the carpet and lecture me unreservedly, either of their own accord or at my invitation, as a service which, to a well-formed soul, surpasses all the services of friendship, not only in usefulness, but also in pleasantness. I have always welcomed it with the wide-open arms of courtesy and gratitude. But to speak of it now in all conscience, I have often found in their reproach or praise such false measure that I would hardly have erred to err rather than to do good in their fashion.

Those of us especially who live a private life that is on display only to ourselves must have a pattern established within us by which to test our actions, and, according to this pattern, now pat ourselves on the back, now punish ourselves. I have my own laws and court to judge me, and I address myself to them more than anywhere else. To be sure, I restrain my actions according to others, but I extend them only according to myself. There is no one but yourself who knows whether you are cowardly and cruel, or loyal and devout. Others do not see you, they guess at you by uncertain conjectures; they see not so much your nature as your art. Therefore do not cling to their judgment; cling to your own. You must use your own judgment. . . . With regard to virtues and vices, your own conscience has great weight: take that away, and everything falls [Cicero].

But the saying that repentance follows close upon sin does not seem to consider the sin that is in robes of state, that dwells in us as in its own home. We can disown and retract the vices that take us by surprise, and toward which we are swept by passion; but those which by long habit are rooted and anchored in a strong and vigorous will cannot be denied. Repentance is nothing but a disavowal of our will and an opposition to our fancies, which leads us about in all directions. It makes this man disown his past virtue and his continence:

Why had I not in youth the mind I have today? Or why, with old desires, have red cheeks flown away? HORACE

It is a rare life that remains well ordered even in private. Any man can play his part in the side show and represent a worthy man on the boards; but to be disciplined within, in his own bosom, where all is permissible, where all is concealed—that's the point. The next step to that is to be so in our own house, in our ordinary actions, for which we need render account to no one, where nothing is studied or artificial. And therefore Bias, depicting an excellent state of family life, says it is one in which the master is the same within, by his own volition, as he is outside for fear of the law and of what people will say. And it was a worthy remark of Julius Drusus to the workmen who offered, for three thousand crowns, to arrange his house so that his neighbors would no longer be able to look into it as they could before. "I will give you six thousand," he said; "make it so that everyone can see in from all sides." The practice of Agesilaus is noted with honor, of taking lodging in the churches when traveling, so that the people and the gods themselves might see into his private actions. Men have seemed miraculous to the world, in whom their wives and valets have never seen anything even worth noticing. Few men have been admired by their own households.

No man has been a prophet, not merely in his own house, but in his own country, says the experience of history. Likewise in things of no importance. And in this humble example you may see an image of greater ones. In my region of Gascony they think it a joke to see me in print. The farther from my lair the knowledge of me spreads, the more I am valued. I buy printers in Guienne, elsewhere they buy me. On this phenomenon those people base their hopes who hide themselves while alive and present, to gain favor when dead and gone. I would rather have less of it. And I cast myself on the world only for the share of favor I get now. When I leave it, I shall hold it quits.

The people escort this man back to his door, with awe, from a public function. He drops his part with his gown; the higher he has hoisted himself, the lower he falls back; inside, in his home, everything is tumultuous and vile. Even if there is order there, it takes a keen and select judgment to perceive it in these humble private actions. Besides, order is a dull and somber virtue. To win through a breach, to conduct an embassy, to govern a people, these are dazzling actions. To scold, to laugh, to sell, to pay, to love, to hate, and to deal pleasantly and justly with our household and ourselves, not to let ourselves go, not to be false to ourselves, that is a rarer matter, more difficult and less noticeable.

Therefore retired lives, whatever people may say, accomplish duties as harsh and strenuous as other lives, or more so. And private persons, says Aristotle, render higher and more difficult service to virtue than those who are in authority. We prepare ourselves for eminent occasions more for glory than for conscience. The shortest way to attain glory would be to do for conscience what we do for glory. And Alexander's virtue seems to me to represent much less vigor in his theater than does that of Socrates in his lowly and obscure activity. I can easily imagine Socrates in Alexander's place; Alexander in that of Socrates, I cannot. If you ask the former what he knows how to do, he will answer, "Subdue the world"; if you ask the latter, he will say, "Lead the life of man in conformity with its natural condition"; a knowledge much more general, more weighty, and more legitimate.

The value of the soul consists not in flying high, but in an orderly pace. Its greatness is exercised not in greatness, but in mediocrity. As those who judge and touch us inwardly make little account of the brilliance of our public acts, and see that these are only thin streams and jets of water spurting from a bottom otherwise muddy and thick; so likewise those who judge us by this brave outward appearance draw similar conclusions about our inner constitution, and cannot associate common faculties, just like their own, with these other faculties that astonish them and are so far beyond their scope. So we give demons wild shapes. And who does not give Tamerlane raised evebrows, open nostrils, a dreadful face, and immense size, like the size of the imaginary picture of him we have formed from the renown of his name? If I had been able to see Erasmus in other days, it would have been hard for me not to take for adages and apophthegms everything he said to his valet and his hostess. We imagine much more appropriately an artisan on the toilet seat or on his wife than a great president, venerable by his demeanor and his ability. It seems to us that they do not stoop from their lofty thrones even to live.

As vicious souls are often incited to do good by some extraneous impulse, so are virtuous souls to do evil. Thus we must judge them by their settled state, when they are at home, if ever they are; or at least when they are closest to repose and their natural position.

Natural inclinations gain assistance and strength from education; but they are scarcely to be changed and overcome. A thousand natures, in my time, have escaped toward virtue or toward vice through the lines of a contrary training:

As when wild beasts grow tame, shut in a cage, Forget the woods, and lose their look of rage, And learn to suffer man; but if they taste Hot blood, their rage and fury is replaced, Their reminiscent jaws distend, they burn, And for their trembling keeper's blood they yearn.

We do not root out these original qualities, we cover them up, we conceal them. Latin is like a native tongue to me; I understand it better than French; but for forty years I have not used it at all for speaking or writing. Yet in sudden and extreme emotions, into which I have fallen two or three times in my life one of them when I saw my father, in perfect health, fall back into my arms in a faint—I have always poured out my first words from the depths of my entrails in Latin; Nature surging forth and expressing herself by force, in the face of long habit. And this experience is told of many others.

Those who in my time have tried to correct the world's morals by new ideas, reform the superficial vices; the essential ones they leave as they were, if they do not increase them; and increase is to be feared. People are likely to rest from all other welldoing on the strength of these external, arbitrary reforms, which cost us less and bring greater acclaim; and thereby they satisfy at little expense the other natural, consubstantial, and internal vices.

Just consider the evidence of this in our own experience. There is no one who, if he listens to himself, does not discover in himself a pattern all his own, a ruling pattern, which struggles against education and against the tempest of the passions that oppose it. For my part, I do not feel much sudden agitation; I am nearly always in place, like heavy and inert bodies. If I am not at home, I am always very near it. My excesses do not carry me very far away. There is nothing extreme or strange about them. And besides I have periods of vigorous and healthy reaction.

The real condemnation, which applies to the common run of men of today, is that even their retirement is full of corruption and filth; their idea of reformation, blurred; their penitence, diseased and guilty, almost as much as their sin. Some, either from being glued to vice by a natural attachment, or from long habit, no longer recognize its ugliness. On others (in whose regiment I belong) vice weighs heavily, but they counterbalance it with pleasure or some other consideration, and endure it and lend themselves to it for a certain price; viciously, however, and basely. Yet it might be possible to imagine a disproportion so extreme that the pleasure might justly excuse the sin, as we say utility does; not only if the pleasure was incidental and not a part of the sin, as in theft, but if it was in the very exercise of the sin, as in intercourse with women, where the impulse is violent, and, they say, sometimes invincible.

The other day when I was at Armagnac, on the estate of a kinsman of mine, I saw a country fellow whom everyone nicknames the Thief. He gave this account of his life: that born a beggar, and finding that by earning his bread by the toil of his hands he would never protect himself enough against want, he had decided to become a thief; and he had spent all his youth at this trade in security, by virtue of his bodily strength. For he reaped his harvest and vintage from

other people's lands, but so far away and in such great loads that it was inconceivable that one man could have carried off so much on his shoulders in one night. And he was careful besides to equalize and spread out the damage he did, so that the loss was less insupportable for each individual. He is now, in his old age, rich for a man in his station, thanks to this traffic, which he openly confesses. And to make his peace with God for his acquisitions, he says that he spends his days compensating, by good deeds, the successors of the people he robbed; and that if he does not finish this task (for he cannot do it all at once), he will charge his heirs with it, according to the knowledge, which he alone has, of the amount of wrong he did to each. Judging by this description, whether it is true or false, this man regards theft as a dishonorable action and hates it, but hates it less than poverty; he indeed repents of it in itself, but in so far as it was thus counterbalanced and compensated, he does not repent of it. This is not that habit that incorporates us with vice and brings even our understanding into conformity with it; nor is it that impetuous wind that comes in gusts to confuse and blind our soul, and hurls us for the moment headlong, judgment and all, into the power of vice.

I customarily do wholeheartedly whatever I do, and go my way all in one piece. I scarcely make a motion that is hidden and out of sight of my reason, and that is not guided by the consent of nearly all parts of me, without division, without internal sedition. My judgment takes all the blame or all the praise for it; and the blame it once takes, it always keeps, for virtually since its birth it has been one; the same inclination, the same road, the same strength. And in the matter of general opinions, in childhood I established myself in the position where I was to remain.

There are some impetuous, prompt, and sudden sins: let us leave them aside. But as for these other sins so many times repeated, planned, and premeditated, constitutional sins, or even professional or vocational sins, I cannot imagine that they can be implanted so long in one and the same heart, without the reason and conscience of their possessor constantly willing and intending it to be so. And the repentance which he claims comes to him at a certain prescribed moment is a little hard for me to imagine and conceive.

I do not follow the belief of the sect of Pythagoras, that men take on a new soul when they approach the images of the gods to receive their oracles. Unless he meant just this, that the soul must indeed be foreign, new, and loaned for the occasion, since their own showed so little sign of any purification and cleanness worthy of this office.

They do just the opposite of the Stoic precepts,

which indeed order us to correct the imperfections and vices that we recognize in us, but forbid us to be repentant and glum about them. These men make us believe that they feel great regret and remorse within; but of amendment and correction, or interruption, they show us no sign. Yet it is no cure if the disease is not thrown off. If repentance were weighing in the scale of the balance, it would outweigh the sin. I know of no quality so easy to counterfeit as piety, if conduct and life are not made to conform with it. Its essence is abstruse and occult; its semblance, easy and showy.

As for me, I may desire in a general way to be different; I may condemn and dislike my nature as a whole, and implore God to reform me completely and to pardon my natural weakness. But this I ought not to call repentance, it seems to me, any more than my displeasure at being neither an angel nor Cato. My actions are in order and conformity with what I am and with my condition. I can do no better. And repentance does not properly apply to the things that are not in our power; rather does regret. I imagine numberless natures loftier and better regulated than mine, but for all that, I do not amend my faculties; just as neither my arm nor my mind becomes more vigorous by imagining another that is so. If imagining and desiring a nobler conduct than ours produced repentance of our own, we should have to repent of our most innocent actions, inasmuch as we rightly judge that in a more excellent nature they would have been performed with greater perfection and dignity, and we should wish to do likewise.

When I consider the behavior of my youth in comparison with that of my old age, I find that I have generally conducted myself in orderly fashion, according to my lights; that is all my resistance can accomplish. I do not flatter myself; in similar circumstances I should always be the same. It is not a spot, it is rather a tincture with which I am stained all over. I know no superficial, halfway, and perfunctory repentance. It must affect me in every part before I will call it so, and must grip me by the vitals and afflict them as deeply and as completely as God sees unto me.

In business matters, several good opportunities have escaped me for want of successful management. However, my counsels have been good, according to the circumstances they were faced with; their way is always to take the easiest and surest course. I find that in my past deliberations, according to my rule, I have proceeded wisely, considering the state of the matter proposed to me, and I should do the same a thousand years from now in similar situations. I am not considering what it is at this moment, but what it was when I was deliberating about it.

The soundness of any plan depends on the time; circumstances and things roll about and change incessantly. I have fallen into some serious and important mistakes in my life, not for lack of good counsel but for lack of good luck. There are secret parts in the matters we handle which cannot be guessed, especially in human nature—mute factors that do not show, factors sometimes unknown to their possessor himself, which are brought forth and aroused by unexpected occasions. If my prudence has been unable to see into them and predict them, I bear it no ill will; its responsibility is restricted within its limitations. It is the outcome that beats me; and if it favors the course I have refused, there is no help for it; I do not blame myself; I accuse my luck, not my work. That is not to be called repentance.

Phocion had given the Athenians some advice that was not followed. When however the affair came out prosperously against his opinion, someone said to him: "Well, Phocion, are you glad that the thing is going so well?" "Indeed I am glad," he said, "that it has turned out this way, but I do not repent of having advised that way."

When my friends apply to me for advice, I give it freely and clearly, and without hesitating as nearly everyone else does because, the affair being hazardous, it may come out contrary to my expectations, wherefore they may have cause to reproach me for my advice; that does not worry me. For they will be wrong, and I should not have refused them this ser-

I have scarcely any occasion to blame my mistakes or mishaps on anyone but myself. For in practice I rarely ask other people's advice, unless as a compliment and out of politeness, except when I need scientific information or knowledge of the facts. But in things where I have only my judgment to employ, other people's reasons can serve to support me, but seldom to change my course. I listen to them all favorably and decently; but so far as I can remember, I have never up to this moment followed any but my own. If you ask me, they are nothing but flies and atoms that distract my will. I set little value on my own opinions, but I set just as little on those of others. Fortune pays me properly. If I do not take advice, I give still less. Mine is seldom asked, but it is followed even less; and I know of no public or private enterprise that my advice restored to its feet and to the right path. Even the people whom fortune has made somewhat dependent on it have let themselves be managed more readily by anyone else's brains. Being a man who is quite as jealous of the rights of my repose as of the rights of my authority, I prefer it so; by leaving me alone, they treat me according to my professed principle, which is to be wholly contained and established within myself. To me it is a pleasure not to be concerned in other people's affairs and to be free of responsibility for them.

In all affairs, when they are past, however they have turned out, I have little regret. For this idea takes away the pain: that they were bound to happen thus, and now they are in the great stream of the universe and in the chain of Stoical causes. Your fancy, by wish or imagination, cannot change a single point without overturning the whole order of things, and the past and the future.

For the rest, I hate that accidental repentance that age brings. The man who said of old that he was obliged to the years for having rid him of sensuality had a different viewpoint from mine; I shall never be grateful to impotence for any good it may do me. Nor will Providence ever be so hostile to her own work that debility should be ranked among the best things [Quintilian]. Our appetites are few in old age; a profound satiety seizes us after the act. In that I see nothing of conscience; sourness and weakness imprint on us a sluggish and rheumatic virtue. We must not let ourselves be so carried away by natural changes as to let our judgment degenerate. Youth and pleasure in other days did not make me fail to recognize the face of vice in voluptuousness; nor does the distaste that the years bring me make me fail to recognize the face of voluptuousness in vice. Now that I am no longer in that state, I judge it as though I were in it.

I who shake up my reason sharply and attentively find that it is the very same I had in my more licentious years, except perhaps in so far as it has grown weaker and worse as it has grown old. And I find that even if it refuses, out of consideration for the interests of my bodily health, to put me in the furnace of this pleasure, it would not refuse to do so, any more than formerly, for my spiritual health. I do not consider it any more valiant for seeing it hors de combat. My temptations are so broken and mortified that they are not worth its opposition. By merely stretching out my hands to them, I exorcise them. If my reason were confronted with my former lust, I fear that it would have less strength to resist than it used to have. I do not see that of itself it judges anything differently than it did then, nor that it has gained any new light. Wherefore, if there is any convalescence, it is a deformed convalescence.

Miserable sort of remedy, to owe our health to disease! It is not for our misfortune to do us this service, it is for the good fortune of our judgment. You cannot make me do anything by ills and afflictions except curse them. They are for people who are only awakened by whipping. My reason runs a much freer course in prosperity. It is much more distracted and busy digesting pains than pleasures. I see much more clearly in fair weather. Health admonishes me more cheerfully and so more usefully than sickness. I advanced as far as I could toward reform and a regulated life when I had health to enjoy. I should be ashamed and resentful if the misery and misfortune of my decrepitude were to be thought better than my good, healthy, lively, vigorous years, and if people were to esteem me not for what I have been, but for ceasing to be that.

In my opinion it is living happily, not, as Antisthenes said, dying happily, that constitutes human felicity. I have made no effort to attach, monstrously, the tail of a philosopher to the head and body of a dissipated man; or that this sickly remainder of my life should disavow and belie its fairest, longest, and most complete part. I want to present and show myself uniformly throughout. If I had to live over again, I would live as I have lived. I have neither tears for the past nor fears for the future. And unless I am fooling myself, it has gone about the same way within me as without. It is one of the chief obligations I have to my fortune that my bodily state has run its course with each thing in due season. I have seen the grass, the flower, and the fruit; now I see the dryness—happily, since it is naturally. I bear the ills I have much more easily because they are properly timed, and also because they make me remember more pleasantly the long felicity of my past life.

Likewise my wisdom may well have been of the same proportions in one age as in the other; but it was much more potent and graceful when green, gay, and natural, than it is now, being broken down, peevish, and labored. Therefore I renounce these casual and painful reformations.

God must touch our hearts. Our conscience must reform by itself through the strengthening of our reason, not through the weakening of our appetites. Sensual pleasure is neither pale nor colorless in itself for being seen through dim and bleary eyes. We should love temperance for itself and out of reverence toward God, who has commanded it, and also chastity; what catarrh lends us, and what I owe to the favor of my colic, is neither chastity nor temperance. We cannot boast of despising and fighting sensual pleasure, if we do not see or know it, and its charms, its powers, and its most alluring beauty.

I know them both; I have a right to speak; but it seems to me that in old age our souls are subject to more troublesome ailments and imperfections than in our youth. I used to say so when I was young; then they taunted me with my beardless chin. I still say so now that my gray hair gives me authority to speak. We call "wisdom" the difficulty of our humors, our distaste for present things. But in truth we do not so much abandon our vices as change them, and, in my opinion, for the worse. Besides a silly and decrepit pride, a tedious prattle, prickly and unsociable humors, superstition, and a ridiculous concern for riches when we have lost the use of them, I find there more envy, injustice, and malice. Old age puts more

wrinkles in our minds than on our faces; and we never, or rarely, see a soul that in growing old does not come to smell sour and musty. Man grows and dwindles in his entirety.

Seeing the wisdom of Socrates and several circumstances of his condemnation, I should venture to believe that he lent himself to it to some extent, purposely, by prevarication, being seventy, and having so soon to suffer an increasing torpor of the rich activity of his mind, and the dimming of its accustomed brightness.

What metamorphoses I see old age producing every day in many of my acquaintances! It is a powerful malady, and it creeps up on us naturally and imperceptibly. We need a great provision of study, and great precaution, to avoid the imperfections it loads upon us, or at least to slow up their progress. I feel that, notwithstanding all my retrenchments, it gains on me foot by foot. I stand fast as well as I can. But I do not know where it will lead even me in the end. In any event, I am glad to have people know whence I shall have fallen.

William Shakespeare TWELFTH NIGHT

From its first performances in 1601, Twelfth Night has been among Shakespeare's most popular and most frequently performed plays. Unlike some of his earlier comedies, its humor depends not on wordplay or on topical allusion but on the endless fascination of human behavior. Its principal subject, as the opening line of the play makes clear, is love. In the course of the first act we learn that the beautiful Countess Olivia is loved by three men: Orsino, Duke of Illyria (the imaginary land where the play is set); the weak-minded and foppish Sir Andrew Aguecheek; and Malvolio, the steward of Olivia's household, a man whose dour humorlessness is equaled only by his self-importance. Olivia complicates things further for herself by falling in love with Cesario—a young man who is in fact a girl, Viola, separated from her twin brother Sebastian in a shipwreck. To complete the circle, Viola falls in love with Orsino. By the end of the act, Shakespeare has set out the three planes on which the action moves: the world of Orsino, with his self-indulgent romantic melancholy; the realm of Viola's energy and independence (like many of Shakespeare's heroines, Viola shows considerable resourcefulness); and Olivia's lively household, which includes, in addition to Malvolio and Sir Andrew, Olivia's disreputable uncle Sir Toby Belch.

Throughout the ensuing entanglements the various threads of the plot are connected and interwoven by one of Shakespeare's most inspired and poetic inventions, the

ironic figure of Feste, the clown. Organizer of the ruse that leads Malvolio to make a fool of himself and introducer of Sebastian, Viola's lost brother, into Olivia's household with unexpected consequences, the clown punctuates the play with his songs and ends it with an odd little ditty that seems to question the real meaning of all the heartache and happiness we have been watching.

The clown's songs serve to underline the importance of music in a play that is among Shakespeare's most lyrical. The opening lines of Twelfth Night once again point the way; indeed, as Orsino's first words make clear, we hear music before any human sound. From then on the romantic beauty of the language, the almost symphonic interweaving of the various themes, and the actual use of music in the clown's songs all give a special resonance to this funny, touching, human comedy.

Persons Represented

orsino. Duke of Illyria SEBASTIAN, brother to VIOLA ANTONIO, a sea captain, friend to SEBASTIAN A SEA CAPTAIN, friend to VIOLA VALENTINE,) gentlemen attending the Duke CURIO, SIR TOBY BELCH, uncle to OLIVIA SIR ANDREW AGUECHEEK MALVOLIO, steward to OLIVIA FABIAN, servants to OLIVIA FESTE, a Clown,

OLIVIA, a countess VIOLA, sister to SEBASTIAN MARIA, attendant to OLIVIA

Lords, a Priest, Sailors, Officers, Musicians, and Attendants

Scene: A city in Illyria, and the nearby seacoast

Act I

Scene I. The Duke's Palace.

Enter ORSINO (Duke of Illyria), CURIO and other LORDS; [and MUSICIANS]. DUKE If music be the food of love, play on; Give me excess of it, that, surfeiting, The appetite may sicken, and so die. That strain again! It had a dying fall; O, it came o'er my ear like the sweet sound That breathes upon a bank of violets, Stealing and giving odor! Enough, no more! 'Tis not so sweet now as it was before. O spirit of love, how quick and fresh art thou, That, notwithstanding thy capacity Receiveth as the sea, naught enters there,

Of what validity and pitch soe'er, But falls into abatement and low price Even in a minute! So full of shapes is fancy That it alone is high fantastical. Will you go hunt, my lord? CURIO What, Curio? DUKE

The hart. CURIO

DUKE Why, so I do, the noblest that I have. O, when mine eyes did see Olivia first, Methought she purged the air of pestilence! That instant was I turned into a hart, And my desires, like fell and cruel hounds, E'er since pursue me.

Enter VALENTINE.

How now? What news from her? VALENTINE So please my lord, I might not be admitted.

But from her handmaid do return this answer: The element itself, till seven years' heat, Shall not behold her face at ample view; But like a cloistress she will veiled walk. And water once a day her chamber round With eye-offending brine: all this to season A brother's dead love, which she would keep

And lasting in her sad remembrance. DUKE O, she that hath a heart of that fine frame To pay this debt of love but to a brother, How will she love when the rich golden shaft Hath killed the flock of all affections else That live in her; when liver, brain, and heart, These sovereign thrones, are all supplied and

Her sweet perfections, with one self king! Away before me to sweet beds of flowers! Love-thoughts lie rich when canopied with bowers.

Exeunt.

20

Scene II. The seacoast.

VIOLA What country, friends, is this? CAPTAIN This is Illyria, lady. VIOLA And what should I do in Illyria? My brother he is in Elysium. Perchance he is not drowned: what think you, sailors? CAPTAIN It is perchance that you yourself were

Enter VIOLA, a CAPTAIN, and SAILORS.

VIOLA O my poor brother! and so perchance may he be.

CAPTAIN True, madam; and, to comfort you with

Assure yourself, after our ship did split,

When you, and those poor number saved with

Hung on our driving boat, I saw your brother, Most provident in peril, bind himself (Courage and hope both teaching him the

To a strong mast that lived upon the sea; Where, like Arion on the dolphin's back. I saw him hold acquaintance with the waves So long as I could see.

VIOLA For saying so, there's gold. Mine own escape unfoldeth to my hope, Whereto thy speech serves for authority, The like of him. Knowst thou this country? CAPTAIN Ay, madam, well, for I was bred and born

60

70

Not three hours' travel from this very place. VIOLA Who governs here? CAPTAIN A noble duke, in nature as in name. VIOLA What is his name? CAPTAIN Orsino. VIOLA Orsino! I have heard my father name

He was a bachelor then.

him.

CAPTAIN And so is now, or was so very late; For but a month ago I went from hence, And then 'twas fresh in murmur (as you know What great ones do, the less will prattle of) That he did seek the love of fair Olivia. VIOLA What's she?

CAPTAIN A virtuous maid, the daughter of a count

That died some twelvemonth since; then leaving

In the protection of his son, her brother, Who shortly also died; for whose dear love, They say, she hath abjured the sight And company of men.

O that I served that lady, And might not be delivered to the world, Till I had made mine own occasion mellow, What my estate is!

That were hard to compass, Because she will admit no kind of suit; No, not the Duke's.

VIOLA There is a fair behavior in thee, Captain; And though that nature with a beauteous wall Doth oft close in pollution, yet of thee I will believe thou hast a mind that suits With this thy fair and outward character. I prithee (and I'll pay thee bounteously) Conceal me what I am, and be my aid For such disguise as haply shall become The form of my intent. I'll serve this duke. Thou shalt present me as an eunuch to him; It may be worth thy pains. For I can sing,

And speak to him in many sorts of music That will allow me very worth his service. What else may hap, to time I will commit; Only shape thou thy silence to my wit.

CAPTAIN Be you his eunuch, and your mute I'll be.

When my tongue blabs, then let mine eyes not

VIOLA I thank thee. Lead me on.

Exeunt.

Scene III. OLIVIA's house.

Enter SIR TOBY and MARIA.

TOBY What a plague means my niece to take the death of her brother thus? I am sure care's an enemy to life.

MARIA By my troth, Sir Toby, you must come in earlier o' nights. Your cousin, my lady, takes great exceptions to your ill hours.

TOBY Why, let her except before excepted!

MARIA Ay, but you must confine yourself within the modest limits of order.

Confine? I'll confine myself no finer than I am. These clothes are good enough to drink in, and so be these boots too. An they be not, let them hang themselves in their own straps.

MARIA That quaffing and drinking will undo you. I heard my lady talk of it yesterday; and of a foolish knight that you brought in one night here to be her wooer.

Who? Sir Andrew Aguecheek? TOBY

MARIA Av, he.

TOBY He's as tall a man as any's in Illyria.

MARIA What's that to the purpose?

TOBY Why, he has three thousand ducats a year. MARIA Ay, but he'll have but a year in all these duc- 130

ats. He's a very fool and a prodigal.

TOBY Fie that you'll say so! He plays o' the viol de gamboys, and speaks three or four languages word for word without book, and hath all the good gifts of nature.

MARIA He hath, indeed, almost natural! for, besides that he's a fool, he's a great quarreler; and but that he hath the gift of a coward to allay the gust he hath in quarreling, 'tis thought among the prudent he would quickly have the gift of a grave. 140

TOBY By this hand, they are scoundrels and substractors that say so of him. Who are they?

MARIA They that add, moreover, he's drunk nightly

in your company.

TOBY With drinking healths to my niece. I'll drink to her as long as there is a passage in my throat and drink in Illyria. He's a coward and a coistrel that will not drink to my niece till his brains turn o' the toe like a parish top. What, wench! Castiliano vulgo! for here comes Sir Andrew Agueface. 150 Enter SIR ANDREW.

ANDREW Sir Toby Belch! How now, Sir Toby Belch?

TOBY Sweet Sir Andrew!

ANDREW Bless you, fair shrew.

MARIA And you too, sir.

TOBY Accost, Sir Andrew, accost.

ANDREW What's that?

TOBY My niece's chambermaid.

ANDREW Good Mistress Accost, I desire better acquaintance.

MARIA My name is Mary, sir.

ANDREW Good Mistress Mary Accost— TOBY You mistake, knight. "Accost" is front her, board her, woo her, assail her.

ANDREW By my troth, I would not undertake her in this company. Is that the meaning of "accost"?

MARIA Fare you well, gentlemen.

TOBY An thou let part so, Sir Andrew, would thou

mightst never draw sword again!

ANDREW An you part so, mistress, I would I might never draw sword again! Fair lady, do you think you have fools in hand?

MARIA Sir. I have not you by the hand.

ANDREW Marry, but you shall have! and here's my hand.

MARIA Now, sir, thought is free. I pray you, bring your hand to the buttery bar and let it drink.

ANDREW Wherefore, sweetheart? What's your metaphor?

MARIA It's dry, sir.

ANDREW Why, I think so. I am not such an ass but I can keep my hand dry. But what's your jest? 180 MARIA A dry jest, sir.

ANDREW Are you full of them?

MARIA Ay, sir, I have them at my fingers' ends. Marry, now I let go your hand, I am barren. Exit.

TOBY O knight, thou lackst a cup of canary! When did I see thee so put down?

ANDREW Never in your life, I think, unless you see canary put me down. Methinks sometimes I have no more wit than a Christian or an ordinary man has. But I am a great eater of beef, and I believe 190 that does harm to my wit.

TOBY No question.

ANDREW An I thought that, I'd forswear it. I'll ride home tomorrow, Sir Toby.

TOBY Pourquoi, my dear knight?

ANDREW What is "pourquoi"? Do, or not do? I would I had bestowed that time in the tongues that I have in fencing, dancing, and bear-baiting. O, had I but followed the arts!

Then hadst thou had an excellent head of hair. 200 ANDREW Why, would that have mended my hair? TOBY Past question, for thou seest it will not curl by nature.

ANDREW But it becomes me well enough, does't not?

TOBY Excellent. It hangs like flax on a distaff; and I hope to see a housewife take thee between her legs and spin it off.

ANDREW Faith, I'll home tomorrow, Sir Toby. Your niece will not be seen; or if she be, it's four to 210 one she'll none of me. The Count himself here hard by woos her.

TOBY She'll none o' the Count. She'll not match above her degree, neither in estate, years, nor wit; I have heard her swear't. Tut, there's life in't, man.

ANDREW I'll stay a month longer. I am a fellow o' the strangest mine i' the world. I delight in masques and revels sometimes altogether.

TOBY Art thou good at these kickshawses, knight? ANDREW As any man in Illyria, whatsoever he be, 220 under the degree of my betters; and yet I will not compare with an old man.

TOBY What is thy excellence in a galliard, knight? ANDREW Faith, I can cut a caper.

TOBY And I can cut the mutton to't.

ANDREW And I think I have the back-trick simply as

strong as any man in Illyria.

Wherefore are these things hid? Wherefore have these gifts a curtain before 'em? Are they like to take dust, like Mistress Mall's picture? Why dost 230 thou not go to church in a galliard and come home in a coranto? My very walk should be a jig. I would not so much as make water but in a sink-apace. What dost thou mean? Is it a world to hide virtues in? I did think, by the excellent constitution of thy leg, it was formed under the star of a galli-

ANDREW Ay, 'tis strong, and it does indifferent well in a flame-colored stock. Shall we set about some revels?

TOBY What shall we do else? Were we not born under Taurus?

ANDREW Taurus? That's sides and heart.

TOBY No, sir; it is legs and thighs. Let me see thee caper. [SIR ANDREW dances.] Ha, higher! Ha, ha, excellent!

Exeunt.

Scene IV. The Duke's Palace.

Enter VALENTINE, and VIOLA in man's attire.

VALENTINE If the Duke continue these favors towards you, Cesario, you are like to be much advanced. He hath known you but three days, and already you are no stranger.

VIOLA You either fear his humor or my negligence, that you call in question the continuance of his love. Is he inconstant, sir, in his favors?

VALENTINE No. believe me.

Enter DUKE, CURIO, and ATTENDANTS. VIOLA I thank you. Here comes the Count.

DUKE Who saw Cesario, ho?

On your attendance, my lord, here. VIOLA DUKE Stand you awhile aloof.—Cesario,

Thou knowst no less but all. I have unclasped To thee the book even of my secret soul. Therefore, good youth, address thy gait unto

Be not denied access, stand at her doors, And tell them there thy fixed foot shall grow Till thou have audience.

VIOLA Sure, my noble lord, If she be so abandoned to her sorrow As it is spoke, she never will admit me. DUKE Be clamorous and leap all civil bounds

Rather than make unprofited return.

VIOLA Say I do speak with her, my lord, what then?

DUKE O, then unfold the passion of my love; Surprise her with discourse of my dear faith! It shall become thee well to act my woes. She will attend it better in thy youth Than in a nuncio's of more grave aspect.

VIOLA I think not so, my lord.

DUKE Dear lad, believe

it;

For they shall yet belie thy happy years That say thou art a man. Diana's lip Is not more smooth and rubious; thy small pipe 280 Is as the maiden's organ, shrill and sound, And all is semblative a woman's part. I know thy constellation is right apt For this affair. Some four or five attend him-

All, if you will; for I myself am best When least in company. Prosper well in this, And thou shalt live as freely as thy lord To call his fortunes thine.

I'll do my best To woo your lady. [Aside] Yet a barful strife! 290 Whoe'er I woo, myself would be his wife.

Exeunt.

Scene V. OLIVIA's house.

Enter MARIA and CLOWN.

MARIA Nay, either tell me where thou hast been, or I will not open my lips so wide as a bristle may enter in way of thy excuse. My lady will hang thee for thy absence.

CLOWN Let her hang me! He that is well hanged in this world needs to fear no colors.

MARIA Make that good.

CLOWN He shall see none to fear.

MARIA A good lenten answer. I can tell thee where 300 that saying was born, of "I fear no colors."

CLOWN Where, good Mistress Mary?

MARIA In the wars; and that may you be bold to say

in your foolery.

CLOWN Well, God give them wisdom that have it; and those that are fools, let them use their talents.

MARIA Yet you will be hanged for being so long absent, or to be turned away—is not that as good as a hanging to you?

CLOWN Many a good hanging prevents a bad mar- 310 riage; and for turning away, let summer bear it

out.

You are resolute then?

CLOWN Not so, neither; but I am resolved on two points.

MARIA That if one break, the other will hold; or if

both break, your gaskins fall.

CLOWN Apt, in good faith; very apt. Well, go thy way! If Sir Toby would leave drinking, thou wert as witty a piece of Eve's flesh as any in Illyria. 320

MARIA Peace, you rogue; no more o' that. Here comes my lady. Make your excuse wisely, you were best. Exit.

Enter LADY OLIVIA with MALVOLIO.

CLOWN Wit, an't be thy will, put me into good fooling! Those wits that think they have thee do very oft prove fools; and I that am sure I lack thee may pass for a wise man. For what says Quinapalus? "Better a witty fool than a foolish wit."—God bless thee, lady!

OLIVIA Take the fool away.

CLOWN Do you not hear, fellows? Take away the lady.

OLIVIA Go to, y'are a dry fool! I'll no more of you.

Besides, you grow dishonest.

CLOWN Two faults, madonna, that drink and good counsel will amend. For give the dry fool drink, then is the fool not dry. Bid the dishonest man mend himself: if he mend, he is no longer dishonest; if he cannot, let the botcher mend him. Anything that's mended is but patched; virtue that 340 transgresses is but patched with sin, and sin that amends is but patched with virtue. If that this simple syllogism will serve, so; if it will not, what remedy? As there is no true cuckold but calamity, so beauty's a flower. The lady bade take away the fool; therefore, I say again, take her away.

OLIVIA Sir, I bade them take away you.

CLOWN Misprision in the highest degree! Lady, cucullus non facit monachum. That's as much to say as, I wear not motley in my brain. Good madonna, 350 give me leave to prove you a fool.

OLIVIA Can you do it?

CLOWN Dexteriously, good madonna.

OLIVIA Make your proof.

CLOWN I must catechize you for it, madonna. Good

my mouse of virtue, answer me.

OLIVIA Well, sir, for want of other idleness, I'll bide your proof.

360

CLOWN Good madonna, why mournest thou?

OLIVIA Good fool, for my brother's death.

CLOWN I think his soul is in hell, madonna.

OLIVIA I know his soul is in heaven, fool.

CLOWN The more fool, madonna, to mourn for your brother's soul being in heaven. Take away the fool, gentlemen.

OLIVIA What think you of this fool, Malvolio? Doth

he not mend?

MALVOLIO Yes, and shall do till the pangs of death shake him. Infirmity, that decays the wise, doth ever make the better fool.

CLOWN God send you, sir, a speedy infirmity, for the better increasing your folly! Sir Toby will be sworn that I am no fox; but he will not pass his word for twopence that you are no fool.

OLIVIA How say you to that, Malvolio?

MALVOLIO I marvel your ladyship takes delight in such a barren rascal. I saw him put down the other day with an ordinary fool that has no more brain than a stone. Look you now, he's out of his guard already. Unless you laugh and minister occasion to 380 him, he is gagged. I protest I take these wise men that crow so at these set kind of fools no better than the fools' zanies.

OLIVIA O, you are sick of self-love, Malvolio, and taste with a distempered appetite. To be generous, guiltless, and of free disposition, is to take those things for bird bolts that you deem cannon bullets. There is no slander in an allowed fool, though he do nothing but rail; nor no railing in a known discreet man, though he do nothing but reprove. 390

CLOWN Now Mercury indue thee with leasing, for thou speakest well of fools!

Enter MARIA.

MARIA Madam, there is at the gate a young gentleman much desires to speak with you.

OLIVIA From the Count Orsino, is it?

MARIA I know not, madam. 'Tis a fair young man, and well attended.

Who of my people hold him in delay? OLIVIA

Sir Toby, madam, your kinsman. MARIA

OLIVIA Fetch him off, I pray you. He speaks noth- 400 ing but madman. Fie on him! [Exit MARIA.] Go you, Malvolio. If it be a suit from the Count, I am sick, or not at home. What you will, to dismiss it. [Exit MALVOLIO.] Now you see, sir, how your fooling grows old, and people dislike it.

CLOWN Thou hast spoke for us, madonna, as if thy eldest son should be a fool; whose skull Jove cram

with brains!

Enter SIR TOBY.

for—here he comes—one of thy kin has a most weak pia mater.

OLIVIA By mine honor, half drunk! What is he at the gate, cousin?

тову A gentleman.

OLIVIA A gentleman? What gentleman?

TOBY 'Tis a gentleman here. A plague o' these pickle-herring! How now, sot?

CLOWN Good Sir Toby!

OLIVIA Cousin, cousin, how have you come so early by this lethargy?

TOBY Lechery? I defy lechery. There's one at the

OLIVIA Ay, marry, what is he?

TOBY Let him be the Devil an he will, I care not! Give me faith, say I. Well, it's all one.

OLIVIA What's a drunken man like, fool?

CLOWN Like a drowned man, a fool, and a madman. One draught above heat makes him a fool, the second mads him, and a third drowns him.

OLIVIA Go thou and seek the crowner, and let him sit o' my coz; for he's in the third degree of drink he's drowned. Go look after him.

CLOWN He is but mad yet, madonna, and the fool shall look to the madman.

Enter MALVOLIO.

MALVOLIO Madam, yound young fellow swears he will speak with you. I told him you were sick: he takes on him to understand so much, and therefore comes to speak with you. I told him you were asleep: he seems to have a foreknowledge of that too, and therefore comes to speak with you. What is to be said to him, lady? He's fortified against any denial.

OLIVIA Tell him he shall not speak with me. 440 MALVOLIO Has been told so; and he says he'll stand at your door like a sheriff's post, and be the supporter to a bench, but he'll speak with you.

What kind o' man is he? OLIVIA

MALVOLIO Why, of mankind.

OLIVIA What manner of man?

MALVOLIO Of very ill manner. He'll speak with you, will you or no.

OLIVIA Of what personage and years is he?

MALVOLIO Not yet old enough for a man nor young 450 OLIVIA Tell me your mind. enough for a boy; as a squash is before 'tis a peasecod, or a codling when 'tis almost an apple. 'Tis with him in standing water, between boy and man. He is very well-favored and he speaks very shrewishly. One would think his mother's milk were scarce out of him.

OLIVIA Let him approach. Call in my gentlewoman. MALVOLIO Gentlewoman, my lady calls.

Enter MARIA.

OLIVIA Give me my veil; come, throw it o'er my face. We'll once more hear Orsino's embassy. 460

Enter VIOLA.

The honorable lady of the house, which is VIOLA she?

OLIVIA Speak to me; I shall answer for her. Your will?

VIOLA Most radiant, exquisite, and unmatchable beauty—I pray you tell me if this be the lady of the house, for I never saw her. I would be loath to cast away my speech; for, besides that it is excellently well penned, I have taken great pains to con it. Good beauties, let me sustain no scorn. I am very 470 comptible, even to the least sinister usage.

OLIVIA Whence came you, sir?

VIOLA I can say little more than I have studied, and that question's out of my part. Good gentle one, give me modest assurance if you be the lady of the house, that I may proceed in my speech.

OLIVIA Are you a comedian?

VIOLA No, my profound heart; and yet (by the very fangs of malice I swear) I am not that I play. Are you the lady of the house?

OLIVIA If I do not usurp myself, I am.

VIOLA Most certain, if you are she, you do usurp yourself; for what is yours to bestow is not yours to reserve. But this is from my commission. I will on with my speech in your praise and then show you the heart of my message.

OLIVIA Come to what is important in't. I forgive

you the praise.

VIOLA Alas, I took great pains to study it, and 'tis poetical.

OLIVIA It is the more like to be feigned; I pray you keep it in. I heard you were saucy at my gates; and allowed your approach rather to wonder at you than to hear you. If you be not mad, be gone; if you have reason, be brief. 'Tis not that time of moon with me to make one in so skipping a dialogue.

Will you hoist sail, sir? Here lies your way. MARIA VIOLA No, good swabber; I am to hull here a little longer. Some mollification for your giant, sweet 500 lady!

VIOLA I am a messenger.

OLIVIA Sure you have some hideous matter to deliver, when the courtesy of it is so fearful. Speak your office.

VIOLA It alone concerns your ear. I bring no overture of war, no taxation of homage. I hold the olive in my hand. My words are as full of peace as matter.

OLIVIA Yet you began rudely. What are you? What would you?

VIOLA The rudeness that hath appeared in me have I learned from my entertainment. What I am, and what I would, are as secret as maidenhead: to your ears, divinity; to any other's, profanation.

OLIVIA Give us the place alone; we will hear this divinity. [Exit MARIA.] Now, sir, what is your

text?

VIOLA Most sweet lady— 520
OLIVIA A comfortable doctrine, and much may be

said of it. Where lies your text?

VIOLA In Orsino's bosom.

OLIVIA In his bosom? In what chapter of his bosom? VIOLA To answer by the method, in the first of his heart.

OLIVIA O, I have read it! it is heresy. Have you no more to say?

VIOLA Good madam, let me see your face.

OLIVIA Have you any commission from your lord 530 to negotiate with my face? You are now out of your text. But we will draw the curtain and show you the picture. [Unveils.] Look you, sir, such a one I was this present. Is't not well done?

VIOLA Excellently done, if God did all.

OLIVIA 'Tis in grain, sir; 'twill endure wind and weather.

VIOLA 'Tis beauty truly blent, whose red and white Nature's own sweet and cunning hand laid on. Lady, you are the cruel'st she alive 540 If you will lead these graces to the grave,

And leave the world no copy.

OLIVIA O, sir, I will not be so hard-hearted. I will give out divers schedules of my beauty. It shall be inventoried, and every particle and utensil labeled to my will:—as, item, two lips, indifferent red; item, two grey eyes, with lids to them; item, one neck, one chin, and so forth. Were you sent hither to praise me?

VIOLA I see you what you are—you are too proud;

But if you were the Devil, you are fair.

My lord and master loves you. O, such love
Could be but recompensed though you were
crowned

The nonpareil of beauty!

OLIVIA How does he love me? VIOLA With adorations, fertile tears,

With groans that thunder love, with sighs of fire.

OLIVIA Your lord does know my mind; I cannot love him.

Yet I suppose him virtuous, know him noble, Of great estate, of fresh and stainless youth; 560 In voices well divulged, free, learned, and valiant,

And in dimension and the shape of nature A gracious person. But yet I cannot love him.

He might have took his answer long ago.
VIOLA If I did love you in my master's flame,
With such a suff'ring, such a deadly life,
In your denial I would find no sense;
I would not understand it.

OLIVIA Why, what would you?

VIOLA Make me a willow cabin at your gate
And call upon my soul within the house;
Write loyal cantons of contemned love
And sing them loud even in the dead of night;
Halloa your name to the reverberate hills
And make the babbling gossip of the air
Cry out. "Olivia!" O, you should not rest
Between the elements of air and earth
But you should pity me!

OLIVIA You might do much. What is your

parentage?

VIOLA Above my fortunes, yet my state is well. 580 I am a gentleman.

OLIVIA Get you to your lord.
I cannot love him. Let him send no more,
Unless, perchance, you come to me again
To tell me how he takes it. Fare you well.
I thank you for your pains. Spend this for me.

VIOLA I am no fee'd post, lady; keep your purse;
My master, not myself, lacks recompense.
Love make his heart of flint that you shall love;
And let your fervor, like my master's, be
Placed in contempt! Farewell, fair cruelty. Exit.

"Above my fortunes, yet my state is well.
I am a gentleman." I'll be sworn thou art.
Thy tongue, thy face, thy limbs, actions, and

spirit

550

Do give thee fivefold blazon. Not too fast! soft, soft!

Unless the master were the man. How now? Even so quickly may one catch the plague? Methinks I feel this youth's perfections With an invisible and subtle stealth To creep in at mine eyes. Well, let it be. What ho, Malvolio!

Enter MALVOLIO.

MALVOLIO Here, madam, at your service.

OLIVIA Run after that same peevish messenger, The County's man. He left this ring behind him,

Would I or not. Tell him I'll none of it.

Desire him not to flatter with his lord

Nor hold him up with hopes. I am not for him.

If that the youth will come this way tomorrow,

I'll give him reasons for't. Hie thee, Malvolio. 610

MALVOLIO Madam, I will. Exit.

...

600

OLIVIA I do I know not what, and fear to find Mine eye too great a flatterer for my mind. Fate, show thy force! Ourselves we do not owe. What is decreed must be—and be this so!

Exit.

Act II

Scene I. The seacoast.

Enter ANTONIO and SEBASTIAN.

ANTONIO Will you stay no longer? nor will you not that I go with you?

SEBASTIAN By your patience, no. My stars shine darkly over me; the malignancy of my fate might perhaps distemper yours. Therefore I shall crave of you your leave, that I may bear my evils alone. It were a bad recompense for your love to lay any of them on you.

ANTONIO Let me yet know of you whither you are bound.

SEBASTIAN No, sooth, sir. My determinate voyage is mere extravagancy. But I perceive in you so excellent a touch of modesty that you will not extort from me what I am willing to keep in; therefore it charges me in manners the rather to express myself. You must know of me then, Antonio, my name is Sebastian, which I called Roderigo. My father was that Sebastian of Messaline whom I know you have heard of. He left behind him myself and a sister, both born in an hour. If the heav- 20 ens had been pleased, would we had so ended! But you, sir, altered that, for some hour before you took me from the breach of the sea was my sister drowned.

ANTONIO Alas the day!

SEBASTIAN A lady, sir, though it was said she much resembled me, was yet of many accounted beautiful. But though I could not with such estimable wonder overfar believe that, yet thus far I will boldly publish her: she bore a mind that envy 30 could not but call fair. She is drowned already, sir, with salt water, though I seem to drown her remembrance again with more.

ANTONIO Pardon me, sir, your bad entertainment. SEBASTIAN O good Antonio, forgive me your trouble!

ANTONIO If you will not murder me for my love, let me be your servant.

SEBASTIAN If you will not undo what you have done, that is, kill him whom you have recovered, 40 desire it not. Fare ye well at once. My bosom is full of kindness; and I am yet so near the manners of my mother that, upon the least occasion more, mine eves will tell tales of me. I am bound to the Count Orsino's court. Farewell.

ANTONIO The gentleness of all the gods go with thee!

I have many enemies in Orsino's court, Else would I very shortly see thee there. But come what may, I do adore thee so That danger shall seem sport, and I will go.

Exit.

Scene II. A street.

Enter VIOLA and MALVOLIO at several doors. MALVOLIO Were not you even now with the Countess Olivia?

VIOLA Even now, sir. On a moderate pace I have since arrived but hither.

MALVOLIO She returns this ring to you, sir. You might have saved me my pains, to have taken it away yourself. She adds, moreover, that you should put your lord into a desperate assurance she will none of him. And one thing more, that you be never so hardy to come again in his affairs, unless it 60 be to report your lord's taking of this. Receive it

VIOLA She took the ring of me. I'll none of it. MALVOLIO Come, sir, you peevishly threw it to her; and her will is, it should be so returned. If it be worth stooping for, there it lies, in your eye; if not, be it his that finds it.

VIOLA I left no ring with her. What means this lady?

Fortune forbid my outside have not charmed

She made good view of me; indeed, so much That methought her eyes had lost her tongue, For she did speak in starts distractedly. She loves me sure; the cunning of her passion Invites me in this churlish messenger. None of my lord's ring? Why, he sent her none! I am the man. If it be so—as 'tis— Poor lady, she were better love a dream! Disguise, I see thou art a wickedness Wherein the pregnant enemy does much. How easy is it for the proper false 80 In women's waxen hearts to set their forms! Alas, our frailty is the cause, not we! For such as we are made of, such we be. How will this fadge? My master loves her dearly;

And I (poor monster) fond as much on him; And she (mistaken) seems to dote on me. What will become of this? As I am man, My state is desperate for my master's love. As I am woman (now alas the day!), What thriftless sighs shall poor Olivia breathe! 90 O Time, thou must untangle this, not I; It is too hard a knot for me t'untie!

Exit.

Scene III. OLIVIA's house.

Enter SIR TOBY and SIR ANDREW.

TOBY Approach, Sir Andrew. Not to be abed after midnight is to be up betimes; and "diluculo surgere," thou knowst—

ANDREW Nay, by my troth, I know not; but I know

to be up late is to be up late.

TOBY A false conclusion! I hate it as an unfilled can. To be up after midnight, and to go to bed then, is early; so that to go to bed after midnight is to go to 100 bed betimes. Does not our life consist of the four elements?

ANDREW Faith, so they say; but I think it rather consists of eating and drinking.

TOBY Th'art a scholar! Let us therefore eat and drink. Marian I say! a stoup of wine!

Enter CLOWN.

ANDREW Here comes the fool, i' faith.

CLOWN How now, my hearts? Did you never see

the picture of We Three?

TOBY Welcome, ass. Now let's have a catch. 110 ANDREW By my troth, the fool has an excellent breast. I had rather than forty shillings I had such a leg, and so sweet a breath to sing, as the fool has. In sooth, thou wast in very gracious fooling last night, when thou spokest of Pigrogromitus, of the Vapians passing the equinoctial of Queubus. 'Twas very good, i' faith. I sent thee sixpence for thy leman. Hadst it?

CLOWN I did impeticos thy gratillity; for Malvolio's nose is no whipstock. My lady has a white hand, and the Myrmidons are no bottle-ale houses. 120

ANDREW Excellent! Why, this is the best fooling, when all is done. Now a song!

TOBY Come on! there is sixpence for you. Let's have a song.

ANDREW There's a testril of me too. If one knight give a-

CLOWN Would you have a love song, or a song of good life?

TOBY A love song, a love song.

ANDREW Ay, ay! I care not for good life.

CLOWN sings.

O mistress mine, where are you roaming? O, stay and hear! your truelove's coming, That can sing both high and low. Trip no further, pretty sweeting; Journeys end in lovers meeting, Every wise man's son doth know.

ANDREW Excellent good, i' faith! тову Good, good!

CLOWN sings.

What is love? 'Tis not hereafter;

Present mirth hath present laughter: What's to come is still unsure: In delay there lies no plenty; Then come kiss me, sweet and twenty! Youth's a stuff will not endure.

140

ANDREW A mellifluous voice, as I am true knight. TOBY A contagious breath.

ANDREW Very sweet and contagious, i' faith.

TOBY To hear by the nose, it is dulcet in contagion.

But shall we make the welkin dance indeed? Shall we 150 rouse the night owl in a catch that will draw three souls out of one weaver? Shall we do that?

ANDREW An you love me, let's do't! I am dog at a catch.

CLOWN By'r Lady, sir, and some dogs will catch

ANDREW Most certain. Let our catch be "Thou knave.

CLOWN "Hold thy peace, thou knave," knight? I shall be constrained in't to call thee knave, knight. 160

ANDREW 'Tis not the first time I have constrained one to call me knave. Begin, fool. It begins, "Hold thy peace."

CLOWN I shall never begin if I hold my peace. ANDREW Good, i' faith! Come, begin.

Catch sung. Enter MARIA.

MARIA What a caterwauling do you keep here! If my lady have not called up her steward Malvolio and bid him turn you out of doors, never trust me.

TOBY My lady's a Cataian, we are politicians, Malvolio's a Peg-a-Ramsey, and [Sings] "Three merry 170 men be we." Am not I consanguineous? Am I not of her blood? Tilly-vally, lady! [Sings] "There dwelt a man in Babylon, lady, lady!"

CLOWN Beshrew me, the knight's in admirable

fooling.

ANDREW Ay, he does well enough if he be disposed, and so do I too. He does it with a better grace, but I do it more natural.

TOBY [Sings] "O' the twelfth day of December"-MARIA For the love o' God, peace! 180

Enter MALVOLIO.

MALVOLIO My masters, are you mad? or what are you? Have you no wit, manners, nor honesty, but to gabble like tinkers at this time of night? Do ye make an alehouse of my lady's house, that ye squeak out your coziers' catches without any mitigation or remorse of voice? Is there no respect of place, persons, nor time in you?

We did keep time, sir, in our catches. Sneck TOBY

up!

MALVOLIO Sir Toby, I must be round with you. My 190 lady bade me tell you that, though she harbors you

as her kinsman, she's nothing allied to your disorders. If you can separate yourself and your misdemeanors, you are welcome to the house. If not, and it would please you to take leave of her, she is very willing to bid you farewell.

TOBY [Sings] "Farewell, dear heart, since I must

needs be gone."

MARIA Nay, good Sir Toby!

CLOWN [Sings] "His eyes do show his days are al- 200 most done.

MALVOLIO Is't even so?

тову "But I will never die."

CLOWN Sir Toby, there you lie.

MALVOLIO This is much credit to you!

тову "Shall I bid him go?"

CLOWN "What an if you do?"

TOBY "Shall I bid him go, and spare not?"

CLOWN "O, no, no, no, you dare not!" TOBY Out o' tune, sir? Ye lie. Art any more than a 210 steward? Dost thou think, because thou art virtu-

ous, there shall be no more cakes and ale? CLOWN Yes, by Saint Anne! and ginger shall be hot i' the mouth too.

TOBY Th'art i' the right—Go, sir, rub your chain with crumbs. A stoup of wine, Maria!

MALVOLIO Mistress Mary, if you prized my lady's favor at anything more than contempt, you would not give means for this uncivil rule. She shall know of it, by this hand. Exit. 220

MARIA Go shake your ears!

ANDREW 'Twere as good a deed as to drink when a man's ahungry, to challenge him the field, and then to break promise with him and make a fool of

TOBY Do't, knight. I'll write thee a challenge; or I'll deliver thy indignation to him by word of mouth.

MARIA Sweet Sir Toby, be patient for tonight. Since the youth of the Count's was today with my lady, she is much out of quiet. For Monsieur Malvolio, 230 let me alone with him. If I do not gull him into a nayword, and make him a common recreation, do not think I have wit enough to lie straight in my bed. I know I can do it.

TOBY Possess us, possess us! Tell us something of him.

MARIA Marry, sir, sometimes he is a kind of Puri-

ANDREW O, if I thought that, I'd beat him like a dog!

TOBY What, for being a Puritan? Thy exquisite reason, dear knight?

ANDREW I have no exquisite reason for't, but I have reason good enough.

MARIA The devil a Puritan that he is, or anything constantly but a time-pleaser; an affectioned ass,

that cons state without book and utters it by great swarths; the best persuaded of himself; so crammed, as he thinks, with excellencies that it is his grounds of faith that all that look on him love 250 him; and on that vice in him will my revenge find notable cause to work.

TOBY What wilt thou do?

MARIA I will drop in his way some obscure epistles of love, wherein by the color of his beard, the shape of his leg, the manner of his gait, the expressure of his eye, forehead, and complexion, he shall find himself most feelingly personated. I can write very like my lady your niece; on a forgotten matter we can hardly make distinction of our hands. 260

Excellent! I smell a device.

ANDREW I have't in my nose too.

TOBY He shall think by the letters that thou wilt drop that they come from my niece, and that she's in love with him.

MARIA My purpose is indeed a horse of that color. ANDREW And your horse now would make him an

MARIA Ass. I doubt not.

ANDREW O, 'twill be admirable!

MARIA Sport royal, I warrant you. I know my physic will work with him. I will plant you two, and let the fool make a third, where he shall find the letter. Observe his construction of it. For this night, to bed, and dream on the event. Farewell.

тову Good night, Penthesilea.

ANDREW Before me, she's a good wench.

TOBY She's a beagle true-bred, and one that adores me. What o' that?

ANDREW I was adored once too.

TOBY Let's to bed, knight. Thou hadst need send for more money.

ANDREW If I cannot recover your niece, I am a foul

TOBY Send for money, knight. If thou hast her not i' the end, call me Cut.

ANDREW If I do not, never trust me, take it how you will.

TOBY Come, come; I'll go burn some sack. 'Tis too late to go to bed now. Come, knight; come, 290 knight.

Exeunt.

Scene IV. The Duke's Palace.

Enter DUKE, VIOLA, CURIO, and others.

DUKE Give me some music. Now good morrow, friends.

Now, good Cesario, but that piece of song, That old and antique song we heard last night. Methought it did relieve my passion much,

More than light airs and recollected terms Of these most brisk and giddy-paced times. Come, but one verse.

CURIO He is not here, so please your lordship, that 300 should sing it.

DUKE Who was it?

CURIO Feste the jester, my lord, a fool that the Lady Olivia's father took much delight in. He is about the house.

DUKE Seek him out. [Exit CURIO.] And play the tune Music plays. the while. Come hither, boy. If ever thou shalt love, In the sweet pangs of it remember me; For such as I am all true lovers are, 310

Unstaid and skittish in all motions else Save in the constant image of the creature That is beloved. How dost thou like this tune?

VIOLA It gives a very echo to the seat Where Love is throned.

Thou dost speak DUKE

masterly.

My life upon't, young though thou art, thine eye Hath stayed upon some favor that it loves. Hath it not, boy?

A little, by your favor. 320 VIOLA What kind of woman is't? DUKE

Of your complexion. VIOLA

DUKE She is not worth thee then. What years, i'

VIOLA About your years, my lord.

DUKE Too old, by heaven! Let still the woman

An elder than herself: so wears she to him, So sways she level in her husband's heart; For, boy, however we do praise ourselves, Our fancies are more giddy and unfirm, More longing, wavering, sooner lost and won, Than women's are.

I think it well, my lord. DUKE Then let thy love be younger than thyself, Or thy affection cannot hold the bent; For women are as roses, whose fair flower, Being once displayed, doth fall that very hour.

VIOLA And so they are; alas, that they are so! To die, even when they to perfection grow!

Enter CURIO and CLOWN.

DUKE O, fellow, come, the song we had last 340

Mark it, Cesario; it is old and plain. The spinsters and the knitters in the sun, And the free maids that weave their thread with

Do use to chant it. It is silly sooth, And dallies with the innocence of love,

Like the old age. CLOWN Are you ready, sir? DUKE Ay; prithee sing.

Music.

The Song.

CLOWN Come away, come away, death, And in sad cypress let me be laid. Fly away, fly away, breath; I am slain by a fair cruel maid. My shroud of white, stuck all with yew, O, prepare it!

My part of death, no one so true Did share it.

Not a flower, not a flower sweet, On my black coffin let there be strown; Not a friend, not a friend greet My poor corpse, where my bones shall be thrown. A thousand thousand sighs to save,

Lay me, O, where Sad true lover never find my grave,

To weep there!

DUKE There's for thy pains. CLOWN No pains, sir. I take pleasure in singing, sir. DUKE I'll pay thy pleasure then.

CLOWN Truly, sir, and pleasure will be paid one time or another.

DUKE Give me now leave to leave thee. CLOWN Now the melancholy god protect thee, and the tailor make thy doublet of changeable taffeta, for thy mind is a very opal! I would have men of such constancy put to sea, that their business might be everything, and their intent everywhere; for that's it that always makes a good voyage of nothing. Farewell.

DUKE Let all the rest give place.

Exeunt CURIO and Attendants. Once more.

Cesario,

Get thee to youd same sovereign cruelty. Tell her, my love, more noble than the world, Prizes not quantity of dirty lands. The parts that Fortune hath bestowed upon her, Tell her I hold as giddily as Fortune; But 'tis that miracle and queen of gems That nature pranks her in, attracts my soul. VIOLA But if she cannot love you, sir— DUKE I cannot be so answered.

Sooth, but you VIOLA

Say that some lady, as perhaps there is, Hath for your love as great a pang of heart As you have for Olivia: You cannot love her; You tell her so. Must she not then be answered? DUKE There is no woman's sides Can bide the beating of so strong a passion As love doth give my heart; no woman's heart So big to hold so much; they lack retention. Alas, their love may be called appetite— No motion of the liver, but the palate— That suffers surfeit, cloyment, and revolt; But mine is all as hungry as the sea And can digest as much. Make no compare Between that love a woman can bear me

VIOLA Ay, but I know— What dost thou know? DUKE

And that I owe Olivia.

VIOLA Too well what love women to men may

In faith, they are as true of heart as we. My father had a daughter loved a man As it might be perhaps, were I a woman, I should your lordship.

And what's her history? VIOLA A blank, my lord. She never told her love. But let concealment, like a worm i' the bud. Feed on her damask cheek. She pined in thought;

And, with a green and yellow melancholy, She sat like Patience on a monument, Smiling at grief. Was not this love indeed? We men may say more, swear more; but indeed Our shows are more than will; for still we 420

Much in our vows but little in our love. DUKE But died thy sister of her love, my boy? VIOLA I am all the daughters of my father's

And all the brothers too—and yet I know not. Sir, shall I to this lady?

Ay, that's the theme. To her in haste! Give her this jewel. Say My love can give no place, bide no denay.

Exeunt.

Scene V. OLIVIA's garden.

Enter SIR TOBY, SIR ANDREW, and FABIAN. TOBY Come thy ways, Signior Fabian.

FABIAN Nay, I'll come. If I lose a scruple of this 430 sport, let me be boiled to death with melan-

TOBY Wouldst thou not be glad to have the niggardly rascally sheepbiter come by some notable shame?

FABIAN I would exult, man. You know he brought me out o' favor with my lady about a bearbaiting here.

TOBY To anger him we'll have the bear again; and we will fool him black and blue. Shall we not, 440 TOBY Shall this fellow live?

Sir Andrew?

ANDREW An we do not, it is pity of our lives.

Enter MARIA.

TOBY Here comes the little villain. How now, my metal of India?

MARIA Get ye all three into the box tree. Malvolio's coming down this walk. He has been yonder i' the sun practicing behavior to his own shadow this half hour. Observe him, for the love of mockery; for I know this letter will make a contemplative idiot of him. Close, in the name of jesting! Lie thou 450 there [Throws down a letter]; for here comes the trout that must be caught with tickling.

Enter MALVOLIO.

MALVOLIO 'Tis but fortune; all is fortune. Maria once told me she did affect me; and I have heard herself come thus near, that, should she fancy, it should be one of my complexion. Besides, she uses me with a more exalted respect than anyone else that follows her. What should I think on't?

TOBY Here's an overweening rogue!

FABIAN O, peace! Contemplation makes a rare tur- 460 key cock of him. How he jets under his advanced plumes!

ANDREW 'Slight, I could so beat the rogue!

FABIAN Peace, I say. MALVOLIO To be Count Malvolio!

TOBY Ah, rogue!

ANDREW Pistol him, pistol him!

FABIAN Peace, peace!

MALVOLIO There is example for't. The Lady of the Strachy married the yeoman of the wardrobe. 470 ANDREW Fie on him, Jezebel!

FABIAN O, peace! Now he's deeply in. Look how imagination blows him.

MALVOLIO Having been three months married to her, sitting in my state—

TOBY O for a stonebow, to hit him in the eye! MALVOLIO Calling my officers about me, in my branched velvet gown; having come from a day bed, where I have left Olivia sleeping-

TOBY Fire and brimstone!

FABIAN O, peace, peace!

MALVOLIO And then to have the humor of state; and after a demure travel of regard—telling them I know my place, as I would they should do theirs to ask for my kinsmen Toby—

TOBY Bolts and shackles!

FABIAN O, peace, peace! Now, now.

MALVOLIO Seven of my people, with an obedient start, make out for him. I frown the while, and perchance wind up my watch, or play with my— 490 some rich jewel. Toby approaches; curtsies there to me-

FABIAN Though our silence be drawn from us with

cars, yet peace!

MALVOLIO I extend my hand to him thus, quenching my familiar smile with an austere regard of control-

TOBY And does not Toby take you a blow o' the lips then?

MALVOLIO Saying, "Cousin Toby, my fortunes having cast me on your niece, give me this prerogative of speech."

TOBY What, what?

MALVOLIO "You must amend your drunkenness." TOBY Out, scab!

FABIAN Nay, patience, or we break the sinews of our plot.

MALVOLIO "Besides, you waste the treasure of your time with a foolish knight"—

ANDREW That's me, I warrant you.

MALVOLIO "One Sir Andrew"-ANDREW I knew 'twas I, for many do call me fool.

MALVOLIO What employment have we here?

[Picks up the letter.]

530

540

FABIAN Now is the woodcock near the gin.

TOBY O, peace! and the spirit of humors intimate

reading aloud to him!

MALVOLIO By my life, this is my lady's hand! These be her very C's, her U's, and her T's; and thus makes she her great P's. It is, in contempt of ques- 520 tion, her hand.

ANDREW Her C's, her U's, and her T's? Why that? MALVOLIO [Reads] "To the unknown beloved, this, and my good wishes." Her very phrases! By your leave, wax. Soft! and the impressure her Lucrece, with which she uses to seal! 'Tis my lady. To whom should this be?

FABIAN This wins him, liver and all.

MALVOLIO [Reads]

'Jove knows I love-But who?

Lips, do not move: No man must know."

"No man must know." What follows? The numbers altered! "No man must know." If this should be thee, Malvolio?

TOBY Marry, hang thee, brock!

MALVOLIO [Reads]

"I may command where I adore; But silence, like a Lucrece knife,

With bloodless stroke my heart doth gore.

M. O. A. I. doth sway my life."

FABIAN A fustian riddle!

TOBY Excellent wench, say I.

MALVOLIO "M. O. A. I. doth sway my life." Nay, but first, let me see, let me see, let me see.

FABIAN What dish o' poison has she dressed him! TOBY And with what wing the staniel checks at it! MALVOLIO "I may command where I adore." Why, she may command me: I serve her; she is my lady. 550 Why, this is evident to any formal capacity. There is no obstruction in this. And the end—what should that alphabetical position portend? If I could make that resemble something in me! Softly! M. O. A. I.

TOBY O, ay, make up that! He is now at a cold scent.

FABIAN Sowter will cry upon't for all this, though it be as rank as a fox.

MALVOLIO M.—Malvolio. M.—Why, that begins 560 my name!

FABIAN Did not I say he would work it out? The cur is excellent at faults.

MALVOLIO M.—But then there is no consonancy in the sequel. That suffers under probation. A should follow, but O does.

FABIAN And O shall end, I hope.

TOBY Ay, or I'll cudgel him, and make him cry O! MALVOLIO And then I comes behind.

FABIAN Ay, an you had an eye behind you, you 570 might see more detraction at your heels than fortunes before you.

MALVOLIO M, O, A, I. This stimulation is not as the former; and yet, to crush this a little, it would bow to me, for every one of these letters are in my name. Soft! here follows prose.

[Reads] "If this fall into thy hand, revolve. In my stars I am above thee; but be not afraid of greatness. Some are born great, some achieve greatness, and some have greatness thrust upon 'em. Thy 580 Fates open their hands; let thy blood and spirit embrace them; and to inure thyself to what thou art like to be, cast thy humble slough and appear fresh. Be opposite with a kinsman, surly with servants. Let thy tongue tang arguments of state; put thyself into the trick of singularity. She thus advises thee that sighs for thee. Remember who commended thy yellow stockings and wished to see thee ever cross-gartered. I say, remember. Go to, thou art made, if thou desirest to be so. If not, 590 let me see thee a steward still, the fellow of servants, and not worthy to touch Fortune's fingers. Farewell. She that would alter services with thee, "THE FORTUNATE UNHAPPY."

Daylight and champion discovers not more. This is open. I will be proud, I will read politic authors, I will baffle Sir Toby, I will wash off gross acquaintance, I will be point-device the very man. I do not now fool myself, to let imagination jade me; for every reason excites to this, that my lady 600 loves me. She did commend my yellow stockings of late, she did praise my leg being cross-gartered; and in this she manifests herself to my love, and

with a kind of injunction drives me to these habits of her liking. I thank my stars, I am happy. I will be strange, stout, in yellow stockings, and crossgartered, even with the swiftness of putting on. Jove and my stars be praised! Here is yet a postscript.

"Thou canst not choose but know who I am. If 610 thou entertainst my love, let it appear in thy smiling. Thy smiles become thee well. Therefore in my presence still smile, dear my sweet, I prithee."

Jove, I thank thee. I will smile; I will do everything that thou wilt have me.

FABIAN I will not give my part of this sport for a pension of thousands to be paid from the Sophy. TOBY I could marry this wench for this device— ANDREW So could I too.

TOBY And ask no other dowry with her but such 620 CLOWN Troth, sir, I can yield you none without another jest.

Enter MARIA.

ANDREW Nor I neither.

FABIAN Here comes my noble gull-catcher.

TOBY Wilt thou set thy foot o' my neck?

ANDREW Or o' mine either?

TOBY Shall I play my freedom at tray-trip and become thy bondslave?

ANDREW I' faith, or I either?

TOBY Why, thou hast put him in such a dream that, when the image of it leaves him, he must run mad. 630 MARIA Nay, but say true, does it work upon him? TOBY Like agua vitae with a midwife.

MARIA If you will, then, see the fruits of the sport. mark his first approach before my lady. He will come to her in yellow stockings, and 'tis a color she abhors, and cross-gartered, a fashion she detests; and he will smile upon her, which will now be so unsuitable to her disposition, being addicted to a melancholy as she is, that it cannot but turn him into a notable contempt. If you will see it, 640 follow me.

TOBY To the gates of Tartar, thou most excellent devil of wit!

ANDREW I'll make one too.

Exeunt.

Act III

Scene I. [OLIVIA's garden.]

Enter VIOLA, and CLOWN [with a tabor and pipe]. VIOLA Save thee, friend, and thy music! Dost thou live by thy tabor?

CLOWN No, sir, I live by the church.

VIOLA Art thou a churchman?

CLOWN No such matter, sir. I do live by the church; for I do live at my house, and my house doth stand

by the church.

VIOLA So thou mayst say, the king lies by a beggar, if a beggar dwell near him; or, the church stands by thy tabor, if thy tabor stand by the church.

CLOWN You have said, sir. To see this age! A sentence is but a chev'ril glove to a good wit. How quickly the wrong side may be turned outward! VIOLA Nay, that's certain. They that dally nicely

with words may quickly make them wanton. CLOWN I would therefore my sister had had no name, sir.

VIOLA Why, man?

CLOWN Why, sir, her name's a word, and to dally with that word might make my sister wanton. But 20 indeed words are very rascals since bonds disgraced them.

VIOLA Thy reason, man?

words, and words are grown so false I am loath to prove reason with them.

VIOLA I warrant thou art a merry fellow and carest for nothing.

CLOWN Not so, sir; I do care for something; but in my conscience, sir, I do not care for you. If that be 30 to care for nothing, sir, I would it would make you invisible.

VIOLA Art not thou the Lady Olivia's fool?

CLOWN No, indeed, sir. The Lady Olivia has no folly. She will keep no fool, sir, till she be married; and fools are as like husbands as pilchards are to herrings—the husband's the bigger. I am indeed not her fool, but her corrupter of words.

VIOLA I saw thee late at the Count Orsino's.

CLOWN Foolery, sir, does walk about the orb like 40 the sun; it shines everywhere. I would be sorry, sir, but the fool should be as oft with your master as with my mistress. I think I saw your wisdom there.

VIOLA Nay, an thou pass upon me, I'll no more with thee. Hold, there's expenses for thee.

[Gives a piece of money.]

CLOWN Now Jove, in his next commodity of hair, send thee a beard!

VIOLA By my troth, I'll tell thee, I am almost sick for one, though I would not have it grow on my 50 chin. Is thy lady within?

CLOWN Would not a pair of these have bred, sir? VIOLA Yes, being kept together and put to use.

CLOWN I would play Lord Pandarus of Phrygia, sir, to bring a Cressida to this Troilus.

VIOLA I understand you, sir. 'Tis well begged.

CLOWN The matter, I hope, is not great, sir, begging but a beggar: Cressida was a beggar. [VIOLA tosses him another coin.] My lady is within, sir. I will conster to them whence you come. Who you are 60 and what you would are out of my welkin-I might say "element," but the word is over-worn.

VIOLA This fellow is wise enough to play the fool.

And to do that well craves a kind of wit. He must observe their mood on whom he jests, The quality of persons, and the time; Not, like the haggard, check at every feather That comes before his eye. This is a practice As full of labor as a wise man's art; For folly that he wisely shows, is fit; But wise men, folly-fall'n, quite taint their wit.

Enter SIR TOBY and [SIR] ANDREW.

TOBY Save you, gentleman!

VIOLA And you, sir.

ANDREW Dieu vous garde, monsieur.

VIOLA Et vous aussi; votre serviteur.

ANDREW I hope, sir, you are, and I am yours.

TOBY Will you encounter the house? My niece is desirous you should enter, if your trade be to her. VIOLA I am bound to your niece, sir. I mean, she is

the list of my voyage.

Taste your legs, sir; put them to motion. VIOLA My legs do better understand me, sir, than I understand what you mean by bidding me taste my legs.

TOBY I mean, to go, sir, to enter.

VIOLA I will answer you with gait and entrance. But we are prevented.

Enter OLIVIA and Gentlewoman [MARIA].

Most excellent accomplished lady, the heavens rain odors on you!

ANDREW [Aside] That youth's a rare courtier. "Rain 90 odors"—well!

VIOLA My matter hath no voice, lady, but to your own most pregnant and vouchsafed ear.

ANDREW [Aside] "Odors," "pregnant," "vouchsafed"—I'll get 'em all three all ready.

OLIVIA Let the garden door be shut, and leave me to my hearing. [Exeunt SIR TOBY, SIR ANDREW, and MARIA.] Give me your hand, sir.

VIOLA My duty, madam, and most humble service.

OLIVIA What is your name?

VIOLA Cesario is your servant's name, fair princess.

OLIVIA My servant, sir? 'Twas never merry world Since lowly feigning was called compliment.

Y'are servant to the Count Orsino, youth. VIOLA And he is yours, and his must needs be yours. Your servant's servant is your servant,

madam. OLIVIA For him, I think not on him; for his thoughts, Would they were blanks, rather than filled with me!

VIOLA Madam, I come to whet your gentle thoughts

On his behalf.

O, by your leave, I pray you! OLIVIA I bade you never speak again of him; But, would you undertake another suit, I had rather hear you to solicit that Than music from the spheres.

Dear lady— VIOLA OLIVIA Give me leave, beseech you. I did send, After the last enchantment you did here, A ring in chase of you. So did I abuse Myself, my servant, and, I fear me, you. Under your hard construction must I sit, To force that on you in a shameful cunning Which you knew none of yours. What might you think?

Have you not set mine honor at the stake And baited it with all the unmuzzled thoughts That tyrannous heart can think? To one of your receiving

Enough is shown; a cypress, not a bosom, Hides my heart. So, let me hear you speak.

VIOLA I pity you.

100

That's a degree to love. OLIVIA VIOLA No, not a grise; for 'tis a vulgar proof That very oft we pity enemies.

OLIVIA Why, then, methinks 'tis time to smile

O world, how apt the poor are to be proud! If one should be a prey, how much the better To fall before the lion than the wolf!

Clock strikes.

The clock upbraids me with the waste of time. Be not afraid, good youth, I will not have you; 140 And yet, when wit and youth is come to harvest,

Your wife is like to reap a proper man. There lies your way, due west.

Then westward VIOLA

Grace and good disposition attend your

You'll nothing, madam, to my lord by me? OLIVIA Stay.

I prithee tell me what thou thinkst of me. VIOLA That you do think you are not what you

If I think so, I think the same of you. OLIVIA VIOLA Then think you right. I am not what I am. OLIVIA I would you were as I would have you hel

Would it be better, madam, than I am?

I wish it might; for now I am your fool. OLIVIA O, what a deal of scorn looks beautiful In the contempt and anger of his lip! A murd'rous guilt shows not itself more soon Than love that would seem hid: love's night is noon

Cesario, by the roses of the spring, By maidhood, honor, truth, and everything, I love thee so that, maugre all thy pride, Nor wit nor reason can my passion hide. Do not extort thy reasons from this clause, For that I woo, thou therefore hast no cause; But rather reason thus with reason fetter: Love sought is good, but given unsought is

VIOLA By innocence I swear, and by my youth, I have one heart, one bosom, and one truth, And that no woman has: nor never none Shall mistress be of it, save I alone. And so adieu, good madam. Never more Will I my master's tears to you deplore. OLIVIA Yet come again; for thou perhaps mayst

move That heart which now abhors to like his love.

Exeunt.

Scene II. OLIVIA's house.

Enter SIR TOBY, SIR ANDREW, and FABIAN. ANDREW No, faith, I'll not stay a jot longer. TOBY Thy reason, dear venom; give thy reason. FABIAN You must needs yield your reason, Sir Andrew.

ANDREW Marry, I saw your niece do more favors to the Count's servingman than ever she bestowed 180 upon me. I saw't i' the orchard.

TOBY Did she see thee the while, old boy? Tell me that.

ANDREW As plain as I see you now.

FABIAN This was a great argument of love in her toward you.

'Slight! will you make an ass o' me? FABIAN I will prove it legitimate, sir, upon the oaths of judgment and reason.

fore Noah was a sailor.

FABIAN She did show favor to the youth in your sight only to exasperate you, to awake your dormouse valor, to put fire in your heart and brimstone in your liver. You should then have accosted her; and with some excellent jests, fire-new from the mint, you should have banged the youth into dumbness. This was looked for at your hand, and this was balked. The double gilt of this opportunity you let time wash off, and you are now sailed 200 into the North of my lady's opinion, where you

will hang like an icicle on a Dutchman's beard unless you do redeem it by some laudable attempt either of valor or policy.

ANDREW An't be any way, it must be with valor; for policy I hate. I had as lief be a Brownist as a politi-

Why then, build me thy fortunes upon the basis of valor. Challenge me the Count's youth to fight with him; hurt him in eleven places. My niece 210 shall take note of it; and assure thyself there is no love-broker in the world can more prevail in man's commendation with woman than report of valor.

FABIAN There is no way but this, Sir Andrew. ANDREW Will either of you bear me a challenge to

him?

TOBY Go, write it in a martial hand. Be curst and brief; it is no matter how witty, so it be eloquent and full of invention. Taunt him with the license of ink. If thou thou'st him some thrice, it shall not be 220 amiss; and as many lies as will lie in thy sheet of paper, although the sheet were big enough for the bed of Ware in England, set 'em down. Go, about it! Let there be gall enough in thy ink, though thou write with a goose-pen, no matter. About it!

ANDREW Where shall I find you?

TOBY We'll call thee at the cubiculo. Go.

Exit SIR ANDREW.

FABIAN This is a dear manikin to you, Sir Toby. тову I have been dear to him, lad—some two thousand strong, or so.

FABIAN We shall have a rare letter from him—but

you'll not deliver't?

TOBY Never trust me then; and by all means stir on the youth to an answer. I think oxen and wainropes cannot hale them together. For Andrew, if he were opened, and you find so much blood in his liver as will clog the foot of a flea, I'll eat the rest of the anatomy.

FABIAN And his opposite, the youth, bears in his visage no great presage of cruelty.

Enter MARIA.

TOBY Look where the youngest wren of mine

TOBY And they have been grand-jurymen since be- 190 MARIA If you desire the spleen, and will laugh yourselves into stitches, follow me. Yond gull Malvolio is turned heathen, a very renegado; for there is no Christian that means to be saved by believing rightly can ever believe such impossible passages of grossness. He's in yellow stockings!

TOBY And cross-gartered?

MARIA Most villainously; like a pendant that keeps a 250 school i' the church I have dogged him like his murderer. He does obey every point of the letter that I dropped to betray him. He does smile his face into more lines than is in the new map with

the augmentation of the Indies. You have not seen such a thing as 'tis. I can hardly forbear hurling things at him. I know my lady will strike him. If she do, he'll smile, and take't for a great favor. TOBY Come bring us, bring us where he is!

Exeunt omnes.

Scene III. A street.

Enter SEBASTIAN and ANTONIO.

SEBASTIAN I would not by my will have troubled

But since you make your pleasure of your pains,

I will no further chide you.

ANTONIO I could not stay behind you. My desire, More sharp than filed steel, did spur me forth; And not all love to see you (though so much As might have drawn one to a longer voyage) But jealousy what might befall your travel, Being skilless in these parts; which to a stranger, Unguided and unfriended, often prove Rough and unhospitable. My willing love, The rather by these arguments of fear, Set forth in your pursuit.

My kind Antonio, I can no other answer make but thanks, And thanks, and ever thanks; and oft good turns Are shuffled off with such uncurrent pay. But, were my worth as is my conscience firm, You should find better dealing. What's to do? Shall we go see the relics of this town?

ANTONIO Tomorrow, sir, best first go see your lodging.

SEBASTIAN I am not weary, and 'tis long to night. I pray you let us satisfy our eyes With the memorials and the things of fame

That do renown this city. Would you'ld pardon ANTONIO

I do not without danger walk these streets. Once in a sea-flight 'gainst the Count his galleys I did some service; of such note indeed That, were I ta'en here, it would scarce be answered.

SEBASTIAN Belike you slew great number of his people?

ANTONIO The offense is not of such a bloody

Albeit the quality of the time and quarrel Might well have given us bloody argument. It might have since been answered in repaying What we took from them, which for traffic's

Most of our city did. Only myself stood out; For which, if I be lapsed in this place, I shall pay dear.

Do not then walk too open. SEBASTIAN ANTONIO It doth not fit me. Hold, sir, here's my purse.

In the south suburbs at the Elephant Is best to lodge. I will bespeak our diet, Whiles you beguile the time and feed your

knowledge

With viewing of the town. There shall you have

SEBASTIAN Why I your purse?

ANTONIO Haply your eye shall light upon some

You have desire to purchase; and your store I think is not for idle markets, sir.

SEBASTIAN I'll be your purse-bearer, and leave you for

An hour.

ANTONIO To the Elephant.

I do remember. SEBASTIAN

Exeunt.

310

Scene IV. OLIVIA's garden.

Enter OLIVIA and MARIA.

OLIVIA I have sent after him; he says he'll come. How shall I feast him? what bestow of him? For youth is bought more oft than begged or borrowed.

I speak too loud.

Where is Malvolio? He is sad and civil, And suits well for a servant with my fortunes. Where is Malvolio?

MARIA He's coming, madam; but in very strange 320 manner. He is sure possessed, madam.

OLIVIA Why, what's the matter? Does he rave?

MARIA No, madam, he does nothing but smile. Your ladyship were best to have some guard about you if he come, for sure the man is tainted in's wits.

OLIVIA Go call him hither. [Exit MARIA.] I am as mad as he,

If sad and merry madness equal be.

Enter [MARIA, with] MALVOLIO. How now, Malvolio?

MALVOLIO Sweet lady, ho, ho!

OLIVIA Smilest thou?

I sent for thee upon a sad occasion.

MALVOLIO Sad, lady? I could be sad. This does make some obstruction in the blood, this cross-gartering; but what of that? If it please the eye of one, it is with me as the very true sonnet is, "Please one, and please all."

OLIVIA Why, how dost thou, man? What is the matter with thee?

MALVOLIO Not black in my mind, though yellow in 340 my legs. It did come to his hands, and commands

330

shall be executed. I think we do know the sweet Roman hand.

OLIVIA Wilt thou go to bed, Malvolio?

MALVOLIO To bed? Ay, sweetheart; and I'll come to

God comfort thee! Why dost thou smile so, OLIVIA and kiss thy hand so oft?

MARIA How do you, Malvolio?

MALVOLIO At your request? Yes, nightingales an- 350 swer daws!

MARIA Why appear you with this ridiculous boldness before my lady?

MALVOLIO "Be not afraid of greatness." 'Twas well writ.

OLIVIA What meanst thou by that, Malvolio?

MALVOLIO "Some are born great"—

OLIVIA Ha?

MALVOLIO "Some achieve greatness"—

OLIVIA What sayst thou?

MALVOLIO "And some have greatness thrust upon them."

OLIVIA Heaven restore thee!

MALVOLIO "Remember who commended thy yellow stockings"—

OLIVIA Thy yellow stockings?

"And wished to see thee cross-gartered." MALVOLIO OLIVIA Cross-gartered?

MALVOLIO "Go to, thou art made, if thou desirest to be so"—

OLIVIA Am I made?

MALVOLIO "If not, let me see thee a servant still." OLIVIA Why, this is very midsummer madness.

Enter SERVANT.

SERVANT Madam, the young gentleman of the Count Orsino's is returned. I could hardly entreat him back. He attends your ladyship's pleasure.

OLIVIA I'll come to him. [Exit SERVANT.] Good Maria, let this fellow be looked to. Where's my cousin Toby? Let some of my people have a special care of him. I would not have him miscarry for the 380 MALVOLIO Sir! half of my dowry. Exit [OLIVIA; then MARIA].

MALVOLIO O ho! do you come near me now? No worse man than Sir Toby to look to me! This concurs directly with the letter. She sends him on purpose, that I may appear stubborn to him, for she incites me to that in the letter. "Cast thy humble slough," says she; "be opposite with a kinsman, surly with servants; let thy tongue tang with arguments of state; put thyself into the trick of singularity";—and consequently sets down the manner 390 how: as a sad face, a reverend carriage, a slow tongue, in the habit of some sir of note, and so forth. I have limed her; but it is Jove's doing, and Jove make me thankful! And when she went away now, "Let this fellow be looked to." "Fellow!" not

"Malvolio," nor after my degree, but "fellow." Why, everything adheres together, that no dram of a scruple, no scruple of a scruple, no obstacle, no incredulous or unsafe circumstance—What can be said? Nothing that can be can come between me 400 and the full prospect of my hopes. Well, Jove, not I, is the doer of this, and he is to be thanked.

Enter [SIR] TOBY, FABIAN, and MARIA.

TOBY Which way is he, in the name of sanctity? If all the devils of hell be drawn in little, and Legion himself possessed him, yet I'll speak to him.

FABIAN Here he is, here he is! How is't with you,

sir? How is't with you, man?

MALVOLIO Go off; I discard you. Let me enjoy my private. Go off.

MARIA Lo, how hollow the fiend speaks within him! 410 Did not I tell you? Sir Toby, my lady prays you to have a care of him.

MALVOLIO Aha! does she so?

тову Go to, go to; peace, peace! We must deal gently with him. Let me alone. How do you, Malvolio? How is't with you? What, man! defy the devil! Consider, he's an enemy to mankind.

MALVOLIO Do you know what you say?

MARIA La you, an you speak ill of the devil, how he takes it at heart! Pray God he be not bewitched! 420

FABIAN Carry his water to the wise woman.

MARIA Marry, and it shall be done tomorrow morning if I live. My lady would not lose him for more than I'll say.

MALVOLIO How now, mistress?

MARIA O Lord!

TOBY Prithee hold thy peace. This is not the way. Do you not see you move him? Let me alone with him.

No way but gentleness; gently, gently. The 430 FABIAN fiend is rough and will not be roughly used.

TOBY Why, how now, my bawcock? How dost thou, chuck?

Ay, biddy, come with me. What, man! 'tis not for gravity to play at cherry-pit with Satan. Hang him, foul collier!

MARIA Get him to say his prayers. Good Sir Toby, get him to pray.

MALVOLIO My prayers, minx?

MARIA No, I warrant you, he will not hear of godli-

MALVOLIO Go hang yourselves all! You are idle shallow things; I am not of your element. You shall know more hereafter. Exit.

TOBY Is't possible?

FABIAN If this were played upon a stage now, I could condemn it as an improbable fiction.

TOBY His very genius hath taken the infection of the

device, man.

MARIA Nay, pursue him now, lest the device take 450 air and taint.

FABIAN Why, we shall make him mad indeed.

MARIA The house will be the quieter.

TOBY Come, we'll have him in a dark room and bound. My niece is already in the belief that he's mad. We may carry it thus, for our pleasure and his penance, till our very pastime, tired out of breath, prompt us to have mercy on him; at which time we will bring the device to the bar and crown thee for a finder of madmen. But see, but see!

Enter SIR ANDREW.

FABIAN More matter for a May morning.

ANDREW Here's the challenge; read it. I warrant there's vinegar and pepper in't.

FABIAN Is't so saucy?

ANDREW Ay, is't, I warrant him. Do but read. TOBY Give me. [Reads] "Youth, whatsoever thou art, thou art but a scurvy fellow."

FABIAN Good, and valiant.

TOBY [Reads] "Wonder not nor admire not in thy mind why I do call thee so, for I will show thee no 470 reason for't."

FABIAN A good note! That keeps you from the blow of the law.

TOBY [Reads] "Thou comest to the Lady Olivia, and in my sight she uses thee kindly. But thou liest in thy throat; that is not the matter I challenge thee for.'

FABIAN Very brief, and to exceeding good sense less.

TOBY [Reads] "I will waylay thee going home; 480 where if it be thy chance to kill me"-

FABIAN Good.

TOBY [Reads] "Thou killst me like a rogue and a villain.

FABIAN Still you keep o' the windy side of the law. Good.

TOBY [Reads] "Fare thee well, and God have mercy upon one of our souls! He may have mercy upon mine, but my hope is better; and so look to thyself. Thy friend, as thou usest him, and thy sworn 490 enemy,

"Andrew Aguecheek."

If this letter move him not, his legs cannot. I'll give't him.

You may have very fit occasion for't. He is MARIA now in some commerce with my lady and will byand-by depart.

TOBY Go, Sir Andrew! Scout me for him at the corner of the orchard like a bum-baily. So soon as ever thou seest him, draw; and as thou drawst, 500 swear horrible; for it comes to pass oft that a terrible oath, with a swaggering accent sharply

twanged off, gives manhood more approbation than ever proof itself would have earned him. Away!

ANDREW Nay, let me alone for swearing. TOBY Now will not I deliver his letter; for the behavior of the young gentleman gives him out to be of good capacity and breeding; his employment between his lord and my niece confirms no less. 510 Therefore this letter, being so excellently ignorant, will breed no terror in the youth. He will find it comes from a clodpoll. But, sir, I will deliver his challenge by word of mouth, set upon Aguecheek a notable report of valor, and drive the gentleman (as I know his youth will aptly receive it) into a most hideous opinion of his rage, skill, fury, and impetuosity. This will so fright them both that they will kill one another by the look, like cockatrices.

Enter OLIVIA and VIOLA.

FABIAN Here he comes with your niece. Give them way till he take leave, and presently after him. TOBY I will meditate the while upon some horrid message for a challenge.

Exeunt SIR TOBY, FABIAN, and MARIA. OLIVIA I have said too much unto a heart of stone And laid mine honor too unchary out.

There's something in me that reproves my fault; But such a headstrong potent fault it is

That it but mocks reproof.

VIOLA With the same 'havior that your passion bears

Goes on my master's grief.

OLIVIA Here, wear this jewel for me; 'tis my

Refuse it not; it hath no tongue to vex you. And I beseech you come again tomorrow. What shall you ask of me that I'll deny,

That honor, saved, may upon asking give?

VIOLA Nothing but this—your true love for my master.

OLIVIA How with mine honor may I give him

Which I have given to you?

I will acquit you.

OLIVIA Well, come again tomorrow. Fare thee

A fiend like thee might bear my soul to hell. Exit.

Enter [SIR] TOBY and FABIAN.

TOBY Gentleman, God save thee!

VIOLA And you, sir.

TOBY That defense thou hast, betake thee to't. Of what nature the wrongs are thou hast done him, I know not; but thy intercepter, full of despite, bloody as the hunter, attends thee at the orchard

530

540

end. Dismount thy tuck, be yare in thy preparation; for thy assailant is quick, skillful, and deadly. 550

VIOLA You mistake, sir. I am sure no man hath any quarrel to me. My remembrance is very free and clear from any image of offense done to any man.

TOBY You'll find it otherwise, I assure you. Therefore, if you hold your life at any price, betake you to your guard; for your opposite hath in him what youth, strength, skill, and wrath can furnish man withal.

VIOLA I pray you, sir, what is he?

TOBY He is knight, dubbed with unhatched rapier 560 and on carpet consideration; but he is a devil in private brawl. Souls and bodies hath he divorced three; and his incensement at this moment is so implacable that satisfaction can be none but by pangs of death and sepulcher. "Hob, nob" is his word; "give't or take't."

VIOLA I will return again into the house and desire some conduct of the lady. I am no fighter. I have heard of some kind of men that put quarrels purposely on others to taste their valor. Belike this is a 570

man of that quirk.

TOBY Sir, no. His indignation derives itself out of a very competent injury; therefore get you on and give him his desire. Back you shall not to the house, unless you undertake that with me which with as much safety you might answer him. Therefore on! or strip your sword stark naked; for meddle you must, that's certain, or forswear to wear iron about you.

VIOLA This is as uncivil as strange. I beseech you do 580 me this courteous office, as to know of the knight what my offense to him is. It is something of my

negligence, nothing of my purpose.

TOBY I will do so. Signior Fabian, stay you by this gentleman till my return.

VIOLA Pray you, sir, do you know of this matter? FABIAN I know the knight is incensed against you, even to a mortal arbitrament; but nothing of the circumstance more.

VIOLA I beseech you, what manner of man is he? 590 FABIAN Nothing of that wonderful promise, to read him by his form, as you are like to find him in the proof of his valor. He is indeed, sir, the most skillful, bloody, and fatal opposite that you could possibly have found in any part of Illyria. Will you walk towards him? I will make your peace with him if I can.

VIOLA I shall be much bound to you for't. I am one that had rather go with sir priest than sir knight. I care not who knows so much of my mettle. 600

Exeunt.

Enter [SIR] TOBY and [SIR] ANDREW.

TOBY Why, man, he's a very devil; I have not seen such a virago. I had a pass with him, rapier, scabbard, and all, and he gives me the stuck-in with such a mortal motion that it is inevitable; and on the answer he pays you as surely as your feet hit the ground they step on. They say he has been fencer to the Sophy.

ANDREW Pox on't, I'll not meddle with him.

Ay, but he will not now be pacified. Fabian can scarce hold him yonder.

ANDREW Plague on't, an I thought he had been valiant, and so cunning in fence, I'd have seen him damned ere I'd have challenged him. Let him let the matter slip, and I'll give him my horse, grey Capilet.

TOBY I'll make the motion. Stand here; make a good show on't. This shall end without the perdition of souls. [Aside] Marry, I'll ride your horse as

well as I ride you.

Enter FABIAN and VIOLA.

I have his horse to take up the quarrel. I have per- 620 suaded him the youth's a devil.

FABIAN He is as horribly conceited of him; and pants and looks pale, as if a bear were at his heels.

TOBY There's no remedy, sir; he will fight with you for's oath sake. Marry, he hath better bethought him of his quarrel, and he finds that now scarce to be worth talking of. Therefore draw for the supportance of his vow. He protests he will not hurt you.

[Aside] Pray God defend me! A little thing 630 would make me tell them how much I lack of a man.

FABIAN Give ground if you see him furious.

TOBY Come, Sir Andrew, there's no remedy. The gentleman will for his honor's sake have one bout with you; he cannot by the duello avoid it; but he has promised me, as he is a gentleman and a soldier, he will not hurt you. Come on, to't!

ANDREW Pray God he keep his oath! [Draws.]

Enter ANTONIO.

VIOLA I do assure you 'tis against my will. [Draws.]

ANTONIO Put up your sword. If this young gentleman

Have done offense, I take the fault on me; If you offend him, I for him defy you.

TOBY You, sir? Why, what are you?

ANTONIO [Draws] One, sir, that for his love dares yet do more

Than you have heard him brag to you he will. TOBY Nay, if you be an undertaker, I am for you. [Draws.] Enter OFFICERS.

FABIAN O good Sir Toby, hold! Here come the officers.

TOBY I'll be with you anon.

VIOLA Pray, sir, put your sword up, if you

ANDREW Marry, will I, sir; and for that I promised you, I'll be as good as my word. He will bear you easily, and reins well.

FIRST OFFICER This is the man; do thy office. SECOND OFFICER Antonio, I arrest thee at the suit Of Count Orsino.

You do mistake me, sir. ANTONIO FIRST OFFICER No, sir, no jot. I know your favor

Though now you have no sea-cap on your head. Take him away. He knows I know him well. 660

ANTONIO I must obey. [To VIOLA] This comes with seeking you.

But there's no remedy; I shall answer it. What will you do, now my necessity Makes me to ask you for my purse? It grieves me

Much more for what I cannot do for you Than what befalls myself. You stand amazed, But be of comfort.

SECOND OFFICER Come, sir, away.

ANTONIO I must entreat of you some of that money.

VIOLA What money, sir?

For the fair kindness you have showed me here, And part being prompted by your present trouble,

Out of my lean and low ability

I'll lend you something. My having is not

I'll make division of my present with you. Hold, there's half my coffer.

Will you deny me ANTONIO now?

Is't possible that my deserts to you Can lack persuasion? Do not tempt my misery, Lest that it make me so unsound a man As to upbraid you with those kindnesses That I have done for you.

I know of none, Nor know I you by voice or any feature. I hate ingratitude more in a man Than lying, vainness, babbling drunkenness, Or any taint of vice whose strong corruption Inhabits our frail blood.

O heavens themselves! ANTONIO SECOND OFFICER Come, sir, I pray you go. ANTONIO Let me speak a little. This youth that you see here

I snatched one half out of the jaws of death; Relieved him with such sanctity of love, And to his image, which methought did

Most venerable worth, did I devotion. FIRST OFFICER What's that to us? The time goes by: away!

ANTONIO But, O, how vile an idol proves this

Thou hast, Sebastian, done good feature shame. In nature there's no blemish but the mind; None can be called deformed but the unkind. 700 Virtue is beauty; but the beauteous evil Are empty trunks, o'erflourished by the devil.

FIRST OFFICER The man grows mad. Away with him!

Come, come, sir.

ANTONIO Lead me on. Exit [with OFFICERS]. VIOLA Methinks his words do from such passion

That he believes himself; so do not I. Prove true, imagination, O, prove true, That I, dear brother, be now ta'en for you! TOBY Come hither, knight; come hither, Fabian. 710

We'll whisper o'er a couplet or two of most sage saws.

VIOLA He named Sebastian. I my brother know Yet living in my glass. Even such and so In favor was my brother, and he went Still in this fashion, color, ornament, For him I imitate. O, if it prove, Tempests are kind, and salt waves fresh in love!

TOBY A very dishonest paltry boy, and more a coward than a hare. His dishonesty appears in leaving his friend here in necessity and denying him; and 720 for his cowardship, ask Fabian.

FABIAN A coward, a most devout coward; religious in it.

ANDREW 'Slid, I'll after him again and beat him! TOBY Do; cuff him soundly, but never draw thy sword.

Exit. ANDREW An I do not— FABIAN Come, let's see the event. TOBY I dare lay any money 'twill be nothing yet.

Exeunt.

Act IV

Scene I. Before OLIVIA's house.

Enter SEBASTIAN and CLOWN. CLOWN Will you make me believe that I am not sent for you?

SEBASTIAN Go to, go to, thou art a foolish fellow. Let me be clear of thee.

CLOWN Well held out, i' faith! No, I do not know you; nor I am not sent to you by my lady, to bid you come speak with her; nor your name is not Master Cesario; nor this is not my nose neither. Nothing that is so is so.

SEBASTIAN I prithee vent thy folly somewhere else. 10

Thou knowst not me.

CLOWN Vent my folly! He has heard that word of some great man, and now applies it to a fool. Vent my folly! I am afraid this great lubber, the world, will prove a cockney. I prithee now, ungird thy strangeness, and tell me what I shall vent to my lady. Shall I vent to her that thou art coming? SEBASTIAN I prithee, foolish Greek, depart from me.

There's money for thee. If you tarry longer, I shall give worse payment.

CLOWN By my troth, thou hast an open hand. These wise men that give fools money get themselves a good report—after fourteen years' purchase.

Enter [SIR] ANDREW, [SIR] TOBY, and FABIAN. ANDREW Now, sir, have I met you again? There's [Striking Sebastian.] SEBASTIAN Why, there's for thee, and there, and there!

[Returning the blow.]

Are all the people mad?

TOBY Hold, sir, or I'll throw your dagger o'er the 30 house.

CLOWN This will I tell my lady straight. I would not be in some of your coats for twopence. TOBY Come on, sir; hold!

ANDREW Nay, let him alone. I'll go another way to work with him. I'll have an action of battery against him, if there be any law in Illyria. Though I stroke him first, yet it's no matter for that.

SEBASTIAN Let go thy hand.

TOBY Come, sir, I will not let you go. Come, my 40 young soldier, put up your iron. You are well fleshed. Come on.

SEBASTIAN I will be free from thee. What wouldst'

If thou darest tempt me further, draw thy sword. TOBY What, what? Nay then, I must have an ounce or two of this malapert blood from you.

[Draws.]

Enter OLIVIA.

OLIVIA Hold, Toby! On thy life I charge thee hold!

TOBY Madam!

OLIVIA Will it be ever thus? Ungracious wretch, 50 Fit for the mountains and the barbarous caves,

Where manners ne'er were preached! Out of my sight!

Be not offended, dear Cesario.

Rudesby, be gone!

[Exeunt SIR TOBY, SIR ANDREW, and FABIAN.] I prithee, gentle friend.

Let thy fair wisdom, not thy passion, sway In this uncivil and unjust extent

Against thy peace. Go with me to my house, And hear thou there how many fruitless pranks This ruffian hath botched up, that thou thereby 60 Mayst smile at this. Thou shalt not choose but

Do not deny. Beshrew his soul for me! He started one poor heart of mine, in thee. SEBASTIAN What relish is in this? How runs the stream?

Or I am mad, or else this is a dream. Let fancy still my sense in Lethe steep; If it be thus to dream, still let me sleep!

OLIVIA Nay, come, I prithee. Would thou'dst be ruled by me!

SEBASTIAN Madam, I will.

OLIVIA O, say so, and so be! 70 Exeunt.

Scene II. [OLIVIA's house.]

Enter MARIA and CLOWN.

MARIA Nay, I prithee put on this gown and this beard; make him believe thou art Sir Topas the curate; do it quickly. I'll call Sir Toby the whilst.

CLOWN Well, I'll put it on, and I will dissemble myself in't, and I would I were the first that ever dissembled in such a gown. I am not tall enough to become the function well, nor lean enough to be thought a good student; but to be said an honest man and a good housekeeper goes as fairly as to say a careful man and a great scholar. The competi- 80 tors enter.

Enter [SIR] TOBY [and MARIA].

TOBY Jove bless thee, Master Parson.

CLOWN Bonos dies, Sir Toby; for, as the old hermit of Prague, that never saw pen and ink, very wittily said to a niece of King Gorboduc, "That that is is": so I, being Master Parson, am Master Parson; for what is "that" but "that," and "is" but "is"?

TOBY To him, Sir Topas.

CLOWN What ho, I say. Peace in this prison! TOBY The knave counterfeits well; a good knave.

MALVOLIO within.

MALVOLIO Who calls there?

CLOWN Sir Topas the curate, who comes to visit Malvolio the lunatic.

MALVOLIO Sir Topas, Sir Topas, good Sir Topas, go

to my lady.

CLOWN Out, hyperbolical fiend! How vexest thou this man! Talkest thou nothing but of ladies?

TOBY Well said, Master Parson.

MALVOLIO Sir Topas, never was man thus wronged. Good Sir Topas, do not think I am mad. They have laid me here in hideous darkness.

CLOWN Fie, thou dishonest Satan! I call thee by the most modest terms; for I am one of those gentle ones that will use the Devil himself with courtesy. Sayst thou that house is dark?

MALVOLIO As hell, Sir Topas.

CLOWN Why, it hath bay windows transparent as barricadoes, and the clerestories toward the south north are as lustrous as ebony; and yet complainest thou of obstruction?

MALVOLIO I am not mad, Sir Topas. I say to you this 110 house is dark.

CLOWN Madman, thou errest. I saw there is no darkness but ignorance, in which thou art more puzzled than the Egyptians in their fog.

MALVOLIO I say this house is as dark as ignorance, though ignorance were as dark as hell; and I say there was never man thus abused. I am no more mad than you are. Make the trial of it in any constant question.

CLOWN What is the opinion of Pythagoras concerning wild fowl?

pily inhabit a bird.

CLOWN What thinkst thou of his opinion?

MALVOLIO I think nobly of the soul and no way ap-

prove his opinion.

CLOWN Fare thee well. Remain thou still in darkness. Thou shalt hold the opinion of Pythagoras ere I will allow of thy wits, and fear to kill a woodcock, lest thou dispossess the soul of thy grandam. 130 Fare thee well.

MALVOLIO Sir Topas, Sir Topas! TOBY My most exquisite Sir Topas!

CLOWN Nay, I am for all waters.

MARIA Thou mightst have done this without thy

beard and gown. He sees thee not.

TOBY To him in thine own voice, and bring me word how thou findst him. I would we were well rid of this knavery. If he may be conveniently delivered, I would he were; for I am now so far in 140 offense with my niece that I cannot pursue with any safety this sport to the upshot. Come by-andby to my chamber. Exit [with MARIA].

CLOWN [Singing] "Hey, Robin, jolly Robin, Tell me how thy lady does."

MALVOLIO Fool! CLOWN "My lady is unkind, perdie!" MALVOLIO Fool! CLOWN "Alas, why is she so?"

MALVOLIO Fool, I say!

CLOWN "She loves another"—Who calls, ha?

MALVOLIO Good fool, as ever thou wilt deserve well at my hand, help me to a candle, and pen, ink, and paper. As I am a gentleman, I will live to be thankful to thee for't.

150

CLOWN Master Malvolio?

MALVOLIO Ay, good fool.

CLOWN Alas, sir, how fell you besides your five wits?

MALVOLIO Fool, there was never man so notori- 160 ously abused. I am as well in my wits, fool, as thou

CLOWN But as well? Then you are mad indeed, if you be no better in your wits than a fool.

MALVOLIO They have here propertied me; keep me in darkness, send ministers to me, asses, and do all they can to face me out of my wits.

CLOWN Advise you what you say. The minister is here. - Malvolio, Malvolio, thy wits the heavens restore! Endeavor thyself to sleep and leave thy 170 vain bibble babble.

MALVOLIO Sir Topas!

CLOWN Maintain no words with him, good fellow.-Who, I, sir? Not I, sir. God be wi' you, good Sir Topas!-Marry, amen.-I will, sir, I will.

MALVOLIO Fool, fool, I say!

MALVOLIO That the soul of our grandam might hap- 120 CLOWN Alas, sir, be patient. What say you, sir? I am shent for speaking to you.

MALVOLIO Good fool, help me to some light and 180 some paper. I tell thee, I am as well in my wits as any man in Illyria.

CLOWN Well-a-day that you were, sir!

MALVOLIO By this hand, I am. Good fool, some ink, paper, and light; and convey what I will set down to my lady. It shall advantage thee more than ever the bearing of letter did.

CLOWN I will help you to't. But tell me true, are you not mad indeed? or do you but counterfeit? MALVOLIO Believe me, I am not. I tell thee true. 190 CLOWN Nay, I'll ne'er believe a madman till I see his brains. I will fetch you light and paper and ink. MALVOLIO Fool, I'll requite it in the highest degree.

I prithee be gone.

CLOWN [Singing]

I am gone, sir; And anon, sir, I'll be with you again, In a trice, Like to the old Vice, Your need to sustain; Who, with dagger of lath, In his rage and his wrath, Cries "aha!" to the Devil. Like a mad lad,

"Pare thy nails, dad." Adieu, goodman Devil.

Exit.

Scene III. OLIVIA's garden.

Enter SEBASTIAN.

SEBASTIAN This is the air; that is the glorious sun; This pearl she gave me, I do feel't and see't; And though 'tis wonder that enwraps me thus, Yet 'tis not madness. Where's Antonio then? 210 I could not find him at the Elephant; Yet there he was; and there I found this credit, That he did range the town to seek me out. His counsel now might do me golden service; For though my soul disputes well with my sense That this may be some error, but no madness, Yet doth this accident and flood of fortune So far exceed all instance, all discourse. That I am ready to distrust mine eyes And wrangle with my reason, that persuades me 220 To any other trust but that I am mad, Or else the lady's mad. Yet, if 'twere so, She could not sway her house, command her

Take and give back affairs and their dispatch With such a smooth, discreet, and stable

As I perceive she does. There's something in't That is deceivable. But here the lady comes.

Enter OLIVIA and PRIEST.

OLIVIA Blame not this haste of mine. If you mean

Now go with me and with this holy man Into the chantry by. There, before him, 230 And underneath that consecrated roof, Plight me the full assurance of your faith, That my most jealous and too doubtful soul May live at peace. He shall conceal it Whiles you are willing it shall come to note, What time we will our celebration keep According to my birth. What do you say? SEBASTIAN I'll follow this good man and go with you

And having sworn truth, ever will be true. OLIVIA Then lead the way, good father; and heavens so shine 240

That they may fairly note this act of mine!

Exeunt.

Act V

Scene I. Before OLIVIA's house.

Enter CLOWN and FABIAN.

FABIAN Now as thou lovest me, let me see his letter. CLOWN Good Master Fabian, grant me another request.

FABIAN Anything.

CLOWN Do not desire to see this letter.

FABIAN This is to give a dog, and in recompense desire my dog again.

Enter DUKE, VIOLA, CURIO, and LORDS.

DUKE Belong you to the Lady Olivia, friends? CLOWN Ay, sir, we are some of her trappings.

DUKE I know thee well. How dost thou, my good 10 fellow?

CLOWN Truly, sir, the better for my foes, and the worse for my friends.

DUKE Just the contrary: the better for thy friends. CLOWN No, sir, the worse.

DUKE How can that be?

CLOWN Marry, sir, they praise me and make an ass of me. Now my foes tell me plainly I am an ass; so that by my foes, sir, I profit in the knowledge of myself, and by my friends I am abused; so that, 20 conclusions to be as kisses, if your four negatives make your two affirmatives, why then, the worse for my friends and the better for my foes.

DUKE Why, this is excellent.

CLOWN By my troth, sir, no; though it please you to be one of my friends.

DUKE Thou shalt not be the worse for me. There's gold.

CLOWN But that it would be double-dealing, sir, I would you could make it another.

DUKE O, you give me ill counsel.

CLOWN Put your grace in your pocket, sir, for this once, and let your flesh and blood obey it.

DUKE Well, I will be so much a sinner to be a double-dealer. There's another.

CLOWN Primo, secundo, tertio is a good play; and the old saying is "The third pays for all." The triplex, sir, is a good tripping measure; or the bells of Saint Bennet, sir, may put you in mind—one, two, three.

DUKE You can fool no more money out of me at this throw. If you will let your lady know I am here to speak with her, and bring her along with you, it may awake my bounty further.

CLOWN Marry, sir, lullaby to your bounty till I come again! I go, sir; but I would not have you to think that my desire of having is the sin of covetousness. But, as you say, sir, let your bounty take a nap; I will awake it anon. Exit.

Enter ANTONIO and OFFICERS.

VIOLA Here comes the man, sir, that did rescue me. 50

DUKE That face of his I do remember well; Yet when I saw it last, it was besmeared As black as Vulcan in the smoke of war. A baubling vessel was he captain of, For shallow draught and bulk unprizable, With which such scathful grapple did he make With the most noble bottom of our fleet That very envy and the tongue of loss Cried fame and honor on him. What's the matter?

FIRST OFFICER Orsino, this is that Antonio That took the "Phœnix" and her fraught from

And this is he that did the "Tiger" board When your young nephew Titus lost his leg. Here in the streets, desperate of shame and

In private brabble did we apprehend him. VIOLA He did me kindness, sir; drew on my side; But in conclusion put strange speech upon me. I know not what 'twas but distraction.

DUKE Notable pirate, thou salt-water thief! What foolish boldness brought thee to their

Whom thou in terms so bloody and so dear Hast made thine enemies?

Orsino, noble sir, Be pleased that I shake off these names you give

Antonio never yet was thief or pirate, Though I confess, on base and ground enough, Orsino's enemy. A witchcraft drew me hither. That most ingrateful boy there by your side From the rude sea's enraged and foamy mouth Did I redeem. A wrack past hope he was. His life I gave him, and did thereto add My love without retention or restraint, All his in dedication. For his sake Did I expose myself (pure for his love) Into the danger of this adverse town; Drew to defend him when he was beset; Where being apprehended, his false cunning (Not meaning to partake with me in danger) Taught him to face me out of his acquaintance, And grew a twenty years removed thing While one would wink; denied me mine own

Which I had recommended to his use Not half an hour before.

How can this be? DUKE When came he to this town? ANTONIO Today, my lord; and for three months

No int'rim, not a minute's vacancy, Both day and night did we keep company. Enter OLIVIA and ATTENDANTS.

DUKE Here comes the Countess; now heaven walks on earth.

But for thee, fellow—fellow, thy words are

Three months this youth hath tended upon me; But more of that anon. Take him aside.

OLIVIA What would my lord, but that he may not

Wherein Olivia may seem serviceable? Cesario, you do not keep promise with me.

VIOLA Madam!

DUKE Gracious Olivia—

OLIVIA What do you say, Cesario?—Good my

VIOLA My lord would speak; my duty hushes

If it be aught to the old tune, my lord, 110 It is as fat and fulsome to mine ear As howling after music.

Still so cruel? OLIVIA Still so constant, lord.

DUKE What, to perverseness? You uncivil lady, To whose ingrate and unauspicious altars

My soul the faithful'st off'rings hath breathed

That e'er devotion tendered! What shall I do? OLIVIA Even what it please my lord, that shall become him.

DUKE Why should I not, had I the heart to do it, 120 Like to the Egyptian thief at point of death, Kill what I love?—a savage jealousy That sometime savors nobly. But hear me this: Since you to non-regardance cast my faith, And that I partly know the instrument That screws me from my true place in your favor.

Live you the marble-breasted tyrant still. But this your minion, whom I know you love, And whom, by heaven I swear, I tender dearly, Him will I tear out of that cruel eye Where he sits crowned in his master's spite. Come, boy, with me. My thoughts are ripe in mischief.

I'll sacrifice the lamb that I do love To spite a raven's heart within a dove. VIOLA And I, most jocund, apt, and willingly, To do you rest a thousand deaths would die.

OLIVIA Where goes Cesario?

After him I love More than I love these eyes, more than my life, More, by all mores, than e'er I shall love wife. 140 If I do feign, you witnesses above

Punish my life for tainting of my love! OLIVIA Ay me detested! how am I beguiled! VIOLA Who does beguile you? Who does do you

OLIVIA Hast thou forgot thyself? Is it so long? Call forth the holy father.

> Exit an ATTENDANT. [To VIOLA] Come,

DUKE away!

OLIVIA Whither, my lord? Cesario, husband, stay. DUKE Husband?

OLIVIA Ay, husband. Can he that deny? 150 DUKE Her husband, sirrah?

VIOLA No, my lord, not I.

OLIVIA Alas, it is the baseness of thy fear That makes thee strangle thy propriety. Fear not, Cesario; take thy fortunes up; Be that thou knowst thou art, and then thou art As great as that thou fearest.

Enter Priest.

O, welcome, father! Father, I charge thee by thy reverence Here to unfold—though lately we intended To keep in darkness what occasion now Reveals before 'tis ripe-what thou dost know Hath newly passed between this youth and me. PRIEST A contract of eternal bond of love, Confirmed by mutual joinder of your hands, Attested by the holy close of lips, Strengthened by interchangement of your rings; And all the ceremony of this compact Sealed in my function, by my testimony: Since when, my watch hath told me, toward my grave 170 I have traveled but two hours.

DUKE O thou dissembling cub! What wilt thou be When time hath sowed a grizzle on thy case? Or will not else thy craft so quickly grow That thine own trip shall be thine overthrow? Farewell, and take her; but direct thy feet Where thou and I, henceforth, may never meet. VIOLA My lord, I do protest— O, do not swear!

Hold little faith, though thou hast too much

Enter SIR ANDREW.

ANDREW For the love of God, a surgeon! Send one presently to Sir Toby.

OLIVIA What's the matter?

ANDREW Has broke my head across, and has given Sir Toby a bloody coxcomb too. For the love of God, your help! I had rather than forty pound I were at home.

OLIVIA Who has done this, Sir Andrew? ANDREW The Count's gentleman, one Cesario. We took him for a coward, but he's the very Devil 190 incardinate.

DUKE My gentleman Cesario?

ANDREW Od's lifelings, here he is! You broke my head for nothing; and that that I did, I was set on to do't by Sir Toby.

VIOLA Why do you speak to me? I never hurt you. You drew your sword upon me without cause, But I bespake you fair and hurt you not.

Enter [SIR] TOBY and CLOWN.

ANDREW If a bloody coxcomb be a hurt, you have hurt me. I think you set nothing by a bloody cox-200 comb. Here comes Sir Toby halting-you shall hear more. But if he had not been in drink, he would have tickled you othergates than he did.

DUKE How now, gentleman? How is't with you? That's all one! Has hurt me, and there's the end on't.—Sot, didst see Dick Surgeon, sot?

CLOWN O, he's drunk, Sir Toby, an hour agone. His eyes were set at eight i' the morning.

TOBY Then he's a rogue and a passy measures pavin. I hate a drunken rogue.

OLIVIA Away with him! Who hath made this havoc with them?

ANDREW I'll help you, Sir Toby, because we'll be dressed together.

TOBY Will you help—an ass-head and a coxcomb and a knave—a thin-faced knave, a gull?

OLIVIA Get him to bed, and let his hurt be looked

Exeunt SIR TOBY, SIR ANDREW, CLOWN, and FABIAN.

Enter SEBASTIAN.

SEBASTIAN I am sorry, madam, I have hurt your

But had it been the brother of my blood, I must have done no less with wit and safety. You throw a strange regard upon me, and by that

I do perceive it hath offended you. Pardon me, sweet one, even for the vows We made each other but so late ago.

DUKE One face, one voice, one habit, and two persons!

A natural perspective, that is and is not! SEBASTIAN Antonio! O my dear Antonio! How have the hours racked and tortured me Since I have lost thee!

230

ANTONIO Sebastian are you?

SEBASTIAN Fearst thou that, Antonio?

ANTONIO How have you made division of yourself?

An apple cleft in two is not more twin

Than these two creatures. Which is Sebastian? OLIVIA Most wonderful!

SEBASTIAN Do I stand there? I never had a

Nor can there be that deity in my nature Of here and everywhere. I had a sister. Whom the blind waves and surges have devoured.

Of charity, what kin are you to me?

What countryman? what name? what parentage?

VIOLA Of Messaline; Sebastian was my father— Such a Sebastian was my brother too; So went he suited to his watery tomb. If spirits can assume both form and suit, You come to fright us.

A spirit I am indeed, SEBASTIAN But am in that dimension grossly clad Which from the womb I did participate. 250 Were you a woman, as the rest goes even, I should my tears let fall upon your cheek And say, "Thrice welcome, drowned Viola!" VIOLA My father had a mole upon his brow— SEBASTIAN And so had mine.

VIOLA And died that day when Viola from her birth

Had numbered thirteen years.

SEBASTIAN O, that record is lively in my soul! He finished indeed his mortal act

That day that made my sister thirteen years. VIOLA If nothing lets to make us happy both But this my masculine usurped attire, Do not embrace me till each circumstance Of place, time, fortune do cohere and jump That I am Viola; which to confirm, I'll bring you to a captain in this town, Where lie my maiden weeds; by whose gentle

I was preserved to serve this noble Count. All the occurrence of my fortune since Hath been between this lady and this lord. SEBASTIAN [To OLIVIA] So comes it, lady, you

have been mistook.

But nature to her bias drew in that. You would have been contracted to a maid: Nor are you therein, by my life, deceived: You are betrothed both to a maid and man.

DUKE Be not amazed; right noble is his blood. If this be so, as yet the glass seems true, I shall have share in this most happy wrack. [To VIOLA] Boy, thou hast said to me a thousand

Thou never shouldst love woman like to me. 280 VIOLA And all those sayings will I over swear, And all those swearings keep as true in soul As doth that orbed continent the fire

That severs day from night.

240

270

Give me thy hand, DUKE And let me see thee in thy woman's weeds. VIOLA The captain that did bring me first on

Hath my maid's garments. He upon some action Is now in durance, at Malvolio's suit,

A gentleman, and follower of my lady's. OLIVIA He shall enlarge him. Fetch Malvolio

And yet alas! now I remember me, They say, poor gentleman, he's much distract.

Enter CLOWN with a letter, and FABIAN. A most extracting frenzy of mine own From my remembrance clearly banished his. How does he, sirrah?

CLOWN Truly, madam, he holds Belzebub at the stave's end as well as a man in his case may do. Has here writ a letter to you; I should have given't you today morning. [Offers the letter.] But as a mad-300 man's epistles are no gospels, so it skills not much when they are delivered.

OLIVIA Open't and read it.

CLOWN Look then to be well edified, when the fool delivers the madman. [Reads loudly] "By the Lord, madam"-

OLIVIA How now? Art thou mad?

CLOWN No, madam, I do but read madness. An your ladyship will have it as it ought to be, you must allow vox.

OLIVIA Prithee read i' thy right wits.

CLOWN So I do, madonna; but to read his right wits is to read thus. Therefore perpend, my princess, and give ear.

OLIVIA [To FABIAN] Read it you, sirrah.

FABIAN [Reads] "By the Lord, madam, you wrong me, and the world shall know it. Though you have put me into darkness, and given your drunken cousin rule over me, yet have I the benefit of my senses as well as your ladyship. I have your own 320 letter that induced me to the semblance I put on; with the which I doubt not but to do myself much right, or you much shame. Think of me as you please. I leave my duty a little unthought of, and speak out of my injury.

'THE MADLY USED MALVOLIO."

OLIVIA Did he write this? CLOWN Ay, madam.

DUKE This savors not much of distraction.

OLIVIA See him delivered, Fabian; bring him hither.

Exit FABIAN.

My lord, so please you, these things further thought on,

To think me as well a sister as a wife, One day shall crown the alliance on't, so please

Here at my house and at my proper cost. DUKE Madam, I am most apt t' embrace your offer.

[To VIOLA] Your master quits you; and for your service done him,

So much against the mettle of your sex, So far beneath your soft and tender breeding, And since you called me master, for so long, Here is my hand: you shall from this time be 340 Your master's mistress.

A sister! you are she. OLIVIA

Enter [FABIAN, with] MALVOLIO. DUKE Is this the madman? OLIVIA

Ay, my lord, this

same.

How now, Malvolio?

MALVOLIO Madam, you have done

me wrong,

Notorious wrong.

Have I. Malvolio? No. MALVOLIO Lady, you have. Pray you peruse that

letter. You must not now deny it is your hand. Write from it if you can, in hand or phrase, Or say 'tis not your seal, not your invention. You can say none of this. Well, grant it then, And tell me, in the modesty of honor,

Why you have given me such clear lights of

Bade me come smiling and cross-gartered to

To put on yellow stockings, and to frown Upon Sir Toby and the lighter people; And, acting this in an obedient hope, Why have you suffered me to be imprisoned, 360 Kept in a dark house, visited by the priest, And made the most notorious geck and gull

That e'er invention played on? Tell me why. OLIVIA Alas, Malvolio, this is not my writing, Though I confess much like the character; But, out of question, 'tis Maria's hand. And now I do bethink me, it was she First told me thou wast mad. Thou camest in smiling,

And in such forms which here were presupposed

Upon thee in the letter. Prithee be content. This practice hath most shrewdly passed upon thee;

But when we know the grounds and authors of

Thou shalt be both the plaintiff and the judge Of thine own cause.

FABIAN Good madam, hear me speak,

And let no quarrel, nor no brawl to come, Taint the condition of this present hour, Which I have wond'red at. In hope it shall not, Most freely I confess myself and Toby Set this device against Malvolio here. 380 Upon some stubborn and uncourteous parts We had conceived against him. Maria writ The letter, at Sir Toby's great importance, In recompense whereof he hath married her. How with a sportful malice it was followed May rather pluck on laughter than revenge, If that the injuries be justly weighed That have on both sides passed.

OLIVIA Alas poor fool, how have they baffled thee!

CLOWN Why, "some are born great, some achieve 390 greatness, and some have greatness thrown upon them." I was one, sir, in this interlude—one Sir Topas, sir; but that's all one. "By the Lord, fool, I am not mad!" Bu do you remember—"Madam, why laugh you at such a barren rascal? An you smile not, he's gagged"? And thus the whirligig of time brings in his revenges.

MALVOLIO I'll be revenged on the whole pack of you!

OLIVIA He hath been most notoriously abused. DUKE Pursue him and entreat him to a peace. 400 He hath not told us of the captain yet. When that is known, and golden time convents, A solemn combination shall be made Of our dear souls. Meantime, sweet sister, We will not part from hence. Cesario, come— For so you shall be while you are a man; But when in other habits you are seen, Orsino's mistress and his fancy's queen.

Exeunt [all but the CLOWN]

CLOWN sings.

410

Exit.

When that I was and a little tiny boy, With hey, ho, the wind and the rain, A foolish thing was but a toy, For the rain it raineth every day.

But when I came to man's estate, With hey, ho, the wind and the rain, 'Gainst knaves and thieves men shut their gate, For the rain it raineth every day.

But when I came, alas! to wive, With hey, ho, the wind and the rain, By swaggering could I never thrive, For the rain it raineth every day.

But when I came unto my beds, With hey, ho, the wind and the rain, With tosspots still had drunken heads, For the rain it raineth every day.

420

A great while ago the world begun, With hey, ho, the wind and the rain; But that's all one, our play is done, And we'll strive to please you every day.

Exit.

	GENERAL EVENTS	LITERATURE & PHILOSOPHY	ART
g 1560	1603 1625 D.: Sl 1		
THIRTY YEARS' WAR DECLINE OF SPANISH POWER 8191	1603-1625 Reign of James I in England 1609 Holland and Flanders given virtual independence in truce with Spain	1565 Teresa of Avila, Autobiography 1582-1584 John of the Cross, The Dark Night 1605-1615 Cervantes, Don Quixote 1611 Publication of Authorized Version of Bible, commissioned by King James I	1595-1600 El Greco, The Baptism of Christ 1597-1604 Caravaggio and the Carracci at work in Rome
			c. 1600-1602 Caravaggio, The Doubting of Thomas, The Conversion of Saint Paul, The Martyrdom of Saint Matthew
			1604 A. Carracci, The Flight into Egypt; decorations for Palazzo Farnese Galleria completed
	1610-1643 Reign of Louis XIII		1616 Hals, Banquet of the Officers of the Saint George Militia Company
	in France; Marie de' Medici is regent during his minority		c. 1616-1617 Rubens, The Rape of the Daughters of Leucippus
	1618 Thirty Years' War begins in Germany	1621 Donne appointed Dean of Saint Paul's, London	1622-1625 Rubens paints cycle of 21 paintings glorifying Marie de' Medici;
	1620 English Pilgrims land at Plymouth	1632 Galileo, founder of modern physics, submits Dialogue Concerning the Two Chief World Systems to Pope Urban VIII; is tried	Bernini, The Rape of Proserpine
	1621-1665 Reign of Philip IV		1623 Bernini, <i>David</i> ; Velázquez appointed court painter to Philip IV
	in Spain	and condemned in 1633	c. 1625 Van Dyck, Portrait of the Marchesa Cattaneo
	1643 Five-year-old Louis XIV ascends throne of France under regency of his mother	1637 Descartes, "Father of Modern Philsophy," publishes <i>The</i> Discourse on Method	1627 Caravaggio's influence spreads northward when Louis XIII summons Vouet back from Rome to become court artist
		1638 Galileo, Dialogues Concerning	c. 1630 A. Gentileschi, Self-Portrait as "La Pittura"
		Two New Sciences c. 1640 French Classical comedy and tragedy at height	1631 Claude Lorrain, The Mill
			1632 Van Dyck court painter to Charles I
		1640-1643 Corneille, Horace, Polyeucte, tragedies	c. 1639 Ribera, The Martyrdom of Saint Bartholomew
		1641 Descartes, Meditations	1642 Rembrandt, The Night Watch
1649	1648 Peace of Westphalia	1646 Crashaw, Steps to the Temple	1645-1652 Bernini, Saint Teresa in Ecstasy
PURITAN	1649 Execution of Charles I of England; Cromwell rules 1649-1658	c. 1650 Locke active in England, Pascal in France, Spinoza in Holland	c. 1650 Poussin, The Arcadian Shepherds; Georges de La Tour, Saint Sebastian Attended by Saint Irene
		1651 Hobbes, Leviathan	
1660		c. 1659-1699 Poet and dramatist John Dryden active in England	1656 Velázquez, Las Meninas
	1660 Restoration of monarchy in England under Charles II		1662-1664 Vermeer, Woman in Blue Reading
Š X	1661 Louis XIV assumes full control of France	1667 Milton, Paradise Lost, epic poem in tradition of Homer and Vergil	1669 Death of Rembrandt;
VAN	1682 Louis XIV moves court to newly remodeled Versailles	1670 Molière, Le bourgeois gentilhomme, comedy 1677 Racine, Phèdre, tragedy	1701 Rigaud, Louis XIV
F LOUIS XIV AND XV	1688 Parliamentary enemies of James II invite William of Orange to invade England	1694 Voltaire born in Paris	
FLOI	1689 Declaration of Rights establishes English	TO SOL	

constitutional government; William and Mary rule 1715 Louis XIV dies after 72-year reign; Louis XV ascends throne

AGE OF I

ARCHITECTURE

MUSIC

late 16th cent. Birth of opera in Florence; development of monody

1594-1595 Peri, Dafne, first play set to music, performed in Florence

1600 Peri, Euridice

Opera, concerto grosso, oratorio, cantata, and sonata established as musical forms; virtuoso tradition begins

1607 Monteverdi, L'Orfeo

The Baroque World

Retention of classical vocabulary of Renaissance but on grandiose scale; civic planning and private-house construction also prevalent because of rise of middle classes

1629 Bernini appointed official architect of Saint Peter's, Rome

1631-1687 Longhena, Santa Maria della Salute. Venice

1638-1641 Borromini, Church of San Carlo alle Quattro Fontane, Rome; facade added 1665-1667

1652 Lully enters service of Louis XIV

1663 Bernini, piazza and colonnades for Saint Peter's, Rome; church proper completed by Carlo Maderno 1607-1615

1669-1685 Le Vau and Hardouin-Mansart, Garden facade Versailles

1678 Le Brun and Hardouin-Mansart begin Hall of Mirrors, Palace of Versailles

1674 Lully's Alceste first performed at Versailles

1685 Births of Bach, Handel, Scarlatti

c. 1720 Vivaldi, The Four Seasons, violin concertos

1721 J. S. Bach, Brandenburg Concertos

1723 Bach appointed Kantor of St. Thomas', Leipzig

1729 J. S. Bach, St. Matthew Passion

c. 1735 Rameau, Les Indes Galantes

1742 Handel's Messiah first performed

The Counter-Reformation Spirit

By about 1600 the intellectual and artistic movements of the Renaissance and Reformation had taken a new turn. Although the cultural activity of the next hundred and fifty years was the natural outgrowth of earlier developments, the difference in spiritalready signaled by the middle of the 16th century was striking.

The chief agent of the new spirit was the Roman Catholic Church. After initial shock at the success of Protestantism, the Catholic Church decided that the best defense was a well-planned attack. Switching to the offensive, the Church relied in great measure on new religious orders like the Jesuits, founded as early as 1534, to lead the movement known as the Counter-Reformation. Putting behind them the anxieties of the past, the chief representatives of the Counter-Reformation gave voice to a renewed spirit of confidence in the universality of the Church and the authority of its teachings. They reinforced this position by vigorous missionary work throughout Europe and in the Americas and the Far East.

At the same time, Catholics at home were reminded of the power and splendor of their religion by a massive quantity of works of art commissioned to enforce the chief principles of Counter-Reformation teachings. The official position of the Church had been newly stated at the Council of Trent, which

met sporadically from 1545 to 1563. Now it was the task of religious leaders and, under their guidance, of the artists to make this position known to the faithful. New emphasis was placed on clarity and directness. The impression of the Church's triumphant resurgence was further reinforced by a new emphasis on material splendor and glory. In Rome itself the construction of a number of lavish churches was crowned by the completion at last of Saint Peter's and the addition of Bernini's spectacular piazza, or square, in front of it [13.1], while throughout Catholic Europe there developed a rich and ornate art that could do justice to the new demands for expressive power and spectacle.

The term used to describe the new style, at first in derision but since the 19th century simply as a convenient label, is baroque. The word's origins are obscure. It may be related to the Portuguese barroco, which means an irregularly shaped pearl, or perhaps to baroco, an Italian term used to describe a complicated problem in medieval logic. In any case, baroque came to be applied in general to anything elaborate and fanciful, in particular to the artistic style of the 17th and early 18th centuries.

Although strictly speaking baroque is a term applied only to the visual arts, it is frequently used to describe the entire cultural achievement of the age. To extend its use to literature, music, and even intellectual developments of the same period inevitably implies that all the arts of the Baroque period had

13.1 Aerial view of Saint Peter's, Rome. Height of facade 147' (44.81 m), width 374' (114 m). The nave and facade were finished by Carlo Maderna (1556-1629) between 1606 and 1612, and the colonnades around the square were built between 1656 and 1663 to the design of Bernini (see page 154). The completion of Saint Peter's was one of the first great achievements of baroque architecture.

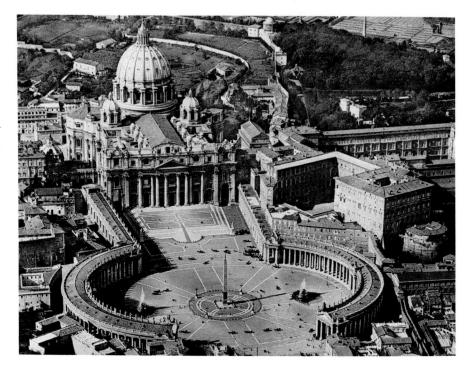

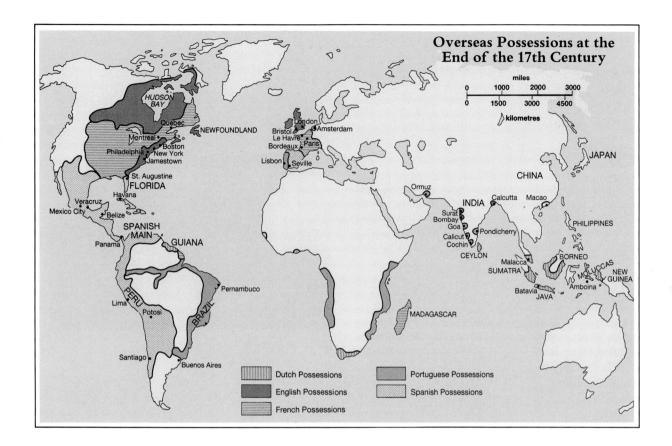

certain characteristics in common. In fact, a close comparison between the visual arts, music, and literature of the 17th and early 18th centuries does reveal a number of shared ideas and attitudes. It is important to remember from the outset, however, that this artistic unity is by no means obvious. A first glance at the cultural range of the period actually reveals a quite astonishing variety of styles, developing individually in widely separated places and subject to very different political and social pressures.

In this respect the Baroque period marks a significant break with the Renaissance, when Italy had been the center of virtually all artistic development. In spite of the impact of the Counter-Reformation, the Reformation itself had begun an irreversible process of decentralization. By the beginning of the 17th century, although Rome was still the artistic capital of Europe, important cultural changes were taking place elsewhere. The economic growth of countries like Holland and England, and the increasing power of France, produced a series of artistic styles that developed locally rather than being imported wholesale from south of the Alps. Throughout northern Europe the rise of the middle class continued to create a new public for the arts, which in turn affected the

development of painting, architecture, and music. For the first time European culture began to spread across the Atlantic, carried to the Americas by Counter-Reformation missionaries.

The much greater geographic spread of artistic achievement was accompanied by the creation of new artistic forms in response to new religious and social pressures. In music, for instance, the 17th century saw the birth of opera and of new kinds of instrumental music, including works for orchestra like the concerto grosso. Painters continued to depict scenes from the Bible and from classical mythology but they turned increasingly to other subjects including portraits, landscapes, and scenes from everyday life. Architects constructed private town houses and started to take an interest in civic planning instead of devoting themselves exclusively to churches and palaces.

A similar richness and variety can be found in the philosophical and scientific thought of the period, which managed temporarily to reconcile its own pursuit of scientific truth with traditional theological and political attitudes. By the end of the 17th century, however, the practical discoveries of science had begun to undermine long-accepted ideas and to lay

EAST MEETS WEST

The Spanish Empire in America

The expedition of Christopher Columbus that discovered America in 1492 had been funded by the Spanish Queen Isabella in the hope that it would beat the Portuguese to the East. America was a consolation prize, and one which the conquistadores were quick to exploit. Mines were opened for precious metals, in which native Indians were put to forced labor; many of them died. Church leaders saw the new territories as ripe for missionary campaigns of conversion, and throughout the 16th and 17th centuries churches were built in the principal centers of Latin (or Spanish) America [13.2].

By the end of the 16th century the Spanish possessions in America were divided into two great viceroyalties: Mexico and Peru. A small white governing class of Castilian Spanish ruled the Indian population and a growing number of mestizos (people of mixed white and Indian descent). American-born whites, or Creoles, were regarded by the Spaniards as inferior. Slaves were imported from Africa, and in general received better status and protection in Spanish America than those employed in the later Dutch, French, and English colonies of North America.

Counter-Reformation missionaries introduced the Spanish language and the faith of the Spanish Church, and with them other aspects of European culture. A printing press was functioning in Mexico City by the mid-16th century. By 1636, when Harvard College (the oldest university in the United States) was founded, there were already five European-style universities in Spanish America, including those of Mexico City and Lima.

13.2 Mexico City Cathedral. 1656-1671.

Many of the most elaborate of Counter-Reformation projects and building schemes in Europe were funded by precious metals mined in Mexico and Peru. It has been calculated that for years half a million pounds of silver and ten thousand pounds of gold were transported annually from America to Spain.

Thus by the 17th century Europe had become transformed from a self-contained world to the center of a global navigation network from which America, Asia, and Africa were all within reach. The consequences for European culture were profound.

the basis for the new skepticism that came to dominate the 18th century.

It would be unwise to look for broad general principles operating in an age of such dynamic and varied change. Nonetheless, to understand and appreciate the baroque spirit as it appears in the individual arts it is helpful to bear in mind the chief assumptions and preoccupations shared by most baroque artists. Whatever the medium in which they worked, baroque artists were united in their commitment to strong emotional statements, to psychological exploration, and to the invention of new and daring techniques.

Perhaps the most striking of these is the expression of intense emotions. In the Renaissance artists had generally tried to achieve the calm balance and order they thought of as typically classical: in the Baroque period artists were attracted by extremes of feeling. Sometimes these strong emotions were personal. Painters and poets alike tried to look into their

own souls and reveal by color or word the depths of their own psychic and spiritual experience. More often artists tried to convey intense religious emotions. In each case, far from avoiding painful or extremely emotional states as subjects, their works sought out and explored them.

The concern with emotion produced in its turn an interest in what came to be called psychology. Baroque artists tried to explain how and why their subjects felt as strongly as they did by representing their emotional states as vividly and analytically as possible. This is particularly evident in 17th-century opera and drama, where music in the one case and words in the other were used to depict the precise state of mind of the characters.

The desire to express the inexpressible required the invention of new techniques. As a result, baroque art put great emphasis on virtuosity. Sculptors and painters achieved astonishing realism in the way in which they handled their media. Stone was carved in such a way as to give the effect of thin, flowing drapery, while 17th-century painters found ways to reproduce complex effects of light and shade (Table 13.1). Baroque writers often used elaborate imagery and complicated grammatical structure to express intense emotional states. In music, both composers and performers began to develop new virtuoso skills; composers in their ability to write works of greater and greater complexity, and performers in their ability to sing or play music in the new style. In fact some pieces, like toccatas—free-form rhapsodies for keyboard—were principally intended to allow instrumentalists to demonstrate their technique, thus inaugurating the tradition of the virtuoso performer that reached a climax in the 19th century.

The Visual Arts in the Baroque Period

Painting in Rome: Caravaggio and the Carracci

The foundations of baroque style, which was to dominate much of European painting for 150 years, were laid in Rome around 1600 by two artists whose work at first glance seems to have little in common. Michelangelo Merisi (1573–1610), better known as Caravaggio—the name of his home town in northern Italy—explored the darker aspects of life and death in some of the most naturalistic and dramatic pictures ever painted. Annibale Carracci (1560-1609) preferred to paint light and elegant depictions of the loves of gods and goddesses and charming landscapes. That both artists exerted an immense influence on their successors says something for the extreme range of baroque painting.

Of the two painters, Caravaggio was certainly the more controversial in his day. His own life style did little to recommend him to the aristocratic and ecclesiastical patrons on whom he depended. From his first arrival in Rome around 1590 Caravaggio seems to have lived an unconventional and violent life, in continual trouble with the police and alienating po-

tential friends by his savage temper.

Any chances Caravaggio had for establishing himself successfully in Rome were brought to an abrupt end in 1606 when he quarreled violently with an opponent in a tennis match and stabbed him to death. He avoided punishment only by fleeing to Naples and then to Malta, where he was thrown into prison for attacking a police officer. Escaping, he made his way to Sicily and then back to Naples, where yet again he got involved in a violent quarrel, this time in a sleazy inn. Seriously wounded, he heard of the pos-

TABLE 13.1 Characteristics and Examples of Baroque Art

Characteristic	Example	
Emotionalism	Caravaggio, Martyrdom of St. Matthew (13.4)	
	Rubens, Rape of the Daughters	
	of Leucippus (13.26)	
Illusionism	Bernini, David (13.9)	
0.1.1	Rembrandt, Night Watch (13.31)	
Splendor	Bernini, St. Peter's Square (13.1)	
	Versailles (13.19, 20)	
	Carracci, Triumph of Bacchus and Ariadne (13.7)	
Light and Shade	Caravaggio, Conversion of	
	St. Paul (13.3)	
	Velázquez, Las Meninas (13.24)	
	Vermeer, Woman Reading a	
	Letter (13.30)	
	De La Tour, Lamentation over	
	St. Sebastian (13.13)	
Movement	Poussin, Rape of the Sabine Women (13.15)	
	El Greco, Burial of Count	
	Orgaz (13.22)	
	Borromini, Facade for	
	San Carlo (13.12)	
Religious Fervor	Ribera, Martyrdom of St.	
	Bartholomew (13.23)	
	El Greco, Martyrdom of St.	
	Maurice (13.21)	
Domestic Intimacy	Caravaggio, Madonna of	
	Loreto (13.5)	
	Rubens, Hélène Fourment (13.25)	
	Rembrandt, Jacob Blessing the	
	Sons of Joseph (13.33)	

sibility of a pardon if he were to return to Rome, but on the journey back he died of a fever (brought on, it was said, by a final attack of rage at some sailors he mistakenly thought had robbed him). The pardon from the pope arrived a few days later.

The spirit of rebellion that governed Caravaggio's life can be seen in his art. In his depiction of religious scenes he refused to accept either the traditionally idealizing versions of earlier artists or the Counter-Reformation demands for magnificent display. Furthermore, instead of placing his figures in an elaborate setting in accordance with Counter-Reformation principles, Caravaggio surrounded them with shadows, a device that emphasizes the drama of the scene and the poverty of the participants.

Caravaggio's preference for extreme contrasts between light and dark, described by the Italian word

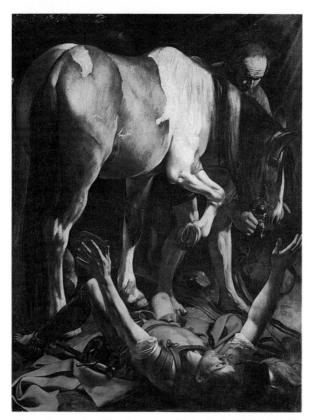

13.3 Caravaggio. The Conversion of Saint Paul. 1601-1602. Oil on canvas, $7'6\frac{1}{2}'' \times 5'9''$ (2.3 × 1.75 m). Cerasi Chapel, Santa Maria del Popolo, Rome. The artist produces a highly dramatic effect by letting the bright light of the divine vision strike the group head-on, rather than from above. The future saint has fallen from his horse and lies in a trance as if trying literally to grasp what he has seen.

chiaroscuro, was one of the aspects of his style most imitated by later painters. When not handled by a master, the use of heavy shadows surrounding brightly lit figures in the foreground tends to become artificial and overtheatrical, but in Caravaggio's works it always serves a true dramatic purpose. In his painting The Conversion of Saint Paul [13.3], the future saint lies on the ground, paralyzed by shock and blinded by the divine light pouring down on him; his old servant stands in the background, in the darkness of bewilderment and ignorance. The repressed violence implicit in this scene becomes explicit in Caravaggio's painting The Martyrdom of Saint Matthew [13.4], one of three pictures painted between 1597 and 1603 for the Contarelli Chapel in the Church of San Luigi dei Francesi at Rome-Caravaggio's first important Roman commission. Caravaggio had seen and felt enough suffering to be able to portray it with painful realism, but the painting tells us as much about the reactions of the onlookers as about Matthew himself. They range from the sadistic violence of the executioner to the apparent indifference of the figures in shadow on the left; only the angel swooping down with the palm of martyrdom relieves the brutality and pessimism of the scene.

It would be a mistake to think of Caravaggio's work as without tenderness. In the Madonna of Loreto [13.5] he shows us not the remote grace of a Botticelli Virgin or the sweet, calm beauty of a Raphael Madonna but a simple Roman mother. As she stands gravely on the doorstep of her backstreet house where the plaster is falling away from the walls, two humble pilgrims fall to their knees in confident prayer. They raise their loving faces to the Virgin and Christ Child while turning toward us their muddy, travel-stained feet. It is perhaps not surprising that some of Caravaggio's contemporaries, brought up on the elegant and well-nourished Madonnas and worshipers of the Renaissance and surrounded by the splendor of Counter-Reformation art, should have found pictures like these disrespectful and lacking in devotion. It should be equally unsurprising that once the initial shock wore off, the honesty and truth of Caravaggio's vision made a profound impact on both artists and the public.

Among the painters working at Rome who fell under the spell of Caravaggio's works was Orazio Gentileschi (1563-1639), who was born in Pisa and studied in Florence. Much impressed by Caravaggio's dramatic naturalism and concern for psycholog-

13.4 Caravaggio. The Martyrdom of Saint Matthew. c. 1602. Oil on canvas, $10'9'' \times 11'6''$ (3.3 × 3.5 m). Contarelli Chapel, San Luigi dei Francesi, Rome. The deeply moved onlooker at the very back of the scene is, according to one tradition, a self-portrait of the artist.

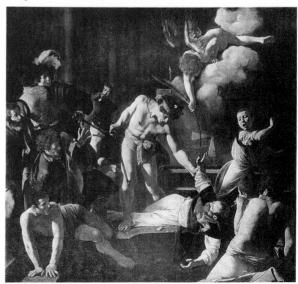

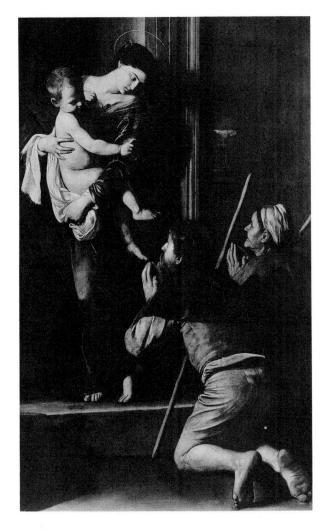

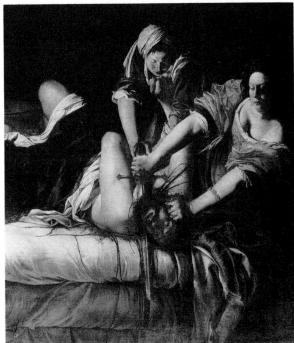

13.6 Artemisia Gentileschi. Judith and Holofernes. c. 1620. Oil on canvas, $78\frac{1}{3}$ " × 64" (199 × 162.5 cm). Uffizi, Florence.

13.5 Caravaggio. Madonna of Loreto. c. 1604. Oil on canvas, $8'6\frac{1}{2}" \times 4'10\frac{1}{2}"$ (2.6 × 1.5 m). Cavaletti Chapel, San Agostino, Rome. The shabby clothes show the poverty of the two pilgrims.

ical truth, Gentileschi based his own style on that of his younger contemporary. Since he spent the last eighteen years of his life traveling and living in northern Europe, first in France and then in England, he played an important part in spreading a knowledge of Caravaggio's style outside Italy. At the same time, moreover, he handed on his enthusiasm to a painter nearer home, his own daughter Artemisia (1592-1652/1653).

Artemisia Gentileschi has been described as the first woman in the history of the Western world to make a significant contribution to the art of her time. The question of why so few women achieved eminence in the visual arts before recent times is a complicated one, and the chief answers are principally social and economic rather than aesthetic. Certainly, Artemisia was typical of the few women painters of the Renaissance and Baroque periods who did become famous in that she was the daughter of a painter and therefore at home in the world of art and artists.

Gentileschi's most famous painting is Judith and Holofernes [13.6]. Done in chiaroscuro (the technique that strongly contrasts light and dark for dramatic purposes), the painting conveys a tremendous sense of violence as Judith and her maid loom over the drastically foreshortened body of Holofernes. There is a stark contrast between the realistic violence of the beheading and the sensual richness of the silken bed, the jewelery, and the cunning drapery. It is not inconceivable that the painter, herself a rape victim in her youth, poured her own passionate protest into this painting of a woman taking retribution against a would-be defiler. This work depicts a scene from the biblical story of the Jewish heroine Judith, who used her charms to save her people from an invading Assyrian army; she won the confidence of its general, Holofernes, and then beheaded him in the privacy of his tent.

It is a far cry from the dark, emotional world of Caravaggio and his followers to the brilliant, ideal-

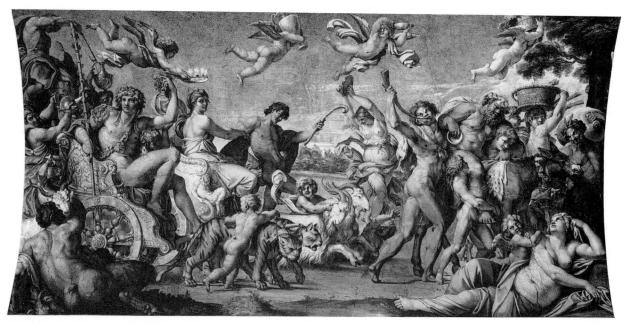

13.7 Annibale Carracci. The Triumph of Bacchus and Ariadne. 1597-1600. Fresco. Farnese Palace, Rome. The god's chariot, drawn by tigers, is accompanied by a wild procession of cupids, nymphs, and satyrs.

ized world of Annibale Carracci, his brother Agostino, and his cousin Ludovico, all often spoken of collectively as the Carracci. The most gifted member of this Bolognese family was Annibale, whose earliest important work in Rome, the decoration of the galleria or formal reception hall of the Palazzo Farnese, was painted between 1597 and 1604, precisely the years when Caravaggio was working on the Contarelli Chapel. The many scenes in the galleria constitute a fresco cycle based on Greek and Roman mythology, depicting the loves of the Gods, including The Triumph of Bacchus and Ariadne [13.7]. The

sense of exuberant life and movement and the mood of unrestrained sensual celebration seem at the farthest remove from Caravaggio's somber paintings, yet both artists share the baroque love of extreme emotion, and both show the same concern for realism of detail.

The same blend of ideal proportion and realistic detail emerges in Annibale's landscape paintings, of which the best-known is probably The Flight into Egypt [13.8]. The scene is the countryside around Rome, with the river Tiber in the foreground and the Alban Hills in the distance. The tiny human figures

13.8 Annibale Carracci. The Flight into Egypt. c. 1604. Oil on canvas, $3' \times 7'5\%''$ (.9 × 2.3 m). Doria-Pamphili Gallery, Rome. In spite of the Holy Family in the center foreground, the painting is not so much religious as a depiction of the landscape around Rome.

are carefully related in proportion to this natural setting, precisely balanced by the distant castle, and located just at the meeting point of the diagonal lines formed by the flock of sheep and the river. As a result, we perceive a sense of idyllic classical order while being convinced of the reality of the landscape.

Roman Baroque Sculpture and Architecture: Bernini and Borromini

The most influential of all Italian baroque artists of the Counter-Reformation was a sculptor and architect, not a painter. The sculptural achievement of Gian Lorenzo Bernini (1598-1680), of seemingly unlimited range of expression and unbelievable technical virtuosity, continued to influence sculptors until the 19th century; as the chief architect of Counter-Reformation Rome he permanently changed the face of that venerable city.

Born the son of a Florentine sculptor in Naples, Bernini showed signs of his extraordinary abilities from an early age. One of his first important works, a statue of David [13.9], seems to have been deliberately intended to evoke comparison with works by his illustrious predecessors. Unlike the Davids of Donatello [see figure 10.14] or Michelangelo [see figure 10.27] which are seen in repose, Bernini's figure is very definitely in the midst of action. From the bitten lips to the muscular tension of the arms to the final detail of the clenched toes of the right foot, this David seems to personify energy, almost exploding through space. Bernini gives the figure additional expressive power by his deep cuts in the stone, producing a strong contrast between light and dark. In its expression of violent emotion, its communication of the psychological state of its subject, and its virtuoso technique, this David is a truly baroque figure.

Many of Bernini's sculptures have religious themes, like the David. Other works depict his aristocratic patrons with the same mastery he applied to less obviously spectacular subjects. The bust of Cardinal Scipione Borghese [13.10], with its quizzical

13.9 Gian Lorenzo Bernini. David. 1623-1624. Marble, height 5'61/4" (1.7 m). Borghese Gallery, Rome. It is said that Bernini carved the face while looking at his own in a mirror. The expression reinforces the tension of the pose.

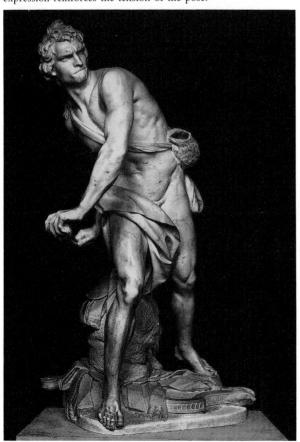

13.10 Gian Lorenzo Bernini. Cardinal Scipione Borghese. 1632. Marble, height 30¾" (78 cm). Borghese Gallery, Rome. Breaking with the tradition of Renaissance portraiture, which showed the subject in repose, Bernini portrays the Cardinal, his first patron, with a sense of lively movement.

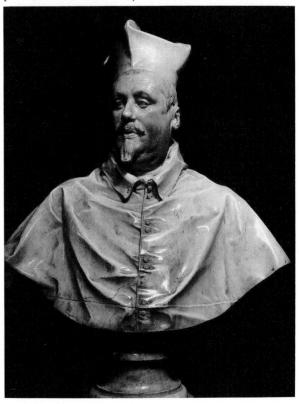

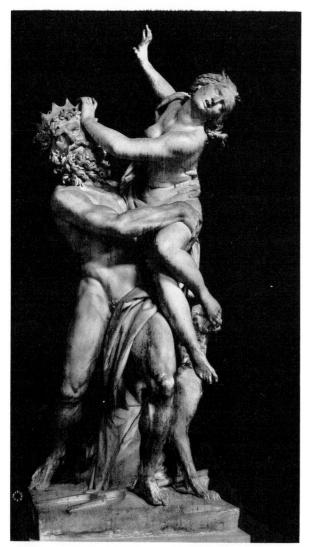

13.11 Gian Lorenzo Bernini. The Rape of Proserpine. 1622-1625. Marble, height 8'31/2" (2.55 m). Borghese Gallery, Rome. In his expression of violent emotion. Bernini was much influenced by Greek sculpture of the Hellenistic period.

expression and almost uncanny sense of movement, conveys the personality of the sitter with sympathy and subtlety. He also illustrates scenes from classical mythology. In The Rape of Proserpine [13.11] Pluto, the god of the underworld, seems to be striving toward the spectator as he catches up Proserpine in his arms. The sense of movement is underlined by the contrary thrust of the girl as she tries vainly to escape. Here, too, the deep cutting of Pluto's face and beard produces a strong contrast to Proserpine's youthful appearance.

Works such as these would have been more than sufficient to guarantee Bernini's immortality, but his architectural achievements are equally impressive.

The physical appearance of baroque Rome was enriched by numerous Bernini fountains. Bernini palaces, and Bernini churches. Most important of all was his work on Saint Peter's, where he created in front of the basilica a vast piazza with its oval colonnade, central obelisk, and fountains, an ensemble [see figure 13.1, page 146] that rivals in grandeur even the fora of Imperial Rome.

Bernini's expansive personality and his success in obtaining important commissions brought him tragically if inevitably into conflict with the other great architect of baroque Rome, Francesco Borromini (1599–1667). Brooding and melancholy much of the time, Borromini spent most of his career in constant competition with his brilliant rival and finally committed suicide. Whereas Bernini was concerned with

13.12 Francesco Borromini. Facade, San Carlo alle Quattro Fontane, Rome. Begun 1638, facade finished 1667. Length 52' (15.86 m), width 34' (10.36 m), width of facade 38' (11.58 m). The curves and countercurves of the facade, together with the rich, almost cluttered, decoration, mark a deliberate rejection of the classical style.

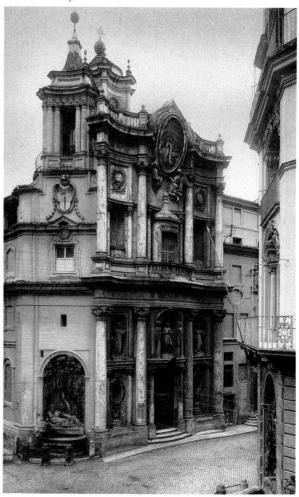

the broad sweep of a design and grandiose effects, Borromini concentrated on elaborate details and

highly complex structures.

Borromini's greatest and most influential achievement was the church of San Carlo alle Quattro Fontane. The inside, designed between 1638 and 1641, was his first important work; the facade, which he added in 1665-1667, was his last [13.12]. On a relatively small exterior wall space Borromini has placed a wide range of decorative elements-columns, niches, arches, statues-while the facade itself flows in sinuous curves. The almost obsessive elaboration of design is in strong contrast to the clarity of many of Bernini's buildings, but its ornateness represents another baroque approach to architecture, one that was to have a continual appeal.

Baroque Art in France and Spain

In general, the more extravagant aspects of Italian baroque art never appealed greatly to French taste, which preferred elegance to display and restraint to emotion. Indeed, the conservative nature of French art found expression before the end of the century in the foundation of the Académie des Beaux-Arts, or Academy of the Fine Arts. The first of the special exhibitions organized by the Academy took place in 1667, under the patronage of Louis XIV. Both then and through the succeeding centuries Academy members saw their function as the defense of traditional standards and values rather than the encouragement of revolutionary new developments. Their innate conservatism affected both the works selected for exhibition and those awarded prizes. The tension between these self-appointed guardians of tradition and those artists who revolted against established ideas lasted well into the 19th century.

The closest parallel in French baroque painting to the intensity of Caravaggio is to be found in the strangely moving paintings of Georges de La Tour (1590-1652), whose candlelit scenes and humbly dressed figures are reminiscent of some aspects of the Italian's work. Yet the mood of such paintings as The Lamentation over Saint Sebastian [13.13] is much more restrained and poetic—the emotions are not stressed.

The greatest French painter of the 17th century, Nicolas Poussin (c. 1593–1665), echoed this French preference for restraint when he decisively rejected the innovations of Caravaggio, whose works he claimed to detest. He saw his own work as a kind of protest against the excesses of the baroque; a strong dislike of his Roman contemporaries nevertheless did

CONTEMPORARY VOICES

Giambattista Passeri

In this passage the 17th-century painter and biographer Giambattista Passeri describes the suicide of Francesco Borromini. In the summer of 1667, tormented by Bernini's triumphant successes, Borromini

. . . was assailed again with even greater violence by hypochondria which reduced him within a few days to such a state that nobody recognized him any more for Borromini, so haggard had his body become, and so frightening his face. He twisted his mouth in a thousand horrid ways, rolled his eyes from time to time in a fearful manner, and sometimes would roar and tremble like an irate lion. His nephew [Bernardo] consulted doctors, heard the advice of friends, and had him visited several times by priests. All agreed that he should never be left alone, nor be allowed any occasion for working, and that one should try to make him sleep at all costs, so that his spirit might calm down. This was the precise order which the servants received from his nephew and which they carried out. But instead of improving, his illness grew worse. Finding that he was never obeyed, as all he asked for was refused him, he imagined that this was done in order to annoy him rather than for his

good, so that his restlessness increased and as time passed his hypochondria changed into pains in his chest, asthma, and a sort of intermittent frenzy. One evening, during the height of summer, he had at last thrown himself into his bed, but after barely an hour's sleep he woke up again, called the servant on duty, and asked for a light and writing material. Told by the servant that these had been forbidden him by the doctors and his nephew, he went back to bed and tried to sleep. But unable to do so in those hot and sultry hours, he started to toss agitatedly about as usual, until he was heard to exclaim: 'When will you stop afflicting me, O dismal thoughts? When will my mind cease being agitated? When will all these woes leave me? . . . What am I still doing in this cruel and execrable life?' He rose in a fury and ran to a sword which, unhappily for him and through carelessness of those who served him, had been left lying on a table, and letting himself barbarously fall on the point was pierced from front to back. The servant rushed in at the noise and seeing the terrible spectacle called others for help, and so, half-dead and covered in blood, he was put back to bed. Knowing then that he had really reached the end of his life, he called for the confessor and made his will.

From R. and M. Wittkower, Born Under Saturn (New York: Norton, 1963), p. 141.

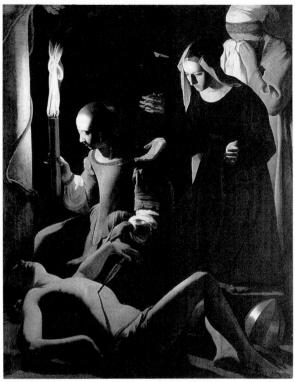

13.13 Georges de La Tour. The Lamentation over Saint Sebastian. 1645. Oil on canvas, c. $5'3'' \times 4'3''$ (1.6 × 1.3 m). Gemäldegalerie Staatliche Museen. Preussischer Kulturbesitz, Berlin (West). The influence of Caravaggio is obvious. Nevertheless, the simplification of details and the distaste for violence (there is no blood around the arrow) are typical of the restraint of La Tour's paintings.

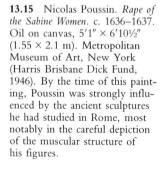

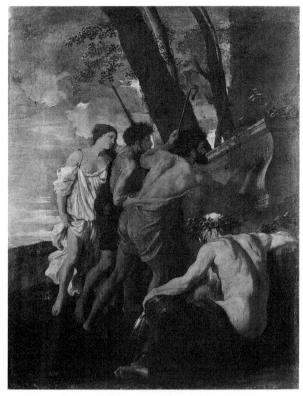

13.14 Nicolas Poussin. Et in Arcadia Ego. c. 1630. Oil on canvas, c. 40 × 32" (102 × 81 cm). Devonshire Collection, Chatsworth Settlement. Although influenced by classical sources, this early version of the subject has a poetic character that owes much to the art of Titian.

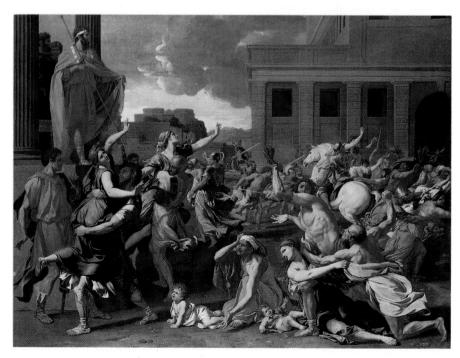

not prevent his spending most of his life in Rome. It may seem strange that so French an artist should have chosen to live in Italy, but what drew him there was the art of ancient, not baroque, Rome. Poussin's only real and enduring enthusiasm was for the world of classical antiquity. His friends at Rome included the leading antiquarians of the day, and his paintings often express a nostalgic yearning for a long-vanished past.

Among Poussin's most poignant early works is Et in Arcadia Ego [13.14], in which four country dwellers gather at a large stone tomb amid an idyllic landscape. The inscription they struggle intently to decipher says Et in Arcadia Ego ("I am also in Arcadia"), a reminder that death exists even in the midst of such beauty and apparently simple charm. (Arcadia, although an actual region in Greece, was also used to refer to an imaginary land of perfect peace and beauty.) That charm is not altogether so simple, however. Poussin's rustic shepherds and casually dressed shepherdess seem to have stepped straight from some actual antique scene, such as Poussin often incorporated into his paintings, while the rich landscape is reminiscent of Venetian painting. The whole work therefore represents not so much the authentic representation of an actual past as the imaginative creation of a world that never really existed.

As his career developed, Poussin's style changed. The poetry of the earlier works was replaced by a grandeur that sometimes verges on stiffness. The Rape of the Sabine Women [13.15] is conceived on a massive scale and deals with a highly dramatic subject, yet the desperate women and violent Roman soldiers seem almost frozen in motion. Every figure

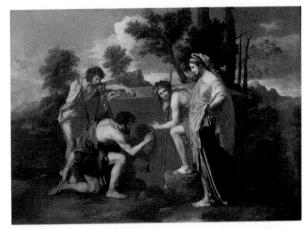

13.16 Nicolas Poussin. Et in Arcadia Ego. 1638–1639. Oil on canvas. $33\frac{1}{2} \times 47\frac{1}{2}8$ " (85 × 121 cm). Louvre, Paris. In comparison with figure 13.14, an earlier version, this treatment is calmer and less dramatic. The group is seen from the front rather than diagonally, and both faces and poses are deliberately unemotional.

is depicted clearly and precisely, as in Carracci's *Triumph of Bacchus and Ariadne* [see figure 13.7, page 152], yet with none of the exuberance of the earlier artist. The artificial, contrived air is deliberate.

By the end of his life, Poussin had returned to the simplicity of his earlier style, but it was drained of any trace of emotion. Another version of the subject of *Et in Arcadia Ego* [13.16], painted some ten years after the earlier one, makes a revealing contrast. The same four figures study the same tomb, but in a mood of deep stillness. Gone is the urgency of the earlier painting—and much of the poetry. In its place Poussin creates a mood of philosophical calm and

13.17 Claude Lorrain. *Mill on a River.* 1631 or 1637. Oil on canvas, 241/4 × 331/4" (61.5 × 85.5 cm). Museum of Fine Arts, Boston (Seth K. Sweetser Fund). Although this is one of Lorrain's early paintings, it already shows his ability to create a sense of infinite space and depth, in part by calculated contrasts between light and dark.

13.18 Hyacinthe Rigaud. Louis XIV. 1701. Oil on canvas, $9'1\frac{1}{2}'' \times 6'2\frac{5}{8}''$ (2.78 × 1.9 m). Louvre, Paris. Louis was 63 when this portrait was painted. The swirling ermine-lined robes are a mark of the king's swagger. The ballet pose of the feet is a reminder of the popularity of dancing at the French court.

13.19 Aerial view, Palace of Versailles. 1661-1688. Width of palace 1935' (589.79 m). The chief architects for the last stage of construction at Versailles were Louis le Vau (1612-1670) and Jules Hardouin-Mansart (1646-1708). Although the external decoration of the palace is classical in style, the massive scale is characteristic of baroque architecture.

tries to recapture the lofty spirit of antiquity, most notably in the noble brow and solemn stance of the shepherdess. Compensating for the loss of warmth is the transcendent beauty of the image.

Even had Poussin been prepared to leave Rome and return to the French court, the austere nature of his art would hardly have served to glorify that most autocratic and magnificent of monarchs, Louis XIV (born 1638, reigned 1643-1715). For the most part the king had only second-rate artists available to him at court: like Poussin, the other great French painter of the day, Claude Lorrain (1600-1682) spent most of his life in Rome, and in any case was only really interested in painting landscapes [13.17].

Although most official court painters achieved only mediocre respectability, an exception must be made for Hyacinthe Rigaud (1659-1743), whose stunning portrait of Louis XIV [13.18] epitomizes baroque grandeur. It would be difficult to claim the intellectual vigor of Poussin or the emotional honesty of Caravaggio for this frankly flattering image of majesty. The stilted pose and the gorgeous robes might even suggest an element of exaggeration, almost of parody; yet a glance at the king's sagging face and stony gaze immediately puts such an idea to flight. Rigaud has captured his patron's outward splendor while not hiding his increasing weakness, due in great part to his decadent life style. The signs of physical collapse are visible—Et in Versailles Ego.

Louis XIV's most lasting artistic achievement was the Palace of Versailles, built a few miles outside

13.20 Jules Hardouin-Mansart and Charles Lebrun. Hall of Mirrors, Palace of Versailles. Begun 1676. Length 240' (73.15 m), width 34' (10.36 m), height 43' (13.11 m). The interior decoration was by Charles Lebrun (1619-1690), who borrowed the idea of a ceiling frescoed with mythological scenes from Carracci's painted ceiling in the Farnese Palace (see figure 13.7, page 152).

Paris as a new center for the court [13.19]. The history of its construction is long and complicated, and the final result betrays some of the uncertainties that went into its planning.

Louis XIV, an acute politician and astute judge of human psychology, was well aware of the fact that the aristocratic courtiers who surrounded him were likely to turn on him at the faintest sign of weakness or hesitation on his part. By constructing at Versailles an elaborate setting in which he could consciously act out the role of Grand Monarch, Louis conveyed the image of himself as supreme ruler and thereby retained his mastery over the aristocracy.

The Palace of Versailles was therefore conceived of by the king in political terms. The architects' task, both inside and out, was to create a building that would illustrate Louis XIV's symbolic concept of himself as the Sun King. Thus each morning the king would rise from his bed, make his way past the assembled court through the Hall of Mirrors [13.20] where the seventeen huge mirrors reflected both the daylight and his own splendor, and enter the gardens along the main wing of the palace—which was laid out in an east-west axis to follow the path of the sun. At the same time both the palace and its gardens, which extend behind it for some two miles, were required to provide an appropriate setting for the balls, feasts, and fireworks displays organized there.

Given the grandiose symbolism of the ground plan and interior decorations, the actual appearance of the outside of the Palace of Versailles, with its rows of Ionic columns, is surprisingly modest. The simplicity of design and decoration is another demonstration of the French ability to combine the extremes of baroque art with a more classical spirit.

The Spanish reaction to the baroque was very different. Strong religious emotion had always been a characteristic of Spanish Catholicism, and the new possibilities presented by baroque painting were foreshadowed in the work of the greatest painter active in Spain in the late 16th century, El Greco (1541-1614)—"the Greek." Domenikos Theotokopoulos (his original name) was born on the Greek island of Crete, which was at the time under Venetian rule. He seems to have traveled to Venice, where he was influenced by Titian, and to Rome. It is not known why he went to Spain, but he is recorded as having lived in Toledo from 1577 until his death.

Although he tried to obtain court patronage, the violence of contrasts in his works—clashes of color, scale, and emotion—did not appeal to official taste: his first royal commission, the Martyrdom of St. Maurice and the Theban Legion (13.21), was his last. The painting illustrates the theme of moral responsibility

13.21 El Greco. Martyrdom of St. Maurice and Theban Legion. 1581-84. Oil on canvas, 14'6" × 9'10" (4.42 × 3 m). Escorial Palace. The saint is facing the viewer, pointing up to the heavenly vision he sees.

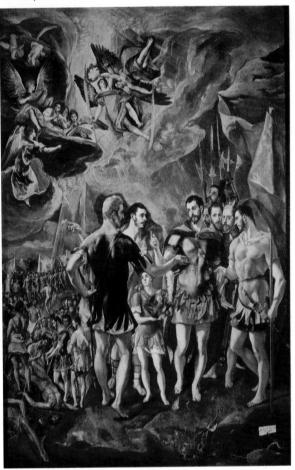

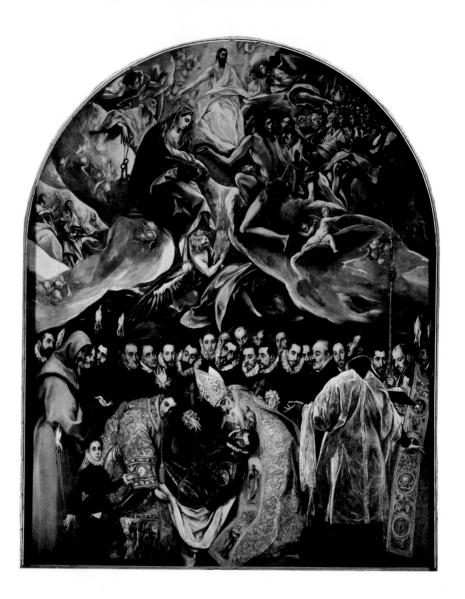

13.22 El Greco. Burial of Count Orgaz. 1586. Oil on canvas, 16' × 11'10" (4.88 × 3.61 m). San Tomé, Toledo, Spain. Note the elongated proportions of the figures in the heavens and the color contrasts between the upper and lower sections of the painting.

and choice. The Roman soldier Maurice, faced with a conflict between the demands of Roman law and of his Christian faith, chooses the latter, together with his fellow Theban and Christian legionnaires. The hallucinatory brightness of the colors is probably derived from Italian Mannerist painting of earlier in the 16th century, as are the elongated proportions, but the effect, underlined by the asymmetrical composition, is incomparably more fierce and disturbing.

In the absence of court patronage, El Greco produced many of his works for Toledo, his city of residence. Among the most spectacular is the Burial of Count Orgaz (13.22), a local benefactor who was rewarded for his generosity by the appearance of St. Augustine and St. Stephen at his funeral in 1323. They can be seen in the lower center of the painting, burying the count while his soul rises up; the small

boy dressed in black in the left-hand corner is the artist's eight-year old son, identified by an inscription. The rich, heavy robes of the saints are balanced by the swirling drapery of the heavenly figures above, while the material and spiritual worlds are clearly separated by a row of grave, brooding local dignitaries.

The same religious fervor appears in the work of Jusepe Ribera (1591-1652) but is expressed in a far more naturalistic style. Like Caravaggio, Ribera used peasants in his religious scenes, which were painted with strong contrasts of light and dark. In his The Martyrdom of Saint Bartholomew [13.23] Ribera spares us nothing in the way of realism as the saint is hauled into position to be flayed. The muscular brutality of his executioners and the sense of impending physical agony are almost masochistic in their vividness.

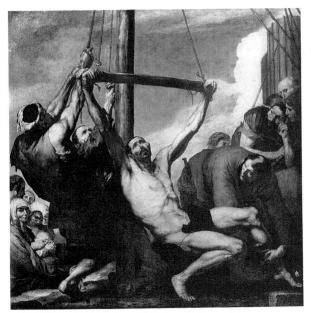

13.23 Jusepe de Ribera. The Martyrdom of Saint Bartholomew. c. 1638. Oil on canvas, 7'71/4" (2.34 m) square. Prado, Madrid. Unlike La Tour (see figure 13.13), Ribera refuses to soften the subject by idealizing his figures.

Only in the compassionate faces of some onlookers do we find any relief from the torment of the scene.

Although paintings like Ribera's are representative of much of Spanish baroque art, the work of Diego Velázquez (1599-1660), the greatest Spanish painter of the Baroque period, is very different in spirit. Velázquez used his superlative technique to depict scenes brimming with life, preferring the court of Phillip IV (where he spent much of his career) and the lives of ordinary people to religious or mythological subjects.

The finest and most complex work of Velázquez is Las Meninas, or The Maids of Honor [13.24]. Unlike Louis XIV, the Spanish king was fortunate enough to have one of the greatest painters in history to preserve the memory of his court. It is to Philip IV's credit that he treated Velázquez with respect and honor. In return Velázquez produced a number of superb portraits of the monarch and his family.

Las Meninas is an evocation of life in the royal palace. The scene is Velázquez' own studio there; the five-year-old Princess Margarita has come, with her two maids, to visit the painter at work on a huge painting that must surely be Las Meninas itself. Despite the size of the picture, the mood is quiet, even intimate: two figures in casual conversation, a sleepy dog, a passing court official, who raises a curtain at the back to peer into the room. Yet so subtle is Velázquez' use of color that we feel the very presence of the room as a three-dimensional space filled with light, now bright, now shadowy. The reality of details like the little princess' hair or dress never distracts from the overall unity of color and composition. That Velázquez was justifiably proud of his abilities is shown by the two distinguished visitors whose presence is felt rather than seen, reflected as they are in the mirror hanging on the back wall: the king and queen themselves, come to honor the artist by visiting him in his own studio.

Baroque Art in Northern Europe

Most baroque art produced in northern Europe was intended for a middle-class rather than an aristocratic audience, as in Italy, France, and Spain. Before examining the effects of this, however, we must look at two very notable exceptions, Peter Paul Rubens (1577–1640) and his assistant and later rival, Anthony van Dyck (1599-1641), both Flemish by birth.

13.24 Diego Velázquez. Las Meninas (The Maids of Honor). 1651. Oil on canvas, 10'5" × 9' (3.18 × 2.74 m). Prado, Madrid. The red cross on the artist's breast, symbol of the noble Order of Santiago, was painted there after his death by the king's command. Velázquez regarded his nomination to the order in 1658 as recognition both of his own nobility and that of his art. He thus became one of the first victors in the war that artists had waged ever since the Renaissance for a social status equal to that of their patrons. Throughout the 16th and 17th centuries their aristocratic and ecclesiastical employers regarded them as little better than servants; only by the end of the 18th century were artists and musicians able to assert their social and political independence.

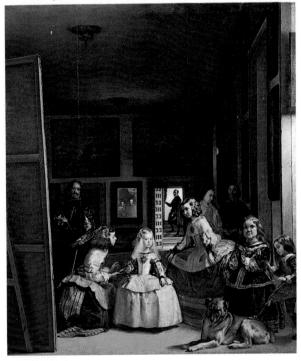

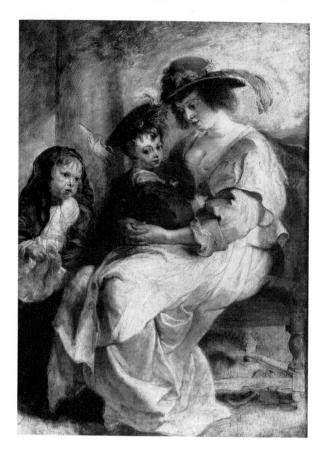

13.26 Peter Paul Rubens. The Rape of the Daughters of Leucippus. c. 1618. Oil on canvas, $7'3'' \times 6'10''$ (2.21 × 2.08 m). Alte Pinakothek, Munich. According to the Greek legend, Castor and Pollux, twin sons of Zeus, carried off the two daughters of King Leucippus, who had been betrothed to their cousins. The myth here becomes symbolic of physical passion.

13.25 Peter Paul Rubens. Hélène Fourment and Her Children. 1636–1637. Oil on canvas, $44\frac{1}{2} \times 32\frac{1}{4}$ " (118 × 82 cm). Louvre, Paris. In this affectionate portrait of his young wife and two of their children, Rubens achieves a sense of immediacy and freshness by his lightness of touch.

Rubens is often called the most universal of painters because he produced with apparent ease an almost inexhaustible stream of works of all kinds-religious subjects, portraits, landscapes, mythological scenes all on the grandest of scales. Certainly he must have been among the most active artists in history: in addition to running the workshop used for the production of his commissions, he pursued a career in diplomacy, which involved considerable traveling throughout Europe, and still had time for academic study. He is said to have spoken and written six modern languages and to have read Latin fluently. He was also versed in theology. Further, in contrast to solitary and gloomy figures like Caravaggio and Borromini, Rubens seems to have been contented in his personal life. After the death of his first wife he remarried, at the age of fifty-three, a girl of sixteen, Hélène Fourment, with whom he spent an ecstatically happy ten years before his death. The paintings of his last decade are among the most intimate and tender of all artistic tributes to married love [13.25].

For the most part, however, intimacy is not the

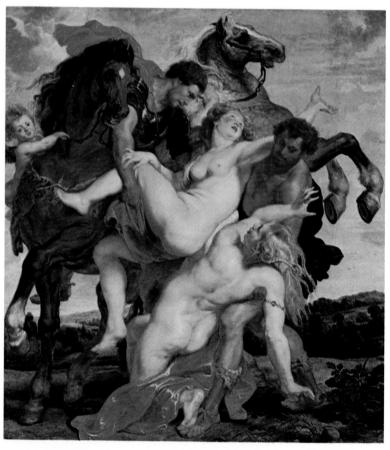

quality most characteristic of Rubens' art. Generally his pictures convey something of the restless energy of his life. In The Rape of the Daughters of Leucippus [13.26] every part of the painting is filled with movement as the mortal women, divine riders, and even the horses are drawn into a single pulsating spiral. The sense of action, so characteristic of Rubens' paintings, is in strong contrast to the frozen movement of Poussin's depiction of a similar episode [see figure 13.15, page 156]. Equally typical of the artist is his frank delight in the girls' sensuous nudity and ample proportions—the slender grace of other artists' nudes was not at all to Rubens' taste.

Perhaps the most extraordinary achievement of Rubens' remarkable career was his fulfillment of a commission from Marie de' Medici, widow of Henry IV and mother of Louis XIII, to decorate an entire gallery with paintings illustrating her life. In a mere three years, from 1622 to 1625, he created 24 enormous paintings commemorating the chief events in which she played a part, with greater flattery than truth. The splendid The Journey of Marie de' Medici [13.27] shows the magnificently attired queen on horseback at the Battle of Ponts-de-Cé, accompanied by the spirit of Power, while Fame and Glory flutter

13.27 Peter Paul Rubens. The Journey of Marie de' Medici. 1622–1625. Oil on canvas, $14'11'' \times 9'6''$ (3.94 × 2.95 m). Louvre, Paris. This painting focuses on the triumphant figure of the queen. As in many of his large works, Rubens probably painted the important sections and left other parts to his assistants.

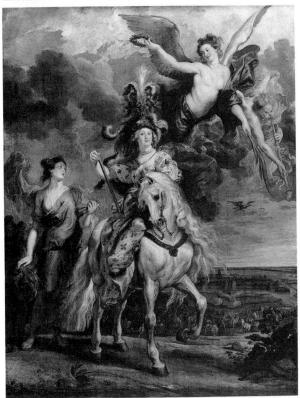

around her head. It hardly matters that the queen's forces were ignominiously defeated in the battle, so convincingly triumphant does her image appear.

Paintings on this scale required the help of assistants, and there is no doubt that in Rubens' workshop much of the preliminary work was done by his staff. One of the many artists employed for this purpose eventually became as much in demand as his former master for portraits of the aristocracy. Anthony van Dyck spent two years, 1618 to 1620, with Rubens before beginning his career as an independent artist. Although from time to time he painted religious subjects, his fame rests on his formal portraits, many of them produced during the years he spent in Italy and England.

Van Dyck's refined taste equipped him for satisfying the demands of his noble patrons that they be shown as they thought they looked rather than as they actually were. It is certainly difficult to believe that any real-life figure could have had quite the haughty bearing and lofty dignity of the Marchesa Cataneo [13.28] in Van Dyck's portrait of her, al-

13.28 Anthony van Dyck. Marchesa Elena Grimaldi, Wife of Marchese Nicola Cataneo. c. 1625. Oil on canvas, 8'1" × 5'8" (2.7 × 1.73 m). National Gallery of Art, Washington (Widener Collection, 1942). Painted fairly early in Van Dyck's career during a stay in Genoa, the portrait emphasizes the aristocratic bearing of its subject by somber colors and an artificial setting.

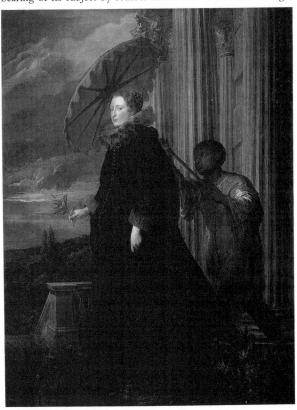

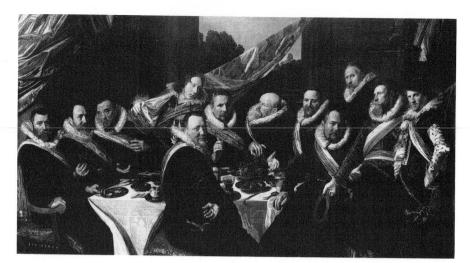

13.29 Frans Hals. Banquet of the Officers of the Civic Guard of Saint George at Haarlem. 1616. Oil on canvas, $5'8\frac{1}{4}'' \times 10'6\frac{3}{8}''$ (1.75 × 3.24 m). Frans Halsmuseum, Haarlem. The diagonal lines of the curtains, banner, and sashes help bind the painting together and make it at the same time both a series of individual portraits and a single unified composition.

though the Genoese nobility of which she was a member was known for its arrogance.

International celebrities like Rubens and Van Dyck, at home at the courts of all Europe, were far from typical of northern artists. Indeed, painters in the Netherlands in particular found themselves in a very different situation from their colleagues elsewhere. The two most lucrative sources of commissions, the Church and the aristocracy, were unavailable to them because the Dutch Calvinist Church followed post-Reformation practice in forbidding the use of images in church, and because Holland had never had its own powerful hereditary nobility. Painters therefore depended on the tastes and demands of the open market.

One highly profitable source of income for Dutch artists in the 17th century was the group portrait, in particular that of a militia, or civic guard company. These bands of soldiers had originally served a practical purpose in the defense of their country, but their regular reunions tended to be social gatherings, chiefly for the purpose of eating and drinking. A group of war veterans today would hire a photographer to commemorate their annual reunion; the militia companies engaged the services of a portrait painter. If they were lucky or rich enough they might even get Frans Hals (c. 1580-1666), whose group portraits capture the individuality of each of the participants while conveying the general convivial spirit of the occasion [13.29]. Hals was certainly not the most imaginative or inventive of artists, but his sheer ability to paint, using broad dynamic brush strokes and cleverly organized compositions, makes his works some of the most attractive of that period.

Very different in spirit was Jan Vermeer (1632-1675), who worked almost unknown in the city of Delft and whose art was virtually forgotten after his

death. Rediscovered in the 19th century, it is now regarded as second only to Rembrandt's for depth of feeling. At first sight this may seem surprising, since Vermeer's subjects are rather limited in scope. A woman reading a letter [13.30], girls sewing or playing music—through such intimate scenes Vermeer

13.30 Jan Vermeer. Woman Reading a Letter. 1662-1664. Oil on canvas, $18\frac{1}{8} \times 15\frac{1}{4}$ " (46 × 39 cm). Rijksmuseum, Amsterdam. Much of the sense of balance and repose that Vermeer conveys is achieved by his careful color contrasts between blue and yellow and the repetition of rectangular surfaces such as the table, chair backs, and the map of the Netherlands on the wall.

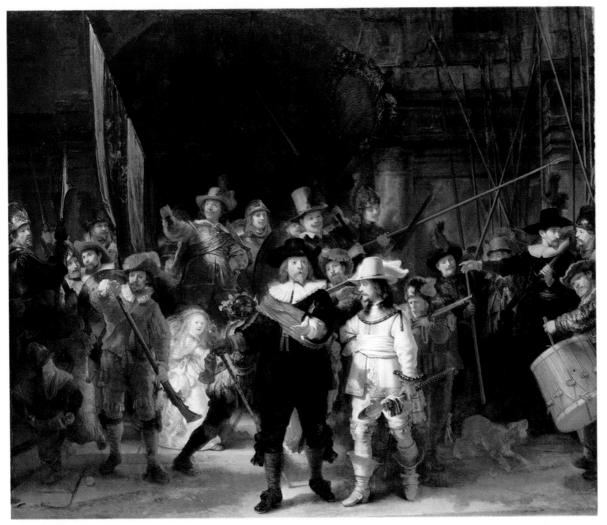

13.31 Rembrandt. The Sortie of Captain Frans Banning Cocq's Company of the Civic Guard (The Night Watch). 1642. Oil on canvas, $11'9\frac{1}{2}'' \times 14'2\frac{1}{2}''$ (3.63 × 4.37 m). Rijksmuseum, Amsterdam. Recent cleaning has revealed that the painting's popular name, though conveniently brief, is inaccurate. Far from being submerged in darkness, the principal figures were originally bathed in light and painted in glowing colors.

reveals qualities of inner contemplation and repose that are virtually unique in the entire history of art. Unlike Hals, Vermeer applied his colors with the most perfect precision in the form of tiny dots, rendering the details with exquisite care. Like Velázquez' Las Meninas [see figure 13.24, page 161], his paintings are dominated by light so palpable as to seem to surround the figures with its presence. However, where Velázquez' canvas is suffused with a warm, Mediterranean glow, Hals' paintings capture the coolness and clarity of northern light. The perfection of his compositions creates a mood of stillness so complete that mundane activities take on a totally unexpected concentration and become endowed with a timeless beauty.

Rembrandt van Rijn (1606-1669) is one of the most deeply loved of all painters. No summary of his achievement can begin to do justice to it. Born in Leiden in the Netherlands, he spent a short time at the university there before beginning his studies as a painter. The early part of his career was spent in Amsterdam, where he moved in 1631 and soon became known as a fashionable portrait painter. His life was that of any successful man of the time, happily married, living in his own fine house.

Rembrandt's interest in spiritual matters and the eternal problems of existence, however, coupled with his researches into new artistic techniques, seem to have prevented his settling down for long to a bourgeois existence of this kind. The artistic turning

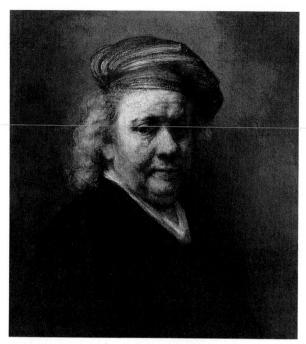

13.32 Rembrandt. Old Self-Portrait. 1669. Oil on canvas, $23\frac{1}{4} \times 20\frac{3}{4}$ " (59 × 53 cm). Mauritshuis, The Hague. In his last self-portrait, painted a few months before his death, the artist seems drained of all emotion, his expression resigned and gaze fixed.

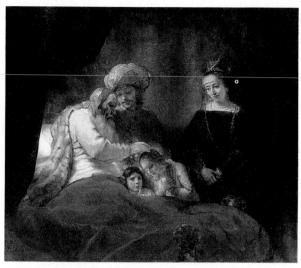

13.33 Rembrandt. Jacob Blessing the Sons of Joseph. 1656. Oil on canvas, 5'81/4" × 6'9" (1.75 × 2.1 m). Staatliche Kunstsammlungen Kassel, Galerie Alte Meister, GK 249. In his very personal version of the biblical story, painted in the year of his financial collapse, Rembrandt includes Asenath, Joseph's wife. Although she is not mentioned in the text, her presence here emphasizes the family nature of the occasion.

point of his career came in 1642, the year of the death of his wife, when he finished the painting known as The Night Watch [13.31]. Although ostensibly the same kind of group portrait as Hals' Banquet of the Officers of the Civic Guard [see figure 13.29], it is composed with much greater complexity and subtlety. The arrangement of the figures and the sense of depth show how far Rembrandt was outdistancing his contemporaries.

The price Rembrandt paid for his genius was growing neglect, which by 1656 had brought bankruptcy. The less his work appealed to the public of his day, the more Rembrandt retreated into his own spiritual world. About 1645 he set up house with Hendrickje Stoffels, although he never married her, and his unconventional behavior succeeded in alienating him still further from his contemporaries. It was the faithful Hendrickje, however, who together with Titus, Rembrandt's son by his first marriage, helped put his financial affairs in some sort of order. Her death in 1663 left him desolate, and its effect on him is visible in some of the last self-portraits [13.32].

Throughout his life Rembrandt had sought selfunderstanding by painting a series of portraits of himself, charting his inner journey through the increasingly tragic events of his life. Without self-pity

or pretense he analyzed his own feelings and recorded them with a dispassion that might be called merely clinical if its principal achievement were not the revelation of a human soul. By the time of Hendrickje's death, which was followed in 1668 by that of Titus, Rembrandt was producing self-portraits that evoke not so much sympathy for his sufferings as awe at their truth. The inexorable physical decay, the universal fate, is accompanied by a growth in spiritual awareness that must at least in part have come from Rembrandt's lifelong meditation on the Scriptures.

In the last years of his life Rembrandt turned increasingly to biblical subjects, always using them to explore some aspect of human feelings. In Jacob Blessing the Sons of Joseph [13.33] all the tenderness of family affection is expressed in the juxtaposition of the heads of the old man and his son, whose expression of love is surpassed only by that of his wife as she gazes almost unseeingly at her sons. The depth of emotion and the dark shadows mark that school of baroque painting initiated by Caravaggio, yet it seems almost an impertinence to categorize so universal a statement. Through this painting Rembrandt seems to offer us a deep spiritual comfort for the tragic nature of human destiny revealed by the selfportraits.

Baroque Music

Although the history of music is as long as that of the other arts, the earliest music with which most modern music lovers are on familiar ground is that of the Baroque period. It is a safe bet that many thousands of listeners have tapped their feet to the rhythm of a baroque concerto without knowing or caring anything about its historical context, and with good reason: baroque music, with its strong emphasis on rhythmic vitality and attractive melody, is easy to respond to with pleasure. Furthermore, in the person of Johann Sebastian Bach, the Baroque period produced one of the greatest geniuses in the history of music, one who shared Rembrandt's ability to communicate profound experience on the broadest level.

The qualities that make baroque music popular today were responsible for its original success: composers of the Baroque period were the first since classical antiquity to write large quantities of music intended for the pleasure of listeners as well as the glory of God. The polyphonic music of the Middle Ages and the Renaissance, with its interweaving of many musical lines, had enabled composers like Machaut or Palestrina to praise the Lord on the highest level of intellectual achievement, but the result was a musical

style far above the heads of most of their contemporary listeners. The Council of Trent, in accordance with Counter-Reformation principles, had even considered prohibiting polyphony in religious works in order to make church music more accessible to the average congregation before finally deciding that this would be too extreme a measure. For once, the objectives of Reformation and Counter-Reformation coincided, for Luther had already simplified the musical elements in Protestant services for the same reason (see page 87).

The time was therefore ripe for a general move toward sacred music with a wider and more universal appeal. Since at the same time the demand for secular music was growing, it is not surprising that composers soon developed a style sufficiently attractive and sufficiently flexible not only for the creation of masses and other liturgical works, but also of instrumental and vocal music that could be played and listened to at home [13.34].

The Birth of Opera

Perhaps the major artistic innovation of the 17th century was a new form of musical entertainment that had been formulated at the beginning of the baroque

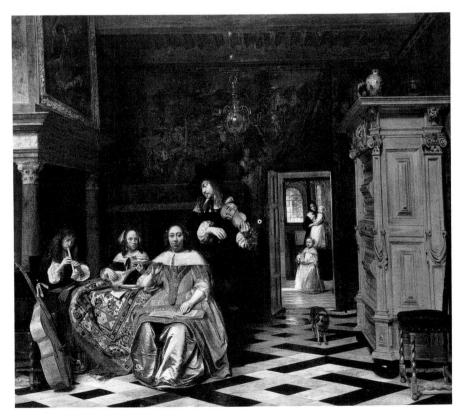

13.34 Pieter de Hooch. The Music Party. 1663. Oil on canvas, $39 \times 47''$ (99 × 119 cm). Cleveland Museum of Art (gift of Hanna Fund). Some prosperous Dutch citizens are relaxing by both performing and listening to music.

period-opera, which consisted of a play in which the text was sung rather than spoken. Throughout the 17th century the taste for opera and operatic music swept Europe, attracting aristocratic and middleclass listeners alike. In the process, the public appetite for music with which it could identify grew even greater. Small wonder that 20th-century listeners have found pleasure and delight in music written to provide our baroque predecessors with precisely those satisfactions.

Like much else of beauty, opera was born in Florence. Ironically enough, an art form that was to become so popular in so short a time was originally conceived of in lofty intellectual terms. Toward the end of the 16th century a number of thinkers, poets, and musicians began to meet regularly at the house of a wealthy Florentine noble, Count Giovanni Bardi. This group, known as the Florentine Camerata, objected strongly to the way in which the polyphonic style in vocal music reduced the text to incomprehensible nonsense. They looked back nostalgically to the time of the Greeks, when almost every word of Greek tragedy was both sung and accompanied by instruments, yet remained perfectly understandable to the spectators. Greek music itself was, of course, lost forever; but at least the group could revive what they considered its essence.

The result was the introduction of a musical form known as monody, or recitative, which consisted of the free declamation of a single vocal line with a simple instrumental accompaniment for support. Thus listeners could follow the text with ease. The addition of music also gave an emotional intensity not present in simple spoken verse, thus satisfying the baroque interest in heightened emotion.

Although in theory monody could be used for either sacred or secular works, its dramatic potential was obvious. In the winter of 1594-1595 the first play set to music, Jacopo Peri's Dafne, was performed in Florence. Its subject was drawn from classical mythology and dealt with Apollo's pursuit of the mortal girl Daphne, who turned into a laurel tree to elude him. In the words of a spectator, "The pleasure and amazement of those present were beyond expression." Dafne is now lost, but another work of Peri, Euridice, has survived to become the earliest extant opera. It too was based on a Greek myth, that of Orpheus and Euridice. The first performance took place in 1600, again in Florence, at the wedding of Henry IV of France to the same Marie de' Medici whom Rubens was to portray a generation later [see figure 13.27].

It is, of course, no coincidence that both of Peri's works as well as many that followed were written on classical subjects, since the Camerata had taken its initial inspiration from Greek drama. The story of Orpheus and Euridice, furthermore, had a special appeal for composers, since it told how the musician Orpheus was able to soften the heart of the King of the Underworld by his music and thereby win back his wife Euridice from the dead. The theme was treated many times in the music of the next 400 years, yet no subsequent version is more moving or psychologically convincing than the one by Claudio Monteverdi (1567–1643), the first great genius in the history of opera.

Monteverdi's Orfeo was first performed in 1607. Its composer brought to the new form not only a complete understanding of the possibilities of monody but in addition an impressive mastery of traditional polyphonic forms such as the madrigal. Equally important for the success of his works was Monteverdi's remarkable dramatic instinct and his ability to transform emotion into musical terms. The contrast between the pastoral gaiety of the first act of Orfeo, depicting the happy couple's love, and the scene in the second act in which Orpheus is brought the news of his wife's death is achieved with marvellous expressive power.

In Orfeo, his first opera, Monteverdi was able to breathe real life into the academic principles of the Florentine Camerata, but the work was written for his noble employer, the Duke of Mantua, and intended for a limited aristocratic public. Monteverdi lived long enough to see the new dramatic form achieve widespread popularity at all levels of society throughout Europe. It did not take long for a taste for Italian opera to spread to Germany and Austria and then to England, where by the end of the century Italian singers dominated the London stage. The French showed their usual unwillingness to adopt a foreign invention wholesale; nonetheless, the leading composer at the court of Louis XIV was a Florentine who tactfully changed his name from Giovanni Batista Lulli to Jean Baptiste Lully (1632–1687). His stately tragedies, which were performed throughout Europe, incorporated long sections of ballet, a custom continued by his most illustrious successor, Jean Philippe Rameau (1683–1764).

It was in Italy itself that opera won its largest public. In Venice alone, where Monteverdi spent the last thirty years of his life, at least sixteen theaters were built between 1637—when the first public opera house was opened—and the end of the century. As in the Elizabethan theater [see figure 12.29, page 105], the design of these opera houses separated the upper ranks of society, who sat in the boxes, from the ordinary citizens, who stood or sat on the ground level.

There is a notable similarity, too, between Elizabethan drama and opera in the way they responded to growing popularity. Just as the groundlings of Shakespeare's day demanded ever more sensational and melodramatic entertainment, so the increasingly demanding and vociferous opera public required new

ways of being satisfied. The two chief means by which these desires were met became a feature of most operas written during the following century. The first was the provision of lavish stage spectacles involving mechanical cloud machines that descended from above and disgorged singers and dancers, complex lighting effects that gave the illusion that the stage was being engulfed by fire, apparently magical transformations, and so on-baroque extravagance at its most extreme. The second was a move away from the declamatory recitative of the earliest operas to self-contained musical "numbers" known as arias. (In the case of both opera and many other musical forms, we continue to use technical terms like aria in their Italian form—a demonstration of the crucial role played by Italy, and in particular Florence, in the history of music.) The function of music as servant of the drama was beginning to change. Beauty of melody and the technical virtuosity of the singers became the glory of baroque opera, although at the expense of dramatic truth.

Baroque Instrumental and Vocal Music: **Johann Sebastian Bach**

The development of opera permitted the dramatic retelling of mythological or historical tales. Sacred texts as stories derived from the Bible were set to music in a form known as the oratorio, which had begun to appear toward the end of the 16th century. One of the baroque masters of the oratorio was the Italian Giacomo Carissimi (1605-1674), whose works, based on well-known biblical episodes, include The Judgment of Solomon and Job. By the dramatic use of the chorus, simple textures, and driving rhythms, Carissimi created an effect of strength and power that late-20th-century listeners have begun to rediscover.

The concept of the public performance of religious works, rather than secular operas, made a special appeal to Protestant Germans. Heinrich Schütz (1585-1672) wrote a wide variety of oratorios and other sacred works. In his early Psalms of David (1619) he combined the choral technique of Renaissance composers like Gabrieli with the vividness and drama of the madrigal. His setting of The Seven Last Words of Christ (1645-1646) uses soloists, chorus, and instruments to create a complex sequence of narrative sections (recitatives), vocal ensembles, and choruses. Among his last works are three settings of the Passion, the events of the last days of the life of Jesus, in the accounts given by Matthew, Luke, and John. Written in 1666, they revert to the style of a century earlier, with none of the instrumental coloring generally typical of Baroque music, both sacred and secular.

Schütz is, in fact, one of the few great Baroque composers who, so far as is known, never wrote any purely instrumental music. The fact is all the more striking because the Baroque period was notable for the emergence of independent instrumental compositions unrelated to texts of any kind. Girolamo Frescobaldi (1583-1643), the greatest organ virtuoso of his day—he was organist at St. Peter's in Rome wrote a series of rhapsodic fantasies known as toccatas that combined extreme technical complexity with emotional and dramatic expression. His slightly earlier Dutch contemporary Jan Pieterszoon Sweelinck (1562-1621), organist at Amsterdam, built sets of variations out of different settings of a chorale melody, or hymn tune. The writing of chorale variations, as this type of piece became known, became popular throughout the Baroque period.

The Swedish Diedrich Buxtehude (1637–1707), who spent most of his career in Germany, combined the brilliance of the toccata form with the use of a chorale theme in his chorale fantasies. Starting with a simple hymn melody, he composed free-form rhapsodies that are almost improvisational in style. His suites for harpsichord include movements in variation form, various dances, slow lyric pieces, and other forms; like other composers of his day, Buxtehude used the keyboard suite as a kind of compen-

dium of musical forms.

One of the greatest composers of the late Baroque period was Domenico Scarlatti (1685-1757). The greatest virtuoso of his day on the harpsichord (the keyboard instrument that was a primary forerunner of the modern piano), he wrote hundreds of sonatas (short instrumental pieces) for it and laid down the foundations of modern keyboard technique.

Scarlatti's contemporary Georg Friedrich Handel (1685-1759) was born at Halle in Germany, christened with a name he later changed to George Frederick Handel when he settled in England and became a naturalized citizen. London was to prove the scene of his greatest successes, among them the Messiah, first performed in Dublin in 1742. This oratorio is among the most familiar of all Baroque musical masterpieces.

Handel also wrote operas, including a series of masterpieces in Italian that were written for performance in England. Among their greatest glories are the arias, which are permeated by Handel's rich melodic sense; among the most famous is "Ombra mai fu" from Xerxes. His best-known orchestral works are probably The Water Music and The Music for the Royal Fireworks, both originally designed for outdoor performance. Written for a large number of instruments, they were later rearranged for regular con-

In the year that saw the births of both Scarlatti and Handel, Johann Sebastian Bach (1685-1750) was

THE ARTS AND INVENTION: The Equally-Tempered Scale

From the time of the Greeks, Western music had been written in a system built on the octave, the eighth note of the scale. There are good acoustic reasons for this: two notes sounded an octave apart produce a perfect consonance, each duplicating the other and the upper vibrating with exactly twice the frequency of the lower. Thus the note used by modern musicians for tuning purposes, a', has a frequency of 880 vibrations per second; the note a at an octave below it has a frequency of 440.

The span of an octave was divided into a series of steps, or intervals; virtually all music since the Renaissance uses the twelve steps of the chromatic scale. In theory all twelve are equally spaced, but as music came increasingly to use the chromatic tones (the sharps and flats: the black keys on a piano) and composers wrote in complex, rather than simple, keys, the system began to produce distortions. Only the octave is acoustically perfect and only simple keys produce correct intonation. Thus, although in theory the notes G# and Ab are identical, in practice the former "sounds" lower than the latter. A violinist or lute player who actually produced

the required note by finger movements could compensate for the difference, but organs and harpsichords were built with fixed notes.

Long before the 17th century composers experimented with ways to solve the problem by tuning each note of the scale slightly impurely in relation to its neighbors and thus distributing the out-of-tuneness evenly; with all notes a little out-of-tune none would be glaringly so. Only a keyboard instrument tuned in this way would be able to play music in all keys. It is generally believed that Bach's Well-Tempered Klavier collections were intended for a keyboard tuned in what is rather misleadingly called Equal Temperament (the point is, of course, that all notes are equally out-oftune). It has recently been suggested, however, that Bach's use of well-tempered does not refer to Equal Temperament but to a different kind of irregular tuning system. Even if this is true (and it seems unlikely, given his son Carl Philipp Emanuel's advocacy of Equal Temperament) Baroque musicians and theorists in general were concerned to resolve the thorny issue.

born at Eisenach, Germany, into a family that had already been producing musicians for well over a century. With the exception of opera, which as a devout Lutheran did not interest him, Bach mastered every musical form of the time, pouring forth some of the most intellectually rigorous and spiritually profound music ever created.

It is among the more remarkable achievements in the history of the arts that most of Bach's music was produced under conditions of grinding toil as organist and choir director in relatively provincial German towns. Even Leipzig—where he spent 27 years from 1723 to his death as kantor (music director) at the school attached to Saint Thomas' Church—was far removed from the glittering centers of European culture where most artistic developments were taking place. As a result, Bach was little known as a composer during his lifetime and virtually forgotten after his death; only in the 19th century did all his works become known and published. He has since taken his place at the head of the Western musical tradition as the figure who raised the art of polyphony to its highest level.

If the sheer quantity of music Bach wrote is stupefying, so is the complexity of his musical thought. Among the styles he preferred was the fugue, a word derived from the Latin word for flight. In the course of a fugue a single theme is passed from voice to voice or instrument to instrument (generally four in

number), each imitating the principal theme in turn. The theme thus becomes combined with itself, and in the process the composer creates a seamless web of sound in which each musical part is equally important; this technique is called *counterpoint*. Bach's ability to endow this highly intellectual technique with emotional power is little short of miraculous. The range of emotions Bach's fugues cover can best be appreciated by sampling his two books of 24 fugues each, all prefaced by a prelude, known collectively as The Well-Tempered Klavier (well-tempered in this context means equally tempered; klavier is any keyboard instrument). Each of the 48 preludes and fugues creates its own mood while remaining logically organized according to contrapuntal technique.

Many of Bach's important works are permeated by a single concern—the expression of his deep religious faith. Many of them were written in his capacity as director of music at Saint Thomas' for performance in the church throughout the year. Organ music, masses, oratorios, motets; in all of these he could use music to glorify God and to explore the deeper mysteries of Christianity. His chorale preludes consist of variations on chorales and use familiar and well-loved songs as the basis for a kind of musical improvisation. He wrote some two hundred cantatas, short oratorios made up of sections of declamatory recitative and lyrical arias, which contain an almost inexhaustible range of religious emotions,

from joyful celebrations of life to profound meditations on death. Most overwhelming of all is his setting of the Saint Matthew Passion, the story of the trial and Crucifixion of Jesus as recorded in the Gospel of Matthew. In this immense work Bach asserted his Lutheranism by using the German rather than the Latin translation of the Gospel and by incorporating Lutheran chorales. The use of self-contained arias is Italian, though, and the spirit of deep religious commitment and dramatic fervor can only be described as universal.

It would be a mistake to think of Bach as somehow unworldly and touched only by religious emotions. Certainly his own life had its share of domestic happiness and tragedy. His parents died when he was ten, leaving him to be brought up by an elder brother who treated him with less than complete kindness. At the age of fifteen he jumped at the chance to leave home and become a choirboy in the little town of Luneberg. He spent the next few years moving from place to place, perfecting his skills as organist, violinist, and composer.

In 1707 Bach married his cousin, Maria Barbara Bach, who bore him seven children, of whom four died in infancy. Bach was always devoted to his family, and the loss of these children, followed by the death of his wife in 1720, made a deep impression on him. It may have been to provide a mother for his three surviving sons that he remarried in 1721. At any event his new wife, Anna Magdalena, proved a loving companion, bearing him thirteen more children and helping him with the preparation and copying of his music. One of the shortest but most touching of Bach's works is the little song, Bist du bei mir, which has survived copied out in her notebook. The words are: "As long as you are with me I could face my death and eternal rest with joy. How peaceful would my end be if your beautiful hands could close my faithful eyes." (Some scholars now believe that the song may originally have been written by G. H. Stölzel, a contemporary musician whom Bach much admired.)

The move to Leipzig in 1723 was dictated at least in part by the need to provide suitable schooling for his children, although it also offered the stability and security Bach seems to have required. The subsequent years of continual work took their toll, however. Bach's sight had never been good, and the incessant copying of manuscripts produced a continual deterioration. In 1749 he was persuaded to undergo two disastrous operations that left him totally blind. A few months later his sight was suddenly restored, but within ten days he died of apoplexy.

Although the vast majority of Bach's works are on religious themes, the best known of all, the six Brandenburg concertos, were written for the private en-

tertainment of a minor prince, the Margrave of Brandenburg. Their form follows the Italian concerto grosso, an orchestral composition in three sections, or movements, fast-slow-fast. The form had been pioneered by the Venetian composer Antonio Vivaldi (c. 1676-1741), who delighted in strong contrasts between the orchestra, generally made up of string instruments and a solo instrument, often a violin (as in his well-known set of four concertos The Four Seasons) but sometimes a flute, bassoon, or other wind instrument. Four of Bach's six Brandenburg concertos use not one but a group of solo instruments, although the group differs from work to work. The whole set forms a kind of compendium of the possibilities of instrumental color, a true virtuoso achievement requiring equal virtuosity in performance. The musical mood is light, as befits works written primarily for entertainment, but Bach was incapable of writing music without depth, and the slow movements in particular are strikingly beautiful.

The second Brandenburg concerto is written for solo trumpet, recorder, oboe, and violin accompanied by a string orchestra. The first movement combines all of these to produce a brilliant rhythmic effect as the solo instruments now emerge from the orchestra, now rejoin it. The melodic line avoids short themes. Instead, as in much baroque music, the melodies are long, elaborate patterns that seem to spread and evolve, having much of the ornateness of baroque art. It does not require an ability to read music to see as well as hear how the opening theme of the second Brandenburg concerto forms an unbroken line of sound, rising and falling and doubling back as it luxuriantly spreads itself out.

The slow second movement forms a tranquil and meditative interlude. The brilliant tone of the trumpet would be inappropriate here and Bach therefore omits it, leaving the recorder, oboe, and violin quietly to intertwine in a delicate web of sound. After its enforced silence, the trumpet seems to burst out irrepressibly at the beginning of the third movement, claiming the right to set the mood of limitless energy that carries the work to its conclusion.

Philosophy and Science in The Baroque Period

Throughout the 17th century philosophy, like the visual arts, continued to extend and intensify ideas first developed in the Renaissance by pushing them to new extremes. With the spread of humanism the 16th century had seen a growing spirit of philosophical and scientific inquiry. In the Baroque period that fresh approach to the world and its phenomena was expressed in clear and consistent terms for the first time since the Greeks. It might be said, in fact, that if the Renaissance marked the birth of modern philosophy, the 17th century signaled its coming of age.

Briefly put, the chief difference between the intellectual attitudes of the medieval period and those inaugurated by the Renaissance was a turning away from the contemplation of the absolute and eternal to a study of the particular and the perceivable. Philosophy ceased to be the preserve of the theologians and instead became an independent discipline, no longer prepared to accept a supernatural or divine explanation for the world and human existence.

For better or worse, we are still living with the consequences of this momentous change. The importance of objective truth, objectively demonstrated, lies at the heart of all scientific method, and most modern philosophy. Yet great thinkers before the Renaissance, such as Thomas Aguinas (1225-1274), had also asked questions in an attempt to understand the world and its workings. How did 17thcentury scientists and philosophers differ from their predecessors in dealing with age-old problems?

The basic difference lay in their approach. When, for example, Aquinas was concerned with the theory of motion, he discussed it in abstract, metaphysical terms. Armed with his copy of Aristotle he claimed that "motion exists because things which are in a state of potentiality seek to actualize themselves." When Galileo wanted to study motion and learn how bodies move in time and space, he climbed to the top of the Leaning Tower of Pisa and dropped weights to watch them fall. It would be difficult to imagine a more dramatic rejection of abstract generalization in favor of objective demonstration (Table 13.2).

Galileo

The life and work of Galileo Galilei (1564-1642) are typical both of the progress made by science in the 17th century and of the problems it encountered. Galileo changed the scientific world in two ways: first, as the stargazer who claimed that his observations through the telescope proved Copernicus right,

TABLE 13.2 Principal Scientific Discoveries of the 17th Century

1609	Kepler announces his first two laws of planetary motion	
1614	Napier invents logarithms	
1632	Galileo publishes Dialogue Concerning the Two Chief World Systems	
1643	Torricelli invents the barometer	
1660	Boyle formulates his law of gas pressure	
1675	Royal Observatory founded at Greenwich, England	
1687	Isaac Newton publishes his account of the principle of gravity	
1710	Leibnitz invents new notations of calculus	
1717	Farenheit invents system of measuring temperature	

for which statement he was tried and condemned by the Inquisition; and second as the founder of modern physics. Although he is probably better known for his work in astronomy, from the scientific point of view his contribution to physics is more important.

Born in Pisa, Galileo inherited from his father Vincenzo, who had been one of the original members of the Florentine Camerata, a lively prose style and a fondness for music. As a student at the University of Padua from 1581 to 1592 he began to study medicine but soon changed to mathematics. After a few months back in Pisa, he took a position at the University of Padua as professor of mathematics, remaining there from 1592 to 1600.

In Padua he designed and built his own telescopes [13.35] and saw for the first time the craters of the moon, sunspots, the phases of Venus, and other phenomena which showed that the universe is in a constant state of change, as Copernicus had claimed. From the time of Aristotle, however, it had been a firm belief that the heavens were unalterable, representing perfection of form and movement. Galileo's discoveries thus disproved what had been a basic philosophical principle for 2000 years and so outraged a professor of philosophy at Padua that he refused to shake his own prejudices by having a look through a telescope for himself.

The more triumphantly Galileo proclaimed his findings, the more he found himself involved in something beyond mere scientific controversy. His real opponent was the Church, which had officially adopted the Ptolemaic view of the universe: that the earth formed the center of the universe around which the sun, moon, and planets circled. This theory accorded well with the Bible, which seemed to suggest that the sun moves rather than the earth; for the Church the Bible naturally took precedence over any

13.35 Galileo Galilei. Telescopes. 1609. Museum of Science, Florence. After his death near Florence in 1642, many of Galileo's instruments, including these telescopes, were collected and preserved. The Museum of Science in Florence, where they can now be seen, was one of the earliest museums to be devoted to scientific rather than artistic works.

reasoning or speculation independent of theology. Galileo, however, considered ecclesiastical officials incompetent to evaluate scientific matters and refused to give way. When he began to claim publicly that his discoveries had proved what Copernicus had theorized but could not validate, the Church initiated a case against him on the grounds of heresy.

Galileo had meanwhile returned to his beloved Pisa, where he found himself in considerable danger from the Inquisition. In 1615 he left for Rome to defend his position in the presence of Pope Paul V. He failed, and as a result was censured and prohibited from spreading the Copernican theory either by teaching or publication.

In 1632 Galileo returned to the attack when a former friend was elected Pope. He submitted to Pope Urban VIII a Dialogue Concerning the Two Chief World Systems, having carefully chosen the dialogue form so that he could put ideas into the mouths of

other characters and thereby claim that they were not his own. Once more, under pressure from the Jesuits, he was summoned to Rome. In 1633 he was put on trial after spending several months in prison. His pleas of old age and poor health won no sympathy from the tribunal. He was made to recant and humiliate himself publicly and was sentenced to prison for the rest of his life. (It might well have appealed to Galileo's sense of bitter irony that 347 years later, in 1980, Pope John Paul II, a fellow countryman of the Polish Copernicus, ordered the case to be reopened so that belated justice might be done.)

Influential friends managed to secure Galileo a relatively comfortable house arrest in his villa just outside Florence, and he retired there to work on physics. His last and most important scientific work, Dialogues Concerning Two New Sciences, was published in 1638. In it he examined many long-standing problems, including that of motion, always basing his conclusions on practical experiment and observation. In the process he established the outlines of many areas of modern physics.

In all his work Galileo set forth a new way of approaching scientific problems. Instead of trying to understand the final cause or cosmic purpose of natural events and phenomena, he tried to explain their character and the manner in which they came about. He changed the question from why? to what? and how?

Descartes

Scientific investigation could not solve every problem of human existence. While it could try to explain and interpret objective phenomena, there remained other more subjective areas of experience involving ethical and spiritual questions. The Counter-Reformation on the one hand and the Protestant churches on the other claimed to have discovered the answers. The debates nevertheless continued, most notably in the writings of the French philosopher René Descartes (1596-1650), often called the "Father of Modern Philosophy" [13.36].

In many ways Descartes' philosophical position was symptomatic of his age. He was educated at a Iesuit school but found traditional theological teaching unsatisfactory. Turning to science and mathematics, he began a lifelong search for reliable evidence in his quest to distinguish truth from falsehood. Attacking philosophical problems, his prime concern was to establish criteria for defining reality. His chief published works, The Discourse on Method (1637) and the Meditations (1641), contain a step-by-step account of how he arrived at his conclusions.

According to Descartes, the first essential in the search for truth was to make a fresh start by refusing

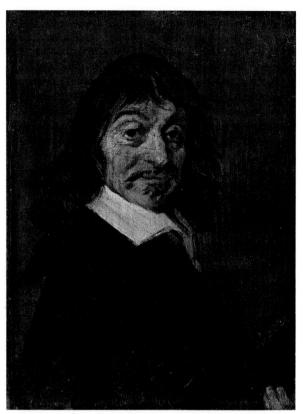

13.36 Frans Hals. René Descartes. Oil on panel. Statens Museum for Kunst, Copenhagen. The great French philosopher spent many years in Holland, where his ideas found a receptive audience and where Hals painted this portrait.

to believe anything that could not be decisively proved to be true. This required that he doubt all his previously held beliefs, including the evidence of his own senses. By stripping away all uncertainties he reached a basis of indubitable certainty on which he could build: that he existed. The very act of doubting proved that he was a thinking being. As he put it in a famous phrase in his second Meditation: Cogito, ergo sum (I think, therefore I am).

From this foundation Descartes proceeded to reconstruct the world he had taken to pieces by considering the nature of material objects. He was guided by the principle that whatever is clearly and distinctly perceived must exist. He was aware at the same time that our perceptions of the exact nature of these objects are extremely likely to be incorrect and misleading. When, for example, we look at the sun we see it as a very small disk, although the sun is really an immense globe. We must be careful, therefore, not to assume that our perceptions are bound to be accurate. All that they demonstrate is the simple existence of the object in question.

If the idea of the sun comes from the perception, however inaccurate, of something that actually exists, what of God? Is the idea of a divine Being imagined or based on truth? Descartes concluded that the very fact that we who are imperfect and doubting can conceive of a perfect God proves that our conception is based on a reality. In other words, who could ever have imagined God unless God existed? At the center of the Cartesian philosophical system, therefore, lay the belief in a perfect Being, not necessarily to be identified with the God of the Old and New Testaments, who had created a world permeated by perfect (that is, mathematical) principles.

At first sight this may seem inconsistent with Descartes' position as the founder of modern rational thought. It may seem even stranger that, just at the time when scientific investigators like Galileo were explaining natural phenomena without recourse to divine intervention, Descartes succeeded in proving to his own satisfaction the undeniable existence of a divine Being. Yet a more careful look at Descartes' method reveals that both he and Galileo shared the same fundamental confidence in the rational powers of human beings.

Hobbes

Although Galileo and Descartes represent the major trends in 17th-century thought, other important figures made their own individual contributions. Descartes' fellow countryman Blaise Pascal (1623–1662), for example, launched a strong attack on the Jesuits while providing his own somewhat eccentric defense of Christianity. A more mystical approach to religion was that of the Dutch philosopher Baruch Spinoza (1632–1677), whose concept of the ideal unity of nature later made a strong appeal to 19th-century romantics. The English philosopher Thomas Hobbes (1588-1679), however, had little in common with any of his contemporaries—as he was frequently at pains to make plain. For Hobbes truth lay only in material things: "All that is real is material, and what is not material is not real."

Hobbes is thus one of the first modern proponents of materialism and, like many of his materialist successors, was interested in solving political rather than philosophical problems. Born in the year of the Spanish Armada, Hobbes lived through the turbulent English Civil War, a period marked by constant instability and political confusion. Perhaps in consequence, he developed an enthusiasm for the authority of the law, as represented by the king, that verges on totalitarianism.

Hobbes' political philosophy finds its fullest statement in his book Leviathan, first published in 1651. The theory of society that he describes there totally denies the existence in the universe of any divinely established morality. (Hobbes never denied the existence of God, not wishing to outrage public and ecclesiastical opinion unnecessarily, although he might as well have.) According to Hobbes, all laws are created by humans to protect themselves from one another—a necessary precaution in view of human greed and violence. Organized society in consequence is arrived at when individuals give up their personal liberty in order to achieve security. As a result, the ideal state is that in which there is the greatest security, specifically one ruled by an absolute

From its first appearance Leviathan created a scandal; it has been subject to continual attack ever since. Hobbes managed to offend both of the chief participants in the intellectual debates of the day: the theologians, by telling them that their doctrines were irrelevant and their terminology "insignificant sound"; and the rationalists, by claiming that human beings, far from being capable of the highest intellectual achievements, are dangerous and aggressive creatures who need to be saved from themselves. Hobbes' pessimism and the extreme nature of his position have won him few whole-hearted supporters in the centuries since his death. Yet many modern readers, like others in the time since Leviathan first appeared, must reluctantly admit that there is at least a grain of truth in his picture of society, which can be attested to by personal experience and observation. At the very least his political philosophy is valuable as a diagnosis and a warning of some aspects of human potential virtually all of his contemporaries and many of his successors have preferred to ignore.

Literature in the 17th Century

French Baroque Comedy and Tragedy

It is hardly surprising that the Baroque age, which put so high a premium on the expression of dramatic emotion, should have been an important period in the development of the theater. In France in particular, three of the greatest names in the history of drama were active at the same time, all of them benefiting at one point or another from the patronage of Louis XIV.

Molière was the stage name of Jean-Baptiste Poquelin (1622–1673), who was the creator of a new theatrical form, French Baroque comedy. Having first made his reputation as an actor, he turned to the writing of drama as a means of deflating pretense and pomposity. In his best works, the deceptions or delusions of the principal characters are revealed for what they are with good humor and considerable understanding of human foibles, but dramatic truth is never sacrificed to mere comic effect. Unlike so many comic creations, Molière's characters remain believable. Jourdain, the good-natured social climber of Le Bourgeois Gentilhomme, and Harpagon, the absurd miser of L'Avare, are by no means mere symbols of their respective vices but victims of those vices, albeit willing ones. Even the unpleasant Tartuffe in the play of that name is a living character with his own brand of hypocrisy.

Classical motifs play a strong part in the works of the two greatest tragic dramatists of the age, Pierre Corneille (1606–1684) and Jean Racine (1639–1699). It was Corneille who created, as counterpart to Molière's comedy, French Baroque tragedy. Most of his plays take as their theme an event in classical history or mythology, which is often used to express eternal truths about human behavior. The themes of patriotism, as in Horace, or martyrdom, as in Polyeucte, are certainly as relevant today as they were in 17th-century France or in ancient Greece or Rome. However, most people's response to Corneille's treatment of subjects such as these is probably conditioned by the degree to which they enjoy the cut and thrust of rhetorical debate.

Racine may well provide for many modern readers an easier entry into the world of French Baroque tragedy. Although for the most part he followed the dramatic form and framework established by Corneille, he used it to explore different areas of human experience. His recurrent theme is self-destruction: the inability to control one's own jealousy, passion, or ambition and the resulting inability, as tragic as it is inevitable, to survive its effects. Furthermore, in plays like *Phèdre* he explored the psychological state of mind of his principal characters, probing for the same kind of understanding of motivation that Monteverdi tried to achieve in music.

The Novel in Spain: Cervantes

By the middle of the 16th century the writing of fiction in Spain had begun to take a characteristic form that was to influence much later European fiction. The picaresque novel was a Spanish invention; books of this type tell a story that revolves around a rogue or adventurer—in Spanish picaro means a rogue or knave. The earliest example is Lazarillo de Tormes, which appeared anonymously in 1554. Its hero, Lazarillo, is brought up among beggars and thieves, and many of the episodes serve as an excuse to satirize priests and church officials—so much so, in fact, that the Inquisition ordered parts omitted in later printings. Unlike prose being written elsewhere at the time, the style is colloquial, even racy, and heavy with irony.

Although Don Quixote, by general agreement the greatest novel in the Spanish language, has picaresque elements, its style and subject are both far more subtle and complex. Miguel de Cervantes Saavedra (1547–1616), its author, set out to satirize medieval tales of chivalry and romance by inventing a character-Don Quixote-who is an amiable elderly gentleman looking for the chivalry of story books in real life. This apparently simple idea takes on almost infinite levels of meaning, as Don Quixote pursues his ideals, in general without much success, in a world with little time for romance or honor. In his adventures, which bring him into contact with all levels of Spanish society, he is accompanied by his squire Sancho Panza, whose shrewd practicality serves as a foil for his own unworldliness.

The structure of the novel is as leisurely and seemingly as rambling as the Don's wanderings. Yet the various episodes are linked by the constant confrontation between reality and illusion, the real world and that of the imagination. Thus at one level the book becomes a meditation on the relationship between art and life.

By the end of his life Don Quixote has learned painfully that his noble aspirations cannot be reconciled with the realities of the world, and he dies disillusioned. In the last part of the book, where the humor of the hero's mishaps does not conceal their pathos, Cervantes reaches that rare height of artistry where comedy and tragedy are indistinguishable.

The English Metaphysical Poets

In England the pinnacle of dramatic expression had been reached by the turn of the century in the works of Shakespeare, and nothing remotely comparable was to follow. The literary form that proved most productive during the 17th century was that of lyric poetry, probably because of its ability to express personal emotions, although the single greatest English work of the age was John Milton's epic poem Paradise Lost.

It might well be argued that the most important of all literary achievements of the 17th century was not an original artistic creation but a translation. It is difficult to know precisely how to categorize the Authorized Version of the Bible, commissioned by King James I and first published in 1611, often called the only great work of literature every produced by a committee. The 54 scholars and translators who worked on the task deliberately tried to create a "biblical" style that would transcend the tone of English as it was then generally used. Their success can be measured by the immense influence the King James Bible has had on speakers and writers of English ever since (see page 85). It remained the Authorized Version for English-speaking people until the late 19th century, when it was revised in the light of new developments in biblical studies.

Of all 17th-century literary figures, the group known as the metaphysical poets, with their concern to give intellectual expression to emotional experience, make a particular appeal to modern readers. As is often pointed out, the label metaphysical is highly misleading for two reasons. In the first place, it suggests an organized group of poets consciously following a common style. It is true that the earliest poet to write in the metaphysical style, John Donne, exerted a strong influence on a whole generation of younger poets, but there never existed any unified group or school. (Some scholars, in fact, would classify Donne's style as Mannerist.)

Secondly, metaphysical seems to imply that the principal subject of their poetry was philosophical speculation on abstruse questions. It is certainly true that the metaphysical poets were interested in ideas and that they used complex forms of expression and a rich vocabulary to express them. The chief subject of their poems was not philosophy, however, but themselves—particularly their own emotions.

Yet this concern with self-analysis should not suggest a limitation of vision. Indeed, some critics have ranked John Donne (1572-1631) as second only to the Shakespeare of the Sonnets in range and depth of expression. His intellectual brilliance and his love of paradox and ambiguity make his poetry sometimes difficult to follow. Donne always avoided the conventional, either in word or thought, while the swift chances of mood within a single short poem from light banter to the utmost seriousness can confuse the careless reader. Although it sometimes takes patience to unravel his full meaning, the effort is more than amply rewarded by contact with one of the most daring and honest of poets.

Donne's poems took on widely differing areas of human experience, ranging from some of the most passionate and frank discussions of sexual love ever penned to profound meditations on human mortality and the nature of the soul. Born a Catholic, he traveled widely as a young man and seems to have led a hectic and exciting life. He abandoned Catholicism, perhaps in part to improve his chances of success in Protestant England, and in 1601, on the threshold of a successful career in public life, entered Parliament. The same year, however, he secretly married his patron's sixteen-year-old niece, Anne More. Her father had him dismissed and even imprisoned for a few days, and Donne's career never recovered from the disgrace.

Although Donne's marriage proved a happy one, its early years were clouded by debt, ill health, and frustration. In 1615, at the urging of friends, he finally joined the Anglican church and entered the ministry. As a preacher he soon became known as among the greatest of his day. By 1621 he was appointed to one of the most prestigious positions in London, Dean of Saint Paul's. During his last years he became increasingly obsessed with death. After a serious illness in the spring of 1631 he preached his own funeral sermon and died within a few weeks.

Thus the successful worldliness of the early years gave way to the growing somberness of his later career. We might expect a similar progression from light to darkness in his works, yet throughout his life the two forces of physical passion and religious intensity seem to have been equally dominant, with the result that in much of his poetry each is sometimes used to express the other.

The poems of Donne's younger contemporary, Richard Crashaw (1613–1649), blend extreme emotion and religious fervor in a way that is completely typical of much baroque art. Yet Crashaw serves as a reminder of the danger of combining groups of artists under a single label, since although he shares many points in common with the other metaphysical poets, his work as a whole strikes a unique note.

There can be little doubt that Crashaw's obsessive preoccupation with pain and suffering has more than a touch of masochism, and that his religious fervor is extreme even by baroque standards. Some of the intensity is doubtless due to his violent rejection of his father's Puritanism and his own enthusiastic conversion to Catholicism. Stylistically Crashaw owed much to the influence of the flamboyant Italian baroque poet Giambattista Marino (1569-1625), whose virtuoso literary devices he imitated. Yet the eroticism that so often tinges his spiritual fervor gives to his work a highly individual air.

Milton's Heroic Vision

While the past hundred years have seen a growing appreciation for Donne and his followers, the reputation of John Milton has undergone some notable ups and downs. Revered in the centuries following his death. Milton's work came under fire in the early years of the 20th century from major poets like T. S. Eliot and Ezra Pound, who claimed that his influence on his successors had been pernicious and had led much of subsequent English poetry astray. Now that the dust of these attacks has settled, Milton has resumed his place as one of the greatest of English poets. The power of his spiritual vision, coupled with his heroic attempt to wrestle with the great problems of human existence, seem in fact to speak directly to the uncertainties of our own time.

Milton's life was fraught with controversy. An outstanding student with astonishing abilities in languages, he spent his early years traveling widely in Europe and in the composition of relatively lightweight verse—lightweight, that is, in comparison with what was to come. Among his most entertaining early works are the companion poems "L' Allegro" and "Il Penseroso," which compare the cheerful and the contemplative character, with appropriate scenery. They were probably written in 1632, following his graduation from Cambridge.

By 1640, however, he had become involved in the tricky issues raised by the English Civil War and the related problems of church government. He launched into the fray with a series of radical pamphlets that advocated, among other things, divorce on the grounds of incompatibility. (It is presumably no coincidence that his own wife had left him six weeks after their marriage.) His growing support for Oliver Cromwell and the Puritan cause won him an influential position at home but considerable enmity in continental Europe, where he was seen as the defender of those who had ordered the execution of King Charles I in 1649. The strain of his secretarial and diplomatic duties during the following years destroyed his eyesight, but although completely blind he continued to work with the help of assistants.

When Charles II was restored to power in 1660 Milton lost his position and was lucky not to lose his life or liberty. Retired to private life, he spent his remaining years in the composition of three massive works. Paradise Lost (1667), Paradise Regained (1671), and Samson Agonistes (1671).

By almost universal agreement Milton's most important, if not most accessible, work is Paradise Lost, composed in the early 1600s and published in 1667. It was intended as an account of the fall of Adam and Eve, and its avowed purpose was to "justify the ways of God to men." The epic is in twelve books (originally ten, but Milton later revised the divisions), written in blank verse.

Milton's language and imagery present an almost inexhaustible combination of biblical and classical reference. From the very first lines of Book I, where the poet calls on a classical Muse to help him tell the tale of The Fall, the two great Western cultural traditions are inextricably linked. Indeed, like Bach, Milton represents the summation of these traditions. In his works, Renaissance and Reformation meet and blend to create the most complete statement in English of Christian humanism, the philosophical reconciliation of humanist principles with Christian doctrine. To the Renaissance Milton owed his grounding in the classics. In composing Paradise Lost, an epic poem that touches on the whole range of human experience, he was deliberately inviting comparison with Homer and Vergil. His language is also classical in its inspiration, with its long, grammatically com-

plex sentences and preference for abstract terms. Yet his deeply felt Christianity and his emphasis on human guilt and repentance mark him as a product of the Reformation. Furthermore, although he may have tried to transcend the limitations of his own age, he was as much a child of his time as any of the other artists discussed in this chapter. The dramatic fervor of Bernini, the spiritual certainty of Bach, the psychological insight of Monteverdi, the humanity of Rembrandt—all have their place in Milton's work and mark him, too, as an essentially Baroque figure.

Summary

If the history and culture of the 16th century were profoundly affected by the Reformation, the prime element to influence those of the 17th century was the Counter-Reformation, the Catholic Church's campaign to regain its authority and influence. By clarifying and forcefully asserting their teaching, backed up with a vigorous program of missionary work, Church leaders aimed to present a positive and optimistic appearance that would eliminate past discords.

Among the resources used by Counter-Reformation reformers were the arts. Imposing architectural complexes like St. Peter's Square in Rome, paintings and sculptures, music and verse could all serve to reinforce the glory of the Church. In some cases works were commissioned officially; in others artists responded individually to the spirit of the times. Bernini's Saint Teresa in Ecstasy, a statue that reflects the artist's own devout faith, was commissioned for the church in Rome in which it still stands. Richard Crashaw's poetry represents a more personal response to the religious ideas of his day.

For all the importance of religion, the 17th century was also marked by significant developments in philosophy and science. Galileo, the father of modern physics, revolutionized astronomy by proving Copernicus' claims of the previous century correct. Thinkers like Descartes and Hobbes, instead of accepting official Church teachings, tried to examine the problems of human existence by their own intellectual approaches. Descartes was the founder of modern rational thought (although a believer in a supreme Being); Hobbes was the first modern materialist.

The principal artistic style of the 17th century was the baroque, a term originally used for the visual arts but also applied by extension to the other arts of the period. Although the Baroque style was created in Italy, it spread quickly throughout Europe and was even carried to the New World by missionaries.

Baroque art is marked by a wide range of achievements, but there are a number of common features. Artists in the 17th century were concerned to express strong emotions. either religious or personal. This in turn led to an interest in exploring human behavior from a psychological point of view. With the new subjects came new techniques, many of them emphasising the virtuosity of the artist. These in turn led to the invention of new forms: in music that of opera, in painting that of landscape scenes, to take only two examples.

The chief characteristics of Baroque painting were created in Rome around 1600 by two artists. Caravaggio's work is emotional and dominated by strong contrasts of light and darkness. Carracci painted scenes of movement and splendor, many on classical themes. Both strongly influenced their contemporaries and successors. Caravaggio's use of light was the forerunner of the work of artists as diverse as the Spaniard Velázquez and the Dutchman Vermeer, while Carracci's choice of classical subjects was followed by the French Poussin. The two greatest painters of northern Europe, Rembrandt and Rubens, were also influenced by the ideas of their day. Rembrandt used strong contrasts of light and dark to paint deeply felt religious scenes as well as the self-portraits that explore his own inner emotions. Rubens, one of the most versatile of artists, ranged from mythological subjects to historical paintings like the Marie de' Medici cycle to intimate personal

Although the 17th century saw architects increasingly employed in designing private houses, most of the principal building projects were public. At Rome the leading architect was Bernini, also one of the greatest sculptors of the age, whose churches, fountains, and piazzas changed the face of the city. In his sculpture Bernini drew on virtually all the themes of Counter-Reformation art, including mythological and religious works and vividly characterized portraits. The other great building project of the century was the palace built for Louis XIV at Versailles, where the splendor of the Sun King was reflected in the grandiose decoration scheme.

In music, as in the visual arts, the Baroque period was one of experimentation and high achievement. Counter-Reformation policy required that music for church use should be easily understood and appreciated, as was already the case in the Protestant countries of northern Europe. At the same time there was a growing demand for secular music for performance both in public and at home.

One of the most important innovations of the 17th century was opera. The first opera was performed just before 1600 in Florence, and by the middle of the century opera houses were being built throughout Europe to house the new art form. The first great composer of operas was the Italian Monteverdi, whose Orfeo is the earliest opera still to hold the stage. Among later musicians of the period to write works for the theater was the German Georg Friedrich Handel, many of whose operas were composed to an Italian text for performance in England.

Handel also wrote oratorios, sacred dramas performed without any staging; indeed the most famous of all oratorios is his Messiah. The oratorio was a form with a special appeal for Protestant Germans; among its leading exponents was Heinrich Schütz. The greatest of all Lutheran composers, Johann Sebastian Bach, wrote masterpieces in just about every musical form other than opera. Like many of the leading artists of the age, Bach produced works inspired by deep religious faith as well as pieces like the Brandenburg concertos for private entertainment.

The Baroque interest in emotion and drama, exemplified by the invention of opera, led to important developments in writing for the theater as well as in the style of poetic composition and the invention of new literary forms. In France the comedies of Molière and the tragedies

of Corneille and Racine, written in part under the patronage of Louis XIV, illustrate the dramatic range of the period. The religious fervor of the English Metaphysical poets is yet another sign of Baroque artists' concern with questions of faith and belief. The more practical problems involved in reconciling ideals with the realities of life are described in Don Quixote, one of the first great novels in Western literature. The most monumental of all literary works of the 17th century, Milton's Paradise Lost, aimed to combine the principles of Renaissance humanism with Christian teaching. Its drama, spirituality, and psychological insight mark it as a truly Baroque masterpiece.

For all the immense range of Baroque art and culture, its principal lines were drawn by reactions to the Counter-Reformation. Furthermore, paradoxically enough, by the end of the 17th century a movement that had been inspired by opposition to the Reformation had accomplished many of the aims of the earlier reformers: through art, music, and literature both artists and their audiences were made more familiar with questions of religious faith and more sensitive to aspects of human experience.

Pronunciation Guide

Annibale Carracci: Ann-IB-a-lay Car-AHCH-

Baroque: Bar-OAK

Borromini: Bo-roe-MEE-ni Caravaggio: Ca-ra-VAJ-yo Cervantes: Ser-VAN-teez

Concerto Grosso: Con-SHIRT-owe GRO-sew

Corneille: Cor-NAY Descartes: Day-CART

Donne: DUN

Don Quixote: Don ki-HOTE-ee

Galileo: Ga-li-LAY-owe Gentileschi: Gen-ti-LESS-key

Lorrain: Lor-ANN Molière: Mo-li-AIR

Monteverdi: Mon-te-VAIR-di

Orfeo: Or-FAY-owe Piazza: pi-AT-sa Racine: Rah-SEEN Rameau: Ram-OWE

Rembrandt van Rijn: REM-brant van RHINE

Rubens: RUE-buns Schütz: SHUETS Sweelinck: SVAY-link

Theotokopoulos: They-ot-ok-OP-ou-loss

Toccata: To-CA-ta Velázquez: Ve-LASS-kes Vermeer: Vur-MERE Versailles: Ver-SIGH

Exercises

- 1. What characteristics are common to all the arts in the Baroque period? Give examples.
- 2. Compare the paintings of Caravaggio and Rembrandt with regard to subject matter and use of contrasts in
- 3. Describe the birth and early development of opera.
- 4. What were the principal scientific and philosophical movements of the 17th century? To what extent were they the result of external historical factors?
- 5. Discuss the treatment of religious subjects by Baroque artists, writers, and musicians. How does it contrast with that of the Renaissance?

Further Reading

- Boyd, M. Bach. London: Dent, 1983. A good recent onevolume study of Bach that interweaves an account of the composer's life with a discussion of his works.
- Brown, J. Images and Ideas in Seventeenth-Century Spanish Painting. Princeton, N.J.: Princeton University Press, 1978. Relates the leading Spanish Baroque painters to their cultural world. A chapter is dedicated to an analysis of Las Meninas.
- Cipolla, C. (ed.). The Fontana Economic History of Europe, Vol. II. London: Fontana, 1974. A useful survey of the principal developments in a period marked by widespread economic change and overseas expansion.
- Kahr, M. Dutch Painting in the Seventeenth Century. New York: Harper, 1978. A concise and readable survey with full discussions of Rembrandt, Vermeer, and Hals.
- Knight, R. C. Racine: Modern Judgments. New York: Macmillan, 1970. A collection of essays on various aspects of French 17th-century drama, with a good general introductory essay.
- Lavin, I. Bernini and the Unity of the Visual Arts. New York: Oxford, 1980. A magnificent achievement that analyzes in depth Bernini's process of artistic creation.
- McCorquodale, C. The Baroque Painters of Italy. New York: Phaidon, 1979. A handy volume especially useful for its excellent color illustrations.
- Orrey, L. (rev. R. Milnes). Opera: A Concise History. London: Thames and Hudson, 1987. An updated edition of the best brief history of opera, with many interesting
- Palisca, C. V. Baroque Music. Englewood Cliffs, N.J.: Prentice-Hall, 1968. A good survey, not too technical, that places Baroque music in its cultural context.
- Sewter, A. C. Baroque and Rococo. New York: Harcourt, 1972. A conveniently short and readable introduction to the visual arts of the period, with a good proportion of color plates.
- Willey, B. The Seventeenth-Century Background. New York: Columbia University Press, 1967. An excellent introduction to 17th-century intellectual developments, including discussions of Galileo, Descartes, Hobbes, and Milton.

Reading Selections

Thomas Hobbes from Leviathan

Hobbes' philosophical masterpiece describes the life of humans in their natural state as "solitary, poor, nasty, brutish, and short." The only remedy lies in the imposition of social order, if possible in the form of an absolute monarchy. In this chapter Hobbes' cynical view of human motivations is expressed in a tone of cool irony, which blends wit and detachment.

Part I

CHAPTER XIII

Of the Natural Condition of Mankind, as Concerning Their Felicity and Misery

Nature hath made men so equal in the faculties of body and mind as that though there be found one man sometimes manifestly stronger in body, or of quicker mind than another, yet when all is reckoned together, the difference between man and man is not so considerable as that one man can thereupon claim to himself any benefit to which another may not pretend as well as he. For as to the strength of body, the weakest has strength enough to kill the strongest, either by secret machination, or by confederacy with 10 others that are in the same danger with himself.

And as to the faculties of the mind, setting aside the arts grounded upon words, and especially that skill of proceeding upon general and infallible rules, called science, which very few have, and but in few things as being not a native faculty, born with us, nor attained, as prudence, while we look after somewhat else, I find yet a greater equality amongst men than that of strength. For prudence is but experience; which equal time equally bestows on all men, in 20 those things they equally apply themselves unto. That which may perhaps make such equality incredible is but a vain conceit of one's own wisdom, which almost all men think they have in a greater degree than the vulgar; that is, than all men but themselves and a few others, whom by fame or for concurring with themselves they approve. For such is the nature of men, that howsoever they may acknowledge many others to be more witty or more eloquent or more learned, yet they will hardly believe there be 30 many so wise as themselves. For they see their own wit at hand, and other men's at a distance. But this proveth rather that men are in that point equal, than unequal. For there is not ordinarily a greater sign of the equal distribution of anything than that every man is contented with his share.

From this equality of ability ariseth equality of hope in the attaining of our ends. And therefore if any two men desire the same thing, which nevertheless they cannot both enjoy, they become enemies; 40 and in the way to their end (which is principally their own conservation, and sometimes their delectation only), endeavor to destroy or subdue one another. And from hence it comes to pass, that where an invader hath no more to fear than another man's single power, if one plant, sow, build or possess a convenient seat, others may probably be expected to come prepared with forces united to dispossess and deprive him, not only of the fruit of his labor, but also of his life or liberty. And the invader again is in the like 50 danger of another.

And from this diffidence of one another, there is no way for any man to secure himself so reasonable as anticipation; that is, by force or wiles to master the persons of all men he can, so long till he see no other power great enough to endanger him; and this is no more than his own conservation requireth, and is generally allowed. Also because there be some, that taking pleasure in contemplating their own power in the acts of conquest, which they pursue farther than 60 their security requires; if others, that otherwise would be glad to be at ease within modest bounds, should not by invasion increase their power, they would not be able, long time, by standing only on their defense, to subsist. And by consequence, such augmentation of dominion over men, being necessary to a man's conservation, it ought to be allowed him.

Again, men have no pleasure, but on the contrary a great deal of grief, in keeping company, where 70 there is no power able to overawe them all. For every man looketh that his companion should value him at the same rate he sets upon himself; and upon all signs of contempt or undervaluing, naturally endeavors, as far as he dares (which amongst them that have no common power to keep them in quiet, is far enough to make them destroy each other), to extort a greater value from his contemners, by damage; and from others, by the example.

So that in the nature of man, we find three princi-80 pal causes of quarrel. First, competition; secondly, diffidence; thirdly, glory.

The first maketh men invade for gain; the second, for safety; and the third, for reputation. The first use violence, to make themselves masters of other men's persons, wives, children, and cattle; the second, to defend them; the third, for trifles, as a word, a smile, a different opinion, and any other sign of undervalue, either direct in their persons, or by reflection in their kindred, their friends, their nation, their profession, 90 or their name.

Hereby it is manifest, that during the time men live without a common power to keep them all in awe, they are in that condition which is called war;

TARTUFFE Ah, well—my heart's not made of stone, you know. All your desires mount heavenward, I'm ELMIRE sure, In scorn of all that's earthly and impure. TARTUFFE A love of heavenly beauty does not preclude A proper love for earthly pulchritude; Our senses are quite rightly captivated By perfect works our Maker has created. Some glory clings to all that Heaven has made; In you, all Heaven's marvels are displayed. On that fair face, such beauties have been lavished. The eyes are dazzled and the heart is ravished; How could I look on you, O flawless creature, And not adore the Author of all Nature, Feeling a love both passionate and pure For you, his triumph of self-portraiture? At first, I trembled lest that love should be A subtle snare that Hell had laid for me; I vowed to flee the sight of you, eschewing A rapture that might prove my soul's undoing; But soon, fair being, I became aware That my deep passion could be made to square With rectitude, and with my bounden duty, I thereupon surrendered to your beauty. It is, I know, presumptuous on my part To bring you this poor offering of my heart, And it is not my merit, Heaven knows, But your compassion on which my hopes repose. You are my peace, my solace, my salvation; On you depends my bliss—or desolation; I bide your judgment and, as you think best, I shall be either miserable or blest. ELMIRE Your declaration is most gallant, Sir, But don't you think it's out of character? You'd have done better to restrain your And think before you spoke in such a fashion. It ill becomes a pious man like you . . .

A man has not the power to be wise. I know such words sound strangely, coming from me, But I'm no angel, nor was meant to be, And if you blame my passion, you must needs Reproach as well the charms on which it feeds. Your loveliness I had no sooner seen Than you became my soul's unrivalled queen; Before your seraph glance, divinely sweet, My heart's defenses crumbled in defeat, And nothing fasting, prayer, or tears might do

TARTUFFE I may be pious, but I'm human too:

With your celestial charms before his eyes,

Could stay my spirit from adoring you. 100 My eyes, my sighs have told you in the past What now my lips make bold to say at last, And if, in your great goodness, you will deign To look upon your slave, and ease his pain,-If, in compassion for my soul's distress, You'll stoop to comfort my unworthiness, I'll raise to you, in thanks for that sweet manna, An endless hymn, an infinite hosanna. With me, of course, there need be no anxiety, No fear of scandal or of notoriety. These young court gallants, whom all the ladies Are vain in speech, in action rash and chancy; When they succeed in love, the world soon knows it: No favor's granted them but they disclose it And by the looseness of their tongues profane 115 The very altar where their hearts have lain. Men of my sort, however, love discreetly, And one may trust our reticence completely. My keen concern for my good name insures The absolute security of yours; 120 In short, I offer you, my dear Elmire, Love without scandal, pleasure without fear. ELMIRE I've heard your well-turned speeches to the end, And what you urge I clearly apprehend. Aren't you afraid that I may take a notion 125 To tell my husband of your warm devotion, And that, supposing he were duly told, His feelings toward you might grow rather TARTUFFE I know, dear lady, that your exceeding Will lead your heart to pardon my temerity; That you'll excuse my violent affection As human weakness, human imperfection; And that—O fairest!—you will bear in mind That I'm but flesh and blood, and am not blind. ELMIRE Some women might do otherwise, perhaps, But I shall be discreet about your lapse; I'll tell my husband nothing of what's occurred If, in return, you'll give your solemn word To advocate as forcefully as you can The marriage of Valère and Mariane, 140 Renouncing all desire to dispossess Another of his rightful happiness,

Scene 4. DAMIS, ELMIRE, TARTUFFE

And . . .

DAMIS [Emerging from the closet where he has been hiding] No! We'll not hush up this vile affair;

I heard it all inside that closet there, Where Heaven, in order to confound the pride Of this great rascal, prompted me to hide. Ah, now I have my long-awaited chance To punish his deceit and arrogance, And give my father clear and shocking proof Of the black character of his dear Tartuffe. ELMIRE As no, Damis; I'll be content if he Will study to deserve my leniency.

I've promised silence—don't make me break my word:

To make a scandal would be too absurd. Good wives laugh off such trifles, and forget

Why should they tell their husbands, and upset them?

You have your reasons for taking such a **DAMIS** course,

And I have reasons, too, of equal force. To spare him now would be insanely wrong. I've swallowed my just wrath for far too long And watched this insolent bigot bringing strife And bitterness into our family life. Too long he's meddled in my father's affairs, Thwarting my marriage-hopes, and poor Valère's.

It's high time that my father was undeceived, And now I've proof that can't be disbelieved— Proof that was furnished me by Heaven above.

25

It's too good not to take advantage of. This is my chance, and I deserve to lose it If, for one moment, I hesitate to use it. ELMIRE Damis . . .

No, I must do what I think right. **DAMIS** Madam, my heart is bursting with delight, And, say whatever you will, I'll not consent To lose the sweet revenge on which I'm bent. I'll settle matters without more ado; And here, most opportunely, is my cue.

Scene 5. ORGON, DAMIS, TARTUFFE, ELMIRE

DAMIS Father, I'm glad you've joined us. Let us advise vou

Of some fresh news which doubtless will surprise you.

You've just now been repaid with interest For all your loving-kindness to our guest. He's proved his warm and grateful feelings toward you;

It's with a pair of horns he would reward you. Yes, I surprised him with your wife, and heard His whole adulterous offer, every word. She, with her all too gentle disposition, Would not have told you of his proposition; But I shall not make terms with brazen lechery, And feel that not to tell you would be treachery.

ELMIRE And I hold that one's husband's peace of mind

Should not be spoilt by tattle of this kind. One's honor doesn't require it: to be proficient

In keeping men at bay is quite sufficient. These are my sentiments, and I wish, Damis, That you had heeded me and held your peace.

15

10

15

Scene 6. ORGON, DAMIS, TARTUFFE

ORGON Can it be true, this dreadful thing I hear? TARTUFFE Yes, Brother, I'm a wicked man, I fear: A wretched sinner, all deprayed and twisted.

The greatest villain that has ever existed. My life's one heap of crimes, which grows each minute;

There's naught but foulness and corruption in it; And I perceive that Heaven, outraged by me, Has chosen this occasion to mortify me. Charge me with any deed you wish to name; I'll not defend myself, but take the blame. Believe what you are told, and drive Tartuffe Like some base criminal from beneath your roof:

Yes, drive me hence, and with a parting curse: I shan't protest, for I deserve far worse.

ORGON [To DAMIS] Ah, you deceitful boy, how dare you try

To stain his purity with so foul a lie? DAMIS What! Are you taken in by such a bluff? Did you not hear . . . ?

ORGON Enough, you rogue, enough! TARTUFFE Ah, Brother, let him speak: you're being unjust.

Believe his story; the boy deserves your

Why, after all, should you have faith in me? How can you know what I might do, or be? Is it on my good actions that you base Your favor? Do you trust my pious face? Ah, no, don't be deceived by hollow shows; I'm far, alas, from being what men suppose; Though the world takes me for a man of worth. I'm truly the most worthless man on earth. [To DAMIS]

Yes, my dear son, speak out now: call me the chief

Of sinners, a wretch, a murderer, a thief; Load me with all the names men most abhor; I'll not complain, I've earned them all, and more:

I'll kneel here while you pour them on my head As a just punishment for the life I've led.

ORGON [To TARTUFFE] This is too much, dear	Scene 7. ORGON, TARTUFFE
Brother.	
[To DAMIS] Have you no heart?	ORGON How he blasphemed your goodness! What
DAMIS Are you so hoodwinked by this rascal's	a son!
art ? 35	TARTUFFE Forgive him, Lord, as I've already
ORGON Be still, you monster.	done.
[To TARTUFFE] Brother, I pray you, rise.	[To orgon] You can't know how it hurts when
[To DAMIS] Villain!	someone tries
DAMIS But	To blacken me in my dear Brother's eyes.
C:1	ORGON Ahh!
	TARTUFFE The mere thought of such
	ingratitude 5
ORGON Just one word more, and I'll tear you	
limb from limb.	Plunges my soul into so dark a mood
TARTUFFE In God's name, Brother, don't be harsh	Such horror grips my heart I gasp for
with him.	breath,
I'd rather far be tortured at the stake	And cannot speak, and feel myself near death.
Than see him bear one scratch for my poor sake.	ORGON [He runs, in tears, to the door through which
ORGON [To DAMIS] Ingrate!	he has just driven his son.]
TARTUFFE If I must beg you, on	You blackguard! Why did I spare you? Why did
bended knee,	I not
To pardon him	Break you in little pieces on the spot?
ORGON [Falling to his knees, addressing TARTUFFE]	Compose yourself, and don't be hurt, dear
Such goodness cannot be!	friend.
[To DAMIS] Now, there's true charity!	TARTUFFE These scenes, these dreadful quarrels,
DAMIS What, you ?	have got to end.
ORGON Villain, be still!	I've much upset your household, and I perceive
I know your motives; I know you wish him ill:	That the best thing will be for me to leave.
Yes, all of you—wife, children, servants, all—	ORGON What are you saying!
Conspire against him and desire his fall,	TARTUFFE They're all against me here;
Employing every shameful trick you can	They'd have you think me false and
To alienate me from this saintly man. 50	insincere. 15
	ORGON Ah, what of that? Have I ceased believing
Ah, but the more you seek to drive him away,	
The more I'll do to keep him. Without delay,	in you? TARTUFFE Their adverse talk will certainly
I'll spite this household and confound its pride	
By giving him my daughter as his bride.	continue,
DAMIS You're going to force her to accept his	And charges which you now repudiate
hand? 55	You may find credible at a later date. 20
ORGON Yes, and this very night, d'you	ORGON No, Brother, never.
understand?	TARTUFFE Brother, a wife can sway
I shall defy you all, and make it clear	Her husband's mind in many a subtle way.
That I'm the one who gives the orders here.	orgon No, no.
Come, wretch, kneel down and clasp his blessed	TARTUFFE To leave at once is the solution;
feet,	Thus only can I end their persecution.
And ask his pardon for your black deceit. 60	orgon No, no, I'll not allow it; you shall
DAMIS I ask that swindler's pardon? Why, I'd	remain. 25
rather	TARTUFFE Ah, well; 'twill mean much martyrdom
ORGON So! You insult him, and defy your father!	and pain,
A stick! A stick! [To TARTUFFE] No, no—release	But if you wish it
me, do.	ORGON Ah!
[To DAMIS.] Out of my house this minute! Be	TARTUFFE Enough; so be it.
off with you,	But one thing must be settled, as I see it.
And never dare set foot in it again. 65	For your dear honor, and for our friendship's
	sake,
DAMIS Well, I shall go, but Well go quickly then	There's one precaution I feel bound to take. 30
ORGON Well, go quickly, then.	I shall avoid your wife, and keep away
I disinherit you; an empty purse	ORGON No, you shall not, whatever they may say.
Is all you'll get from me—except my curse!	ORGON INO, you shall not, whatever they may say.

It pleases me to vex them, and for spite I'd have them see you with her day and night. What's more, I'm going to drive them to despair

35 By making you my only son and heir; This very day, I'll give to you alone Clear deed and title to everything I own. A dear, good friend and son-in-law-to-be Is more than wife, or child, or kin to me. Will you accept my offer, dearest son? TARTUFFE In all things, let the will of Heaven be

done.

ORGON Poor fellow! Come, we'll go draw up the deed.

Then let them burst with disappointed greed!

Miguel de Cervantes Saavedra The Adventures of Don Quixote: Part II, Chapters 10 and 11

These two chapters, from the beginning of the second half of the story, illustrate some of the many layers of meaning in Cervantes' novel. The two heros are hidden outside the town of El Toboso, where they have come in search of Don Quixote's ideal (and imaginary) mistress, Dulcinea. Sancho, who realizes the absurdity of the quest, pretends to recognize a passing peasant girl as the beloved Dulcinea. Don Quixote can see immediately that the girl is plain, poorly dressed, and riding on a donkey, yet Sancho's conviction—as well as his own need to be convinced persuades him to greet her as his beautiful mistress. But how to reconcile her appearance with her noble identity? The Don rushes to the conclusion that some malion, persecuting enchanter has bewitched him; as a result he cannot see the real Dulcinea on her magnificent horse, but only a rough girl on an ass. Thus he see the truth yet invents his own interpretation of it.

The two travelers then meet up with a band of actors dressed as the characters they play: Death, Cupid, the Emperor, and so on. The resulting confusion between reality and illusion, with its implicit questioning of the nature of role-playing, has significance far beyond the man of La Mancha and his delusions.

In both these episodes Cervantes touches on profound questions of identity and truth, yet his style is always easy, even conversational. The narrator's apparent detachment adds to the touching effect of the Don's madness.

Chapter x. In which is related the device Sancho adopted to enchant the Lady Dulcinea, and other incidents as comical as they are true.

When the author of this great history comes to recount the contents of this chapter, he says that he would have liked to pass it over in silence, through fear of disbelief. For Don Quixote's delusions here

reach the greatest imaginable bounds and limits, and even exceed them, great as they are, by two bowshots. But finally he wrote the deeds down, although with fear and misgivings, just as our knight performed them, without adding or subtracting one atom of truth from the history, or taking into ac- 10 count any accusations of lying that might be laid against him. And he was right, for truth, though it may run thin, never breaks, and always flows over the lie like oil over water. So, continuing his history, he says that as soon as Don Quixote had hidden himself in the thicket, or oak wood, or forest, beside great El Toboso, he ordered Sancho to go back to the city, and not return to his presence without first speaking to his lady on his behalf, and begging her to be so good as to allow herself to be seen by her cap- 20 tive knight, and to deign to bestow her blessing on him, so that he might hope thereby to meet with the highest success in all his encounters and arduous enterprises. Sancho undertook to do as he was commanded, and to bring his master as favourable a reply as he had brought the first time.

"Go, my son," said Don Quixote, "and do not be confused when you find yourself before the light of the sun of beauty you are going to seek. How much more fortunate you are than all other squires in the 30 world! Bear in your mind, and let it not escape you, the manner of your reception; whether she changes colour whilst you are delivering her my message; whether she is stirred or troubled on hearing my name; whether she shifts from her cushion, should you, by chance, find her seated on the rich dais of her authority. If she is standing, watch whether she rests first on one foot and then on the other; whether she repeats her reply to you two or three times; whether she changes from mild to harsh, from cruel to amo- 40 rous; whether she raises her hand to her hair to smooth it, although it is not untidy. In fact, my son, watch all her actions and movements; because, if you relate them to me as they were, I shall deduce what she keeps concealed in the secret places of her heart as far as concerns the matter of my love. For you must know, Sancho, if you do not know already, that between lovers the outward actions and movements they reveal when their loves are under discussion are most certain messengers, bearing news of what is 50 going on in their innermost souls. Go, friend, and may better fortune than mine guide you, and send you better success than I expect, waiting between fear and hope in this bitter solitude where you leave me."

"I'll go, and come back quickly," said Sancho. "Cheer up that little heart of yours, dear master, for it must be no bigger now than a hazel nut. Remember the saying that a stout heart breaks bad luck; and where there are no flitches there are no hooks; and 60 they say, too, where you least expect it, out jumps the hare. This I say because now that it's day I hope to find my lady's palaces or castles where I least expect them, even though we didn't find them last night: and once found, leave me to deal with her alone."

"Indeed, Sancho," said Don Quixote, "you always bring in your proverbs very much to the purpose of our business. May God give me as good luck in my ventures as you have in your sayings."

At these words Sancho turned away and gave Dapple the stick; and Don Quixote stayed on horseback, resting in his stirrups and leaning on his lance, full of sad and troubled fancies, with which we will leave him and go with Sancho Panza, who parted from his master no less troubled and thoughtful than he. So much so that scarcely had he come out of the wood than he turned round and, seeing that Don Ouixote was out of sight, dismounted from his ass. Then, sitting down at the foot of a tree, he began to 80 commune with himself to this effect:

"Now, let us learn, brother Sancho, where your worship is going. Are you going after some ass you have lost? No, certainly not. Then what are you going to look for? I am going to look, as you might say, for nothing, for a Princess, and in her the sun of beauty and all heaven besides. And where do you expect to find this thing you speak of, Sancho? Where? In the great city of El Toboso. Very well, and on whose behalf are you going to see her? On behalf 90 of the famous knight Don Quixote de la Mancha, who rights wrongs, gives meat to the thirsty, and drink to the hungry. All this is right enough. Now, do you know her house? My master says it will be some royal palace or proud castle. And have you by any chance ever seen her? No, neither I nor my master have ever seen her. And, if the people of El Toboso knew that you are here for the purpose of enticing away their Princesses and disturbing their ladies, do you think it would be right and proper for 100 them to come and give you such a basting as would grind your ribs to powder and not leave you a whole bone in your body? Yes, they would be absolutely in the right, if they did not consider that I am under orders, and that

You are a messenger, my friend And so deserve no blame.

"Don't rely on that, Sancho, for the Manchegans are honest people and very hot-tempered, and they won't stand tickling from anyone. God's truth, if 110 they smell you, you're in for bad luck. Chuck it up, you son of a bitch, and let someone else catch it. No, you won't find me searching for a cat with three legs for someone else's pleasure. What's more, looking for Dulcinea up and down El Toboso will be like

looking for little Maria in Ravenna, or the Bachelor in Salamanca. It's the Devil, the Devil himself who has put me into this business. The Devil and no other!"

This colloquy Sancho held with himself, and it led 120 him to the following conclusion: "Well, now, there's a remedy for everything except death, beneath whose yoke we must all pass, willy-nilly, at the end of our lives. I have seen from countless signs that this master of mine is a raving lunatic who ought to be tied up-and me, I can't be much better, for since I follow him and serve him, I'm more of a fool than he if the proverb is true that says: tell me what company you keep and I will tell you what you are; and that other one too: not with whom you are born but with 130 whom you feed. Well, he's mad-that he is-and it's the kind of madness that generally mistakes one thing for another, and thinks white black and black white, as was clear when he said that the windmills were giants and the friars' mules dromedaries, and the flocks of sheep hostile armies, and many other things to this tune. So it won't be very difficult to make him believe that the first peasant girl I run across about here is the lady Dulcinea. If he doesn't believe it I'll swear, and if he swears I'll outswear him, and if he 140 sticks to it I shall stick to it harder, so that, come what may, my word shall always stand up to his. Perhaps if I hold out I shall put an end to his sending me on any more of these errands, seeing what poor answers I bring back. Or perhaps he'll think, as I fancy he will, that one of those wicked enchanters who, he says, have a grudge against him, has changed her shape to vex and spite him.'

With these thoughts Sancho quieted his conscience, reckoning the business as good as settled. 150 And there he waited till afternoon, to convince Don Ouixote that he had had time to go to El Toboso and back. And so well did everything turn out that when he got up to mount Dapple he saw three peasant girls coming in his direction, riding on three young asses or fillies—our author does not tell us which—though it is more credible that they were she-asses, as these are the ordinary mounts of village women; but as nothing much hangs on it, there is no reason to stop and clear up the point. To continue—as soon as San- 160 cho saw the girls, he went back at a canter to look for his master and found him, sighing and uttering countless amorous lamentations. But as soon as Don Ouixote saw him, he cried: "What luck, Sancho? Shall I mark this day with a white stone or with a black?"

"It'll be better," replied Sancho, "for your worship to mark it in red chalk, like college lists, to be plainly seen by all who look."

"At that rate," said Don Quixote, "you bring 170 good news."

"So good," answered Sancho, "that your worship has nothing more to do than to spur Rocinante and go out into the open to see the lady Dulcinea del Toboso, who is coming to meet your worship with two of her damsels."

"Holy Father! What is that you say, Sancho my friend?" cried Don Quixote. "See that you do not deceive me, or seek to cheer my real sadness with

false joys."

"What could I gain by deceiving your worship?" replied Sancho. "Especially as you are so near to discovering the truth of my report. Spur on, sir, come, and you'll see the Princess, our mistress, coming dressed and adorned—to be brief, as befits her. Her maidens and she are one blaze of gold, all ropes of pearls, all diamonds, all rubies, all brocade of more than ten gold strands; their hair loose on their shoulders, like so many sunrays sporting in the wind and, what's more, they are riding on three piebald nack- 190 neys, the finest to be seen."

"Hackneys you mean, Sancho."

"There is very little difference," replied Sancho, "between nackneys and hackneys. But let them come on whatever they may, they are the bravest ladies you could wish for, especially the Princess Dulcinea, my lady, who dazzles the senses."

"Let us go, Sancho my son," replied Don Quixote, "and as a reward for this news, as unexpected as it is welcome, I grant you the best spoil I shall gain in 200 the first adventure that befalls me; and, if that does not content you, I grant you the fillies that my three mares will bear me this year, for you know that I left them to foal on our village common."

"The fillies for me," cried Sancho, "for it's not too certain that the spoils of the first adventure will

be good ones."

At this point they came out of the wood and discovered the three village girls close at hand. Don Quixote cast his eye all along the El Toboso road, 210 and seeing nothing but the three peasant girls, asked Sancho in great perplexity whether he had left the ladies outside the city.

"How outside the city?" he answered. "Can it be that your worship's eyes are in the back of your head that you don't see that these are they, coming along shining like the very sun at noon?"

"I can see nothing, Sancho," said Don Quixote, "but three village girls on three donkeys."

"Now God deliver me from the Devil," replied 220 Sancho, "Is it possible that three hackneys, or whatever they're called, as white as driven snow, look to your worship like asses? Good Lord, if that's the truth, may my beard be plucked out.'

"But I tell you, Sancho my friend," said Don Quixote, "that it is as true that they are asses, or she-asses, as that I am Don Quixote and you Sancho Panza. At least, they look so to me."

"Hush, sir!" said Sancho. "Don't say such a thing, but wipe those eyes of yours, and come and do hom- 230 age to the mistress of your thoughts, who is drawing near."

As he spoke he rode forward to receive the three village girls, and dismounting from Dapple, took one of the girls' asses by the bridle and sank on both knees to the ground, saying: "Queen and Princess and Duchess of beauty, may your Highness and Mightiness deign to receive into your grace and good liking your captive knight, who stands here, turned to marble stone, all troubled and unnerved at finding 240 himself in your magnificent presence. I am Sancho Panza, his squire, and he is the travel-weary knight, Don Quixote de la Mancha, called also by the name of the Knight of the Sad Countenance."

By this time Don Quixote had fallen on his knees beside Sancho, and was staring, with his eyes starting out of his head and a puzzled look on his face, at the person whom Sancho called Queen and Lady. And as he could see nothing in her but a country girl, and not a very handsome one at that, she being round- 250 faced and flat-nosed, he was bewildered and amazed, and did not dare to open his lips. The village girls were equally astonished at seeing these two men, so different in appearance, down on their knees and preventing their companion from going forward. But the girl they had stopped broke the silence by crying roughly and angrily: "Get out of the way, confound you, and let us pass. We're in a hurry."

To which Sancho replied: "O Princess and worldfamous Lady of El Toboso! How is it that your mag- 260 nanimous heart is not softened when you see the column and prop of knight errantry kneeling before

your sublimated presence?"

On hearing this, one of the two others exclaimed: "Wait till I get my hands on you, you great ass! See how these petty gentry come and make fun of us village girls, as if we couldn't give them as good as they bring! Get on your way, and let us get on ours. You had better!"

"Rise, Sancho," said Don Quixote at this; "for I 270 see that Fortune, unsatisfied with the ill already done me, has closed all roads by which any comfort may come to this wretched soul I bear in my body. And you, O perfection of all desire! Pinnacle of human gentleness! Sole remedy of this afflicted heart, that adores you! Now that the malignant enchanter persecutes me, and has put clouds and cataracts into my eyes, and for them alone, and for no others, has changed and transformed the peerless beauty of your countenance into the semblance of a poor peasant 280 girl, if he has not at the same time turned mine into

the appearance of some spectre to make it abominable to your sight, do not refuse to look at me softly and amorously, perceiving in this submission and prostration, which I make before your deformed beauty, the humility with which my soul adores vou.'

"Tell that to my grandmother!" replied the girl. "Do you think I want to listen to that nonsense? Get

you."

Sancho moved off and let her pass, delighted at having got well out of his fix. And no sooner did the girl who had played the part of Dulcinea find herself free than she prodded her nackney with the point of a stick she carried, and set off at a trot across the field. But when the she-ass felt the point of the stick, which pained her more than usual, she began to plunge so wildly that my lady Dulcinea came off upon the ground. When Don Quixote saw this accident he 300 rushed to pick her up, and Sancho to adjust and strap on the packsaddle, which had slipped under the ass's belly. But when the saddle was adjusted and Don Quixote was about to lift his enchanted mistress in his arms and place her on her ass, the lady picked herself up from the ground and spared him the trouble. For, stepping back a little, she took a short run, and resting both her hands on the ass's rump, swung her body into the saddle, lighter than a hawk, and sat astride like a man.

At which Sancho exclaimed: "By St. Roque, the lady, our mistress, is lighter than a falcon, and she could train the nimblest Cordovan or Mexican to mount like a jockey. She was over the crupper of the saddle in one jump, and now without spurs she's making that hackney gallop like a zebra. And her maidens are not much behind her. They're all going like the wind."

And so they were, for once Dulcinea was mounted, they all spurred after her and dashed away 320 saddle and which you set straight—was it a plain sadat full speed, without once looking behind them till they had gone almost two miles. Don Quixote followed them with his eyes, and, when he saw that they had disappeared, turned to Sancho and said:

"Do you see now what a spite the enchanters have against me, Sancho? See to what extremes the malice and hatred they bear me extend, for they have sought to deprive me of the happiness I should have enjoyed in seeing my mistress in her true person. In truth, I was born a very pattern for the unfortunate, and to 330 his amusement on hearing this crazy talk from his be a target and mark for the arrows of adversity. You must observe also, Sancho, that these traitors were not satisfied with changing and transforming my Dulcinea, but transformed her and changed her into a figure as low and ugly as that peasant girl's. And they have deprived her too of something most proper to

great ladies, which is the sweet smell they have from always moving among ambergris and flowers. For I must tell you, Sancho, that when I went to help my Dulcinea on to her hackney—as you say it was, 340 though it seemed a she-ass to me—I got such a whiff of raw garlic as stank me out and poisoned me to the heart.'

"Oh, the curs!" cried Sancho at this. "Oh, out of the way and let us go on, and we'll thank 290 wretched and spiteful enchanters! I should like to see you strung up by the gills like pilchards on a reed. Wise you are and powerful—and much evil you do! It should be enough for you, ruffians, to have changed the pearls of my lady's eyes into corktree galls, and her hair of purest gold into red ox tail bris- 350 tles, and all her features, in fact, from good to bad, without meddling with her smell. For from that at least we have gathered what lay concealed beneath that ugly crust. Though, to tell you the truth, I never saw her ugliness, but only her beauty, which was enhanced and perfected by a mole she had on her right lip, like a moustache, with seven or eight red hairs like threads of gold more than nine inches long."

"To judge from that mole," said Don Quixote, 360 "by the correspondence there is between those on the face and those on the body, Dulcinea must have another on the fleshy part of her thigh, on the same side as the one on her face. But hairs of the length you 310 indicate are very long for moles."

"But I can assure your worship," replied Sancho, "that there they were, as if they had been born with her."

"I believe it, friend," said Don Quixote, "for nature has put nothing on Dulcinea which is not perfect 370 and well-finished. And so, if she had a hundred moles like the one you speak of on her, they would not be moles, but moons and shining stars. But tell me, Sancho, that which appeared to me to be a packdle or a side-saddle?"

"It was just a lady's saddle," replied Sancho, "with an outdoor covering so rich that it was worth half a kingdom."

"And to think that I did not see all this, Sancho!" 380 cried Don Quixote, "Now I say once more—and I will repeat it a thousand times—I am the most unfortunate of men."

And that rascal Sancho had all he could do to hide master, whom he had so beautifully deceived. In the end, after much further conversation between the pair, they mounted their beasts once more, and followed the road to Saragossa, where they expected to arrive in time to be present at a solemn festival which 390 is held every year in that illustrious city. But before

they got there certain things happened to them, so many, so important, and so novel that they deserve to be written down and read, as will be seen hereafter.

Chapter XI. Of the strange Adventure which befell the valorous Don Quixote with the Car or Waggon of the Parliament of Death.

Very much downcast Don Quixote went on his way. pondering on the evil trick the enchanters had played on him in turning his lady Dulcinea into the foul shape of a village girl, and he could think of no remedy he could take to restore her to her original state. These thoughts took him so much out of himself that he gave Rocinante the reins without noticing it. And his horse, feeling the liberty he was given, lingered at each step to browse the green grass, which grew thickly in those fields. But Sancho roused his master 10 from his musing by saving:

"Sir, griefs were not made for beasts but for men. Yet if men feel them too deeply they turn to beasts. Pull yourself together, your worship, and come to your senses and pick up Rocinante's reins. Cheer up and wake up, and show that gay spirit knights errant should have. What the devil is it? What despondency is this? Are we here or in France? Let all the Dulcineas in the world go to Old Nick, for the well-being of a single knight errant is worth more than all the en-20 chantments and transformations on earth.'

"Hush, Sancho," replied Don Quixote with more spirit than might have been expected. "Hush, I say, and speak no more blasphemies against that enchanted lady. For I alone am to blame for her misfortune and disaster. From the envy the wicked bear me springs her sad plight."

"And so say I," answered Sancho, "who saw her and can still see her now. What heart is there that would not weep?"

"You may well say that, Sancho," replied Don Quixote, "since you saw her in the perfect fullness of her beauty, for the enchantment did not go so far as to disturb your vision or conceal her beauty from you. Against me alone, against my eyes, was directed the power of their venom. But for all that, Sancho, one thing occurs to me: you described her beauty to me badly. For, if I remember rightly, you said that she had eyes like pearls, and eyes like pearls suit a sea-bream better than a lady. According to my belief, 40 Dulcinea's eyes must be green emeralds, full and large, with twin rainbows to serve them for eyebrows. So take these pearls from her eyes and transfer them to her teeth, for no doubt you got mixed up, Sancho, taking her teeth for her eyes.'

"Anything's possible," replied Sancho, "for her

beauty confused me, as her ugliness did your worship. But let's leave it all in God's hands. For He knows all things that happen in this vale of tears, in this wicked world of ours, where there's hardly any-50 thing to be found without a tincture of evil, deceit and roguery in it. But one thing troubles me, dear master, more than all the rest: I can't think what we're to do when your worship conquers a giant or another knight and commands him to go and present himself before the beauteous Dulcinea. Where is he to find her, that poor giant or that poor miserable conquered knight? I seem to see them wandering about El Toboso, gaping like dummies, in search of my lady Dulcinea; and even if they meet her in the 60 middle of the street they won't know her any more than they would my father."

"Perhaps, Sancho," answered Don Quixote, "the enchantment will not extend so far as to deprive vanquished and presented giants and knights of the power to recognize Dulcinea. But we will make the experiment with one or two of the first I conquer. We will send them with orders to return and give me an account of their fortunes in this respect, and so discover whether they can see her or not."

"Yes, sir," said Sancho; "that seems a good idea to me. By that trick we shall find out what we want to, and if it proves that she is only disguised from your worship, the misfortunes will be more yours than hers. But so long as the lady Dulcinea has her health and happiness, we in these parts will make shift to put up with it as best we can. We'll seek our adventures and leave Time to look after hers; for Time's the best doctor for such ailments and for worse."

Don Quixote was about to reply to Sancho, but he 80 was interrupted by a waggon, which came out across the road loaded with some of the strangest shapes imaginable. Driving the mules and acting as carter was an ugly demon, and the waggon itself was open to the sky, without tilt or hurdle roof. The first figure which presented itself before Don Quixote's eyes was Death himself with a human face. Beside him stood an angel with large painted wings. On one side was an Emperor with a crown on his head, apparently of gold. At the feet of Death was the God they 90 call Cupid, without his bandage over his eyes, but with his bow, his quiver and his arrows. There was also a knight in complete armour, except that he wore no helmet or headpiece, but a hat instead adorned with multi-coloured plumes. And there were other personages differing in dress and appearance. The sudden vision of this assembly threw Don Quixote into some degree of alarm, and struck fear into Sancho's heart. But soon the knight's spirits mounted with the belief that there was some new and 100 perilous adventure presenting itself; and with this

idea in his head, and his heart ready to encounter any sort of danger, he took up his position in front of the cart, and cried in a loud and threatening voice:

"Carter, coachman, devil, or whatever you may be, tell me instantly who you are, where you are going, and who are the people you are driving in your coach, which looks more like Charon's bark

than an ordinary cart."

To which the Devil, stopping the cart, politely 110 replied: "Sir, we're players of Angulo El Malo's company. We've been acting this morning in a village which lies behind that hill-for it's Corpus Christi week. Our piece is called The Parliament of Death; and we have to perform this evening, in that village which you can see over there. So because it's quite near, and to spare ourselves the trouble of taking off our clothes and dressing again, we are travelling in the costumes we act in. That young man there plays Death. The other fellow's the Angel. That 120 il's carried Dapple off." lady, who is the manager's wife, is the Queen. This man plays the Soldier. That man's the Emperor. And I'm the Devil and one of the chief characters in the piece, for I play the principal parts in this company. If your worship wants to know anything more about us, ask me. I can tell you every detail, for being the Devil I'm up to everything."

"On the faith of a knight errant," answered Don Quixote, "when I saw this cart I imagined that some great adventure was presenting itself to me. But now 130 I declare that appearances are not always to be trusted. Go, in God's name, good people, and hold your festival; and think whether you have any request to make of me. If I can do you any service I gladly and willingly will do so, for from my boyhood I have been a lover of pantomimes, and in my youth I was always a glutton for comedies."

Now, whilst they were engaged in this conversation, as Fate would have it, one of the company caught them up, dressed in motley with a lot of bells 140 about him, and carrying three full blown ox-bladders on the end of a stick. When this clown came up to Don Quixote, he began to fence with his stick, to beat the ground with his bladders, and leap into the air to the sound of his bells; and this evil apparition so scared Rocinante that he took the bit between his teeth, and started to gallop across the field with more speed than the bones of his anatomy promised; nor was Don Quixote strong enough to stop him. Then, realizing that his master was in danger of being 150 thrown off, Sancho jumped down from Dapple and ran in all haste to his assistance. But when he got up to him he was already on the ground, and beside him lay Rocinante, who had fallen with his master-for such was the usual upshot of the knight's exploits and Rocinante's high spirits.

But no sooner had Sancho left his own mount to help Don Quixote than the dancing devil jumped on to Dapple, and dealt him a slap with the bladders, whereat, startled by the noise rather than by the pain 160 of the blows, the ass went flying off across country towards the village where the festival was to take place. Sancho watched Dapple's flight and his master's fall, undecided which of the two calls to attend to first. But finally, good squire and good servant that he was, love of his master prevailed over affection for his ass, though each time he saw the bladders rise in the air and fall on his Dapple's rump, he felt the pains and terrors of death, for he would rather have had those blows fall on his own eyeballs than on 170 the least hair of his ass's tail. In this sad state of perplexity he arrived where Don Quixote lay in a great deal worse plight than he cared to see him in and, helping him on to Rocinante, he said: "Sir, the Dev-

"What Devil?" asked Don Quixote.

"The one with the bladders," replied Sancho.
"Then I shall get him back," said Don Quixote,

"even if he were to lock him up in the deepest and darkest dungeons of Hell. Follow me, Sancho. For 180 the waggon goes slowly, and I will take its mules to make up for the loss of Dapple."

"There's no need to go to that trouble, sir," said Sancho. "Cool your anger, your worship, for it looks to me as if the Devil has let Dapple go and is off

to his own haunts again."

And so indeed he was. For when the Devil had given an imitation of Don Quixote and Rocinante by tumbling off Dapple he set off to the village on foot, and the ass came back to his master.

"All the same," said Don Quixote, "it will be as well to visit that demon's impoliteness on one of those in the waggon, perhaps on the Emperor him-

self."

"Put that thought out of your head, your worship," answered Sancho. "Take my advice and never meddle with play-actors, for they're a favoured race. I've seen an actor taken up for a couple of murders and get off scot-free. As they're a merry lot and give pleasure, I would have your worship know that 200 everybody sides with them and protects them, aids them, and esteems them, particularly if they belong to the King's companies and have a charter. And all of them, or most of them, look like princes when they have their costumes and make-up on."

"For all that," answered Don Quixote, "that player devil shall not go away applauding himself, even if the whole human race favours him."

And as he spoke, he turned towards the waggon, which was now very close to the village, calling out 210 loudly, as he rode: "Halt! Stop, merry and festive

crew! For I would teach you how to treat asses and animals which serve as mounts to the squires of

knights errant."

So loudly did Don Quixote shout that those in the waggon heard and understood him; and judging from his words the purpose of their speaker, Death promptly jumped out of the waggon, and after him the Emperor, the Demon-driver, and the Angel; nor did the Queen or the god Cupid stay behind. Then 220 less exciting than the last. they all loaded themselves with stones and took up their positions in a row, waiting to receive Don Quixote with the edges of their pebbles. But when he saw them drawn up in so gallant a squadron, with their arms raised in the act of discharging this powerful volley of stones, he reined Rocinante in, and began to consider how to set upon them with least peril to his person. While he was thus checked Sancho came up and, seeing him drawn up to attack that 230 well-ordered squadron, said:

"It would be the height of madness to attempt such an enterprise. Consider, your worship, that there is no defensive armour in the world against the rain of these fellows' bullets, unless you could ram yourself into a brass bell and hide. And you must consider too, master, that it is rashness and not valour for a single man to attack an army with Death in its ranks, Emperors in person fighting in it, and assisted by good and bad angels. What's more, if this isn't reason enough to persuade you to stay quiet, 240 consider that it's a positive fact that although they look like Kings, Princes and Emperors, there isn't a single knight errant among the whole lot of them there.'

"Now, Sancho," said Don Quixote, "you have certainly hit on a consideration which should deflect me from my determination. I cannot and must not draw my sword, as I have told you on many occasions before now, against anyone who is not a knight. It rests with you therefore, Sancho, if you 250 wish to take revenge for the injury done to your Dapple; and I will help you from here with words of salutary counsel."

"There's no reason, sir, to take revenge on anyone," replied Sancho, "for it's not right for a good Christian to avenge his injuries. What's more I shall persuade Dapple to leave his cause in my hands, and it's my intention to live peacefully all the days of life

that Heaven grants me."

"Since that is your decision," answered Don 260 Quixote, "good Sancho, wise Sancho, Christian Sancho, honest Sancho, let us leave these phantoms and return to our quest for better and more substantial adventures. For I'm sure that this is the sort of country that can't fail to provide us with many and most miraculous ones."

Then he turned Rocinante, Sancho went to catch his Dapple, and Death and all his flying squadron 270 returned to their waggon and continued their journey. And this was the happy ending of the encounter with the waggon of Death, thanks to the healthy advice which Sancho Panza gave his master, to whom on the next day there came another adventure. with an enamoured knight errant, which proved no

John Milton Paradise Lost, Book I

The reader who approaches Book I by itself must bear in mind the perhaps obvious but important fact that it represents only the introduction to a cosmic struggle on a massive scale. The events of the book prefigure the eventual fall of Adam and Eve and are dominated by the figure of Satan, who is depicted in language so powerful as to seem almost heroic. His defiance of God's punishment in lines 94 to 111 has been compared by some critics to Prometheus' defiance in the face of the threats of Zeus and subsequent punishment at the hands of the father of the Greek gods. The description of his kingdom in lines 670 to 798 is of epic grandeur. Yet Milton leaves no doubt that the grandeur is fatally flawed. In lines 158 to 165 Satan himself reminds us that in Hell "ever to do ill [is] our sole delight." To see Satan as the hero of the epic, a kind of underdog, victim of the divine tyranny, is to misinterpret Milton. Satan is a courageous and formidable opponent, but neither quality is inconsistent with the utmost evil.

Milton's language and imagery present an almost inexhaustible combination of biblical and classical reference. From the very first lines of Book I, where the poet calls upon a classical Muse to help him tell the tale of The Fall, the two great Western cultural traditions are inextricably linked. Toward the end of the book, for example, we learn that the chief architect of both Heaven and Hell was none other than the Greek god Hephaistos, the Roman Vulcan (lines 732-751). Much of the poetic effect is gained by Milton's love of exotic or romantic names from ancient sources, many of them obscure. He would, of course, have hoped that his readers could identify them all and understand the references; but the modern reader may be somewhat comforted to find that the sheer musical value of lines like 406 to 411, or 582 to 587 is considerable without regard to their detailed significance. The richness of effect is in keeping with the lavishness of much of Baroque art.

Book I of Paradise Lost provides, therefore, an introduction to many aspects of the entire epic. It partially conceals the true nature of the conflict between good and evil and fails to introduce us to Adam and Eve themselves. Yet a reading of even this small part of the whole work makes it absolutely clear why Milton so profoundly affected successive generations of poets. After Milton, English literature was never the same again.

The Argument

This First Book proposes, first in brief, the whole subject—Man's disobedience, and the loss thereupon of Paradise, wherein he was placed; then touches the prime cause of his fall—the Serpent, or rather Satan in the Serpent; who, revolting from God, and drawing to his side many legions of Angels, was, by the command of God, driven out of Heaven, with all his crew, into the great Deep. Which action passed over, the Poem hastens into the midst of things; presenting Satan, with his Angels, now fallen into Helldescribed here not in the Centre (for heaven and earth may be supposed as yet not made, certainly not yet accursed), but in a place of utter darkness, fitliest called Chaos. Here Satan, with his Angels lying on the burning lake, thunderstruck and astonished, after a certain space recovers, as from confusion; calls up him who, next in order and dignity, lay by him: they confer of their miserable fall. Satan awakens all his legions, who lay till then in the same manner confounded. They rise: their numbers; array of battle: their chief leaders named, according to the idols known afterwards in Canaan and the countries adjoining. To these Satan directs his speech; comforts them with hope yet of regaining Heaven; but tells them, lastly, of a new world and new kind of creature to be created, according to an ancient prophecy, or report, in Heaven-for that Angels were long before this visible creation was the opinion of many ancient Fathers. To find out the truth of this prophecy, and what to determine thereon, he refers to a full council. What his associates thence attempt. Pandemonium, the palace of Satan, rises, suddenly built out of the Deep: the infernal Peers there sit in council.

Of Man's first disobedience, and the fruit Of that forbidden tree whose mortal taste Brought death into the World, and all our woe, With loss of Eden, till one greater Man Restore us, and regain the blissful seat, Sing, Heavenly Muse, that, on the secret top Of Oreb, or of Sinai, didst inspire That shepherd who first taught the chosen seed In the beginning how the heavens and earth Rose out of Chaos: or, if Sion hill Delight thee more, and Siloa's brook that flowed Fast by the oracle of God, I thence Invoke thy aid to my adventurous song, That with no middle flight intends to soar Above the Aonian mount, while it pursues Things unattempted yet in prose or rhyme.

And chiefly Thou, O Spirit, that dost prefer Before all temples the upright heart and pure. Instruct me, for Thou know'st; Thou from the

Wast present, and, with mighty wings outspread,

Dove-like sat'st brooding on the vast Abyss, And mad'st it pregnant: what in me is dark Illumine, what is low raise and support; That, to the highth of this great argument, I may assert Eternal Providence, And justify the ways of God to men.

Say first—for heaven hides nothing from thy view.

Nor the deep tract of Hell—say first what cause Moved our grand Parents, in that happy state, Favored of Heaven so highly, to fall off From their Creator, and transgress his will For one restraint, lords of the World besides. Who first seduced them to that foul revolt?

The infernal Serpent; he it was whose guile, Stirred up with envy and revenge, deceived The mother of mankind, what time his pride Had cast him out from Heaven, with all his host Of rebel Angels, by whose aid, aspiring To set himself in glory above his peers, He trusted to have equalled the Most High, If he opposed, and, with ambitious aim Against the throne and monarchy of God, Raised impious war in Heaven and battle proud, With vain attempt. Him the Almighty Power Hurled headlong flaming from the ethereal sky, With hideous ruin and combustion, down To bottomless perdition, there to dwell In adamantine chains and penal fire, Who durst defy the Omnipotent to arms. Nine times the space that measures day and

50 To mortal men, he, with his horrid crew, Lay vanquished, rolling in the fiery gulf, Confounded, though immortal. But his doom Reserved him to more wrath; for now the thought Both of lost happiness and lasting pain Torments him: round he throws his baleful eyes, That witnessed huge affliction and dismay, Mixed with obdurate pride and steadfast hate. At once, as far as Angel's ken, he views The dismal situation waste and wild. A dungeon horrible, on all sides round, As one great furnace flamed; yet from those flames No light; but rather darkness visible Served only to discover sights of woe, Regions of sorrow, doleful shades, where peace And rest can never dwell, hope never comes That comes to all, but torture without end

20

Still urges, and a fiery deluge, fed With ever-burning sulphur unconsumed. Such place Eternal Justice had prepared For those rebellious; here their prison ordained In utter darkness, and their portion set, As far removed from God and light of Heaven As from the centre thrice to the utmost pole. Oh how unlike the place from whence they fell! There the companions of his fall, o'erwhelmed With floods and whirlwinds of tempestuous fire, He soon discerns; and, weltering by his side. One next himself in power, and next in crime, Long after known in Palestine, and named BEËLZEBUB. To whom the Arch-Enemy, And thence in Heaven called SATAN, with bold words

Breaking the horrid silence, thus began:-"If thou beest he—but Oh how fallen! how

From him!—who, in the happy realms of light, Clothed with transcendent brightness, didst outshine

Myriads, though bright—if he whom mutual

United thoughts and counsels, equal hope And hazard in the glorious enterprise, Joined with me once, now misery hath joined In equal ruin; into what pit thou seest From what highth fallen: so much the stronger proved

He with his thunder: and till then who knew The force of those dire arms? Yet not for those, Nor what the potent Victor in his rage Can else inflict, do I repent, or change, Though changed in outward lustre, that fixed

And high disdain from sense of injured merit, That with the Mightiest raised me to contend, And to the fierce contention brought along Innumerable force of Spirits armed, That durst dislike his reign, and, me preferring, His utmost power with adverse power opposed In dubious battle on the plains of heaven, And shook his throne. What though the field be

100

110

All is not lost—the unconquerable will, And study of revenge, immortal hate, And courage never to submit or yield: And what is else not to be overcome. That glory never shall his wrath or might Extort from me. To bow and sue for grace With suppliant knee, and deify his power Who, from the terror of this arm, so late Doubted his empire—that were low indeed; That were an ignominy and shame beneath

This downfall; since, by fate, the strength of Gods. And this empyreal substance, cannot fail; Since, through experience of this great event, In arms not worse, in foresight much advanced, We may with more successful hope resolve 120 To wage by force or guile eternal war. Irreconcilable to our grand Foe, Who now triumphs, and in the excess of joy Sole reigning holds the tyranny of Heaven.

So spake the apostate Angel, though in pain, Vaunting aloud, but racked with deep despair; And him thus answered soon his bold compeer:—

"O Prince, O Chief of many thronèd Powers That led the embattled Seraphim to war Under thy conduct, and, in dreadful deeds 130 Fearless, endangered Heaven's perpetual King, And put to proof his high supremacy, Whether upheld by strength, or chance, or fate! Too well I see and rue the dire event That, with sad overthrow and foul defeat. Hath lost us Heaven, and all this mighty host In horrible destruction laid thus low, As far as Gods and heavenly Essences Can perish: for the mind and spirit remains Invincible, and vigor soon returns, 140 Though all our glory extinct, and happy state Here swallowed up in endless misery. But what if He our Conqueror (whom I now Of force believe almighty, since no less Than such could have o'erpowered such force as

Have left us this our spirit and strength entire, Strongly to suffer and support our pains, That we may so suffice his vengeful ire Or do him mightier service as his thralls By right of war, whate'er his business be, Here in the heart of Hell to work in fire, Or do his errands in the gloomy Deep? What can it then avail though yet we feel Strength undiminished, or eternal being To undergo eternal punishment?"

150

160

Whereto with speedy words the Arch-Fiend replied:-

"Fallen Cherub, to be weak is miserable, Doing or suffering: but of this be sure— To do aught good never will be our task, But ever to do ill our sole delight, As being the contrary to His high will Whom we resist. If then his providence Out of our evil seek to bring forth good, Our labor must be to pervert that end, And out of good still to find means of evil; Which ofttimes may succeed so as perhaps Shall grieve him, if I fail not, and disturb His inmost counsels from their destined aim. But see! the angry Victor hath recalled His ministers of vengeance and pursuit Back to the gates of Heaven: the sulphurous hail, Shot after us in storm, o'erblown hath laid The fiery surge that from the precipice Of Heaven received us falling; and the thunder, Winged with red lightning and impetuous rage, Perhaps hath spent his shafts, and ceases now To bellow through the vast and boundless Deep. Let us not slip the occasion, whether scorn Or satiate fury yield it from our Foe. Seest thou you dreary plain, forlorn and wild, The seat of desolation, void of light, Save what the glimmering of these livid flames Casts pale and dreadful? Thither let us tend From off the tossing of these fiery waves; There rest, if any rest can harbor there; And, re-assembling our afflicted powers, Consult how we may henceforth most offend Our enemy, our own loss how repair, How overcome this dire calamity, What reinforcement we may gain from hope, If not what resolution from despair."

Thus Satan, talking to his nearest mate, With head uplift above the wave, and eyes That sparkling blazed; his other parts besides Prone on the flood, extended long and large Lay floating many a rood, in bulk as huge As whom the fables name of monstrous size, Titanian or Earth-born, that warred on Jove, Briareos or Typhon, whom the den By ancient Tarsus held, or that sea-beast Leviathan, which God of all his works Created hugest that swim the ocean-stream. Him, haply slumbering on the Norway foam, The pilot of some small night-foundered skiff, Deeming some island, oft, as seamen tell, With fixed anchor in his scaly rind, Moors by his side under the lee, while night Invests the sea, and wished morn delays. So stretched out huge in length the Arch-Fiend lav.

Chained on the burning lake; nor ever thence Had risen, or heaved his head, but that the will And high permission of all-ruling Heaven Left him at large to his own dark designs, That with reiterated crimes he might Heap on himself damnation, while he sought Evil to others, and enraged might see How all his malice served but to bring forth Infinite goodness, grace, and mercy, shewn On Man by him seduced, but on himself Treble confusion, wrath, and vengeance

poured, Forthwith upright he rears from off the pool His mighty stature; on each hand the flames Driven backward slope their pointing spires, and,

170

190

200

220

In billows, leave i' the midst a horrid vale. Then with expanded wings he steers his flight Aloft, incumbent on the dusky air, That felt unusual weight; till on dry land He lights-if it were land that ever burned With solid, as the lake with liquid fire, And such appeared in hue as when the force 230 Of subterranean wind transports a hill Torn from Pelorus, or the shattered side Of thundering Ætna, whose combustible And fuelled entrails, thence conceiving fire, Sublimed with mineral fury, aid the winds, And leave a singed bottom all involved With stench and smoke. Such resting found the

Of unblest feet. Him followed his next mate; Both glorying to have scaped the Stygian flood As gods, and by their own recovered strength, Not by the sufferance of supernal power.

"Is this the region, this the soil, the clime," Said then the lost Archangel, "this the seat That we must change for Heaven?—this mournful gloom

For that celestial light? Be it so, since He Who now is sovran can dispose and bid What shall be right: farthest from Him is best, Whom reason hath equalled, force hath made supreme

Above his equals. Farewell, happy fields, Where joy for ever dwells! Hail, horrors! hail, Infernal World! and thou, profoundest Hell, Receive thy new possessor—one who brings A mind not to be changed by place or time. The mind is its own place, and in itself Can make a Heaven of Hell, a Hell of Heaven. What matter where, if I be still the same, And what I should be, all but less than he Whom thunder hath made greater? Here at least We shall be free; the Almighty hath not built Here for his envy, will not drive us hence: Here we may reign secure; and, in my choice, To reign is worth ambition, though in Hell: Better to reign in Hell than serve in Heaven. But wherefore let we then our faithful friends, The associates and co-partners of our loss, Lie thus astonished on the oblivious pool, And call them not to share with us their part In this unhappy mansion, or once more With rallied arms to try what may be yet Regained in Heaven, or what more lost in Hell?"

So Satan spoke; and him Beëlzebub Thus answered:—"Leader of those armies bright Which, but the Omnipotent, none could have foiled!

If once they hear that voice, their liveliest pledge Of hope in fears and dangers—heard so oft In worst extremes, and on the perilous edge Of battle, when it raged, in all assaults Their surest signal—they will soon resume New courage and revive, though now they lie Grovelling and prostrate on you lake of fire, As we erewhile, astounded and amazed; No wonder, fallen such a pernicious highth!"

He scarce had ceased when the superior Fiend Was moving toward the shore; his ponderous shield.

Ethereal temper, massy, large, and round, Behind him cast. The broad circumference Hung on his shoulders like the moon, whose orb Through optic glass the Tuscan artist views At evening, from the top of Fesolè, Or in Valdarno, to descry new lands, Rivers, or mountains, in her spotty globe. His spear—to equal which the tallest pine Hewn on Norwegian hills, to be the mast Of some great ammiral, were but a wand-He walked with, to support uneasy steps Over the burning marle, not like those steps On Heaven's azure; and the torrid clime Smote on him sore besides, vaulted with fire. Nathless he so endured, till on the beach Of that inflamed sea he stood, and called 300 His legions—Angel Forms, who lav entranced Thick as autumnal leaves that strow the brooks In Vallombrosa, where the Etrurian shades High over-arched embower; or scattered sedge Afloat, when with fierce winds Orion armed Hath vexed the Red-Sea coast, whose waves o'erthrew

290

320

Busiris and his Memphian chivalry, While with perfidious hatred they pursued The sojourners of Goshen, who beheld From the safe shore their floating carcases 310 And broken chariot-wheels. So thick bestrown. Abject and lost, lay these, covering the flood, Under amazement of their hideous change. He called so loud that all the hollow deep Of Hell resounded:—"Princes, Potentates, Warriors, the Flower of heaven—once yours; now

If such astonishment as this can seize Eternal Spirits! Or have ye chosen this place After the toil of battle to repose Your wearied virtue, for the ease you find To slumber here, as in the vales of Heaven? Or in this abject posture have ye sworn To adore the Conqueror, who now beholds

Cherub and Seraph rolling in the flood With scattered arms and ensigns, till anon His swift pursuers from Heaven-gates discern The advantage, and, descending, tread us down Thus drooping, or with linked thunderbolts Transfix us to the bottom of this gulf?-Awake, arise, or be for ever fallen!"

They heard, and were abashed, and up they

330

340

350

370

Upon the wing, as when men wont to watch. On duty sleeping found by whom they dread, Rouse and bestir themselves ere well awake. Nor did they not perceive the evil plight In which they were, or the fierce pains not feel; Yet to their General's voice they soon obeyed Innumerable. As when the potent rod Of Amram's son, in Egypt's evil day, Waved round the coast, up-called a pitchy

Of locusts, warping on the eastern wind, That o'er the realm of impious Pharaoh hung Like Night, and darkened all the land of Nile; So numberless were those bad Angels seen Hovering on wing under the cope of Hell, 'Twixt upper, nether, and surrounding fires; Till, as a signal given, the uplifted spear Of their great Sultan waving to direct Their course, in even balance down they light On the firm brimstone, and fill all the plain: A multitude like which the populous North Poured never from her frozen loins to pass Rhene or the Danaw, when her barbarous sons Came like a deluge on the South, and spread Beneath Gibraltar to the Libyan sands. Forthwith, from every squadron and each band. The heads and leaders thither haste where stood Their great Commander—godlike Shapes, and Forms

Excelling human; princely Dignities; And Powers that erst in Heaven sat on

Though of their names in Heavenly records now Be no memorial, blotted out and rased By their rebellion from the Books of Life. Nor had they yet among the sons of Eve Got them new names, till, wandering o'er the earth,

Through God's high sufferance for the trial of

By falsities and lies the greatest part Of mankind they corrupted to forsake God their Creator, and the invisible Glory of Him that made them to transform Oft to the image of a brute, adorned With gay religions full of pomp and gold,

And devils to adore for deities: Then were they known to men by various names, And various idols through the Heathen World.

Say, Muse, their names then known, who first, who last,

Roused from the slumber on that fiery couch, At their great Emperor's call, as next in worth Came singly where he stood on the bare strand, While the promiscuous crowd stood yet aloof.

The chief were those who, from the pit of Hell Roaming to seek their prey on Earth, durst fix Their seats, long after, next the seat of God, Their altars by His altar, gods adored Among the nations round, and durst abide Jehovah thundering out of Sion, throned Between the Cherubim; yea, often placed Within His sanctuary itself their shrines, Abomination; and with cursed things His holy rites and solemn feasts profaned, And with their darkness durst affront His light. First, Moloch, horrid king, besmeared with blood Of human sacrifice, and parents' tears; Though, for the noise of drums and timbrels loud, Their children's cries unheard that passed through

To his grim idol. Him the Ammonite Worshiped in Rabba and her watery plain, In Argob and in Basan, to the stream Of utmost Arnon. Nor content with such Audacious neighborhood, the wisest heart 400 Of Solomon he led by fraud to build His temple right against the temple of God On that opprobrious hill, and made his grove The pleasant valley of Hinnom, Tophet thence And black Gehenna called, the type of Hell. Next Chemos, the obscene dread of Moab's sons, From Aroar to Nebo and the wild Of southmost Abarim; in Hesebon And Horonaim, Seon's realm, beyond The flowery dale of Sibma clad with vines, 410 And Elealè to the Asphaltic Pool: Peor his other name, when he enticed Israel in Sittim, on their march from Nile, To do him wanton rites, which cost them woe. Yet thence his lustful orgies he enlarged Even to that hill of scandal, by the grove Of Moloch homicide, lust hard by hate, Till good Josiah drove them thence to Hell. With these came they who, from the bordering

Of old Euphrates to the brook that parts Egypt from Syrian ground, had general names Of Baalim and Ashtaroth—those male, These feminine. For Spirits, when they please, Can either sex assume, or both; so soft

And uncompounded is their essence pure, Not tied or manacled with joint or limb, Nor founded on the brittle strength of bones, Like cumbrous flesh; but, in what shape they

Dilated or condensed, bright or obscure, Can execute their aery purposes, 430 And works of love or enmity fulfil. For those the race of Israel oft forsook Their Living Strength, and unfrequented left His righteous altar, bowing lowly down To bestial gods; for which their heads, as low Bowed down in battle, sunk before the spear Of despicable foes. With these in troop Came Astoreth, whom the Phoenicians called Astarte, queen of heaven, with crescent horns; To whose bright image nightly by the moon 440 Sidonian virgins paid their vows and songs; In Sion also not unsung, where stood Her temple on the offensive mountain, built By that uxorious king whose heart, though large, Beguiled by fair idolatresses, fell To idols foul. Thammuz came next behind, Whose annual wound in Lebanon allured The Syrian damsels to lament his fate In amorous ditties all a summer's day, While smooth Adonis from his native rock 450 Ran purple to the sea, supposed with blood Of Thammuz yearly wounded: the love-tale Infected Sion's daughters with like heat, Whose wanton passions in the sacred porch Ezekiel saw, when, by the vision led, His eye surveyed the dark idolatries Of alienated Judah. Next came one Who mourned in earnest, when the captive ark Maimed his brute image, head and hands lopt off, In his own temple, on the grunsel-edge, Where he fell flat and shamed his worshipers: Dagon his name, sea-monster, upward man And downward fish; yet had his temple high Reared in Azotus, dreaded through the coast Of Palestine, in Gath and Ascalon, And Accaron and Gaza's frontier bounds. Him followed Rimmon, whose delightful seat Was fair Damascus, on the fertile banks Of Abbana and Pharphar, lucid streams. He also against the house of God was bold: 470 A leper once he lost, and gained a king-Ahaz, his sottish conqueror, whom he drew God's altar to disparage and displace For one of Syrian mode, whereon to burn His odious offerings, and adore the gods Whom he had vanquished. After these appeared A crew who, under names of old renown-Osiris, Isis, Orus, and their train-

With monstrous shapes and sorceries abused Fanatic Egypt and her priests to seek Their wandering gods disguised in brutish forms Rather than human. Nor did Israel scape The infection, when their borrowed gold composed

The calf in Oreb; and the rebel king Doubled that sin in Bethel and in Dan, Likening his Maker to the grazed ox— Jehovah, who, in one night, when he passed From Egypt marching, equalled with one stroke Both her first-born and all her bleating gods. Belial came last; than whom a spirit more lewd Fell not from Heaven, or more gross to love Vice for itself. To him no temple stood Or altar smoked; yet who more oft than he In temples and at altars, when the priest Turns atheist, as did Eli's sons, who filled With lust and violence the house of God? In courts and palaces he also reigns. And in luxurious cities, where the noise Of riot ascends above their loftiest towers, And injury and outrage; and, when night 500 Darkens the streets, then wander forth the sons Of Belial, flown with insolence and wine. Witness the streets of Sodom, and that night In Gibeah, when the hospitable door Exposed a matron, to avoid worse rape.

These were the prime in order and in might: The rest were long to tell; though far renowned The Ionian gods—of Javan's issue held Gods, yet confessed later than Heaven and Earth, Their boasted parents;—Titan, Heaven's first-born

510

520

With his enormous brood, and birthright seized By younger Saturn: he from mightier Jove, His own and Rhea's son, like measure found; So Jove usurping reigned. These, first in Crete And Ida known, thence on the snowy top Of cold Olympus ruled the middle air, Their highest heaven; or on the Delphian cliff, Or in Dodona, and through all the bounds Of Doric land; or who with Saturn old Fled over Adria to the Hesperian fields, And o'er the Celtic roamed the utmost Isles.

All these and more came flocking; but with looks

Downcast and damp; yet such wherein appeared Obscure some glimpse of joy to have found their

Not in despair, to have found themselves not lost In loss itself; which on his countenance cast Like doubtful hue. But he, his wonted pride Soon recollecting, with high words, that bore Semblance of worth, not substance, gently raised

Their fainting courage, and dispelled their

Then straight commands that, at the warlike

530

Of trumpets loud and clarions, be upreared His mighty standard. That proud honor claimed Azazel as his right, a Cherub tall: Who forthwith from the glittering staff unfurled The imperial ensign; which, full high advanced, Shone like a meteor streaming to the wind, With gems and golden lustre rich emblazed, Seraphic arms and trophies; all the while Sonorous metal blowing martial sounds: 540 At which the universal host up-sent A shout that tore Hell's concave, and beyond Frighted the reign of Chaos and old Night. All in a moment through the gloom were seen Ten thousand banners rise into the air, With orient colors waving: with them rose A forest huge of spears; and thronging helms Appeared, and serried shields in thick array Of depth immeasurable. Anon they move In perfect phalanx to the Dorian mood 550 Of flutes and soft recorders—such as raised To highth of noblest temper heroes old Arming to battle, and instead of rage Deliberate valor breathed, firm, and unmoved With dread of death to flight or foul retreat: Nor wanting power to mitigate and swage With solemn touches troubled thoughts, and chase Anguish and doubt and fear and sorrow and pain From mortal or immortal minds. Thus they, Breathing united force with fixed thought, 560 Moved on in silence to soft pipes that charmed Their painful steps o'er the burnt soil. And now Advanced in view they stand—a horrid front Of dreadful length and dazzling arms, in guise Of warriors old, with ordered spear and shield, Awaiting what command their mighty Chief Had to impose. He through the armed files Darts his experienced eye, and soon traverse The whole battalion views—their order due, Their visages and stature as of gods; 570 Their number last he sums. And now his heart

strength, Glories: for never, since created Man, Met such embodied force as, named with these, Could merit more than that small infantry Warred on by cranes—though all the giant brood Of Phlegra with the heoric race were joined That fought at Thebes and Ilium, on each side Mixed with auxiliar gods; and what resounds In fable or romance of Uther's son. Begirt with British and Armoric knights;

Distends with pride, and, hardening in his

And all who since, baptized or infidel, Jousted in Aspramont, or Montalban, Damasco, or Marocco, or Trebisond, Or whom Biserta sent from Afric shore When Charlemain with all his peerage fell By Fontarabia. Thus far these beyond Compare of mortal prowess, yet observed Their dread Commander. He, above the rest In shape and gesture proudly eminent, 590 Stood like a tower. His form had yet not lost All her original brightness, nor appeared Less than Archangel ruined, and the excess Of glory obscured: as when the sun new-risen Looks through the horizontal misty air Shorn of his beams, or, from behind the moon. In dim eclipse, disastrous twilight sheds On half the nations, and with fear of change Perplexes monarchs. Darkened so, yet shone Above them all the Archangel: but his face Deep scars of thunder had intrenched, and care Sat on his faded cheek, but under brows Of dauntless courage, and considerate pride Waiting revenge. Cruel his eye, but cast Signs of remorse and passion, to behold The fellows of his crime, the follower's rather (Far other once beheld in bliss), condemned For ever now to have their lot in pain— Millions of Spirits for his fault amerced Of Heaven, and from eternal splendors flung 610 For his revolt—yet faithful how they stood, Their glory withered; as, when heaven's fire Hath scathed the forest oaks or mountain pines, With singed top their stately growth, though bare, Stands on the blasted heath. He now prepared To speak; whereat their doubled ranks they bend From wing to wing, and half enclose him round With all his peers: Attention held them mute. Thrice he assayed, and thrice, in spite of scorn, Tears, such as Angels weep, burst forth: at last Words interwove with sighs found out their

"O myriads of immortal Spirits! O Powers Matchless, but with the Almighty!-and that strife Was not inglorious, though the event was dire, As this place testifies, and this dire change, Hateful to utter. But what power of mind, Foreseeing or presaging, from the depth Of knowledge past or present, could have feared How such united force of gods, how such As stood like these, could ever know repulse? For who can yet believe, though after loss, That all these puissant legions, whose exile Hath emptied Heaven, shall fail to re-ascend, Self-raised, and re-possess their native seat? For me, be witness all the host of heaven,

If counsels different, or danger shunned By me, have lost our hopes. But he who reigns Monarch in Heaven till then as one secure Sat on his throne, upheld by old repute, Consent or custom, and his regal state Put forth at full, but still his strength concealed-Which tempted our attempt, and wrought our fall. Henceforth his might we know, and know our

So as not either to provoke, or dread New war provoked: our better part remains To work in close design, by fraud or guile, What force effected not; that he no less At length from us may find, Who overcomes By forth hath overcome but half his foe. Space may produce new Worlds; whereof so

There went a fame in Heaven that He ere long Intended to create, and therein plant A generation whom his choice regard Should favor equal to the Sons of Heaven. Thither, if but to pry, shall be perhaps Our first eruption—thither, or elsewhere; For this infernal pit shall never hold Celestial Spirits in bondage, nor the Abyss Long under darkness cover. But these thoughts Full counsel must mature. Peace is despaired; For who can think submission? War, then, war Open or understood, must be resolved."

He spake; and, to confirm his words, out-flew Millions of flaming swords, drawn from the thighs

Of mighty Cherubim; the sudden blaze Far round illumined Hell. Highly they raged Against the Highest, and fierce with grasped arms Clashed on their sounding shields the din of war, Hurling defiance toward the vault of Heaven.

There stood a hill not far, whose grisly top Belched fire and rolling smoke; the rest entire Shone with a glossy scurf—undoubted sign That in his womb was hid metallic ore, The work of sulphur. Thither, winged with speed. A numerous brigade hastened: as when bands Of pioneers, with spade and pickaxe armed, Forerun the royal camp, to trench a field, Or cast a rampart. Mammon led them on-Mammon, the least erected Spirit that fell From Heaven; for even in Heaven his looks and thoughts 680

Were always downward bent, admiring more The riches of Heaven's pavement, trodden gold, Than aught divine or holy else enjoyed In vision beatific. By him first Men also, and by his suggestion taught, Ransacked the Centre, and with impious hands

650

Rifled the bowels of their mother Earth For treasures better hid. Soon had his crew Opened into the hill a spacious wound. And digged out ribs of gold. Let none admire That riches grow in Hell; that soil may best Deserve the precious bane. And here let those Who boast in mortal things, and wondering tell Of Babel, and the works of Memphian kings, Learn how their greatest monuments of fame. And strength, and art, are easily outdone By Spirits reprobate, and in an hour What in an age they, with incessant toil And hands innumerable, scarce perform. Nigh on the plain, in many cells prepared, That underneath had veins of liquid fire Sluiced from the lake, a second multitude With wondrous art founded the massy ore. Severing each kind, and scummed the bulliondross.

700

730

A third as soon had formed within the ground A various mould, and from the boiling cells By strange conveyance filled each hollow nook; As in an organ, from one blast of wind, To many a row of pipes the sound-board breathes. Anon out of the earth a fabric huge Rose like an exhalation, with the sound Of dulcet symphonies and voices sweet-Built like a temple, where pilasters round Were set, and Doric pillars overlaid With golden architrave; nor did there want Cornice or frieze, with bossy sculptures graven: The roof was fretted gold. Not Babylon Nor great Alcairo such magnificence Equalled in all their glories, to enshrine Belus or Serapis their gods, or seat 720 Their kings, when Egypt with Assyria strove In wealth and luxury. The ascending pile Stood fixed her stately highth; and straight the doors,

Opening their brazen folds, discover, wide Within, her ample spaces o'er the smooth And level pavement: from the archèd roof, Pendent by subtle magic, many a row Of starry lamps and blazing cressets, fed With naphtha and asphaltus, yielded light As from a sky. The hasty multitude Admiring entered; and the work some praise, And some the architect. His hand was known In Heaven by many a towered structure high, Where sceptred Angels held their residence. And sat as Princes, whom the supreme King Exalted to such power, and gave to rule, Each in his hierarchy, the Orders bright. Nor was his name unheard or unadored

In ancient Greece: and in Ausonian land Men called him Mulciber; and how he fell 740 From Heaven they fabled, thrown by angry Jove Sheer o'er the crystal battlements: from morn To noon he fell, from noon to dewy eve. A summer's day, and with the setting sun Dropt from the zenith like a falling star, On Lemnos, the Ægæan isle. Thus they relate, Erring; for he with this rebellious rout Fell long before; nor aught availed him now To have built in Heaven high towers; nor did he

By all his engines, but was headlong sent, 750 With his industrious crew, to build in Hell. Meanwhile the wingèd Heralds, by command Of sovran power, with awful ceremony And trumpet's sound, throughout the host

A solemn council forthwith to be held At Pandemonium, the high capital Of Satan and his peers. Their summons called From every band and squared regiment By place or choice the worthiest: they anon With hundreds and with thousands trooping

proclaim

Attended. All access was thronged; the gates And porches wide, but chief the spacious hall (Though like a covered field, where champions 760

Wont ride in armed, and at the Soldan's chair Defied the best of Panim chivalry To mortal combat, or career with lance), Thick swarmed, both on the ground and in the air, Brushed with the hiss of rustling wings. As bees In spring-time, when the Sun with Taurus rides. Pour forth their populous youth about the hive 770

In clusters; they among fresh dews and flowers Fly to and fro, or on the smoothed plank. The suburb of their straw-built citadel. New rubbed with balm, expatiate, and confer Their state affairs: so thick the aery crowd Swarmed and were straitened; till, the signal given, Behold a wonder! They but now who seemed In bigness to surpass Earth's giant sons, Now less than smallest dwarfs, in narrow room Throng numberless—like that pygmean race 780 Beyond the Indian mount; or faery elves, Whose midnight revels, by a forest-side Or fountain, some belated peasant sees, Or dreams he sees, while overhead the Moon Sits arbitress, and nearer to the Earth Wheels her pale course: they, on their mirth and dance

Intent, with jocund music charm his ear; At once with joy and fear his heart rebounds. Thus incorporeal Spirits to smallest forms Reduced their shapes immense, and were at

Though without number still, amidst the hall Of that infernal court. But far within.

And in their own dimensions like themselves, The great Seraphic Lords and Cherubim In close recess and secret conclave sat, A thousand demi-gods on golden seats, Frequent and full. After short silence then, And summons read, the great consult began.

790

AND NAPOLEONIC WARS

AGE OF ENLIGHTENED DESPOTS 1789 REVOLUTIONARY

LITERATURE **GENERAL EVENTS** & PHILOSOPHY

ART

1710-c. 1795 Rise of Prussia and Russia 1715 Death of Louis XIV 1715-1774 Reign of Louis XV in France

1711 Pope, Essay on Criticism 1712 Pope, The Rape of the Lock, mock-heroic epic 18th cent. Translations of classical authors; Pope's Iliad (1713-1720), Odyssey (1725-1726) 1726 Swift, Gulliver's Travels; Voltaire exiled from France (returns 1729)

1729 Swift, A Modest Proposal 1733-1734 Pope, Essay on Man 1734 Voltaire, Lettres philosophiques

1739 Hume, Treatise of Human Nature 1750-1753 Voltaire at court of

Frederick the Great in Potsdam 1751-1772 Diderot's Encyclopédie includes writings by Montesquieu and J. J. Rousseau

1758-1778 Voltaire sets up own court in Ferney

1772 Political writer Thomas Paine meets Benjamin Franklin in

publishes Common Sense, series of

1776-1788 Gibbon, History of the

Decline and Fall of the Roman Empire

1776 In Philadelphia, Paine

1759 Voltaire, Candide

1762 J. J. Rousseau,

The Social Contract

London

pamphlets

1773-1814 Jesuits disbanded 1774-1792 Reign of Louis XVI and Marie Antoinette in France

1740-1786 Reign of Frederick

the Great in Prussia

1776 American Declaration of Independence

1778-1783 American War of Independence

1788 Collapse of French

1789 French Revolution begins; new American Constitution 1793 Execution of Louis XVI 1793-1795 Reign of Terror in France 1799-1804 Napoleon rules France as consul

1804-1814 Napoleon rules France as emperor

c. 1715 Rococo style emerges in France

c. 1730 Carriera, Portrait of a Lady

1743-1745 Hogarth paints satirical series, Marriage à la Mode

1748 Excavations begin at Pompeii; interest in ancient classical styles increases

Sculpture more virtuosic than profound; Queirolo, Deception Unmasked (after 1750)

1754 Boucher, Cupid Captive

c. 1765 Gainsborough, Mary, Countess Howe 1769 Tiepolo, The Immaculate Conception, rococo style applied to religious subject

1771 Houdon, Diderot

1773 Fragonard, Love Letters

1774 Reynolds, Three Ladies Adorning a Term of Hymen, influenced by classical and Renaissance models

c. 1776 Vanvitelli, The Great Cascade, fountains at castle of Caserta near Naples

1784-1785 David, Oath of the Horatii, establishes official style of revolutionary art

c. 1785 Gainsborough, Haymaker and Sleeping Girl

c. 1790 Houdon, George Washington, statue

1800 David, Napoleon Crossing the Alps 1808 Canova, Pauline Bonaparte Borghese as Venus

economy; riots in Paris

1792 Paine, The Rights of Man

1815

ARCHITECTURE

MUSIC

1732 Boffrand begins Hôtel de Soubise, Paris; rococo style applied to room decoration

c. 1700-1730 Couperin leading composer of *style galant* music at French court

1743 Henry Hoare begins to lay out classical-inspired park at Stourhead

1743-1772 Neumann, Vierzehnheiligen Pilgrim Church near Bamberg

1755-1792 Soufflot converts church of Saint Geneviève into the Panthéon, neoclassical memorial for dead of French Revolution

1785-1796 Jefferson's state capitol, Richmond, Virginia, modeled on ancient Roman Maison Carée at Nimes

1750 Death of J. S. Bach c. 1750 C. P. E. Bach chief representative of emotional empfindsamer Stil at court of Frederick the Great

1750-1800 Development of classical style and symphonic form

1752 J. J. Rousseau, Le Devin du Village, opera

1759 Death of Handel

1761 Haydn ("Father of the Symphony") begins 30-year service with Esterhazys

1786 First performance of Mozart's The Marriage of Figaro, opera based on Beaumarchais play

1788 Mozart, Symphony No. 40 in Gminor

1791 Mozart, Piano Concerto 27 in B flat Major; opera The Magic Flute 1791-1795 Haydn composes 12 symphonies during visits to London; Symphony No. 104 in D Major (1795)

14

The 18th Century: From Rococo to Revolution

Age of Diversity

Even the most determined cultural historians, fully armed with neat labels for successive stages of Western cultural development, acknowledge serious difficulty in categorizing the 18th century. Although it has often been called the Age of Enlightenment or the Age of Reason, these labels—which do, in fact, describe some of its aspects—fail to encompass the full spirit of the age.

From one perspective, the 18th century was an age of optimism. It had trust in science and in the power of human reason, belief in a natural order, and an overriding faith in the theory of progress—that the world was better than it had ever been and was

bound to get better still. Looked at from another perspective, however, the 18th century was marked by pervasive resentment and dissatisfaction with established society. By its end, criticism and the press for reform had actually grown into a desire for violent change, producing the American and then the French revolutions. Furthermore, even these two apparently contradictory views—of unqualified optimism and of extreme discontent—do not cover all aspects of 18th-century culture. For example, one of the most popular artistic styles of the period, the rococo, was characterized by frivolity and lightheartedness. Rococo artists deliberately aimed to create a fantasy world of pleasure into which their patrons could escape from the problems around them.

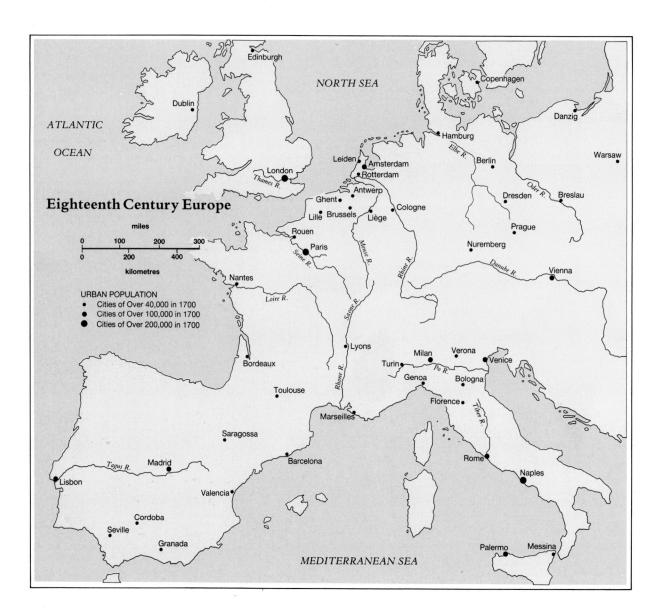

14.1 Jacques Louis David. Oath of the Horatii. 1784-1785. Oil on canvas, 10'10" × 14' (3.3 × 4.27 m). Louvre, Paris. The story of the Horatii, three brothers who swore an oath to defend Rome even at the cost of their lives, is here used to extol patriotism. Painted only five years before the French Revolution, David's work established the official style of revolutionary art.

The 18th century, then, presents an immense variety of artistic and intellectual ideas, seemingly contradictory vet in fact coexistent. Each style or idea seems far easier to grasp and categorize by itself than as part of an overall pattern of cultural development. Nevertheless, it is possible to discern at least one characteristic that links together a number of the diverse artistic achievements of the century: a conscious engagement with social issues. An opera such as Wolfgang Amadeus Mozart's The Marriage of Figaro, a series of satiric paintings of daily life such as William Hogarth's Marriage à la Mode, a mock epic poem such as Alexander Pope's The Rape of the Lock, and revolutionary ideas such as those of Jean Jacques Rousseau are all examples of ways in which artists and thinkers joined with political leaders to effect social change.

Meanwhile, artists who supported the Establishment and were resistant to change were equally engaged in social issues. They too used their art to express and defend their position. François Boucher's portraits of his wealthy aristocratic patrons, for example, often show them in the guise of Greek gods and goddesses, thus imparting a sense of glamour and importance to an aristocracy that was shortly to be fighting for its survival.

The contrast between revolutionaries and conservatives lasted right to the eve of the French Revolution. Jacques Louis David's famous painting *Oath of the Horatii* of 1784-1785 [14.1], a clarion call to action and resolve, was painted in the same year as Thomas Gainsborough's idealized picture of a *Haymaker and Sleeping Girl* [14.2]. The former, in keeping with the

14.2 Thomas Gainsborough. Haymaker and Sleeping Girl (Mushroom Girl). c. 1785. Oil on canvas, 7'5½" × 4'11" (2.27 × 1.50 m). Museum of Fine Arts, Boston (M. Theresa B. Hopkins Fund and Seth K. Sweetser Fund). These charming and elegant peasants, neither of whom looks exactly ravaged by hard work in the fields, represent the artificial world of rococo art.

TABLE 14.1 European Rulers in the 18th Century

Enlightened Despots			
Frederick II of Prussia	1740-1786*		
Catherine the Great of Russia	1762-1796		
Gustavus III of Sweden	1771-1792		
Charles III of Spain	1759-1788		
Joseph II of Austria	1780-1790		
Rulers Bound by Parliamentary Government†			
George I of England	1714-1727		
George II of England	1727-1760		
George III of England	1760-1820		
Aristocratic Rulers			
Louis XV of France	1715-1774		
Louis XVI of France	1774-1792		

^{*}All dates are those of reigns

spirit of the times, prefigures the mood of revolution. The latter turns its back on reality, evoking a nostalgic vision of love among the haystacks. In so doing it reinforces the aristocracy's refusal to see the working classes as real people with serious problems of their own.

The 18th century opened with Louis XIV still strutting down the Hall of Mirrors at Versailles, but his death in 1715 marked the beginning of the end of absolute monarchy. Although most of Europe continued to be ruled by hereditary kings, the former emphasis on splendor and privilege was leavened with a new concern for the welfare of the ordinary citizen. Rulers such as Frederick the Great of Prussia (ruled 1740-1786) were no less determined than their predecessors to retain all power in their own hands, but they no longer thought of their kingdoms as private possessions to be manipulated for personal pleasure. Instead they regarded them as trusts, which required them to show a sense of duty and responsibility. They built new roads, drained marshes, and reorganized legal and bureaucratic systems along rational lines.

Because of their greater concern for the welfare of their people these new more liberal kings, often known as "enlightened despots," undoubtedly postponed for a while the growing demand for change. Inevitably, however, by drawing attention to the injustices of the past they stimulated an appetite for reform that they themselves were in no position to satisfy. Furthermore, for all their claims—Frederick the Great, for example, described himself as "first servant of the state"—their regimes remained essentially autocratic.

The Visual Arts in the 18th Century

The Rococo Style

In spite of the changing social climate of the time, the vast majority of 18th-century artists still depended on the aristocracy for commissions. The baroque style had been partially evolved to satisfy just these patrons, and throughout the early part of the 18th century many artists continued to produce works following baroque precedents. Yet, despite the continued fondness for the baroque characteristics of richness and elaboration, there was a significant change of emphasis. The new enlightened despots and their courts had less time for pomposity or excessive grandeur. They wanted to be not so much glorified as entertained. In France, too, the death of Louis XIV served as an excuse to escape the oppressive ceremony of life at Versailles; the French court moved back to Paris, to live in elegant comfort.

The artistic style that developed to meet these new, less grandiose needs first reached its maturity in France. It is generally called rococo, a word derived from the French word rocaille, which means a kind of elaborate decoration of rocks and shells that often adorned the grottoes of baroque gardens. Rococo art was conceived of as anti-Baroque, a contrast to the weighty grandeur of 17th-century art. It makes plentiful use of shell motifs, along with other decorative elements like scrolls and ribbons, to produce an overall impression of lightness and gaiety. The subject matter is rarely serious, often frivolous, with strong emphasis on romantic dalliance and the pursuit of pleasure.

The style is graceful and harmonious, in contrast to the flamboyant, dramatic effects of much baroque art. It might be said that whereas Baroque artists preached or declaimed to their public, rococo art was the equivalent of polite, civilized conversation. Indeed, the 18th century was an age of polite society: a time of letter-writing, chamber music, dancing. Clearly such pastimes only represented one aspect of 18th-century life, and the revolutions that shook Europe and the European colonies of North America at the end of the century called on a very different artistic style, the neoclassical, discussed below. Neoclassical artists rejected baroque extravagance and rococo charm in favor of dignity and austerity.

Critics have often said that the only purpose of rococo art was to provide pleasure, but this is a somewhat incomplete view of its social role. The rococo style was aimed for the most part at an aristocratic audience; its grace and charm served the important purpose of shielding this class from the

[†]English political life was dominated not by the kings but by two powerful prime ministers: Robert Walpole and William Pitt

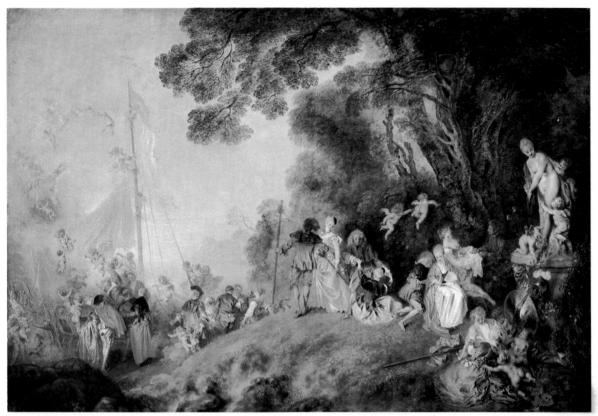

14.3 Jean Antoine Watteau. Pilgrimage to Cythera. 1717. Oil on canvas, 4'3" × 6'4½" (1.3 × 1.94 m). Staatliche Schlösser und Gärten, Schloss Charlottenburg, Berlin (West). One ancient Greek tradition claimed the isle of Cythera as the birthplace of Venus, goddess of love; thus the island became symbolic of ideal, tender love. Note that the mood of nostalgia and farewell is conveyed not only by the autumnal colors but also by the late-afternoon light that washes over the scene.

growing problems of the real world. The elegant picnics, the graceful lovers, the Venuses triumphant represent an almost frighteningly unrealistic view of life. Yet even the sternest moralist can hardly fail to respond to the enticing fantasy existence that the best of rococo art presents. In a sense the knowledge that the whole rococo world was to be so completely swept away imparts an added (and, it must be admitted, unintentional) poignance to its art. The existence of all those fragile ladies and their refined suitors was to be cut short by the guillotine.

The first and probably the greatest French rococo painter, Jean Antoine Watteau (1684-1721), seems to have felt instinctively the transitoriness and impermanence of the world he depicted. Watteau is best known for his paintings of fêtes galantes, elegant outdoor festivals attended by courtly figures dressed in the height of fashion. Yet the charming scenes are always touched with a mood of nostalgia that often verges on melancholy. In *Pilgrimage to Cythera* [14.3], for instance, the handsome young couples are returning home (despite the traditional title of the painting) from a visit to Cythera, the island sacred to Venus

and to love. As they leave, a few of them gaze wistfully over their shoulders at the idyllic life, symbolized by the statue of Venus herself, which they must leave behind. Watteau thus emphasizes the moment of renunciation, underscoring the sense of departure and farewell by the autumnal colors of the landscape.

François Boucher (1703-1770), the other leading French rococo painter, was also influenced by Rubens. Lacking the restraint or poetry of Watteau's, Boucher's paintings carry Rubens' theme of voluptuous beauty to an extreme. His canvases often seem to consist of little beyond mounds of pink flesh, as in Cupid a Captive [14.4]. It would certainly be difficult to find profundity of intellectual content in most of his work, the purpose of which is to depict only one aspect of human existence. His visions of erotic delights are frankly intended to arouse other than aesthetic feelings.

Among Boucher's pupils was Jean Honoré Fragonard (1732-1806), the last of the great French rococo painters, who lived long enough to see all demand for rococo art disappear with the coming of the French Revolution. Although his figures are gen-

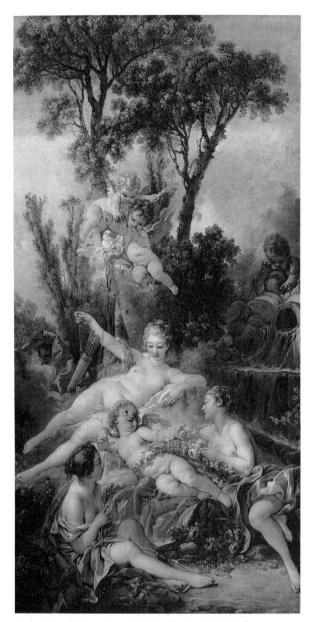

14.4 François Boucher. Cupid a Captive. 1754. Oil on canvas, 5'5" × 2'9" (1.64 × .83 m). Wallace Collection, London (reproduced by courtesy of the Trustees). Venus is seen in a relaxed and playful mood as she teases her little son by dangling his quiver of arrows above his head. Nonetheless, the presence of her seductive nymphs reminds us that she is not simply the goddess of motherly love.

erally more clothed than those of Boucher, they are no less erotic. Even more than his master, Fragonard was able to use landscape to accentuate the mood of romance. In Love Letters [14.5], for example, the couple flirting in the foreground is surrounded by a jungle of trees and bushes that seems to impart a heady, humid air to the apparently innocent confrontation.

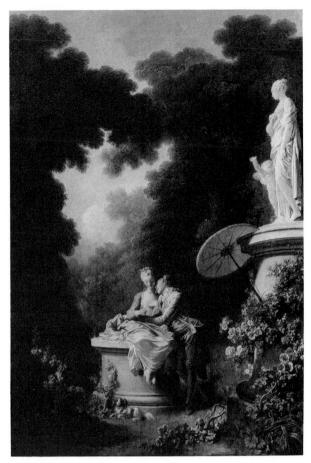

14.5 Jean Honoré Fragonard. Love Letters. 1773. Oil on canvas, $10'5'' \times 7'1''$ (3.17 × 2.17 m). Frick Collection, New York. Fragonard's style is much more free and less precise than Boucher's: compare the hazy, atmospheric landscape of this painting with the background of Cupid a Captive.

The end of Fragonard's career is a reminder of how much 18th-century artists were affected by contemporary historical developments. When his aristocratic patrons either died or fled France during the Revolution, he was reduced to complete poverty. It was perhaps because Fragonard supported the ideals of the Revolution, in spite of its disastrous effect on his personal life, that Jacques Louis David, one of the Revolution's chief artistic arbiters, found him a job in the Museums Service. The last representative of the rococo tradition died poor and in obscurity as a minor official in the new French Republic.

Taken together, the three leading representatives of rococo painting provide a picture of the fantasy life of 18th-century aristocratic society. The work of other rococo artists, however, gives us a clearer impression of what life was really like in that aristocratic world. The Venetian artist Rosalba Carriera (1675-1757) traveled widely throughout Europe producing

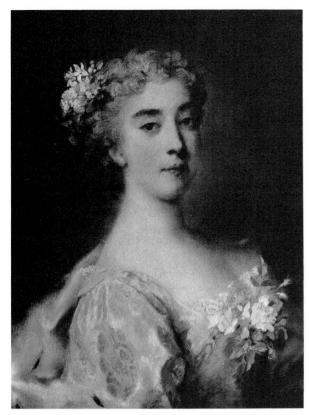

14.6 Rosalba Carriera. Anna Sofia d'Este, Princess of Modena. c. 1730. Pastel. Uffizi, Florence. The pale elegance of the subject is typical of most of Carriera's aristocratic sitters, as is the charming untidiness of her dress.

large numbers of portraits in the rather unusual medium of pastel, dry sticks of color that disintegrate when rubbed on paper, leaving behind a fine powder. The medium is very delicate, but so, unfortunately, are the works executed in it, since the powder smudges easily and tends to fall off if the paper is shaken. It is unlikely that Carriera was concerned with conveying psychological depths. Her chief aim was to provide her subjects flattering likenesses that reinforced their own favorable visions of themselves. Works like her portrait of the Princess of Modena [14.6] emphasize the delicacy, charm, and sensuality of 18th-century society beauties.

English art in the 18th century was also notable for its artistocratic portraits. The more extreme elements of rococo eroticism had little appeal to the English nobility, but the artists who were commissioned to paint their portraits could hardly help being influenced by the style of their day. Thomas Gainsborough (1727-1788), who together with Sir Joshua Reynolds (1723-1792) dominated the English art of the time, even studied for a while with a pupil of Boucher. At a time when rococo art had already

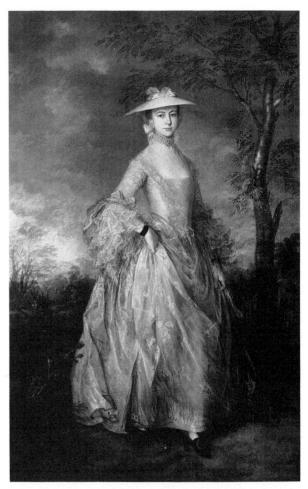

14.7 Thomas Gainsborough. Mary, Countess Howe. c. 1765. Oil on canvas, $8 \times 5'$ (2.44 × 1.52 m). The Iveagh Bequest, Kenwood (English Heritage). The wild background and threatening sky set off the subject, but their artificiality is shown by her shoes—hardly appropriate for a walk in the country.

fallen into disfavor in France, Gainsborough was still producing paintings like Haymaker and Sleeping Girl [see figure 14.2], an idealizing rococo vision that recalls the world of Fragonard. Gainsborough's chief reputation, however, was made by his landscapes and portraits. Most of the portraits are themselves set against a landscape background, as in the case of Mary, Countess Howe [14.7]. In this painting, setting and costume are reminiscent of Watteau, but the dignified pose and cool gaze of the subject suggest that she had other than romantic thoughts in mind. There is no lack of poetry in the scene, though, and the resplendent shimmer of the countess' dress is perfectly set off by the more somber tones on the background.

Portraits and landscapes lend themselves naturally to rococo treatment, but what of religious art? One

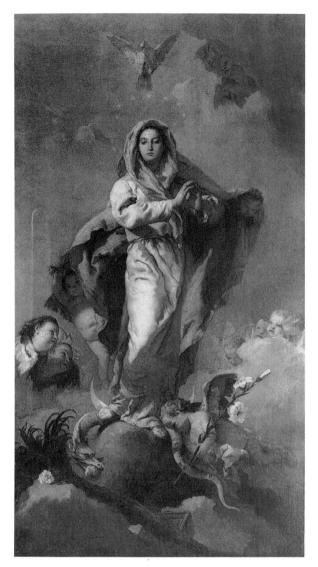

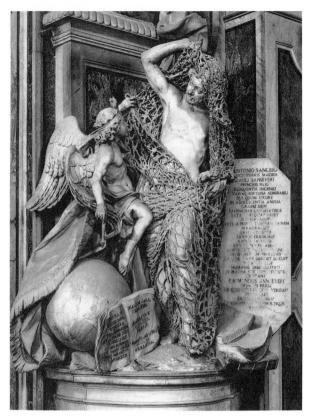

Francesco Queirolo. Deception Unmasked. After 1752. Marble, height c. 5'81/4" (1.75 m). Cappella Sansevero, Santa Maria della Pieta di Sangro, Naples. The figure is a Christian sinner freeing himself, with the help of an angel, from the net of deception.

14.8 Giovanni Battista Tiepolo. The Immaculate Conception. 1769. Oil on canvas, 9'2" × 5' (2.79 × 1.52 m). Prado, Madrid. The sense of weightlessness and the wonderful cloud effects are both typical of Tiepolo's style.

of the very few painters who tried to apply rococo principles to religious subjects was the Venetian painter Giovanni Battista Tiepolo (1696-1770). Many of Tiepolo's most ambitious and best-known works are decorations for the ceilings of churches and palaces, for which projects he was helped by assistants. A more personal work is his painting The Immaculate Conception [14.8]. The light colors and chubby cherubs of Boucher and the haughty assurance of Gainsborough's society ladies are here applied to the life of the Virgin Mary.

Rococo sculptors were, for the most part, more concerned with displaying their virtuosity in works aimed at a brilliant effect than with exploring finer shades of meaning. For instance, the figure of Deception Unmasked [14.9] by the Genoese sculptor Francesco Queirolo (1704-1762) theoretically has serious

religious significance; in practice its principal purpose is to dazzle us with the sculptor's skill at rendering such details as the elaborate net in which Deception hides.

Rococo architecture likewise was principally concerned with delighting the eye rather than inspiring noble sentiments. It is most successful in decorative interiors like those of the Hôtel de Soubise in Paris [14.10], where the encrustation of ornament flows from the ceiling down onto the walls, concealing the break between them.

One region of Europe in which the rococo style did exert a powerful influence on religious architecture was southern Germany and Austria. Throughout the 17th century, a series of wars in that area had discouraged the construction of new churches or public buildings; with the return of relatively stable

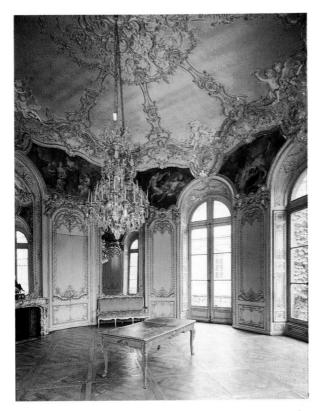

14.10 Germain Boffrand. Salon de la Princesse, Hôtel de Soubise, Paris. Begun 1732. Oval, $33 \times 26'$ (10.06×7.92 m). The decoration is typical of the rococo style. The shape of the room, the paintings that flow from ceiling to walls, and the reflections in the mirrors all create an impression of light and grace.

conditions in the German states new building became possible again. By one of those fortunate chances in the history of the arts, the fantasy and complexity of the rococo style provided a perfect complement to the new mood of exuberance. The result is a series of churches that is among the happiest of all rococo achievements.

The leading architect of the day was Balthazar Neumann (1687-1753), who had begun his career as an engineer and artillery officer. Among the many palaces and churches he designed, none is more spectacular than the Vierzehnheiligen (fourteen saints) near Bamberg. The relative simplicity of the exterior deliberately leaves the visitor unprepared for the spaciousness and elaborate decoration of the interior [14.11], with its rows of windows and irregularly placed columns. As in the Hôtel de Soubise, the joint between the ceiling and walls is hidden by a fresco that, together with its border, spills downward in a series of gracious curves. It is not difficult to imagine what John Calvin would have said of such an interior, but if a church can be allowed to be a place of light and joy, Neumann's design succeeds admirably.

Neoclassical Art

For all its importance, the rococo style was not the only one to influence 18th-century artists. The other principal artistic movement of the age was neoclassicism, which increased in popularity as the appeal of the rococo declined.

There were good historical reasons for the rise of neoclassicism. The excavation of the buried cities of Herculaneum and Pompeii, beginning in 1711 and 1748 respectively, evoked immense interest in the art of classical antiquity in general and that of Rome in particular. The wall paintings from Pompeian villas of the 1st century A.D. were copied by countless visitors to the excavations, and reports of the finds were published throughout Europe. The German scholar Johannes Winckelmann (1717-1768), who is sometimes called the Father of Archaeology, played a major part in creating a new awareness of the importance of classical art; in many of his writings he encouraged his contemporaries not only to admire ancient masterpieces but to imitate them.

Furthermore, the aims and ideals of the Roman Republic—freedom, opposition to tyranny, valor held a special appeal for 18th-century republican politicians, and the evocation of classical models became a characteristic of the art of the French Revolution. The painter who best represents the official revolutionary style is Jacques Louis David (1748-1825). His

TABLE 14.2 The Rediscovery of Classical Antiquity in the 18th Century

Antiquity	in the 18th Century
1711	First excavations at Herculaneum
1734	Society of Dilettanti formed at London to encourage exploration
1748	First excavations at Pompeii
1753	Robert Wood and James Dawkins publish The Ruins of Palmyra
1757	Wood and Dawkins publish The Ruins of Baalbec
1762	James Stuart and Nicholas Revett publish the first volume of <i>The Antiquities</i>
1764	of Athens Robert Adam publishes The Ruins of the Palace of Diocletian at Spalato;
	Johannes Winckelmann publishes his History of Ancient Art
1769	Richard Chandler and William Pars publish the first volume of <i>The</i>
	Antiquities of Ionia
1772	The Hamilton collection of Greek vases bought by the British Museum
1785	Richard Colt Hoare explores Etruscan sites in Tuscany
1801	Lord Elgin receives Turkish permission to work on the Parthenon in Athens

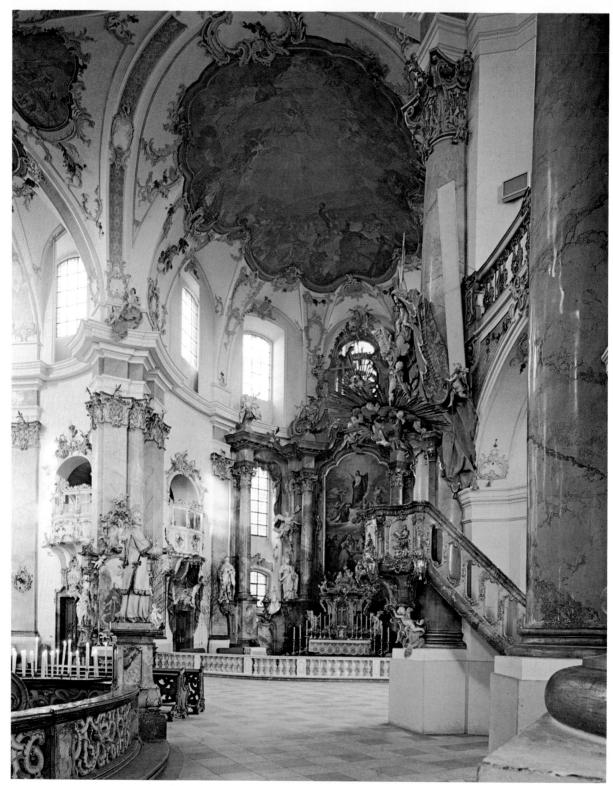

14.11 Balthazar Neumann. The nave of Vierzehnheiligen Pilgrim Church, near Bamberg, West Germany. 1743–1772. This view of the interior shows the high altar at the back of the nave (center) and part of the oval altar in the middle of the church (left). The oval altar, the *Gnadenaltar* or "Mercy Altar," is a mark of the pilgrimage churches of southern Germany and Austria. Its shape is echoed in the oval ceiling paintings. The architect deliberately rejected the soaring straight lines of Cothic architecture and the balance and supports of the Pennissance study in force of an invision. Gothic architecture and the balance and symmetry of the Renaissance style in favor of an intricate interweaving of surfaces, solid volumes, and empty spaces.

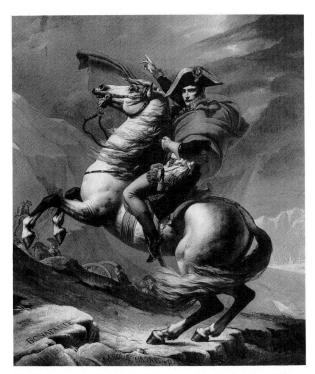

14.12 Jacques Louis David. Napoleon Crossing the Alps. 1800. Oil on canvas, 8' × 7'7" (2.44 × 2.31 m). Musée de Versailles. After he took his army across the Alps, Napoleon surprised and defeated an Austrian army. His calm, controlled figure guiding a wildly tearing horse is symbolic of his own vision of himself as bringing order to post-Revolution France.

Oath of the Horatii [see figure 14.1] draws not only upon a story of ancient Roman civic virtue but also upon a knowledge of ancient dress and armor derived from excavations of Pompeii and elsewhere. The simplicity of its message—the importance of united opposition to tyranny—is expressed by the simple austerity of its style and composition, a far cry from the lush, effete world of Fragonard. David used the same lofty grandeur to depict Napoleon soon after his accession to power [14.12], although there is considerable if unintentional irony in the use of the revolutionary style to represent the military dictator.

The austere poses and orderly decorations of ancient art came as a refreshing change for those artists who, regardless of politics, were tired of the excesses of the baroque and rococo styles. One of the most notable painters to introduce a neoclassical sense of statuesque calmness into his works was Sir Ioshua Reynolds, Gainsborough's chief rival in England. Three Ladies Adorning a Term of Hymen [14.13] shows three fashionable ladies-about-town in the guise of figures from Greek mythology. Their static poses seem derived from actual ancient statues. The classical bust and antique vessel on the right are evidence of a careful attempt to imitate ancient models. Even the stool at center is based on examples found at Pompeii.

Although the rococo and neoclassical styles dominated most of 18th-century painting, a few important

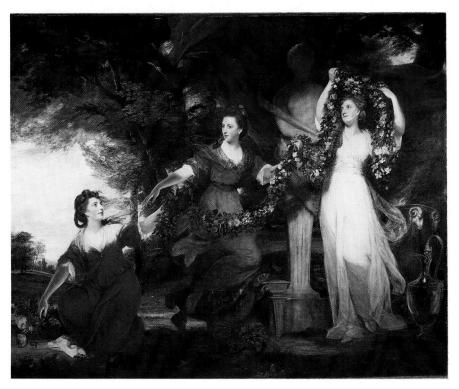

14.13 Sir Joshua Reynolds. Three Ladies Adorning a Term of Hymen. 1773. Oil on canvas, $7'8'' \times 10'4\frac{1}{2}''$ (2.34 × 2.90 m). Tate Gallery, London (reproduced by courtesy of the Trustees). A term is a pillar topped with a bust, in this case of Hymen, god of marriage. Revnolds introduced a marriage theme because the fiancé of one of the ladies, who were the daughters of Sir William Montgomery, commissioned the painting. The neoclassical composition was deliberately chosen by the artist because it gave him "an opportunity of introducing a variety of graceful historical attitudes.'

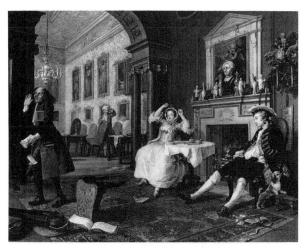

14.14 William Hogarth. Shortly After the Marriage, from the Marriage à la Mode series. 1743-1745. Oil on canvas, 27 × 35" (69 × 89 cm). National Gallery, London (reproduced by courtesy of the Trustees). Although he achieved his effects through laughter, Hogarth had the serious moral purpose of attacking the corruption and hypocrisy of his day.

artists avoided both the escapism of the one and the idealism of the other to provide a more truthful picture of the age. The work of William Hogarth, for example, presents its own very individual view of aristocratic society in the 18th century.

As a master of line, color, and composition Hogarth was in no way inferior to such contemporaries

as Fragonard or Gainsborough, but he used his skills to paint a series of "moral subjects" that satirized the same patrons his colleagues aimed to entertain and to flatter. In his series of paintings called Marriage à la Mode he illustrated the consequences of a loveless marriage between an impoverished earl and the daughter of a wealthy city merchant who wants to improve his social position. By the second scene in the series, Shortly After the Marriage [14.14], matters have already started to deteriorate.

The principal neoclassical sculptors, the Italian Antonio Canova (1757-1822) and, the Frenchman Jean Antoine Houdon (1741-1829), succeeded in using classical models with real imagination and creativity [Houdon: figure 14.20, page 225, and figure 14.22, page 230]. Canova's portrait, Pauline Bonaparte Borghese as Venus Victorious [14.15], depicts Napoleon's sister with an idealized classical beauty as she reclines on a couch modeled on one found at Pompeii. The cool worldly elegance of the figure, however, is Canova's own contribution.

For serious projects such as major public buildings, architects tended to follow classical models, as in the portico of the Pantheon in Paris [14.16], the design of which makes use of classical proportions. As might have been expected, the architects of the American Revolution also turned to classical precedents when they constructed their new public buildings. Thomas Jefferson's State Capitol at Richmond [14.17], for example, shows a conscious rejection of

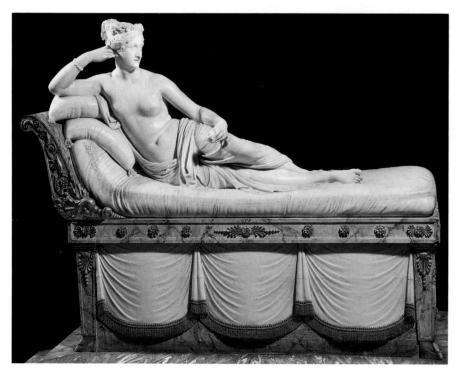

14.15 Antonio Canova. Pauline Bonaparte Borghese as Venus Victorious. 1808. Marble, length 6'6" (1.98 m). Borghese Gallery, Rome. Canova's blend of simplicity and grace was widely imitated by European and American sculptors throughout the 19th century. The apple is the apple of discord, inscribed "to the fairest." According to legend, the goddesses Aphrodite (Venus), Hera, and Athena each offered a tempting bribe to the Trojan Paris. who was to award the apple to one of them. Paris chose Venus, who had promised him the most beautiful of women. The result was the Trojan War, which started when Paris abducted his prize, Helen, wife of a Greek king.

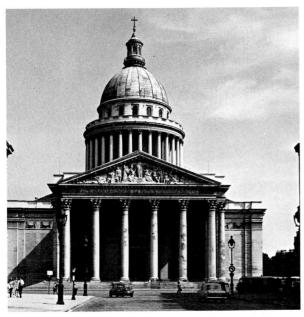

14.16 Germain Soufflot. Panthéon (Sainte Geneviève), Paris. 1755-1792. Originally built as the church of Sainte Geneviève, the building was converted into a memorial to the illustrious dead at the time of the French Revolution. The architect studied in Rome for a time; the columns and pediment were inspired by ancient Roman temples.

the rococo and all it stood for in favor of the austere world (as it seemed to him) of ancient Rome.

Classical Music

For the most part, music in the 18th century followed the example of literature in retaining a serious purpose, and was relatively untouched by the mood of the rococo style. At the French court, it is true, there was a demand for elegant, light-hearted music to serve as entertainment. The leading composer in this style galant was François Couperin (1668-1733), whose many compositions for keyboard emphasize grace and delicacy at the expense of the rhythmic drive and intellectual rigor of the best of baroque music. Elsewhere in Europe, however, listeners continued to prefer music that expressed emotion. At the court of Frederick the Great (himself an accomplished musician), for example, a musical style known as the empfindsamer Stil, or expressive style, developed.

The chief exponent of the expressive style was Carl Philipp Emanuel Bach (1714-1788), a son of Johann Sebastian Bach. His works have considerable emotional range and depth; their rich harmonies and contrasting moods opened up new musical possibili-

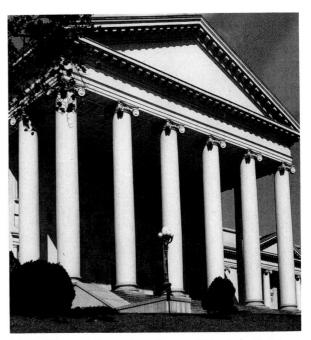

14.17 Thomas Jefferson. State Capitol, Richmond, Virginia. 1785-1796. Courtesy Virginia State Library and Archives. Like the Panthéon, Jefferson's building was modeled on a Roman temple, the Maison Carrée at Nîmes, but the austere spirit of the American Revolution prompted Jefferson to replace the elaborate Corinthian capitals of the original with simpler Ionic

ties. Like all his contemporaries, C.P.E. Bach was searching for a formal structure with which to organize them. A single piece or movement from a baroque work had first established a single mood and then explored it fully, whether it be joyful, meditative, or tragic. Now composers were developing a musical organization that would allow them to put different emotions side by side, contrast them, and thereby achieve expressive variety.

By the middle of the 18th century a musical style developed that made possible this new range of expression. It is usually called classical, although the term is also used in a more general sense, which can be confusing. It would be as well to begin by carefully distinguishing between these two usages.

In its general sense, the term classical is frequently used to distinguish so-called "serious" music from "popular," so that all music likely to be met with in a concert hall or opera house, no matter what its age, is labeled classical. One reason this distinction is confusing is that for many composers before our own time, there was essentially no difference between serious and popular music. They used the same musical style and techniques for a formal composition to be listened to attentively by an audience of musiclovers, as for a religious work to be performed in church, or for dance music or background music for

a party or festive occasion. Furthermore, used in this sense, classical tells us nothing significant about the music itself or its period or form. It does not even describe its mood, since many pieces of "classical" or "serious" music were in fact deliberately written to provide light entertainment.

The more precise and technical meaning of classical in relation to music denotes a musical style that was in use from the second half of the 18th century and reached its fulfillment in the works of Franz Joseph Haydn (1732-1809) and Wolfgang Amadeus Mozart (1756-1791). It evolved in answer to new musical needs the baroque style could not satisfy and lasted until the early years of the 19th century, when it in turn gave way to the romantic style. The figure chiefly responsible for the change from classical to romantic music was Ludwig van Beethoven (1770-1827). Although his musical roots were firmly in the classical style, he is more appropriately seen as a representative of the new romantic age and is discussed in Chapter 15.

It is no coincidence that the classical style in music developed at much the same time painters, architects, and poets were turning to Greek and Roman models. for the aims of classical music and neoclassical art and literature were very similar. After the almost obsessive exuberance and display of the baroque period, the characteristic qualities of ancient art—balance, clarity, intellectual weight—seemed especially appealing. The 18th-century composer, however, faced a different problem than did the artist or writer. Unlike literature or the visual arts, ancient music has disappeared almost without trace. As a result the classical style in music had to be newly invented to express ancient concepts of balance and order. In addition, it had to combine these intellectual principles with the no-less-important ability to express a wide range of emotion. Haydn and Mozart were the two supreme masters of the classical style because of their complete command of the possibilities of the new idiom within which they wrote.

The Classical Symphony

The most popular medium in the classical period was instrumental music. In extended orchestral works, symphonies, divided into a number of self-contained sections called movements, composers were most completely able to express classical principles.

One reason for this is the new standardization of instrumental combinations. In the baroque period, composers such as Bach had felt free to combine instruments into unusual groups that varied from composition to composition. Each of Bach's Brandenburg concertos was written for a different set of solo instruments. By about 1750, however, most instru-

mental music was written for a standard orchestra. the nucleus of which was formed by the string instruments: violins (generally divided into two groups known as first and second), violas, cellos, and double basses. To the strings were added wind instruments. almost always the oboe and bassoon and fairly frequently the flute; the clarinet began to be introduced gradually and by about 1780 had become a regular member of the orchestra. The only brass instrument commonly included was the French horn. Trumpets, along with the timpani or kettledrums, were reserved for reinforcing volume or rhythm. Trombones were never used in classical symphonies until Beethoven.

Orchestras made up of these instruments were capable of rich and varied sound combinations, ideally suited to the new classical form of the symphony. In general, the classical symphony has four movements (as opposed to the baroque concerto's three): a first, relatively fast one, usually the most complex in form; then a slow, lyrical movement, often songlike; a third movement in the form of a minuet, a stately dance; and a final one, which brings the entire work to a spirited and usually cheerful conclusion. As time went on, the length and complexity of the movements grew, and many of Haydn's later symphonies last for half an hour or more. In most cases, however, the most elaborate musical "argument" was always reserved for the first movement, presumably because during it the listeners were freshest and most able to concentrate.

The structure almost invariably chosen for the first movement of a classical symphony was that called sonata form. Since sonata form is not only one of the chief features of classical style but was also a principle of musical organization that remained popular throughout the 19th century, it merits our attention in some detail. The term itself is actually rather confusing, since the word *sonata* is used to describe a work in several movements, like a symphony, but written for one or two instruments rather than an orchestra. Thus a piano sonata is a piece for solo piano, a violin sonata is a piece for violin and an accompanying instrument, almost always a piano, and so on. A symphony is, in fact, a sonata for orchestra.

The term *sonata form*, however, does not, as might be reasonably expected, describe the form of a sonata but a particular kind of musical organization frequently found in the first movements of both symphonies and sonatas as well as other instrumental combinations like string quartets (two violins, viola, and cello). Since these movements are generally played at a fast tempo or speed, the term sonata allegro form is also sometimes used. (The Italian word allegro means "fast"; Italian terms are traditionally used in music, as we have seen.)

Unlike baroque music, with its unity based on the

use of a single continually expanding theme, sonata form is dominated by the idea of contrasts. The first of the three main sections of a sonata form movement is called the exposition, since it sets out, or "exposes," the musical material. This consists of at least two themes, or groups of themes, that differ from one another in melody, rhythm, and key. They represent, so to speak, the two principal characters in the drama. If the first theme is lively, the second may be thoughtful or melancholy; or a strong marchlike first theme may be followed by a gentle, romantic second one. During the exposition the first of these themes (or subjects, as they are often called) is stated, followed by a linking passage leading to the second subject and a conclusion that rounds off the exposition.

During the course of the movement it is of the utmost importance that listeners be able to remember these themes and identify them when they reappear. To help make this easier, classical composers replaced the long, flowing lines of baroque melodies with much shorter tunes, often consisting of only a few notes, comparatively easy to recognize when they recur. The difference between baroque and classical melody is clearly visible even on paper. Compare, for example, the continuous pattern of the melodic line on page 171, from Bach's Brandenburg Concerto No. 2, with the theme below from Mozart's Symphony No. 40 in G minor. The tune consists basically of a group of three notes (a) repeated three times to produce a melodic phrase (b). This procedure is then repeated three more times to impress it firmly on our memory.

Just in case their listeners were still not perfectly familiar with the basic material of a movement, composers reinforced it by repeating the entire exposition note for note.

In the second section of a sonata-form movement, the development, the themes stated in the exposition are changed and varied in whatever way the composer's imagination suggests. One part of the first subject is often detached and treated on its own, passing up and down the orchestra, now loud, now soft, as happens in the first movement of Mozart's Symphony No. 40 to the notes marked a above. Sometimes different themes will be combined and played simultaneously. In almost all cases the music passes through a wide variety of keys and moods. In the process the composer sheds new light on what have by now become familiar ideas.

At the end of the development the original themes return to their original form for the third section of the movement, the recapitulation. The first section is repeated, or recapitulated, with both first and second subjects now in the same key. In this way the conflict implicit in the development section is resolved. A final "tailpiece" or coda (from the Italian word for tail) is sometimes added to bring the movement to a suitably firm conclusion.

Sonata form embodies many of the classical principles of balance, order, and control. The recapitulation, which carefully balances the exposition, and the breaking down of the material in the development and its subsequent reassembling both emphasize the sense of structure behind a sonata-form movement.

Haydn

The long and immensely productive career of Franz Joseph Haydn (1732-1809) spanned a period of great change in both artistic and social terms. Born in Rohrau on the Austro-Hungarian border, he sang as a child in the choir of Saint Stephen's Cathedral in Vienna. After scraping together a living for a few precarious years, in 1761 he entered the service of a wealthy nobleman, Prince Esterhazy.

Haydn began work for the prince on the same terms as any carpenter, cook, or artisan in his master's employ. That he was a creative artist was irrelevant, since social distinctions were made on grounds of wealth or birth, not talent. By the time he left the Esterhazy family, however, almost thirty years later, the aristocracy were competing for the privilege of entertaining him. The world was indeed changing; in the course of two visits to London he found himself feted and honored, and during his last years in Vienna he was among the most famous figures in Europe. Thus Haydn was one of the very first musicians to attain a high social position solely on the strength of his genius. His success signaled the new relationship between the artist and society that was to characterize the 19th century.

In personal terms Haydn seems to have been little affected by his fame. During the long years of service to Prince Esterhazy and his descendants he used the enforced isolation of the palace where he lived to experiment with all the musical forms available to him. In addition to operas, string quartets, piano sonatas, and hundreds of other pieces, he wrote some ninety symphonies that exploit almost every conceivable variation on sonata and other classical forms, winning him the nickname "Father of the Symphony." During his visits to London in 1791-1792

and 1794-1795 he wrote his last twelve symphonies, which are often known as the London Symphonies. Although less obviously experimental than his earlier works, they contain perhaps the finest of all his orchestral music; the slow movements in particular manage to express the greatest seriousness and profundity without tragedy or gloom.

Mozart

In 1781, in his fiftieth year and at the height of his powers, Haydn met a young man about whom he was to say a little while later to the young man's father: "Before God and as an honest man, I tell you that your son is the greatest composer known to me either in person or by name." Many of us, for whom the music of Wolfgang Amadeus Mozart (1756-1791) represents a continual source of inspiration and joy and a comforting reminder of the heights the human spirit can attain, would see no reason to revise Haydn's judgment [14.18].

Although Mozart's life, in contrast to Haydn's, was to prove one of growing disappointments and setbacks, his early years were comparatively happy. During his childhood he showed extraordinary musical ability. By the age of six he could already play the violin and piano and had begun to compose. His father Leopold, himself a professional musician in the service of the Archbishop of Salzburg, where the family lived, took Wolfgang on a seemingly neverending series of trips throughout Europe to exhibit his son's musical prowess. The effect of these trips on the boy's health and temperament can be imagined, but it was during them that he became exposed to the most sophisticated and varied musical ideas of the day; the universality of his own musical style must in part be due to the wide range of influences he was able to assimilate, from the style galant of the rococo to the Renaissance polyphonies he heard in Rome. From time to time father and son would return to Salzburg, where by this time they both held appointments at the court of the archbishop.

In 1772, however, the old archbishop died. His successor, Hieronymus Colloredo, was far less willing to allow his two leading musicians to come and go as they pleased. Artistic independence of the kind Haydn was to achieve was still in the future, and the next ten years were marked by continued quarreling between Mozart and his aristocratic employer. Finally, in 1781, when Mozart could take no more and asked the archbishop for his freedom, he was literally kicked out of the door of the palace. From 1781 to 1791 Mozart spent the last years of his life in Vienna, trying in vain to find a permanent position while writing some of the most sublime masterpieces in the

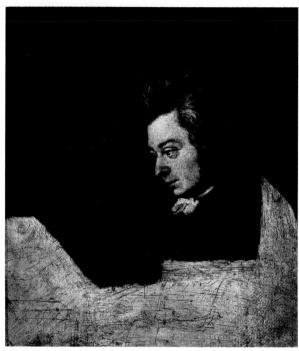

14.18 Joseph Lange. Mozart at the Pianoforte. 1789. Oil. 13½ × 111/2" (35 × 30 cm). Mozart Museum, Salzburg. This unfinished portrait shows the composer for once without the wig customary at the time. Mozart must have liked the painting because he had a copy made and sent to his father.

history of music. When he died at the age of thirtyfive, he was buried in a pauper's grave.

The relationship between an artist's life and work is always fascinating. In Mozart's case it raises particular problems. We might expect that continual frustration, poverty, and depression would have left its mark on his music, yet it is a grave mistake to look for autobiographical self-expression in the work of an artist who devoted his life to achieving perfection in his art. In general, Mozart's music reflects only the highest and most noble of human aspirations. Perhaps more than any other artist in any medium Mozart combines ease and grace with profound learning in his art to come as near to ideal beauty as anything can. Nevertheless, his music remains profoundly human. We are reminded many times not of Mozart's own suffering but of the tragic nature of life itself.

A year before his death Mozart wrote the last of his great series of concertos for solo piano and orchestra, the Piano Concerto No. 27 in Bb, K. 595 (Mozart's works are generally listed according to the catalogue first made by Köchel; hence the letter K that precedes their catalogue numbers). The wonderful slow movement of this work expresses, with a profundity no less moving for its utter simplicity, the

THE ARTS AND INVENTION: The Keyboard: From Harpsichord to Pianoforte

The instrument for which Mozart's mature keyboard works were composed was an early form of the pianoforte. This most sophisticated form of keyboard instrument was invented and popularized in the latter part of the 18th century and played a major part in the musical life of the 19th century, both at public concerts and in people's homes.

The earliest of all keyboard instruments was the organ, invented by the Greek engineer Ktesibios of Alexandria (c. 300-250 B.C.). Known as a hydraulis, its sounds were produced by using hydraulic (water) pressure to pump air. Organs using manual pumping devices were in use throughout the medieval period, and by Bach's time had become complex and subtle instruments: the Baroque period marks the golden age of organ-building.

For much of his keyboard music, however, Bach would have turned to the harpsichord. This instrument first became popular in the early 16th century under a variety of names and forms-harpsichord, clavicembalo, clavecin, virginal. They all work in the same basic way: when a key is pressed down, an arm attached to it plucks a string. From the modern point of view the greatest disadvantage of the harpsichord is that the volume of sound cannot be changed by lighter or heavier touch. On the other hand this characteristic makes it ideal for baroque music; in a piece composed of three or four (or more) lines interwoven contrapuntally, every line acquires equal weight.

By the early 18th century, instrumentmakers were experimenting with a different technique, that of striking the strings with hammers rather than plucking them. The weight with which the key on a pianoforte is pressed affects the loudness or softness of the note produced (pianoforte means "soft-loud"). With the addition of pedal devices the sound can be sustained, muted, or

Small, light pianos were made in Vienna by Johann Stein (1728-1792); Mozart visited his workshop in 1777 and was delighted by what he heard. The English manufacturer John Broadwood (1732-1812) produced a heavier instrument that produced a more weighty, sonorous sound; Beethoven preferred his Broadwood piano to the Viennese instruments. Nonetheless the first editions of almost all his early piano sonatas are inscribed "for the clavecin or pianoforte": his publishers knew that both harpsichords and pianos were in use among potential customers.

resignation of one for whom the beauty of life is perpetually tinged with sadness. We can only marvel at so direct a statement of so universal a truth.

The need to earn a living, coupled with the inexhaustibility of his inspiration, drew from Mozart works in almost every conceivable category. Symphonies, concertos, masses, sonatas, string quartets are only some of the forms he enriched. It is his operas, however, that many admirers of Mozart would choose if faced with a decision as to what to save if all else were to be lost. Furthermore, his operas provide the clearest picture of his historical position.

Mozart's opera The Marriage of Figaro is based on a play of the same name by the French dramatist Pierre Augustin Beaumarchais (1732-1799). Although a comedy, the play, which was first performed in 1784, contains serious overtones. The plot is too complicated to permit even a brief summary, but among the characters are a lecherous and deceitful, though charming, Count; his deceived wife, the Countess; her maid Susanna, who puts up a determined resistance against the Count's advances; and Susanna's husband-to-be, Figaro, who finally manages to outwit and embarrass the would-be seducer of his future wife, who is also his employer [14.19]. In other words, the heroes of the play are the servants and the villain their master. Written as it was on the eve of the French Revolution, Beaumarchais' play was interpreted rightly as an attack on the morals of the ruling classes and a warning that the lower classes would fight back. Beaumarchais himself was firmly associated with the moves toward social and political change; he was an early supporter of the American Revolution and helped organize French support for the insurgent colonists.

Mozart's opera was first performed in 1786. It retains the spirit of protest in the original but adds a sense of humanity and subtlety perhaps only music can bring. No one suffered more than Mozart from the highhandedness of the aristocracy, yet when The Marriage of Figaro gives voice to the growing mood of revolution, it does so as a protest against the abuse of human rights rather than in a spirit of personal resentment. In the first act, Figaro's aria "Se vuol' ballare" expresses the pent-up frustration of generations of men and women who had endured injustices and who could take no more. The musical form and expression is still restrained, indeed classical, but Mozart pours into it the feelings of the age.

Mozart's ability to create characters who seem real, with whose feelings we can identify, reaches its height in the Countess. Ignored and duped by her

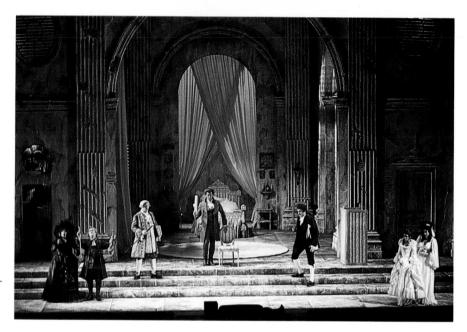

14.19 The Marriage of Figaro. Metropolitan Opera, New York. 1985. Finale, Act II, of Mozart's opera. The singers are, left to right, Jacqueline Taillon as Marcellina, Michel Senechal as Don Basilio, Richard Korn as Bartolo. Thomas Allen as the Count, Ruggero Raimondi as Figaro, Kathleen Battle as Susannah, and Carol Vaness as the Countess.

husband, the laughingstock of those around her, she expresses the conflicting emotions of a woman torn between resentment and deep attachment. Her aria in the third act, "Dove sono," begins with a recitative in which she gives vent to her bitterness. Gradually it melts into a slow and meditative section where she asks herself what went wrong: "Where are those happy moments of sweetness and pleasure, where did they go, those vows of a deceiving tongue?" The poignant theme to which these words are set returns toward the end of the slow section to provide one of the most affecting moments in all opera. Mozart's gift for expressing human behavior at its most noble is conveyed in the aria's final section, where the Countess decides, in spite of everything, to try to win back her husband's love. Thus, in seven or eight minutes, we have been carried from despair to hope, and Mozart has combined his revelation of a human heart with music that by itself is of extraordinary beauty.

The opera as a whole is far richer than discussion of these two arias can suggest. For instance, among the other characters is one of the composer's most memorable creations, the pageboy Cherubino, whose aria "Non so più" epitomizes the breathless, agonizing joy of adolescent love. An accomplishment of another kind is exemplified by the ensembles, scenes in which a large number of characters are involved. Here Mozart combines clarity of musical and dramatic action while advancing the plot at a breakneck pace.

The Marriage of Figaro expresses at the same time the spirit of its age and the universality of human nature, a truly classical achievement. Equally impressively, it illuminates the personal emotions of individual people, and through them teaches us about our own reactions to life and its problems. As one distinguished writer has put it, in this work Mozart has added to the world's understanding of people of human nature.

Literature in the 18th Century

Intellectual Developments

While painters, poets, and musicians were reflecting the changing moods of the 18th century in their art, social and political philosophers were examining the problems of contemporary society in a more systematic way. Individual thinkers frequently alternated between optimism and despair, since awareness of the greatness of which human beings were capable was always qualified by the perception of the sorry state of the world. The broad range of diagnosis and or proposed solutions makes it difficult to generalize on the nature of 18th-century intellectual life, but two contrasting trends can be discerned. A few writers, notably Jonathan Swift, reacted to the problems of the age with deep pessimism, bitterly opposing the view that human nature is basically good. Others, convinced that progress was possible, sought to devise new systems of intellectual, social, or political organization. Rational humanists like Diderot and political philosophers like Rousseau based their arguments on an optimistic view of human nature. However, Voltaire, the best-known of all 18th-century thinkers, fitted into neither of these two categories rather, he moved from one to the other. The answer he finally proposed to the problems of existence is as applicable to the world of today as it was to that of the 18th century, although perhaps no more wel-

The renewed interest in classical culture, visible in the portraits by Sir Joshua Reynolds and buildings like the Pantheon, also made a strong impression on literature. French writers like Racine (see page 175) had already based works on classical models, and the Fables of Jean de La Fontaine. La Fontaine (1621-1695) drew freely on Aesop and other Greek and Roman sources. Elsewhere in Europe, throughout the 18th century poets continued to produce works on classical themes, from the plays of Pietro Metastasio (1698-1782) in Italy to the lyric poetry of Friedrich von Schiller (1759-1805) in Germany.

The appeal of neoclassical literature was particularly strong in England, where major Greek and Roman works like Homer's Iliad and Odyssey or Vergil's Aeneid had long been widely read and admired. In the 17th century, Milton's Paradise Lost had represented a deliberate attempt to create an equally monumental epic poem in English. Before the 18th century, however, a number of important works, including the tragedies of Aeschylus, had never been translated into English.

The upsurge of enthusiasm for classical literature that characterized the 18th century English literary scene had two chief effects: poets and scholars began to translate or retranslate the most important classical authors, and creative writers began to produce original works on classical forms, dealt with classical themes, and included classical references. The general reading public was by now expected to understand and appreciate both the ancient masterpieces themselves and modern works inspired by them.

The principal English writers formed a group calling themselves Augustans. The name reveals the degree to which these writers admired and modeled themselves on the Augustan poets of ancient Rome. In 27 B.C. the victory of the first Roman emperor Augustus ended the chaos of civil war at Rome and brought peace and stability to the Roman world. The principal poets of Rome's Augustan age, writers like Vergil and Horace, had subsequently commemorated Augustus' achievement in works intended for a sophisticated public. In the same way in England the restoration to power of King Charles II in 1660 seemed to some of his contemporaries a return to order and civilization after the tumultuous English Civil War. The founders of the English Augustan movement, writers like John Dryden (1631-1700), explored not only the historical parallel by glorifying English achievement under the monarchy but also the literary one by imitating the highly polished style of the Roman Augustan poets in works intended for an aristocratic audience.

Pope's Rococo Satires

Alexander Pope (1688-1744), the greatest English poet of the 18th century, was one of the Augustans, vet the lightness and elegance of his wit reflect the rococo spirit of his age.

His genius lay precisely in his awareness that the dry bones of classical learning needed to have life breathed into them. The spirit that would awaken art in his own time, as it had done for the ancient writers, was that of Nature—not in the sense of the natural world but in the sense of that which is universal and unchanging in human experience. Pope's conception of the vastness and truth of human experience given form and meaning by rules first devised in the ancient past represents 18th-century thought at its most constructive.

Like Watteau, Pope suffered throughout his life from ill health. At the age of twelve an attack of spinal tuberculosis left him permanently crippled: perhaps in compensation he soon developed the passion for reading and for the beauty of the world around him that shines through his work. A Catholic in a Protestant country, he was unable to make a career for himself in public life or obtain public patronage for his literary work. As a result he was forced to support himself entirely by writing and translating. Pope's literary reputation was first made by the Essay on Criticism, but he won economic independence by producing highly successful translations of Homer's Iliad (1713-1720) and Odyssey (1721-1726) and an edition of the works of Shakespeare (1725). With the money he made from these he abandoned commercial publishing and confined himself, for the most part, to his house on the river Thames at Twickenham, where he spent the rest of his life writing, entertaining friends, and indulging his fondness for gar-

Pope's range as a poet was considerable, but his greatest achievements were in the characteristically rococo medium of satire. Like his fellow countryman Hogarth, his awareness of the heights to which humans can rise was coupled with an acute sense of the frequency of their failure to do so. In the long poem Essay on Man (1733-1734), for example, Pope combines Christian and humanist teaching in a characteristically 18th-century manner to express his philosophical position with regard to the preeminent place occupied by human beings in the divine scheme of life. He is at his best, however, when applying his principles to practical situations and uncovering human folly. His reverence for order and reason made him the implacable foe of those who in his eyes were responsible for the declining political morality and artistic standards of the day. It is sometimes said that Pope's satire is tinged with personal hostility. In fact, a series of literary and social squabbles marked his life, suggesting that he was not always motivated by the highest ideals; nonetheless, in his poetry he nearly always based his moral judgments on what he himself described as "the strong antipathy of good to bad," a standard he applied with courage and wit.

Swift's Savage Indignation

Perhaps the darkest of all visions of human nature in the 18th century was that of Jonathan Swift (1667-1745). In a letter to Alexander Pope he made it clear that, whatever his affection for individuals, he hated the human race as a whole. According to Swift, human beings were not to be defined automatically as rational animals, as so many 18th-century thinkers believed, but as animals capable of reason. It was precisely because so many of them failed to live up to their capabilities that Swift turned his "savage indignation" against them into bitter satire, never more so than when the misuse of reason served "to aggravate man's natural corruptions" and provide him with new ones.

Swift was in a position to observe at close quarters the political and social struggles of the times. Born in Dublin, for much of his life he played an active part in supporting Irish resistance to English rule. After studying at Trinity College, Dublin, he went to England and in 1694 was ordained a priest in the Anglican church. For the next few years he moved back and forth between England and Ireland, taking a leading role in the political controversies of the day by publishing articles and pamphlets which, in general, were strongly conservative.

A fervent supporter of the monarchy and of the Anglican church, Swift had good reason to hope that his advocacy of their cause would win him a position of high rank. In 1713 these hopes were partially realized with his appointment as Dean of Saint Patrick's Cathedral in Dublin. Any chances he had of receiving an English bishopric were destroyed in 1714 by the death of Queen Anne and the subsequent dismissal of his political friends from power.

Swift spent the rest of his life in Ireland, cut off

from the mainstream of political and cultural life. Here he increasingly emerged as a publicist for the Irish cause. During his last years his mind began to fail, but not before he had composed the epitaph under which he lies buried in Saint Patrick's Cathedral: Ubi saeva indignatio ulterius cor lacerare nequit (He has gone where savage indignation can tear his heart

During his years in Ireland Swift wrote his bestknown work, Gulliver's Travels, first published in 1726. In a sense Gulliver's Travels has been a victim of its own popularity, since its surprising success as a work for young readers has distracted attention from the author's real purpose, to satirize human behavior. (It says much for the 18th century's richness that it could produce two writers working in the same genre, the satirists Swift and Pope, with such differing results). The first two of Gulliver's four voyages, to the miniature land of Lilliput and to Brobdingnag. the land of giants, are the best known. In these sections the harshness of Swift's satire is to some extent masked by the charm and wit of the narrative. In the voyage to the land of the Houyhnhnms, however, Swift draws a bitter contrast between the Houyhnhnms, a race of horses whose behavior is governed by reason, and their slaves the Yahoos, human in form but bestial in behavior. As expressed by the Yahoos, Swift's vision of the depths to which human beings can sink is profoundly pessimistic. His insistence on their deep moral and intellectual flaws is in strong contrast to the rational humanism of many of his contemporaries, who believed in the innate dignity and worth of human beings.

Yet even the Yahoos do not represent Swift's most bitter satire. It took his experience of the direct consequences of "man's inhumanity to man" to draw from his pen a short pamphlet, A Modest Proposal for Preventing the Children of Poor People in Ireland from Being a Burden to Their Parents or Country, and for Making Them Beneficial to the Public, the title of which is generally abbreviated to A Modest Proposal. First published in 1729, this brilliant and shocking work was inspired by the poverty and suffering of a large section of the population of Ireland. Even today the nature of the supposedly benevolent author's "modest proposal" can take the reader's breath away, both by the calmness with which it is offered and by the devastatingly quiet logic with which its implications are explained. All the irony of which this master satirist was capable is here used to express anger and disgust at injustice and the apparent inevitability of human suffering. Although Swift was writing in response to a particular historical situation, the deep compassion for the poor and oppressed that inspired him transcends its time. Our own world has certainly

not lost the need for it.

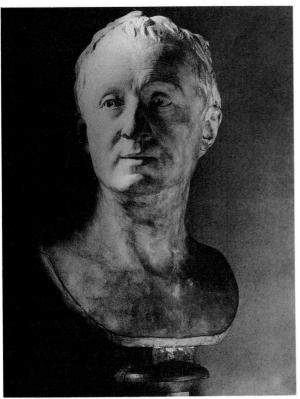

14.20 Jean Antoine Houdon. Denis Diderot. 1771. Terra cotta, height 16" (41 cm). Louvre, Paris. Unlike most official portraiture of the 18th century, Houdon's works aim to reveal the character of his sitters. Here he vividly conveys Diderot's humanity and quizzical humor.

Rational Humanism: The **Encyclopedists**

Belief in the essential goodness of human nature and the possibility of progress, which had first been expressed by the humanists of the Renaissance, continued to find supporters throughout the 18th century. Indeed, the enormous scientific and technical achievements of the two centuries since the time of Erasmus tended to confirm the opinions of those who took a positive view of human capabilities. It was in order to provide a rational basis for this positive humanism that the French thinker and writer Denis Diderot (1713-1784) [14.20] conceived the project of preparing a vast encyclopedia that would describe the state of contemporary science, technology, and thought and provide a system for the classification of knowledge.

Work on the Encyclopédie, as it is generally called, began in 1747; the last of its seventeen volumes appeared in 1765. By its conclusion, what had begun as a compendium of information had become the statement of a philosophical position: that the extent of human powers and achievements conclusively demonstrates that humans are rational beings. The implication of this position is that any political or religious system seeking to control the minds of individuals is to be condemned. It is hardly surprising, therefore, that some years before the conclusion of the project, the Encyclopédie had been banned by decree of Louis XV: the last volumes were published clandestinely.

In religious terms the Encyclopédie took a position of considerable skepticism, advocating freedom of conscience and belief. Politically, however, its position was less extreme and less consistent. One of the most distinguished philosophers to contribute political articles was Charles-Louis Montesquieu (1689-1755), whose own aristocratic origins may have helped mold his relatively conservative views. Both in the Encyclopédie and in his own writings Montesquieu advocated the retention of a monarchy, with powers divided between the king and a series of "intermediate bodies" that included parliament, aristocratic organizations, the middle class, and even the church. By distributing power in this way Montesquieu hoped to achieve a workable system of "checks and balances," thereby eliminating the possibility of a central dictatorial government. His ideas proved particularly interesting to the authors of the Constitution of the United States.

A very different point of view was espoused by another contributor to the Encyclopédie, Jean-Jacques Rousseau (1712-1778), whose own quarrelsome and neurotic character played a considerable part in influencing his political philosophy. Diderot had originally commissioned Rousseau to produce some articles on music, since the latter was an accomplished composer (his opera Le Devin du Village is still revived from time to time). After violently quarreling with Diderot and others, however, Rousseau spent much of an unhappy and restless life writing philosophical treatises and novels that expressed his political convictions. Briefly put, Rousseau believed that the natural goodness of the human race had been corrupted by the growth of civilization and that the freedom of the individual had been destroyed by the growth of society. For Rousseau humans were good and society was bad.

Rousseau's praise of the simple virtues like unselfishness and kindness and his high regard for natural human feelings have identified his philosophy with a belief in the "noble savage," but this is misleading. Far from advocating a return to primitive existence in some nonexistent Garden of Eden, Rousseau passionately strove to create a new social order. In The Social Contract of 1762 he tried to describe the basis of his ideal state in terms of the General Will of the people, which would delegate authority to individual organs of government, although neither most of his

readers nor Rousseau himself seemed very clear on how this General Will should operate.

Although Rousseau's writings express a complex political philosophy, most of his readers were more interested in his emphasis on spontaneous feeling than in his political theories. His comtempt for the superficial and the artificial, and his praise for simple and direct relationships between individuals, did a great deal to help demolish the principles of aristocracy and continue to inspire believers in human equality.

Voltaire's Philosophical Cyncism: Candide

It may seem extravagant to claim that the life and work of François Marie Arouet (1694-1778), best known to us as Voltaire (one of his pen names), can summarize the events of a period as complex as the 18th century. That the claim can be not only advanced but also supported is some measure of the breadth of his genius. A writer of poems, plays, novels, and history; a student of science, philosophy, and politics: a man who spent time at the courts of Louis XV and Frederick the Great but also served a prison sentence: a defender of religious and political freedom who at the same time supported enlightened despotism, Voltaire was above all a man engagé—one committed to the concerns of his age [14.21].

After being educated by the Jesuits, he began to publish writings in the satirical style he was to use throughout his life. His belief that the aristocratic society of the times was unjust must have received strong confirmation when his critical position earned him first a year in jail and then, in 1726, exile from France. He chose to go to England, where he found a system of government that seemed to him far more liberal and just than the French one. On his return home in 1729 he discussed the advantages of English political life in his Lettres philosophiques, published in 1734, and escaped from the scandal and possibility of arrest his work created by spending the next ten years in the country.

In 1744 Voltaire was finally tempted back to the French court but found little in its formal and artificial life to stimulate him. He discovered a more congenial atmosphere at the court of Frederick the Great at Potsdam, where he spent the years from 1750 to 1753. Frederick's warm welcome and considerable intellectual stature must have come as an aggreeable change from the sterile ceremony of the French court, and the two men soon established a close friendship. It seems, however, that Potsdam was not big enough to contain two such powerful intellects and temperaments, for after a couple of years Vol-

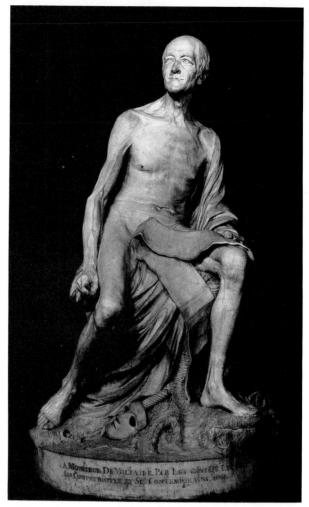

14.21 Jean Baptiste Pigalle. Voltaire. 1770-1776. Marble, height 4'93/8" (1.47 m). Louvre, Paris. This most unusual statue of the great philosopher places a powerful head on the torso of an old man. The head was modeled from life when Voltaire was 76; the body is based on that of a Roman statue. The statue seems to represent the triumph of the spirit over the frailty of the body.

taire quarreled with his patron and once again abandoned sophisticated life for that of the country.

In 1758 Voltaire finally settled in the village of Ferney, where he set up his own court. Here the greatest names in Europe—intellectuals, artists, politicians made the pilgrimage to talk and, above all, listen to the sage of Ferney, while he published work after work, each of which was distributed throughout Europe. Only in 1778, the year of his death, did Voltaire return to Paris, where the excitement brought on by a hero's welcome proved too much for his failing strength.

It is difficult to summarize the philosophy of a

man who touched on so many subjects. Nevertheless, one theme recurs continually in Voltaire's writings, the importance of freedom of thought. Voltaire's greatest hatred was reserved for intolerance and bigotry; in letter after letter he ended with the phrase he made famous, Ecrasez l'infâme (Crush the infamous thing). the "infamous thing" is superstition, which breeds fanaticism and persecution. Those Voltaire judged chiefly responsible for superstition were the Christians, Catholic and Protestant alike.

Voltaire vehemently attacked the traditional view of the Bible as the inspired word of God. He claimed that it contained a mass of anecdotes and contradictions totally irrelevant to the modern world and that the disputes arising from it, which had divided Christians for centuries, were absurd and pointless. Yet Voltaire was far from being an atheist. He was a firm believer in a God who had created the world, but whose worship could not be tied down to one religion or another: "The only book that needs to be read is the great book of nature." Only natural religion and morality would end prejudice and ignorance.

Voltaire's negative criticisms of human absurdity are more convincing than his positive views on a universal natural morality. It is difficult not to feel at times that even Voltaire himself had only the vaguest ideas of what natural morality really meant. In fact, in Candide (1759), his best-known work, he reaches a much less optimistic conclusion. Candide was written with the avowed purpose of ridiculing the optimism of the German philosopher Gottfried von Leibnitz (1646-1716), who believed that "everything is for the best in the best of all possible worlds." Since both intellect and experience teach that this is very far from the case, Voltaire chose to demonstrate the folly of unreasonable optimism, as well as the cruelty and stupidity of the human race, by subjecting his hero Candide to a barrage of disasters and suffering.

Throughout his journeys from Germany to Portugal to the New World and back to Europe, Candide has the opportunity to compare the theory of philosophical optimism with the evil, stupidity, and ignorance that he finds wherever he goes. The conclusion he reaches is expressed in the book's final words, "we must cultivate our gardens." The world is a cruel place where human life is of little account, but to give way to total pessimism is fruitless. Instead, we should try to find some limited activity we can perform well. By secceeding in this small task we can construct a little island of peace and sanity in a hostile world.

This message is, of course, hardly a comforting one. It is a measure of Voltaire's courage that his final

EAST MEETS WEST

The Slave Trade

At the beginning of the 18th century a new economic system, plantation farming, began to develop rapidly. Plantations were large tracts of land, either in America or on islands such as Jamaica and Haiti, generally belonging to absentee owners in England or France and worked with slave labor imported from Africa. The principal crop was sugar, which had been introduced into the New World by Europeans in the form of sugar cane from Asia. The climate was excellent for its growth and the demand for sugar seemed inexhaustible.

Slaves had been imported into Europe from Africa since Roman times. The Muslim world also bought and sold African slaves, although without distinguishing between black and white. The earliest black Africans to be transported to North America were brought to what is now Virginia by Dutch traders in 1619, a year before the arrival in America of the Pilgrim Fathers. With the rise of the plantation economy, slaves became the basis of a substantial and heavily underwritten industry, sugar production, and the numbers of black Africans shipped to America rose sharply. Total figures are impossible to calculate, but some impression can be formed from the numbers imported into the island of Jamaica alone between 1700 and 1786: around 610,000.

The transatlantic slave trade was principally in the hands of English merchants operating either from their home country or from branches in New England; the French provided the fiercest competition. Goods were manufactured in Britain and shipped to Africa, where they were exchanged for slaves. Thus the plantation economy not only produced a valuable commodity but indirectly stimulated production in the home countries. Liverpool, for instance, which at the beginning of the 18th century was a quiet town on the west coast of England, became a transatlantic center of international commerce and would play a major role in the industrial revolution of the 19th century.

By the end of the 18th century the mass exploitation of human labor had begun to concern humane observers. After the American Revolution all states north of Maryland took steps toward the abolition of slavery, and the French revolutionary government abolished it in 1794 throughout French colonies; black Africans in France had already received their civil rights. Not until 1865, however, did the Thirteenth Amendment to the U.S. Constitution prohibit slavery throughout the United States.

advice to "cultivate our gardens" manages to extract something positive from the despair his humor and irony mask.

The Late 18th Century: Time of Revolution

Throughout the 18th century Europe continued to prosper economically. The growth of trade and industry, particularly in Britain, France, and Holland, led to a number of significant changes in the lifestyle of increasing numbers of people. Technological improvements in coal mining and iron-casting began to lay the foundations for the industrial revolution of the 19th century. The circulation of more books and newspapers increased general awareness of the issues of the day. As states began to accumulate more revenues, they increased both the size of their armies and the number of those in government employment. The Baroque period had seen the exploitation of imported goods and spices from Asia and gold from Latin America; the 18th century was marked by the development of trade with North America and the Caribbean.

Amid such vast changes, it was hardly possible that the very systems of government should remain unaffected. Thinkers like Rousseau and Voltaire began to question the hitherto unquestioned right of the wealthy aristocracy to rule throughout Europe.

In Britain, both at home and in the colonies, power was gradually transferred from the king to Parliament. Prussia, Austria, and Russia were ruled by socalled enlightened despots, as we have seen.

In France, however, center of much of the intellectual pressure for change, the despots were not even enlightened. Louis XV, who ruled from 1715 to 1774, showed little interest in the affairs of his subjects or the details of government. The remark often attributed to him, "Après moi le déluge" (After me the flood), suggests that he was fully aware of the consequences of his indifference. Subsequent events fully justified his prediction, yet throughout his long reign he remained either unwilling or unable to follow the example of his fellow European sovereigns and impose some order on government. By the time his grandson Louis XVI succeeded him in 1774 the damage was done. Furthermore, the new king's continued reliance on the traditional aristocratic class, into whose hands he put wealth and political power, offended both the rising middle class and the peasants. When in 1788 the collapse of the French economy was accompanied by a disastrous harvest and consequent steep rise in the cost of food in the first phase of the Revolution, riots broke out in Paris and in rural districts. In reaction to the ensuing violence the "Declaration of the Rights of Man and Citizen," which asserted the universal right to "liberty, property, security, and resistance to oppression," was passed on August 26, 1789. Its opening section clearly shows the influence of the American Declaration of Independence (see page 231).

CONTEMPORARY VOICES

Horace Walpole

A visit to the court of Louis XV. The English writer and connoisseur Horace Walpole (1717-1797) has been presented to the king and queen and describes the encounter to a friend:

You perceive that I have been presented. The Queen took great notice of me; none of the rest said a syllable. You are let into the King's bedchamber just as he has put on his shirt; he dresses and talks goodhumouredly to a few, glares at strangers, goes to mass, to dinner, and a-hunting. The good old Queen, who is like Lady Primrose in the face, and Queen Caroline in the immensity of her cap, is at her dressing-table, attended by two or three old ladies, who are languishing to be in Abraham's bosom, as the only man's bosom to whom they can hope for admittance. Thence you go to the Dauphin, for all is done in an hour. He scarce stays a minute; indeed, poor creature, he is a ghost, and cannot possibly last three months. The Dauphiness is in her bedchamber, but dressed and standing; looks cross, is not civil, and has the true Westphalian grace and accents. The four Mesdames, who are clumsy plump old wenches, with a bad likeness to their father, stand in a bedchamber in a row, with black cloaks and knitting-bags, looking good-humoured, not knowing what to say, and wriggling as if they wanted to make water. This ceremony too is very short; then you are carried to the Dauphin's three boys, who you may be sure only bow and stare. The Duke of Berry looks weak and weak-eyed: the Count de Provence is a fine boy; the Count d' Artois well enough. The whole concludes with seeing the Dauphin's little girl dine, who is as round and as fat as a pudding.

From The Letters of Horace Walpole, ed. P. Cunningham. London, 1892.

from THE DECLARATION OF THE RIGHTS OF MAN

The representatives of the French people, organized in National Assembly, considering that ignorance, forgetfulness, or contempt of the rights of man are the sole causes of public misfortunes and of the corruption of governments, have resolved to set forth in a solemn declaration the natural, inalienable, and sacred rights of man, in order that such declaration, continually before all members of the social body, may be a perpetual reminder of their rights and duties; in order that the acts of the legislative power and those of the executive power may constantly be compared with the aim of every political institution and may accordingly be more respected; in order that the demands of the citizens, founded henceforth upon simple and incontestable principles, may always be directed towards the maintenance of the Constitution and the welfare of all.

Accordingly, the National Assembly recognizes and proclaims, in the presence and under the auspices of the Supreme Being, the following rights of man and citizen.

1. Men are born and remain free and equal in rights; social distinctions may be based only upon

general usefulness.

2. The aim of every political association is the preservation of the natural and inalienable rights of man; these rights are liberty, property, security, and resistance to oppression.

3. The source of all sovereignty resides essentially in the nation; no group, no individual may exercise authority not emanating expressly there-

from.

Liberty consists of the power to do whatever is not injurious to others; thus the enjoyment of the natural rights of every man has for its limits only those that assure other members of society the enjoyment of those same rights; such limits may be determined only by law.

5. The law has the right to forbid only actions which are injurious to society. Whatever is not forbidden by law may not be prevented, and no one may be constrained to do what it does not

prescribe.

6. Law is the expression of the general will; all citizens have the right to concur personally, or through their representatives, in its formation; it must be the same for all, whether it protects or punishes. All citizens, being equal before it, are equally admissible to all public offices, positions, and employments, according to their capacity, and without other distinction than that of virtues and talents.

Declarations alone hardly sufficed, however; after two and a half years of continual political bickering and unrest, the Revolution entered its second phase. On September 20, 1792, a National Convention was assembled. One of its first tasks was to try Louis XVI. by now deposed and imprisoned, for treason. After unanimously finding him guilty, the Convention was divided on whether to execute him or not. He was finally condemned to the guillotine by a vote of 361 to 360 and beheaded forthwith. The resulting Reign of Terror lasted until 1795. During it, utopian theories of a republic based on liberty, equality, and fraternity were ruthlessly put into practice. The revolutionary leaders cold-bloodedly eliminated all opponents, real or potential, and created massive upheaval throughout all levels of French society.

The principal political group in the Convention, the Jacobins, was at first led by Maximilien Robespierre (1758-1794). One of the most controversial figures of the Revolution, Robespierre is viewed by some as a demagogue and bloodthirsty fanatic, by others as a fiery idealist and ardent democrat; his vigorous commitment to revolutionary change is disputed by no one. Following Rousseau's belief in the virtues of natural human feelings, Robespierre aimed to establish a "republic of virtue," democratically

made up of honest citizens.

In order to implement these goals, revolutionary courts were set up, which tried and generally sentenced to death those perceived as the enemies of the Revolution. The impression that the Reign of Terror was aimed principally at the old aristocracy is incorrect. Only nobles suspected of political agitation were arrested, and the vast majority of the guillotine's victims—some 70 percent—were rebellious peasants and workers. Nor were revolutionary leaders immune. Georges-Jacques Danton (1759-1794), one of the earliest spokesmen of the Revolution and one of Robespierre's principal political rivals, was executed in March 1794 along with a number of his followers.

Throughout the rest of Europe, events in France were followed with horrified attention. Austria and Prussia were joined by England, Spain, and several smaller states in a war against the revolutionary government. After suffering initial defeat, the French enlarged and reorganized their army and succeeded in driving back the allied troops at the battle of Fleurus in June 1794. Paradoxically, the military victory, far from reinforcing Robespierre's authority, provided his opponents the strength to eliminate him; he was declared an outlaw on July 27, 1794, and guillotined the next day.

By the spring of the following year the country was in economic chaos and Paris was torn by street rioting. Many of those who had originally been in

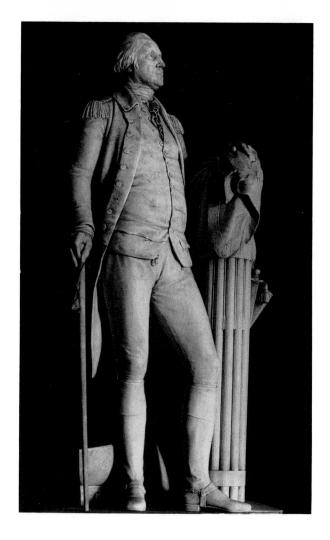

14.22 Jean Antoine Houdon. George Washington. 1788. Marble, height 6'8" (2.03 m). Virginia State Capitol, Richmond (courtesy of the Virginia State Library and Archives). The sculptor has emphasized the dignity and lofty calm of the first president.

favor of revolutionary change, including businessmen and land-owning peasants, realized that whatever the virtues of democracy, constitutional government was essential. In reply to these pressures the Convention produced a new constitution, known as the Directory. This first formally established French republic lasted only until 1799, when political stability returned to France with the military dictatorship of Napoleon Bonaparte.

Although the French Revolution was an obvious consequence of extreme historical pressures, many of its leaders were additionally inspired by the successful outcome of another revolution, that of the Americans against their British rulers. More specifically, the Americans had rebelled against not the British king but the British parliament. In 18th-century England the king was given little chance to be enlightened or otherwise, since supreme power was concentrated in the legislative assembly, which ruled both

England itself and, by its appointees, British territories abroad. A series of economic measures enacted by Parliament succeeded in thoroughly rousing American resentment. The story of what followed the Declaration of Independence of July 4, 1776, is too involved to be summarized here. Its result was the signing of a peace treaty in 1783 and the inauguration of the new American Constitution in 1789.

Although the Declaration of Independence was certainly not intended as a work of literature, its author, generally assumed to be Thomas Jefferson, was as successful as any of the literary figures of the 18th century in expressing the more optimistic views of the age. The principles enshrined in it assume that human beings are capable of achieving political and social freedom. Positive belief in equality and justice is expressed in universal terms like man and nature universal for their day, that is-typical of 18thcentury enlightened thought [14.22].

nent French physician [Rabelais], that fish being a prolific diet, there are more children born in Roman 130 Catholic countries about nine months after Lent than at any other season; therefore, reckoning a year after Lent, the markets will be more glutted than usual, because the number of popish infants is at least three to one in this kingdon; and therefore it will have one other collateral advantage, by lessening the number

of Papists among us.

I have already computed the charge of nursing a beggar's child (in which list I reckon all cottagers, laborers, and four fifths of the farmers) to be about 140 two shillings per annum, rags included; and I believe no gentleman would repine to give ten shillings for the carcass of a good fat child, which, as I have said, will make four dishes of excellent nutritive meat. when he hath only some particular friend or his own family to dine with him. Thus the squire will learn to be a good landlord, and grow popular among the tenants; the mother will have eight shillings net profit, and be fit for work till she produces another

Those who are more thrifty (as I must confess the times require) may flay the carcass; the skin of which artificially dressed will make admirable gloves for ladies and summer boots for fine gentlemen.

As to our city of Dublin, shambles may be appointed for this purpose in the most convenient parts of it, and butchers we may be assured will not be wanting; although I rather recommend buying the children alive, and dressing them hot from the knife

as we do roasting pigs.

A very worthy person, a true lover of his country, and whose virtues I highly esteem, was lately pleased in discoursing on this matter to offer a refinement upon my scheme. He said that many gentlemen of this kingdom, having of late destroyed their deer, he conceived that the want of venison might be well supplied by the bodies of young lads and maidens, not exceeding fourteen years of age nor under twelve, so great a number of both sexes in every county being now ready to starve for want of work 170 proposal which I have made are obvious and many, and service; and these to be disposed of by their parents, if alive, or otherwise by their nearest relations. But with due deference to so excellent a friend and so deserving a patriot, I cannot be altogether in his sentiments; for as to the males, my American acquaintance assured me from frequent experience that their flesh was generally tough and lean, like that of our schoolboys, by continual exercise, and their taste disagreeable; and to fatten them would not answer the charge. Then as to the females, it would, I think with 180 humble submission, be a loss to the public, because they soon would become breeders themselves: and besides, it is not improbable that some scrupulous people might be apt to censure such a practice (al-

though indeed very unjustly) as little bordering upon cruelty; which, I confess, hath always been with me the strongest objection against any project, how well soever intended.

But in order to justify my friend, he confessed that this expedient was put into his head by the famous 190 Psalmanazar, a native of the island Formosa, who came from thence to London above twenty years ago, and in conversation told my friend that in his country when any young person happened to be put to death, the executioner sold the carcass to persons of quality as a prime dainty; and that in his time the body of a plump girl of fifteen, who was crucified for an attempt to poison the emperor, was sold to his Imperial Majesty's prime minister of state, and other great mandarins of the court, in joints from the gib- 200 bet, at four hundred crowns. Neither indeed can I deny that if the same use were made of several plump young girls in this town, who without one single groat to their fortunes cannot stir abroad without a chair, and appear at the playhouse and assemblies in 150 foreign fineries which they never will pay for, the kingdom would not be the worse.

Some persons of a desponding spirit are in great concern about that vast number of poor people who are aged, diseased, or maimed, and I have been de-210 sired to employ my thoughts what course may be taken to ease the nation of so grievous an encumbrance. But I am not in the least pain upon that matter, because it is very well known that they are every day dying and rotting by cold and famine, and filth and vermin, as fast as can be reasonably expected. And as to the younger laborers, they are now in almost as hopeful a condition. They cannot get work, and consequently pine away for want of nourishment to a degree that if at any time they are accidentally 220 hired to common labor, they have not strength to perform it; and thus the country and themselves are

happily delivered from the evils to come.

I have too long digressed, and therefore shall return to my subject. I think the advantages by the

as well as of the highest importance.

For first, as I have already observed, it would greatly lessen the number of Papists, with whom we are yearly overrun, being the principal breeders of 230 the nation as well as our most dangerous enemies; and who stay at home on purpose to deliver the kingdom to the Pretender, hoping to take their advantage by the absence of so many good Protestants, who have chosen rather to leave their country than to stay at home and pay tithes against their conscience to an Episcopal curate.

Secondly, the poorer tenants will have something valuable of their own, which by law may be made liable to distress, and help to pay their landlord's 240 rent, their corn and cattle being already seized and

money a thing unknown.

Thirdly, whereas the maintenance of an hundred thousand children, from two years old and upwards, cannot be computed at less than ten shillings a piece per annum, the nation's stock will be thereby increased fifty thousand pounds per annum, besides the profit of a new dish introduced to the tables of all gentlemen of fortune in the kingdom who have any refinement in taste. And the money will circulate 250 among ourselves, the goods being entirely of our own growth and manufacture.

Fourthly, the constant breeders, besides the gain of eight shillings sterling per annum by the sale of their children, will be rid of the charge of maintain-

ing them after the first year.

Fifthly, this food would likewise bring great custom to taverns, where the vinters will certainly be so prudent as to procure the best receipts for dressing it to perfection, and consequently have their houses fre-260 quented by all the fine gentlemen, who justly value themselves upon their knowledge in good eating; and a skillful cook, who understands how to oblige his guests, will contrive to make it as expensive as they please.

Sixthly, this would be a great inducement to marriage, which all wise nations have either encouraged by rewards or enforced by laws and penalties. It would increase the care and tenderness of mothers toward their children, when they were sure of a set-270 tlement for life to the poor babes, provided in some sort by the public, to their annual profit instead of expense. We should see an honest emulation among the married women, which of them could bring the fattest child to the market. Men would become as fond of their wives during the time of their pregnancy as they are now of their mares in foal, their cows in calf, or sows when they are ready to farrow; nor offer to beat or kick them (as is too frequent a practice) for fear of a miscarriage.

Many other advantages might be enumerated. For instance, the addition of some thousand carcasses in our exportation of barreled beef, the propagation of swine's flesh, and improvement in the art of making good bacon, so much wanted among us by the great destruction of pigs, too frequent at our tables, which are no way comparable in taste of magnificence to a well-grown, fat, yearling child, which roasted whole will make a considerable figure at a lord mayor's feast or any other public entertainment. But this and many 290 others I omit, being studious of brevity.

Supposing that one thousand families in this city would be constant customers for infants' flesh, besides others who might have it at merry meetings, particularly weddings and christenings, I compute that Dublin would take off annually about twenty thousands carcasses, and the rest of the kingdom (where probably they will be sold somewhat cheaper) the remaining eighty thousand.

I can think of no one objection that will possibly be raised against this proposal, unless it should be 300 urged that the number of people will be thereby much lessened in the kingdom. This I freely own, and it was indeed one principal design in offering it to the world. I desire the reader will observe, that I calculate my remedy for this one individual kingdom of Ireland and for no other that ever was, is, or I think ever can be upon earth. Therefore let no man talk to me of other expedients: of taxing our absentees at five shillings a pound: of using neither clothes nor household furniture except what is of our own 310 growth and manufacture: of utterly rejecting the materials and instruments that promote foreign luxury: of curing the expensiveness of pride, vanity, idleness, and gaming in our women: of introducing a vein of parsimony, prudence, and temperance: of learning to love our country, in the want of which we differ even from Laplanders and the inhabitants of Topinamboo: of quitting our animosities and factions, nor acting any longer like the Jews, who were murdering one another at the very moment their city was taken: of 320 being a little cautious not to sell our country and conscience for nothing: of teaching landlords to have at least one degree of mercy toward their tenants: lastly: of putting a spirit of honesty, industry, and skill into our shopkeepers; who, if a resolution could now be taken to buy only our native goods, would immediately unite to cheat and exact upon us in the price, the measure, and the goodness, nor could ever yet be brought to make one fair proposal of just dealing, though often and earnestly invited to it.

Therefore I repeat, let no man talk to me of these and the like expedients, till he hath at least some glimpse of hope that there will ever be some hearty and sincere attempt to put them in practice.

But as to myself, having been wearied out for many years with offering vain, idle, visionary thoughts, and at length utterly despairing of success, I fortunately fell upon this proposal, which, as it is wholly new, so it hath something solid and real, of no expense and little trouble, full in our own power 340 and whereby we can incur no danger in disobliging England. For this kind of commodity will not bear exportation, the flesh being of too tender a consistence to admit a long continuance in salt, although perhaps I could name a country which would be glad to eat up our whole nation without it.

After all, I am not so violently bent upon my own opinion as to reject any offer proposed by wise men, which shall be found equally innocent, cheap, easy, and effectual. But before something of that kind shall 350 be advanced in contradiction to my scheme, and offering a better, I desire the author or authors will be pleased maturely to consider two points. First, as things now stand, how they will be able to find food and raiment for an hundred thousands useless mouths and backs. And secondly, there being a round million of creatures in human figure throughout this kingdon, whose sole subsistence put into a common stock would leave them in debt two millions of pounds sterling, adding those who are beg-360 gars by profession to the bulk of farmers, cottagers, and laborers, with their wives and children who are beggars in effect; I desire those politicians who dislike my overture, and may perhaps be so bold to attempt an answer, that they will first ask the parents of these mortals whether they would not at this day think it a great happiness to have been sold for food at a year old in the manner I prescribe, and thereby have avoided such a perpetual scene of misfortunes as they have since gone through by the oppression of land-370 cal point of view from that of Dr. Pangloss, total pessilords, the impossibility of paying rent without money or trade, the want of common sustenance, with neither house nor clothes to cover them from the inclemencies of the weather, and the most inevitable prospect of entailing the like or greater miseries upon their breed forever.

I profess, in the sincerity of my heart, that I have not the least personal interest in endeavoring to promote this necessary work, having no other motive than the public good of my country, by advancing 380 our trade, providing for infants, relieving the poor, and giving some pleasure to the rich. I have no children by which I can propose to get a single penny; the youngest being nine years old, and my wife past

childbearing.

Voltaire from CANDIDE or Optimism

Candide is a simple young man of charm and courage who at an early age has been subjected to the opinions of his tutor, Dr. Pangloss. According to Dr. Pangloss, who is a parody of the rational philosophers of the day, everything that happens is bound to happen for the best, be it rape, murder, or earthquake. In a famous scene in Chapter 5, Candide and Pangloss become involved in an actual historical event, the disastrous earthquake that destroyed most of Lisbon in 1755. When called upon to help the injured, the learned doctor meditates instead on the causes and effects of the earthquake and duly comes to the conclusion that if Lisbon and its inhabitants were destroyed, it had to be so, and therefore was all for the best.

It is, incidentally, typical of the breadth of Voltaire's satire that in the very first sentence of the next chapter he turns from philosophical optimism to an attack on religious superstition and fanaticism, when he describes the decision taken to find some victims injured in the earthquake and burn them alive as a means of averting further disasters. That this decision is made by the University of Coimbra, supposedly an establishment of reason, is of course an extra twist of the knife on Voltaire's part.

Among the chosen victims is Candide himself; by the time he has escaped even he, innocent follower of his tutor's precepts, is beginning to have serious doubts. When he hears of the disasters which have befallen his childhood sweetheart Cunegonde and the old lady who is her companion, the absurdity of philosophical optimism becomes clear. Much of the rest of the book is devoted to underlining precisely how absurd it is and exploring alternative schools of thought. Candide travels from Spain to the New World and back to Europe, and wherever he goes finds nothing but evil, stupidity, and ignorance. In the course of his travels he decides to find himself a companion and joins up with Martin, an old scholar who represents the opposite philosophimism. The two travel to Venice and then to Constantinople, where Candide and his once-beloved Cunegonde are reunited.

By the end of his journeys Candide has had a chance to think about the optimism of Dr. Pangloss and the pessimism of his friend Martin and to compare them both with real life. The conclusion he reaches is expressed in the book's final words, "we must cultivate our gardens." The world is a cruel place where human life is of little account, but to give way to total pessimism is fruitless. Instead, we should try to find some limited activity we can perform well. By succeeding in this small task we can construct a little island of peace and sanity in a hostile world.

The reader who expects to find fully developed characters and a convincing plot in Candide is likely to be severely disappointed. Voltaire's aim is to teach, and to this end he manipulates the narrative to make his points as powerfully as possible. This does not mean that he does not write entertainingly, however; indeed, Candide is probably one of the most enjoyable of the great literary works. With inexhaustible imagination and dry wit, Voltaire even succeeds in making us laugh at the impossible disasters he invents and the absurd reactions of his characters to them, since, given the choice of laughter or tears at the injustices of life, he chooses the former. Nonetheless, the message of the work is far from comforting. It is a measure of Voltaire's courage that his final advice to "cultivate our gardens" manages to extract something positive from the despair his humor and irony mask.

The two long selections that follow are not intended to present every twist and turn of the plot but to convey something of the flavor and spirit of the whole. The first selection (chapters 1-13) sees the story well on its way, with Candide separated from Cunegonde, reunited with her and separated yet again, while Voltaire takes on an assortment of targets that includes the aristocracy, the law, war, religious intolerance and hypocrisy, and, of course, Dr.

Pangloss. The episode of the old woman and her story, furthermore, contains some of Voltaire's most bizarre inventions. The note of suspense on which the thirteenth chapter closes is typical of much of the rest of the book, where characters are placed in an impossible situation from which they find a highly unlikely means of escape.

How Candide was brought up in a noble castle and how he was expelled from the same

In the castle of Baron Thunder-ten-tronckh in Westphalia there lived a youth, endowed by Nature with the most gentle character. His face was the expression of his soul. His judgment was quite honest and he was extremely simple-minded; and this was the reason, I think, that he was named Candide. Old servants in the house suspected that he was the son of the Baron's sister and a decent honest gentleman of the neighborhood, whom this young lady would never marry because he could only prove seventy- 10 one quarterings, and the rest of his genealogical tree was lost, owing to the injuries of time. The Baron was one of the most powerful lords in Westphalia, for his castle possessed a door and windows. His Great Hall was even decorated with a piece of tapestry. The dogs in his stable-yards formed a pack of hounds when necessary; his grooms were his huntsmen; the village curate was his Grand Almoner. They all called him "My Lord," and laughed heartily at his stories. The Baroness weighed about three 20 hundred and fifty pounds, was therefore greatly respected, and did the honors of the house with a dignity which rendered her still more respectable. Her daughter Cunegonde, aged seventeen, was rosycheeked, fresh, plump and tempting. The Baron's son appeared in every respect worthy of his father. The tutor Pangloss was the oracle of the house, and little Candide followed his lessons with all the candor of his age and character. Pangloss taught metaphysico-theologo-cosmo-lonigology. He proved admira- 30 bly that there is no effect without a cause and that in this best of all possible worlds, My Lord the Baron's castle was the best of castles and his wife the best of all possible Baronesses. "'Tis demonstrated," said he, "that things cannot be otherwise; for, since everything is made for an end, everything is necessarily for the best end. Observe that noses were made to wear spectacles; and so we have spectacles. Legs were visibly instituted to be breeched, and we have breeches. Stones were formed to be quarried and to 40 build castles; and My Lord has a very noble castle; the greatest Baron in the province should have the best house; and as pigs were made to be eaten, we eat pork all the year round; consequently, those who have asserted that all is well talk nonsense; they ought

to have said that all is for the best." Candide listened attentively and believed innocently; for he thought Mademoiselle Cunegonde extremely beautiful, although he was never bold enough to tell her so. He decided that after the happiness of being born Baron 50 of Thunder-ten-tronckh, the second degree of happiness was to be Mademoiselle Cunegonde; the third, to see her every day; and the fourth to listen to Doctor Pangloss, the greatest philosopher of the province and therefore of the whole world. One day when Cunegonde was walking near the castle, in a little wood which was called The Park, she observed Doctor Pangloss in the bushes, giving a lesson in experimental physics to her mother's waiting-maid, a very pretty and docile brunette. Mademoiselle Cunegonde 60 had a great inclination for science and watched breathlessly the reiterated experiments she witnessed; she observed clearly the Doctor's sufficient reason, the effects and the causes, and returned home very much excited, pensive, filled with the desire of learning, reflecting that she might be the sufficient reason of young Candide and that he might be hers. On her way back to the castle she met Candide and blushed; Candide also blushed. She bade him good-morning in a hesitating voice; Candide replied without know-70 ing what he was saying. Next day, when they left the table after dinner, Cunegonde and Candide found themselves behind a screen; Cunegonde dropped her handkerchief, Candide picked it up; she innocently held his hand; the young man innocently kissed the young lady's hand with remarkable vivacity, tenderness and grace; their lips met, their eyes sparkled, their knees trembled, their hands wandered. Baron Thunder-ten-tronckh passed near the screen, and, observing this cause and effect, expelled Candide 80 from the castle by kicking him in the backside frequently and hard. Cunegonde swooned; when she recovered her senses, the Baroness slapped her in the face; and all was in consternation in the noblest and most agreeable of all possible castles.

II

What happened to Candide among the Bulgarians

Candide, expelled from the earthly paradise, wandered for a long time without knowing where he was going, turning up his eyes to Heaven, gazing back frequently at the noblest of castles which held the most beautiful of young Baronesses; he lay down to sleep supperless between two furrows in the open fields; it snowed heavily in large flakes. The next morning the shivering Candide, penniless, dying of cold and exhaustion, dragged himself towards the neighboring town, which was called Waldberghoff- 10 trarbk-dikdorff. He halted sadly at the door of an inn. Two men dressed in blue noticed him. "Comrade," said one, "there's a well-built young man of the right height." They went up to Candide and very civilly invited him to dinner. "Gentlemen," said Candide with charming modesty, "you do me a great honor, but I have no money to pay my share." "Ah, sir," said one of the men in blue, "persons of your figure and merit never pay anything; are you not five feet five tall?" "Yes, gentlemen," said he, 20 bowing, "that is my height." "Ah, sir, come to table; we will not only pay your expenses, we will never allow a man like you to be short of money; men were only made to help each other." "You are in the right," said Candide, "that is what Doctor Pangloss was always telling me, and I see that everything is for the best." They begged him to accept a few crowns, he took them and wished to give them an I O U; they refused to take it and all sat down to table. "Do you not love tenderly . . ." "Oh, yes," said he. "I love 30 Mademoiselle Cunegonde tenderly." "No," said one of the gentlemen. "We were asking if you do not tenderly love the King of the Bulgarians." "Not a bit," said he, "for I have never seen him." "What! He is the most charming of Kings, and you must drink his health." "Oh, gladly, gentlemen." And he drank. "That is sufficient," he was told. "You are now the support, the aid, the defender, the hero of the Bulgarians; your fortune is made and your glory assured." They immediately put irons on his legs and 40 took him to a regiment. He was made to turn to the right and left, to raise the ramrod and return the ramrod, to take aim, to fire, to march double time, and he was given thirty strokes with a stick; the next day he drilled not quite so badly, and received only twenty strokes; the day after, he only had ten and was looked on as a prodigy by his comrades. Candide was completely mystified and could not make out how he was a hero. One fine spring day he thought he would take a walk, going straight ahead, 50 in the belief that to use his legs as he pleased was a privilege of the human species as well as of animals. He had not gone two leagues when four other heroes, each six feet tall, fell upon him, bound him and dragged him back to a cell. He was asked by his judges whether he would rather be thrashed thirtysix times by the whole regiment or receive a dozen lead bullets at once in his brain. Although he protested that men's wills are free and that he wanted neither one nor the other, he had to make a choice; by 60 virtue of that gift of God which is called *liberty*, he determined to run the gauntlet thirty-six times and actually did so twice. There were two thousand men in the regiment. That made four thousand strokes which laid bare the muscles and nerves from his neck to his backside. As they were about to proceed to a third turn, Candide, utterly exhausted, begged as a favor that they would be so kind as to smash his

head; he obtained this favor; they bound his eyes and he was made to kneel down. At that moment the 70 King of the Bulgarians came by and inquired the victim's crime; and as this King was possessed of a vast genius, he perceived from what he learned about Candide that he was a young metaphysician very ignorant in worldly matters, and therefore pardoned him with a clemency which will be praised in all newspapers and all ages. An honest surgeon healed Candide in three weeks with the ointments recommended by Dioscorides. He had already regained a little skin and could walk when the King of the Bul-80 garians went to war with the King of the Abares.

Ш

How Candide escaped from the Bulgarians and what became of him

Nothing could be smarter, more spendid, more brilliant, better drawn up than the two armies. Trumpets, fifes, hautboys, drums, cannons, formed a harmony such as has never been heard even in hell. The cannons first of all laid flat about six thousand men on each side; then the musketry removed from the best of worlds some nine or ten thousand blackguards who infested its surface. The bayonet also was the sufficient reason for the death of some thousands of men. The whole might amount to thirty thousand 10 souls. Candide, who trembled like a philosopher, hid himself as well as he could during this heroic butchery. At last, while the two Kings each commanded a Te Deum in his camp, Candide decided to go elsewhere to reason about effects and causes. He clambered over heaps of dead and dying men and reached a neighboring village, which was in ashes; it was an Abare village which the Bulgarians had burned in accordance with international law. Here, old men dazed with blows watched the dying agonies of their 20 murdered wives who clutched their children to their bleeding breasts; there, disembowelled girls who had been made to satisfy the natural appetites of heroes gasped their last sighs; others, half-burned, begged to be put to death. Brains were scattered on the ground among dismembered arms and legs. Candide fled to another village as fast as he could; it belonged to the Bulgarians, and Abarian heroes had treated it in the same way. Candide, stumbling over quivering limbs or across ruins, at last escaped from the theatre of 30 war, carrying a little food in his knapsack, and never forgetting Mademoiselle Cunegonde. His provisions were all gone when he reached Holland; but, having heard that everyone in that country was rich and a Christian, he had no doubt at all but that he would be as well treated as he had been in the Baron's castle before he had been expelled on account of Mademoiselle Cunegonde's pretty eyes. He asked alms of sev-

eral grave persons, who all replied that if he continued in that way he would be shut up in a house of 40 correction to teach him how to live. He then addressed himself to a man who had been discoursing on charity in a large assembly for an hour on end. This orator, glancing at him askance, said: "What are you doing here? Are you for the good cause?" "There is no effect without a cause," said Candide modestly, "Everything is necessarily linked up and arranged for the best. It was necessary that I should be expelled from the company of Mademoiselle Cunegonde, that I ran the gauntlet, and that I beg my 50 bread until I can earn it; all this could not have happened differently." "My friend," said the orator, "do you believe that the Pope is Anti-Christ?" "I had never heard so before," said Candide, "but whether he is or isn't, I am starving." "You don't deserve to eat," said the other. "Hence, rascal; hence, you wretch; and never come near me again." The orator's wife thrust her head out of the window and seeing a man who did not believe that the Pope was Anti-Christ, she poured on his head a full . . . O Heavens! 60 To what excess religious zeal is carried by ladies! A man who had not been baptized, an honest Anabaptist named Jacques, saw the cruel and ignominious treatment of one of his brothers, a featherless twolegged creature with a soul; he took him home, cleaned him up, gave him bread and beer, presented him with two florins, and even offered to teach him to work at the manufacture of Persian stuffs which are made in Holland. Candide threw himself at the man's feet, exclaiming: "Doctor Pangloss was right 70 in telling me that all is for the best in this world, for I am vastly more touched by your extreme generosity than by the harshness of the gentleman in the black cloak, and his good lady," The next day when he walked out he met a beggar covered with sores, dulleyed, with the end of his nose fallen away, his mouth awry, his teeth black, who talked huskily, was tormented with a violent cough and spat out a tooth at every cough.

IV

How Candide met his old master in philosophy, Doctor Pangloss, and what happened

Candide, moved even more by compassion than by horror, gave this horrible beggar the two florins he had received from the honest Anabaptist, Jacques. The phantom gazed fixedly at him, shed tears and threw its arms round his neck. Candide recoiled in terror. "Alas!" said the wretch to the other wretch, "don't you recognize your dear Pangloss?" "What do I hear? You, my dear master! You, in this horrible state! What misfortune has happened to you? Why are you no longer in the noblest of castles? What has 10

become of Mademoiselle Cunegonde, the pearl of young ladies, the masterpiece of Nature?" "I am exhausted," said Pangloss. Candide immediately took him to the Anabaptist's stable where he gave him a little bread to eat; and when Pangloss had recovered: "Well!" said he, "Cunegonde?" "Dead," replied the other. At this word Candide swooned; his friend restored him to his senses with a little bad vinegar which happened to be in the stable. Candide opened his eyes. "Cunegonde dead! Ah! best of worlds, 20 where are you? But what illness did she die of? Was it because she saw me kicked out of her father's noble castle?" "No," said Pangloss. "She was disembowelled by Bulgarian soldiers, after having been raped to the limit of possibility; they broke the Baron's head when he tried to defend her; the Baroness was cut to pieces; my poor pupil was treated exactly like his sister; and as to the castle, there is not one stone standing on another, not a barn, not a sheep, not a duck, not a tree; but we were well avenged, for 30 the Abares did exactly the same to a neighboring barony which belonged to a Bulgarian Lord." At this, Candide swooned again; but, having recovered and having said all that he ought to say, he inquired the cause and effect, the sufficient reason which had reduced Pangloss to so piteous a state. "Alas!" said Pangloss, "'tis love; love, the consoler of the human race, the preserver of the universe, the soul of all tender creatures, gentle love," "Alas!" said Candide. "I am acquainted with this love, this sovereign of 40 hearts, this soul of our soul; it has never brought me anything but one kiss and twenty kicks in the backside. How could this beautiful cause produce in you so abominable an effect?" Pangloss replied as follows: "My dear Candide! You remember Paquette, the maid-servant of our august Baroness; in her arms I enjoyed the delights of Paradise which have produced the tortures of Hell by which you see I am devoured; she was infected and perhaps is dead. Paquette received this present from a most learned 50 monk, who had it from the source; for he received it from an old countess, who had it from a cavalry captain, who owed it to a marchioness, who derived it from a page, who had received it from a Jesuit, who, when a novice, had it in a direct line from one of the companions of Christopher Columbus. For my part, I shall not give it to anyone, for I am dying." "O Pangloss!" exclaimed Candide, "this is a strange genealogy! Wasn't the devil at the root of it?" "Not at all," replied that great man. "It was something indis- 60 pensable in this best of worlds, a necessary ingredient; for, if Columbus in an island of America had not caught this disease, which poisons the source of generation, and often indeed prevents generation, we should not have chocolate and cochineal; it must also be noticed that hitherto in our continent this disease

is peculiar to us, like theological disputes. The Turks, the Indians, the Persians, the Chinese, the Siamese and the Japanese are not yet familiar with it; but there is a sufficient reason why they in their turn should 70 become familiar with it in a few centuries. Meanwhile, it has made marvelous progress among us, and especially in those large armies composed of honest, well-bred stipendiaries who decide the destiny of States; it may be asserted that when thirty thousand men fight a pitched battle against an equal number of troops, there are about twenty thousand with the pox on either side." "Admirable!" said Candide. "But you must get cured." "How can I?" said Pangloss. "I haven't a sou, my friend, and in the 80 whole extent of this globe, you cannot be bled or receive an enema without paying or without someone paying for you." This last speech determined Candide; he went and threw himself at the feet of his charitable Anabaptist, Jacques, and drew so touching a picture of the state to which his friend was reduced that the good easy man did not hesitate to succor Pangloss; he had him cured at his own expense. In this cure Pangloss only lost one eye and one ear. He could write well and knew arithmetic perfectly. The 90 Anabaptist made him his book-keeper. At the end of two months he was compelled to go to Lisbon on business and took his two philosophers on the boat with him. Pangloss explained to him how everything was for the best. Jacques was not of this opinion. "Men," said he, "must have corrupted nature a little, for they were not born wolves, and they have become wolves. God did not give them twenty-fourpounder cannons or bayonets, and they have made bayonets and cannons to destroy each other. I might 100 bring bankruptcies into the account and Justice which seizes the goods of bankrupts in order to deprive the creditors of them." "It was all indispensable," replied the one-eyed doctor, "and private misfortunes make the public good, so that the more private misfortunes there are, the more everything is well," While he was reasoning, the air grew dark, the winds blew from the four quarters of the globe and the ship was attacked by the most horrible tempest in sight of the port of Lisbon.

Storm, shipwreck, earthquake, and what happened to Doctor Pangloss, to Candide and the Anabaptist Jacques

Half the enfeebled passengers, suffering from that inconceivable anguish which the rolling of a ship causes in the nerves and in all the humours of bodies shaken in contrary directions, did not retain strength enough even to trouble about the danger. The other half screamed and prayed; the sails were torn, the masts broken, the vessel leaking. Those worked who could, no one cooperated, no one commanded. The Anabaptist tried to help the crew a little; he was on the main-deck; a furious sailor struck him violently 10 and stretched him on the deck; but the blow he delivered gave the sailor so violent a shock that he fell head-first out of the ship. He remained hanging and clinging to part of the broken mast. The good Jacques ran to his aid, helped him to climb back, and from the effort he made was flung into the sea in full view of the sailor, who allowed him to drown without condescending even to look at him. Candide came up, saw his benefactor reappear for a moment and then be engulfed for ever. He tried to throw him-20 self after him into the sea; he was prevented by the philosopher Pangloss, who proved to him that the Bay of Lisbon had been expressly created for the Anabaptist to be drowned in it. While he was proving this a priori, the vessel sank, and every one perished except Pangloss, Candide and the brutal sailor who had drowned the virtuous Anabaptist; the blackguard swam successfully to the shore and Pangloss and Candide were carried there on a plank. When they had recovered a little, they walked to-30 ward Lisbon; they had a little money by the help of which they hoped to be saved from hunger after having escaped the storm. Weeping the death of their benefactor, they had scarcely set foot in the town when they felt the earth tremble under their feet; the sea rose in foaming masses in the port and smashed the ships which rode at anchor. Whirlwinds of flame and ashes covered the streets and squares; the houses collapsed, the roofs were thrown upon the foundations, and the foundations were scattered; thirty 40 thousand inhabitants of every age and both sexes were crushed under the ruins. Whistling and swearing, the sailor said: "There'll be something to pick up here." "What can be the sufficient reason for this phenomenon?" said Pangloss. "It is the last day!" cried Candide. The sailor immediately ran among the debris, dared death to find money, found it, seized it, got drunk, and having slept off his wine, purchased the favors of the first woman of good-will he met on the ruins of the houses and among the dead and 50 dying. Pangloss, however, pulled him by the sleeve. "My friend," said he, "this is not well, you are disregarding universal reason, you choose the wrong time." "Blood and 'ounds!" he retorted. "I am a sailor and I was born in Batavia; four times have I stamped on the crucifix during four voyages to Japan; you have found the right man for your universal reason!" Candide had been hurt by some falling stones; he lay in the street covered with debris. He said to Pangloss: "Alas! Get me a little wine and oil; I 60 am dying." "This earthquake is not a new thing," replied Pangloss. "The town of Lima felt the same shocks in America last year; similar causes produce

similar effects; there must certainly be a train of sulphur underground from Lima to Lisbon." "Nothing is more probable," replied Candide; "but, for God's sake, a little oil and wine." "What do you mean, probable?" replied the philosopher; "I maintain that it is proved." Candide lost consciousness, and Pangloss brought him a little water from a neighbor- 70 ing fountain. Next day they found a little food as they wandered among the ruins and regained a little strength. Afterwards they worked like others to help the inhabitants who had escaped death. Some citizens they had assisted gave them as good a dinner as could be expected in such a disaster; true, it was a dreary meal; the hosts watered their bread with their tears. but Pangloss consoled them by assuring them that things could not be otherwise. "For," said he, "all this is for the best; for, if there is a volcano at Lisbon, 80 it cannot be anywhere else; for it is impossible that things should not be where they are; for all is well." A little, dark man, a familiar of the Inquisition, who sat beside him, politely took up the conversation, and said: "Apparently, you do not believe in original sin; for, if everything is for the best, there was neither fall nor punishment." "I most humbly beg your excellency's pardon," replied Pangloss still more politely, "for the fall of man and the curse necessarily entered into the best of all possible worlds." "Then you do 90 not believe in free-will?" said the familiar. "Your excellency will pardon me," said Pangloss; "free-will can exist with absolute necessity; for it was necessary that we should be free; for in short, limited will . . . Pangloss was in the middle of his phrase when the familiar nodded to his armed attendant who was pouring out port or Oporto wine for him.

VI

How a splendid auto-da-fé was held to prevent earthquakes and how Candide was flogged

After the earthquake which destroyed three-quarters of Lisbon, the wise men of that country could discover no more efficacious way of preventing a total ruin than by giving the people a splendid auto-da-fé. It was decided by the university of Coimbra that the sight of several persons being slowly burned in great ceremony is an infallible secret for preventing earthquakes. Consequently they had arrested a Biscavan convicted of having married his fellow-godmother, and two Portuguese who, when eating a chicken, had 10 thrown away the fat; after dinner they came and bound Doctor Pangloss and his disciple Candide, one because he had spoken and the other because he had listened with an air of approbation; they were both carried separately to extremely cool apartments, where there was never any discomfort from the sun; a week afterwards each was dressed in a sanbenito

and their heads were ornamented with paper mitres. Candide's mitre and sanbenito were painted with flames upside down and with devils who had neither 20 tails nor claws; but Pangloss's devils had claws and tails, and his flames were upright. Dressed in this manner they marched in procession and listened to a most pathetic sermon, followed by lovely plain-song music. Candide was flogged in time to the music, while the singing went on; the Biscayan and the two men who had not wanted to eat fat were burned, and Pangloss was hanged, although this is not the custom. The very same day, the earth shook again with a terrible clamor. Candide, terrified, dumbfounded, 30 bewildered, covered with blood, quivering from head to foot, said to himself: "If this is the best of all possible worlds, what are the others? Let it pass that I was flogged, for I was flogged by the Bulgarians, but, O my dear Pangloss! The greatest of philosophers! Must I see you hanged without knowing why! O my dear Anabaptist! The best of men! Was it necessary that you should be drowned in port! O Mademoiselle Cunegonde! The pearl of women! Was it necessary that your belly should be slit!" He was re- 40 turning, scarcely able to support himself, preached at, flogged, absolved and blessed, when an old woman accosted him and said: "Courage, my son, follow me."

VII

How an old woman took care of Candide and how he regained that which he loved

Candide did not take courage, but he followed the old woman to a hovel; she gave him a pot of ointment to rub on, and left him food and drink; she pointed out a fairly clean bed; near the bed there was a suit of clothes. "Eat, drink, sleep," said she, "and may our Lady of Atocha, my Lord Saint Anthony of Padua and my Lord Saint James of Compostella take care of you; I shall come back tomorrow." Candide, still amazed by all he had seen, by all he had suffered, and still more by the old woman's charity, tried to 10 kiss her hand. "'Tis not my hand you should kiss," said the old woman, "I shall come back to-morrow. Rub on the ointment, eat and sleep." In spite of all his misfortune, Candide ate and went to sleep. Next day the old woman brought him breakfast, examined his back and smeared him with another ointment; later she brought him dinner, and returned in the evening with supper. The next day she went through the same ceremony. "Who are you?" Candide kept asking her. "Who has inspired you with so much kind- 20 ness? How can I thank you?" The good woman never made any reply; she returned in the evening but without any supper. "Come with me," said she, "and do not speak a word." She took him by the arm

and walked into the country with him for about a quarter of a mile; they came to an isolated house, surrounded with gardens and canals. The old woman knocked at a little door. It was opened; she led Candide up a back stairway into a gilded apartment, left him on a brocaded sofa, shut the door and went 30 away. Candide thought he was dreaming, and felt that his whole life was a bad dream and the present moment an agreeable dream. The old woman soon reappeared; she was supporting with some difficulty a trembling woman of majestic stature, glittering with precious stones and covered with a veil. "Remove the veil," said the old woman to Candide. The young man advanced and lifted the veil with a timid hand. What a moment! What a surprise! He thought he saw Mademoiselle Cunegonde, in fact he was 40 looking at her, it was she herself. His strength failed him, he could not utter a word and fell at her feet. Cunegonde fell on the sofa. The old woman dosed them with distilled waters; they recovered their senses and began to speak: at first they uttered only broken words, questions and answers at cross purposes, sighs, tears, exclamations. The old woman advised them to make less noise and left them alone. "What! Is it you?" said Candide. "You are alive, and I find you here in Portugal! Then you were not 50 raped? Your belly was not slit, as the philosopher Pangloss assured me?" "Yes, indeed," said the fair Cunegonde; "but those two accidents are not always fatal." "But your father and mother were killed?" " 'Tis only too true," said Cunegonde, weeping. "And your brother?" "My brother was killed too." "And why are you in Portugal? And how did you know I was here? And by what strange adventure have you brought me to this house?" "I will tell you everything," replied the lady, "but first of all you 60 must tell me everything that has happened to you since the innocent kiss you gave me and the kicks you received." Candide obeyed with profound respect; and, although he was bewildered, although his voice was weak and trembling, although his back was still a little painful, he related in the most natural manner all he had endured since the moment of their separation. Cunegonde raised her eyes to heaven; she shed tears at the death of the good Anabaptist and Pangloss, after which she spoke as follows to Can-70 dide, who did not miss a word and devoured her with his eyes.

VIII

Cunegonde's story

"I was fast asleep in bed when it pleased Heaven to send the Bulgarians to our noble castle of Thunderten-tronckh; they murdered my father and brother and cut my mother to pieces. A large Bulgarian six feet tall, seeing that I had swooned at the spectacle, began to rape me; this brought me to, I recovered my senses, I screamed, I struggled, I bit, I scratched, I tried to tear out the big Bulgarian's eyes, not knowing that what was happening in my father's castle was a matter of custom; the brute stabbed me with a 10 knife in the left side where I still have the scar." "Alas! I hope I shall see it," said the naïve Candide. "You shall see it," said Cunegonde, "but let me go on." "Go on," said Candide. She took up the thread of her story as follows: "A Bulgarian captain came in, saw me covered with blood, and the soldier did not disturb himself. The captain was angry at the brute's lack of respect to him, and killed him on my body. Afterwards, he had me bandaged and took me to his billet as a prisoner of war. I washed the few 20 shirts he had and did the cooking; I must admit he thought me very pretty; and I will not deny that he was very well built and that his skin was white and soft; otherwise he had little wit and little philosophy; it was plain that he had not been brought up by Doctor Pangloss. At the end of three months he lost all his money and got tired of me; he sold me to a Jew named Don Issachar, who traded in Holland and Portugal and had a passion for women. This Jew devoted himself to my person but he could not tri- 30 umph over it; I resisted him better than the Bulgarian soldier; a lady of honor may be raped once, but it strengthens her virtue. In order to subdue me, the Jew brought me to this country house. Up till then I believed that there was nothing on earth so splendid as the castle of Thunder-ten-tronckh; I was undeceived. One day the Grand Inquisitor noticed me at Mass; he ogled me continually and sent a message that he wished to speak to me on secret affairs. I was taken to his palace; I informed him of my birth; he 40 pointed out how much it was beneath my rank to belong to an Israelite. A proposition was made on his behalf to Don Issachar to give me up to His Lordship. Don Issachar, who is the court banker and a man of influence, would not agree. The Inquisitor threatened him with an auto-da-fé. At last the Jew was frightened and made a bargain whereby the house and I belong to both in common. The Jew has Mondays, Wednesdays and the Sabbath day, and the Inquisitor has the other days of the week. This arrange- 50 ment has lasted for six months. It has not been without quarrels; for it has often been debated whether the night between Saturday and Sunday belonged to the old law or the new. For my part, I have hitherto resisted them both; and I think that is the reason why they still love me. At last My Lord the Inquisitor was pleased to arrange an auto-da-fé to remove the scourge of earthquakes and to intimidate Don Issachar. He honored me with an invitation. I had an excellent seat; and refreshments were served 60

to the ladies between the Mass and the execution. I was indeed horror-stricken when I saw the burning of the two Jews and the honest Biscayan who had married his fellow-godmother; but what was my surprise, my terror, my anguish, when I saw in a sanbenito and under a mitre a face which resembled Pangloss's! I rubbed my eyes, I looked carefully, I saw him hanged; and I fainted. I had scarcely recovered my senses when I saw you stripped naked; that was the height of horror, of consternation, of grief 70 and despair. I will frankly tell you that your skin is even whiter and of a more perfect tint than that of my Bulgarian captain. This spectacle redoubled all the feelings which crushed and devoured me. I exclaimed, I tried to say: 'Stop, Barbarians!' but my voice failed and my cries would have been useless. When you had been well flogged, I said to myself: 'How does it happen that the charming Candide and the wise Pangloss are in Lisbon, the one to receive a hundred lashes, and the other to be hanged, by order 80 of My Lord the Inquisitor, whose darling I am? Pangloss deceived me cruelly when he said that all is for the best in the world.' I was agitated, distracted, sometimes beside myself and sometimes ready to die of faintness, and my head was filled with the massacre of my father, of my mother, of my brother, the insolence of my horrid Bulgarian soldier, the gash he gave me, my slavery, my life as a kitchen-wench, my Bulgarian captain, my horrid Don Issachar, my abominable Inquisitor, the hanging of Dr. Pangloss, 90 that long miserere in counterpoint during which you were flogged, and above all the kiss I gave you behind the screen that day when I saw you for the last time. I praised God for bringing you back to me through so many trials, I ordered my old woman to take care of you and to bring you here as soon as she could. She has carried out my commission very well; I have enjoyed the inexpressible pleasure of seeing you again, of listening to you, and of speaking to you. You must be very hungry; I have a good appe- 100 tite; let us begin by having supper." Both sat down to supper; and after supper they returned to the handsome sofa we have already mentioned; they were still there when Signor Don Issachar, one of the masters of the house, arrived. It was the day of the Sabbath. He came to enjoy his rights and to express his tender love.

IX

What happened to Cunegonde, to Candide, to the Grand Inquisitor and to a Jew

This Issachar was the most choleric Hebrew who had been seen in Israel since the Babylonian captivity.

"What!" said he. "Bitch of a Galilean, isn't it enough to have the Inquisitor? Must this scoundrel share with me too?" So saying, he drew a long dagger which he always carried and, thinking that his adversary was unarmed, threw himself upon Candide; but our good Westphalian had received an excellent sword from the old woman along with his suit of clothes. He drew his sword, and although he had a 10 most gentle character, laid the Israelite stone-dead on the floor at the feet of the fair Cunegonde. "Holy Virgin!" she exclaimed, "what will become of us? A man killed in my house! If the police come we are lost." "If Pangloss had not been hanged," said Candide, "he would have given us good advice in this extremity, for he was a great philosopher. In default of him, let us consult the old woman." She was extremely prudent and was beginning to give her advice when another little door opened. It was an hour 20 after midnight, and Sunday was beginning. This day belonged to My Lord the Inquisitor. He came in and saw the flogged Candide sword in hand, a corpse lying on the ground, Cunegonde in terror, and the old woman giving advice. At this moment, here is what happened in Candide's soul and the manner of his reasoning: "If this holy man calls for help, he will infallibly have me burned; he might do as much to Cunegonde; he had me pitilessly lashed; he is my rival; I am in the mood to kill, there is no room for 30 hesitation." His reasoning was clear and swift; and, without giving the Inquisitor time to recover from his surprise, he pierced him through and through and cast him beside the Jew. "Here's another," said Cunegonde. "There is no chance of mercy; we are excommunicated, our last hour has come. How does it happen that you, who were born so mild, should kill a Jew and a prelate in two minutes?" "My dear young lady," replied Candide, "when a man is in love, jealous, and has been flogged by the Inquisi- 40 tion, he is beside himself." The old woman then spoke up and said: "In the stable are three Andalusian horses, with their saddles and bridles; let the brave Candide prepare them; mademoiselle has moidores and diamonds; let us mount quickly, although I can only sit on one buttock, and go to Cadiz; the weather is beautifully fine, and it is most pleasant to travel in the coolness of the night." Candide immediately saddled the three horses. Cunegonde, the old woman and he rode thirty miles without stopping. While 50 they were riding away, the Holy Hermandad arrived at the house; My Lord was buried in a splendid church and Issachar was thrown into a sewer. Candide, Cunegonde and the old woman had already reached the little town of Avacena in the midst of the mountains of the Sierra Morena; and they talked in their inn as follows.

How Candide, Cunegonde and the old woman arrived at Cadiz in great distress, and how they embarked

"Who can have stolen my pistoles and my diamonds?" said Cunegonde, weeping. "How shall we live? What shall we do? Where shall we find Inquisitors and Jews to give me others?" "Alas!" said the old woman, "I strongly suspect a reverend Franciscan father who slept in the same inn at Badajoz with us; Heaven forbid that I should judge rashly! But he twice came into our room and left long before we did." "Alas!" said Candide, "the good Pangloss often proved to me that this world's goods are com- 10 mon to all men and that every one has an equal right to them. According to these principles the monk should have left us enough to continue our journey. Have you nothing left then, my fair Cunegonde?" "Not a maravedi," said she. "What are we to do?" said Candide. "Sell one of the horses," said the old woman. "I will ride postillion behind Mademoiselle Cunegonde, although I can only sit on one buttock, and we will get to Cadiz." In the same hotel there was a Benedictine friar. He bought the horse very 20 cheap. Candide, Cunegonde and the old woman passed through Lucena. Chillas, Lebrixa, and at last reached Cadiz. A fleet was there being equipped and troops were being raised to bring to reason the reverend Jesuit fathers of Paraguay, who were accused of causing the revolt of one of their tribes against the kings of Spain and Portugal near the town of Sacramento. Candide, having served with the Bulgarians, went through the Bulgarian drill before the general of the little army with so much grace, celerity, skill, 30 pride and agility, that he was given the command of an infantry company. He was now a captain; he embarked with Mademoiselle Cunegonde, the old woman, two servants, and the two Andalusian horses which had belonged to the Grand Inquisitor of Portugal. During the voyage they had many discussions about the philosophy of poor Pangloss. "We are going to a new world," said Candide, "and no doubt it is there that everything is for the best; for it must be admitted that one might lament a little over 40 the physical and moral happenings in our own world." "I love you with all my heart," said Cunegonde, "but my soul is still shocked by what I have seen and undergone." "All will be well," replied Candide, "the sea in this new world already is better than the seas of our Europe; it is calmer and the winds are more constant. It is certainly the new world which is the best of all possible worlds." "God grant it!" said Cunegonde, "but I have been so horribly unhappy in mine that my heart is nearly closed 50 to hope." "You complain," said the old woman to

them. "Alas! you have not endured such misfortunes as mine." Cunegonde almost laughed and thought it most amusing of the old woman to assert that she was more unfortunate. "Alas! my dear," said she, "unless you have been raped by two Bulgarians, stabbed twice in the belly, have had two castles destroved, two fathers and mothers murdered before your eyes, and have seen two of your lovers flogged in an auto-da-fé, I do not see how you can surpass me; 60 moreover. I was born a Baroness with seventy-two quarterings and I have been a kitchen wench." "You do not know my birth," said the old woman, "and if I showed you my backside you would not talk as you do and you would suspend your judgment." This speech aroused intense curiosity in the minds of Cunegonde and Candide. And the old woman spoke as follows.

XI

The old woman's story

"My eyes were not always bloodshot and redrimmed; my nose did not always touch my chin and I was not always a servant. I am the daughter of Pope Urban X and the Princess of Palestrina. Until I was fourteen I was brought up in a palace to which all the castles of your German Barons would not have served as stables; and one of my dresses cost more than all the magnificence of Westphalia. I increased in beauty, in grace, in talents, among pleasures, respect and hopes; already I inspired love, my breasts were 10 forming; and what breasts! White, firm, carved like those of the Venus de' Medici. And what eyes! What eyelids! What black eyebrows! What fire shone from my two eye-balls, and dimmed the glitter of the stars, as the local poets pointed out to me. The women who dressed and undressed me fell into ecstasy when they beheld me in front and behind; and all the men would have liked to be in their place. I was betrothed to a ruling prince of Massa-Carrara. What a prince! As beautiful as I was, formed of gen- 20 tleness and charms, brilliantly witty and burning with love; I loved him with a first love, idolatrously and extravagantly. The marriage ceremonies were arranged with unheard-of pomp and magnificence; there were continual fêtes, revels and comic operas; all Italy wrote sonnets for me and not a good one among them. I reached the moment of my happiness when an old marchioness who had been my prince's mistress invited him to take chocolate with her: less than two hours afterwards he died in horrible con-30 vulsions; but that is only a trifle. My mother was in despair, though less distressed than I, and wished to absent herself for a time from a place so disastrous. She had a most beautiful estate near Gaeta; we embarked on a galley, gilded like the altar of St. Peter's at Rome. A Salle pirate swooped down and boarded us; our soldiers defended us like soldiers of the Pope; they threw down their arms, fell on their knees and asked the pirates for absolution in articulo mortis. They were immediately stripped as naked as monkeys and 40 my mother, our ladies of honor and myself as well. The diligence with which these gentlemen strip people is truly admirable; but I was still more surprised by their inserting a finger in a place belonging to all of us where women usually only allow the end of a syringe. This appeared to me a very strange ceremony; but that is how we judge everything when we leave our own country. I soon learned that it was to find out if we had hidden any diamonds there; 'tis a custom established from time immemorial among 50 the civilized nations who roam the seas.

"I have learned that the religious Knights of Malta never fail in it when they capture Turks and Turkish women; this is an international law which has never been broken. I will not tell you how hard it is for a young princess to be taken with her mother as a slave to Morocco; you will also guess all we had to endure in the pirates' ship. My mother was still very beautiful; our ladies of honor, even our waiting-maids possessed more charms than could be found in all Africa: 60 and I was ravishing, I was beauty, grace itself, and I was a virgin; I did not remain so long; the flower which had been reserved for the handsome prince of Massa-Carrara was ravished from me by a pirate captain; he was an abominable Negro who thought he was doing me a great honor. The Princess of Palestrina and I must indeed have been strong to bear up against all we endured before our arrival in Morocco! But let that pass; these things are so common that they are not worth mentioning. Morocco was swim-70 ming in blood when we arrived. The fifty sons of the Emperor Muley Ismael had each a faction; and this produced fifty civil wars, of blacks against blacks, browns against browns, mulattoes against mulattoes. There was continual carnage throughout the whole extent of the empire. Scarcely had we landed when the blacks of a party hostile to that of my pirate arrived with the purpose of depriving him of his booty. After the diamonds and the gold, we were the most valuable possessions. I witnessed a fight such as is 80 never seen in your European climates. The blood of the northern peoples is not sufficiently ardent; their madness for women does not reach the point which is common in Africa. The Europeans seem to have milk in their veins; but vitriol and fire flow in the veins of the inhabitants of Mount Atlas and the neighboring countries. They fought with the fury of the lions, tigers and serpents of the country to determine who should have us. A Moor grasped my mother by the right arm, my captain's lieutenant held 90 her by the left arm; a Moorish soldier held one leg and one of our pirates seized the other. In a moment nearly all our women were seized in the same way by four soldiers. My captain kept me hidden behind him; he had a scimitar in his hand and killed everybody who opposed his fury. I saw my mother and all our Italian women torn to pieces, gashed, massacred by the monsters who disputed them. The prisoners, my companions, those who had captured them, soldiers, sailors, blacks, browns, whites, mulattoes and 100 finally my captain were all killed and I remained expiring on a heap of corpses. As everyone knows, such scenes go on in an area of more than three hundred square leagues and yet no one ever fails to recite the five daily prayers ordered by Mahomet. With great difficulty I extricated myself from the bloody heaps of corpses and dragged myself to the foot of a large orange-tree on the bank of a stream; there I fell down with terror, weariness, horror, despair and hunger. Soon afterwards, my exhausted senses fell 110 into a sleep which was more like a swoon than repose. I was in this state of weakness and insensibility between life and death when I felt myself oppressed by something which moved on my body. I opened my eyes and saw a white man of good appearance who was sighing and muttering between his teeth: O che sciagura d'essere senza coglioni!

XII

Continuation of the old woman's misfortunes

"Amazed and delighted to hear my native language, and not less surprised at the words spoken by this man, I replied that there were greater misfortunes than that of which he complained. In a few words I informed him of the horrors I had undergone and then swooned again. He carried me to a neighboring house, had me put to bed, gave me food, waited on me, consoled me, flattered me, told me he had never seen anyone so beautiful as I, and that he had never so much regretted that which no one could give back to 10 him. 'I was born at Naples,' he said, 'and every year they make two or three thousand children there into capons; some die of it, others acquire voices more beautiful than women's, and others become the governors of States. This operation was performed upon me with very great success and I was a musician in the chapel of the Princess of Palestrina.' 'Of my mother,' I exclaimed. 'Of your mother!' cried he, weeping 'What! Are you that young princess I brought up to the age of six and who even then gave 20 promise of being as beautiful as you are?' 'I am! my mother is four hundred yards from here, cut into quarters under a heap of corpses . . . 'I related all that had happened to me; he also told me his adventures and informed me how he had been sent to the King

of Morocco by a Christian power to make a treaty with that monarch whereby he was supplied with powder, cannons and ships to help to exterminate the commerce of other Christians. 'My mission is accomplished,' said this honest eunuch, 'I am about to 30 embark at Ceuta and I will take you back to Italy. Ma che sciagura d'essere senza coglioni! I thanked him with tears of gratitude; and instead of taking me back to Italy he conducted me to Algiers and sold me to the Dev. I had scarcely been sold when the plague which had gone through Africa, Asia and Europe, broke out furiously in Algiers. You have seen earthquakes; but have you ever seen the plague?" "Never," replied the Baroness. "If you had," replied the old woman, "you would admit that it is much worse than an 40 earthquake. It is very common in Africa; I caught it. Imagine the situation of a Pope's daughter aged fifteen, who in three months had undergone poverty and slavery, had been raped nearly every day, had seen her mother cut into four pieces, had undergone hunger and war, and was now dying of the plague in Algiers. However, I did not die; but my eunuch and the Dev and almost all the seraglio of Algiers perished. When the first ravages of this frightful plague were over, the Dev's slaves went sold. A merchant 50 bought me and carried me to Tunis; he sold me to another merchant who re-sold me at Tripoli; from Tripoli I was re-sold to Alexandria, from Alexandria re-sold to Smyrna; from Smyrna to Constantinople. I was finally bought by an Aga of the Janizaries, who was soon ordered to defend Azov against the Russians who were besieging it. The Aga, who was a man of great gallantry, took his whole seraglio with him, and lodged us in a little fort on the Islands of Palus-Maeotis, guarded by two black eunuchs and 60 twenty soldiers. He killed a prodigious number of Russians but they returned the compliment as well. Azov was given up to fire and blood, neither sex nor age was pardoned; only our little fort remained; and the enemy tried to reduce it by starving us. The twenty Janizaries had sworn never to surrender us. The extermities of hunger to which they were reduced forced them to eat our two eunuchs for fear of breaking their oath. Some days later they resolved to eat the women. We had with us a most pious and 70 compassionate Imam who delivered a fine sermon to them by which he persuaded them not to kill us altogether. 'Cut,' said he, 'only one buttock from each of these ladies and you will have an excellent meal; if you have to return, there will still be as much left in a few days; Heaven will be pleased at so charitable action and you will be saved.' He was very eloquent and persuaded them. This horrible operation was performed upon us; the Imam anointed us with the same balm that is used for children who have just 80 been circumcised; we were all at the point of death.

Scarcely had the Janizaries finished the meal we had supplied when the Russians arrived in flat-bottomed boats; not a Janizary escaped. The Russians paid no attention to the state we were in. There are French doctors everywhere; one of them who was very skilful, took care of us; he healed us and I shall remember all my life that, when my wounds were cured, he made propositions to me. For the rest, he told us all to cheer up; he told us that the same thing had hap- 90 pened in several sieges and that it was a law of war. As soon as my companions could walk they were sent to Moscow. I fell to the lot of a Boyar who made me his gardener and gave me twenty lashes a day. But at the end of two years this lord was broken on the wheel with thirty other Boyars owing to some court disturbance, and I profited by this adventure; I fled: I crossed all Russia; for a long time I was servant in an inn at Riga, then at Rostock, at Wismar, at Leipzig, at Cassel, at Utrecht, at Leyden, at the 100 Hague, at Rotterdam; I have grown old in misery and in shame, with only half a backside, always remembering that I was the daughter of a Pope; a hundred times I wanted to kill myself but I still loved life. This ridiculous weakness is perhaps the most disastrous of our inclinations; for is there anything sillier than to desire to bear continually a burden one always wishes to throw on the ground; to look upon oneself with horror and yet to cling to oneself; to short, to caress the serpent which devours us until he 110 has eaten our heart? In the countries it has been my fate to traverse and in the inns where I have served I have seen a prodigious number of people who hated their lives; but I have only seen twelve who voluntarily put an end to their misery: three Negroes, four Englishmen, four Genevans and a German professor named Robeck. I ended up as servant to the Jew, Don Issachar; he placed me in your service, my fair young lady; I attached myself to your fate and have been more occupied with your adventures than with my 120 own. I should never even have spoken of my misfortunes, if you had not piqued me a little and if it had not been the custom on board ship to tell stories to pass the time. In short, Mademoiselle, I have had experience, I know the world; provide yourself with an entertainment, make each passenger tell you his story; and if there is one who has not often cursed his life, who has not often said to himself that he was the most unfortunate of men, throw me head-first into the sea."

XIII

How Candide was obliged to separate from the fair Cunegonde and the old woman

The fair Cunegonde, having heard the old woman's story, treated her with all the politeness due to a per-

son of her rank and merit. She accepted the proposition and persuaded all the passengers one after the other to tell her their adventures. She and Candide admitted that the old woman was right. "It was most unfortuante," said Candide, "that the wise Pangloss was hanged contrary to custom at an auto-da-fe; he would have said admirable things about the physical and moral evils which cover the earth and the sea, 10 and I should feel myself strong enough to urge a few objections with all due respect." While each of the passengers was telling his story the ship proceeded on its way. They arrived at Buenos Ayres. Cunegonde. Captain Candide and the old woman went to call on the governor, Don Fernando d'Ibaraa y Figueora y Mascarenes y Lampourdos y Souza. This gentleman had the pride befitting a man who owned so many names. He talked to men with a most noble disdain, turning his nose up so far, raising his voice so piti- 20 lessly, assuming so imposing a tone, affecting so lofty a carriage, that all who addressed him were tempted to give him a thrashing. He had a furious passion for women. Cunegonde seemed to him the most beautiful woman he had ever seen. The first thing he did was to ask if she were the Captain's wife. The air with which he asked this question alarmed Candide; he did not dare say that she was his wife, because as a matter of fact she was not; he dared not say she was his sister, because she was not that either: 30 and though this official lie was formerly extremely fashionable among the ancients, and might be useful to the moderns, his soul was too pure to depart from truth. "Mademoiselle Cunegonde," said he, "is about to do me the honor of marrying me, and we beg your excellency to be present at the wedding." Don Fernando d'Ibaraa y Figuerora y Mascarenes y Lampourdos y Souza twisted his moustache, smiled bitterly and ordered Captain Candide to go and inspect his company. Candide obeyed; the governor 40 remained with Mademoiselle Cunegonde. He declared his passion, vowed that the next day he would marry her publicly, or otherwise, as it might please her charms. Cunegonde asked for a quarter of an hour to collect herself, to consult the old woman and to make up her mind. The old woman said to Cunegonde: "You have seventy-two quarterings and you haven't a shilling; it is in your power to be the wife of the greatest Lord in South America, who has an exceedingly fine moustache; is it for you to pride 50 yourself on a rigid fidelity? You have been raped by Bulgarians, a Jew and an Inquisitor have enjoyed your good graces; misfortunes confer certain rights. If I were in your place, I confess I should not have the least scruple in marrying the governor and making Captain Candide's fortune." While the old woman was speaking with all that prudence which comes from age and experience, they saw a small ship come into the harbor; an Alcayde and some Alguazils were

on board, and this is what had happened. The old 60 woman had guessed correctly that it was a longsleeved monk who stole Cunegonde's money and jewels at Badajoz, when she was flying in all haste with Candide. The monk tried to sell some of the gems to a jeweller. The merchant recognized them as the property of the Grand Inquisitor. Before the monk was hanged he confessed that he had stolen them; he described the persons and the direction they were taking. The flight of Cunegonde and Candide was already known. They were followed to Cadiz; 70 without any waste of time a vessel was sent in pursuit of them. The vessel was already in the harbor at Buenos Ayres. The rumor spread that an Alcayde was about to land and that he was in pursuit of the murderers of His Lordship the Grand Inquisitor. The prudent old woman saw in a moment what was about to be done. "You cannot escape," she said to Cunegonde, "and you have nothing to fear; you did not kill His Lordship; moreover, the governor is in love with you and will not allow you to be mal-80 treated; stay here." She ran to Candide at once. "Fly," said she, "or in an hour's time you will be burned." There was not a moment to lose; but how could he leave Cunegonde and where could he take refuge?

By the beginning of chapter 26, where our second selection opens, Candide has lost both Cunegonde and his personal servant Cacambo but gained Martin, his pessimistic friend. After his reunion with Cacambo and their extraordinary experience at the inn he sets out for Constantinople and Cunegonde, while Voltaire begins to pull the threads of his narrative together. Both Dr. Pangloss and Cunegonde's brother turn up yet again, the doctor still refusing to budge from his philosophical position. The lovers' meeting in chapter 29 is handled with typical cynicism, while the last chapter reassesses the views on life we have heard. It ends with Candide's resigned but by no means hopeless conclusion.

XXVI

How Candide and Martin supped with six strangers and who they were

One evening when Candide and Martin were going to sit down to table with the strangers who lodged in the same hotel, a man with a face the color of soot came up to him from behind and, taking him by the arm, said: "Get ready to come with us, and do not fail." He turned round and saw Cacambo. Only the sight of Cunegonde could have surprised and pleased him more. He was almost wild with joy. He embraced his dear friend. "Cunegonde is here, of course? Where is she? Take me to her, let me die of 10 joy with her." "Cunegonde is not here," said Cacambo. "She is in Constantinople." "Heavens! In Constantinople! But were she in China, I would fly to her; let us start at once." "We will start after supper," replied Cacambo. "I cannot tell you any more; I am a slave, and my master is waiting for me; I must go and serve him at table! Do not say anything; eat your supper and be in readiness." Candide, torn between joy and grief, charmed to see his faithful agent again, amazed to see him a slave, filled with the idea 20 of seeing his mistress again, with turmoil in his heart, agitation in his mind, sat down to table with Martin (who met every strange occurrence with the same calmness), and with six strangers, who had come to spend the Carnival at Venice. Cacambo, who acted as butler to one of the strangers, bent down to his master's head towards the end of the meal and said: "Sire, your Majesty can leave when you wish, the ship is ready." After saying this, Cacambo withdrew. The guests looked at each other with surprise without 30 saying a word, when another servant came up to his master and said: "Sire, your Majesty's post-chaise is at Padua, and the boat is ready." The master made a sign and the servant departed. Once more all the guests looked at each other, and the general surprise doubled. A third servant went up to the third stranger and said: "Sire, believe me, your Majesty cannot remain here any longer; I will prepare everything." And he immediately disappeared. Candide and Martin had no doubt that this was a Carnival masquer- 40 ade. A fourth servant said to the fourth master: "Your Majesty can leave when you wish." And he went out like the others. The fifth servant spoke similarly to the fifth master. But the sixth servant spoke differently to the sixth stranger who was next to Candide, and said: "Faith, sire, they will not give your Majesty any more credit nor me either, and we may very likely be jailed to-night, both of us; I am going to look to my own affairs, good-bye." When the servants had all gone, the six strangers, Candide 50 and Martin remained in profound silence. At last it was broken by Candide. "Gentlemen," said he, "this is a curious jest. How is it you are all kings? I confess that neither Martin nor I are kings." Cacambo's master then gravely spoke and said in Italian: "I am not jesting, my name is Achmet III. For several years I was Sultan; I dethroned my brother; my nephew dethroned me; they cut off the heads of my viziers; I am ending my days in the old seraglio; my nephew, Sultan Mahmoud, sometimes allows me to travel for my 60 health, and I have come to spend the Carnival at Venice." A young man who sat next to Achmet spoke after him and said: "My name is Ivan; I was Emperor of all the Russias; I was dethroned in my cradle; my father and mother were imprisoned and I was brought up in prison; I sometimes have permission to travel, accompanied by those who guard me, and I

have come to spend the Carnival at Venice." The third said: "I am Charles Edward, King of England; my father gave up his rights to the throne to me and I 70 fought a war to assert them; the hearts of eight hundred of my adherents were torn out and dashed in their faces. I have been in prison; I am going to Rome to visit the King, my father, who is dethroned like my grandfather and me; and I have come to spend the Carnival at Venice." The fourth then spoke and said: "I am the King of Poland; the chance of war deprived me of my hereditary states; my father endured the same reverse of fortune; I am resigned to Providence like the Sultan Achmet, the Emperor Ivan and King 80 Charles Edward, to whom God grant long life; and I have come to spend the Carnival at Venice." The fifth said: "I also am the King of Poland: I have lost my kingdom twice; but Providence has given me another state in which I have been able to do more good than all the kings of the Sarmatians together have been ever able to do on the banks of the Vistula; I also am resigned to Providence and I have come to spend the Carnival at Venice." It was now for the sixth monarch to speak. "Gentlemen," said he, "I am 90 not so eminent as you; but I have been a king like anyone else. I am Theodore; I was elected King of Corsica; I have been called Your Majesty and now I am barely called Sir. I have coined money and do not own a farthing; I have had two Secretarics of State and now have scarcely a valet; I have occupied a throne and for a long time lay on straw in a London prison. I am much afraid I shall be treated in the same way here, although I have come, like your Majesties, to spend the Carnival at Venice." The five other 100 kings listened to this speech with a noble compassion. Each of them gave King Theodore twenty sequins to buy clothes and shirts; Candide presented him with a diamond worth two thousand sequins. "Who is this man," said the five kings, "who is able to give a hundred times as much as any of us, and who gives it?" As they were leaving the table, there came to the same hotel four serene highnesses who had also lost their states in the chance of war, and who had come to spend the rest of the Carnival at 110 Venice; but Candide did not even notice these newcomers. He could think of nothing but of going to Constantinople to find his dear Cunegonde.

XXVII

Candide's voyage to Constantinople

The faithful Cacambo had already spoken to the Turkish captain who was to take Sultan Achmet back to Constantinople and had obtained permission for Candide and Martin to come on board. They both entered this ship after having prostrated themselves before his miserable Highness. On the way, Candide said to Martin: "So we have just supped with six dethroned kings! And among those six kings there was one to whom I gave charity. Perhaps there are many other princes still more unfortunate. Now, I 10 have only lost a hundred sheep and I am hastening to Cunegonde's arms. My dear Martin, once more, Pangloss was right, all is well." "I hope so," said Martin. "But," said Candide, "this is a very singular experience we have just had at Venice. Nobody has ever seen or heard of six dethroned kings supping together in a tavern." "Tis no more extraordinary, said Martin, "than most of the things which have happened to us. It is very common for kings to be dethroned; and as to the honor we have had of sup- 20 ping with them, 'tis a trifle not deserving our attention." Scarcely had Candide entered the ship when he threw his arms round the neck of his old valet, of his friend Cacambo. "Well!" said he, "what is Cunegonde doing? Is she still a marvel of beauty? Does she still love me? How is she? Of course you have bought her a palace in Constantinople?" "My dear master," replied Cacambo, "Cunegonde is washing dishes on the banks of Propontis for a prince who possesses very few dishes; she is a slave in the 30 house of a former sovereign named Ragotsky, who receives in his refuge three crowns a day from the Grand Turk; but what is even sadder is that she has lost her beauty and has become horribly ugly." "Ah! beautiful or ugly," said Candide, "I am a man of honor and my duty is to love her always. But how can she be reduced to so abject a condition with the five or six millions you carried off?" "Ah! said Cacambo, "did I not have to give two millions to Senor Don Fernando d'Ibaraa y Figueora y Mas-40 carenes y Lampourdos y Souza, Governor of Buenos Ayres, for permission to bring away Mademoiselle Cunegonde? And did not a pirate bravely strip us of all the rest? And did not this pirate take us to Cape Matapan, to Milo, to Nicaria, to Samos, to Petra, to the Dardanelles, to Marmora, to Scutari? Cunegonde and the old woman are servants to the prince I mentioned, and I am slave to the dethroned Sultan." "What a chain of terrible calamities!" said Candide. "But after all, I still have a few diamonds; I shall 50 easily deliver Cunegonde. What a pity she has become so ugly." Then turning to Martin, he said: "Who do you think is the most to be pitied, the Sultan Achmet, the Emperor Ivan, King Charles Edward, or me?" "I do not know at all," said Martin. "I should have to be in your hearts to know." "Ah!" said Candide, "if Pangloss were here he would know and would tell us." "I do not know," said Martin, "what scales your Pangloss would use to weigh the misfortunes of men and to estimate their sufferings. 60 All I presume is that there are millions of men on the earth a hundred times more to be pitied than King Charles Edward, the Emperor Ivan and the Sultan

Achmet." "That may very well be," said Candide. In a few days they reached the Black Sea channel. Candide began by paying a high ransom for Cacambo and, without wasting time, he went on board a galley with his companions bound for the shores of Propontis, in order to find Cunegonde however ugly she might be. Among the galley slaves were two 70 convicts who rowed very badly and from time to time the Levantine captain applied several strokes of a bull's pizzle to their naked shoulders. From a natural feeling of pity Candide watched them more attentively than the other galley slaves and went up to them. Some features of their disfigured faces appeared to him to have some resemblance to Pangloss and the wretched Jesuit, the Baron, Mademoiselle Cunegonde's brother. This idea disturbed and saddened him. He looked at them still more carefully. 80 "Truly," said he to Cacambo, "if I had not seen Doctor Pangloss hanged, and if I had not been so unfortunate as to kill the Baron, I should think they were rowing in this galley." At the words Baron and Pangloss, the two convicts gave a loud cry, stopped on their seats and dropped their oars. The Levantine captain ran up to them and the lashes with the bull's pizzle were redoubled. "Stop! Stop, sir!" cried Candide. "I will give you as much money as you want." "What! Is it Candide?" said one of the convicts. 90 "What! Is it Candide?" said the other. "Is it a dream?" said Candide. "Am I awake? Am I in this galley? Is that my Lord the Baron whom I killed? Is that Doctor Pangloss whom I saw hanged?" "It is, it is," they replied. "What! Is that the great philosopher?" said Martin. "Ah! sir," said Candide to the Levantine captain, "how much money do you want for My Lord Thunder-ten-tronckh, one of the first Barons of the empire, and for Dotor Pangloss, the most profound metaphysician of Germany?" "Dog 100 of a Christian," replied the Levantine captain, "since these two dogs of Christian convicts are Barons and metaphysicians, which no doubt is a high rank in their country, you shall pay me fifty thousand sequins." "You shall have them, sir. Row back to Constantinople like lightning and you shall be paid at once. But, no, take me to Mademoiselle Cunegonde." The captain, at Candide's first offer had already turned the bow towards the town, and rowed there more swiftly than a bird cleaves the air. 110 Candide embraced the Baron and Pangloss a hundred times. "How was it I did not kill you, my dear Baron? And, my dear Pangloss, how do you happen to be alive after having been hanged? And why are you both in a Turkish galley?" "Is it really true that my dear sister is in this country?" said the Baron. "Yes," replied Cacambo. "So once more I see my dear Candide!" cried Pangloss. Candide introduced Martin and Cacambo. They all embraced and all talked at the same time. The galley flew; already they 120 were in the harbor. They sent for a Jew, and Candide sold him for fifty thousand sequins a diamond worth a hundred thousand, for which he swore by Abraham he could not give any more. The ransom of the Baron and Pangloss was immediately paid. Pangloss threw himself at the feet of his liberator and bathed them with tears; the other thanked him with a nod and promised to repay the money at the first opportunity. "But is it possible that my sister is in Turkey?" said he. "Nothing is so possible," replied 130 Cacambo, "since she washes the dishes of a prince of Transylvania." They immediately sent for two Jews; Candide sold some more diamonds; and they all set out in another galley to rescue Cunegonde.

XXVIII

What happened to Candide, to Cunegonde, to Pangloss, to Martin, etc.

"Pardon once more," said Candide to the Baron, "pardon me, reverend father, for having thrust my sword through your body." "Let us say no more about it," said the Baron. "I admit I was a little too sharp; but since you wish to know how it was you saw me in a galley, I must tell you that after my wound was healed by the brother apothecary of the college, I was attacked and carried off by a Spanish raiding party; I was imprisoned in Buenos Ayres at the time when my sister had just left. I asked to re- 10 turn to the Vicar-General in Rome. I was ordered to Constantinople to act as almoner to the Ambassador of France. A week after I had taken up my office I met towards evening a very handsome young page of the Sultan. It was very hot; the young man wished to bathe; I took the opportunity to bathe also. I did not know that it was a most serious crime for a Christian to be found naked with a young Mahometan. A cadi sentenced me to a hundred strokes on the soles of my feet and condemned me to the galley. I do not think a 20 more horrible injustice has ever been committed. But I should very much like to know why my sister is in the kitchen of a Transylvanian sovereign living in exile among the Turks." "But, my dear Pangloss," said Candide, "how does it happen that I see you once more?" "It is true," said Pangloss, "that you saw me hanged; and in the natural course of events I should have been burned. But you remember, it poured with rain when they were going to roast me; the storm was so violent that they despaired of light-30 ing the fire; I was hanged because they could do nothing better; a surgeon bought my body, carried me home and dissected me. He first made a crucial incision in me from the navel to the collar-bone. Nobody could have been worse hanged than I was. The executioner of the holy Inquisition, who was a sub-deacon, was marvellously skilful in burning people, but he was not used to hanging them; the rope

was wet and did not slide easily and it was knotted; in short, I still breathed. The crucial incision caused me 40 to utter so loud a scream that the surgeon fell over backwards and, thinking he was dissecting the devil, fled away in terror and fell down the staircase in his flight. His wife ran in from another room at the noise; she saw me stretched out on the table with my crucial incision; she was still more frightened than her husband, fled, and fell on top of him. When they had recovered a little, I heard the surgeon's wife say to the surgeon: 'My dear, what were you thinking of, to dissect a heretic? Don't you know the devil always 50 possesses them? I will go and get a priest at once to exorcise him.' At this I shuddered and collected the little strength I had left to shout: 'Have pity on me!' At last the Portuguese barber grew bolder; he sewed up my skin; his wife even took care of me, and at the end of a fortnight I was able to walk again. The barber found me a situation and made me lackey to a Knight of Malta who was going to Venice; but, as my master had no money to pay me wages, I entered the service of a Venetian merchant and followed him 60 to Constantinople. One day I took it into my head to enter a mosque: there was nobody there except an old Imam and a very pretty young devotee who was reciting her prayers; her breasts were entirely unconvered; between them she wore a bunch of tulips, anemones, ranunculus, hyacinths auriculas; she dropped her bunch of flowers; I picked it up and returned it to her with a most respectful alacrity. I was so long putting them back that the Imam grew angry and, seeing I was a Christian, 70 called for help. I was taken to the cadi, who sentenced me to receive a hundred strokes on the soles of my feet and sent me to the galleys. I was chained on the same seat and in the same galley as My Lord the Baron. In this galley there were four young men from Marseilles, five Neapolitan priests and two monks from Corfu, who assured us that similar accidents occurred every day. His Lordship the Baron claimed that he had suffered a greater injustice than I; and I claimed that it was much more permissible to 80 replace a bunch of flowers between a woman's breasts than to be naked with one of the Sultan's pages. We argued continually, and every day received twenty strokes of the bull's pizzle, when the chain of events of this universe led you to our galley and you ransomed us." "Well! my dear Pangloss," said Candide, "when you were hanged, dissected, stunned with blows and made to row in the galleys, did you always think that everything was for the best in this world?" "I am still of my first opinion," re-90 plied Pangloss, "for after all I am a philosopher; and it would be unbecoming for me to recant, since Leibnitz could not be in the wrong and pre-established harmony is the finest thing imaginable like the plenum and subtle matter."

XXIX

How Candide found Cunegonde and the old woman again

While Candide, the Baron, Pangloss, Martin and Cacambo were relating their adventures, reasoning upon contingent or noncontingent events of the universe, arguing about effects and causes, moral and physical evil, free-will and necessity, and the consolations to be found in the Turkish galleys, they came to the house of the Transylvanian prince on the shores of Propontis. The first objects which met their sight were Cunegonde and the old woman hanging out towels to dry on the line. At this sight the Baron 10 grew pale. Candide, that tender lover, seeing his fair Cunegonde sunburned, blear-eyed, flat-breasted, with wrinkles round her eyes and red, chapped arms, recoiled three paces in horror, and then advanced from mere politeness. She embraced Candide and her brother. They embraced the old woman; Candide bought them both. In the neighborhood was a little farm; the old woman suggested that Candide should buy it, until some better fate befell the group. Cunegonde did not know that she had become ugly, 20 for nobody had told her so; she reminded Candide of his promises in so peremptory a tone that the good Candide dared not refuse her. He therefore informed the Baron that he was about to marry his sister. "Never," said the Baron, "will I endure such baseness on her part and such insolence on yours; nobody shall ever reproach me with this infamy; my sister's children could never enter the noble assemblies of Germany. No, my sister shall never marry anyone but a Baron of the Empire." Cunegonde threw her- 30 self at his feet and bathed him in tears; but he was inflexible. "Madman," said Candide, "I rescued you from the galleys, I paid your ransom and your sister's; she was washing dishes here, she is ugly, I am so kind as to make her my wife, and you pretend to oppose me! I should kill you again if I listened to my anger." "You may kill me again," said the Baron, "but you shall never marry my sister while I am alive.'

XXX

Conclusion

At the bottom of his heart Candide had not the least wish to marry Cunegonde. But the Baron's extreme impertinence determined him to complete the marriage, and Cunegonde urged it so warmly that he could not retract. He consulted Pangloss, Martin and the faithful Cacambo. Pangloss wrote an excellent memorandum by which he proved that the Baron had no rights over his sister and that by all the laws of the empire she could make a left-handed marriage with Candide. Martin advised that the Baron should 10 be thrown into the sea; Cacambo decided that he should be returned to the Levantine captain and sent back to the galleys, after which he could be returned by the first ship to the Vicar-General at Rome. This was thought to be very good advice; the old woman approved it; they said nothing to the sister; the plan was carried out with the aid of a little money and they had the pleasure of duping a Jesuit and punishing the pride of a German Baron.

It would be natural to suppose that when, after so 20 many disasters, Candide was married to his mistress. and living with the philosopher Pangloss, the philosopher Martin, the prudent Cacambo and the old woman, having brought back so many diamonds from the country of the ancient Incas, he would lead the most pleasant life imaginable. But he was so cheated by the Jews that he had nothing left but his little farm; his wife, growing uglier every day, became shrewish and unendurable: the old woman was ailing and even more bad-tempered than Cunegonde. 30 Cacambo, who worked in the garden and then went to Constantinople to sell vegetables, was overworked and cursed his fate. Pangloss was in despair because he did not shine in some German university. As for Martin, he was firmly convinced that people are equally uncomfortable everywhere; he accepted things patiently. Candide, Martin and Pangloss sometimes argued about metaphysics and morals. From the windows of the farm they often watched the ships going by, filled with effendis, pashas, and cadis, who were being exiled to Lemnos, to Mitylene and Erzerum. They saw other cadis, other pashas and 40 other effendis coming back to take the place of the exiles and to be exiled in their turn. They saw the neatly impaled heads which were taken to the Sublime Porte. These sights redoubled their discussions; and when they were not arguing, the boredom was so excessive that one day the old woman dared to say to them: "I should like to know which is worse, to be raped a hundred times by Negro pirates, to have a 50 buttock cut off, to run the gauntlet among the Bulgarians, to be whipped and flogged in an auto-da-fé, to be dissected, to row in a galley, in short, to endure all the miseries through which we have passed, or to remain here doing nothing?" "Tis a great question." said Candide.

These remarks led to new reflections, and Martin especially concluded that man was born to live in the convulsions of distress or in the lethargy of boredom. Candide did not agree, but he asserted nothing. 60 Pangloss confessed that he had always suffered horribly; but, having once maintained that everything was for the best, he had continued to maintain it without believing it.

One thing confirmed Martin in his detestable principles, made Candide hesitate more than ever, and embarrassed Pangloss. And it was this. One day

there came to their farm Paquette and Friar Giroflée, who were in the most extreme misery; they had soon wasted their three thousand piastres, had left each 70 other, made up, quarrelled again, been put in prison, escaped, and finally Friar Giroflée had turned Turk. Paquette continued her occupation everywhere and now earned nothing by it. "I foresaw," said Martin to Candide, "that your gifts would soon be wasted and would only make them the more miserable. You and Cacambo were once bloated with millions of piastres and you are no happier than Friar Giroflée and Paquette." "Ah! Ha!" said Pangloss to Paquette, "so Heaven brings you back to us, my dear child? Do 80 you know that you cost me the end of my nose, an eye and an ear! What a plight you are in! Ah! What a world this is!" This new occurrence caused them to philosophize more than ever.

In the neighborhood there lived a very famous Dervish, who was supposed to be the best philosopher in Turkey; they went to consult him; Pangloss was the spokesman and said: "Master, we have come to beg you to tell us why so strange an animal as man was ever created." "What has it to do with you?" 90 said the Dervish, "Is it your business?" "But, reverend father," said Candide, "there is a horrible amount of evil in the world." "What does it matter," said the Dervish, "whether there is evil or good? When his highness sends a ship to Egypt, does he worry about the comfort or discomfort of the rats in the ship?" "Then what should we do?" said Pangloss. "Hold your tongue," said the Dervish. "I flattered myself." said Pangloss, "that I should discuss with you effects and causes, this best of all possi-100 Pangloss, "for, when man was placed in the Garden ble worlds, the origin of evil, the nature of the soul and pre-established harmony." At these words the Dervish slammed the door in their faces.

During this conversation the news went round that at Constantinople two viziers and the mufti had been strangled and several of their friends impaled. This catastrophe made a prodigious noise everywhere for several hours. As Pangloss, Candide and Martin were returning to their little farm, they came upon an old man who was taking the air under a 110 bower of orange-trees at his door. Pangloss, who was as curious as he was argumentative, asked him what was the name of the mufti who had just been strangled. "I do not know," replied the old man. "I have never known the name of any mufti or of any vizier. I am entirely ignorant of the occurrence you mention; I presume that in general those who meddle with public affairs sometimes perish miserably and that they deserve it; but I never inquire what is going on in Constantinople; I content myself with sending 120 there for sale the produce of the garden I cultivate.' Having spoken thus, he took the strangers into his house. His two daughters and his two sons presented them with several kinds of sherbet which they made

themselves, caymac flavored with candied citron peel, ornages, lemons, limes, pineapples, dates, pistachios and Mocha coffe which had not been mixed with the bad coffee of Batavia and the Isles. After which this good Mussulman's two daughters perfumed the beards of Candide, Pangloss and Martin. 130 "You must have a vast and magnificent estate?" said Candide to the Turk. "I have only twenty acres," replied the Turk. "I cultivate them with my children; and work keeps at bay three great evils: boredom, vice and need.'

As Candide returned to his farm he reflected deeply on the Turk's remarks. He said to Pangloss and Martin: "That good old man seems to me to have chosen an existence preferably by far to that of the six kings with whom we had the honor to sup." 140 "Exalted rank," said Pangloss, "is very dangerous, according to the testimony of all philosophers; for Eglon, King of the Moabites, was murdered by Ehud; Absolom was hanged by the hair and pierced by three darts; King Nadab, son of Jeroboam, was killed by Baasha; King Elah by Zimri; Ahaziah by Jehu; Athaliah by Jehoiada; the Kings Jehoiakim, Jeconiah and Zedekiah were made slaves. You know in what manner died Croesus, Astyages, Darius, Denvs of Syracuse, Pyrrhus, Perseus, Hannibal, 150 Jugurtha, Ariovistus, Caesar, Pompey, Nero, Otho, Vitellius, Domitian, Richard II of England, Edward II. Henry VI, Richard III, Mary Stuart, Charles I, the three Henrys of France, the Emperor Henry IV. You know . . ." "I also know," said Candide, "that we should cultivate our garden." "You are right," said of Eden, he was placed there ut operaretur eum, to dress it and to keep it; which proves that man was not born for idleness." "Let us work without theoriz-160 ing," said Martin, "tis the only way to make life endurable."

The whole small fraternity entered into this praiseworthy plan, and each started to make use of his talents. The little farm yielded well. Cunegonde was indeed very ugly, but she became an excellent pastry-cook; Paquette embroidered; the old woman took care of the linen. Even Friar Giroflée performed some service; he was a very good carpenter and even became a man of honor; and Pangloss sometimes said to Candide: "All events are linked up in this best of 170 all possible worlds; for, if you had not been expelled from the noble castle, by hard kicks in your backside for love of Mademoiselle Cunegonde, if you had not been clapped into the Inquisition, if you had not wandered about America on foot, if you had not stuck your sword in the Baron, if you had not lost all your sheep from the land of Eldorado, you would not be eating candied citrons and pistachios here." "That's well said," replied Candide, "but we must cultivate our garden."

1870

1789

1789 French Revolution begins
1793-1795 Reign of Terror in
France
1799-1804
Napoleon rules
France as consul

1804-1814 Napoleon rules France as emperor 1812 Failure of Napoleon's Russian campaign 1814 Napoleon exiled to Elba.

Stephenson's first locomotive.

1814-1815 Congress of Vienna

1815 Napoleon escapes Elba; defeated at Battle of Waterloo 1815-1850 Industrialization of England

1816 Wreck of French vessel Medusa

1821 Death of Napoleon 1821-1829 Greek War of Independence against Turks

1830-1860 Industrialization of France and Belgium 1837-1901 Reign of Queen Victoria in England

1840-1870 Industrialization of Germany

1848 Revolutionary uprisings

throughout Europe 1859 Darwin publishes theory of evolution, *Origin of Species* 1860-1870 Unification of Italy 1861-1865 American Civil War 1866-1871 Unified Germany

1867 Canada granted dominion status

1869 First transcontinental railroad completed in America

1773 Goethe leads Sturm und Drang movement against neoclassicism

1774 Goethe, The Sufferings of Young Werther

1790 Kant, The Critique of Judgment, expounding Transcendental Idealism

1794 Blake, "London"

1798 Wordsworth, "Tintern Abbey"

1807-1830 Philosophy of Hegel published in Germany

1808 Goethe's Faust, Part I

1819 Schopenhauer, The World as Will and Idea

c. 1820 English romantic peak 1820 Shelley, *Prometheus Unbound*

1821 Byron, Don Juan

1824 Byron dies in Greece

1829-1847 Balzac, *The Human Comedy*, 90 realistic novels

1832 Goethe, Faust, Part II 1836-1860 Transcendentalist

movement in New England 1837-1838 Dickens, Oliver Twist

1846 Sand, Lucrezia Floriani

1847 E. Brontë, Wuthering Heights

1848 Marx, Communist Manifesto 1851 Melville, Moby-Dick

1853 Dickens, Bleak House

1854 Thoreau, Walden

1855 First edition of Whitman's *Leaves of Grass*

1856-1857 Flaubert, Madame Bovary

1862 Hugo, Les Misérables 1869 Tolstoy, War and Peace c. 1774 Copley leaves Boston to study in England 1784-1785 David, Oath of the Horatii

1799 David, The Battle of the Romans and the Sabines. Goya becomes court painter to Charles IV of Spain; The Family of Charles IV (1800)

19th cent. Romantic emphasis on emotion, nature, exotic images, faraway lands

1808 Girodet, *The Entombment of Atala*, inspired by Chateaubriand's romantic novel *Atala*

1810 Friedrich, Cloister Graveyard in the Snow

1811 Ingres, Jupiter and Thetis 1814 Goya, Executions of May 3, 1808, a retreat from idealism in art

1818-1819 Géricault,
Rafi of the Medusa, first exhibited 1819

1820-1822 Goya paints nightmare scenes on walls of his house; Saturn Devouring One of His Sons

1824 Delacroix, Massacre at Chios

1827 Delacroix, The Death of Sardanapalus

c. 1830 Social realism follows romanticism; Daumier, Th Legislative Belly (1834)

1836 Constable, Stoke-by-Nayland

1844 Turner, Rain, Steam, and Speed

c. 1847 Development of national styles. American artists influenced by Transcendentalism; Cole, *View of the Falls of Munda* (1847)

1854-1855 Courbet, The Painter's Studio

c. 1860 American luminist painting develops; Heade, Lake George (1862)

1866 Homer, Prisoners from the Front, chronicles Civil War

1873-1877 Tolstoy, Anna Karenina 1870 Corot, Ville d'Avray

c. 1880 Eakins uses photography and scientific techniques in search for realism; *The Swimming Hole* (1883)

ARCHITECTURE MUSIC

1788 Mozart composes last three symphonies

1785-1796 Jefferson, State Capitol, Richmond, Virginia 1795 Debut of Beethoven as pianist

Development from classical to romantic music most evident in work of Beethoven; "Pathetique" *Sonata* (1799)

1804 First performance of Beethoven's "Eroica" *Symphony*, originally meant to honor Napoleon

1814 Beethoven's opera Fidelio performed

19th cent. Sequence of revival styles: neoclassical, neo-Gothic, neo-Renaissance; forms affected by growth of industry and technology

1836 Barry and Pugin begin neo-Gothic Houses of Parliament, London

1861-1874 Garnier, Opéra, Paris

1865 Reynaud, Gare du Nord, Paris c. 1815-1828 Schubert creates genre of art song (*lied*), setting to music poetry of Goethe, Schiller, others

1822 Schubert, "Unfinished" Symphony

1824 First performance of Beethoven's Symphony No. 9; finale is choral version of Schiller's "Ode to Joy"

1830 Berlioz, Fantastic Symphony

1831 Bellini's bel canto opera Norma performed

1835 Donizetti, Lucia di Lammermoor

c. 1835-c. 1845 Virtuoso performance at peak; brilliant composer-performers create works of immense technical difficulty: Chopin, Piano Sonata in B^b Minor, Op. 35 (1839)

1839 Chopin completes Twenty-Four Preludes, Op. 28

1842 Verdi's *Nabucco* performed; symbolic of Italians' suffering under Austrian rule

1846 Berlioz, The Damnation of Faust

1853 First performances of Verdi's Il Trovatore and La Traviata, the latter based on Dumas' novel The Lady of the Camelias

1853-1874 Wagner, The Ring of the Nibelung; first staged at new Bayreuth opera house 1876

1865 Wagner experiments with harmony in Tristan and Isolde

1874 First production of Mussorgsky's opera Boris Godunov in St. Petersburg

1876 Brahms, Symphony No. 1 in C Minor

1882 Wagner, Parsifal

1887 Verdi, Otello; Bruckner begins Symphony No. 8 in C Minor 15

The Romantic Era

The Concerns of Romanticism

The tide of revolution that swept away much of the old political order in Europe and America in the last quarter of the 18th century had momentous consequences for the arts. Both the American and the French revolutions had, in fact, used art as a means of expressing their spiritual rejection of the artistocratic society against which they were physically rebelling, and both had adopted the neoclassical style to do so. Jacques Louis David's images of stern Roman virtue [see figure 14.1, page 207] and Jefferson's evocation of the simple grandeur of classical architecture [see figure 14.17, page 217] represented, as it were, the revolutionaries' view of themselves and their accomplishments. Neoclassicism, however, barely survived into the beginning of the 19th century. The movement that replaced it, romanticism, eventually dominated virtually every aspect of 19th-century artistic achievement.

The essence of romanticism is particularly difficult to describe because romanticism is much more concerned with broad general attitudes than with specific stylistic features. Painters, writers, and musicians in the 19th century shared a number of concerns in their approach to their art. First was the important emphasis they placed on personal feelings and their expression. Ironically enough, the very revolutionary movements that had encouraged artists to rebel against the conventional styles of the early 18th century had themselves proved too restricting and conventional.

Second, emphasis on emotion rather than intellect led to the expression of subjective rather than objective visions; after all, the emotions known best are the ones we have experienced. The romantics used art to explore and dissect their own personal hopes and fears (more often the latter) rather than as a means to arrive at some general truth.

This in turn produced a third attitude of romanticism: its love of the fantastic and the exotic, which made it possible to probe more deeply into an individual's creative imagination. Dreams, for example, were a way of releasing the mind from the constraints of everyday experience and bringing to the surface those dark visions reason had submerged, as the Spanish artist Francisco Goya shows us unforgettably in a famous etching [15.1]. Artists felt free to invent their own dream worlds. Some chose to reconstruct such ages long past as the medieval period, which was particularly popular (Britain's Houses of Parliament [15.2] were begun in 1836 in the Gothic style of six centuries earlier). Others preferred to imagine remote and exotic lands and dreamed of life in the mysterious Orient or on a primitive desert is-

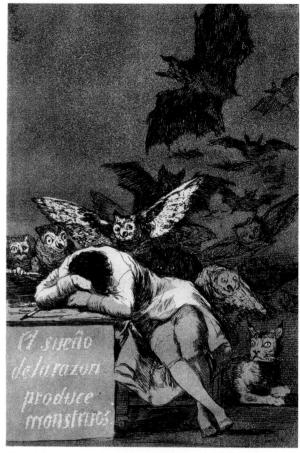

15.1 Francisco Goya. The Sleep of Reason Produces Monsters, from Los Caprichos. 1796-1798. Etching, $8\frac{1}{2} \times 6''$ (22 × 15 cm). Metropolitan Museum of Art, New York (gift of M. Knoedler & Company, 1918). The precise meaning of the work is not clear, but it evidently represents the inability of Reason to banish monstrous thoughts. Its title is written on the desk below the student, who sleeps with his head on his textbooks.

land. Still others simply trusted to the powers of their imagination and invented a fantasy world of their own

A fourth characteristic of much romantic art is a mystical attachment to the world of nature that was also the result of the search for new sensations. Painters turned increasingly to landscape, composers sought to evoke the rustling of leaves in a forest or the noise of a storm, and poets tried to express their sense of union with the natural world. Most 18thcentury artists had turned to nature in search of order and reason. In the 19th century the wild unpredictability of nature became emphasized, depicted neither objectively nor realistically but as a mirror of the artist's individual emotions. At the same time, the romantic communion with nature expressed a rejection of the classical notion of a world centered on human activity.

15.2 Charles Barry and A. W. N. Pugin. Houses of Parliament, London, 1836-1860. Length 940' (286.51 m). The relative symmetry of the facade is broken only by the placing of the towers-Gothic in style, as is the decorative detail.

These attitudes, and the new imaginative and creative power they unleashed, had two very different but equally important effects on the relationship between the artist and society. On one hand many creative artists became increasingly alienated from their public. Whereas they had once filled a precise role in providing entertainment or satisfying political and religious demands, now their self-expressive works met no particular needs except their own.

On the other hand, an increasing number of artists sought to express the national characteristics of their people by art. Abandoning the common artistic language of earlier periods and instead developing local styles that made use of traditional folk elements, artists were able to stimulate (and in some cases to initiate) the growth of national consciousness and the demand for national independence (see map, page 259). This was particularly effective in the Russian and Austrian empires (which incorporated many nationalities) and even in America, which had always been only on the fringe of the European cultural tradition, but it also became an increasingly strong tendency in the art of France and Italy, countries that had hitherto shared the same general culture. Thus at the same time, some artists were retreating into a private world of their own creation, but others were in the forefront of the social and political movements of their own age (Table 15.1).

The Intellectual Background

It might be expected that a movement like romanticism, which put a high value on the feelings of the

TABLE 15.1 Principal Characteristics of the Romantic Movement

The Expression of Personal Feelings Chopin, Preludes (p. 263) Goya, Family of Charles IV (15.11) Goethe, Sufferings of Young Werther (p. 278) Self-Analysis Berlioz, Fantastic Symphony (p. 262) Poetry of Keats (p. 280) Whitman, Leaves of Grass (p. 283) Love of the Fantastic and Exotic Music and performances of Paganini (p. 264) Girodet, Entombment of Atala (15.13) Delacroix, Death of Sandanapalus (15.16) Interest in Nature Beethoven, "Pastoral" Symphony (p. 262) Constable, Hay Wain (15.23) Poetry of Wordsworth (p. 279) Emerson, The American Scholar (p. 283) Nationalism and Political Commitment Verdi, Nabucco (p. 265) Smetana, My Fatherland (p. 264) Goya, Execution of the Madrileños (15.10) Byron's support of the Greeks (p. 279) Erotic Love and the Eternal Feminine Goethe, Faust, Part II (p. 279) Wagner, Tristan und Isolde (p. 267)

moment at the expense of conscious reason, would remain relatively unaffected by intellectual principles. Nonetheless, a number of romantic artists did in fact draw inspiration from contemporary philosophy. A rapid survey of the chief intellectual developments of the 19th century therefore provides a background to the artistic ones.

The ideas that proved most attractive to the romantic imagination had developed in Germany at the end of the 18th century. Their chief spokesman was Immanuel Kant (1724–1804), whose Critique of Judgment (1790) defined the pleasure we derive from art as "disinterested satisfaction." Kant conceived of art as uniting opposite principles: it unites the general with the particular, for example, and reason with the imagination. For Kant, the only analogy for the way in which art is at the same time useless and yet useful was to be found in the world of nature.

Even more influential than Kant was Georg Wilhelm Friedrich Hegel (1770–1831), whose ideas continued to affect attitudes toward art and artistic criticism into the 20th century. Like Kant, Hegel stressed art's ability to reconcile and make sense of opposites, and to provide a synthesis of the two opposing components of human existence, called thesis (pure, infinite being) and antithesis (the world of nature).

Both Kant and Hegel developed their ideas in the relatively optimistic intellectual climate of the late

18th and early 19th centuries, and their approach both to art and to existence is basically positive. A very different position was that of Arthur Schopenhauer (1788-1860), whose major work, The World as Will and Idea (1819), expresses the belief that the dominating will, or power, in the world is evil. At the time of its appearance, Schopenhauer's work made little impression, due in large measure to the popularity of Kant's and Hegel's idealism. Schopenhauer himself did not help matters by launching a bitter personal attack on Hegel. But the failure of the nationalist uprisings of 1848 in many parts of Europe produced a growing mood of pessimism and gloom. against which background Schopenhauer's vision of a world condemned perpetually to be ravaged by strife and misery seemed more convincing. Thus his philosophy, if it did not mold the romantic movement, came to reflect its growing despondency.

It must be admitted, of course, that many of the major developments in 19th-century thought had little direct impact on the contemporary arts. The most influential of all 19th-century philosophers was probably Karl Marx (1818-1883), whose belief in the inherent evil of capitalism and in the historical inevitability of the proletarian revolution was powerfully expressed in the Communist Manifesto of 1848.

Marx's belief that revolution was both unavoidable and necessary was based at least in part on his own observation of working conditions in industrial England, where his friend and fellow Communist Friedrich Engels (1820-1895) had inherited a textile factory. Marx and Engels both believed that the factory workers, although creating wealth for the middle classes, received no benefit from it for themselves. Living in overcrowded, unsanitary conditions, the workers were deprived of any effective political power, and only kept quiet by the drug of religion, which offered them the false hope of rewards in a future life. The plight of the working classes seemed to Marx to transcend all national boundaries and create a universal proletariat that could only achieve freedom through revolution: "Workers of the world, unite! You have nothing to lose but your chains!"

The drive to political action was underpinned by Marx's economic philosophy, with its emphasis on the value of labor and, more generally, on the supreme importance of economic and social conditions as the true moving forces behind historical events. This so-called materialist concept of history was to have worldwide repercussions in the century that followed Marx's death. In our own time, writers such as Bertolt Brecht (1898-1956) have embraced Marxist principles, and Marxist critics have developed a school of aesthetic criticism that applies standards based on Marxist doctrines. For the 19th and early

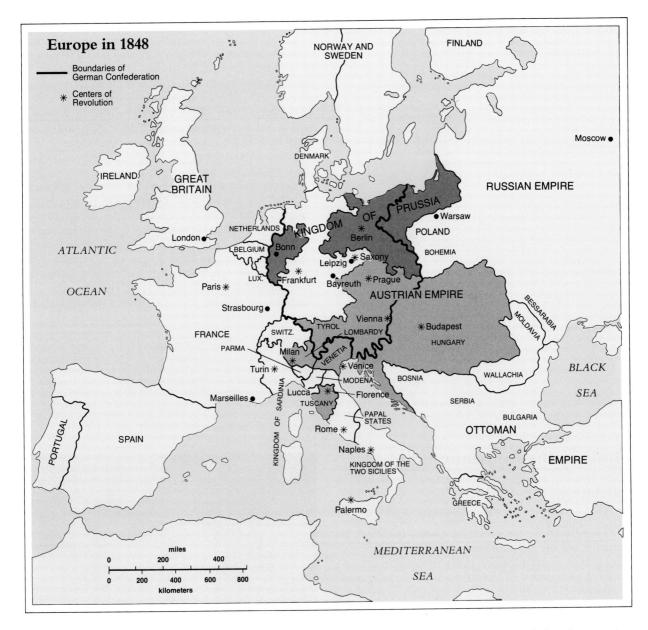

20th centuries, however, Marx's influence was exclusively social and political.

Achievements in science and technology are reflected to a certain extent in romantic art, although chiefly from a negative point of view. The growing industrialization of life in the great cities, and the effect of inventions like the railway train on urban architecture served to stimulate a "back-to-nature" movement. Many artists contrasted the growing problems of urban life with an idyllic (and highly imaginative) picture of rustic bliss.

Scientific ideas had something of the same negative effect on 19th-century artists. The English Victorian writers (so called after Queen Victoria, who reigned from 1837 to 1901) responded to the growing scientific materialism of the age. Although few were, strictly speaking, romantics, much of their resistance to progress in science and industry and their portraval of its evil effects has its roots in the romantic tradition. No scientific figure aroused more controversy than Charles Darwin (1809-1882), whose Origin of Species (1859) advanced the case for evolution. According to Darwin, living creatures had not been formed once and for all at the Creation, as described in Genesis, but had evolved over millennia according to a principle described by one of his supporters as "the survival of the fittest." The religious and social implications of Darwinism are still debated, but even

TABLE 15.2	19th-Century	Scientific and
Technological		

	-8
1814	Stephenson builds first locomotive
1821	Faraday discovers principle of electric dynamo
1825	Erie Canal opened in the United States First railway completed (England)
1839	Daguerre introduces his process of photography
1844	Morse perfects the telegraph
1853	First International Exhibition of Industry (New York)
1858	Transatlantic cable begun (completed 1866)
1859	Darwin publishes Origin of Species First oil well drilled (in Pennsylvania)
1867	Nobel invents dynamite
1869	Transcontinental Railway completed in the United States
	Suez Canal opened
1876	Bell patents the telephone
1877	Edison invents the phonograph
1885	First internal combustion engines using gasoline

in Darwin's own time evolutionary ideas were picked up, discussed, and developed (Table 15.2).

Music in the Romantic Era

Beethoven

For many of the romantics, music was the supreme art. Free from the intellectual concepts involved in language and the physical limits inherent in the visual arts, it was capable of the most wholehearted and intuitive expression of emotion. Since Ludwig van Beethoven (1770–1827), widely regarded as the pioneer of musical romanticism, also manifested many characteristically romantic attitudes—such as love of nature, passionate belief in the freedom of the individual, and fiery temperament—it is not surprising that he has come to be regarded as the prototype of the romantic artist [15.3]. When he wrote proudly to one of his most loyal aristocratic supporters "There will always be thousands of princes, but there is only one Beethoven," he spoke for a new generation of creators. When he used the last movement of his Symphony No. 9 to preach the doctrine of universal brotherhood he inspired countless ordinary listeners by his fervor. Even today familiarity with Beethoven's music has not dulled its ability to give dramatic expression to the noblest of human sentiments.

Although Beethoven's music served as the springboard for the Romantic movement in music, his own roots were deep in the classical tradition. He pushed to the limits classical forms like the sonata allegro. In spirit, furthermore, his work is representative of the Age of Enlightenment and the revolutionary mood of the turn of the century, as is proved by both the words and music of his opera Fidelio. A complex and many-sided genius, Beethoven transcended the achievements of the age in which he was born and set the musical tone for the 19th century.

Beethoven was born in Bonn, Germany, where he received his musical training from his father. An alcoholic, Beethoven's father saw the possibility of producing a musical prodigy in his son. He forced him to practice hours at the keyboard, often locking him in his room and beating him on his return from drinking bouts. All possibilities of a happy family life were brought to an end in 1787 by the death of Beethoven's mother and his father's subsequent de-

15.3 Ferdinand Georg Waldmüller. Ludwig van Beethoven. 1823. 28 × 22¾" (72 × 58 cm). Archiv Breitkopf und Härtel. Painted a year before the first performance of Beethoven's Symphony No. 9 in D minor, the portrait emphasizes the composer's stubborn independence by both the set of the mouth and the casual, even untidy, dress and hair. Beethoven, who had become irascible in his later years, allowed the artist only one sitting for this portrait commissioned by one of his music publishers.

cline into advanced alcoholism. Beethoven sought compensation in the home of the von Breuning family, where he acted as private tutor. It was there that he met other musicians and artists and developed a love of literature that he kept throughout his life. He also struck up a friendship with a local minor aristocrat, Count Waldstein, who remained his devoted admirer until the composer's death.

In 1792 Waldstein was one of the aristocrats who helped Beethoven go to Vienna to study with Haydn, then regarded as the greatest composer of his day; but although Haydn agreed to give him lessons, the young Beethoven's impatience and suspicion, and Haydn's deficiencies as a teacher, did not make for a happy relationship. Nevertheless, many of the works Beethoven wrote during his first years in Vienna are essentially classical in both form and spirit; only by the end of the century had he begun to extend the emotional range of his music.

One of the first pieces to express the characteristically Beethovenian spirit of rebellion against Fate and the determination to struggle on is his Piano Sonata No. 8 in C minor, Op. 13, generally known as the "Pathétique." The first movement begins with a slow introduction, but unlike similar introductions in the classical music of Haydn, it sets the emotional tone of the entire piece rather than merely capturing the listener's attention. As is so often the case, the significance of Beethoven's music is as easy to grasp on hearing as it is difficult to express in words. The heavy, foreboding chords seem to try to pull themselves up, only to fall back again and again in defeat, until finally they culminate in a burst of defiant energy that sets the main allegro (fast) portion of this movement on its stormy way. Just before the very end of the movement the ghost of the slow introduction returns briefly, as if to emphasize the odds against which the struggle has been-and will be-

It is important to understand precisely how Beethoven used music in a new and revolutionary way. Other composers had written music to express emotion long before Beethoven's time, from Bach's outpouring of religious fervor to Mozart's evocation of human joy and sorrow. What is different about Beethoven is that his emotion is autobiographical. His music tells us how he feels, what his succession of moods is, and what conclusion he reaches. It does other things at the same time, and at this early stage in his career for the most part it self-consciously follows classical principles of construction, but the vivid communication of personal emotions is its prime concern. That Beethoven's range was not limited to anger and frustration is immediately demonstrated by the beautiful and consoling middle slow movement of the "Pathétique," with its lyrical main theme, but the final movement returns to turbulent passion.

Parallels for the turbulent style of "Pathétique" can be found in other contemporary arts, especially literature, but although to some extent Beethoven was responding to the climate of the times, there can be no doubt that he was also expressing a personal reaction to the terrible tragedy that had begun to afflict him as early as 1796. In that year the first symptoms of his deafness began to appear; by 1798 his hearing had grown very weak, and by 1802 he was virtually totally deaf.

Nonetheless, although obviously affected by his condition, Beethoven's music was not exclusively concerned with his own fate. The same heroic attitude with which he faced his personal problems was also given universal expression, never more stupendously than in the Symphony No. 3 in Eb, Op. 55, subtitled the Eroica, the Heroic Symphony. As early as 1799 the French ambassador to Vienna had suggested that Beethoven write a symphony in honor of Napoleon Bonaparte. At the time Napoleon was widely regarded as a popular hero who had triumphed over his humble origins to rise to power as a champion of liberty and democracy. Beethoven's own democratic temperament made him one of Napoleon's many admirers. The symphony was duly begun, but in 1804, the year of its completion, Napoleon had himself crowned Emperor. When Beethoven heard the news, he angrily crossed out Napoleon's name on the title page. The first printed edition, which appeared in 1806, bore only the dedication "to celebrate the memory of a great man."

It would be a mistake to see the Eroica merely as a portrait of Napoleon. Rather, inspired by what he saw as the heroic stature of the Frenchman, Beethoven created his own heroic world in sound, in a work of vast dimensions. The first movement alone lasts for almost as long as many a classical symphony. Its complicated structure requires considerable concentration on the part of the listener. The form is basically the old classical sonata allegro form (see page 219), but on a much grander scale and with a wealth of musical ideas. Yet the principal theme of the movement, which the cellos announce at the very beginning, after two hammering, impatient chords demand our attention, is of a rocklike sturdiness and simplicity:

Beethoven's genius emerges as he uses this and other similarly straightforward ideas to build his mighty structure. Throughout the first movement his use of harmony and, in particular, discord, adds to the emotional impact, especially in the middle of the development section, where slashing dissonances seem to tear the orchestra apart. His classical grounding emerges in the recapitulation, where the infinite variety of the development section gives way to a restored sense of unity; the movement ends triumphantly with a long and thrilling coda. The formal structure is recognizably classical, but the intensity of expression, depth of personal commitment, and heroic defiance are all totally romantic.

The second movement of the Eroica is a worthy successor to the first. A funeral march on the same massive scale, it alternates a mood of epic tragedy, which has been compared with the impact of the works of the Greek playwright Aeschylus, with rays of consolation that at times achieve a transcendental exaltation. Although the many subtleties of construction deserve the closest attention, even a first hearing will reveal the grandeur of Beethoven's conception.

The third and fourth movements relax the tension. For the third, Beethoven replaces the stately minuet of the classical symphony with a scherzo—the word literally means joke and is used to describe a fast-moving, generally lighthearted piece of music. Beethoven's introduction of this kind of music, which in his hands often has something of the crude flavor of a peasant dance, is another illustration of his "democratization" of the symphony. The last movement is a brilliant and energetic series of variations on a theme Beethoven had composed a few years earlier for a ballet he had written on the subject (from classic mythology) of Prometheus, who defied the ancient gods by giving mortals the gift of fire, for which he was punished by Zeus—a final reference to the heroic mood of the entire work.

Many of the ideas and ideals that permeate the Eroica reappear throughout Beethoven's work. His love of liberty and hatred of oppression are expressed in his only opera, Fidelio, which describes how a faithful wife rescues her husband who has been unjustly imprisoned for his political views. A good performance of Fidelio is still one of the most uplifting and exalting experiences music has to offer. The concept of triumph over Fate recurs in his best-known symphony, the Fifth, Op. 67, while Symphony No. 6, Op. 68, the Pastoral, consists of a romantic evocation of nature and the emotions it arouses. Symphony No. 9, Op. 125, is perhaps the most complete statement of the human striving to conquer all obstacles and win through to universal peace and joy. In it Beethoven introduced a chorus and soloists to give voice to the "Ode to Joy" by his compatriot Friedrich Schiller (1759–1805). The symphony represents the most complete artistic vindication of Kant's Transcendental Idealism. It is also one of the most influential works of the entire romantic movement.

Instrumental Music after Beethoven

After Beethoven, music could never again return to its former mood of classical objectivity. Although Beethoven's music may remain unsurpassed for its universalization of individual emotion, his successors tried—and in large measure succeeded—to find new ways to express their own feelings. Among the first to follow Beethoven was Hector Berlioz (1803-1869), the most distinguished French romantic composer who produced, among other typically romantic works, the Fantastic Symphony, which describes the hallucinations of an opium-induced dream, and The Damnation of Faust, a setting of Part One of Goethe's work. In both of these he used the full romantic apparatus of dreams, witches, demons, and the grotesque to lay bare the artist's innermost feelings-although, like Goethe, he never lost an innately classical streak.

A much more intimate and poetic form of romantic self-revelation is the music of Franz Schubert (1797-1828), who explored in the few years before his premature death the new possibilities opened up by Beethoven in a wide range of musical forms. In general he was happiest when working on a small scale, as evidenced by his more than six hundred lieder (songs), which are an inexhaustible store of musical and emotional expression.

On the whole, the more rhetorical nature of the symphonic form appealed to Schubert less, although the wonderful Symphony No. 8 in B minor, called the "Unfinished" because he only completed two movements, combines great poetic feeling with a genuine sense of drama. His finest instrumental music was written for small groups of instruments. The two Trios for Piano, Violin, and Cello, Op. 99 and 100, are rich in the heavenly melodies that seemed to come to him so easily; the second, slow movement of the Trio in Eb, Op. 100, touches profound depths of romantic expression. Like the slow movement of Mozart's Piano Concerto No. 27 in Bb (see page 220), its extreme beauty is tinged with an unutterable sorrow. But whereas Mozart seems to speak for humanity at large, Schubert moves us most deeply by communicating his own personal feelings.

Most 19th-century composers followed Beethoven in using the symphony as the vehicle for their most serious musical ideas. Robert Schumann (1810-1856) and Johannes Brahms (1833-1897) regarded the symphonic form as the most lofty means of musical expression, and each as a result wrote only four symphonies. Brahms did not even dare to write a symphony until he was 44, and is said to have felt the presence of Beethoven's works "like the tramp of a giant" behind him. When it finally appeared, Brahms' Symphony No. 1 in C minor, Op. 68, was

inevitably compared with Beethoven. Although Brahms' strong sense of form and conservative style won him the hostility of the archromantics of the day, other critics hailed him as the true successor to Beethoven.

Both responses were, of course, extreme. Brahms' music certainly is romantic—with its emphasis on warm melody and a passion no less present for being held tightly in rein-but far from echoing the heaven-storming mood of his great predecessor, Brahms was really more at home in relaxed vein. Although the Symphony No. 1 begins with a gesture of defiant grandeur akin to Beethoven's, the first movement ends by fading dreamily into a glowing tranquility. The lovely slow movement is followed not by a scherzo but by a quiet and graceful intermezzo or interlude, and only in the last movement do we return to the mood of the opening.

Closer to the more cosmic mood of the Beethoven symphonies are the nine symphonies of Anton Bruckner (1824-1896). A deeply religious man imbued with a romantic attachment to the beauties of nature. Bruckner combined his devout Catholicism and mystical vision in music of epic grandeur. It has often been remarked that Bruckner's music requires time and patience on the listener's part. His pace is leisurely and he creates huge structures in sound that demand our full concentration if we are to appreciate their "architecture." There is no lack of incidental beauty, however, and the rewards are immense. No other composer has been able to convey quite the tone of mystical exaltation that Bruckner achieves, above all in the slow movements of his last three symphonies. The adagio movement from the Symphony No. 8 in C minor, for instance, moves from the desolate romanticism of its opening theme to a mighty, blazing climax as thrilling and stirring as anything in 19th-century music.

The Age of the Virtuosos

Beethoven's emphasis on the primacy of the artist inspired another series of romantic composers to move in a very different direction from that of the symphony. Beethoven himself had first made his reputation as a brilliant pianist, and much of his music, both for piano and for other instruments, was of considerable technical difficulty. As composers began to demand greater and greater feats of virtuosity from their performers, performing artists themselves came to attract more attention. Singers had already, in the 18th century, commanded high fees and attracted crowds of fanatical admirers, and continued to do so. Now, however, they were joined by instrumental virtuosos, some of whom were also highly successful composers.

15.4 Eugène Delacroix. Frédéric Chopin. 1838. Oil on canvas, $18 \times 15''$ (46 × 38 cm). Louvre, Paris. Delacroix's portrait of his friend captures Chopin's romantic introspection. Delacroix himself was a great lover of music, though perhaps surprisingly the great romantic painter preferred Mozart to Beethoven.

The life of Frédéric Chopin (1810-1849) seems almost too romantic to be true [15.4]. Both in his piano performances and in the music he composed he united the aristocratic fire of his native Poland with the elegance and sophistication of Paris, where he spent much of his life. His concerts created a sensation throughout Europe, while his piano works exploited (if they did not always create) new musical forms like the nocturne, a short piano piece in which an expressive, if melancholy, melody floats over a murmuring, rustling accompaniment. Chopin is characteristically romantic in his use of music to express his own personal emotions. The structure of works like the twenty-four Preludes, Op. 28, is dictated not by formal considerations but by the feeling of the moment. Thus the first three take us from excited agitation to brooding melancholy to bubbling high spirits in just over three minutes.

In private, Chopin's life was dominated by a much-talked-about liaison with the leading French woman author of the day, George Sand (1804–1876). His early death from tuberculosis put the final romantic touch to the life of a composer who has been described as the soul of the piano.

Franz Liszt (1811-1886) shared Chopin's brilliant

skill at the keyboard and joined to it his own more robust temperament. A natural romantic, he ran the gamut of romantic themes and experiences. After beginning his career as a handsome, impetuous young rebel, the idol of the salons of Paris, he conducted a number of well-publicized affairs and ended up by turning to the consolations of religion. His vast musical output includes some of the most difficult of all piano works (many of them inspired by the beauties of nature), two symphonies on the characteristically romantic subjects of Faust and Dante (with special emphasis, in the latter case, on the Inferno), and a host of pieces that made use of the folk tunes of his native Hungary.

Assessment of Liszt's true musical stature is difficult. He was probably a better composer than his present reputation suggests, although not so great a one as his contemporaries (and he) thought. As a virtuoso performer even he takes second place to Nicolò Paganini (1782-1840), the greatest violinist of the age, if not of all time.

Like Chopin and Liszt, Paganini also composed. but it was his public performances that won him his amazing reputation. So apparently impossible were the technical feats he so casually executed that rumor spread that, like Faust, he had sold his soul to the devil. This typically romantic exaggeration was, of course, assiduously encouraged by Paganini himself, who cultivated a suitably ghoulish appearance to enhance his public image. Nothing more clearly illustrates the 19th century's obsession with music as emotional expression (in this case diabolical) than the fact that Paganini's concerts earned him both honors throughout Europe and a considerable fortune.

Musical Nationalism

Both Chopin and Liszt introduced the music of their native lands into their works, Chopin in his mazurkas and polonaises (traditional Polish dances) and Liszt in his Hungarian Rhapsodies. For the most part, however, they adapted their musical styles to the prevailing international fashions of the day.

Other composers placed greater emphasis on their native musical traditions. In Russia a group of five composers (Moussorgsky, Balakirev, Borodin, Cui, and Rimsky-Korsakov) consciously set out to exploit their rich musical heritage. The greatest of the five was Modest Moussorgsky (1839-1881), whose opera Boris Godunov (1874) is based on an episode in Russian history. It makes full use of Russian folk songs and religious music in telling the story of Tsar Boris Godunov, who rises to power by killing the true heir to the throne. Although Boris is the opera's single most important character, the work is really dominated by the chorus, which represents the Russian

people. Moussorgsky powerfully depicts their changing emotions, from bewilderment to awe, to fear, to rage, and in doing so gives voice to the feelings of his nation.

Elsewhere in Eastern Europe composers were finding similar inspiration in national themes and folk music. The Czech composer Bedřich Smetana (1824-1884), who aligned himself with his native Bohemia in the uprising against Austrian rule in 1848, composed a set of seven pieces for orchestra that bear the collective title of Má Vlast (My Fatherland). The best known, Vltava (The Moldau), depicts the course of the river Vltava as it flows from its source through the countryside to the capital city of Prague. His fellow countryman Antonin Dvořák (1841-1904) also drew on the rich tradition of folk music in works like his Slavonic Dances, colorful settings of Czech folk tunes.

Opera in Italy: Verdi

Throughout the 19th century opera achieved new heights of popularity in Europe and "operamania" began to spread to America, where opera houses opened in New York in 1854 and Chicago in 1865. On both sides of the Atlantic opera houses are still dominated by the works of the two 19th-century giants in the history of opera—the Italian Giuseppe Verdi and the German Richard Wagner.

When Giuseppe Verdi (1813-1901) began his career, the Italian opera-going public was interested in beautiful and brilliant singing rather than realism of plot or action. This love of what is often called bel canto (beautiful song) should not be misunderstood. Composers like Gaetano Donizetti (1797-1848) and Vincenzo Bellini (1801-1835) used their music to express sincere and deep emotions and even drama, but the emotional expression was achieved primarily by means of song and not by a convincing dramatic situation. The plots of their operas serve only as an excuse for music; thus characters in bel canto operas are frequently given to fits of madness in order to give musical expression to deep emotion. Within the necessary framework provided by the plot a great singer, inspired by great music, could use the magic of the human voice to communicate a dramatic emotion that transcended the time and place of the action. Under the inspiration of Verdi and Wagner, however, opera began to move in a different direction. The subjects composers chose remained larger than life, but dramatic credibility became increasingly important.

Beginning in the 1950s, however, many music lovers began to discover a rich source of musical beauty and even drama in a work like Bellini's Norma, first performed in 1831. The revival and sub-

15.5 Maria Callas as Norma in Bellini's opera. Covent Garden, London, 1957. The Greek-American Maria Callas (1923-1977), one of the great sopranos of this century, made her first professional debut in Verona in 1947. Her debuts at La Scala, Milan, Covent Garden, London, and the Metropolitan Opera, New York, followed in 1950, 1952, and 1956.

sequent popularity of much early 19th-century opera are due in large measure to the performances and recordings of Maria Callas [15.5], whose enormous talent showed how a superb interpreter could bring such works to life. Following her example, other singers turned to bel canto opera, with the result that performances of Norma and of Donizetti's bestknown opera, Lucia di Lammermoor (1835), have become a regular feature of modern operatic life, while lesser-known works are revived in increasing numbers.

The revival of bel canto works has certainly not been at the expense of Verdi, perhaps the best-loved of all opera composers. His works showed a new concern for dramatic and psychological truth. Even in his early operas like Nabucco (1842) or Luisa Miller (1849) Verdi was able to give convincing expression to human relationships. At the same time his music became associated with the growing nationalist movement in Italy. Nabucco, for example, deals ostensibly with the captivity of the Jews in Babylon and their oppression by Nebucadnezzar, but the plight of the Jews became symbolic of the Italians' suffering under Austrian rule. The chorus the captives sing as they think of happier days, "Va, pensiero . . . " ("Fly, thought, on golden wings, go settle on the slopes and hills where the soft breezes of our native land smell gentle and mild"), became a kind of theme song for the Italian nationalist movement, the Risorgimento, in large measure because of the inspiring yet nostalgic quality of Verdi's tune.

Verdi's musical and dramatic powers reached their first great climax in three major masterpieces, Rigoletto (1851), Il Trovatore (1853), and La Traviata (1853), which remain among the most popular of all operas. They are very different in subject and atmosphere. Il Trovatore is perhaps the most traditional in approach, with its gory and involved plot centering around the troubadour Manrico and its abundance of superb melodies. In Rigoletto Verdi achieved one of his most convincing character portrayals in the hunchback court jester Rigoletto, who is forced to suppress his human feelings and play the fool to his vicious and lecherous master, the Duke of Mantua. With La Traviata Verdi broke new ground in the history of opera by dealing with contemporary life rather than a historical or mythological subject.

The principal character of La Traviata is Violetta, a popular courtesan in Paris, who falls in love with Alfredo Germont, a young man from the provinces, and decides to give up her sophisticated life in the capital for country bliss. Her reputation follows her there, however, in the form of Alfredo's father. In a long and emotional encounter he persuades her to abandon his son and put an end to the disgrace she is bringing on his family [15.6]. Violetta, who is aware that she is suffering from a fatal illness, returns alone to the cruel glitter of her life in Paris. By the end of the opera, her money gone, she lies dying in poverty and solitude. At this tragic moment Verdi gives her one of his most moving arias, "Addio del passato" ("Goodbye to the past"), as she thinks back over her earlier life. Alfredo, who has finally learned of the sacrifice she has made for his sake, rushes to find her, only to arrive for a final farewell-Violetta dies in his arms.

Throughout the later part of his career Verdi's powers continued to develop and enrich, until in 1887 he produced in Otello, a version of Shakespeare's tragedy Othello, perhaps the supreme work in the entire Italian operatic tradition. From the first shattering chord that opens the first act to Otello's heartbreaking death at the end of the last, Verdi rose to the Shakespearean challenge with music of unsurpassed eloquence. In a work that is so consistently inspired it seems invidious to pick out highlights, but the ecstatic love duet of Act I between Otello and Desdemona deserves mention as one of the noblest

15.6 La Traviata. Metropolitan Opera, New York, 1981. Alfredo's father begs Violetta to leave his son. This is the scene in Act II of Verdi's opera, set in the salon of Violetta's and Alfredo's country house. The singers are Cornell MacNeil as Giorgio Germont and Catherine Malfitano as Violetta. La Traviata was first performed in Venice in 1853 and in New York in 1856. Many noted sopranos have taken the role of Violetta, including Maria Callas (figure 15.5).

15.7 Wilhelm Beckmann. Richard Wagner at His Home in Bayreuth. 1880. Oil on canvas. $4'\sqrt[3]{4''} \times 5'\sqrt{15}$ %" (1.25 × 1.58 m). Richard Wagner Museum, Triebschen-Luzern, Switzerland. Characteristically, Wagner is holding forth to his wife and friends, in this case Liszt in his abbé's garb and the author Hans von Wolzogen. At lower left are some stage designs for Wagner's last work, Parsifal.

and most moving of all depictions of romantic passion.

Opera in Germany: Wagner

The impact of Richard Wagner (1813-1883) on his times went far beyond the opera house. Not only did his works change the course of the history of music, but many of his ideas had a profound effect on writers and painters [15.7]. This truly revolutionary figure even became actively involved with the revolutionary uprisings of 1848 and spent a number of years in exile in Switzerland.

It is difficult to summarize the variety of Wagner's ideas, which ranged from art to politics to vegetarianism and in general are not noted for their tolerance. Behind many of his writings on opera and drama lay the concept that the most powerful form of artistic expression was one that united all the arts, music, painting, poetry, movement, in a single work of art, the Gesamtkunstwerk (all-art work). To illustrate this theory Wagner wrote both the words and music of what he called "music dramas" and even designed and built a special theater for their performance at Bayreuth, where they are still performed every year at the Bayreuth Festival.

A number of characteristics link all Wagner's mature works. First, he abolished the old separation between recitatives (in which the action was advanced) and arias, duets, or other individual musical numbers (which held up the action). Wagner's music flowed continuously from the beginning to the end of each act with no pauses. Second, he eliminated the vocal display and virtuosity that had been traditional in opera. Wagner roles are certainly not easy to sing, but their difficulties are always for dramatic reasons and not to show off a singer's skill. Third, he put a new emphasis on the orchestra, which not only accompanied the singers but also provided a rich musical argument of its own. This was enhanced by his fourth contribution, the famous device of the leitmotiv (leading motif), which consisted of giving each of the principal characters, ideas, and even objects an individual theme of his, her, or its own. By recalling these themes and by combining them or changing them Wagner achieved highly complex dramatic and psychological effects.

Wagner generally drew his subjects from German mythology. By peopling his stage with heroes, gods, giants, magic swans, and the like, he aimed to create universal dramas that would express universal emotions. In his most monumental achievement, The Ring of the Nibelung, written between 1851 and 1874, he even represented the end of the world. The Ring consists of four separate music dramas, Rhinegold, The Valkyrie, Siegfried, and The Twilight of the Gods, the plot of which defies summary. In music of incredible richness Wagner depicted not only the actions and reactions of his characters but also the wonders of nature. In Siegfried, for example, we hear the rustling of the forest and the songs of woodbirds, while throughout The Ring and especially in the wellknown "Rhine Journey" from The Twilight of the Gods the mighty river Rhine sounds through the music. At the same time The Ring has a number of philosophical and political messages, many of them derived from Schopenhauer (see page 258). One of its main themes is that power corrupts, while Wagner also adopted Goethe's idea of redemption by a woman in the final resolution of the drama.

No brief discussion can begin to do justice to so stupendous a work. It is probably easier to see Wagner's genius in operation by looking at a work on small scale, a single self-contained music dramaalbeit one of some four hours' duration. Tristan and Isolde was first performed in 1865, and its very first notes opened a new musical era. Its subject is the overwhelming love of the English knight Tristan and the Irish princess Isolde, so great that the pair betray his dearest friend and lord and her husband, King Mark of Cornwall, and so overpowering that it can achieve its complete fulfillment only in death.

Wagner's typically romantic preoccupation with love and death may seem morbid and far-fetched, but under the sway of his intoxicating music it is difficult to resist. The sense of passion awakened but unfulfilled is expressed in the famous opening bars of the Prelude, with their theme that yearns upward and the discords that dissolve into one another only to hang unresolved in the air:

The music gives the sense of having no settled harmony or clear direction. This lack of tonality, used here for dramatic purpose, was to have a considerable influence on modern music.

15.8 Scene from Tristan and Isolde, Act II. This is the Bayreuth staging designed and produced by Wagner's grandson, Wieland Wagner. First mounted in 1962, the production starred Wolfgang Windgassen and Birgit Nilsson as the lovers. The abstract sets and complex lighting have influenced much stage design since then.

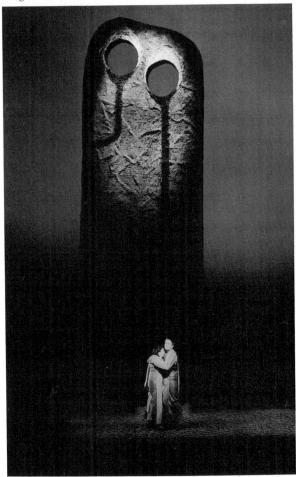

The core of Tristan and Isolde is the long love scene at the heart of the second part, where the music reaches heights of erotic ecstasy too potent for some listeners. Whereas Verdi's love duet in Otello presents two noble spirits responding to one another with deep feeling but with dignity, Wagner's characters are racked by passions they cannot begin to control. If ever music expressed what neither words nor images could depict it is in the overwhelming physical emotion of this scene [15.8]. The pulsating orchestra and the surging voices of the lovers build up an almost unbearable tension that Wagner suddenly interrupts and breaks by the arrival of King Mark. Once again, as in the Prelude, fulfillment is denied both to the lovers and to us.

That fulfillment is reached only at the very end of the work in Isolde's "Liebestod" ("Love Death"). Tristan has died, and over his body Isolde begins to sing a kind of incantation. She imagines she sees the spirit of her beloved, and in obscure, broken words describes the bliss of union in death before sinking lifeless upon him. Although the "Liebestod" makes its full effect only when heard at the end of the entire work, even out of context the emotional power of the music as it rises to its climax can hardly fail to affect the sensitive listener.

Romantic Art

Painting at the Turn of the Century: Goya

Just as Beethoven and his Romantic successors rejected the idealizing and universal qualities of classical music to achieve a more intense and personal communication, so painters began to abandon the lofty, remote world of neoclassical art for more vivid images. In the case of painting, however, the question of style was far more related to political developments. We have already seen in Chapter 14 that neoclassicism had become, as it were, the official artistic dress of the Revolution, so it was not easy for a painter working in France, still the center of artistic life, suddenly to abandon the revolutionary style. The problem is particularly visible in the works of Jacques Louis David (1748–1825), whose Oath of the Horatii [see figure 14.1, page 207] had been inspired by the prerevolutionary longing for austere Republican virtue. By the end of the Revolution, David had come to appreciate the advantages of peace; his painting The Battle of the Romans and the Sabines of 1799 [15.9] expresses his desire for an end to violence and bloodshed. The subject is drawn from Roman mythology and focuses on that moment when Hersilia,

wife of the Roman leader Romulus, interrupts the battle between Romans and Sabines and begs for an end to war. Its significance is precisely the reverse of the Oath of the Horatii. In place of a masculine call to arms and sacrifice, David shows his heroine making an impassioned plea for peace. The style, however, remains firmly neoclassical, not only in the choice of subject but also in its execution. For all the weapons and armor, there is no sign of actual physical violence. The two opponents, with their heroic figures and noble brows, are idealized along typically neoclassical lines. The emotional gestures of Hersilia and others are also stylized and frozen. The painting is powerful, but it depicts a concept rather than individual human feelings.

The contrast between the neoclassical representation of the horrors of war and a romantic treatment of the same theme can be seen by comparing David's painting with Execution of the Madrileños on May 3, 1808 [15.10] by Francisco Goya (1746-1828). In Goya's painting, nothing is idealized. The horror and the terror of the victims, their faceless executioners, the blood streaming in the dust all combine to create an almost unbearable image of protest against human cruelty. Goya's painting is romantic because it conveys to us his own personal emotions at the thought of the executions and because, great artist that he was, his emotions become our own.

As Beethoven convinces us of the necessity to struggle against the injustices of human beings and of Fate by his own passionate commitment, so Goya by his intensity urges us to condemn the atrocities of war. Furthermore, both Beethoven and Goya shared a common sympathy with the oppressed and a hatred of tyranny. The soldiers firing their bayoneted guns in Goya's painting were serving in the army of Napoleon; the event shown took place some four years after Beethoven had seen the danger Napoleon presented to the cause of liberty and had erased his name from the Eroica.

It was, of course, easier for an artist outside France to abandon the artistic language of neoclassicism for more direct ways of communication. Although from 1824 to his death Goya lived in France, he was born in Spain and spent most of his working life there. Removed from the mainstream of artistic life, he seems never to have been attracted by the neoclassical style. Some of his first paintings were influenced by the rococo style of Tiepolo [see figure 14.8, page 212], who was in Spain from 1762 until 1770, but his own introspective nature and the strength of his feelings seem to have driven him to find more direct means of expression. Personal suffering may have played a part also, since Goya, like Beethoven, became totally deaf.

In 1799 Goya became official painter to Charles

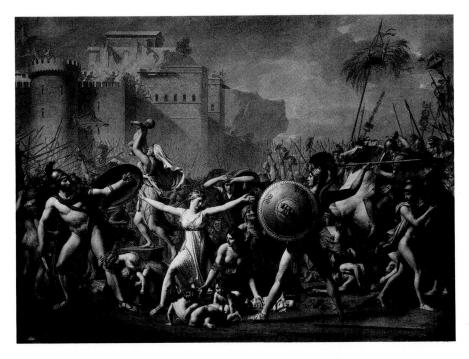

15.9 Jacques Louis David. The Battle of the Romans and the Sabines. 1799. Oil on canvas, $12'8'' \times 17'3/4''$ (3.86 \times 5.2 m). Louvre, Paris. David may have intended his depiction of feminine virtue as a tribute to his wife, who had left him when he voted for the execution of Louis XVI but returned to him when he was imprisoned for a time.

IV, the king of Spain, and was commissioned to produce a series of formal court portraits. The most famous of these, The Family of Charles IV [15.11], was deliberately modeled on Velásquez' Las Meninas [see 13.24, page 161]. Goya shows us the royal familyking, queen, children, and grandchildren—in the artist's studio, where they have come to visit. The comparison he intends us to make between his own painting and this of his distinguished predecessor is devastating. At first glance Goya's painting may

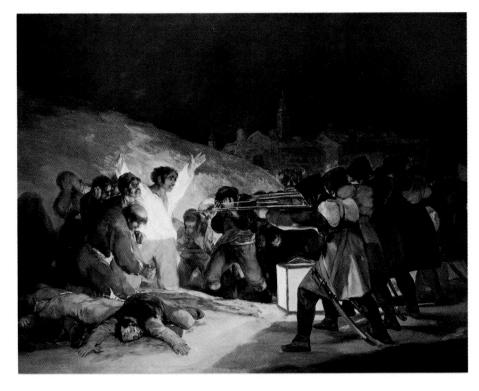

15.10 Francisco Goya. Execution of the Madrileños on May 3, 1808. 1814. Oil on canvas, 8'83/4" × 11'33/4" (2.66 × 3.45 m). Prado, Madrid. The painting shows the execution of a group of citizens of Madrid who had demonstrated against the French occupation by Napoleon's troops. The Spanish government commissioned the painting after the expulsion of the French army.

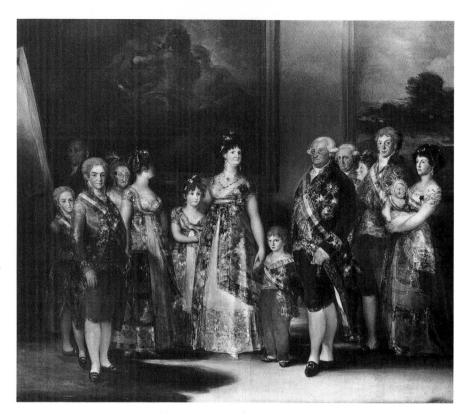

15.11 Francisco Goya. The Family of Charles IV. 1800. Oil on canvas, $9'2'' \times 11'$ (2.79 × 3.35 m). Prado, Madrid. In this scathing portrayal of the Spanish royal family the artist himself is working away quietly at the far left. The French writer Alphonse Daudet said the painting showed "the grocer and his family who have just won top prize in the Lottery."

seem just another official portrait, but it does not take a viewer very long to realize that something is very wrong at the court of Spain. Instead of grace and elegance, Goya's patrons radiate arrogance, vanity, and stupidity. The king and queen, in particular, are especially unappealing.

The effect of Goya's painting is not so much one of realism as of personal comment, although there is every reason to believe that the queen was in fact quite as ugly as she appears here. The artist is communicating his own feelings of disgust at the emptiness, indeed the evil, of court life. That he does so through the medium of an official court portrait that is itself a parody of one of the most famous of all court portraits is of course an intentional irony.

Even at the time of his official court paintings Gova was obsessed by the darker side of life. His engraving The Sleep of Reason Produces Monsters [see figure 15.1] foreshadowed the work of his last years. Between 1820 and 1822 he covered the walls of his own house with paintings that depict a nightmare world of horror and despair. Saturn Devouring One of His Sons [15.12] makes use of a classical myth to portray the god of Time in the act of destroying humanity, but the treatment owes nothing to neoclassicism. Indeed, no simple stylistic label seems adequate to describe so personal a vision. The intensity of expression, the fantastic nature of the subject, and the mood

of introspection are all typically romantic, yet the totality transcends its components. No one but Goya has ever expressed a vision of human existence in quite these terms.

Painting and Architecture in France: Romantics and Realists

Although the events of the French Revolution and Napoleon's subsequent dictatorship had an immediate impact on artists, writers, and musicians outside France, their effect on French artists was more complex. As we have seen earlier in this chapter, David was never able to throw off the influence of neoclassicism, and his immediate successors had a hard time finding a style that could do justice to romantic themes while remaining within neoclassical limits. One solution was offered by Anne-Louis Girodet-Trioson (1767–1824), whose painting The Entombment of Atala [15.13] depicts a highly romantic subject acted out, as it were, by classical figures.

The subject is from a popular novel by the French romantic novelist René de Chateaubriand (1768-1848) and depicts the burial of its heroine, Atala, in the American wilderness where the book is set. The other figures are her Indian lover, Choctas, and a priest from a nearby mission in the Florida swamps. The story of the painting therefore contains just

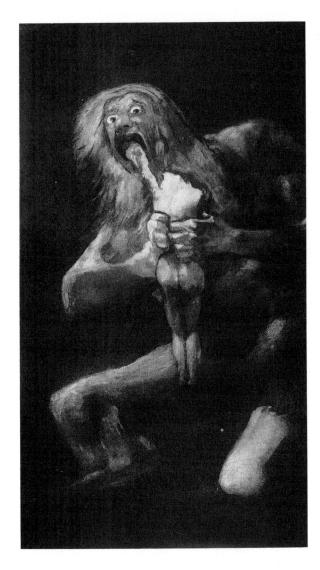

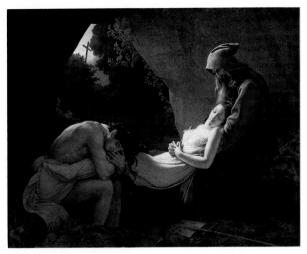

15.13 Anne-Louis Girodet-Trioson. The Entombment of Atala. 1808. Oil on canvas, $6'11\frac{3}{4}'' \times 8'9''$ (2.13 × 2.67 m). Louvre, Paris. The anticlassical nature of the subject is emphasized by the Christian symbolism of the two crosses, one on Atala's breast and the other rather improbably placed high up in the jungle, outside the cave.

15.12 Francisco Goya. Saturn Devouring One of His Sons. c. 1821. Fresco detached on canvas, $4'9\frac{1}{2}" \times 2'8\frac{1}{8}"$ (1.46 × .83 m). Prado, Madrid. The painting originally decorated a wall in Goya's country house, La Quinta del Sordo (Deaf Man's Villa).

about every conceivable element of romanticism: an exotic location, emphasis on personal emotion, the theme of unfulfilled love. Girodet provides for his characters a romantic setting, with its dramatic light and mysterious jungle background, but the figures themselves are idealized in a thoroughly classical way. Atala's wan beauty and elegant drapery and the muscular nudity of her lover are obviously reminiscent of classical models. Only the mysterious figure of the old priest provides a hint of romantic gloom.

It took a real-life disaster and a major national scandal to inspire the first genuinely romantic French painting. In 1816 a French government vessel, the Medusa, bound for Africa with an incompetent political appointee as captain, was wrecked in a storm. The 149 passengers and crew members were crowded onto a hastily improvised raft that drifted for days under the equatorial sun. Hunger, thirst, madness,

and even, it was rumored, cannibalism had reduced the survivors to fifteen by the time the raft was finally sighted.

The young French painter Théodore Géricault (1791-1824), whose original enthusiasm for Napoleon had been replaced by adherence to the liberal cause, depicted the moment of the sighting of the raft in his painting Raft of the Medusa [15.14]. Horror at the suffering of the victims and anger at the corruption and incompetence of the ship's officers (and their political supporters) inspired a work that, from its first exhibition in 1819, created a sensation in artistic circles. Even the general public flocked to see a painting that so dramatically illustrated contemporary events. In the process they became exposed to the principles of romantic painting. Géricault's work deliberately rejects the ideal beauty of classical models. The agonizing torment of the survivors is powerfully

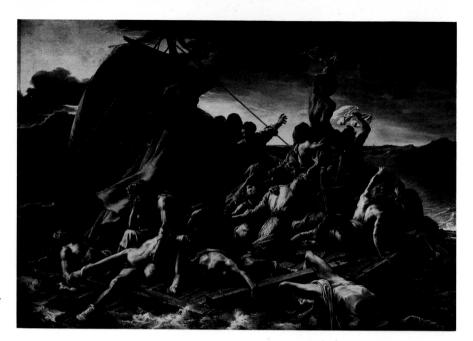

15.14 Theodore Géricault. Raft of the Medusa. 1818. Oil on canvas, 16'11/4" × 23'6" (4.91 × 7.16 m). Louvre, Paris. Note the careful composition of this huge work, built around a line that leads from the bottom left corner to the top right, where a survivor desperately waves his shirt.

rendered, and the dramatic use of lighting underlines the intense emotions of the scene.

When Géricault died following a fall from a horse, the cause of romanticism was taken up by his young friend and admirer, Eugène Delacroix (1798–1863).

whose name has become synonymous with romantic painting. Although the subjects of many of his paintings involve violent emotions, Delacroix himself seems to have been aloof and reserved. He never married, or for that matter formed any lasting rela-

EAST MEETS WEST

European Perceptions of the American Indian

Chateaubriand and Girodet were by no means the first Europeans to be impressed by the nobility and simple grandeur of North America's native Indian population. In 1687 the governor of French Canada captured a group of Iroquois chieftains and shipped them to Louis XIV. The king, scandalized by so shocking a breach of protocol against fellow rulers, ordered them to be immediately released, entertained them as distinguished visitors, and had them sent home in style. In general the Indians fared better at the hands of the French colonists in North America than at those of the British; the French did not expropriate Indian territory, and their missionaries encouraged peaceful settlement.

By the beginning of the 19th century European travelers were beginning to see for themselves the superb natural setting of Indian culture, untouched by industrialization or the plagues of civilized life; their general reaction can be summed up in the words of one visitor to the Mohawk, near modern Utica, N.Y.: "No more roads, no more towns, no monarchy, no republic, no presidents, no kings. . . !"

In the course of traveling round America to provide himself with background material for Atala, Chateaubriand sailed down the Ohio River into Tennessee. where he met some Seminole Indians from Florida (he calls them Siminoles). They were horsetraders by profession, but, according to the great romantic novelist they were driven by passions "not of rank, education, or prejudice, but of nature, untrammelled and unimpaired, proceeding only to their goal, a valley that could never be discovered, a river without name." The Seminoles told him of Indian girls abandoned by white lovers in Pensacola and of others who had managed to exploit their European exploiters.

Early-19th-century American writers like James Fenimore Cooper (1789-1851) convey an equal respect for the Indians' life at one with nature; and in his epic poem Hiawatha Henry Wadsworth Longfellow (1807–1882) used Indian myths to try to provide America a legendary past. By the end of the century, however, the "noble savage" had become the "ruthless savage," as American and European pioneers in the Far West struggled to conquer and hold on to Indian territory. In the process the Indians became perceived as the enemies of progress, and their remoteness from "civilization" as a weakness. The white settlers, in order to justify the wholesale slaughter of the native population or depopulation of vast tracts of the country, portrayed their Indian enemies as cruel and cunning. The consequence was the stereotyped image of popular fiction and movies.

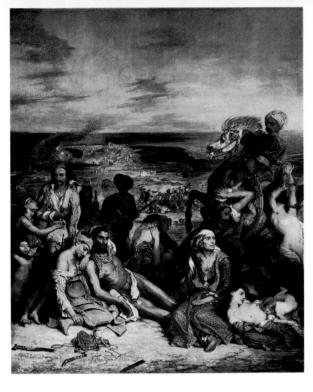

15.15 Eugène Delacroix. *Massacre at Chios.* 1824. Oil on canvas, $13'7'' \times 11'10''$ (4.19 \times 3.64 m). Louvre, Paris. Rather than depict a single scene, the painter chose to combine several episodes, contrasting the static misery of the figures on the left with a swirl of activity on the right.

tionship. His *Journal* reveals him as a man constantly stimulated by ideas and experience but he preferred to live his life through his art, a true romantic. Among his few close friends was Chopin; his portrait of the composer [see figure 15.4, page 263] seems to symbolize the introspective creative vision of the romantic artist.

Like his mentor Géricault, Delacroix supported the liberal movements of the day. His painting *Massacre at Chios* [15.15] depicted a particularly brutal event in the Greek War of Independence. In 1824, the year in which Lord Byron died while supporting the Greek cause, the Turks massacred some 90 percent of the population of the Greek island of Chios, and Delacroix' painting on the subject was intended to rouse popular indignation. It certainly roused the indigna-

15.16 Eugène Delacroix. *The Death of Sardanapalus*. 1826. Oil on canvas, c. 12'1" × 16'3" (3.68 × 4.95 m). Louvre, Paris. The painting makes no attempt to achieve archaeological accuracy but concentrates on exploiting the violence and cruelty of the story. Delacroix himself called this work "Massacre No. 2," a reference to his earlier painting, the *Massacre at Chios* (figure 15.15). Although this suggests a certain detachment on the artist's part, there is no lack of energy or commitment in the free, almost violent, brush strokes.

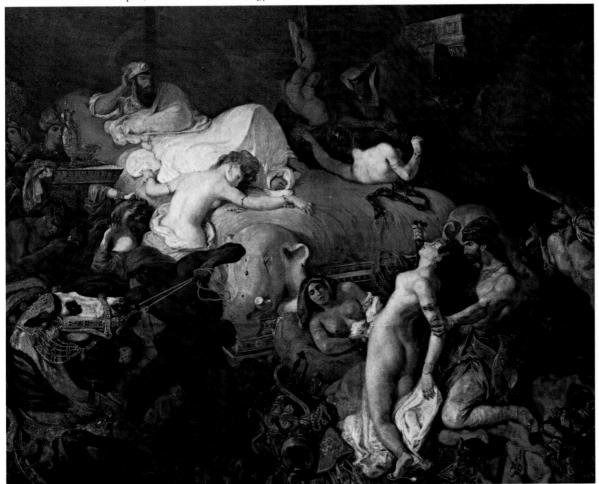

tion of the traditional artists of the day, one of whom dubbed it "the massacre of painting," principally because of its revolutionary use of color. Whereas David and other neoclassical painters had drawn their forms and then filled them in with color, Delacroix used color itself to create form. The result is a much more fluid use of paint.

Lord Byron figures again in another of Delacroix's best-known paintings, since it was on one of the poet's works that the artist based The Death of Sardanapalus [15.16]. The Assyrian king, faced with the destruction of his palace by the Medes, decided to prevent his enemies from enjoying his possessions after his death by ordering that his wives, horses, and dogs be killed and their bodies piled up, together with his treasures, at the foot of the funeral pyre he intended for himself. The opulent, violent theme is treated with appropriate drama; the savage brutality of the foreground contrasts with the lonely, brooding figure of the king reclining on his couch above. Over the whole scene, however, hovers an air of unreality, even of fantasy, as if Delacroix is trying to convey not so much the sufferings of the victims as the intensity of his own imagination.

15.17 Jean Auguste Dominique Ingres. Jupiter and Thetis. 1811. Oil on canvas, $10'10'' \times 8'5''$ (3.3 × 2.57 m). Musée Granet, Aix-en-Provence. The figure of Jupiter, with his youthful face surrounded by a vast wreath of beard and hair, is highly unconventional. Thetis' arms and throat are purposely distorted to emphasize her supplication.

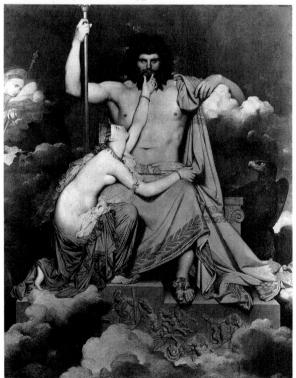

Although with Delacroix's advocacy romanticism acquired a vast popular following, not all French artists joined the romantic cause. A fierce and bitter rear-guard action was fought by the leading neoclassical proponents, headed by Jean Auguste Dominque Ingres (1780–1867)—who was, in his own very different way, as great a painter as Delacroix. The selfappointed defender of classicism, Ingres once said of Delacroix that "his art is the complete expression of an incomplete intelligence." Characteristically, his war against romantic painting was waged vindictively and on the most personal terms. Now that the dust has settled, however, it becomes clear that Ingres himself, far from religiously adhering to classical doctrines, was unable to suppress a romantic streak of his own. His extraordinary painting Jupiter and Thetis [15.17] deals with an event from Homer's Iliad and shows Thetis, the mother of Achilles, begging the father of gods and mortals to avenge an insult by the Greek commander Agamemnon to her son by allowing the Trojans to be victorious. The

15.18 Jean Auguste Dominique Ingres. La Comtesse d'Haussonville. 1845. Oil on canvas, $4'5\frac{1}{2}" \times 3'\frac{1}{4}"$ (1.36 × .92 m). Frick collection, New York. The artist seems to have been more interested in his subject's dress, which is marvelously painted, than in her personality. The reflection in the mirror reinforces the highly polished air of the painting.

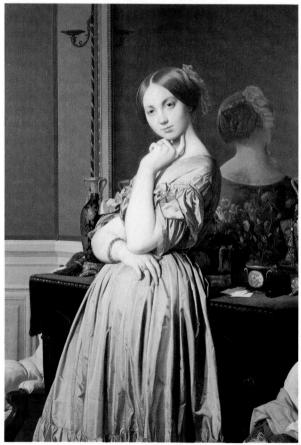

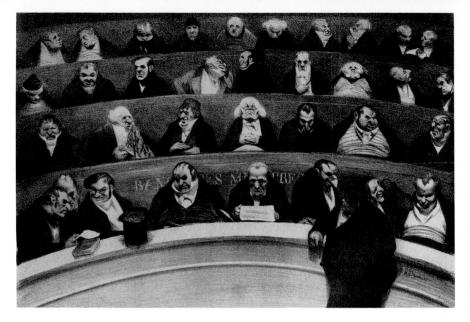

15.19 Honoré Daumier. Le Ventre législatif (The Legislative Belly). 1834. Lithograph, 111/16 × $17\frac{1}{16}$ " (28.1 × 43.3 cm). Philadelphia Museum of Art (gift of Carl Zigrosser). Although obviously caricatures, the politicians ranged in tiers are recognizable as individual members of the legislative assembly of the time.

subject may be classical, but Ingres' treatment of it is strikingly personal, even bizarre. Sensuality blends with an almost hallucinatory sharpness of detail to create a memorable if curiously disturbing image. Even in his more conventional portraits [15.18] Ingres' stupendous technique endows subject and setting with an effect that is the very reverse of academic.

The style that in the end succeeded in replacing the full-blown romanticism of Delacroix and his followers was not that of the neoclassical school, with its emphasis on idealism, but a style that stressed precisely the reverse qualities. The greatest French painters of the second half of the 19th century were realists, who used the everyday events of the world around them to express their views of life. One of the

first realist artists was Honoré Daumier (1808–1879), who followed the example of Gova in using his work to criticize the evils of society in general and government in particular. In *The Legislative Body*—or, more accurately, Belly [15.19]—he produced a powerful image of the greed and corruption of political opportunists that has lost neither its bitterness nor, unfortunately, its relevance.

Equally political was the realism of Gustave Courbet (1819-1877), a fervent champion of the working class, whose ability to identify with ordinary people won him the label of Socialist. Courbet tried to correct this political impression of his artistic and philosophical position in a vast and not entirely successful allegorical work, The Studio [15.20]. Like Goya's royal portrait [see figure 15.11], the painting deliber-

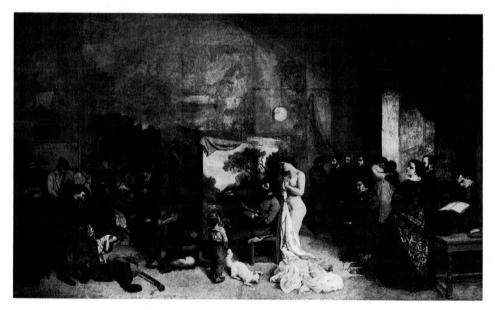

15.20 Gustave Courbet. The Studio: A Real Allegory of the Last Seven Years of My Life. 1855. Oil on canvas, 11'93/4" × 19'65/8" $(3.6 \times 5.96 \text{ m})$. Louvre, Paris. Although most of the figures can be convincingly identified as symbols or real people, no one has ever satisfactorily explained the small boy admiring Courbet's work or the cat at his feet.

15.21 Charles Garnier, Opéra, Paris, 1861–1875. The incredibly rich and complex ornamentation has earned this style of architecture the label neobaroque.

ately evokes memories of Velásquez' Las Meninas [see figure 13.24, page 161], although the artist is now placed firmly in the center of the picture, hard at work on a landscape, inspired by a nude model who may represent Realism or Truth. The various other figures symbolize the forces that made up Courbet's world. There is some doubt as to the precise identification of many of them, and it is not even clear that Courbet himself had any single allegory in mind. The total effect of the confusion, unintentional though it may be, is to underline the essentially romantic origins of Courbet's egocentric vision.

15.22 Caspar David Friedrich. Cloister Graveyard in the Snow. 1810. Oil on panel, 3'115/8" × 5'10'' (1.21 × 1.78 m). Formerly Nationalgalerie, Berlin (now lost). The vast bare trees in the foreground and the ruined Gothic abbey behind emphasize the insignificance of the human figures.

Neither romanticism nor its realistic vision made much impression on architectural styles in 19thcentury France. French architects retained a fondness for classical forms and abandoned them only to revive the styles of the Renaissance. In some of the public buildings designed to meet the needs of the age, however, the elaborate decoration makes use of classical elements to achieve an ornateness of effect that is not very far from the opulent splendor of Delacroix' Death of Sardanapalus.

The most ornate of all 19th-century French buildings was the Paris Opera [15.21] of Charles Garnier (1824-1898). The new opera house had to be sufficiently large to accommodate the growing public for opera and sufficiently ostentatious to satisfy its taste. Garnier's building, designed in 1861 and finally opened in 1875, makes use of classical ornamentation like Corinthian columns and huge winged Victories, but the total effect is highly unclassical, a riot of confusion that would surely have appalled classical and Renaissance architects alike.

Painting in Germany and England

Unlike their French counterparts, romantic artists in both England and Germany were particularly attracted by the possibilities offered by landscape painting. The emotional range of their work illustrates once again the versatility of the romantic style. The German painter Caspar David Friedrich (1774–1840) seems to have drawn some of his Gothic gloom from a tradition that had been strong in Germany since the

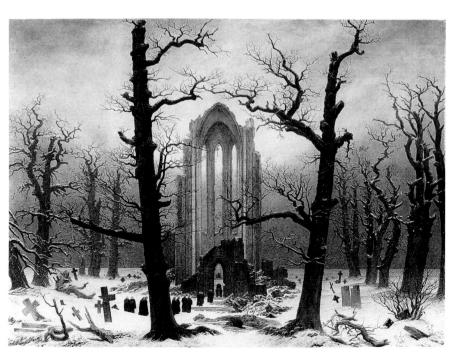

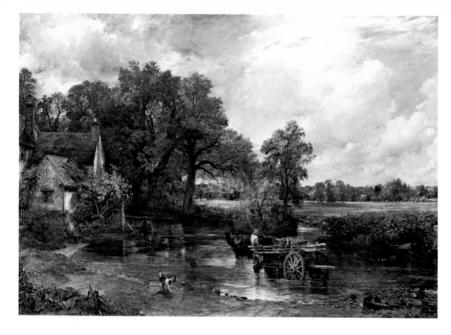

15.23 John Constable. Hay Wain. 1821. Oil on canvas, 4'21/2" × 6'1" (1.28 × 1.85 m). National Gallery. London (reproduced by courtesy of the Trustees). Note Constable's bold use of color, which impressed Delacroix.

Middle Ages, although he uses it to romantic effect. His Cloister Graveyard in the Snow [15.22], in fact, illustrates a number of romantic preoccupations, with its ruined medieval architecture and melancholy dreamlike atmosphere.

The English painter John Constable (1776–1837). on the other hand, shared the deep and warm love of nature expressed by Wordsworth. His paintings convey not only the physical beauties of the landscape but also a sense of the less tangible aspects of the natural world. In Hay Wain [15.23], for example, we not only see the peaceful rustic scene, with its squat, comforting house on the left, but we can even sense that light and quality of atmosphere, prompted by the billowing clouds that, responsible for the fertility of the countryside, seem about to release their moisture.

Constable's use of color pales besides that of his contemporary, Joseph Mallord William Turner (1775-1851). In a sense, the precise subjects of Turner's paintings are irrelevant. All his mature works use light, color, and movement to represent a cosmic union of the elements in which earth, sky, fire, and water dissolve into one another and every trace of the material world disappears. His technique is seen at its most characteristic in *The Slave Ship* [15.24].

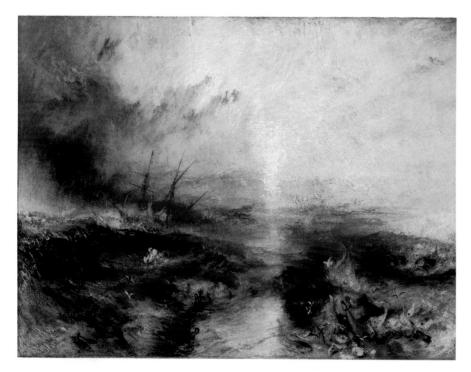

15.24 Joseph Mallord William Turner. The Slave Ship. 1840. Oil on canvas, 353/4" × 481/4" $(91 \times 122 \text{ cm})$. Courtesy Museum of Fine Arts, Boston (Henry and Lillie Pierce Fund). The title of this painting is an abbreviation of a longer one: Slavers Throwing Overboard the Dead and Dying; Typhoon Coming On. Turner includes a horrifying detail at lower center: the chains still binding the slaves whose desperate hands show above the water. Note the extreme contrast between Turner's interpretation of color and light and that of the American luminists as shown in Heade's painting (figure 15.32).

Like Géricault's Raft of the Medusa [see figure 15.14]. Turner's Slave Ship deals with a social disgrace of the time; in this case the horrifyingly common habit of the captains of ships loaded with slaves to jettison their entire cargo if an epidemic broke out. Turner only incidentally illustrates his specific subject—the detail of drowning figures in the lower right corner seems to have been added as an afterthought—and concentrates instead on conveying his vision of the grandeur and mystery of the universe.

Literature in the 19th Century

Goethe

The towering figure of Johann Wolfgang von Goethe (1749–1832) spans the transition from neoclassicism to romanticism in literature like a colossus. So great was the range of his genius that in the course of a long and immensely productive life he wrote works in a bewildering variety of styles. One of the first writers to rebel against the principles of neoclassicism, he used both poetry and prose to express the most turbulent emotions; yet he continued to produce works written according to neoclassical principles of clarity and balance until his last years, when he expressed in his writing a profound if abstruse symbolism.

Although the vein of romanticism is only one of many that runs through Goethe's work, it is an important one. As a young man Goethe studied law, first at Leipzig and then at Strassburg, where by 1770 he was already writing lyric poetry of astonishing directness and spontaneity. By 1773 he was acknowledged as the leader of the literary movement known as Sturm und Drang (Storm and Stress). This German manifestation of romanticism rebelled against the formal structure and order of neoclassism, replacing it with an emphasis on originality, imagination, and feelings. Its chief subjects were nature, primitive emotions, and protest against established authority. Although the Storm and Stress movement was originally confined to literature, its precepts were felt elsewhere. For instance, it was partly under the inspiration of this movement that Beethoven developed his fiery style.

The climax of this period in Goethe's life is represented by his novel The Sufferings of Young Werther (1774), which describes how an idealistic young man comes to feel increasingly disillusioned and frustrated by life, develops a hopeless passion for a happily married woman, and ends his agony by putting a bullet through his head. All of these events but the last were autobiographical. Instead of committing suicide Goethe left town and turned his life experi-

15.25 Tony Johannot. Illustration for a later edition of The Sufferings of Young Werther. 1852. By permission of Houghton Library, Harvard University. The hero has just declared his hopeless passion for Charlotte.

ences into the novel that won him international fame. Not surprisingly it became a key work of the romantic movement. Young men began to dress in the blue jacket and yellow trousers Werther is described as wearing, and some, disappointed in love, even committed suicide with copies of the book in their pocket—a dramatic if regrettable illustration of Goethe's ability to communicate his own emotions to others [15.25].

The years around the turn of the century found Goethe extending the range of his output. Along with such plays as the classical drama Iphigeneia in Tauris, which expressed his belief in purity and sincere humanity, were stormy works like Egmont, inspired by the idea that human life is controlled by demonic forces. The work for which Goethe is probably best known, Faust, was begun about the turn of the century, although its composition took many years. Part One was published in 1808, and Part Two was only finished in 1832, shortly before his death.

The subject of Dr. Faustus and his pact with the devil had been treated before in literature, notably in the play by Christopher Marlowe (see page 106). The theme was guaranteed to appeal to the romantic sensibility with its elements of the mysterious and fantastic, and in Part One Goethe put additional stress on the human emotions involved. The chief victim of Faust's lust for experience and power is the pure and innocent Gretchen, whom he callously seduces and then abandons. She becomes deranged as a result. At the end of Part One of Faust. Gretchen is accused of the murder of her illegitimate child, condemned to death, and executed. Moving from irony to wit to profound compassion, the rich tapestry of Part One shows Goethe, like Beethoven and Goya, on the side of suffering humanity.

Part Two of Faust is very different. Its theme, expressed symbolically through Faust's pact with the devil, is nothing less than the destiny of Western culture. Our civilization's unceasing activity and thirst for new experience inevitably produces error and suffering; at the same time, it is the result of the divine spark within us and will, in the end, guarantee our salvation. In his choice of the agent of this salvation Goethe established one of the other great themes of romanticism, the Eternal Feminine. Faust is finally redeemed by the divine love of Gretchen, who leads him upward to salvation.

Romantic Poetry

English romantic poetry of the first half of the 19th century represents a peak in the history of English literature. Its chief writers, generally known as the romantic poets, touched on a number of themes characteristic of the age. William Wordsworth's deep love of the country led him to explore the relationship between human beings and the world of nature; Percy Bysshe Shelley and George Gordon, Lord Byron, probed the more passionate, even demonic aspects of existence; and John Keats expressed his own sensitive responses to the eternal problems of art, life, and death.

William Wordsworth (1770–1850), often called the founder of the romantic movement in English poetry, clearly described his aims and ideals in his critical writings. For Wordsworth, the poet was a person with special gifts, "endowed with more lively sensibility, more enthusiasm and tenderness, who has a greater knowledge of human nature, and a more comprehensive soul" than ordinary people. Rejecting artificiality and stylization, Wordsworth aimed to make his poetry communicate directly in easily comprehensible terms. His principal theme was the relation between human beings and nature, which he explored by thinking back calmly on experiences that had earlier produced a violent emotional

15.26 Thomas Phillips. Lord Byron in Albanian Costume. 1820. Oil on canvas, $29\frac{1}{2} \times 24\frac{1}{2}$ " (75 × 62 cm). National Portrait Gallery, London. Byron is shown during his first visit to Greece, appropriately dressed for the role of romantic sympathizer with exotic lands and peoples.

reaction: his famous "emotion recollected in tranquility."

Wordsworth's emotion recollected in tranquility is in strong contrast to the poetry of George Gordon. Lord Byron (1788–1824), who filled both his life and work with the same moody, passionate frenzy of activity [15.26]. Much of his time was spent wandering throughout Europe, where he became a living symbol of the unconventional, homeless, tormented romantic hero who has come to be called Byronic after him. Much of his flamboyant behavior was no doubt calculated to produce the effect it did, but his personality must indeed have been striking for no less a figure than Goethe to describe him as "a personality of such eminence as has never been before and is not likely to come again." Byron's sincere commitment to struggles for liberty like the Greek war of independence against the Turks can be judged by the fact that he died while actually on military duty in Greece.

Percy Bysshe Shelley (1792-1822), who like Byron spent many of his most creative years in Italy, lived a life of continual turmoil. After being expelled from Oxford for publishing his atheist views, he espoused the cause of anarchy and eloped with the daughter of one of its chief philosophical advocates.

The consequent public scandal, coupled with ill health and critical hostility to his works, gave him a sense of bitterness and pessimism that lasted until his death by drowning.

Shelley's brilliant mind and restless temperament produced poetry that united extremes of feeling, veering from the highest pitch of exultant joy to the most extreme despondency. His belief in the possibility of human perfection is expressed in his greatest work, Prometheus Unbound (1820), where the means of salvation is love, the love of human beings for one another expressed in the last movement of Beethoven's Ninth Symphony, rather than the redeeming female love of Goethe and Wagner. His most accessible works, however, are probably the short lyrics in which he seized a fleeting moment of human emotion and captured it by his poetic imagination.

Even Shelley's sensitivity to the poetic beauty of language was surpassed by that of John Keats (1795– 1821), whose life, clouded by unhappy love and by the tuberculosis that killed him so tragically young, inspired poetry of rare poignance and sensitivity. In his Odes (lyric poems of strong feeling), in particular, he conveys both the glory and the tragedy of human existence and dwells almost longingly on the peace of death. In the wonderful "Ode to a Nightingale" the song of a bird comes to represent a permanent beauty beyond human grasp. The sensuous images, the intensity of emotion, and the flowing rhythm join to produce a magical effect.

The Novel

Although great novels have been written in our own time, the 19th century probably marked the high point in the creation of fiction. Increase in literacy and a rise in the general level of education resulted in a public eager for entertainment and instruction, and the success of such writers as Charles Dickens and Leo Tolstoy was due in large measure to their ability to combine the two. The best of 19th-century novels were those rare phenomena, great works of art that achieved popularity in their own day. Many of them are still able to enthrall the modern reader by their humanity and insight.

Most of the leading novelists of the mid-19th century wrote within a tradition of realism that came gradually to replace the more self-centered vision of romanticism. Instead of describing an imaginary world of their own creation, they looked outward to find inspiration in the day-to-day events of real life. The increasing social problems produced by industrial and urban development produced not merely a lament for the spirit of the times but a passionate desire for the power to change them as well. In some

cases writers were able to combine a romantic style with a social conscience, as in the case of the French novelist Victor Hugo (1802-1885), whose Les Misérables (1862) describes the plight of the miserable victims of society's injustices. The hero of the novel, Jean Valjean, is an exconvict who is rehabilitated through the agency of human sympathy and pity. Hugo provides graphic descriptions of the squalor and suffering of the poor, but his high-flown rhetorical style is essentially romantic.

Increasingly, however, writers found that they could best do justice to the problems of existence by adopting a more naturalistic style and describing their characters' lives in realistic terms. One of the most subtle attacks on contemporary values is Madame Bovary (1856-1857) by Gustave Flaubert (1821-1880). Flaubert's contempt for bourgeois society finds expression in his portrait of Emma Bovary, who tries to discover in her own provincial life the romantic love she reads about in novels. Her shoddy affairs and increasing debts lead to an inevitably dramatic conclusion. Flaubert is at his best in portraying the banality of her everyday existence.

Honoré de Balzac (1779-1850) was the most versatile of all French novelists. He created a series of some ninety novels and stories, under the general title of The Human Comedy, in which many of the same characters appear more than once. Above all a realist, Balzac depicted the social and political currents of his time while imposing on them a sense of artistic unity. His novels are immensely addictive. The reader who finds in one of them a reference to characters or events described in another novel hastens there to be led on to a third, and so on. Balzac thus succeeds in creating a fictional world that seems, by a characteristically romantic paradox, more real than historical reality.

Among the leading literary figures of Balzac's Paris, and a personal friend of Balzac himself, was the remarkable Aurore Dupin (1804–1876), better known by her pseudonym George Sand. This redoubtable defender of women's rights and attacker of male privilege used her novels to wage war on many of the accepted conventions of society. In her first novel, Lélia (1833) she attacked, among other institutions, the church, marriage, the laws of property, and the double standard of morality whereby women were condemned for doing what was condoned for

Unconventional in her own life, Sand became the lover of Chopin, with whom she lived from 1838 to 1847. Her autobiographical novel Lucrenzia Floriani (1846) chronicles as thinly disguised fiction the remarkable course of this relationship albeit very much from its author's point of view.

If France was one of the great centers of 19th-

century fiction, another was Russia, where Leo Tolstoy (1828-1910) produced, among other works, two huge novels of international stature, War and Peace (1863-1869) and Anna Karenina (1873-1877). The first is mainly set against the background of Napoleon's invasion of Russia in 1812. Among the vast array of characters is the Rostov family, aristocratic but far from wealthy, who, together with their acquaintances, have their lives permanently altered by the great historical events through which they live. Tolstoy even emphasizes the way in which the course of the war affects his characters by combining figures he created for the novel with real historical personages, including Napoleon himself, and allowing them to meet.

At the heart of the novel is the young and impressionable Natasha Rostov, whose own confused love life seems to reflect the confusion of the times. Yet its philosophy is profoundly optimistic, in spite of the tragedies of Natasha's own life and the horrors of war that surround her. Her final survival and triumph represent the glorification of the irrational forces of life, which she symbolizes as the "natural person," over sophisticated and rational civilization. Tolstov's high regard for irrationality and contempt for reason link him with other 19th-century romantics, and his ability to analyze character through the presentation of emotionally significant detail and to sweep the reader up in the panorama of historical events make War and Peace the most important work of Russian realistic fiction.

Toward the end of his life Tolstoy gave up his successful career and happy family life to undertake a mystical search for the secret of universal love. Renouncing his property, he began to wear peasant dress and went to work in the fields, although at the time of his death he was still searching in vain for peace. Russia's other great novelist, Feodor Dostoyevsky (1821-1881), although he died before Tolstoy, had far more in common with the late 19th century than with the romantic movement, and he is accordingly discussed in Chapter 16.

The riches of the English 19th-century novel are almost unlimited. They range from the profoundly intellectual and absorbing works of George Eliot (1819-1880), the pen name of Mary Ann Evans, to Wuthering Heights (1847), the only novel by Emily Brontë (1818-1848) and one of the most dramatic and passionate pieces of fiction ever written. The book's brilliant evocation of atmosphere and violent emotion produces a shattering effect. Like the two already mentioned, many of the leading novelists of the time were women, and the variety of their works soon puts to flight any facile notions about the feminine approach to literature. Elizabeth Gaskell (1810–1865), for example, was one of the leading

15.27 George Cruikshank. "Please sir, I want some more." 1838. From Oliver Twist, or The Parish Boy's Progress by "Boz," published by Richard Bentley, London. New York Public Library. In the workhouse, young Oliver Twist dares to ask for a second bowl of gruel. George Cruikshank (1792-1878), a famed illustrator and caricaturist of the 19th century, illustrated more than 850 books; probably his best-known work is that for Oliver Twist.

social critics of the day; her novels study the effects of industrialization on the poor.

If one figure stands out in the field of the English novel, it is Charles Dickens (1812-1870), immensely popular in his own lifetime and widely read ever since. It is regrettable that Dickens' best-known novel, A Tale of Two Cities (1859), is one of his least characteristic, since its melodramatic and not totally successful historical reconstruction of the French Revolution may have deterred potential readers from exploring the wealth of humor, emotion, and imagination in his more successful books. Each of Dickens' novels and short stories creates its own world, peopled by an incredible array of characters individualized by their tics and quirks of personality. His ability to move us from laughter to tears and back again gives his work a continual human appeal, although it has won him the censure of some of the severer crit-

Throughout his life Dickens was an active campaigner against social injustices and used his books to focus on individual institutions and their evil effects. Oliver Twist (1837-1838) attacked the treatment of the poor in workhouses and revealed Dickens' view of crime as the manifestation of a general failing in society [15.27]. In Hard Times (1854) he turned, like Mrs. Gaskell, to the evils of industrialization and pointed out some of the harm that misguided attempts at education can do.

The Romantic Era in America

The early history of the arts in America was intimately linked to developments in Europe. England, in particular, by virtue of its common tongue and political connections, exerted an influence on literature and painting that even the War of Independence did not end. American writers sought publishers and readers there, and modeled their style on that of English writers. American painters went to London to study, sometimes with less than happy results. John Singleton Copley (1738-1815), for example, produced a series of portraits in a simple, direct style of his own [15.28] before leaving Boston for England. where he fell victim to Sir Joshua Reynolds' Grand

15.28 John Singleton Copley. Portrait of Nathaniel Hurd. c. 1765. Oil on canvas, $30 \times 25\frac{1}{2}$ " (76 × 65 cm). Cleveland Museum of Art (gift of the John Huntington Art and Polytechnic Trust). In this portrait of a friend Copley avoids technical tricks. The result is an attractive simplicity of style that still lets him reveal something of the subject's personality.

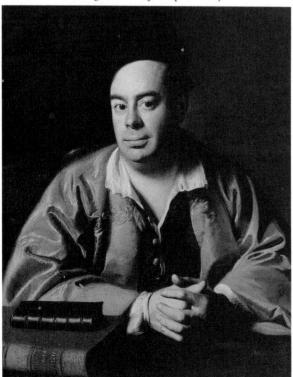

Manner [see figure 14.13, page 215]. Of American music we cannot say much, since the earliest American composers confined their attention to settings of hymns and patriotic songs. A recognizably American musical tradition of composition did not develop before the very end of the 19th century, although much earlier European performers found a vast and enthusiastic musical public in the course of their American tours [15.29].

In the case of literature and the visual arts, the French Revolution provided a change of direction. for revolutionary ties inevitably resulted in the importation of neoclassicism into America. With the dawning of the Romantic Era, however, American artists began to develop for the first time an authentic voice of their own. In many cases they still owed much to European examples. Indeed, the tradition of the expatriate American artist who left home to study in Europe and remained there had been firmly established by the 18th century. Throughout the 19th century writers like Washington Irving (1783-1859) and painters like Thomas Eakins (1844-1916) continued to bring back to America themes and styles they had acquired during their European travels. Something about the very nature of romanticism, however, with its emphasis on the individual, seemed to fire the American imagination, and so for the first time American artists began to produce work that was both a genuine product of their native land and at the same time of international stature.

15.29 Nathaniel Currier. First Appearance of Jenny Lind in America: At Castle Garden, September 11, 1850, detail. 1850. Lithograph. J. Clarence Davies Collection, Museum of the City of New York. The great soprano, inevitably known as the Swedish Nightingale, made a very successful tour of America under the management of P. T. Barnum in 1850-1851, during which she earned the staggering sum of \$120,000 (multiply by ten for present value). At this first appearance in New York, the total receipts were \$26,238. Nathaniel Currier (1813-1888) and James Merritt Ives (1824-1895), who became his partner in 1857, were lithographers who sold thousands of hand-colored prints that show many aspects of 19th-century American life.

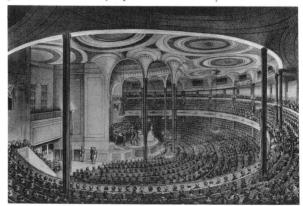

CONTEMPORARY VOICES

Isabella Bird Meets a Mountain Man

Isabella Bird (1831-1904), the English travel writer, meets Rocky Mountain Jim in Colorado in 1873-"a man who any woman might love, but who no sane woman would marry." A tireless traveler throughout America, Asia, and Australia, Isabella finally did settle down for a while and get married; her husband observed that he "had only one formidable rival in Isabella's heart, and that is the high Table Land of Central

Roused by the growling of the dog, his owner came out, a broad, thickset man, about the middle height. with an old cap on his head, and wearing a grey hunting-suit much the worse for wear (almost falling to pieces, in fact), a digger's scarf knotted round his waist, a knife in his belt, and 'a bosom friend', a revolver, sticking out of the breast-pocket of his coat; his feet, which were very small, were bare, except for some dilapidated moccasins made of horse hide. The marvel was how his clothes hung together, and on him. The scarf round his waist must have had something to do with it. His face was remarkable. He is a man about 45, and must have been strikingly handsome. He has large grey-blue eyes, deeply set, with well-marked eyebrows, a handsome aquiline nose, and a very handsome mouth. His face was smooth shaven except for a dense moustache and imperial. Tawny hair, in thin uncared-for curls, fell from under his hunter's cap and over his collar. One eye was entirely gone, and the loss made one side of the face repulsive, while the other might have been modelled in marble. "Desperado" was written in large letters all over him. I almost repented of having sought his acquaintance.

His first impulse was to swear at the dog, but on seeing a lady he contented himself with kicking him, and coming up to me he raised his cap, showing as he did so a magnificently formed brow and head, and in a cultured tone of voice asked if there were anything he could do for me? I asked for some water, and he brought some in a battered tin, gracefully apologizing for not having anything more presentable. We entered into conversation, and as he spoke I forgot both his reputation and appearance, for his manner was that of a chivalrous gentleman, his accent refined, and his language easy and elegant. I inquired about some beavers' paws which were drying, and in a moment they hung on the horn of my saddle. Apropos of the wild animals of the region, he told me that the loss of his eye was owing to a recent encounter with a grizzly bear, which after giving him a death hug, tearing him all over, breaking his arm and scratching out his eye, had left him for dead.

From A Lady's Life in the Rocky Mountains, London, 1879; reprinted by Virago Press, London, 1982.

American Literature

In a land where daily existence was lived so close to the wildness and beauty of nature, the romantic attachment to the natural world was bound to make a special appeal. The romantic concept of the transcendental unity of humans and nature was quickly taken up in the early 19th century by a whole group of American writers who even called themselves the Transcendentalists. Borrowing ideas from Kant and from his English followers such as Coleridge and Wordsworth, they developed notions of an order of truth that transcends what we can perceive by our physical senses and which unites the entire world. One of their leading representatives, Ralph Waldo Emerson (1803–1882), underlined the particular importance of the natural world for American writers in his essay The American Scholar, first published in 1837. In calling for the development of a national literature, Emerson laid down as a necessary condition for its success that his compatriots should draw their inspiration from the wonders of their own country. A few years later he was to write: "America is a poem in our eyes; its ample geography dazzles the imagination, and it will not wait long for metres."

Emerson always tried to make his own work "smell of pines and resound with the hum of insects," but although his ideas have exerted a profound effect on the development of American culture, Emerson himself was a better thinker than creative artist. Far more successful as a literary practitioner of Transcendentalist principles was Henry David Thoreau (1817-1862), whose masterpiece Walden (1854) uses his day-to-day experiences as he lived in solitude on the shore of Walden Pond to draw general conclusions about the nature of existence. Thoreau's passionate support of the freedom of the individual led him to be active in the antislavery movement, and by the end of his life he had moved from belief in passive resistance to open advocacy of violence against slavery.

Ideas of freedom, tolerance, and spiritual unity reached their most complete poetic expression in the works of America's first great poet, Walt Whitman (1819–1892). His first important collection of poems was published in 1855 under the title Leaves of Grass. From then until his death he produced edition after edition, retaining the same title but gradually adding many new poems and revising the old ones.

Whitman was defiantly, even aggressively, an American poet, yet the central theme of most of his work was the importance of the individual. The contradiction this involves serves as a reminder of the essentially romantic character of Whitman's mission. since by describing the details of his own feelings and reactions he hoped to communicate a sense of the essential oneness of the human condition. Much of the time the sheer vitality and flow of his language helps to make his experiences our own, although many of his earlier readers were horrified at the explicit sexual descriptions in some of his poems. Above all, Whitman was a fiery defender of freedom and democracy. His vision of the human race united with itself and with the universe has a special significance for the late 20th century.

The essential optimism of the Transcendentalists, especially as interpreted by Whitman, is absent from the work of the two great American novelists of the 19th century, Nathaniel Hawthorne (1804-1864) and Herman Melville (1819–1891). Hawthorne in particular was deeply concerned with the apparently ineradicable evil in a society dedicated to progress. In The Scarlet Letter (1850), his first major success, and in many of his short stories he explored the conflicts between traditional values and the drive for change.

Melville imitated Hawthorne's example in combining realism with allegory and in dealing with profound moral issues. His subjects and style are both very different, however. Moby-Dick (1851), his masterpiece, is often hailed as the greatest of all American works of fiction. It shares with Goethe's Faust the theme of the search for truth and self-discovery, which Melville works out by using the metaphor of the New England whaling industry. Both Melville and Hawthorne were at their greatest when using

15.30 Thomas Cole. Genesee Scenery (Landscape with Waterfall). 1847. Oil on canvas, $4'3'' \times 3'3\frac{1}{2}''$ (1.3 × 1 m). Museum of Art, Rhode Island School of Design, Providence (Jesse Metcalf Fund). One of Cole's last works, this shows a meticulous care for detail that is never allowed to detract from the broad sweep of the view.

uniquely American settings and characters to shed light on universal human experience.

American Painting

Under the influence of the Transcendentalists, landscape painting in America took on a new signifi-

15.31 Martin Johnson Heade. Lake George. 1862. Oil on canvas, $2'2'' \times 4'2''$ $(.66 \times 1.26 \text{ m})$. Courtesy Museum of Fine Arts, Boston (bequest of Maxim Karolik). Note the smooth surface of the painting, which reveals no trace of the artist's brush strokes, and the extreme precision of the rendering of the rocks at right.

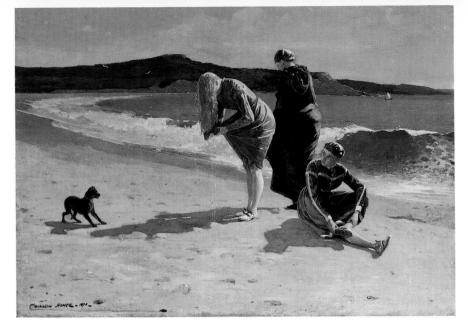

15.32 Winslow Homer. Eagle Head, Manchester, Massachusetts (High Tide: The Bathers). 1870. Oil on canvas, $26 \times 38''$ (66 × 97 cm). Metropolitan Museum of Art, New York (gift of Mrs. William F. Milton, 1923). This painting, produced after Homer's visit to France, shows a new, more impressionistic approach to light and to the sea.

cance. Emerson reminded the artist who set out to paint a natural scene that "landscape has a beauty for his eye because it expresses a thought which to him is good, and this because the same power which sees through his eyes is seen in that spectacle." Natural beauty, in other words, is moral beauty, and both of them demonstrate the transcendental unity of the universe.

The earliest painters of landscapes intended to glorify the wonders of nature are known collectively as the Hudson River School. The foundations of their style were laid by Thomas Cole (1801–1848), himself born in England, whose later paintings combine grandeur of effect with accurate observation of details. His Genesee Scenery [15.30] is particularly successful in capturing a sense of atmosphere and presence.

15.33 Thomas Eakins. The Swimming Hole. 1883. Oil on canvas, 27 × 36" (69 × 91 cm). Collection of the Modern Art Museum, Fort Worth, Texas (purchased by the Friends of Art, Fort Worth). Eakins painted the figures directly from models placed in poses from Greek sculpture in order to try to see nature as the Greeks saw it, but without the Greeks' idealization. The figure swimming in the bottom right-hand corner is Eakins himself.

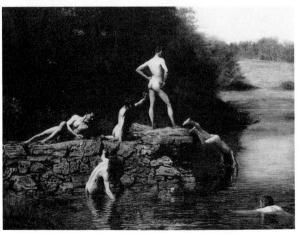

By midcentury a new approach to landscape painting had developed. Generally called luminism, it aimed to provide the sense of artistic anonymity Emerson and other Transcendentalists demanded. In a way this is the exact antithesis of romanticism. Instead of sharing with the viewer their own reactions, the luminists tried by realism to eliminate their own presence and let nothing stand between the viewer and the scenes. Yet the results, far from achieving only a photographic realism, have an utterly characteristic and haunting beauty that has no real parallel in European art of the time. The painting Lake George [15.31] by Martin J. Heade (1819-1904), one of the leading luminists, seems almost to foreshadow the surrealist art of the 20th century.

The two great American painters of the later 19th century, Winslow Homer (1836-1910) and Thomas Eakins (1844–1916), both used the luminist approach to realism as a basis for their own very individual styles. In the case of Homer, the realism of his early paintings was in large measure the result of his work as a documentary artist, recording the events of the Civil War. His style underwent a notable change as he became exposed to contemporary French impressionist painting (discussed in Chapter 16). His mysterious Eagle Head [15.32] is certainly far more than a naturalistic depiction of three women and a dog on a beach. By the way in which he has positioned the figures, Homer suggests rather than spells out greater emotional depths than initially meet the eye. The sense of restrained drama occurs elsewhere in his work, while the sea became a growing obsession with him and provided virtually the only subject of his last works.

Thomas Eakins used realism as a means of achieving objective truth. His pursuit of scientific accuracy led him to make a particular study of the possibilities

of photography. Animals and, more particularly, humans in motion continually fascinated him. This trait can be observed in The Swimming Hole [15.33]. where the variety of poses and actions produces a series of individual anatomical studies rather than a unified picture.

In his own day Eakins' blunt insistence on accuracy of perception did not endear him to a public that demanded more glamorous art. Yet if many of his works seem essentially antiromantic in spirit, foreshadowing as they do the age of mechanical precision, in his portraits he returns to the romantic tradition of expressing emotions by depicting them. The sitter in Miss Van Buren [15.35], as in most of his portraits, turns her eyes away from us, rapt in profound inner contemplation. The artist's own emotional response to the mood of his subject is made visible in his painting.

Painters such as Homer and Eakins, like Whitman and other writers discussed here, are important in the history of American culture not only for the value of their individual works. Their achievements demon-

THE ARTS AND INVENTION: Photography

On August 19, 1839, a joint meeting of the French Academy of Sciences and Academy of Fine Arts heard the first public account of Louis Daguerre's discovery of a process of photography; the images he produced are called daguerrotypes, after him. From the beginning, reaction to the invention of photography was wildly enthusiastic, and both public and artists realized that the new medium had enormous significance for the development of art. Even Delacroix and Ingres were in agreement for once; the former said if a man of genius used the daguerrotype properly, "he will raise himself to a height that we do not know," while Ingres admired photography "for an exactitude that I shall like to achieve.'

Daguerre's technique had its disadvantages. The exposure time was several minutes, rendering portrait photography difficult and scenes from life involving movement virtually impossible. Furthermore, each picture was unique and could only be duplicated by either being rephotographed or copied by hand. By the end of 1840, however, new chemical methods and forms of lens had been developed that simplified the entire process and over the following decade further improvements were introduced. Among the principal figures in

the early history of photography were the English scientist William Henry Fox Talbot, who discovered how to make prints from paper, and the French photographer Gaspard Tournachon, better known by his pseudonym of Nader, the first person to take pictures from a balloon and among the first to photograph by electric light. The work of these early photographers was to have an important impact on the painting of the Impressionists, especially Degas (see p. 327).

In America Thomas Cole was among the few artists who remained unimpressed; he called the daguerrotype a mechanical contrivance. Most other American painters of the 19th century seem to have used photographs both for study and as models for paintings. Thomas Eakins, analytical as ever in his response, was convinced that the new medium could be immensely valuable in studying motion, although he also perceptively recognized that the photograph was a convention as much as painting. He examined the physiology of motion, both in his own photographs and in those of the Englishborn Edward Muggeridge, who worked in America under the name of Eadward Muybridge [15.34]. The results are clearly visible in works like The Swimming Hole of 1883. [see figure 15.33].

15.34 Eadward Muybridge. Head-spring, a flying pigeon interfering, June 26, 1885. Plate 365, Animal Locomotion, 1887; print from original master negative. International Museum of Photography at George Eastman House, Rochester, N.Y.

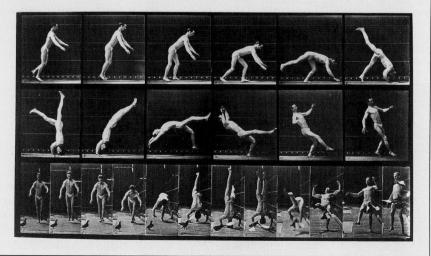

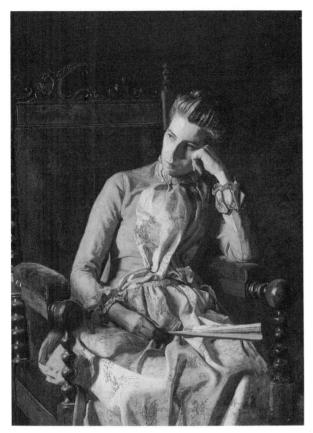

15.35 Thomas Eakins. Miss Van Buren. c. 1889-1891. Oil on canvas, 45 × 32" (114 × 81 cm). Phillips Collection, Washington. Note how, in contrast to the portraits by Ingres (figure 15.18, page 274) and Copley (figure 15.28, page 282), Eakins achieves deep feeling and sensitivity by the angle of his subject's head and her position in the chair.

strated that American society could at last produce creative figures capable of absorbing the European cultural experience without losing their individuality. From this time on there could be no doubt that American artists and writers had their own distinctive contribution to make to the Western cultural tradition.

Summary

The revolutionary changes that ushered in the 19th century, and that were to continue throughout it, profoundly affected society and culture. The industrialization of Europe produced vast changes in the lifestyles of millions of people. The Greek struggle for independence, the unification of Italy and of Germany, and the nationalist revolutionary uprisings of 1848 in many parts of Europe all radically changed the balance of power and the nature of society. The same period, furthermore, saw the gradual assertion of the United States, tested and tried by its own Civil War, as one of the leading Western nations. By the

end of the 19th century America had not only established itself as a world power; it had produced artists, writers, and musicians who created works with an authentically American spirit.

A period of such widespread change was naturally also one of major intellectual ferment. The political philosophy of Karl Marx and the scientific speculations of Charles Darwin, influential in their day, remain powerful and controversial in the late 20th century. The optimism of Immanuel Kant and Friedrich Hegel and the pessimism of Arthur Schopenhauer were reflected in numerous works of art.

The artistic movement that developed alongside these ideas was romanticism. The romantics, for all their divergences, shared a number of common concerns. They sought to express their personal feelings in their works rather than searching for some kind of abstract philosophical or religious "truth." They were attracted by the fantastic and the exotic, and by worlds remote in time—the Middle Ages-or in place-the mysterious Orient. Many of them felt a special regard for nature, in the context of which human achievement seemed so reduced. For some, on the other hand, the new age of industry and technology was itself exotic and exciting. Many romantic artists identified with the nationalist movements of the times and either supported their own country's fight for freedom (as in the case of Verdi) or championed the cause of others (as did

In music the transition from the classical to the romantic style can be heard in the works of Ludwig von Beethoven. With roots deep in the classical tradition, Beethoven used music to express emotion in a revolutionary way, pushing traditional forms like the sonata to their limits. Typical of the age is his concern with freedom, which appears in Fidelio (his only opera), and human unity, as expressed in the last movement of the Ninth Symphony.

Many of Beethoven's successors in the field of instrumental music continued to use symphonic forms for their major works. Among the leading symphonists of the century were Hector Berlioz, Johannes Brahms, and Anton Bruckner. Other composers, although they wrote symphonies, were more at home in the intimate world of songs and chamber music; they included Franz Schubert and Robert Schumann. The romantic emphasis on personal feelings and the display of emotion encouraged the development of another characteristic of 19th-century music: the virtuoso composer-performer. Frédéric Chopin, Franz Liszt, and Niccolo Paganini all won international fame performing their own works. The nationalist spirit of the times was especially appealing to musicians who could draw on a rich tradition of folk music. The Russian Modest Moussorgsky and the Czech Bedrich Smetana both wrote works using national themes and folk tunes.

The world of opera was dominated by two giants, Giuseppi Verdi and Richard Wagner. The former took the forms of early-19th-century opera and used them to create powerful and dramatic masterpieces. An enthusiastic supporter of Italy's nationalist movement, Verdi never abandoned the basic elements of the Italian operatic tradition expressive melody and vital rhythm—but he infused them with new dramatic truth. Wagner's quest for "music drama" led him in a very different direction. His works break with the operatic tradition of individual musical numbers; the music, in which the orchestra plays an important part, runs continuously from the beginning to the end of each act. In addition, the use of leading motifs to represent characters or ideas makes possible complex dramatic effects. Wagner's works revolutionized the development of both operatic and nonoperatic music, and his theoretical writings on music and much else made him one of the 19th century's leading cultural figures.

Just as Beethoven spanned the transition from classical to romantic in music, so Francesco Goya, some of whose early works were painted in the rococo style, produced some of the most powerful of romantic paintings. His concern with justice and liberty, as illustrated in Execution of the Madrileños on May 3, 1808 and with the world of dreams, as in The Sleep of Reason Produces Monsters, was prototypical of much romantic art.

In France, painters were divided into two camps. The fully committed romantics included Théodore Géricault, also concerned to point out injustice, and Eugène Delacroix, whose work touched on virtually every aspect of romanticism: nationalism, exoticism, eroticism. The other school was that of the realists. Henri Daumier's way of combating the corruption of his day was to portray it as graphically as possible. In the meantime Ingres waged his campaign against both progressive movements by continuing to paint in the academic neoclassical style of the preceding century—or at least his version of it.

Painters in England and Germany were particularly attracted by the romantic love of nature. Caspar David Friedrich used the grandeur of the natural world to underline the transitoriness of human achievement, while in John Constable's landscapes there is greater harmony between people and their surroundings. Joseph M. W. Turner, Constable's contemporary, falls into a category by himself. Although many of his subjects were romantic, his use of form and color make light and movement the real themes of his paintings.

In literature no figure dominated his time more than Johann Wolfgang von Goethe, the German poet, dramatist, and novelist. One of the first writers to break the fetters of neoclassicism, he nonetheless continued to produce neoclassical works as well as more romantic ones. The scale of his writings runs from the most intimate love lyrics to the monumental two parts of his Faust drama.

The work of the English romantic poets William Wordsworth, Percy Bysshe Shelley, John Keats, and George Gordon, Lord Byron touched on all the principal romantic themes. Other English writers used the novel as a means of expressing their concern with social issues, as in the case of Charles Dickens, or their absorbtion with strong emotion, as did Emily Brontë. Indeed, the 19th century was the great age of the novel, with Honoré Balzac and Gustave Flaubert writing in France and—above all— Leo Tolstoy in Russia.

The Romantic era was the first period in which American artists created their own original styles rather than borrowing them from Europe. Love of nature inspired writers like Henry David Thoreau and painters like Thomas Cole. The description of strong emotions, often personal ones, characterizes the poetry of Walt Whitman and many of the

paintings of Winslow Homer. Thomas Eakins, with his interest in realism, made use of a 19th-century invention that had an enormous impact on the visual arts: photography.

By the end of the century the audience for art of all kinds had expanded immeasurably. No longer commissioned by the church or the aristocracy, artworks expressed the hopes and fears of individual artists and of humanity at large. Furthermore, as the revolutionaries of the 18th century had dreamed, they had helped bring about social change.

Pronounciation Guide

Balzac: Bal-ZAK Berlioz: BER-li-owes Bruckner: BROOK-ner

Chios: KEY-os Chopin: Show-PAN Courbet: Coor-BAY Daumier: Doe-MYAY Delacroix: De-la-KRWA

Eakins: ACHE-ins Fidelio: Fi-DAY-li-owe Géricault: Jay-rick-OWE Goethe: GUER-te

Ingres: ANG Kant: CANT

Leitmotiv: LITE-mow-teef Liebestod: LEE-bis-toe-t

Liszt: LIST

Moussorgsky: Mus-OR-g-ski Nabucco: Na-BOO-kowe Sardanapalus: Sar-dan-AP-al-us

Scherzo: SCARE-ts-owe

Schopenhauer: SHOWP-en-how-er

Thoreau: THOH-row Traviata: Tra-vi-AHE-ta Wagner: VAHG-ner Waldstein: VALD-stine

Exercises

- 1. Analyze the elements of the romantic style and compare its effect on the various arts.
- 2. Discuss the career of Beethoven and assess his influence on the development of music in the 19th century.
- 3. What were the principal schools of French romantic painting, and who were their leaders? What kinds of subject did they choose and why?
- 4. What factors—historical, cultural, social—favored the popularity of the novel in the 19th century? How do

- they compare to present conditions, and what is the status of the novel today?
- 5. Discuss the American contribution to the romantic movement

Further Reading

- Canaday, J. Mainstreams of Modern Art, 2nd ed. New York: Holt, 1981. A survey that combines scholarship, deep feeling, and unusually enjoyable prose. Many excellent illustrations.
- Chissell, I. Clara Schumann: A Dedicated Spirit. London: Hamish Hamilton, 1983. An absorbing biography of a woman whose life was divided between her composer husband and her own career as pianist and composer.
- Clark, K. The Romantic Rebellion. New York: Harper, 1986. The latest edition of a magisterial survey of the romantic movement, plentifully illustrated.
- Cooper, M. Beethoven: The Last Decade. New York: Oxford University Press, 1985. An unusually detailed study of the events and compositions of Beethoven's last years, with an interesting appendix on his medical history.
- Fischer-Dieskau, D. Schubert: A Biographical Study of His Songs. London: Cassell, 1976. In this fascinating book one of the greatest singers (and Schubert interpreters) of this century traces the composer's life through his songs.
- Gage, J. (ed. and trans.). Goethe on Art. Berkeley: University of California Press, 1980. This book contains many of Goethe's observations on art and throws considerable light on the poet's own work.
- Johnson, E. Charles Dickens: His Tragedy and Triumph. New York: Viking, 1977. An updated and abridged edition of an earlier work, this fine biography is particularly good on Dickens' visits to America.
- Kerman, J. and A. Tyson. Beethoven. London: Macmillan, 1983. Based on the entry in the New Grove Dictionary of Music, this provides a great deal of information, including a complete catalogue of Beethoven's works.
- Osborne, C. The Complete Operas of Verdi. New York: Knopf, 1970. An engrossing book that combines synopses and analyses of all Verdi's operas with an account of his life and extracts from his letters.
- Paulson, R. Literary Landscape: Turner and Constable. New Haven: Yale University Press, 1982. A cross-discipline study, this difficult but rewarding work attempts to "read" the landscape paintings of Turner and Constable by finding literary meanings for them.
- Wolf, B. Romantic Re-Vision: Culture and Consciousness in Nineteenth Century Painting and Literature. Chicago: University of Chicago Press, 1982. A sophisticated discussion of 19th-century American art, using the critical tools of the late 20th century—structuralism, semiotics, and psychoanalysis.

Reading Selections

Johann Wolfgang von Goethe Faust, Part II, final scene

In Part I of Faust Goethe shows us the consequences of Faust's pact with Mephistopheles: the destruction of Gretchen, whom Faust had seduced. Yet his love for her and its tragic outcome have made him aware of the nature of human suffering and human responsibility. In the course of Part II Faust marries Helen of Troy (in an episode that Goethe borrowed from the medieval Faust legend), and their union produces the child Euphorion, the spirit of the future, happy humanity. Faust even sees the vision of a future world in which all people live in contentment.

At the end of the play, in the final scene, Faust's soul is rescued by the angels from the forces of evil and borne triumphantly to Heaven. Through suffering—his own and that of others—and through his errors Faust has learned to recognize the nature of good and wins redemption.

The language of the scene is, at least in part, identifiably Christian. Goethe makes specific reference to biblical events in the words of the Mulier Samaritana (Samaritan Woman) and the Magna Peccatrix (Great Sinner) and Maria Aegyptiaca (the Egyptian Mary)—these last two again allusions to medieval legend. Gretchen appears in the form of a penitent, Una Poenitentium. Yet the emphasis on the redemptive power of woman, in this case the Virgin, gives a characteristically romantic air to the resolution of the story. The words of the last Mystical Chorus, one of Goethe's most famous pronouncements, are the epitome of the mysterious concept of the Eternal Feminine.

Ravines, forests, rocks, wilderness. Holy anchorites disposed here and there on the mountains, resting in chasms in the rocks.

CHORUS AND ECHO

Forests sway, rocks bear down, roots cling. tree-trunks densely thrust. Wave splashes on wave; only the deepest cave affords shelter. Lions silently pad mildly around us, honouring the sacred place, the sanctuary of holy love.

PATER ECSTATICUS

(soaring up and down) Eternal ecstatic fire, glowing bond of love, pain seething in the breast,

brimming love of God. Arrows, transfix me. lances, overcome me, cudgels, batter me, lightning, shatter me, so that all vanities may be annihilated and the constant star shinethe essence of eternal love.

PATER PROFUNDUS

(in the depths) as a rocky chasm at my feet weighs down upon a deeper abyss, as a thousand streams flow, sparkling, to the dread fall of foaming waters, as the trunk, by its own strong urge, resolutely lifts itself into the air, even so is the almighty love which forms and fosters all. Around me is a savage roar, as if forest and abyss were heaving! Yet, rushing lovingly, the torrents plunge into the chasm, equally ordained to irrigate the valley; the lightning that struck in flames to cleanse the atmosphere that bore poison and fog in its bosomthese are tokens of love, proclaiming the eternal creation that surrounds us. May my inmost being also be kindled where the spirit, confused and cold, is racked in bonds of blunted sense. riveted fast in fetters of pain. O God, soothe my thoughts, enlighten my needy heart!

ANGELS

(soaring in the higher atmosphere, carrying Faust's immortal soul) Saved from the Evil one is the noble part of the spirit world: to one who strives continually we can bring redemption. And if love has been granted him from on high. the heavenly host will receive him with heartfelt welcome.

CHORUS OF BLESSED BOYS (circling the highest peaks) Link your hands joyfully in a round dance! Move and sing of your holy feelings. Divinely guided,

you may have trust: you shall behold Him whom you revered.

THE YOUNGER ANGELS Those roses, from the hands of holy-loving women penitents, helped us to gain victory and complete the lofty task of capturing this precious soul. Evil ones retreated as we scattered them, devils fled at their touch. the spirits feeling love's pangs instead of their accustomed hellish torments. Even the old Satan-Master was pierced by keen pain. Rejoice! We have succeeded!

60

70

80

100

THE MORE PERFECT ANGELS To us is left a scrap of earth painful to bear; even were it of asbestos, it would not be clean. When strong spiritual power has snatched up the elements to itself, no angel could divide twin natures intimately united eternal love alone could separate them.

THE YOUNGER ANGELS Just now I sense, mistily round the rocky height, the presence of a spirit moving closer. I see a moving throng of blessed boys, freed from earth's stress, grouped in a circle, who are refreshing themselves in the new springtide decking the world above. Let him be their peer at the outset

THE BLESSED BOYS We gladly receive him in his chrysalis form: in this way we redeem the angels' pledge. Break loose the cocoon that envelops him: through divine life he is already fair and tall.

in their rising advancement.

DOCTOR MARIANUS

(in the highest, purest cell) Here the prospect is free, the spirit exalted. There women pass by, drifting upwards: therein I see, star-garlanded, the Glorious One, the Queen of Heaven in splendour. (enraptured) Supreme sovereign of the world, in the azure, unfurled tent of heaven let me gaze on thy mystery! Sanction that which earnestly and tenderly moves the heart of man and with love's holy bliss bears him towards thee. Invincible is our courage at thy august command: ardour is suddenly cooled when thou dost pacify us.

DOCTOR MARIANUS

(and Chorus) Virgin, pure in the most perfect sense, mother worthy of honour, our chosen queen, ranking with the gods! (Mater Gloriosa soars into view)

CHORUS

It is not improper that those easily led astray should come trustingly to thee, the immaculate. Those snatched in their weakness by death are hard to save: who by his own strength can break the fetters of desire? How quickly the foot slips on sloping, slippery ground!

CHORUS OF PENITENT WOMEN

(and Una Poenitentium) Thou dost soar to heights of realms eternal. Receive our pleas, O fount of mercy, O matchless one!

MAGNA PECCATRIX

By the love that at the feet of thy God-transfigured Son caused tears to flow as balsam, despite the Pharisees' derision; by the cup that so liberally poured sweet perfume; by the hair that so tenderly dried the holy limbs . . .

MULIER SAMARITANA

110

120

140

150

By the well to which of yore Abraham's flocks were driven; by the bucket that was allowed to touch and cool the Savior's lips; by the pure, bountiful spring which gushes forth from there, overflowing, eternally crystal, flowing through all creation . . .

MARIA AEGYPTIACA

By the holiest of places where the Lord was laid down; by the arm that, in warning, thrust me back from the portal; by the forty years' repentance that I faithfully served in the desert; by the blessed word of farewell that I wrote in the sand . . .

THE THREE

Thou who dost not deny thy presence to women who greatly sin, and dost raise a penitent to eternal victory, grant a suitable pardon to this good soul also, who forgot herself but once, unaware it was a sin.

UNA POENITENTIUM

(once named Gretchen) Incline thy countenance, O thou beyond compare, thou glorious one, graciously upon my bliss! He, once beloved, troubled no more, is returning to me.

BLESSED BOYS

(approaching in a circle) He is already outgrowing us in strength of limb, and will return ample reward for true care. We were removed early from the chorus of life; vet he has learned,

and he will teach us.

190

160

170

UNA POENITENTIUM

(Gretchen) Surrounded by the noble spirit-choir, the new-comer, already like the heavenly host, is scarcely conscious, scarcely senses this fresh life. See how he strips away all earthly ties from his old garb, and in ethereal apparel emerges in his pristine youthful strength! Grant me to instruct him, dazzled as yet by the new day.

MATER GLORIOSA

(and Chorus) Come, rise to higher spheres: when he feels your presence, he will follow. Come! Come!

DOCTOR MARIANUS

(and Chorus) (gazing in adoration) Raise your eyes to the gaze of salvation, all tender penitents, to be gratefully transformed into blissful fate. Let every reformed soul be dedicated to thy service: Virgin, Mother, Queen, Goddess, still be merciful!

CHORUS MYSTICUS

All that is transitory is but a symbol; all inadequacy here is fulfilled; the indescribable here is done: the eternal feminine leads us aloft.

William Wordsworth Tintern Abbey

The principal theme of Wordsworth's poetry, the relation between humans and nature, emerges in "Lines Composed a Few Miles Above Tintern Abbey on Revisiting the Banks of the Wye During a Tour," written in 1798, which describes the poet's reactions on his return to the place he had visited five years earlier. After describing the scene, he recalls the joy its memory has brought to him in the intervening years (lines 23-49). This in turn brings to mind the passage of time in his own life (lines 65-88) and the importance that the beauty of nature has always had for him (88–111). The last part of the poem shows how his love of nature has illuminated his relationships with other human

beings, in this case his beloved sister. The complex thought processes are expressed in the simplest language. In contrast to such 18th-century poets as Alexander Pope (see page 223) the words are straightforward and there are no learned biblical, classical, or even literary references.

Five years have past: five summers, with the

200

210

Of five long winters! and again I hear These waters, rolling from their mountain-springs With a soft inland murmur.—Once again Do I behold these steep and lofty cliffs, That on a wild secluded scene impress Thoughts of more deep seclusion: and connect The landscape with the quiet of the sky. The day is come when I again repose Here, under this dark sycamore, and view These plots of cottage-ground, these orchard-tufts. Which at this season, with their unripe fruits, Are clad in one green hue, and lose themselves 'Mid groves and copses. Once again I see These hedge-rows, hardly hedge-rows, little lines Of sportive wood run wild: these pastoral farms, Green to the very door; and wreaths of smoke Sent up, in silence, from among the trees! With some uncertain notice, as might seem Of vagrant dwellers in the houseless woods, 20 Or of some Hermit's cave, where by his fire The Hermit sits alone.

These beauteous forms. Through a long absence, have not been to me As is a landscape to a blind man's eye: But oft, in lonely rooms, and 'mid the din Of towns and cities, I have owed to them. In hours of weariness, sensations sweet, Felt in the blood, and felt along the heart; And passing even into my purer mind. With tranquil restoration:—feelings too Of unremembered pleasure: such, perhaps, As have no slight or trivial influence On that best portion of a good man's life, His little, nameless, unremembered, acts Of kindness and of love. Nor less, I trust, To them I may have owed another gift, Of aspect more sublime; that blessed mood, In which the burthen of the mystery, In which the heavy and the weary weight Of all this unintelligible world, Is lightened:—that serene and blessed mood, In which the affections gently lead us on,-Until, the breath of this corporeal frame And even the motion of our human blood Almost suspended, we are laid asleep In body, and become a living soul: While with an eye made quiet by the power Of harmony, and the deep power of joy,

30

We see into the life of things.

If this Be but a vain belief, yet, oh! how oft-In darkness and amid the many shapes Of joyless daylight; when the fretful stir Unprofitable, and the fever of the world, Have hung upon the beatings of my heart— How oft, in spirit, have I turned to thee, O sylvan Wye! thou wanderer thro' the woods, How often has my spirit turned to thee! And now, with gleams of half-extinguished

thought, With many recognitions dim and faint, And somewhat of a sad perplexity, The picture of the mind revives again: While here I stand, not only with the sense Of present pleasure, but with pleasing thoughts That in this moment there is life and food For future years. And so I dare to hope, Though changed, no doubt, from what I was

when first I came among these hills; when like a roe I bounded o'er the mountains, by the sides Of the deep rivers, and the lonely streams, Wherever nature led: more like a man Flying from something that he dreads than one Who sought the thing he loved. For nature then (The coarser pleasures of my boyish days, And their glad animal movements all gone by) To me was all in all.—I cannot paint What then I was. The sounding cataract Haunted me like a passion: the tall rock. The mountain, and the deep and gloomy wood, Their colours and their forms, were then to me An appetite; a feeling and a love, That had no need of a remoter charm, By thought supplied, nor any interest Unborrowed from the eye.—That time is past, And all its aching joys are now no more, And all its dizzy raptures. Not for this Faint I, nor mourn nor murmur; other gifts Have followed; for such loss, I would believe, Abundant recompense. For I have learned To look on nature, not as in the hour Of thoughtless youth; but hearing oftentimes The still, sad music of humanity, Nor harsh nor grating, though of ample power To chasten and subdue. And I have felt A presence that disturbs me with the joy Of elevated thoughts; a sense sublime Of something far more deeply interfused, Whose dwelling is the light of setting suns, And the round ocean and the living air, And the blue sky, and in the mind of man: A motion and a spirit, that impels

All thinking things, all objects of all thought,

And rolls through all things. Therefore am I still A lover of the meadows and the woods, And mountains; and of all that we behold From this green earth; of all the mighty world Of eye, and ear,—both what they half create, And what perceive; well pleased to recognise In nature and the language of the sense The anchor of my purest thoughts, the nurse, The guide, the guardian of my heart, and soul Of all my moral being.

Nor perchance, If I were not thus taught, should I the more Suffer my genial spirits to decay: For thou art with me here upon the banks Of this fair river; thou my dearest Friend, My dear, dear Friend; and in thy voice I catch The language of my former heart, and read My former pleasures in the shooting lights Of thy wild eyes. Oh! yet a little while May I behold in thee what I was once, 120 My dear, dear Sister! and this prayer I make, Knowing that Nature never did betray The heart that loved her; 'tis her privilege, Through all the years of this our life, to lead From joy to joy: for she can so inform The mind that is within us, so impress With quietness and beauty, and so feed With lofty thoughts, that neither evil tongues, Rash judgments, nor the sneers of selfish men, Nor greetings where no kindness is, nor all 130 The dreary intercourse of daily life, Shall e'er prevail against us, or disturb Our cheerful faith, that all which we behold Is full of blessings. Therefore let the moon Shine on thee in thy solitary walk; And let the misty mountain-winds be free To blow against thee; and, in after years. When these wild ecstasies shall be matured Into a sober pleasure; when thy mind Shall be a mansion for all lovely forms, 140 Thy memory be as a dwelling-place For all sweet sounds and harmonies; oh! then, If solitude, or fear, or pain, or grief, Should be thy portion, with what healing thoughts Of tender joy wilt thou remember me, And these my exhortations! Nor, perchance— If I should be where I no more can hear Thy voice, nor catch from thy wild eyes these

Of past existence—wilt thou then forget That on the banks of this delightful stream We stood together; and that I, so long A worshipper of Nature, hither came Unwearied in that service: rather say With warmer love—oh! with far deeper zeal Of holier love. Nor wilt thou then forget

That after many wanderings, many years Of absence, these steep woods and lofty cliffs. And this green pastoral landscape, were to me More dear, both for themselves and for thy sake!

Percy Bysshe Shelley

The first of these two poems illustrates Shelley's ability to capture intense emotions by the use of the simplest of language. Without any overstatement and with direct, uncomplicated images the poem makes an impression out of all proportion to its length.

In the second poem Shelley sounds deeper and more resonant chords. Ozymandias was the Greek name for the mighty Egyptian Pharaoh Ramses II, and Shelley uses the image of his shattered statue to symbolize the impermanence of human achievement.

TO-

Music, when soft voices die, Vibrates in the memory: Odours, when sweet violets sicken. Live within the sense they quicken. Rose leaves, when the rose is dead. Are heaped for the beloved's bed: And so thy thoughts, when thou art gone, Love itself shall slumber on.

OZYMANDIAS

I met a traveller from an antique land Who said: Two vast and trunkless legs of stone Stand in the desert . . . Near them, on the sand.

Half sunk, a shattered visage lies, whose frown, And wrinkled lip, and sneer of cold command, Tell that its sculptor well those passions read Which yet survive, stamped on these lifeless things

The hand that mocked them and the heart that fed:

And on the pedestal these words appear: "My name is Ozymandias, king of kings: Look on my works, ye Mighty, and despair!" Nothing beside remains. Round the decay Of that colossal wreck, boundless and bare The lone and level sands stretch far away.

John Keats

Keats wrote this poem while living in Hampstead, and his companion, Charles Brown, left an account of the circumstances of its composition: "In the spring of 1819 a nightingale had built her nest near my house. Keats felt a tranquil and continual joy in her song; and one morning he took his chair from the breakfast table to the grass plot under a plumtree where he sat for two or three hours. When he came into the house, I perceived he had some scraps of paper in his hand. . . .

The song of the bird serves as inspiration for a meditation on the nature of human experience. The poem begins in despondency as Keats (only twenty-four years old but already stricken by tuberculosis) broods on life's sorrows. As he muses, the immortal song and the beauty of nature it represents console him, bringing comfort and release, and he accepts his tragic fate. Less than two years later he was dead.

ODE TO A NIGHTINGALE

My heart aches, and a drowsy numbness pains My sense, as though of hemlock I had drunk, Or emptied some dull opiate to the drains One minute past, and Lethe-wards had sunk: 'Tis not through envy of thy happy lot, But being too happy in thine happiness.— That thou, light-winged Dryad of the trees, In some melodious plot Of beechen green, and shadows numberless, Singest of summer in full-throated ease.

II

O, for a draught of vintage! that hath been Cool'd a long age in the deep-delved earth, Tasting of Flora and the country green, Dance, and Provençal song, and sunburnt mirth!

O for a beaker full of the warm South. Full of the true, the blushful Hippocrene, With beaded bubbles winking at the brim, And purple-stained mouth;

That I might drink, and leave the world unseen,

And with thee fade away into the forest dim:

Ш

Fade far away, dissolve, and quite forget What thou among the leaves hast never known, The weariness, the fever, and the fret

Here, where men sit and hear each other groan; Where palsy shakes a few, sad, last grey hairs,

Where youth grows pale, and spectre-thin, and

Where but to think is to be full of sorrow And leaden-eyed despairs,

Where Beauty cannot keep her lustrous eyes, Or new Love pine at them beyond tomorrow.

30

20

IV

Away! away! for I will fly to thee, Not charioted by Bacchus and his pards, But on the viewless wings of Poesy, Though the dull brain perplexes and retards: Already with thee! tender is the night, And haply the Queen-Moon is on her throne, Cluster'd around by all her starry Fays; But here there is no light, Save what from heaven is with the breezes blown Through verdurous glooms and winding mossy ways.

I cannot see what flowers are at my feet, Nor what soft incense hangs upon the boughs, But, in embalmed darkness, guess each sweet Wherewith the seasonable month endows The grass, the thicket, and the fruit-tree wild; White hawthorn, and the pastoral eglantine; Fast fading violets cover'd up in leaves; And mid-May's eldest child, The coming musk-rose, full of dewy wine, The murmurous haunt of flies on summer

VI

Darkling I listen: and, for many a time I have been half in love with easeful Death, Call'd him soft names in many a musèd rhyme, To take into the air my quiet breath; Now more than ever seems it rich to die, To cease upon the midnight with no pain, While thou art pouring forth thy soul abroad In such an ecstasy! Still wouldst thou sing, and I have ears in To thy high requiem become a sod.

VII

Thou wast not born for death, immortal Bird! No hungry generations tread thee down; The voice I hear this passing night was heard In ancient days by emperor and clown: Perhaps the self-same song that found a path Through the sad heart of Ruth, when, sick for home. She stood in tears amid the alien corn; The same that oft-times hath Charm'd magic casements, opening on the foam Of perilous seas, in faery lands forlorn.

VIII

Forlorn! the very word is like a bell To toll me back from thee to my sole self! Adieu! the fancy cannot cheat so well As she is fam'd to do, deceiving elf. Adieu! adieu! thy plaintive anthem fades Past the near meadows, over the still stream. Up the hill-side; and now 'tis buried deep In the next valley-glades. Was it a vision, or a waking dream? Fled is that music:—Do I wake or sleep?

Honoré de Balzac, Lost Illusions, Part Two, Chapters 3

Although Balzac's novels contain an almost infinite range of characters, most are set in two contrasting worlds: the French provinces—boring, conventional, but decent—and Paris—exciting, ruthless, corrupt. Lost Illusions tells the story of the young poet Lucien Chardon, who leaves his provincial home to seek fame in the capital. The long book reveals much of Balzac's ambivalence toward Parisian life and literary circles. Although Lucien has returned home by its end, he reappears in Paris in a later book of the Human Comedy series: like Balzac himself, while appreciating the virtues of provincial life, he cannot resist the enticements of the big city.

The two chapters included here illustrate the good and bad sides of Paris. In the first, Lucien tries to interest a publisher in his new novel. The consequences will be familiar to anyone who has tried the same venture, suggesting that neither authors nor publishers have changed much. The episode allows Balzac to have some fun at the expense of both sides.

In the second scene, Lucien discovers one of the compensations of anonymous city life: the possibility of forming sudden intense friendships with strangers. His new acquaintance introduces him to the rituals of the world of letters in Paris and shares his own experiences. Balzac was well established when he wrote Lost Illusions, but he clearly identified with both young men. At the same time, however, the absurd nature of their ambitions is never in doubt.

Two varieties of publishers

One quite cold autumnal morning he walked down the rue de la Harpe with his two manuscripts under his arm. He made his way to the Quai des Augustins and strolled along the pavement, looking alternately at the flowing Seine and the booksellers' stalls as if his presiding genius were advising him to throw himself into the river rather than the career of letters. After anguished hesitations and an attentive scrutiny of the

more or less kindly, enheartening, surly, merry or dreary faces he observed through the windows or on 10 the door-steps, his eye caught a building in front of which shop attendants were packing up books. The walls were covered with posters:

ON SALE WITHIN

Le Solitaire, by Monsieur le Vicomte d'Arlincourt, 3rd

Léonide, by Victor Ducange, 5 vols printed on fine paper.

Price 12 francs.

Inductions morales, by Kératry.

"They're lucky people!" Lucien exclaimed.

Posters, a new and original invention of the fa-20 mous Ladvocat, were then flourishing on walls for the first time. Paris was soon to become a medley of colours thanks to the imitators of this method of advertisement, the source of one kind of public revenue. His heart bursting with excitement and anxiety. Lucien, once so important in Angoulême and now so small in Paris, sidled his way alongside the row of publishing-houses and summoned up enough courage to enter the shop he had noticed. It was crowded with assistants, customers and booksellers—authors 30 too perhaps, Lucien supposed.

"I should like to speak to Monsieur Vidal or Monsieur Porchon," he said to an assistant. He had read the shop-sign on which was written in large letters:

VIDAL AND PORCHON

WHOLESALE BOOKSELLERS COMMISSION AGENTS FOR FRANCE AND ABROAD

"Both of those gentlemen are engaged," replied a busy assistant.

"I will wait."

The poet was left alone in the shop, where he examined the batches of books. Two hours went by while he looked at the titles, opened the volumes and read pages here and there. In the end he leaned his shoulder against a glazed door draped with short green curtains behind which, he suspected, was either Vidal or Porchon. He overheard the following conversation:

"Will you take five hundred copies? If so I'll let 50 you have them at five francs each and give you sixteen per cent on sales."

"What price would that come to per volume?"

"A reduction of sixteen sous."

"That would be four francs four sous," said Vidal—or was it Porchon?—to the man who was offering his books for sale.

"Yes," replied the vendor.

"On credit?" asked the buyer.

"You old humbug! And then I suppose you'd set-60 tle with me in eighteen months with bills postdated a

"No, I'd settle straight away," replied Vidal—or Porchon.

"To fall due when? In nine months?" asked the publisher or author who was evidently offering a book for sale.

"No, my dear man: in a year," answered the wholesale bookseller. There was a moment's silence.

"You're bleeding me white!" cried the unknown. 70

"But surely you don't suppose we shall have got rid of five hundred copies of Léonide in twelve months," the bookseller replied to Victor Ducange's publisher. "If books sold as the publishers liked we should be millionaires; but they sell as the public likes. Walter Scott's novels bring us eighteen sous a volume, three francs sixty for the complete works, and you want me to sell your rubbishy books for more than that? If you want me to push your novel make it worthy my while.—Vidal!"

A stout man left the cash-desk and came forward

with a pen behind his ear.

"In the last trip you made," Porchon asked him, "how many of Ducange's books did you place?"

"I unloaded two hundred copies of Le petit Vieillard de Calais. But, in order to get them off my hands, I had to lower the price of two other works which were not bringing so much discount. They have turned into very pretty 'nightingales'."

Later Lucien was to learn that the term 'nightin-90 gale' was applied by booksellers to works which stay perched up on shelves in the remote recesses of their store-rooms.

"Besides," continued Vidal, "you know that Picard is about to bring out some novels. We are promised twenty per cent discount on the retail price so that we may make a success of them."

"All right. One year," the publisher dolefully replied: he was dumbfounded by Vidal's last confiden-

tial remark to Porchon.

"It's agreed?" Porchon asked the publisher in a sharp tone.

"Yes."

The publisher left, and Lucien heard Porchon saying to Vidal. "We have orders for three hundred copies. We'll put off the date for settlement with him, sell the Léonide volumes at five francs each, demand payment for them in six months, and . . . "

"And," added Vidal, "that's a profit of fifteen

hundred francs."

"Well, I could see he's getting into difficulties."

"He'll be in the soup! He's paying Ducange four thousand francs for two thousand copies."

Lucien halted Vidal by planting himself squarely

in the doorway of this cage.

"Gentlemen," he said to the booksellers. "I have the honour of greeting you."

The booksellers scarcely returned his salutation.

"I am the author of a novel on the history of France, after the manner of Walter Scott, entitled The 120 Archer of Charles the Ninth, and I have come to pro-

pose that you should buy it."

Porchon laid his pen on his desk and threw a tepid glance at Lucien. As for Vidal, he gave the author a brutal stare and replied: "Monsieur, we are not publishing booksellers. When we produce books on our own account, that is an operation we only undertake with established authors. Besides that, we only purchase serious books, works of history and digests."

"But mine is a very serious book. It reveals the 130 true significance of the conflict between the Catholics, who stood for absolutism, and the Protestants,

who wanted to found a republic."

"Monsieur Vidal!" an assistant shouted. Vidal

slipped away.

"I am not saying, Monsieur, that your book is not a masterpiece," replied Porchon with a very discourteous shrug, "but that we are only concerned with books which are already in print. Go and see the firms which buy manuscripts—Papa Doguereau, in 140 the rue du Coq, near the Louvre. He is one of those who publish novels. If only you had told me earlier! you have just seen us talking to Pollet, a competitor of Doguereau and the publishers in the Wooden Galleries.

"Monsieur, I have also a volume of poetry . . . " "Monsieur Porchon!" came a voice from outside.

"Poetry!" Porchon angrily exclaimed. "Who do you take us for?" He laughed in his face and vanished into the back premises. 150

Lucien crossed the Pont-Neuf a prey to innumerable reflections. By what he had understood of this commercial jargon he was able to guess that to these publishers books were like cotton bonnets to haberdashers, a commodity to be bought cheap and sold

"I shouldn't have gone there," he told himself; but he was none the less struck by the brutally materialistic aspect that literature could assume.

In the rue du Coq he espied a modest shop by 160 which he had already passed, and over which were painted, in yellow letters on a green background, the words DOGUEREAU, PUBLISHER.

He remembered having seen these words printed under the frontispiece of several novels he had read in Blosse's reading-room. He went in, not without inner misgivings such as men of imagination feel when they know they have a struggle before them. In the shop he discovered an extraordinary old man, an eccentric figure typical of a publisher of Imperial 170 must have something to say." times. Doguereau was wearing a black coat with big

square tails, long outmoded by the swallow-tails now in fashion. He had a waistcoat of common material, chequered in various colours, from the pocket of which hung a steel chain and copper key which dangled over an ample pair of black breeches. His watch was about the size of an onion. This costume was completed by iron-grey milled stockings and shoes graced with silver buckles. The old man's head was bare and adorned with greying hair, poetically 180 sparse. Judging by his coat, breeches and shoes you would have taken Papa Doguereau, as Porchon had called him, for a professor of literature; judging by his waistcoat, watch and stockings, for a tradesman. His physiognomy did not belie this singular combination: he had the pedantic, dogmatic air and the wrinkled face of a teacher of rhetoric and the keen eyes, the wary mouth and the vague uneasiness of a publisher.

"Monsieur Doguereau?" asked Lucien.

"I am he, Monsieur," said the publisher.

"I have written a novel," said Lucien.

"You're very young," said the publisher.

"But my age, Monsieur, has nothing to do with

"That's true," said the publisher, taking the manuscript. "Ah, I do declare! The Archer of Charles the Ninth. A good title. Now, young man, tell me your subject briefly."

"Monsieur, it's an historical work in the manner of Walter Scott which presents the conflict between Catholics and Protestants as a combat between two systems of government, involving a serious threat to the monarchy. I have taken sides with the Catholics.'

"Why now, young man: quite an idea. Very well, I will read your work, I promise you. I should have preferred a novel in the manner of Mrs Radcliffe, but if you are a hard worker, if you have some sense of 210 style, power of conception, ideas and artistry of setting, I ask nothing better than to be useful to you. What do we need after all? Good manuscripts.'

"When may I return?"

"I am leaving town this evening and shall be back the day after tomorrow. I shall have read your book, and if I like it we can talk business that very day."

Then Lucien, finding him so amenable, had the fatal idea of trotting out the manuscript of his Mar-

"Monsieur, I have also written a collection of

poems."

"Oh, so you're a poet! I no longer want your novel," the old man said, holding out the manuscript. "Rhymesters come to grief when they write prose. There are no stop-gaps in prose. One simply

"But Walter Scott, Monsieur, also wrote verses."

"True," said Doguereau. He softened down, guessed the young man's penury and kept the manu- 230 milk and a small bread roll. The sight of genius in script. "Where do you live? I will come and see you."

Lucien gave the address without suspecting that the old man had any ulterior motive. He failed to recognize him for what he was—a publisher of the old school, a man belonging to the age when publishers liked to keep even a Voltaire or a Montesquieu under lock and key, starving in an attic.

"My way back takes me right through the Latin quarter," said the old publisher after reading the ad-

dress.

"What a kind man!" thought Lucien as he took his leave. "So I have found someone who is friendly to the young, a connoisseur who knows something. There's a man for you! It's just as I said to David: talent easily makes good in Paris."

He returned home happy and light-hearted. dreaming of glory. Thinking no more of the sinister remarks which had just now fallen on his ears in the office of Vidal and Porchon, he could see himself with at least twelve hundred francs in pocket. Twelve 250 joy. He was entering the world of literature; at last he hundred francs meant one year's stay in Paris, a year during which he would get new works ready. How many plans he built on this hope! How many pleasant dreams he indulged in as he foresaw a life given over to writing! He imagined himself living an orderly and settled existence: he only just managed not to go out and make some purchases. He could only curb his impatience by assiduous study in Blosse's reading-room. Two days later, Old Doguereau, surprised that Lucien had given such care to style in his 260 first work, delighted at the exaggeration in characterdrawing which was accepted in a period when drama was being developed, impressed by the impetuosity of imagination with which a young author always plans his first book—Papa Doguereau was not hard to please!—he came to the lodginghouse where his budding Walter Scott was living. He was resolved to pay one thousand francs for sole rights in The Archer of Charles the Ninth, and to bind Lucien by a contract for several other works. But when the old fox saw 270 come to terms. Please give me back my manuscript." the building he had second thoughts. "A young man in such a lodging," he told himself, "has modest tastes; he's in love with study and toil. I need only pay him eight hundred francs."

The landlady, when asked for Monsieur Lucien de Rubempré, replied "Fourth floor!" The publisher looked up and saw nothing but sky above the fourth storey. "This young man," he thought, "is a nicelooking boy, very handsome in fact. If he made too much money he would become a spendthrift and 280 stop working. In our mutual interest, I will offer him six hundred francs—but in cash, not bills." He mounted the staircase and gave three knocks at Lucien's door. Lucien came and opened it. The room

was desperately bare. On the table were a bowl of distress impressed the worthy Doguereau.

"Let him persevere," he thought, "in this simple way of life, this frugality, these modest requirements."—"It gives me pleasure to see you," he said 290 to Lucien. "This, Monsieur, is how Jean-Jacques lived, and you will be like him in many respects. In such lodgings the flame of genius burns and great works are written. This is how men of letters ought to live instead of carousing in coffee-houses and res-240 taurants and wasting their time, their talent and our money."

He sat down. "Young man, this isn't a bad novel. I have been a teacher of rhetoric and know French history: there are excellent things in it. In short you 300 have a future before you."

"Oh. Monsieur!"

"Yes, it's a fact. We can come to terms. I will buy vour novel."

Lucien felt his heart swelling and palpitating with was going to find himself in print.

"I will buy it for four hundred francs," said Doguereau in honeyed tones, looking at Lucien with an air which seemed to indicate that he was carrying 310 generosity to the straining-point.

"Per volume?" asked Lucien.

"No, for the novel," said Doguereau, showing no astonishment at Lucien's surprise. "But," he added, "cash down. You will undertake to write two novels per annum for six years. If your first novel is sold within six months I will pay you six hundred francs for the following ones. Thus, at two novels a year, you will earn a hundred francs a month, your living will be assured and you will be happy. Some of my 320 authors only get two hundred francs for each of their novels. I pay two hundred francs for a translation from the English. In former times that would have been an extravagant price."

"Monsieur," said Lucien in icy tones. "We cannot

"Here it is," said the aged publisher. "You don't understand business, Monsieur. When an editor publishes an author's first novel he has to risk sixteen hundred francs for printing and paper. It's easier to 330 write a novel than to find such a sum. I have a hundred manuscripts in my drawers, but less than a hundred and sixty thousand francs in my till. Alas! I have not made such a sum during the twenty years I have been a publisher. You can see then that the trade of printing novels doesn't bring in a fortune. Vidal and Porchon only take them from us on terms which daily become more onerous. You only invest your time, while I have to lay out two thousand francs. If things go wrong—for habent sua fata libelli—I lose 340 two thousand francs; as for you, all you have to do is to launch an ode against the stupidity of the public.

"After you have thought over what I have the honour of telling you, you will come and see me again.—You'll come back to me"—this the publisher repeated emphatically in response to a proudly

defiant gesture from Lucien.

"Far from finding a publisher ready to risk two thousand francs for a young and unknown writer, you won't even find a publisher's assistant who'll 350 take the trouble to read your scrawl. I have read it, and can point out several mistakes of French in it. You have written observer for faire observer and malgré que . . . Malgré takes a direct object." Lucien looked humiliated. "When I see you again, you will have lost a hundred francs," he added, "for then I shall only give you a hundred crowns." He got up and bowed, but at the doorway he said: "If you hadn't talent and promise, if I didn't take an interest in studious young people, I shouldn't have offered you such 360 fine terms. A hundred francs a month! Think it over. After all, a novel tucked away in a drawer isn't like a horse in a stable: it doesn't need food. But it doesn't provide any either!"

Lucien took his manuscript, threw it on the floor

and exclaimed:

"Monsieur, I would rather burn it!"

"That's a poet all over!" said the old man.

Lucien devoured his roll and gulped down his milk and went downstairs. His room was not spa- 370 times already they had exchanged glances, as if they 50 cious enough: if he had stayed in it he would have stalked round and round like a caged lion in the Paris Zoo.

4. First friendship

In the Sainte-Geneviève Library, which Lucien was making for, he had noticed, sitting always in the same corner, a young man of about twenty-four who worked with that kind of steady application which nothing can distract or disturb and by which one may recognize real toilers in the literary sphere. This young man was no doubt a reader of long standing, for both the staff and the librarian himself were very obliging to him: the librarian let him take books home and Lucien used to see the studious stranger 10 return them the next day: our poet felt that here was a brother in poverty and hopefulness. Short, thin and pale, this hard-working man had a fine forehead hidden behind a mass of black, somewhat unruly hair; he also had fine hands, and the eye of casual observers was drawn to him by his vague resemblance to the portrait of Bonaparte in the engraving taken from the painting by Robert Lefebvre. This engraving is a poem in itself: one of ardent melancholy, restrained ambition and concealed energy. Study it closely, and 20

you will find that it breathes of genius, discretion, subtlety and grandeur. The eyes, like a woman's eyes, gleam with intelligence. They express a yearning for infinite space and a longing for difficulties to be overcome. Even if Bonaparte's name were not inscribed underneath, you would still gaze at it for just as long a time. The young man who was a replica of this engraving usually wore stocking-footed trousers, thick soled shoes, a frock-coat of coarse cloth, a black cravat, a grey and white cloth waistcoat but-30 toned right up and a cheap hat. His disdain for superfluous adornment was obvious. This mysterious stranger, marked with the stamp which genius imprints on the brow of its slaves was, as Lucien observed, one of the most regular customers at Flicoteaux's. He ate sparingly, paying no attention to items on the menu, with which he seemed to be quite familiar, and drank water only. At the library or at the restaurant, in all he said or did, he manifested a kind of dignity which no doubt came from the con- 40 sciousness that his life was dedicated to a great task, something which set him apart from other men. There was thought in the very look he gave. Meditation had its abode in that fine, nobly-shaped forehead. His bright black eyes, with their prompt and keen regard, betokened the habit of seeing into the heart of things. His gestures were simple and his countenance was grave.

Lucien felt an instinctive respect for him. Several were about to speak to one another, on entering or leaving the library or the restaurant; but so far neither of them had ventured to do so. The young man worked in silence at the far end of the reading-room, in that part of it backing on to the Place de la Sorbonne. And so Lucien had not been able to make his acquaintance, although he felt drawn to this assiduous young student and the indefinable symptoms of exceptional talent that were evident in him. Both of them, as they acknowledged to each other later on, 60 were naturally modest and timid and subject to all the tremors of self-consciousness which men of solitude tend to enjoy. Had it not been for their sudden meeting at the moment when disaster had just befallen Lucien, they might never perhaps have got into communication. But on entering the rue des Grès, Lucien caught sight of the young stranger as he was coming away from Sainte-Geneviève.

"The library is closed, Monsieur. I don't know why," the latter said to him.

At this moment Lucien had tears in his eyes. He thanks the stranger with one of those gestures which are more eloquent than speech and induce young men to open their hearts to one another. They walked together down the rue des Grès in the direction of the rue de La Harpe.

"In that case I shall take a walk in the Luxembourg gardens," said Lucien. "Once one has left one's room it is difficult to go back and work."

"True," replied the stranger, "one has lost the 80 thread of necessary ideas. You seem downcast, Monsieur."

"A strange thing has just happened to me," said Lucien.

He recounted his visit to the quays, then the old publisher's visit to him and the proposals which had been put to him, giving his name and saying a few words about his predicament, telling him that in the course of about a month, he had spent sixty francs on food, thirty francs for his room, twenty francs on 90 theatre tickets, ten francs for the reading-room: a hundred francs in all. He had only a hundred and twenty francs left.

"Monsieur," said the stranger. "Your history is mine and that of a thousand or more young people who each year migrate from the provinces to Paris. And still we are not the unluckiest ones. You see that theatre?"—he pointed to the roof-tops of the Odéon— "One day there came to live in one of the houses in the square a man of talent who had been plunged into 100 the depths of poverty. He was married—an additional misfortune with which as yet neither of us is afflicted—to a woman he loved; he was blessed—if that is the word to use—with two children; he was riddled with debts but he trusted to his pen. He offered the Odéon a five-act comedy; it was accepted and put first on the waiting-list, the actors were rehearsing it, and the manager was speeding up the rehearsals: five strokes of luck, one might say five dramas even more difficult of accomplishment than 110 the actual writing of his five acts. The poor author, lodging in a garret which you can see from here, used up his last resources in order to keep going while his play was being produced; his wife took her clothes to the pawnshop; their family lived on bread alone. On the day of the final rehearsal, the day before the first performance, he owed fifty francs in the district for household expenses—the baker, the milkman, the concierge. He had kept to the strict necessities of life: one coat, one shirt, one pair of trousers, one waist- 120 coat and a pair of boots. Being sure of success, he came and embraced his wife and announced the end of their privations. "At last nothing stands in our way!" he cried. "Fire does," his wife replied. "Look, the Odéon is burning." Yes, Monsieur, the Odéon was on fire. And so do not complain. You have clothes, you have neither wife nor children, you happen to have a hundred and twenty francs in your pocket, and you owe nothing to anyone. Actually, the play in question ran to a hundred and fifty perfor- 130 mances at the Louvois theatre. The King allotted a pension to the author. As Buffon said, genius is pa-

tience. Patience is indeed the quality in man which most resembles the process which Nature follows in her creations. And what is Art, Monsieur? It is Nature in concentrated form."

By then the two young men were pacing up and down the Luxembourg gardens. Soon Lucien learned the name, which has since become famous, of the stranger who was striving to console him. He was 140 Daniel d'Arthez, today one of the most illustrious writers of our time and one of those rare people who, as a poet has neatly expressed it, present

Fine talent matched with fine integrity.

"It costs a lot," said Daniel in his gentle voice, "to become a great man. The works of genius are watered with its tears. Talent is a living organism whose infancy, like that of all creatures, is liable to malady. Society rejects defective talent as Nature sweeps away weak or misshapen creatures. Whoever wishes 150 to rise above the common level must be prepared for a great struggle and recoil before no obstacle. A great writer is just simply a martyr whom the stake cannot kill.'

"You bear the stamp of genius on your brow," d'Arthez continued, summing Lucien up in a single glance. "If at heart you have not the will-power and the seraphic patience needed, if, while the caprice of destiny keeps you still far from your goal, you do not continue on your path towards the infinite, as a tor-160 toise in any country follows the path leading it back to its beloved ocean, give up this very day.

"You also then expect to suffer great trials?" asked Lucien.

"Ordeals of every kind," the young man replied in a resigned tone. "Calumny, treachery, injustice from my rivals; effrontery, trickery, ruthlessness from the business world. If you are doing fine work, what does an initial setback matter?"

"Will you read and judge my work?" asked Lu-170

"I will," said d'Arthez. "I live in the rue des Quatre-Vents, in a house where once lived a most illustrious man, one of the brightest geniuses of our time, and a phenomenon in the world of science. He was Desplein, the greatest surgeon known, and here he first endured martyrdom as he battled with the initial difficulties of life and reputation in Paris. Remembering this every evening gives me the dose of courage I need every morning. I live in the room 180 where often, like Rousseau, but with no Thérèse, he fed on bread and cherries. Come in an hour's time. I shall be there."

The two poets parted, clasping each other's hand with an indescribable effusion of melancholy tenderness. Daniel d'Arthez went and pawned his watch in order to buy two large faggots of wood so that his new friend might find a fire to warm him, for the weather was cold. Lucien arrived on time and his first view was that of an even less respectable-looking 190 building than the one in which he was lodging, with a gloomy passage from the far end of which rose a dark staircase. Daniel d'Arthez's room on the fifth floor had two miserable windows, and between them was a bookcase of blackened wood, full of labelled filing cases. A narrow little bed of painted wood, like those used in schools, a secondhand night-commode and two armchairs upholstered in horsechair occupied the farther end of this room, whose walls were covered with chequered paper to which smoke and 200 age had given a sort of varnish. A long table laden with papers stood between the fireplace and one of the windows. Opposite the fireplace was a shabby mahogany chest of drawers. The floor was completely covered with a carpet picked up at a sale, and this necessary luxury saved the expense of heating. In front of the table was a commonplace desk-chair covered in red sheepskin faded through long use; six poor-quality chairs made up the rest of the furniture. On the mantelpiece Lucien noticed an old branched 210 sconce of the kind used at the card-table, furnished with four wax candles and a shade. When Lucien, discerning all round him the symptoms of stark poverty, asked why he used wax candles, d'Arthez replied that he could not bear the smell of burning tallow. This peculiarity indicated his very delicate physical sensitivity, which is also a sign of acute moral sensibility.

The reading lasted seven hours. Daniel listened with scrupulous attention without saying a word or 220 making any remark—one of the rarest proofs of good taste that can be given by anyone who is himself an author.

"Well?" Lucien asked as he laid his manuscript on the mantelpiece.

"You are on the right and proper track," the young man answered gravely. "But you must reshape your work. If you don't want to ape Walter Scott you must invent a different manner for yourself, whereas you have imitated him. Like him, you 230 ing him out to dinner at Edon's restaurant, and it cost begin with long conversations in order to pose your characters; after they have talked you proceed with description and action. The clash of wills necessary in any work of dramatic quality comes last. Let me see you reverse the terms of the problem. Replace these diffuse colloquies, at which Scott is magnificent but which lack colour in your novel, by the sort of description for which the French language is so well adapted. Let your dialogue be the expected sequel and the climax of your preparations. Launch yourself 240 thought and fact. Among his friends were erudite straight into the action. Let me see you attack your subject sometimes broadside on, sometimes from the rear. In short, vary your plan of action so as never to

repeat yourself. You will thus blaze a new trail while adapting the Scotsman's drama in dialogue form to the history of France. Walter Scott lacks passion; it is a closed book to him; or perhaps he found it was ruled out by the hypocritical morals of his native land. Woman for him is duty incarnate. With rare exceptions, his heroines are absolutely identical; as 250 painters say, he has only one pouncing pattern. His women all proceed from Clarissa Harlowe; reducing them all to one simple idea, he was only able to strike off copies of one and the same type and vary them with a more or less vivid colouring. Woman brings disorder into society through passion. Passion is infinite in its manifestations. Therefore, depict the passions and you will have at your command the immense resources which this great genius denied himself in order to provide reading matter for every 260 family in prudish England. Dealing with France, you will be able to oppose to the dour figures of Calvinism the attractive peccadillos and brilliant manners of Catholicism against the background of the most impassioned period of our history. Every authentic reign from Charlemagne onwards will require at least one work, and sometimes four or five, as in the case of Louis the Fourteenth, Henry the Fourth and Francis the First. In this way you will write a pictorial history of France in which you will describe cos- 270 tume, furniture, the outside and inside of buildings and private life, whilst conveying the spirit of times instead of laboriously narrating a sequence of known facts. You will find scope for originality in correcting the popular errors which give a distorted view of most of our kings. Be so bold, in your first work, as to rehabilitate that great and magnificent figure, Catherine de Medici, whom you have sacrificed to the prejudices which still cling to her memory. And then depict Charles the Ninth as he really was, and 280 not as Protestant writers make him out to have been. After ten years of perseverance you will achieve fame and fortune."

By then it was nine o'clock. Lucien emulated the unsuspected generosity of his future friend by invithim twelve francs. While they were dining Daniel confided to Lucien the secret of his hopes and studies. D'Arthez would not allow that any talent could be exceptional without a profound knowledge of meta-290 physics. At present he was delving into and assimilating all the philosophic treasures of ancient and modern times. He wanted to be a profound philosopher, like Molière before he ever wrote a comedy. He was studying the world in writing and the living world: naturalists, young medical men, political writers and artists: a confraternity of studious, serious and promising people. He made his way by writing conscientious and poorly-paid articles for biographical and 300 encyclopaedic dictionaries or dictionaries of natural science. He kept such writing to the minimum required for earning his living and continuing his studies. D'Arthez had in hand an imaginative work which he had undertaken solely in order to explore the resources of language. This book, still unfinished, which he took up and laid down as the whim came, was reserved for his days of great penury. It was a psychological work of considerable scope cast in the form of a novel. Although Daniel was modest 310 in his revelations, he seemed a gigantic figure to Lucien. When he left the restaurant at eleven o'clock. Lucien had conceived a lively friendship for this man of such unassuming virtue and, unwittingly, of so sublime a nature. Faithfully and unquestioningly he followed Daniel's advice. Daniel's fine talent, already matured by reflection and an original kind of criticism developed in solitude for his own especial purposes, had suddenly opened a door admitting Lucien to the most splendid palaces of the imagination. The 320 Mrs. Malderton. "Decidedly the most gentlemanlips of the provincial had been touched by a burning coal, and the words of the industrious Parisian had fallen on fertile soil in the brain of the poet from Angoulême. He began to reshape his novel.

Charles Dickens Horatio Sparkins

Dickens needed the large canvas of the novel to do full justice to his genius, but his short stories contain many of his characteristic touches on a small scale. Much of the weight of the narrative is carried by dialogue, which brings his figures vividly alive. His descriptions are brief but immediately summon up a visual image: "the young man with the black whiskers and the white cravat." He uses language with what seems limitless flexibility and imagination: "Horatio looked handsomely miserable." The characters are allowed to show us their comic side, but Dickens handles them affectionately.

In this story Dickens deals in miniature with a theme that recurs in his novels: snobbery and pretension. The Malderton family, and Miss Teresa in particular, have unreasonable social expectations. They look down on Mrs. Malderton's brother, who is a grocer, "and so lost to all sense of feeling, that he actually never scrupled to avow that he wasn't above his business." They therefore fabricate an interesting history for Teresa's mysterious suitor, Horatio Sparkins. The interest of the situation lies in the hypocrisy of all concerned (including the unfortunate Horatio), which emerges memorably in the dinner scene, a small-scale comic masterpiece. The end of the tale is predictable, and Dickens passes over it with masterly speed, only pausing to remind us in the very last words that some people, at least, never learn from experience.

"Indeed, my love, he paid Teresa very great attention on the last assembly night," said Mrs. Malderton, addressing her spouse, who, after the fatigues of the day in the City, was sitting with a silk handkerchief over his head, and his feet on the fender, drinking his port;—"very great attention; and I say again, every possible encouragement ought to be given him. He positively must be asked down here to dine."

"Who must?" inquired Mr. Malderton.

"Why, you know whom I mean, my dear-the 10 young man with the black whiskers and the white cravat, who has just come out at our assembly, and whom all the girls are talking about. Young-Dear me! what's his name?—Marianne, what is his name?" continued Mrs. Malderton, addressing her youngest daughter, who was engaged in netting a purse and looking sentimental.

"Mr. Horatio Sparkins, ma," replied Miss Mari-

anne, with a sigh.

"Oh! yes, to be sure—Horatio Sparkins," said 20 like young man I ever saw. I am sure, in the beautifully made coat he wore the other night, he looked like—like——"

"Like Prince Leopold, ma-so noble, so full of sentiment!" suggested Marianne, in a tone of enthusiastic admiration.

"You should recollect, my dear," resumed Mrs. Malderton, "that Teresa is now eight-and-twenty; and that it really is very important that something 30 should be done.'

Miss Teresa Malderton was a very little girl, rather fat, with vermilion cheeks, but good-humoured, and still disengaged, although, to do her justice, the misfortune arose from no lack of perseverance on her part. In vain had she flirted for ten years; in vain had Mr. and Mrs. Malderton assiduously kept up an extensive acquaintance among the young eligible bachelors of Camberwell, and even of Wandsworth and Brixton; to say nothing of those who "dropped in" 40 from town. Miss Malderton was as well known as the lion on the top of Northumberland House, and had an equal chance of "going off."

"I am quite sure you'd like him," continued Mrs.

Malderton; "he is so gentlemanly!"

"So clever!" said Miss Marianne.

"And has such a flow of language!" added Miss Teresa.

"He has a great respect for you, my dear," said Mrs. Malderton to her husband. Mr. Malderton 50 coughed, and looked at the fire.

"Yes, I'm sure he's very much attached to pa's

society," said Miss Marianne.

"No doubt of it," echoed Miss Teresa.

"Indeed, he said as much to me in confidence." observed Mrs. Malderton.

"Well, well," returned Mr. Malderton, somewhat flattered; "if I see him at the assembly to-morrow, perhaps I'll ask him down. I hope he knows we live at Oak Lodge, Camberwell, my dear?"

"Of course—and that you keep a one-horse car-

"I'll see about it," said Mr. Malderton, composing

himself for a nap; "I'll see about it."

Mr. Malderton was a man whose whole scope of ideas was limited to Lloyd's, the Exchange, the India House, and the Bank. A few successful speculations had raised him from a situation of obscurity and comparative poverty, to a state of affluence. As frequently happens in such cases, the ideas of himself 70 and his family became elevated to an extraordinary pitch as their means increased; they affected fashion, taste, and many other fooleries, in imitation of their betters, and had a very decided and becoming horror of anything which could, by possibility, be considered low. He was hospitable from ostentation, illiberal from ignorance, and prejudiced from conceit. Egotism and the love of display induced him to keep an excellent table: convenience, and a love of the good things of this life, insured him plenty of guests. 80 He liked to have clever men, or what he considered such, at his table, because it was a great thing to talk about; but he never could endure what he called "sharp fellows." Probably, he cherished this feeling out of compliment to his two sons, who gave their respected parent no uneasiness in that particular. The family were ambitious of forming acquaintances and connections in some sphere of society superior to that in which they themselves moved; and one of the necessary consequences of this desire, added to their 90 utter ignorance of the world beyond their own small circle, was, that any one who could lay claim to an acquaintance with people of rank and title, had a sure passport to the table at Oak Lodge, Camberwell.

The appearance of Mr. Horatio Sparkins at the assembly had excited no small degree of surprise and curiosity among its regular frequenters. Who could he be? He was evidently reserved, and apparently melancholy. Was he a clergyman?—He danced too well. A barrister?—He said he was not called. He 100 used very fine words, and talked a great deal. Could he be a distinguished foreigner, come to England for the purpose of describing the country, its manners and customs; and frequenting public balls and public dinners, with the view of becoming acquainted with high life, polished etiquette, and English refinement?—No, he had not a foreign accent. Was he a surgeon, a contributor to the magazines, a writer of fashionable novels, or an artist?—No; to each and all of these surmises there existed some valid objection. — 110 "Then," said everybody, "he must be somebody."— "I should think he must be," reasoned Mr. Malder-

ton, within himself, "because he perceives our superiority, and pays us so much attention."

The night succeeding the conversation we have just recorded, was "assembly night." The double-fly was ordered to be at the door of Oak Lodge at nine o'clock precisely. The Miss Maldertons were dressed in sky-blue satin trimmed with artificial flowers; and Mrs. M. (who was a little fat woman), in ditto ditto, 120 looked like her eldest daughter multiplied by two. Mr. Frederick Malderton, the eldest son, in full-dress costume, was the very beau idéal of a smart waiter; and Mr. Thomas Malderton, the youngest, with his white dress-stock, blue coat, bright buttons, and red watch-ribbon, strongly resembled the portrait of that interesting, but rash young gentleman, George Barnwell. Every member of the party had made up his or her mind to cultivate the acquaintance of Mr. Horatio Sparkins. Miss Teresa, of course, was to be as 130 amiable and interesting as ladies of eight-and-twenty on the look-out for a husband, usually are. Mrs. Malderton would be all smiles and graces. Miss Marianne would request the favour of some verses for her album. Mr. Malderton would patronise the great unknown by asking him to dinner. Tom intended to ascertain the extent of his information on the interesting topics of snuff and cigars. Even Mr. Frederick Malderton himself, the family authority on all points of taste, dress, and fashionable arrangement; who 140 had lodgings of his own in town; who had a free admission to Covent Garden Theatre; who always dressed according to the fashions of the months; who went up the water twice a week in the season; and who actually had an intimate friend who once knew a gentleman who formerly lived in the Albany,—even he had determined that Mr. Horatio Sparkins must be a devilish good fellow, and that he would do him the honor of challenging him to a game at billiards.

The first object that met the anxious eyes of the 150 expectant family on their entrance into the ballroom, was the interesting Horatio, with his hair brushed off his forehead, and his eyes fixed on the ceiling, reclining in a contemplative attitude on one of the seats.

"There he is, my dear," whispered Mrs. Malderton to Mr. Malderton.

"How like Lord Byron!" murmured Miss Teresa. "Or Montgomery!" whispered Miss Marianne.

"Or the portraits of Captain Cook!" suggested 160

"Tom—don't be an ass!" said his father, who checked him on all occasions, probably with a view to prevent his becoming "sharp"—which was very unnecessary.

The elegant Sparkins attitudinised with admirable effect, until the family had crossed the room. He then started up, with the most natural appearance of sur-

prise and delight; accosted Mrs. Malderton with the utmost cordiality; saluted the young ladies in the 170 most enchanting manner; bowed to, and shook hands with, Mr. Malderton, with a degree of respect amounting almost to veneration; and returned the greetings of the two young men in a half-gratified, half-patronising manner, which fully convinced them that he must be an important, and, at the same time, condescending personage.

"Miss Malderton," said Horatio, after the ordinary salutations, and bowing very low, "may I be permitted to presume to hope that you will allow me 180

to have the pleasure—"

"I don't think I am engaged," said Miss Teresa, with a dreadful affectation of indifference—"but, really—so many—

Horatio looked handsomely miserable.

"I shall be most happy," simpered the interesting Teresa, at last. Horatio's countenance brightened up, like an old hat in a shower of rain.

"A very genteel young man, certainly!" said the gratified Mr. Malderton, as the obsequious Sparkins 190 his snuffbox to his new acquaintance, "that I don't and his partner joined the quadrille which was just forming.

"He has a remarkably good address," said Mr. Frederick.

"Yes, he is a prime fellow," interposed Tom, who always managed to put his foot in it—"he talks just like an auctioneer."

"Tom!" said his father solemnly, "I think I desired you, before, not to be a fool." Tom looked as happy 200

as a cock on a drizzly morning.

"How delightful!" said the interesting Horatio to his partner, as they promenaded the room at the conclusion of the set—"how delightful, how refreshing it is, to retire from the cloudy storms, the vicissitudes, and the troubles, of life, even if it be but for a few short fleeting moments; and to spend those moments, fading and evanescent though they be, in the delightful, the blessed, society, of one individual whose frowns would be death, whose coldness would be madness, whose falsehood would be ruin, 210 whose constancy would be bliss; the possession of whose affection would be the brightest and best reward that Heaven could bestow on man!"

"What feeling! what sentiment!" thought Miss Teresa, as she leaned more heavily on her companion's arm.

"But enough—enough!" resumed the elegant Sparkins, with a theatrical air. "What have I said? what have I—I—to do with sentiments like these? Miss Malderton"—here he stopped short—"may I 220 miss Marianne. "How charmingly romantic!" hope to be permitted to offer the humble tribute of----"

"Really, Mr. Sparkins," returned the enraptured Teresa, blushing in the sweetest confusion, "I must

refer you to papa. I never can, without his consent, venture to-

"Surely he cannot object—"

"Oh, yes. Indeed, indeed, you know him not!" interrupted Miss Teresa, well knowing there was nothing to fear, but wishing to make the interview 230 resemble a scene in some romantic novel.

"He cannot object to my offering you a glass of negus," returned the adorable Sparkins, with some

surprise.

"Is that all?" thought the disappointed Teresa.

"What a fuss about nothing!"

"It will give me the greatest pleasure, sir, to see you to dinner at Oak Lodge, Camberwell, on Sunday next at five o'clock, if you have no better engagement," said Mr. Malderton, at the conclusion of the 240 evening, as he and his sons were standing in conversation with Mr. Horatio Sparkins.

Horatio bowed his acknowledgments, and ac-

cepted the flattering invitation.

"I must confess," continued the father, offering enjoy these assemblies half so much as the comfort— I had almost said the luxury—of Oak Lodge. They have no great charms for an elderly man.'

"And, after all, sir, what is man?" said the meta- 250

physical Sparkins. "I say, what is man?"

"Ah! very true," said Mr. Malderton; "very true."

"We know that we live and breathe," continued Horatio, "that we have wants and wishes, desires and appetites——"

"Certainly," said Mr. Frederick Malderton, look-

ing profound.

"I say, we know that we exist," repeated Horatio, raising his voice, "but there, we stop; there, is an end 260 to our knowledge; there, is the summit of our attainments; there, is the termination of our ends. What more do we know?"

"Nothing," replied Mr. Frederick-than whom no one was more capable of answering for himself in that particular. Tom was about to hazard something, but, fortunately for his reputation, he caught his father's angry eye, and slunk off like a puppy convicted of petty larceny.

"Upon my word," said Mr. Malderton the elder, 270 as they were returning home in the fly, "that Mr. Sparkins is a wonderful young man. Such surprising knowledge! such extraordinary information! and such a splendid mode of expressing himself!"

"I think he must be somebody in disguise," said

"He talks very loud and nicely," timidly observed Tom, "but I don't exactly understand what he means."

"I almost begin to despair of your understanding 280

anything, Tom," said his father, who, of course, had been much enlightened by Mr. Horatio Sparkins's conversation.

"It strikes me, Tom," said Miss Teresa, "that you have made yourself very ridiculous this evening."

"No doubt of it," cried everybody—and the unfortunate Tom reduced himself into the least possible space. That night, Mr. and Mrs. Malderton had a long conversation respecting their daughter's prospects and future arrangements. Miss Teresa went to 290 bold guess. bed, considering whether, in the event of her marrying a title, she could conscientiously encourage the visits of her present associates; and dreamed, all night, of disguised noblemen, large routs, ostrich plumes, bridal favours, and Horatio Sparkins.

Various surmises were hazarded on the Sunday morning, as to the mode of conveyance which the anxiously expected Horatio would adopt. Did he keep a gig?—was it possible he could come on horseback?—or would he patronise the stage? These, and 300 must know him." various other conjectures of equal importance, engrossed the attention of Mrs. Malderton and her daughters during the whole morning after church.

"Upon my word, my dear, it's a most annoying thing that that vulgar brother of yours should have invited himself to dine here to-day," said Mr. Malderton to his wife. "On account of Mr. Sparkins's coming down, I purposely abstained from asking any one but Flamwell. And then to think of your brother—a tradesman—it's insufferable! I declare I 310 name for some temporary purpose." wouldn't have him mention his shop before our new guest—no, not for a thousand pounds! I wouldn't care if he had the good sense to conceal the disgrace he is to the family; but he's so fond of his horrible business, that he will let people know what he is."

Mr. Jacob Barton, the individual alluded to, was a large grocer; so vulgar, and so lost to all sense of feeling, that he actually never scrupled to avow that he wasn't above his business: "he'd made his money by it, and he didn't care who know'd it."

"Ah! Flamwell, my dear fellow, how d'ye do?" said Mr. Malderton, as a little spoffish man, with green spectacles, entered the room. "You got my note?"

"Yes, I did; and here I am in consequence."

"You don't happen to know this Mr. Sparkins by

name? You know everybody."

Mr. Flamwell was one of those gentlemen of remarkably extensive information whom one occasionally meets in society, who pretend to know 330 everybody, but in reality know nobody. At Malderton's, where any stories about great people were received with a greedy ear, he was an especial favourite; and, knowing the kind of people he had to deal with, he carried his passion of claiming acquaintance with everybody to the most immoderate length. He

had rather a singular way of telling his greatest lies in a parenthesis, and with an air of self-denial, as if he feared being thought egotistical.

"Why, no, I don't know him by that name," re- 340 turned Flamwell, in a low tone, and with an air of immense importance. "I have no doubt I know him, though. Is he tall?"

"Middle-sized," said Miss Teresa.

"With black hair?" inquired Flamwell, hazarding a

"Yes," returned Miss Teresa, eagerly.

"Rather a snub nose?"

"No," said the disappointed Teresa, "he has a Roman nose."

"I said a Roman nose, didn't I?" inquired Flamwell. "He's an elegant young man?"

"Oh, certainly."

"With remarkably prepossessing manners?"

"Oh, yes!" said all the family together. "You

"Yes, I thought you knew him, if he was anybody," triumphantly exclaimed Mr. Malderton. "Who'd ve think he is?"

"Why, from your description," said Flamwell, 360 ruminating, and sinking his voice almost to a whisper, "he bears a strong resemblance to the Honourable Augustus Fitz-Edward Fitz-John Fitz-Osborne. He's a very talented young man, and rather eccentric. It's extremely probable he may have changed his

Teresa's heart beat high. Could he be the Honourable Augustus Fitz-Edward Fitz-John Fitz-Osborne? What a name to be elegantly engraved upon two glazed cards, tied together with a piece of white satin 370 ribbon! "The Honourable Mrs. Augustus Fitz-Edward Fitz-John Fitz-Osborne!" The thought was

"It's five minutes to five," said Mr. Malderton, looking at his watch: "I hope he's not going to disap-

320 point us."

"There he is!" exclaimed Miss Teresa, as a loud double-knock was heard at the door. Everybody endeavoured to look—as people when they particularly expect a visitor always do—as if they were per- 380 fectly unsuspicious of the approach of anybody.

The room-door opened. "Mr. Barton!" said the

servant.

"Confound the man!" murmured Malderton. "Ah! my dear sir, how d'ye do? Any news?"

"Why, no," returned the grocer, in his usual bluff manner. "No, none partickler. None that I am much aware of. How d'ye do, gals and boys? Mr. Flamwell, sir-glad to see you."

"Here's Mr. Sparkins!" said Tom, who had been 390 looking out at the window, "on such a black horse!" There was Horatio, sure enough, on a large black

horse, curyetting and prancing along, like an Astley's supernumerary. After a great deal of reining in, and pulling up, with the accompaniments of snorting, rearing, and kicking, the animal consented to stop at about a hundred yards from the gate, where Mr. Sparkins dismounted, and confided him to the care of Mr. Malderton's groom. The ceremony of introduction was gone through, in all due form. Mr. Flam-400 well looked from behind his green spectacles at Horatio with an air of mysterious importance; and the gallant Horatio looked unutterable things at Teresa.

"Is he the Honourable Mr. Augustus What's-hisname?" whispered Mrs. Malderton to Flamwell, as he was escorting her to the dining-room.

"Why, no—at least not exactly," returned that great authority—"not exactly."

"Who is he then?"

"Hush!" said Flamwell, nodding his head with a grave air, importing that he knew very well; but was prevented, by some grave reasons of state, from disclosing the important secret. It might be one of the ministers making himself acquainted with the views

of the people.

"Mr. Sparkins," said the delighted Mrs. Malderton, "pray divide the ladies. John, put a chair for the gentleman between Miss Teresa and Miss Marianne." This was addressed to a man who, on ordi-420 nary occasions, acted as half-groom, half-gardener; but who, as it was important to make an impression on Mr. Sparkins, had been forced into a white neckerchief and shoes, and touched up and brushed, to look like a second footman.

The dinner was excellent; Horatio was most attentive to Miss Teresa, and every one felt in high spirits, except Mr. Malderton, who, knowing the propensity of his brother-in-law, Mr. Barton, endured that sort of agony which the newspapers inform us is ex-430 perienced by the surrounding neighbourhood when a potboy hangs himself in a hay-loft, and which is 'much easier to be imagined than described."

"Have you seen your friend, Sir Thomas Noland, lately, Flamwell?" inquired Mr. Malderton, casting a sidelong look at Horatio, to see what effect the men-

tion of so great a man had upon him.

"Why, no—not very lately. I saw Lord Gubbleton

the day before yesterday."

"Ah! I hope his lordship is very well?" said Mal-440 derton, in a tone of the greatest interest. It is scarcely necessary to say that, until that moment, he had been quite innocent of the existence of such a person.

"Why, yes; he was very well—very well indeed. He's a devilish good fellow. I met him in the City, and had a long chat with him. Indeed, I'm rather intimate with him. I couldn't stop to talk to him as long as I could wish, though, because I was on my way to a banker's, a very rich man, and a Member of Parliament, with whom I am also rather, indeed I 450 may say very, intimate."

"I know whom you mean," returned the host, consequentially—in reality knowing as much about the matter as Flamwell himself. "He has a capital business "

This was touching on a dangerous topic.

"Talking of business," interposed Mr. Barton, from the centre of the table. "A gentleman whom you knew very well, Malderton, before you made that first lucky spec of yours, called at our shop the 460 other day, and——"

"Barton, may I trouble you for a potato?" interrupted the wretched master of the house, hoping to

nip the story in the bud.

"Certainly," returned the grocer, quite insensible of his brother-in-law's object—"and he said in a very plain manner——"

"Floury, if you please," interrupted Malderton again; dreading the termination of the anecdote, and

fearing a repetition of the word "shop."

"He said, says he," continued the culprit, after dispatching the potato; "says he, how goes on your business? So I said, jokingly—you know my way says I, I'm never above my business, and I hope my business will never be above me. Ha, ha!"

"Mr. Sparkins," said the host, vainly endeavouring to conceal his dismay, "a glass of wine?"

"With the utmost pleasure, sir."

"Happy to see you."

"Thank you."

"We were talking the other evening," resumed the host, addressing Horatio, partly with the view of displaying the conversational powers of his new acquaintance, and partly in the hope of drowning the grocer's stories—"we were talking the other night about the nature of man. Your argument struck me very forcibly."

"And me," said Mr. Frederick. Horatio made a

graceful inclination of the head.

"Pray, what is your opinion of woman, Mr. 490 Sparkins?" inquired Mrs. Malderton. The young lad-

ies simpered.

"Man," replied Horatio, "man, whether he ranged the bright, gay, flowery plains of a second Eden, or the more sterile, barren, and I may say, common-place regions, to which we are compelled to accustom ourselves, in times such as these; man, under any circumstances, or in any place—whether he were bending beneath the withering blasts of the frigid zone, or scorching under the rays of a vertical 500 sun-man, without woman, would be-alone."

"I am very happy to find you entertain such honourable opinions, Mr. Sparkins," said Mrs. Malder-

ton.

"And I," added Miss Teresa. Horatio looked his delight, and the young lady blushed.

"Now it's my opinion—" said Mr. Barton.

"I know what you're going to say," interposed Malderton, determined not to give his relation another opportunity, "and I don't agree with 510 vou."

"What?" inquired the astonished grocer.

"I am sorry to differ from you, Barton," said the host, in as positive a manner as if he really were contradicting a position which the other had laid down, "but I cannot give my assent to what I consider a very monstrous proposition."

"But I meant to say—"

"You never can convince me," said Malderton, with an air of obstinate determination. "Never."

"And I," said Mr. Frederick, following up his father's attack, 'cannot entirely agree in Mr. Sparkins's

argument."

"What!" said Horatio, who became more metaphysical, and more argumentative, as he saw the female part of the family listening in wondering delight. "What! Is effect the consequence of cause? Is cause the precursor of effect?"

"That's the point," said Flamwell. "To be sure," said Mr. Malderton.

"Because, if effect is the consequence of cause, and if cause does precede effect, I apprehend you are wrong," added Horatio.

"Decidedly," said the toad-eating Flamwell.

"At least, I apprehend that to be the just and logical deduction?" said Sparkins, in a tone of interrogation.

"No doubt of it," chimed in Flamwell again. "It settles the point."

didn't see it before."

"I don't exactly see it now," thought the grocer;

"but I suppose it's all right."

"How wonderfully clever he is!" whispered Mrs. Malderton to her daughters, as they retired to the drawing-room.

"Oh, he's quite a love!" said both the young ladies together; "he talks an oracle. He must have seen a

great deal of life!"

The gentlemen being left to themselves, a pause 550 ensued, during which everybody looked very grave, as if they were quite overcome by the profound nature of the previous discussion. Flamwell, who had made up his mind to find out who and what Mr. Horatio Sparkins really was, first broke silence.

"Excuse me, sir," said that distinguished personage, "I presume you have studied for the bar? I thought of entering once, myself-indeed, I am rather intimate with some of the highest ornaments of that distinguished profession."

"N-no!" said Horatio, with a little hesitation; "not exactly."

"But you have been much among the silk gowns, or I mistake?" inquired Flamwell, deferentially.

"Nearly all my life," returned Sparkins.

The question was thus pretty well settled in the mind of Mr. Flamwell. He was a young gentleman "about to be called."

"I shouldn't like to be a barrister," said Tom, speaking for the first time, and looking round the 570 table to find somebody who would notice the re-

No one made any reply.

"I shouldn't like to wear a wig," said Tom, haz-

arding another observation.

"Tom, I beg you will not make yourself ridiculous," said his father. "Pray listen, and improve vourself by the conversation you hear, and don't be constantly making these absurd remarks."

"Very well, father," replied the unfortunate Tom, 580 who had not spoken a word since he had asked for another slice of beef at a quarter-past five o'clock

P.M., and it was then eight.

"Well, Tom," observed his good-natured uncle, "never mind! I think with you. I shouldn't like to 530 wear a wig. I'd rather wear an apron."

Mr. Malderton coughed violently. Mr. Barton resumed—"For if a man's above his business—"

The cough returned with tenfold violence, and did not cease until the unfortunate cause of it, in his 590 alarm, had quite forgotten what he intended to say.

"Mr. Sparkins," said Flamwell, returning to the charge, "do you happen to know Mr. Delafontaine,

of Bedford Square?"

"I have exchanged cards with him; since which, "Well, perhaps it does," said Mr. Frederick; "I 540 indeed, I have had an opportunity of serving him considerably," replied Horatio, slightly colouring; no doubt, at having been betrayed into making the acknowledgment.

"You are very lucky, if you have had an opportu- 600 nity of obliging that great man," observed Flamwell,

with an air of profound respect.

"I don't know who he is," he whispered to Mr. Malderton, confidentially, as they followed Horatio up to the drawing-room. "It's quite clear, however, that he belongs to the law, and that he is somebody of great importance, and very highly connected."

"No doubt, no doubt," returned his companion.

The remainder of the evening passed away most delightfully. Mr. Malderton, relieved from his ap-610 prehensions by the circumstance of Mr. Barton's falling into a profound sleep, was as affable and gracious as possible. Miss Teresa played the "Fall of Paris," as Mr. Sparkins declared, in a most masterly manner, and both of them, assisted by Mr. Frederick, tried over glees and trios without number; they having

made the pleasing discovery that their voices harmonised beautifully. To be sure, they all sang the first part; and Horatio, in addition to the slight drawback of having no ear, was perfectly innocent of 620 derton. knowing a note of music; still, they passed the time very agreeably, and it was past twelve o'clock before Mr. Sparkins ordered the morning-coach-looking steed to be brought out—an order which was only complied with, on the distinct understanding that he was to repeat his visit on the following Sunday.

"But, perhaps, Mr. Sparkins will form one of our party to-morrow evening?" suggested Mrs. M. "Mr. Malderton intends taking the girls to see the pantomime." Mr. Sparkins bowed, and promised to join 630 the party in box 48, in the course of the evening.

"We will not tax you for the morning," said Miss Teresa, bewitchingly; "for ma is going to take us to all sorts of places, shopping. I know that gentlemen have a great horror of that employment." Mr. Sparkins bowed again, and declared that he should be delighted, but business of importance occupied him in the morning. Flamwell looked at Malderton significantly—"It's term time!" he whispered.

At twelve o'clock on the following morning, the 640 "fly" was at the door of Oak Lodge, to convey Mrs. Malderton and her daughters on their expedition for the day. They were to dine and dress for the play at a friend's house. First, driving thither with their bandboxes, they departed on their first errand to make some purchases at Messrs. Jones, Spruggins, and Smith's, of Tottenham Court Road; after which, they were to go to Redmayne's in Bond Street; thence, to innumerable places that no one ever heard of. The young ladies beguiled the tediousness of the 650 chance of a husband as Captain Ross had of the ride by eulogising Mr. Horatio Sparkins, scolding their mamma for taking them so far to save a shilling, and wondering whether they should ever reach their destination. At length, the vehicle stopped before a dirty-looking ticketed linendraper's shop, with goods of all kinds, and labels of all sorts and sizes, in the window. There were dropsical figures of seven with a little three-farthings in the corner, "perfectly invisible to the naked eye;" three hundred and fifty thousand ladies' boas, from one shilling and a penny 660 halfpenny; real French kid shoes, at two and ninepence per pair; green parasols, at an equally cheap rate; and "every description of goods," as the proprietors said—and they must know best—"fifty per cent under cost price."

"Lor! ma, what a place you have brought us to!" said Miss Teresa; "what would Mr. Sparkins say if he could see us?"

"Ah! what, indeed!" said Miss Marianne, horrified at the idea.

"Pray be seated, ladies. What is the first article?" inquired the obsequious master of the ceremonies of the establishment, who, in his large white neckcloth

and formal tie, looked like a bad "portrait of a gentleman" in the Somerset House exhibition.

"I want to see some silks," answered Mrs. Mal-

"Directly, ma'am—Mr. Smith! Where is Mr. Smith?"

"Here, sir," cried a voice at the back of the shop. 680 "Pray make haste, Mr. Smith," said the M.C. "You never are to be found when you're wanted,

Mr. Smith, thus enjoined to use all possible dispatch, leaped over the counter with great agility, and placed himself before the newly-arrived customers. Mrs. Malderton uttered a faint scream; Miss Teresa, who had been stooping down to talk to her sister, raised her head, and beheld—Horatio Sparkins!

"We will draw a veil," as novel writers say, over 690 the scene that ensued. The mysterious, philosophical, romantic, metaphysical Sparkins—he who, to the interesting Teresa, seemed like the embodied idea of the young dukes and poetical exquisites in blue silk dressing-gowns, and ditto ditto slippers, of whom she had read and dreamed, but had never expected to behold, was suddenly converted into Mr. Samuel Smith, the assistant at a "cheap shop;" the junior partner in a slippery firm of some three weeks' existence. The dignified evanishment of the hero of Oak 700 Lodge, on this unexpected recognition, could only be equalled by that of a furtive dog with a considerable kettle at his tail. All the hopes of the Maldertons were destined at once to melt away, like the lemon ices at a Company's dinner; Almack's was still to them as distant as the North Pole; and Miss Teresa had as much north-west passage.

Years have elapsed since the occurrence of this dreadful morning. The daisies have thrice bloomed 710 on Camberwell Green; the sparrows have thrice repeated their vernal chirps in Camberwell Grove; but the Miss Maldertons are still unmated. Miss Teresa's case is more desperate than ever; but Flamwell is yet in the zenith of his reputation; and the family have the same predilection for aristocratic personages, with an increased aversion to anything low.

Walt Whitman, Leaves of Grass, Five Poems from Songs of Parting

The second and third of these poems date to 1865, the others to the 1860 edition of Leaves of Grass. Between them they illustrate many of the characteristics of Whitman's poetry. The mood is optimistic, even when the poet contemplates his own end. America, with its Manifest Destiny, symbolizes hope for the world. Even the tragedy of the Civil War can teach a positive lesson.

The style is rhetorical, and Whitman uses the device of

repetition to hammer home his message. Place names are given a magic ring. We are reminded again and again that these are songs, while always in the forefront is the poet himself, the ever-present I.

AS THE TIME DRAWS NIGH

As the time draws nigh glooming a cloud, A dread beyond of I know not what darkens me.

I shall go forth,

I shall traverse the States awhile, but I cannot tell whither or how long,

Perhaps soon some day or night while I am singing my voice will suddenly cease.

O book, O chants! must all then amount to but this?

Must we barely arrive at this beginning of us? and yet it is enough, O soul;

O soul, we have positively appear'd—that is enough.

YEARS OF THE MODERN

Years of the modern! years of the unperform'd! Your horizon rises, I see it parting away for more august dramas,

I see not America only, not only Liberty's nation but other nations preparing,

I see tremendous entrances and exits, new combinations, the solidarity of races,

I see that force advancing with irresistible power on the world's stage,

(Have the old forces, the old wars, played their parts? are the acts suitable to them closed?)

I see Freedom, completely arm'd and victorious and very haughty, with Law on one side and Peace on the other,

A stupendous trio all issuing forth against the idea

What historic denouements are these we so rapidly approach?

I see men marching and countermarching by swift millions,

I see the frontiers and boundaries of the old aristocracies broken,

I see the landmarks of European kings removed,

I see this day the People beginning their landmarks, (all others give way;)

Never were such sharp questions ask'd as this day, Never was average man, his soul, more energetic, more like a God.

Lo, how he urges and urges, leaving the masses no rest!

His daring foot is on land and sea everywhere, he colonizes the Pacific, the archipelagoes,

With the steamship, the electric telegraph, the newspaper, the wholesale engines of war,

With these and the world-spreading factories he interlinks all geography, all lands;

What whispers are these O lands, running ahead of you, passing under the seas?

Are all nations communing? is there going to be but one heart to the globe?

Is humanity forming en-masse? for lo, tyrants tremble, crowns grow dim,

The earth, restive, confronts a new era, perhaps a general divine war,

No one knows what will happen next, such portents fill the days and nights;

Years prophetical! the space ahead as I walk, as I vainly try to pierce it, is full of phantoms,

Unborn deeds, things soon to be, project their shapes around me.

This incredible rush and heat, this strange ecstatic fever of dreams O years!

Your dreams O years, how they penetrate through me! (I know not whether I sleep or wake;)

The perform'd America and Europe grow dim, retiring in shadow behind me,

The unperform'd, more gigantic than ever, advance, advance upon me.

ASHES OF SOLDIERS

Ashes of soldiers South or North.

As I muse retrospective murmuring a chant in thought,

The war resumes, again to my sense your shapes, And again the advance of the armies.

Noiseless as mists and vapors,

From their graves in the trenches ascending, From cemeteries all through Virginia and Tennessee,

From every point of the compass out of the countless graves,

In wafted clouds, in myriads large, or squads of twos or threes or single ones they come,

And silently gather round me.

Now sound no note O trumpeters,

Not at the head of my cavalry parading on spirited

With sabres drawn and glistening, and carbines by their thighs, (ah my brave horsemen!

My handsome tan-faced horsemen! what life, what joy and pride,

With all the perils were yours.)

Nor you drummers, neither at reveillé at dawn, Nor the long roll alarming the camp, nor even the muffled beat for a burial.

Nothing from you this time O drummers bearing my warlike drums.

But aside from these and the marts of wealth and the crowded promenade,

Admitting around me comrades close unseen by the rest and voiceless,

The slain elate and alive again, the dust and debris

I chant this chant of my silent soul in the name of all dead soldiers.

Faces so pale with wondrous eyes, very dear, gather closer yet,

Draw close, but speak not.

Phantoms of countless lost, Invisible to the rest henceforth become my companions,

Follow me ever—desert me not while I live.

Sweet are the blooming cheeks of the living sweet are the musical voices sounding,

But sweet, ah sweet, are the dead with their silent eyes.

Dearest comrades, all is over and long gone, But love is not over—and what love, O comrades Perfume from battle-fields rising, up from the foetor arising.

Perfume therefore my chant, O love, immortal

Give me to bathe the memories of all dead soldiers.

Shroud them, embalm them, cover them all over with tender pride.

Perfume all—make all wholesome, Make these ashes to nourish and blossom, O love, solve all, fructify all with the last chemistry.

Give me exhaustless, make me a fountain, That I exhale love from me wherever I go like a moist perennial dew, For the ashes of all dead soldiers South or North.

THOUGHTS

I

Of these years I sing,

How they pass and have pass'd through convuls'd pains, as through parturitions,

How America illustrates birth, muscular youth, the promise, the sure fulfilment, the absolute success, despite of people—illustrates evil as well as good,

The vehement struggle so fierce for unity in one'sself:

How many hold despairingly yet to the models departed, caste, myths, obedience, compulsion, and to infidelity,

How few see the arrived models, the athletes, the Western States, or see freedom or spirituality,

or hold any faith in results.

(But I see the athletes, and I see the results of the war glorious and inevitable, and they again leading to other results.)

How the great cities appear—how the Democratic masses, turbulent, wilful, as I love them,

How the whirl, the context, the wrestle of evil with good, the sounding and resounding, keep on and on,

How society waits unform'd, and is for a while 10 between things ended and things begun,

How America is the continent of glories, and of the triumph of freedom and of the Democracies, and of the fruits of society, and of all that is begun,

And how the States are complete in themselves and how all triumphs and glories are complete in themselves, to lead onward,

And how these of mine and of the States will in their turn be convuls'd, and serve other parturitions and transitions,

And how all people, sights, combinations, the democratic masses too, serve—and how every fact, and war itself, with all its horrors, serves,

And how now or at any time each serves the exquisite transition of death.

Of seeds dropping into the ground, of births, Of the steady concentration of America, inland, upward, to impregnable and swarming places,

Of what Indiana, Kentucky, Arkansas, and the rest, are to be.

Of what a few years will show there in Nebraska, Colorado, Nevada, and the rest,

(Or afar, mounting the Northern Pacific to Sitka or Aliaska,)

Of what the feuillage of America is the preparation for—and of what all sights, North, South, East and West are,

Of this Union welded in blood, of the solemn price paid, of the unnamed lost ever present in my mind;

Of the temporary use of materials for identity's sake.

Of the present, passing, departing—of the growth of completer men than any yet,

Of all sloping down there were the fresh free giver the mother, the Mississippi flows,

Of mighty inland cities yet unsurvey'd and unsuspected,

Of the new and good names, of the modern developments, of inalienable homesteads,

Of a free and original life there, of simple diet and clean and sweet blood.

Of litheness, majestic faces, clear eyes, and perfect physique there,

Of immense spiritual results future years far West, each side of the Anahuacs,

Of these songs, well understood there, (being made for that area,)

Of the native scorn of grossness and gain there, (O it lurks in me night and day—what is gain after all to savageness and freedom?)

SONG AT SUNSET

Splendor of ended day floating and filling me, Hour prophetic, hour resuming the past, Inflating my throat, you divine average, You earth and life till the last ray gleams I sing.

Open mouth of my soul uttering gladness, Eyes of my soul seeing perfection, Natural life of me faithfully praising things, Corroborating forever the triumph of things.

Illustrious every one!

Illustrious what we name space, sphere of unnumber'd spirits,

Illustrious the mystery of motion in all beings, even the tiniest insect,

Illustrious the attribute of speech, the senses, the body,

Illustrious the passing light—illustrious the pale reflection on the new moon in the western

Illustrious whatever I see or hear or touch, to the last.

Good in all.

In the satisfaction and aplomb of animals,

In the annual return of the seasons,

In the hilarity of youth,

In the strength and flush of manhood,

In the grandeur and exquisiteness of old age, In the superb vistas of death.

Wonderful to depart!

Wonderful to be here!

The heart, to jet the all-alike and innocent blood! To breathe the air, how delicious!

To speak—to walk—to seize something by the hand!

To prepare for sleep, for bed, to look on my rosecolor'd flesh!

To be conscious of my body, so satisfied, so large! To be this incredible God I am!

To have gone forth among other Gods, these men and women I love.

Wonderful how I celebrate you and myself! How my thoughts play subtly at the spectacles

How the clouds pass silently overhead!

How the earth darts on and on! and how the sun, moon, stars, dart on and on!

How the water sports and sings! (surely it is alive!) How the trees rise and stand up, with strong trunks, with branches and leaves!

(Surely there is something more in each of the trees, some living soul.)

O amazement of things—even the least particle!

O spirituality of things!

O strain musical flowing through ages and continents, now reaching me and America!

I take your strong chords, intersperse them, and cheerfully pass them forward.

I too carol the sun, usher'd or at noon, or as now, setting,

I too throb to the brain and beauty of the earth and of all the growths of the earth,

I too have felt the resistless call of myself.

As I steam'd down the Mississippi,

As I wander'd over the prairies,

As I have lived, as I have look'd through my windows my eyes,

As I went forth in the morning, as I beheld the light breaking in the east,

As I bathed on the beach of the Eastern Sea, and again on the beach of Western Sea,

As I roam'd the streets of inland Chicago, whatever streets I have roam'd,

Or cities or silent woods, or even amid the sights of war,

Wherever I have been I have charged myself with contentment and triumph.

I sing to the last the equalities modern or old, I sing the endless finalés of things, I say Nature continues, glory continues, I praise with electric voice, For I do not see one imperfection in the universe, And I do not see one cause or result lamentable at

O setting sun! though the time has come, I still warble under you, if none else does, unmitigated adoration.

last in the universe.

INTERLUDE

Frédéric Chopin and George Sand

From their first meeting in October 1836 to their final separation in 1847 Frédéric Chopin (1810–1849) and George Sand (1804–1876) provided their friends—and enemies—a real-life romantic saga as remarkable as anything in 19th-century art. Both were highly acclaimed creative artists: Chopin was one of the leading composers and pianists of his day; Aurore Dupin, known as George Sand, was a successful author and travel writer. In every other respect, however, they could scarcely have been more different. Chopin was temperamentally delicate and reticent, plagued throughout his life by poor health. Sand's male pseudonym and habit of wearing men's attire were only two indications of her dominating personality.

A woman of robust constitution as well, Sand had already run through a series of tempestuous and violent affairs with much younger men by the time she met Chopin. It would nevertheless have seemed incredible to any of their acquaintances that a close relationship between them—beyond the improbability of its occurring at all—could have lasted for more than a few weeks. Yet for ten years they lived and traveled together and, like the profoundly romantic artists they were, channeled

their joys as well as their tempests into their art.

They first met in Paris, where Chopin had arrived some five years earlier in the hope of establishing himself as a performer and composer. Born in provincial Poland, he had trained at the Warsaw Conservatory and subsequently moved to Vienna, then the capital of the musical world. Competition was fierce, however, and a young foreigner still in his teens had little chance of breaking into the tough world of Viennese concert life, where new artists came and went unnoticed. Italy, which he considered trying next, was in the throes of political turmoil. So he turned

to Paris, where he spent most of the rest of his life.

The attractions of the French capital included a large colony of Polish exiles, among whom Chopin soon found himself at home. Parisian intellectual life was filled with excitement as the romantics battled for recognition. The ongoing conflict between Eugène Delacroix and Jean Auguste Dominique Ingres divided Parisian painters and art-lovers into fervent romantics or stern neoclassicists; the cause of romantic literature was waged notably and often violently by Victor Hugo. The musical life in Paris was perhaps even richer than that of Vienna, with three orchestras, two opera houses, and numerous concerts and recitals. Gioacchino Rossini could be heard conducting his own works, and in his first few weeks in the French capital Chopin heard concerts by both Liszt and Paganini.

Well before his own first Paris concert, on February 26,1832, Chopin's genius as a composer had been recognized by the great German composer Robert Schumann, who published an article on the young Pole containing his judgment: "Hats off, gentlemen—a genius!" In spite of the growing fame of his compositions, however, Chopin soon realized that as a performer his delicate playing style and his own shy personality were not suited to large public concert halls. He once told Franz Liszt, who possessed a strong element of showmanship: "I am not fit to give concerts; the crowd intimidates me, and I feel asphxyiated by its eager breath, paralyzed by its

inquisitive stare, silenced by its alien faces."

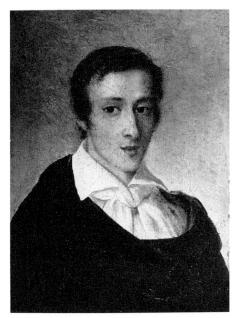

Ambroise Mieroszevski. Frédéric Chopin. 1829. This earliest surviving portrait of the composer shows him at the age of nineteen, shortly before he left home for Vienna and Paris.

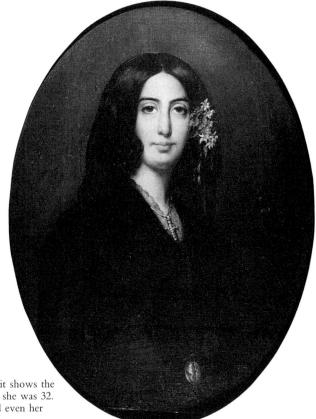

Auguste Charpentier. George Sand. This portrait shows the author at the time she first met Chopin, when she was 32. Note her large, lustrous eyes, which impressed even her detractors by their beauty.

> Chopin therefore began to perform increasingly often for intimate groups in the homes of the leading figures of Parisian society. Liszt, who had befriended the younger man, was able to provide him introductions to many of the aristocracy and his Polish connections offered other openings. Within a short time Chopin's private recitals had won him financial independence and a chain of admirers. Among society ladies and their daughters in particular, Chopin's elegant manners and intelligent, sensitive appearance made a considerable impression.

> We can get some idea of the magic of his playing from the descriptions of some of his listeners. Among those who heard him around this time was the German pianist and conductor Charles Hallé, who wrote in his memoirs (published in 1896):

I sat entranced, filled with wonderment, and if the room had suddenly been peopled with fairies I should not have been astonished. The marvelous charm, the poetry and originality, the perfect freedom and absolute lucidity of Chopin's playing at that time cannot be described. It was perfection in every sense . . . I could have dropped to my knees to worship him.

One of the few listeners who failed to respond immediately to Chopin's playing was George Sand, who heard him at the time of their first meeting in the fall of 1836 and judged him inferior to Liszt. Chopin's opinion of the most famous female author of the day was less complimentary. "What an unattractive person La Sand is," he remarked to a friend, "but is she really a woman?"

His cruel jibe was not altogether without foundation. By the time they met, George Sand had already developed the image she was to maintain for the rest of her life: aggressive and melodramatic, that of an ardent feminist who cultivated a male image by her dress and manners (which included cigar-smoking), an insistent propagandist who stunned her audience with her work. Her more conventional contemporaries were shocked, and even her fellow writers were not exactly sympathetic: the French writer Stendhal (1783–1842) once described her as "a great cow swollen up with printer's ink."

It is now clear, of course, that many of Sand's attackers were fully deserving victims of her violent thrusts at them. Her first novel, *Lélia*, was written in 1833 after a disastrous marriage (to a country squire, Baron Dudevant) and a torrid series of affairs. Among the accepted conventions of society that she lambasted were the Church, marriage, the laws of property (which almost exclusively permitted male control), and the double standard of morality whereby women were condemned for doing what was condoned for men. *Lélia* also included a number of graphic descriptions of sexual passion and its effects. Among the characters are Magnus, a priest driven to madness by the stifling of his desires, and Lélia's sister Pulchérie, a kindhearted prostitute who thinks of little else but gratifying hers. Lélia herself realizes the importance of physical satisfaction but finds that she is unable to achieve it.

George Sand's attack on the hypocrisy of bourgeois society won her instant notoriety throughout Europe, and within the artistic community of Paris she was befriended by the leading revolutionaries of the day, including Liszt and Delacroix. For some time after her first meeting with Chopin, however, their mutually unfavorable opinions of each other remained unchanged. As his reputation increased, Chopin began to travel throughout Europe, deterred only by ill health. George Sand retired to her country home at Nohant to supervise the education of her two children.

When they met again, in the spring of 1838, both had changed. George Sand's self-imposed country exile had made her more sober and thoughtful, while Chopin had paid the price of success with an increasing sense of loneliness and isolation. To her astonishment Sand found herself falling in love. A few weeks later she wrote to a friend: "I must say that I was confused and amazed at the effect this little creature wrought on me." Chopin's vulnerability and gentleness clearly formed much of his attraction; for his part, he began to realize that beneath her tough exterior George Sand was equally sensitive and shy. By the summer they had begun to live together.

There was a problem, however. George Sand's previous lover was by no means prepared to surrender her without protest. To avoid unpleasant scenes, the couple decided to spend the winter abroad, where in any case a warm climate would be beneficial to Chopin's health. Their choice fell, for no particular reason, on the Spanish island of Majorca, where they arrived in November 1838.

At first the island and the villa they rented there seemed like paradise and there were blue skies and warm days. A moment's inquiry, however, could have warned them that the rainy season was due. After a week or so, their idyllic love nest had become damp, cold, and full of smoke from stoves without flues. Chopin developed severe bronchitis, and George Sand coped as cheerfully as she could with running the house and looking after the invalid, reporting that "Instead of making literature, I am making the food."

In search of a drier climate they rented a cell in the abandoned monastery of Valldemosa, high in the mountains, which had been taken over by the government. The scenery was stupendous. George Sand wrote: "Everything the poet and the painter might have dreamt up has been created in this place by nature." The weather remained cold and the monastery was uncomfortable, but Chopin began to compose again. His 24 Preludes, Op. 28, were finished there, inspired in part by the romantic beauty of the place and the "poetry with which everything breathes." Sand had a rather less happy time. Her days were spent in nursing Chopin and trying to persuade the locals to sell them food—no easy task. Her unconventional behavior so alienated the natives that she was forced to buy her own goat to provide milk. At night, fortified with innumerable cups of coffee, she tried to keep up with her writing.

By the spring Chopin was coughing blood, and they fled Majorca for Marseilles,

where for a few months they lived quietly. George Sand's frustrations abated, Chopin's health improved, and they decided to move to Sand's country retreat at Nohant. In comfort and tranquility they settled into a routine that was to last, with

interruptions, for eight years.

After their final separation and Chopin's death George Sand looked back on this period with some bitterness. In her autobiography, the twenty volumes of which appeared between 1854 and 1856, she claimed that Chopin insisted on living with her against her will and that she had only agreed because of his state of health. But the evidence, including her own letters, demonstrates that this was far from the case. Although their initial passion cooled, they seem to have retained a considerable bond of affection. Certainly Chopin produced some of his finest music in the calmness of Nohant, including the Piano Sonata No. 2 in Bb minor, Op. 35, with its famous second-movement funeral march, finished there in 1839.

The course of their relationship was indeed hardly smooth. Chopin's natural tendency to fits of irritability was accentuated by regular bouts of bad health. Sand did her best to deal with his medical needs, but it is hardly surprising that she began to look upon him more as a sick child than a lover. The quiet life at Nohant, with its unvarying routine, drove them every so often to move back to Paris; but after a short while in the capital Chopin would begin to yearn again for the peace of the country, and back they would go. Something of his spirit of nervous restlessness, as well as the melancholy that increasingly overwhelmed him, emerges in works like the Fantaisie in F minor, Op. 49, composed at Nohant in the summer of 1841 after an exhausting trip to Paris.

In October 1843 Chopin decided to try to break out of the pattern by going to Paris alone. Although within a few months George Sand followed to nurse him through yet another illness, a distinct change in their relationship was noticeable to all their friends. She began to refer to him as her son and to seek consolation for the loss of a lover by turning to new ones. The two nevertheless seem to have remained on good terms and from time to time would return to Nohant together, where Chopin distracted himself by a mild flirtation with Sand's daughter, Solange.

In personal terms the next few years were unsettled, to say the least. Artistically, however, both Chopin and Sand remained highly productive. In 1844 Chopin wrote his Piano Sonata No. 3 in B minor, Op. 58, and in the following year one of his

greatest works, the Barcarolle in F# Major, Op. 60.

In 1846 George Sand began her novel Lucrezia Floriani, perhaps the most remarkable of all artistic consequences of a remarkable relationship. Lucrezia, the novel's heroine, is a famous actress who has retired to a country villa with her two children to escape from the sufferings of fame. By chance there arrives at the villa young Prince Karol, a refined and delicate invalid, whose nursing Lucrezia undertakes. Gradually they fall in love, although Lucrezia suffers continually from Prince Karol's bouts of nervous temperament. As the novel continues, Lucrezia's nobility and patience are put to increasingly severe strain by Prince Karol's jealousy and neuroses. At the end she dies of grief.

It would have taken a readership far less sophisticated than George Sand's not to have realized that Lucrezia Floriani was largely autobiographical. Furthermore, its author's attempt at self-justification was as obvious as it was one-sided. The glowing colors in which Lucrezia is painted and the unfavorable impression made by Prince Karol are clearly the result of Sand's desire to depict her own actions in the

most flattering light, but they present an impossibly biased picture.

Only Chopin and George Sand seemed to be unaware of the book's significance. The painter Delacroix was present at a party when the author read aloud sections to an appalled group of friends. "I was in agony during the reading," he wrote. "The victim and executioner amazed me equally. Madame Sand seemed to be completely at ease, and Chopin did not stop making admiring comments about the story."

But Lucrezia Floriani marked the beginning of the end. Although the couple remained in contact, when Chopin returned to Paris in 1847 he went there alone. Throughout the year they continued to correspond at length (one of George Sand's letters ran to 71 pages). As Chopin continued to assert his independence George Sand's temper rose, until she convinced herself that Chopin had always hated her and was really passionately in love with her daughter. It seems never to have occurred to her that he simply wanted to be free.

The following year they met by chance. According to Sand's autobiography, "I pressed his trembling and icy hand, I wanted to speak to him; he fled." Throughout 1848 and the early months of 1849 Chopin's health continued to deteriorate; by September it was plain that he had not much longer to live. George Sand wrote to him, but the tone of her letter irritated the dying composer and he did not answer. He died on October 17, 1849, without seeing her again.

Apart from its intrinsic interest in revealing the private lives of two of the most famous creative artists of the 19th century, the story of Frédéric Chopin and George Sand casts light on a number of aspects of the Romantic Age. The first is the close correspondence between personal experience and artistic creation. There can be little doubt that Chopin's music was directly affected by the course of their affair, while George Sand would have written neither Lucrezia Floriani nor many of her later novels if she had never met Chopin. A related phenomenon is the public exposure of private emotion. The development of their relationship was eagerly followed not only by lovers of music and literature but also by much of the general public.

Today we are quite familiar with highly publicized love affairs, but in the 19th century such cases were still the exception.

Especially fascinating, finally, to our own world is the conflict in George Sand between her militant feminism, which inspired her to seek independence at all costs, and her spirit of motherly protectiveness. However much she may have publicly advocated free love and the dissolution of the marriage bond, her own deep and genuine affection for Chopin kept this volatile woman bound to him for eight years.

Left: Chopin. 1849. This and the portrait of Sand mark the era of the beginnings of photography when for the first time people were portrayed as they actually looked to the objective lens of the camera. The first successful photograph was made in France in 1837. By the late 1840s many people were having their portraits made, undaunted by the fact that they had to sit rigidly still and unblinking for half a minute or more.

Right: Nadar. George Sand. c. 1864. Archives Photographiques, Paris. George Sand survived Chopin by 27 years. When this photograph was taken, she was about 60.

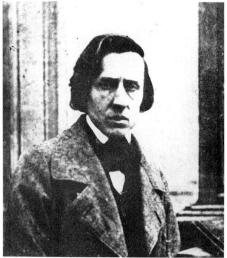

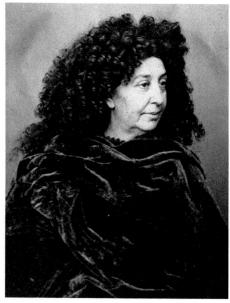

Further Reading

- Atwood, W. G. The Lioness and the Little One. New York: Columbia University Press. 1980. A modern, scholarly account of the relationship between Chopin and George Sand that successfully avoids taking sides. Interesting illustrations.
- Cate, Curtis. George Sand. Boston: Houghton Mifflin, 1975. The best and most complete biography of George Sand in English.
- Jordan, R. Nocturne: A Life of Chopin. London: Constable, 1978. A popular and easy-to-read biography of the composer that emphasizes his life rather than his music.
- Winegarten, R. The Double Life of George Sand. New York: Basic Books, 1978. An interesting study of the conflicting claims of private life and public works in the career of its subject.
- Zamovski, A. Chopin: A Biography. London: Collins, 1979. A good account of Chopin's life that makes use of the latest research.

GENERAL EVENTS

LITERATURE & PHILOSOPHY

ART

1860

1876 Speech first transmitted through telephone by Alexander Graham Bell

1880-1914 Height of European colonialism

1886 Dedication of Statue of Liberty, presented by France to America 1866 Dostoyevsky, Crime and Punishment 1870-1914 New areas explored in writing: impact of subconscious on human behavior, the role of women

1879 First performance of

1881 Death of Dostoyevsky 1883-1892 Nietzsche, *Thus*

House

Ibsen's realistic drama A Doll's

1863 Manet exhibits Déjeuner sur l'Herbe to public outrage

1869-1872 Degas, Degas' Father Listening to Lorenzo Pagans Singing

1874 Impressionism emerges when Monet and others exhibit at Café Guerbois, Paris; Impression: Sunrise (1872)

1875 Monet, Red Boats at Argenteuil

1876 Renoir, Le Moulin de la Galette

c. 1880 Postimpressionists reject impressionism

1881-1882 Manet, Bar at the Folies-Bergère

1884-1886 Seurat, A Sunday Afternoon on the Island of La Grande Jatte

c. 1885 Protocubist experiments of Cézanne; Still Life with Commode

1886 Rodin, The Kiss; Degas, The Tub

1888 Van Gogh, The Night Café

1889 Van Gogh, The Starry Night; Cassatt, Mother and Child

1890-1914 Industrialization of

1899-1902 Boer War

1891 Shaw, drama critic for Saturday Review, champions Ibsen

1893 Wilde, Salome

Spoke Zarathustra

1894 Kate Chopin, The Story of an Hour

1899 Kate Chopin, The Awakening

1891 Gauguin, *Ia Orana Maria* 1893 Munch, *The Scream;* Rodin begins *Balzac* 1894-1898 Kollwitz,

1894-1898 Kollwitz, The Weavers, etching based on Hauptmann play

c. 1902-1906 Cézanne paints last series of landscapes depicting *Mont Sainte-Victoire*

1903–1913 German expressionist movement Die Brücke 1905 First Fauve exhibition in Paris; Matisse, The Joy of Living (1905–1906)

1907-1914 Picasso and Braque develop cubism in Paris

1909 Nolde, Pentecost; Rodin, Portrait of Mahler

1911 Matisse, *The Red Studio*. German expressionist group *Der Blaue Reiter* formed

1912 Heckel, Two Men at a Table (To Dostoyevsky)

1900

1890

1901 Death of Queen Victoria of England; reign of Edward VII begins. First message sent over Marconi's transatlantic wireless telegraph

1903 Wright brothers make first airplane flight

1904 Russo-Japanese War

1905 First Revolution breaks out in Russia; Einstein formulates theory of relativity; first motion-picture theater opens in Pittsburgh

1908 Model T touring car introduced by Ford 1914 World War I begins

1900 Freud, Interpretation of Dreams

1913 Publication of Swann's Way, first volume of Proust's Remembrance of Things Past; final volume published posthumously (1927)

ARCHITECTURE MUSIC

mid-19th cent. Liszt's symphonic poems precursors of program music

1886 R. Strauss begins tone poem Don Juan

1883 Birth of Gropius

Toward the Modern Era: 1870-1914

1890-1891 Sullivan, Wainwright Building, St. Louis, first skyscraper

1893 Tchaikovsky, "Pathetique" Symphony, precedes composer's suicide. Mahler's Symphony No. 1 in D marks transition from romantic to modern music.

1894 Debussy, musical impressionist, composes Prélude à l'après-midi d'un faune

1895 R. Strauss, Till Eulenspiegel

1896 Puccini champions verismo in Italian opera; La Bohème

1899 R. Strauss, A Hero's Life

1905-1907 Gaudí, Casa Milá, Barcelona 1909 Robie House, Chicago, Frank Lloyd Wright's first big success

1900-1904 Puccini, Tosca; Madama Butterfly 1905 First performance of R. Strauss' opera Salome, based on Wilde's play; Debussy, La Mer 1908 Schoenberg, Three Piano Pieces, Op. 11, first major atonal work

1909-1910 Mahler, Symphony No. 9

1910-1913 Stravinsky composes Firebird, Petrouchka, Rite of Spring for Diaghilev's Ballet Russe in Paris

1911-1915 R. Strauss, Alpine Symphony

1912 Schoenberg, Pierrot Lunaire

1913 Ravel composes Daphnis and Chloe for Diaghilev

Distance lends perspective in human experience. The more intimately we are affected by events, the more difficult it is to evaluate them objectively. Looking back, we can see that the world in which we live. with its great hopes and even greater fears, began to take its present shape in the early years of the 20th century. The First World War of 1914 to 1918 marked an end to almost three thousand years of European political and cultural supremacy as well as the beginning of a world in which events in any corner of the globe could—and still do—have immense consequences for good or ill for the entire human race. The effects on the humanities of so vast a change in direction are the subject of Chapters 17 and 18. Here we will consider some of the causes and early symptoms of the change.

The period in which the modern world was formed is the historical era that directly affects our daily lives and, to repeat, this presents problems in evaluating it. Even though our cultural traditions go back to ancient Greece and Rome, and even though the cataclysmic events of the 20th century have not destroyed the value of centuries of accumulated experience, we naturally feel more intimately linked to the generation of our parents and grandparents than to more distant generations of ancestors of which we are also the product. Nevertheless, our parents and grandparents are the very people whose nearness to us in time and emotional impact makes them and their world more difficult to understand objectively.

Our own responses to the increasing complexity of historical forces during the formative stages of modern culture are still so confused that it is helpful to turn to the reactions of individual artists and thinkers who themselves lived through the times and can to some extent interpret them to us. Further, within the relatively limited sphere of artistic creativity we can observe at work forces that also operated on a much larger scale. As so often in the history of Western civilization, the arts provide a direct and powerful, if incomplete, expression of the spirit of an age in this case an age that happens to be our own. It may even be that the enduring importance of the humanities as a reflection of human condition is one of the few aspects of Western civilization to survive a century of global turmoil, and help us on our way into the 21st century.

The Growing Unrest

By the last quarter of the 19th century there was a widespread if unfocused feeling in Europe that life could not continue as before. Social and political revolutions had replaced the old monarchies with more

16.1 Ludwig Meidner. The Eve of War. 1914. Städtische Kunsthalle, Recklinghausen. The distorted faces and violent, heaving composition reflect the spirit of a world on the point of collapse.

nearly equitable forms of government. Scientific and technological developments had affected millions of ordinary people, bringing them improved standards of living and a more congenial existence. As a result, a new mood of cheerfulness began to make itself felt in the great cities of Europe; in Paris, for example, the period became known as the belle époque (beautiful age).

But the apparent gaiety was only superficial. The price of the immense changes that made it possible had been unrest and violence, and the forces that had been built up to achieve them remained in existence. Thus, in a period of nominal peace, most of the leading countries in Europe were maintaining huge armies and introducing compulsory military service. Long before 1914 a growing mood of frustration led many people to assume that sooner or later war would break out—a belief that certainly did not help to avert it [16.1].

The many historical causes of this mood are beyond the scope of this book but some of the more important underlying factors are easy enough to perceive. In the first place, the growth of democratic systems of government had taught increasing numbers of people that they had a right to share in the material benefits made possible by the industrial rev-

16.2 Käthe Kollwitz. March of the Weavers, from The Weavers Cycle. 1897. Etching, 83/8 × 115/8" $(21 \times 29 \text{ cm})$. University of Michigan Museum of Art, Ann Arbor. This print is based on a play, The Weavers, by the German playwright Gerhart Hauptmann (1862-1946) dealing with the misery and helplessness of both workers and owners in the industrial age. The axes and mattocks in the workers' hands point to the coming violence.

olution. Discontent grew on all sides. In the richest countries in Europe-France, England, and Germany—the poor compared their lot with that of the more affluent. At the same time, in the poorer European countries, including Ireland, Spain, Portugal, and all of Eastern Europe, everyone looked with envy at their wealthier neighbors. Even more significantly, those vast continents that the empire-building European powers were introducing to European civilization for the first time, including parts of Africa, Asia, and South America, began increasingly to resent European domination.

In the second place, the scientific progress that made possible improvements in people's lives created problems of its own. New medical advances reduced the rate of infant mortality, cured hitherto fatal diseases, and prolonged life expectancy. As a result the population of most of Europe soared to a record level, creating food and housing shortages. New forms of transport and new industrial processes brought vast numbers of workers to the cities. In consequence the lives of many people were uprooted and their daily existence became anonymous and impersonal.

Third, the growth of a world financial market, dependent primarily on the value of gold, gave new power to the forces of big business. In turn, the rise of capitalism, fiercely opposed by the growing forces of socialism [16.2], provoked the development of trade unions to protect the interests of the workers.

Finally, at a time when so many political and social forces were pitted against one another there seemed to be no certainty on which to fall back. Religion had lost its hold over intellectual circles by the 18th century, and by the end of the 19th century strong religious faith and its manifestation in churchgoing had begun to fall off drastically at all levels of society. The newly developing fields of anthropology and psychology, far from replacing religion, provided fresh controversy with their radically different explanations of human life and behavior.

In a state of such potential explosiveness it is hardly surprising that a major collapse of the fabric of European civilization seemed inevitable. Only in America, where hundreds of thousands of Europeans emigrated in the hope of making a new start, did optimism seem possible [16.3]. Events were moving at so fast a pace that few thinkers were able to detach themselves from their times and develop a philosophical basis for dealing with them. One of the few who did was Friedrich Nietzche (1844-1900), whose ominous diagnosis of the state of Western civilization in Thus Spake Zarathustra (1883-1892) and other works led him to propose drastic remedies.

For Nietzsche religion, morality, science, and the arts represented merely the fantasies of feeble cowards unable to face reality. The only valid life force, according to Nietzsche, is the "will to power," the energy that casts off all moral restraints in its pursuit of independence. The being who would develop as the outcome of a highly Nietzschean process of evolution is the person who can survive the loss of illusions and, by the free assertion of the will, establish new values of nobility and goodness. Nietzsche called this superior individual an *Übermensch* (literally "overperson"). Like Schopenhauer in the early 19th

16.3 Frédéric Auguste Bartholdi. Statue of Liberty (Liberty Enlightening the World). Constructed and erected in Paris, 1876-1884; disassembled, shipped to New York, re-erected, dedicated 1886. Hammered copper sheets over iron trusswork and armature; height of figure 151' (46 m), total height, including pedestal, above sea level 306' (93 m). This famous monument, which still dominates New York's harbor, became the symbol to European immigrants in the late 19th century of the welcome they would find in the New World. The colossal statue (the head alone is 13'6", or 4.4 m, high) was a gift from France to the United States. It was designed by the French sculptor Frédéric Auguste Bartholdi (1834-1904); its supporting framework was designed by the French engineer Gustave Eiffel (1832-1923), known mainly for his Eiffel Tower in Paris, France's national monument, completed in 1889.

EAST MEETS WEST

The Emergence of Japan

From the 16th century, traders and missionaries maintained links between Europe and China that were to have profound effects on later Chinese economic and political developments. Their Japanese neighbors, by contrast, maintained a careful policy of self-imposed isolation. The few Jesuits who had arrived there were driven out in the early 17th century, and in 1640 all Europeans were expelled, apart from a small group of Dutch merchants confined to Nagasaki under strict supervision. Japan was ruled by the emperor's commander-in-chief, a shogun, in a system of government that was principally feudal. The great lords, or daimyo, used their private armies of samurai warriors to impose order and advance their own interests.

In 1853 the American commodore Matthew Perry led a mission to Japan to establish commercial relations between the Japanese and the United States; the imposing fleet of steam warships he took with him no doubt played its part in persuading Japan to open its ports to foreign trade. Other nations hastened to take advantage of the new market, and Japan's seclusion was over.

The period of Japan's westernization is known as the Meiji era, the name given to the reign of the emperor Mutsuhito (1858-1912). Feudalism was abolished, and the country became a modern nation-state. Universal education and national service played their part in transforming illiterate peasants into trained and efficient workers. The result was the development of an economy that has become among the world's most powerful market forces.

The Japanese had been able to satisfy their limited curiosity about events elsewhere in the world, but the internal affairs of the island nation remained shrouded in mystery for Westerners. Not surprisingly, therefore, Japan's emergence into the modern world caused a considerable stir. In artistic circles Japanese woodcuts, with their elegant simplicity, became prized collector's pieces; Degas was an enthusiastic connoisseur, and works like The Tub (16.12) show their influence. On a less sophisticated level, Western delight at the "quaintness" of Japanese life, dress, and customs was expressed in William Gilbert and Arthur Sullivan's operetta The Mikado (1885), while Japanese vulnerability to insensitive Western ways was the subject of Giacomo Puccini's popular opera Madama Butterfly (1904).

THE ARTS AND INVENTION: The Movies

On April 23, 1896, Koster and Bial's New York Music Hall gave the first Broadway exhibition of moving pictures. The vitascope, as the new medium was called, was based on a process invented by Thomas B. Edison, who had devised a machine he called a kinetoscope for the viewing of moving scenes. The great inventor lost interest in what he regarded as a rather childish toy, but the movies were to revolutionize popular entertainment and to provide the 20th century a new medium for artistic creation.

At first movies served as one of the many entertainments offered by vaudeville theaters, along with acrobats and popular songs, but by 1905 special buildings were being constructed for the presentation of moving pictures. In 1907 alone, three hundred "nickelodeons" were opened in New York, with a daily attendance figure of two hundred thousand people. Even more significantly, movie houses were built in virtually every community across America and most of Europe, attracting a vast public that had never before attended the theater. From the beginning the movies' first appeal was to the masses rather than to the educated: they were cheap and

Predictably, the new entertainment drew harsh criticism from the elite. A Chicago journalist, writing of the cinema's first close-up kiss (between May Irwin and John C. Rice) complained that "magnified to gargantuan proportions and repeated three times over, it is absolutely disgusting. . . . Such things call for police interference." Local censorship was commonly applied, and permits were generally given only on condition that movie houses did not operate on Sundays and refrained from showing pictures which tended to "degrade the morals of the community." Even proponents of the movies defended it as "a harmless diversion of the poor." Few people seem to have foreseen how the movie business would expand and assume a rapid importance both as mass entertainment and as commercial enterprise.

century (see page 258), Nietzsche is valuable principally for the way in which he anticipated future ideas rather than because he was the leader of a movement. Unfortunately, his concepts were later taken up in a distorted form by many of the would-be world rulers of the 20th century, most notoriously the leaders of Nazi Germany.

Cut adrift from the security of religion or philosophy, the arts responded to the restless mood of the times by searching for new subjects and styles. Often these subjects and styles challenged principles that had been accepted for centuries. In music traditional concepts of harmony and rhythm were first radically extended and then, by some composers at least, completely discarded. In literature new areas of experience were explored, including the impact of the subconscious on human behavior, and traditional attitudes like the role of women were examined afresh. In the visual arts, the impressionists found a totally new way of looking at the world, which in turn opened up other exciting new fields of artistic expression. Whatever their defects, the formative years of the modern world were certainly not dull with respect to the arts.

New Movements in the Visual Arts

Something of the feverish activity in the visual arts during this period can be gauged by the sheer number of movements and styles that followed one another in rapid succession: impressionism, postimpressionism, fauvism, expressionism, culminating in the birth of cubism around the time of World War I. Cubism is discussed in Chapter 17 because of its effects on the whole of 20th-century art, but all the other movements form important stages in the transition from traditional artistic styles to the art of our own time, much of which rejects any attempt at realism in favor of abstract values of line, shape, and color. An understanding of their significance is thus a necessary prerequisite for a full appreciation of modern abstract art. Quite apart from their historical interest, however, the artistic movements of the late 19th and 20th centuries have much visual pleasure to

As so often in the past, the center of artistic activity was Paris, where Edouard Manet (1832-1883) had created a sensation in 1863 with his painting Le Déjeuner sur l'Herbe (Luncheon on the Grass) [16.4]. Public outcry had been directed against the subject of the painting, which shows a female nude among two fully clothed young men and another clothed female figure. Other artists had combined nude females and clothed males before in a single picture, but Manet's scene has a particular air of reality; the way the unclad young woman stares out from the canvas and the two smartly dressed young men appear nonchalantly indifferent to her condition can still take the spectator by surprise. The true break with tradition, however, lay not in the picture's subject but its style. The artist is much less interested in telling us what his charac-

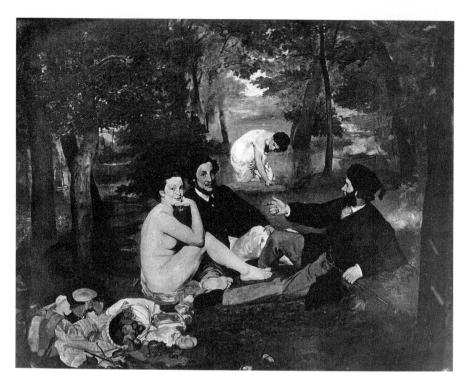

16.4 Édouard Manet. Le Déjeuner sur L'Herbe. 1863. Oil on canvas, $7'^{3/4}'' \times 8'10^{3/8}''$ (2.15 × 2.7 m). Louvre, Paris. Manet probably based the landscape on sketches made out-of-doors but painted the figures from models in his studio, something a careful look at the painting seems to confirm.

16.5 Édouard Manet. A Bar at the Folies-Bergère. 1881–1882. Oil on canvas, 3'1½" × 4'3" (.95 × 1.3 m). Courtauld Institute Galleries, London (Courtauld Collection). Note the very impressionistic way in which Manet painted the girl's top-hatted cus-tomer, reflected in the mirror at right.

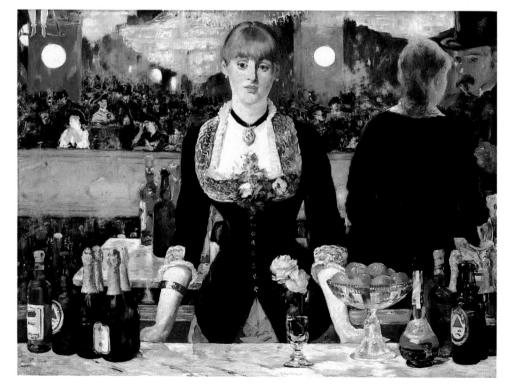

ters are doing than in showing us how he sees them and their surroundings. Instead of representing them as rounded, three-dimensional forms, he has painted them as a series of broad, flat areas in which the brilliance of color is unmuted. In creating this style, Manet laid the philosophical foundations that made

Impressionism possible.

The massive, almost monumental human form reappears in one of Manet's last paintings, A Bar at the Folies-Bergère of 1881 [16.5], where the barmaid amid her bottles and dishes presents the same solid appearance as the nude in Déjeuner. If we glance over her shoulder, however, and look into the mirror as it reflects her back and the crowded scene of which we have temporarily become a part, the style changes. The sharp outlines and fully defined forms of the foreground are replaced by a blur of shapes and colors that conveys the general impression of a crowded theater without reproducing specific details. A comparison between the background of the two pictures makes it clear that between 1863 and 1881 something drastic had occurred in the way painters looked at scenes and then reproduced them.

Impressionism

In 1874 a group of young artists organized an exhibition of their work during conversations at the Café Guerbois in Paris. Their unconventional approach to art and their contempt for traditional methods meant that normal avenues of publicity were closed to them; they hoped that the exhibition would succeed in bringing their work to public attention. It certainly did. One of the paintings, Impression: Sunrise [16.6] by Claude Monet (1840–1926), particularly scandalized the more conventional critics, some of whom derisively borrowed its title and nicknamed the whole group impressionists. Within a few years the impressionists had revolutionized European painting.

Although impressionism seemed at the time to represent a radical break with the past, it first developed out of yet another attempt to achieve greater realism, a tradition that had begun at the dawn of the Renaissance with Giotto. The impressionists concentrated, however, on realism of light and color rather than realism of form and sought to reproduce with the utmost fidelity the literal impression an object made on their eyes. If, for example, we look at a house or a human face from a distance, we automatically interpret it on the basis of our mental knowledge, and "see" details that are not really visible. Impressionist painters tried to banish all such interpretations from their art and to paint with an "innocent eye." In Red Boats at Argenteuil [16.7] Monet has recorded all the colors he saw in the water and the reflections of the boats without trying to blend them together conventionally (or intellectually). The result is not a painting of boats at anchor but a representa-

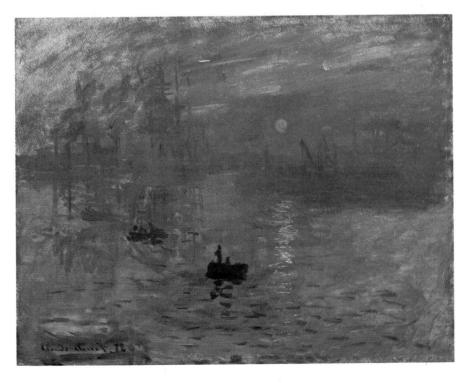

16.6 Claude Monet. Impression: Sunrise. 1872. Oil on canvas. $19\frac{1}{2} \times 24\frac{1}{2}$ " (50 × 62 cm). Musée Marmottan, Paris. Although this was the painting after which the impressionist movement was named, its use of impressionist techniques is relatively undeveloped compared with 16.7 and 168

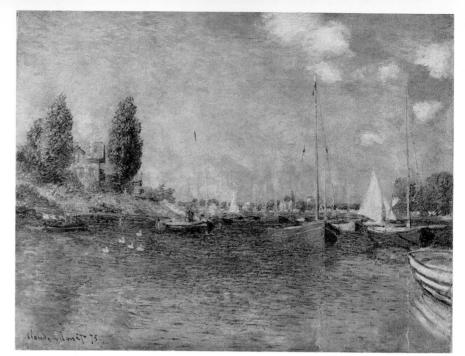

16.7 Claude Monet. Red Boats, Argenteuil. 1875. Oil on canvas, $23\frac{5}{8} \times 31\frac{7}{8}$ " (60 × 81 cm). Courtesy of the Harvard University Art Museums. Fogg Art Museum (Bequest-Collection of Maurice Wertheim, Class of 1906). Painted the year after the first impressionist exhibition in Paris, this shows Monet's characteristic way of combining separate colors to reproduce the effect of light.

tion of the instantaneous impact on the eye of the lights and colors of those boats—that is, what the artist saw rather than what he knew.

Throughout his long career Monet retained a total fidelity to visual perception. His fellow painter Paul Cézanne is said to have called him "only an eye, but my God what an eye!" His preoccupation with the effects of light and color reached its most complete expression in his numerous paintings of water lilies in his garden. In version after version he tried to capture in paint the effect of the shimmering, ever-changing appearance of water, leaves, and blossoms. The result, as in the Water Lilies of 1920 [16.8], reproduces not so much the actual appearance of Monet's lily pond as an abstract symphony of glowing colors and reflecting lights. Paradoxically, the most complete

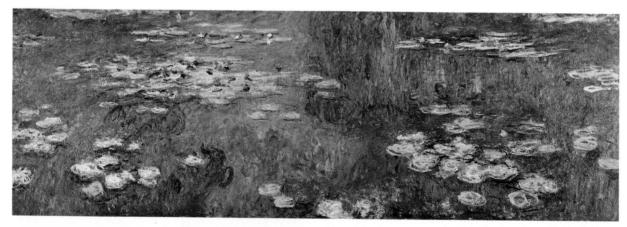

16.8 Claude Monet. Nymphéas (Water Lilies). 1920-1921. Oil on canvas, $6'6''\times19'7''$ (1.98 \times 5.97 m). The Carnegie Museum of Art, Pittsburgh (acquired through the generosity of Mrs. Alan M. Scaife, 1962). This is one of a number of huge paintings (in this case almost 20 feet long) that Monet produced in the garden of his house in Giverny. Note the contrast with his Red Boats, Argenteuil of 45 years earlier (figure 16.7); in Water Lilies there is a very different attitude to realism of form. The greatly enlarged detail at left gives an idea of Monet's technique—one that looks simple at first glance but actually results from many separate, complex decisions. In every case the artist was guided by purely visual factors rather than formal or intellectual ones.

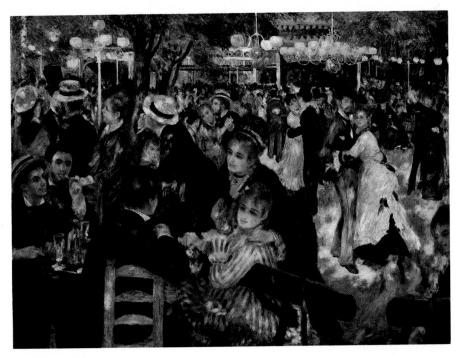

16.9 Auguste Renoir. Le Moulin de la Galette. 1876. Oil on canvas, 4'3½" × 5'9" (1.31 × 1.75 m). Musée d'Orsay, Paris. By using small patches of color Renoir achieves the impression of dappled sunlight filtering through the trees.

devotion to naturalism was to pave the way for abstraction and for what we know as modern art.

Monet's art represents impressionism in its purest form. Other painters, while preserving its general principles, devised variants on it. Pierre Auguste Renoir (1841-1919) shared Monet's interest in reproducing the effects of light in patches of color, but he brought to his subjects a human interest that derived from his own joy in life. It is a refreshing change, in fact, to find an artist whose work consistently explored the beauty of the world around him rather than the great problems of human existence. Nor was Renoir's interest limited, as was Monet's, to the wonders of nature. His most enduring love was for women as symbols of life itself; in his paintings they radiate an immense warmth and charm. His painting of the Moulin de la Galette [16.9], a popular Parisian restaurant and dance hall, captures the spirit of the crowd by means of the same fragmentary patches of color Manet had used in the background of A Bar at the Folies-Bergère [see figure 16.5], but Renoir adds his own sense of happy activity. The group in the foreground is particularly touching, with its sympathetic depiction of adolescent love. The boy leans impetuously forward, nervously fingering his chair, while the girl who has attracted his attention leans back and looks gravely yet seductively into his face, restrained by the protective arm of an older companion. Although the encounter may be commonplace, Renoir endows it with a significance and a humanity far different from Monet's more austere, if more literal, vision of the world by setting it against the warmth and movement of the background.

Unlike many other impressionists, Renoir traveled widely throughout Europe in order to see the paintings of the great Renaissance and Baroque masters. The influence of artists like Raphael, Velázquez, and Rubens is visible in his work. This combination of an impressionist approach to color with a more traditional attitude to form and composition emerges in Two Girls at the Piano [16.10], where the girls' arms have a genuine sense of roundness and weight. This painting is not a mere visual exercise, for Renoir endows his figures with a sense of self-assurance that only emphasizes their vulnerability.

The artist Edgar Degas (1834-1917) shared Renoir's interest in people, but unlike Renoir (who emphasized the positive side of life) he simply reported what he saw, stressing neither the good nor the bad. By showing us intimate moments in other people's lives, revealed by a momentary gesture or expression, his frankness, far from being heartless, as some of his critics have claimed, conveys the universality of human experience. Although Degas exhibited with the impressionists and, like them, chose to paint scenes from the everyday events of life, his psychological penetration distinguishes his art from their more literal approach to painting. Even the impressionist principle of capturing a scene spontaneously, in action, becomes in Degas' hands a powerful means of expression. One of the themes he turned to again and again was ballet, perhaps because of the range of movement it involved, although he also often underlined the gulf between the romantic façade of ballet and its down-to-earth reality. In The Rehearsal [16.11] we are left in no doubt that neither ballet nor

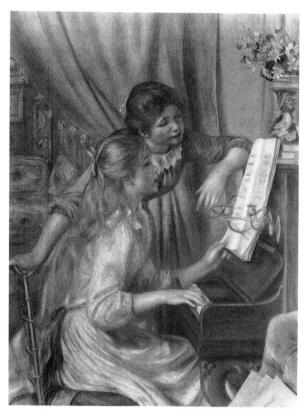

16.10 Auguste Renoir. *Two Girls at the Piano*. 1892. Oil on canvas, $45\frac{1}{2} \times 34\frac{1}{2}$ " (116 × 88 cm). Louvre, Paris. The position of the two girls, one leaning forward and resting her arm on the shoulder of the other, is almost exactly the same as that of the woman and the girl in the center of figure 16.9; this position seems to have appealed to Renoir as a gesture of affection.

16.11 Edgar Degas. *The Rehearsal*. 1874. Oil on canvas, 26 × 32½" (66 × 82 cm). Louvre, Paris. Degas' careful observation extends even to the director of the ballet troupe at the right-hand edge of the stage, hat almost over his eyes, holding the back of his chair.

ballet dancers are entirely glamorous. Degas' point of view is emphasized by the unusual vantage point from which the stage is shown: close to and from a position high up on the side. Far from coldly observing and reproducing the scene, Degas creates an instant bond between us and the hard-worked dancers, based on our perception of them as human beings.

Degas' honesty won him the reputation of being a woman-hater, since many of his representations of female nudes lack the idealizing qualities of Renoir's and other painters' work. In a series of pastels he shows women caught unawares in simple natural poses. *The Tub* [16.12], with its unusual angle of vision, shows why these were sometimes called "keyhole visions." Far from posing, his subjects seem to be spied on while they are engrossed in the most intimate and natural activities.

One of Degas' closest friends was the American artist Mary Cassatt (1844–1926), who, after overcoming strong opposition from her father, settled in Europe to pursue an artistic career. Like Degas she painted spontaneous scenes from daily life, particularly situations involving mothers and children. Mother and Child [16.13] shows the mother turned away from us and a child who is saved from sentimentality by his complete unawareness of our presence. Cassatt herself never married, but there is no reason to think that her paintings of children were created out of frustration. She seems to have had a rich and happy life, and her championship of the impressionist cause among her American friends led to many of them buying impressionist works and

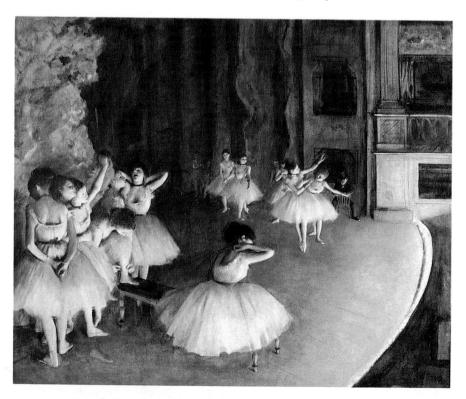

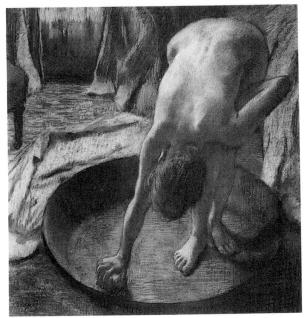

16.12 Edgar Degas. *The Tub*. c. 1886. Pastel, 27%" (70 cm) square. Hill-Stead Museum, Farmington, Connecticut. The beautiful simplicity of Degas' drawing gives an impression of action glimpsed momentarily, as if by one passing by.

taking them home with them. Cassatt's artist friends had much to thank her for, and so do the curators of many American museums and galleries, which have inherited collections of impressionist paintings.

Another member of the same circle was Berthe Morisot (1841–1895) whose early painting career was encouraged by Corot. In 1868 she met Manet and

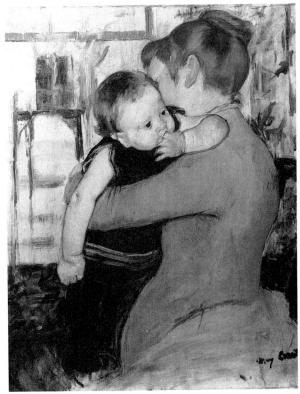

16.13 Mary Cassatt. Mother and Child. c. 1889. Oil on canvas, $29 \times 23 \frac{1}{2}$ " (74 × 60 cm). Cincinnati Art Museum (John J. Emery Endowment, 1928). By turning the mother's face away the artist concentrates attention on the child, an effect enhanced by the vague background.

16.14 Berthe Morisot. Paris Seen from the Trocadero. 1872. Oil on canvas, $18\frac{1}{4} \times 32^{\prime\prime}$ (46.3 \times 81.3 cm). Santa Barbara Museum of Art (gift of Mrs. Hugh N. Kirkland). The separation between the various planes of the view produces an effect of breadth and tranquility.

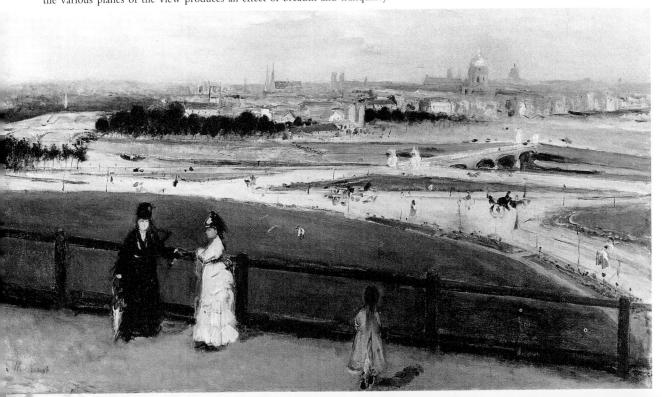

they became warm friends; a few years later she married his younger brother. An active member of the impressionist group, she exhibited works in almost all their shows.

Morisot's work has often been labeled "feminine," both by her contemporaries and by more recent critics. Like Cassatt, a close friend, she often painted women and children. Yet she also produced works of considerable breadth. Paris Seen from the Trocadero [16.14] presents a panoramic view of the city. The sense of light and atmosphere is conveyed by loose, fluid brushstrokes, while the figures in the foreground do not seem part of any story or incident: they help focus the scale of the view, which is seen as if from a height.

The impact of impressionism on sculptors was inevitably limited, since many of its principles were dependent on color and light and could only be applied in paint. Nevertheless, the greatest sculptor of the age (according to many, the greatest since Bernini), Auguste Rodin (1840-1918), reproduced in bronze something of the impressionist love of shifting forms and light and shadow. His remarkable fig-

16.15 Auguste Rodin. Monument to Balzac. 1897-1898. Bronze, (cast 1954), height 8'10" (2.7 m). Collection, The Museum of Modern Art, New York (presented in memory of Curt Valentin by his friends). Unlike most sculptors who worked in bronze, Rodin avoided a smooth surface by roughening and gouging the metal.

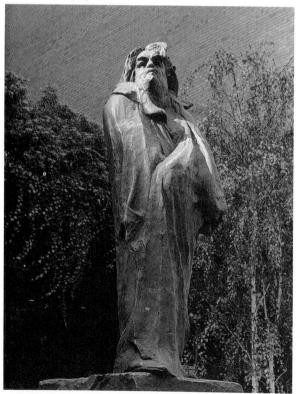

ure of Balzac [16.15] demonstrates the irregularity of surface by which Rodin converted two-dimensional impressionist effects to a three-dimensional format. It also reveals one of the ways in which he differed from his impressionist contemporaries, since his themes are generally massive and dramatic rather than drawn from everyday life. The portrait of Balzac shows the great novelist possessed by creative inspiration, rather than his actual physical appearance. The subject of this sculpture is really the violent force of genius (a concept also illustrated in his portrait of the composer Gustav Mahler [see figure 16.31, page 341], and Rodin conveys it with almost elemental power.

It should perhaps not be surprising that critics of the day were unprepared for such burning intensity. One of them dubbed the statue a "toad in a sack." But in retrospect Rodin breathed new life into sculpture. The "primitive" grandeur of his images formed a powerful attraction for 20th-century sculptors.

16.16 Auguste Rodin. The Kiss. 1886. Marble, height 6'2" (1.9 m). Musée Rodin, Paris. As in his Balzac, the artist used the texture of his material to enhance the appearance of his work. But the smooth, slightly blurred surface of the marble here, in contrast to the rough surface of the portrait, produces a glowing effect.

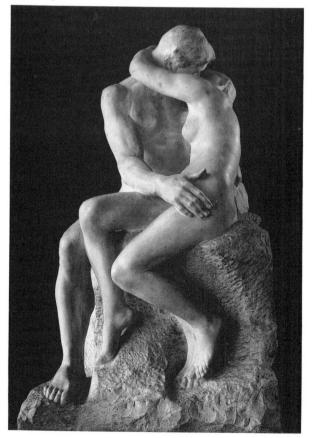

In general Rodin's works in marble are less impressionistic than those in bronze, but his famous The Kiss [16.16] achieves something of Renoir's blurred sensuality by the soft texture of the stone and the smooth transitions between the forms of the figures. Yet even though Rodin at times seems to strive for an impressionistic surface effect, the drama and full-blooded commitment of many of his works show the inadequacy of stylistic labels. We can only describe Rodin as a sculptor who used the impressionist style in works that foreshadow modern developments—that is, as a great original.

Post-Impressionism

As a stylistic category post-impressionism is one of the least helpful or descriptive terms in art history. The artists who are generally grouped together under it have as their only real common characteristic a rejection of impressionism for new approaches to painting. All of them arrived at their own individual styles. Their grouping together is therefore more a matter of historical convenience than critical judgment. The scientific precision of Georges Seurat (1859-1891), for example—whose paintings, based on the geometric relationship of forms in space, are made up of thousands of tiny dots of paint applied according to strict theories of color [16.17]—has little in common with the flamboyant and exotic art of Paul Gauguin (1848-1903). Particularly in his last paintings, based on his experiences in Tahiti, Gauguin attacked primitive subjects in a highly sophisticated manner, producing results like Ia Orana Maria [16.18], which may attract or repel viewers but rarely leave them indifferent.

The greatest post-impressionist painter was Paul Cézanne (1839-1906). It would be difficult to overestimate the revolutionary quality of Cézanne's art, which has been compared to that of the proto-Renaissance Florentine painter Giotto as an influence on Western art. Cézanne's innovations brought to an end the six-hundred-year attempt since Giotto's time to reproduce nature in painting. In place of nature Cézanne looked for order; or rather he tried to impose order on nature, without worrying if the results were realistic. It is not easy to comprehend or express in intellectual terms the character of Cézanne's vision, although, as so often in the arts, the works speak for themselves. His paintings convey the essence, in terms of both shape and color, of his subject

16.17 Georges Seurat. Sunday Afternoon on the Island of La Grande Jatte. 1884-1886. Oil on canvas, 6'9" × 10'3%" (2.06 × 3.06 m). The Art Institute of Chicago (Helen Birch Bartlett Memorial Collection). For all the casual activity in this scene of strollers in a park on an island in the river Seine, Seurat's remarkable sense of form endows it with an air of formality. Both shape and color (applied in minute dots) are rigorously ordered.

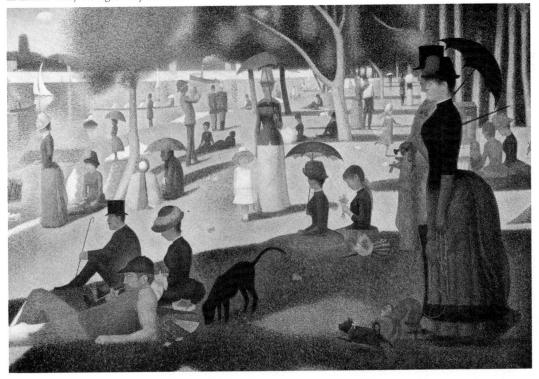

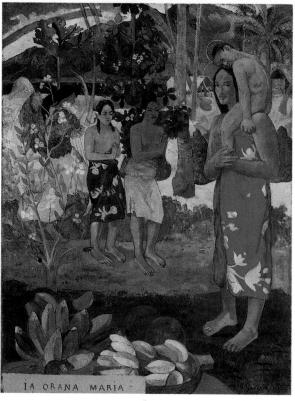

16.18 Paul Gauguin. *Ia Orana Maria*. 1891. Oil on canvas, 44½ × 34½" (114 × 88 cm). Metropolitan Museum of Art, New York (bequest of Samuel A. Lewisohn, 1951). The title means "We hail thee, Mary"; the painting shows a Tahitian Madonna and Child being worshipped by two women with an angel standing behind them. The whole scene presents a fusion of Western spiritual values and the simple beauty of primitive Polynesian life.

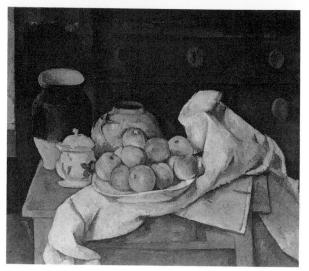

16.19 Paul Cézanne. Still Life with Commode. c. 1885. Oil on canvas, $25\% \times 31\%$ " (65 × 85 cm). Courtesy of the Harvard University Art Museums. Fogg Art Museum (Bequest—Collection of Maurice Wertheim, Class of 1906). So painstakingly did the artist work on the precise arrangement of the objects in his still lifes and on their depiction that the fruit usually rotted long before a painting was complete.

matter rather than its literal physical appearance. His Still Life with Commode [16.19] does not try to show how the fruit, vase, and cloth really look or reproduce their actual relationship to one another. On the contrary, the painter has deliberately distorted the surface of the table and the shape of the objects to achieve a totally satisfying design. Abstract considerations, in other words, take precedence over fidelity to nature. In the process a simple plate of fruit takes on a quality that can only be called monumental.

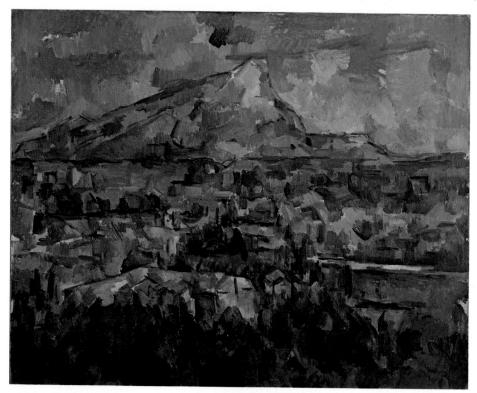

16.20 Paul Cézanne. Mont Sainte-Victoire. 1904–1906. Oil on canvas, 287/s × 361/4" (73 × 92 cm). Philadelphia Museum of Art (George W. Elkins Collection). The reduction of the elements in the landscape to flat planes and the avoidance of the effect of perspective give the painting a sense of concentrated intensity.

The miracle of Cézanne's paintings is that for all their concern with ideal order they are still vibrantly alive. Mont Sainte-Victoire [16.20] is one of a number of versions Cézanne painted of the same scene, visible from his studio window. Perhaps the contrast between the peaceful countryside and the grandeur of the mountain beyond partially explains the scene's appeal to him. He produced the transition from foreground to background and up to the sky by the wonderful manipulation of planes of pure color. It illustrates his claim that he tried to give the style of impressionism a more solid appearance by giving his shapes a more continuous surface, an effect produced by broad brushstrokes. Yet equally the painting conveys the vivid colors of a Mediterranean landscape, with particular details refined away so as to leave behind the pure essence in all its beauty.

Nothing could be in greater contrast to Cézanne's ordered world than the tormented vision of Vincent van Gogh (1853-1890), the tragedy of whose life found its expression in his work. The autobiographical nature of Van Gogh's painting, together with its

16.21 Vincent van Gogh. The Starry Night. 1889. Oil on canvas, 29 × 361/4" (74 × 92 cm). Collection, The Museum of Modern Art, New York (acquired through the Lillie P. Bliss bequest). The impression of irresistible movement is the result of the artist's careful use of line and shape. The scene is dominated by spirals, vertical ones formed by the cypress trees and horizontal ones in the sky, which create a sense of rushing speed.

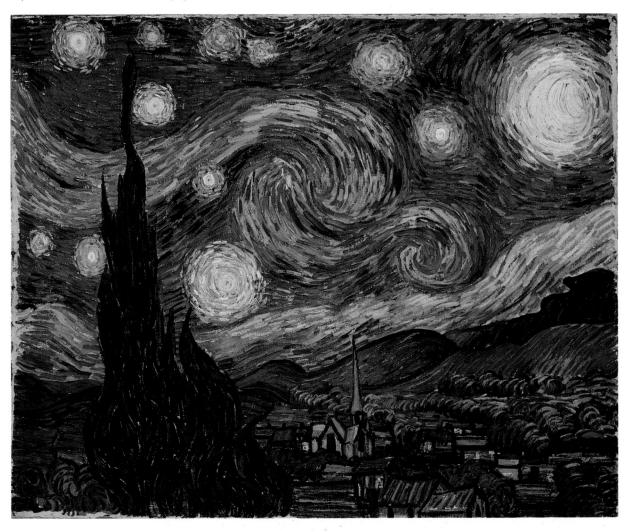

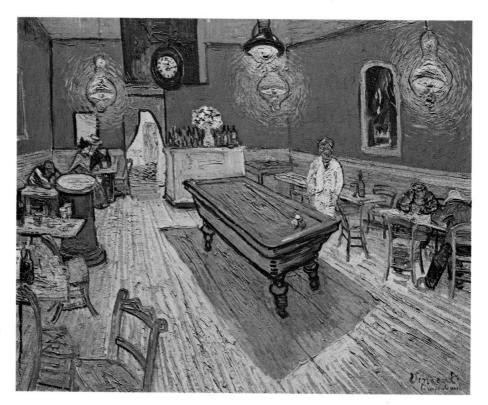

16.22 Vincent van Gogh. The Night Café. 1888. Oil on canvas, 28½ × 36¼" (72 × 92 cm). Yale University Art Gallery, New Haven (bequest of Stephen C. Clark). Compare the lack of perspective in Cézanne's Mont Saint-Victoire (figure 16.20) with the highly exaggerated perspective used by Van Gogh here to achieve a sense of violent intensity.

passionate feelings, has a special appeal to modern sensibilities. In fairness to Van Gogh, however, we should remember that by giving expression to his desperate emotions the artist was, however briefly, triumphing over them. Further, in a way that only the arts make possible, the suffering of a grim, even bizarre life became transformed into a profound if admittedly partial statement on the human condition. Desperate ectasy and passionate frenzy are not emotions common to most people, yet The Starry Night [16.21] communicates them immediately and unforgettably.

The momentum of swirling, flickering forms in The Starry Night is intoxicating, but for the most part Van Gogh's vision of the world was profoundly pessimistic. The Night Café [16.22] was described by the artist himself as "one of the ugliest I have done," but the ugliness is deliberate. Van Gogh's subject was "the terrible passions of humanity," expressed by the harsh contrasts between red, green, and yellow, which were intended to convey the idea that "the café is a place where one can ruin oneself, go mad, or commit a crime."

Much of Van Gogh's pessimism was undoubtedly the result of the unhappy circumstances of his own life, but it is tempting to place it in the wider context of his times and see it also as a terrifying manifestation of the growing social and spiritual alienation of

TABLE 16.1 Principal Characteristics of

Fauvism and Expressionism Fauvism: Violent, startling color contrasts Paintings reflect the effect of visual contact on the psyche Nature interpreted and subjected to the spirit of the artists Composition a decorative arrangement of elements to express the artist's feelings Technique deliberately crude to disturb the form of objects No effect of light or depth Art for art's sake Expressionism: Brilliant, clashing colors Paintings reflect mysticism, selfexamination, speculation on the Nature used to interpret the universe Composition distorted forms in a controlled space, derived from late Gothic woodcut tradition Technique influenced by medieval art and the primitivistic art of Africa and Oceania

No use of traditional perspective

logical truth

Art to convey emotional or psycho-

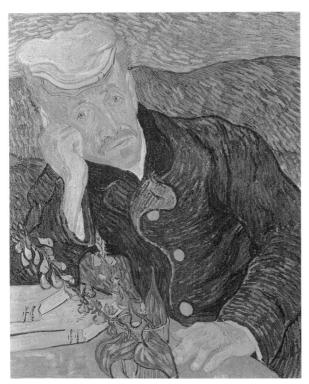

16.23 Vincent van Gogh. Portrait of Dr. Gachet. 1890. Oil on canvas, $26\frac{1}{4} \times 22\frac{1}{2}$ " (67 × 57 cm). Private collection, U.S.A. Gachet was an amateur artist and friend of Van Gogh who often provided medical treatment for his painter acquaintances without taking any fee. Mentally ill and in despair, Van Gogh committed suicide while staying with Gachet.

society in the late 19th century. That Van Gogh was actually aware of this is shown by a remark he made about his Portrait of Dr. Gachet [16.23], the physician who treated him in his last illness. He had painted the doctor, he said, with the "heartbroken expression of our times."

Fauvism and Expressionism

By the early years of the 20th century the violent mood of the times had intensified still further, and artists continued to express this in their art. The impact of post-impressionists like Van Gogh inspired several new movements of which the most important was fauvism, which developed in France, and expressionism, which reached its high point in Germany.

The origin of the term fauvism reveals much of its character. In 1905 a group of artists exhibited paintings that broke with tradition so violently in their use of color and form that a critic described the painters as les fauves (the wild beasts). These painters had little in common apart from their desire to discard all traditional values; not surprisingly, the group broke up after a short while. But one of their number, Henri Matisse (1869–1954), became a major force in 20thcentury art.

Henri Matisse was the leading spirit of the fauves. His works are filled with the bold accents and brilliant color typical of fauvist art. Yet the flowing images of Matisse's paintings strike an individual note, expressing a mood of optimism and festivity curi-

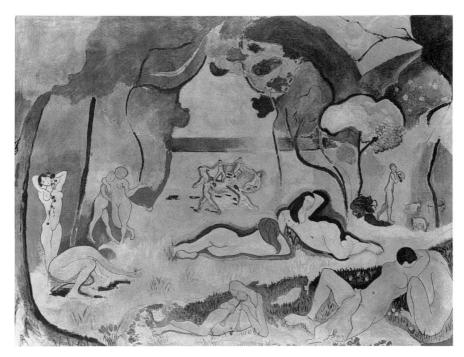

16.24 Henri Matisse. The Joy of Life. 1905-1906. Oil on canvas, $5'8'' \times 7'9^{3/4}''$ (1.74 × 2.38 m). Barnes Foundation, Merion Station, Pennsylvania. By varying the sizes of the figures without regard to the relationship of one group to another the artist accentuates the sense of dreamlike unreality. Note Matisse's characteristically simple, flowing lines.

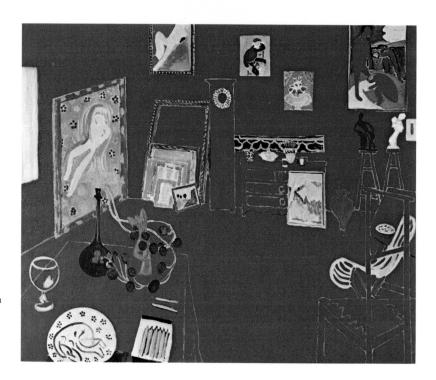

16.25 Henri Matisse. The Red Studio. 1911. Oil on canvas, $5'11\frac{1}{4}'' \times 7'2\frac{1}{4}''$ $(1.81 \times 2.19 \text{ m})$. Collection, The Museum of Modern Art, New York (Mrs. Simon Guggenheim Fund). The paintings and small sculptures in the studio are actual works by Matisse himself; they show the brilliant colors typical of fauve art.

ously at odds with the times. One of his first important paintings, The Joy of Life [16.24], shows fields and trees in bright sunlight, where men and women are sleeping, dancing, and making music and love. It is difficult to think of any work of art further removed from the anguish of the years immediately preceding World War I than this image of innocent joy painted in 1905 and 1906.

Matisse was saved from the gloom of his contemporaries by his sheer pleasure in seeing and painting; his work eloquently communicates the delight of visual sensation. His still-life paintings, like those of Cézanne, sacrifice realism in effective and satisfying design, but his use of color and the distortion of the natural relationships of the objects he paints are even greater than Cézanne's. In The Red Studio [16.25] every form is clearly recognizable but touched by the painter's unique vision. It is as if Matisse compels us to look through his eyes and see familiar objects suddenly take on new, vibrant life.

Matisse's sunny view of the world was very unusual, however. In northern Europe, particularly, increasing social and political tensions inspired a group of artists who are generally known as the expressionists to produce works that are at best gloomy and foreboding, sometimes chilling.

The forerunner of expressionist art was the Norwegian painter Edvard Munch (1863-1944), whose influence on German painting was comparable to that of Cézanne on French. The morbid insecurity that characterized Munch's own temperament

16.26 Edvard Munch. The Scream. 1893. Oil on cardboard, $35\frac{1}{2} \times 28\frac{3}{4}$ " (91 × 74 cm). Nasjonalgalleriet, Oslo. Munch himself once said, "I hear the scream in nature," and in this painting the anguish of the human figure seems to be echoed by the entire world around.

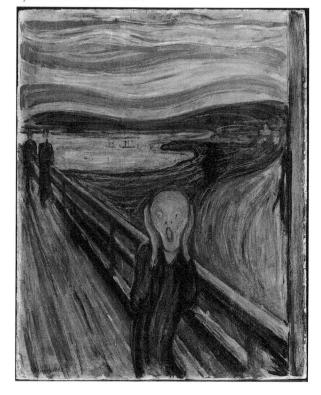

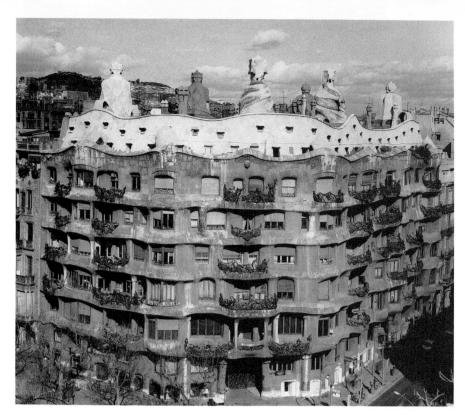

16.27 Antonio Gaudí, Casa Milá, Barcelona. 1907. Note the rough surface of the stone and the absence of any straight lines.

emerges with horrifying force in his best-known work, The Scream [16.26], from which the lonely figure's cry seems to reverberate visibly through space. This painting is more than autobiographical, however, since it reflects a tendency on the part of Norwegian and other Scandinavian artists and writers to explore social and psychological problems. Elsewhere in Europe the Spanish architect Antonio Gaudí (1852–1926) applied the same artistic principles to his buildings, with often startling results. His Casa Milá [16.27], an apartment house in Barcelona, like The Scream, makes use of restless, waving lines that seem to undulate as we look. The sense of disturbance is continued by the spiraling chimneys—although Gaudi's intention was neither to upset nor necessarily to protest.

By 1905 expressionist artists in Germany were using the bold, undisguised brushstrokes and vivid colors of fauvism to paint subjects with more than a touch of Munch's torment. The German expressionists, many of them grouped in "schools" with such names as Die Brücke (The Bridge) and Der Blaue Reiter (The Blue Rider), were relatively untouched by the intellectual and technical explorations of their contemporaries elsewhere. Instead, they were concerned with the emotional impact that a work could produce on the viewer. They were fascinated by the power of color to express mood, ideas, and emotion. They wanted their art to affect not only the eye but the viewer's inner sense. When they succeeded, as they often did, their works arouse strong emotions.

One of their principal themes was alienation and loneliness, so it is not surprising that they often turned to the writings of Dostoyevsky (see page 344) for inspiration. Two Men at a Table [16.28], by Erich Heckel (1883-1970), is in fact subtitled To Dostoyevsky.

16.28 Erich Heckel. Two Men at a Table (To Dostovevsky). 1912. Kunsthalle, Hamburg. The two figures seem separated from one another by doubt and distrust, each wrapped up in his own isolation. Behind them is a distorted image of the crucified Christ.

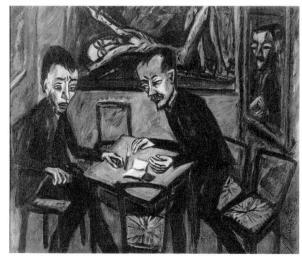

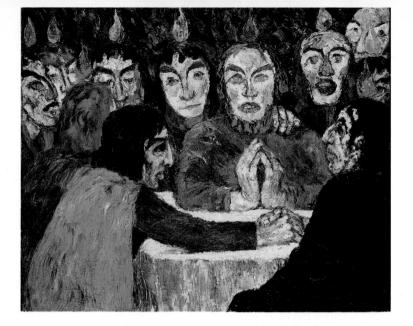

16.29 Emil Nolde. Pentecost. 1909. Oil on canvas, $2'8'' \times 3'6''$ (87 × 107 cm). Staatliche Museen Preussischer Kulturbesitz, Nationalgalerie Berlin (West). The broad, simplified faces and the powerful gestures of Christ in the center and of the two apostles clasping hands impart to the scene a concentration of emotional intensity.

Emil Nolde (1867–1956), who identified himself with Die Brücke after 1906, was one of the few expressionists to paint biblical scenes. To these he brought his own ecstatic, barbaric intensity. Pentecost [16.29] shows the apostles seated around the table literally burning with inspiration; the tongues of flame of the biblical account are visible above their heads. Their faces have a masklike simplicity, but the huge eyes and heavy eyebrows convey frighteningly intense emotion. The image is far more disturbing than inspiring. Even in a religious context, expressionist art touches chords of alarm, even hysteria, unhappily appropriate to the times.

New Styles in Music

The impressionists had forced both artists and public to think afresh about painting and about seeing; by the early years of the 20th century musicians and music lovers, too, were to have many of their preconceptions challenged. Not only were traditional forms like the symphony either discarded or handled in a radically new way, but even the basic ingredients of musical expression, melody, harmony, and rhythm, were subject to startling new developments. Few periods in the history of music are more packed with change, in fact, than those between 1870 and 1914, which saw a fresh approach to symphonic form, the rise of a musical version of impressionism, and the revolutionary innovations of the two giants of modern music, Schoenberg and Stravinsky.

Orchestral Music at the Turn of the Century

Although many extended orchestral works written in the last years of the 19th and the early 20th centuries were called symphonies by their composers, they would hardly have been recognizable as such to Haydn or Beethoven. The custom of varying the traditional number and content of symphonic movements had already begun during the romantic period; Berlioz had written his Fantastic Symphony as early as 1829 (see page 262). Nonetheless, by the turn of the century, so-called symphonies were being written that had little in common with one another, much less the classical symphonic tradition.

The driving force behind many of these works was the urge to communicate something beyond purely musical values. From the time of the ancient Greeks, many composers have tried to write instrumental music that tells a story or describes some event, including Vivaldi and his Four Seasons and Beethoven in his curious work known as the Battle Symphony. By the mid-19th century, however, composers had begun to devise elaborate programs, or plots, which their music would then describe. Music of this kind is generally known as program music, the first great exponent of which was Liszt (see page 264), who wrote works with titles like Hamlet, Orpheus, and The Battle of the Huns, for which he invented the generic description "symphonic poem."

The principle behind program music is no better or worse than many another. The success of any individual piece naturally depends on the degree to which narrative and musical interest can be combined. There are, to be sure, some cases where a composer has been carried away by eagerness for realism. Ottorino Respighi (1879–1936), for example, incorporated the sound of a nightingale by including a record player and a recording of live birdsong in a score.

No one was more successful at writing convincing program symphonies and symphonic poems (tone poems, as he called them) than the German composer Richard Strauss (1864–1949). One of his first success-

ful tone poems, Don Juan, begun in 1886, deals with the familiar story of the compulsive Spanish lover from a characteristically late-19th-century point of view. Instead of the unrepentant Don Giovanni of Mozart or Byron's amused (and amusing) Don Juan, Strauss presents a man striving to overcome the bonds of human nature, only to be driven by failure and despair to suicide. The music, gorgeously orchestrated for a vast array of instruments, moves in bursts of passion, from the surging splendor of its opening to a bleak and shuddering conclusion.

Strauss was not limited to grand and tragic subjects. Till Eulenspiegel is one of the most successful examples of humor in music. It tells the story of a notorious practical joker and swindler. Even when Till goes too far in his pranks and ends up on the gallows (vividly depicted by Strauss' orchestration), the music returns to a cheerful conclusion.

One of Strauss' most remarkable works, and one that clearly demonstrates the new attitude toward symphonic form, is his Alpine Symphony, written between 1911 and 1915. In one huge movement lasting some fifty minutes it describes a mountainclimbing expedition, detailing the adventures on the way (with waterfalls, cowbells, glaciers all in the music) and, at its climax, the arrival on the summit. The final section depicts the descent, during which a violent storm breaks out, and the music finally sinks to rest in the peace with which it opened. All this may sound more like the sound track to a movie than a serious piece of music, but skeptical listeners should try the Alpine Symphony for themselves. It is as far from conventional notions of a symphony as Cézanne's painting of Mont Sainte-Victoire [see figure 16.20] is from a conventional landscape, but genius makes its own rules. Strauss' work should be taken on its own terms.

Not surprisingly, a composer capable of such exuberant imagination was also fully at home in the opera house. Several of Strauss' operas are among the greatest of all 20th-century contributions to the operatic repertoire. In some of them he was clearly influenced by the prevailingly gloomy and morbid mood of German expressionist art. His first big success, for example, was a setting of the English writer Oscar Wilde's play Salome, based on the biblical story, first performed to a horrified audience in 1905. After one performance in 1907 at the Metropolitan Opera House in New York, it was banned in the United States for almost thirty years. The final scene provides a frightening yet curiously moving depiction of erotic depravity, as Salome kisses the lips of the severed head of John the Baptist. This subject had been gruesomely represented by the German expressionist painter Lovis Corinth (1858-1925) in 1899 [16.30].

Works like Don Juan and the Alpine Symphony deal with stories we know or describe events with which

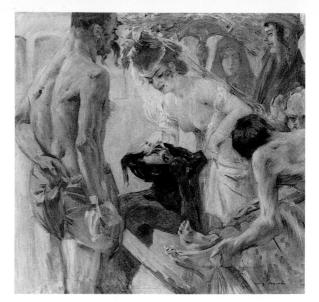

16.30 Lovis Corinth. Salome. 1899. Oil on canvas, 30 × 32" (76 × 83 cm). Busch-Reisinger Museum, Harvard University (gift of Hans H. A. Meyn). Note the strikingly modern look of Salome, here representing the degeneracy of the artist's own times.

we are familiar. In other cases, however, Strauss took as his subject his own life, and a number of his pieces, including the Domestic Symphony and the somewhat immodestly entitled Hero's Life, are frankly autobiographical. In this he was following a custom that had become increasingly popular in the late 19th century the composition of music concerned with the detailed revelation of its composer's inner emotional

One of the first musicians to make his personal emotions the basis for a symphony was the lateromantic composer Peter Ilych Tchaikovsky (1840– 1893), whose Symphony No. 6 in B minor, known as the "Pathétique," was written in the year of his death. An early draft outline of its "story" was found among his papers, describing its "impulsive passion, confidence, eagerness for activity," followed by love and disappointments, and finally collapse and death. It is now believed that the Russian composer's death from cholera was not, as used to be thought, accidental, but deliberate suicide. The reasons are still not clear, but they perhaps related to a potentially scandalous love affair in high places with which Tchaikovsky had become involved. In the light of this information the "Pathétique" Symphony takes on new poignance. Its last movement sinks mournfully into silence after a series of climaxes that seem to protest bitterly if vainly against the injustices of life.

The revelation of a composer's life and emotions through his music reached its most complete expression in the works of Gustav Mahler (1860–1911). Until around 1960, the centenary of his birth in Bohemia, Mahler's music was almost unknown and he was generally derided as unoriginal and overambitious. Now that he has become one of the most frequently performed and recorded of composers, we

CONTEMPORARY VOICES

Gustav Mahler

A letter from Mahler to his wife Alma reporting on a meeting with Richard Strauss. Mahler had heard Salome, and was impressed. The she in the second line is Pauline, Strauss' wife.

Berlin, January 1907

My dear, good Almschili:

Yesterday afternoon I went to see Strauss. She met me at the door with pst! pst! Richard is sleeping, pulled me into her (very slovenly) boudoir, where her old mama was sitting over some mess (not coffee) and filled me full of nonsensical chatter about various financial and sexual occurrences of the last two years, in the meantime asking hastily about a thousand and one things without waiting for a reply, would not let me go under any circumstances, told me that yesterday morning Richard had had a very exhausting rehearsal in Leipzig, then returned to Berlin and conducted Götterdämmerung in the evening, and this afternoon, worn to a frazzle, he had gone to sleep, and she was carefully guarding his sleep. I was dumbfounded.

Suddenly she burst out: "Now we have to wake up the rascal!" Without my being able to prevent it, she pulled me with both her fists into his room and yelled at him in a very loud voice: "Get up, Gustav is here!" (For an hour I was Gustav-then suddenly Herr Direktor again.) Strauss got up, smiled patiently, and then we went back to a very animated discussion of all that sheer bilge. Later we had tea and they brought me back to my hotel in their automobile, after arranging for me to take lunch with them at noon Saturday.

There I found two tickets for parquet seats in the first row for Salome and I took Berliner along. The performance was excellent in every respect orchestrally, vocally, and scenically it was pure Kitsch and Stoll, and again it made an extraordinary impression on me. It is an extremely clever, very powerful piece, which certainly belongs among the most significant of our time! Beneath a heap of rubbish an infernal fire lives and burns in it—not just fireworks.

That's the way it is with Strauss's whole personality and it's difficult to separate the wheat from the chaff. But I had felt tremendous respect for the whole manifestation and this was confirmed again. I was tremendously pleased. I go the whole hog on that. Yesterday Blech conducted—excellently. Saturday Strauss is conducting and I am going again. Destinn was magnificent; the Jochanaan (Berger) very fine. The others, so-so. The orchestra, really superb.

From G. Norman and M. L. Shrifte, Letters of Composers (New York: Grosset & Dunlap, 1946), p. 301.

can begin to appreciate his true worth and learn the danger of hasty judgments.

The world of Mahler's symphonies is filled with his own anxieties, triumphs, hopes, and fears, but it also illuminates our own problem-ridden age. It may well be that Mahler speaks so convincingly and so movingly to a growing number of ordinary music lovers because his music touches on areas of human experience unexplored before his time and increasingly significant to ours. In purely musical terms, however, Mahler can now be seen as a profoundly original genius. Like Rodin, who produced a marvelous portrait of him [16.31], he stands as both the last major figure of the 19th century in his field and a pioneer in the modern world. Indeed, it was precisely his innovations that won him the scorn of earlier listeners: his deliberate use of popular, banal tunes, for example, and the abrupt changes of mood in his music. A symphony, he once said, should be like the world; it should contain everything. His own nine symphonies and The Song of the Earth, a symphony for two singers and orchestra, certainly contain just about every human emotion.

As early as the Symphony No. 1 in D, we can hear the highly individual characteristics of Mahler's music. The third movement of the symphony is a funeral march, but its wry, ironic tone is totally un-

like any other in the history of music. The movement opens with the mournful sound of a solo double bass playing the old round "Frère Jacques," which is then taken up by the rest of the orchestra. There are sudden bursts of trite nostalgia and violent aggression until the mood gradually changes to one of genuine tenderness. After a gentle middle section the movement returns to the bizarre and unsettling spirit of the opening.

By the end of his life Mahler was writing much less optimistic music than Symphony No. 1, which its third-movement funeral march concludes with a long finale ending in a blaze of triumphant glory. Mahler's last completed works, The Song of the Earth and the Symphony No. 9, composed under the shadow of fatal heart disease and impending death, express all the beauty of the world together with the sorrow and ultimate resignation of one who has to leave it. The final movement of the Symphony No. 9, in particular, is a uniquely eloquent statement of courage in the face of human dissolution. Opening with a long, slow theme of great passion and nobility, the movement gradually fades away as the music dissolves into fragments and finally sinks into silence. Like all Mahler's music, and like the paintings of Van Gogh or Munch, the Symphony No. 9 does not turn its back on the ugliness and

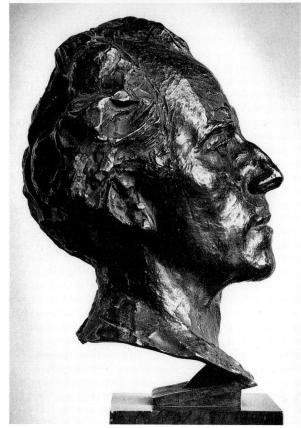

16.31 Auguste Rodin. Gustav Mahler. 1909. Bronze, height 13" (34 cm). Musée Rodin, Paris. As in his Monument to Balzac (figure 16.15, page 330), Rodin deliberately roughened the surface of the bronze for dramatic effect. In this case Mahler's hollow cheeks and intense gaze are powerfully suggested.

tragedy of life; but Mahler, unlike many of his contemporaries, was able to see beyond them and express something of the painful joy of human existence. Perhaps that is why his music has become so revered in our own times.

Impressionism in Music

At about the same time painters in France were developing the style we call impressionist, Claude Debussy (1862–1918), a young French composer, began to break new musical ground. Abandoning the concept of the development to themes in a systematic musical argument, which lies behind classical sonata form and romantic symphonic structure, he aimed for a constantly changing flow of sound. Instead of dealing with human emotions, his music evoked the atmosphere of nature, the wind and rain and the sea. The emphasis on shifting tone colors led inevitably to comparisons with impressionist painting. Like Monet or Renoir, he avoided grand, dramatic subjects in favor of ephemeral, intangible sensations and replaced romantic opülence with refinement.

These comparisons should nevertheless not be exaggerated. Debussy and the impressionists shared a strong reaction against tradition in general and the romantic tradition in particular, in response to which they created a radically new approach to their respective arts, but impressionism permanently changed the history of painting, while the only really successful impressionist composer was Debussy himself. Later musicians have borrowed some of Debussy's musical devices, including his very fluid harmony and frequent dissonances, but Debussy never really founded a school. The chief developments in 20thcentury music after Debussy took a very different direction, summed up rather unsympathetically by the French writer Jean Cocteau (1891-1963): "After music with the silk brush, music with the axe." These developments represent a more determined break with tradition than the refined style of Debussy. Indeed, with the passing of time Debussy's musical style appears increasingly to represent the last gasp of romanticism rather than the dawn of a new era.

Whatever his historical position, Debussy was without doubt one of the great creative musical figures in the last hundred years. He is at his best and most impressionist in orchestral works like La Mer (The Sea), which Debussy himself called symphonic sketches—a rather curious term that shows the composer for once willing to accept a traditional label. This marine counterpart of Strauss' Alpine Symphony is in three movements, the titles of which ("From Dawn to Noon on the Sea," "Play of the Waves," and "Dialogue of the Wind and the Sea") describe the general atmosphere that concerned Debussy rather than literal sounds. There are no birdcalls or thunderclaps in the music; instead the continual ebb and flow of the music suggest the mood of a seascape. The second movement, for example, depicts the sparkling sunlight on the waves by means of delicate, flashing violin scales punctuated by bright flecks of sound color from the wind instruments. It is scarcely possible to resist a comparison with the shimmering colors of Monet's Water Lilies [see figure 16.8, page 326].

Elsewhere Debussy's music is less explicitly descriptive. His piano music, among his finest, shows an incredible sensitivity for the range of sound effects that instruments can achieve. Many of his pieces have descriptive titles—"Footsteps in the Snow," "The Girl with the Flaxen Hair," and so on—but often these were added after their composition as the obligatory touch of musical impressionism. Sometimes they were even suggested by Debussy's friends as their own personal reactions to his music.

The only composer to make wholehearted use of Debussy's impressionistic style was his fellow countryman Maurice Ravel (1875-1937), who, however, added a highly individual quality of his own. Ravel was far more concerned with classical form and balance than Debussy. His musical god was Mozart, and

something of the limpid clarity of Mozart's music can be heard in many of his pieces—although certainly not in the all-too-familiar Bolero. His lovely Piano Concerto in G alternates a Mozartian delicacy and grace with an exuberance born of Ravel's encounters with jazz. Even in his most overtly impressionistic moments, like the scene in his ballet Daphnis and Chloe that describes dawn rising, he retains an elegance and verve distinctly different from the veiled and muted tones of Debussy.

The Search for a New Musical Language

In 1908 the Austrian composer Arnold Schoenberg (1874–1951) wrote his Three Piano Pieces, Op. 11, in which he was "conscious of having broken all restrictions" of past musical traditions. After their first performance one critic described them as "pointless ugliness" and "perversion." In 1913 the first performance of The Rite of Spring, a ballet by the Russian-born composer Igor Stravinsky (1882-1971), was given in Paris, where he was then living. It was greeted with hissing, stamping, and yelling, and Stravinsky was accused of the "destruction of music as an art." Stravinsky and Schoenberg are now justly hailed as the founders of modern music, but we can agree with their opponents in at least one respect: their revolutionary innovations permanently changed the course of musical development.

It is a measure of their achievement that today listeners find The Rite of Spring exciting, even explosive, but perfectly approachable. If Stravinsky's ballet score has lost its power to shock and horrify, it is principally because we have become accustomed to music written in its shadow. The Rite of Spring has created its own musical tradition, one without which the music of the 20th century at all levels of popularity would be unthinkable. Schoenberg's effect has been less widespread and more subtle; nonetheless, no serious composer writing since his time has been able to ignore his music. It is significant that Stravinsky himself, who originally seemed to be taking music down a radically different "path to destruction," eventually adopted principles of composition based on Schoenberg's methods.

As is true of all apparently revolutionary breaks with the past, Stravinsky and Schoenberg were really only pushing to extreme conclusions developments that had been underway for some time. Traditional harmony had been collapsing since the time of Wagner, and Schoenberg only dealt it a death blow by his innovations. Wagner's Tristan and Isolde had opened with a series of chords that were not firmly rooted in any key and had no particular sense of direction (see page 267), a device Wagner used to express the poetic concept of restless yearning. Other composers followed him in rejecting the concept of a fixed harmonic center from which the music might stray as long as it returned there, replacing it with a much more fluid use of harmony. (Debussy, in his attempts to go beyond the bounds of conventional harmony, often combined chords and constructed themes in such a way as to avoid the sense of a tonal center; the result can be heard in the wandering, unsettled quality of much of his music.)

Schoenberg believed that the time had come to abandon a harmonic (or tonal) system that had served music well for over three hundred years but had simply become worn out. He therefore began to write atonal music—music that deliberately avoided traditional chords and harmonies. Thus Schoenberg's atonality was a natural consequence of earlier musical developments. At the same time, it was fully in accordance with the spirit of the times. The sense of a growing rejection of traditional values, culminating in a decisive and violent break with the past, can be felt not only in the arts but also in the political and social life of Europe; Schoenberg's drastic abandonment of centuries of musical tradition prefigured by only a few years the far more drastic abandonment of centuries of tradition brought by World War I.

There is another sense of which Schoenberg's innovations correspond to contemporary developments. One of the principal effects of atonality is a mood of instability, even disturbance, which lends itself to the same kind of morbid themes that attracted expressionist painters—in fact, many of Schoenberg's early atonal works deal with such themes. Schoenberg himself was a painter of some ability and generally worked in an expressionist style.

One of Schoenberg's most extraordinary pieces is Pierrot Lunaire, finished in 1912, a setting of twentyone poems for women's voice and small instrumental group. The poems describe the bizarre experiences of their hero, Pierrot, who is an expressionist version of the eternal clown, and their mood is grotesque and at times demonic. The eighth poem, for example, describes a crowd of gigantic black moths flying down to block out the sunlight, while in the eleventh, entitled "Red Mass," Pierrot holds his own heart in his blood-stained fingers to use as a "horrible red sacrificial wafer." Schoenberg's music clothes these verses in appropriately fantastic and macabre music. The effect is enhanced by the fact that the singer is instructed to *speak* the words at specific pitches. This device of *Sprechstimme* (speech melody), invented by Schoenberg for *Pierrot Lunaire*, is difficult to execute, but when it is done properly by a skilled performer, it imparts a wistfully dreamlike quality to the music.

The freedom atonality permitted the composer became something of a liability, and by the 1920s Schoenberg replaced it with a system of composition as rigid as any earlier method in the history of music. His famous twelve-tone technique makes use of the twelve notes of the chromatic scale (on the piano, all the black and white notes in an octave), which are arranged arbitrarily in a row or series, the latter term having given rise to the name serialism to describe the technique. The basic row, together with variant forms, then serves as the basis for a movement or even an entire work, with the order of the notes remaining always the same. The following example presents the row used in the first movement of Schoenberg's Piano Suite, Op. 25, together with three of its variant forms. No. 1 is the row itself, No. 2 its inversion (that is, the notes are separated by the same distance but in the opposite direction, down instead of up, and up instead of down), No. 3 is the row retrograde or backward, and No. 4 the inversion of this backward form, known as retrograde inversion.

Just as with program music, the only fair way to judge the twelve-tone technique is by its results. Not all works written in it are masterpieces, but we can hardly expect them to be. It is not a system that appeals to all composers or brings out the best in them, but few systems ever have universal application. A number of Schoenberg's own twelve-tone works, including his unfinished opera Moses and Aaron and the Violin Concerto of 1934, demonstrate that serial music can be both beautiful and moving. The 21st century will decide whether the system has permanent and enduring value.

Like Pierrot Lunaire, Stravinsky's The Rite of Spring deals with a violent theme. It is subtitled "Pictures from Pagan Russia" and describes a springtime ritual culminating in the sacrifice of a chosen human victim. Whereas Schoenberg had jettisoned traditional harmony, Stravinsky used a new approach to rhythm as the basis of his piece. Constantly changing, immensely complex, and frequently violent, his rhythmic patterns convey a sense of barbaric frenzy that is enhanced by the weight of sound obtained from the use of a vast orchestra. There are some more peaceful moments, notably the nostalgic opening section, but in general the impression is of intense exhilaration. Something of the rhythmic vitality of The Rite of Spring can be seen in this brief extract from the final orgiastic dance. The same melodic fragment is re-

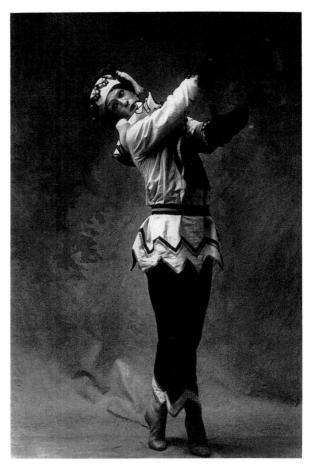

16.32 Vaslav Nijinsky as the Puppet Petrouchka in Igor Stravinsky's ballet of that name, as choreographed by Michel Fokine and performed by the Ballet Russe. Paris, 1911. New York Public Library at Lincoln Center (Roger Pryor Dodge Collection). Nijinsky (1890-1950), a Russian, was one of the greatest dancers of all time. Fokine (1880-1942), also a Russian, was a choreographer who broke new ground in the ballet just as the impressionists did in art and music.

peated over and over again, but in a constantly fluctuating rhythm that changes almost from bar to bar.

The Rite of Spring was the last of three ballets (the others were The Firebird and Petrouchka) that Stravinsky based on Russian folk subjects [16.32]. In the years following World War I he wrote music in a wide variety of styles, absorbing influences as varied as Bach, Tchaikovsky, and jazz. Yet a characteristically Stravinskian flavor pervades all his best works, with the result that his music is almost always instantly recognizable. Short, expressive melodies and unceasing rhythmic vitality, both evident in The Rite

of Spring, recur in works like the Symphony in Three Movements in 1945. Even when, in the 1950s, he finally adopted the technique of serialism he retained his own unique musical personality. Indeed, Stravinsky is a peculiarly 20th-century cultural phenomenon, an artist uprooted from his homeland, cut off (by choice) from his cultural heritage, and exposed to a barrage of influences and counterinfluences. That he never lost his sense of personal identity or his belief in the enduring value of art makes him a 20thcentury hero.

New Subjects for Literature

Psychological Insights in the Novel

At the end of the 19th century many writers were still as concerned with exploring the nature of their own individual existences as they had been when the century began. In fact, the first years of the 20th century saw an increasing interest in the effect of the subconscious on human behavior, a result in large measure of the work of the Austrian psychoanalyst Sigmund Freud (1856–1939); the general conclusions Freud reached are discussed in Chapter 17. In many ways his interest in the part played by individual frustrations, repressions, and neuroses (particularly sexual) in creating personality was prefigured in the writing of two of the greatest novelists of the late 19th century. Fyodor Dostoyevsky (1821-1881) and Marcel Proust (1871-1922).

Self-knowledge played a major part in Dostoyevsky's work, and his concern for psychological truth led him into a profound study of his characters subconscious motives. His sympathy with human suffering derived in part from his identification with Russian Orthodox Christianity, with its emphasis on suffering as a means to salvation. Although well aware of social injustices, he was more concerned with their effect on the individual soul than on society as a whole. His books present, to be sure, a vivid picture of the Russia of his day, with characters at all levels of society brought brilliantly to life. Nevertheless, he was able to combine realism of perception with a deep psychological understanding of the workings of the human heart. Few artists have presented so convincing a picture of individuals struggling between good and evil.

The temptation to evil forms a principal theme of one of his most powerful works, Crime and Punishment. In it he tells the story of a poor student, Raskolnikov, whose growing feeling of alienation from his fellow human beings leads to a belief that he is superior to society and above conventional morality. To prove this to himself Raskolnikov decides to commit an act of defiance: the murder of a defenseless old woman, not for gain but as a demonstration of his own power.

He murders the old woman and also her younger sister, who catches him in the act. Crime is followed immediately, however, not by the punishment of the law but by the punishment of his own conscience. Guilt and remorse cut him off even further from human contact until finally, in utter despair and on the verge of madness, he goes to the police and confesses to the murder. Here and in his other works Dostovevsky underlines the terrible dangers of intellectual arrogance. The world he portrays is essentially cruel, one in which simplicity and self-awareness are the only weapons against human evil and suffering is a necessary price for victory.

Self-awareness is also the prime concern of one of the most influential of all modern writers, the French novelist Marcel Proust, although with very different results. Proust's youth was spent in the fashionable world of Parisian high society, where he entertained lavishly and mixed with the leading figures of the day while writing elegant if superficial poems and stories. The death of his father in 1903 and of his mother in 1905 brought a complete change. He retired to his house in Paris and rarely left his soundproofed bedroom, where he wrote the vast work for which he is famous, Remembrance of Things Past. The first volume appeared in 1913; the eighth and last volume was not published until 1927, five years after his death.

It is difficult to do justice to this amazing work. The lengthy story is told in the first person by a narrator who, though never named, obviously has much in common with Proust himself. Its entire concern is to recall the narrator's past life, from earliest childhood to middle age, by bringing to mind the people, places, things, and events that have affected him. In the course of the narrator's journey back into his past he realizes that all of it lies hidden inside him and that the tiniest circumstance—a scent, a taste, the appearance of someone's hair—can trigger a whole chain of memory associations. By the end of the final volume the narrator has decided to preserve the recollection of his past life by making it permanent in the form of a book—the book the reader has just finished.

Proust's awareness of the importance of the subconscious and his illustration of the way in which it can be unlocked have had a great appeal to modern writers, as has his stream-of-consciousness style, which appears to reproduce his thought processes as they actually occur rather than as edited by a writer for logical connections and development. Further, as we follow Proust's (or the narrator's) careful and painstaking resurrection of his past, it is important to remember that his purpose is far more than a mere intellectual exercise. By recalling the past we bring it back to life in a literal sense. Memory is our most powerful weapon against death.

Responses to a Changing Society: The Role of Women

Not all writers in the late 19th and early 20th centuries devoted themselves to the kind of psychological investigation found in the works of Dostovevsky and Proust. The larger question of the nature of society continued to attract the attention of more socially conscious writers who explored the widening range of problems created by industrial life as well as a whole new series of social issues (Table 16.2).

One of the most significant aspects of the development of the modern world has been the changing role of women in family life and in society at large. The issue of women's right to vote was bitterly fought out in the early years of the 20th century, and not until 1918 in Great Britain and 1920 in the United States were women permitted to participate in the electoral process. On a more personal basis, the growing availability and frequency of divorce began to cause many women (and men) to rethink the nature of the marriage tie. The pace of women's emancipation from the stock role assigned to them over centuries was, of course, extremely slow, and the process is far from complete. A beginning had to be made somewhere, however, and it is only fitting that a period characterized by cultural and political change should also be marked by social change in this most fundamental of areas.

In the same way Dickens had led the drive against industrial oppression and exploitation in the mid-19th century, writers of the late 19th and early 20th centuries not only reflected feminist concerns but actively promoted them as well. They tackled a range of problems so vast that we can do no more than look at just one area, marriage, through the eyes of two writers of the late 19th century. One of them, Henrik Ibsen (1828–1906), was the most famous playwright of his day and a figure of international renown. The other, Kate Chopin (1851-1904), was ignored in her own lifetime even in her native America.

Ibsen was born in Norway, although he spent much of his time abroad. Most of his mature plays deal with the conventions of society and their consequences, generally tragic. Although many of them are technically set in Norway their significance was intended to be a general one. The problems Ibsen explored were frequently ones regarded as taboo, including venereal disease, incest, and insanity. The realistic format of the plays brought issues like these home to his audience with shocking force. At first derided. Ibsen eventually became a key figure in the development of drama, particularly in the Englishspeaking world, where his work was championed by George Bernard Shaw (1856-1950), himself later to inherit Ibsen's mantle as a progressive social critic.

In one of his first important plays, A Doll's House

TABLE 16.2 Social and Intellectual Developments 1870-1914

1875	German Social Democratic Party founded
1879	Edison invents electric lightbulb
1881	Pasteur and Koch prove German theory of disease
1883	Social insurance initiated by Bismarck in Germany
1888	Brazil abolishes slavery, the last nation to do so
1889	International league of Socialist parties founded, the so-called Second International
1894–1906	Dreyfus affair in France reveals widespread anti-Semitism and leads to separation of church and state
1895	Roentgen discovers x-rays Marconi invents wireless telegraphy
1900	Freud publishes Interpretation of Dreams
1903	Wright brothers make first flight with power-driven plane
1905	Einstein formulates theory of relativity
	Revolution in Russia fails to produce significant social change
1906–1911	Social insurance and parliamentary reform enacted in Britain
1909	Ford produces assembly-line-made automobiles
1911	Revolution in China establishes republic
	Rutherford formulates theory of positively charged atomic nucleus.

(1879), Ibsen dealt with the issue of women's rights. The principal characters, Torvald Helmer and his wife Nora, have been married for eight years, apparently happily enough. Early in their marriage, however, before Helmer had become a prosperous lawyer, Nora had secretly borrowed some money from Krogstad, a friend, to pay for her husband's medical treatment; she had told Torvald that the money came from her father, for Helmer himself was too proud to borrow. As the play opens Krogstad, to whom Nora is still in debt, threatens to blackmail her if she does not persuade Helmer to find him a job. When she refuses to do so Krogstad duly writes a letter to Helmer revealing the truth. Helmer recoils in horror at his wife's deception. The matter of the money is eventually settled by other means and Helmer eventually forgives Nora, but not before the experience has given her a new and unforgettable insight into her relationship with her husband. In the final scene, she walks out the door, slams it, and leaves him for-

Nora decides to abandon her husband on two

grounds. In the first place she realizes how small a part she plays in her husband's real life. As she says, "Ever since the first day we met, we have never exchanged so much as one serious word about serious things." The superficiality of their relationship horrifies her. In the second place, Helmer's inability to rise to the challenge presented by the discovery of his wife's deception and prove his love for her by claiming that it was he who had borrowed and failed to repay the debt diminishes him in Nora's eyes. Ibsen tries to express what he sees as an essential difference between men and women when, in reply to Helmer's statement "One doesn't sacrifice one's honor for love's sake," Nora replies, "Millions of women have done so." Nora's decision not to be her husband's childish plaything-to leave the doll's house in which she was the doll—was so contrary to accepted social behavior that one noted critic remarked: "That slammed door reverberated across the roof of the world."

In comparison with the towering figure of Ibsen. the American writer Kate Chopin found few readers in her own lifetime; even today she is not widely known. Only recently have critics begun to do justice to the fine construction and rich psychological insight of her novel The Awakening, denounced as immoral and banned when first published in 1899. Its principal theme is the oppressive role women are forced to play in family life. Edna, its heroine, like Nora in A Doll's House, resents the meaninglessness of her relationship with her husband and the tedium of her daily existence. Her only escape is to yield to her sexual drives and find freedom not in slamming the door behind her but by throwing herself into a passionate if unloving affair.

In her short stories Kate Chopin dealt with the same kind of problem, but with greater delicacy and often with a wry humor. Frequently on the smallest of scales, these stories examine the prison that marriage seems so often to represent. In the course of a couple of pages Chopin exposes an all-too-common area of human experience and, like Ibsen, touches a chord that rings as true now as it did at the turn of the century.

Summary

The last years of the 19th century saw the threat of war gathering with increasing speed over Europe. The gap between the prosperous and the poor, the growth of the forces of big business, overcrowding and food shortages in the cities all tended to create a climate of unease that the rivalries of the major European powers exacerbated. Many emigrated to America in search of a new start. For the philosopher Friedrich Nietsche, only drastic remedies could prevent the collapse of Western civilization.

In each of the arts the years leading up to World War I were marked by far-reaching changes. In the case of painting, the impressionist school developed at Paris. Foreshadowed in the work of Edouard Manet, impressionist art represented a new way of looking at the world. Painters like Claude Monet, Auguste Renoir, and Berthe Morisot reproduced what they saw rather than visually interpreting their subjects. The depiction of light and atmosphere became increasingly important. The figure studies of Edgar Degas and Mary Cassatt avoided the careful poses of earlier times in favor of natural, intimate scenes.

The various schools that developed out of impressionism are collectively known as post-impressionist although they have little in common with one another. Among the leading artists were Paul Gauguin, with his love of exotic subjects, and Vincent Van Gogh, whose deeply moving images have made him perhaps the best-known of all 19thcentury painters. In historical terms, the most important figure was probably Paul Cézanne: his works are the first since the dawn of the Renaissance to eliminate perspective and impose order on nature rather than trying to repro-

In the early years of the 20th century two movements began to emerge: fauvism and expressionism, the former in France and the latter in Germany and Scandinavia. Both emphasised bright colors and violent emotions, and the works of Edvard Munch and other expressionists are generally tormented in spirit. Henri Matisse, however, the leading fauve artist, produced works that are joyous and optimistic; he was to become a major force in 20th-century painting.

Composers of orchestral music in the late 19th and early 20th centuries turned increasingly to the rich language of post-Wagnerian harmony and instrumentation to express either extramusical "programs" or to compose autobiographical works. The leading figures of the period included Richard Strauss and Gustav Mahler. Many of Strauss' operas have held the stage since their first performances, while his tone poems use a vast orchestra either to tell a story (as in Don Juan) or to describe his own life (Domestic Symphony). Mahler's symphonies, neglected in the composer's lifetime, have come to represent one of the highest achievements of the symphonic tradition. Openly autobiographical, at the same time they reflect the universal human problems of loss and anxiety.

In France the music of Claude Debussy, and to a lesser extent Maurice Ravel, set out to achieve the musical equivalent of Impressionism. In works like Le Mer Debussy used new harmonic combinations to render the atmosphere of a

The experiments of composers like Mahler and Debussy at least retained many of the traditional musical forms and modes of expression, although they vastly extended them. In the early years of the 20th century Arnold Schoenberg and Igor Stravinsky wrote works that represented a significant break with the past. Schoenberg's atonal and, later, serial music sought to replace the traditional harmonic structure of Western musical style with a new freedom, albeit one limited by the serial system. In The Rite of Spring and other works Stravinsky revealed a new approach to rhythm. Both composers profoundly influenced the development of 20th-century music.

Like the other arts, literature also underwent revolutionary change in the last decades of the 19th century. In the hands of Fyodor Dostoyevsky and Marcel Proust the novel became a vehicle to reveal the effects of the subconscious on human behavior. In Dostoyevsky's books selfknowledge and psychological truth are combined to explore the nature of human suffering. Proust's massive exploration of the past not only seeks to uncover his own memories; it deals with the very nature of time itself. Both writers, along with many of their contemporaries, joined painters and musicians in pushing their art to its limits in order to extend its range of expression.

A more traditional aim of literature was to effect social change. At a time when society was becoming aware of the changing role of women in the modern world, writers aimed to explore the implications for marriage and the family of the gradual emancipation of women and the increasing availability of divorce. The plays of Henrik Ibsen not only described the issues of his day, including feminist ones; they were also intended to open up discussion of topics-veneral disease, incest-that his middle-class audience would have preferred to ignore.

By the outbreak of war in 1914 the arts had been wrenched from their traditional lines of development to express the anxieties of the age. Nothing—in art, culture, politics, or society—was ever to return to its former state.

Pronounciation Guide

Belle Epoque: Bell Ep-OCK

Cézanne: Say-ZAN Degas: Duh-GA

Dostoyevsky: Doh-stoy-EV-ski

Gauguin: Go-GAN

Ibsen: IB-sun Manet: Ma-NAY Monet: Mo-NAY Morisot: Mo-ri-SEW Munch: MOONK Nietsche: NEE-che Proust: PROOST Renoir: Ren-WAAR Rodin: Roe-DAN

Schoenberg: SHURN-burg

Till Eulenspiegel: til OY-lin-shpee-gull

Van Gogh: van CHOCH

Exercises

1. Assess the impact of political and philosophical developments on the arts in the late 19th century.

2. Describe the goals and achievements of the impressionist movement in painting. How do you account for the enormous popularity of impressionist art ever since?

3. How did Arnold Schoenberg's music break with the past? How does his serial system function, and what is its purpose?

- 4. In what ways is the changing role of women reflected in art and literature at the turn of the century?
- 5. Compare the fiction of Dostovevsky and Proust. How does it differ from earlier 19th-century novels discussed in Chapter 15?

Further Reading

- Clark, T. J. The Painting of Modern Life: Paris in the Art of Manet and His Followers. New York: Knopf, 1984. A Marxist analysis of impressionist art and the society in which it was created, with much valuable information about the development of urban life. Controversial but stimulating.
- Goldwater, R. Symbolism. New York: Harper, 1979. A thoughtful and absorbing account of the ideas and principles behind much of early-20th-century art. Among the artists discussed are Van Gogh, Gauguin, and
- Grossman, L. Dostoyevsky: His Life and Work. Indianapolis: Bobbs-Merrill, 1975. As the title suggests, this book combines biography with a critical discussion of Dostoyevsky's works. Authoritative and perceptive, it incorporates important information its author gained from conversations with Dostoyevsky's widow.
- Hamilton, G. H. Manet and His Critics. New Haven: Yale University Press, 1986. The latest edition of an important study of the origins of Impressionism.
- Holloway, R. Debussy and Wagner. London: Eulenburg, 1979. A groundbreaking analysis of connections between two of the most influential figures in the development of modern music.
- Kroegger, M. E. Literary Impressionism. New Haven: College and University Press, 1973. A useful guide to the main literary movements of the impressionist period.
- Lipton, E. Looking into Degas: Uneasy Images of Women and Modern Life. Berkeley: University of California Press, 1986. A feminist analysis of Degas' art, cogently argued and profusely illustrated.
- Meyer, M. Ibsen. Garden City, N.Y.: Doubleday, 1971. This massive book provides a highly readable account of the great dramatist's life and work and at the same time conveys much of the intellectual atmosphere of the
- Mitchell, D. Gustav Mahler: The Wunderhorn Years. Berkeley: University of California Press, 1975. A rich and detailed study of Mahler's crucial middle years, which reveals much about his techniques of composition.
- Newlin, D. Bruckner, Mahler, Schoenberg. New York: Norton, 1978. An updated edition of a classic account of the formation of Schoenberg's musical style, with valuable insights into the music of the other composers discussed.
- Rewald, J. Cézanne: A Biography. New York: Abrams, 1986. A lavish new biography of one of the founding fathers of modern art. Excellent illustrations, a high proportion of them in color.

Fyodor Dostovevsky from CRIME AND PUNISHMENT

Toward the beginning of Crime and Punishment, after Raskolnikov has decided to demonstrate his power by killing an old woman, he falls deeply asleep by the side of the road during a long, exhausting walk. He has a dream whose relationship to his waking life is so obvious that he immediately realizes it when he wakes up. Dostoyevsky's description of Raskolnikov's dream, reprinted here, probes the nature of the significance of dreams with shattering force. Especially effective is the way in which the confusion and lack of focus of the earlier episodes in the dream give way to a growing concentration on its chief scene, the killing of the horse. The precision with which details and colors are described and the vivid portrayal of the characters involved add to the nightmare reality.

Raskolnikov had a fearful dream. He dreamt he was back in his childhood in the little town of his birth. He was a child about seven years old, walking into the country with his father on the evening of a holiday. It was a grey and heavy day, the country was exactly as he remembered it, indeed he recalled it far more vividly in his dream than he had done in memory. The little town stood on a level flat as bare as the hand, not even a willow near it; only in the far distance, a copse lay, a dark blur on the very edge of the horizon. A few paces beyond the last market garden stood a tavern, a big tavern, which had always aroused in him a feeling of aversion, even of fear, when he walked by it with his father. There was always a crowd there, always shouting, laughter and abuse, hideous hoarse singing and often fighting. Drunken and horrible-looking figures were hanging about the tavern. He used to cling close to his father. trembling all over when he met them. Near the tavern the road became a dusty track, the dust of which was always black. It was a winding road, and about a hundred paces further on, it turned to the right to the graveyard. In the middle of the graveyard stood a stone church with a green cupola where he used to go to mass two or three times a year with his father and mother, when a service was held in memory of his grandmother, who had long been dead, and whom he had never seen. On these occasions they used to take on a white dish tied up in a table napkin a special sort of rice pudding with raisins stuck in it in the shape of a cross. He loved that church, the old-fashioned, unadorned ikons and the old priest with the shaking head. Near his grandmother's grave, which was marked by a stone, was the little grave of his younger brother who had died at six months old. He did not remember him at all, but he had been told

about his little brother, and whenever he visited the graveyard he used religiously and reverently to cross himself and to bown down and kiss the little grave. And now he dreamt that he was walking with his father past the tavern on the way to the graveyard; he was holding his father's hand and looking with dread at the tavern. A peculiar circumstance attracted his attention: there seemed to be some kind of festivity going on, there were crowds of gaily dressed townspeople, peasant women, their husbands, and riff-raff of all sorts, all singing and all more or less drunk. Near the entrance of the tavern stood a cart, but a strange cart. It was one of those big carts usually drawn by heavy cart-horses and laden with casks of wine or other heavy goods. He always liked looking at those great cart-horses, with their long manes, thick legs, and slow even pace, drawing along a perfect mountain with no appearance of effort, as though it were easier going with a load than without it. But now, strange to say, in the shafts of such a cart he saw a thin little sorrel beast, one of those peasants' nags which he had often seen straining their utmost under a heavy load of wood or hay, especially when the wheels were stuck in the mud or in a rut. And the peasants would beat them so cruelly, sometimes even about the nose and eyes and he felt so sorry, so sorry for them that he almost cried, and his mother always used to take him away from the window. All of a sudden there was a great uproar of shouting, singing and the balalaika, and from the tavern a number of big and very drunken peasants came out, wearing red and blue shirts and coats thrown over their shoulders.

"Get in, get in!" shouted one of them, a young thick-necked peasant with a fleshy face red as a carrot. "I'll take you all, get in!"

But at once there was an outbreak of laughter and exclamations in the crowd.

"Take us all with a beast like that!"

"Why, Mikolka, are you crazy to put a nag like that in such a cart?"

"And this mare is twenty if she is a day, mates!"

"Get in, I'll take you all," Mikolka shouted again, leaping first into the cart, seizing the reins and standing straight up in front. "The bay has gone with Marvey," he shouted from the cart— "and this brute, mates, is just breaking my heart, I feel as if I could kill her. She's just eating her head off. Get in, I tell you! I'll make her gallop! She'll gallop!" and he picked up the whip, preparing himself with relish to flog the little mare.

"Get in! Come along!" The crowd laughed.

"D'you hear, she'll gallop!"

"Gallop indeed! She has not had a gallop in her for the last ten years!"

"She'll jog along!"

"Don't you mind her, mates, bring a whip each of you, get ready!"

"All right! Give it to her!"

They all clambered into Mikolka's cart, laughing and making jokes. Six men got in and there was still room for more. They hauled in a fat, rosy-cheeked woman. She was dressed in red cotton, in a pointed, beaded headdress and thick leather shoes; she was cracking nuts and laughing. The crowd round them was laughing too and indeed, how could they help laughing? That wretched nag was to drag all the cartload of them at a gallop! Two young fellows in the cart were just getting whips ready to help Mikolka. With the cry of "now," the mare tugged with all her might, but far from galloping, could scarcely move forward; she struggled with her legs, gasping and shrinking from the blows of the three whips which were showered upon her like hail. The laughter in the cart and in the crowd was redoubled, but Mikolka flew into a rage and furiously thrashed the mare, as though he supposed she really could gallop.

"Let me get in, too, mates," shouted a young man

in the crowd whose appetite was aroused.

"Get in, all get in," cried Mikolka, "she will draw you all. I'll beat her to death!" And he thrashed and thrashed at the mare, beside himself with fury.

"Father, father," he cried, "father, what are they doing? Father, they are beating the poor horse!"

"Come along, come along!" said father. "They are drunken and foolish, they are in fun; come away, don't look!" and he tried to draw him away, but he tore himself away from his hand, and, beside himself with horror, ran to the horse. The poor beast was in a bad way. She was gasping, standing still, then tugging again and almost falling.

"Beat her to death," cried Mikolka, "it's come to

that. I'll do for her!"

"What are you about, are you a Christian, you devil?" shouted an old man in the crowd.

"Did any one ever see the like? A wretched nag like that pulling such a cartload," said another.

"You'll kill her," shouted the third.

"Don't meddle! It's my property. I'll do what I choose. Get in, more of you! Get in, all of you! I will

have her go at a gallop! . . ."

All at once laughter broke into a roar and covered everything: the mare, roused by the shower of blows, began feebly kicking. Even the old man could not help smiling. To think of a wretched little beast like that trying to kick!

Two lads in the crowd snatched up whips and ran to the mare to beat her about the ribs. One ran each

side.

"Hit her in the face, in the eyes, in the eyes," cried Mikolka.

"Give us a song, mates," shouted some one in the

cart and every one in the cart joined in a riotous song, jingling a tambourine and whistling. The woman went on cracking nuts and laughing.

. . . He ran beside the mare, ran in front of her, saw her being whipped across the eyes, right in the eyes! He was crying, he felt choking, his tears were streaming. One of the men gave him a cut with the whip across the face, he did not feel it. Wringing his hands and screaming, he rushed up to the greyheaded old man with the grey beard, who was shaking his head in disapproval. One woman seized him by the hand and would have taken him away, but he tore himself from her and ran back to the mare. She was almost at the last gasp, but began kicking once

"I'll teach you to kick," Mikolka shouted ferociously. He threw down the whip, bent forward and picked up from the bottom of the cart a long, thick shaft, he took hold of one end with both hands and with an effort brandished it over the mare.

"He'll crush her," was shouted round him. "He'll

"It's my property," shouted Mikolka and brought the shaft down with a swinging blow. There was a sound of a heavy thud.

"Thrash her, thrash her! Why have you stopped?"

shouted voices in the crowd.

And Mikolka swung the shaft a second time and it fell a second time on the spine of the luckless mare. She sank back on her haunches, but lurched forward and tugged forward with all her force, tugged first on one side and then on the other, trying to move the cart. But the six whips were attacking her in all directions, and the shaft was raised again and fell upon her a third time, then a fourth, with heavy measured blows. Mikolka was in a fury that he could not kill her at one blow.

"She's a tough one," was shouted in the crowd. "She'll fall in a minute, mates, there will soon be an end of her," said an admiring spectator in the

"Fetch an axe to her! Finish her off," shouted a third.

"I'll show you! Stand off," Mikolka screamed frantically; he threw down the shaft, stooped down in the cart and picked up an iron crowbar. "Look out," he shouted, and with all his might he dealt a stunning blow at the poor mare. The blow fell; the mare staggered, sank back, tried to pull, but the bar fell again with a swinging blow on her back and she fell on the ground like a log.

"Finish her off," shouted Mikolka and he leapt, beside himself, out of the cart. Several young men, also flushed with drink, seized anything they could come across—whips, sticks, poles, and ran to the dying mare. Mikolka stood on one side and began

dealing random blows with the crowbar. The mare stretched out her head, drew a long breath and died.

"You butchered her," some one shouted in the crowd.

"Why wouldn't she gallop then?"

"My property!" shouted Mikolka, with bloodshot eyes, brandishing the bar in his hands. He stood as though regretting that he had nothing more to beat.

"No mistake about it, you are not a Christian,"

many voices were shouting in the crowd.

But the poor boy, beside himself, made his way screaming through the crowd to the sorrel nag, put his arms round her bleeding dead head and kissed it. kissed the eyes and kissed the lips. . . . Then he jumped up and flew in a frenzy with his little fists out at Mikolka. At that instant his father who had been running after him, snatched him up and carried him out of the crowd.

"Come along, come! Let us go home," he said to

"Father! Why did they . . . kill . . . the poor horse!" he sobbed, but his voice broke and the words came in shrieks from his panting chest.

"They are drunk. . . . they are brutal . . . it's not our business!" said his father. He put his arms round his father but he felt choked, choked. He tried to draw a breath, to cry out—and woke up.

He waked up, gasping for breath, his hair soaked

with perspiration, and stood up in terror.

"Thank God, that was only a dream," he said, sitting down under a tree and drawing deep breaths. "But what is it? Is it some fever coming on? Such a hideous dream!"

He felt utterly broken; darkness and confusion were in his soul. He rested his elbows on his knees and leaned his head on his hands.

"Good God!" he cried, "can it be, can it be, that I shall really take an axe, that I shall strike her on the head, split her skull open . . . that I shall tread in the sticky warm blood, break the lock, steal and tremble; hide, all spattered in the blood . . . with the axe. . . Good God, can it be?"

He was shaking like a leaf as he said this.

"But why am I going on like this?" he continued, sitting up again, as it were in profound amazement. "I knew that I could never bring myself to it, so what have I been torturing myself for till now? Yesterday, yesterday, when I went to make that . . . experiment, yesterday I realised completely that I could never bear to do it. . . . Why am I going over it again, then? Why am I hesitating? As I came down the stairs yesterday, I said myself that it was base, loathsome, vile, vile . . . the very thought of it made me feel sick and filled me with horror.

"No, I couldn't do it, I couldn't do it! Granted,

granted that there is no flaw in all that reasoning, that all that I have concluded this last month is clear as day, true as arithmetic. . . . My God! Anyway I couldn't bring myself to it! I couldn't do it, I couldn't do it! Why, why then am I still . . . ?"

He rose to his feet, looked round in wonder as though surprised at finding himself in this place, and went towards the bridge. He was pale, his eyes glowed, he was exhausted in every limb, but he seemed suddenly to breathe more easily. He felt he had cast off that fearful burden that had so long been weighing upon him, and all at once there was a sense of relief and peace in his soul. "Lord," he prayed, "show me my path—I renounce that accursed . . . dream of mine.

Crossing the bridge, he gazed quietly and calmly at the Neva, at the glowing red sun setting in the glowing sky. In spite of his weakness he was not conscious of fatigue. It was as though an abscess that had been forming for a month past in his heart had suddenly broken. Freedom, freedom! He was free from that spell, that sorcery, that obsession!

Henrik Ibsen, A Doll's House, Act III, final scene

In this famous scene Ibsen, through the words of his character Nora, challenges many of the 19th century's most cherished illusions about marriage and the family. The insights Nora has gained into her husband's nature and the quality of their relationship mean nothing to Helmer when she tries to explain them to him. In the course of the dialogue the two struggle in mutual incomprehension as Nora describes her feelings of alienation and Helmer continues to respond with astonishment to the idea of his wife being concerned with "serious thoughts." By the end she leaves because she "can't spend the night in a strange man's house."

Ibsen has sometimes been accused of writing "problem plays" in which the ideas are more important than the characters. It is certainly true that Nora and Helmer are chiefly concerned with articulating their points of view. Yet amid the heated arguments both of them emerge as individuals. With great difficulty Helmer gradually begins to understand something of Nora's anguish. As for Nora, the whole of her past life is unforgettably described in the metaphor she uses to sum it up, which gives the play its name: a doll's

[The action takes place late at night, in the Helmers' living room. Nora, instead of going to bed, has suddenly reappeared in everyday clothes.]

HELMER . . . What's all this? I thought you were going to bed. You've changed your dress?

Yes, Torvald; I've changed my dress.

HELMER But what for? At this hour?

NORA I shan't sleep tonight.

HELMER But, Nora dear-

NORA [looking at her watch] It's not so very late—Sit down. Torvald; we have a lot to talk about. [She sits at one side of the table.]

HELMER Nora—what does this mean? Why that

stern expression?

NORA Sit down. It'll take some time. I have a lot to say to you.

[HELMER sits at the other side of the table.]

HELMER You frighten me, Nora. I don't understand you.

NORA No, that's just it. You don't understand me; and I have never understood you either—until tonight. No, don't interrupt me. Just listen to what I have to say. This is to be a final settlement, Torvald.

HELMER How do you mean?

NORA [after a short silence] Doesn't anything special strike you as we sit here like this?

HELMER I don't think so—why?

NORA It doesn't occur to you, does it, that though we've been married for eight years, this is the first time that we two-man and wife-have sat down for a serious talk?

HELMER What do you mean by serious?

NORA During eight whole years, no-more than that—ever since the first day we met—we have 30 never exchanged so much as one serious word about serious things.

HELMER Why should I perpetually burden you with all my cares and problems? How could you possi-

bly help me to solve them?

NORA I'm not talking about cares and problems. I'm simply saying we've never once sat down seriously and tried to get to the bottom of anything.

HELMER But, Nora, darling—why should you be

concerned with serious thoughts?

NORA That's the whole point! You've never understood me-A great injustice has been done me, Torvald; first by Father, and then by you.

HELMER What a thing to say! No two people on earth could ever have loved you more than we

NORA [shaking her head] You never loved me. You just thought it was fun to be in love with me.

HELMER This is fantastic!

NORA Perhaps. But it's true all the same. While I 50 was still at home I used to hear Father airing his opinions and they became my opinions; or if I didn't happen to agree, I kept it to myself—he would have been displeased otherwise. He used to call me his doll-baby, and played with me as I

played with my dolls. Then I came to live in your house-

HELMER What an expression to use about our mar-

riage!

NORA [undistrubed] I mean—from Father's hands I 60 passed into yours. You arranged everything according to your tastes, and I acquired the same tastes, or I pretended to-I'm not sure which-a little of both, perhaps. Looking back on it all, it seems to me I've lived here like a beggar, from hand to mouth. I've lived by performing tricks for you. Torvald. But that's the way you wanted it. You and Father have done me a great wrong. You've prevented me from becoming a real per-

HELMER Nora, how can you be so ungrateful and unreasonable! Haven't you been happy here?

NORA No, never. I thought I was; but I wasn't really.

HELMER Not—not happy!

NORA No, only merry. You've always been so kind to me. But our home has never been anything but a play-room. I've been your doll-wife, just as at home I was Papa's doll-child. And the children in turn, have been my dolls. I thought it fun when 80 you played games with me, just as they thought it fun when I played games with them. And that's been our marriage, Torvald.

HELMER There may be a grain of truth in what you say, even though it is distorted and exaggerated. From now on things will be different. Play-time is

over now: tomorrow lessons begin!

Whose lessons? Mine, or the children's? HELMER Both, if you wish it, Nora, dear.

Torvald, I'm afraid you're not the man to 90 teach me to be a real wife to you.

HELMER How can you say that?

NORA And I'm certainly not fit to teach the children.

HELMER Nora!

NORA Didn't you just say, a moment ago, you didn't dare trust them to me?

HELMER That was in the excitement of the moment!

You mustn't take it so seriously!

NORA But you were quite right, Torvald. That job 100 is beyond me; there's another job I must do first: I must try and educate myself. You could never help me to do that; I must do it quite alone. So, you see—that's why I'm going to leave you.

HELMER [jumping up] What did you say—?

NORA I shall never get to know myself—I shall never learn to face reality—unless I stand alone. So I can't stay with you any longer.

HELMER Nora! Nora!

NORA I am going at once. I'm sure Kristine will let 110

me stay with her tonight—

HELMER But, Nora—this is madness! I shan't allow

you to do this. I shall forbid it!

NORA You no longer have the power to forbid me anything. I'll only take a few things with methose that belong to me. I shall never again accept anything from you.

HELMER Have you lost your senses?

NORA Tomorrow I'll go home—to what was my home, I mean. It might be easier for me there, to 120 find something to do.

HELMER You talk like an ignorant child, Nora—! NORA Yes. That's just why I must educate myself. HELMER To leave your home—to leave your husband, and your children! What do you suppose people would say to that?

NORA It makes no difference. This is something I

must do.

HELMER It's inconceivable? Don't you realize you'd be betraying your most sacred duty?

What do you consider that to be?

HELMER Your duty towards your husband and your children—I surely don't have to tell you that!

NORA I've another duty just as sacred. HELMER Nonsense! What duty do you mean?

NORA My duty towards myself.

HELMER Remember—before all else you are a wife and mother.

NORA I don't believe that anymore. I believe that before all else I am a human being, just as you 140 HELMER [mastering himself with difficulty] You feel are—or at least that I should try and become one. I know that most people would agree with you, Torvald—and that's what they say in books. But I can no longer be satisfied with what most people say—or what they write in books. I must think things out for myself-get clear about them.

HELMER Surely your position in your home is clear enough? Have you no sense of religion? Isn't that

an infallible guide to you?

NORA But don't you see, Torvald—I don't really 150 know what religion is.

HELMER Nora! How can you!

NORA All I know about it is what Pastor Hansen told me when I was confirmed. He taught me what he thought religion was—said it was this and that. As soon as I get away by myself, I shall have to look into that matter too, try and decide whether what he taught me was right—or whether it's right for me, at least.

HELMER A nice way for a young woman to talk! It's 160 unheard of! If religion means nothing to you, I'll appeal to your conscience; you must have some sense of ethics, I suppose? Answer me! Or have you none?

NORA It's hard for me to answer you, Torvald. I

don't think I know—all these things bewilder me. But I do know that I think quite differently from you about them. I've discovered that the law, for instance, is quite different from what I had imagined; but I find it hard to believe it can be right. It 170 seems it's criminal for a woman to try and spare her old, sick, father, or save her husband's life! I can't agree with that.

You talk like a child. You have no under-

standing of the society we live in.

NORA No, I haven't. But I'm going to try and learn. I want to find out which of us is right-society

HELMER You are ill, Nora; you have a touch of fever; you're quite beside yourself.

NORA I've never felt so sure—so clear-headed—as I do tonight.

HELMER "Sure and clear-headed" enough to leave your husband and your children?

130 NORA

HELMER Then there is only one explanation possible.

NORA What?

HELMER You don't love me any more.

NORA No; that is just it.

HELMER Nora!—What are you saying!

NORA It makes me so unhappy, Torvald; for you've always been so kind to me. But I can't help it. I don't love you any more.

190

"sure and clear-headed" about this too?

NORA Yes, utterly sure. That's why I can't stay here any longer.

HELMER And can you tell me how I lost your love? NORA Yes, I can tell you. It was tonight—when the 200 wonderful thing didn't happen; I knew then you weren't the man I always thought you were.

HELMER I don't understand.

NORA For eight years I've been waiting patiently; I knew, of course, that such things don't happen every day. Then, when this trouble came to me—I thought to myself: Now! Now the wonderful thing will happen! All the time Krogstad's letter was out there in the box, it never occurred to me for a single moment that you'd think of submitting 210 to his conditions. I was absolutely convinced that you'd defy him-that you'd tell him to publish the thing to all the world; and that then—

HELMER You mean you thought I'd let my wife be

publicly dishonored and disgraced?

NORA No. What I thought you'd do, was to take the blame upon yourself.

HELMER Nora—!

NORA I know! You think I never would have accepted such a sacrifice. Of course I wouldn't! But 220 my word would have meant nothing against yours. That was the wonderful thing I hoped for, Torvald, hoped for with such terror. And it was to prevent that, that I chose to kill myself.

HELMER I'd gladly work for you day and night, Nora-go through suffering and want, if need be-but one doesn't sacrifice one's honor for

love's sake.

NORA Millions of women have done so.

HELMER You think and talk like a silly child.

Perhaps. But you neither think nor talk like the man I want to share my life with. When you'd recovered from your fright—and you never thought of me, only of yourself-when you had nothing more to fear-you behaved as though none of this had happened. I was your little lark again, your little doll—whom you would have to guard more carefully than ever, because she was so weak and frail. [stands up] At that moment it suddenly dawned on me that I had been living here for 240 HELMER May I write to you? eight years with a stranger and that I'd borne him three children. I can't bear to think about it! I could tear myself to pieces!

HELMER [sadly] I see, Nora—I understand; there's suddenly a great void between us—Is there no way

to bridge it?

NORA Feeling as I do now, Torvald—I could never be a wife to you.

HELMER But, if I were to change? Don't you think I'm capable of that?

NORA Perhaps—when you no longer have your doll to play with.

HELMER It's inconceivable! I can't part with you, Nora. I can't endure the thought.

NORA [going into room on the right] All the more reason it should happen. [She comes back with outdoor things and a small traveling-bag, which she places on a chair.

HELMER But not at once, Nora—not now! At least wait till tomorrow.

NORA [putting on cloak] I can't spend the night in a strange man's house.

HELMER Couldn't we go on living here together? As brother and sister, if you like—as friends.

NORA [fastening her hat] You know very well that wouldn't last, Torvald. [puts on the shawl] Goodbye. I won't go in and see the children. I know they're in better hands than mine. Being what I am—how can I be of any use to them?

HELMER But surely, some day, Nora—?

NORA How can I tell? How do I know what sort of person I'll become?

HELMER You are my wife, Nora, now and always! NORA Listen to me, Torvald—I've always heard that when a wife deliberately leaves her husband as I am leaving you, he is legally freed from all responsibility towards her. At any rate, I release you now from all responsibility. You mustn't feel yourself bound, any more than I shall. There must be complete freedom on both sides. Here is your ring. Now give me mine.

HELMER That too?

NORA That too.

HELMER Here it is.

So—it's all over now. Here are the keys. The 230 NORA servants know how to run the house-better than I do. I'll ask Kristine to come by tomorrow, after I've left town; there are a few things I brought with me from home; she'll pack them up and send them

HELMER You really mean it's over, Nora? Really over? You'll never think of me again?

NORA I expect I shall often think of you; of you and the children, and this house.

NORA No-never. You mustn't! Please!

HELMER At least, let me send you-

NORA Nothing!

HELMER But, you'll let me help you, Nora— NORA No, I say! I can't accept anything from strangers.

HELMER Must I always be a stranger to you, Nora? 300 HELMER [taking her traveling-bag] Yes. Unless it were to happen—the most wonderful thing of all— What? 250 HELMER

NORA Unless we both could change so that—Oh, Torvald! I no longer believe in miracles, you see! HELMER Tell me! Let me believe! Unless we both could change so that—?

—So that our life together might truly be a marriage. Good-bye. [She goes out by the hall door.]

HELMER [sinks into a chair by the door with his face in his hands] Nora! Nora! [he looks around the room and 310 rises] She is gone! How empty it all seems! [a hope springs up in him] The most wonderful thing of

260 [From below is heard the reverberation of a heavy door closing.

CURTAIN

280

Kate Chopin THE STORY OF AN HOUR

This story illustrates several aspects of Chopin's narrative art. Most of it consists of a stream-of-consciousness account of Mrs. Mallard's thoughts, but at the very end there is a sudden switch to objective observation—except, of course, that we know that the observation is wrong. The ability to think the unthinkable is characteristically bold. The ironies in the tale are many-layered. Finally the proportions are perfect, and brevity serves to reinforce the story's considerable impact.

Knowing that Mrs. Mallard was afflicted with a heart trouble, great care was taken to break to her as gently as possible the news of her husband's death.

It was her sister Josephine who told her, in broken sentences; veiled hints that revealed in half concealing. Her husband's friend Richards was there, too, near her. It was he who had been in the newspaper office when intelligence of the railroad disaster was received, with Brently Mallard's name leading the list of "killed." He had only taken the time to assure himself of its truth by a second telegram, and had hastened to forestall any less careful, less tender friend in bearing the sad message.

She did not hear the story as many women have heard the same, with a paralyzed inability to accept its significance. She wept at once, with sudden, wild abandonment, in her sister's arms. When the storm of grief had spent itself she went away to her room alone. She would have no one follow her.

There stood, facing the open window, a comfortable, roomy armchair. Into this she sank, pressed down by a physical exhaustion that haunted her body and seemed to reach into her soul.

She could see in the open square before her house the tops of trees that were all aquiver with the new spring life. The delicious breath of rain was in the air. In the street below a peddler was crying his wares. The notes of a distant song which some one was singing reached her faintly, and countless sparrows were twittering in the eaves.

There were patches of blue sky showing here and there through the clouds that had met and piled one above the other in the west facing her window.

She sat with her head thrown back upon the cushion of the chair, quite motionless, except when a sob came up into her throat and shook her, as a child who has cried itself to sleep continues to sob in its dreams.

She was young, with a fair, calm face, whose lines bespoke repression and even a certain strength. But now there was a dull stare in her eyes, whose gaze was fixed away off yonder on one of those patches of blue sky. It was not a glance of reflection, but rather indicated a suspension of intelligent thought.

There was something coming to her and she was waiting for it, fearfully. What was it? She did not know; it was too subtle and elusive to name. But she felt it, creeping out of the sky, reaching toward her through the sounds, the scents, the color that filled the air.

Now her bosom rose and fell tumultuously. She was beginning to recognize this thing that was approaching to possess her, and she was striving to beat it back with her will—as powerless as her two white slender hands would have been.

When she abandoned herself a little whispered word escaped her slightly parted lips. She said it over and over under her breath: "free, free, free!" The vacant stare and the look of terror that had followed it went from her eyes. They stayed keen and bright. Her pulses beat fast, and the coursing blood warmed and relaxed every inch of her body.

She did not stop to ask if it were or were not a monstrous joy that held her. A clear and exalted perception enabled her to dismiss the suggestion as trivial.

She knew that she would weep again when she saw the kind, tender hands folded in death; the face that had never looked save with love upon her, fixed and gray and dead. But she saw beyond that bitter moment a long procession of years to come that would belong to her absolutely. And she opened and spread her arms out to them in welcome.

There would be no one to live for her during those coming years; she would live for herself. There would be no powerful will bending hers in that blind persistence with which men and women believe they have a right to impose a private will upon a fellowcreature. A kind intention or a cruel intention made the act seem no less a crime as she looked upon it in that brief moment of illumination.

And yet she had loved him—sometimes. Often she had not. What did it matter! What could love, the unsolved mystery, count for in face of this possession of self-assertion which she suddenly recognized as the strongest impulse of her being!

"Free! Body and soul free!" she kept whispering. Josephine was kneeling before the closed door with her lips to the keyhole, imploring for admission. "Louise, open the door! I beg; open the door you will make yourself ill. What are you doing, Louise? For heaven's sake open the door.

"Go away. I am not making myself ill." No; she was drinking in a very elixir of life through that open

Her fancy was running riot along those days ahead of her. Spring days, and summer days, and all sorts of days that would be her own. She breathed a quick prayer that life might be long. It was only vesterday she had thought with a shudder that life might be long.

She arose at length and opened the door to her sister's importunities. There was a feverish triumph in her eyes, and she carried herself unwittingly like a

goddess of Victory. She clasped her sister's waist, and together they descended the stairs. Richards stood waiting for them at the bottom.

Some one was opening the front door with a latchkey. It was Brently Mallard who entered, a little travel-stained, composedly carrying his grip-sack and umbrella. He had been far from the scene of the accident, and did not even know there had been one. He stood amazed at Josephine's piercing cry; at Richards' quick motion to screen him from the view of his wife.

But Richards was too late.

When the doctors came they said she had died of heart disease—of joy that kills.

1901 EDWARDIAN AGE IN ENGLAND

1900-1905 Einstein researches the theory of relativity

1900-1905 Freud formulates basic ideas of psychoanalysis; The Interpretation of Dreams (1900)

1908-1915 Marinetti publishes futurist manifestos

1907 African sculpture fascinates artists in Paris: Picasso, Les Demoiselles D'Avignon. Retrospective of Cézanne's

work in Paris, Picasso and Braque begin cubist experiments: Braque, Violin and Palette (1909-1910); Picasso, Daniel-Henry Kahnweiler (1910)

1909-1915 Italian futurists glorify technological progress

1910

THE CALM AND THE

"GREAT WAR"

1910 Death of Edward VII of England

1914 World War I begins; European colonialism wanes

1917 Bolshevik Revolution ends tsarist rule in Russia

1910 Death of Tolstov

1910-1941 British Bloomsbury Group around Virginia and Leonard Woolf rejects Edwardian

1913 Carl Jung breaks with Freud 1915-1916 Dada movement founded Café Voltaire in Zurich: Dada manifesto by Tristan Tzara (1918)

1917 Cocteau, scenario for ballet Parade; Wilfred Owen, "Dulce et Decorum Est." Leonard Woolf begins Hogarth Press

1910 Roger Fry's First Post-Impressionist Exhibition scandalizes London

c. 1911 German expressionism flourishes

1912 Kandinsky, Concerning the Spiritual in Art

1912-1914 Mondrian in Paris influenced by cubists; Color Squares in Oval (1914-1915)

1913 New York Armory Show brings avant-garde art to attention of American public

1915 End of futurist movement; Severini, Armoured Train

1915-1916 Dada artists begin assault on traditional concepts of art; Duchamp L.H.O.O.Q. (1919)

1916 Arp, Fleur Marteau

1917 Picasso designs Parade set

1918

1918 World War I ends; women granted right to vote in Great Britain

1920 Women granted right to vote in United States

1922 Fascists come to power in Italy after Mussolini's march on Rome

1927 Lindbergh's solo flight across Atlantic

1928 First sound movie produced

1929 Great Depression begins in Europe and America

1933 Nazis come to power in Germany under Hitler; first refugees leave country

1936-1939 Spanish Civil War; Guernica bombed 1937

1919 Yeats, "The Second Coming"

1922 Alienation and cultural despair themes in postwar literature: T. S. Eliot, The Waste Land; Joyce, Ulysses. Sinclair Lewis satirizes American middle class in Babbitt

1924 Freudian theory and dadaism foster surrealism; Breton, First Surrealist Manifesto. Freudian themes appear in American drama; O'Neill, Desire Under the Elms (1924)

c. 1925 Black cultural regeneration, "Harlem Renaissance," in Northern U.S.

1925 Eliot, The Hollow Men: Kafka, The Trial

1926 Kafka, The Castle

1929 V. Woolf, A Room of One's Own

1930 Freud, Civilization and Its Discontents

1932 Huxley warns against unrestrained growth of technology in Brave New World

1918 Chagall, The Green Violonist

1921 Picasso, Three Musicians

1921-1931 Klee teaches at Bauhaus; Kandinsky appointed professor in 1922

1924 Surrealism begins; Buñuel and Dali collaborate on films Un Chien Andalou (1929), L'Age d'Or (1930)

1925 Eisenstein completes influential film Potemkin

1926 Gris, Guitar with Sheet of Music; Kandinsky, Several Circles, No. 323: Klee, Around the Fish

1927 Rouault, This will be the last time, little Father! (Miserere series)

1928 Magritte, Man with Newspaper

1930 Cocteau film Blood of a Poet 1931 Dali, The Persistence of Memory 1935-1940 WPA photographers active

1936 Riefenstahl, Triumph of the Will, film glorifying Nazis 1937 Picasso paints Guernica in protest against war; Dali uses Freudian symbolism in Inventions of the Monsters

1938 Eisenstein film Alexander Nevsky, score by Prokofiev; Riefenstahl, Olympia

1939

WORLD WAR II

BETWEEN THE WORLD WARS

1939 Germany invades Poland; World War II begins 1939 First commercial TV 1941 United States enters War 1939 Death of Freud; Auden, In Memory of Sigmund Freud

1945 Orwell, Animal Farm

1942-1943 Mondrian, Broadway Boogie-Woogie

1944-1946 Eisenstein, Ivan the Terrible, parts I and II

1945 1945 World War II ends

1949 Orwell, 1984

ARCHITECTURE MUSIC

c. 1900 Jazz originates among black musicians of New Orleans

1909 Wright, Robie House, Chicago

Between the World Wars

c. 1910 Peak and decline of ragtime music; jazz becomes fully developed 1911 Piano rag composer Scott Joplin

1911 Piano rag composer Scott Joplin completes opera *Treemonisha*

1913 Stravinsky's *Rite of Spring* first performed in Paris

1917 Satie composes score for ballet Parade

1916 Death of futurist architect Antonio Sant' Elia in World War I

1919 Bauhaus design school founded at Weimar; Bauhaus ideas find wide acclaim in architecture and many industrial fields

1919-1920 Russian constructivist sculptor and visionary architect Tatlin builds model for Monument to the Third International

late 1930s Bauhaus architects Gropius and Van der Rohe flee Nazi Germany for U.S. Avant-garde composers come under influence of jazz and ragtime: Stravinsky, *L'Histoire du Soldat* (1918), Hindemith, *Klaviersuite* (1922)

c. 1920 Chicago becomes jazz center; in New York's Harlem, Cotton Club provides showcase for jazz performers

1920s Josephine Baker and other American performers bring jazz and blues to Paris

1923 Schoenberg perfects twelve-tone technique (serialism)

1924 Gerswin, Rhapsody in Blue

1926 Gershwin, Concerto in F Major for piano

1930 Weill, *The Threepenny Opera*, text by Bertolt Brecht

1935 Gershwin's *Porgy and Bess*, first widely successful American opera

1943 Duke Ellington's symphonic suite Black, Brown, and Beige premieres at Carnegie Hall

The "Great War" and Its Significance

The armed conflict that raged in Europe from 1914 to 1918 put to rest forever the notion that war was a heroic rite of passage conferring nobility and glory. The use of technology—especially poison gas, tanks, and planes—made possible slaughter on a scale hitherto only imagined by storytellers. The sheer numbers of soldiers killed in the major battles of World War I continue to stagger the imagination. By the end of the war the Germans had lost three and a half million men and the Allies five million.

The sociopolitical consequences of the "Great War" were monumental. The geopolitical face of Europe was considerably altered. The October Revolution of 1917 led by V. I. Lenin toppled the tzarist regime and produced a Communist government in Russia; it was a direct result of Russia's humiliation in the war. The punitive attitude of the Allies and the stricken state of Germany's economy after the war provided the seedbed from which Hitler's National Socialist movement (Nazism) sprang. Postwar turmoil led to Mussolini's ascendancy in Italy. England had lost many of its best young men in the war. Those who survived leaned toward either frivolity or pacifism.

Culturally, World War I sounded the death knell for the world of settled values. The battle carnage and the senseless destruction, in no small part the result of callous and incompetent military leadership, made a mockery of patriotic slogans, appeals to class, and the metaphysical unity of nations. One result of this disillusionment was a spirit of frivolity but another was bitterness and cynicism about anything connected with military glory. A whole school of poets, many of whom did not survive the war, gave vent to their hatred and disgust with this first modern war.

The political upheavals and cultural tremors of the immediate postwar period coincided with a technological revolution in transportation and communications. After World War I radio came into its own. It is hard for us to comprehend what this information linkup meant for people previously isolated by lack of access to the larger world of information and culture. Similarly, the mass production of the automobile, made possible by the assembly-line techniques of Henry Ford in the United States, provided mobility to many who a generation before were confined to an urban neighborhood or a rural village. The widespread popularity of the cinema gave new forms of entertainment and instruction to those who already were accustomed to the voices of the radio coming into their homes each evening.

Literary Modernism

At the end of World War I the Irish poet William Butler Yeats (1865-1939), profoundly moved by unrest in his own country (particularly the Easter Rebellion of 1916) and the rising militarism on the Continent, wrote one of the most extraordinarily beautiful and prophetic poems of modern times, "The Second Coming." The title of the poem is deeply ironic because the title refers not to the glorious promised return of the Savior but an event the poet only hints at in an ominous manner. A line from that poem with its prescient look into the future, is as strikingly relevant for our times as it was for Yeats:

Things fall apart; the centre cannot hold; Mere anarchy is loosed upon the world. The blood-dimmed tide is loosed, and everywhere The ceremony of innocence is drowned; The best lack all conviction, while the worst

T. S. Eliot and James Joyce

Are full of passionate intensity.

The year 1922 was a turning point for literary modernism. In that year T. S. Eliot (1888–1965), an expatriate American living in England, published his poem The Waste Land and James Joyce (1882–1941), an expatriate Irish writer living on the Continent, published his novel *Ulysses*. In their respective works Eliot and Joyce reflect some of the primary characteristics of what is called the modernist temper in literature. There is fragmentation of line and image, the abandonment of traditional forms, and overwhelming sense of alienation and human homelessness (both authors were self-imposed exiles), an ambiva-

TABLE 17.1 Some American Poets Active Between the Wars

Edgar Lee Masters (1868-1950) Robert Frost (1874-1963) Carl Sandburg (1878-1967) Wallace Stevens (1879-1955) William Carlos Williams (1883–1963) Ezra Pound (1885-1972) Robinson Jeffers (1887-1962) Marianne Moore (1887-1972) Claude McKay (1890-1948) e. e. cummings (1894-1962) Edna St. Vincent Millay (1892-1950) Hart Crane (1899-1932) Langston Hughes (1902-1967) Countee Cullen (1903-1946) Richard Wright (1908-1960) Elizabeth Bishop (1911–1979)

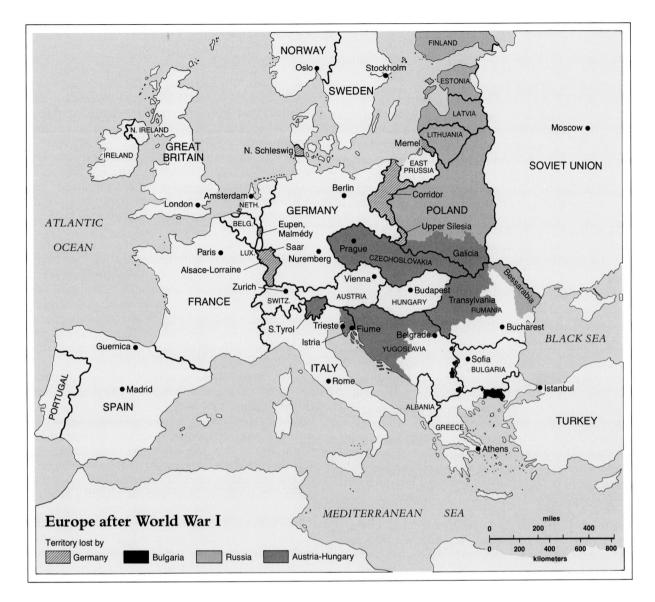

lence about the traditional culture, an intense desire to find some anchor in a past that seems to be escaping, a blurring of the distinction between reality "out there" and the world of subjective experience, and, finally, a straining and pushing of language to provide new meanings for a world they see as exhausted.

Both Eliot and Joyce reflect the conviction that, in Yeats' phrase, "the centre cannot hold." For Joyce, only art would give people a new world view that would provide meaning. Eliot felt that if culture was to survive one had to recover a sense of cultural continuity through a linkage of the artistic and religious tradition of the past. That perceived need for past cultural links helps explain why Eliot's poems are filled with allusions to works of art and literature as well as fragments from Christian rituals.

The gradual shift from cultural despair in The Waste Land can be traced in Eliot's later poems beginning with The Hollow Men (1925) and Ash Wednesday (1930) and culminating in Four Quartets, which were finished in the early forties. The Quartets, were Eliot's mature affirmation of his Christian faith as a bulwark against the ravages of modernist culture. To read The Waste Land and the Four Quartets in tandem is to see one way in which a sensitive mind moved from chaos to stability in the period between the wars.

Before the First World War Joyce had already published his collection of short stories under the title Dubliners (1912) and his Portrait of the Artist as a Young Man (1916). The former was a series of linked short stories in which persons come to some spiritual insight (which Toyce called "epiphanies") while the latter was a thinly disguised autobiographical memoir of his own youth before he left for the Continent in self-imposed exile after his graduation from college. With the 1922 publication of *Ulysses* Joyce was recognized as a powerful innovator in literature. In 1939, two years before his death, Joyce published the dauntingly difficult Finnegans Wake. Joyce once said that *Ulysses* was a book of the day (it takes place in one day) while Finnegans Wake was a haunting dream book of the night.

Joyce's blend of myth and personal story, his many-layered puns and linguistic allusions, his fascination with stream of consciousness, his sense of the artist alienated from his roots, and his credo of the artist as maker of the world have all made him one of the watershed influences on literature in the 20th cen-

Franz Kafka

Perhaps the quintessential modernist in literature is the Czech writer Franz Kafka (1883-1924). A German-speaking Jew born and raised in Prague, Kafka was by heritage alienated both from the majority language of his city and its predominant religion. An obscure clerk for a major insurance company in Prague, he published virtually nothing during his lifetime. He ordered that his works be destroyed after his death, but a friend did not accede to his wish. What we have from Kafka's pen is so unique that it has contributed the adjective kafkaesque to our language. A kafkaesque experience is one in which a person feels trapped by forces that seem simultaneously ridiculous, threatening, incomprehensible, and dangerous.

This is precisely the tone of Kafka's fiction. In Kafka's The Trial (1925) Joseph K. (note the nearanonymity of the name) is arrested for a crime that is never named by a court authority that is not part of the usual system of justice. At the end of the novel the hero (if he can be called that) is executed in a vacant lot by two seedy functionaries of the court. In The Castle (1926) a land surveyor known merely as K., hired by the lord of a castle overlooking a remote village, attempts in vain to approach the castle, to communicate with its lord, to learn of his duties. In time, he would be satisfied just to know if there actually is a lord who has hired him.

No critic has successfully uncovered the meaning of these novels—if in fact they should be called novels. Kafka's works might better be called extended parables that suggest, but do not explicate, a terrible sense of human guilt, a feeling of loss, and an air of oppression and muted violence.

Virginia Woolf

Virginia Woolf (1882-1941) is one of the most important writers in the period of literary modernism. Novels like Mrs. Dalloway (1925), To the Lighthouse (1927), and The Waves (1931) have been justly praised for their keen sense of narrative, sophisticated sense of time shifts, and profound feeling for the textures of modern life.

Woolf's reputation would be secure if she had only been known for her novels but she was also an accomplished critic, a founder (with her husband Leonard Woolf) of the esteemed Hogarth Press, and a member of an intellectual circle in London known as the Bloomsbury Group. That informal circle of friends was at the cutting edge of some of the most important cultural activities of the period. Lytton Strachey, the biographer, was a member, as was John Maynard Keynes, the influential economist. The group also included the art critics Roger Fry and Clive Bell, who championed the new art coming from France. The Bloomsbury Group also had close contacts with the mathematician-philosopher Bertrand Russell and the poet T. S. Eliot.

Two small books, written by Woolf as polemical pieces, are of special contemporary interest. A Room of One's Own (1929) and Three Guineas (1938) were passionate but keenly argued polemics against the discrimination of women in public intellectual life. Woolf argued that English letters had failed to provide the world with a tradition of great women writers not because women lacked talent but because social structures never provided them with a room of their own, that is, the social and economic aid to be free to write and think or the encouragement to find outlets for their work. Woolf, a brilliant and intellectually restless woman, passionately resented the kind of society that had barred her from full access to English university life and entry to the professions. Her books were early salvos in the coming battle for women's rights.

The Revolution in Art: Cubism

Between 1908 and 1914 two young artists, the Frenchman Georges Braque (1882-1963) and the expatriate Spaniard, Pablo Ruiz Picasso (1881–1973), began a series of artistic experiments in Paris that revolutionized the direction of Western painting. For nearly five hundred years painting in the West had attempted a reconstruction on canvas of a real or ideal world "out there" by the use of three-dimensional perspective and the rules of geometry. This artistic tradition, rooted in the ideas of the Italian Renais-

EAST MEETS WEST

"Primitive" Arts

A great deal of art from the world of the native peoples of Africa, Oceania, and North and South America came into Europe in the 19th and 20th centuries as a result of the colonial presence of Europe in those regions. At first, this material was of interest only to ethnographers and anthropologists. Before too long, however, artists began to take a keen interest in and become influenced by this art. Pablo Picasso's homage to African sculptured masks has already been noted. Picasso and other cubists were struck by the formal power of this art to distort and saw it as a new alternative to the Western tradition of seeing the human figure.

The fascination with these cultures triggered a mania for collecting such art and, in turn, this interest touched a wide range of artists. The English sculptor Henry Moore was deeply moved by the simplicity and suggestiveness of prehistoric art. In the 1920s, when he was beginning his career as a sculptor, he haunted the museums of England studying the pre-Columbian art of Mexico and the sculpture of Africa. The monumental works found in many major cities today reflect his deep debt to those great works of the Aztecs, Incas, and Afri-

The enormous popularity of jazz in the 1920s both in the United States and abroad led to a fresh appreciation of African motifs in everything from painting to the graphic arts. Painting and sculpture of the Harlem Renaissance looked to Africa in the 1920s and 1930s to recover the roots of their own tradition as they carved out an identity as Afro-Americans. That interest in things African, begun between the wars, continues to influence Afro-American artists.

The roots of the Western interest in the arts of other cultures began, largely, as a byproduct of Western colonialism but, in time, came to be appreciated as a rich source of artistic inspiration so that, like many things in the 20th century, the visual arts began to move away from narrow cultural interests into a more global consciousness.

sance, created the expectation that when one looked at a painting one would see the immediate figures more clearly and proportionately larger while the background figures and the background in general would be smaller and less clearly defined. After all, it was reasoned, that is how the eye sees the real world. Braque and Picasso challenged that view as radically as Einstein, a decade before, had challenged all of the classical assumptions we had made about the physical world around us.

To Braque and Picasso, paint on an essentially two-dimensional and flat canvas represented a challenge: how could one be faithful to a medium that by its very nature was not three-dimensional while still portraying objects which by their very nature are three-dimensional? Part of their answer came from a study of Paul Cézanne's many paintings of Mont Sainte-Victoire executed the century before. Cézanne saw and emphasized the geometric characteristics of nature; his representations of the mountain broke it down as a series of geometrical planes. With the example of Cézanne and their own native genius, Braque and Picasso began a series of paintings to put this new way of "seeing" into practice. These experiments in painting began an era called "analytical cubism" since the artists were most concerned with exploring the geometric qualities of objects seen without reference to linear perspective.

Picasso's Les Demoiselles d'Avignon [17.1], painted in 1907, is regarded as a landmark of 20th-century painting. Using the traditional motif of a group of bathers (the title of the painting is a joke; it alludes to

a brothel on Avignon Street in Barcelona), Picasso moves from poses that echo classical sculpture on the left to increasingly fragmented and distorted figures on the right. His acquaintance with African art prompted him to repaint the faces the same year to reflect his delight with the highly angular and "primitive" African masks he had seen in a Paris exhibition. The importance of this work rests in its violently defiant move away from both the classical perspective of Renaissance art and the experiments of Cézanne in the preceding century. It heralds the cubism with which both Picasso and Braque became identified the following year.

A look at representative paintings by Braque and Picasso will help to clarify the aim of the cubists. In Violin and Palette [17.2] Braque depicts a violin so that the viewer sees, simultaneously, the front, the sides, and the back of the instrument while at the same time they appear on a single flat plane. The ordinary depth of the violin has disappeared. The violin is recognizable but the older notion of the violin as appearing "real" has been replaced by the artist's vision of the violin as a problem to be solved according to his vision and through his analysis.

In Picasso's portrait of Daniel-Henry Kahnweiler [17.3] the entire picture plane has become a geometric grid in which the traditional portrait form has been broken into separate cubelike shapes and scattered without reference to traditional proportion. The viewer must reconstruct the portrait from the various positions on the cubist grid. Within the picture one detects here a face, there a clasped hand, and

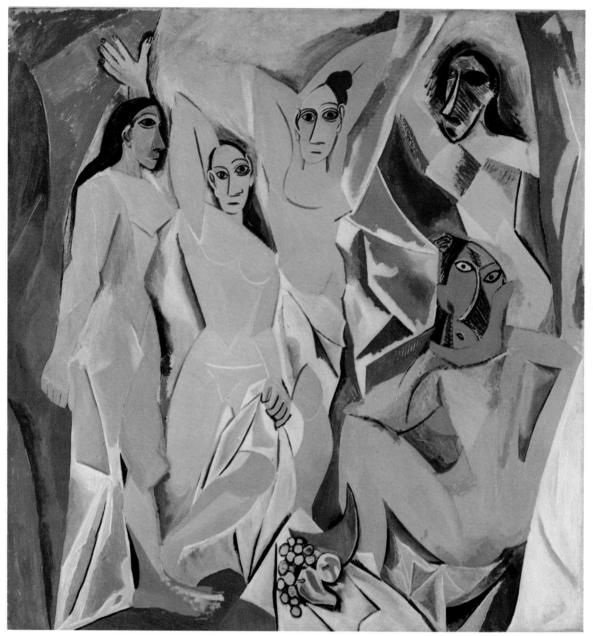

17.1 Pablo Picasso. Les Demoiselles d'Avignon. 1907. Oil on canvas, 8 × 7'8" (2.43 × 2.33 m). Collection, The Museum of Modern Art, New York (acquired through the Lillie P. Bliss bequest). Note the increasing distortion of the faces as one's eyes move from the left to the right.

a table with a bottle on it. The intense preoccupation in this work with line and form can be noted by a close examination of the tiled surface facets that provide the painting with its artistic unity.

In the postwar period the impact of cubism on the artistic imagination was profound and widespread. Picasso himself moved away from the technically refined yet somewhat abstractly intellectual style of analytic cubism to what has been called synthetic

cubism. In Three Musicians [17.4] he still employs the flat planes and two-dimensional linearity of cubism, as the geometric masks of the three figures and the way they are lined up clearly show, but their color, vivacity, playfulness, and expressiveness somehow make us forget that they are worked out in terms of geometry. These postwar paintings seem more humane, alive, and less intellectually abstract.

The visual revolution of cubism stimulated other

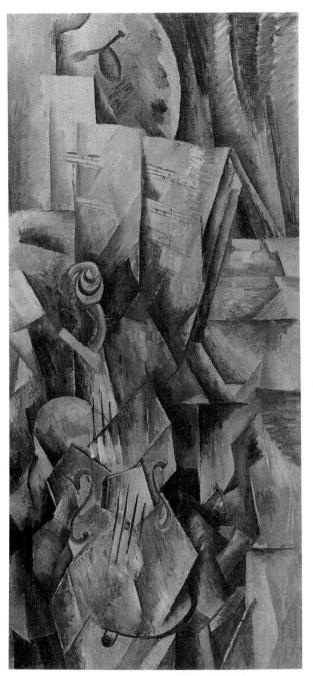

17.2 Georges Braque. Violin and Palette. 1909–1910. Oil on canvas, $36\frac{1}{8} \times 16\frac{1}{8}$ " (92 × 43 cm). Solomon R. Guggenheim Museum, New York. The cubist strategy of breaking up planes can be seen clearly by attempting to reconstruct the normal shape of the violin with the eye.

17.3 Pablo Picasso. Daniel-Henry Kahnweiler. 1910. Oil on canvas, $39\% \times 28\%$ " (101×73 cm). The Art Institute of Chicago (gift of Mrs. Gilbert W. Chapman). Note the intensely two-dimensional plane of the painting.

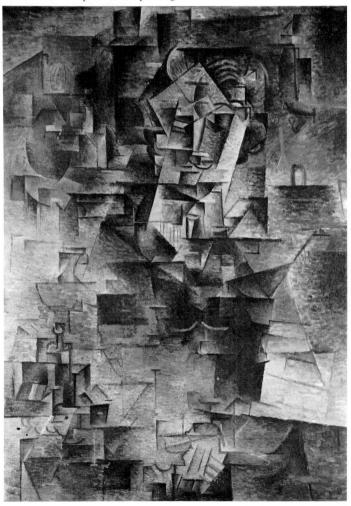

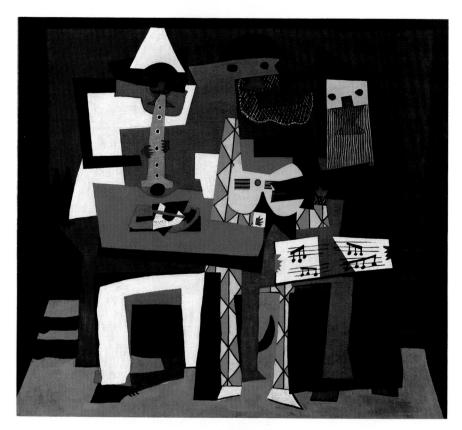

17.4 Pablo Picasso. Three Musicians. 1921. Oil on canvas, $79 \times 87\frac{3}{4}$ " (2 × 2.23 m). Collection, The Museum of Modern Art, New York (Mrs. Simon Guggenheim Fund). Another, less severe version of this painting done in the same year now hangs in the Philadelphia Museum of Art.

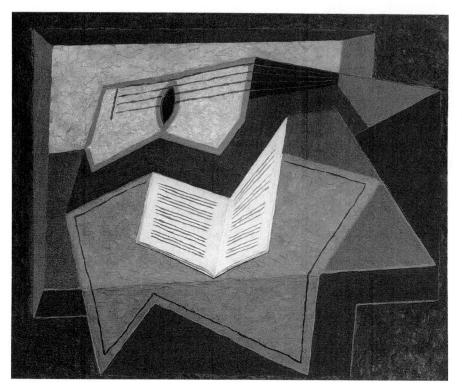

17.5 Juan Gris. Guitar and Music Paper. 1926. Oil on canvas, $25\frac{5}{8} \times 31\frac{7}{8}$ " (65 × 81 cm). Private collection. It is instructive to compare this work with Braque's painting of a similar subject (figure 17.2) to see how a similar theme was handled differently by another cubist painter.

artists to use the cubist insight in a variety of ways. Only a close historical analysis could chart the many ways in which cubism made its mark on subsequent art, but a sampling shows both the richness and the diversity of art in the West after the Great War.

Some painters, like Juan Gris (1887–1927), continued to experiment rather faithfully with the problems Picasso and Braque explored before the war. His Guitar and Music Paper [17.5] demonstrates that such experimentation was not merely an exercise in copying. Other artists followed along the lines of Gris. The Dutch painter Piet Mondrian (1872–1944), after visits to Paris, where he saw cubist work, abandoned his earlier naturalistic works for paintings like Color Planes in Oval [17.6], a work whose main focus is on line and square highlighted by color.

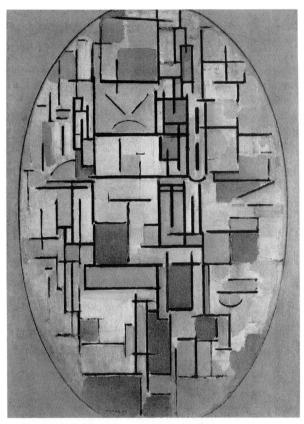

17.6 Piet Mondrian. Color Planes in Oval. 1914(?). Oil on canvas, $42\% \times 31''$ (108 × 79 cm). Collection, The Museum of Modern Art, New York (purchase). Color experiments of this kind would exert an enormous influence on clothing design and the graphic arts in subsequent decades.

17.7 Marc Chagall. Green Violinist. 1923-1924. Oil on canvas, $6'8'' \times 3'6'/4''$ (1.98 × 1.09 cm). Solomon R. Guggenheim Museum, New York. This highly complex work blends cubist, primitivist, and dreamlike characteristics. Chagall's work blends memories of his Russian past and Jewish mysticism in a highly formal manner.

The influence of cubism was not confined to a desire for simplified line and color even though such a trend has continued to our day in minimalist and hard edge art. The Green Violinist [17.7] by Marc Chagall (1889–1985) combines cubist touches (in the figure of the violinist) with the artist's penchant for dreamy scenes evoking memories of Jewish village life in Eastern Europe.

Although cubism was the most radical departure in modern art, it was not the only major art trend that overarched the period of the Great War. German painters continued to paint works in the expressionist style of the early years of the century. Perhaps the most accomplished exponent of expressionism was Wassily Kandinsky (1866–1944), who was also one of the few painters of his time who attempted to state

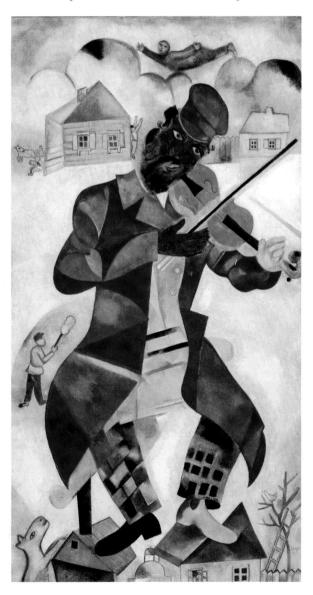

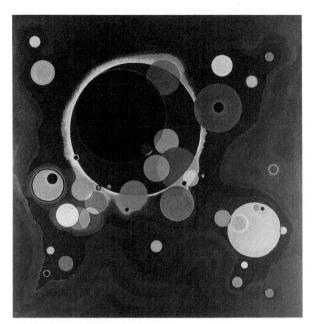

17.8 Wassily Kandinsky. Several Circles. 1926. Oil on canvas, 4'71/8" (1.4 m) square. Solomon R. Guggenheim Museum, New Vork

his theories of art in writing. Kandinsky's Concerning the Spiritual in Art (1910) argued his conviction that the inner, mystical core of a human being is the truest source of great art. That attitude, together with Kandinsky's conviction that the physical sciences were undermining confidence in the solidity of the world as we see it, led him closer to color abstraction and further away from any form of representation. By 1926 he was attempting to express the infinity and formlessness of the world (indeed, the cosmos) in

17.9 Salvador Dali. The Persistence of Memory. 1931. Oil on canvas, $9\frac{1}{2} \times 13''$ (24 × 33 cm). Collection, The Museum of Modern Art, New York (anonymous gift).

paintings like Several Circles [17.8] without appeal to any representative figures or sense of narration.

Freud, the Unconscious, and Surrealism

In 1900, on the very threshold of the century, a Viennese physician, Sigmund Freud (1856-1939), published The Interpretation of Dreams—one of the most influential works of modern times, Freud argued that deep in the unconscious, which Freud called the Id, were chaotic emotional forces of life and love (called Libido or Eros) and death and violence (called Thanatos). These unconscious forces, often at war with each other, are kept in check by the Ego, which is the more conscious self, and the Super Ego, which is the formally received training of parental control and social reinforcements. Human life is shaped largely by the struggle of the Ego and Super Ego to prevent the deeply submerged drives of the Unconscious from emerging. One way to penetrate the murky realm of the human unconscious, according to Freud, was the dream. In the life of sleep and dreams the Ego and Super Ego are more vulnerable in their repressive activities. "The dream," Freud wrote, "is the royal road to the Unconscious." To put it simply, Freud turned the modern mind inward to explore those hidden depths of the human personality where the most primitive and dynamic forces of life dwell. Freudian psychoanalysis is not only a therapeutic technique to help anxious patients but also a descriptive philosophy that proposes to account both for human behavior and for culture in general.

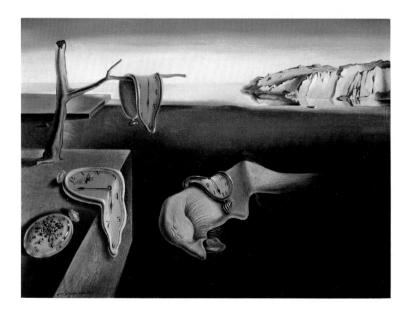

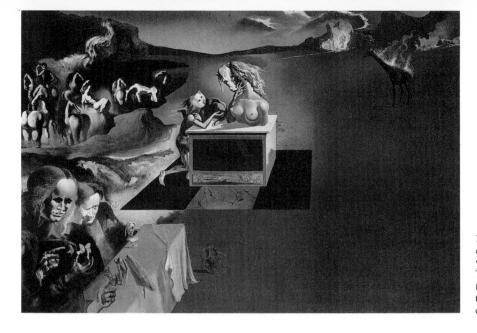

17.10 Salvador Dali. Inventions of the Monsters. 1937. Oil on canvas, $20\frac{1}{8} \times 30\frac{7}{8}$ " (51 × 78 cm). The Art Institute of Chicago (Joseph Winterbotham Collection). Note the highly charged erotic character of the painting.

After the Great War Freud's ideas were readily accessible to large numbers of European intellectuals. His emphasis on nonrational elements in human behavior exercised a wide influence on those who had been horrified by the carnage of the war. One group in particular was anxious to use Freud's theories about the dream world of the Unconscious as a basis for a new aesthetics. The result was the movement known as surrealism.

17.11 René Magritte. Man with a Newspaper. 1928. Oil on canvas, $45\frac{1}{2} \times 32''$ (116 × 81 cm). Tate Gallery, London (reproduced by courtesy of the Trustees). Magritte's power to invoke solitude is evident in this picture.

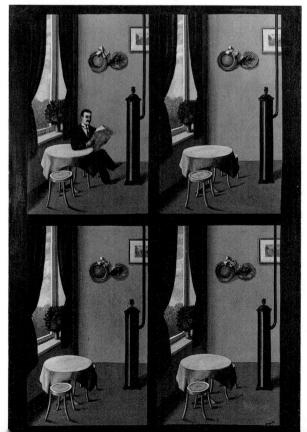

Surrealism was both a literary and artistic movement, gathered around the journal Littérature, edited in Paris by the French critic André Breton. In 1924 Breton published his first Manifesto of Surrealism, which paid explicit homage to Freud's ideas on the subjective world of the dream and the unconscious. "Surrealism," Breton declared, "is based on the belief in the superior reality of certain forms of association hitherto neglected, in the omnipotence of the dream, and in the disinterested play of thought."

The painters first associated with surrealism are familiar to every museumgoer: Jean Arp, Giorgio de Chirico, Max Ernst, Paul Klee, Joan Miró, Pablo Picasso. The Spanish artist Salvador Dali (1904– 1989), who joined the movement in its later period, however, was to become almost synonymous with surrealism. His The Persistence of Memory [17.9] is perhaps the most famous surrealist painting. Its dreamlike quality comes from the juxtaposition of almost photographic realism with a sense of infinite quiet space and objects that seem unwilling to obey the laws of physics. The soft watches seem to melt in their plasticity. It is the very juxtaposition of solidity and lack of solidity that contributes to the "surreal" tone of the painting, In other paintings, like Inventions of the Monsters [17.10], Dali's surreal world has more conscious allusions to the Freudian unconscious. There are open references to terror, violence, and sexuality. The double portrait is an allusion to the male/female principles that constitute each person, and Dali frequently alludes to this bisexual dynamic in his work.

Dali utilized strong realist draftmanship to set out his dream world. The iconography of his work, at least in the 1930s, was orthodox in its Freudianism. Another surrealist, René Magritte (1898–1967), was no less a draftsman but was less concerned with the dark side of the unconscious. His work, done with scrupulous attention to realistic detail, calls into question our assumptions about the reality of our world. In his Man with a Newspaper [17.11] even the title of the painting misleads us since the man, like a figure in the frame of a moving-picture film, has disappeared after the first frame.

Film was a major influence on Magritte's development—as it was on other surrealists. The motionpicture camera could be used to make images that corresponded closely with surreal intentions. Figures could dissolve, blend into other figures, be elongated, or slowly disappear. Some of the first artists associated with surrealism like the American Man Ray experimented with both still photography and moving pictures. Dali collaborated with his compatriot film director Luis Bunuel to produce two famous surrealistic films: Un Chien Andalou (1929) and L'Age d'Or (1930). The French poet Jean Cocteau also produced a famous surrealistic film in 1931, Blood of a Poet.

One artist deserves a separate mention; although his association with the surrealist movement was important it does not adequately define his originality. The Swiss painter Paul Klee (1879-1940) had touched most of the major art movements of his day. He knew the work of Picasso in Paris: he exhibited for a time with the Blaue Reiter in Germany; after the war he taught at the famous design school in Germany called the Bauhaus. Finally, he showed his work at the first surrealist exhibition of art in Paris. It was characteristic of Klee's talent that he could absorb elements of cubist formalism, expressionist colorism, and the fantasy of the surrealists without being merely a derivative painter. He was, in fact, one of the most original and imaginative artists of the first half of the century. A painting like his 1926 Around the Fish [17.12] is typical. The cylindrical forms hint at cubism but the floating shapes, some enigmatic, and the brilliant coloring evoke the dreamlike world of the surreal.

We have already noted that Freud's pioneering researches into the nature of the unconscious profoundly impressed those writers associated with André Breton. Other writers more fully explored the implication of Freud and his followers throughout this century in fiction, poetry, drama, and criticism. The great American dramatist Eugene O'Neill (1888–1953) restated basic Freudian themes of love and hate between children and parents (the so-called Oedipus and Electra complexes) in plays like Desire Under the Elms and Mourning Becomes Electra. Other writers of world repute like Franz Kafka and the American novelist William Faulkner (1897–1962) may not have been directly dependent on Freud's writings but their works are more accessible when

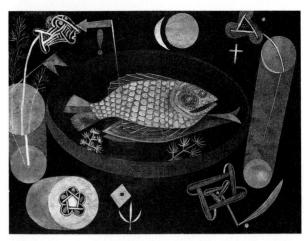

17.12 Paul Klee. Around the Fish. 1926. Oil on canvas, 183/8" × 251/8" (47 × 64 cm). Collection, The Museum of Modern Art, New York (Abby Aldrich Rockefeller Fund). The figures in the painting seem to float freely in an indeterminate space.

we understand that they are dealing with similar issues and problems.

The Age of Jazz

Jazz is a peculiarly American contribution to Western culture, born out of the unique experience of American blacks. The matrix out of which jazz was born is an imperfectly documented history of a process that includes, among other elements: (1) certain intonations, rhythmic patterns (such as love of repetition), and melodic lines that come ultimately from the African ancestors of American blacks; (2) the tradition of the spirituals. Christian hymns sung both in the slave culture of the South and in the free churches of blacks after the Civil War; (3) the ineffable music of the blues, developed in the Deep South with its characteristic blue note, the flattening by a semitone of a note of the melodic line, which produces a sound hard to describe but instantly recognized; and (4) adaptations of certain European songs, especially French quadrilles and polkas, into a slightly different style of music that became known as ragtime.

Jazz made its first organized appearance in New Orleans around the turn of the century. The musicians, who were all black, performed without written music and were self-taught. They formed bands and played in the streets and in the cabarets of the city. By the end of World War I many of these musicians had migrated north to Chicago—which, in the early 1920s, was the center of jazz music. From there jazz spread to Harlem in New York City and to other urban centers of both coasts.

The influence of black jazz (and its white counter-

17.13 Alexander Calder. Josephine Baker. 1927-1929. Iron wire construction, $39 \times 22\% \times 94''$ (99 × 57 × 25 cm). Collection, The Museum of Modern Art, New York (gift of the artist). This is one of many such works Calder made during his stay in Europe in the late 1920s.

part) on American culture is hard to overestimate. In fact, that period directly after World War I has been called "The Jazz Age," borrowing from an F. Scott Fitzgerald title. Some of the musicians of that era have permanent niches in American culture: the great blues singer Bessie Smith (1895-1937) and the trumpeter Louis Armstrong (1900–1975), along with such rediscovered masters as Eubie Blake (1883–1983) and Alberta Hunter. Jazz figures who reach down into contemporary culture would include such classic masters as Duke Ellington (1899-1974), Count Basie (1906–1984), and Lionel Hampton (1909–).

The popularity of jazz, a peculiarly black musical idiom, was soon appropriated by the predominant white culture in America so that often white jazz bands and the mass media (the first talking motion picture in this country starred a white actor, Al Jolson, portraying a black man in The Jazz Singer) overshadowed the unheralded black musicians of the time. Only more recently have serious and systematic attempts been made to recover early jazz record-

ings (since written music is, by and large, nonexistent) and to bring out of retirement or obscurity the now-old blues singers who are the most authentic exponents of this art form.

Jazz as a musical and cultural phenomenon was not limited to the United States in the period after World War I. Jazz had a tremendous following in Paris in the 1920s, where one of the genuine celebrities was the black American singer Josephine Baker [17.13].

Just as Pablo Picasso had assimilated African sculptural styles in his painting, so serious musicians on the Continent began to understand the possibilities of this American black music for their own explorations in modern music. As early as 1913 Igor Stravinsky (1882–1971) utilized the syncopated rhythms of jazz in his pathbreaking ballet The Rite of Spring. His L'Histoire du soldat (1918) incorporates a "ragtime" piece Stravinsky composed based only on sheet-music copies he had seen of such music. Other avant-garde composers in Europe also came under the influence of jazz. Paul Hindemith's 1922 Klaviersuite shows the clear influence of jazz. Kurt Weill's 1928 Dreigroschenoper (Threepenny Opera), with a libretto by Bertolt Brecht, shows a deep acquaintance with jazz—demonstrated notably in the song "Mack the Knife."

By the 1930s in the United States the influence of jazz had moved into the cultural consciousness of the country at large. Jazz was now commonly referred to as swing, and swing bands toured the country and were featured in films. The bands of Duke Ellington (see below) and Count Basie were well known even though their members, on tour, had to put up with the indignities of racial segregation: they often played in hotels and clubs which they themselves would have been unable to patronize. By the late 1930s there was even a renewed interest in the older roots of jazz. In 1938, for example, Carnegie Hall in New York City was the site of the "Spirituals to Swing" concert, which presented a range of musicians from oldtime New-Orleans-style jazz performers to such avant-garde performers as Lester Young.

Many of the musicians of the swing era were extremely talented musicians who were quite able to cross musical boundaries. The great clarinetist Benny Goodman recorded the Mozart Clarinet Quintet with the Budapest String Quartet in 1939, the year he commissioned a composition from classical composer Bela Bartok. The black jazz musician Fats Waller, in the same year, wrote his London Suite, his impressionistic tribute to that city.

Such crossovers were the exception rather than the rule, but they do underscore the rich musical tradition of the jazz movement. In the period after the Second World War there would be a new wave of experiments in avant-garde, new wave, and cool jazz that would give performers the opportunity to extend the definition and range of jazz to where it would intersect with other forms of avant-garde music, as is evident in the musical career of the late Charley ("Bird") Parker and the still-active Miles Davis.

George Gershwin

The most persistent effort to transpose jazz into the idiom of symphonic and operatic music was that made by the American composer George Gershwin (1898–1937). In large symphonic works like Rhapsody in Blue (1924) and Concerto in F Major (1926), Gershwin utilized such jazz characteristics as blue notes, syncopation, and seemingly improvised variations on a basic theme (riffs) along with the more classically disciplined form of large orchestral music.

It is certainly appropriate, perhaps inevitable, that the first widely successful American opera should have a jazz background. George Gershwin's Porgy and Bess (1935) incorporated jazz and other black musical material such as the "shouting" spirituals of the Carolina coastal black churches to a libretto written by the Southern novelist Dubose Heyward. Porgy and Bess was not an immediate success in New York, but later revivals in the 1940s and after World War II established its reputation. In 1952 it had a full week's run at the La Scala opera house in Milan, in 1976 the Houston Opera mounted a full production with earlier cuts reintroduced into the text that subsequently was seen at the Metropolitan Opera in New York. It now ranks as a classic. Some of its most famous songs (such as "Summertime" and "It Ain't Necessarily So") have also become popular favorites.

Gershwin was white and thus had easier access to the world stage than did many of the black musicians in the first half of this century. It has only been in the last two decades or so that a fine composer like Scott Joplin (1868–1917), for example, has achieved any wide recognition in this country. The great blues singer Bessie Smith died after an automobile accident in the South because of delays in finding a hospital that would treat blacks. Many other singers and instrumentalists have remained in obscurity all their lives, although some—artists like the late Louis Armstrong—were so extraordinarily gifted that not even the hostile and segregated culture of the times could repress their talent.

Duke Ellington

One black American who managed to emerge decisively from the confines of black nightclubs into international fame was Edward Kennedy ("Duke")

Ellington (1899–1974). Ellington gained fame at the Cotton Club in Harlem in the 1920s both for his virtuoso orchestral skills and for his prolific output as a composer. He was not only a successful writer of such popular musical pieces as "Take the A Train" and "Mood Indigo" but also a true original in his attempt to extend the musical idiom of jazz into a larger arena. Beginning after World War II, he produced any number of works for symphonic settings. His symphonic suite Black, Brown, and Beige had its first hearing at Carnegie Hall in 1943. This work was to be followed by others whose titles alone indicate the ambition of his musical interests: Shakespearean Suite (1957), Nutcracker Suite (1960), Peer Gynt Suite (1962), and his ballet The River (1970), which he wrote for the dance company of Alvin Ailey, a notable black choreographer.

Ballet: Collaboration in Art

In the period between the world wars one form of culture where the genius of the various arts most easily fused was the ballet. The most creative experiments took place in Paris through the collaboration of a cosmopolitan and talented group of artists.

The driving force behind ballet in this period in Paris was Serge Diaghilev (1872-1929), a Russianborn impresario who founded a dance company called the Ballet Russe, which opened its first artistic season in 1909. Diaghilev brought from Russia two of the most famous dancers of the first half of the century: Vaslav Nijinsky (1890-1950) and Anna Pavlova (1881-1931).

Diaghilev had a particular genius for recruiting artists to produce works for his ballet. Over the years the Ballet Russe danced to the commissioned music of Igor Stravinsky, Maurice Ravel, Serge Prokofiev, Claude Debussy, Erik Satie, and Darius Milhaud. In that same period sets, costumes, and stage curtains were commissioned from such artists as Pablo Picasso, Georges Rouault, Naum Gabo, Giorgio de Chirico, and Jean Cocteau.

In 1917 Diaghilev produced a one-act dance called Parade in Paris. This short piece (revived in 1981 at the Metropolitan Opera with sets by the young English painter David Hockney) is an excellent example of the level of artistic collaboration Diaghilev could obtain. The story of the interaction of street performers and men going off to war was by the poet Jean Cocteau (1891–1963); the avant-garde composer Erik Satie (1866-1925) contributed a score replete with street sounds, whistles, horns, and other accouterments of urban life. Pablo Picasso designed the curtain drop, the sets, and the costumes [17.14]. Parade

17.14 Pablo Picasso. Curtain for the ballet Parade. Paris, 1917. Tempera on cloth, $34'9'' \times 56'^{3/4}''$ (10.6 × 17.3 m). Musée National d'Art Moderne, Centre Georges Pompidou, Paris. Many critics agree that both the music and the choreography of the ballet were overwhelmed by Picasso's brilliant sets, which dominated the production.

had much to say about musicians, players, and street performers, so the production was readymade for Picasso's well-known interest in these kinds of peo-

The collaborative effort of these important figures was a fertile source of artistic inspiration. Picasso had a great love for such work and returned to it on a number of other occasions. He designed the sets for Pulcinella (1920), which had music by Igor Stravinsky. He designed sets for a balletic interpretation of the Euripidean Greek tragedy Antigone done from a translation of the play into French by Jean Cocteau. In 1924 he also did designs for a ballet, which had original music written by Erik Satie, called Mercury.

Ballet, like opera, is an art form that lends itself to artistic integration. To enjoy ballet one must see the disciplined dancers in an appropriate setting, hear the musical score that at once interprets and guides the movements of the dancers, and follow the narrative or "book" of the action. It is no wonder that an organizational genius like Diaghilev would seek out and nurture the efforts of the most creative artists of his era.

Art as Escape: Dada

A group of artists, writers, and musicians who gathered around the tables of the Café Voltaire in Zurich in 1915 founded a movement to protest what they considered the madness of the war and its senseless slaughter. They decided to fight the "scientific" and "rational" warmakers and politicians with nonsense language, ugly dissonant music, and a totally irreverent and iconoclastic attitude toward the great masterpieces of past culture. It was called dada, a nonsense word of disputed origin that could be a diminutive of "father" or the word for "yes" or a slang word for a hobbyhorse. One of its poets, Tristan Tzara, wrote a dada manifesto in 1918 that called for, among other things, a destruction of good manners, the abolition of logic, the destruction of memory, forgetfulness with respect to the future, and the elevation of the spontaneous at the highest good.

One of the most representative and creative of the dada artists was Marcel Duchamp (1887–1968), who after 1915 was associated with an avant-garde art gallery in New York founded by the American photographers Alfred Stieglitz (1864-1946) and Edward Steichen (1879–1973). Duchamp was a restless innovator who originated two ideas in sculpture that became part of the common vocabulary of modern art: sculptures with moving parts (mobiles) and sculptures constructed from preexisting fabricated material originally intended for other purposes (readymades). Besides these important innovations Duchamp also has gained notoriety for his whimsically irreverent attitude toward art, illustrated by his gesture of exhibiting a urinal at an art show as well as his humorous but lacerating spoofs of high culture, the most "dada" of which is his famous defacement of the Mona Lisa [17.15].

The dadaists could not maintain the constant energy of their anarchy, so it was inevitable that they would move individually into other directions. Dada was a movement symptomatic of the crisis of the times, a reaction to chaos but no adequate answer to

17.15 Marcel Duchamp. L.H.O.O.Q. 1919. Rectified readymade, pencil on colored reproduction of Leonardo da Vinci's Mona Lisa; $7\frac{3}{4} \times 4\frac{7}{8}$ " (20 × 12 cm). Private collection. The French pronunciation of the letters under the picture sounds like an off-color expression.

17.16 Pablo Picasso. Guernica. 1937. Oil on canvas, 11'5½" × 25'5¼" (3.49 × 7.77 m). Prado Museum, Madrid. This monumental painting was on extended loan in New York until after the death of General Francisco Franco, when Picasso agreed to its return to his native Spain.

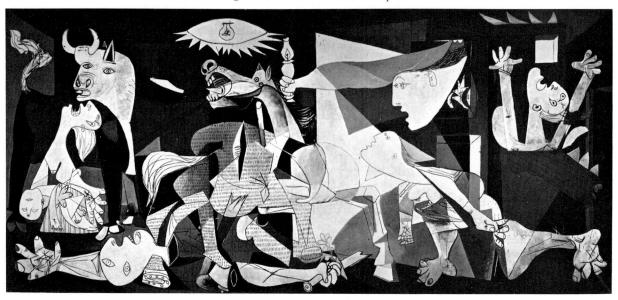

it. It is no small irony that while the dada theater group performed in Zurich's Voltaire cabaret in 1916, there lived across the street an obscure Russian political activist in exile from his native land. He also would respond to the chaos of the time but in a far different way. His name was V. I. Lenin.

Art as Protest: Guernica

The late Protestant theologian Paul Tillich once called Picasso's Guernica [17.16] the great Protestant painting. He said this not because Picasso was religious (which he was not) but because of the quality and depth of Picasso's protest against inhumanity. The title of the painting comes from the name of a small Basque town that was saturation-bombed by Germany's Condor Legion in the service of Franco's Fascist rebel forces during the Spanish Civil War. Picasso completed the huge canvas in two months— May and June 1937—so that he could exhibit it at the Paris World's Fair for that year.

There have been intense studies of the genesis and development of Guernica in order to "unlock" its symbolism, but it would be safe to begin with Picasso's particular images. Many of these images recur over and over again in his work to convey Picasso's sense of horror at the destruction of war together with his muted affirmation of hope in the face of the horror. His iconography is reinforced by its somber palette—gradations of black, brown, and white.

The very complexity of images in Guernica at first glance seems chaotic, but prolonged looking reveals a dense and ordered rhythm. Starting at the left with the bull—Picasso's symbol of brute force, of Spain, and at times of the artist himself—we see beneath the animal a woman with a broken body of a child. The echo of the Pietà theme is obvious. In the lower center and to the right is a dismembered figure, in the cubist style, over whom rears up a "screaming" horse. At the top right of the work are Picasso's only hints of hope in the face of such evil: a small open window above a supplicant figure and an emerging figure holding a lamp. Over the center is an oculus (eye) in which a lamp burns and casts off light.

As a social document the importance of Guernica cannot be overestimated. The German bombing of the little town was an experiment in a new style of warfare, a style that would be refined into a deadly technique in World War II. In Guernica Picasso innovatively combines various stylistic techniques that were employed on the eve of World War Iexpressionistic distortion and cubist abstraction—to protest a technological development that became a commonplace in the next war. In this sense, Guernica is a pivotal document—it straddles two cataclysmic struggles in the century. Guernica's cry of outrage provides an important observation about human culture. The painting reminds us that at its best the human imagination calls up the most primordial symbols of our collective experience (the woman and child, the horse and bull, the symbol of light) and invests them with new power and expressiveness fit for the demands of the age.

Art as Propaganda: Film

Propaganda is the diffusion of a point of view with the intention to persuade and convince. We usually think of it in political terms. Throughout history propagandists have used books, art, and music to spread their ideas. Inventions in the early part of the 20th century, however, added immeasurably to the propagandist's weapons.

Besides the radio the other medium that most successfully blended propaganda with attempts at some artistic vision in the first half of this century was film. Two acknowledged masters of the use of film for propaganda need be singled out since they set such a standard of excellence that, at least through their finest work, propaganda became high art.

Sergei Eisenstein (1898–1948) remains not only the greatest filmmaker the Soviet Union has produced but one of the most influential artists in the history of the cinema as well.

A dedicated supporter of the Russian Revolution, Eisenstein fully appreciated Lenin's observation that the cinema would become the foremost cultural weapon in winning the proletariat to the Revolution. From his early film Strike! (1925) to his last works, Ivan the Terrible, Parts I and II (1944/1946), Eisenstein was conscious of the class struggle, the needs of the working class, and the inevitable advance of socialism in history—themes dear to the official line of Stalin's U.S.S.R. Despite this orthodox line, Eisenstein was never an ideological hack. His films were meticulously thought out and he brought to bear his own considerable culture and learning to make films of high art. His Alexander Nevskÿ (1938) had an impressive musical score by Serge Prokofiev, and the two men worked closely to integrate musical and visual concepts. His vast Ivan the Terrible was deeply indebted to a study of El Greco's paintings; Eisenstein was struck by the cinematic possibilities in that artist's striking canvases.

Eisenstein's most influential film was Potemkin (finished at the end of 1925), the story of the 1905 naval mutiny on the battleship Potemkin and the subsequent riot in Odessa that was put down by the tsarist police. The Communists saw in that historical incident a major foreshadowing of the October Revolution of 1917, which brought the Bolsheviks to power.

17.17 Sergei Eisenstein. Still from the Odessa Steps sequence of the film Potemkin. 1925. Museum of Modern Art, Film Stills Archive, New York. This close-up is a classic shot in the history of film. The single image stands for the horror of the entire scene.

The scene in *Potemkin* of the crowd cheering the mutineers on a broad flight of stairs in Odessa and the subsequent charge of the police is a classic sequence in film history. In that sequence Eisenstein used the device of montage, the sharp juxtaposition of shots by film cutting and editing, with such power that the scene would become a benchmark for subsequent filmmakers. His close-ups were meant to convey a whole scene quickly: a shot of a wounded woman cuts to a close-up of a clenched hand that slowly opens, telling the story of death in a moment. A crazily moving baby carriage is a macabre metaphor for the entire crowd in panic and flight. Shattered eyeglasses and blood pouring from an eye [17.17] become a terrible shorthand statement of police violence.

For sheer explicit propaganda one must turn to two documentary films made in Nazi Germany in the 1930s by the popular film actress and director Leni Riefenstahl (1902–1987). Her first great film was a documentary of the 1934 Nazi Congress in Nuremburg called Triumph of the Will (1936). Designed to glorify the Nazi Party and to impress the rest of the world, the film made ample use of the great masses of party stalwarts who gathered for their rally. That documentary allowed the young filmmaker to show the party congress as a highly stylized and ritualistic celebration of the Nazi virtues of discipline, order, congregated might, and the racial superiority of the Teutonic elite of the party members.

Riefenstahl's other great film, and arguably her masterwork, was a long documentary made at the

THE ARTS AND INVENTION: Mass Media: Radio and Television

Researches into the possibility of sending sound waves from one point to another without the use of wire had advanced so far from the efforts of scientists that by 1920 there was a commercially established radio station in the United States at Pittsburgh, Pennsylvania, with the (still used) call letters KDKA. Within the next decade radio stations linked the entire country and extended beyond its borders. By the 1930s the enormous power of this new medium was apparent to everyone from manufacturers who wished to advertise their goods for sale to politicians who desired to persuade voters to their cause. The famous radio adaptation of H. G. Wells' War of the Worlds by Orson Welles, from which people actually thought that there was an invasion from Mars (causing a panic in the country), demonstrated the power of the medium. That was in 1938, in a decade that was also to see the power of radio to communicate put to brilliant use by both totalitarian governments like Nazi Germany and democracies like the United States and Great Britain.

The widespread availability of radio had a profound effect on culture. It stopped the isolation of rural people who could hear of events as they happened while, with the twist of a dial, could enrich themselves with music and drama or be entertained by light programs of humor or variety. More important, by the use of national networks (the United States was one of the few countries in which the government did not have a monopoly on national radio), a common language, a common culture, and common access to news and information were assured.

Although television was not available on a widespread basis until after the Second World War, the basic scientific work demonstrating its practicality was already evident in the 1920s. There were limited channels (and even more limited receivers) broadcasting in a number of countries before the war. Many of the advances in television derived from war-related research and in the 1950s television became a worldwide phe-

The marriage of television and space satellites, first utilized in the 1960s, gave rise to the notion of a world becoming a "global village" where it was possible for people to sit in their living rooms and watch events happening continents away. Current debates on the impact of television on everything from literacy and violence to morals and war testify to the truly revolutionary character of the invention. It is estimated that a television set is on in a typical American home about seven hours a day.

17.18 Leni Riefenstahl. Still shot from the diving sequence of Olympia. 1938. This still shows the uniquely original camera angles Riefenstahl used. Such angles became a model for documentary filmmakers.

Berlin Olympics of 1936 and issued in 1938 under the title Olympia. Riefenstahl used five camera technicians and 38 assistants as well as footage shot by news-agency photographers to make her film. The completed documentary, divided in two parts, pays tribute to the Olympic spirit of ancient Greece, develops a long section on the carrying of the Olympic torch to Berlin, records the homage to Hitler and the Nazi Party, and shows most of the major athletic competitions.

As a film Olympia is matchless in its imaginative use of the camera to catch the beauty of sport [17.18]. The vexing question is to what degree the film is political beyond the obvious homage paid to the German Reich, which sponsored the Olympics in 1936. Many critics note its elitist attitude to justify their contention that it is propaganda, albeit of a very high and subtle quality. Athletes are depicted as superior beings who act beyond the range of the ordinary mortal. They give all and seem almost demigods. The film praises the heroic, the conquest, the struggle. It praises the ritualized discipline of the crowds and lovingly seeks out examples of the adoring Berlin masses surrounding the party leaders.

Photography

Photography is a 19th-century invention, as we have seen. During the 19th century photography had a complex technological evolution as photographers sought ways to make cameras and photographic equipment more mobile. As this mobility increased, photography developed a number of specialties: portraiture, landscapes, documentation, and reportage.

More important and more basic, photography gave to the world what no other visual medium could: immediacy. Before the advent of photography it was the job of the field artist to transcribe an event in sketches and then transfer those drawings onto etching plates for reproduction in newspapers and magazines. With the photograph people could "see" events as they were actually happening. The idea that "a picture is worth a thousand words" has become a tired cliché, but it is difficult for us today to comprehend the impact the first photographs of war must have made when traveling photographers sent back to England pictures of dying soldiers in the Crimean War of the 1850s or when the American public first saw the pictures of death and devastation made by Mathew Brady (1823–1896) and his assistants during the Civil War in the 1860s.

Further technical advances, like the small portable Kodak camera invented by the American George Eastman in the late 19th century and 35mm cameras (including the famous Leica) invented in the early 20th century in Germany, contributed to the advance of photography in our century. In the period after World War I there was an intense interest in photography as a new instrument for art. Man Ray (1890-1976), an American artist living in Paris, experimented with darkroom manipulations to produce what he called rayograms. Laszlo Moholy-Nagy (1895-1946) taught a wide range of techniques in photography while he was an instructor at the influential Bauhaus school of design in Germany. When the school was closed by the Nazis, Moholy-Nagy came to the United States in 1933, where he continued to be a great influence on the development of American photography. A group of American photographers loosely connected with what was called the "f/64 Group" included pioneer photographers who are now recognized as authentic geniuses of the medium: Edward Weston (1886–1958), Ansel Adams (1902–1984), and Imogen Cunningham (1883–1975). We have already noted the influence of Alfred Stieglitz on the avant-garde art of New York. These photographers, and others like them, emphasized direct, crisp, and nonmanipulative pictures that set the standard for much of modern photography.

In the United States the most powerful pictures between the world wars that were produced for social purposes were those photographs made to show the terrible economic deprivations of the Great Depression of the 1930s. In the mid-1930s the Farm Security Administration of the United States Department of Agriculture commissioned a number of photographers to record the life of America's rural poor. The resulting portfolios of these pictures taken by such photographers as Dorothea Lange, Arthur Rothstein, and Walker Evans have become classics of

17.19 Walker Evans. The Bud Fields Family at Home, Alabama. 1935. Evans and James Agee often visited this family. Agee wrote about the family in Let Us Now Praise Famous Men. With Bud Fields, a one-mule tenant farmer, aged fifty-nine, are his second wife, Ivy (mid-twenties), their daughter (20 months), Ivy's daughter by an earlier common-law marriage (eight), Bud's and Ivy's son (three), and Ivy's mother (early fifties).

their kind. In 1941 the Pulitzer Prize-winning writer James Agee wrote a prose commentary on some of the photographs of Walker Evans. The photos of Evans and the text of James Agee were published together under the title Let Us Now Praise Famous Men [17.19]. Along with John Steinbeck's novel The Grapes of Wrath (itself turned into an Academy Award-winning film), Agee's book is one of the most moving documents of the Great Depression as well as a model of how word and picture can be brought together into an artistic whole for both social and aesthetic purposes.

Art as Prophecy: From Futurism to Brave New World

Great art always has a thrust to the future. This chapter began with the observation of William Butler Yeats that "the centre cannot hold"—a prescient observation, as the aftermath of World War I was to

Not all artists were either so pessimistic or so prophetic as Yeats. A small group of painters, sculptors, architects, and intellectuals in Italy looked to the future with hope and to the past with contempt. Known as the futurists, they exalted the values of industrial civilization, the power of urban accomplishment, and (with equal intensity) despised the artistic culture of the past. The theorist of the movement was a Milanese poet and writer, Filippo Tommaso Marinetti (1876-1944), who issued a long series of futurist manifestos between 1908 and 1915.

In the few years during which futurism flourished its followers produced some significant painting, sculpture, and ideas about city planning and urban architecture. World War I was to end their posturings; the sculptor Umberto Boccioni and the futurist architect Antonio Sant'Elia were both to die in 1916, victims of the war. Some of the futurists, including Marinetti, true to their fascination with power, war, destruction, and the exaltation of might, would be increasingly used as apologists for the emerging Fascist movement in Italy. Thus a painting like Gino Severini's Armored Train [17.20] proved prophetic in ways not quite appreciated in 1915.

The futurist romance with industrial culture and the idea of technological "progress" was not shared by all artists of the 20th century. We have already noted that T. S. Eliot pronounced his world a waste

CONTEMPORARY VOICES

Virginia Woolf

Then Joyce is dead: Joyce about a fortnight younger than I am. I remember Miss Weaver, in wool gloves, bringing Ulysses in typescript to our teatable at Hogarth House . . . One day Catherine [sic] Mansfield came, and I had it out. She began to read, ridiculing: then suddenly said: But there's something in this: a scene that should figure I suppose in the history of literature . . . Then I remember Tom [T. S. Eliot] saying: how could anyone write again after the immense prodigy of that last chapter?

We were in London on Monday. I went to London Bridge. I looked at the river; very misty; some tufts of smoke, perhaps from burning houses. There was another fire on Saturday. Then I saw a cliff of wall, eaten out, at one corner; a great corner all smashed: a bank; the monument erect: tried to get a bus; but such a block I dismounted; and the second bus advised me to walk. A complete jam of traffic; for streets were being blown up. So by Tube to the Temple; and there wandered in the desolate ruins of my old squares: gashed, dismantled; the old red bricks all white powder, something like a builder's vard. Grey dirt and broken windows. Sightseers; all that completeness ravished and demolished.

An abridged entry in Virginia Woolf's diary for January 15, 1941, describing the results of the German bombing of London. Shortly after this entry Virginia Woolf committed suicide.

17.20 Gino Severini. Armored Train in Action. 1915. Oil on canvas, $45\frac{3}{8}$ " × $34\frac{7}{8}$ " (177 × 88 cm). Collection, The Museum of Modern Art, New York (gift of Richard S. Zeisler). The influence of cubism in the composition is obvious.

land. The American novelist Sinclair Lewis (1885-1951) viciously satirized American complacency in the postwar period. His novel Babbitt (1922) was a scathing indictment of the middle-class love of the concept of "a chicken in every pot and two cars in every garage." His philistine hero, George Babbitt, became synonymous with a mindless materialism in love with gadgets, comfort, and simplistic Midwestern values.

By contrast, the English novelist Aldous Huxley (1894–1963) saw the unrestrained growth of technology as an inevitable tool of totalitarian control over individuals and society. His 1932 novel Brave New World was a harbinger of a whole literature of prophetic warning about the dangers in our future. The two most famous prophetic works of the post-World War II era are Animal Farm (1945) and 1984 (1949), both by the English writer George Orwell, the pen name used by Eric Arthur Blair (1903-1950).

Huxley's Brave New World is set in the far distant future—600 A.F. (After [Henry] Ford, who had been deified as the founder of industrial society because he developed the assembly line). In this society babies are raised in state hatcheries according to the needs of the state. They are produced in five classes (from

Alpha to Epsilon) so that the exact numbers of needed intellectuals (Alphas) and menials (Epsilons) are produced. The goal of society is expressed in three words: Community/Identity/Stability. All sensory experience is supplied either by machines or a pleasure-drug called soma. Individuality, family relationships, creativity, and a host of other "unmanageable" human qualities have been eradicated from society either by coercion or programming.

Toward the end of the novel there is a climactic conversation between John Savage, a boy from the wilds of New Mexico raised outside the control of society, and Mustapha Mond, one of the controllers of the "brave new world" of the future. Patiently, Mustapha Mond explains to the uncivilized young man the reasons why certain repressions are inevitable and necessary in the society of the future. The reader sees rather clearly how aware Huxley is that the great humanistic achievements of the past literature, art, religion—are threatening forces to any totalitarian society and as such are logical targets for a "scientifically" constructed society. His explanations now have a prescient and somber reality to us in the light of what we know about the real totalitarian societies of our own time.

Summary

What made World War I so terrible was the advanced technologies used in the service of death. The old military charge against an enemy was obsolete with the invention of the machine gun just as the use of poison gas (not outlawed until after the war) made a mockery of military exercises of strategy. The result was an appalling slaughter of youth on a scale unparalleled in human history.

In the period between the wars the memory of that slaughter shook the intellectuals to the core. Their response to it was predictable enough: protest or pacifism or a total distrust of the powers of rationality to cope with human evil. The reaction to the Great War ranged, in short, from T. S. Eliot's combination of pessimism and faith to the playful nonsense of the dada artists and the inner retreat of the surrealists.

The technological advances that had made the war so terrible also gave promise of new forms of communication that would radically advance the arts into new and different fields. The widespread development of radio networks, the transition of the movies from the silent screen to the "talkies," the increased mobility brought about by the automobile, and the advances in photography would not only produce new art forms but make their availability to larger

Coupled with these advances were some profound shifts in social status. People were leaving rural areas in great numbers for the factories of the cities of America and Europe. The old social stratification of the classes was beginning to break down in Europe. The economic dislocations brought on by the war caused urban poverty in Europe and, after a giddy decade of prosperity in the 1920s, the depression years in the United States. In response to these social and economic dislocations new political movements seemed attractive and compelling. Hitler's National Socialist Party rose against the background of Germany's defeat, as did Mussolini's Fascists. The period between the wars also saw the consolidation of Communist power in Russia and the rise of the totalitarian state under Stalin.

Finally, we should note some other fundamental (and radical) ideas that were beginning to gain currency. Einsteinian physics were changing the picture of the world in which we lived while containing the seeds of the atomic era. Sigmund Freud's ideas were also radically reshaping our notions of the interior landscape of the human soul.

All of these forces—political, technological, scientific, social, and artistic—gave a shape to a culture that in its richness (and sadness) we call the Western world between the two great wars.

Pronunciation Guide

Braque: BRAWK **Breton:** Bre-TAWN Buñuel: BON-well Chagall: SHAW-ghel Diaghilev: DAWG-awl-eff Duchamp: Dew-SHAWM Guernica: GHER-knee-ka

Kafka: KAUF-ka

Mustapha Mond: MUS-taw-fa MOND

Nijinsky: Nidge-IN-ski Riefenstahl: REEF-in-stall Stravinsky: Stra-VIN-ski

Exercises

1. Look carefully at a cubist painting. Can you analyze the precise manner in which a Picasso or a Braque tries to get us to see in a new and unaccustomed way?

2. Some people have called Kafka a surrealist writer. Is that an apt description of his writing? Is "dreamlike" ("nightmarish"?) an apt way to think of his writing?

3. Jazz is still a much-respected art form today. Give a description of what you understand by jazz and distinguish it from rock music.

4. Discuss ways in which photography and film are used for propaganda purposes and/or political ends. You could begin by exploring how election films are used in our culture or television commercials made for public persuasion either as advertisements or for public-service

5. Discuss Brave New World as an antitotalitarian novel. Tell about other books you have read or films you have seen that attempt to convey the same message.

6. Identify the religious message of Eliot's poems. How do they relate to the protest that is so much a part of the culture of the time?

7. Make (or describe) a dada art work that would outrage a contemporary viewer.

Further Reading

Arnason, H. H. History of Modern Art. Englewood Cliffs, N.J.: Prentice-Hall, 1977. The standard basic survey of modern art in English.

Berman, Marshall. All That is Solid Melts into the Air: The Experience of Modernity. New York: Simon & Schuster, 1981. An ambitious account of modernity in the 20th

Ellmann, Richard and Feidelson R., eds. The Modern Tradition: Backgrounds of Modern Literature. New York: Oxford, 1965. A somewhat dated but still useful and wideranging collection of texts.

Fussell, Paul. The Great War and Modern Memory. New York: Oxford, 1976. A brilliant study of how World War I changed the artistic life of Europe and America.

Harrison, Max. "Jazz" in The New Grove Dictionary of Music and Musicians, edited by S. Sadie (New York: Macmillan, 1980). A panoramic treatment with full bibliographies of books and journals as well as discographies. Grove is the standard reference in English for

Hayman, Ronald. Kafka: A Biography. New York: Oxford, 1981. A readable biography. Good for the intellectual background of German culture between the wars.

Hughes, Robert. The Shock of the New. New York: Knopf, 1981. A provocative study of modern art developed from the television series of the same name.

Newhall, Beaumont. The History of Photography from 1839 to the Present Day, rev. ed. New York: New York Graphic Society, 1978. An excellent survey.

Wilson, Edmund. Axel's Castle. New York: Scribner, 1936. The classic critical work on literary modernism; still useful.

Reading Selections

T. S. Eliot THE HOLLOW MEN

This poem tracks two basic themes that run through all of Eliot's poetry: the alienation of modern people as a result of a loss of traditional values and the response of faith as an affirmation of some deep center that anchors human life in such a time of cultural decay.

Mistah Kurtz—he dead, A penny for the Old Guy.

We are the hollow men We are the stuffed men Leaning together Headpiece filled with straw. Alas! Our dried voices, when We whisper together Are quiet and meaningless As wind in dry grass Or rats' feet over broken glass In our dry cellar Shape without form, shade without colour, Paralysed force, gesture without motion; Those who have crossed With direct eyes, to death's other Kingdom Remember us-if at all-not as lost Violent souls, but only As the hollow men

II

The stuffed men.

Eves I dare not meet in dreams In death's dream kingdom These do not appear: There, the eyes are Sunlight on a broken column There, is a tree swinging And voices are In the wind's singing More distant and more solemn Than a fading star.

Let me be no nearer In death's dream kingdom Let me also wear Such deliberate disguises Rat's coat, crowskin, crossed staves In a field Behaving as the wind behaves No nearer-Not that final meeting In the twilight kingdom.

Ш

This is the dead land This is cactus land Here the stone images Are raised, here they receive The supplication of a dead man's hand Under the twinkle of a fading star. Is it like this In death's other kingdom Waking alone At the hour when we are Trembling with tenderness Lips that would kiss Form prayers to broken stone.

IV

The eyes are not here There are no eyes here In this valley of dying stars In this hollow valley This broken jaw of our lost kingdoms.

In this last of meeting places We grope together And avoid speech Gathered on this beach of the tumid river.

Sightless, unless The eyes reappear As the perpetual star Multifoliate rose Of death's twilight kingdom The hope only Of empty men.

Here we go round the prickly pear Prickly pear prickly pear Here we go round the prickly pear At five o'clock in the morning.

Between the idea And the reality Between the motion And the act Falls the shadow For Thine is the Kingdom

Between the conception And the creation

70

30

50

Between the emotion And the response Falls the Shadow Life is very long

Between the desire And the spasm Between the potency And the existence Between the essence And the descent Falls the Shadow For Thine is the Kingdom

For Thine is Life is For Thine is the

This is the way the world ends This is the way the world ends This is the way the world ends Not with a bang but a whimper.

James Joyce From the opening chapter of **ULYSSES**

The great novel of modernism opens with echos of Catholic religious services and an introduction of Stephen Dedalus who bears an "absurd name" which is more Greek than Irish. Dedalus had previously appeared in Portrait of the Artist as a Young Man and represents the experiences of Joyce himself as he grew up in turn-of-the-century Dublin.

To get some sense of Joyce's style and technique one must read carefully and slowly as he weaves together conversation, allusions to the city of Dublin, fragments of songs, recollections of family life, and the theme of search in this great retelling of the ancient myth of Ulysses.

Stately, plump Buck Mulligan came from the stairhead, bearing a bowl of lather on which a mirror and a razor lay crossed. A yellow dressinggown, ungirdled, was sustained gently behind him by the mild morning air. He held the bowl aloft and intoned:

—Introibo ad altare Dei.

Halted, he peered down the dark winding stairs and called up coarsely:

—Come up, Kinch. Come up, you fearful jesuit. Solemnly he came forward and mounted the round gunrest. He faced about and blessed gravely thrice the tower, the surrounding country and the awaking mountains. Then, catching sight of Stephen Dedalus, he bent towards him and made rapid crosses in the air, gurgling in this throat and shaking his head. Stephen Dedalus, displeased and sleepy, leaned his arms on the top of the staircase and looked coldly at the shaking gurgling face that blessed him, equine in its length, and at the light untonsured hair, grained and hued like pale oak.

Buck Mulligan peeped an instant under the mirror

and then covered the bowl smartly.

—Back to barracks, he said sternly.

He added in a preacher's tone:

-For this, O dearly beloved, is the genuine Christine: body and soul and blood and ouns. Slow music, please. Shut your eyes, gents. One moment. A little trouble about those white corpuscles. Silence, all.

He peered sideways up and gave a long low whistle of call, then paused awhile in rapt attention, his even white teeth glistening here and there with gold points. Chrysostomos. Two strong shrill whistles answered through the calm.

—Thanks, old chap, he cried briskly. That will do

nicely. Switch off the current, will you?

He skipped off the gunrest and looked gravely at his watcher, gathering about his legs the loose folds of his gown. The plump shadowed face and sullen oval jowl recalled a prelate, patron of arts in the middle ages. A pleasant smile broke quietly over his lips.

—The mockery of it, he said gaily. Your absurd

name, an ancient Greek.

He pointed his finger in friendly jest and went over to the parapet, laughing to himself. Stephen Dedalus stepped up, followed him wearily halfway and sat down on the edge of the gunrest, watching him still as he propped his mirror on the parapet, dipped the brush in the bowl and lathered cheeks and neck.

Buck Mulligan's gay voice went on.

—My name is absurd too: Malachi Mulligan, two dactyls. But it has a Hellenic ring, hasn't it? Tripping and sunny like the buck himself. We must go to Athens. Will you come if I can get the aunt to fork out twenty quid?

He laid the brush aside and, laughing with delight,

cried:

—Will he come? The jejune jesuit. Ceasing, he began to shave with care.

—Tell me, Mulligan, Stephen said quietly.

—Yes, my love?

—How long is Haines going to stay in this tower? Buck Mulligan showed a shaven cheek over his right shoulder.

-God, isn't he dreadful? he said frankly. A ponderous Saxon. He thinks you're not a gentleman. God, these bloody English. Bursting with money and indigestion. Because he comes from Oxford. You know, Dedalus, you have the real Oxford manner. He can't make you out. O, my name for you is the best: Kinch, the knifeblade.

He shaved warily over his chin.

—He was raving all night about a black panther, Stephen said. Where is his guncase?

-A woful lunatic, Mulligan said. Were you in a

funk?

—I was, Stephen said with energy and growing fear. Out here in the dark with a man I don't know raving and moaning to himself about shooting a black panther. You saved men from drowning. I'm not a hero, however. If he stays on here I am off.

Buck Mulligan frowned at the lather on his razorblade. He hopped down from his perch and began to

search his trouser pockets hastily.

—Scutter, he cried thickly.

He came over to the gunrest and, thrusting a hand into Stephen's upper pocket, said:

-Lend us a loan of your noserag to wipe my

razor.

Stephen suffered him to pull out and hold up on show by its corner a dirty crumpled handkerchief. Buck Mulligan wiped the razorblade neatly. Then, gazing over the handkerchief, he said:

—The bard's noserag. A new art colour for our Irish poets: snotgreen. You can almost taste it, can't

He mounted to the parapet again and gazed out over Dublin bay, his fair oakpale hair stirring

-God, he said quietly. Isn't the sea what Algy calls it: a grey sweet mother? The snotgreen sea. The scrotumtightening sea. Epi oinopa ponton. Ah, Dedalus, the Greeks. I must teach you. You must read them in the original. Thalatta! Thalatta! She is our great sweet mother. Come and look.

Stephen stood up and went over to the parapet. Leaning on it he looked down on the water and on the mailboat clearing the harbour mouth of Kings-

—Our mighty mother, Buck Mulligan said.

He turned abruptly his great searching eyes from the sea to Stephen's face.

—The aunt thinks you killed your mother, he said. That's why she won't let me have anything to do with you.

—Someone killed her, Stephen said gloomily.

-You could have knelt down, damn it, Kinch, when your dying mother asked you, Buck Mulligan said. I'm hyperborean as much as you. But to think of your mother begging you with her last breath to kneel down and pray for her. And you refused. There is something sinister in you. .

He broke off and lathered again lightly his farther

cheek. A tolerant smile curled his lips.

—But a lovely mummer, he murmured to himself. Kinch, the loveliest mummer of them all.

He shaved evenly and with care, in silence, seriously.

Stephen, an elbow rested on the jagged granite, leaned his palm against his brow and gazed at the fraying edge of his shiny black coatsleeve. Pain, that was not yet the pain of love, fretted his heart. Silently, in a dream she had come to him after her death, her wasted body within its loose brown graveclothes giving off an odour of wax and rosewood, her breath, that had bent upon him, mute, reproachful, a faint odour of wetted ashes. Across the threadbare cuffedge he saw the sea hailed as a great sweet mother by the wellfed voice beside him. The ring of bay and skyline held a dull green mass of liquid. A bowl of white china had stood beside her deathbed holding the green sluggish bile which she had torn up from her rotting liver by fits of loud groaning vomiting.

Buck Mulligan wiped again his razorblade.

—Ah, poor dogsbody, he said in a kind voice. I must give you a shirt and a few noserags. How are the secondhand breeks?

—They fit well enough, Stephen answered.

Buck Mulligan attacked the hollow beneath his underlip.

—The mockery of it, he said contentedly, secondleg they should be. God knows what poxy bowsy left them off. I have a lovely pair with a hair stripe, grey. You'll look spiffing in them. I'm not joking, Kinch. You look damn well when you're dressed.

—Thanks, Stephen said. I can't wear them if they

are grey.

—He can't wear them, Buck Mulligan told his face in the mirror. Etiquette is etiquette. He kills his mother but he can't wear grey trousers.

He folded his razor neatly and with stroking palps

of fingers felt the smooth skin.

Stephen turned his gaze from the sea and to the

plump face with its smokeblue mobile eyes.

—That fellow I was with in the Ship last night, said Buck Mulligan, says you have g. p. i. He's up in Dottyville with Conolly Norman. General paralysis of the insane.

He swept the mirror a half circle in the air to flash the tidings abroad in sunlight now radiant on the sea. His curling shaven lips laughed and the edges of his white glittering teeth. Laughter seized all his strong wellknit trunk.

—Look at yourself, he said, you dreadful bard. Stephen bent forward and peered at the mirror held out to him, cleft by a crooked crack, hair on end. As he and others see me. Who chose this face for me? This dogsbody to rid of vermin. It asks me too.

—I pinched it out of the skivvy's room, Buck Mulligan said. It does her all right. The aunt always keeps plainlooking servants for Malachi. Lead him not into temptation. And her name is Ursula.

Laughing again, he brought the mirror away from Stephen's peering eyes.

—The rage of Caliban at not seeing his face in a mirror, he said. If Wilde were only alive to see you.

Drawing back and pointing, Stephen said with bitterness:

-It is a symbol of Irish art. The cracked lookingglass of a servant.

Buck Mulligan suddenly linked his arm in Stephen's and walked with him round the tower, his razor and mirror clacking in the pocket where he had thrust them.

—It's not fair to tease you like that, Kinch, is it? he said kindly. God knows you have more spirit than any of them.

Parried again. He fears the lancet of my art as I fear

that of his. The cold steelpen.

-Cracked lookingglass of a servant. Tell that to the oxy chap downstairs and touch him for a guinea. He's stinking with money and thinks you're not a gentleman. His old fellow made his tin by selling jalap to Zulus or some bloody swindle or other. God, Kinch, if you and I could only work together we might do something for the island. Hellenize it.

Cranly's arm. His arm.

—And to think of your having to beg from these swine. I'm the only one that knows what you are. Why don't you trust me more? What have you up your nose against me? Is it Haines? If he makes any noise here I'll bring down Seymour and we'll give him a ragging worse than they gave Clive Kempthorpe.

Young shouts of moneyed voices in Clive Kempthorpe's rooms. Palefaces: they hold their ribs with laughter, one clasping another, O, I shall expire! Break the news to her gently, Aubrey! I shall die! With slit ribbons of his shirt whipping the air he hops and hobbles round the table, with trousers down at heels, chased by Ades of Magdalen with the tailor's shears. A scared calf's face gilded with marmalade. I don't want to be debagged! Don't you play the giddy ox with me!

Shouts from the open window startling evening in the quadrangle. A deaf gardener, aproned, masked with Matthew Arnold's face, pushes his mower on the sombre lawn watching narrowly the dancing motes of grasshalms.

To ourselves . . . new paganism . . . omphalos.

—Let him stay, Stephen said. There's nothing wrong with him except at night.

-Then what is it? Buck Mulligan asked impatiently. Cough it up. I'm quite frank with you. What have you against me now?

They halted, looking towards the blunt cape of Bray Head that lay on the water like the snout of a sleeping whale. Stephen freed his arm quietly.

—Do you wish me to tell you? he asked.

—Yes, what is it? Buck Mulligan answered. I

don't remember anything.

He looked in Stephen's face as he spoke. A light wind passed his brow, fanning softly his fair uncombed hair and stirring silver points of anxiety in his eyes.

Stephen, depressed by his own voice, said:

—Do you remember the first day I went to your house after my mother's death?

Buck Mulligan frowned quickly and said:

—What? Where? I can't remember anything. I remember only ideas and sensations. Why? What

happened in the name of God?

- -You were making tea, Stephen said, and I went across the landing to get more hot water. Your mother and some visitor came out of the drawingroom. She asked you who was in your
- —Yes? Buck Mulligan said. What did I say? I forget.
- —You said, Stephen answered, O, it's only Dedalus whose mother is beastly dead.

A flush which made him seem younger and more engaging rose to Buck Mulligan's cheek.

—Did I say that? he asked. Well? What harm is that?

He shook his constraint from him nervously.

-And what is death, he asked, your mother's or yours or my own? You saw only your mother die. I see them pop off every day in the Mater and Richmond and cut up into tripes in the dissecting room. It's a beastly thing and nothing else. It simply doesn't matter. You wouldn't kneel down to pray for your mother on her deathbed when she asked you. Why? Because you have the cursed jesuit strain in you, only it's injected the wrong way. To me it's all a mockery and beastly. Her cerebral lobes are not functioning. She calls the doctor Sir Peter Teazle and picks buttercups off the quilt. Humour her till it's over. You crossed her last wish in death and yet you sulk with me because I don't whinge like some hired mute from Lalouette's. Absurd! I suppose I did say it. I didn't mean to offend the memory of your mother.

He had spoken himself into boldness. Stephen, shielding the gaping wounds which the words had left in his heart, said very coldly:

—I am not thinking of the offence to my mother.

—Of what, then? Buck Mulligan asked.

—Of the offence to me, Stephen answered. Buck Mulligan swung round on his heel.

—O, an impossible person! he exclaimed.

He walked off quickly round the parapet. Stephen stood at his post, gazing over the calm sea towards the headland. Sea and headland now grew dim.

Pulses were beating in his eyes, veiling their sight, and he felt the fever of his cheeks.

A voice within the tower called loudly:

—Are you up there, Mulligan?

—I'm coming, Buck Mulligan answered.

He turned towards Stephen and said:

-Look at the sea. What does it care about offences? Chuck Loyola, Kinch, and come on down. The Sassenach wants his morning rashers.

His head halted again for a moment at the top of

the staircase, level with the roof.

—Don't mope over it all day, he said. I'm inconsequent. Give up the moody brooding.

His head vanished but the drone of his descending voice boomed out of the stairhead:

And no more turn aside and brood Upon love's bitter mystery For Fergus rules the brazen cars.

Woodshadows floated silently by through the morning peace from the stairhead seaward where he gazed. Inshore and farther out the mirror of water whitened, spurned by lightshod hurrying feet. White breast of the dim sea. The twining stresses, two by two. A hand plucking the harpstrings merging their twining chords. Wavewhite wedded words shimmering on the dim tide.

A cloud began to cover the sun slowly, shadowing the bay in deeper green. It lay behind him, a bowl of bitter waters. Fergus' song: I sang it alone in the house, holding down the long dark chords. Her door was open: she wanted to hear my music. Silent with awe and pity I went to her bedside. She was crying in her wretched bed. For those words, Stephen: love's

bitter mystery.

Where now?

Her secrets: old feather fans, tasselled dancecards, powdered with musk, a gaud of amber beads in her locked drawer. A birdcage hung in the sunny window of her house when she was a girl. She heard old Royce sing in the pantomime of Turko the terrible and laughed with others when he sang:

I am the boy That can enjoy Invisibility.

Phantasmal mirth, folded away: muskperfumed.

And no more turn aside and brood

Folded away in the memory of nature with her toys. Memories beset his brooding brain. Her glass of water from the kitchen tap when she had approached the sacrament. A cored apple, filled with brown sugar, roasting for her at the hob on a dark autumn evening. Her shapely fingernails reddened by the blood of squashed lice from the children's shirts.

In a dream, silently, she had come to him, her wasted body within its loose graveclothes giving off an odour of wax and rosewood, her breath bent over him with mute secret words, a faint odour of wetted

Her glazing eyes, staring out of death, to shake and bend my soul. On me alone. The ghostcandle to light her agony. Ghostly light on the tortured face. Her hoarse loud breath rattling in horror, while all prayed on their knees. Her eyes on me to strike me down. Liliata rutilantium te confessorum turma circumdet: iubilantium te virginum chorus excipiat.

Ghoul! Chewer of corpses!

No mother. Let me be and let me live.

—Kinch ahoy!

Buck Mulligan's voice sang from within the tower. It came nearer up the staircase, calling again. Stephen, still trembling at his soul's cry, heard warm running sunlight and in the air behind him friendly

—Dedalus, come down, like a good mosey. Breakfast is ready. Haines is apologizing for waking us last night. It's all right.

—I'm coming, Stephen said, turning.

—Do, for Jesus' sake, Buck Mulligan said. For my sake and for all our sakes.

His head disappeared and reappeared.

—I told him your symbol of Irish art. He says it's very clever. Touch him for a quid, will you? A guinea, I mean.

—I get paid this morning, Stephen said.

—The school kip? Buck Mulligan said. How much? Four quid? Lend us one.

—If you want it, Stephen said.

-Four shining sovereigns, Buck Mulligan cried with delight. We'll have a glorious drunk to astonish the druidy druids. Four omnipotent sovereigns.

He flung up his hands and tramped down the stone stairs, singing out of tune with a Cockney accent:

O, won't we have a merry time Drinking whisky, beer and wine, On coronation. Coronation day? O, won't we have a merry time On coronation day?

Warm sunshine merrying over the sea. The nickel shaving-bowl shone, forgotten, on the parapet. Why should I bring it down? Or leave it there all day, forgotten friendship?

He went over to it, held it in his hands awhile, feeling its coolness, smelling the clammy slaver of the lather in which the brush was stuck. So I carried the boat of incense then at Clongowes. I am another now and yet the same. A servant too. A server of a servant.

In the gloomy domed livingroom of the tower Buck Mulligan's gowned form moved briskly about the hearth to and fro, hiding and revealing its yellow glow. Two shafts of soft daylight fell across the flagged floor from the high barbicans: and at the meeting of their rays a cloud of coalsmoke and fumes of fried grease floated, turning.

—We'll be choked, Buck Mulligan said. Haines,

open that door, will you?

Stephen laid the shavingbowl on the locker. A tall figure rose from the hammock where it had been sitting, went to the doorway and pulled open the inner doors.

—Have you the key? a voice asked.

Dedalus has it, Buck Mulligan said. Janey Mack, I'm choked.

He howled without looking up from the fire:

—Kinch!

—It's in the lock, Stephen said, coming forward. The key scraped round harshly twice and, when the heavy door had been set ajar, welcome light and bright air entered. Haines stood at the doorway, looking out. Stephen haled his upended valise to the table and sat down to wait. Buck Mulligan tossed the fry on to the dish beside him. Then he carried the dish and a large teapot over to the table, set them down heavily and sighed with relief.

—I'm melting, he said, as the candle remarked when . . . But hush. Not a word more on that subject. Kinch, wake up. Bread, butter, honey. Haines, come in. The grub is ready. Bless us, O Lord, and these thy gifts. Where's the sugar? O, jay, there's no

milk.

Stephen fetched the loaf and the pot of honey and the buttercooler from the locker. Buck Mulligan sat down in a sudden pet.

—What sort of a kip is this? he said. I told her to come after eight.

—We can drink it black, Stephen said. There's a lemon in the locker.

—O, damn you and your Paris fads, Buck Mulligan said. I want Sandycove milk.

Haines came in from the doorway and said quietly:

—That woman is coming up with the milk.

—The blessings of God on you, Buck Mulligan cried, jumping up from his chair. Sit down. Pour out the tea there. The sugar is in the bag. Here, I can't go fumbling at the damned eggs. He hacked through the fry on the dish and slapped it out on three plates, saying:

—In nomine Patris et Filii et Spiritus Sancti.

Haines sat down to pour out the tea.

—I'm giving you two lumps each, he said. But, I say, Mulligan, you do make strong tea, don't you? Buck Mulligan, hewing thick slices from the loaf.

said in an old woman's wheedling voice:

—When I makes tea I makes tea, as old mother Grogan said. And when I makes water I makes water.

—By Jove, it is tea, Haines said.

Buck Mulligan went on hewing and wheedling: —So I do, Mrs Cahill, says she. Begob, ma'am, says Mrs Cahill, God send you don't make them in the one pot.

He lunged towards his messmates in turn a thick

slice of bread, impaled on his knife.

—That's folk, he said very earnestly, for your book, Haines. Five lines of text and ten pages of notes about the folk and the fishgods of Dundrum. Printed by the weird sisters in the year of the big

He turned to Stephen and asked in a fine puzzled

voice, lifting his brows:

—Can you recall, brother, is mother Grogan's tea and water pot spoken of in the Mabinogion or is it in the Upanishads?

—I doubt it, said Stephen gravely.

-Do you now? Buck Mulligan said in the same

tone. Your reasons, pray?

—I fancy, Stephen said as he ate, it did not exist in or out of the Mabinogion. Mother Grogan was, one imagines, a kinswoman of Mary Ann.

Buck Mulligan's face smiled with delight.

—Charming, he said in a finical sweet voice, showing his white teeth and blinking his eyes pleasantly. Do you think she was? Quite charming.

Then, suddenly overclouding all his features, he growled in a hoarsened rasping voice as he hewed again vigorously at the loaf:

-For old Mary Ann

She doesn't care a damn,

But, hising up her petticoats. . .

He crammed his mouth with fry and munched and droned.

The doorway was darkened by an entering form.

—The milk, sir.

—Come in, ma'am, Mulligan said. Kinch, get the

An old woman came forward and stood by Stephen's elbow.

—That's a lovely morning, sir, she said. Glory be

—To whom? Mulligan said, glancing at her. Ah, to be sure.

Stephen reached back and took the milkjug from the locker.

—The islanders, Mulligan said to Haines casually, speak frequently of the collector of prepuces.

-How much, sir? asked the old woman.

—A quart, Stephen said.

He watched her pour into the measure and thence into the jug rich white milk, not hers. Old shrunken paps. She poured again a measureful and a tilly. Old and secret she had entered from a morning world, maybe a messenger. She praised the goodness of the milk, pouring it out. Crouching by a patient cow at daybreak in the lush field, a witch on her toadstool, her wrinkled fingers quick at the squirting dugs. They lowed about her whom they knew, dewsilky cattle. Silk of the kine and poor old woman, names given her in old times. A wandering crone, lowly form of an immortal serving her conqueror and her gay betrayer, their common cuckquean, a messenger from the secret morning. To serve or to upbraid, whether he could not tell: but scorned to beg her favour.

—It is indeed, ma'am, Buck Mulligan said, pouring milk into their cups.

-Taste it, sir, she said. He drank at her bidding.

—If we could only live on good food like that, he said to her somewhat loudly, we wouldn't have the country full of rotten teeth and rotten guts. Living in a bogswamp, eating cheap food and the streets paved with dust, horsedung and consumptives' spits.

—Are you a medical student, sir? the old woman

asked.

—I am, ma'am, Buck Mulligan answered.

Stephen listened in scornful silence. She bows her old head to a voice that speaks to her loudly, her bonesetter, her medicineman; me she slights. To the voice that will shrive and oil for the grave all there is of her but her woman's unclean loins, of man's flesh made not in God's likeness, the serpent's prey. And to the loud voice that now bids her be silent with wondering unsteady eyes.

—Do you understand what he says? Stephen

asked her.

—Is it French you are talking, sir? the old woman said to Haines.

Haines spoke to her again a longer speech, confidently.

-Irish, Buck Mulligan said. Is there Gaelic on you?

—I thought it was Irish, she said, by the sound of it. Are you from west, sir?

—I am an Englishman, Haines answered.

-He's English, Buck Mulligan said, and he thinks we ought to speak Irish in Ireland.

-Sure we ought to, the old woman said, and I'm ashamed I don't speak the language myself. I'm told it's a grand language by them that knows.

—Grand is no name for it, said Buck Mulligan. Wonderful entirely. Fill us out some more tea,

Kinch. Would you like a cup, ma'am?

-No, thank you, sir, the old woman said, slipping the ring of the milkcan on her forearm and about to go.

Haines said to her:

—Have you your bill? We had better pay her, Mulligan, hadn't we?

Stephen filled the three cups.

-Bill, sir? she said, halting. Well, it's seven mornings a pint at twopence is seven twos is a shilling and twopence over and these three mornings a quart at fourpence is three quarts is a shilling and one and two is two and two, sir.

Buck Mulligan sighed and having filled his mouth with a crust thickly buttered on both sides, stretched forth his legs and began to search his trouser pockets.

—Pay up and look pleasant, Haines said to him

smiling.

Stephen filled a third cup, a spoonful of tea colouring faintly the thick rich milk. Buck Mulligan brought up a florin, twisted it round in his fingers and cried:

—A miracle!

He passed it along the table towards the old woman, saying:

—Ask nothing more of me, sweet. All I can give you I give.

Stephen laid the coin in her uneager hand.

—We'll owe twopence, he said.

—Time enough, sir, she said, taking the coin. Time enough. Good morning, sir.

She curtseved and went out, followed by Buck Mulligan's tender chant:

—Heart of my heart, were it more, More would be laid at your feet.

He turned to Stephen and said:

-Seriously, Dedalus. I'm stony. Hurry out to your school kip and bring us back some money. Today the bards must drink and junket. Irelands expects that every man this day will do his duty.

—That reminds me, Haines said, rising, that I

have to visit your national library today.

—Our swim first, Buck Mulligan said. He turned to Stephen and asked blandly:

—Is this the day for your monthly wash, Kinch? Then he said to Haines?

-The unclean bard makes a point of washing once a month.

—All Ireland is washed by the gulfstream, Stephen said as he let honey trickle over a slice of the loaf.

Haines from the corner where he was knotting easily a scarf about the loose collar of his tennis shirt spoke:

—I intend to make a collection of your sayings if you will let me.

Speaking to me. They wash and tub and scrub. Agenbite of inwit. Conscience. Yet here's a spot.

—That one about the cracked lookingglass of a servant being the symbol of Irish art is deuced good.

Buck Mulligan kicked Stephen's foot under the table and said with warmth of tone:

-Wait till you hear him on Hamlet, Haines.

- -Well, I mean it, Haines said, still speaking to Stephen. I was just thinking of it when that poor old creature came in.
- -Would I make money by it? Stephen asked. Haines laughed and, as he took his soft grey hat from the holdfast of the hammock, said:

—I don't know, I'm sure.

He strolled out to the doorway. Buck Mulligan bent across to Stephen and said with coarse vigour:

—You put your hoof in it now. What did you say that for?

-Well? Stephen said. The problem is to get money. From whom? From the milkwoman or from him. It's a toss up, I think.

—I blow him out about you, Buck Mulligan said, and then you come along with your lousy leer and your gloomy jesuit jibes.

—I see little hope, Stephen said, from her or from him.

Buck Mulligan sighed tragically and laid his hand on Stephen's arm.

—From me, Kinch, he said.

In a suddenly changed tone he added:

—To tell you the God's truth I think you're right. Damn all else they are good for. Why don't you play them as I do? To hell with them all. Let us get out of the kip.

He stood up, gravely ungirdled and disrobed himself of his gown, saying resignedly:

—Mulligan is stripped of his garments. He emptied his pockets on to the table.

—There's your snotrag, he said.

And putting on his stiff collar and rebellious tie, he spoke to them, chiding them, and to his dangling watchchain. His hands plunged and rummaged in his trunk while he called for a clean handkerchief. Agenbite of inwit. God, we'll simply have to dress the character. I want puce gloves and green boots. Contradiction. Do I contradict myself? Very well then, I contradict myself. Mercurial Malachi. A limp black missile flew out of his talking hands.

—And there's your Latin quarter hat, he said. Stephen picked it up and put it on. Haines called to them from the doorway:

—Are you coming, you fellows?

-I'm ready, Buck Mulligan answered, going towards the door. Come out, Kinch. You have eaten all we left, I suppose. Resigned he passed out with grave words and gait, saying, wellnigh with sorrow:

—And going forth he met Butterly.

Stephen, taking his ashplant from its leaningplace, followed them out and, as they went down the ladder, pulled to the slow iron door and locked it. He put the huge key in his inner pocket.

At the foot of the ladder Buck Mulligan asked:

—Did you bring the key?

—I have it, Stephen said, preceding them.

He walked on. Behind him he heard Buck Mulligan club with his heavy bathtowel the leader shoots of ferns or grasses.

—Down, sir. How dare you, sir?

Haines asked.

—Do you pay rent for this tower?

—Twelve quid, Buck Mulligan said.

—To the secretary of state for war, Stephen added over his shoulder.

They halted while Haines surveyed the tower and

—Rather bleak in wintertime, I should say. Martello you call it?

—Billy Pitt had them built, Buck Mulligan said, when the French were on the sea. But ours is the omphalos.

—What is your idea of Hamlet? Haines asked Stephen.

—No, no, Buck Mulligan shouted in pain. I'm not equal to Thomas Aquinas and the fiftyfive reasons he has made to prop it up. Wait till I have a few pints in me first.

He turned to Stephen, saying as he pulled down neatly the peaks of his primrose waistcoat:

-You couldn't manage it under three pints, Kinch, could you?

—It has waited so long, Stephen said listlessly, it can wait longer.

—You pique my curiosity, Haines said amiably. Is

it some paradox?

—Pooh! Buck Mulligan said. We have grown out of Wilde and paradoxes. It's quite simple. He proves by algebra that Hamlet's grandson is Shakespeare's grandfather and that he himself is the ghost of his own father.

—What? Haines said, beginning to point at Stephen. He himself?

Buck Mulligan slung his towel stolewise round his neck and, bending in loose laughter, said to Stephen's

—O, shade of Kinch the elder! Japhet in search of a father!

—We're always tired in the morning, Stephen said to Haines. And it is rather long to tell.

Buck Mulligan, walking forward again, raised his

—The sacred pint alone can unbind the tongue of Dedalus, he said.

—I mean to say, Haines explained to Stephen as they followed, this tower and these cliffs here remind me somehow of Elsinore. That beetles o'er his base into the sea, isn't it?

Buck Mulligan turned suddenly for an instant towards Stephen but did not speak. In the bright silent instant Stephen saw his own image in cheap dusty mourning between their gay attires.

-It's a wonderful tale, Haines said, bringing

them to halt again.

Eyes, pale as the sea the wind had freshened, paler, firm and prudent. The seas' ruler, he gazed southward over the bay, empty save for the smokeplume of the mailboat, vague on the bright skyline, and a sail tacking by the Muglins.

—I read a theological interpretation of it somewhere, he said bemused. The Father and the Son idea. The Son striving to be atoned with the Father.

Buck Mulligan at once put on a blithe broadly smiling face. He looked at them, his wellshaped mouth open happily, his eyes, from which he had suddenly withdrawn all shrewd sense, blinking with mad gaiety. He moved a doll's head to and fro, the brims of his Panama hat quivering, and began to chant in a quiet happy foolish voice:

—I'm the queerest young fellow that ever you heard. My mother's a jew, my father's a bird. With Joseph the joiner I cannot agree, So here's to disciples and Calvary.

He held up a forefinger of warning.

—If anyone thinks that I amn't divine He'll get no free drinks when I'm making the wine But have to drink water and wish it were plain That I make when the wine becomes water again.

He tugged swiftly at Stephen's ashplant in farewell and, running forward to a brow of the cliff, fluttered his hands at his sides like fins or wings of one about to rise in the air, and chanted:

-Goodbye, now, goodbye. Write down all I said And tell Tom, Dick and Harry I rose from the dead. What's bred in the bone cannot fail me to fly And Olivet's breezy . . . Goodbye, now, goodbye.

He capered before them down towards the fortyfoot hole, fluttering his winglike hands, leaping nimbly, Mercury's hat quivering in the fresh wind that bore back to them his brief birdlike cries.

Haines, who had been laughing guardedly,

walked on beside Stephen and said:

—We oughtn't to laugh, I suppose. He's rather blasphemous. I'm not a believer myself, that is to say. Still his gaiety takes the harm out of it somehow, doesn't it? What did he call it? Joseph the Joiner?

—The ballad of Joking Jesus, Stephen answered.

—O, Haines said, you have heard it before? —Three times a day, after meals, Stephen said drily.

—You're not a believer, are you? Haines asked. I mean, a believer in the narrow sense of the word. Creation from nothing and miracles and a personal God.

—There's only one sense of the word, it seems to me, Stephen said.

Haines stopped to take out a smooth silver case in which twinkled a green stone. He sprang it open with his thumb and offered it.

—Thank you, Stephen said, taking a cigarette. Haines helped himself and snapped the case to. He put it back in his sidepocket and took from his waistcoatpocket a nickel tinderbox, sprang it open too, and having lit his cigarette, held the flaming spunk towards Stephen in the shell of his hands.

—Yes, of course, he said, as they went on again. Either you believe or you don't, isn't it? Personally I couldn't stomach that idea of a personal God. You

don't stand for that, I suppose?

—You behold in me, Stephen said with grim dis-

pleasure, a horrible example of free thought.

He walked on, waiting to be spoken to, trailing his ashplant by his side. Its ferrule followed lightly on the path, squealing at his heels. My familiar, after me, calling Steeeeeeeeeephen. A wavering line along the path. They will walk on it tonight, coming here in the dark. He wants that key. It is mine, I paid the rent. Now I eat his salt bread. Give him the key too. All. He will ask for it. That was in his eyes.

—After all, Haines began. . .

Stephen turned and saw that the cold gaze which had measured him was not all unkind.

-After all, I should think you are able to free yourself. You are your own master, it seems to me.

—I am the servant of two masters, Stephen said, an English and an Italian.

—Italian? Haines said.

A crazy queen, old and jealous. Kneel down before me.

—And a third, Stephen said, there is who wants me for odd jobs.

—Italian? Haines said again. What do you mean?

—The imperial British state, Stephen answered, his colour rising, and the holy Roman catholic and apostolic church.

Haines detached from his underlip some fibres of

tobacco before he spoke.

—I can quite understand that, he said calmly. An Irishman must think like that, I daresay. We feel in England that we have treated you rather unfairly. It seems history is to blame.

The proud potent titles clanged over Stephen's memory the triumph of their brazen bells: et unam sanctam catholicam et apostolicam ecclesiam: the slow growth and change of rite and dogma like his own rare thoughts, a chemistry of stars. Symbol of the apostles in the mass for pope Marcellus, the voices blended, singing alone loud in affirmation: and behind their chant the vigilant angel of the church militant disarmed and menaced her heresiarchs. A horde of heresies fleeing with mitres awry: Photius and the brood of mockers of whom Mulligan was one, and Arius, warring his life long upon the consubstantiality of the Son with the Father, and Valentine, spurning Christ's terrene body, and the subtle African heresiarch Sabellius who held that the Father was Himself His own Son. Words Mulligan had spoken a moment since in mockery to the stranger. Idle mockery. The void awaits surely all them that weave the wind: a menace, a disarming and a worsting from those embattled angels of the church, Michael's host, who defend her ever in the hour of conflict with their lances and their shields.

Hear, hear. Prolonged applause. Zut! Nom de Dieu!

-Of course I'm a Britisher, Haines' voice said, and I feel as one. I don't want to see my country fall into the hands of German jews either. That's our national problem, I'm afraid, just now.

Two men stood at the verge of the cliff, watching: businessman, boatman.

—She's making for Bullock harbour.

The boatman nodded towards the north of the bay with some disdain.

—There's five fathoms out there, he said. It'll be swept up that way when the tide comes in about one. It's nine days today.

The man that was drowned. A sail veering about the blank bay waiting for a swollen bundle to bog up, roll over to the sun a puffy face, salt white. Here I

They followed the winding path down to the creek. Buck Mulligan stood on a stone, in shirtsleeves, his unclipped tie rippling over his shoulder. A young man clinging to a spur of rock near him moved slowly frogwise his green legs in the deep jelly of the water.

—Is the brother with you, Malachi?

—Down in Westmeath. With the Bannons.

-Still there? I got a card from Bannon. Says he found a sweet young thing down there. Photo girl he calls her.

-Snapshot, eh? Brief exposure.

Buck Mulligan sat down to unlace his boots. An elderly man shot up near the spur of rock a blowing red face. He scrambled up by the stones, water glistening on his pate and on its garland of grey hair, water rilling over his chest and paunch and spilling jets out of his black sagging loincloth.

Buck Mulligan made way for him to scramble past and, glancing at Haines and Stephen, crossed himself piously with his thumbnail at brow and lips and breastbone.

—Seymour's back in town, the young man said, grasping again his spur of rock. Chucked medicine and going in for the army.

-Ah, go to God, Buck Mulligan said.

—Going over next week to stew. You know that red Carlisle girl, Lily?

—Yes.

-Spooning with him last night on the pier. The father is rotto with money.

—Is she up the pole?

-Better ask Seymour that.

-Seymour a bleeding officer, Buck Mulligan

He nodded to himself as he drew off his trousers and stood up, saying tritely:

—Redheaded women buck like goats.

He broke off in alarm, feeling his side under his flapping shirt.

-My twelfth rib is gone, he cried. I'm the Uebermensch. Toothless Kinch and I, the supermen.

He struggled out of his shirt and flung it behind him to where his clothes lay.

—Are you going in here, Malachi?

—Yes. Make room in the bed.

The young man shoved himself backward through the water and reached the middle of the creek in two long clean strokes. Haines sat down on a stone, smoking.

—Are you not coming in? Buck Mulligan asked.

-Later on, Haines said. Not on my breakfast. Stephen turned away.

—I'm going, Mulligan, he said.

—Give us that key, Kinch, Buck Mulligan said, to keep my chemise flat.

Stephen handed him the key. Buck Mulligan laid it across his heaped clothes.

—And twopence, he said, for a pint. Throw it there.

Stephen threw two pennies on the soft heap. Dressing, undressing. Buck Mulligan erect, with joined hands before him, said solemnly:

—He who stealeth from the poor lendeth to the Lord. Thus spake Zarathustra.

His plump body plunged.

—We'll see you again, Haines said, turning as Stephen walked up the path and smiling at wild Irish.

Horn of a bull, hoof of a horse, smile of a Saxon. -The Ship, Buck Mulligan cried. Half twelve.

—Good, Stephen said.

He walked along the upwardcurving path.

Liliata rutilantium.

Turma circumdet.

Iubilantium te virginum.

The priest's grey nimbus in a niche where he

dressed discreetly. I will not sleep here tonight. Home also I cannot go.

A voice, sweettoned and sustained, called to him from the sea. Turning the curve he waved his hand. It called again. A sleek brown head, a seal's, far out on the water, round.

Usurper.

Franz Kafka from THE TRIAL

This parable, told to Joseph K. in a cathedral, is meant to be an enigma and a puzzle. As a parable it mirrors the confusion of the hero, who is pursued by the Court for crimes he cannot identify and for a guilt he recognizes but whose source he cannot name. Pay attention to the nightmarish quality of both the setting and the parable itself.

Before the Law

And K. certainly would not have noticed it had not a lighted lamp been fixed above it, the usual sign that a sermon was going to be preached. Was a sermon going to be delivered now? In the empty church? K. peered down at the small flight of steps which led upward to the pulpit, hugging the pillar as it went, so narrow that it looked like an ornamental addition to the pillar rather than a stairway for human beings. But at the foot of it, K. smiled in astonishment, there actually stood a priest ready to ascend, with his hand on the balustrade and his eyes fixed on K. The priest gave a little nod and K. crossed himself and bowed, as he ought to have done earlier. The priest swung himself lightly on to the stairway and mounted into the pulpit with short, quick steps. Was he really going to preach a sermon? Perhaps the verger was not such an imbecile after all and had been trying to urge K. toward the preacher, a highly necessary action in that deserted building. But somewhere or other there was an old woman before an image of the Madonna; she ought to be there too. And if it were going to be a sermon, why was it not introduced by the organ? But the organ remained silent, its tall pipes looming faintly in the darkness.

K. wondered whether this was not the time to remove himself quickly; if he did not go now he would have no chance of doing so during the sermon, he would have to stay as long as it lasted, he was already behindhand in the office and was no longer obliged to wait for the Italian; he looked at his watch, it was eleven o'clock. But was there really going to be a sermon? Could K. represent the congregation all by himself? What if he had been a stranger merely visiting the church? That was more or less his position. It was absurd to think that a sermon was going to be preached at eleven in the morning on a weekday, in such dreadful weather. The priest-he was beyond doubt a priest, a young man with a smooth, dark face—was obviously mounting the pulpit simply to turn out the lamp, which had been lit by mistake.

It was not so, however; the priest after examining the lamp screwed it higher instead, then turned slowly toward the balustrade and gripped the angular edge with both hands. He stood like that for a while, looking around him without moving his head. K. had retreated a good distance and was leaning his elbows on the foremost pew. Without knowing exactly where the verger was stationed, he was vaguely aware of the old man's bent back, peacefully at rest as if his task had been fulfilled. What stillness there was now in the Cathedral! Yet K. had to violate it, for he was not minded to stay; if it were this priest's duty to preach a sermon at a certain hour regardless of circumstances, let him do it, he could manage it without K.'s support, just as K.'s presence would certainly not contribute to its effectiveness. So he began slowly to move off, feeling his way along the pew on tiptoe until he was in the broad center aisle, where he advanced undisturbed except for the ringing noise that his lightest footstep made on the stone flags and the echoes that sounded from the vaulted roof faintly but continuously, in manifold and regular progression. K. felt a little forlorn as he advanced, a solitary figure between the rows of empty seats, perhaps with the priest's eyes following him; and the size of the Cathedral struck him as bordering on the limit of what human beings could bear. When he came to the seat where he had left the album he simply snatched the book up without stopping and took it with him. He had almost passed the last of the pews and was emerging into the open space between himself and the doorway when he heard the priest lifting up his voice. A resonant, well-trained voice. How it rolled through the expectant Cathedral! But it was no congregation the priest was addressing, the words were unambiguous and inescapable, he was calling out: "Joseph K.!"

K. paused and stared at the ground before him. For the moment he was still free, he could continue on his way and vanish through one of the small, dark, wooden doors that faced him at no great distance. It would simply indicate that he had not understood the call, or that he had understood it and did not care. But if he were to turn round he would be caught, for that would amount to an admission that he had understood it very well, that he was really the person addressed, and that he was ready to obey. Had the priest called his name a second time K. would certainly have gone on, but as everything remained silent, though he stood waiting for a long time, he could not help turning his head a little just to see what the priest was doing. The priest was stand-

ing calmly in the pulpit as before, yet it was obvious that he had observed K.'s turn of the head. It would have been like a childish game of hide-and-seek if K. had not turned right round to face him. He did so, and the priest beckoned him to come nearer. Since there was now no need for evasion, K. hurried backhe was both curious and eager to shorten the interview—with long flying strides toward the pulpit. At the first rows of seats he halted, but the priest seemed to think the distance still too great; he stretched out an arm and pointed with sharply bent forefinger to a spot immediately before the pulpit. K. followed this direction too; when he stood on the spot indicated he had to bend his head far back to see the priest at all. "You are Joseph K.," said the priest, lifting one hand from the balustrade in a vague gesture. "Yes," said K., thinking how frankly he used to give his name and what a burden it had recently become to him; nowadays people he had never seen before seemed to know his name. How pleasant it was to have to introduce oneself before being recognized! "You are an accused man," said the priest in a very low voice. "Yes," said K., "so I have been informed," "Then you are the man I seek," said the priest. "I am the prison chaplain." "Indeed," said K. "I had you summoned here," said the priest, "to have a talk with you." "I didn't know that," said K. "I came here to show an Italian round the Cathedral." "That is beside the point." said the priest. "What is that in your hand? Is it a prayer book?" "No," replied K., "it is an album of sights worth seeing in the town." "Lay it down." said the priest. K. threw it away so violently that it flew open and slid some way along the floor with disheveled leaves. "Do you know that your case is going badly?" asked the priest. "I have that idea myself," said K. "I've done what I could, but without any success so far. Of course, my petition isn't finished yet." "How do you think it will end?" asked the priest. "At first I thought it must turn out well," said K. "but now I frequently have my doubts. I don't know how it will end. Do you?" "No," said the priest, "but I fear it will end badly. You are held to be guilty. Your case will perhaps never get beyond a lower Court. Your guilt is supposed, for the present, at least, to have been proved." "But I am not guilty," said K.; "it's a mistake. And, if it comes to that, how can any man be called guilty? We are all simply men here, one as much as the other." "That is true," said the priest. "but that's how all guilty men talk." "Are you prejudiced against me too?" asked K. "I have no prejudices against you," said the priest. "Thank you," said K.; "but all the others who are concerned in these proceedings are prejudiced against me. They are influencing outsiders too. My position is becoming more and more difficult." "You are misinterpreting the facts of the case," said the priest.

"The verdict is not suddenly arrived at, the proceedings only gradually merge into the verdict." "So that's how it is," said K., letting his head sink. "What is the next step you propose to take in the matter?" asked the priest. "I'm going to get more help," said K., looking up again to see how the priest took his statement. "There are several possibilities I haven't explored yet." "You cast about too much for outside help," said the priest disapprovingly, "especially from women. Don't you see that it isn't the right kind of help?" "In some cases, even in many I could agree with you," said K., "but not always. Women have great influence. If I could move some women I know to join forces in working for me, I couldn't help winning through. Especially before this Court, which consists almost entirely of petticoat-hunters. Let the Examining Magistrate see a woman in the distance and he knocks down his desk and the defendant in his eagerness to get at her." The priest leaned over the balustrade, apparently feeling for the first time the oppressiveness of the canopy above his head. What fearful weather there must be outside! There was no longer even a murky daylight; black night had set in. All the stained glass in the great window could not illumine the darkness of the wall with one solitary glimmer of light. And at this very moment the verger began to put out the candles on the high altar, one after another. "Are you angry with me?" asked K. of the priest. "It may be that you don't know the nature of the Court you are serving." He got no answer. "These are only my personal experiences," said K. There was still no answer from above. "I wasn't trying to insult you," said K. And at that the priest shrieked from the pulpit: "Can't you see one pace before you?" It was an angry cry, but at the same time sounded like the unwary shriek of one who sees another fall and is startled out of his senses.

Both were now silent for a long time. In the prevailing darkness the priest certainly could not make out K.'s features, while K. saw him distinctly by the light of the small lamp. Why did he not come down from the pulpit? He had not preached a sermon, he had only given K. some information which would be likely to harm him rather than help him when he came to consider it. Yet the priest's good intentions seemed to K. beyond question, it was not impossible that they could come to some agreement if the man would only quit his pulpit, it was not impossible that K. could obtain decisive and acceptable counsel from him which might, for instance, point the way, not toward some influential manipulation of the case, but toward a circumvention of it, a breaking away from it altogether, a mode of living completely outside the jurisdiction of the Court. This possibility must exist, K. had of late given much thought to it. And should the priest know of such a possibility, he might perhaps impart his knowledge if he were appealed to, although he himself belonged to the Court and as soon as he heard the Court impugned had forgotten his own gentle nature so far as to shout K. down.

"Won't you come down here?" said K. "You haven't got to preach a sermon. Come down beside me." "I can come down now," said the priest, perhaps repenting of his outburst. While he detached the lamp from its hook he said: "I had to speak to you first from a distance. Otherwise I am too easily influ-

enced and tend to forget my duty.'

K. waited for him at the foot of the steps. The priest stretched out his hand to K. while he was still on the way down from a higher level. "Have you a little time for me?" asked K. "As much time as you need," said the priest, giving K. the small lamp to carry. Even close at hand he still wore a certain air of solemnity. "You are very good to me," said K. They paced side by side up and down the dusky aisle. "But you are an exception among those who belong to the Court. I have more trust in you than in any of the others, though I know many of them. With you I can speak openly." "Don't be deluded," said the priest. "How am I being deluded?" asked K. "You are deluding yourself about the Court," said the priest. "In the writings which preface the Law that particular delusion is described thus: before the Law stands a doorkeeper. To this doorkeeper there comes a man from the country who begs for admittance to the Law. But the doorkeeper says that he cannot admit the man at the moment. The man, on reflection, asks if he will be allowed, then, to enter later. 'It is possible,' answers the doorkeeper, 'but not at this moment.' Since the door leading into the Law stands open as usual and the doorkeeper steps to one side, the man bends down to peer through the entrance. When the doorkeeper sees that, he laughs and says: 'If you are so strongly tempted, try to get in without my permission. But note that I am powerful. And I am only the lowest doorkeeper. From hall to hall, keepers stand at every door, one more powerful than the other. And the sight of the third man is already more than even I can stand.' These are difficulties which the man from the country has not expected to meet, the Law, he thinks, should be accessible to every man and at all times, but when he looks more closely at the doorkeeper in his furred robe, with his huge pointed nose and long thin Tartar beard, he decides that he had better wait until he gets permission to enter. The doorkeeper gives him a stool and lets him sit down at the side of the door. There he sits waiting for days and years. He makes many attempts to be allowed in and wearies the doorkeeper with his importunity. The doorkeeper often engages him in brief conversation, asking him about his home and about other matters, but the questions are put quite impersonally, as great men put questions, and always conclude with the statement that the man cannot be allowed to enter yet. The man, who has equipped himself with many things for his journey, parts with all he has, however valuable, in the hope of bribing the doorkeeper. The doorkeeper accepts it all, saying, however, as he takes each gift: 'I take this only to keep you from feeling that you have left something undone.' During all these long years the man watches the doorkeeper almost incessantly. He forgets about the other doorkeepers, and this one seems to him the only barrier between himself and the Law. In the first years he curses his evil fate aloud; later, as he grows old, he only mutters to himself. He grows childish, and since in his prolonged study of the doorkeeper he has learned to know even the fleas in his fur collar, he begs the very fleas to help him and to persuade the doorkeeper to change his mind. Finally his eyes grow dim and he does not know whether the world is really darkening around him or whether his eyes are only deceiving him. But in the darkness he can now perceive a radiance that streams inextinguishably from the door of the Law. Now his life is drawing to a close. Before he dies, all that he has experienced during the whole time of his sojourn condenses in his mind into one question, which he has never yet put to the doorkeeper. He beckons the doorkeeper, since he can no longer raise his stiffening body. The doorkeeper has to bend far down to hear him, for the difference in size between them has increased very much to the man's disadvantage. 'What do you want to know now?' asks the doorkeeper. 'you are insatiable.' 'Everyone strives to attain the Law,' answers the man, 'how does it come about, then, that in all these years no one has come seeking admittance but me?' The doorkeeper perceives that the man is nearing his end and his hearing is failing, so he bellows in his ear: 'No one but you could gain admittance through this door, since this door was intended for you. I am now going to shut it."

"So the doorkeeper deceived the man," said K. immediately, strongly attracted by the story. "Don't be to hasty," said the priest, "don't take over someone else's opinion without testing it. I have told you the story in the very words of the scriptures. There's no mention of deception in it." "But it's clear enough," said K., "and your first interpretation of it was quite right. The doorkeeper gave the message of salvation to the man only when it could no longer help him." "He was not asked the question any earlier," said the priest, "and you must consider, too, that he was only a doorkeeper, and as such fulfilled his duty." "What makes you think he fulfilled his duty?" asked K. "He didn't fulfill it. His duty might have been to keep all strangers away, but this man, for whom the door was intended, should have been

let in." "You have not enough respect for the written word and you are altering the story," said the priest. "The story contains two important statements made by the doorkeeper about admission to the Law, one at the beginning, the other at the end. The first statement is: that he cannot admit the man at the moment, and the other is: that this door was intended only for the man. If there were a contradiction between the two, you would be right and the doorkeeper would have deceived the man. But there is no contradiction. The first statement, on the contrary, even implies the second. One could almost say that in suggesting to the man the possibility of future admittance the doorkeeper is exceeding his duty. At that time his apparent duty is only to refuse admittance and indeed many commentators are surprised that the suggestion should be made at all, since the doorkeeper appears to be a precisian with a stern regard for duty. He does not once leave his post during these many years, and he does not shut the door until the very last minute; he is conscious of the importance of his office, for he says: 'I am powerful'; he is respectful to his superiors, for he says: 'I am only the lowest doorkeeper'; he is not garrulous, for during all these years he puts only what are called 'impersonal questions'; he is not to be bribed, for he says in accepting a gift: 'I take this only to keep you from feeling that you have left something undone'; where his duty is concerned he is to be moved neither by pity nor rage, for we are told that the man 'wearied the doorkeeper with his importunity'; and finally even his external appearance hints at a pedantic character, the large, pointed nose and the long, thin, black, Tartar beard. Could one imagine a more faithful doorkeeper? Yet the doorkeeper has other elements in his character which are likely to advantage anyone seeking admittance and which make it comprehensible enough that he should somewhat exceed his duty in suggesting the possibility of future admittance. For it cannot be denied that he is a little simple-minded and consequently a little conceited. Take the statements he makes about his power and the power of the other doorkeepers and their dreadful aspect which even he cannot bear to see—I hold that these statements may be true enough, but that the way in which he brings them out shows that his perceptions are confused by simpleness of mind and conceit. The commentators note in this connection: 'This right perception of any matter and a misunderstanding of the same matter do not wholly exclude each other.' One must at any rate assume that such simpleness and conceit, however sparingly manifest, are likely to weaken his defense of the door; they are breaches in the character of the doorkeeper. To this must be added the fact that the doorkeeper seems to be a friendly creature by nature, he is by no means always on his official dignity. In

the very first moments he allows himself the jest of inviting the man to enter in spite of the strictly maintained veto against entry; then he does not, for instance, send the man away, but gives him, as we are told, a stool and lets him sit down beside the door. The patience with which he endures the man's appeals during so many years, the brief conversations, the acceptance of the gifts, the politeness with which he allows the man to curse loudly in his presence the fate for which he himself is responsible—all this lets us deduce certain feelings of pity. Not every doorkeeper would have acted thus. And finally, in answer to a gesture of the man's he bends down to give him the chance of putting a last question. Nothing but mild impatience—the doorkeeper knows that this is the end of it all—is discernible in the words: 'You are insatiable.' Some push this mode of interpretation even further and hold that these words express a kind of friendly admiration, though not without a hint of condescension. At any rate the figure of the doorkeeper can be said to come out very differently from what you fancied." "You have studied the story more exactly and for a longer time than I have," said K. They were both silent for a little while. Then K. said: "So you think the man was not deceived?" "Don't misunderstand me," said the priest, "I am only showing you the various opinions concerning that point. You must not pay too much attention to them. The scriptures are unalterable and the comments often enough merely express the commentators' despair. In this case there even exists an interpretation which claims that the deluded person is really the doorkeeper." "That's a far-fetched interpretation," said K. "On what is it based?" "It is based," answered the priest, "on the simple-mindedness of the doorkeeper. The argument is that he does not know the Law from inside, he knows only the way that leads to it, where he patrols up and down. His ideas of the interior are assumed to be childish, and it is supposed that he himself is afraid of the other guardians whom he holds up as bogies before the man. Indeed, he fears them more than the man does, since the man is determined to enter after hearing about the dreadful guardians of the interior, while the doorkeeper has no desire to enter, at least not so far as we are told. Others again say that he must have been in the interior already, since he is after all engaged in the service of the Law and can only have been appointed from inside. This is countered by arguing that he may have been appointed by a voice calling from the interior, and that anyhow he cannot have been far inside, since the aspect of the third doorkeeper is more than he can endure. Moreover, no indication is given that during all these years he ever made any remarks showing a knowledge of the interior, except for the one remark about the doorkeep-

ers. He may have been forbidden to do so, but there is no mention of that either. On these grounds the conclusion is reached that he knows nothing about the aspect and significance of the interior, so that he is in a state of delusion. But he is deceived also about his relation to the man from the country, for he is inferior to the man and does not know it. He treats the man instead as his own subordinate, as can be recognized from many details that must be still fresh in your mind. But, according to this view of the story, it is just as clearly indicated that he is really subordinated to the man. In the first place, a bondman is always subject to a free man. Now the man from the country is really free, he can go where he likes, it is only the Law that is closed to him, and access to the Law is forbidden him only by one individual, the doorkeeper. When he sits down on the stool by the side of the door and stays there for the rest of his life, he does it of his own free will; in the story there is no mention of any compulsion. But the doorkeeper is bound to his post by his very office, he does not dare go out into the country, nor apparently may he go into the interior of the Law, even should he wish to. Besides, although he is in the service of the Law, his service is confined to this one entrance; that is to say, he serves only this man for whom alone the entrance is intended. On that ground too he is inferior to the man. One must assume that for many years, for as long as it takes a man to grow up to the prime of life, his service was in a sense an empty formality, since he had to wait for a man to come, that is to say someone in the prime of life, and so he had to wait a long time before the purpose of his service could be fulfilled, and, moreover, had to wait on the man's pleasure, for the man came of his own free will. But the termination of his service also depends on the man's term of life, so that to the very end he is subject to the man. And it is emphasized throughout that the doorkeeper apparently realizes nothing of all this. That is not in itself remarkable, since according to this interpretation the doorkeeper is deceived in a much more important issue, affecting his very office. At the end, for example, he says regarding the entrance to the Law: 'I am now going to shut it,' but at the beginning of the story we are told that the door leading into the Law always stands open, and if it always stands open, that is to say at all times, without reference to the life or death of the man, then the doorkeeper cannot close it. There is some difference of opinion about the motive behind the doorkeeper's statement, whether he said he was going to close the door merely for the sake of giving an answer, or to emphasize his devotion to duty, or to bring the man into a state of grief and regret in his last moments. But there is no lack of agreement that the doorkeeper will not be able to shut the door. Many indeed profess to find that he is subordinate to the man even in knowledge, toward the end, at least, for the man sees the radiance that issues from the door of the Law while the doorkeeper in his official position must stand with his back to the door, nor does he say anything to show that he has perceived the change." "That is well argued," said K., after repeating to himself in a low voice several passages from the priest's exposition. "It is well argued, and I am inclined to agree that the doorkeeper is deceived. But that has not made me abandon my former opinion, since both conclusions are to some extent compatible. Whether the doorkeeper is clearsighted or deceived does not dispose of the matter. I said the man is deceived. If the doorkeeper is clearsighted, one might have doubts about that, but if the doorkeeper himself is deceived, then his deception must of necessity be communicated to the man. That makes the doorkeeper not, indeed, a deceiver, but a creature so simple-minded that he ought to be dismissed at once from his office. You mustn't forget that the doorkeeper's deceptions do himself no harm but do infinite harm to the man." "There are objections to that," said the priest. "Many aver that the story confers no right on anyone to pass judgment on the doorkeeper. Whatever he may seem to us, he is vet a servant of the Law; that is, he belongs to the Law and as such is beyond human judgment. In that case one must not believe that the doorkeeper is subordinate to the man. Bound as he is by his service, even only at the door of the Law, he is incomparably greater than anyone at large in the world. The man is only seeking the Law, the doorkeeper is already attached to it. It is the Law that has placed him at his post; to doubt his dignity is to doubt the Law itself." "I don't agree with that point of view," said K., shaking his head, "for if one accepts it, one must accept as true everything the doorkeeper says. But you yourself have sufficiently proved how impossible it is to do that." "No," said the priest, "it is not necessary to accept everything as true, one must only accept it as necessary." "A melancholy conclusion, said K. "It turns lying into a universal principle."

K. said that with finality, but it was not his final judgement. He was too tired to survey all the conclusions arising from the story, and the trains of thought into which it was leading him were unfamiliar, dealing with impalpabilities better suited to a theme for discussion among Court officials than for him. The simple story had lost its clear outline, he wanted to put it out of his mind, and the priest, who now showed great delicacy of feeling, suffered him to do so and accepted his comment in silence, although undoubtedly he did not agree with it.

They paced up and down for a while in silence, K. walking close beside the priest, ignorant of his

whereabouts. The lamp in his hand had long since gone out. The silver image of some saint once glimmered into sight immediately before him, by the sheen of its own silver, and was instantaneously lost in the darkness again. To keep himself from being utterly dependent on the priest, K. asked: "Aren't we near the main doorway now?" "No," said the priest, "we're a long way from it. Do you want to leave already?" Although at that moment K. had not been thinking of leaving, he answered at once: "Of course, I must go. I'm the Chief Clerk of a Bank, they're waiting for me, I only came here to show a business friend from abroad round the Cathedral." "Well," said the priest, reaching out his hand to K., "then go." "But I can't find my way alone in this darkness," said K. "Turn left to the wall," said the priest, "then follow the wall without leaving it and you'll come to a door." The priest had already taken a step or two away from him, but K. cried out in a loud voice, "Please wait a moment." "I am waiting," said the priest. "Don't you want anything more from me?" asked K. "No," said the priest. "You were so friendly to me for a time," said K., "and explained so much to me, and now you let me go as if you cared nothing about me." "But you have to leave now," said the priest. "Well, yes," said K., "you must see that I can't help it." "You must first see who I am," said the priest. "You are the prison chaplain," said K., groping his way nearer to the priest again; his immediate return to the Bank was not so necessary as he had made out, he could quite well stay longer. "That means I belong to the Court," said the priest. "So why should I want anything from you? The Court wants nothing from you. It receives you when you come and it dismisses you when you go."

Aldous Huxley from BRAVE NEW WORLD

Written at a time when totalitarian powers were gaining strength in Europe, this passage is an incisive meditation on the power of language and art to undermine the authority of the state. Art, the totalitarian mind argues, provides an alternative way of seeing things and that, in a total society, is an unthinkable danger.

Chapter 16

The room into which the three were ushered was the Controller's study.

"His fordship will be down in a moment." The Gamma butler left them to themselves.

Helmholtz laughed aloud.

"It's more like a caffeine-solution party than a trial," he said, and let himself fall into the most luxurious of the pneumatic arm-chairs. "Cheer up, Bernard," he added, catching sight of his friend's green unhappy face. But Bernard would not be cheered; without answering, without even looking at Helmholtz, he went and sat down on the most uncomfortable chair in the room, carefully chosen in the obscure hope of somehow deprecating the wrath of the higher powers.

The Savage meanwhile wandered restlessly round the room, peering with a vague superficial inquisitiveness at the books in the shelves, at the soundtrack rolls and the reading machine bobbins in their numbered pigeon-holes. On the table under the window lay a massive volume bound in limp black leathersurrogate, and stamped with large golden T's. He picked it up and opened it. MY LIFE AND WORK. BY OUR FORD. The book had been published at Detroit by the Society for the Propagation of Fordian Knowledge. Idly he turned the pages, read a sentence here, a paragraph there, and had just come to the conclusion that the book didn't interest him, when the door opened, and the Resident World Controller for Western Europe walked briskly into the room.

Mustapha Mond shook hands with all three of them; but it was to the Savage that he addressed himself. "So you don't much like civilization, Mr. Savage," he said.

The Savage looked at him. He had been prepared to lie, to bluster, to remain sullenly unresponsive; but, reassured by the good-humoured intelligence of the Controller's face, he decided to tell the truth, straightforwardly. "No." He shook his head.

Bernard started and looked horrified. What would the Controller think? To be labelled as the friend of a man who said that he didn't like civilization-said it openly and, of all people, to the Controller—it was terrible. "But, John," he began. A look from Mustapha Mond reduced him to an abject silence.

"Of course," the Savage went on to admit, "there are some very nice things. All that music in the air, for instance . . ."

"Sometimes a thousand twangling instruments will hum about my ears and sometimes voices."

The Savage's face lit up with a sudden pleasure. "Have you read it too?" he asked. "I thought nobody knew about that book here, in England."

"Almost nobody. I'm one of the very few. It's prohibited, you see. But as I make the laws here, I can also break them. With impunity, Mr. Marx," he added, turning to Bernard. "Which I'm afraid you can't do."

Bernard sank into a yet more hopeless misery. "But why is it prohibited?" asked the Savage. In the excitement of meeting a man who had read Shakespeare he had momentarily forgotten everything else.

The Controller shrugged his shoulders. "Because

it's old: that's the chief reason. We haven't any use for old things here."

"Even when they're beautiful?"

"Particularly when they're beautiful. Beauty's attractive, and we don't want people to be attracted by old things. We want them to like the new ones."

"But the new ones are so stupid and horrible. Those plays, where there's nothing but helicopters flying about and you feel the people kissing." He made a grimace. "Goats and monkeys!" Only in Othello's words could he find an adequate vehicle for his contempt and hatred.

"Nice tame animals, anyhow," the Controller

murmured parenthetically.

"Why don't you let them see Othello instead?" "I've told you; it's old. Besides, they couldn't understand it.

Yes, that was true. He remembered how Helmholtz had laughed at Romeo and Juliet. "Well then," he said, after a pause, "something new that's like Othello, and that they could understand."

"That's what we've all been wanting to write."

said Helmholtz, breaking a long silence.

"And it's what you never will write," said the Controller. "Because, if it were really like Othello nobody could understand it, however new it might be. And if it were new, it couldn't possibly be like Othello."

"Why not?"

"Yes, why not?" Helmholtz repeated. He too was forgetting the unpleasant realities of the situation. Green with anxiety and apprehension, only Bernard remembered them; the others ignored him. "Why not?"

"Because our world is not the same as Othello's world. You can't make flivvers without steel-and you can't make tragedies without social instability. The world's stable now. People are happy; they get what they want, and they never want what they can't get. They're well off; they're safe; they're never ill; they're not afraid of death; they're blissfully ignorant of passion and old age; they're plagued with no mothers or fathers; they've got no wives, or children, or lovers to feel strongly about; they're so conditioned that they practically can't help behaving as they ought to behave. And if anything should go wrong, there's soma. Which you go and chuck out of the window in the name of liberty, Mr. Savage. Liberty!" He laughed. "Expecting Deltas to know what liberty is! And now expecting them to understand Othello! My good boy!'

The Savage was silent for a little. "All the same," he insisted obstinately, "Othello's good, Othello's bet-

ter than those feelies.

"Of course it is," the Controller agreed. "But that's the price we have to pay for stability. You've

got to choose between happiness and what people used to call high art. We've sacrificed the high art. We have the feelies and the scent organ instead."

"But they don't mean anything."

"They mean themselves; they mean a lot of agreeable sensations to the audience.'

"But they're . . . they're told by an idiot."

The Controller laughed. "You're not being very polite to your friend, Mr. Watson. One of our most distinguished Emotional Engineers . . ."

"But he's right," said Helmholtz gloomily. "Because it is idiotic. Writing when there's nothing to

say . . . "

"Precisely. But that requires the most enormous ingenuity. You're making flivvers out of the absolute minimum of steel—works of art out of practically nothing but pure sensation."

The Savage shook his head. "It all seems to me

quite horrible."

"Of course it does. Actual happiness always looks pretty squalid in comparison with the over-compensations for misery. And, of course, stability isn't nearly so spectacular as instability. And being contented has none of the glamour of a good fight against misfortune, none of the picturesqueness of a struggle with temptation, or a fatal overthrow by passion or doubt. Happiness is never grand."

"I suppose not," said the Savage after a silence. "But need it be quite so bad as those twins?" He passed his hand over his eyes as though he were trying to wipe away the remembered image of those long rows of identical midgets at the assembling tables, those queued-up twin-herds at the entrance to the Brentford monorail station, those human maggots swarming round Linda's bed of death, the endlessly repeated face of his assailants. He looked at his bandaged left hand and shuddered. "Horrible!"

"But how useful! I see you don't like our Bokanovsky Groups; but, I assure you, they're the foundation on which everything else is built. They're the gyroscope that stabilizes the rocket plane of state on its unswerving course." The deep voice thrillingly vibrated; the gesticulating hand implied all space and the onrush of the irresistible machine. Mustapha Mond's oratory was almost up to synthetic stan-

"I was wondering," said the Savage, "why you had them at all—seeing that you can get whatever you want out of those bottles. Why don't you make everybody an Alpha Double Plus while you're about it?"

Mustapha Mond laughed. "Because we have no wish to have our throats cut," he answered. "We believe in happiness and stability. A society of Alphas couldn't fail to be unstable and miserable. Imagine a factory staffed by Alphas—that is to say by separate and unrelated individuals of good heredity and conditioned so as to be capable (within limits) of making a free choice and assuming responsibilities. Imagine it!" he repeated.

The Savage tried to imagine it, not very successfully.

"It's an absurdity. An Alpha-decanted, Alphaconditioned man would go mad if he had to do Epsilon Semi-Moron work—go mad, or start smashing things up. Alphas can be completely socialized—but only on condition that you make them do alpha work. Only an Epsilon can be expected to make Epsilon sacrifices, for the good reason that for him they aren't sacrifices; they're the line of least resistance. His conditioning has laid down rails along which he's got to run. He can't help himself; he's foredoomed. Even after decanting, he's still inside a bottle—an invisible bottle of infantile and embryonic fixations. Each one of us, of course," the Controller meditatively continued, "goes through life inside a bottle. But if we happen to be Alphas, our bottles are, relatively speaking, enormous. We should suffer acutely if we were confined in a narrower space. You cannot pour upper-caste champagne-surrogate into lower-caste bottles. It's obvious theoretically. But it has also been proved in actual practice. The result of the Cyprus experiment was convincing."

"What was that?" asked the Savage.

Mustapha Mond smiled. "Well, you can call it an experiment in rebottling if you like. It began in A.F. 473. The Controllers had the island of Cyprus cleared of all its existing inhabitants and re-colonized with a specially prepared batch of twenty-two thousand Alphas. All agricultural and industrial equipment was handed over to them and they were left to manage their own affairs. The result exactly fulfilled all the theoretical predictions. The land wasn't properly worked; there were strikes in all the factories; the laws were set at naught, orders disobeyed; all the people detailed for a spell of low-grade work were perpetually intriguing for high-grade jobs, and all the people with high-grade jobs were counter-intriguing at all costs to stay where they were. Within six years they were having a first class civil war. When nineteen out of the twenty-two thousand had been killed, the survivors unanimously petitioned the World Controllers to resume the government of the island. Which they did. And that was the end of the only society of Alphas that the world has ever seen."

The Savage sighed, profoundly.

"The optimum population," said Mustapha Mond, "is modelled on the iceberg-eight-ninths below the water line, one-ninth above."

"And they're happy below the water line?"

"Happier than above it. Happier than your friend here, for example." He pointed.

"In spite of that awful work?"

"Awful? They don't find it so. On the contrary, they like it. It's light, it's childishly simple. No strain on the mind or the muscles. Seven and a half hours of mild, unexhausting labour, and then the soma ration and games and unrestricted copulation and the feelies. What more can they ask for? True," he added, "they might ask for shorter hours. And of course we could give them shorter hours. Technically, it would be perfectly simple to reduce all lower-caste working hours to three or four a day. But would they be any the happier for that? No, they wouldn't. The experiment was tried, more than a century and a half ago. The whole of Ireland was put on to the four-hour day. What was the result? Unrest and a large increase in the consumption of soma; that was all. Those three and a half hours of extra leisure were so far from being a source of happiness, that people felt constrained to take a holiday from them. The Inventions Office is stuffed with plans for labour-saving processes. Thousands of them." Mustapha Mond made a lavish gesture. "And why don't we put them into execution? For the sake of the labourers; it would be sheer cruelty to afflict them with excessive leisure. It's the same with agriculture. We could synthesize every morsel of food, if we wanted to. But we don't. We prefer to keep a third of the population on the land. For their own sakes—because it takes longer to get food out of the land than out of a factory. Besides, we have our stability to think of. We don't want to change. Every change is a menace to stability. That's another reason why we're so chary of applying new inventions. Every discovery in pure science is potentially subversive; even science must sometimes be treated as a possible enemy. Yes, even science."

Science? The Savage frowned. He knew the word. But what it exactly signified he could not say. Shakespeare and the old men of the pueblo had never mentioned science, and from Linda he had only gathered the vaguest hints: science was something you made helicopters with, something that caused you to laugh at the Corn Dances, something that prevented you from being wrinkled and losing your teeth. He made a desperate effort to take the Controller's meaning.

"Yes," Mustapha Mond was saying, "that's another item in the cost of stability. It isn't only art that's incompatible with happiness; it's also science. Science is dangerous; we have to keep it most carefully chained and muzzled."

"What?" said Helmholtz, in astonishment. "But we're always saying that science is everything. It's a hypnopædic platitude."

'Three times a week between thirteen and seven-

teen," put in Bernard.

"And all the science propaganda we do at the Col-

lege . . ."

"Yes, but what sort of science?" asked Mustapha Mond sarcastically. "You've had no scientific training, so you can't judge. I was a pretty good physicist in my time. Too good—good enough to realize that all our science is just a cookery book, with an orthodox theory of cooking that nobody's allowed to question, and a list of recipes that mustn't be added to except by special permission from the head cook. I'm the head cook now. But I was an inquisitive young scullion once. I started doing a bit of cooking on my own. Unorthodox cooking, illicit cooking. A bit of real science, in fact." He was silent.

"What happened?" asked Helmholtz Watson.

The Controller sighed. "Very nearly what's going to happen to you young men. I was on the point of

being sent to an island."

The words galvanized Bernard into a violent and unseemly activity. "Send me to an island?" He jumped up, ran across the room, and stood gesticulating in front of the Controller. "You can't send me. I haven't done anything. It was the others, I swear it was the others." He pointed accusingly to Helmholtz and the Savage. "Oh, please don't send me to Iceland. I promise I'll do what I ought to do. Give me another chance. Please give me another chance." The tears began to flow. "I tell you, it's their fault," he sobbed. "And not to Iceland. Oh please, your fordship, please . . ." And in a paroxysm of abjection he threw himself on his knees before the Controller. Mustapha Mond tried to make him get up; but Bernard persisted in his grovelling; the stream of words poured out inexhaustibly. In the end the Controller had to ring for his fourth secretary.

"Bring three men," he ordered, "and take Mr. Marx into a bedroom. Give him a good soma vaporization and then put him to bed and leave him.'

The fourth secretary went out and returned with three green-uniformed twin footmen. Still shouting

and sobbing, Bernard was carried out.

"One would think he was going to have his throat cut," said the Controller, as the door closed. "Whereas, if he had the smallest sense, he'd understand that his punishment is really a reward. He's being sent to an island. That's to say, he's being sent to a place where he'll meet the most interesting set of men and women to be found anywhere in the world. All the people who, for one reason or another, have got too self-consciously individual to fit into community-life. All the people who aren't satisfied with orthodoxy, who've got independent ideas of their own. Every one, in a word, who's any one. I almost envy you, Mr. Watson."

Helmholtz laughed. "Then why aren't you on an island yourself?"

"Because, finally, I preferred this," the Controller answered. "I was given the choice: to be sent to an island, where I could have got on with my pure science, or to be taken on to the Controllers' Council with the prospect of succeeding in due course to an actual Controllership. I chose this and let the science go." After a little silence, "Sometimes," he added, "I rather regret the science. Happiness is a hard master particularly other people's happiness. A much harder master, if one isn't conditioned to accept it unquestioningly, than truth." He sighed, fell silent again, then continued in a brisker tone. "Well, duty's duty. One can't consult one's own preferences. I'm interested in truth. I like science. But truth's a menace. science is a public danger. As dangerous as it's been beneficent. It has given us the stablest equilibrium in history. China's was hopelessly insecure by comparison; even the primitive matriarchies weren't steadier than we are. Thanks, I repeat, to science. But we can't allow science to undo its own good work. That's why we so carefully limit the scope of its researches—that's why I almost got sent to an island. We don't allow it to deal with any but the most immediate problems of the moment. All other enquiries are most sedulously discouraged. It's curious." he went on after a little pause, "to read what people in the time of Our Ford used to write about scientific progress. They seemed to have imagined that it could be allowed to go on indefinitely, regardless of everything else. Knowledge was the highest good, truth the supreme value; all the rest was secondary and subordinate. True, ideas were beginning to change even then. Our Ford himself did a great deal to shift the emphasis from truth and beauty to comfort and happiness. Mass production demanded the shift. Universal happiness keeps the wheels steadily turning; truth and beauty can't. And, of course, whenever the masses seized political power, then it was happiness rather than truth and beauty that mattered. Still, in spite of everything, unrestricted scientific research was still permitted. People still went on talking about truth and beauty as though they were the sovereign goods. Right up to the time of the Nine Years' War. That made them change their tune all right. What's the point of truth or beauty or knowledge when the anthrax bombs are popping all around you? That was when science first began to be controlled -after the Nine Years' War. People were ready to have even their appetites controlled then. Anything for a quiet life. We've gone on controlling ever since. It hasn't been very good for truth, of course. But it's been very good for happiness. One can't have something for nothing. Happiness has got to be paid for. You're paying for it, Mr. Watson—paying because you happen to be too much interested in beauty. I was too much interested in truth; I paid too."

"But you didn't go to an island," said the Savage,

breaking a long silence.

The Controller smiled. "That's how I paid. By choosing to serve happiness. Other people's—not mine. It's lucky," he added, after a pause, "that there are such a lot of islands in the world. I don't know what we should do without them. Put you all in the lethal chamber, I suppose. By the way, Mr. Watson, would you like a tropical climate? The Marguesas, for example; or Samoa? Or something rather more bracing?"

Helmholtz rose from his pneumatic chair. "I should like a thoroughly bad climate," he answered. "I believe one would write better if the climate were bad. If there were a lot of wind and storms, for ex-

ample . . ."

The Controller nodded his approbation. "I like your spirit, Mr. Watson. I like it very much indeed. As much as I officially disapprove of it." He smiled. "What about the Falkland Islands?"

"Yes, I think that will do," Helmholtz answered. "And now, if you don't mind, I'll go and see how poor Bernard's getting on."

Chapter 17

"Art, science—you seem to have paid a fairly high price for your happiness," said the Savage, when they were alone. "Anything else?"

"Well, religion, of course," replied the Controller."There used to be something called Godbefore the Nine Years' War. But I was forgetting;

you know all about God, I suppose."

"Well . . ." The Savage hesitated. He would have liked to say something about solitude, about night, about the mesa lying pale under the moon, about the precipice, the plunge into shadowy darkness, about death. He would have liked to speak; but there were no words. Not even in Shakespeare.

The Controller, meanwhile, had crossed to the other side of the room and was unlocking a large safe let into the wall between the bookshelves. The heavy door swung open. Rummaging in the darkness within, "It's a subject," he said, "that has always had a great interest for me." He pulled out a thick black volume. "You've never read this, for example."

The Savage took it. "The Holy Bible, containing the Old and New Testaments," he read aloud from the

"Nor this." It was a small book and had lost its cover.

"The Imitation of Christ."

"Nor this." He handed out another volume.

"The Varieties of Religious Experience. By William James."

"And I've got plenty more," Mustapha Mond continued, resuming his seat. "A whole collection of pornographic old books. God in the safe and Ford on the shelves." He pointed with a laugh to his avowed library—to the shelves of books, the racks full of reading-machine bobbins and sound-track rolls.

"But if you know about God, why don't you tell them?" asked the Savage indignantly. "Why don't

you give them these books about God?"

"For the same reason as we don't give them Othello: they're old; they're about God hundreds of years ago. Not about God now."

"But God doesn't change."

"Men do, though."

"What difference does that make?"

"All the difference in the world," said Mustapha Mond. He got up again and walked to the safe. "There was a man called Cardinal Newman." he said. "A cardinal," he exclaimed parenthetically, "was a kind of Arch-Community-Songster."

"'I Pandulph, of fair Milan, cardinal.' I've read

about them in Shakespeare."

"Of course you have. Well, as I was saying, there was a man called Cardinal Newman. Ah, here's the book." He pulled it out. "And while I'm about it I'll take this one too. It's by a man called Maine de Biran. He was a philosopher, if you know what that was."

"A man who dreams of fewer things than there are in heaven and earth," said the Savage promptly.

"Quite so. I'll read you one of the things he did dream of in a moment. Meanwhile, listen to what this old Arch-Community-Songster said." He opened the book at the place marked by a slip of paper and began to read. "We are not our own any more than what we possess is our own. We did not make ourselves, we cannot be supreme over ourselves. We are not our own masters. We are God's property. Is it not our happiness thus to view the matter? Is it any happiness or any comfort, to consider that we are our own? It may be thought so by the young and prosperous. These may think it a great thing to have everything, as they suppose, their own way-to depend on no one-to have to think of nothing out of sight, to be without the irksomeness of continual acknowledgement, continual prayer, continual reference of what they do to the will of another. But as time goes on, they, as all men, will find that independence was not made for man—that it is an unnatural state—will do for a while, but will not carry us on safely to the end . . . " Mustapha Mond paused, put down the first book and, picking up the other, turned over the pages. "Take this, for example," he said, and in his deep voice once more began to read: "'A man grows old; he feels in himself that radical sense of weakness, of listlessness, of discomfort, which accompanies the advance of age; and, feeling thus, imagines himself merely sick, lulling his fears with the notion that this distressing condition is

due to some particular cause, from which, as from an illness, he hopes to recover. Vain imaginings! That sickness is old age; and a horrible disease it is. They say that it is the fear of death and of what comes after death that makes men turn to religion as they advance in years. But my own experience has given me the conviction that, quite apart from any such terrors or imaginings, the religious sentiment tends to develop as we grow older; to develop because, as the passions grow calm, as the fancy and sensibilities are less excited and less excitable, our reason becomes less troubled in its working, less obscured by the images, desires and distractions, in which it used to be absorbed; whereupon God emerges as from behind a cloud; our soul feels, sees, turns towards the source of all light; turns naturally and inevitably; for now that all that gave to the world of sensations its life and charm has begun to leak away from us, now that phenomenal existence is no more bolstered up by impressions from within or from without, we feel the need to lean on something that abides, something that will never play us false—a reality, an absolute and everlasting truth. Yes, we inevitably turn to God; for this religious sentiment is of its nature so pure, so delightful to the soul that experiences it, that it makes up to us for all our other losses." Mustapha Mond shut the book and leaned back in his chair. "One of the numerous things in heaven and earth that these philosophers didn't dream about was this" (he waved his hand), "us, the modern world. You can only be independent of God while you've got youth and prosperity; independence won't take you safely to the end.' Well, we've now got youth and prosperity right up to the end. What follows? Evidently, that we can be independent of God. 'The religious sentiment will compensate us for all our losses.' But there aren't any losses for us to compensate; religious sentiment is superfluous. And why should we go hunting for a substitute for youthful desires, when youthful desires never fail? A substitute for distractions, when we go on enjoying all the old fooleries to the very last? What need have we of repose when our minds and bodies continue to delight in activity? of consolation, when we have *soma*? of something immovable, when there is the social order?"

"Then you think there is no God?"

"No, I think there quite probably is one."

"Then why? . . . "

Mustapha Mond checked him. "But he manifests himself in different ways to different men. In premodern times he manifested himself as the being that's described in these books. Now . . . "

"How does he manifest himself now?" asked the

"Well, he manifests himself as an absence; as

though he weren't there at all."

"That's your fault."

"Call it the fault of civilization. God isn't compatible with machinery and scientific medicine and universal happiness. You must make your choice. Our civilization has chosen machinery and medicine and happiness. That's why I have to keep these books locked up in the safe. They're smut. People would be shocked if . . ."

The Savage interrupted him. "But isn't it natural to feel there's a God?"

"You might as well ask if it's natural to do up one's trousers with zippers," said the Controller sarcastically. "You remind me of another of those old fellows called Bradley. He defined philosophy as the finding of bad reason for what one believes by instinct. As if one believed anything by instinct! One believes things because one has been conditioned to believe them. Finding bad reasons for what one believes for other bad reasons—that's philosophy. People believe in God because they've been conditioned to believe in God."

"But all the same," insisted the Savage, "it is natural to believe in God when you're alone—quite alone, in the night, thinking about death . . ."

"But people never are alone now," said Mustapha Mond. "We make them hate solitude; and we arrange their lives so that it's almost impossible for them ever to have it.

The Savage nodded gloomily. At Malpais he had suffered because they had shut him out from the communal activities of the pueblo, in civilized London he was suffering because he could never escape from those communal activities, never be quietly alone.

"Do you remember that bit in King Lear?" said the Savage at last. "The gods are just and of our pleasant vices make instruments to plague us; the dark and vicious place where thee he got cost him his eyes,' and Edmund answers—you remember, wounded, he's dying—'Thou hast spoken right; 'tis true. The wheel has come full circle; I am here.' What about that now? Doesn't there seem to be a God managing things, punishing, rewarding?"

"Well, does there?" questioned the Controller in his turn. "You can indulge in any number of pleasant vices with a freemartin and run no risks of having your eyes put out by your son's mistress. 'The wheel has come full circle; I am here.' But where would Edmund be nowadays? Sitting in a pneumatic chair, with his arm around a girl's waist, sucking away at his sex-hormone chewing-gum and looking at the feelies. The gods are just. No doubt. But their code of law is dictated, in the last resort, by the people who organize society; Providence takes its cue from men."

"Are you sure?" asked the Savage. "Are you quite sure that the Edmund in that pneumatic chair hasn't been just as heavily punished as the Edmund who's wounded and bleeding to death? The gods are just. Haven't they used his pleasant vices as an instrument to degrade him?"

"Degrade him from what position? As a happy, hard-working, goods-consuming citizen he's perfect. Of course, if you choose some other standard than ours, then perhaps you might say he was degraded. But you've got to stick to one set of postulates. You can't play Electro-magnetic Golf according to the rules of Centrifugal Bumble-puppy."

"But value dwells not in particular will," said the Savage. "It holds his estimate and dignity as well wherein 'tis precious of itself as in the prizer."

"Come, come," protested Mustapha Mond,

"that's going rather far isn't it?"

"If you allowed yourselves to think of God, you wouldn't allow yourselves to be degraded by pleasant vices. You'd have reason for bearing things patiently, for doing things with courage. I've seen it with the Indians.'

"I'm sure you have," said Mustapha Mond. "But then we aren't Indians. There isn't any need for a civilized man to bear anything that's seriously unpleasant. And as for doing things-Ford forbid that he should get the idea into his head. It would upset the whole social order if men started doing things on their own."

"What about self-denial, then? If you had a God,

you'd have a reason for self-denial.

"But industrial civilization is only possible when there's no self-denial. Self-indulgence up to the very limits imposed by hygiene and economics. Otherwise the wheels stop turning."

"You'd have a reason for chastity!" said the Sav-

age, blushing a little as he spoke the words.

"But chastity means passion, chastity means neurasthenia. And passion and neurasthenia mean instability. And instability means the end of civilization. You can't have a lasting civilization without plenty of pleasant vices."

"But God's the reason for everything noble and

fine and heroic. If you had a God . . . '

"My dear young friend," said Mustapha Mond, "civilization has absolutely no need of nobility or heroism. These things are symptoms of political inefficiency. In a properly organized society like ours, nobody has any opportunities for being noble or heroic. Conditions have got to be thoroughly unstable before the occasion can arise. Where there are wars. where there are divided allegiances, where there are temptations to be resisted, objects of love to be fought for or defended—there, obviously, nobility and heroism have some sense. But there aren't any wars nowadays. The greatest care is taken to prevent you from loving any one too much. There's no such thing as a divided allegiance; you're so conditioned that you can't help doing what you ought to do. And what you ought to do is on the whole so pleasant, so many of the natural impulses are allowed free play, that there really aren't any temptations to resist. And if ever, by some unlucky chance, anything unpleasant should somehow happen, why, there's always soma to give you a holiday from the facts. And there's always soma to calm your anger, to reconcile you to your enemies, to make you patient and long-suffering. In the past you could only accomplish these things by making a great effort and after years of hard moral training. Now, you swallow two or three half-gramme tablets, and there you are. Anybody can be virtuous now. You can carry at least half your morality about in a bottle. Christianity without tears—that's what soma is."

"But the tears are necessary. Don't you remember what Othello said? 'If after every tempest came such calms, may the winds blow till they have wakened death.' There's a story one of the old Indians used to tell us, about the Girl of Mátaski. The young men who wanted to marry her had to do a morning's hoeing in her garden. It seemed easy; but there were flies and mosquitoes, magic ones. Most of the young men simply couldn't stand the biting and stinging. But the one that could—he got the girl."

"Charming! But in civilized countries," said the Controller, "you can have girls without hoeing for them; and there aren't any flies or mosquitoes tosting you. We got rid of them centuries ago."

The Savage nodded, frowning. "You got rid of them. Yes, that's just like you. Getting rid of everything unpleasant instead of learning to put up with it. Whether 'tis better in the mind to suffer the slings and arrows of outrageous fortune, or to take arms against a sea of troubles and by opposing end them . . . But you don't do either. Neither suffer nor oppose. You just abolish the slings and arrows. It's too

He was suddenly silent, thinking of his mother. In her room on the thirty-seventh floor, Linda had floated in a sea of singing lights and perfumed caresses—floated away, out of space, out of time, out of the prison of her memories, her habits, her aged and bloated body. And Tomakin, ex-director of Hatcheries and Conditioning, Tomakin was still on holiday—from humiliation and pain, in a world where he could not hear those words, that derisive laughter, could not see that hideous face, feel those moist and flabby arms round his neck, in a beautiful world . . .

"What you need," the Savage went on, "is something with tears for a change. Nothing costs enough here.'

("Twelve and a half million dollars." Henry Foster had protested when the Savage told him that. "Twelve and a half million—that's what the new Conditioning Centre cost. Not a cent less.")

"Exposing what is mortal and unsure to all that fortune, death and danger dare, even for an egg-shell. Isn't there something in that?" he asked, looking up at Mustapha Mond. "Quite apart from Godthough of course God would be a reason for it. Isn't there something in living dangerously?"

"There's a great deal in it," the Controller replied. "Men and women must have their adrenals stimulated from time to time."

"What?" questioned the Savage, uncomprehend-

"It's one of the conditions of perfect health. That's

why we've made the V.P.S. treatments compulsory."

"V.P.S.?"

"Violent Passion Surrogate. Regularly once a month. We flood the whole system with adrenin. It's the complete physiological equivalent of fear and

rage. All the tonic effects of murdering Desdemona and being murdered by Othello, without any of the inconveniences."

"But I like the inconveniences."

"We don't," said the Controller. "We prefer to do things comfortably."

"But I don't want comfort. I want God, I want poetry, I want real danger, I want freedom, I want goodness. I want sin."

"In fact," said Mustapha Mond, "you're claiming the right to be unhappy."

"All right then," said the Savage defiantly, "I'm

claiming the right to be unhappy.

"Not to mention the right to grow old and ugly and impotent; the right to have syphilis and cancer; the right to have too little to eat; the right to be lousy; the right to live in constant apprehension of what may happen to-morrow; the right to catch typhoid; the right to be tortured by unspeakable pains of every kind.

There was a long silence.

"I claim them all," said the Savage at last.

Mustapha Mond shrugged his shoulders. "You're welcome," he said.

INTERLUDE

Virginia and Leonard Woolf

In 1912 Virginia Stephen (1882–1941) married Leonard Woolf (1880–1969) in London. Virginia Woolf became one of the finest British writers of this century. Novels of hers like *Mrs. Dalloway* (1925), *To The Lighthouse* (1927), and *The Waves* (1931) rank with some of the great works of literary modernism. Leonard Woolf created for himself a long and distinguished career as a political activist, editor, writer,

critic, and publisher.

Viewed individually, each has a place in the cultural history of England in our century. What is more important, however, is the significant interplay of this extraordinary couple in the cultural life of England between the two world wars. Their marriage was not only an extraordinarily happy one but a constant source of intellectual and moral nourishment. A recent study of Virginia and Leonard Woolf is called *A Marriage of True Minds*, an appropriate title, since for all their individual accomplishment Virginia and Leonard Woolf worked as a team. Leonard was Virginia's best and most sympathetic critic while she was an unfailing support and fellow laborer at his many causes.

Virginia and Leonard Woolf were at the center of a group of intellectuals, social rebels, and writers called (after the area of London where they lived and met) the Bloomsbury Group. This rather loose and shifting group of friends had common ties to Cambridge University and to each other. Through the 1920s and 1930s they

met regularly for discussion, debate, and social engagements.

The Bloomsbury Group had a very distinguished membership. It included biographer Lytton Strachey; John Maynard Keynes, whose theories of economics dominated much of Western thinking until our own day; novelist E. M. Forster; artist and critic Clive Bell; his wife and Virginia Woolf's sister Vanessa Stephen, also an artist; and Roger Fry, critic and art connoisseur. At the periphery of the group were British mathematician and philosopher Bertrand Russell and expatriate American poet and critic T. S. Eliot.

Beyond their friendship the Bloomsbury Group stood for a certain attitude of life which reacted against English ideas of the late 19th and early 20th centuries. They valued an open discussion of all ideas and a search for truth in the face of any past authority. They wanted to examine political ideas, literary theories, and social questions with an approach based on common sense. The guiding spirit behind this attitude was Cambridge philosopher G. E. Moore, although he never lived in Bloomsbury and rarely attended their social gatherings. Leonard Woolf later said about his old teacher that Moore "suddenly removed from our eyes an obscuring accumulation of scales, cobwebs, and curtains, revealing for the first time to us, so it seemed, the nature of truth and reality, of good and evil and character and conduct. . . ."

The Bloomsbury style for expressing this attitude was brash, highly intellectual, rather iconoclastic, and fully modern. Many of the group, children of Victorian intellectuals and writers were in revolt against the ideas of their forebears. This style, for all its snobberies and pretensions, was a foretaste of much of what was to come in England. In 1910 the Bloomsbury Group stood for equality for women, less punitive criminal law, some English disengagement from its colonial holdings, and freedom from sexual repression. They heartily detested the class-ridden public (really private) schools of England, the adoration of money, pseudo-standards of respectability, and the conformity of mass taste.

Vanessa Stephen. Portrait of Virginia Stephen. c. 1905. Oil on canvas. Vanessa painted her sister Virginia many times. This is one of the few finished works.

Vanessa Bell. Leonard Woolf. Oil on canvas, 32 × 251/2" (81 × 65 cm). National Portrait Gallery, London. Leonard Woolf was not only a man of letters but also a political activist who was an important figure in the early history of England's Labour Party. He was a passionate Socialist and social reformer.

In 1917 Leonard Woolf bought a small hand-operated printing press. The idea was to provide something close to a hobby for himself and Virginia. They planned to produce limited editions of poetry collections or occasional essays. Within a short time this idyllic idea had turned into a large publishing enterprise with a life of its own. The Hogarth Press quickly became an important outlet for new as well as established writers. As incredibly busy as they were with their own writing, Leonard and Virginia Woolf (and a whole procession of not-so-satisfactory assistants) ran the press from the basement of their home in London. The diaries and letters of both Woolfs are filled with references to their afternoons spent in such tasks as bundling up parcels of books for this or that London bookseller.

Looking back over the catalogues of the Hogarth Press from the period between the two world wars one sees a list of some of the most influential writers of the era. The Woolfs were the first in England to publish the American poets John Crowe Ransom, Robinson Jeffers, and Edwin Arlington Robinson. They published the first complete English translations of the works of Sigmund Freud. T. S. Eliot's The Waste Land appeared on their list in 1922. They had been offered James Joyce's Ulysses in the same year but, despite the enthusiasm of Eliot, decided against publication because of their fears of the censor's office. They were the early publishers of two English poets who later became poets laureate in England: C. Day Lewis and John Betjeman. Continental authors such as the German poet Rainer Maria Rilke and the Italian novelist Italo Svevo found their first English translations on the Hogarth list. In the 1930s newer English writers like Christopher Isherwood and Stephen Spender were published. Naturally enough, older Bloomsburians like Maynard Keynes and E. M. Forster were also on the lists.

The Hogarth Press was not only an outlet for those authors congenial to the Bloomsbury sensibility. It was an outlet for the Woolfs' own writing. Virginia Woolf published nineteen volumes with the Hogarth Press during her lifetime. This included her novels as well as her major works of literary criticism like The Common Reader (1925; second series, 1932). Two of her shorter works, A Room of One's Own (1929) and Three Guineas (1938), are of particular interest. These two polemical works anticipate many of the objections of contemporary feminists in their critique of women's roles in a largely male-dominated society.

A Room of One's Own is based on some lectures Virginia Woolf gave on women writers. Rather than speak on the accomplishments of Jane Austen in the 19th century or her own in the 20th, Virginia Woolf addressed herself to this question: Why have there been so few notable women writers in the history of English letters? Why, for instance, in the great age of Queen Elizabeth I, when Shakespeare created a whole range of notable fictional women, is there no record of any major female poet or dramatist? What explains that curious fact? Virginia Woolf's answer, succinctly, is that women had no room of their own—they had neither the economic or social independence to allow them that modicum of freedom and leisure necessary for a life of letters. Until nearly her own time women were barred from the professions, their marriages were often arranged, and motherhood seemed their only destiny. Until the preceding century they had been barred from the universities, and all of the dogmas about feminine weakness or incapacity, which had been evolved by men, had been generally held to be true.

After an analysis of this situation in England, Virginia Woolf calls for an androgynous literature: a literature that takes into account both femininity and masculinity. The alternative, as her biographer tersely puts it, is a literature of men that breeds nagging resentment of women and a literature of women shrill in its indictment of masculine repression. Neither attitude breeds great literature. Great literature demands a "comprehensive sympathy which transcends and comprehends the feelings of both sexes.

Three Guineas (1938) takes up the same argument from a somewhat different perspective. It is cast in the form of a response to three letters each asking for a guinea (an English pound plus a shilling) for a worthy cause: the support of a women's college, a committee to help professional women gain employment, a league for peace and the preservation of culture. Woolf analyzes the economic and social discrimination against women—the root cause, as she argued in A Room of One's Own,

of the suppression of female freedom and creativity.

In the section of *Three Guineas* on university education she analyzes the links between the great colleges of Oxford and Cambridge and the economic powers which she felt determined the possibility of war and peace, a burning issue in the England of 1938, then on the eve of war with Germany. Virginia Woolf obviously wanted to advance the cause of women's colleges but she wanted them free of the encrusted privilege and snobbery of the past. In her somewhat utopian vision of what a new college might look like she manages, by indirection, to sum up all the ills of university education as she then saw it. Her description must be seen against its own time, but there is enough of the universal in it to make the contemporary reader think long and hard.

While both Virginia and Leonard Woolf were primarily literary people, they had connections to the art world by both family tie and basic sympathy. Vanessa Stephen (1879–1961), Virginia's sister, was a painter. In 1906 she married Clive Bell (1881–1964), a Cambridge friend of her brother, who made for himself a brilliant career as art critic and painter. In 1910, her marriage already shaky, Vanessa met and fell in love with Roger Fry (1867–1934), another art critic and painter. When that liaison cooled, as it rather quickly did, Vanessa Bell then fell in love and lived for a

long time with another English painter, Duncan Grant (1885-1977).

Roger Fry was an important and close friend of the Bloomsbury Group and an extremely important figure in the British art world. A good if not quite first-rate painter, he was esteemed as an art critic and author. His reputation was such that for a period he was chief European buyer for New York's Metropolitan Museum of Art as well as personal art counselor to the American collector and multimillionaire J.

Pierpont Morgan.

In 1910 Roger Fry mounted a major art show in London that he entitled "The First Post-Impressionist Exhibition." Fry had obtained from France works of the major continental artists of the period. He called the show post-impressionist almost as an afterthought. He wanted to single out the artists who were in the generation after the first of the impressionists. The exhibition had a generous selection of works by Van Gogh, Gauguin, and Cézanne as well as Picasso (although there were none of his new cubist canvases) and Matisse.

Seven decades after the event it is hard to understand the furor of the British public's reaction to this exhibition. Today every discount store in every shopping mall sells reproductions of Van Geogh's *Sunflower* (a work shown at the exhibition) and Henri Matisse now has the status of an Old Master. Yet when the critics walked into London's Grafton Galleries in 1910 they could barely find words to express their bewilderment and shock. Wilfred Blunt, the aged poet and statesman, called it a "pornographic show." The reviewer for *The Times* worried that Roger Fry was setting a bad example for the younger generation. The reviewer for the *Morning Post* compared the show to the signs of an approaching plague, adding that "the source of the infection ought to be destroyed."

Nevertheless, "The First Post-Impressionist Exhibition" was enough of a success for Fry to mount in 1912 a second one with Leonard Woolf as its secretary. This second show included not only continental artists but also a generous sprinkling of works by Bloomsbury artists like Mark Girtler, Duncan Grant, and Vanessa Bell, all of whom were enthusiastic supporters of the work shown at the 1910 exhibition. The 1912 show evoked less acrimony from the public but, as Virginia Woolf later noted in her appreciative biography of Roger Fry (written in 1940, six years after her friend's death), the "two exhibitions had made an immense impression both upon the artists and the public."

In a lecture in 1924 Virginia Woolf said that "on or about December 1910 human character changed." She no doubt had the Fry "Post-Impressionist Exhibition" in mind when she made that rather startling pronouncement, but from the vantage point of 1924 the year 1910 was probably some sort of a watershed year. King

Edward VII, the son of Queen Victoria, died in that year, bringing to an end the opulent and glittering era historians now call the Edwardian Age. The Great War was but a few years away. Tolstoy died that year—a symbol, perhaps, of the end of Old Russia, since the turmoils that would bring about the Bolshevik Revolution had already begun. Freud had already done much of his important work. Einstein's theory of relativity had been published, and Picasso and Braque had already begun their experiments in cubist perspective.

From the vantage point of 1924, then, Virginia Woolf could look back to her early association with Fry and the other Bloomsburians and see that the nature of perception had changed radically. She knew a bit about Einstein, more about Freud, and was conversant with the avant garde in painting. Her own works of fiction made it clear that she had fully assimilated the uses of temporal and spatial perspective that were at the heart of modernism in its many forms. Like Eliot, Proust, and Joyce she understood the relativity of perception and the terror of time as well as the

fragile nature of our received values and our accustomed perceptions.

The deceptive nature of human perception was not merely of academic interest to Virginia Woolf. From her youth she had suffered recurrent bouts of mental illness. One of the most touching aspects of the Woolf marriage is the fidelity with which Leonard Woolf, in the midst of an extremely busy life as a political figure, book publisher, and writer, nurtured and protected Virginia Woolf from the pressures, demands, and pace that could trigger episodes of nervous exhaustion or mental derangement. When she finally committed suicide in 1941 she left behind a note in which she explained that she feared another bout of mental illness. She begged Leonard Woolf not to think that he had failed. She testified to her immense love for him and her gratefulness for his constant concern for her. Her years with him, she wrote, were the happiest years of her life.

The Woolfs lived at a time, now largely destroyed by the telephone and other quicker means of communication, when letter writing, keeping diaries, and the daily discipline of writing were not only common but ordinary parts of an educated person's life. Over recent years we have seen the publication of multivolume collections of Virginia Woolf's diaries and letters as well as the five-volume autobiography of Leonard Woolf. In addition to these volumes there are many studies, collections, biographies, and appreciations of the major figures of the Bloomsbury Group. The result is that we can reconstruct in rather close detail the thoughts and actions of

these people.

To study this circle of friends—and that marriage of true minds exemplified by the Woolfs—is to get an almost unparalleled look at the intellectual history of people who were acutely conscious of and participants in the rising tide of modernism in this century. For all their vanities and eccentricities they were a class of people who had an immense influence on various spheres of intellectual and social life. Beyond that they were a people who demonstrated one thing very clearly: there is passion, romance, and inexhaustible richness in the world of ideas.

Further Reading

Bell, Quentin. Virginia Woolf: A Biography. New York: Harcourt, 1972. The standard biography, written by Virginia Woolf's nephew. Very readable.

Edel, Leon. Bloomsbury: A House of Lions. Philadelphia: Lippincott, 1979. A serviceable introduction to the group by the distinguished biographer of Henry James.

Gadd, David. The Loving Friends: A Portrait of Bloomsbury. New York: Harcourt, 1974. A very readable brief study with wonderful vignettes of many of the curious peripheral members of the Bloomsbury circle like Lady Ottoline Morrell and Dora Carrington.

Spater, George, with Ian Parsons. A Marriage of True

Minds: An Intimate Portrait of Leonard and Virginia Woolf. New York: Harcourt, 1977. Written by close friends of Leonard Woolf, this is a splendid and highly recommended work. It is especially good on the Hogarth Press. First-rate.

Woolf, Leonard, and Virginia Woolf. The Diaries and the Letters of Virginia Woolf are coming out from Harcourt. The same publisher did the five-volume autobiography of Leonard Woolf: Sowing (1960); Growing (1961); Beginning Again (1963); Downhill All the Way (1967); The Journey Not the Arrival Matters (1969). These many volumes, splendid reading in their own right, are essential for an understanding of the Bloomsbury Group.

1960

THE ATOMIC ERA

Beat Generation

Youth Movement

1975

1975 American withdrawal from 1977 New Chinese government

1939 World War II begins; start of commercial television

1941 Japanese attack Pearl Harbor

1945 First atomic bombs used in warfare against Japan; World War II ends; Nazi extermination of lews becomes

widely known

1946 First meeting of UN General Assembly in London

1948 Israel becomes independent state; Berlin airlift marks beginning of "cold war" 1949 China becomes communist under leadership of Mao Zedung

1950 Korean War begins; FCC

transmission of color TV 1952 U.S. explodes first hydrogen

approves first commercial

1954 School segregation outlawed by Supreme Court

1955 Civil Rights Movement starts in South

1957 First earth satellite launched by USSR

1961 East Germans erect Berlin Wall; Soviets put first person in

1962 First American orbits earth in space; transatlantic transmission of television signal via earth satellite

1963 President John F. Kennedy assassinated

1964 Massive buildup of American troops in Vietnam; Cultural Revolution in Communist China

1966 Founding of National Organization for Women in U.S.

1968 Assassination of Martin Luther King, Jr., and Robert F. Kennedy; youth movement at apex 1969 First walk on moon

1945 Salinger, The Catcher in the Rye

1946 Orwell, 1984; Sartre, Existentialism as a Humanism

Existentialist philosophy influences writers and dramatists: Camus, The Stranger (1946); Beckett, Waiting for Godot (1953)

1949 Miller's Death of a Salesman given Pulitzer Prize for Drama; Faulkner awarded Nobel Prize for Literature

1950 Sociologist David Riesman writes The Lonely Crowd

1951 Langston Hughes, "Harlem," "Theme for English B"

1950s Alienation and anxiety become major themes of "Beat" writers Kerouac and Ginsberg

late 1930s Refugee artists Hoffman, Albers, Grosz bring ideas to America

1942 Cornell, Medici Slot Machine. Peggy Guggenheim exhibits European art at New York Gallery

1943 Pollock's first exhibition

c. 1945 New York becomes international art center; New York School includes abstract expressionism, color-field painting

1948 Pollock, Number 1

1949 Shahn, Death of a Miner

1951 Frankenthaler begins stained canvases: The Bay (1963); Moore, Reclining Figure

1950s Rauschenberg experiments with "combine" paintings

and, with Cage, "happenings" 1953-1954 Motherwell, Elegy to the Spanish Republic XXXIV

c. 1955 Reaction to abstract expressionism results in "Pop" art; Johns, Flag (1954-1955); Warhol Soupcans

1956 Hopper, Office in a Small City; Bergman film Wild Strawberries

1957-1960 Nevelson, Sky Cathedral - Moon Garden + One

1959 Rauschenberg, Monogram; Gottlieb, Thrust; Calder, Big Red

1960 Wiesel, Night, memoir of Nazi concentration camps

1961 Heller, Catch-22, satire on absurdity of war

1963 Flannery O'Connor, "Revelation"

1964 Stoppard, Rosenkrantz and Guildenstern Are Dead

1970 Solzhenitsyn awarded Nobel Prize for Literature: Toffler, Future Shock; Nikki Giovanni, "Ego Tripping"

1971 Plath, The Bell Jar, published posthumously 1973 Pynchon, Gravity's

Rainbow

1960 Johns, beer cans Painted Bronze

1960s Rothko panels for Houston Chapel, opened 1971 1962 Chamberlain, Velvet White, sculpture of crushed auto parts

1963 Smith, Cubi I: Manzù, Doors of Saint Peter's 1964 Kubrick, film Dr. Strangelove

1964-1966 Segal, The Diner; Kienholz, The State Hospital

1966 Oldenburg, Soft Toilet

1970s Resurgence of realism; incorporation of technology in art: videotapes, computers, lasers

1974 Kelly, Grey Panels 2; Pearlstein, Two Female Nudes with Regency Sofa

1976 Leslie, The 7 A.M. News

1981 Picasso's Guernica "returned" to Spain

Vietnam

allows art previously banned 1981 First space shuttle flight

1982

ARCHITECTURE

MUSIC

late 1930s Bauhaus architects Gropius and Van der Rohe flee Nazi Germany for U.S.

1943 Wright designs Guggenheim Museum, New York

c. 1947 Buckminster Fuller develops geodesic dome

1945 Britten composes opera Peter Grimes

1948 Structuralist Boulez composes Second Piano Sonata; LP recordings become commercially available

music; first use of synthesizer

1950s Beginnings of electronic

1952 Boulez, Structures; Cage experiments with aleatoric music: 4'3"

> 1955-1956 Stockhausen, Song of the Boys 1958 Cage, Concert for Piano and Orchestra

1952 Le Corbusier, L'Unité d'Habitation, Marseilles

Reinforced concrete technology results in building as sculpture: Nervi and Vitellozzi, Palazzo dello Sport, Rome (1956-1957) 1958 Van der Rohe and Johnson, Seagram Building, New York

1959 Guggenheim Museum completed

1959-1972 Utzon, Opera House, Sydney

1960 Niemeyer completes government buildings at Brasilia

1962 Saarinen, TWA Flight Center, New York

1970 Soleri begins utopian city Arconsanti in Arizona

1960 Penderecki, Threnody for the Victims of Hiroshima

1962 Britten, War Requiem; Shostakovich, Symphony No. 13, text from poems by Yevtushenko

1965 Stockhausen, Mixtur

c. 1965 Baez, Seeger, Dylan entertain with protest songs; height of rock music and Beatles; Lennon, Yesterday; eclectic music of Zappa and Mothers of Invention

1971 Shostakovich, Symphony No. 15

1973 Stockhausen, Stop; Britten, opera Death in Venice

1977 Piano and Rogers, Pompidou Center, Paris

1978 Pei, East Wing of National Gallery of Art, Washington, D.C. 1978 Penderecki, opera Paradise Lost

The Contemporary Contour

Toward a Global Culture

As we approach the end of the 20th century the period after 1945 seems to recede into history. It is difficult to remember what has happened to us as a culture in the two generations since the end of World War II. Events that have happened in the past decade or two are perhaps too close for us to know whether or not they have permanently changed us as a people. Was the moon landing of 1969 really a watershed in our consciousness as humans? Is the "American Century" so proudly forecast by commentators at the end of World War II slowly coming to an end? Has the revolution in communications already radically changed the way we learn things? Is the age of microtechnology and computers going to bring in a new, wonderful era or an antiutopia?

The postwar period is rightly called The Atomic Era. Developed largely by refugee scientists during World War II, atomic weaponry looms like an ominous shadow over all international tensions and all potentially belligerent situations. It is not simply a question of atomic bombs being bigger or more deadly weapons, although they are surely that. Atomic weapons can have long-term and littleunderstood consequences both for nature and for individuals who happen to survive their first devastation.

Because modern war is so far beyond the power of the human imagination to depict, contemporary artists have turned to satire as a way of expressing their fear and hatred of it. Novels like Joseph Heller's Catch-22 and Thomas Pynchon's Gravity's Rainbow sketch out war in terms of insanity, irrationality, and the blackest of humor while Stanley Kubrick's brilliant movie Doctor Strangelove mounts a scathing attack on those who speak cooly about "megadeaths" and "mutual assured destruction" (MAD in military lingo). Any attempt at mere realism, these artists seem to say, pales into triviality.

Second, at the end of World War II the United States emerged both as a leading economic power in the world and as the leader of the "Free World" in its struggle against communism. This preeminence explains both the high standard of living in the West and the resentment of those who do not share it. Only lately have we understood that economic supremacy does not permit a nation to live free from outside forces. The energy crisis, the need for raw materials, the quest for labor, and the search for new markets bind many nations together in a delicate economic and social network of political relationships. The United States depends on other countries; the shifting patterns of economic relationships between North America, Europe, the Third World, Japan, and the oil producers are all reminders of how fragile that network really is.

The material satisfactions of Western life have spawned other kinds of dissatisfaction. While we may be the best-fed, best-housed, and best-clothed people in history, the hunger for individual and social meaning remains a constant in our lives. For instance, the many movements in this country—for civil rights, the rights of women, for minority recognition—are signs of that human restlessness that will not be satisfied by bread alone.

The incredible achievements of modern society have exacted their price. Sigmund Freud shrewdly pointed out in Civilization and Its Discontents (1929) that the price of advanced culture is a certain repression of the individual together with the need of that individual to conform to the larger will of the community. North Americans have always been sensitive to the constraints of the state, since their history began as a revolt against statist domination.

The Western world tends to see repression in terms that are more social than political. The very complexity of the technological management of modern life has led many to complain that we are becoming mere numbers or ciphers under the indifferent control of data banks and computers. Such warnings began as early as George Orwell's political novel 1984, written right after the war (1946), and progress through David Riesman's sociological tract of the 1950s, The Lonely Crowd, to the futurist predictions of Alvin Toffler's Future Shock in the 1970s.

Art, of course, reflects not only the materials of its age but also its hopes and anxieties. The art, literature, and music of our times attempt to diagnose our ills, protest our injustices, and offer alternative visions of what life might be. On very exceptional occasions the voice of the artist can sum up a cultural condition in such a way that change can come. Who would have thought that an obscure convict, buried in the vast prison complex of the Siberian wasteland, would raise his voice against injustice and repression in such a way as radically to change the way a whole society is understood? That is surely what Alexsandr Solzhenitsvn has done in our own time with respect to the ominous character of Soviet communism.

Finally, the true artist can articulate a vision of what humanity can trust. In the midst of alienation, the artist can bring community and in the midst of ugliness, beauty. The artist, in short, acts not only as a voice of protest but as a voice of hope. The American novelist William Faulkner (1897–1962) spent a lifetime chronicling the violence, decay, injustice, poverty, and lost dreams of the American South. His novels are difficult to read, for they reflect the modernist sense of dislocated place and fragmented time. His most famous novel, The Sound and the Fury

EAST MEETS WEST

A Global Culture

While nationalism is still a fact of life, it is clear that we are rapidly becoming a global culture. New forms of information technology, intercontinental travel, and the complex nature of economics are all elements in such a change. Japan, an ancient Eastern culture, now dominates the West economically while its own traditional culture is rapidly becoming westernized in the process.

It does not take a great deal of analysis to see the vast interchanges of cultural influences in the world today. The thirst for Western fashions, popular music, and the other elements of consumer culture make great inroads in non-Western lands while the West seeks out everything from the religious traditions of the East to the art and music these countries produce. In the field of literature, to cite one conspicuous example, contemporary readers seek books beyond those of the West. Latin American authors, as well as those from Africa, Asia, and India, now find appreciative audiences.

A global culture does not mean a unitary or "one

world" culture. It does mean that people are increasingly aware of the diversity of culture. World events enter our living rooms so that things that may once have been thought of as distant events now greet us immediately and in color. We may watch those events on a television made in Japan while wearing clothes sewn in Thailand and shoes made in Hungary while snacking on food grown in Mexico. Such an economic interdependence reflects the reality of a global banking system, the globalization of the economy, and the increasing globalization of information and information technologies.

Nowhere has this shrinking of distances (and attitudes) become more clear than in the academic debates over what constitutes a liberal arts education today. Is it possible (or desirable) to have the Western core of humanities as the centerpiece of a curriculum? The place of non-Western and nontraditional cultures as part of the general education of a student is hotly argued in educational circles. The very fact of that discussion points to the emergence of a global consciousness with a continued shrinking of parochial attitudes. The fact that such globalization is hotly debated only emphasizes the profound nature of the changes taking place in our culture.

(1929), was notorious for its depiction of defective children, incestuous relationships, loutish drunkenness, and violence. In that sense it reflects the bleak landscape of the modern literary imagination. Yet Faulkner insisted that beneath the horror of modern life was a strong residue of human hope and goodness. Faulkner reaffirmed it ringingly in his acceptance speech when awarded the Nobel Prize for Literature in 1949: "I believe that man will not merely endure; he will prevail."

Existentialism

The philosophy that most persistently gripped the intellectual imagination of the Western world in the postwar period was existentialism. Existentialism is more an attitude than a single philosophical system. Its direct ancestry can be traced to the 19th-century Danish theologian and religious thinker Sören Kierkegaard (1813-1855), who set out its main emphases. Kierkegaard strongly reacted against the great abstract philosophical systems developed by such philosophers as Georg Hegel (1770-1831) in favor of an intense study of the individual person in his or her actual existing situation in the world. Kierkegaard emphasized the single individual ("the crowd is untruth") who exists in a specific set of circumstances at a particular time in history with a specific consciousness. Philosophers like Hegel, Kierkegaard once noted ironically, answer every question about the universe except "Who am I?," "What am I doing here?," and "Where am I going?"

This radically subjective self-examination was carried on all through the last century by philosophers like Friedrich Nietzsche and novelists like Fyodor Dostovevsky, who are regarded as forerunners of modern existentialist philosophy. In our own century writers like Franz Kafka, the German poet Rainer Maria Rilke, the Spanish critic Miguel de Unamuno, and, above all, the German philosopher Martin Heidegger gave sharper focus to the existentialist creed. The writer who best articulated existentialism both as a philosophy and a style of life, however, was the French writer and philosopher Jean-Paul Sartre (1905-1980).

Sartre believed it the task of the modern thinker to take seriously the implications of atheism. If there is not God, Sartre insisted, then there is no blueprint of what a person should be and there is no ultimate significance to the universe. People are thrown into life and their very aloneness forces them to make decisions about who they are and what they shall be. "People are condemned to be free," Sartre wrote. Existentialism was an attempt to help people understand their place in an absurd world, their obligation to face up to their freedom, and the kinds of ethics available to people in a world bereft of any absolutes.

Sartre began his mature career just as Germany was beginning its hostilities in the late 1930s. After being a prisoner of war in Germany Sartre lived in occupied France, where he was active in the French

Resistance, especially as a writer for the newspaper Combat. With the novelist Albert Camus (1913–1960) and the writer Simone de Beauvoir (1908–1986) his was the major voice demanding integrity in the face of the absurdities and horrors of wartorn Europe. Such an attitude might be considered a posture if it were not for the circumstances in which these existentialist writers worked.

The appeal of existentialism was its marriage of thought and action, its analysis of modern anxiety, and its willingness to express its ideas through the media of plays, novels, films, and newspaper polemics. After the close of the war in 1945 there was a veritable explosion of existentialist theater (Samuel Beckett, Harold Pinter, Jean Gênet, Eugène Ionesco) and existentialist fiction (Camus, Sartre, Beauvoir) in Europe. In the United States existentialist themes were eagerly taken up by intellectuals and writers who were attracted to its emphasis on anxiety and alienation.

The so-called beat writers of the 1950s embraced a rather vulgarized style of existentialism filtered through the mesh of jazz and the black experience. Such beat writers as the late Jack Kerouac, Gregory Corso, and Allan Ginsberg embraced the existentialist idea of alienation even though they rejected the austere tone of their European counterparts. Their sense of alienation was united with the idea of experience heightened by ecstasy either of a musical, sexual, or chemical origin. The beats, at least in that sense, were the progenitors of the hippies of the

The existentialist ethic has remained alive mainly through the novels of Albert Camus. In works like The Stranger (1942), The Plague (1947), and The Fall (1956), Camus, who disliked being called an existentialist, continues to impress his readers with heroes who fight the ultimate absurdity of the world with lucidity and dedication and without illusion.

Painting Since 1945

Art critic Barbara Rose has written that the history of world art in the second half of the 20th century bears an unmistakable American stamp. It is hard to quarrel with that judgment since in the 1940s the United States, and more specifically New York, became the center of new impulses in art, much the way Paris had been in the first half of the century.

Part of this geographic shift from Paris to New York can be explained by the pressures of World War II. Numerous artists and intellectuals fled the totalitarian regimes of Europe to settle in America. Refugee artist teachers like Hans Hofmann (1880–1966),

TABLE 18.1 Some Writers in the **Existentialist Tradition**

Fyodor Dostoevsky (1821-1881)—Russian Sören Kierkegaard (1813-1855)—Danish Friedrich Nietzsche (1844–1900)—German Miguel de Unamuno (1864-1936)—Spanish Rainer Maria Rilke (1875-1926)—Czech/German Franz Kafka (1883-1924)—Czech/German Martin Heidegger (1889-1976)—German Jean-Paul Sartre (1905-1980)—French Jose Ortega y Gasset (1883–1955)—Spanish Albert Camus (1913-1960)—French Nicholas Berdyaev (1874-1948)—Russian Martin Buber (1878-1965)—Austrian/Israeli Karl Jaspers (1883-1969)—German Jacques Maritain (1882-1973)—French

Josef Albers (1888–1976), and George Grosz (1893– 1959) brought European ideas to a new generation of American painters. The American patron and art collector Peggy Guggenheim, then married to the surrealist painter Max Ernst, fled her European home when war broke out to return to New York City, where at her Art of This Century gallery she exhibited such European painters as Braque, Léger, Arp, Brancusi, Picasso, Severini, and Miró. She quickly became patron to American painters who eventually led the American avant-garde. Peggy Guggenheim's support of this group in New York was crucial to the "Americanization" of modern art.

History nevertheless rarely records total and immediate shifts in artistic style. Thus, while a revolution was taking place in American art and, for that matter, in world art, some excellent artists continued to work in an older tradition relatively untouched by this revolution. Edward Hopper (1882–1967), for instance, continued to produce paintings that explored his interest in light and his sensitivity to the problems of human isolation and loneliness. His Office in a Small City [18.1] is a late example of Hopper's twin concerns. Ben Shahn (1898-1969) never lost the social passion that had motivated his work all through the 1930s. His Death of a Miner [18.2] is both a tribute to and an outcry against the death of a workingman in a senseless accident.

Another painter who remained untouched by the American revolution in painting is Georgia O'Keeffe (1887–1987), who had her first show in New York in 1916 at the galleries of Alfred Stieglitz, the photographer she married in 1924. Her early paintings, like L. K. Calla with Roses [18.3], show both a masterful sense of color and a precise sense of line. She belonged to the early strain of American modernism but continued in her own style. O'Keeffe has not only been recognized as a major artist in her own

18.1 Edward Hopper. Office in a Small City. 1953. Oil on canvas, 28 × 40" (71 × 102 cm). Metropolitan Museum of Art, New York (George A. Hearn Fund). Hopper's style, set by the 1920s, used light to set the tone of emotional isolation.

18.2 Ben Shahn. *Death of a Miner*. 1949. Tempera on muslin treated with gesso, on panel; 2'3" × 4' (.69 × 1.22 m). Metropolitan Museum of Art, New York (Arthur H. Hearn Fund, 1950).

18.3 Georgia O'Keeffe. L. K. Calla with Roses. 1926. Oil on canvas, $30 \times 48''$ (76 × 122 cm). Private collection. The artist took the common subject of flowers and, through her profound line and strong sense of color, turned them into mysterious, nearly abstract, shapes of feminine power.

CONTEMPORARY VOICES

Georgia O'Keeffe

I have picked voices where I have found them-Have picked up sea shells and rocks and pieces of wood where there were sea shells and rocks and pieces of wood that I liked.

When I found beautiful white bones in the desert I picked them up and took them home too.

I have used these things to say what it is to me the wideness and the wonder of the world as I live in it.

A pelvis bone has always been useful in any animal that has it—quite as useful as a head I suppose. For years in the country the pelvis bones lay about the house indoors and out—always underfoot—seen and not seen as such things can be-seen in many different ways. . . .

I was the sort of child that ate around the raisin on the cookie and ate around the hole in the doughnut saving either the raisin or the hole for the last and

So probably—not having changed much—when I started painting the pelvis bones I was most interested in the holes in the bones—what I saw through them—particularly the blue from holding them up to the sun against the sky as one is apt to do when one seems to have more sky than earth in one's

They were most wonderful against the Blue—the Blue that will be there as it is now after all men's destruction is finished.

I have tried to paint the Bones and the Blue.

A catalogue statement of Georgia O'Keeffe about her desert paintings, 1944.

right but as the focus for serious discussion about a feminist aesthetic in art for our time.

Abstract Expressionism

The artists mentioned above have a secure reputation in the history of art, but it was the abstract expressionists who gave art in the period after 1945 its "unmistakable American stamp." The term abstract expressionism is useful because it alludes to two characteristics fundamental to the work of these artists: it was devoid of recognizable content (and thus abstract) and it used color, line, and shape to express interior states of subjective aesthetic experience. Action painting and New York School are two other terms used to classify these painters.

The acknowledged leader of the abstract expressionists was the Wyoming-born painter Jackson Pollock (1912–1956), who had his first one-man show at Peggy Guggenheim's Art of This Century gallery in 1943. Pollock's early work was characterized by an interest in primitive symbolism, deriving from the artist's long encounter with the psychology of Carl Jung. By the early 1940s, under the influence of the surrealists and their technique of automatic creation in which the artist allows the unconscious rather than

18.4 Jackson Pollock. Number 1, 1948, 1948, Oil on canvas, $5'8'' \times 8'8''$ $(1.73 \times 2.64 \text{ m})$. Collection, The Museum of Modern Art, New York (purchase). The theoretical basis for such random painting can be traced to the Freudian idea of free association and the surrealist adaptation of that technique for art called psychic automatism.

18.5 Adolph Gottlieb. *Thrust.* 1959. Oil on canvas, $9' \times 7'6''$ (2.74 × 2.29 m). Metropolitan Museum of Art, New York (George A. Hearn Fund). Gottlieb's art is partly inspired by a year he spent in Arizona studying the Native American tradition of pictographs. The paintings also have a strong sexual undercurrent.

18.6 Robert Motherwell. Elegy to the Spanish Republic XXXIV. 1953–1954. Oil on canvas, $6'8'' \times 8'4''$ (2.03 × 2.54 m). Albright-Knox Art Gallery-Buffalo (gift of Seymour H. Knox). The title of the painting was inspired by the poetry of Federico Garcia Lorca, but no direct literary reference should be seen in the painting. Motherwell insists that the "painter communes with himself.'

the conscious will to stimulate the act of creation—he had begun to depart radically from traditional ways of painting.

At first Pollock discarded brush and palette for sticks, small mops, and sponges to apply paint in coarse, heavy gestures. Then he set aside instruments altogether and poured, dripped, and spattered paint directly on the canvas in nervous gestural lines rather than enclosed shapes. For his colors he mixed the expensive oils of the artists with the utilitarian enamels used by house painters. Perhaps most radically, instead of using an easel he rolled out large expanses of canvas on the floor of his studio and applied paint in his unusual manner as he walked around and on them. The dimensions of the finished painting were fixed when Pollock decided to cut out from this canvas a particular area and then attach it to the traditional wooden support or stretcher.

The result of these unorthodox procedures was huge paintings composed of intricate patterns of dribbles, drops, and lines—webs of color vibrant in their complexity [18.4]. The energy-filled nets of paint extended to the limits of the stretched canvas and by implication beyond, seeming to have no beginning or end and hence attracting the stylistic label over-all painting. Neither did these colors and lines suggest the illusion of space receding in planes behind the surface of the picture, although they did create a sense of continuous rhythmic movement.

Other painters of the New York School in the 1940s and 1950s were more interested in the potentialities of large fields of color and abstract symbol systems, often with obvious psychological meanings. Adolph Gottlieb (1903-1974) painted a series of "bursts" in the 1950s in which a luminous sunlike color field hung over a primordial exploding mass [18.5]. Robert Motherwell (1915–) did hundreds of paintings in which huge primitive black shapes are in the foreground of subtle, broken color fields [18.6]. Mark Rothko (1903-1970) experimented restlessly with floating color forms of the most subtle variation and hue. In the 1960s Rothko painted a series of panels for a chapel in Houston [18.7] in which he attempted with some success to use color variations alone to evoke a sensibility of mystical awareness of transcendence.

What did these artists have in common? Their energy and originality make it difficult to be categorical although some generalizations are possible. They all continued the modernist tendency to break with the older conventions of art. As the cubists turned away from traditional perspective so the abstract expressionists turned away from recognizable content to focus on the implications of color and line. Second, they were expressionists, which is to say that they were concerned with the ability of their paintings to

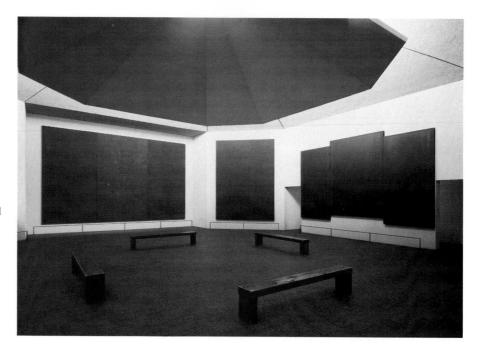

18.7 Mark Rothko. The Rothko Chapel, Rice University, Houston. 1965-66. Left to right: North, northeast, and east wall paintings. Oil on canvas. Chapel design by Philip Johnson. Murals by Mark Rothko. This ecumenical chapel contains fourteen panels finished several years before the artist's death. The fourteen panels may make an oblique reference to the traditional fourteen stations of the cross, but the artist desired their brooding simplicity to be a focus for the personal meditation of each viewer.

express not what they saw but what they felt and what they hoped to communicate to others. As one critic has put it, in an age when organized religion could no longer compel people with the notion of revelation, these artists wished to express their sense of ultimate meaning and their thirst for the infinite.

"Instead of making cathedrals out of Christ, Man, or 'Life,'" painter Barnett Newman wrote, "we are making them out of ourselves, out of our own feel-

The desire to expand the possibilities of pure color detached from any recognizable imagery has been

18.8 Helen Frankenthaler. The Bay. 1963. Acrylic resin on canvas, $6'8\frac{1}{4}'' \times 6'9\frac{1}{4}''$ (2.02 × 2.08 m). The Detroit Institute of Arts (gift of Dr. and Mrs. Hilbert D. Delawter). Frankenthaler's work gains its almost watercolor luminosity by her practice of thinning her paints to the consistency of washes.

carried on and extended by a second generation of color-field painters, the most notable of whom is Helen Frankenthaler (1928-). Around 1951 Frankenthaler began to saturate unprimed canvases with poured paint so that the figure (the paint) merged into the ground (the canvas) of the work. By staining the canvas she carried Pollock's action painting one step further, emphasizing the pure liquidity of paint and the color that derives from it. Frankenthaler uses the thinnest of paints to take advantage of the light contrast between the paint and the unstained canvas (unlike Pollock she does not paint "all over" her ground). The result has been paintings with the subtlety of watercolors but distinctively and inescapably different [18.8].

The Return to Representation

It was inevitable that some artists would break with abstract expressionism and return to a consideration of the object. This reaction began in the middle 1950s with painters like Jasper Johns (1930– "Flag" series [18.9] heralded a new appreciation of objects. Further, Johns' art focused on objects taken from the mundane world. Johns went on to paint and sculpt targets, toothbrushes, beer cans, and even his own artist's brushes. This shift signaled a whimsical and ironic rejection of highly emotive, content-free, and intellectualized abstract art.

) was another Robert Rauschenberg (1925artist who helped define the sensibility emerging as a counterforce to abstract expressionism in the 1950s. Rauschenberg had studied at Black Mountain College, an experimental school in North Carolina, under the tutelage of the refugee Bauhaus painter Josef Albers. A more important influence from his Black Mountain days was the avant-garde musician and composer John Cage (1912–), who encouraged experiments combining music, drama, dance, art, and other media into coherent artistic wholes which were called happenings. Rauschenberg began to experiment with what he called "combine" paintings that utilized painting combined with any number of assembled objects in a manner that had deep roots in the avant-garde. By 1959 he was doing large-scale works like his Monogram [18.10], which combined an assortment of elements (including a stuffed goat!) in an outrageous yet delightful collage.

The third artist who emerged in the late 1950s is Andy Warhol (1930-1987). Warhol became notorious for his paintings of soup cans, soap boxes, cola bottles, and the other throwaway detritus of our society, which made his name synonymous with pop art, a term first used in England to describe the art of popular culture. The long-range judgment on Warhol as a serious artist may be harsh, but he under-

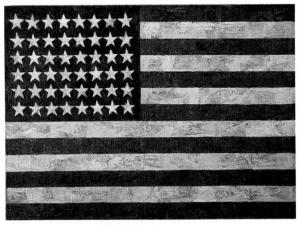

18.9 Jasper Johns. Flag. 1954–55. Encaustic, oil, and collage on canvas, $3'61/4'' \times 5'5/8''$ (1.07 \times 1.54 m). Collection, The Museum of Modern Art, New York (gift of Phillip Johnson in honor of Alfred H. Barr, Jr.). The rather banal subject should not detract from Johns' phenomenal technique. Encaustic is painting done with molten colored wax.

stood one thing very well: taste today is largely shaped by the incessant pressure of advertising, the mass media, pulp writing, and the transient culture of fads. Warhol, who started his career as a commercial illustrator, exploited that fact relentlessly.

Over the years Warhol increasingly turned his attention away from painting and toward printmaking, videotapes, movies, and Polaroid photography. His subjects tended to be the celebrities of the film and social world. Whether his art is a prophetic judgment on our culture or a subtle manipulation of it is difficult to answer since Warhol could be bafflingly indi-

18.10 Robert Rauschenberg. Monogram. 1955-1959. Freestanding combine, $5'4\frac{1}{2} \times 3'6'' \times 5'3\frac{1}{4}''$ (1.64 × 1.07 × 1.61 m). Moderna Museet, Stockholm. Although Rauschenberg's work was considered a spoof of abstract art—a sort of contemporary dada—he is now regarded as one of the most inventive of American artists.

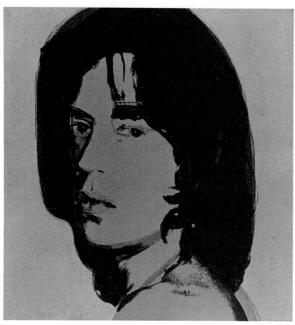

18.11 Andy Warhol. Mick Jagger. 1975. Acrylic paint and silkscreen enamel on canvas, 40" (102 cm) square. Private collection. Warhol incorporated into high art the world of the media, money, and fashion. Until his death in 1987 he incarnated the notion of the artist as celebrity figure with his explorations in video, film, photography, magazine publishing, graphics, and painting.

18.12 Ellsworth Kelly. Grey Panels 2. 1974. Oil on canvas, $7'8'' \times 8'6''$ (2.34 × 2.59 m). Leo Castelli Gallery, New York. By comparing this work with Frankenthaler's (18.8) one can see the different approaches to color in the post-abstractexpressionist period.

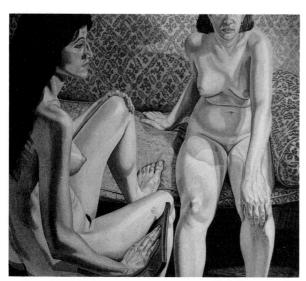

18.13 Philip Pearlstein. Two Female Models on a Regency Sofa. 1974. Oil on canvas, $5' \times 5'10''$ (1.52 × 1.78 m). Private collection, New York. Compare Pearlstein's nudes with those of the Renaissance tradition represented by an artist like Titian to get a feeling for the modern temper.

18.14 Alfred Leslie. 7 A.M. News. 1976–1978. Oil on canvas, 7 × 5' (2.13 × 1.52 m). Courtesy, Frumkin/Adams Gallery, New York. Leslie uses the technique of chiaroscuro in conscious homage to the Baroque masters like Caravaggio and Rembrandt.

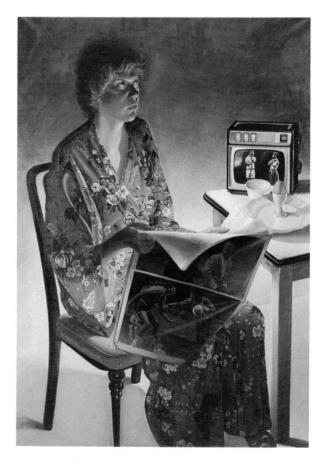

rect. His lightly retouched silkscreen prints of entertainment celebrities [18.11] seem banal and of little permanent value, but that may be exactly what he

wished to express.

Painting from the 1970s is difficult to categorize. Some artists continue to explore color-field painting with great verve. Others, such as Ellsworth Kelly, Kenneth Noland, and Frank Stella, explore more formal elements with carefully drawn "hard edges," primary colors, and geometrically precise compositions. They are almost ascetic in their use of line and color, as recent "minimalist" works of an artist like Ellsworth Kelly show [18.12].

Another group of painters has gone back totally to the recognizable object painted in a manner so realistic that critics have called them "photorealists." Less glossy than the photorealists but almost classical in their fine draftsmanship are the erotically charged nudes of Philip Pearlstein, who takes a position somewhere between the fragmented world of cubism and the slick glossiness of popular magazines. His Two Female Models on Regency Sofa [18.13] is a serious and unsentimental study of the female figure.

For Alfred Leslie (1927–) the past can still be a teacher for the modern painter. In a work like 7 A.M. News [18.14] Leslie combines an eye for contemporary reality and the use of chiaroscuro, a technique he consciously borrows directly from the 17th-century painter Caravaggio. With Alfred Leslie we have

come, as it were, full circle from the abstract expressionist break with tradition to a contemporary painter who consciously looks back to the 17thcentury masters for formal inspiration.

One can say that two intellectual trends seem to have emerged in American painting in this period. One strain, abstract expressionism and its various offspring, is heavily indebted to the modernist intellectual tradition, with its many roots in psychological theories of Jung and Freud and the existentialist vocabulary of anxiety and alienation. By contrast, the work of painters like Johns, Warhol, Rauschenberg, and others is far more closely linked to the vast world of popular culture in post-industrial America. Its material, its symbols, and its intentions reflect the values of consumer culture more than the work of the New York School of the 1940s. Pop art, largely free from the brooding metaphysics of the abstract expressionists, can be seen—perhaps simultaneously—as a celebration and a challenge to middleclass values.

Painting in the late 1970s and 1980s has gone in many directions. Critics are agreed on one point: there is no predominant "ism" that defines contemporary art. The profusion of styles apparent on today's art scene testifies to either a vigorous eclecticism or a sense of confusion. Older painters like Frank Stella still push the limits of abstract art [18.15], while Susan Rothenberg's canvases reflect a

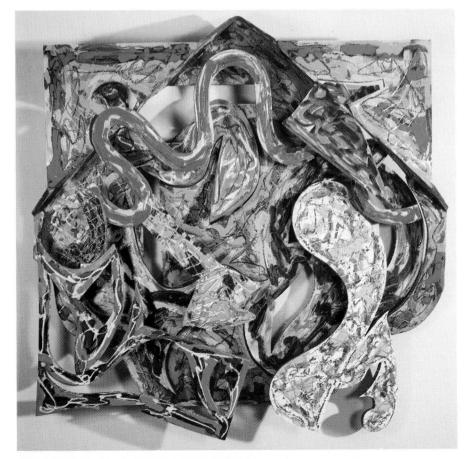

18.15 Frank Stella. Thruxton 3X. 1982. Mixed media on etched aluminum, $6'3'' \times 7'1''$ $(1.90 \times 2.16 \times .38 \text{ m})$. The Shidler Collection, Honolulu.

18.16 Susan Rothenberg. Flanders. 1976. Acrylic and tempera on canvas, $65\frac{3}{4} \times 98\frac{3}{4}$ ". Collection Jacques Kaplan.

concern with the very texture of painting, in which recognizable figures emerge like risen ghosts [18.16]. The same polarity of styles can be seen by contrasting the sunny optimism of the English-born David Hockney (now living in California) [18.17] with the brooding work of the German expressionist painter, Anselm Kiefer [18.18]. These artists work in a time when the older "masters" like Johns, Rauschenberg, and others still push the limits of their original insights and flights of imagination.

Contemporary Sculpture

Sculpture since 1945 shows both continuities and radical experimentation. The Italian sculptor Giacomo Manzù (1908-) still works with traditional forms of bronze-casting to produce works like the doors of Saint Peter's [18.19] commissioned by the Vatican in the 1950s and cast in the 1960s. While his style is modern, the overall concept and the nature of the commission hark back to the Italian Renaissance and earlier.

Much of contemporary sculpture has utilized newer metals (stainless steel or rolled steel, for instance) and welding techniques to allow some freedom from the inherent density of cast bronze, the traditional metal of the sculptor. David Smith (1906-1965) used his skills as a onetime auto-body assembler to produce simple and elegant metal sculptures that reflected his not inconsiderable technical skills with metal as well as his refined sense of aesthetic balance. In works like Cubi I [18.20] he utilized stain-

18.17 David Hockney. Self Portrait, July 1986. 1986. Homemade print from an office copier. Two panels, $22 \times 8\frac{1}{2}$ " (56 × 21.6 cm). Collection of the artist. This work was done by running the page through commercial copying machines to get the various colors of the finished portrait.

18.18 Anselm Kiefer. Innenraum. 1981. Oil, paper, and canvas; 113' × 122' (34.45 × 37.2 m). Stedelijk Museum, Amsterdam. Kiefer's monumental paintings have echos of past masters combined with a brooding sense of Germany's own past, mythic and historical.

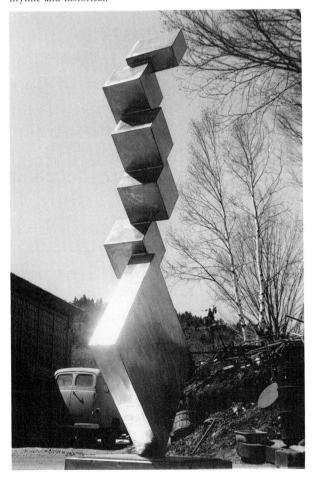

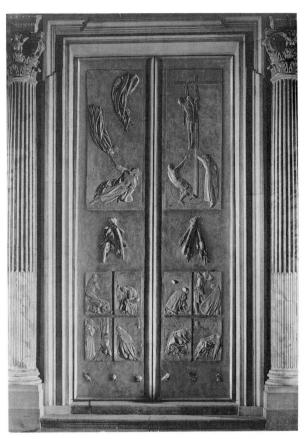

18.19 Giacomo Manzù. Doors of St. Peter's. 1963. Cast bronze, $24'3'' \times 11'9''$ (7.4 × 3.6 m). Vatican City, Rome. These doors are on the extreme left of the portico of the basilica. (Opposite is the entrance opened only for Holy Year celebrations, every quarter-century.)

18.20 David Smith. Cubi I. 1963. Metal, steel, stainless steel construction, height 10'4" (3.15 m). The Detroit Institute of Arts (Special Purchase Fund). Critics recognize Smith as one of the most important sculptors of the century. Smith took this photograph at his studio in Bolton Landing, New York.

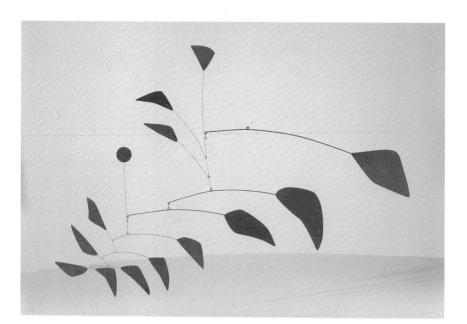

18.21 Alexander Calder. Big Red. 1959. Painted sheet metal and steel wire, $6'2'' \times 9'6''$ (1.9 × 2.9 m). Whitney Museum of American Art, New York (purchase with funds from the Friends of the Whitney Museum of American Art).

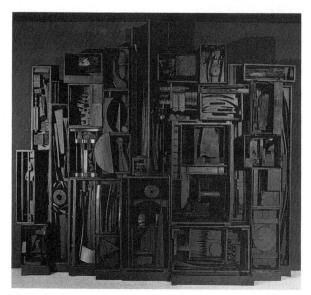

18.22 Louise Nevelson. Sky Cathedral—Moon Garden + One, detail. 1957-1960. Painted wood, 9'1" × 10'10" × 19" (2.77 × 3.3 × 48 m). Milly and Arnold Glimcher Collection. This detail shows the intricate and complex nature of Nevelson's work. At her death in 1988, she was considered one of the most accomplished sculptors in the world.

less steel to produce a geometrically balanced work of solidity that conveys a sense of airy lightness.

Alexander Calder (1898–1976) used his early training as a mechanical engineer to combine the weightiness of metal with the grace of movement. Mobiles like Big Red [18.21] are made of painted sheet metal and wire; these constructions move because they are so delicately balanced that they respond to even the slightest currents of air. Calder

18.23 Joseph Cornell. Medici Slot Machine. 1942. Construction, $15\frac{1}{2} \times 12 \times 4\frac{1}{4}$ " (39 × 30 × 11 cm). Private collection. Though he shows the influence of both dada and surrealism, Cornell's sense of innocence and nostalgia marks him as a genuine original.

18.24 George Segal. The Diner. 1964-1966. Plaster, wood, chrome, formica, masonite, fluorescent lamp; $8'6'' \times 9' \times 7'3''$ (2.59 × 2.75 × 2.14 m). Walker Art Center, Minneapolis (gift of the T. B. Walker Foundation). More recently, Segal has been experimenting with colored plasters and large bronze cast outdoor pieces.

once said that people think monuments "come out of the ground, never out of the ceiling"; his mobiles were meant to demonstrate just the opposite.

Other contemporary sculptors have expanded the notion of assembling disparate materials into a coherent artistic whole. Employing far from traditional materials, these artists utilize a variety of found and manufactured articles of the most amazing variety to create organic artistic wholes. Louise Nevelson (1900-1988), for example, used pieces of wood, many of which had been lathed or turned for commercial uses, to assemble large-scale structures that seem at the same time to function as walls closing off space and as containers to hold the items that make up her compositions [18.22]. Joseph Cornell (1903-1972), early influenced by both surrealism and dada, constructed small boxes that he filled with dimestore trinkets, maps, bottles, tops, stones, and other trivia.

18.25 Edward Kienholz. The State Hospital, detail. 1966. Mixed media, $8 \times 12 \times 10''$ (2.44 × 3.66 × 3.05 m). Moderna Museet, Stockholm. Kienholz's work provoke such violent reactions that in 1966 some works were threatened with removal from a one-person show he had in Los Angeles.

In contrast to the larger brooding, almost totemic spirit of Nevelson, Cornell's painstakingly organized boxes [18.23] allude to a private world of fantasy.

The sculptural interest in assemblage has been carried a step further by such artists as George Segal) and Edward Kienholz (1927-(1924 -Their works re-create entire tableaux into which realistically sculptured figures are placed. Segal, once a painting student of Hans Hofmann in New York, likes to cast human figures in plaster of Paris and then set them in particular but familiar settings [18.24]. The starkness of the lone white figures evokes a mood of isolation and loneliness not unlike that of the paintings of Edward Hopper. Kienholz, a California-based artist, is far more prepared to invest his works with strong social comment. His State Hospital [18.25] is a strong, critical indictment of the institutional neglect of the mentally ill. The chained figure at the bottom of the tableau "dreams" of his own self-image (note the cartoonlike bubble) on the top bunk. In the original version of this powerful piece goldfish were swimming in the plastic-enclosed faces of the two figures.

Both Segal and Kienholz have certain ties to pop art but neither works within its whimsical or humorous vein. Claes Oldenburg (1929-), however, is one of the more humorously outrageous and inventively intelligent artists working today. He has proposed (and, in some cases, executed) monumental outdoor sculptures depicting teddy bears, ice-cream bars, lipsticks, and baseball bats. From the 1960s on he has experimented with sculptures that turn normally rigid objects into "soft" or "collapsing" versions made from vinvl or canvas and stuffed with kapok. A piece like his Soft Toilet [18.26] is at the same time humorous and mocking. It echoes pop art and recalls the oozing edges so characteristic of surrealism.

Overarching these decades of sculptural development is the work of the British sculptor Henry Moore (1898–1986). Moore's work, which extends back into the 1920s, is a powerful amalgam of the monumental tradition of Western sculpture deriving from the Renaissance masters like Michelangelo and his love for the forms coming from the early cultures of Africa, Mexico, and pre-Columbian Latin America. From these two sources Moore worked out hauntingly beautiful works—some on a massive scale—that speak of the most primordial realities of

Moore's Reclining Figure [18.27] is a complex work that illustrates many of the sculptor's mature interests. The outline is obviously that of a woman in a rather abstract form. There is also the hint of bone-

18.26 Claes Oldenburg. Soft Toilet. 1966. Vinvl filled with kapok, painted with liquitex, and wood; $52 \times 32 \times 30'$ $(132.1 \times 81.3 \times 76.2 \text{ m})$. Whitney Museum of Modern Art, New York. (50th anniversary gift of Mr. and Mrs. Victor W. Ganz). Oldenburg's humor derives from the well-known device of taking the expected and rendering it in an unexpected selfparodying form.

18.27 Henry Moore. Reclining Figure. 1951. Bronze, length 7'5" (2.25 m). Musée National d'Art Moderne, Centre Georges Pompidou, Paris. Note the allusions to bones in the figure, allusions that serve as a counterpoint to the curved character of the figure.

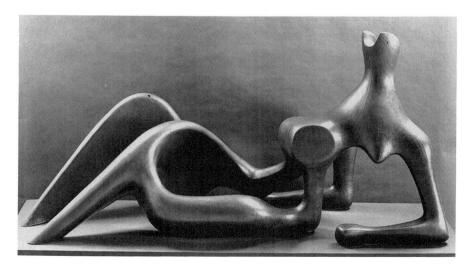

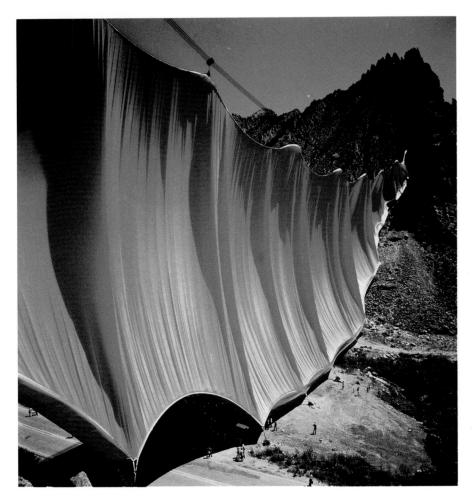

18.28 Christo. Valley Curtain. 1971-1972. Span 1250' (381 m). Height 185-365" (56.39-111.25 m). 200,000 square feet (18,587 square meters) of nylon polyamide; 110,000 pounds of steel cables. Grand Hogback, Rifle, Colorado. Project Director: Ian van der Marck. Since that project, Christo has run a nylon fabric fence miles in California, surrounded a group of Florida islands with sheeting, and draped a bridge in Paris.

like structures, a favorite motif in Moore's abstract sculpture, and holes pierce the figure. The holes, Moore once said, reminded him of caves and openings in hillsides with their hint of mystery, and critics have also noted their obvious sexual connotations. The figure reclines after the fashion of Etruscan and Mexican burial figures. In a single work Moore hints at three primordial forces in the universal human experience: life (the female figure), death (the bonelike configurations), and sexuality (the holes). It is a sculpture contemporary in style but timeless in its message.

Most of the sculpture just discussed was made for a gallery or a collector. Thanks to increased government and corporate patronage in recent decades it is possible for the average citizen to see outdoor sculpture as part of the urban environment. A walk in the downtown area of Chicago, for example, provides a chance to see monumental works of Picasso, Chagall, Bertoia, Calder, and Oldenburg. The fact that the federal government had set aside a certain percentage of its building budget for works of art to enhance public buildings has been an impetus for wider diffusion of modern art and sculpture. In one sense, the government, the large foundations, and the corporation have supplanted the church and the aristocracy as the patrons for monumental art in our time.

As we move into the 1980s sculpture demonstrates a variety not unlike that of contemporary painting. The Bulgarian-born Christo still seeks out large natural and urban sites to drape with various fabrics for temporary alteration of our perception of familiar places [18.28]. By contrast, the haunting work of Magdalena Abakanowicz uses basic fibers to make pieces that have fearful references to the human disasters of 20th-century history [18.29]. The American sculptor Duane Hanson takes advantage of new materials like polyvinyl to create hyperrealistic visions of ordinary people in ordinary experiences [18.30]. All these sculptors draw on the most advanced contributions of material science and technology while meditating on problems of the human condition as old as art itself.

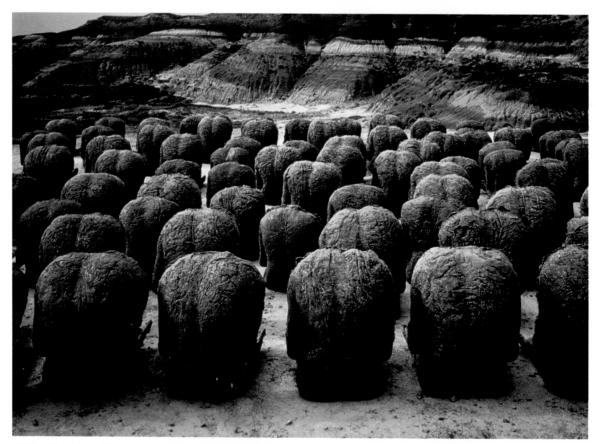

18.29 Magdalena Abakanowicz. Backs. 1976-1982. Burlap and glue, 20 pieces. These figures speak of human degradation, the horrors of war and servitude, and inhumanity. Abakanowicz has pushed fiber arts to new and profound directions beyond the mere designation of "craft art."

Architecture

The most influential American architect of this century was Frank Lloyd Wright (1869-1959). Wright was a disciple of Louis Sullivan (1856-1924), who had built the first skyscrapers in the United States in the last decade of the 19th century. Like Sullivan, Wright championed an architecture that produced buildings designed for their specific function with an eye to the natural environment in which the building was to be placed and with a sensitivity to what the building should "say." "Form follows function" was Sullivan's famous aphorism for this belief. For Wright and his disciples there was something ludicrous about making a post office look like a Greek temple and then building it in the center of a Midwestern American city. Wright wanted an organic architecture—an architecture that grows out of its location rather than being superimposed on it.

For decades Wright designed private homes, college campuses, industrial buildings, and churches

18.31 Frank Lloyd Wright. Solomon R. Guggenheim Museum, New York. 1957-1959. Reinforced concrete; diameter at ground level c. 100' (30.48 m), at roof level 128' (39 m), height of dome 92' (28 m). One of the most discussed American buildings of the century, it is hard to realize that it sits in the midst of New York's Fifth Avenue buildings.

that reflected this basic philosophy. In the postwar period Wright finished his celebrated Solomon R. Guggenheim Museum [18.31] in New York City from plans he had made in 1943. This building, one of Wright's true masterpieces, is a capsule summary of his architectural ideals. Wright was interested in the flow of space rather than its obstruction ("Democracy needs something basically better than a box"), so the Guggenheim Museum interior tries hard to eliminate corners and angles. The interior is essentially one very large room with an immensely airy central space. Rising from the floor in a continuous flow for six stories is a long simple spiraling ramp cantilevered off the supporting walls. A museumgoer can start walking down the ramp to view an exhibition without ever encountering a wall or partition. The viewing of the art is a continuous unfolding experience. Thus the function of the museum (to show art) is accomplished by the *form* of the building.

The exterior of the Guggenheim Museum vividly demonstrates the possibilities inherent in the new building materials becoming available in this century. By the use of reinforced or ferroconcrete one can model or sculpt a building easily. The Guggenheim Museum, with its soft curves and cylindrical forms, seems to rise up from its base. The undulating lines stand in sharp contrast to the boxy angles and corners of most of the buildings found in New York City. By using such a design, made to fit a rather restricted urban space, the Guggenheim almost takes on the quality of sculpture.

The sculptural possibilities of reinforced and prestressed concrete have given other architects the means to "model" buildings in dramatically attractive ways. The Italian engineer and architect Pier Luigi Nervi (1891-1979) demonstrated the creative use of concrete in a series of buildings he designed for the 1960 Olympic Games in Rome [18.32]. Eero Saarinen (1910–1961) showed in the TWA Flight Center at John F. Kennedy Airport in New York

18.32 Pier Luigi Nervi and Annibale Vitellozi. Palazzetto dello Sport, Rome. 1956-1957. The walls beneath the dome are of glass. The Y-shaped ferroconcrete columns are reminiscent of carvatids; their outstretched "arms" support the dome.

City [18.33] that a building can become almost pure sculpture; Saarinen's wing motif is peculiarly appropriate for an airport terminal. That architects have not exhausted the potentialities of this modeled architecture seems clear from the recently opened Opera House complex in Sydney, Australia [18.34]. Here the Danish architect Jörn Utzon utilized Saarinen's wing motif, but it is not a slavish copy since Utzon gives it a new and dramatic emphasis.

The influential French architect Le Corbusier (1887–1965; born Charles Édouard Jeanneret-Gris) did not share Wright's enthusiasm for "organic" architecture. Le Corbusier saw architecture as a human achievement that should stand in counterpoint to the world of nature. During his long career Le Corbusier designed and oversaw the construction of both individual buildings and more ambitious habitations ranging from apartment complexes to an entire city. One of his most important contributions to architecture is his series of Unités d'Habitation in Marseille (1952) and Nantes [18.35]. These complexes were attempts to make large housing units into livable modules that would not only provide a living space but would also be sufficiently self-contained to incorporate shopping, recreation, and walking areas. Le Corbusier used basic forms (simple squares, rectangles) for the complexes and set them on pylons both to give more space beneath the buildings and to break up their rather blocky look. Many of these buildings would be set in green park areas situated to capture something of the natural world and the sun. The basic building material was concrete and steel (often the concrete was not finished or polished since Le

18.33 Eero Saarinen. Trans World Flight Center, Kennedy International Airport, New York. 1962. The building brilliantly shows the sculptural possibilities of concrete. There is a hint of a bird in flight in the general configuration of the roof as it flares out on both sides.

Corbusier liked the texture of the material). Less inspired architects have utilized these same concepts for public housing with indifferent success—as visits to the peripheries of most urban centers will attest.

Le Corbusier's influence in North America has mainly been derivative. Two other European archi-

18.34 Jörn Utzon. Opera House, Sydney, Australia. 1959-1972. Reinforced concrete, height of highest shell 200' (60.96 m). The building juts dramatically into Sydney's harbor. Structural technology was pushed to the limit by the construction of the shells, which are both roof and walls. The openings between the shells are closed with two layers of amber-tinted glass to reduce outside noise and to give views to people in the lobbies of the buildings.

18.35 Le Corbusier. L'Unité d'Habitation. Marseille, France. 1947-1952. Length 550' (167.64 m), height 184' (56.08 m), width 79' (24.08 m). The individual balconies have colored panels to break up the stark rough concrete exterior. Imitation of this style has resulted in much soulless public housing in the large cities of the world.

tects, however, have had an immense impact on American architecture. Walter Gropius (1883–1969) and Ludwig Miës van der Rohe (1896-1969) came to this country in the late 1930s, refugees from Nazi Germany. Both men had long been associated with the German school of design, the Bauhaus.

Miës van der Rohe's Seagram Building [18.36] in New York City, designed with Philip Johnson), beautifully illustrates the intent of Bauhaus design. It is a severely chaste building of glass and anodized bronze set on stainless steel pylons placed on a wide granite platform. The uncluttered plaza (broken only by pools) contrasts nicely with the essentially monolithic glass building that rises up from it. The lines of the building are austere in their simplicity while the materials are few and well chosen, with a resultant integration of the whole. It illustrates the "modern" principle of the Bauhaus that simplicity of design results in an aesthetically harmonic whole—"less is more" according to the slogan of this art.

The Seagram Building now seems rather ordinary to us, given the unending procession of glass-andsteel buildings found in most of our large city centers. That many of these buildings are derivative cannot be denied; that they may result in sterile jungles of glass and metal is likewise a fact. Imitation does not always flatter the vision of the artist but excesses do not invalidate the original goal of the Bauhaus designers. They were committed to crispness of design and the imaginative use of material. In the hands of a master architect that idea is still valid, as the stunning new East Wing of the National Gallery of Art in Washington, D.C., clearly demonstrates [18.37].

18.36 Ludwig Mies van der Rohe and Philip Johnson. Seagram Building. New York. Height 512' (156.2 m). Compare the cleanly severe lines of this building with those of the more ornate buildings in the background.

18.37 I. M. Pei. East Wing, National Gallery of Art, Washington, D.C. 1978. Pei combined a "modernist" look with a "classical" one that prevents the edifice from clashing with the older buildings on the mall leading to the Capitol.

18.38 Renzo Piano and Richard Rogers. Georges Pompidou National Center for Art and Culture, Paris. 1977. In the last few years this center has taken on a lively bohemian air; nearby streets are lined with galleries and adjoining squares are dotted with street performers and musicians.

This building, designed by I. M. Pei (1917utilizes pink granite and glass within the limits of a rather rigid geometric design to create a building monumental in scale without loss of lightness or crispness of design.

One can profitably contrast the chaste exterior East Wing of Washington's National Gallery with the Georges Pompidou National Center for Arts and Culture in Paris [18.38], designed by Renzo Piano and Richard Rogers. The Pompidou Center was opened in 1977 as a complex of art, musical research, industrial design, and public archives. The architects eschewed the clean lines of classical sculpture, covering the exterior with brightly colored heating ducts, elevators, escalators, and building supports. It has been an extremely controversial building since its inception but Parisians (and visitors) have found it a beautiful and intriguing place. Whether its industrial style will endure is, of course, open to question, but for now its garishness and nervous energy have made it a cultural mecca. It may even in time rival that other monument once despised by Parisians and now practically a symbol for the city, the Eiffel Tower.

Since the 1970s a number of architects, including

18.39 Kohn, Pederson, Fox. 1201 Third Avenue in Seattle. Seattle, Washington, 1988. The post-modern character of the building may be seen clearly by contrasting this building with the two office towers to the right and left in the photograph.

Philip Johnson and Robert Venturi, have moved beyond the classic modern design of large buildings to reshape them with decorative elements and more broken lines; this break with the severe lines of modernist taste has come to be called post-modernism in architecture. The country now has many such buildings but one, a skyscraper in Seattle, Washington, well illustrates the post-modern sensibility [18.39]. The designer, William Pederson, retains the severe lines and the ample use of glass characteristic of most modern business buildings, but he breaks those lines up with a bowed center of the building that stands in contrast to the classical sides. The last floors break up the design of the lower floors, and in an almost postmodern signature, he caps the building with a halfarch students will remember seeing on the facades of Renaissance and Baroque buildings but whose ultimate inspiration is the Roman half-arch. One architectural critic has said that this building sums up what is best in innovative skyscraper design today. Its sense of color (the stone is a pinkish granite); its homage to classical decorative motifs; its advance upon Bauhaus severity (without a firm rejection of it) summarize what is known as the post-modern in architecture.

Some Trends in Contemporary Literature

By the end of World War II literary figures who had defined the modernist temper—writers like T. S. Eliot, James Joyce, Thomas Mann, Ezra Poundwere either dead or had already done their best work. Their passionate search for meaning in an alienated world, however, still inspired the work of others. The great modernist themes received attention by other voices in other media. The Swedish filmmaker Ingmar Bergman (1918–) began a series of classic films starting with Wild Strawberries in 1956, done in black and white, which explored the loss of religious faith and the demands of modern despair. The enigmatic Irish playwright (who lives in France and writes in French and English) Samuel Beckett) has produced plays like Waiting for Godot (1952) that explore an absurdist world beyond logic, decency, and the certainty of language itself.

Waiting for Godot, for all its apparent simplicity, is maddeningly difficult to interpret. Two characters, Vladimir and Estragon, wait at an unnamed and barren crossroads for Godot. Their patient wait is interrupted by antic encounters with two other characters. In the two acts, each representing one day, a

young boy announces that Godot will arrive the next day. At the end of the play Vladimir and Estragon decide to wait for Godot although they toy momentarily with the idea of splitting up or committing suicide if Godot does not come to save them.

The language of Godot is laced with biblical allusions and religious puns. Is Godot God and does the play illuminate the nature of an absurd world without final significance? Beckett does not say and critics do not agree, although they are in accord with the judgment that Waiting for Godot is a classic—if cryptic—statement about language, human relations, and the ultimate significance of the world.

Gradually, as the war receded in time other voices that told us of the horrors of the war experience began to be heard. The most compelling atrocity of the war period, the extermination of six million Jews and countless other dissidents or enemies in the Nazi concentration camps, has resulted in many attempts to tell the world that story. The most significant voice of the survivors of the event is the European-), himself a survivor of born Elie Wiesel (1928the camps. Wiesel describes himself as a "teller of tales." He feels a duty, beyond the normal duty of art, to keep alive the memory of the near-extermination of his people. Wiesel's autobiographical memoir Night (1960) recounts his own years in the camps. It is a terribly moving book with its juxtaposition of a young boy's fervent faith as it comes in contact with the demonic powers of the camp.

In the United States an entirely new generation of writers has defined the nature of the American experience. Arthur Miller's play Death of a Salesman (1949) explores the failure of the American dream in the person of its tragic hero, Willie Loman, an ordinary man defeated by life. J. D. Salinger's Catcher in the Rye (1951) documented the bewildering coming of age of an American adolescent in so compelling a manner that it was, for a time, a cult book for the young. Southern writers like Eudora Welty, William Styron, Walker Percy, and Flannery O'Connor have continued the meditations of William Faulkner about an area of the United States that has tasted defeat in a way no other region has. Poets like Wallace Stevens, Theodore Roethke, William Carlos Williams, and Marianne Moore continued to celebrate the beauties and terrors of both nature and people.

We have already noted that existentialism was well suited to the postwar mood. One aspect of existentialism's ethos was its insistence on protest and human dissatisfaction. That element of existential protest has been very much a part of the postwar scene. The civil rights movement of the late 1950s and early 1960s became a paradigm for other more recent protests such as those against the Vietnam war; in favor of the rights of women; for the rights of the dispossessed, underprivileged, or the victims of discrimination. The literature of protest has been very much a part of this cry for human rights.

First and foremost, one can trace the Afro-Americans' struggle for dignity and full equality through the literature they produced, especially in the period after the First World War. The great pioneers were those writers who are grouped loosely under the name "Harlem Renaissance." Writers like Claude McKay, Jean Toomer, Countee Cullen, and, above all, Langston Hughes refused the stereotype of the Negro to craft an eloquent literature demanding humanity and unqualified justice. The work of these writers presaged the powerful torrent of black fiction chronicling racial injustice in America. Two novels in particular, Richard Wright's Native Son (1940) and Ralph Ellison's Invisible Man (1952), have taken on the character of American classics. Younger writers followed, most notably James Baldwin, whose Go Tell It On the Mountain (1953) fused vivid memories of black Harlem, jazz, and the intense religion of the black church into a searing portrait of growing up black in America. Alice Walker has explored her Southern roots in the explosively powerful *The Color* Purple (1982).

For many of the younger black writers in America the theme of black pride has been linked with the consciousness of being a woman. Nikki Giovanni) has produced a whole body of poetry celebrating both her sense of "blackness" and her pride in her femininity. Her poetry has been a poetic blend of black history and female consciousness done in an American mode.

The rightful claims of women have been advanced in our day by an activist spirit that seeks equality of all people, free from any sexual discrimination. The battle for women's rights began in the last century. It was fought again in the drive for women's suffrage in the first part of this century and continues today in the feminist movement. The cultural oppression of women has been a major concern of the great women writers of our time. Writers like Doris Lessing, Margaret Atwood, Adrienne Rich, Maxine Kumin, and others are exploring feminine consciousness in great depth and from different angles of vision.

Two contemporary poets deserve particular mention, since both of them dealt so clearly with the dissatisfaction of women. Sylvia Plath (1932-1963) and Anne Sexton (1928–1974) used the imagery of traditional sexual roles to complain about the restraints of their position. Ironically enough, the precociously talented Sylvia Plath and Anne Sexton briefly knew each other when they studied poetry together. Sylvia Plath not only produced an important body of poetry but a largely autobiographical novel The Bell Jar

(1962), describing most of her short and unhappy life. Anne Sexton, by contrast, wrote only poetry.

A Note on the Post-modern

For the past decade or so some literary critics have been insisting, with varying degrees of acceptance, that much of contemporary literature has moved beyond the modernist preoccupation with alienation, myth, fragmentation of time, and the interior states of the self. The most debated question now is: What exactly has followed modernism (by definition it is post-modern) and does it have a shaping spirit? Further, who are its most significant practitioners? The latter question seems to be the easier of the two. Many critics would mention the following among those who are setting and defining the post-modernist literary agenda: Italo Calvino in Italy; Jorge Luis Borges in Argentina; Gabriel García Márquez in Colombia; and a strong group of American writers that includes Donald Barthelme, Robert Coover, John Barth, Stanley Elkin, Thomas Pynchon, Renata Adler, Susan Sontag, and Kurt Vonnegut, Jr. Borges is perhaps the writer most influential in shaping the post-modern sensibility.

That list of writers represents far-ranging and diverse sensibilities. What do they hold in common that permits them to be considered representative post-modernists? Some critics see the post-modernists as those who push the modernist world view to its extreme limit. Post-modernist writing, these critics would say, is less concerned with traditional plot lines, more antirational, more private in its vision, more concerned to make the work a private world of meanings and significations. This is hardly a satisfactory definition since it merely defines the postmodern as more of the same. It does not define, it merely extends the definition. Post-modernism is a form of literary art in the process of birth. It must build on what modernism has accomplished but it must find its own voice.

It is impossible to make art today as if cubism or abstract expressionism had never existed, just as it is impossible to compose music as if Stravinsky had never lived. Further, we cannot live life (or even look at it) as if relativity, atomic weapons, and Freudian explorations of the unconscious were not part of our intellectual and social climate. If art is to be part of the human enterprise it must surely reflect its past without being a prisoner of it. In fact, most of the great achievements in the arts have done precisely that: they have mastered the tradition and then extended it. The terrain of modernism has been fairly well mapped; it is time to move on. But in what direction?

Avant-Garde Developments

Since World War II many avant-garde composers have been moving toward greater and greater complexity of musical organization, coupled with an increasing use of new kinds of sound. At the same time other musicians, disturbed by their colleagues' obsessive concern for order, have tried to introduce an element of chance, even chaos, into the creation of a work of music. Both the "structuralists" and the advocates of random music have attracted followers. and only time will tell which approach will prove more fruitful.

Before considering the nature of these two schools in detail, some general observations are in order. It must be admitted that advanced contemporary music presents a tough challenge to the patience and sympathy of many sincere music-lovers. Unlike the visual arts and literature, modern music seems, superficially at least, to have made a virtually complete break with past traditions. Furthermore, much of it seems remote from our actual experience. Developments in painting or architecture are visible around us in one form or another on a daily basis, and modern writers deal with problems that affect us in our own lives. Many creative musicians, however, have withdrawn to the scientific laboratory, where they construct their pieces with the aid of machines and in accordance with mathematical principles. It is hardly surprising that the results may seem sterile at first.

Yet it is well worth making an effort to understand and enjoy the latest developments in music. Concentration and open-mindedness will remove many of the barriers. So will persistence. Music lovers who listen twenty times to a recording of a Chopin waltz or a Mahler symphony for every one time they listen to a work by Boulez or Stockhausen can hardly expect to make much progress in understanding a new and admittedly difficult idiom. Much of today's music may well not survive the test of time, but it is equally probable that some pieces will become the classics of the 21st century. By discriminating listening we can play our own part in judging which music is worthless and which will be of permanent value.

The principle of precise musical organization had already become important in 20th-century music with the serialism of Arnold Schoenberg. Schoenberg's ordering of pitch (the melodic and harmonic element of music) in rigidly maintained twelve-note rows has been extended by recent composers to other elements. Pierre Boulez (1925-), for example, constructed rows of twelve note-durations (the length of time each note sounds), twelve levels of volume, and twelve ways of striking the keys for works like his Second Piano Sonata (1948) and Structures for two pianos (1952). In this music every element (pitch, length of notes, volume, and attack) is totally ordered and controlled by the composer in accordance with his predetermined rows, since none of the twelve components of each row can be repeated until after the other eleven.

The effect of this "total control" is to eliminate any sense of traditional melody, harmony, or counterpoint along with the emotions they evoke. Instead the composer aims to create a pure and abstract "structure" that deliberately avoids any kind of subjective emotional expression.

There remains, however, one element in these piano works that even Boulez cannot totally control the human one. All the composer's instructions. however precise, have to be interpreted and executed by a performer, and as long as composers are dependent on performers to interpret their works they cannot avoid a measure of subjectivity. Different pianists will inevitably produce different results, and even the same pianist will not produce an identical performance on every occasion.

It was to solve this problem that in the 1950s some composers began to turn to electronic music, the sounds of which are produced not by conventional musical instruments but by an electronic oscillator, a machine that produces pure sound waves. A composer can order the sounds by means of a computer and then transfer them to recording tape for playback. In the last few years the process of manipulating electronic sound has been much simplified by the invention of the *synthesizer*, a piece of equipment that can produce just about any kind of sound effect. In combination with a computer, machines like the Moog synthesizer can be used either for original electronic works or for creating electronic versions of traditional music, as in the popular "Switched-on Bach" recordings.

From its earliest days, electronic music has alarmed many listeners by its apparent lack of humanity. The whistles, clicks, and hisses that characterize it may be eerily appropriate to the mysteries of the space age, but they have little to do with traditional musical expression. Indeed, composers of electronic music have had considerable difficulty in inventing formal structures for organizing the vast range of sounds available to them. In addition, there still exists no universally agreed-on system of writing down electronic compositions; most of them exist only on tape. It is probably significant that even Karlheinz Stockhausen (1928-), one of the leading figures in electronic music, has tended to combine electronic sounds with conventional musical in-

18.40 From Karlheinz Stockhausen. Nr. 11 Refrain. © by Universal Edition (London), Ltd., London 1961. © Renewed. All rights reserved. Used by permission of European American Music Distributors Corporation, sole U.S. and Canadian agent for Universal Edition (London). This portion of the score was reproduced in the composer's own work, Test on Electronic and Instrumental Music. The system of musical notation that Stockhausen devised for this piece is as revolutionary as the music itself; it is explained in a preface to the score.

struments [18.40]. His Mixtur (1965), for example, is written for five orchestras, electronic equipment, and loudspeakers. During performance the sounds produced by the orchestral instruments are electronically altered and simultaneously mixed with the instrumental sound and with a prerecorded tape. In this way an element of live participation has been reintroduced.

For all its radical innovations, however, Mixtur at least maintains the basic premise of music in the Western tradition: that composers can communicate with their listeners by predetermining ("composing") their works according to an intellectual series of rules. The laws of baroque counterpoint, classical sonata form, or Stockhausen's ordering and altering of sound patterns all represent systems that have enabled composers to plan and create musical works. One of the most revolutionary of all recent developments, however, has been the invention of aleatoric

music. The name is derived from the Latin word alea (a dice game) and is applied to music in which an important role is played by the element of chance.

One of the leading exponents of this kind of music is the American composer John Cage (1912– who has been much influenced by Zen philosophy. Adopting the Zen attitude that one must go beyond logic in life, Cage has argued that music should reflect the random chaos of the world around us and so does not seek to impose order on it. His Concert for Piano and Orchestra of 1958 has a piano part consisting of 84 different "sound events," some, all, or none of which are to be played in any random order. The orchestral accompaniment consists of separate pages of music, some, all, or none of which can be played by any (or no) instrument, in any order and combination. Clearly every performance of the Concert is going to be a unique event, largely dependent on pure chance for its actual sound. In other pieces Cage has instructed the performers to determine the sequence of events by even more random methods, including the tossing of coins.

Works like these are, of course, more interesting for the questions they ask about the nature of music than for any intrinsic value of their own. Cage has partly reacted against what he regards as the excessive organization and rigidity of composers like Boulez and Stockhausen, but at the same time he has also raised some important considerations. What is the function of the artist in the modern world? What is the relationship between creator and performer? And what part, if any, should the listeners themselves play in the creation of a piece of music? Need it always be a passive one? If Cage's own answers to questions like these may not satisfy everyone, he has at least posed the problems in an intriguing form.

The New Minimalists

A very different solution to the search for a musical style has been proposed by a younger generation of American composers. Steve Reich (b. 1936) was one of the first musicians to build lengthy pieces out of the multiple repetition of simple chords and rhythms. Critics have sometimes assumed that the purpose of these repetitions is to achieve a hypnotic effect by inducing a kind of state of trance. Reich himself has stated that his aim is, in fact, the reverse: a state of heightened concentration.

In The Desert Music, a composition for chorus and instruments completed in 1983, Reich's choice of texts is helpful to an understanding of his music. The work's central section consists of a setting of words by the American poet William Carlos Williams (1883-1963):

It is a principle of music to repeat the theme. Repeat and repeat again, as the pace mounts. The theme is difficult but no more difficult than the facts to be resolved.

The piece begins with the pulsing of a series of broken chords, which is sustained in a variety of ways, chiefly by tuned mallets. This pulsation, together with a wordless choral vocalise, gives the work a rhythmical complexity and richness of sound which at times are reminiscent of some African or Balinese

The works of Philip Glass (b. 1937) are even more openly influenced by non-Western music. Glass himself studied the Indian tabla drums for a time; he is also interested in West African music, and he has worked with Ravi Shankar, the great Indian sitar virtuoso. Many of Glass' compositions are based on combinations of rhythmical structures derived from classical Indian music. They are built up into repeating modules, the effect of which has been likened by unsympathetic listeners to a needle stuck in a record groove.

Length plays an important part in Glass' operas, for which he has collaborated with the American dramatist Robert Wilson. Wilson, like Glass, is interested in "apparent motionlessness and endless durations during which dreams are dreamed and significant matters are understood." They have produced together three massive stage works in the years between 1975 and 1985: Einstein on the Beach, Satyagraha, and Akhnaten. The performances involve a team of collaborators that includes directors, designers, and choreographers; the results have the quality of a theatrical "happening." Although a description of the works makes them sound remote and difficult, performances of them have been extremely successful. Even New York's Metropolitan Opera House, not famous for its adventurousness in repertory, was sold out for two performances of Einstein on the Beach. Clearly, whatever its theoretical origins, the music of Glass touches a wide public.

Traditional Approaches to Modern Music

Not all composers have abandoned the traditional means of musical expression. Musicians like Benjamin Britten (1913-1976) and Dmitri Shostakovich (1906-1975) demonstrated that an innovative approach to the traditional elements of melody, harmony, and rhythm can still produce exciting and moving results. Nor can either of them be accused of losing touch with the modern world. Britten's War Requiem (1962) is an eloquent plea for an end to the violence of contemporary life, while Shostakovich's entire musical output reflects his uneasy relationship with Soviet authority. His Symphony No. 13 (1962) includes settings of poems by the Russian poet Yevtushenko on anti-Semitism in Russia and earned him unpopularity in Soviet artistic and political circles.

Both Britten and Shostakovich did not hesitate to write recognizable "tunes" in their music. In his last symphony, No. 15 (1971), Shostakovich even quoted themes from Rossini's William Tell Overture (the familiar "Lone Ranger" theme) and from Wagner. The work is at the same time easy to listen to and deeply serious. Like much of Shostakovich's music, it is concerned with the nature of death (a subject also explored in his Symphony No. 14). Throughout its four movements, Shostakovich's sense of rhythm is much in evidence, as is his feeling for orchestral color, in which he demonstrates that the resources of a traditional symphony orchestra are far from exhausted. The final mysterious dying close of Symphony No. 15 is especially striking in its use of familiar ingredients—repeating rhythmic patterns, simple melodic phrases—to achieve an unusual effect.

If Shostakovich demonstrated that a musical form as old-fashioned as the symphony can still be used to create masterpieces, Britten did the same for opera. His first great success, Peter Grimes (1945), employed traditional operatic devices like arias, trios, and choruses to depict the tragic fate of its hero, a man whose alienation from society leads to his persecution at the hands of his fellow citizens. In other works Britten followed the example of many of his illustrious predecessors in turning to earlier literary masterpieces for inspiration. A Midsummer Night's Dream (1960) is a setting of Shakespeare's play, while Death in Venice (1973) is based on the story by Thomas Mann. In all of his operas Britten writes music that is easy to listen to (and, equally important, not impossible to sing), but he never condescends to his audience. Each work deals with a recognizable area of human experience and presents it in a valid musical and dramatic form. It is always dangerous to make predictions about the verdict of posterity, but from today's vantage point the music of Britten seems to have as good a chance as any of surviving into the next century.

Popular Music

No discussion of music since 1945 would be complete without mention of pop music, the worldwide

THE ARTS AND INVENTION: The Computer

As early as the 17th century attempts were made to construct rapid calculating machines like the one invented by the French mathematician and philosopher Blaise Pascal (1623-1662). It was in the 1940s, however, that the first true computers were invented. Until the developments of micro technology matured, these computers were huge in size and voracious consumers of power to operate. Today's desktop computers would have required rooms of machinery to operate only forty years

The incredible power of computers to process information has not only revolutionized life today (it is a commonplace that we live in the midst of an "information revolution") but their potential has only begun to be explored. As computers become more and more common in today's scientific, commercial, and social life, it is inevitable that such a new technology would also impact on the arts. That impact is already being felt. We might list some of the ways in which the computer is changing the face of the humanities.

Computers as Servants of the Artistic Process. The color capability of computers has made possible a whole new range of artistic possibilities and greatly enhances the design process in the applied arts. Similarly, the computer assists in the composition of music and, in some cases, becomes an instrument in its own right that allows for the playing of music. There already exist interdisciplinary teams of artists and computer scientists at centers like MIT who are exploring the interface of technology and the arts.

Computers as a Step Beyond Books. The combined use of computers and laser technology already makes it possible to store enormous bodies of literature on a small disc. Computerized libraries linked together can reach an average home by the use of a modem. This makes it possible for the most remote village to have immediate access to the great libraries of a country or, in time, the whole world. Such access to information, happening in our very midst, is as revolutionary as the invention of paper or the development of printing.

The link between computers and printing technologies has also made it possible for people to produce books (the phenomenon of so-called desktop publishing) while bypassing publishing houses. The result of that technology has been a cottage industry in homeproduced journals, books, manifestos, and so on. It should not surprise us that totalitarian governments are caught in a terrible dilemma: the need to enter the computer revolution and the fear that such technologies will destroy the traditional governmental hold over the sources of information, news, and commentary.

appeal of which is a social fact of our times. Much of pop music is American in origin, although its ancestry is deeply rooted in the larger Western musical tradition. Its development both in this country and abroad is so complex as to be outside the scope of this book. One cannot adequately describe in a few pages the character of folk music, rhythm and blues, country and western, and the various shades of rock, much less sketch out their tangled interrelationships.

A single example demonstrates this complexity. During the 1960s, protest singers like Joan Baez, Pete Seeger, and Bob Dylan had in their standard repertoire a song called "This Land Is Your Land." The song had been written by Woody Guthrie as an American leftist reaction to the sentiments expressed in Irving Berlin's "God Bless America." Guthrie had adapted an old mountain ballad sung by the Carter Family, who had been a formative part of country and western music at the Grand Ol' Opry since the late 1920s. The Carters played and sang mountain music that was a complex blending of Old English balladry, Scottish drills, some black music, and the hymn tradition of the mountain churches.

The worldwide appeal of pop music must be recognized. The numbers in themselves are staggering. Between 1965 and 1973 nearly twelve hundred different recorded versions of the Beatles' song "Yesterday" (written by Paul McCartney and John Lennon) were available. By 1977 the Beatles had sold over one hundred million record albums and the same number of singles. Elvis Presley had sold more than eighty million singles at the time of his death in 1977; today, some years after his death, all his major albums remain in stock in record stores. Behind the Iron Curtain records and tapes are among the more prized objects in the underground or black-market econ-

The very best of popular music, both folk and rock, is sophisticated and elegant. Classic rock albums of the Beatles like Revolver reflect influences from the blues, ballads, the music of India, jazz harmonies, and some baroque orchestrations. The talented (and outrageous) Frank Zappa and the Mothers of Invention dedicated their 1960s album Freak Out to "Charles Mingus, Pierre Boulez, Anton Webern, Igor Stravinsky, Willie Dixon, Guitar Slim, Edgar Varèse, and Muddy Waters." Zappa's experiments with mixing rock and classical music were deemed serious enough for Zubin Mehta and the Los Angeles Philharmonic to have attempted some joint concerts. The popular folk singer Judy Collins' most successful album of the 1960s-Wildflowers-was orchestrated and arranged by Joshua Rifkin, a classical composer once on the music faculty of Princeton University. The crossbreeding of folk, rock, and classical modes of music continues with increasing interest in the use of electronic music and advanced amplification systems.

The folk and rock music of the 1960s saw itself as in the vanguard of social change and turmoil. Rock music was inextricably entwined with the youth culture. In fact, popular music provided one of the most patent examples of the so-called generation gap. If the Beatles upset the older generation with their sunny irreverence, their coded language about drugs, and their open sexuality, groups like the Rolling Stones were regarded by many as a clear menace to society. With their hard-driving music, their aggressive style of life, their sensuality, and their barely concealed flirtation with violence and nihilism, the Stones were seen by many as a living metaphor for the anarchy of the turbulent 1960s. It was hardly reassuring for parents to see their young bring home a Stones album entitled Their Satanic Majesties Request inside the cover of which is an apocalyptic collage of Hieronymous Bosch, Ingres, Mughal Indian miniatures, and pop photography. Nor were many consoled when the violence of the music was translated into actual violence as rock stars like Jimi Hendrix, Janis Joplin, Phil Ochs, and Jim Morrison destroyed themselves with alcohol or drugs.

Whatever the long-range judgment of history may be, pop music in its variegated forms is as much an indicator of our present culture as the novels of Dickens were of the 19th century. It partakes of both brash commercial hype and genuine social statement. The record album of a major rock group today represents the complex interaction of advanced technology, big business, and high-powered marketing techniques as well as the music itself. Likewise, a rock concert is not merely the live presentation of music to an audience but a multimedia "happening" in which the plastic arts, dramatic staging, sophisticated lighting and amplification, and a medley of other visual and aural aids are blended to create an artistic whole with the music. Beyond (or under) this glitter, notoriety, and hype, however, is a music arising from real issues and expressing real feelings. New wave and punk rock, for instance, reflect the alienation of the working-class youth of Great Britain today.

Finally, pop music is not a phenomenon of the moment alone. Its roots are in the tribulations of urban blacks, the traditionalism of rural whites, the protest of activists, and the hopes and aspirations of the common people, causes with a lengthy history in the United States yet still alive today. Pop music, then, is both a social document of our era and a record of our past.

The very best pop music hymns the joy of love. the anxiety of modern life, the yearning for ecstasy, and the damnation of institutionalized corruption. Rock music in particular creates and offers the possibility of ecstasy. For those who dwell in the urban wastelands of post-technological America or the stultifying structures of post-Stalinist Eastern Europe the vibrant beat and incessant sound of rock music must be a welcome, if temporary, refuge from the bleakness of life.

As we move to the end of the 20th century the popular music scene has shown two new trends that coincide with some of the themes we have noted in this chapter.

In the first place, advances in communication technology have not only spawned the music video (in which the visual arts, drama, and music can be joined in a single art experience) but—with the easy access of television linkups—it is now possible to put on transcontinental shows (like the famous Live Aid show of 1987) in which rock concerts take on a simultaneous character and showcase the international idiom of rock music.

Secondly, and closely allied to the first trend, there has been a powerful crossfertilization of music brought about through easy communication. Rock music, with its old roots in American forms of music, has now expanded to absorb everything from Caribbean and Latin American music to the music of West Africa and Eastern Europe. If there is any truth in the thesis of the global culture it is most easily seen, in its infant stages, in the world of popular music.

Summary

This chapter deals with Western culture after the time of the Second World War. In the postwar period, with Europe in shambles and the Far East still asleep, we confidently felt that the 20th was the American century; many people, not always admiringly, spoke of the "Coca-Colazation" of the world. From the vantage point of the near-end of the century we now see that, however powerful the United States may be, there now exist other countervailing powers, as the economic power of Japan readily demonstrates.

This period has also seen some dramatic shifts in the arts. The modernist temper that prevailed both in literature and in the arts has had its inevitable reaction. The power of the New York School of painting (abstract expressionism/ color field painting/minimalism) has been challenged by new art forces, mainly from Europe, that emphasize once again the picture plane and the expressive power of emotion. In literature, the modernist temper exemplified in writers like Eliot, Woolf, and others has now given way to a post-modern sensibility represented in writers who are from Latin America, Japan, and Europe. Increasing attention is being paid to the writers both from Eastern Europe and from Africa.

Out of the human rights movement of the past decades has arisen a determined effort to affirm the place of women in the world of the arts both by retrieving their overlooked work from the past and by careful attention to those who work today. Similarly, peoples of color, both male and female, have come to the attention of large audiences as the arts democratize. Contemporary debates over the core humanities requirements in universities (Should they restrict themselves to the old "classics" or should they represent many voices and many cultures?) simply reflect the pressures of the culture, which is no longer sure of its older assumptions.

No consensus exists on a humanistic worldview. The power of existentialism after the war sprang both from its philosophical ideas and from its adaptability to the arts, especially the literary arts. While the writings of Albert Camus are still read and the plays of Beckett and Ionesco are still performed, they now reflect a settled place in the literary canon with no new single idea providing the power to energize the arts as a whole.

It may well be that the key word to describe the contemporary situation is *pluralism*: a diversity of influences, ideas, and movements spawned by an age of instant communication and ever-growing technology. The notion of a global culture argues for a common culture growing out of mutual links. There is some evidence of commonality, but it must be said that in other areas there are regional differences and even antagonisms. What we seem to be seeing in an age when more people buy books, see films, watch television, listen to tapes and records, go to plays and concerts than ever before is a situation the Greek philosophers wrote about millennia ago: the curious puzzle about the relationship of unity and diversity in the observable world: we are one, but we are also many.

Pronunciation Guide

Borges: BOR-hes Boulez: Boo-LAY Camus: Cam-OO

existentialism: eggs-es-TEN-shall-ism

Godot: go-DOUGH

Sören Kierkegaard: SORE-en keer-KAY-gar

Le Corbusier: luh cor-BOO-see-ay

Miës van der Rohe: MEESE van-der-ROW

Rauschenberg: RAW-shum-berg Shostakovich: SHAH-stah-KO-vich

Wiesel: Vee-ZELL

Exercises

- 1. When we look at abstract expressionist art it is tempting to think that "anyone could do that." But can "anyone" do it? How does one go about describing in writing the character of abstract art?
- 2. Look closely at a work by Alexander Calder. Would a classical sculptor (Rodin, Michelangelo) have recognized his work as "sculpture"? What makes it different and why is it sculpture?

3. After reading Sartre's essay on existentialism, ask yourself: Is this a philosophy that could serve as a guide to my life? Give the reasons for your answer.

4. Look carefully at your campus buildings. Does "form follow function"? Is "less more"? Can you detect the styles that have influenced the campus architect?

- 5. A classic is said to have a "surplus of meaning"—it is so good that one can always go back and learn more from it. Are there compositions in popular music which are now "classics" in that sense? List five records or songs that still inspire musicians today.
- 6. Have the new forms of communication (especially television) made you less of a reader? How does reading differ from watching television? How does looking at art differ from looking at television? Listening to music?

Further Reading

Armstrong, Tom, et al. 200 Years of American Sculpture. New York: Whitney Museum, 1976. This well-illustrated catalogue has abundant bibliographies. A good first look at sculpture in this country from a historical perspective.

Cage, John. Silence. Cambridge, Mass.: MIT Press, 1969. A manifesto from one of the leaders of the artistic avant-

Cantor, Norman F. Twentieth Century Culture: Modernism to Deconstruction. New York: Peter Lang, 1988. A survey of critical theory in this century that includes developments after structuralism.

Glass, Philip and R. T. Jones. Music by Philip Glass. New York: Harper, 1987. A good introduction to the minimalist spirit in music, with a discography.

Hilberg, Raoul. The Destruction of the European Jews. Chicago: Quadrangle, 1967. The standard history of the subject; essential background for reading Wiesel and other Holocaust authors.

Kaufmann, Walter (ed.). Existentialism from Dostoevsky to Sartre. New York: New American Library, 1975. A standard anthology, although not everyone agrees that "revolt" is the prime category for understanding the movement.

Rubin, William. Pablo Picasso: A Retrospective. New York: Museum of Modern Art, 1980. This profusely illustrated catalogue sums up a good deal of the 20th century with its scholarly concentration on the century's major figure in art.

Sandler, Irving. The Triumph of American Painting. New York: Praeger, 1970. Sandler is the best chronicler of the New York School of painting.

Yates, Gayle Graham. What Women Want: The Idea of the Movement. Cambridge, Mass.: Harvard University Press, 1975. A good introduction to the feminist movement considered historically.

Reading Selections

Jean Paul Sartre from EXISTENTIALISM AS A **HUMANISM**

Sartre's essay argues, basically, that humans are thrown into the world and must define who they are and what they want to be bereft of any divine purpose. We are and must judge how best to live; this is the stern optimism that Sartre demands of modern people.

It is to various reproaches that I shall endeavor to reply today; that is why I have entitled this brief exposition, Existentialism and Humanism. Many may be surprised at the mention of humanism in this connection, but we shall try to see in what sense we understand it. In any case, we can begin by saying that existentialism, in our sense of the word, is a doctrine that does render human life possible; a doctrine, also, which affirms that every truth and every action imply both an environment and a human subjectivity. The essential charge laid against us is, of course, that of overemphasis upon the evil side of human life. I have lately been told of a lady who, whenever she lets slip a vulgar expression in a moment of nervousness, excuses herself by exclaiming, "I believe I am becoming an existentialist." So it appears that ugliness is being identified with existentialism. Those who appeal to the wisdom of the people—which is a sad wisdom—find ours sadder still. Indeed their excessive protests make me suspect that what is annoying them is not so much our pessimism, but, much more likely, our optimism. For at bottom, what is alarming in the doctrine that I am about to try to explain to you is—is it not? that it confronts man with a possibility of choice. To verify this, let us review the whole question upon the strictly philosophic level. What, then, is this that we call existentialism?

Most of those who are making use of this word would be highly confused if required to explain its meaning. For since it has become fashionable, people cheerfully declare that this musician or that painter is "existentialist." A columnist in Clartes signs himself "The Existentialist," and, indeed, the word is now so loosely applied to so many things that it no longer means anything at all. It would appear that, for the lack of any novel doctrine such as that of surrealism, all those who are eager to join in the latest scandal or movement now seize upon this philosophy in which, however, they can find nothing to their purpose. For in truth this is of all teachings the least scandalous and the most austere: it is intended strictly for experts and philosophers. All the same, it can easily be defined.

The question is only complicated because there are two kinds of existentialists. There are, on the one hand, the Christian existentialists and on the other hand the existential atheists, among whom I place myself. What they have in common is simply the fact that they believe that existence comes before essence or, if you will, that we must begin from the subjec-

What do we mean by saying that existence precedes essence? We mean that man first of all exists, encounters himself, surges up in the world—and defines himself afterwards. If man is as the existentialist sees him, as not definable, it is because to begin with he is nothing. He will not be anything until later, and then he will be what he makes of himself. Thus, there is no human nature, because there is no God to have a conception of it. Man simply is. Not that he is simply what he conceives himself to be, but he is what he wills, and as he conceives himself after already existing—as he wills to be after that leap towards existence. Man is nothing else but that which he makes of himself. That is the first principle of existentialism. And this is what people call its "subjectivity," using the word as a reproach against us. But what do we mean to say by this, but that man is of a greater dignity than a stone or a table? For we mean to say that man primarily exists—that man is, before all else, something which propels itself towards a future and is aware that it is doing so. Man is, indeed, a project which possesses a subjective life, instead of being a kind of moss, or a fungus, or a cauliflower. Before that projection of the self nothing exists; not even in the heaven of intelligence; man will only attain existence when he is what he proposes to be. Thus, the first effect of existentialism is that it puts every man in possession of himself as he is, and places the entire responsibility for his existence squarely upon his own shoulders. And when we say that man is responsible for himself, we do not mean that he is responsible only for his own individuality, but that he is responsible for all men.

The word "subjectivism" is to be understood in two senses, and our adversaries play upon only one of them. Subjectivism means, on the one hand, the freedom of the individual subject and, on the other, that man cannot pass beyond human subjectivity. It is the latter which is the deeper meaning of existentialism. When we say that man chooses himself, we do mean that every one of us must choose himself; but by that we also mean that in choosing for himself he chooses for all men. For in effect, of all the actions a man may take in order to create himself as he wills to be, there is not one which is not creative, at the same time, of an image of man such as he believes he ought to be. To choose between this or that is at the same time to affirm the value of that which is chosen, for we are unable ever to choose the worse. What we choose is always the better; and nothing can be better for us unless it is better for all. If moreover, existence precedes essence and we will to exist at the same time as we fashion our image, that image is valid for all and for the entire epoch in which we find ourselves. Our responsibility is thus much greater than we had supposed, for it concerns mankind as a whole. I am thus responsible for myself and for all men, and I am creating a certain image of man as I would have him be. "In fashioning myself I fashion man."

This may enable us to understand what is meant by such terms—perhaps a little grandiloquent—as anguish, abandonment, and despair. As you will soon see, it is very simple. First, what do we mean by anguish? The existentialist frankly states that man is in anguish. His meaning is as follows—When a man commits himself to anything, fully realizing that he is not only choosing what he will be, but is thereby at the same time a legislator deciding for the whole of mankind—in such a moment a man cannot escape from the sense of complete and profound responsibility. There are many, indeed, who show no such anxiety. But we affirm that they are merely disguising their anguish or are in flight from it. Certainly, many people think that in what they are doing they commit no one but themselves to anything; and if you ask them, "What would happen if everyone did so?" they shrug their shoulders and reply, "Everyone does not do so." But in truth, one ought always to ask oneself what would happen if everyone did as one is doing; nor can one escape from that disturbing thought except by a kind of self-deception. The man who lies in self-excuse, by saying "Everyone will not do it" must be ill at ease in his conscience for the act of lying implies the universal value which it denies. By its very disguise his anguish reveals itself. This is the anguish that Kierkegaard called "the anguish of

Abraham." You know the story: An angel commanded Abraham to sacrifice his son; and obedience was obligatory, if it really was an angel who had appeared and said, "Thou, Abraham, shalt sacrifice thy son." But anyone in such a case would wonder, first, whether it was indeed an angel and secondly, whether I am really Abraham. Where are the proofs?

I shall never find any proof whatever; there will be no sign to convince me of it. If a voice speaks to me, it is still I myself who must decide whether the voice is or is not that of an angel. If I regard a certain course of action as good, it is only I who choose to say that it is good and not bad. There is nothing to show that I am Abraham; nevertheless, I also am obliged at every instant to perform actions which are examples. Everything happens to every man as though the whole human race had its eyes fixed upon what he is doing and regulated its conduct accordingly. So every man ought to say, "Am I really a man who has the right to act in such a manner that humanity regulates itself by what I do?" If a man does not say that, he is dissembling his anguish. Clearly, the anguish with which we are concerned here is not one that could lead to quietism or inaction. It is anguish pure and simple, of the kind well known to all those who have borne responsibilities. Far from being a screen which could separate us from action, it is a condition of action itself.

And when we speak of "abandonment"—a favorite word of Heidegger-we only mean to say that God does not exist, and that it is necessary to draw the consequences of his absence right to the end. The existentialist is strongly opposed to a certain type of secular moralism which seeks to suppress God at the least possible expense. Toward 1880, when the French professors endeavored to formulate a secular morality, they said something like this:—God is a useless and costly hypothesis, so we will do without it. However, if we are to have morality, a society, and a law-abiding world, it is essential that certain values should be taken seriously; they must have an a priori existence ascribed to them. It must be considered obligatory a priori to be honest, not to lie, not to beat one's wife, to bring up children, and so forth; so we are going to do a little work on this subject, which will enable us to show that these values exist all the same, inscribed in an intelligible heaven although, of course, there is no God. In other words and this is, I believe, the purport of all we in France call radicalism—nothing will be changed if God does not exist; we shall rediscover the same norms of honesty, progress, and humanity, and we shall have disposed of God as an out-of-date hypothesis which will die away quietly of itself.

The existentialist, on the contrary, finds it extremely embarrassing that God does not exist, for

there disappears with Him all possibility of finding values in an intelligible heaven. There can no longer by any good a priori since there is no infinite and perfect consciousness to think it. It is nowhere written that "the good" exists, that one must be honest or must not lie, since we are now upon the plane where there are only men. Dostoevski once wrote, "If God did not exist, everything would be permitted"; and that, for existentialism, is the starting point. Everything is indeed permitted if God does not exist, and man is in consequence forlorn, for he cannot find anything to depend upon either within or outside himself. He discovers forthwith that he is without excuse. For if indeed existence precedes essence, one will never be able to explain one's action by reference to a given and specific human nature; in other words, there is no determinism—man is free, man is freedom.

You are free, therefore choose—that is to say, invent. No rule of general morality can show you what you ought to do: no signs are vouchsafed in this world. That is what "abandonment" implies, that we ourselves decide our being. And with this abandon-

ment goes anguish.

As for "despair" the meaning of this expression is extremely simple. It merely means that we limit ourselves to a reliance upon that which is within our wills, or within the sum of the probabilities which render our action feasible. Whenever one wills anything, there are always these elements of probability. If I am counting upon a visit from a friend, who may be coming by train or by tram, I presuppose that the train will arrive at the appointed time, or that the tram will not be derailed. I remain in the realm of possibilities; but one does not rely upon any possibilities beyond those that are strictly concerned in one's action, beyond the point at which the possibilities under consideration cease to affect my action. I ought to disinterest myself. For there is no God and no prevenient design which can adapt the world and all its possibilities to my will. When Descartes said, "Conquer yourself rather than the world," what he meant was, at bottom, the same—that we should act without hope.

In the light of all this, what people reproach us with is not, after all, our pessimism but the sternness of our optimism. If people condemn our works of fiction, in which we describe characters that are base, weak, cowardly, and sometimes even frankly evil, it is not only because those characters are base, weak, cowardly or evil. For suppose that, like Zola, we showed that the behavior of these characters was caused by their heredity, or by the action of their environment upon them, or by determining factors, psychic or organic. People would be reassured, they would say, "You see, that is what we are like, no one can do anything about it." But the existentialist, when he

portrays a coward, shows him as responsible for his cowardice. The existentialist says that the coward makes himself cowardly, the hero makes himself heroic; and that there is always a possibility for the coward to give up cowardice and for the hero to stop being a hero. What counts is the total commitment, and it is not by a particular case or particular action that you are committed altogether.

We have now, I think, dealt with a certain number of the reproaches against existentialism. You have seen that it cannot be regarded as a philosophy of quietism since it defines man by his action; nor as a pessimistic description of man, for no doctrine is more optimistic, the destiny of man is placed within himself. Nor is it an attempt to discourage man from action since it tells him that there is no hope except in his action, and that the one thing which permits him to have life is the deed. Upon this level therefore, what we are considering is an ethic of action and selfcommitment.

Man makes himself; he is not found ready-made; he makes himself by the choice of his morality, and he cannot but choose a morality, such is the pressure of circumstances upon him. We define man only in relation to his commitments; it is therefore absurd to reproach us for irresponsibility in our choice. And moreover, to say that we invent values means neither more nor less than this; that there is no sense in life a priori. Life is nothing until it is lived; but it is yours to make sense of, and the value of it is nothing else but the sense that you choose. Therefore, you can see that there is a possibility of creating a human community. I have been reproached for suggesting that existentialism is a form of humanism.

Man is all the time outside of himself: it is in projecting and losing himself beyond himself that he makes man to exist; and, on the other hand, it is by pursuing transcendent aims that he himself is able to exist. Since man is thus self-surpassing, and can grasp objects only in relation to his self-surpassing, he is himself the heart and center of his transcendence. There is no other universe except the human universe, the universe of human subjectivity. This relation of transcendence as constituitive of man (not in the sense that God is transcendent, but in the sense of self-surpassing) with subjectivity (in such a sense that man is not shut up in himself but forever present in a human universe)—it is this that we call existential humanism. This is humanism, because we remind man that there is no legislator but himself; that he himself, thus abandoned, must decide for himself; also because we show that it is not by turning back upon himself, but always by seeking, beyond himself, an aim which is one of liberation or of some particular realization, that man can realize himself as truly human.

Elie Wiesel From NIGHT, Chapter V

This selection, based on his own personal experiences, recounts life in a concentration camp as seen by a teenage boy. Reading, one begins to see why Wiesel calls camp lire the "Kingdom of the Night."

The summer was coming to an end. The Jewish year was nearly over.

On the eve of Rosh Hashanah, the last day of that accursed year, the whole camp was electric with the tension which was in all our hearts. In spite of everything, this day was different from any other. The last day of the year. The word "last" rang very strangely. What if it were indeed the last day?

They gave us our evening meal, a very thick soup, but no one touched it. We wanted to wait until after prayers. At the place of assembly, surrounded by the electrified barbed wire, thousands of silent Jews gathered, their faces stricken.

Night was falling. Other prisoners continued to crowd in, from every block, able suddenly to conquer time and space and submit both to their will.

"What are You, my God," I thought angrily, "compared to this afflicted crowd, proclaiming to You their faith, their anger, their revolt? What does Your greatness mean, Lord of the Universe, in the face of all this weakness, this decomposition, and this decay? Why do You still trouble their sick minds, their crippled bodies?"

Ten thousand men had come to attend the solemn service, heads of the blocks, Kapos, functionaries of death.

"Bless the Eternal. . . ."

The voice of the officiant had just made itself heard. I thought at first it was the wind.

"Blessed be the Name of the Eternal!"

Thousands of voices repeated the benediction; thousands of men prostrated themselves like trees before a tempest.

"Blessed be the Name of the Eternal!"

Why, but why should I bless Him? In every fiber I rebelled. Because He had had thousands of children burned in His pits? Because He kept six crematories working night and day, on Sundays and feast days? Because in His great might He had created Auschwitz, Birkenau, Buna, and so many factories of death? How could I say to Him: "Blessed art Thou, Eternal, Master of the Universe, Who chose us from among the races to be tortured day and night, to see our fathers, our mothers, our brothers, end in the crematory? Praised be Thy Holy Name, Thou Who hast chosen us to be butchered on Thine altar?"

I heard the voice of the officiant rising up, power-

ful yet at the same time broken, amid the tears, the sobs, the sighs of the whole congregation:

"All the earth and the Universe are God's!"

He kept stopping every moment, as though he did not have the strength to find the meaning beneath the words. The melody choked in his throat.

And I, mystic that I had been, I thought:

"Yes, man is very strong, greater than God. When You were deceived by Adam and Eve, You drove them out of Paradise. When Noah's generation displeased You, You brought down the Flood. When Sodom no longer found favor in Your eyes, You made the sky rain down fire and sulphur. But these men here, whom You have betraved, whom You have allowed to be tortured, butchered, gassed, burned, what do they do? They pray before You! They praise Your name!"

"All creation bears witness to the Greatness of

God!"

Once, New Year's Day had dominated my life. I knew that my sins grieved the Eternal; I implored his forgiveness. Once, I had believed profoundly that upon one solitary deed of mine, one solitary prayer,

depended the salvation of the world.

This day I had ceased to plead. I was no longer capable of lamentation. On the contrary, I felt very strong. I was the accuser, God the accused. My eyes were open and I was alone—terribly alone in a world without God and without man. Without love or mercy. I had ceased to be anything but ashes, yet I felt myself to be stronger than the Almighty, to whom my life had been tied for so long. I stood amid that praying congregation, observing it like a stran-

The service ended with the Kaddish. Everyone recited the Kaddish over his parents, over his children, over his brothers, and over himself.

We stayed for a long time at the assembly place. No one dared to drag himself away from this mirage. Then it was time to go to bed and slowly the prisoners made their way over to their blocks. I heard people wishing one another a Happy New Year!

I ran off to look for my father. And at the same time I was afraid of having to wish him a Happy

New Year when I no longer believed in it.

He was standing near the wall, bowed down, his shoulders sagging as though beneath a heavy burden. I went up to him, took his hand and kissed it. A tear fell upon it. Whose was that tear? Mine? His? I said nothing. Nor did he. We had never understood one another so clearly.

The sound of the bell jolted us back to reality. We must go to bed. We came back from far away. I raised my eyes to look at my father's face leaning over mine, to try to discover a smile or something resembling one upon the aged, dried-up countenance. Nothing. Not the shadow of an expression. Beaten. Yom Kippur. The Day of Atonement.

Should we fast? The question was hotly debated. To fast would mean a surer, swifter death. We fasted here the whole year round. The whole year was Yom Kippur. But others said that we should fast simply because it was dangerous to do so. We should show God that even here, in this enclosed hell, we were capable of singing His praises.

I did not fast, mainly to please my father, who had forbidden me to do so. But further, there was no longer any reason why I should fast. I no longer accepted God's silence. As I swallowed my bowl of soup, I saw in the gesture an act of rebellion and pro-

test against Him.

And I nibbled my crust of bread.

In the depths of my heart, I felt a great void.

The SS gave us a fine New Year's gift.

We had just come back from work. As soon as we had passed through the door of the camp, we sensed something different in the air. Roll call did not take so long as usual. The evening soup was given out with great speed and swallowed down at once in anguish.

I was no longer in the same block as my father. I had been transferred to another unit, the building one, where, twelve hours a day, I had to drag heavy blocks of stone about. The head of my new block was a German Jew, small of stature, with piercing eyes. He told us that evening that no one would be allowed to go out after the evening soup. And soon a terrible word was circulating-selection.

We knew what that meant. An SS man would examine us. Whenever he found a weak one, a musulman as we called them, he would write his number

down: good for the crematory.

After soup, we gathered together between the

beds. The veterans said:

"You're lucky to have been brought here so late. This camp is paradise today, compared with what it was like two years ago. Buna was a real hell then. There was no water, no blankets, less soup and bread. At night we slept almost naked, and it was below thirty degrees. The corpses were collected in hundreds every day. The work was hard. Today, this is a little paradise. The Kapos had orders to kill a certain number of prisoners every day. And every week-selection. A merciless selection. . . Yes, you're lucky."

"Stop it! Be quiet!" I begged. "You can tell your

stories tomorrow or on some other day."

They burst out laughing. They were not veterans for nothing.

"Are you scared? So were we scared. And there was plenty to be scared of in those days."

The old men stayed in their corner, dumb, motionless, hunted. Some were praying.

An hour's delay. In an hour, we should know the

verdict—death or a reprieve.

And my father. Suddenly I remembered him. How would he pass the selection? He had aged so much. . . .

The head of our block had never been outside concentration camps since 1933. He had already been through all the slaughterhouses, all the factories of death. At about nine o'clock, he took up his position in our midst:

"Achtung!"

There was instant silence.

"Listen carefully to what I am going to say." (For the first time, I heard his voice quiver.) "In a few moments the selection will begin. You must get completely undressed. Then one by one you go before the SS doctors. I hope you will all succeed in getting through. But you must help your own chances. Before you go into the next room, move about in some way so that you give yourselves a little color. Don't walk slowly, run! Run as if the devil were after you! Don't look at the SS. Run, straight in front of you!"

He broke off for a moment, then added:

"And, the essential thing, don't be afraid!"

Here was a piece of advice we should have liked very much to be able to follow.

I got undressed, leaving my clothes on the bed. There was no danger of anyone stealing them this evening.

Tibi and Yossi, who had changed their unit at the same time as I had, came up to me and said:

"Let's keep together. We shall be stronger."

Yossi was murmuring something between his teeth. He must have been praying. I had never realized that Yossi was a believer. I had even always thought the reverse. Tibi was silent, very pale. All the prisoners in the block stood naked between the beds. This must be how one stands at the last judg-

"They're coming!"

There were three SS officers standing round the notorious Dr. Mengele, who had received us at Birkenau. The head of the block, with an attempt at a smile, asked us:

"Ready?"

Yes, we were ready. So were the SS doctors. Dr. Mengele was holding a list in his hand: our numbers. He made a sign to the head of the block: "We can begin!" As if this were a game!

The first to go by were the "officials" of the block: Stubenaelteste, Kapos, foreman, all in perfect physical condition of course! Then came the ordinary prisoners' turn. Dr. Mengele took stock of them from head to foot. Every now and then, he wrote a number down. One single thought filled my mind: not to let my number be taken; not to show my left arm.

There were only Tibi and Yossi in front of me. They passed. I had time to notice that Mengele had not written their numbers down. Someone pushed me. It was my turn. I ran without looking back. My head was spinning: you're too thin, you're weak, you're too thin, you're good for the furnace. . . . The race seemed interminable. I thought I had been running for years. . . . You're too thin, you're too weak. . . . At last I had arrived exhausted. When I regained my breath, I questioned Yossi and Tibi:

"Was I written down?"

"No," said Yossi. He added, smiling: "In any case, he couldn't have written you down, you were running too fast. . . ."

I began to laugh. I was glad. I would have liked to kiss him: At that moment, what did the others matter! I hadn't been written down.

Those whose number had been noted stood apart, abandoned by the whole world. Some were weeping in silence. The SS officers went away. The head of the block appeared, his face reflecting the general weariness.

"Everything went off all right. Don't worry. Nothing is going to happen to anyone. To anyone.'

Again he tried to smile. A poor, emaciated, driedup Jew questioned him avidly in a trembling voice:

"But . . . but, Blockaelteste, they did write me down!'

The head of the block let his anger break out. What! Did someone refuse to believe him!

"What's the matter now? Am I telling lies then? I tell you once and for all, nothing's going to happen to you! To anyone! You're wallowing in your own despair, you fool!"

The bell rang, a signal that the selection had been

completed throughout the camp.

With all my might I began to run to Block 36. I met my father on the way. He came up to me:

"Well? So you passed?"

"Yes. And you?"

"Me too."

How we breathed again, now! My father had brought me a present—half a ration of bread obtained in exchange for a piece of rubber, found at the warehouse, which would do to sole a shoe.

The bell. Already we must separate, go to bed. Everything was regulated by the bell. It gave me orders, and I automatically obeyed them. I hated it. Whenever I dreamed of a better world, I could only imagine a universe with no bells.

Several days had elapsed. We no longer thought

about the selection. We went to work as usual, loading heavy stones into railway wagons. Rations had become more meager: this was the only change.

We had risen before dawn, as on every day. We had received black coffee, the ration of bread. We were about to set out for the yard as usual. The head of the block arrived, running.

"Silence for a moment. I have a list of numbers here. I'm going to read them to you. Those whose numbers I call won't be going to work this morning; they'll stay behind in the camp."

And, in a soft voice, he read out about ten numbers. We had understood. These were numbers chosen at the selection. Dr. Mengele had not forgotten.

The head of the block went toward his room. Ten prisoners surrounded him, hanging onto his clothes:

"Save us! You promised . . . ! We want to go to the yard. We're strong enough to work. We're good workers. We can . . . we will. . . . "

He tried to calm them, to reassure them about their fate, to explain to them that the fact that they were staying behind in the camp did not mean much, had no tragic significance.

"After all, I stay here myself every day," he

added.

It was a somewhat feeble argument. He realized it, and without another word went and shut himself up in his room.

The bell had just rung.

"Form up!"

It scarcely mattered now that the work was hard. The essential thing was to be as far away as possible from the block, from the crucible of death, from the center of hell.

I saw my father running toward me. I became frightened all of a sudden.

'What's the matter?"

Out of breath, he could hardly open his mouth. "Me, too . . . me, too . . . ! They told me to stay behind in the camp."

They had written down his number without his being aware of it.

"What will happen?" I asked in anguish.

But it was he who tried to reassure me.

"It isn't certain yet. There's still a chance of escape. They're going to do another selection today . . . a decisive selection."

I was silent.

He felt that his time was short. He spoke quickly. He would have liked to say so many things. His speech grew confused; his voice choked. He knew that I would have to go in a few moments. He would have to stay behind alone, so very alone.

"Look, take this knife," he said to me. "I don't need it any longer. It might be useful to you. And take this spoon as well. Don't sell them. Quickly! Go

on. Take what I'm giving you!"

The inheritance.

"Don't talk like that, father." (I felt that I would break into sobs.) "I don't want you to say that. Keep the spoon and knife. You need them as much as I do. We shall see each other again this evening, after work."

He looked at me with his tired eyes, veiled with

despair. He went on:

"I'm asking this of you. . . . Take them. Do as I ask, my son. We have no time. . . . Do as your father asks."

Our Kapo yelled that we should start.

The unit set out toward the camp gate. Left, right! I bit my lips. My father had stayed by the block, leaning against the wall. Then he began to run, to catch up with us. Perhaps he had forgotten something he wanted to say to me. . . . But we were marching too quickly. . . . Left, right!

We were already at the gate. They counted us, to

the din of military music. We were outside.

The whole day, I wandered about as if sleepwalking. Now and then Tibi and Yossi would throw me a brotherly word. The Kapo, too, tried to reassure me. He had given me easier work today. I felt sick at heart. How well they were treating me! Like an orphan! I thought: even now, my father is still helping me.

I did not know myself what I wanted—for the day to pass quickly or not. I was afraid of finding myself alone that night. How good it would be to die here!

At last we began the return journey. How I longed

for orders to run!

The military march. The gate. The camp.

I ran to Block 36.

Were there still miracles on this earth? He was alive. He had escaped the second selection. He had been able to prove that he was still useful. . . . I gave him back his knife and spoon.

Flannery O'Connor REVELATION

This short story by Flannery O'Connor has its deepest meaning in the title itself. The reader might well ask what is revealed to Mrs. Turpin, who is the agent of that revelation. And how will she be different as she grasps the revelation? Pay particular attention to the closing paragraphs of the story.

The doctor's waiting room, which was very small, was almost full when the Turpins entered and Mrs. Turpin, who was very large, made it look even smaller by her presence. She stood looming at the head of the magazine table set in the center of it, a living demonstration that the room was inadequate and ridiculous. Her little bright black eyes took in all the patients as she sized up the seating situation. There was one vacant chair and a place on the sofa occupied by a blond child in a dirty blue romper who should have been told to move over and make room for the lady. He was five or six, but Mrs. Turpin saw at once that no one was going to tell him to move over. He was slumped down in the seat, his arms idle at his sides and his eyes idle in his head; his nose ran unchecked.

Mrs. Turpin put a firm hand on Claud's shoulder and said in a voice that included anyone who wanted to listen, "Claud, you sit in that chair there," and gave him a push down into the vacant one. Claud was florid and bald and sturdy, somewhat shorter than Mrs. Turpin, but he sat down as if he were accustomed to doing what she told him to.

Mrs. Turpin remained standing. The only man in the room besides Claud was a lean stringy old fellow with a rusty hand spread out on each knee, whose eyes were closed as if he were asleep or dead or pretending to be so as not to get up and offer her his seat. Her gaze settled agreeably on a well-dressed grayhaired lady whose eyes met hers and whose expression said: if that child belonged to me, he would have some manners and move over-there's plenty of room there for you and him too.

Claud looked up with a sigh and made as if to rise.

"Sit down," Mrs. Turpin said. "You know you're not supposed to stand on that leg. He has an ulcer on his leg," she explained.

Claud lifted his foot onto the magazine table and rolled his trouser leg up to reveal a purple swelling on a plump marble-white calf.

"My!" the pleasant lady said. "How did you do

that?'

"A cow kicked him," Mrs. Turpin said.

"Goodness!" said the lady.

Claud rolled his trouser leg down.

"Maybe the little boy would move over," the lady

suggested, but the child did not stir.

'Somebody will be leaving in a minute," Mrs. Turpin said. She could not understand why a doctor with as much money as they made charging five dollars a day to just stick their head in the hospital door and look at you—couldn't afford a decent-sized waiting room. This one was hardly bigger than a garage. The table was cluttered with limp-looking magazines and at one end of it there was a big green glass ash tray full of cigarette butts and cotton wads with little blood spots on them. If she had had anything to do with the running of the place, that would have been emptied every so often. There were no chairs against the wall at the head of the room. It had a rectangularshaped panel in it that permitted a view of the office

where the nurse came and went and the secretary listened to the radio. A plastic fern in a gold pot sat in the opening and trailed its fronds down almost to the floor. The radio was softly playing gospel music.

Just then the inner door opened and a nurse with the highest stack of yellow hair Mrs. Turpin had ever seen put her face in the crack and called for the next patient. The woman sitting beside Claud grasped the two arms of her chair and hoisted herself up; she pulled her dress free from her legs and lumbered through the door where the nurse had disappeared.

Mrs. Turpin eased into the vacant chair, which held her tight as a corset. "I wish I could reduce," she said, and rolled her eyes and gave a comic sigh.

"Oh, you aren't fat," the stylish lady said.

"Ooooo I am too," Mrs. Turpin said. "Claud he eats all he wants to and never weighs over one hundred and seventy-five pounds, but me I just look at something good to eat and I gain some weight," and her stomach and shoulders shook with laughter. "You can eat all you want to, can't you, Claud?" she asked, turning to him.

Claud only grinned.

"Well, as long as you have such a good disposition," the stylish lady said, "I don't think it makes a bit of difference what size you are. You just can't beat a good disposition."

Next to her was a fat girl of eighteen or nineteen, scowling into a thick blue book which Mrs. Turpin saw was entitled Human Development. The girl raised her head and directed her scowl at Mrs. Turpin as if she did not like her looks. She appeared annoyed that anyone should speak while she tried to read. The poor girl's face was blue with acne and Mrs. Turpin thought how pitiful it was to have a face like that at that age. She gave the girl a friendly smile but the girl only scowled the harder. Mrs. Turpin herself was fat but she had always had good skin, and, though she was forty-seven years old, there was not a wrinkle in her face except around her eyes from laughing too much.

Next to the ugly girl was the child, still in exactly the same position, and next to him was a thin leathery old woman in a cotton print dress. She and Claud had three sacks of chicken feed in their pump house that was in the same print. She had seen from the first that the child belonged with the old woman. She could tell by the way they sat-kind of vacant and white-trashy, as if they would sit there until Doomsday if nobody called and told them to get up. And at right angles but next to the well-dressed pleasant lady was a lank-faced woman who was certainly the child's mother. She had on a yellow sweat shirt and wine-colored slacks, both gritty-looking, and the rims of her lips were stained with snuff. Her dirty yellow hair was tied behind with a little piece of red paper ribbon. Worse than niggers any day, Mrs. Turpin thought.

The gospel hymn playing was, "When I looked up and He looked down," and Mrs. Turpin, who knew it, supplied the last line mentally, "And wona these days I know I'll we-eara crown.

Without appearing to, Mrs. Turpin always noticed people's feet. The well-dressed lady had on red and gray suede shoes to match her dress. Mrs. Turpin had on her good black patent leather pumps. The ugly girl had on Girl Scout shoes and heavy socks. The old woman had on tennis shoes and the whitetrashy mother had on what appeared to be bedroom slippers, black straw with gold braid threaded through them—exactly what you would have expected her to have on.

Sometimes at night when she couldn't go to sleep, Mrs. Turpin would occupy herself with the question of who she would have chosen to be if she couldn't have been herself. If Jesus had said to her before he made her, "There's only two places available for you. You can either be a nigger or white-trash," what would she have said? "Please, Jesus, please," she would have said, "just let me wait until there's another place available," and he would have said, "No, you have to go right now and I have only those two places so make up your mind." She would have wiggled and squirmed and begged and pleaded but it would have been no use and finally she would have said, "All right, make me a nigger then—but that don't mean a trashy one." And he would have made her a neat clean respectable Negro woman, herself but black.

Next to the child's mother was a red-headed youngish woman, reading one of the magazines and working a piece of chewing gum, hell for leather, as Claud would say. Mrs. Turpin could not see the woman's feet. She was not white-trash, just common. Sometimes Mrs. Turpin occupied herself at night naming the classes of people. On the bottom of the heap were most colored people, not the kind she would have been if she had been one, but most of them; then next to them-not above, just away from—were the white-trash; then above them were the home-owners, and above them the home-andland owners, to which she and Claud belonged. Above she and Claud were people with a lot of money and much bigger houses and much more land. But here the complexity of it would begin to bear in on her, for some of the people with a lot money were common and ought to be below she and Claud and some of the people who had good blood had lost their money and had to rent and then there were colored people who owned their homes and land as well. There was a colored dentist in town who had two red Lincolns and a swimming pool and

a farm with registered white-face cattle on it. Usually by the time she had fallen asleep all the classes of people were moiling and roiling around in her head, and she would dream they were all crammed in together in a box car, being ridden off to be put in a gas

"That's a beautiful clock," she said and nodded to her right. It was a big wall clock, the face encased in a brass sunburst.

"Yes, it's very pretty," the stylish lady said agreeably. "And right on the dot too," she added, glancing at her watch.

The ugly girl beside her cast an eye upward at the clock, smirked, then looked directly at Mrs. Turpin and smirked again. Then she returned her eyes to her book. She was obviously the lady's daughter because, although they didn't look anything alike as to disposition, they both had the same shape of face and the same blue eyes. On the lady they sparkled pleasantly but in the girl's seared face they appeared alternately to smolder and to blaze.

What if Jesus had said, "All right, you can be

white-trash or a nigger or ugly"!

Mrs. Turpin felt an awful pity for the girl, though she thought it was one thing to be ugly and another

to act ugly.

The woman with the snuff-stained lips turned around in her chair and looked up at the clock. Then she turned back and appeared to look a little to the side of Mrs. Turpin. There was a cast in one of her eyes. "You want to know wher you can get you one of themther clocks?" she asked in a loud voice.

"No, I already have a nice clock," Mrs. Turpin said. Once somebody like her got a leg in the conver-

sation, she would be all over it.

"You can get you one with green stamps," the woman said. "That's most likely wher he got hisn. Save you up enough, you can get you most anythang. I got me some joo'ry."

Ought to have got you a wash rag and some soap,

Mrs. Turpin thought.

"I get contour sheets with mine," the pleasant

lady said.

The daughter slammed her book shut. She looked straight in front of her, directly through Mrs. Turpin and on through the yellow curtain and the plate glass window which made the wall behind her. The girl's eves seemed lit all of a sudden with a peculiar light, an unnatural light like night road signs give. Mrs. Turpin turned her head to see if there was anything going on outside that she should see, but she could not see anything. Figures passing cast only a pale shadow through the curtain. There was no reason the girl should single her out for her ugly looks.

"Miss Finley," the nurse said, cracking the door. The gum-chewing woman got up and passed in front of her and Claud and went into the office. She had on red high-heeled shoes.

Directly across the table, the ugly girl's eyes were fixed on Mrs. Turpin as if she had some very special reason for disliking her.

"This is wonderful weather, isn't it?" the girl's

mother said.

"It's good weather for cotton if you can get the niggers to pick it," Mrs. Turpin said, "but niggers don't want to pick cotton any more. You can't get the white folks to pick it and now you can't get the niggers—because they got to be right up there with the white folks."

"They gonna try anyways," the white-trash woman said, leaning forward.

"Do you have one of the cotton-picking ma-

chines?" the pleasant lady asked.

"No," Mrs. Turpin said, "they leave half the cotton in the field. We don't have much cotton anyway. If you want to make it farming now, you have to have a little of everything. We got a couple of acres of cotton and a few hogs and chickens and just enough white-face that Claud can look after them himself."

"One thang I don't want," the white-trash woman said, wiping her mouth with the back of her hand. "Hogs. Nasty stinking things, a-gruntin and

a-rooting all over the place.'

Mrs. Turpin gave her the merest edge of her attention. "Our hogs are not dirty and they don't stink," she said. "They're cleaner than some children I've seen. Their feet never touch the ground. We have a pig-parlor—that's where you raise them on concrete," she explained to the pleasant lady, "and Claud scoots them down with the hose every afternoon and washes off the floor." Cleaner by far than that child right there, she thought. Poor nasty little thing. He had not moved except to put the thumb of his dirty hand into his mouth.

The woman turned her face away from Mrs. Turpin. "I know I wouldn't scoot down no hog with no hose," she said to the wall.

You wouldn't have no hog to scoot down, Mrs. Turpin said to herself.

"A-gruntin and a-rootin and a-groanin," the

woman muttered.

"We got a little of everything," Mrs. Turpin said to the pleasant lady. "It's no use in having more than you can handle yourself with help like it is. We found enough niggers to pick our cotton this year but Claud he has to go after them and take them home again in the evening. They can't walk that half a mile. No they can't. I tell you," she said and laughed merrily, "I sure am tired of buttering up niggers, but you got to love em if you want em to work for you. When they come in the morning, I run out and I say, 'Hi yawl this morning?' and when Claud drives them

off to the field I just wave to beat the band and they just wave back." And she waved her hand rapidly to

"Like you read out of the same book," the lady

said, showing she understood perfectly.

"Child, yes," Mrs. Turpin said. "And when they come in from the field, I run out with a bucket of icewater. That's the way it's going to be from now on," she said. "You may as well face it."

"One thang I know," the white-trash woman said. "Two thangs I ain't going to do: love no niggers or scoot down no hog with no hose." And she let out

a bark of contempt.

The look that Mrs. Turpin and the pleasant lady exchanged indicated they both understood that you had to have certain things before you could know certain things. But every time Mrs. Turpin exchanged a look with the lady, she was aware that the ugly girl's peculiar eyes were still on her, and she had trouble bringing her attention back to the conversation.

"When you got something," she said, "you got to look after it." And when you ain't got a thing but breath and britches, she added to herself, you can afford to come to town every morning and just sit on

the Court House coping and spit.

A grotesque revolving shadow passed across the curtain behind her and was thrown palely on the opposite wall. Then a bicycle clattered down against the outside of the building. The door opened and a colored boy glided in with a tray from the drugstore. It had two large red and white paper cups on it with tops on them. He was a tall, very black boy in discolored white pants and a green nylon shirt. He was chewing gum slowly, as if to music. He set the trav down in the office opening next to the fern and stuck his head through to look for the secretary. She was not in there. He rested his arms on the ledge and waited, his narrow bottom stuck out, swaving to the left and right. He raised a hand over his head and scratched the base of his skull.

"You see that button there, boy?" Mrs. Turpin said. "You can punch that and she'll come. She's

probably in the back somewhere."

"Is that right?" the boy said agreeably, as if he had never seen the button before. He leaned to the right and put his finger on it. "She sometime out," he said and twisted around to face his audience, his elbows behind him on the counter. The nurse appeared and he twisted back again. She handed him a dollar and he rooted in his pocket and made the change and counted it out to her. She gave him fifteen cents for a tip and he went out with the empty tray. The heavy door swung to slowly and closed at length with the sound of suction. For a moment no one spoke.

"They ought to send all them niggers back to Af-

rica," the white-trash woman said. "That's wher they come from in the first place."

"Oh, I couldn't do without my good colored

friends," the pleasant lady said.

"There's a heap of things worse than a nigger," Mrs. Turpin agreed. "It's all kinds of them just like it's all kinds of us."

'Yes, and it takes all kinds to make the world go

round," the lady said in her musical voice.

As she said it, the raw-complexioned girl snapped her teeth together. Her lower lip turned downwards and inside out, revealing the pale pink inside of her mouth. After a second it rolled back up. It was the ugliest face Mrs. Turpin had ever seen anyone make and for a moment she was certain that the girl had made it at her. She was looking at her as if she had known and disliked her all her life—all of Mrs. Turpin's life, it seemed too, not just all the girl's life. Why, girl, I don't even know you, Mrs. Turpin said silently.

She forced her attention back to the discussion. "It wouldn't be practical to send them back to Africa," she said. "They wouldn't want to go. They got it too good here."

"Wouldn't be what they wanted—if I had

anythang to do with it," the woman said.

"It wouldn't be a way in the world you could get all the niggers back over there," Mrs. Turpin said. "They'd be hiding out and lying down and turning sick on you and wailing and hollering and raring and pitching. It wouldn't be a way in the world to get them over there."

"They got over here," the trashy woman said. "Get back like they got over."

"It wasn't so many of them then," Mrs. Turpin explained.

The woman looked at Mrs. Turpin as if here was an idiot indeed but Mrs. Turpin was not bothered by the look, considering where it came from.

"Nooo," she said, "they're going to stay here where they can go to New York and marry white folks and improve their color. That's what they all want to do, every one of them, improve their color."

"You know what comes of that, don't you?"

Claud asked.

"No, Claud, what?" Mrs. Turpin said.

Claud's eyes twinkled. "White-faced niggers," he said with never a smile.

Everybody in the office laughed except the whitetrash and the ugly girl. The girl gripped the book in her lap with white fingers. The trashy woman looked around her from face to face as if she thought they were all idiots. The old woman in the feed sack dress continued to gaze expressionless across the floor at the high-top shoes of the man opposite her, the one

who had been pretending to be asleep when the Turpins came in. He was laughing heartily, his hands still spread out on his knees. The child had fallen to the side and was lying now almost face down in the old woman's lap.

While they recovered from their laughter, the nasal chorus on the radio kept the room from silence.

"You go to blank blank and I'll go to mine But we'll all blank along To-geth-ther, And all along the blank We'll hep eachother out Smile-ling in any kind of Weath-ther!"

Mrs. Turpin didn't catch every word but she caught enough to agree with the spirit of the song and it turned her thoughts sober. To help anybody out that needed it was her philosophy of life. She never spared herself when she found somebody in need, whether they were white or black, trash or decent. And of all she had to be thankful for, she was most thankful that this was so. If Jesus had said, "You can be high society and have all the money you want and be thin and svelte-like, but you can't be a good woman with it," she would have had to say, "Well don't make me that then. Make me a good woman and it don't matter what else, how fat or how ugly or how poor!" Her heart rose. He had not made her a nigger or white-trash or ugly! He had made her herself and given her a little of everything. Jesus, thank you! she said. Thank you thank you thank you! Whenever she counted her blessings she felt as buoyant as if she weighed one hundred and twenty-five pounds instead of one hundred and eighty.

"What's wrong with your little boy?" the pleasant

lady asked the white-trashy woman.

"He has a ulcer," the woman said proudly. "He ain't give me a minute's peace since he was born. Him and her are just alike," she said, nodding at the old woman, who was running her leathery fingers through the child's pale hair. "Look like I can't get nothing down them two but Co' Cola and candy."

That's all you try to get down em, Mrs. Turpin said to herself. Too lazy to light the fire. There was nothing you could tell her about people like them that she didn't know already. And it was not just that they didn't have anything. Because if you gave them everything, in two weeks it would all be broken or filthy or they would have chopped it up for lightwood. She knew all this from her own experience. Help them you must, but help them you couldn't.

All at once the ugly girl turned her lips inside out again. Her eyes fixed like two drills on Mrs. Turpin. This time there was no mistaking that there was something urgent behind them.

Girl, Mrs. Turpin exclaimed silently, I haven't done a thing to you! The girl might be confusing her with somebody else. There was no need to sit by and let herself be intimidated. "You must be in college," she said boldly, looking directly at the girl. "I see you reading a book there.'

The girl continued to stare and pointedly did not

Her mother blushed at this rudeness. "The lady asked you a question, Mary Grace," she said under her breath.

"I have ears," Mary Grace said.

The poor mother blushed again. "Mary Grace goes to Wellesley College," she explained. She twisted one of the buttons on her dress. "In Massachusetts," she added with a grimace. "And in the summer she just keeps right on studying. Just reads all the time, a real book worm. She's done real well at Wellesley; she's taking English and Math and History and Psychology and Social Studies," she rattled on, "and I think it's too much. I think she ought to get out and have fun."

The girl looked as if she would like to hurl them all through the plate glass window.

"Way up north," Mrs. Turpin murmured and thought, well, it hasn't done much for her manners.

"I'd almost rather to have him sick," the whitetrash woman said, wrenching the attention back to herself. "He's so mean when he ain't. Look like some children just take natural to meanness. It's some gets bad when they get sick but he was the opposite. Took sick and turned good. He don't give me no trouble now. It's me waitin to see the doctor," she said.

If I was going to send anybody back to Africa, Mrs. Turpin thought, it would be your kind, woman. "Yes, indeed," she said aloud, but looking up at the ceiling, "it's a heap of things worse than a nigger." And dirtier than a hog, she added to herself.

"I think people with bad dispositions are more to be pitied than anyone on earth," the pleasant lady

said in a voice that was decidedly thin.

"I thank the Lord he has blessed me with a good one," Mrs. Turpin said. "The day has never dawned that I couldn't find something to laugh at."

"Not since she married me anyways," Claud said

with a comical straight face.

Everybody laughed except the girl and the whitetrash.

Mrs. Turpin's stomach shook. "He's such a caution," she said, "that I can't help but laugh at him."

The girl made a loud ugly noise through her teeth. Her mother's mouth grew thin and tight. "I think

the worst thing in the world," she said, "is an ungrateful person. To have everything and not appreciate it. I know a girl," she said, "who has parents who would give her anything, a little brother who loves her dearly, who is getting a good education, who wears the best clothes, but who can never say a kind word to anyone, who never smiles, who just criticizes and complains all day long."

"Is she too old to paddle?" Claud asked.

The girl's face was almost purple.

"Yes," the lady said, "I'm afraid there's nothing to do but leave her to her folly. Some day she'll wake up and it'll be too late."

"It never hurt anyone to smile," Mrs. Turpin said. "It just makes you fell better all over."

"Of course," the lady said sadly, "but there are just some people you can't tell anything to. They can't take criticism."

"If it's one thing I am," Mrs. Turpin said with feeling, "it's grateful. When I think who all I could have been besides myself and what all I got, a little of everything, and a good disposition besides, I just feel like shouting, 'Thank you, Jesus, for making everything the way it is!' It could have been different!" For one thing, somebody else could have got Claud. At the thought of this, she was flooded with gratitude and a terrible pang of joy ran through her. "Oh thank you, Jesus, Jesus, thank you!" she cried aloud.

The book struck her directly over her left eye. It struck almost at the same instant that she realized the girl was about to hurl it. Before she could utter a sound, the raw face came crashing across the table toward her, howling. The girl's fingers sank like clamps into the soft flesh of her neck. She heard the mother cry out and Claud shout, "Whoa!" There was an instant when she was certain that she was about to be in an earthquake.

All at once her vision narrowed and she saw everything as if it were happening in a small room far away, or as if she were looking at it through the wrong end of a telescope. Claud's face crumpled and fell out of sight. The nurse ran in, then out, then in again. Then the gangling figure of the doctor rushed out of the inner door. Magazines flew this way and that as the table turned over. The girl fell with a thud and Mrs. Turpin's vision suddenly reversed itself and she saw everything large instead of small. The eyes of the white-trashy woman were staring hugely at the floor. There the girl, held down on one side by the nurse and on the other by her mother, was wrenching and turning in their grasp. The doctor was kneeling astride her, trying to hold her arm down. He managed after a second to sink a long needle into it.

Mrs. Turpin felt entirely hollow except for her heart which swung from side to side as if it were agitated in a great empty drum of flesh.

"Somebody that's not busy call for the ambulance," the doctor said in the off-hand voice young doctors adopt for terrible occasions.

Mrs. Turpin could not have moved a finger. The old man who had been sitting next to her skipped nimbly into the office and made the call, for the secretary still seemed to be gone.

"Claud!" Mrs. Turpin called.

He was not in his chair. She knew she must jump up and find him but she felt like some one trying to catch a train in a dream, when everything moves in slow motion and the faster you try to run the slower you go.

"Here I am," a suffocated voice, very unlike

Claud's, said.

He was doubled up in the corner on the floor, pale as paper, holding his leg. She wanted to get up and go to him but she could not move. Instead, her gaze was drawn slowly downward to the churning face on the floor, which she could see over the doctor's shoulder.

The girl's eyes stopped rolling and focused on her. They seemed a much lighter blue than before, as if a door that had been tightly closed behind them was

now open to admit light and air.

Mrs. Turpin's head cleared and her power of motion returned. She leaned forward until she was looking directly into the fierce brilliant eyes. There was no doubt in her mind that the girl did know her, knew her in some intense and personal way, beyond time and place and condition. "What you got to say to me?" she asked hoarsely and held her breath, waiting, as for a revelation.

The girl raised her head. Her gaze locked with Mrs. Turpin's. "Go back to hell where you came from, you old wart hog," she whispered. Her voice was low but clear. Her eyes burned for a moment as if she saw with pleasure that her message had struck

its target.

Mrs. Turpin sank back in her chair.

After a moment the girl's eyes closed and she turned her head wearily to the side.

The doctor rose and handed the nurse the empty syringe. He leaned over and put both hands for a moment on the mother's shoulders, which were shaking. She was sitting on the floor, her lips pressed together, holding Mary Grace's hand in her lap. The girl's fingers were gripped like a baby's around her thumb. "Go on to the hospital," he said. "I'll call and make the arrangements.'

"Now let's see that neck," he said in a jovial voice to Mrs. Turpin. He began to inspect her neck with his first two fingers. Two little moon-shaped lines like pink fish bones were indented over her windpipe. There was the beginning of an angry red swelling above her eye. His fingers passed over this also.

"Lea' me be," she said thickly and shook him off. "See about Claud. She kicked him."

"I'll see about him in a minute," he said and felt her pulse. He was a thin gray-haired man, given to pleasantries. "Go home and have yourself a vacation the rest of the day," he said and patted her on the shoulder.

Quit your pattin me, Mrs. Turpin growled to herself.

"And put an ice pack over that eye," he said. Then he went and squatted down beside Claud and looked at his leg. After a moment he pulled him up and Claud limped after him into the office.

Until the ambulance came, the only sounds in the room were the tremulous moans of the girl's mother, who continued to sit on the floor. The white-trash woman did not take her eyes off the girl. Mrs. Turpin looked straight ahead at nothing. Presently the ambulance drew up, a long dark shadow, behind the curtain. The attendants came in and set the stretcher down beside the girl and lifted her expertly onto it and carried her out. The nurse helped the mother gather up her things. The shadow of the ambulance moved silently away and the nurse came back in the office.

"That ther girl is going to be a lunatic, ain't she?" the white-trash woman asked the nurse, but the nurse kept on to the back and never answered her.

"Yes, she's going to be a lunatic," the white-trash woman said to the rest of them.

"Po' critter," the old woman murmured. The child's face was still in her lap. His eyes looked idly out over her knees. He had not moved during the disturbance except to draw one leg up under him.

"I thank Gawd," the white-trash woman said fervently, "I ain't a lunatic."

Claud came limping out and the Turpins went home.

As their pick-up truck turned into their own dirt road and made the crest of the hill, Mrs. Turpin gripped the window ledge and looked out suspiciously. The land sloped gracefully down through a field dotted with lavender weeds and at the start of the rise their small vellow frame house, with its little flower beds spread out around it like a fancy apron, sat primly in its accustomed place between two giant hickory trees. She would not have been startled to see a burnt wound between two blackened chimneys.

Neither of them felt like eating so they put on their house clothes and lowered the shade in the bedroom and lay down, Claud with his leg on a pillow and herself with a damp washcloth over her eye. The instant she was flat on her back, the image of a razorbacked hog with warts on its face and horns coming out behind its ears snorted into her head. She moaned, a low quiet moan.

"I am not," she said tearfully, "a wart hog. From hell." But the denial had no force. The girl's eyes and her words, even the tone of her voice, low but clear, directed only to her, brooked no repudiation. She had been singled out for the message, though there was trash in the room to whom it might justly have been applied. The full force of this fact struck her only now. There was a woman there who was neglecting her own child but she had been overlooked. The message had been given to Ruby Turpin, a respectable, hard-working, church-going woman. The tears dried. Her eyes began to burn instead with

She rose on her elbow and the washcloth fell into her hand. Claud was lying on his back, snoring. She wanted to tell him what the girl had said. At the same time, she did not wish to put the image of herself as a wart hog from hell into his mind.

"Hey, Claud," she muttered and pushed his shoulder.

Claud opened one pale baby blue eye.

She tooked into it warily. He did not think about anything. He just went his way.

"Wha, whasit?" he said and closed the eye again. "Nothing," she said. "Does your leg pain you?"

"Hurts like hell," Claud said.

"It'll quit derreckly," she said and lay back down. In a moment Claud was snoring again. For the rest of the afternoon they lay there. Claud slept. She scowled at the ceiling. Occasionally she raised her fist and made a small stabbing motion over her chest as if she was defending her innocence to invisible guests who were like the comforters of Job, reasonableseeming but wrong.

About five-thirty Claud stirred. "Got to go after those niggers," he sighed, not moving.

She was looking straight up as if there were unintelligible handwriting on the ceiling. The protuberance over her eye had turned a greenish-blue. "Listen here," she said.

"What?"

"Kiss me."

Claud leaned over and kissed her loudly on the mouth. He pinched her side and their hands interlocked. Her expression of ferocious concentration did not change. Claud got up, groaning and growling, and limped off. She continued to study the ceil-

She did not get up until she heard the pick-up truck coming back with the Negroes. Then she rose and thrust her feet in her brown oxfords, which she did not bother to lace, and stumped out onto the back porch and got her red plastic bucket. She emptied a tray of ice cubes into it and filled it half full of water and went out into the back yard. Every afternoon after Claud brought the hands in, one of the boys

helped him put out hay and the rest waited in the back of the truck until he was ready to take them home. The truck was parked in the shade under one of the hickory trees.

"Hi yawl this evening?" Mrs. Turpin asked grimly, appearing with the bucket and the dipper. There were three women and a boy in the truck.

"Us doin nicely," the oldest woman said. "Hi you doin?" and her gaze stuck immediately on the dark lump on Mrs. Turpin's forehead. "You done fell down, ain't you?" she asked in a solicitous voice. The old woman was dark and almost toothless. She had on an old felt hat of Claud's set back on her head. The other two women were younger and lighter and they both had new bright green sunhats. One of them had hers on her head; the other had taken hers off and the boy was grinning beneath it.

Mrs. Turpin set the bucket down on the floor of the truck. "Yawl hep yourselves," she said. She looked around to make sure Claud had gone. "No, I didn't fall down," she said, folding her arms. "It was something worse than that."

"Ain't nothing bad happen to you!" the old woman said. She said it as if they all knew that Mrs. Turpin was protected in some special way by Divine Providence. "You just had you a little fall."

"We were in town at the doctor's office for where the cow kicked Mr. Turpin," Mrs. Turpin said in a flat tone that indicated they could leave off their foolishness. "And there was this girl there. A big fat girl with her face all broke out. I could look at that girl and tell she was peculiar but I couldn't tell how. And me and her mama was just talking and going along and all of a sudden WHAM! She throws this big book she was reading at me and . . ."

"Naw!" the old woman cried out.

"And then she jumps over the table and commences to choke me."

"Naw!" they all exclaimed, "naw!"

"Hi come she do that?" the old woman asked. "What ail her?"

Mrs. Turpin only glared in front of her. "Somethin ail her," the old woman said.

"They carried her off in an ambulance," Mrs. Turpin continued, "but before she went she was rolling on the floor and they were trying to hold her down to give her a shot and she said something to me." She paused. "You know what she said to me?"

"What she say?" they asked.

"She said," Mrs. Turpin began, and stopped, her face very dark and heavy. The sun was getting whiter and whiter, blanching the sky overhead so that the leaves of the hickory tree were black in the face of it. She could not bring forth the words. "Something real ugly," she muttered.

"She sho shouldn't said nothin ugly to you," the

old woman said. "You so sweet. You the sweetest lady I know."

"She pretty too," the one with the hat on said. "And stout," the other one said. "I never knowed no sweeter white lady."

"That's the truth befo' Jesus," the old woman said. "Amen! You des as sweet and pretty as you can

Mrs. Turpin knew exactly how much Negro flattery was worth and it added to her rage. "She said," she began again and finished this time with a fierce rush of breath, "that I was an old wart hog from

There was an astounded silence.

"Where she at?" the youngest woman cried in a piercing voice.

"Lemme see her. I'll kill her!"

"I'll kill her with you!" the other one cried.

"She b'long in the sylum," the old woman said emphatically. "You the sweetest white lady I know."

"She pretty too," the other two said. "Stout as she can be and sweet. Jesus satisfied with her!"

"Deed he is," the old woman declared.

Idiots! Mrs. Turpin growled to herself. You could never say anything intelligent to a nigger. You could talk at them but not with them. "Yawl ain't drunk your water," she said shortly. "Leave the bucket in the truck when you're finished with it. I got more to do than just stand around and pass the time of day," and she moved off and into the house.

She stood for a moment in the middle of the kitchen. The dark protuberance over her eye looked like a miniature tornado cloud which might any moment sweep across the horizon of her brow. Her lower lip protruded dangerously. She squared her massive shoulders. Then she marched into the front of the house and out the side door and started down the road to the pig parlor. She had the look of a woman going single-handed, weaponless, into battle.

The sun was a deep yellow now like a harvest moon and was riding westward very fast over the far tree line as if it meant to reach the hogs before she did. The road was rutted and she kicked several good-sized stones out of her path as she strode along. The pig parlor was on a little knoll at the end of a lane that ran off from the side of the barn. It was a square of concrete as large as a small room, with a board fence about four feet high around it. The concrete floor sloped slightly so that the hog wash could drain off into a trench where it was carried to the field for fertilizer. Claud was standing on the outside, on the edge of the concrete, hanging onto the top board, hosing down the floor inside. The hose was connected to the faucet of a water trough nearby.

Mrs. Turpin climbed up beside him and glowered down at the hogs inside. There were seven longsnouted bristly shoats in it-tan with liver-colored spots—and an old sow a few weeks off from farrowing. She was lying on her side grunting. The shoats were running about shaking themselves like idiot children, their little slit pig eyes searching the floor for anything left. She had read that pigs were the most intelligent animal. She doubted it. They were supposed to be smarter than dogs. There had even been a pig astronaut. He had performed his assignment perfectly but died of a heart attack afterwards because they left him in his electric suit, sitting upright throughout his examination when naturally a hog should be on all fours.

A-gruntin and a-rootin and a-groanin.

"Gimme that hose," she said, yanking it away from Claud. "Go on and carry them niggers home and then get off that leg."

"You look like you might have swallowed a mad dog," Claud observed, but he got down and limped

off. He paid no attention to her humors.

Until he was out of earshot, Mrs. Turpin stood on the side of the pen, holding the hose and pointing the stream of water at the hind quarters of any shoat that looked as if it might try to lie down. When he had had time to get over the hill, she turned her head slightly and her wrathful eyes scanned the path. He was nowhere in sight. She turned back again and seemed to gather herself up. Her shoulders rose and she drew in her breath.

"What do you send me a message like that for?" she said in a low fierce voice, barely above a whisper but with the force of a shout in its concentrated fury. "How am I a hog and me both? How am I saved and from hell too?" Her free fist was knotted and with the other she gripped the hose, blindly pointing the stream of water in and out of the eye of the old sow whose outraged squeal she did not hear.

The pig parlor commanded a view of the back pasture where their twenty beef cows were gathered around the hay-bales Claud and the boy had put out. The freshly cut pasture sloped down to the highway. Across it was their cotton field and beyond that a dark green dusty wood which they owned as well. The sun was behind the wood, very red, looking over the paling of trees like a farmer inspecting his own hogs.

"Why me?" she rumbled. "It's no trash around here, black or white, that I haven't given to. And break my back to the bone every day working. And

do for the church."

She appeared to be the right size woman to command the arena before her. "How am I a hog?" she demanded. "Exactly how am I like them?" and she jabbed the stream of water at the shoats. "There was plenty of trash there. It didn't have to be me.

"If you like trash better, go get yourself some

trash then," she railed. "You could have made me trash. Or a nigger. If trash is what you wanted why didn't you make me trash?" She shook her fist with the hose in it and a watery snake appeared momentarily in the air. "I could quit working and take it easy and be filthy," she growled. "Lounge about the sidewalks all day drinking root beer. Dip snuff and spit in every puddle and have it all over my face. I could be nasty.

"Or you could have made me a nigger. It's too late for me to be a nigger," she said with deep sarcasm, "but I could act like one. Lay down in the middle of the road and stop traffic. Roll on the

ground."

In the deepening light everything was taking on a mysterious hue. The pasture was growing a peculiar glassy green and the streak of highway had turned lavender. She braced herself for a final assault and this time her voice rolled out over the pasture. "Go on," she yelled, "call me a hog! Call me a hog again. From hell. Call me a wart hog from hell. Put that bottom rail on top. There'll still be a top and bottom!"

A garbled echo returned to her.

A final surge of fury shook her and she roared, "Who do you think you are?"

The color of everything, field and crimson sky, burned for a moment with a transparent intensity. The question carried over the pasture and across the highway and the cotton field and returned to her clearly like an answer from beyond the wood.

She opened her mouth but no sound came out

A tiny truck, Claud's, appeared on the highway, heading rapidly out of sight. Its gears scraped thinly. It looked like a child's toy. At any moment a bigger truck might smash into it and scatter Claud's and the niggers' brains all over the road.

Mrs. Turpin stood there, her gaze fixed on the highway, all her muscles rigid, until in five or six minutes the truck reappeared, returning. She waited until it had had time to turn into their own road. Then like a monumental statue coming to life, she bent her head slowly and gazed, as if through the very heart of mystery, down into the pig parlor at the hogs. They had settled all in one corner around the old sow who was grunting softly. A red glow suffused them. They appeared to pant with a secret life.

Until the sun slipped finally behind the tree line, Mrs. Turpin remained there with her gaze bent to them as if she were absorbing some abysmal lifegiving knowledge. At last she lifted her head. There was only a purple streak in the sky, cutting through a field of crimson and leading, like an extension of the highway, into the descending dusk. She raised her hands from the side of the pen in a gesture hieratic and profound. A visionary light settled in her eyes.

She saw the streak as a vast swinging bridge extending upward from the earth through a field of living fire. Upon it a vast horde of souls were rumbling toward heaven. There were whole companies of white-trash, clean for the first time in their lives, and bands of black niggers in white robes, and battalions of freaks and lunatics shouting and clapping and leaping like frogs. And bringing up the end of the procession was a tribe of people whom she recognized at once as those who, like herself and Claud, had always had a little of everything and the God-given wit to use it right. She leaned forward to observe them closer. They were marching behind the others with great dignity, accountable as they had always been for good order and common sense and respectable behavior. They alone were on key. Yet she could see by their shocked and altered faces that even their virtues were being burned away. She lowered her hands and gripped the rail of the hog pen, her eyes small but fixed unblinkingly on what lay ahead. In a moment the vision faded but she remained where she was, immobile.

At length she got down and turned off the faucet and made her slow way on the darkening path to the house. In the woods around her the invisible cricket choruses had struck up, but what she heard were the voices of the souls climbing upward into the starry field and shouting hallelujah.

Jorge Luis Borges THE BOOK OF SAND

Jorge Luis Borges' story helps explain why he is a major influence on the post-modern writers: it is a brief story with a deep sense of mystery and an edge of terror. It has to do with books and language and symbols and their meaning. It uses the traditional literary culture but seems to subvert it. Compare it with Kafka's parable.

Thy rope of sands . . . —George Herbert

The line is made up of an infinite number of points; the plane of an infinite number of lines; the volume of an infinite number of planes; the hypervolume of an infinite number of volumes. . . . No, unquestionably this is not—more geometrico—the best way of beginning my story. To claim that it is true is nowadays the convention of every made-up story. Mine, however. is true.

I live alone in a fourth-floor apartment on Belgrano Street, in Buenos Aires. Late one evening, a few months back, I heard a knock at my door. I opened it and a stranger stood there. He was a tall man, with nondescript features—or perhaps it was

my myopia that made them seem that way. Dressed in gray and carrying a gray suitcase in his hand, he had an unassuming look about him. I saw at once that he was a foreigner. At first, he struck me as old; only later did I realize that I had been misled by his thin blond hair, which was, in a Scandinavian sort of way, almost white. During the course of our conversation, which was not to last an hour, I found out that he came from the Orkneys.

I invited him in, pointing to a chair. He paused awhile before speaking. A kind of gloom emanated from him—as it does now from me.

"I sell Bibles," he said.

Somewhat pedantically, I replied, "In this house are several English Bibles, including the first—John Wiclif's. I also have Cipriano de Valera's, Luther's which, from a literary viewpoint, is the worst—and a Latin copy of the Vulgate. As you see, it's not exactly Bibles I stand in need of.'

After a few moments of silence, he said, "I don't only sell Bibles. I can show you a holy book I came across on the outskirts of Bikaner. It may interest

He opened the suitcase and laid the book on a table. It was an octavo volume, bound in cloth. There was no doubt that it had passed through many hands. Examining it, I was surprised by its unusual weight. On the spine were the words "Holy Writ" and, below them, "Bombay."

"Nineteenth century, probably," I remarked. "I don't know," he said. "I've never found out."

I opened the book at random. The script was strange to me. The pages, which were worn and typographically poor, were laid out in double columns, as in a Bible. The text was closely printed, and it was ordered in versicles. In the upper corners of the pages were Arabic numbers. I noticed that one lefthand page bore the number (let us say) 40.514 and the facing right-hand page 999. I turned the leaf; it was numbered with eight digits. It also bore a small illustration, like the kind used in dictionaries—an anchor drawn with pen and ink, as if by a schoolboy's clumsy hand.

It was at this point that the stranger said, "Look at the illustration closely. You'll never see it again."

I noted my place and closed the book. At once, I reopened it. Page by page, in vain, I looked for the illustration of the anchor. "It seems to be a version of Scriptures in some Indian language, is it not?" I said to hide my dismay.

"No," he replied. Then, as if confiding a secret, he lowered his voice. "I acquired the book in a town out on the plain in exchange for a handful of rupees and a Bible. Its owner did not know how to read. I suspect that he saw the Book of Books as a talisman. He was of the lowest caste; nobody but other untouchables

could tread his shadow without contamination. He told me his book was called the Book of Sand, because neither the book nor the sand has any beginning or end."

The stranger asked me to find the first page.

I laid my left hand on the cover and, trying to put my thumb on the flyleaf, I opened the book. It was useless. Every time I tried, a number of pages came between the cover and my thumb. It was as if they kept growing from the book.

"Now find the last page."

Again I failed. In a voice that was not mine, I barely managed to stammer, "This can't be."

Still speaking in a low voice, the stranger said, "It can't be, but it is. The number of pages in this book is no more or less than infinite. None is the first page, none the last. I don't know why they're numbered in this arbitrary way. Perhaps to suggest that the terms of an infinite series admit any number."

Then, as if he were thinking aloud, he said, "If space is infinite, we may be at any point in space. If time is infinite, we may be at any point in time."

His speculations irritated me. "You are religious, no doubt?" I asked him.

"Yes, I'm a Presbyterian. My conscience is clear. I am reasonably sure of not having cheated the native when I gave him the Word of God in exchange for his devilish book."

I assured him that he had nothing to reproach himself for, and I asked if he were just passing through this part of the world. He replied that he planned to return to his country in a few days. It was then that I learned that he was a Scot from the Orkney Islands. I told him I had a great personal affection for Scotland, through my love of Stevenson and Hume.

"You mean Stevenson and Robbie Burns," he corrected.

While we spoke, I kept exploring the infinite book. With feigned indifference, I asked, "Do you intend to offer this curiosity to the British Museum?"

"No. I'm offering it to you," he said, and he stipulated a rather high sum for the book.

I answered, in all truthfulness, that such a sum was out of my reach, and I began thinking. After a minute or two, I came up with a scheme.

"I propose a swap," I said. "You got this book for a handful of rupees and a copy of the Bible. I'll offer you the amount of my pension check, which I've just collected, and my black-letter Wiclif Bible. I inherited it from my ancestors."

"A black-letter Wiclif!" he murmured.

I went to my bedroom and brought him the money and the book. He turned the leaves and studied the title page with all the fervor of a true bibliophile.

"It's a deal," he said.

It amazed me that he did not haggle. Only later was I to realize that he had entered my house with his mind made up to sell the book. Without counting the money, he put it away.

We talked about India, about Orkney, and about the Norwegian jarls who once ruled it. It was night when the man left. I have not seen him again, nor do I know his name.

I thought of keeping the Book of Sand in the space left on the shelf by the Wiclif, but in the end I decided to hide it behind the volumes of a broken set of The Thousand and One Nights. I went to bed and did not sleep. At three or four in the morning, I turned on the light. I got down the impossible book and leafed through its pages. On one of them I saw engraved a mask. The upper corner of the page carried a number; which I no longer recall, elevated to the ninth power.

I showed no one my treasure. To the luck of owning it was added the fear of having it stolen, and then the misgiving that it might not truly be infinite. These twin preoccupations intensified my old misanthropy. I had only a few friends left; I now stopped seeing even them. A prisoner of the book, I almost never went out anymore. After studying its frayed spine and covers with a magnifying glass, I rejected the possibility of a contrivance of any sort. The small illustrations, I verified, came two thousand pages apart. I set about listing them alphabetically in a notebook, which I was not long in filling up. Never once was an illustration repeated. At night, in the meager intervals my insomnia granted, I dreamed of the book.

Summer came and went, and I realized that the book was monstrous. What good did it do me to think that I, who looked upon the volume with my eyes, who held it in my hands, was any less monstrous? I felt that the book was a nightmarish object, an obscene thing that affronted and tainted reality it-

I thought of fire, but I feared that the burning of an infinite book might likewise prove infinite and suffocate the planet with smoke. Somewhere I recalled reading that the best place to hide a leaf is in a forest. Before retirement, I worked on Mexico Street, at the Argentine National Library, which contains nine hundred thousand volumes. I knew that to the right of the entrance a curved staircase leads down into the basement, where books and maps and periodicals are kept. One day I went there and, slipping past a member of the staff and trying not to notice at what height or distance from the door, I lost the Book of Sand on one of the basement's musty shelves.

Italicized terms within the definitions are themselves defined within the glossary.

- **a capella** Music sung without instrumental accompaniment.
- **abacus** (1) The slab that forms the upper part of a *capital*. (2) A computing device using movable counters.
- **Academy** Derived from Akademeia, the name of the garden where Plato taught his students, the term came to be applied to (generally conservative) official teaching establishments.
- **accompaniment** The musical background to a melody.
- **acoustics** The science of the nature and character of sound.
- **acrylic** A clear plastic used to make paints and as a casting material in sculpture.
- **adagio** Italian for "slow"; used as an instruction to musical performers.
- **aesthetic** Describes the pleasure derived from a work of art as opposed to any practical or informative value it might have. In philosophy, aesthetics is the study of the nature of art and its relation to human experience.
- **aisle** In church *architecture*, the long open spaces parallel to the *nave*.
- aleatory music Music made in a random way after the composer sets out the elements of the musical piece.
- allegory A dramatic or artistic device in which the superficial sense is accompanied by a deeper or more profound meaning.
- **allegro** Italian for "merry" or "lively"; a musical direction.
- altar In ancient religion, a table at which offerings were made or victims sacrificed. In Christian churches, a raised structure at which the sacrament of the Eucharist is consecrated, forming the center of the ritual.
- **altarpiece** A painted or sculptured panel placed above and behind an altar to inspire religious devotion.
- alto The lowest range of the female voice; also called contralto.

- **ambulatory** Covered walkway around the *apse* of a church.
- **anthropomorphism** The endowing of nonhuman objects or forces with human characteristics.
- antiphony Music in which two or more *voices* alternate with one another.
- apse Eastern end of a church, generally semicircular, in which the altar is housed.
- architecture The art and science of designing and constructing buildings for human use.
- **archivault** The molding that frames an arch.
- **aria** Song for a solo voice in an *opera*, an *oratorio*, or a *cantata*.
- Ars Nova Latin for "New Art."

 Describes the more complex new music of the 14th century, marked by richer harmonies and elaborate rhythmic devices.
- **assemblage** The making of a sculpture or other three-dimensional art piece from a variety of materials. Compare collage, montage.
- atelier Workshop.
- **atonality** Absence of a *key* or tonal center in a musical composition.
- **atrium** An open court in front of a church.
- **augmentation** In music, the process of slowing a melody or musical phrase by increasing (generally doubling) the length of its notes.
- **avant garde** Advance guard. Used to describe artists using innovative or experimental techniques.
- **axis** An imaginary line around which the elements of a painting, sculpture, or building are organized; the direction and focus of these elements establishes the axis.
- **ballad** A narrative poem or song with simple stanzas and a refrain that is usually repeated at the end of each stanza.
- **ballet** A dance performance, often involving a narrative or plot se-

- quence, usually accompanied by music.
- **band** A musical performance group made up of *woodwind*, *brass*, and *percussion*, but no *strings*.
- **baritone** The male singing voice of medium register, between *bass* and *tenor*.
- **barrel vault** A semicircular *vault* unbroken by ribs or groins.
- basilica In Roman times, a large hall used for public meetings, law courts, etc.; later applied to a specific type of early Christian church.
- bas-relief Low relief; see relief.
- bass The lowest range of the male voice.
- **beat** The unit for measuring time and *meter* in music.
- **binary form** A two-part musical form in which the second part is different from the first and both parts are usually repeated.
- bitonality A musical technique involving the simultaneous performance of two melodies in different tonalities.
- **blank verse** Unrhymed verse often used in English *epic* and dramatic poetry. Its meter is *iambic pentameter*. Compare *heroic couplet*.
- **blue note** A flattened third or seventh note in a *chord*, characteristic of iazz and blues.
- **brass instruments** The French horn, trumpet, trombone, and tuba, all of which have metal mouthpieces and bodies.
- **burin** Steel tool used to make copper *engravings*.
- **buttress** An exterior architectural support.
- **cadenza** In music, a free or improvised passage, usually inserted toward the end of a *movement* or *aria*, intended to display the performer's technical skill.
- caliph An Arabic term for leader or
- campanile In Italy, the bell tower of

a church, often standing next to but separate from the church building.

canon From the Greek meaning "rule" or "standard." In architecture it is a standard of proportion. In literature it is the authentic list of an author's works. In music it is the melodic line sung by overlapping voices. In religious terms it represents the authentic books in the Bible or the authoritative prayer of the Eucharist in the Mass or the authoritative law of the church promulgated by ecclesiastical authority.

cantata The Italian for a piece of music that is sung rather than played; an instrumental piece is known as a sonata.

cantus firmus Latin for "fixed song," a system of structuring a polyphonic composition around a preselected melody by adding new meloabove and/or below. A technique used by medieval and Renaissance composers.

canzoniere The Italian word for songbook.

capital The head, or crowning part, of a column; takes the weight of the entablature.

capitulary A collection of rules or regulations promulgated by a legislative body.

cartoon (1) A full-scale preparatory drawing for a picture generally a large one such as a wall painting. (2) A humorous drawing.

cast A molded replica made by a process whereby plaster, wax, clay, or metal is poured in liquid form into a mold. When the material has hardened the mold is removed, leaving a replica of the original from which the mold was taken.

cathedra The bishop's throne. From that word comes the word "cathedral"—a church where a bishop officiates.

Objects made of baked clay, such as vases and other forms of pottery, tiles, and small sculpture.

chamber music Music written to be performed by small groups.

chancel The part of a church east of the nave; includes choir and sanctu-

chant A single line of unaccompanied melody in free rhythm. The term is most frequently used for liturgical music such as Gregorian Ambrosian chant.

chapel A small space within a church or a secular building such as a palace or castle that contains an altar consecrated for ritual use.

chevet The eastern (altar) end of a church.

chiaroscuro In painting, the use of strong contrasts between light and dark.

Choir (1) The part of a church *chancel* between nave and sanctuary where the monks sang the offices. (2) A group of singers.

chorale A simple hymn tune sung either in unison or harmonized.

chord Any combination of three or more notes sounded together.

chorus In ancient Greek drama, a group of performers who comment collectively on the main action. The term came to be used, like choir, for a group of singers.

classical Generally applied to the civilizations of Greece and Rome, more specifically to Greek art and culture in the 5th and 4th centuries B.C. Later imitations of classical styles are called neoclassical. "Classical" is also often used as a broad definition of excellence: a classic can date to any period.

clavecin French for "harpsichord." clef French for "key." În written music the term denotes the sign placed at the beginning of the staff to indicate the range of notes it contains.

clerestory A row of windows in a wall above an adjoining roof.

cloister The enclosed garden of a monastery, surrounded by a covered walkway; by extension the monastery itself. Also, a covered walkway alone.

coda Italian for "tail." Final section of a musical movement in sonata form that sums up the previous material. codex Manuscript volume.

coffer In architecture, a recessed panel in a ceiling.

collage A composition produced by pasting together disparate objects such as train tickets, newspaper clippings, and textiles. Compare assemblage, montage.

colonnade A row of columns.

comedy An amusing and lighthearted play intended to provoke laughter.

composer The writer of a piece of

composition Generally, the arrangement or organization of the elements that make up a work of art. More specifically, a piece of music.

concerto A piece of music for one or more solo instruments and orchestra, usually with three contrasting movements.

concerto grosso A piece of music similar to a concerto but designed to display the *orchestra* as a whole.

concetto Italian for "concept." In Renaissance and Baroque art, the idea that undergirds an artistic ensemble.

contralto See alto.

contrapposto In sculpture, placing a human figure so that one part (for example, shoulder) is turned in a direction opposite to another part (such as hip and leg).

cori spezzati Italian for "split choirs." The use of two or more choirs for a musical performance.

cornice The upper part of an entabla-

counterpoint Two or more distinct melodic lines sung or played simultaneously in a single unified composition.

crescendo In music, a gradual increase in loudness.

cruciform Arranged or shaped like a

crypt A vaulted chamber, completely or partially underground, which usually contains a chapel. It is found in a church under the choir.

da capo Italian for "from the beginning." In a musical performance, return to and repetition of the beginning section.

Daguerrotype Early photograph in which the image is produced on a silver-coated plate.

decrescendo In music, a gradual decrease in loudness.

design The overall conception or scheme of a work of art. In the visual arts, the organization of a work's composition based on the arrangement of lines or contrast between light and dark.

development Central section of a sonata-form movement, in which the themes of the exposition are developed.

dialectics A logical process of arriving at the truth by putting in juxtaposition contrary propositions; a term often used in medieval philosophy and theology as well as in the writings of Hegel and Marx.

diatonic Denoting the seven notes of a major or minor *scale*, corresponding to the piano's white *keys* in an *octave*.

diminuendo In music, a gradual decrease in volume.

diminution The speeding up of a musical phrase by decreasing (usually halving) the length of the notes. **dome** A hemispherical *vault*.

dominant The fifth note of a diatonic scale.

dramatis personae The characters in a play.

dynamics In music, the various levels of loudness and softness of sound, together with their increase and decrease.

elevation In *architecture*, a drawing of the side of a building that does not show perspective.

encaustic A painting technique using molten wax colored by pigments.

engraving (1) The art of producing a depressed design on a wood or metal block by cutting it in with a tool. (2) The impression or image made from such a wood or metal block by ink that fills the design, Compare burin, etching, woodcut.

entablature The part of a Greek or Roman temple above the columns, normally consisting of architrave, frieze, and cornice.

epic A long narrative poem celebrating the exploits of a heroic character.

essay A short literary composition, usually in prose, dealing with a specific topic.

etching (1) The art of producing a depressed design on a metal plate by cutting lines through a wax coating and then applying corrosive acid that removes the metal under the lines. (2) The impression or image made from such a plate by ink that fills the design. Compare engraving, woodcut.

Evangelist One of the authors of the four *Gospels* in the Bible: Matthew, Mark, Luke, and John.

exposition In music, the statement of the themes or musical ideas in the first section of a *sonata-form move-ment*.

facade The front of a building.

ferroconcrete A modern building material consisting of concrete and steel reinforcing rods or mesh.

finale In music, the final section of a large instrumental composition or of the act of an *opera*.

flat A symbol (b) used in music to signify that the note it precedes should be lowered by one half step.

foot In poetry, the unit for measuring *meter*.

foreshortening The artistic technique whereby a sense of depth and three-dimensionality is obtained by the use of receding lines.

form The arrangement of the general structure of a work of art.

forte Italian for "loud."

fresco A painting technique that employs the use of pigments on wet plaster.

friar A member of one of the religious orders of begging brothers founded in the Middle Ages.

frieze The middle section of an entablature. A band of painted or carved decoration often found around the outside of a Greek or Roman temple.

fugue A *polyphonic* composition, generally for two to four vocal or instrumental voices, in which the same themes are passed from voice to voice and combined in *counterpoint*.

gallery A long, narrow room or corridor, such as the space above an *aisle* of a church.

genre A type or category of art. In the visual arts, the depiction of scenes from everyday life.

Gesamtkunstwerk German for "complete work of art." The term, coined by Richard Wagner, refers to an artistic ensemble in which elements from literature, music, art, and the dance are combined into a single artistic totality.

Glaze In oil painting, a transparent layer of paint laid over a dried painted canvas. In *ceramics*, a thin coating of clay fused to the piece by firing in a kiln.

Gospels The four biblical accounts of the life of Jesus, ascribed to Matthew, Mark, Luke, and John. Compare *Evangelists*.

gouache An opaque watercolor medium.

graphic Description and demonstration by visual means.

Greek cross A cross with arms of equal length.

Gregorian chant Monophonic religious music, usually sung without accompaniment; also called plainsong. Compare melisma, neum, trope.

ground A coating applied to a surface to prepare it for design.

guilloche A decorative band made up of interlocking lines of design.

happening In art, a multimedia event performed with audience participation to create a single artistic expression.

harmony The *chords* or vertical structure of a piece of music; the relationships existing between simultaneously sounding notes and *chord* progressions.

heroic couplet The *meter* generally employed in *epic* poetry, consisting of pairs of rhyming *iambic pentameter* lines. Compare *blank verse*.

hierarchy A system of ordering people or things that places them in higher and lower ranks.

high relief See relief.

homophonic Describes music in which a single melody is supported by a harmonious accompaniment. Compare *monophonic*.

humanist In the Renaissance, someone trained in the humane letters of the ancient classics and employed to use those skills. More generally, one who studies the humanities as opposed to the sciences.

hymn A religious song intended to give praise and adoration.

iambic pentameter The *meter* of poetry written in lines consisting of five groups (pentameter) of two syllables each, the second syllable stressed more than the first (iambic *foot*).

icon Greek word for "image." Panel paintings used in the Orthodox church as representations of divine realities.

iconography The set of symbols and allusions that gives meaning to a complex work of art.

ideal The depiction of people, objects, and scenes according to an idealized, preconceived model.

idol An image of a deity that serves as the object of worship.

image The representation of a human or nonhuman subject or of an event.

imitation In music, the restatement of a melodic idea in different voice parts of a *counterpoint* composition.

impasto Paint laid on in thick tex-

improvization In musical performance, the spontaneous invention of music for voice or instrument.

incising Cutting into a surface with a sharp instrument.

interval Musical term for the difference in pitch between two musical notes.

isorhythmic Describes *polyphonic* music in which the various sections are unified by repeated rhythmic patterns but the melodies are varied.

italic The typeface (like this) designed in the Renaissance that was based on a form of handwriting often used in manuscript copying.

jamb Upright piece of a window or door frame, often decorated in medieval churches.

jazz Form of American music, first developed in the black community in the early 20th century, consisting of improvization on a melodic theme.

jongleur Wandering minstrel. A professional musician, actor, or mime who went from place to place, offering entertainment.

key (1) The tonal center around which a composer bases a musical work. (2) The mechanism by which a keyboard instrument (piano, organ) or wind instrument (clarinet, bassoon) is made to sound.

keystone Central stone of an arch.

lancet A pointed window frame of a Gothic cathedral.

landscape In the visual arts, the depiction of scenery in nature.

Latin cross A cross of which the vertical arm is longer than the horizontal arm.

legato Italian for "tied." In music, the performance of notes in a smooth line. (The opposite, with notes detached, is called *staccato*.)

leitmotif German for "leading motive." A system devised by Richard Wagner whereby a melodic idea rep-

resents a character, an object, or an idea.

libretto Italian for "little book." In music, the text or words of an *opera*, *oratorio*, or other musical work involving text.

lied German for "song."

line engraving A type of *engraving* in which the image is made by scored lines of varying width.

lintel In *architecture*, the piece that spans two upright posts.

lithography A method of producing a print from a slab of stone on which an image has been drawn with a grease crayon or waxy liquid.

liturgy The rites used in public and official religious worship.

loggia A gallery open on one or more sides, often with arches.

low relief See relief.

lunette Semicircular space in wall for window or decoration.

lyric (1) Words or verses written to be set to music. (2) Description of a work of art that is poetic, personal, even ecstatic in spirit.

Madonna Italian for "My Lady." Used generically for the Virgin Mary.

madrigal Polyphonic song for three or more voices, with verses set to the same music and a refrain set to different music.

mandorla Almond-shaped light area surrounding a sacred personage in a work of art.

Mass The most sacred rite of the Catholic *liturgy*.

mausoleum Burial chapel or shrine. melisma In *Gregorian chant*, singing an intricate chain of notes on one syllable. Compare *trope*.

meter A systematically arranged and measured rhythm in poetry or music.

Minnesingers German medieval musicians of the aristocratic class who composed songs of love and chivalry. Compare *troubadors*.

minuet A French 17th-century dance, the form of which was eventually incorporated into the sonata and symphony as the third movement.

mobile A sculpture so constructed that its parts move by either mechanical or natural means.

mode (1) In ancient and medieval music, an arrangement of notes forming a scale that, by the character of intervals, determines the nature of the composition. Compare *tetrachord*. (2) In modern music one of the two classes, major or minor, into which musical scales are divided.

modulation In music, movement from one *key* to another.

monastery Â place where monks live in communal style for spiritual purposes.

monochrome A single color, or variations on a single color.

monody A *monophonic* vocal piece of music.

monophonic From the Greek meaning "one voice." Describes music consisting of a single melodic line. Compare polyphonic.

montage (1) In the cinema, the art of conveying an idea and/or mood by the rapid juxtaposition of different images and camera angles. (2) In art, the kind of work made from pictures or parts of pictures already produced and now forming a new composition. Compare assemblage, collage.

mosaic Floor or wall decoration consisting of small pieces of stone, ceramic, shell, or glass set into plaster or cement.

motet (1) Musical composition developed in the 13th century in which words (French "mots") were added to fragments of *Gregorian chant*. (2) In 16th-century composition, four- or five-voiced sacred work, generally based on a Latin text.

movement In music, an individual section of a *symphony*, *concerto*, or other extended composition.

mullions The lines dividing windows into separate units.

mural Wall painting or mosaics attached to a wall.

myth Story or legend whose origin is unknown; myths often help to explain a cultural tradition or cast light on a historical event.

narthex The porch or vestibule of a church.

natural In music, the sign that cancels any previously indicated *sharp* (*) or *flat* (b).

nave From the Latin for "ship." The central space of a church.

neum The basic symbol used in the notation of *Gregorian chant*.

niche A hollow recess or indentation

in a wall to hold a statue or other object.

notation The system of writing music in symbols.

obelisk A rectangular shaft of stone that tapers to a pyramidal point.

octave The *interval* from one note to the next with the same pitch, as from middle C to the C above or below.

oculus From the Latin for "eye"; a circular window or opening at the top of a dome.

ode A lyric poem, often exalted and emotional in character.

oil painting Painting in a medium made of powdered colors bound together with oil, usually linseed.

opera Theatrical performance involving a drama, the text of which is sung to the accompaniment of an orchestra.

opus Latin for "work." Used for chronological lists of composers' works.

Opus Dei Latin for "work of God."
Used to describe the choral offices
sung by monks during the course of
a day.

oral composition The composition and transmission of works of literature by word of mouth, as in the case of the Homeric epics.

oratorio An extended musical composition for solo singers, chorus, and orchestra on a religious subject. Unlike opera, oratorio is not staged.

orchestra (1) In Greek theaters, the circular space in front of the stage in which the *chorus* moves. (2) A group of instrumentalists gathered to perform musical *compositions*.

order (1) In classical architecture a specific form of column and entablature.
(2) More generally, the arrangement imposed on the various elements in a work of art.

organum An early form of *poly-phonic* music in which one or more melody lines were sung along with the song line of plainsong. Compare *Gregorian chant*.

overture An instrumental *composition* played as an introduction to a *ballet*, *opera*, or *oratorio*.

palette (1) The tray on which a painter mixes colors. (2) The range and combination of colors typical of a particular painter.

panels A rigid flat support, generally square or rectangular, for a painting; the most common material is wood.

pantheon The collected gods; by extension, a temple to them. In modern usage, a public building containing the tombs or memorials of famous people.

parable A story told to point up a philosophical or religious truth.

parallelism A literary device, common in the Psalms, of either repeating or imaging one line of poetry with another that uses different words but expresses the same thought.

pastel A drawing made by rubbing colored chalks on paper.

pathos That aspect of a work of art which evokes sympathy or pity.

pendentives Triangular architectural devices used to support a dome of a structure; a dome may rest directly on the pendentives. Compare squinches.

percussion instruments Musical instruments (such as drums, tambourines, cymbals) that are struck or shaken to produce a sound.

perspective In the visual arts, a technique for producing on a flat or shallow surface the effect of three dimensions and deep space.

piano Italian for "soft."

piazza Italian term for a large open public square.

pietà An image of the Virgin with the dead Christ.

pietra serena Italian for "serene stone"; a characteristic building stone often used in Italy.

pilaster In architecture, a pillar in re-

pitch In music, the relative highness or lowness of a note as established by the frequency of vibrations occurring per second within it.

pizzicato Italian for "plucked." An instruction to performers on string instruments to pluck rather than bow their strings.

plainsong See Gregorian chant.

plan An architectural drawing showing in two dimensions the arrangement of space in a building.

podium A base, platform, or pedestal for a building, statue, or monument.

polychrome Several colors. Compare monochrome.

polyphonic From the Greek mean-

ing "many voices." Describes a musical composition built from the simultaneous interweaving of different melodic lines into a single whole. Compare *monophonic*.

portal A door, usually of a church or cathedral.

portico A porch with a roof supported by columns.

prelude In music, a short piece that precedes a large-scale *composition*.

presto Italian for "fast."

program music Instrumental compositions that imitate sound effects, describe events, or narrate a dramatic sequence of events.

proportion The relation of one part to another and each part to the whole with respect to size, whether of height, width, length, or depth.

prosody The art of setting words to music.

prototype An original model or form on which later works are based.

Psalter (1) Another name for the book of Psalms in the Bible. (2) A collection of Psalms for use in worship.

realism A 19th-century style in the visual arts in which people, objects, and events were depicted in a manner that aimed to be true to life. In film, the style of neorealism developed in the post–World-War-II period governed by similar principles.

recapitulation The third section of a sonata-form movement in which the ideas set out in the exposition are repeated.

recitative A style of musical declamation that is halfway between singing and ordinary speech.

register In music, the range of notes within the capacity of a human voice or an instrument.

relief Sculptural technique whereby figures are carved from a block of stone, part of which is left behind to form a background. Depending on the degree to which the figures project, the relief is described as either high or low.

reliquary A small casket or shrine in which sacred relics are kept.

requiem A Mass for the dead.

rondo A musical form in which one main theme recurs in alternation with various other themes, a form

often used in the last movement of a sonata or symphony.

sanctuary In religion, a sacred place. The part of a church where the altar is placed.

sarcophagus From the Greek meaning "flesh-eater." A stone (usually limestone) coffin.

satire An amusing exposure of folly and vice that usually aims to produce moral reform.

scale (1) In music, a succession of notes arranged in ascending or descending order. (2) More generally, the relative or proportional size of an object or image.

scherzo A light-hearted and fastmoving piece of music.

score The written form of a musical composition.

section An architectural drawing that shows the side of a building.

secular Not sacred; pertaining to the worldly.

sequence In music, the repetition of a melodic phrase at different pitches.

serenade A type of instrumental composition originally performed in the 18th century as background music for public occasions.

serial music A type of 20th-century musical composition in which various components (notes, rhythms, dynamics, etc.) are organized into a fixed series.

sharp In music, a sign (#) that indicates the note it precedes is to be raised by one half step.

silhouette The definition of a form by its outline; also, a form's outline

soliloquy A speech delivered by an actor either while alone on stage or unheard by the other characters, generally so constructed as to indicate inner feelings.

An extended instrumental composition, generally in three or four movements.

sonata form A structural form for instrumental music that employs exposition, development, and recapitulation as its major divisions.

sonnet A fourteen-line poem, either eight lines (octave) and six lines (sestet) or three quatrains of four lines and an ending couplet. Often attributed to Petrarch, the form (retaining the basic fourteen lines) was modified by such poets as Spenser, Shakespeare, and Milton.

soprano The highest register of the female voice.

spandrel A triangular space above a window in a barrel-vault ceiling, or the space between two arches in an arcade.

squinches Either columns or lintels used in corners of a room to carry the weight of a superimposed mass. Their use resembles that of pendentives

staccato See legato.

staff The five horizontal lines with four spaces between on which musical notation is written.

still life A painting of inanimate objects such as fruit, flowers, dishes, and the like arranged to form a visual composition.

stretcher A wooden or metal frame on which a painter's canvas is

string quartet A performing group consisting of two violins, viola, and cello; a composition in sonata form written for such a group.

string instruments The violin, viola, violoncello, and double bass. All have strings that produce sound when stroked with a bow or plucked.

suite In music, a collection of various movements performed as a whole, sometimes with a linkage in key or theme between the movements.

summa The summation or a body of learning, particularly in the fields of philosophy and theology.

symmetry An arrangement in which various elements are so arranged as to parallel one another on either side of an axis.

symphonic poem A one-movement orchestral work meant to illustrate a nonmusical object like a poem, painting, or view of nature. Also called "tone poem."

symphony An extended orchestral composition, generally in three or four movements, in sonata form.

syncopation In music, the accentuation of a beat that is normally weak or unaccented.

synthesizer An electronic instrument for the production and control of sound that can be used for the making of music.

tabernacle A container for a sacred object; a receptacle on the altar of a Roman Catholic church to contain the Eucharist.

tambour The drum that supports the cupola of a church.

tempera A painting technique using coloring mixed with egg volk, glue, or casein.

tempo In music, the speed at which the notes are performed.

tenor The highest range of the male voice. In medieval organum the voice that holds the melody of the plain-

ternary form A musical form composed of three separate sections, the second in contrast to the first and third and the third a modified repeat of the first.

terracotta Italian for "baked earth." Baked clay used for ceramics. Also, sometimes refers to the reddishbrown color of baked clay.

tesserae The small pieces of colored stone used for the creation of a mosaic.

tetrachord Musical term for a series of four notes. Two tetrachords form a mode.

theme In music, a short melody or a self-contained musical phrase.

The particular quality of sound produced by a voice or instrument.

toccata In music, a virtuoso instrumental composition characterized by a free style with long, technically difficult passages.

tonality In music, the organization of all tones and chords of a piece in relation to the first tone of a key.

tonic The first and principal note of a key, which serves as a point of departure and return.

transept In a cruciform church, the entire part set at right angles to the

treble In music, the higher voices, whose music is written on a staff marked by a treble clef.

triptych A painting consisting of three panels. A painting with two panels is called a diptych; one with several panels is a polyptych.

trompe l'œil From the French "to fool the eye." A painting technique by which the viewer seems to see real subjects or objects instead of their artistic representation.

In Gregorian chant, words added to a long melisma.

troubadors Aristocratic southernFrench musicians of the Middle Ages who composed *secular* songs with themes of love and chivalry; called trouvères in northern France. Compare *Minnesingers*.

trumeau A supporting pillar for a church *portal*, common in medieval churches.

method of *composition* devised by Arnold Schoenberg in the early 20th century. Works in this style are based on a tone row consisting of an arbitrary arrangement of the twelve notes of the *octave*.

tympanum The space, usually decorated, above a *portal*, between the *lintel* and arch.

unison The sound that occurs when two or more voices or instruments simultaneously produce the same note or melody at the same *pitch*.

value (1) In music, the length of a note. (2) In painting, the property of a color that makes it seem light or dark.

vanishing point In perspective, the point at which receding lines seem to converge and vanish.

vault A roof composed of arches of masonry or cement construction.

virginal A stringed keyboard instrument, sometimes called a spinet, that was a predecessor of the harpsichord.

vivace Italian for "lively" or "vivacious."

virtuoso A person who exhibits great technical ability, especially in music. As an adjective, it describes a musical performance that exhibits, or a musical composition that demands, great technical ability.

votive An offering made to a deity either in support of a request or in

gratitude for the fulfillment of an earlier prayer.

voussoirs Wedge-shaped blocks in an arch.

Waltz A dance in triple rhythm.

woodcut (1) A wood block with a raised design produced by gouging out unwanted areas. (2) The impression or image made from such a block by inking the raised surfaces. Compare engraving, etching, lithograph.

woodwind instruments The flute, oboe, English horn, clarinet, bass clarinet, bassoon, contrabassoon, and saxophone. All are pipes perforated by holes in the sides and produce musical sound when the column of air within them are vibrated by blowing on a mouthpiece.

References are to page numbers. **Boldface** numbers indicate illustrations and literary selections. Works are listed under the names of their creators, when known; otherwise under their titles. Architectural works and the art associated with them are listed under the cities where they are located. Unless

repeated in the text, events cited in the chapteropening chronologies are not indexed. Many technical terms are included in the index, with reference to their text definitions. For a more complete list of terms, consult the Glossary.

Abakanowicz, Magdalena, 423 Backs, **424** abstract expressionism (New York School), 412-415, 412, 413, 414 color fields and abstract symbols in, 413-415, 413, creative action of artist visible in, 413, 413, 415 Académie des Beaux-Arts (Academy of Fine Arts), 55 a cappella, 63 Act of Supremacy (1534), 83 action painting, 413, 415 Adams, Ansel, 375 Adler, Renata, 430 Aeschylus, 223, 262 Age of Reason. See eighteenth century Agee, James, Let Us Now Praise Famous Men, 376 Ailey, Alvin, 370 Albers, Josef, 410, 415 Aldine Press, 32, 65, 85 Aldus Manutius. See Manutius aleatoric music, 432 allegro, 218 Altdorfer, Albrecht, 90, 94-95 Battle of Alexander and Darius, 94-95, 95 Danube Landscape near Regensburg, 94, 95 America (United States): classical architecture in, 216-217, 217 Constitution of, 225, 227 Counter-Reformation and, 147–148 discovery of, 64, 148 landscape painting in, 284-287, 284, 285, 287 philosophy in, 229-230, 283 photography in, 375-376 romantic era in, 282-287 slave trade and, 227 Spanish conquest of, 148 American Revolution, 216, 227 Declaration of Independence and, 228, 231

anabaptists, 82 Angelico, Fra, 21, 23, 35 Annunciation, 21, 22 Anne, queen of England, 224 anthem, 103 full, 103 verse, 103 Aguinas, Saint Thomas, 172 archaeology, neoclassical art and, 213, 216-217 architecture: Baroque, 154, 155, 154, 158-159, 158, 159 early Renaissance, 16-18, 16, 17, 18, 21 form and function in, 425 French, in sixteenth century, 99–100, 99 Gothic, 17 High Renaissance, 57-58, 57, 58 Mannerist, 62, 62 natural environment and, 425 neoclassical, 216-217, 217 in postwar period, 424-429, 425, 426, 427, 428 rococo, 212-213, 213, 214 romantic, 276, 276 sculptural possibilities of, 425-426 aria, 169 Ariosto, Lodovico, 104 Aristophanes, 32 Aristotle, 31, 32, 35-36, 90 armature, 67 Armstrong, Louis, 369, 370 Arnolfo di Cambio, Florence Cathedral, 16 Arp, Jean, 367 Ars Nova, 35 Artist: medieval view of, 91 nineteenth-century concept of, 256 in postwar period, 408-409 Renaissance conception of, 91 assemblage, 421-422

atomic weapons, 408, 430 Barry, Sir Charles, Houses of Parliament, 256, 257 atonality, 342 Barth, John, 430 Atwood, Margaret, 430 Barthelme, Donald, 430 Augustans, 223 Bartholdi, Frédéric Auguste, Statue of Liberty (Liberty Augustine, Saint, 64, 84 Enlightening the World), 321, 322 Augustus, Roman emperor, 223 Bartok, Bela, 369 automobile, mass production of, 358 Basie, William (Count), 369 Bauhaus, 368, 375, 415, 427, 429 Bayreuth Festival, 266 Bach, Anna Magdalena, 171 Beatles, 434, 435 Bach, Carl Philipp Emanuel, 217 Revolver, 434 Bach, Johann Sebastian, 87, 170-171, 177, 178, 218, "Yesterday," 434 261, 343 Beaumarchais, Pierre Augustin, The Marriage of Figaro, Bist du bei Mir, 171 221 Brandenburg Concertos, 171, 171, 218 Beauvoir, Simone de, 410 as master of counterpoint, 170 Beckett, Samuel, 410, 429 Saint Matthew Passion, 171 Waiting for Godot, 429 The Well-Tempered Klavier, 170 Beckmann, Wilhelm, 266 Bach, Maria Barbara, 170 Richard Wagner at His Home in Bayreuth, 266 Bacon, Francis, 90 Beethoven, Ludwig van, 218, 221, 260-262, 260, 263, Novum Organum, 90 268 Baez, Joan, 434 background and training of, 260-261 Baker, Josephine, 369 Battle Symphony, 338 Balakirev, Mili A., 264 Fidelio, 260, 262 Baldwin, James, 430 influence of, 260-261 Go Tell It on the Mountain, 430 Piano Sonata No. 8 in C minor, Op. 13 ("Pathétique"), ballet, 370-371 Ballet Russe, 370 as prototype of romantic artist, 260 Balzac, Honoré de, 280 Symphony No. 3 in Eb, Op. 55 (Eroica), 261-262, 261, The Human Comedy, 280, 295-302 Bamberg, Vierzehnheiligen Pilgrim Church, 213, 214 Symphony No. 5 in C minor, Op. 67, 262 banking system, European, 12, 19 Symphony No. 6, Op. 68 (Pastoral), 262 Baptistery of Saint John. See Florence Symphony No. 9, Op. 125, 260, 262, 280 Barcelona, Casa Milá, 337 bel canto, 264, 265 Bardi, Giovanni (Count), 168 Bell, Clive, 360, 402, 404 Bardi, Donato. See Donatello Bell, Vanessa, 404. See also Stephen, Vanessa Baroque period, 146-203 belle époque, 320 architecture in, 154-155, 154, 158-159, 158, 159 Bellini, Vincenzo, 264 characteristics of artistic style during, 146-149 Norma, 264-265, 265 Counter-Reformation spirit in, 146-149, 167 Bergman, Ingmar, Wild Strawberries, 429 drama in, 175 Berlin, Irving, "God Bless America," 434 economic developments in, 147 Berlioz, Hector, 262, 338 exploration and discovery in, 148 The Damnation of Faust, 262 geographical spread of artistic activity in, 147 Fantastic Symphony, 262, 338 missionaries in, 146, 147, 148 lieder, 262 music in, 167-171, 171 Bernini, Gian Lorenzo, 146, 153-154, 178 origin of term, 146-147 Cardinal Scipione Borghese, 153-154, 153 painting in, 149-153, 150, 151, 155-158, 156, 157, David, 153, 153 **158**, 159–166, **159**, **160**, **161**, **162**, **163**, **164**, **165**, The Rape of Proserpine, 154, 154 Betjeman, John, 403 poetry in, 176-179, 181-183, 194-203 Beyle, Marie Henri. See Stendhal Renaissance distinguished from, 147 Bible: richness and variety of style in, 147 Gutenberg, 32, 87 rise of middle class during, 147 King James Version, 85, 86, 176 science and philosophy in, 147-148, 172-175, 180-181 literacy and study of, 86

Luther's translation of, 85, 86

sculpture in, 153-154, 153, 154

Bronté, Emily, Wuthering Heights, 281 Reformation and study of, 34, 85, 86 Brücke, Die (The Bridge), 337 black experience: Bruckner, Anton, 263 jazz and, 368-369 Symphony No. 8 in C minor, 263 poetry as expression of, 429-430 Bruegel, Pieter, the Elder, 95, 97-98 Blake, Eubie, 369 Hunters in the Snow, 98, 98 Blaue Reiter, Der (The Blue Rider), 337, 368 Peasant Wedding Feast, 97-98, 97 Bloomsbury Group, 360, 402, 404 The Triumph of Death, 96, 97 attitudes of, 402 Brunelleschi, Filippo, 14–18 membership, 402 dome of Florence Cathedral, 16-17, 17 blue note, 368 Foundling Hospital, 17, 17 blues (music), 368 Pazzi Chapel, 17-18, 18 Blunt, Wilfred, 404 The Sacrifice of Isaac, 14, 15 Boccaccio, Giovanni, 12 Budé, Guillaume, 25 Boccioni, Umberto, 376 Buñuel, Luis, 368 Boffrand, Germain, Hôtel de Soubise, 212, 213 L'Age d'Or, 368 Bonaparte, Napoleon. See Napoleon Bonaparte Un Chien Andalou, 368 Bonaparte, Pauline, 216, 216 Burckhardt, Jakob, The Civilization of the Renaissance in Book of Common Prayer, 86, 103, 103 Italy, 31 Borges, Jorge Luis, 430 burin, 92 The Book of Sand, 452-453 buttress, 17 Borghese, Pauline Bonaparte, 216, 216 Byrd, William, 65 Borghese, Scipione, Cardinal, 153 My Ladye Nevells Booke, 103-104 Borodin, Aleksandr P., 264 "Ye Sacred Muses," 103, 103 Borromini, Francesco, 153, 154-155, 162 Byron, George Gordon, Lord, 274 as described by Giambattista Passeri, 155 Byzantine art style, 12 San Carlo alle Quattro Fontane, 154, 155 Bosch, Hieronymus, 95-97 Garden of Earthly Delights, 95–97, 96 Botticelli, Sandro (Alessandro di Mariano dei Filipepi), Cabot, John, 64 Cage, John, 415, 432 23, 25-26, 29, 63 Concert for Piano and Orchestra, 432 The Adoration of the Magi, 23, 23 Calder, Alexander, 420-421, 422 The Birth of Venus, 26, 26 Big Red, 420, 420 La Primavera, 25-26, 25 Josephine Baker, 369 Boucher, François, 207, 209, 211 Callas, Maria, 265 Cupid a Captive, 209, 210 as Norma, 265, 265 Boulez, Pierre, 431, 432 Calvin, John, 82, 83, 84, 213 Second Piano Sonata, 431 Calvinism, 82 Structures, 431 capitalism and, 86 Brady, Mathew, 375 Calvino, Italo, 430 Brahms, Johannes, 262-263 Camerata. See Florentine Camerata Symphony No. 1 in C minor, Op. 58, 262-263 Campagnola, Guilio, The Astrologer, 89, 89 Bramante, Donato: Camus, Albert, 410 Saint Peter's Basilica, 52, 57-58, 57, 58 The Fall, 410 Brandenberg, Margrave of, 171 The Plague, 410 Braque, Georges, 360-361, 365, 405 The Stranger, 410 Violin and Palette, 361, 363 Canova, Antonio, 216 Brecht, Bertolt, 258 Pauline Bonaparte Borghese as Venus Victorious, 216, 216 Dreigroschenoper (The Threepenny Opera), 369 Cantaneo, Marchesa (Elena Grimaldi), 163-164, 163 Breton, André, 367, 368 cantata, 171 Manifesto of Surrealism, 367 canto carnascialesco (carnival song), 36 Britten, Benjamin, 433 Caravaggio (Michelangelo Merisi), 149-153, 155, 160, Death in Venice, 433 162, 166 A Midsummer Night's Dream, 433 The Conversion of Saint Paul, 150, 150 Peter Grimes, 433 Madonna of Loreto, 150, 151 War Requiem, 433 The Martyrdom of Saint Matthew, 150, 150 Broadwood, John, 221

Carolingian Renaissance, 31 Piano Sonata No. 2 in Bb minor, Op. 35, 315 Caracci, Agostino, 152 Piano Sonata No. 3 in B minor, Op. 58, 315 Carracci, Annibale, 149, 152 Preludes, Op. 28, 263 The Flight into Egypt, 152, 153 Sand's relationship with, 263, 312-316 The Triumph of Bacchus and Ariadne, 152, 152 as virtuoso pianist, 263-264 Carracci, Ludovico, 152 Chópin, Kate, 345, 346 Carriera, Rosalba, 210-211 The Awakening, 346 Anna Sofia d'Este, Princess of Modena, 211, 211 "The Story of an Hour," 353-355 Carrissimi, Giocoma, 169 chorale, 169 The Judgment of Solomon and Job, 169 chorale fantasies, 169 Carter Family, 434 chorale variations, 169 cartoon (in fresco technique), 18 Christian IV, king of Denmark, 104 Cassatt, Mary, 328-329 Christianity: Mother and Child, 329, 329 Erasmus's view of, 34-35 Castiglione, Baldassare, 65-67, 104 humanist approach to, 31, 52, 55, 85-86 The Courtier, 65-67, 69-74 Machiavelli's view of, 33-34 Catherine the Great, Russian empress, 34 Voltaire's criticism of, 227 Catholic Church: See also Catholic Church; Counter-Reformation; corruption in, 82, 83 Reformation Index of Prohibited Books, 34, 86 Christo, John, 423 universe theories and, 90, 172-173 Valley Curtain, 423 See also Counter-Reformation; Reformation Cicero, Marcus Tullius, 65, 88 Caxton, William, 32, 104 cinema. See film Cellini, Benvenuto, 63, 67-68, 80 civil rights movement, 408, 429 Autobiography, 67-68, **74-77** -classical style in music, 217-222 Perseus, 66, 67, 74-77 defined, 217-218 The Saltcellar of Francis I, 80, 80 in opera, 222-223 Cervantes Saavedra, Miguel de, 86, 175-176 in symphonies, 218-219 Don Quixote, 176 Clement VII, Pope, 56, 63, 67 Cézanne, Paul, 326, 331-333, 336, 361, 404 Clouet, Jean, 99 Mont Sainte-Victoire, 332, 333, 339 Cocteau, Jean, 341, 368, 370 Still Life with Commode, 332, 332 Antigone, 371 Chagall, Marc, 365, 422 Blood of a Poet, 368 The Green Violinist, 365 Parade, 370 Chambord, Château of, 99, 99 coda, 219 chansons, 102 Cole, Thomas, 285, 286 Charles I, king of England, 177 Genesee Scenery (Landscape with Waterfall), 284, 285 Charles I, king of Spain, 81 Coleridge, Samuel Taylor, 283 Charles II, king of England, 177, 233 Colet, John, 25, 34 Charles IV, king of Spain, 268-269, **269** collaboration in art, 370-371 Charles V, Holy Roman emperor, 65, 81 Collins, Judy, Wildflowers, 435 Charpentier, Auguste, George Sand, 313 Colloredo, Hieronymus, 220 Chartres, Cathedral, 88 Colonna, Donna Vittorio, letter to Michelangelo, 58 Chateaubriand, René de, 270, 272 color-field painting, 413-415, 413, 414 Chaucer, Geoffrey, 12 Columbus, Christopher, 64, 148 chiaroscuro, 150, 151, 417 Combat, 410 choirs: concerto grosso, 147, 171 multiple, 65 Constable, John, 277 Sistine and Julian, 63-64, 65 Hay Wain, 277, 277 Chopin, Frédéric, 263-264, 273, 313 Constantine, Roman emperor, 58 Barcarolle in F# Major, Op. 60, 315 Constantinople, fall of, 32 Charles Hallé's description of, 313 Constitution, U.S., 225, 227 early death of, 263 Cooper, James Fenimore, 272 Fantaisie in F minor, Op. 49, 315 Copernicus, Nicolas, 90, 172, 173 Mazurkas, 264 On the Revolutions of Celestial Bodies, 90 photograph of, 316 Copley, John Singleton, 282

"Footsteps in the Snow," 341 Portrait of Nathaniel Hurd, 282, 282 "The Girl with the Flaxen Hair," 341 Corelli, Arcangelo, 169 La Mer (The Sea), 341 Corinth, Lovis, Salome, 339, 339 de Chirico, Giorgio, 367, 370 Corneille, Pierre, 175 Declaration of the Rights of Man (France), 228, 229-230 Horace, 175 Degas, Edgar, 286, 327 Polyeucte, 175 The Rehearsal, 327-328, 328 Cornell, Joseph, 421 The Tub, 328, 329 Medici Slot Machine, 420 Delacroix, Eugène, 272-275, 286, 312, 314 Corso, Gregory, 410 The Death of Sardanapalus, 273, 274, 276 counterpoint, 103, 170 Frédéric Chopin, 263, 263 Counter-Reformation, 86 journal of, 273 Baroque style and, 146-149 Massacre at Chios, 273-274, 273 Couperin, François, 217 Demosthanes, 32 Courbet, Gustave, 275 Descartes, René, 173-174, 174 The Studio: A Real Allegory of the Last Seven Years of The Discourse on Method, 173 My Life, 275-276, 275 as father of modern philosophy, 173 Cranach, Lucas, Portrait of Martin Luther, 82, 82 Meditations, 173 Cranmer, Thomas, 102 d'Este, Anna Sofia, 211, 211 Crashaw, Richard, 171 development, in sonata form, 219 On the Wounds of Our Crucified Lord, 181-182 Diaghiley, Serge, 370-371 Cromwell, Oliver, 177 Cruikshank, George, "Please, sir, I want some more," Parade, 370-371 Dickens, Charles, 280, 281, 345 281–282, **281** Hard Times, 282 cubism, 323, 360-366 Horatio Sparkins, 302-308 analytical, 361 Oliver Twist, 281-282 impact of, 362-364 linear perspective abandoned in, 361 A Tale of Two Cities, 281 Diderot, Denis, 223, 225 in painting, 360-366, 362, 363, 364, 365 dome, 16–18, **17** Cui, César, 264 Donatello (Donato di Niccolò di Betto Bardi), 16, Cullen, Countee, 430 20-21, 29Cunningham, Imogen, 375 Currier, Nathaniel, First Appearance of Jenny Lind in David, 20, 21 America: At Castle Garden, September 11, 1850, Saint George, 20, 20 Saint Mary Magdalene, 21, 21 282, **282** Donizetti, Gaetano, 264, 265 Lucia de Lammermoor, 265 Donne, John, 176-177 dada, 371-373, 372 "The Canonization," 182 da Gama, Vasco, 30, 80 "Holy Sonnet X," 182-183 Daguerre, Louis, 286 Dostoyevsky, Fyodor, 281, 337, 344, 345, 409 daguerrotype, 286 Crime and Punishment, 344, 348-350 Dali, Salvador, 367 Dowland, John, 104 Inventions of the Monsters, 367, 367 The Persistence of Memory, 366, 367 drama: in ancient Rome, 104-105, 106 Dante Alighieri, 12, 32 audience for, 107 The Divine Comedy, 264 early opera and, 167–169 Vita Nuova, 24 Elizabethan, 104-107, 107, 115-143, 168-169 Darwin, Charles, 259-260 in postwar period, 429-430 Origin of Species, 259 romantic, 278-279, 289-292 Daumier, Honoré, 275 Le Ventre Législatif (The Legislative Belly), 275, **275** in seventeenth century, 175–178, **180–203** theater design and, 105, 105, 168 David, Jacques Louis, 207, 210, 213, 268 Dryden, John, 223 The Battle of the Romans and the Sabines, 268, 260 Duchamp, Marcel, 371 Napoleon Crossing the Alps, 215, 215 L.H.O.O.Q., 372 Oath of the Horatii, 207, 207, 215, 268 Dunstable, John, 102 Davis, Miles, 370 Debussy, Claude, 341, 342, 370 Duomo. See Florence

Dupin, Aurore. See Sand, George Ellington, Edward Kennedy ("Duke"), 369, 370 Dürer, Albrecht, 90-93 Nutcracker Suite, 370 Adam and Eve, 92, 92 Peer Gynt Suite, 370 Apocalypse series, 91, 92 Shakespearean Suite, 370 Erasmus of Rotterdam, 34, 34 Ellison, Ralph, Invisible Man, 430 The Fall of Man, 94 Emerson, Ralph Waldo, 283 Four Books on Human Proportion, 93 The American Scholar, 283 Knight, Death, and the Devil, 92, 93 empfindsamer Stil (expressive style), 217 Saint Michael Fighting the Dragon, 91, **92** Encyclopédie, 225-226 Self-Portrait, 91, 91 Encyclopedists, 225-226 Dvorák, Antonin, 264 Engels, Friedrich, 258 Slavonic Dances, 264 England: Dylan, Bob, 434 cultural and psychological isolation of, 100-101 drama in, 80, 104-107, 107, 115-143, 168-169 Eakins, Thomas, 282, 285-287 Elizabethan, 81, 100-102, 102-104 Miss Van Buren, 286, 287 history of, 81, 100 The Swimming Hole, 285, 286 humanism in, 104-107 Eastman, George, 375 literature in, 104-107, 281 education, humanist concept of, 85 metaphysical poetry in, 176-177, 182-183 Edward VII, king of England, 405 music in, 102-104, 103, 104, 168, 169-170 Ego, 366 painting in, 100-102, 100, 101, 211, 211, 215, 215 eighteenth century, 206-253 Reformation in, 83, 100 as age of optimism, 206 romantic poetry in, 279-280, 292-296 architecture in, 212-213, 213, 214 English Civil War (1642–1648), 174, 177, 223 diversity of style in, 206-208 engravings and etchings: intellectual developments during, 222-223 line, 92, 92 literature in, 222-228, 233-253 Northern Renaissance, 84, 91-92, 92, 93 monarchy in, 208 woodcuts, 91, 92 music in, 217-222 "enlightened despotism," 207 painting in, 208-216, 209, 210, 211, 212, 213, 214, Enlightenment. See eighteenth century epic poetry, 104, 177-178, 194-203 philosophy in, 225-228 Erasmus, Desiderius, 32, 34-35, 83, 104 revolutionary spirit in, 207-208, 228-231 De Libero Arbitrio (On Free Will), 85 sculpture in, 212, **212** Enchiridion Militis Christiani, 34 view of human nature in, 225-228 Greek New Testament, 34, 85 See also neoclassicism; rococo style The Praise of Folly (Encomium Moriae), 34, 42-47 Eisenstein, Sergei, 373-374 Ernst, Max, 367, 410 Alexander Nevsky, 373 Esterhazy, Prince Miklós József, 219 Ivan the Terrible, Parts I and II, 373 etchings. See engravings and etchings Potemkin, 373-374, 374 ethos, in Greek music, 35 Strike!, 373 Evans, Mary Ann. See Eliot, George electronic music, 431-432 Evans, Walker, 375-376 El Greco (Domenikos Theotocopoulos), 159-160, 373 The Bud Fields Family at Home, Alabama, 376 Burial of Count Orgaz, 160, 160 Let Us Now Praise Famous Men, 376 Martyrdom of St. Maurice and the Theban Legion, evolution, 259-260 159-160, **159** excavations, archaeological, 213 Eliot, George (Mary Ann Evans), 281 existentialism, 409-410, 437-439 Eliot, T. S., 358-359, 360, 376, 402, 405, 429 exposition, in sonata form, 219 Ash Wednesday, 359 expressionism, 335, 336-338 cultural links with past sought by, 359 color and mood in, 337, 365 Four Quartets, 359 in painting, 335, 336-338, 336, 337, 338 The Hollow Men, 359, 379-380 See also abstract expressionism The Waste Land, 358, 403 Elizabeth I, queen of England, 81, 100, 101-102, 103, Fabriano, Gentile da, 13 104, 105, 403 Adoration of the Magi, 13, 13 Elkin, Stanley, 430 fantasies (music), 169

Francis, Saint, 12 Fascism, 358, 375, 429 Francis I, king of France, 80, 81, 99 Faulkner, William, 368, 402-403 Franciscan movement, 31 "Nobel Prize Award Speech," 409, 409 Frankenthaler, Helen, 415 The Sound and the Fury, 402-403 The Bay, 414 Faust myth, 264, 278-279, 284, 289-292 Frederick the Great, king of Prussia, 208, 226 fauvism, 335-336, 335, 336 French Revolution, 207, 228, 268, 270 feminism, 345-346, 408, 430 Declaration of the Rights of Man and, 228, 229-230 of George Sand, 280, 314, 316 Frescobaldi, Girolamo, 169 of Virginia Woolf, 403-404 frescos: See also women buon, 18 Ferdinand I, Holy Roman emperor, 81 early Renaissance, 13-14, 14, 15, 21, 22, 27, 27 fêtes galantes, 209 secco, 18 Ficino, Marsilio, 20, 25, 31, 35 technique of, 18 Theologia Platonica, 20 Freud, Sigmund, 366-368, 403 Filipepi, Alessandro di Mariano dei. See Botticelli Civilization and Its Discontents, 408 film, 323, 415, 429 The Interpretation of Dreams, 366 as propaganda, 373-375 Friedrich, Caspar David, 95, 276-277 surrealist, 368 Cloister Graveyard in the Snow, 276, 277 Fitzgerald, F. Scott, 369 Froben, Johann, 85 Flauberg, Gustave, 208 frottola, 36 Madame Bovary, 208 Frv. Roger, 360, 402, 404 Florence: "The First Post-Impressionist Exhibition" mounted Baptistery of Saint John, 14-16, 15, 16 bv, 404 Church of the Carmine, 13 fugue, 170 commerce in, 12 full anthem, 103 Convent of San Marco, 21, 29, 30 futurism, 376-377 Duomo (Cathedral), 16, 17, 17 Foundling Hospital, 17, 17 government of, 12, 18-20 Gabo, Naum, 370 Laurentian Library vestibule, 62, 62 Gabrieli, Andrea, 65, 169 Medici Palace, 22, 56, 56 Gabrieli, Giovanni, 65, 169 Palazzo Vecchio, 29, 30, 67 Gainsborough, Thomas, 207, 211, 215, 216 Pazzi Chapel, 17-18, 18, 56 Haymaker and Sleeping Girl, 207-208, 207, 211 and Renaissance, 12-18 Mary, Countess Howe, 211, 211 revolutionary changes in arts centered in, 12-18 Galilei, Galileo, 25, 90, 172-173 Santa Croce, 17 Dialogue Concerning the Two Chief World Systems, 173 Santa Maria Novella, 13, 23 Dialogues Concerning Two New Sciences, 173 Santa Reparata, 16 telescopes designed by, 172, 173 Santa Trinità, 13 Galilei, Vincenzio, 172 Studium, 19-20, 25 Garnier, Charles, Paris Opéra, 276, 276 Tuscan dialect in, 12 Gaskell, Elizabeth, 281 Florentine Camerata, 168, 172 gates (in bronze casting), 67 folk music, 257, 343 Gaudi, Antonio, 337 Ford, Henry, 358, 377 Casa Milá, 337, 337 Forster, E. M., 402, 403 Gauguin, Paul, 331, 404 Foundling Hospital. See Florence la Orana Maria, 331, 332 Fragonard, Jean Honoré, 209-210, 215, 216 Genet, Jean, 410 Love Letters, 210, 210 Gentileschi, Artemisia, 150-151 France: Judith and Holofernes, 151, 151 art and architecture in (sixteenth century), 99-100, 99 Géricault, Théodore, 271-272, 273 art and architecture in (nineteenth century), 270-276, Raft of the Medusa, 271-272, 272, 278 271, 272, 273, 274, 275, 276 Germany: Baroque art and architecture in, 155-159, 156, 157, architecture in, 212-213 158, 159 drama in, 278-279, 289-292 classical comedy and tragedy in, 175 engravings and woodcuts in, 91-92, 92, 93 music in (sixteenth century), 102, 168

Germany—continued The Journey of the Magi, 23-24, 24 history of, 80-81 Grand Ol' Opry, 434 music in, 87, 88, 102, 168, 169–171, 218–222, Grant, Duncan, 404 266 - 268Greece, ancient: novels in, 279, 281-282 music in, 35-36 opera in, 218-222, 266-268 philosophy in, 172 painting in, 90-95, 91, 94, 276-277 Renaissance and renewed interest in, 18, 31 poetry in, 223, 279-280 science in, 172 Reformation in, 82–83 Studium of Florence and, 19-20, 25 Romantic movement in, 258–259 tragedies of, 168, 223 Sturm und Drang (Storm and Stress) movement in, 278 Gregorian chant, 63 Gershwin, George, 370 Gregory the Great, Pope, 63 Concerto in F Major, 370 Grimaldi, Elena (Marchesa Cantaneo), 163, 163 Porgy and Bess, 370 Gris, Juan, 365 Rhapsody in Blue, 370 Guitar with a Sheet of Music, 364, 365 Gesamtkunstwerk (all-art-work), 266 Grocyn, William, 25 Ghiberti, Lorenzo, 14-16 Grosz, George, 410 "Gates of Paradise," 16, 16 ground (pit), 105 The Sacrifice of Isaac, 14-16, 15 groundlings, 105 Gilbert, William, 89, 322 Grünewald, Matthias (Mathis Gothart Neithart), 90, The Mikado, 322 93 - 95Ginsberg, Allan, 410 Crucifixion, 93, 94 Giorgione (Giorgio di Castelfranco), 59, 61, 94 Isenheim Altarpiece, 93, 94 Le Concert Champêtre, 59, 60 Resurrection, 93, 94 Enthroned Madonna with Saint Liberalis and Saint Guggenheim, Peggy, 410, 412 Francis, 59, 59 Guidi, Tommaso. See Masaccio Giotto di Bondone, 12, 325, 331 guilds, in Florence, 12 Giovanni, Nikki, 430 Gutenberg, Johannes, 32 Girodet-Trioson, Anne-Louis, 270, 272 Gutenberg Bible, 32, 86–87, **87** The Entombment of Atala, 270-271, 271 Guthrie, Woody, "This Land Is Your Land," 434 Glass, Philip, 433 Akhnaten, 433 Einstein on the Beach, 433 Hallé, Charles, memoirs of, 313, 313 Satyagraha, 433 Hals, Frans, 164 God, perception of: Banquet of the Officers of the Civic Guard of Saint George by Descartes, 174 at Haarlem, 164, 164, 166 by Renaissance humanists, 31–36, 52 René Descartes, 173, 174 by Voltaire, 227 Hampton, Lionel, 369 Goethe, Johann Wolfgang von, 262, 267, 278-279, 284 Handel, George Frederick, 169-170 Egmont, 278 melodic arias of, 169 Faust, 278-279, 289-292 Messiah, 169 Iphigeneia in Tauris, 278 The Music for the Royal Fireworks, 169-170 The Sufferings of Young Werther, 278 The Water Music, 169 Goodman, Benny, 369 Hanson, Duane, 423 recording of Mozart's Clarinet Quintet by, 369 Trucker, 424 Gordon, George. See Byron, Lord Hapsburg family, 81 Gothic, French, 99 Hardouin-Mansart, Jules, Palace of Versailles, 158, 159, Gothic architecture, 17 Gottlieb, Adolf, 413 "Harlem Renaissance," 430 Thrust, 413 harpsichord, 169, 221 Goya, Francesco, 256, 268-270 Hartt, Frederick, 62-63 Executions of the Madrileños on May 3, 1808, 268, 269 Harvey, Sir William, 89 The Family of Charles IV, 269-270, 270 Haskins, Charles Homer, The Renaissance of the Twelfth Saturn Devouring One of His Sons, 270, 271 Century, 31 The Sleep of Reason Produces Monsters, 256, 256, 270 Hathaway, Anne, 106 Gozzoli, Benozzo, 23-24 Hawthorne, Nathaniel, 284

The Scarlet Letter, 284 Haydn, Franz Joseph, 218, 219-220, 261, 338 as father of the symphony, 219-220 London Symphonies, 221 Heade, Martin I., Lake George, 284, 285 Heckel, Erich, Two Men at a Table (To Dostoyevsky), 337, **337** Hegel, Georg Wilhelm Friedrich, 258, 409 Heidegger, Martin, 409 Heller, Joseph, Catch-22, 408 Hendrix, Jimi, 435 Henry, Prince, of Portugal (the Navigator), 30 Henry IV, king of France, 163, 168 Henry VIII, king of England, 83, 100, 101 Herodotus, 32 Heyward, Dubose, Porgy and Bess, 370 Hilliard, Nicholas, 101-102 Ermine Portrait of Queen Elizabeth I, 100, 100 Portrait of a Youth, 101, 101 Hindemith, Paul, 369 Klaviersuite, 369 Hitler, Adolf, 358, 375 Hobbes, Thomas, 174-175 Leviathan, 174-175, 180-181 Hoby, Sir Thomas, 66 Hockney, David, 370, 418 Self-Portrait, 418 Hoffman, Hans, 410, 421 Hogarth, William, 216, 223, 403 Marriage à la Mode, 207 Hogarth Press, 360, 416, 416 Holbein, Hans, the Younger, 101 Anne of Cleves, 101, 101 Henry VIII in Wedding Dress, 83, 83 Nikolaus Kratzer, 89, 89 Homer, 177, 223, 224 Iliad, 223, 224 Odyssey, 223, 224 Homer, Winslow, 285-287 Eagle Head, Manchester, Massachusetts, 285, 285 Hooch, Pieter de, The Music Party, 167, 167 Hopper, Edward, 410, 421 Office in a Small City, 410, 411 Horace, 223 Houdon, Jeane Antoine, 216 Denis Diderot, 225, 225 George Washington, 230, 230 Houston, Rothko Chapel, 413, 414 Hudson River School, 285 Hughes, Langston, 430 Hugo, Victor, 280, 312 Les Misérables, 280 humanism, 31-35 Christian, 34-35, 177, 225 distinctive character of Renaissance and, 31

Greek scholars and, 32

human perfectibility as concept in, 85 modern philosophy and, 172 in Northern Europe, 34–35, 80, 90, 104 printing technology and spread of, 32 rational, 225–228 Reformation and, 83–86 scientific investigation and, 172 secular reform and, 34–35 two styles of, 32–35 universal religion constructed in, 86 Hunter, Alberta, 369 Huxley, Aldous, 377 Brave New World, 377, 394–401 hymns. Reformation and, 87, 87

Ibsen, Henrik, 345-346 A Doll's House, 345-346, 350-353 iconoclasm, Reformation and, 82, 87 Id. 366 impressionism, 286, 325-331 in music, 341-342 origin of term, 325 in painting, 325-330, 325, 326, 327, 328, 329 realism of light and color in, 325-327 in sculpture, 330-331, 330 See also post-impressionism Ingres, Jean Auguste Dominique, 274, 286, 312 La Comtesse d'Haussonville, 274, 275 Jupiter and Thetis, 274-275, 274 International Style, 80 intonaco, 18 intonazione (prelude), 65 investment (in bronze casting), 67 Ionesco, Eugene, 410 Irving, Washington, 282 Isaac, Heinrich, 36, 102 Isherwood, Christopher, 403 italic (scribal hand), 14 italic (type), 32 Italy: in fifteenth century. See Renaissance, early language of music and, 169 opera in, 167–169, 264–266

James I, King of England, 105, 106, 107

Janequin, Clement, 102

La Guerre (The War), 102

Japan, emergence of, 322

jazz, 368–370

origins of, 368–369

in symphonic and operatic music, 369–370

"Jazz Age, The," 368–370

Jazz Singer, The, 369

Jeaneret-Gris, Charles Édouard. See Le Corbusier

Jeffers, Robinson, 403 La Fontaine, Jean de, Fables, 223 Jefferson, Thomas, 216 landscape painting: State Capitol, Richmond, 216-217, 217 American, 284–287, 284, 285, 287 Jesuits, 146, 226 Baroque, 147, 152–153, **152, 157,** 158 Johannot, Tony, illustration for The Sufferings of Young beginning of, 59, 61 Werther, 278, 278 eighteenth-century, 211 John Paul II, Pope, 173 High Renaissance, 59, 61 Johns, Jaspar, 415, 417, 418 Lange, Dorothea, 375 Flag, 415, **415** Lange, Joseph, Mozart at the Pianoforte, 220, 220 Johnson, Philip, Seagram Building, 427 la Tour, Georges de, 155 Jolson, Al, 369 The Lamentation over Saint Sebastian, 155, 156 Jonson, Ben, 66–67, 106 Lazarillo de Tormes, 175 Joplin, Janis, 435 Lebrun, Charles, Palace of Versailles, 159 Joplin, Scott, 370 Le Corbusier (Charles Édouard Jeanneret-Gris), 426-427 Josquin des Prez, 64, 65 Unités d'Habitation, 426, 427 Tu Pauperum Refugium, 64 Lefèvre d'Etaples, Jacques, 25, 83 Joyce, James, 358, 359-360, 405, 429 Leibnitz, Baron Gottfried Wilhelm von, 227 The Dubliners, 359 leitmotiv, 267 Finnegans Wake, 360 Lenin, V. I., 358, 373 Portrait of the Artist as a Young Man, 359 Lennon, John, 434 stream-of-consciousness style of, 360 Leonardo da Vinci, 26-29, 51, 65, 80 Ulysses, 358, 360, 380-389, 403 Helicopter or Aerial Screw, 27, 26 Julius II, Pope, 50, 52, 57, 63 Last Supper, 26, 27, 27 tomb of, 52-55, **52, 53** Madonna of the Rocks, 27-29, 27 Jung, Carl, 412 Mona Lisa, 26, 371 Notebooks, 26 Leoni, Leone, Bust of Emperor Charles V, 81, 81 Kafka, Franz, 361, 368, 409 Leo X, Pope, 56, 82 The Castle, 361 Leon, Juan Ponce de, 64 The Trial, 361, 389-394 Lescot, Pierre, Square Court of the Louvre, 99-100, 99 kafkaesque, meaning of, 361 Leslie, Alfred, 417 Kandinsky, Wassily, 365–366 The 7 A.M. News, 416, 417 Concerning the Spiritual in Art, 366 Lessing, Doris, 430 Several Circles, 366, 366 le Vau, Louis, Palace of Versailles, 158 Kant, Immanuel, 258, 262, 283 Lewis, C. Day, 403 Critique of Judgment, 258 Lewis, Sinclair, 377 kantos, 170 Babbitt, 377 Keats, John, 279, 280 Libido, 366 Odes, 280, 294-295 Limbourgh brothers, Très Riches Heures, 98 Kelly, Ellsworth, 417 Linacre, Thomas, 25 Gray Panels 2, 416, 417 line engraving, 92 Kerouac, Jack, 410 linear perspective, 91 Keynes, John Maynard, 360, 402, 403 Lippi, Fra Filippo, 23 Kiefer, Anselm, 418 Liszt, Franz, 263-264, 312, 313, 314 Inneraum, 419 Hungarian Rhapsodies, 264 Kienholz, Edward, 421, 422 symphonic poems of, 338 The State Hospital, 421-422, 421 as virtuoso pianist, 263-264 Kierkegaard, Sören, 409 literacy, Reformation and, 86, 87 Klee, Paul, 367, 368 literary modernism, 358-360 Around the Fish, 368, 368 in novels, 358, 359-360, 380-394, 429 Knox, John, 82 in poetry, 358–359, **379–380** Köchel, L. von, 220 postmodernist writing and, 430 Kollwitz, Käthe, March of the Weavers, 321, 321 primary characteristics of, 358-359 Ktesibios of Alexandria, 221 literature: Kubrick, Stanley, Doctor Strangelove, 408 in Baroque era, 175-178, 180-203 Kunun, Maxine, 430 from 1870-1914, 344-346

in sculpture, 62-63, **62** in eighteenth century, 228, 233-253 Mantua, Duke of, 168 feminist concerns and, 280, 314, 316, 345-346, Manutius, Aldus, 32, 85 403-404, 408, 430 Manzù, Giacomo, Doors of Saint Peter's, 418, 419 futurist, 376-377 Marguerite of Navarre, 80 modernist, 358-360, 379-394, 429 Marinetti, Filippo Tommaso, 376 of postwar period, 429-430, 440-443, 443-452, Marlowe, Christopher, 105-106, 279 452-453 Dr. Faustus, 106 Renaissance, 65-68, 88, 104-107, 109-143. See also Hero and Leander, 106 humanism Tamburlaine, 106 romantic, 278-282, 283-284, 289-312, 315-316 Marot, Clement, 102 stream-of-consciousness style in, 345, 360 Marseilles, L'Unité de Habitation, 426, 427 subconscious and psychological investigation in, 344 Martini, Simone, 12 surrealist, 367, 368 Marx, Karl, 258 Littérature, 367 Communist Manifesto, 258 Live Aid show of 1987, 435 Masaccio (Tommaso Guidi), 12-13, 21 London: The Expulsion from the Garden, 14, 15 Globe Playhouse, 105, 105 The Holy Trinity, 13, 13 Houses of Parliament, 256, 257 revolutionary character of work of, 14 Longfellow, Henry Wadsworth, 272 The Tribute Money, 14, 14 Lorrain, Claude, 158 mass, as musical form, 64, 65 The Mill, 157, 158 Matisse, Henri, 335-336, 404 Lorrenzetti brothers, 12 The Joy of Life, 335, 336 Louis XIII, king of France, 163 Louis XIV, king of France, 155, 158-159, 158, 168, 175, The Red Studio, 336, 336 mazurka, 264 208 Mazzola, Francesco. See Parmigianino Palace of Versailles and, 158-159, 208, 272 Medici, Cosimo de', 19-23 Louis XV, king of France, 225 ancient manuscripts collected by, 20 Lully, Jean Baptiste, 168 Luther, Martin, 32, 65, 81, 82, 87, 91, 93, 102 as art patron, 20-24 Greek studies and, 19-20 Bible translated by, 85 illness and death of, 23 De Servo Arbitrio (On the Bondage of the Will), 86 Medici, Giovanni de', 82 Medici, Guiliano de', 23, 57 Medici, Lorenzo de', 24-30, 31, 32, 36, 57 Machaut, Guillaume de, 167 as art patron, 24, 35 Machiavelli, Niccolò, 32-34, 35 Comento ad alcuni sonetti (A Commentary on Some The Prince, 33-34, 38-42 Sonnets), 24 McCartney, Paul, 434 "The Song of Bacchus," 24, 24-25 McKay, Claude, 430 Medici, Maria de', 163, 163, 168 Maderna, Carlo, Saint Peter's Basilica, 58, 58 Medici, Piero de', 23-24, 25 madrigal, 64, 102, 104, **104,** 105 Medici family, 12, 19, 56 Magritte, René, 367-368 Mehta, Zubin, 435 Man with Newspaper, 367, 368 Meidner, Ludwig, The Eve of the War, 320, 320 Mahler, Gustav, 339-341 Melville, Herman, 284 The Song of the Earth, 340 Moby Dick, 284 Symphony No. 1 in D, 340 Merbeck, John, The Book of Common Praier Noted, 103, Symphony No. 9, 340 103 Manet, Édouard, 323-325, 329 Merisi, Michelangelo. See Caravaggio The Bar at the Folies-Bergère, 324, 325, 327 metaphysical poetry, 166-167, **182-183** Le Déjeuner sur l'Herbe (Luncheon on the Grass), Metastasio, Pietro, 223 323-325, **324** Michelangelo Buonarroti, 14, 17, 25, 29, 30, 422 Mann, Thomas, 429 Boboli Captives, 53, 53 Mannerism, 61-63 Creation of Adam, 55-56, 55 in architecture, 62, 62 David, 29, 29 Hartt's schema for, 61-62 Dawn, 57 in painting, 63, 63 Day, 57 in poetry, 176

Michelangelo Buonarroti-continued Reclining Figure, 422, 422 Dusk, 57 Moore, Marianne, 429 Laurentian Library vestibule, 62, 62 More, Anne, 176 Madonna of the Stairs, 28, 29 More, Sir Thomas, 34, 83, 104 Mannerist tendencies of, 62 Utopia, 104 Medici Chapel, 56–57, **56** Morgan, J. Pierpont, 404 Moses, 52-53, **52** Morisot, Berthe, Paris Seen from the Trocadero, 329, 330 Neoplatonism as interest of, 53, 55 Morley, Thomas, 104 Night, 56, 57 Now is the month of Maying, 104 Pietà, 28, 29, 63 Sing we and chaunt it, 104 as poet, 58 Morrison, Jim, 413 Saint Peter's Basilica, 58, 58 motet, 64, 102 sculptural method of, 53 Mothers of Invention, 434 Sistine Chapel ceiling, 54-55, 54, 62 Motherwell, Robert, 413 tomb of Pope Julius II, 53-54, 53 Elegy to the Spanish Republic XXXIV, 413 Michelet, Jules, 31 Moussorgsky, Modest, 264 Michelozzo di Bartolommeo, 21 Boris Godunov, 264 Mieroszevski, Ambroise, Frédéric Chopin, 313 movement, in orchestral composition, 218 Miës van der Rohe, Ludwig, 427 movies. See film Seagram Building, 427, 427 Mozart, Wolfgang Amadeus, 218, 220-222, 220, 261. Milhaud, Darius, 370 341 - 342Miller, Arthur, Death of a Salesman, 429 Clarinet Quintet, 369 Milton, John, 176, 177-178 The Marriage of Figaro, 207, 221, 222 "Il Penseroso," 177 Piano Concerto No. 27 in Bb, 220-221, 262 "L'Allegro," 177 Symphony No. 40 in G minor, 219, 219 Paradise Lost, 176, 177, 194-203, 223 Muggeridge, Edward. See Muybridge, Eadward Paradise Regained, 177 Munch, Edvard, 336-337, 340 Samson Agonistes, 177 The Scream, 336, 337 minimalism, 365, 432-433, 433 music: Miró, Joan, 367 aesthetics and, 167 missionaries, in Counter-Reformation, 146, 147, 148 aleatoric, 432 modernism, literary. See literary modernism American, 282, 368-370 Moholy-Nagy, László, 375 Ars Nova and, 35 Molière (Jean-Baptiste Poquelin), 175 atonal, 342 L'Avare, 175 avant-garde developments in, 431-432 Le Bourgeois Gentilhomme, 175 Baroque, 167-172, 171 Tartuffe, 175, 183-188 classical style in, 217-222 monasticism, Renaissance attitude toward, 84 communications technology and, 435 Mondrian, Piet, 365 cross-fertilization of styles in, 435 Color Planes in Oval, 365, 365 early Renaissance, 35-36 Monet, Claude, 325 from 1870 to 1914, 338-344 Impression: Sunrise, 325, 325 electronic, 431-432 Nymphéas (Water Lilies), 326, 326, 341 in Elizabethan England, 102-104, 103, 104 Red Boats at Argenteuil, 325-326, 326 empfindsamer Stil (expressive style) in, 217 monody, 168 of High Renaissance, 63-65, 64 montage (film), 374 impressionist, 341-342 Montaigne, Michel Eyquem de, 86, 88 Italian as language of, 169 Essays (Essais), 88 jazz, 368–370 "Of Repentance," 109-115 modern, origins of, 167 Montesquieu, Charles Louis, 225 nationalism and, 264 Monteverdi, Claudio, 168, 175, 178 native traditions as inspiration in, 257 Orfeo, 168 of Northern Renaissance, 102-104, 103 Montoro, Church of San Pietro, 58 overlapping voices in, 64 Moog synthesizer, 431 popular, 433-435 Moore, G. E., 402 in postwar period, 431-435 Moore, Henry, 361, 422-423 program, 338-339

Nietzsche, Friedrich, 321-323, 409 as protest form, 434 Thus Spake Zarathustra, 321 random, 431 Nijinsky, Vaslav, 343, 370 Reformation and, 87, 88, 102, 103 as Petrouchka, 343, 343 Roman, 35-36 "noble savage" concept (Rousseau), 225 romantic, 260-268, 312-316, 338-341 sacred, 63-65, 87, 88, 102, 103, 167, 169, 171 nocturne, 263 Noel, Henry, 104 search for new language for, 342-344, 431-432 Noland, Kenneth, 417 "structuralist," 431 Nolde, Emil, 338 style galant in, 217, 220 Pentecost, 338, 338 virtuoso tradition in, 149, 169, 263-264 North, Sir Thomas, Plutarch's Lives translated by, 107 See also opera; symphonies Musica Transalpina (Music from Across the Alps), 102 Northern Renaissance. See Renaissance, Northern Mussolini, Benito, 358 American (nineteenth century), 284 Mutsuhito, emperor of Japan, 322 changing role of women and, 345-346 Muybridge, Eadward (Edward Muggeridge), 286 modernist, 358-360, 380-394, 429 Animal Locomotion, 286 in postwar period, 429-430 Head-spring of a flying pigeon interfering, June 26, 1885, as prophetic warnings, 377, 394-401 romantic, 278, 280-282 subconscious and psychological investigation in, 344-345 Nadar (Gaspard Félix Tournachon), 286 Napier, John, 89 Napoleon Bonaparte, 215, 215, 261, 268, 270 Ochs, Phil, 435 O'Connor, Flannery, 429 National Socialist movement (Nazism), 358, 375, 429 "Revelation," 443-452 nationalism, 257 octave, 170 musical, 264 O'Keeffe, Georgia, 410-412 Nazism. See National Socialist movement Calla Lily with Red Roses, 410, 411 neoclassicism: catalogue statement of, 412 archaeological excavations and, 213 Oldenburg, Claes, 422 in architecture, 216-217, 217 Soft Toilet, 422, 422 historical reasons for rise of, 213 O'Neill, Eugene, 368 in literature, 233 Desire under the Elms, 368 in painting, 213-216, 215, 216 Mourning Becomes Electra, 368 revolutionary spirit and, 213-215 opera: in sculpture, 216, 216 Baroque, 167-169 See also eighteenth century bel canto, 264, 265 Neithart, Mathis. See Grünewald, Matthias birth of, 167-168 Neoplatonism, 20, 53, 55, 67 classical, 222-223 Nervi, Pier Luigi, 425 dramatic truth versus beauty of melody in, 169 Palazzetto dello Sport, 425, 425 orchestra and, 260 romantic, 264-268 Baroque art in, 161-166, 162, 163, 164, 165, 166 painting in (sixteenth century), 95-98, 96, 97 set design in, 168 in twentieth century, 339, 342, 370, 433 patronage in, 164 opera houses, 168 Neumann, Balthazar, 213 oratorio, 169 Vierzehnheiligen Pilgrim Church, 213, 214 orchestra: Nevelson, Louise, 421 standard instruments in, 218 Sky Cathedral—Moon Garden + One, 421 Wagner's emphasis on, 260 Newman, Barnett, 413 New York: hydraulic, 221 as postwar art center, 410 in liturgical music, 65 Seagram Building, 427, 427 Orwell, George, 377 Solomon R. Guggenheim Museum, 425, 425 Animal Farm, 377 Trans World Flight Center, Kennedy Airport, 426, 1984, 377, 408 over-all painting, 413, 413, 415

New York School. See abstract expressionism

Padua, University of, 172	Pascal, Blaise, 434
Paganini, Niccolò, 264, 312	Passeri, Giambattista, description of Borromini by, 155
painting:	pastels, 211, 211
abstract expressionist, 412-415, 412, 413, 414	patina, 67
action, 413, 415	patronage, 164
American (nineteenth century), 284-287, 284, 285, 287	iconoclasm of Reformation and, 164
Baroque, 149-153, 150, 151, 155-158, 156, 157, 158,	of Medici family, 21–25
159–166, 159, 160, 161, 162, 163, 164, 165, 166	papal, 50–58
color-field, 413–415, 413, 414	Paul V, Pope, 173
cubist, 323, 360-366, 362, 363, 364, 365	pavana, 35
early Renaissance, 12-18, 13, 14, 15, 19, 19, 21, 21,	Pavlova, Anna, 370
22, 22, 23–24, 23, 24, 25–27, 25, 26, 27, 29–30, 29	Pazzi Chapel. See Florence
from 1870 to 1914, 323–338, 324, 325, 326, 327, 328,	Pazzi family, 12, 17
329, 331, 332, 333, 334, 335, 336, 337, 338	
expressionist, 336–338, 336 , 337 , 338	Pearlstein, Philip, 417
fauvist, 335–336, 335, 336	Two Female Models with Regency Sofa, 416, 417
futurist, 376, 377	Peasants' War (1524–1526), 82, 93
High Renaissance, 50–52, 50, 51, 54–56, 54, 55,	Pederson, William, 429
59–63, 59, 60, 61, 62, 63	1201 Third Avenue in Seattle, 428
impressionist, 286, 325–330, 325, 326, 327	Pei, I. M., 427
International Style of, 80	East Wing, National Gallery of Art, 426–427, 426 pentimenti, 18
landscape, 57, 61, 152–153, 152, 157, 158, 211	
Mannerist, 61–63, 62, 63	Percy, Walker, 429
minimalist, 365, 432–433, 433	Peri, Jacopo, 168
neoclassical, 213–216, 215, 216	Dafne, 168
Northern Renaissance, 90–102, 80, 82, 83, 89, 91, 94,	Euridice, 168 peristyle, 58
95, 96, 97, 98, 100, 101	Perry, Mathew, 322
oil, color, and light in, 59	perspective:
over-all style of, 413	cubism and, 361
popular culture and, 415	linear, 91
post-impressionist, 331–335, 331, 332, 333, 334, 335	Perugino, II (Pietro Vannucci), 63
in postwar period, 410–418, 411, 412, 413, 414, 415,	Petrarch (Francesco Petrarca), 12, 31, 32, 104
416, 417, 418, 419	Philip II, king of Spain, 81, 100
as protest form, 372, 373	Philip IV, king of Spain, 161
Reformation and, 88	Phillips, Thomas, Lord Byron in Albanian Costume, 278,
rococo, 208–212, 209, 210, 211	279
romantic, 268-278, 269, 270, 271, 272, 273, 274, 275,	philosophy:
276, 277, 278	American, 229–230, 283–284
surrealist, 367-368, 367, 368, 369, 413	in Baroque period, 147–148, 172–175, 180–181
Palestrina, Giovanni Pierluigi da, 65, 167	birth of modern, 172–173
Mass in Honor of Pope Marcellus, 65	Descartes as founder of modern, 173
Palmieri, Matteo, 31	in eighteenth century, 225–228
papacy:	Neoplatonic, 20, 53, 55, 67
patronage of, 50-58	pessimistic view of human nature in, 225–228
Reformation and, 82, 83, 84	political. See political philosophy
Paracelsus, Philippus Aureolus, 89	in postwar period, 409–410, 437–439
Paris:	in Renaissance. See humanism
Georges Pompidou National Center for Arts and	in Romantic era, 257–260
Culture, 428, 428	societal unrest and, 321-323
Hôtel de Soubise, 212, 213, 213	photography, 286, 375–376, 415
Opéra, 276	Polaroid, 415
Panthéon (Sainte Geneviève), 216, 217, 223	Piano, Renzo, Georges Pompidou National Center for
Square Court of the Louvre, 99, 99	Arts and Culture, 428, 428
Parker, Charlie ("Bird"), 370	piano sonata, 219
Parmigianino (Francesco Mazzola), 63	pianoforte, 220
Madonna of the Long Neck, 63, 63	picaro, 175

Picasso, Pablo Ruiz, 360-365, 367, 368, 370, 371, 404, polyphony, 63-65 Pompeii, excavation of, 213, 215 405, 422 Pontormo, Jacopo Carucci da, 62 curtain drop for Parade, 370, 371 Deposition, 62, 63 Daniel-Henry Kahnweiler, 361-362, 363 Ponts-de-Cé, battle of, 163 Les Demoiselles d'Avignon, 361, 362 pop art, 415 Guernica, 372, 373 Pope, Alexander, 223-224 Three Musicians, 362, 364 "Epigram," 233 Pico della Mirandola, Count Giovanni, 30, 31-32, 86 Essay on Criticism, 223 nine hundred theses of, 31 Essay on Man, 223-224 Oration on the Dignity of Man, 31-32 "On Receiving from the Right Hon. the Lady Frances originality of, as thinker, 32 Shirley a Standish and Two Pens," 233 philosophy of, 32 popular music, 434–435 Pierfrancesco, Lorenzi di', 25, 26 as cultural indicator, 435 pietà theme, 373 as protest form, 434, 435 pietra serena, 56 roots of, 435 Pigalle, Jean Baptiste, Voltaire, 226, 226 sophistication of, 434-435 Pindar, 32 worldwide appeal of, 433-434 Pinter, Harold, 410 Poquelin, Jean-Baptiste. See Molière pit (ground), 105 Porta, Giacomo della, Saint Peter's Basilica, 58, 58 Plath, Sylvia, 430 portal, 58 The Bell Jar, 430 post-impressionism, 331-335, 331, 332, 333, 334, 335 Plato, 20, 32, 65 post-modernism, 430, 452-453 on music, 35-36 postwar period (1945-), 408-453 On the Sovereign Good, 20 architecture in, 424-429, 425, 426, 427, 428 Republic, 104 artist's role in, 408-409 See also Neoplatonism as Atomic Era, 408 Platonic love, origin of term, 20 global culture of, 408-409 Plautus, 105, 106 literature in, 429-430, 440-443, 443-452, 452-453 Plethon, Genisthos, 19 music in, 431-435 Plotinus, 20 painting in, 410-418, 411, 412, 413, 414, 415, 416, Plutarch, 107 417, 418, 419 Lives, 107 philosophy in, 409-410, 437-439 poetry: repression of individual in, 408, 429-430 American, 284-287 sculpture in, 418-424, 419, 420, 421, 422, 423, 424 black experience and, 429-430 war experience as subject matter in, 408 in early Renaissance, 24, 24-25 Pound, Ezra, 429 Elizabethan, 104 Poussin, Nicolas, 155-158 epic, 104, 177–178, **194–203** Et in Arcadia Ego (c. 1630), 156, 157 in High Renaissance, 57, 57 Et in Arcadia Ego (1638-1639), 157-158, 157 Mannerist, 176 The Rape of the Sabine Women, 156, 157 metaphysical, 176-177, 182-183 pragmatism, 34 neoclassical, 233 prelude: religious, 181-182 intonazione as, 65 romantic, 279-280, 283-284, 292-295 virtuoso toccata as, 69, 149, 169 in seventeenth century, 181-182, 182-203 Presley, Elvis, 434 women's consciousness and, 430 printing, 32, 86-87, 93 Polaroid photography, 415 spread of humanism and, 32, 104 political philosophy: secular humanism as, 32-34, 38-42 program music, 338-339 Prokofiev, Serge, 370, 373 in eighteenth century, 225-226 propaganda, 373 in nineteenth century, 257-260 defined, 373 in seventeenth century, 175-176, 180-181 film as, 373-375, **374** Poliziano, 32 photography as, 375-376, 376 Pollock, Jackson, 412-413, 415 Protestant Reformation. See Reformation over-all painting of, 413 Proust, Marcel, 344, 345, 405 Number 1, 412

Proust, Marcel-continued conception of artist in, 91 Remembrance of Things Past, 344 explorations during, 30, 64 psychoanalysis, 386-387 origin of term, 31 psychology, 344, 366-367 philosophy in. See humanism Ptolemy, 30 printing and, 32, 81-87, 93, 104 view of universe of, 172 twelfth-century, 31 Puccini, Giacomo, Madama Butterfly, 322 Renaissance, early, 12-47 Puritan ethic, 86 architecture in, 16-18, **16, 17, 18,** 21 Pynchon, Thomas, 430 first phase of, 12-18 Gravity's Rainbow, 408 Florence as center of, 12-18 learning in. See humanism Medici era of, 18-30 Queirolo, Francesco, 212 music in, 135-136 Deception Unmasked, 212, 212 painting in, 12–18, 13, 14, 15, 19, 19, 21, 21, 22, 22, 23-24, **23, 24,** 25-27, **25, 26, 27,** 29-30, **29** poetry in, 24, 24-25 Racine, 175, 223 sculpture in, 14–16, **15, 16,** 20–21, **20, 21** Phédre, 175 Renaissance, High, 50-77 radio, 358 architecture in, 57-58, **57, 58** Rameau, Jean Philippe, 168 beginning of, 50 Ransom, John Crowe, 403 contrasts in, 65 Raphael Sanzio, 50-52, 50, 51, 58, 65, 327 Mannerism and, 61-63, **62**, **63** Baldassare Castiglione, 65, 66 music in, 63-65, 64 Madonna of the Meadow, 50, 51 painting in, 50–52, **50**, **51**, 54–56, **54**, **55**, 59–63, **59**, School of Athens, 51-52, 51 60, 61, 62, 63 Rational humanism, 225–228 poetry in, 57, 57 Rauschenberg, Robert, 415, 417, 418 in Rome and Florence, 50-58 Monogram, 415, 415 sculpture in, 52–53, **52, 53,** 56–57, **56, 57** Rayel, Maurice, 341–342, 370 in Venice, 59-61 Bolero, 342 Renaissance, Northern, 80-143 Daphnis and Chloe, 342 architecture in, 99-100, 99 Piano Concerto in G, 342 engravings in, 84, 91-92, 92, 93 recapitulation, in sonata form, 219 humanism and, 80, 90, 104 recitative, 168 individualism emphasized in, 80 Recuyell of the Historyes of Troye, The, 32 intellectual developments during, 88-90 Reformation, 82-88 Italian ideas and artistic styles in, 80, 90 aural culture of, 88 literature in, 104–107, **109–143** Catholic practices rejected in, 82 music in, 102-104, 103 causes of, 83 painting in, 90-102, 80, 82, 83, 89, 91, 94, 95, 96, 97, cultural significance of, 86-88, 91 98, 100, 101 hymnody and, 87, 88 science in, 89-90 iconoclastic spirit of, 82, 87 sculpture in, 81 literacy and, 86, 87 Renoir, Pierre Auguste, 327, 340 outbreak and spread of, 82-83 Moulin de la Galette, 327, 327 printing and, 32 Two Girls at the Piano, 327, 328 Renaissance humanism and, 34-35, 83-86 Reuchlin, Johann, 32, 85 See also Counter-Reformation Reynolds, Sir Joshua, 211, 215, 223, 282 Rembrandt Harmensz van Rijn, 88, 165, 165-166, 178 Three Ladies Adorning a Term of Hymen, 215, 215 Jacob Blessing the Sons of Joseph, 166, **166** Ribera, Jusepe de, 160-161 The Militia Company of Captain Frans Banning Cocq The Martyrdom of Saint Bartholomew, 160-161, 161 (The Night Watch), 165, 166 Rich, Adrienne, 430 Old Self-Portrait, 166, 166 Richmond, State Capitol, 216-217, 217 Reich, Steve, 432-433 Riefenstahl, Leni, 374 The Desert Music, 432-433, 433 Olympia, 375, 375 Renaissance, 12-77 Triumph of the Will, 374 Carolingian, 131 Riesman, David, The Lonely Crowd, 408

Rifkin, Joshua, 435 Rome, ancient: drama in, 104-105, 106 Rigaud, Hyacinthe, 158 Louis XIV, 158, 158 neoclassicism and interest in, 213, 216-217, 223 Rilke, Ranier Maria, 403, 409 Renaissance and renewed interest in, 18 Rimsky-Korsakov, Nikolai, 264 Rose, Barbara, 410 Robinson, Edwin Arlington, 403 Rossini, Gioacchino, 433 William Tell, 433 rococo style, 208-213 in architecture, 212-213, 213, 214 Rothenberg, Susan, 417-418 Flanders, 418 characteristics of, 208-209 Rothko, Mark, 413 in literature, 223-224 origin of term, 208 murals for Houston chapel, 413, 414 in painting, 208-212, 209, 210, 211, 212 Rothstein, Arthur, 375 Rouault, Georges, 370 in sculpture, 212, 212 social role of, 208-209 Rousseau, Jean Jacques, 223, 225-226, 228 Le Devin du Village, 205 Rodin, Auguste, 330–331, 340 Monument to Balzac, 330, 330 "noble savage" concept of, 225 Gustav Mahler, 340, 341 The Social Contract, 225-226 The Kiss, 330, 331 Rubens, Peter Paul, 61, 161-163, 164, 168, 327 Hélène Fourment and Her Children, 162, 162 Roethke, Theodore, 429 The Journey of Marie de' Medici, 163, 163, 168 Rogers, Richard, Georges Pompidou National Center The Rape of the Daughters of Leucippus, 162, 163 for Arts and Culture, 428, 428 Russell, Bertrand, 360, 402 Rolling Stones, 435 Russia: Their Satanic Majesties Request, 435 ballet in, 370 Romantic era, romanticism, 256-316 in America, 282-287 literature in, 281, 344 architecture in, 276, 276 music in (nineteenth century), 264 Russian Revolution (October 1917), 358, 373 attachment to natural world in, 256 characteristics of, 256-257, 258 drama in, 278-279, 289-292 Saarinen, Eero, 425-426 emotional expression and subjectivity in, 256 Eternal Feminine theme in, 279 Trans World Flight Center, Kennedy Airport, exoticism in, 256 425-426, **426** fantasy and dreams in, 256 Saint Bartholomew's Day Massacre (August 24, 1572), folk elements in, 257, 264 Saint Peter's Basilica. See Rome intellectual background to, 257-260 Salinger, J. D., Catcher in the Rye, 429 music in, 260-268, 312-316 nationalism and, 257, 264 salterello, 35 Salzburg, Archbishop of, 220 novels in, 270, 280-282 San Carlo alle Quattro Fontane. See Rome opera in, 264-268 painting in, 268-276, 269, 270, 271, 272, 273, 274, Sand, George (Aurore Dupin), 263, 280, 313 **275**, 276–278, **276**, **277**, **278** autobiography, 316 Chopin's relationship with, 263, 312-316 philosophy in, 257–260 feminism of, 280, 374, 316 poetry in, 279–280, 282–284, **292–295** Lelia, 280, 314 relationship between artist and society in, 257 science in, 259-260 Lucrezia Floriani, 280, 315, 316 photograph of, 316 Sangallo, Giuliano da, Saint Peter's Basilica, 58 Castel San Angelo, 67 Contarelli Chapel, San Luigi dei Francesci, 150, 150, Sant'Elia, Antonio, 376 Sarto, Andrea del, 80 Sartre, Jean Paul, 409-410 Farnese Palace, 152, 152 "Existentialism as a Humanism," 437-439 Palazzetto dello Sport, 425, 425 Satie, Erik, 370 Pantheon, 17 San Carlo alle Quattro Fontane, 154, 155 Mercury, 371 Parade, 370 Saint Peter's Basilica, 17, 51, 57-58, 57, 58, 146, 146, satire, in eighteenth century, 223-224, 226-228, 154 Sistine Chapel, 54-56, 54, 55 233 - 253

Savonarola, Girolamo, 29–31, 35, 36	Senfl, Ludwig, 102
sermon of, 30	serialism, 343, 431
scale, in music, 170	Seurat, Georges, 331
equally tempered, 170	Sunday Afternoon on the Island of La Grande Jatte, 331.
Scarlatti, Domenico, 169	331
Schiller, Friedrich von, 223, 262	Severini, Gino, 376
Schoenberg, Arnold, 338, 342–343	Armored Train, 376, 377
atonality as innovation of, 342	Sexton, Anne, 430
Moses and Aaron, 343	Shahn, Ben, Death of a Miner, 410, 411
Piano Suite, 343, 343	Shakespeare, William, 80, 100, 105, 106–107, 168, 403
Pierrot Lunaire, 342, 343	433
Three Piano Pieces, 342	Antony and Cleopatra, 107
twelve-tone technique of, 343	Comedy of Errors, 106
Violin Concerto, 343	First Folio, 106, 106
scholasticism, Renaissance and, 12, 84	Hamlet, 67, 67, 107
Schopenhauer, Arthur, 258, 267, 321	Henry IV, Parts I and II, 106
The World as Will and Idea, 258	Julius Caesar, 106–107
Schubert, Franz, 262	King Lear, 107
Symphony No. 8 in B minor, 262	Macbeth, 107
Trios for Piano, Violin, and Cello, Op. 99 and 100, 262	The Merchant of Venice, 106
Schumann, Robert, 262, 312	Othello, 107
Schütz, Heinrich, 169	Richard II, 100, 100–101
Psalms of David, 169	Romeo and Juliet, 106
The Seven Last Words of Christ, 169	The Tempest, 107
science and technology:	Twelfth Night, 106, 115–143
abstract metaphysics versus objective demonstration	Shaw, George Bernard, 345
in, 172	Shelley, Percy Bysshe, 279–280
assemblage interest and, 421–422	"Ozymandias," 294
in Baroque period, 147–148, 172–174	Prometheus Unbound, 280
common sense versus scientific truth in, 96	"To," 294
from 1870 to 1914, 320, 321	Shostakovich, Dmitri, 433
futurism as celebration of, 376–377	Symphony No. 13, 433
music and, 431–432	Symphony No. 14, 433
photography and, 375	Symphony No. 15, 433
in Romantic era, 259–260, 286	Sidney, Sir Philip, 104
in sixteenth century, 89–90	sinopia, 18
theology related to, 172	Sistine Chapel. See Rome
transportation and communications revolutions in, 358	Sistine Choir, 63–64, 65
warfare and, 408	Sixtus IV, Pope, 54, 63
sculpture:	Smetana, Bedrich, 264
Baroque, 153–154, 153, 154	Má Vlast (My Fatherland), 264
dada and innovations in, 371	Smith, Bessie, 369, 370
early Renaissance, 14-16, 15, 16, 20-21, 20, 21, 28,	Smith, David, 418-419
29–30	Cubi I, 418, 419
in eighteenth century, 212, 212	soliloquy, 107
High Renaissance, 52–53, 52, 53, 56–57, 56, 57	sonata, 169, 218
impressionist, 330–331, 330	piano, 219
Mannerist, 63, 63	sonata form (sonata allegro form), 218-219
neoclassical, 216, 216	sonnets, 176, 182–183
Northern Renaissance, 81	Sontag, Susan, 430
in postwar period, 418-424, 419, 420	Sophocles, 32
rococo, 212, 212	Soufflot, Germain, Panthéon (Sainte Geneviève), 216,
Seattle, 1201 Third Avenue, 428	217
Segal, George, 421, 422	Spain:
The Diner, 421	Baroque art in, 159–161, 159, 160, 161
Seneca, 88, 104	history of, 81, 100, 373

Gulliver's Travels, 224 seventeenth-century literature in, 175-176, 188-194 A Modest Proposal, 224, 233-237 Spanish Armada, 100 Sydney, Opera House, 426, 426 Spenser, Edmund, 104 symphonic poems, 338-339 The Faerie Queene, 104 symphonic sketches, 341 Spinoza, Baruch, 174 sprechstimme (speech melody), 342 symphonies: classical, 218-219 Steichen, Edward, 371 impressionist, 341-342 Stein, Johann, 221 jazz incorporated into, 369-370 Stella, Frank, 417 in postwar period, 431-433 Stendhal (Marie Henri Beyle), 314 program, 338-339 Stephen, Vanessa, 402, 404 revelation of composer's life and emotions in, 339-340 Leonard Woolf, 403 romantic, 338-341 Portrait of Virginia Stephen, 403 sonata form for, 218-219 Stephen, Virginia. See Woolf, Virginia Stevens, Wallace, 429 standard orchestra for, 218 at turn of twentieth century, 338-341 Stieglitz, Alfred, 371 synthesizers, 431 Stockhausen, Karlheinz, 431-432 Moog, 431 Mixtur, 432 Sweelinck, Jan Pieterszoon, 169 Nr. 11 Refrain, 432 Test on Electronic and Instrumental Music, 432 Stoffels, Hendrickje, 166 Strachey, Lytton, 402 Talbot, William Henry Fox, 286 Tallis, Thomas, 103 Stratford-on-Avon, 106 Lamentations of Jeremiah, 103 Strauss, Richard, 338-339 Spem in Alium (Hope in Another), 103 Alpine Symphony, 339, 341 Tasso, Torquato, 104 Domestic Symphony, 339 Tchaikovsky, Peter Ilych, 339, 343 Don Juan, 339 Symphony No. 6 in B minor, 339 Hero's Life, 339 Salome, 339 technology. See science and technology Till Eulenspiegel, 339 tempietto, 58 tempo, in music, 218 Stravinsky, Igor, 338, 342, 343, 370, 430 Terence, 105 The Firebird, 343 theater. See drama Petrouchka, 343, 343 theme, musical, 219 Pulcinella, 371 The Rite of Spring, 342, 343-344, 343 Theotokopoulos, Domenikos. See El Greco Thoreau, Henry David, Walden, 283 Symphony in Three Movements, 344 use of folk subjects by, 343 Tiepolo, Giovanni Battista, 212, 268 stream-of-consciousness, 344, 360 Tillich, Paul, 373 timpani, 218 Strozzi (poet), 57, 57 Titian (Tiziano Vecelli), 60-62 Strozzi, Palla, 13 Assumption of the Virgin, 60, 61 Strozzi family, 12 Venus of Urbino, 61, 61 Sturm und Drang (Storm and Stress), 278 toccata, 65, 149, 169 style galant, 217, 220 Tolstoy, Leo, 280, 281, 405 Styron, William, 429 subject, musical, 219 Anna Karenina, 281 War and Peace, 281 Sullivan, Arthur, The Mikado, 322 tonality, 267 Sullivan, Louis, 425 tone poems, 338-339 Super Ego, 366 surrealism, 366-368, 413 tone row, 343 in film, 368 Tornabuoni, Lucrezia, 23 Freud and origins of, 366-367 Tornabuoni family, 12 in literature, 367, 368 Toscanelli, Paolo, 64 Tournachon, Gaspard (Nadar), 286 in painting, 367-368, 367, 368, 369 Transcendental Idealism, 283-285 Svevo, Italo, 403 Swift, Jonathan, 222, 224-225 Trent, Council of (1545–1564), 86, 146, 167 epitaph of, 224 triptych, 95

Tudor family, 81 Hall of Mirrors of, 159, 159, 208 Turner, Joseph Mallord William, 277-278 verse anthem, 103 The Slave Ship, 277-278, 277 Vesalius, Andreas, 89, 93 Tuscan dialect, 12 Seven Books on the Structure of the Human Body, 89 Tuscany, University of, 25 Third Musculature Table, 89-90, 90 twelve-tone technique, 343, 431 Vespucci, Amerigo, 64 Tzara, Tristan, 371 Victoria, queen of England, 259, 405 Vietnam war, 429-430 Vinci, Leonardo da. See Leonardo da Vinci Übermensch, 321 virtuoso tradition, in music, 149, 263-264 Uccello, Paolo, 22 Vitellozzi, Annibale, Palazzetto dello Sport, 425 The Rout of San Romano, 22-23, 22 Vittoria, Tommaso Luigi da, O Vos Omnes, 65 Unamuno, Miguel de, 409 Vivaldi, Antonio, 171, 338 unconscious, the, 366 The Four Seasons, 171, 338 Freud's theory of, 360 Voltaire (François Marie Arouet), 223, 226-228 surrealism and, 366-368 Candide, 226, 227, 237-253 United States. See America Lettres philosophiques, 226 uomo universale, 66 Vonnegut, Kurt, Jr., 430 Urban VIII, Pope, 173 usury, 81 Utzon, Jörn, 426 Wagner, Richard, 264, 266-268, 266, 433 Sydney Opera House, 426 Gesamtkunstwerk theory of, 266 The Ring of the Nibelung, 269 Tristan and Isolde, 267-268, 267, 342 van Dyck, Anthony, 161, 164-165 Waldmüller, Ferdinand, Ludwig van Beethoven, 260, 260 Marchesa Elena Grimaldi, Wife of Marchese Nicola Waldstein, Count, 261 Cataneo, 163-164, 163 Walker, Alice, 430 van Eyck, Jan, 57 The Color Purple, 430 Giovanni Amolfini and His Bride, 19, 19 Waller, Fats, 369 van Gogh, Vincent, 333-335, 340, 404 London Suite, 369 The Night Café, 334, 334 Walpole, Horace, letter of, 228 Portrait of Dr. Gachet, 335, 335 Warhol, Andy, 415-417 The Starry Night, 333, 334 Mick Jagger, 416 Sunflower, 404 Washington, D.C., East Wing, National Gallery of Art, variations, as musical form, 169 427-428, **427** Vasari, Giorgio, 14, 26 Watteau, Jean Antoine, 209, 211, 224 Lives of the Artists, 14 Pilgrimage to Cythera, 209, 209 Velásquez, Diego, 61, 161, 165, 327 Weber, Max, 86 Las Meninas (The Maids of Honor), 161, 161, 165, 269, Weelkes, Thomas, 104 276 Noel, adieu, 104, 104 Venice: Weill, Kurt, Dreigroschenoper (The Threepenny Opera), cosmopolitanism of, 59 easel painting in, 59-61, 59, 60, 61 Welty, Eudora, 429 Venus pudica figures, 26 Weston, Edward, 375 Verdi, Giuseppe, 264–266 Whitman, Walt, 283-284 Luisa Miller, 265 Leaves of Grass, 283, 308-312 Nabucco, 265 Wiesel, Elie, 429 Otello, 265, 268 Night, 429, 440-443 Rigoletto, 265 Wilde, Oscar, Salome, 339 La Traviata, 265, 266 Willaert, Adrian, 65 Il Trovatore, 265 Williams, William Carlos, 429, 432-433 Vergil, 177, 223 Wilson, Robert, 433 Aeneid, 36 Akhnaten, 433 Vermeer, Jan, 164-165 Einstein on the Beach, 433 Woman Reading a Letter, 164-165, 164 Satyagraha, 433

Winckelman, Johannes, 213

Versailles, Palace of, 158-159, 158

women:

poetry and consciousness of, 430 role of, in literature, 280, 314, 316, 345–346, 403–404 *See also* feminism

woodcuts, 91, 92

Woolf, Leonard, 360, 402–405, 403 Woolf, Virginia, 360, 402–405, 403

diary of, 376

The Common Reader, 403

Mrs. Dalloway, 360

A Room of One's Own, 360, 403, 404

Three Guineas, 360, 403, 404

To the Lighthouse, 360

Wordsworth, William, 277, 279

"Lines Composed a Few Miles Above Tintern

Abbey," 292-294

World War I, 320, 342 societal unrest leading to, 320-323, 376

cultural significance of, 358

World War II, 369, 373
migration of artists and intellectuals to America
during, 410
See also postwar period

work ethic, 86

Wright, Richard, Native Son, 430

Yeats, William Butler, 358, 376 "The Second Coming," 358, **358** Yevtushenko, Yevgeny Alexsandrovich, 433

Zappa, Frank, 434-435

Zappa, Frank, and the Mothers of Invention, Freak Out,

Zell, Catherine, letter by, 85

Zell, Matthew, 85

Zen philosophy, music and, 432

Zwingli, Ulrich, 82

Literary Acknowledgments

37-38 From "Oration on the Dignity of Man" by Pico della Mirandola, translated by Elizabeth Forbes, in Renaissance Philosophy of Man, edited by Cassirer, et al. Reprinted by permission of The University of Chicago Press. Copyright © 1948 University of Chicago. 38-42 From The Prince by Niccolò Machiavelli, translated by Allan Gilbert, in Niccolò Machiavelli: The Chief Works and Others, Vol. I, pp. 57-67. Copyright © 1965 Allan H. Gilbert. Reprinted by permission. 42-47 From "The Praise of Folly" by Desiderus Erasmus, translated by John P. Dolan in The Essential Erasmus. Copyright © by John P. Dolan. Reprinted by arrangement with The New American Library, Inc., New York. 69-74 From The Book of the Courtier by Baldassare Castiglione, translated by George Bull (Penguin Classics, 1967, pp. 212-223). Copyright © 1967 by George Bull. Reproduced by permission of Penguin Books, Ltd. 74-77 From Autobiography by Benvenuto Cellini, translated by George Bull (Penguin Classics, 1956, pp. 302-309). Copyright © 1956 by George Bull. Reproduced by permission of Penguin Books, Ltd. 109-115 Reprinted from The Complete Works of Montaigne: Essays, Travel Journal, Letters, translated by Donald M. Frame, with the permission of the publishers, Stanford University Press. Copyright © 1943 by Donald M. Frame; copyright © 1948, 1957 by the Board of Trustees of the Leland Stanford Junior University. 181-182 "On the Wounds of our Crucified Lord" by J.R. Crashaw from The Complete Poetry of Richard Crashaw by G.W. Williams, copyright © 1970 by Doubleday, a division of Bantam, Doubleday, Dell Publishing Group, Inc. Used by permission of the publisher. 183-188 "Moliere's Tartuffe," Act III from Moliere: Four Comedies, copyright 1954, © 1955, 1961. 1962, 1963, 1965, 1971, 1977, 1978, 1982 by Richard Wilbur, and copyright © 1978 by Harcourt Brace Jovanovich, Inc., reprinted by permission of the publisher. 188-194 From The Adventures of Don Quixote by Miguel de Cervantes Saavedra, translated by J.M. Cohen (Penguin Classics, 1950, pp. 524-538). Copyright © 1950 by J.M. Cohen. Reproduced by permission of Penguin Books, Ltd. 194-203 From "Paradise Lost," Book 1, in John Milton: Complete Poems and Major Prose, edited by Merritt Y. Hughes. Reprinted with permission of Macmillan Publishing Company. Copyright © 1957, 1985 by Macmillan Publishing Company. 237-253 From Candide and Other Writings

by Voltaire, edited by Haskell M. Block. Copyright © 1956 by Random House, Inc. Reprinted by permission of Random House, Inc. 289-292 From Faust by Johann Wolfgang von Goethe, translated by Leonard Salter (copyright). Reproduced by permission of Leonard Salter. 295-302 From Lost Illusions by Honoré de Balzac, translated by Herbert I. Hunt (Penguin Classics, 1971, pp. 199-215). Copyright © 1971 by Herbert J. Hunt. Reproduced by permission of Penguin Books, Ltd. 350-353 From "A Doll's House" by Henrik Ibsen, translated by Eva LeGallienne, in Six Plays by Henrik Ibsen. Copyright © 1957 by Eva LeGallienne. Reprinted by permission of Random House, Inc. 379–380 "The Hollow Men" from Collected Poems 1909-1962 by T.S. Eliot. Copyright 1936 by Harcourt Brace Jovanovich, Inc.; Copyright © 1963 by T.S. Eliot. Reprinted by permission of the publisher. 380-389 From Ulysses by James Joyce. Copyright © 1914, 1918 by Margaret Caroline Anderson and renewed 1942, 1946 by Nora Joseph Joyce. Reprinted by permission of Random House, Inc. 389-394 From The Trial, Definitive Edition, by Franz Kafka, translated by Willa and Edwin Muir, revised and with additional materials translated by E.M. Butler. Copyright 1936, © 1956 and renewed 1965, 1984 by Alfred A. Knopf, Inc. Reprinted by permission of Alfred A. Knopf, Inc. 394-401 Chapters 16 and 17 from Brave New World by Aldous Huxley. Copyright 1932, © 1960 by Aldous Huxley. Reprinted by permission of Harper & Row. Publishers, Inc. 437-439 "Existentialism as a Humanism" by Jean Paul Sartre in Essays in Existentialism, edited by Wade Baskin. Copyright © 1965 by the Philosophical Library, Inc. Reprinted by permission of Citadel Press, Inc. 440-443 From Night by Elie Wiesel, translated from the French by Stella Rodway. English translation © MacGibbon & Kee, 1960. Reprinted by permission of Hill and Wang, Inc., a division of Farrar, Straus and Giroux, Inc. 443-452 "Revelation" from Everything That Rises Must Converge by Flannery O'Conner. Copyright © 1964, 1965 by the Estate of Mary Flannery O'Conner. Reprinted by permission of Farrar, Straus and Giroux, Inc. 452-453 From The Book of Sand by Jorge Luis Borges, translated by Norman Thomas di Giovanni. Copyright © 1971, 1975, 1976, 1977 by Emece Editores, S.A. Reprinted by permission of the publisher, E.P. Dutton, a division of Penguin Books USA, Inc.

Photographic Credits

The authors and publisher wish to thank the custodians of the works of art for supplying photographs and granting permission to use them. Photographs have been obtained from sources noted in the captions, unless listed below.

A/AR: Alinari/Art Resource, New York

BAM/AR: Bildarchiv Marburg/Art Resource, New York

CNMHS: Caisse Nationale des Monuments Historiques et des Sites, Paris

G/AR: Giraudon/Art Resource, New York

JA: Jorg P. Anders, Berlin

LCG: Leo Castelli Gallery, New York NYPL: New York Public Library PR: Photo Researchers, New York

RMN: Service de Documentation Photographique de la Reunion des Musees

Nationaux, Paris

S/AR: Scala/Art Resource, New York

References are to figure numbers (boldface).

Cover: S/AR

Chapter 10 10.1: S/AR. 10.2: BAM/AR. 10.3: A/AR. 10.4: S/AR. 10.5, 10.6: A/AR. 10.7: S/AR. 10.8, 10.9: George Rich in Brunelleschi: Studies of His Technology and Inventions by Frank Prager and Gustina Scaglia © 1970, M.I.T. Press, Cambridge, Massachusetts. 10.10: AR. 10.11, 10.13: A/AR. 10.14: Archivo Fotografico Soprintendenza, Florence. 10.15: A/AR. 10.16: S/AR. 10.17, 10.18: Soprintendenza alle Gallerie, Florence. 10.19, 10.20, 10.21: S/AR. 10.23: A/AR. 10.24: Lauros/G/AR. 10.25: A/AR. 10.26: Sansaini/AR. 10.27: S/AR.

Chapter 11 11.2, 11.3: S/AR. 11.6: A/AR. 11.8: S/AR. 11.9, 11.10: A/AR. 11.11: Bramante, Sangallo and Michelangelo floor plans from Paul Le Tarouilly, Vatican, Vol. I, "The Basilica of St. Peter," Academy Editions, London, 1953; Maderna floor plan, 1606; A/AR. 11.12, 11.13: A/AR. 11.14: G/AR. 11.15: A/AR. 11.16: S/AR. 11.17: A/AR. 11.18: Scala/AR. 11.19: A/AR. 11.20: RMN. 11.21: A/AR.

Chapter 12 12.1: Photo Meyer, Vienna. 12.3: A/AR. 12.4: G/AR. 12.8: RMN. 12.10: Artothek. 12.14: G/AR. 12.15, 12.18: S/AR. 12.21: AR. 12.22: RMN. 12.23: Gerold Jung/Image Bank. 12.24: RMN. 12.25: Courtauld Institute photograph used by permission of the Marquess of Salisbury. 12.26: RMN. 12.29: Reprinted by permission of Coward-McCann, Inc. from Shakespeare and the Players by C. Walter Hodges. Copyright 1948 by C. Walter Hodges/NYPL.

Chapter 13 13.1: A/AR. 13.2: Pan American World Airways. 13.3: S/AR. 13.4, 13.5, 13.6, 13.7, 13.8, 13.9, 13.10, 13.11, 13.12: A/AR. 13.13: JA. 13.16: RMN. 13.19: Courtesy of The French Government Tourist Office, New York. 13.20: CNMHS. 13.21, 13.22: MAS, Barcelona. 13.23: A/AR. 13.24: MAS, Barcelona. 13.25, 13.27: RMN. 13.29: Foto A. Dingjam. 13.35: S/AR. 13.36: Hans Petersen, Copenhagen.

Chapter 14 14.1: RMN. 14.6: A/AR. 14.8: MAS, Barcelona. 14.9: A/AR. 14.10: H. 14.11: A.F. Kersting, London. 14.12: G/AR. 14.13: AR. 14.15: S/AR. 14.16: Pierre Berger/PR. 14.17: Ward Allan Howe/Ewing Galloway, New York. 14.18: Austrian State Library, Vienna. 14.19: © Beth Bergman. 14.20: RMN. 14.21: G/AR. 14.22: Dementi Foster Studios.

Chapter 15 15.2: Walter Rawlings/Robert Harding Picture Library. 15.3: Archiv fur Kunst und Geschichte, Berlin. 15.4: RMN. 15.5: Collection of Henry Wisneski, New York. 15.6: Copyright © Beth Bergman 1981, New York. 15.8: Festspiele Bayreuth/Siegfried Lauterwasser/German Information Center, New York. 15.9: A/AR. 15.10: MAS, Barcelona. 15.11, 15.12: A/AR. 15.13, 15.14, 15.15: RMN. 15.16: S/AR. 15.17: G/AR. 15.20: S/AR. 15.21: A.F. Kersting, London. 15.22: BPK. 15.27: NYPL. Interlude p. 313, left: H. Roger-Viollet, Paris; right © Francoise Foliot, Paris. p. 316, left: H. Roger Viollet, Paris; right, CNMHS.

Chapter 16 16.1: Paul Wiemann, Recklinghausen. 16.3: Jack Boucher, National Park Service. 16.4: G/AR. 16.9, 16.10, 16.11: RMN. 16.16: Photo by Bruno Jarret, Paris. Copyright 1990 ARS N.Y./ADAGP. 16.26: Jacques Lathion. 16.27: MAS, Barcelona. 16.29: JA. 16.31: Photo by Bruno Jarret, Paris. Copyright 1990 ARS N.Y./ADAGP.

Chapter 17 17.2: Robert E. Mates. 17.7: David Heald. 17.8 Robert E. Mates. 17.18: Phoenix Films, New York. 17.19: The Library of Congress, Washington, D.C.

Chapter 18 18.3: Hirschl and Adler Galleries, Inc., New York. 18.7: Hickey-Robertson. 18.10: LCG. 18.11: Photo © 1985 Harry Shunk, New York. 18.12: Eric Pollitzer/LCG. 18.14: eeva-inkeri, New York. 18.16: Innervisions, New York. 18.17: © David Hockney 1986. 18.22: Al Mozell/The Pace Gallery, New York. 18.23: Robert Mates and Paul Katz. 18.25: © Edward Kienholz. 18.28: Copyright © Christo 1972. Photo

Harry Shunk. 18.29: Photo courtesy Marlborough Gallery. 18.30: Murray Spitzer/OK Harris Works of Art, New York. 18.31: David Heald. 18.32: A/AR. 18.33: Ezra Stoller © ESTO, Mamaroneck, New York. 18.34: Guido Alberto Rossi/The Image Bank. 18.35, 18.36: Ezra Stoller © ESTO, Mamaroneck, New York. 18.38: Dimitri Kessel, Paris. 18.39: James E. Housel/ Kohn Pedersen Fox Associates.

Works by Kollwitz, Nolde, Mondrian, Shahn, Motherwell, Johns, Rauschenberg, Kelly, Smith, Segal, Abakanowicz: © the artist/VAGA New York 1989.

Works by Picasso, Gris, Le Corbusier: Copyright 1990 ARS N.Y./SPADEM. Works by Braque, Chagall, Kandinsky, Calder, Duchamp, Severini: Copyright 1990 ARS N.Y./ADAGP. Works by Matisse: Copyright 1990 Succession H. Matisse/ARS N.Y. Works by Dali: Copyright 1990 Demart Pro Arte/ARS N.Y. Work by Magritte: Copyright 1990 C. Herscovici/ARS N.Y. Work by Klee: Copyright 1990 ARS N.Y./Cosmopress. Work by Pollock: Copyright 1990 Pollock-Krasner Foundation/ARS N.Y. Work by Rothko: Copyright 1990 Kate Rothko Prizel and Christopher Rothko/ARS N.Y. Work by Warhol: Copyright 1990 The Estate and Foundation of Andy Warhol/ARS N.Y. Work by Stella: Copyright 1990 Frank Stella/ARS N.Y. Fig. 13.20 and Interlude p. 316: Copyright 1990 ARS N.Y./ARCH. PHOT. PARIS.